1997
PHOTOGRAPHER'S
MARKET

Managing Editor, Annuals Department:
Constance J. Achabal.
Production Editors: Barbara Kuroff and Alice P. Buening
Cover Illustration: Celia Johnson

This 1997 hardcover edition of *Photographer's Market* features a "self-jacket" that eliminates the need for a separate dust jacket. It provides sturdy protection for your book while it saves paper, trees and energy.

International Standard Serial Number 0147-247X
International Standard Book Number 0-89879-743-8

Attention Booksellers: This is an annual directory of F&W Publications. Return deadline for this edition is December 31, 1997.

1 9 9 7
PHOTO GRAPHER'S MARKET

WHERE & HOW TO SELL YOUR PHOTOGRAPHS

EDITED BY

MICHAEL WILLINS

WRITER'S DIGEST BOOKS
CINCINNATI, OHIO

Contents

The Markets

© Design & More Inc.

Page 97

112 Book Publishers

*If you're looking to sell stock images, attract assignments or sign book contracts, these listings are for you. One of photography's masters, **William Wegman**, discusses book projects on **page 127**.*

151 Businesses & Organizations

Listings in this section use photos for a variety of projects, such as annual reports, brochures and inhouse newsletters. You will also find some nonprofit organizations that could use your skills and generosity.

167 Galleries

*Fine art photography has become a collectible art form in recent years and many of these markets would love to showcase your work. On **page 196**, **Peter MacGill** of Pace/MacGill Gallery in New York City guides you through the process of getting an exhibition.*

Courtesy Lizardi/Harp Gallery, Los Angeles

Page 190

207 Paper Products

Photos of floppy-eared pets and cute, sloppy kids are perfect for these markets. These buyers are calendar and greeting card companies, game producers and makers of gift items.

222 Publications

222 Consumer Publications

*This section is filled with photo editors who want to put your pictures in print. It also contains interviews with three of the photo industry's foremost professionals—1996 Photographer of the Year **Eugene Richards (page 238)**, Life magazine Photo Editor **Barbara Baker Burrows (page 277)**, and Sports Illustrated photographer **John McDonough (page 293)**.*

339 Newspapers & Newsletters

*If you like tight deadlines and covering breaking news, this section is for you. And if you can't find inspiration from this year's Insider Report subject, photographer **Carol Guzy** of the Washington Post, you're not trying. Guzy is a two-time Pulitzer Prize winner (including 1995) and her interview appears on **page 347**.*

©Mike Copeman

Page 352

357 Special Interest Publications

These periodicals cover distinct subjects—some cater to animal lovers, other highlight hobbies. Perhaps your photographs are right for their pages.

396 Trade Publications

Various occupations have magazines specifically designed to supply workers with job-related information. Journals that cover everything from real estate management to commercial fishing.

449 Record Companies

Once you've photographed the musical stars of today what can you do with the photos? Simple. Sell them to companies listed here for publicity pieces, tape cassette or CD covers.

Page 467

©David Hodgson/Barnaby's Picture Library

From the Editor

Charles Porter IV, 1996 Pulitzer Prize winner for Best Spot News Photograph. Occupation . . .bank employee. This fact might not seem fair to die-hard photographers with years of experience and thousands of dollars invested in equipment and film processing—here comes an amateur stumbling upon a scene and winning one of the most prestigious awards possible. Twenty years from now when people remember the bombing of the federal building in Oklahoma City, Oklahoma, they will visualize a fireman holding the body of a bloody baby. A painful memory courtesy of Mr. Porter.

Photos have power. They can take us places and show us things, often things we'd rather not see. As you turn these pages keep in mind, it doesn't always matter who snaps the shutter. What matters is the finished product.

We're excited about this edition of *Photographer's Market* for several reasons. First, along with the 400 new markets that are listed, we have made some useful changes. Several of these modifications come as a result of recent trends that are drawing buyers into digital imagery. Markets that are interested in receiving digital images from photographers can be found on page 581 in the new Digital Markets Index. You'll also notice that many of the listings have added website addresses and e-mail numbers. Check out some of their Internet sites to learn more about these markets. Some of the more interesting webpages that provide marketing assistance and technical information for photographers are highlighted in the new Websites of Interest on page 572.

This edition also excites me because the interview subjects are tremendous. In the five years I've edited this book, there never has been such a group of talented, well-known professionals who understand the photography business and the road to success.

We lead off with a special feature on one of the industry's most acclaimed masters, photographer **Eddie Adams**, of New York City. A 1969 Pulitzer Prize winner best known for his war coverage in Vietnam, Adams photographs celebrities and heads-of-state from all over the world. Beginning on page 27, he discusses his move into advertising and digital technology, and his workshop, Barnstorm, which attracts many of photography's rising stars.

Our Insider Reports are loaded. On page 127, **William Wegman** discusses his weimaraners and what he does to keep himself, and the dogs, interested in book projects. On page 238, 1996 Picture of the Year-winnner **Eugene Richards** offers insight into hard-hitting journalism and what it takes to tackle genuinely gut-wrenching stories. To give you a double whammy of information relating to photojournalism, we spoke with 1995 Pulitzer Prize winner **Carol Guzy** of the *Washington Post*. Guzy's interview appears on page 347 and she dispels any misconceptions about the "glamour" of her profession. On page 293 photographer **John McDonough** of San Diego, California, discusses his work with *Sports Illustrated* and what it takes to shoot the sports stars of today. And if you are still honing your talents, check out the interview with photographer/workshop instructor **John Sexton**, on page 556.

While the crop of photographers is amazingly talented, so, too, is the list of image buyers and brokers. One of the largest advertising agencies in the U.S. is TBWA/Chiat/Day and, on page 40, we have insight from the firm's Director of Art Buying **Amy Moorman**. If you want to learn about fine art photography, who better to teach you than one of the nation's top gallery directors, **Peter MacGill** of Pace/Wildenstein/

MacGill. His interview appears on page 196. And for those of you wanting to learn more about getting published in major magazines, we interviewed *Life* Photo Editor **Barbara Baker Burrows**, page 277.

And, to complete our lineup of interviews, we have two stories on subjects from outside the United States. Toronto-based photographer **Derek Shapton**, whose unique style is becoming extremely popular with art directors in Canada, shares his thoughts on page 101. Finally, if stock agency representation interests you, turn to page 510 and read the comments of **Alberto Sciama**, managing director for Pictor International Ltd. in London.

While the interview subjects are outstanding, there are other articles and more changes from our 1996 edition that will assist you in your marketing endeavors. Pages 3-26 are filled with articles covering various business aspects of photography, such as how to package your submissions, pricing and negotiating, understanding copyright, taxes and insurance. We also have an article on page 12 entitled "Make the Most Out of Rejection," which came from one of our readers, Joseph Rogate of Seaford, New York. Rogate gives some helpful tips for those photographers who are frustrated by rejection letters and wasted postage.

In light of the growing electronic movement we decided to give you some input about how to price your work to digital markets. Writer Gail Deibler Finke of Cincinnati, Ohio, gives useful tips from industry leaders who understand how to price electronic images. Check out the article on page 21, "Negotiating Prices in the Digital Environment."

Photographer's Market also went through a partial redesign. We've changed the look of our interviews, sidebars and feature articles—even our cover has a new font. In the indexes at the back of this book, notice the asterisks and codes beside certain entries. The asterisks indicate new markets in this edition while the two-letter codes are for listings that appeared in 1996, but don't appear this year.

As you work through this book, let us know what you find out. Often our readers provide the best insight into the photography markets, so don't be afraid to drop us a line. We're here to help—whether your a long-time professional or an amateur seeking your first sale.

Michael Willins

Michael Willins
e-mail: MikeW99722@aol.com

How To Use This Book to Sell Your Work

Every year, we attempt to turn *Photographer's Market* into a more useful tool for you. We want you to have success locating dozens of potential clients and, eventually, selling some photos. Seeing your work in print is our reward and we hope you develop some long-lasting clients from the markets you contact. But what, exactly, is the best way to use this book to your advantage?

First, know what kinds of buyers you want to reach. This can be determined by the subjects you photograph, your location, or, perhaps, your style of living. The key is to concentrate on what you like to do and market your efforts accordingly. For instance, if you love the outdoors and often take photographs on nature walks, find publications that are interested in nature photos. To simplify such searches, we have once again included a Subject Index that begins on page 583. This index lists potential buyers in 24 different categories and makes it easy to find publications or newspapers to which you can sell your images.

As mentioned, the Subject Index contains a couple dozen categories, but these topics may seem rather broad. For more specific information about what markets prefer from freelancers, check out the "**Needs:**" subhead within listings. The information contained under this subhead lets you know exactly what photos each market wants and often gives you an estimate of how much freelance material is used by each market. For example, the listing for *Nevada Magazine* states:

> **Needs:** Buys 40-50 photos/issue; 30-35 supplied by freelance photographer. Buys 10% of freelance on assignment, 20% from freelance stock. Nevada stock photos only—not generic. Towns and cities, scenics, outdoor recreation with people, events, state parks, tourist attractions, travel, wildlife, ranching, mining and general Nevada life. Must be Nevada subjects. Captions required; include places, dates and names if available.

After you've found potential buyers it's important to know how to submit your material. This can be investigated in several ways. If you are into digital imagery and have many of your photos in electronic format, turn to the Digital Markets Index located on page 581. New this year, this index lists those markets that are interested in acquiring photos digitally, either on CD-ROM, computer disks or via online services. If you want more specific information about how to approach markets, read the information under "**Making Contact & Terms:**" within listings. This subhead spells out submission information. For example, book publisher Loompanics Unlimited gives you these options for contacting them:

> **Making Contact & Terms:** Query with samples. Query with stock photo list. Provide tearsheets to be kept on file for possible future assignments.

Each listing also provides information about the preferred formats that are accepted (e.g., transparencies or prints) and whether the market accepts black & white, color, or both. One important note here, do not submit originals unless you're sure a buyer plans to use your work and needs originals for production purposes. And, when submitting

black & white images, never send the negatives. Duplicate slides, tearsheets and prints are replaceable if an image is damaged or lost. Originals aren't!

Now that you know what to send and how to send it, you should find out something about the company you are approaching. Many of the markets offer photo guidelines to freelancers who send self-addressed stamped envelopes (SASEs). If you are unfamiliar with a publication, send away for recent sample copies to see if your work is appropriate. This kind of research is essential, especially if the client is unfamiliar with your work.

For the past several years we also have included editorial comments within listings. Denoted by bullets (●), these comments give you extra information about markets, such as mergers that have taken place, company awards and digital technology that businesses are adopting. For instance, the editorial comment for *Marlin Magazine* states:

●This publication is using more high-resolution enhancements, blends, collages, etc. Also, at *Photographer's Market* press time, *Marlin* was in the process of creating a policy for purchasing electronic rights to images.

Not all of the marketing advice comes from within the listings. You also will find helpful information in the feature articles throughout the book. In the first 33 pages we have stories that should improve your business knowledge. Various topics are covered, such as pricing, copyright, proper ways to submit and store images, and insurance. In many of the sections we also include interviews, called Insider Reports, with buyers and fellow photographers.

Finally, while payment is important, don't judge markets solely on the basis of money. Through negotiations you may find that stated pay ranges are flexible. Markets that failed to provide payment information contain the code "NPI," which stands for "No payment information given."

Minding Your Own Business

Anyone who sells his photographic skills for a living knows that setting exposures and composing images are only part of being a professional photographer. Success comes as much from business knowledge as it does from understanding the technical aspects of the craft. Maybe even more. After all, what good is having great images if you have no idea how to market them or what they are worth to clients?

This article outlines some of photography's business basics. The goal is to provide you with some understanding of how to organize your images, create standard business forms and market your work. We also want you to think about things like taxes and insurance, which must not be overlooked if you plan to sell photos.

After you've read this article, consider creating a business plan for yourself. Think about what types of subjects you like to shoot and establish some goals. Ask yourself, "Who is going to buy what I'm selling?" Then scour the listings in this book and develop a client list based on the type of work you shoot. How much money do you want to make from your photography? What kind of financial commitment do you want to make toward your business in the way of self-promotion and/or equipment? Knowing where you want to end up, and periodically reminding yourself of your goals, will help you when conducting business.

STORING IMAGES

There is no magic formula for filing prints and transparencies. The key is to have a system in which images can be easily located when necessary. Perhaps you need to find an image for a portfolio that you want to ship to a prospective client. Or maybe a client calls and asks to use a specific shot. Unless you can find these images quickly, you may lose valuable sales.

In order to have easy access to images you must consider two things: a simple coding system and proper storage of your work. Your coding system can be designed any way you want as long as you remember what each code means. For example, let's create a code for a photo that was taken in September 1996 of elk in the Wyoming portion of Yellowstone National Park. Your code might look something like this: 996-WWY-0001. Reading this code from left to right, the first "9" stands for the month; "96" stands for the year; "W" refers to wildlife; "WY" is a state code for Wyoming; and "0001" means the shot was the first one cataloged in the month of September.

For slides, your code should be placed on the slide mount along with your copyright notice (see Understanding the Basics of Copyright on page 24). Larger transparencies should have plenty of room for a small label on which you can write this information. For prints, write codes and copyright information on labels and place these labels on the back of each print.

Writing this information by hand can be extremely tedious and time consuming. If you have a computer consider buying slide labeling software that helps you organize your images. You can get by with database software that prints onto labels, but, in most instances, the capabilities are limited compared to software that is designed for slide labeling.

You might want to check out the Norton Slide Captioning System, created by Boyd Norton of Evergreen, Colorado. This software not only allows you to neatly insert codes

onto labels, but you also can write captions and easily insert your copyright notice. For information, contact Boyd Norton, Norton Slide Captioning System, P.O. Box 2605, Evergreen CO 80437-2605, (303)674-3009. Cost of this software is $99 (plus shipping and handling). It also can be purchased as part of a package with another software called Freelancin', which helps users track submissions. The cost of Freelancin' is $149 (plus shipping and handling).

Once all your images are coded they must be stored properly. Plastic, archival quality sheets are perfect for most transparencies, negatives and prints. Simply tuck your work inside appropriate sheets and organize them inside a filing cabinet or in three-ring binders. Not only are these handy storage methods, but proper storage keeps mold from attacking and ruining film.

As you look through this year's *Photographer's Market* you will notice that many buyers are interested in acquiring work in digital format (see the new Digital Markets Index beginning on page 581). If you have a large number of photographs, you might consider digital storage, either on SyQuest cartridges, diskettes or on CD-ROM. More and more buyers are requesting digital versions of photos and, as technology speeds forward, it's possible that digital transmission of images could become standard.

Storing images digitally, however, does require a major financial commitment. Typi-

PROTECT YOUR LIVELIHOOD

We've all heard the expression "Better safe than sorry," and if you plan to build a business this phrase goes doubly for you. What would happen to your business if a fire swept through your office? What if someone stole your computers? Maybe you were injured and couldn't work. Could your business withstand these setbacks?

Proper planning can keep you from taking that "major hit." Talk with financial planners and insurance agents about protecting your livelihood. From an insurance standpoint, here are a few points to consider:

● Devise an apt system of storage for transparencies, valuable papers and backup computer disks. Consider opening a safety deposit box for duplicate transparencies and other irreplaceable information. Then if disaster strikes in the office you won't be totally devastated. Some professionals place transparencies in fireproof safes.

● Make sure you have adequate liability coverage and worker's compensation. If someone is injured, perhaps a model who is hit by a falling studio light, you must be insured.

● Make sure you have adequate health/disability coverage. If you are injured or become ill and can't work, the effects on your business could be devastating. In the case of disability insurance, however, take a close look to see if you will be suitably covered. A disabled stock photographer, for example, who has a large file of images, could draw an income from stock sales even though he is unable to shoot. By selling stock he might be ineligible for disability benefits.

● Unfortunately, most insurance companies will only pay for the cost of replacing film if images are destroyed or lost. They consider the market value of an image "intangible," and, therefore, uninsurable.

● When acquiring property insurance make sure you are covered if you shoot on location. You don't want to drop a camera during an aerial shoot, for example, and then discover that your insurance only covers equipment in your studio.

● Finally, consider joining trade organizations that offer members group insurance packages. The cost of membership could be worth the insurance benefits you receive.

cally, the cost of scanning slides onto CDs is $1-3 per image. Research this area carefully before you decide to electronically archive your images. Weigh the value of digital storage to you and your clients against the expenses of electronic archiving.

BUSINESS FORMS

Just as labels will make you appear more professional in the eyes of potential clients, so, too, will business forms. Most forms can be reproduced quickly and inexpensively at most quick-print services. If you have a computer system with some graphic capabilities you can design simple and fairly attractive forms that can be used every day.

When producing detailed contracts, remember that proper wording is imperative. You want to protect your copyright and, at the same time, be fair to clients. Therefore, it's a good idea to have a lawyer examine your contracts before using such forms.

Several photography books include sample forms if you want to get an idea what should be included in your documents. There is a list of suggested reading at the back of this book (see page 574). Check your local library or bookstore for these resources. You also might want to order FORMS, a booklet of sample forms that was produced by the American Society of Media Photographers. To order copies of FORMS write to ASMP, Washington Park, Suite 502 Washington Rd., Princeton Junction NJ 08550-1033. (609)799-8300. The price is $19.95 plus $2 shipping and handling.

The following forms are useful when selling stock photography, as well as when shooting on assignment:

Delivery Memo—This document should be mailed to potential clients along with a cover letter when an initial submission is made. A delivery memo provides an accurate count of the images that are enclosed and it provides rules of usage. Ask clients to sign and return a copy of this form if they agree to the terms you've spelled out.

Terms & Conditions—Also known as a boilerplate, this form outlines in fine detail all aspects of usage, including copyright, client liability and a sales agreement. You also should include a statement that protects you from having your work digitally stored and/or manipulated. Often this form is placed on the back of a delivery memo.

Invoice—This is the form you want to send more than any of the others, because mailing it means you have made a sale. The invoice should provide clients with your mailing address, an explanation of usage and amount due (include a due date for payment). You also should include a business tax identification number or social security number.

Model/Property Releases—Get into the habit of obtaining releases from anyone you photograph. They increase the sales potential for images and can protect you from liability. A model release is a short form, signed by the person/people in the photo, that allows you to sell the image for commercial or editorial purposes. (See sample page 8). The property release does the same thing for photos of personal property. When photographing children, remember that a parent or guardian must sign before the release is legally binding. In exchange for signed releases some photographers give their subjects copies of the photos, others pay the models. Figure out a system that works best for you. Once you obtain a release, keep it on file.

You do not need a release if the image is being sold editorially. However, some magazine editors are beginning to require such forms in order to protect themselves. You always need a release for advertising purposes or for purposes of trade and promotion. There are times when it is impossible to get a release. In those cases, remember that the image only can be used editorially.

If you shoot photographs of private property, and you want to use these photographs for commercial purposes, secure a property release from the owner of the property. If in doubt, check it out! The Volunteer Lawyers for the Arts (VLA) is a nonprofit, tax-exempt

organization based in New York City, dedicated to providing all artists, including photographers, with sound legal advice. The VLA can be reached at (212)319-2787 or write to: Volunteer Lawyers for the Arts, 1 E. 53rd St., 6th Floor, New York NY 10022.

Finally, if you are traveling in a foreign country it is a good idea to carry releases written in that country's native language. To translate releases into a foreign language, check with embassies or professors at a college near you.

SAMPLE MODEL RELEASE

I hereby grant (photographer), his/her legal representatives and assigns (including any agency, client, or publication), irrevocable permission to publish photographs of me, taken at _____. These images may be published in any manner, including advertising, periodicals, greeting cards and calendars. Furthermore, I will hold harmless aforementioned photographer, his/her representatives and assigns, from any liability by virtue of any blurring, distortion or alteration that may occur in producing the finished product, unless it can be proven that such blurring, distortion or alteration was done with malicious intent toward me.

I affirm that I am more than 18 years of age and competent to sign this contract on my own behalf. I have read this release and fully understand its contents.

Please Print:
Model's Name _____
Address _____
City _____ State _____ Zip Code _____
Country _____

Model's Signature: _____
Witness: _____ Date: _____

Parent/Guardian Consent (if applicable):
I am the parent or guardian of the minor named above and have legal authority to execute this release. I consent to use of said photographs based on the contents of this release.

Parent/Guardian Name: _____
Parent/Guardian Signature: _____
Witness: _____ Date: _____

SUBMISSIONS

When submitting images to potential clients you want to cater your submission to the needs of the market. Make it simpler for them to buy your work than reject it. Now, how can you do that?

First, don't be sloppy. Editors constantly complain about the unprofessional manner in which images are submitted. Some photographers, for example, mail photos with no explanations as to what they are or why they are being sent. Others send cover letters written in illegible script on crumpled paper. When an editor receives these types of

submissions he will invariably reject them on the basis of appearance.

Invest in a professional appearance—and not just in the form of money, but in time, too. If you have a typewriter or computer, use it when putting together cover letters or query letters. If you don't have a typewriter, visit a local library which lends office equipment to the public. For a more polished look, purchase your own stationery and business cards and use them when putting together submissions.

What should you include in your submission? We've already mentioned several pieces of the marketing puzzle, but let's break it down:

Cover Letters and Query Letters—These are slightly different approaches to the same goal—making a sale. They are used to convince photo buyers that your photography will enhance their products or services. Both of these letters are excellent opportunities to provide more information about your photographic abilities. Cover letters should include an itemized list of photos you are submitting and caption information pertinent to each image. Keep it brief.

In publishing, query letters are used to propose photo essays or photo/text packages. Ideas must sound exciting to interest buyers in your work. In the query letter you can either request permission to shoot an assignment for further consideration, submit stock photos, or ask to be considered for upcoming assignments.

Résumé and Client List—Résumés provide clients with more information about your skills and previous experience. Include job experience, photo-related education and any professional trade association memberships you have. A client list is simply a list of credits, past buyers of your work. You also should include any awards you've won and shows or exhibits you've been in.

Self-Promotion Piece—Art directors and photo editors love to keep self-promotion pieces on file as references for future assignments. Often these pieces are essential when trying to get a picture editor to review your portfolio. Tearsheets or postcards show your style and area of expertise and should be included in any direct mail to potential buyers. Make sure you include your address and phone directly on the piece.

Also, spend at least one day a week working on self-promotion. This may seem like a lot, but the work you do in this area can mean the difference between success and failure. Remember that each piece should show your creativity and make photo editors want to hire you for assignments.

Self-promotion can appear in numerous forms, including:
- Sourcebook advertisements in books like *The Workbook*, *Creative Black Book* and *Klik*;
- Postcards and other direct mail pieces with your best images on them;
- Press releases (for example, when you win photography awards);
- Brochures explaining the services you offer and listing past clients.

Stock Photo List—This is a detailed description of the subjects you have available. You also should include whether the images are color or b&w. A travel photographer, for example, might want to outline what countries he has photographed. Editors like to keep such resources in their files for future reference.

The package

To ensure your images' safe arrival and return, pay attention to the way you package them. Insert 8 × 10 prints into plastic pages; transparencies should be shipped in protective vinyl pages. *Do not send original transparencies or negatives unless they are requested by the client.* You do not want to risk losing or damaging originals. Slides can be duplicated at a relatively low cost and if they are damaged or lost, there is no real harm done.

To further protect your submissions it's a good idea to send your work via certified

mail. That way a client must sign for the package when it is delivered. You also can use delivery services, such as UPS or Federal Express, which track packages.

When submitting material, include the following items: a cover letter or query letter, a résumé and client list, a delivery memo with terms and conditions attached, a self-addressed, stamped envelope, and, of course, your work. For proper protection of your prints and transparencies, sandwich all images between two pieces of cardboard. You also can try insulated envelopes. *Note: When mailing to countries other than your own you will need International Reply Coupons instead of stamps. Check with your local post office for IRCs.*

Finally, before you submit work, find out what editors want in the way of submissions. Most markets in this book explain their likes and dislikes when it comes to submissions. Some prefer tearsheets and self-promotion pieces instead of slides, others only want stock photo lists. Many review portfolios and want you to drop off your work on specific days. By doing a little legwork you can sell more photos.

TRACKING DOWN THE TAX PICTURE

The financial concerns that go along with freelancing are demanding. You are the sole proprietor of your business and, therefore, must tend to tasks such as recording expenses and income. These tasks are time consuming, but necessary.

Every photographer is in a different situation. You may make occasional sales from your work or your entire livelihood may derive from your photography skills. Whatever the case, it is a good idea to consult with a tax professional. If you are just starting out, an accountant can give you solid advice for organizing financial records. If you are an established professional, an accountant can double check your system and possibly find a few more deductions.

When consulting with a tax professional, it is best to see someone who is familiar with the needs and concerns of small business people, particularly photographers. You also can conduct your own tax research by contacting the Internal Revenue Service. The IRS has numerous free booklets that provide specific information, such as allowable deductions and tax rate structures. These include: Publication 334: Tax Guide for Small Business; Publication 463: Travel, Entertainment and Gift Expense; Publication 505: Tax Withholding and Estimated Tax; Publication 525: Taxable and Nontaxable Income; Publication 533: Self-Employment Tax; Publication 535: Business Expenses; Publication 538: Accounting Periods and Methods; Publication 587: Business Use of Your Home; Publication 910: Guide to Free Tax Services. To order any of these booklets, phone the IRS at (800)829-3676.

Self-employment tax

As a freelancer it's important to be aware of tax rates on self-employment income. All income you receive without taxes being taken out by an employer qualifies as self-employment income. Normally, when you are employed by someone else, your income is taxed at a lower rate and the employer shares responsibility for the taxes due. However, when you are self-employed, even if only part-time, you are taxed at a higher rate on that income, and you must pay the entire amount yourself.

Freelancers frequently overlook self-employment taxes and fail to set aside a sufficient amount of money. They also tend to forget state and local taxes are payable on self-employment income. If the volume of your photo sales reaches a point where it becomes a substantial percentage of your income, then you are required to pay esti-

mated tax on a quarterly basis. This requires you to project what amount of sales you expect to generate in a three-month period. However burdensome this may be in the short run, it works to your advantage in that you plan for and stay current with the various taxes you are required to pay.

Deductions

Many deductions can be claimed by self-employed photographers. It's in your best interest to be aware of them. Examples of 100 percent deductible claims include production costs of résumés, business cards and brochures; photographer's rep commissions; membership dues; costs of purchasing portfolios and education/business-related magazines and books; insurance, legal and professional services.

Additional deductions may be taken if your office or studio is home-based. The catch here is that your work area must be used only on a professional basis; your office can't double as a family room after hours. The IRS also wants to see evidence that you use the work space on a regular basis via established business hours and proof of actively marketing your work. If you can satisfy these criteria then a percentage of mortgage interests, real estate taxes, rent, maintenance costs, utilities, and homeowner's insurance, plus office furniture and equipment, can be claimed on your tax form at year's end.

Some of the aforementioned deductions are available to hobbyists as well as professionals. If you are working out of your home, keep separate records and bank accounts for personal and business finances, as well as a separate business phone. Since the IRS can audit tax records as far back as seven years, it's vital to keep all paperwork related to your business. This includes invoices, vouchers, expenditures and sales receipts, canceled checks, deposit slips, register tapes and business ledger entries for this period. The burden of proof will be on you if the IRS questions any deductions claimed. To maintain professional status in the eyes of the IRS, you will need to show a profit for three years out of a five-year period.

Sales tax

Sales taxes are deceptively complicated and need special consideration. For instance, if you work in more than one state, use models or work with reps in one or more states, or work in one state and store equipment in another, you may be required to pay sales tax in each of the states that apply. In particular, if you work with an out-of-state stock photo agency which has clients over a wide geographic area, you should explore your tax liability with a tax professional.

As with all taxes, sales taxes must be reported and paid on a timely basis to avoid audits and/or penalties. In regard to sales tax, you should:

1) Always register your business at the tax offices with jurisdiction in your city and state.

2) Always charge and collect sales tax on the full amount of the invoice, unless an exemption applies.

3) If an exemption applies because of resale, you must provide a copy of the customer's resale certificate.

4) If an exemption applies because of other conditions (e.g., selling one-time reproduction rights or working for a tax-exempt, nonprofit organization) you must also provide documentation.

Make the Most Out of Rejection

BY JOSEPH ROGATE

As photographers, we all know rejection. After all, if God had wanted us to submit our photos to editors and have them accepted every time, He would have granted us telepathic powers. Then we could read an editor's mind, and predict what that editor wants. Unless you've got an inside line to the Almighty, you'll have to settle for the next best method of reducing rejections—learning how to benefit from rejection.

I'd like to tell you that an earth-moving experience improved my success as a freelancer, but I can't. One day I simply learned to take a closer look at rejection letters and actually see what buyers were telling me. This knowledge cut my losses and drastically reduced the number of rejections, but earth shattering it wasn't.

Here's what happened. I had submitted pictures for consideration and back came another rejection. Along with my returned images came a note—the type of note I'd seen before, but never read much beyond the words, "We are sorry, but. . . ." Notes like these were always too painful to dwell upon. I don't know what made me read, then reread this particular note. It simply said, "Thank you for your submission, although quite good, we have no need for that kind of photography right now."

Rejection? Yes! But what was the editor actually telling me? That I am a rotten photographer? That my pictures were lousy? No! In fact, she actually used the words "quite good." I drew some consolation from that. Then the key phrase caught my eye, "no need for that type of picture right now." The editor liked what I submitted, but could not use my images because they did not fit her current needs. In other words, I had not done my homework!

RESEARCH YOUR TARGET MARKETS!

If I had researched the publication before submitting my images I would have guaranteed I was sending pictures the editor needed—not just pictures she liked. There are a number of ways to research publications:

• Obtain current copies of the magazines you plan to approach. Reviewing current and back issues will give you a better understanding of the editorial content in each periodical. Also, most magazines list key staff members, so you can find out the current names of photo editors, picture editors or art directors for your direct mail pieces.

• Call or write the magazines and acquire photo guidelines if they are available. Guidelines describe how your submission should be put together, including the preferred formats, subject needs and portfolio review policies.

• Review monthly or quarterly trade journals and newsletters to see what's happening in the magazine world. Trade journals are a great way to find information about magazines that have gone out of business or merged with other companies. You can find out which photo editors have left magazines or been hired. Some newsletters even have market listings for publications that are searching for specific photos.

JOSEPH ROGATE *of Seaford, New York, has been a photographer for more than 20 years. His work has appeared in the LaFond Gallery in Pittsburgh, Pennsylvania,* The Midwest Motorist *and* JDL Communications. *He also is a regular contributor to the Freelancer's Press Association newsletter.*

The bottom line is you do not want to waste an editor's time with aimless submissions. Besides hurting yourself with unnecessary rejections, you may well ruin your credibility with that editor. Research pays big dividends. It reduces your rejections and expenses, while increasing your sales. Prove you understand, and can supply what a publication needs, and you may well be called for assignments.

Also remember that you do not have to sell pictures to *National Geographic*, *Time*, or *Sports Illustrated* to make good money. There are many publications out there just waiting for you to send what they "need." Research those subjects you enjoy and concentrate on them when you shoot photos. Sales will follow.

Editors often develop a stable of freelancers they know they can count on. Frequently editors move on to other publications and retain the services of their favorite photographers. This can double your market penetration, because almost always the assistant editors are left behind. They know you, and when they move up to fill vacant editorial positions, guess who they'll want shooting for them? You!

Pricing Your Photos in Today's Market

BY MICHAEL WILLINS

In college I remember having to write a speech for a communication class on something I valued. I chose my alarm clock. Not being a morning person, it was important that my alarm clock was perfect. It had to wake me without jarring me out of bed. When it sounded every morning I didn't want it to wail with loud rock music. It couldn't screech with a high pitch that shattered glass. I just wanted it to simply beep, softly, so that I could slowly open my eyes and adjust to the day. I would have paid anything for it. To me, that's value.

As a professional photographer it's important to understand the meaning of value to your clients. This is one key to pricing your images. Clients will pay almost anything for images that solve their problems. Likewise, they will pay extra to work with good photographers—those who can provide quality photos, on time, without any headaches. When negotiating with clients remember this fact. Educate yourself about clients' needs so that you know how important your work is to their success. Remember, *the greater their dependency on you, the higher the price should be for your images.*

In this article we're going to talk about value, along with other vital aspects of negotiating fair prices. You'll learn how to compose a business plan. You'll discover the importance of establishing a fee based on usage. And, by the end of this article, you'll know how to properly bid projects for clients.

BUILD A BUSINESS PLAN

As a professional photographer it's extremely important for you to know what it costs to conduct business every day. This includes expenses for everything, from cameras and equipment to paper clips and other office supplies. Without knowing this information you may find yourself undercharging clients. Your expenses will be greater than your income and, eventually, you'll be out of business.

The best way to safeguard against financial ruin is to create a business plan. In this document you will account for your annual overhead expenses. (This does not include fees for film, processing, travel expenses or other expenditures that can be passed on to clients.) By knowing your overhead expenses you will know what it costs to open your doors each day. The following is a list of overhead expenses that ought to be accounted for in your business plan. Note that this list includes an expense for your salary. It's important to pay yourself based on the lifestyle you plan to keep.

- Studio Rent or Mortgage Payment
- Utilities
- Insurance (for liability and your equipment)
- Equipment Expenses
- Office Supplies
- Postage
- Dues for Professional Organizations
- Workshop/Seminar Fees

- Self-Promotion/Advertising (such as soucebook ads and direct mail pieces)
- Fees for Professional Services (such as lawyers and accountants)
- Equipment Depreciation
- Salary Expenses for Yourself, Assistants and Office Help (including benefits and taxes)
- Other Miscellaneous Expenses

Once you know your overhead expenses, estimate the number of assignments and sales you will have each year. In order to do this you will need to know how many weeks in the year are actually "billable weeks." Assume that one day a week is going to be spent conducting office business and marketing your work. This amounts to approximately ten weeks. Add in days for vacation and sick time, perhaps three weeks, and add another week for workshops or seminars. This totals 14 weeks of nonbillable time and 38 billable weeks throughout the year.

Now estimate the number of assignments/sales you expect to complete each week and multiply that number by 38. This will give you a total for your yearly assignments/ sales. Finally, divide the total overhead expenses by the total number of assignments. This will give you an average price per assignment.

As an example, let's say that your overhead expenses came to approximately $65,000 a year (this includes a $35,000 salary). If you completed two assignments each week for 38 weeks (76 assignments/year) your average price per assignment must equal approximately $855. This is what you should charge just to break even on each job.

To learn more about pricing and creating a business plan, contact the American Society of Media Photographers (609-799-8300) to inquire about the group's Strictly Business Seminar. This traveling seminar is excellent for photographers who are searching for business guidance.

ESTABLISH PHOTO USAGE

When pricing a photo or job, you also must consider the usage: "What is going to be done with the photo?" Too often, photographers shortchange themselves in negotiations because they do not understand how images will be used. Instead, they allow clients to set prices and prefer to accept lower fees rather than lose sales. Photographers argue that they would rather make the sale than lose it because they refused to lower their price.

Unfortunately, those photographers who look at short-term profits are actually bringing down the entire industry. Clients realize, if they shop around, they can find photographers willing to shoot assignments or sell image rights at very low rates. Therefore, prices stay depressed because buyers, not photographers, are setting usage fees.

However, there are ways to combat low prices. First, educate yourself about a client's line of work. This type of professionalism helps during negotiations because it shows buyers that you are serious about your work. The added knowledge also gives you an advantage when settling on fees because photographers are not expected to understand a client's profession.

For example, if most of your clients are in the advertising field, acquire advertising rate cards for magazines so that you know what a client pays for ad space. You also can find ad rates in the *SRDS* directory, which can be found at your local library. During negotiations it's good to know what clients pay for ads. Businesses routinely spend well over $100,000 on advertising space in national magazines. They establish budgets for such advertising campaigns, keeping the high ad rates in mind, but often restricting funds for photography. Ask yourself, "What's fair?" If the image is going to anchor a national advertisement and it conveys the perfect message for the client, don't settle for a low fee. Your image is the key to the campaign.

Some photographers, at least in the area of assignment work, operate on day rates or half-day rates. Editorial photographers will typically quote fees in the low hundreds, while advertising and corporate shooters may quote fees in the low thousands. However, all photographers are finding that day rates by themselves are incomplete. Day rates only account for time and don't substantiate numerous other pricing variables. In place of day rates, photographers are assessing "creative fees," which include overhead costs, profit and varying expenses, such as assignment time, experience and image value. They also bill clients for the number of finished pictures and rights purchased, as well as additional expenses, such as equipment rental and hiring assistants.

Keep in mind that there are all sorts of ways to negotiate sales. Some clients, such as paper product companies, prefer to pay royalties on the number of times a product is sold. Special markets, such as galleries and stock agencies, typically charge photographers a commission, from 20 to 50 percent, for displaying or representing their images. In these markets, payment on sales comes from the purchase of prints by gallery patrons, or from commission on the rental of photos by clients of stock agencies. Pricing formulas should be developed depending on your costs and current price levels in those markets, as well as on the basis of submission fees, commissions and other administrative costs charged to you.

The accompanying charts were reprinted with permission from *Stock Photography: The Complete Guide*, by Carl and Ann Purcell (Writer's Digest Books). These charts should give you a starting point for negotiating fees for magazines, newsletters, book publishers and advertisements. However, only use them as guides and adjust your prices according to your experience and photographic skills.

BIDDING A JOB

As you build your business you will encounter another aspect of pricing and negotiating that can be very difficult. Like it or not, clients often ask photographers to supply "bids" for jobs. In some cases, the bidding process is merely procedural and the assignment will go to the photographer who can best complete the assignment. In other instances, the photographer who submits the lowest bid will earn the job. When contacted, it is imperative to find out which bidding process is being used. Putting together an accurate estimate takes time and you do not want to waste a lot of effort if your bid is being sought merely to meet some quota.

However, correctly working through the steps is necessary if you want to succeed. You do not want to bid too much on a project and repeatedly get turned down, but you also don't want to bid too low and forfeit income. When a potential client calls to ask for a bid there are several dos and don'ts to consider:

• Always keep a list of questions by the telephone, so that you can refer to it when bids are requested. The questions should give you a solid understanding of the project and help you in reaching a price estimate.

• Never quote a price during the initial conversation, even if the caller pushes for a "ballpark figure." A spot estimate can only hurt you in the negotiating process.

• Immediately find out what the client intends to do with the photos and ask who will own copyrights to the images after they are produced. It is important to note that many clients believe, if they hire you for a job, they own all rights to the images you create. If they want all rights make sure the price they pay is worth it to you.

• If it is an annual project, ask who completed the job last time. Then contact that photographer to see what he charged.

• Find out who you are bidding against and contact those people to make sure you received the same information about the job. While agreeing to charge the same price is illegal, sharing information on prices is not.

These charts were reprinted from *Stock Photography: The Complete Guide*, by Carl and Ann Purcell. You will notice the phrasing "we" because the charts were created by the Purcells. Their charts should be used as guides and your prices should be adjusted according to your experience and skill level.

Editorial Use—Magazines, House Organs & Newsletters

We use the numbers below when we start to negotiate for *editorial use in consumer magazines* and *internal house organs* (a term used for magazines published within an organization, company or corporation for internal distribution to the employees or membership).

- We charge 50 percent (multiply the numbers below by 0.5) when negotiating for *internal house newsletters* that will be used for internal distribution only.

- We charge 75 percent (multiply the numbers below by 0.75) when negotiating for editorial use in *consumer newsletters* that will be distributed or sold to the public at large.

- We charge 170 percent (multiply the numbers below by 1.7) when negotiating for *editorial use in external house organs* (a term used for magazines published within an organization, company or corporation for both internal and external distribution to its membership).

- If the client is using the photograph as an interior shot plus a spot insertion on the Page of Contents, we charge the space fee plus 25 percent (multiply the space fee by 1.25). If the spot insertion is on the cover, we charge the space fee plus 50 percent (multiply by 1.5).

Magazines, House Organs and Newsletters—Editorial Use

Circulation	¼ page	½ page	¾ page	full page	double page	cover
Over 3M	$425	$495	$565	$700	$1,150	$1,235
1-3M	385	445	510	635	1,050	1,115
500,000-1M	345	400	460	575	945	1,000
250,000-500,000	265	310	350	445	735	775
100,000-250,000	240	280	320	400	675	710
50,000-100,000	220	250	290	365	600	640
20,000-50,000	200	235	275	350	550	625

Advertising in Magazines, House Organs or Newsletters

Advertising in magazines can be local, regional, national or specialized editions. Most of our invoices specify that we are granting the rights for one year. We charge an additional fee for longer use or repeated use and we base it on a percentage of the original billing.

- In the chart below are the prices we charge for *advertisements in consumer magazines—national exposure.*
- We charge 80 percent (multiply by 0.8) of the fees below for *regional exposure.*
- We charge 60 percent (multiply by 0.6) of the fees listed below for *local exposure.*
- We charge the same fee for *advertisements in trade magazines* as we charge for *regional advertisements in consumer magazines.*
- We charge 75 percent (multiply the numbers below by 0.75) when negotiating for *advertisements in newsletters* that will be distributed or sold to the public.

ADDITIONAL FEES:

Rights: One Year Exclusive: Subtotal plus 100 percent
 Five Year Exclusive: Subtotal plus 200 percent
 Unlimited use—1 year—Subtotal plus 250 percent

Insertions: 2-4: Space fee plus 25 percent
 5-10: Space fee plus 50 percent

Inside Cover: We usually start negotiations halfway between the full page price and back cover price.

Advertising in Magazines—National Exposure

Circulation	¼ page	½ page	¾ page	full page	double page	back cover
Over 3M	$1,300	$1,750	$2,200	$2,600	$4,200	$3,500
1-3M	780	1,020	1,250	1,575	2,575	2,080
500,000-1M	625	810	990	1,250	2,050	1,675
250,000-500,000	520	675	835	1,050	1,720	1,400
100,000-250,000	475	625	775	950	1,550	1,280
50,000-100,000	400	525	650	750	1,200	1,000
20,000-50,000	375	440	540	675	1,125	925

Books—Textbooks, Encyclopedias, Trade Books & Paperbacks

Photo use in books is usually considered strictly editorial unless the book is a single destination promotional piece. For textbooks, guidebooks and encyclopedias, we offer a special rate if multiple sales are made.

The normal run for a book is around 10,000 copies. Rarely are books published in runs over 40,000, unless they are paperbacks. We have divided out the pricing for books, therefore, into two categories: under 40,000 and over 40,000.

If the run is for 5,000 copies, we will usually negotiate a price of approximately 80 percent (multiply by 0.8) of the under 40,000 fee.

Press Run	¼ page	½ page	¾ page	full page	double page	jacket or cover
TEXTBOOKS						
Over 40,000	$185	$200	$225	$270	$550	$550-820
Under 40,000	145	170	195	225	450	450-650
ENCYCLOPEDIAS						
Over 40,000	215	270	300	325	650	825-1,075
Under 40,000	190	215	250	275	550	435-650
TRADE BOOKS						
Over 40,000	185	200	225	270	550	550-825
Under 40,000	145	170	195	225	450	450-675
PAPERBACKS						
Over 40,000	200	220	250	285	565	510-780
Under 40,000	175	200	235	260	525	425-650

ADDITIONAL FEES:

- Reuse or revisions: We usually charge 50 percent of the original price each time a new edition comes out or the photo is reused in a foreign edition. If world rights are requested during initial negotiations, we charge 150 percent of the price listed above for a book being published in one language. We charge 200 percent for world rights for a book being published in several languages.

- For chapter openers, we usually charge 125 percent (multiply by 1.25) plus the space fee listed above.

- For wraparound covers, we start negotiations at the top listed price for covers.

- We usually charge $350 for an author head shot, plus traveling costs to get it and $15 per roll of film taken.

Reprinted from *Stock Photography: The Complete Guide* with permission of Writer's Digest Books.

• Talk to photographers not bidding on the project and ask them what they would charge.
• Finally, consider all aspects of the shoot, including preparation time, fees for assistants and stylists, rental equipment and other material costs. Don't leave anything out.

OTHER PRICING RESOURCES

If you are a newcomer to negotiating, there are some extraordinary resources available that can help you when establishing usage fees. One of the best tools available is a software package called fotoQuote, produced by the CRADOC Corporation. This software is ideal for beginners and established photographers who want to earn the most money for their work.

Written by lecturer/photographer Cradoc Bagshaw, the software walks you through pricing structures in numerous fields, such as advertising markets, calendar companies and puzzle producers, and then provides negotiating tips that help you establish fees. For example, if you want to sell photos to a consumer magazine, a preliminary usage fee is given. The fee changes as you adjust factors that affect the sale price. In this case, prices increase when selling to magazines with higher circulations; common images pay less than unique photos; an aerial shot warrants higher fees than normal images.

Whatever the circumstances, you can input them and receive an estimated photo value. The pricing structures in fotoQuote also can be adapted to fit your negotiating style of sales history. For example, you may sell to companies in major metropolitan areas and find that these markets pay more than the software indicates. After a few modifications the program will operate based on your fee structures.

fotoQuote also provides coaching tips from stock photographer Vince Streano, former president of the American Society of Media Photographers. The tips give you negotiating advice. You also will find scripted telephone conversations. The cost of fotoQuote 2.0 is $129.95 plus $5 shipping and handling. For those people who own the first version of fotoQuote, software upgrade costs $50 plus $6 shipping and handling. Washington residents are required to pay sales tax and the program is not available in stores. For information, call or write the CRADOC Corporation, 16625 Redmond Way, Suite M424, Redmond WA 98052. (800)679-0202.

Besides fotoQuote, there are several books that can help with pricing. Two of the more useful resources are *Pricing Photography: The Complete Guide to Assignment & Stock Prices*, by Michal Heron and David MacTavish (Allworth Press) and *Negotiating Stock Photo Prices*, by Jim Pickerell. See our list of Recommended Books & Publications at the back of this book for ordering information.

Negotiating Prices in the Digital Environment

BY GAIL DEIBLER FINKE

Don't let the high-tech aura of "new media" intimidate you when it comes to selling your photos for digital use. Webpages, CD-ROMs, and other digital media depend largely on graphics for their impact. Photography is important to their success, and after a little study, it's no more difficult to price and sell your photography for new media uses than it is for traditional print uses.

Although photographers may be confused about when and how much to charge for digital rights to their pictures, those in the know say it's no mystery. Any digital use should be paid for, unless the photographer donates it. "Regardless of media or application, the right to reproduce an image must be secured from the copyright owner," says Peter Skinner, communications director of the American Society of Media Photographers.

ASMP contends that digital use of photography is no different than any other use. Photographers should base their charges as they would for print use—on quality and uniqueness of the image, size and placement, type of product, duration of use, circulation, exclusivity, and other traditional print criteria. And just as photographers should not hesitate to charge clients for second print uses of photographs, they also should charge fees for digital usage of photographs originally assigned or bought for print projects.

Is the ASMP just setting high standards in hopes that buyers will live up to them? Not at all, according to Vince Streano. A professional photographer and former ASMP president who has researched digital photography prices for the popular software foto-Quote, Streano says that photographers around the country are asking for and getting fair prices for digital rights.

"Photographers have sold web usages for $3,000," he says. "Agencies charge around $2,500." While these prices aren't average, they demonstrate that the biggest web users understand the value of good photography. Smaller webpages with fewer "hits" (number of people tuning in) pay proportional fees.

The large webpages charge advertisers as much as $30,000 each month—and the World Wide Web is still only in its infancy, says Streano. "The web could become one of the top advertising media," he says. Because good photography is part of what makes webpages attractive to advertisers, photographers should also benefit as the web grows.

Even those who have never touched a computer can understand the extent of digital use after a few minute's study. An image can take up a full computer screen (rarely) or a fraction of one. It can be a primary image or a secondary one. It can stand alone,

GAIL DEIBLER FINKE *is a freelance writer from Cincinnati, Ohio, who specializes in design topics. She is author of* City Signs, Fresh Ideas in Letterhead *and* Business Card Design 2, *and* Fresh Ideas for Designing With Black, White & Gray. *Her articles have appeared in the design magazines* HOW *and* Identity.

or form part of a collage. It can be on-screen for a minute or more, or for mere seconds. It can be reproduced in low or high resolutions.

Circulation is no more difficult. CD-ROMs are pressed in batches of varying sizes, just as traditional publications are printed in quantities. Software and computer games are also made in specific quantities. Companies with webpages know how many hits they get each day or month, and photographers with Internet access can also check a site that lists all webpages, the number of hits they get, and the amount they charge for advertising.

The ASMP has a white paper on digital rights available to photographers (609-799-8300). A white paper from the Picture Agency Council of America, the trade association for stock agencies, outlines contract language and procedures for numerous digital uses (800-457-7222). Another white paper, "Licensing Still Images: Some Basic Information for Multimedia Producers," is aimed at photography clients but contains valuable information on traditional and new media pricing. It's available from Index Stock Photography Inc. (800-729-7466). fotoQuote software also covers this subject (800-679-0202).

UPPING THE ANTE FOR ADDITIONAL RIGHTS

What about selling additional digital rights to pictures sold to magazines or other print media, such as CD-ROM versions of books or online versions of magazines? Photographers are sometimes hesitant to ask for additional fees for these rights, and both Streano and Skinner admit that some publications have balked at paying for them. But, they say, the same principles apply.

Copyright law is clear that each use of an intellectual property requires a separate granting of rights. "Some publications that have online editions are trying to secure all rights to a photo, to get it as cheaply as possible," Skinner says. He and Streano suggest that photographers reject such offers and instead ask up front whether an image will be used digitally.

"If the answer is 'no' get the words 'no digital rights' in writing," says Streano. "If it's 'yes,' negotiate the rate up front." He suggests charging an extra 25-50% for digital rights, depending on use, and making sure that the image will be used for a limited time, ideally the same amount of time that the print publication is available on newsstands.

Because electronic publications are so new, there is no industry standard for paying photographers for digital rights. Photographers who make their livings selling to smaller markets, such as travel photographers Carl and Ann Purcell, say they still run into clients who want to buy all rights to their photos, and who balk at paying extra for digital rights.

"It's a mixed bag," says Carl Purcell, who notes that he has found newspapers particularly insistent on buying all rights. The Purcells license their extensive library of photographs through America Online and, at times, have lost clients by refusing to grant exclusive rights to their photos. Carl Purcell says that overall, digital products such as webpages, electronic puzzles and interactive games will be a boon to photographers. "A great part of our income now comes from digital sales," he says. "We recently made one $2,500 sale of over 300 images. New markets that never existed are opening up, and if photographers don't adapt to the new technology and changes in business, they're not going to survive."

If the Purcells demonstrate how smaller markets are adapting to new technologies, then media giant Time, Inc., represents how more sophisticated media buyers are setting the standards that other companies will eventually follow. Time has a company-wide policy for photographers on assignment.

According to Sheldon Czapnik, director of editorial services, Time offers photographers a choice: either an extra $100 per day to its standard $400 daily rate for non-exclusive, digital use of photographs, or a flat rate of $75 per image for each digital use. The rate chosen varies by magazine, but "by and large, they'd be better off if they all took the higher day rate," says Czapnik.

With the flat rate, he says, photographers end up with nothing if no images are used digitally. Photographers choose that option partly because of the opportunity for extra income and because they want to set a precedent for charging by the image. "Some of them feel that, down the road, there will be more electronic use of photography," Czapnik says.

LEARNING FROM STOCK AGENCIES

Another benchmark to examine is how the biggest photography sellers of all, stock photo agencies, charge for digital use. They've been working with new media for several years and have learned—sometimes the hard way—what the market will bear. According to Kathy Mullins at Index Stock Photography Inc., buyer confusion about digital photography rights is largely over. "At first, buyers had the assumption that they had the right to use a photo they had purchased for print use again for digital use," she says, "but now they've pretty well accepted that intellectual property has a price tag."

It's the business of stock agencies to understand fair pricing for photography, and most agencies have created elaborate pricing charts for every conceivable digital use. Index Stock's website (http://www.indexstock.com) displays its pricing schedule, along with explanations of U.S. copyright laws and other valuable information for buyers.

The agency's pricing, Mullins says, takes into account the differences between traditional and electronic use of photos. While electronic publications tend to use many images, "electronic use doesn't tend to be lingering use," she says. "A website can have lots of hits, but people aren't lingering at them. To display a picture, a person's computer has to be on and open to the right page. It's not like a magazine on a desk." The combination of many photographs seen only briefly can mean a lower licensing fee per image.

According to Barbara Roberts, president of FPG International stock agency, the biggest electronic publishing clients are either traditional publishers or large companies, both of whom are familiar with the ins and outs of licensing photographs. "Our problems are mainly with one- or two-person start-up companies, and they're not the right market for stock photography anyway."

They can, however, be the right market for photographers who don't mind explaining copyright law and justifying the importance of their work to clients who are new to many business practices and, perhaps, short on funds. Though inexperienced, new media clients will become more established markets for photography. Learning to negotiate with them now may mean the key to success in the future.

"One of the most important skills any photographer can learn is to negotiate," says Vince Streano. "Every publication is a different negotiation, because there are so many parameters to consider. But photographers who learn to negotiate will do very well."

The important thing to remember, Streano says, is that whenever a photograph is used for commercial purposes, even in the brave new digital world, the photographer is entitled to, and deserves, payment. "If there's one thing I want to say to photographers it's, 'Don't give pictures away!' "

Understanding the Basics of Copyright

Photography industry leaders lecture repeatedly about the importance of maintaining control of your copyright. "Losing control of your images is verboten," they say, adding horror stories of how some unscrupulous characters steal images. With advances in digital technology taking place almost on a daily basis, these cries seem to be growing even louder.

What makes copyright so important to a photographer? First of all, there's the moral issue. Simply put, stealing someone's work is wrong and it's a joyous occasion when an infringer is caught and punished. By registering your photos with the Copyright Office in Washington DC you are safeguarding against theft. You're making sure that, if someone illegally uses one of your images they can be held accountable. By failing to register your work, it is often more costly to pursue a lawsuit than it is to ignore the fact that the image was stolen.

Which brings us to issue number two—money. You should consider theft of your images to be a loss of income. After all, the person stealing one of your photos used it for a project, their project or someone else's. That's a lost sale for which you will never be paid, especially if you never find out that the image was stolen.

THE IMPORTANCE OF REGISTRATION

There is a major misconception about copyright that we probably should address. Once you create a photo it becomes yours. You own the copyright, regardless of whether or not you register it. Also, you cannot copyright an idea. Just thinking about something that would make a great photograph does not make that scene yours. You have to actually have something on film.

The fact that an image is automatically copyrighted does not mean that it shouldn't be registered. Quite the contrary. You cannot even file a copyright infringement suit until you've registered your work. Also, without timely registration of your images, you only can recover actual damages—money lost as a result of sales by the infringer plus any profits the infringer earned. Recovering $2,000, for example, for an ad sale can be minimal when weighed against the expense of hiring a copyright attorney. Often this deters photographers from filing lawsuits if they haven't registered their work. They know that the attorney's fees will be more than the actual damages that are recovered, and, therefore, infringers go unpunished.

Registration allows you to recover certain damages to which you, otherwise, would not be legally entitled. Attorney fees and court costs, for instance, can be recovered. So too can statutory damages—awards based on how deliberate and harmful the infringement. Statutory damages can run as high as $100,000. These are the fees that make registration so important.

In order to recover these fees there are certain rules regarding registration that you must follow. The rules have to do with the timeliness of your registration in relation to the infringement:

- **Unpublished images** must be registered before the infringement takes place.
- **Published images** must be registered within three months of the first date of

publication or before the infringement began.

The process of registering your work is simple. Contact the Register of Copyrights, Library of Congress, Washington DC 20559, (202)707-9100, and ask for Form VA (works of the visual arts). Registration costs $20, but you can register photographs in large quantities for that fee. Unpublished works actually can be videotaped and sent with the registration form and $20 fee. If you have any questions contact the Copyright Office. There also are plenty of books on the subject that simplify copyright laws.

THE COPYRIGHT NOTICE

Another way to protect your copyright is to mark each image with a copyright notice. This informs everyone reviewing your work that you own the copyright. It may seem basic, but in court this can be very important. In a lawsuit, one avenue of defense for an infringer is "innocent infringement"—basically the "I-didn't-know" argument. By placing your copyright notice on your images, you negate this defense for an infringer.

The copyright notice basically consists of three elements: the symbol, the year of first publication and the copyright holder's name. Here's an example of a copyright notice for an image published in 1996—© 1996 John Q. Photographer. Instead of the symbol ©, you can use the word "Copyright" or simply "Copr." However, most foreign countries prefer © as a common designation.

Also consider adding the notation "All rights reserved." after your copyright notice. This phrase is not necessary in the U.S. since all rights are automatically reserved, however, it is recommended in other parts of the world.

KNOW YOUR RIGHTS

As mentioned before, the digital era is making copyright protection more difficult. Often images are manipulated so much that it becomes nearly impossible to recognize the original version. As this technology grows, more and more clients will want digital versions of your photos. Don't be alarmed, just be careful. Not every client wants to steal your work. They often need digital versions to conduct color separations or place artwork for printers.

So, when you negotiate the usage of your work, consider adding a phrase to your contract that limits the rights of buyers who want digital versions of your photos. You might want them to guarantee that images will be removed from computer files once the work appears in print. You might say it's OK to do limited digital manipulation, and then specify what can be done. The important thing is to discuss what the client intends to do with the image and spell it out in writing.

Even a knowledgeable photographer will find himself at risk when dealing with a misinformed or intentionally deceptive client. So, it's essential not only to know your rights under the Copyright Law, but also to make sure that every photo buyer you deal with understands them. The following list of typical image rights should help you in your dealings with clients:

• **One-time rights.** These photos are "leased" on a one-time basis; one fee is paid for one use.

• **First rights.** This is generally the same as purchase of one-time rights, though the photo buyer is paying a bit more for the privilege of being the first to use the image. He may use it only once unless other rights are negotiated.

• **Serial rights.** The photographer has sold the right to use the photo in a periodical. It shouldn't be confused with using the photo in "installments." Most magazines will want to be sure the photo won't be running in a competing publication.

• **Exclusive rights.** Exclusive rights guarantee the buyer's exclusive right to use the

photo in his particular market or for a particular product. A greeting card company, for example, may purchase these rights to an image with the stipulation that it not be sold to a competing company for a certain time period. The photographer, however, may retain rights to sell the image to other markets. Conditions should always be in writing to avoid any misunderstandings.

• **Electronic rights.** These rights allow a buyer to place your work on electronic media, such as CD-ROMs or online services. Often these rights are requested with print rights

• **Promotion rights.** Such rights allow a publisher to use the photographer's photo for promotion of a publication in which the photo appeared. The photographer should be paid for promotional use in addition to the rights first sold to reproduce the image. Another form of this—agency promotion rights—is common among stock photo agencies. Likewise, the terms of this need to be negotiated separately.

• **Work for hire.** (See sidebar below for detailed definition.)

• **All rights.** This involves selling or assigning all rights to a photo for a specified period of time. This differs from work for hire, which always means the photographer permanently surrenders all rights to a photo and any claims to royalties or other future compensation. Terms for all rights—including time period of usage and compensation—should only be negotiated and confirmed in a written agreement with the client.

It is understandable for a client not to want a photo he used to appear in a competitor's ad. Skillful negotiation usually can result in an agreement between the photographer and the client that says the image(s) will not be sold to a competitor, but could be sold to other industries, possibly offering regional exclusivity for a stated time period.

Finally, a valuable tool for any photographer dealing with copyright language and various forms of the photography business is the *SPAR* Do-It-Yourself Kit*. This survival package includes sample forms, explanations and checklists of all terms and questions a photographer should ask himself when negotiating a job and pricing it. It's available from SPAR (the Society of Photographer and Artist Representatives, Inc.), 60 E. 42nd St., Suite 1166, New York NY 10165, (212)779-7464. Price $53 plus $3 shipping and handling. New York state residents pay in-state tax of $4.37.

WORK FOR HIRE DEFINITION

Under the Copyright Act of 1976, section 101, a "work for hire" is defined as:

"(1) a work prepared by an employee within the scope of his or her employment; or (2) a work . . .

• specially ordered or commissioned for use as a contribution to a collective work*
• as part of a motion picture or audiovisual work*
• as a translation
• as a supplementary work*
• as a compilation
• as an instructional text
• as a test
• as answer material for a test
• or as an atlas

. . . if the parties expressly agree in a written instrument signed by them that the work shall be considered a work made for hire."

NOTE: The asterisk (*) denotes categories within the Copyright Law which apply to photography.

Special Feature:

An Interview with Eddie Adams

BY MICHAEL WILLINS

In 1990 Eddie Adams was a featured speaker during the Hoosier State Press Association annual conference in Indianapolis. Before he was introduced I noticed him sitting at the back of the room—elbows on his knees, head down, hands clutching some notecards that would help him navigate through an obviously painful experience. He stepped behind a podium wearing all black and a silver pony tail that protruded from beneath a wide-brimmed hat. The hat reminded me of those worn in Clint Eastwood spaghetti westerns. I was attending the conference as a reporter/photographer for a chain of weekly newspapers in southeastern Indiana. I thought to myself, "What's up with this guy?"

© Tim Rasmussen

Adams wasn't well prepared. The notes on the cards were probably scribbled down on an airplane just hours before. His introduction was simple and filled with a sort of heavy sigh of anxiety. "They asked me to talk to you about photography, so here's some stuff I brought to show you."

The "stuff" Adams brought was astounding. His photos ranged in subject matter from his early work documenting wars to his present collection of portraits (celebrities and heads-of-state). I instantly grasped what photojournalism is all about. I also became a fan.

Recently I had a chance to meet Adams for an interview at his farm near Liberty, New York, in the Catskill Mountains. The farm is his weekend oasis where he gets away from his New York City studio. This time he looked much more at ease, riding his tractor and mowing his lawn, dressed in faded blue jeans and a white button-down cotton shirt. He still wore the trademark pony tail. He was preparing for a party that would occur the following day. "Can you give me a couple minutes?" he asked from atop his tractor. "I just want to finish this real quick." After mowing he needed time to trim grass from the base of a swing set and a few trees. He handed me keys so that I could take a look inside his barn where his annual workshop is held. At that moment I realized two things—the man never stops moving and he hates interviews.

"Elyse told me you were coming," says Adams, referring to his photo rep Elyse Weissberg. By now he has put his chores on hold and we're sitting at his kitchen table. "People ask me for interviews, but usually I just (blow them off)."

Time is of the essence for Adams. Life's too short. It occurs to me that this attitude developed while Adams watched people suffer in the 13 wars he covered. Who can forget his photo from the Vietnam War of a general executing a Viet Cong prisoner, shooting him in the head from point-blank range? The photograph helped earn Adams the Pulitzer Prize in 1969. Perhaps this image taught him an appreciation for life . . . and death.

"Everybody should be a free spirit," says Adams. "You can be ten years old, twenty

years old, and you can die tomorrow. You can get hit by a car. You can be in a plane crash. You can have some rare disease and you will always regret having not done something."

If Pete Rose was the "Charlie Hustle" of Major League Baseball, then Adams is the photo industry's equivalent. Regardless of the project or the client, Adams constantly reinvents himself. "When I shoot a photo of somebody I want it to be the best picture of that person," he says. "No matter what assignment I'm working on—it could be for a publication with a circulation of two—I'd work just as hard for them as I would a larger publication. A lot of photographers don't do that."

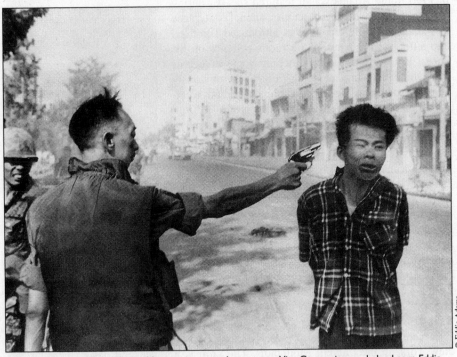

<div style="transform: rotate(90deg)">© Eddie Adams</div>

This image from 1968, in which a Vietnamese general executes a Viet Cong prisoner, helped earn Eddie Adams the Pulitzer Prize for his coverage of the Vietnam War. Adams covered 13 wars in his career. To-day he concentrates on portraiture and continues to challenge himself. "I get (mad) at photographers who live off their old stuff," he says.

Adams is his own harshest critic. He concedes that he doesn't particularly like his own work, even though his photos regularly appear worldwide in top periodicals, including *Parade*, *Life*, *Newsweek*, *Stern* and *Paris Match*. In fact, the only magazine cover openly displayed at his farm house is a mock cover of *Parade* with his face on it—a gift from the magazine's editor, Walter Anderson. "A picture has to do something to you. You have to look at it and think 'Wow.' I don't have a lot of wows. I have a couple."

Many would argue the point that Adams has "only a couple wows." He has earned more than 500 awards, including the 1996 Photographer of the Year award given by the Photographer's Manufacturer's and Distributor's Association. Past recipients include Mary Ellen Mark and Gordon Parks.

In recent months, Adams has tested the advertising market, completing projects for AT&T, Miramax Films, Nikon and Kodak. The shift towards advertising is alien to Adams, a long-time editorial photographer. "My problem is I like to shoot a lot of

things. This world is a world of specialization. And that's what hurts me more than anything else," he says. "Some things that Elyse wants to put in the portfolio are things that I think are so elementary and so basic. But she says that's what sells. I guess she knows what she's talking about. But it's stuff you can do with your eyes closed. Anybody can do it. So why hire me?"

Adams would rather reflect on the extraordinary talent of others—such as Pete Turner, James Nachtwey and Richard Avedon—than pontificate about his own work. "Everybody tries to imitate Avedon and they can't," says Adams. "And Nachtwey is just amazing. He can do anything. He's unique."

Almost certainly these photographers have similar accolades for Adams. He's always willing to explore and venture into the unknown. Take, for instance, his new studio, a 12,000-square-foot bathhouse in Manhattan's East Village. "I've gambled all my life," says Adams. "I don't know anything about business, nothing. The bathhouse is not in a good section of New York. It's the last place in the world anybody would put a studio. But I'm taking chances. I know it's going to work. I have a good feeling about it." The space is being renovated and should be ready for use in the spring of 1997.

ALONG FOR THE RIDE

It's nearing 1 p.m. and Adams realizes that he's late. He's supposed to pick up two long-time friends at the local bus station. We head out, only after Adams posts a note on his front door— "Make Yourself at Home, Eddie." It's obvious that the note is meant for no one in particular. Friends come and go, evident by the chocolate chip cookies Adams recently found sitting in a tin on the kitchen table.

We pile into a light blue, slightly worn Mercedes and head off for the station. Along the way I learn several things. First, the friends we are picking up are Harry Koundakjian and his wife, Aida. Harry is the international picture editor for the Associated Press— a big, good natured man with a quick wit. Second, Adams loves yard sale junk. We pass numerous sales along the way and he slows down several times to take a gander.

I also learn that Adams remains excited about the photo industry, despite naysayers who feel photography is oversaturated with talent. "There are always jobs. If you're any good, you'll have work. But you can't sit back. Nobody's going to call you up. You have to go after it. There are more magazines today than there ever were, but they're smaller and more specialized. A lot of them are using really good photography. I don't like excuses. I don't think the market is dying. I really don't."

What Adams sees is a market that is evolving toward digital imagery and he's willing to change with it. He has worked with Weissberg to create a portfolio on disk and he even found his own little corner of the Internet to showcase his photos. He also plans to combine efforts with Kodak and Applied Graphics Technologies to create a website for his workshop.

In many ways the shift toward electronic media is good, because of the creative possibilities. But Adams also sees great photographers who are relying too much on computers to conceive images. "Computers are taking over the minds of some photographers. And that's bad, man," shaking his head as he a stares down the road. "They think they're doing really good work. It's really sad. . . . Maybe I'm too old fashioned. I just like straight, good photography. Solid pictures that say something, do something."

We pass another yard sale. The pickins are slim, but Adams sneaks a peak anyway. "That's really junk there," he says.

Along with Adams's distaste for photographers who rely on computers comes his resentment for shooters who live off past successes. After all, it would be easy for Adams to sit back and accept praise for his wartime imagery. Book publishers, for instance, keep hounding him for a retrospective, something he views as a waste of time.

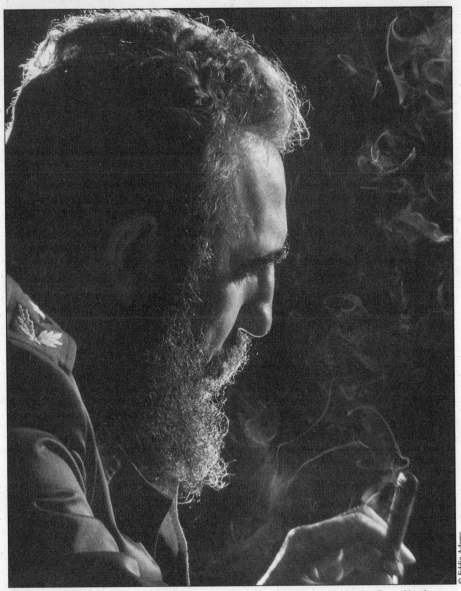

© Eddie Adams

Over the years Eddie Adams has grown close to many of the subjects he photographs. One of his favorites is Cuban President Fidel Castro who took Adams duck hunting and even promised to take him scuba diving. Adams says when photographing celebrities and world leaders it's important not to waste time. "A lot of times these people are not in a hurry. It's the people around them trying to keep them on schedule. . . . You don't know when they're going to whisk them away."

"We've talked about that for 20 years. At one point I had at least 10 publishers on my ass," he says. "I don't want to do a book because I'm not ready to die."

Adams has been in love with photography since he was a kid in New Kensington, Pennsylvania. He bought a 16mm movie camera from a junk store and charged neighborhood pals a penny or two to watch old Hopalong Cassidy movies in his backyard. "I paid about three bucks for the camera. It didn't even have a motor. It had a crank," says Adams. He began shooting still pictures in high school because he was too little

to play football. "They didn't even want to make me a water boy."

Adams learned a lot about photojournalism in his early years. One of the most important things he discovered is that nobody has a lock on good ideas. "When I started out on a little tiny newspaper in New Kensington I used to ask the janitor for ideas. He'd come up with stuff. Many photographers are too proud to ask for ideas, and that's too bad. I'm not. I don't care where the idea comes from if it's going to make a better picture."

His time on newspapers also taught him the importance of working on tight deadlines with limited assistance. This is something that often comes into play today as he works with celebrities and world leaders. His past subjects include Cuban leader Fidel Castro; President Bill Clinton; clothing designer Calvin Klein; and actors Eastwood, Anthony Hopkins and Robert De Niro. Often photographers only get a few minutes with such personalities and timing is critical. "A lot of times these people are not in a hurry. It's the people around them trying to keep them on schedule. I'm sure it's all legit, but you don't know when they're going to whisk them away," says Adams.

He, however, does not limit himself to the rich and famous. One of his favorite projects from 1995 involved kids with physical disabilities. Some of the kids have diseases, such as leukemia or HIV. One girl was even born without eyes. "She's beautiful," he says of the 4-year-old. "She's very delicate, really sweet and feminine. And very happy. She can't see. She's never going to see. There's no research out there that will make her see." For her portrait, Adams had assistants search nationwide for a field of flowers. "I wanted to make her part of a beautiful picture that she will never see."

REFLECTING BACK AND MOVING FORWARD

Although the door on his career is far from closed, I ask Adams what he would do differently in his career if he had the chance to do it again. He ponders the question with a touch of sadness for things he's missed out on, but also with a sense of accomplishment. "I worked very hard to get things that I had. I wasn't necessarily the kid on the other side of the tracks, but pretty close to it. My dad worked for Alcoa and died at the age of 50. When he died my mother scrubbed floors. It wasn't a tough life. I'm not crying poverty. She took care of us. But for me to get places and get jobs, I really worked for it. I was determined.

"I think back over the years if I would have done anything different. Probably not, because when I think back, the best years of my life were spent trying to get to these other places. I didn't realize it then. That's when you cry a lot and sweat a lot and think the whole world is going to end.

"Success is different things for different people. . . . One close friend of mine was a plumber. I used to envy him because this guy worked regular hours and planned a vacation for his family one or two years in advance. I can't plan anything because if an assignment comes up that I want to do, I do it. . . . I'm not crying about this, but I envied him because he had a really good relationship with his kids. I have three grown kids who are married. And I hardly know my own kids, because I was always on the road. My career was very, very important. Photography was my whole life. Now I regret a lot of it, but I probably would do the same thing again."

After greeting Harry and Aida we head back to Adams's farm. There's talk about the next day's party and about radio talk show personality Howard Stern, who wanted to use the execution photo from Vietnam for a publicity shot. Adams refused, seemingly appalled at the idea.

When we arrive back at the farm I take a second look at the barn. It sits on a hill

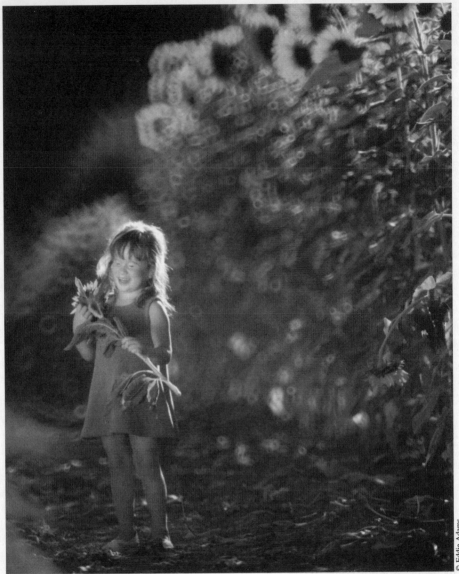

© Eddie Adams

Adams gets passionate about many of his stories. This image of a girl born without eyes, comes from a story he wrote and photographed in the December 24, 1995, issue of *Parade*. "I wanted to make her part of a beautiful picture that she will never see," Adams says of the girl. In the article Adams reported on physically-challenged children in the hopes that readers would donate money for research.

100 yards or so behind the house. Adams says "the lines of the barn" attracted him to the property when he bought it.

The barn has since become a toy for fellow photographers who renovate the structure at will. It is also home to "Barnstorm," Adams's workshop held every fall. The workshop, which in 1995 attracted over 1,000 applicants for 100 spots, has gained recognition as one of photography's best. Speakers for the workshop donate their time, as do the instructors and other staff members. Applicants must submit a portfolio and have

two years experience working with a pro. Students also can apply, but they must have a letter of recommendation.

During the workshop, attendees are split into ten teams and matched up with picture editors, well-known photographers, technicians and researchers. "There's so much energy because we have the best people in the business here from all over the world," he says. Teams compete against each other while completing projects, but the main goal is to give the students proper guidance. "We only want the serious people here. We don't want the clowns. Also, if you're really polished, we don't want you." The workshop has been known to advance the careers of some young photographers, because of the contacts they made at Barnstorm.

Adams, the Koundakjians and I enter the kitchen, break out some salami and cheese for sandwiches, and sit down for a late lunch. We discuss the workshop. Almost for my benefit, Aida reminds Adams that the workshop is something special that he has given young photographers. He should be proud. "You know, it's always the great ones who are modest," she says.

"Many photographers are too proud to ask for ideas, and that's too bad. I'm not. I don't care where the idea comes from if it's going to make a better picture."
—*Eddie Adams*

Important Information on Market Listings

• The majority of markets listed in this book are those which are actively seeking new freelance contributors. Some important, well-known companies which have declined complete listings are included within their appropriate section with a brief statement of their policies. In addition, firms which for various reasons have not renewed their listings from the 1996 edition are listed in the General Index at the back of this book.

• Market listings are published free of charge to photography buyers and are not advertisements. While every measure is taken to ensure that the listing information is as accurate as possible, we cannot guarantee or endorse any listing.

• *Photographer's Market* reserves the right to exclude any listing which does not meet its requirements.

• Although every buyer is given the opportunity to update his listing information prior to publication, the photography marketplace changes constantly throughout the year and between editions. Therefore, it is possible that some market information will be out of date by the time you make use of it.

• This book is edited (except for quoted material) in the masculine gender because we think "he/she," "she/he," "he or she," "him or her" is distracting.

Key to Symbols and Abbreviations

✦	Canadian Markets
‡	*Markets located outside the United States and Canada*
■	*Audiovisual Markets*
*	*New Markets*
●	*Introduces special comments that were inserted by the editor of Photographer's Market.*
NPI	No payment information given
SASE	Self-addressed stamped envelope
IRC	International Reply Coupon, for use on reply mail in markets outside of your own country
Ms, Mss	Manuscript(s)
©	Copyright

(For definitions and abbreviations relating specifically to the photographic industry, see the Glossary in the back of the book.)

The Markets

Advertising, Public Relations and Audiovisual Firms

When examining most ads today it becomes obvious that creativity and technical excellence are musts for photographers wanting to crack the advertising market. Ads that sport digitally manipulated images are common, as are beautiful black & white photos. There also has been a rise in "realistic" images—those taken of events or situations involving real people rather than models. Much of this realism comes from the cameras of editorial photographers who are being hired by art directors for advertising assignments. Photojournalists are appealing to art directors because they can create believable scenes and tell stories.

Many of the people who produce cutting-edge concepts can be found in the 211 markets in this section. Of these listings, 38 are new to this edition. They range in stature from the very small, one- or two-person operations to the big boys on the block, such as Chiat-Day in Venice, California, Foote Cone & Belding Communications in Chicago, and Ammirati Puris Lintas in New York City. Chiat Day's Amy Moorman shares her advice for freelancers in an Insider Report on page 40.

In some listings you will notice figures for annual billing and total employees. While researching we found that readers appreciate this type of information when assessing the quality of markets. If you are a beginning photographer trying to get your feet wet in the advertising arena, consider approaching smaller houses. They may be more willing to work with newcomers. On the flip side, if you have a sizable list of advertising credits, larger firms might be receptive to your work.

We also have information about changes that are taking place as a result of new technologies. Many of the art directors/creative directors we contacted said they are now digitally storing and manipulating photos. They also are beginning to search online networks for stock images. Any technological changes of note have been mentioned inside the listings after a bullet (●).

Along with advertising and public relations firms you will find audiovisual companies listed in this section. Markets with audiovisual, film or video needs have been designated with a solid, black square (■) before them. These listings also contain detailed information under the subhead "Audiovisual Needs."

Whatever your skill level, be professional in the way you present yourself. Organize your portfolio into an attractive showpiece. Also create some innovative self-promotion pieces that can be sent to art directors once your portfolio presentations are over.

Alabama

■**HUEY, COOK & PARTNERS**, 3800 Colonnade Pkwy., Suite 450, Birmingham AL 35243. (205)969-3200. Fax: (205)969-3136. Art Directors: Mike Macon/Shane Paris. Estab. 1972. Ad agency. Types of clients: retail and sporting goods.

Needs: Works with 6-10 freelance photographers/month. Uses photos for consumer magazines, trade magazines, P-O-P displays, catalogs, posters and audiovisuals. Subjects include: fishing industry, water sports. Model release preferred. Captions preferred.

Audiovisual Needs: Uses AV for product introductions, seminars and various presentations.

Specs: Uses 5×7 b&w prints; 35mm, 2¼×2¼, 4×5 and 8×10 transparencies.

Making Contact & Terms: Submit portfolio for review. Provide business card, brochure, flier or tearsheets to be kept on file for possible future assignments. Works on assignment basis only. Pays $50-400/b&w photo; $85-3,000/color photo; $500-1,600/day; $150-20,000/job. Payment is made on acceptance plus 90 days. Buys all rights.

Tips: Prefers to see "table top products with new, exciting lighting, location, mood images of various forms of fishing and boating."

■**J.H. LEWIS ADVERTISING, INC.**, 1668 Government St., Mobile AL 36604. (334)476-2507. President; Mobile Office: Emil Graf; Birmingham Office: Larry Norris. Creative Director; Birmingham Office: Spencer Till. Senior Art Directors; Mobile Office: Ben Jordan and Helen Savage. Ad agency. Uses photos for billboards, consumer and trade magazines, direct mail, foreign media, newspapers, P-O-P displays, radio and TV. Serves industrial, entertainment, financial, agricultural, medical and consumer clients. Commissions 25 photographers/year.

Specs: Uses b&w contact sheet and 8×10 b&w glossy prints; uses 8×10 color prints and 4×5 transparencies; produces 16mm documentaries.

Making Contact & Terms: NPI. Pays per job, or royalties on 16mm film sales. Buys all rights. Model release preferred. Arrange a personal interview to show portfolio; submit portfolio for review; or send material, "preferably slides we can keep on file," by mail for consideration. SASE. Reports in 1 week.

■**TOWNSEND, BARNEY & PATRICK**, 300 St. Francis St., Mobile AL 36602. (334)433-0401. Ad agency. Vice President/Creative Services: George Yurcisin. Types of clients: industrial, financial, medical, retail, fashion, fast food, tourism, packaging, supermarkets and food services.

Needs: Works with 1-3 freelance photographers/month. Uses photos for consumer magazines, trade magazines, direct mail, brochures, P-O-P displays, audiovisuals, posters and newspapers. Model release required.

Audiovisual Needs: Works with freelance filmmakers to produce audiovisuals.

Specs: Uses 8×10 and 11×17 glossy b&w prints; 35mm, 2¼×2¼, 4×5 and 8×10 transparencies; 16mm, 35mm film and videotape.

Making Contact & Terms: Arrange a personal interview to show portfolio. Query with samples and list of stock photo subjects. Provide résumé, business card, brochure, flier or tearsheets to be kept on file for possible future assignments. Does not return unsolicited material. Reports as needed. NPI; payment "varies according to budget." Pays net 30. Buys all rights.

Alaska

THE NERLAND AGENCY, 808 E St., Anchorage AK 99501. (907)274-9553. Ad agency. Contact: Curt Potter. Types of clients: retail, hotel, restaurant, fitness, health care. Client list free with SASE.

Needs: Works with 1 freelance photographer/month. Uses photos for consumer magazines, trade magazines, direct mail and brochures and collateral pieces. Subjects include people and still lifes.

Specs: Uses 11×14 matte b&w prints; 35mm, 2¼×2¼ and 4×5 transparencies.

Making Contact & Terms: Query with samples. Provide résumé, business card, brochure, flier or tearsheets to be kept on file for possible future assignments. Does not return unsolicited material. Pays $500-800/day or minimum $100/job (depends on job). **Pays on receipt of invoice.** Buys all rights or one-time rights. Model release and captions preferred.

Tips: Prefers to see "high technical quality (sharpness, lighting, etc). All photos should capture a mood. Simplicity of subject matter. Keep sending updated samples of work you are doing (monthly). We are demanding higher technical quality and looking for more 'feeling' photos than still life of product."

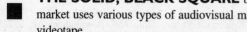 **THE SOLID, BLACK SQUARE** before a listing indicates that the market uses various types of audiovisual materials, such as slides, film or videotape.

Arizona

JOANIE L. FLATT AND ASSOC. LTD, 623 W. Southern Ave., Suite 2, Mesa AZ 85210. (602)835-9139. Fax: (602)835-9597. PR firm. President: Joanie L. Flatt. Types of clients: health care, pharmaceuticals, service, educational, insurance companies, developers, builders and finance.
Needs: Works with 2-3 photographers/month. Uses photos for consumer magazines, brochures and group presentations. Subject matter varies.
Specs: Vary depending on client and job.
Making Contact & Terms: Query with list of stock photo subjects. Provide résumé, business card, brochure, flier or tearsheets to be kept on file for possible future assignments. Works with local freelance photographers only. Does not return unsolicited material. Reports in 3 weeks. NPI. Photographer bids a job in writing. Payment is made 30 days after invoice. Buys all rights and sometimes one-time rights. Model release required. Captions preferred. Credit line given if warranted depending on job.

■PAUL S. KARR PRODUCTIONS, 2925 W. Indian School Rd., Phoenix AZ 85017. (602)266-4198. Contact: Kelly Karr. Film and tape firm. Types of clients: industrial, business and education. Works with freelancers on assignment only.
Needs: Uses filmmakers for motion pictures. "You must be an experienced filmmaker with your own location equipment, and understand editing and negative cutting to be considered for any assignment." Primarily produces industrial films for training, marketing, public relations and government contracts. Does high-speed photo instrumentation. Also produces business promotional tapes, recruiting tapes and instructional and entertainment tapes for VCR and cable. "We are also interested in funded co-production ventures with other video and film producers."
Specs: Uses 16mm films and videotapes. Provides production services, including sound transfers, scoring and mixing and video production, post production, and film-to-tape services.
Making Contact & Terms: Query with résumé of credits and advise if sample reel is available. NPI. Pays/job; negotiates payment based on client's budget and photographer's ability to handle the work. Pays on production. Buys all rights. Model release required.
Tips: Branch office in Utah: Karr Productions, 1045 N. 300 East, Orem UT 84057. (801)226-8209. Contact: Mike Karr.

***WALKER AGENCY**, #160, 15855 N. Greenway Hayden Loop, Scottsdale AZ 85260-1726. (602)483-0185. Fax: (602)948-3113. E-mail: 76167,301compuserve. Website: 76167.301@compuserv e.comwalker48@aok. President: Mike Walker. Estab. 1982. Member Outdoor Writers Association of America, Public Relations Society of America. Marketing communications firm. Number of employees: 8. Types of clients: banking, marine industry, shooting sports and outdoor recreation products.
Needs: Uses photos for consumer and trade magazines, posters and newspapers. Subjects include outdoor recreation scenes: fishing, camping, etc. "We also publish a newspaper supplement, 'Escape to the Outdoors,' which goes to 11,000 papers." Model/property release required.
Specs: Uses 8×10 glossy b&w prints with borders; 35mm, 2¼×2¼, 4×5 and 8×10 transparencies.
Making Contact & Terms: Query with résumé of credits. Query with list of stock photo subjects. Provide résumé, business card, brochure, flier or tearsheets to be kept on file for possible future assignments. Reports in 1 week. Pays $25/b&w or color photo; $150-500/day; also pays per job. Pays on receipt of invoice. Buys all rights; other rights negotiable.
Tips: In portfolio/samples, prefers to see a completely propped scene. "There is more opportunity for photographers within the advertising/PR industry."

Arkansas

BLACKWOOD, MARTIN, AND ASSOCIATES, 3 E. Colt Square Dr., P.O. Box 1968, Fayetteville AR 72703. (501)442-9803. Ad agency. Creative Director: Gary Weidner. Types of clients: food, financial, medical, insurance, some retail. Client list provided on request.
Needs: Works with 3 freelance photographers/month. Uses photos for direct mail, catalogs, consumer magazines, P-O-P displays, trade magazines and brochures. Subject matter includes "food shots—fried foods, industrial."
Specs: Uses 8×10 high contrast b&w prints; 35mm, 4×5 and 8×10 transparencies.
Making Contact & Terms: Arrange a personal interview to show portfolio; query with samples; provide résumé, business card, brochure, flier or tearsheets to be kept on file for possible future assignments. Works with freelance photographers on assignment basis only. Does not return unsolicited material. Reports in 1 month. NPI. Payment depends on budget—"whatever the market will bear." Buys all rights. Model release preferred.

Tips: Prefers to see "good, professional work, b&w and color" in a portfolio of samples. "Be willing to travel (we have been doing location shots) and willing to work within our budget. We are using less b&w photography because of newspaper reproduction in our area. We're using a lot of color for printing."

■**CEDAR CREST STUDIO**, P.O. Box 28, Mountain Home AR 72653. (800)514-6082. Fax: (501)488-5255. Owner: Bob Ketchum. Estab. 1972. AV firm. Number of employees: 4. Types of clients: corporate, industrial, financial, broadcast, fashion, retail, food. Examples of recent projects: "T-Lite, T-Slumber," Williams Pharmaceuticals (national TV spots); "Christmas," Peoples Bank and Trust (regional TV spots); CBM demo, Baxter Healthcare Corp. (corporate sales).
● Cedar Crest is using computers for photo manipulation.
Needs: Works with 4 freelancers/month. Uses photos for covers on CDs and cassettes.
Audiovisual Needs: Uses slides, film and videotape.
Specs: Uses ½", 8mm and ¾" videotape.
Making Contact & Terms: Works with local freelancers only. Does not keep samples on file. Cannot return material. Pays $75 maximum/hour; $200 minimum/day. Pays on publication. Credit line sometimes given. Buys one-time rights; negotiable.

■**WILLIAMS/CRAWFORD & ASSOCIATES, INC.**, P.O. Box 789, Ft. Smith AR 72901. (501)782-5230. Fax: (501)782-6970. Creative Director: David Turner. Estab. 1983. Types of clients: financial, health care, manufacturing, tourism. Examples of ad campaigns: Touche-Ross, 401K and employee benefits (videos); Cummins diesel engines (print campaigns); and Freightliner Trucks (sales promotion and training videos).
Needs: Works with 2-3 freelance photographers—filmmakers—videographers/month. Uses photos for consumer magazines, trade magazines, direct mail, P-O-P displays, catalogs, posters, newspapers and audiovisual uses. Subjects include: people, products and architecture. Reviews stock photos, film or video of health care and financial.
Audiovisual Needs: Uses photos/film/video for 30-second video and film TV spots; 5-10-minute video sales, training and educational.
Specs: Uses 5×7, 8×10 b&w prints; 35mm, 2¼×2¼ and 4×5 transparencies.
Making Contact & Terms: Query with samples, provide résumé, business card, brochure, flier or tearsheets to be kept on file for possible future assignments. Works with freelancers on assignment basis only. Cannot return material. Reports in 1-2 weeks. Pays $500-1,200/day. Pays on receipt of invoice and client approval. Buys all rights (work-for-hire). Model release required; captions preferred. Credit line given sometimes, depending on client's attitude (payment arrangement with photographer).
Tips: In freelancer's samples, wants to see "quality and unique approaches to common problems." There is "a demand for fresh graphics and design solutions." Freelancers should "expect to be pushed to their creative limits, to work hard and be able to input ideas into the process, not just be directed."

California

ADVANCE ADVERTISING AGENCY, 606 E. Belmont, #202, Fresno CA 93701. (209)445-0383. Manager: Martin Nissen. Ad and PR agency and graphic design firm. Types of clients: industrial, commercial, retail, financial. Examples of projects: Spyder Autoworks (direct mail, trade magazines); Windshield Repair Service (radio, TV, newspaper); Mr. G's Carpets (radio, TV, newspaper); Fresno Dixieland Society (programs and newsletters).
Needs: Model release required.
Specs: Uses color and b&w prints.
Making Contact & Terms: Send unsolicited photos by mail for consideration. Provide business card, brochure, flier to be kept on file for possible future assignments. Keeps samples on file. Reports in 1-2 weeks. NPI; payment negotiated per job. Pays 30 days from invoice. Credit line given. Buys all rights.
Tips: In samples, looks for "not very abstract or overly sophisticated or 'trendy.' Stay with basic, high quality material." Advises that photographers "consider *local* market target audience."

● **A BULLET** has been placed within some listings to introduce special comments by the editor of *Photographer's Market*.

■**AMERTRON-AMERICAN ELECTRONIC SUPPLY**, 1200 N. Vine St., Hollywood CA 90038-1600. (213)462-1200. Fax: (213)871-0127. General Manager: Fred Rosenthal. Estab. 1953. AV firm. Approximate annual billing: $5 million. Number of employees: 35. Types of clients: industrial, financial, fashion and retail. "We participate in shows and conventions throughout the country."
Needs: Most photos used for advertising purposes.
Audiovisual Needs: Uses slides, film and videotape.
Making Contact & Terms: Interested in receiving work from newer, lesser-known photographers. Query with samples. Provide résumé, business card, brochure, flier or tearsheets to be kept on file for possible future assignments. Cannot return material. Reports in 6 months. NPI.

AUSTIN/KERR MARKETING, (formerly Austin Associates), 160 W. Santa Clara St., Suite 1300, San Jose CA 95113. Fax: (408)295-1313. E-mail: nate@akm—online.com. Ad agency. Art Director: Nate Digre. Serves high technology and consumer technology clients. Examples of recent projects: Phrenia campaign, NEC Electronics Inc., spread ads.
Needs: Works with 3 photographers/month. Uses work for billboards, consumer magazines, trade magazines, direct mail, P-O-P displays, newspapers. Subject matter of photography purchased includes: conceptual shots of people and table top (tight shots of electronics products).
Specs: Uses 8×10 matte b&w and color prints; 35mm, 2¼×2¼, 4×5 or 8×10 transparencies.
Making Contact & Terms: Arrange a personal interview to show portfolio. Send unsolicited photos by mail for consideration. Provide résumé, business card, brochure, flier or tearsheets to be kept on file for possible future assignments. Works on assignment basis only. Does not return unsolicited material. Reports in 3 weeks. Pays $500-3,000/b&w photo; $500-5,000/day; $200-2,000 for electronic usage (Web banners, etc.), depending on budget. Pays on receipt of invoice. Buys one-time, exclusive product, electronic and all rights (work-for-hire); negotiable. Model release required, captions preferred.
Tips: Prefers to see "originality, creativity, uniqueness, technical expertise" in work submitted. There is more use of "photo composites, dramatic lighting, and more attention to detail" in photography.

CHIAT-DAY, 320 Hampton Dr., Venice CA 90291. (310)314-5000. Contact: Art Buyer. Types of clients: industrial, financial, fashion, retail, food. Examples of recent projects: Nissan, Sony, Jack-in-the-Box and Eveready Battery Company.
Needs: Works with 10-50 freelancers/month. Uses photos for billboards, consumer and trade magazines, direct mail, P-O-P displays, catalogs, posters, newspapers, signage and audiovisual uses. Subjects used depend on the company. Model/property release required.
Specs: Uses 8×10 and 11×14 matte b&w prints; 35mm, 2¼×2¼, 4×5, 8×10 transparencies (prefers 4×5 and 8×10).
Making Contact & Terms: Interested in receiving work from newer, lesser-known photographers. Contact through rep. Arrange personal interview to show portfolio. Submit portfolio for review. Query with samples. Leave promo sheet. Provide résumé, business card, brochure, flier or tearsheets to be kept on file for possible future assignments. Reporting time depends; can call for feedback. NPI. Pays on receipt of invoice. Rights purchased vary; negotiable.

***COAKLEY HEAGERTY**, 1155 N. First St., San Jose CA 95112. (408)275-9400. Fax: (408)995-0600. Art Directors: Ray Bauer, Tundra Alex, JD Keser. Estab. 1960. Member of MAAN. Ad agency. Approximate annual billing: $25 million. Number of employees: 25. Types of clients: industrial, financial, retail, food and real estate. Examples of recent projects: Valley Medical Center (hospital); Florsheim Homes (real estate); and ABHOW (senior care).
Needs: Works with 2-3 freelance photographers, 1 filmmaker and 1 videographer/month. Uses photos for consumer magazines, trade magazines, direct mail and newspapers. Subjects vary. Model release required.
Specs: Uses b&w prints; 35mm, 2¼×2¼, 4×5, 8×10, transparencies; 16 mm, 35mm film; and Beta SP D-2 videotape.
Making Contact & Terms: Interested in receiving work from newer, lesser-known photographers. Send unsolicited photos by mail for consideration. Keeps samples on file. Cannot return material. Reports as needed. Pays on receipt of invoice; 60 days net. Credit line not given. Buys all rights; negotiable.

 THE ASTERISK before a listing indicates that the market is new in this edition. New markets are often the most receptive to freelance submissions.

INSIDER REPORT

Courting the Agency: Beware of Digital Hype

Enter the offices of TBWA/Chiat/Day and you'll know you're not in Kansas anymore. You'll likely see account reps wandering the halls attached to cellular phones. Or denim-clad creatives brainstorming on neo-psychedelic divans. You might even witness actual walls moving before your eyes to create new rooms.

In 1994, this leading-edge agency went "virtual," cutting its physical workspace by two-thirds. Traditional offices were replaced by movable computer workstations. Paper file cabinets were outlawed in favor of shared electronic files and e-mail. And employees were given the option to work in-house, or, if they preferred, elsewhere.

Amy Moorman

<div style="text-align: right; writing-mode: vertical-rl;">Photo Courtesy TBWA/Chiat/Day</div>

"It's not so much about the physical space anymore," says Amy Moorman, director of art buying at Chiat's Los Angeles office. "It's more about getting your job done. You don't have to be in the office every hour of every day."

Under the new system, Chiat staffers are not relegated to specific "departments," either. They are drawn onto client project teams, as needed. This reconfiguration has been revolutionary for agency employees. But for photographers, it's a habitat that's familiar. After all, freelancers by nature are "virtual" creatures.

In fact, Chiat's overhaul has had a minimal effect on relations with photographers, says Moorman. "We've always had a situation where 85 to 90 percent of what we do print-wise incorporates some photography," she says. "And we always go out of house. Two of our major clients are Nissan and Infiniti, and the client always wants a beautiful shot of the car." So photo needs have remained pretty constant.

Although the agency's internal communications are now almost completely digital, the photo-buying process remains pretty traditional. "I have used the Internet for various searches, but few photographers are utilizing it right now," says Moorman.

In truth, viewing images digitally is not that desirable, she says. "[Electronic files] take a long time to download. Sometimes the software is incompatible. And ultimately, a digital scan doesn't really do the image justice—not like a beautiful transparency or print. So even if an image catches my eye digitally, I'll still ask to see what the end product really looks like."

These days, electronic promos actually can annoy art directors because the technology still hasn't been refined. "A CD or disk promo controls you," says

INSIDER REPORT, *Moorman*

Moorman. "A lot of times, it forces you to look at each image for 10 seconds or 30 seconds, and in a specific order. If I'm looking at a portfolio and the first five or six images are beautiful, I don't always need to look any further. I'm ready to start the bidding process. On the other hand, if the first few images are lousy, I know I've seen enough."

Simple, printed promos are still crucial in breaking through the clutter, she says. "Although one drawback to the [virtual office] is I no longer have a bulletin board where I can hang things." So mailers really have to register in the brain to be remembered.

In addition to promo pieces, directories and portfolio reviews are mainstays in Moorman's cache of resources. "The virtual office doesn't allow everybody to have a predictable schedule, so we schedule twice-a-month portfolio showings." Books are laid out for a two-day period and notices are sent out to all the art directors. "It's sort of like a mini-gallery exhibition. We discover a lot of people this way."

Timing and luck are still part of the business, too. "I just got a piece in the mail the other day that, coincidentally, was exactly the kind of work I was looking for in a campaign that hasn't even been approved yet. Now, if it gets approved, we'll call in the portfolio."

Aside from great work, a photographer's most important selling tool is passion for his or her work, says Moorman. "We want someone who is as excited about the project as we are. We don't hire people who mindlessly execute. We want people with strong opinions—who will take ownership and make it better. To use an old cliché, they really have to bring something to the party."

At Chiat/Day, shooters are definitely part of a team. It's not uncommon for photographers to be called into preproduction meetings with clients—and clients are encouraged to attend shoots. "If a client can put a name with a face and is familiar with the photographer's work, when I go down with an estimate, it's more likely that I'll be able to sell that estimate—which means we can execute the kind of work we want to."

As an instructor at the LA Art Center College of Design, Moorman frequently gives advice on how to crack the ad biz. "It really pays to know who has which accounts and who has won awards," she says. "Just pick up *Ad Age* or *Adweek*. Be aware of the award books so you can approach an agency intelligently and know something about what they've been doing. Check to see if they have a website. Be creative with your research."

Above all else, she says, follow your heart. "Really look at who is doing the kind of work you want to be doing. I sometimes have photographers come in and show me their, quote, 'product book.' But then they show me a few other images and I can tell that they are more fashion- or editorial-oriented. And I can tell that's what they love to do. I want to hire photographers for what they love to do—not for what they make their bread and butter off of."

—*Jenny Pfalzgraf*

■**EVANS & PARTNERS, INC.**, 55 E. G St., Encinitas CA 92024-3615. (619)944-9400. Fax: (619)944-9422. President/Creative Director: David R. Evans. Estab. 1989. Ad agency. Approximate annual billing: $1.2 million. Number of employees: 7. Types of clients: industrial, financial, medical. Examples of recent projects: "Hit the Road," North Island Federal Credit Union (in-house promotion); "Expander," Ortho Organizer (direct mail/advertising); "Profusion '95," Askor, Inc. (ads, brochures, annual report video).

 • This agency is utilizing photo manipulation technologies, which gives photographers the latitude to create.

Needs: Works with 2-3 freelance photographers, 1-6 videographers/month. Uses photos for billboards, trade magazines, direct mail, P-O-P displays, catalogs, posters, newspapers, signage and audiovisual uses. Subjects include: medical, medical high tech, real estate. Reviews stock photos. Model release required for people. Property release preferred. Captions preferred; include name of photographer. **Audiovisual Needs:** Uses slides and video for presentations, educational.
Specs: Uses 35mm, 2¼×2¼, 4×5 transparencies; ½″ VHS-SVHS videotape.
Making Contact & Terms: Interested in receiving work from newer, lesser-known photographers. Query with stock photo list and samples. Provide résumé, business card, brochure, flier or tearsheets to be kept on file for possible future assignments. Works with local freelancers on assignment only. Keeps samples on file. SASE. Will notify if interested. Pays $700-2,000/day; $175 and up/job. Pays upon receipt of payment from client. Credit line given depending upon nature of assignment, sophistication of client. Buys first, one-time, all, exclusive product, electronic rights; negotiable.
Tips: Looking for "ability to see structure, line tensions, composition innovation; finesse in capturing people's energy; ability to create visuals equal to the level of sophistication of the business or product."

■**KEN FONG ADVERTISING, INC.**, 178 W. Adams St., Stockton CA 95204-5338. (209)466-0366. Fax: (209)466-0387. Art Director: Donna Yee. Estab. 1953. Ad agency. Number of employees: 9. Types of clients: industrial, financial, fashion, retail and food.
Needs: Uses photos for billboards, consumer and trade magazines, direct mail, P-O-P displays, catalogs, posters, newspapers, signage and audiovisual. Subject matter varies. Reviews stock photos of diverse, "real" and business-type people, lifestyle/leisure, nature, commerce, sports/recreation. Model/property release required.
Audiovisual Needs: Uses slides and video.
Specs: Uses 8×10 and larger glossy color and b&w prints; 35mm, 2¼×2¼, 4×5 transparencies; ½″ VHS videotape.
Making Contact & Terms: Interested in receiving work from newer, lesser-known photographers. Provide résumé, business card, brochure, flier or tearsheets to be kept on file for possible future assignments. Works on assignment only. Keeps samples on file. SASE. Reports in 1 month. **Pays on receipt of invoice.** Credit line not given. Buys one-time and all rights; negotiable.

■**HAYES ORLIE CUNDALL INC.**, 46 Varda Landing, Sausalito CA 94965. (415)332-7414. Fax: (415)332-5924. Executive Vice President and Creative Director: Alan W. Cundall. Estab. 1991. Ad agency. Uses all media except foreign. Types of clients: industrial, retail, fashion, finance, computer and hi-tech, travel, healthcare, insurance and real estate.
Needs: Works with 1 freelance photographer/month on assignment only. Model release required. Captions preferred.
Making Contact & Terms: Provide résumé, business card and brochure to be kept on file for future assignments. "Don't send anything unless it's a brochure of your work or company. We keep a file of talent—we then contact photographers as jobs come up." NPI. Pays on a per-photo basis; negotiates payment based on client's budget, amount of creativity required and where work will appear. "We abide by local photographer's rates."
Tips: "Most books are alike. I look for creative and technical excellence, then how close to our offices; cheap vs. costly; personal rapport; references from friends in agencies who've used him/her. Call first. Send samples and résumé if I'm not able to meet with you personally due to work pressure. Keep in touch with new samples." Produces occasional audiovisual for industrial and computer clients; also produces a couple of videos a year.

THE HITCHINS COMPANY, 22756 Hartland St., Canoga Park CA 91307. Phone/fax: (818)715-0510. E-mail: whitchins@aol.com. President: W.E. Hitchins. Estab. 1985. Ad agency. Approximate annual billing: $350,000. Number of employees: 2. Types of clients: industrial, retail (food) and auctioneers. Examples of recent projects: Electronic Expediters (brochure showing products).
Needs: Uses photos for trade magazines, direct mail and newspapers. Model release required.
Specs: Uses b&w and color prints. "Copy should be flexible for scanning."
Making Contact & Terms: Provide résumé, business card, brochure, flier or tearsheets to be kept on file for possible future assignments. Works on assignment only. Cannot return material. NPI; payment negotiable depending on job. Pays on receipt of invoice (30 days). Rights purchased negotiable; "varies as to project."

Tips: Wants to see shots of people and products in samples.

■**IMAGE INTEGRATION**, 2418 Stuart St., Berkeley CA 94705. (510)841-8524. Owner: Vince Casalaina. Estab. 1971. Specializes in material for TV productions. Approximate annual billing: $100,000. Examples of projects: "Ultimate Subscription" for *Sailing World* (30 second spot); "Road to America's Cup" for ESPN (stock footage); and "Sail with the Best" for US Sailing (promotional video).
Needs: Works with 1 freelance photographer and 1 videographer/month. Reviews stock photos of sailing. Property release preferred. Captions required; include regatta name, regatta location, date.
Audiovisual Needs: Uses videotape. Subjects include: sailing.
Specs: Uses 4×5 or larger matte color or b&w prints; 35mm transparencies; 16mm film and Betacam videotape.
Making Contact & Terms: Interested in receiving work from newer, lesser-known photographers. Send unsolicited photos by mail for consideration. Works on assignment only. Keeps samples on file. SASE. Reports in 1-2 weeks. NPI; payment depends on distribution. Pays on publication. Credit line sometimes given, depending upon whether any credits included. Buys nonexclusive rights; negotiable.

KOVEL KRESSER & PARTNERS, (formerly Kresser/Craig), 2501 Colorado Ave., Santa Monica CA 90404. Prefers not to share information.

■**LINEAR CYCLE PRODUCTIONS**, Box 2608, Sepulveda CA 91393-2608. E-mail: lincycprod@ kbbs.com. Production Manager: R. Borowy. Estab. 1980. Member of Internation United Photographer Publishers, Inc. Ad agency, PR firm. Approximate annual billing: $5 million. Number of employees: 10. Types of clients: industrial, commercial, advertising. Examples of recent projects: "The Sam Twee," Bob's Bob-O-Bob (ad); "Milk the Milk," Dolan's (ad); "Faster . . . not better," Groxnic, O'Fopp & Pippernatz (ad).
Needs: Works with 7-10 freelance photographers, 8-12 filmmakers, 8-12 videographers/month. Uses photos for billboards, consumer magazines, direct mail, P-O-P displays, posters, newspapers, audiovisual uses. Subjects include: candid photographs. Reviews stock photos, archival. Model/property release required. Captions required; include description of subject matter.
Audiovisual Needs: Uses slides and/or film or video for television/motion pictures. Subjects include: archival-humor material.
Specs: Uses 8×10 color and b&w prints; 35mm, 8×10 transparencies; 16mm-35mm film; ½″, ¾″, 1″ videotape.
Making Contact & Terms: Interested in receiving work from newer, lesser-known photographers. Submit portfolio for review. Query with résumé of credits. Query with stock photo list. Send unsolicited photos by mail for consideration. Provide résumé, business card, brochure, flier or tearsheets to be kept on file for possible future assignments. Works with local freelancers on assignment only. Keeps samples on file. Reports in 1 month. Pays $100-500/b&w photo; $150-750/color photo; $100-1,000/ job. Prices paid depend on position. Pays on publication. Credit line given. Buys one-time rights; negotiable.
Tips: "Send a good portfolio with color pix shot in color (not b&w of color). No sloppy pictures or portfolios!! The better the portfolio is set up, the better the chances that we would consider it . . . let alone look at it!!" Seeing a trend toward "more archival/vintage, and a lot of humor pieces!!!"

■**MARKEN COMMUNICATIONS**, 3375 Scott Blvd., Suite 108, Santa Clara CA 95054-3111. (408)986-0100. Fax: (408)986-0162. E-mail: marken@cerfnet.com. President: Andy Marken. Production Manager: Leslie Posada. Estab. 1977. Ad agency and PR firm. Approximate annual billing: $4.5 million. Number of employees: 8. Types of clients: furnishings, electronics and computers. Examples of recent ad campaigns include: Burke Industries (resilient flooring, carpet); Boole and Babbage (mainframe software); Maxar (PCs).
Needs: Works with 3-4 freelance photographers/month. Uses photos for trade magazines, direct mail, publicity and catalogs. Subjects include: product/applications. Model release required.
Audiovisual Needs: Slide presentations and sales/demo videos.
Specs: Uses color and b&w prints; 35mm, 2¼×2¼ and 4×5 transparencies.
Making Contact & Terms: Arrange a personal interview to show portfolio. Query with samples. Submit portfolio for review. "Call." Works with freelancers on an assignment basis only. SASE. Reports in 1 month. Pays $50-1,000/b&w photo; $100-1,800/color photo; $50-100/hour; $500-1,000/ day; $200-2,500/job. Pays 30 days after receipt of invoice. Credit line given "sometimes." Buys one-time rights.

■**NEW & UNIQUE VIDEOS**, 2336 Sumac Dr., San Diego CA 92105. (619)282-6126. Fax: (619)283-8264. Director of Acquisitions: Candace Love. Estab. 1981. AV firm. Types of clients: industrial, financial, fashion, retail and special interest video distribution. Examples of recent projects: "Full-Cycle: A World Odyssey" (special-interest video); "Ultimate Mountain Biking," Raleigh Cycle

Co. of America (special interest video); "John Howard's Lessons in Cycling," John Howard (special interest video); and "Battle at Durango: First-Ever World Mountain Bike Championships," *Mountain & City Biking Magazine* (special interest video).
Needs: Works with 8-10 photographers and/or videographers/year. Subjects include "new and unique" special interest, such as cycling and sports. Reviews stock footage: cycling, sports, comedy, romance, "new and unique." Model/property release preferred.
Audiovisual Needs: Uses VHS videotape, Hi-8 and Betacam SP.
Making Contact & Terms: Query with list of video subjects. Works on assignment only. Keeps samples on file. SASE. Reports in 3 weeks. NPI; "payment always negotiated." **Pays on acceptance.** Credit line given. Buys exclusive and nonexclusive rights.
Tips: In samples looks for "originality, good humor and timelessness. We are seeing an international hunger for action footage; good wholesome adventure; comedy, educational, how-to—special interest. The entrepreneurial, creative and original video artiste—with the right attitude—can always feel free to call us."

NORTON-WOOD PR SERVICES, 1430 Tropical Ave., Pasadena CA 91107-1623. (818)351-9216. Fax: (818)351-9446. PR firm. Partner/Owner: Nat Wood. Types of clients: industrial, manufacturing, computers, aerospace.
Needs: Works with 1 freelance photographer/month. Uses freelance photographers for trade magazines, catalogs and brochures. Model release required; property release preferred. Captions required.
Making Contact & Terms: Interested in receiving work from newer, lesser-known photographers if industrial-oriented. Query with résumé of credits. Query with list of stock photo subjects. Works with local freelancers only. Reports in 2 weeks. Pays $20-250/b&w photo; $35-75/color photo; $40-60/hour; $500-750/day; $500-1,000/job. **Pays on receipt of invoice.** Buys one-time rights; negotiable. Credit line sometimes given.
Tips: Prefers to see industrial products, in-plant shots, personnel, machinery in use. "Be available for Western states assignments primarily. Use other than 35mm equipment."

■**ON-Q PRODUCTIONS INC.**, 618 E. Gutierrez St., Santa Barbara CA 93103. (805)963-1331. President: Vincent Quaranta. Estab. 1984. Producers of multi-projector slide presentations and computer graphics. Types of clients: industrial, fashion and finance.
Needs: Buys 100 freelance photos/year; offers 50 assignments/year. Uses photos for brochures, posters, audiovisual presentations, annual reports, catalogs and magazines. Subjects include: scenic, people and general stock. Model release required. Captions required.
Specs: Uses 35mm, 2¼ × 2¼ and 4 × 5 transparencies.
Making Contact & Terms: Provide stock list, business card, brochure, flier or tearsheets to be kept on file for possible future assignments. Pays $100 minimum/job. Buys rights according to client's needs.
Tips: Looks for stock slides for AV uses.

■**BILL RASE PRODUCTIONS, INC.**, 955 Venture Court, Sacramento CA 95825. (916)929-9181. Manager/Owner: Bill Rase. Estab. 1965. AV firm. Types of clients: industry, business, government, publishing and education. Produces slide sets, multimedia kits, motion pictures, sound-slide sets, videotapes, mass cassette, reel and video duplication. Photo and film purchases vary.
Needs: "Script recording for educational clients is our largest need, followed by industrial training, state and government work, motivational, video transfer, etc." Freelance photos used sometimes in motion pictures. No nudes. Color only. Vertical format for TV cutoff only. Sound for TV public service announcements, commercials, and industrial films. Uses stock footage of hard-to-find scenes, landmarks in other cities, shots from the 1920s to 1980s, etc. Special subject needs include 35mm and ¾-inch video shot of California landmark locations, especially San Francisco, Napa Valley Wine Country, Gold Country, Lake Tahoe area, Delta area and Sacramento area. "We buy out the footage—so much for so much," or ¾-inch video or 35mm slides. Uses 8 × 10 prints and 35mm transparencies.
Making Contact & Terms: NPI. Payment depends on job, by bid. Pays 30 days after acceptance. Buys one-time rights or all rights; varies according to clients' needs. Model release required. Query with samples and résumé of credits. Freelancers within 100 miles only. Does not return samples. SASE. Reports "according to the type of project. Sometimes it takes a couple of months to get the proper bid info."
Tips: "Video footage of the popular areas of this country and others is becoming more and more useful. Have price list, equipment list and a few slide samples in a folder or package available to send."

■**RED HOTS ENTERTAINMENT**, 634 N. Glenoaks Blvd., Suite 374, Burbank CA 91502-2024. (818)954-0092. President/Creative Director: Chip Miller. Estab. 1987. Motion picture, music video, commercial, and promotional trailer film production company. Types of clients: industrial, fashion, entertainment, motion picture, TV and music.

Needs: Works with 2-6 freelance photographers/month. Uses freelancers for TV, music video, motion picture stills and production. Model release required. Property release preferred. Captions preferred.
Making Contact & Terms: Provide business card, résumé, references, samples or tearsheets to be kept on file for possible future assignments. NPI; payment negotiable "based on project's budget." Rights negotiable.
Tips: Wants to see minimum of 2 pieces expressing range of studio, location, style and model-oriented work. Include samples of work published or commissioned for production.

■**VISUAL AID MARKETING/ASSOCIATION**, (formerly Visitors Aid Marketing/Visaid Marketing/Passengers Aid), Box 4502, Inglewood CA 90309-4502. (310)399-0696. Manager: Lee Clapp. Estab. 1965. Ad agency. Number of employees: 3. Types of clients: industrial, fashion, retail, food, travel hospitality. Examples of projects: "Robot Show, Tokyo" (magazine story) and "American Hawaii Cruise" (articles).
Needs: Works with 1-2 freelance photographers, 1-2 filmmakers and 1-2 videographers/month. Uses photos for billboards, consumer magazines, trade magazines, direct mail, P-O-P displays, catalogs, posters, newspapers, signage. Model/property release required for models, printed matter (copyrighted). Captions required; include how, what, where, when, identity.
Audiovisual Needs: Uses slides for travel presentations.
Specs: Uses 8×10, glossy color and b&w prints; 35mm, $2\frac{1}{4} \times 2\frac{1}{4}$, 4×5, 8×10 transparencies; Ektachrome film; Beta/Cam videotape..
Making Contact & Terms: Interested in receiving work from newer, lesser-known photographers. Query with résumé of credits. Query with stock photo list. Provide résumé, business card, brochure, flier or tearsheets. Works with local freelancers on assignment only. Material cannot be returned. Reports in 1-2 weeks. NPI, payment negotiable upon submission. **Pays on acceptance,** publication or **receipt of invoice**. Credit line given depending upon client's wishes. Buys first, one-time rights; negotiable.

■**DANA WHITE PRODUCTIONS, INC.**, 2623 29th St., Santa Monica CA 90405. (310)450-9101. Full-service audiovisual, multi-image, photography and design, video/film production studio. President: Dana White. Estab. 1977. Types of clients: corporate, government and educational. Examples of productions: Southern California Gas Company/South Coast AQMD (Clean Air Environmental Film Trailers in 300 LA-based motion picture theaters); Glencoe/Macmillan/McGraw-Hill (textbook photography and illustrations, slide shows); Pepperdine University (awards banquets presentations, fundraising, biographical tribute programs); US Forest Service (slide shows and training programs); Venice Family Clinic (newsletter photography); Johnson & Higgins (brochure photography).
Needs: Works with 2-3 freelance photographers/month. Uses photos for catalogs, audiovisual and books. Subjects include: people, products, still life and architecture. Interested in reviewing 35mm stock photos, by appointment. Signed model release for people and companies photographed is required.
Audiovisual Needs: Uses all AV formats; also slides for multi-image presentations using 1-9 projectors.
Specs: Uses color and b&w; 35mm, $2\frac{1}{4} \times 2\frac{1}{4}$ transparencies.
Making Contact & Terms: Interested in receiving work from newer, lesser-known photographers. Arrange a personal interview to show portfolio and samples. Works with freelancers on assignment only. Will assign certain work on spec. Do not submit unsolicited material. Will not return material. Pays when images are shot to White's satisfaction—never delays until acceptance by client. Pays according to job: $25-100/hour, up to $500/day; $20-50/shot; or fixed fee based upon job complexity and priority of exposure. Hires according to work-for-hire and will share photo credit when possible.
Tips: In freelancer's portfolio or demo, Mr. White wants to see "quality of composition, lighting, saturation, degree of difficulty and importance of assignment." The trend seems to be toward "more video, less AV." Clients are paying less and expecting more. To break in, freelancers should "diversify, negotiate, be flexible, go the distance to get and keep the job. Don't get stuck in thinking things can be done just one way. Support your co-workers."

■**WORLDWIDE MARKETING GROUP**, 1874 S. Pacific Coast Hwy., #906, Redondo Beach CA 90277. (310)540-5374. Fax: (310)543-3081. President: Anne-Marie Fahrenkrug-Ortiz. Ad agency. Approximate annual billing: $6 million. Number of employees: 10. Types of clients: Audiotext. Examples of recent clients: Interwest Communications (London/Santa Monica, California); 3-Net Communications (Sweden); Telecard (Norway).
Needs: Uses photos for consumer magazines, direct mail and newspapers. Subjects include: photos of Asian men and women—with and without nudity and cleavage—and lingerie stock photos.
Audiovisual Needs: Uses videotape for adult commercials on late night TV.
Specs: Uses color and b&w prints (color preferred); $2\frac{1}{4} \times 2\frac{1}{4}$ transparencies.
Making Contact & Terms: Interested in receiving work from newer, lesser-known photographers. Query with stock photo list. Send unsolicited photos by mail for consideration. Query with samples.

Works on assignment only. Keeps samples on file. SASE. Reports in 1-2 weeks. Usually pays from $125/photo (full buyout). **Pays on acceptance**. Credit line not given. Buys all rights.
Tips: "We book space and create ads for clients in the adult audiotext industry. We prefer full buyouts of material with model releases."

Los Angeles

■**BRAMSON + ASSOCIATES**, 7400 Beverly Blvd., Los Angeles CA 90036. (213)938-3595. Fax: (213)938-0852. Principal: Gene Bramson. Estab. 1970. Ad agency. Approximate annual billing: $2 million. Number of employees: 8. Types of clients: industrial, financial, food, retail, health care. Examples of recent projects: Hypo Tears ad, 10 Lab Corporation (people shots); brochure, Chiron Vision (background shots).
Needs: Works with 2-5 freelance photographers and 1 videographer/month. Uses photos for trade magazines, direct mail, catalogs, posters, newspapers, signage. Subject matter varies. Reviews stock photos. Model/property release required. Captions preferred.
Audiovisual Needs: Uses slides and/or videotape for industrial, product.
Specs: Uses 11×15 color and b&w prints; 35mm, 2¼×2¼, 4×5, 8×10 transparencies.
Making Contact & Terms: Interested in receiving work from newer, lesser-known photographers. Submit portfolio for review. Send unsolicited photos by mail for consideration. Provide résumé, business card, brochure, flier or tearsheet to be kept on file for possible future assignments. Works with local freelancers on assignment only. Keeps samples on file. SASE. Reports in 3 weeks. NPI. Pays on receipt of invoice. Payment varies depending on budget for each project. Credit line not given. Buys one-time and all rights.
Tips: "Innovative—crisp—dynamic—unique style—different—otherwise we'll stick with our photographers. If it's not great work don't bother."

■**HALLOWES PRODUCTIONS & ADVERTISING**, 11260 Regent St., Los Angeles CA 90066-3414. (310)390-4767. Fax: (310)397-2977. Creative Director/Producer-Director: Jim Hallowes. Estab. 1984. Produces TV commercials, corporate films and print advertising.
Needs: Buys 8-10 photos annually. Uses photos for magazines, posters, newspapers and brochures. Reviews stock photos; subjects vary.
Audiovisual Needs: Uses film and video for TV commercials and corporate films.
Specs: Uses 35mm, 4×5 transparencies; 35mm/16mm film; Beta SP videotape.
Making Contact & Terms: Interested in receiving work from newer, lesser-known photographers. Query with résumé of credits. Do not fax unless requested. Keeps samples on file. SASE. Reports if interested. NPI. Pays on usage. Credit line sometimes given, depending upon usage, usually not. Buys first and all rights; rights vary depending on client.

■**BERNARD HODES ADVERTISING**, 11755 Wilshire Blvd., Suite 1600, Los Angeles CA 90025. (310)575-4000. Ad agency. Creative Directors: Steve Mitchell and Morris Hertz. Produces "recruitment advertising for all types of clients."
Needs: Uses photos for billboards, trade magazines, direct mail, brochures, catalogs, posters, newspapers and internal promotion. Model release required.
Making Contact & Terms: Query with samples "to be followed by personal interview if interested." Does not return unsolicited material. Reporting time "depends upon jobs in house; I try to arrange appointments within three-four weeks." NPI. Payment "depends upon established budget and subject." **Pays on acceptance** for assignments; on publication per photo. Buys all rights.
Tips: Prefers to see "samples from a wide variety of subjects. No fashion. People-oriented location shots. Nonproduct. Photos of people and/or objects telling a story—a message. Eye-catching." Photographers must have "flexible day and ½-day rates, work fast and be able to get a full day's (or ½) work from a model or models. Excellent sense of lighting. Awareness of the photographic problems with newspaper reproduction."

*****JB West**, P.O. Box 66895, Los Angeles CA 90066. (800)393-9278. Creative Director: John Belletti. Estab. 1979. Ad agency. Approximate annual billing: $500,000. Number of employees: 7. Types of clients: industrial, financial and food. Examples of recent projects: "Train of Values" for Coca-Cola (promotion); and "Game of Credit" for N.Y. Credit (book project).
Needs: Works with 1 or 2 freelancers/month. Uses photos for consumer magazines, trade magazines, direct mail, P-O-P displays, catalogs, poster. Subjects include: food and people. Reviews stock photos of business and finance.
Audiovisual Needs: Uses slides for slide shows.
Specs: Uses 35mm, 2¼×2¼, 4×5 transparencies.
Making Contact & Terms: Interested in receiving work from newer, lesser-known photographers. Arrange personal interview to show portfolio. Works with freelancers on assignment only. Keeps

samples on file. Cannot return material. Reports in 1-2 weeks. NPI. Pays on receipt of invoice after 30 days. Credit line sometimes given depending upon project. Buys all rights; negotiable.

LEVINSON ASSOCIATES, 1440 Veteran Ave., Suite 650, Los Angeles CA 90024. (213)460-4545. Fax: (213)663-2820. E-mail: Jed222@aol.com. Assistant to President: Jed Leland, Jr. Estab. 1969. PR firm. Types of clients: industrial, financial, entertainment. Examples of recent projects: Cougar Records; Steve Yeager's Stars of Sports; the Boyce & Hart Project; Time Line Productions; DCC Compact Classics; Romance Alive Audio.
Needs: Works with varying number of freelancers/month. Uses photos for trade magazines and newspapers. Subjects vary. Model release required. Property release preferred. Captions preferred.
Making Contact & Terms: Works with local freelancers only. Keeps samples on file. Cannot return material. NPI. Buys all rights; negotiable.

OGILVY & MATHER DIRECT, 11766 Wilshire Blvd., Suite 1100, Los Angeles CA 90025. Prefers not to share information.

San Francisco

GOODBY SILVERSTEIN & PARTNERS, 915 Front St., San Francisco CA 94111. Prefers not to share information.

PURDOM PUBLIC RELATIONS, 395 Oyster Point Blvd., Suite 319, San Francisco CA 94080. (415)588-5700. Fax: (415)588-1643. E-mail: purcom@netcom.com. President: Paul Purdom. Estab. 1965. Member of International Public Relations Exchange, Public Relations Society of America. PR firm. Approximate annual billing: $1.75 million. Number of employees: 17. Types of clients: computer manufacturers, software, industrial, general high-technology products. Examples of recent PR campaigns: Sun Microsystems, Autodesk, Vanian Assoc., Acuron Corporation (all application articles in trade publications).
Needs: Works with 4-6 freelance photographers/month. Uses photos for trade magazines, direct mail and newspapers. Subjects include: high technology and scientific topics. Model release preferred.
Specs: Uses 35mm and 2¼×2¼ transparencies; film: contact for specs.
Making Contact & Terms: Query with résumé of credits, list of stock photo subjects. Provide résumé, business card, brochure, flier or tearsheets to be kept on file for possible future assignments. Works on assignment only. Does not return material. Reports as needed. Pays $50-150/hour, $400-1,500/day. Pays on receipt of invoice. Buys all rights; negotiable.

HAL RINEY & PARTNERS INC., 735 Battery St., San Francisco CA 94111. Prefers not to share information.

■**VARITEL**, One Union, San Francisco CA 94111. (415)693-1111. Senior Post Producer: Blake Padilla. Types of clients: advertising agencies.
Needs: Works with 10 freelance photographers/month. Uses freelance photos for filmstrips, slide sets and videotapes. Also works with freelance filmmakers for CD-ROM, Paint Box.
Specs: Uses color prints; 35mm transparencies; 16mm, 35mm film; VHS, Beta, U-matic ¾" or 1" videotape. Also, D2.
Making Contact & Terms: Provide résumé, business card, self-promotion piece or tearsheets to be kept on file for possible future assignments. Does not return unsolicited material. Reports in 1 week. Pays $50-100/hour; $200-500/day. **Pays on acceptance.** Rights vary.
Tips: Apply with résumé and examples of work to Julie Resing, general manager.

Colorado

■**FRIEDENTAG PHOTOGRAPHICS**, 356 Grape St., Denver CO 80220. (303)333-7096. Manager: Harvey Friedentag. Estab. 1957. AV firm. Serves clients in business, industry, government, trade and union organizations. Produces slide sets, motion pictures and videotape.
Needs: Works with 5-10 freelancers/month on assignment only. Buys 1,000 photos and 25 films/year. Reviews stock photos of business, training, public relations and industrial plants showing people and equipment or products in use. Model release required.
Audiovisual Needs: Uses freelance photos in color slide sets and motion pictures. No posed looks. Also produces mostly 16mm Ektachrome and some 16mm b&w; ¾" and VHS videotape. Length

requirement: 3-30 minutes. Interested in stock footage on business, industry, education and unusual information. "No scenics please!"

Specs: Uses 8×10 glossy b&w and color prints; transparencies; 35mm, 2¼×2¼ or 4×5 color transparencies.

Making Contact & Terms: Send material by mail for consideration. Provide flier, business card and brochure and nonreturnable samples to show clients. SASE. Reports in 3 weeks. Pays $400/day for still; $600/day for motion picture plus expenses; $35/b&w photo; $75/color photo. **Pays on acceptance.** Buys rights as required by clients.

Tips: "More imagination needed, be different, and above all, technical quality is a must. There are more opportunities now than ever, especially for new people. We are looking to strengthen our file of talent across the nation."

■**WARREN MILLER ENTERTAINMENT**, 2540 Frontier Ave., Unit #104, Boulder CO 80301. (303)442-3430. Fax: (303)442-3402. Vice President of Production: Don Brolin. Motion picture production house. Buys 5 films/year.

Needs: Works with 5-20 freelance photographers/month. Uses photographers for outdoor cinematography of skiing (snow) and other sports. Also travel, documentary, promotional, educational and indoor studio filming. "We do everything from TV commercials to industrial films to feature length sports films."

Audiovisual Needs: Uses 16mm film. "We purchase exceptional sport footage not available to us."

Making Contact & Terms: Filmmakers may query with résumé of credits and sample reel. "We are only interested in motion picture-oriented individuals who have practical experience in the production of 16mm motion pictures." Works on assignment only. SASE. Reports in 1 week. Pays $150-200/day. Also pays by the job. **Pays on receipt of invoice.** Buys all rights. Credit line given.

Tips: Looks for technical mastering of the craft and equipment—decisive shot selection. "Make a hot demo reel and be a hot skier; be willing to travel."

Connecticut

THE MORETON AGENCY, P.O. Box 749, East Windsor CT 06088. (203)627-0326. Art Director: Keith Malone. Ad agency. Types of clients: industrial, sporting goods, corporate and consumer.

Needs: Works with 3-4 photographers/month. Uses photos for consumer and trade magazines, direct mail, catalogs, newspapers and literature. Subjects include: people, sports, industrial, product and fashion. Model release required.

Specs: Uses b&w prints; 35mm, 2¼×2¼, 4×5 and 8×10 transparencies.

Making Contact & Terms: Provide business card, brochure, flier or tearsheets to be kept on file for possible future assignments. Works with freelance photographers on assignment only. Cannot return material. NPI. Credit line negotiable. Buys all rights.

Delaware

■**LYONS MARKETING COMMUNICATIONS**, 715 Orange St., Wilmington DE 19801. (302)654-6146. Ad agency. Creative Director: Erik Vaughn. Types of clients: consumer, corporate and industrial.

Needs: Works with 6 freelance photographers/month. Uses photos for consumer and trade magazine ads, direct mail, P-O-P displays, catalogs, posters and newspaper ads. Subjects vary greatly. Some fashion, many "outdoor-sport" type of things. Also, high-tech, business-to-business. Model release required. Captions preferred.

Specs: Format varies by use.

Making Contact & Terms: Query with résumé of credits and list of stock photo subjects. Provide examples of work, business card, brochure, flier or tearsheets to be kept on file for possible future assignments. NPI. Payment varies based on scope of job, abilities of the photographer. Pays on publication. Credit line given depending on job. Rights purchased vary.

Tips: "We consider the subjects, styles and capabilities of the photographer. Rather than guess at what we're looking for, show us what you're good at and enjoy doing. Be available on a tight and changing schedule; show an ability to pull together the logistics of a complicated shoot."

District of Columbia

■**HILLMANN & CARR INC.**, 2121 Wisconsin Ave. NW, Washington DC 20007. (202)342-0001. Art Director: Michal Carr. Estab. 1975. Types of clients: museums, corporations, industrial, government and associations.
Needs: Model releases required. Captions preferred.
Audiovisual Needs: Uses slides, films and videotapes for multimedia productions. "Subjects are extremely varied and range from the historical to current events. We do not specialize in any one subject area. Style also varies greatly depending upon subject matter."
Specs: Uses 35mm transparencies; video, 16mm and 35mm film.
Making Contact & Terms: Provide résumé, business card, self-promotion pieces, tearsheets or video samples to be kept on file for possible future assignments. Works on assignment only. Cannot return material. "If material has been unsolicited and we do not have immediate need, material will be filed for future reference." NPI; payment negotiable. Rights negotiable.
Tips: Looks for photographers with artistic style. "Quality reproduction of work which can be kept on file is extremely important."

■**WORLDWIDE TELEVISION NEWS (WTN)**, 1705 DeSales St. NW, Suite 300, Washington DC 20036. (202)222-7889. Fax: (202)222-7891. Bureau Manager, Washington: Paul C. Sisco. Estab. 1952. AV firm. "We basically supply TV news on tape for TV networks and stations. At this time, most of our business is with foreign nets and stations."
Needs: Buys dozens of "news stories per year, especially sports." Works with 6 freelance photographers/month on assignment only. Generally hard news material, sometimes of documentary nature and sports.
Audiovisual Needs: Produces motion pictures and videotape.
Making Contact & Terms: Send name, phone number, equipment available and rates with material by mail for consideration. Provide business card to be kept on file for possible future assignments. Fast news material generally sent counter-to-air shipment; slower material by air freight. SASE. Reports in 2 weeks. Pays $100 minimum/job. Pays on receipt of material; nothing on speculation. Video rates about $500/half day, $900/full day. Negotiates payment based on amount of creativity required from photographer. Buys all video rights. Dupe sheets for film required.

Florida

*****AD CONSULTANT GROUP INC.**, 3111 University Dr., #408, Coral Springs FL 33065. (954)340-0883. President: B. Weisblum. Estab. 1994. Ad agency. Approximate annual billing: $3 million. Number of employees: 3. Types of clients: fashion, retail and food.
Needs: Works with 1 freelancer and 1 videographer/month. Uses photos for consumer magazines, trade magazines, direct mail, catalogs and newspapers. Reviews stock photos. Model/property release required.
Audiovisual Needs: Uses videotape.
Making Contact & Terms: Interested in receiving work from newer, lesser-known photographers. Query with stock photo list. Send unsolicited photos by mail for consideration. Provide résumé, business card, brochure, flier or tearsheets to be kept on file for possible future assignments. Works with freelancers on assignment only. Cannot return material. Reports in 3 weeks. Payment negotiable. **Pays on acceptance.** Credit line sometimes given. Buys all rights; negotiable.

*****■STEVEN COHEN MOTION PICTURE PRODUCTION**, 4800 NW 96th Dr., Coral Springs FL 33076. (305)346-7370. Contact: Steven Cohen. Examples of productions: TV commercials, documentaries, 2nd unit feature films and 2nd unit TV series.
Needs: Model release required.
Specs: Uses 16mm, 35mm film; 1″, ¾″ U-Matic and ½″ VHS, Beta videotape.
Making Contact & Terms: Query with résumé. Provide business card, self-promotion piece or tearsheets to be kept on file for possible future assignments. Works on assignment only. Cannot return material. Reports in 1 week. NPI. Pays on acceptance or publication. Credit line given. Buys all rights (work-for-hire).

THE CODE NPI (no payment information given) appears in listings that have not given specific payment amounts.

HACKMEISTER ADVERTISING & PUBLIC RELATIONS, INC., 2631 E. Oakland, Suite 204, Ft. Lauderdale FL 33306. (305)568-2511. President: Dick Hackmeister. Estab. 1979. Ad agency and PR firm. Serves industrial, electronics manufacturers who sell to other businesses.
Needs: Works with 1 freelance photographer/month. Uses photos for trade magazines, direct mail, catalogs. Subjects include: electronic products. Model release and captions required.
Specs: Uses 8×10 glossy b&w and color prints and 4×5 transparencies.
Making Contact & Terms: "Call on telephone first." Does not return unsolicited material. Pays by the day and $200-2,000/job. Buys all rights.
Tips: Looks for "good lighting on highly technical electronic products—creativity."

■**INTRAVUE**, 6 E. Bay St., 5th Floor, Jacksonville FL 32202. (904)353-8755. Fax: (904)353-8778. Art Director: John Kerr. Estab. 1988. Member of ASI, Jacksonville Ad Federation, Florida Chamber of Commerce, Jacksonville Chamber of Commerce. Ad agency. Approximate annual billing: $4 million. Number of employees: 12. Types of clients: industrial, financial, fashion, retail and food. Examples of recent projects: "Clean Shower" for Automation, Inc.; "The Fresh 'n Fit Padette" for Athena Medical.
Needs: Works with 2-5 freelance photographers, 1 videographer/month. Uses photos for consumer and trade magazines, direct mail, P-O-P displays, catalogs, posters, newspapers and audiovisual. Subjects vary per client (specific subjects are selected by creative/art director). Reviews stock photos; all subjects. Model/property release required. Captions preferred.
Audiovisual Needs: Uses slides, film and videotape for all print work.
Specs: Uses 5×7, 8×10 glossy or matte color or b&w prints; 35mm, 2¼×2¼, 4×5 transparencies.
Making Contact & Terms: Interested in receiving work from newer, lesser-known photographers. Arrange personal interview to show portfolio. Send unsolicited photos by mail for consideration. Provide résumé, business card, brochure, flier or tearsheets to be kept on file for possible future assignments. Works on assignment only. Keeps samples on file. SASE. Reports in 1-2 weeks (if interested). NPI. Pays on receipt of client payment. Credit line sometimes given, depending on client, usage. Buys all rights.
Tips: Mixture of styles is a plus. Show an ability to do studio stills and avant garde work as well.

■**MYERS, MYERS & ADAMS ADVERTISING, INC.**, 938 N. Victoria Park Rd., Ft. Lauderdale FL 33304. (305)523-0202. Creative Director: Virginia Sours-Myers. Estab. 1986. Member of Ad Federation of Fort Lauderdale, Marine Industries Assoc. Ad agency. Approximate annual billing: $2 million. Number of employees: 6. Types of clients: industrial, manufacturing, marine and health care. Examples of projects: Music Marketing Network (direct mail campaign); Advanced Games & Engineering (trade ad); The Landis Group (corporate brochure).
Needs: Works with 3-5 photographers, filmmakers and/or videographers/month. Uses photos for billboards, consumer and trade magazines, direct mail, P-O-P displays, catalogs, newspapers and audiovisual. Subjects include: marine, food, real estate, medical and fashion. Wants to see "all subjects" in stock images and footage.
Audiovisual Needs: Uses photos/film/video for slide shows, film and videotape.
Specs: Uses all sizes b&w/color prints; 35mm, 2¼×2¼, 4×5 transparencies; 35mm film; 1", ¾", but to review need ½".
Making Contact & Terms: Provide résumé, business card, brochure, flier or tearsheets to be kept on file for possible future assignments. Works with freelancers on assignment basis only. Cannot return material. Reports as needed. Pays $50-400/b&w photo; $100-800/color photo; $50-250/hour; $200-1,200/day; $50-30,000/job. Credit line given sometimes, depending on usage. Buys all rights (work-for-hire) and 1 year's usage; negotiable.
Tips: "We're not looking for arty-type photos or journalism. We need photographers who understand an advertising sense of photography: good solid images that sell the product." Sees trend in advertising toward "computer-enhanced impact and color effects. Send samples, tearsheets and be patient. Please don't call us. If your work is good we keep it on file and as a style is needed we will contact the photographer. Keep us updated with new work. Advertising is using a fair amount of audiovisual work. We use a lot of stills within our commercials. Make portfolio available to production houses."

*■**STEVE POSTAL PRODUCTIONS**, P.O. Box 428, 108 Carraway St., Bostwick FL 32007. (904)325-5254. Director: Steve Postal. Estab. 1957. Member of SMPTE. AV firm. Approximate annual billing: $1 million plus. Number of employees: 10-48. Types of clients: distributors. Examples of recent projects: "The Importance of Going Amtrak," Washington DC AMTRAK (overseas info film); and many feature films on video for release (distributed to many countries).
Needs: Works with 2-3 freelance photographers, 2-3 filmmakers and 3-4 videographers/month. Uses photos for billboards, consumer magazines, trade magazines, direct mail and audiovisual. Subjects include: feature film publicity. Reviews stock photos of travel, food, glamour modeling and industrial processes. Model/property release preferred for glamour modeling. Captions required; include name, address, telephone number, date taken and equipment used.

Audiovisual Needs: Uses slides and/or film or video.
Specs: Uses 4×5, 8×10 glossy color and/or b&w prints; 35mm, 2¼×2¼ transparencies; 16mm film; VHS (NTSC signal) videotape.
Making Contact & Terms: Interested in receiving work from newer, lesser-known photographers. Send unsolicited photos by mail for consideration. Query with samples. Provide résumé, business card, brochure, flier or tearsheets to be kept on file for possible future assignments. Works with freelancers on assignment only. Keeps samples on file. Photographers should call in 3 weeks for report. Pays per job or feature film; negotiable. **Pays on acceptance.** Credit line given. Buys all rights.
Tips: Looks for sharpness of image, trueness of color, dramatic lighting or very nice full lighting.

PRODUCTION INK, 2826 NE 19 Dr., Gainesville FL 32609-3391. (352)377-8973. Fax: (352)373-1175. President: Terry Van Nortwick. Ad agency, PR, marketing and graphic design firm. Types of clients: hospital, industrial, computer.
Needs: Works with 1 freelance photographer/month. Uses photos for ads, billboards, trade magazines, catalogs and newspapers. Reviews stock photos. Model release required.
Specs: Uses b&w prints and 35mm, 2¼×2¼ and 4×5 transparencies.
Making Contact & Terms: Arrange personal interview to show portfolio. Submit portfolio for review. Provide résumé, business card, brochure, flier or tearsheets to be kept on file for possible future assignments. Keeps samples on file. NPI. **Pays on receipt of invoice.** Credit line sometimes given; negotiable. Buys all rights.

SARTORY O'MARA, 5840 Corporate Way, Suite 100, West Palm Beach FL 33407. (407)683-7500. Fax: (407)683-1806. Ad agency. Art Director: Christine Christianson. Types of clients: various.
Needs: Works with 2-3 photographers/month. Uses photos for trade magazines, newspapers, brochures. Subjects include: residential, pertaining to client.
Specs: Uses b&w and color prints; 35mm, 2¼×2¼ and 4×5 transparencies.
Making Contact & Terms: Provide résumé, business card, brochure, flier or tearsheets to be kept on file for possible future assignments. Works with local freelance photographers on assignment only. NPI. Buys all rights. Model release required.

Georgia

■**FRASER ADVERTISING**, 1201 George C. Wilson Dr. #B, Augusta GA 30909. (706)855-0343. President: Jerry Fraser. Estab. 1980. Ad agency. Approximate annual billing: $800,000. Number of employees: 5. Types of clients: automotive, industrial, manufacturing, residential. Examples of recent projects: Pollock Company (company presentation); STV Corp. (national ads).
Needs: Works with "possibly one freelance photographer every two or three months." Uses photos for consumer and trade magazines, catalogs, posters and AV presentations. Subject matter: "product and location shots." Also works with freelance filmmakers to produce TV commercials on videotape. Model release required. Property release preferred.
Specs: Uses glossy b&w and color prints; 35mm, 2¼×2¼ and 4×5 transparencies; videotape and film. "Specifications vary according to the job."
Making Contact & Terms: Interested in receiving work from newer, lesser-known photographers. Provide résumé, business card, brochure, flier or tearsheets to be kept on file for possible future assignments. Works with freelance photographers on assignment only. Cannot return unsolicited material. Reports in 1 month. NPI; payment varies according to job. Pays on publication. Buys exclusive/product, electronic, one-time and all rights; negotiable.
Tips: Prefers to see "samples of finished work—the actual ad, for example, not the photography alone. Send us materials to keep on file and quote favorably when rate is requested."

■**PAUL FRENCH & PARTNERS, INC.**, 503 Gabbettville Rd., LaGrange GA 30240. (706)882-5581. Contact: Glen Vanderbeek. Estab. 1969. AV firm. Types of clients: industrial, corporate.
Needs: Works with freelance photographers on assignment basis only. Uses photos for filmstrips, slide sets, multimedia. Subjects include: industrial marketing, employee training and orientation, public and community relations.
Specs: Uses 35mm and 4×5 color transparencies.
Making Contact & Terms: Query with résumé of credits to be kept on file for possible future assignments. Pays $75-150 minimum/hour; $600-1,200/day; $150 minimum/job, plus travel and expenses. **Payment on acceptance.** Buys all rights, but may reassign to photographer after use.
Tips: "We buy photojournalism . . . journalistic treatments of our clients' subjects. Portfolio: industrial process, people at work, interior furnishings, product, fashion. We seldom buy single photos."

■**GRANT/GARRETT COMMUNICATIONS**, P.O. Box 53, Atlanta GA 30301. Phone/fax: (404)755-2513. President/Owner: Ruby Grant Garrett. Estab. 1979. Ad agency. Types of clients: technical. Examples of ad campaigns: Simons (help wanted); CIS Telecom (equipment); Anderson Communication (business-to-business).
Needs: Uses photos for trade magazines, direct mail and newspapers. Interested in reviewing stock photos/video footage of people at work. Model/property release required. Photo captions preferred.
Audiovisual Needs: Uses stock video footage.
Specs: Uses 4×5 b&w prints; VHS videotape.
Making Contact & Terms: Interested in receiving work from newer, lesser-known photographers. Query with résumé of credits. Query with list of stock photo subjects. Provide résumé, business card, brochure, flier or tearsheets to be kept on file for possible future assignments. Works with freelancers on an assignment basis only. SASE. Reports in 1 week. NPI; pays per job. **Pays on receipt of invoice.** Credit line sometimes given, depending on client. Buys one-time and other rights; negotiable.
Tips: Wants to see b&w work in portfolio.

■**MYRIAD PRODUCTIONS**, 4923 Four Oaks Court, Atlanta GA 30360. (770)698-8600. President: Ed Harris. Estab. 1965. Primarily involved with sports productions and events. Works with freelance photographers on assignment only basis.
Needs: Uses photos for portraits, live-action and studio shots, special effects, advertising, illustrations, brochures, TV and film graphics, theatrical and production stills. Model/property release required. Captions preferred; include name(s), location, date, description.
Specs: Uses 8×10 b&w glossy prints, 8×10 color prints and 2¼×2¼ transparancies.
Making Contact & Terms: Provide brochure, résumé and samples to be kept on file for possible future assignments. Send material by mail for consideration. Cannot return material. Reporting time "depends on urgency of job or production." NPI. Credit line sometimes given. Buys all rights.
Tips: "We look for an imaginative photographer; one who captures all the subtle nuances, as the photographer is as much a part of the creative process as the artist or scene being shot. Working with us depends almost entirely on the photographer's skill and creative sensitivity with the subject. All materials submitted will be placed on file and not returned, pending future assignments. Photographers should not send us their only prints, transparencies, etc., for this reason."

Idaho

CIPRA AD AGENCY, 314 E. Curling Dr., Boise ID 83702. (208)344-7770. President: Ed Gellert. Estab. 1979. Ad agency. Types of clients: agriculture (regional basis) and gardening (national basis).
Needs: Works with 1 freelance photographer/month. Uses photos for trade magazines. Subjects include: electronic, agriculture and garden. Reviews general stock photos. Model release required.
Specs: Uses 4×5, 8×10, 11×14 glossy or matte, color, b&w prints; also 35mm and 4×5 transparencies.
Making Contact & Terms: Provide résumé, business card, brochure, flier or tearsheets to be kept on file for possible future assignments. Usually works with local freelancers only. Keeps samples on file. Cannot return material. Reports as needed. Pays $75/hour. Pays on publication. Buys all rights.

Illinois

BRAGAW PUBLIC RELATIONS SERVICES, 800 E. Northwest Hwy., Suite 1040, Palatine IL 60067. (708)934-5580. Contact: Richard S. Bragaw. Estab. 1981. PR firm. Types of clients: professional service firms, high-tech entrepreneurs.
Needs: Works with 1 freelance photographer/month. Uses photos for trade magazines, direct mail, brochures, newspapers, newsletters/news releases. Subjects include: "products and people." Model release preferred. Captions preferred.
Specs: Uses 3×5, 5×7 and 8×10 glossy prints.
Making Contact & Terms: Provide résumé, business card, brochure, flier or tearsheets to be kept on file for possible future assignments. Works with freelance photographers on assignment basis only. SASE. Pays $25-100/b&w photo; $50-200/color photo; $35-100/hour; $200-500/day; $100-1,000/job. **Pays on receipt of invoice.** Credit line "possible." Buys all rights; negotiable.
Tips: "Execute an assignment well, at reasonable costs, with speedy delivery."

JOHN CROWE ADVERTISING AGENCY, 2319½ N. 15th St., Springfield IL 62702-1226. (217)528-1076. President: Bryan J. Crowe. Ad agency. Serves clients in industry, commerce, aviation, banking, state and federal government, retail stores, publishing and institutes.

Needs: Works with 1 freelance photographer/month on assignment only. Uses photos for billboards, consumer and trade magazines, direct mail, newspapers and TV. Model release required.
Specs: Uses 8×10 glossy b&w prints; also uses color 8×10 glossy prints and 2¼×2¼ transparencies.
Making Contact & Terms: Send material by mail for consideration. Provide letter of inquiry, flier, brochure and tearsheet to be kept on file for future assignments. SASE. Reports in 2 weeks. Pays $50 minimum/job or $18 minimum/hour. Payment negotiable based on client's budget. Buys all rights.

■**EGD & ASSOCIATES, INC.**, 4300 Lincoln Ave., Suite K, Rolling Meadows IL 60008. (708)991-1270. Fax: (708)991-1519. Vice President: Kathleen Williams. Estab. 1970. Ad agency. Types of clients: industrial, retail, finance, food. Examples of ad campaigns: National ads for Toshiba and Sellstrom; packaging for Barna.
Needs: Works with 7-8 freelance photographers and videographers/month. Uses photos for billboards, consumer and trade magazines, direct mail, P-O-P displays, catalogs and audiovisual. Subjects include: industrial products and facilities. Reviews stock photos/video footage of "creative firsts." Model release required. Captions preferred.
Audiovisual Needs: Uses photos/video for slide shows and videotape.
Specs: Uses 5×7 b&w/color prints; 35mm, 2¼×2¼, 4×5, 8×10 transparencies; videotape.
Making Contact & Terms: Interested in receiving work from newer, lesser-known photographers. Arrange personal interview to show portfolio. Provide résumé, business card, brochure, flier or tearsheets to be kept on file for possible future assignments. Works on assignment basis only. Cannot return material. Reports in 3 weeks. NPI; pays according to "client's budget." Pays within 30 days of invoice. Credit line sometimes given; credit line offered in lieu of payment. Buys all rights.
Tips: Sees trend toward "larger budget for exclusive rights and creative firsts. Contact us every six months."

QUALLY & COMPANY, INC., Suite 3, 2238 Central St., Evanston IL 60201-1457. (708)864-6316. Creative Director: Robert Qually. Ad agency and graphic design firm. Types of clients: finance, package goods and business-to-business.
Needs: Works with 4-5 freelance photographers/month. Uses photos for billboards, consumer and trade magazines, direct mail, P-O-P displays, posters and newspapers. "Subject matter varies, but is always a 'quality image' regardless of what it portrays." Model release required.
Specs: Uses b&w and color prints; 35mm, 2¼×2¼, 4×5 and 8×10 transparencies.
Making Contact & Terms: Query with samples or submit portfolio for review. Provide résumé, business card, brochure, flier or tearsheets to be kept on file for possible future assignments. Works with local freelance photographers on assignment only. Cannot return material. Reports in 2 weeks. NPI; payment depends on circumstances. Pays on acceptance or net 45 days. Credit line sometimes given, depending on client's cooperation. Rights purchased depend on circumstances.

■**VIDEO I-D, INC.**, 105 Muller Rd., Washington IL 61571. (309)444-4323. Fax: (309)444-4333. E-mail: videoid@videoid.com. Website: http://www.videoid.com. President: Sam B. Wagner. Number of employees: 5. Types of clients: health, education, industry, cable and broadcast.
Needs: Works with 5 freelance photographers/month to shoot slide sets, multimedia productions, films and videotapes. Subjects "vary from commercial to industrial—always high quality." "Somewhat" interested in stock photos/footage. Model release required.
Specs: Uses 35mm transparencies; 16mm film; U-matic ¾" and 1" videotape, Beta SP.
Making Contact & Terms: Provide résumé, business card, self-promotion piece or tearsheets to be kept on file for possible future assignments; "also send video sample reel." Works with freelancers on assignment only. SASE. Reports in 3 weeks. Pays $8-25/hour; $65-250/day. Usually pays by the job; negotiable. **Pays on acceptance.** Credit line sometimes given. Buys all rights; negotiable.
Tips: Sample reel—indicate goal for specific pieces. "Show good lighting and visualization skills. Be willing to learn. Show me you can communicate what I need to hear — and willingness to put out effort to get top quality."

Chicago

LEO BURNETT COMPANY, INC., 35 W. Wacker Dr., Chicago IL 60601. Prefers not to share information.

■**DARBY GRAPHICS, INC.**, 4015 N. Rockwell St., Chicago IL 60618. (312)583-5090. Production Manager: Dennis Cyrier. Types of clients: corporate and agency.
Needs: Uses photographers for filmstrips, slide sets, multimedia productions, videotapes, print and publication uses.

Making Contact & Terms: Provide résumé, business card, self-promotion piece or tearsheets to be kept on file for possible future assignments. Works on assignment only; interested in stock photos/footage. NPI. Payment is made to freelancers net 30 days. Captions preferred; model release required.

DEFRANCESCO/GOODFRIEND, 444 N. Michigan Ave., Suite 1000, Chicago IL 60611. (312)644-4409. Fax: (312)644-7651. E-mail: office@dgpr.com. Partner: John DeFrancesco. Estab. 1985. PR firm. Approximate annual billing: $700,000. Number of employees: 8. Types of clients: industrial, consumer products. Examples of recent projects: publicity campaigns for Promotional Products Association International and S-B Power Tool Company, and a newsletter for Teraco Inc.
Needs: Works with 1-2 freelancers/month. Uses photos for consumer magazines, trade magazines, direct mail, newspapers, audiovisual. Subjects include: people, equipment. Model/property release required. Captions preferred.
Audiovisual Needs: Uses slides and video for publicity, presentation and training.
Specs: Uses 5×7, 8×10, glossy color and b&w prints; 35mm transparencies; ½″ VHS videotape.
Making Contact & Terms: Interested in receiving work from newer, lesser-known photographers. Query with résumé of credits. Provide résumé, business card, brochure, flier or tearsheets to be kept on file for possible future assignments. Works with freelancers on assignment only. Keeps samples on file. SASE. Reports in 1-2 weeks. Pays $25-100/hour; $100-1,000/day; $250/job; payment negotiable. Pays on receipt of invoice. Credit line sometimes given.
Tips: "Because most photography is used in publicity, the photo must tell the story. We're not interested in high-style, high-fashion techniques."

FOOTE CONE & BELDING COMMUNICATIONS, 101 E. Erie St., Chicago IL 60611. (312)751-7000. Contact: Art Director. Types of clients: industrial, financial, fashion, retail and food. Examples of projects: Citibank, Kraft, Payless.
Needs: Uses photos for billboards, consumer and trade magazines, direct mail, P-O-P displays, catalogs, posters, newspapers, signage, audiovisual uses. Subjects include: industrial, financial, fashion, retail, food. Reviews stock photos. Model/property release required.
Specs: Uses 35mm, 2¼×2¼, 4×5 and 8×10 transparencies.
Making Contact & Terms: Interested in receiving work from newer, lesser-known photographers. Contact through rep. Reports in 1-2 weeks. NPI. **Pays on receipt of invoice.** Rights purchased depend on advertisement and advertisement form.

GARFIELD-LINN & COMPANY, 142 E. Ontario Ave., Chicago IL 60611. (312)943-1900. Creative Director: Mr. Terry Hackett. Associate Creative Director: Ralph Woods. Art Director: Karen Schmidt. Ad agency. Types of clients: Serves a "wide variety" of accounts; client list provided upon request.
Needs: Number of freelance photographers used varies. Works on assignment only. Uses photographs for billboards, consumer and trade magazines, direct mail, brochures, catalogs and posters.
Making Contact & Terms: Arrange interview to show portfolio and query with samples. NPI. Payment is by the project; negotiates according to client's budget.

■**MSR ADVERTISING, INC.**, P.O. Box 10214, Chicago IL 60610-0214. (312)573-0001. Fax: (312)573-1907. E-mail: zoe@msradv.com. President: Marc S. Rosenbaum. Vice President: Barry Waterman. Creative Director: Indiana Wilkins. Estab. 1983. Ad agency. Types of clients: industrial, financial, retail, food, aerospace, hospital and medical. Examples of recent projects: "Back to Basics," MPC Products; and "Throw Mother Nature a Curve," New Dimensions Center for Cosmetic Surgery.
Needs: Works with 4-6 freelance photographers, 1-2 videographers/month. Uses photos for billboards, consumer and trade magazines, direct mail, P-O-P displays, catalogs, posters and signage. Subject matter varies. Reviews stock photos. Model/property release required.
Audiovisual Needs: Uses slides and videotape for business-to-business seminars, consumer focus groups, etc. Subject matter varies.
Specs: Uses 35mm, 2¼×2¼, 4×5 and 8×10 transparencies.
Making Contact & Terms: Interested in receiving work from newer, lesser-known photographers. Submit portfolio for review. Send unsolicited photos by mail for consideration. Query with samples. Provide résumé, business card, brochure, flier or tearsheets to be kept on file for possible future assignments. Works on assignment only. Keeps samples on file. SASE. Reports in 1-2 weeks. Pays $750-1,500/day. Payment terms stated on invoice. Credit line sometimes given. Buys all rights; negotiable.

SANDRA SANOSKI COMPANY, INC., 166 E. Superior St., Chicago IL 60611. (312)664-7795. President: Sandra Sanoski. Estab. 1974. Marketing communications and design firm specializing in display and publication design, packaging and web/internet design. Types of clients: retail and consumer goods.
Needs: Works with 3-4 freelancers/month. Uses photos for catalogs and packaging. Subject matter varies. Reviews stock photos. Model/property release required.

Specs: Uses 35mm, 2¼×2¼, 4×5, 8×10 transparencies.
Making Contact & Terms: Interested in receiving work from newer, lesser-known photographers and digital images. Query with list of stock photo images. Arrange personal interview to show portfolio. Works on assignment only. Keeps samples on file. SASE. NPI. Pays net 30 days. Credit line not given. Buys all rights.

Indiana

■**KELLER CRESCENT COMPANY**, 1100 E. Louisiana, Evansville IN 47701. (812)426-7551 or (812)464-2461. Manager Still Photography: Cal Barrett. Ad agency, PR and AV firm. Serves industrial, consumer, finance, food, auto parts and dairy products clients. Types of clients: Old National Bank, Fruit of The Loom and Eureka Vacuums.
Needs: Works with 2-3 freelance photographers/month on assignment only basis. Uses photos for billboards, consumer and trade magazines, direct mail, newspapers, P-O-P displays, radio and TV. Model release required.
Specs: Uses 8×10 b&w prints; 35mm, 4×5 and 8×10 transparencies.
Making Contact & Terms: Query with résumé of credits, list of stock photo subjects. Send material by mail for consideration. Provide business card, tearsheets and brochure to be kept on file for possible future assignments. Prefers to see printed samples, transparencies and prints. Cannot return material. Pays $200-2,500/job; negotiates payment based on client's budget, amount of creativity required from photographer and photographer's previous experience/reputation. Buys all rights.

*■**OMNI PRODUCTIONS**, 12955 Old Meridian St., P.O. Box 302, Carmel IN 46032-0302. (317)844-6664. Fax: (317)573-8189. President: Winston Long. AV firm. Types of clients: industrial, corporate, educational, government and medical.
Needs: Works with 6-12 freelance photographers/month. Uses photographers for AV presentations. Subject matter varies. Also works with freelance filmmakers to produce training films and commercials.
Specs: Uses b&w and color prints; 35mm transparencies; 16mm and 35mm film and videotape.
Making Contact & Terms: Provide résumé, business card, brochure, flier or tearsheets to be kept on file for possible future assignments. Works with freelance photographers on assignment basis only. Does not return unsolicited material. NPI. **Pays on acceptance.** Buys all rights "on most work; will purchase one-time use on some projects." Model release required. Credit line given "sometimes, as specified in production agreement with client."

■**B.J. THOMPSON ASSOCIATES**, 201 S. Main, Mishawaka IN 46544. Senior Art Director: David J. Marks. Estab. 1979. Ad agency. Types of clients: industrial, retail, RV. Examples of previous projects: "Welcome Home" Friendly People Campaign, Jayco Inc. (brochure campaign); annual stock holders' report for Valley American Bank; "The Grand Vienna Ball" Germany trip, Mark IV Audio (incentive trip campaign).
Needs: Works with 2-3 freelance photographers, 1 videographer/month. Uses photos for consumer magazines, trade magazines, direct mail, P-O-P displays, catalogs, posters. Subjects vary. Reviews background, landscape, scenic stock photos. Model/property release required for property (locations), models.
Audiovisual Needs: Uses slides and video for TV spots, informational videos. Subjects vary.
Specs: Uses 35mm, 2¼×2¼, 4×5 transparencies; videotape.
Making Contact & Terms: Arrange personal interview to show portfolio. Provide résumé, business card, brochure, flier or tearsheets to be kept on file for possible future assignments. Works with local freelancers on assignment only. Keeps samples on file. SASE. Reports in 1-2 weeks. Payment varies per job (quotes based on per job). **Pays on receipt of invoice.** Credit line not given. Buys all rights; negotiable.
Tips: Portfolios "need recreational vehicles, automotive and table top. Freelancers must work well on location and have a good knowledge of interior lighting."

 THE SOLID, BLACK SQUARE before a listing indicates that the market uses various types of audiovisual materials, such as slides, film or videotape.

Iowa

■PHOENIX ADVERTISING CO., W. Delta Park, Hwy. 18 W., Clear Lake IA 50428. (515)357-9999. Fax: (515)357-5364. Ad agency. Estab. 1986. Types of clients: industrial, financial and consumer. Examples of projects: "Western Tough," Bridon (print/outdoor/collateral); "Blockbuster," Video News Network (direct mail, print); and "Blue Jeans," Clear Lake Bank & Trust (TV/print/newspaper).
Needs: Works with 2-3 photographers or videographers/month. Uses photos for billboards, consumer and trade magazines, direct mail, P-O-P displays, catalogs, posters, newspapers, signage, audiovisual uses. Subjects include: people/products. Reviews stock photos and/or video.
Audiovisual Needs: Uses slides and videotape.
Specs: Uses 8×10 color and b&w prints; 35mm, 2¼×2¼, 4×5, 8×10 transparencies; ½″ or ¾″ videotape.
Making Contact & Terms: Contact through rep. Submit portfolio for review. Provide résumé, business card, brochure, flier or tearsheets to be kept on file for possible future assignments. Works on assignment only. Keeps samples on file. SASE. Reports in 3 weeks. Pays $1,000-10,000/day. **Pays on receipt of invoice.** Buys first rights, one-time rights, all rights and others; negotiable. Model/property release required. Credit line sometimes given; no conditions specified.

Kansas

MARKETAIDE, INC., Dept. PM, 1300 E. Iron, P.O. Box 500, Salina KS 67402-0500. (800)204-2433. (913)825-7161. Fax: (913)825-4697. Copy Chief: Ted Hale. Art Director: Pamela Harris. Ad agency. Uses all media. Serves industrial, retail, financial, nonprofit organizations, political, agribusiness and manufacturing clients.
Needs: Needs industrial photography (studio and on site), agricultural photography, and photos of banks, people and places.
Making Contact & Terms: Call to arrange an appointment. Provide résumé and tearsheets to be kept on file for possible future assignments. Reports in 3 weeks. SASE. Buys all rights. "We generally work on a day rate ranging from $200-1,000/day." Pays within 30 days of invoice.
Tips: Photographers should have "a good range of equipment and lighting, good light equipment portability, high quality darkroom work for b&w, a wide range of subjects in portfolio with examples of processing capabilities." Prefers to see "set-up shots, lighting, people, heavy equipment, interiors, industrial and manufacturing" in a portfolio. Prefers to see "8×10 minimum size on prints, or 35mm transparencies, preferably unretouched" as samples.

PATON & ASSOCIATES, INC./PAT PATON PUBLIC RELATIONS, P.O. Box 7350, Leawood KS 66207. (913)491-4000. Contact: N.E. (Pat) Paton, Jr. Estab. 1956. Ad agency. Clients: medical, financial, home furnishings, professional associations, vacation resorts, theater and entertainment.
Needs: Uses photos for billboards, consumer and trade magazines, direct mail, newspapers, P-O-P displays and TV. Model release required. Captions required.
Making Contact & Terms: Interested in receiving work from newer, lesser known photographers. Call for personal appointment to show portfolio. Works on assignment only. NPI. Payment negotiable according to amount of creativity required from photographer.

Kentucky

■BARNEY MILLERS INC., 232 E. Main St., Lexington KY 40507. (606)252-2216. Fax: (606)253-1115. Chairman: Harry Miller. Estab. 1922. Types of clients: retail, fashion, industrial, legal and government. Examples of projects: Bluegrass AAA (internal training); Bank One (internal training); and Renfro Valley (television promotion).
Needs: Works with 3-4 freelance photographers/month. Uses photos for video transfer, editing and titling. Reviews stock photos/footage. Captions preferred.
Specs: Uses color prints; 35mm transparencies; 8mm, super 8, 16mm and 35mm film. "We are very proficient in converting to video."
Making Contact & Terms: Interested in receiving work from newer, lesser-known photographers. Arrange a personal interview to show portfolio or submit portfolio by mail. Provide résumé, business card, self-promotion piece or tearsheets to be kept on file for possible future assignments. Works with local freelancers only. SASE. Reports in 1 week. Pays $35-200/hour. **Pays on acceptance.** Credit line given if desired. Rights negotiable.

■**KINETIC CORPORATION**, 240 Distillery Commons, Louisville KY 40206. (502)583-1679. Fax: (502)583-1104. Director of Creative Service: Rob Kennedy. Estab. 1968. Types of clients: industrial, financial, fashion, retail and food.
Needs: Works with freelance photographers and/or videographers as needed. Uses photos for audiovisual and print. Subjects include: location photography. Model and/or property release required.
Audiovisual Needs: Uses photos for slides and videotape.
Specs: Uses varied sizes and finishes color and b&w prints; 35mm, 2¼×2¼, 4×5, 8×10 transparencies; and ¾″ Beta SP videotape.
Making Contact & Terms: Provide résumé, business card, brochure, flier or tearsheets to be kept on file for possible future assignments. Works with local freelancers only. Keeps samples on file. SASE. Reports only when interested. NPI. Pays within 30 days. Buys all rights.

Louisiana

RICHARD SACKETT EXECUTIVE CONSULTANTS, 101 Howard Ave., Suite 3400, New Orleans LA 70113-2036. (504)522-4040. Fax: (504)524-8839. Art Director: Matthew Spisak. Ad agency. Approximate annual billing: $8-9 million. Number of employees: 14. Types of clients: legal, retail and gaming. Examples of projects: "One call, that's all" outdoor ad campaign for Morris Bart attorneys; "LA Everything" advertising campaign for LA Auto; brochure and ads for a Las Vegas casino. Client list free with SASE.
Needs: Works with 3 photographers/month. Uses photographers for billboards, consumer and trade magazines, direct mail, P-O-P displays, posters, newspapers. Subject matter includes portraits, merchandise, cityscapes, scenery of construction sites, mood photos and food. Model release required.
Specs: Uses 35mm, 4×5 and 8×10 transparencies.
Making Contact & Terms: Arrange a personal interview to show portfolio. Send unsolicited photos by mail for consideration. Works with freelance photographers on an assignment basis only. SASE. Reports in 1 week. Pays $600-1,000/day and $3,000-40,000/job. Pays on publication or on **receipt of invoice**. Credit line given when appropriate. Buys one-time and all rights; negotiable.

Maryland

■**MARC SMITH COMPANY, INC.**, P.O. Box 5005, Severna Park MD 21146. (410)647-2606. Art Director: Ed Smith. Estab. 1963. Ad agency. Types of clients: industrial. Client list on request with SASE.
Needs: Uses photos for trade magazines, direct mail, catalogs, slide programs and trade show booths. Subjects include: products, sales literature (still life), commercial buildings (interiors and exteriors). Model release required for building owners, designers, incidental persons. Captions required.
Specs: Vary: b&w and color prints and transparencies.
Making Contact & Terms: Provide résumé, business card, brochure, flier or tearsheets to be kept on file for possible future assignments. Works with freelance photographers on assignment only. Cannot return material. Reports in 1 month. NPI; pays by the job. Pays when client pays agency, usually 30-60 days. Buys all rights.
Tips: Wants to see "proximity, suitability, cooperation and reasonable rates."

Massachusetts

BUYER ADVERTISING AGENCY, INC., 85 Wells Ave., Newton MA 02159. (617)969-4646. Production Manager: Marion Buyer. Ad agency. Uses all media. Serves clients in food and industry.
Needs: Needs photos of food, fashion and industry; and candid photos. Buys up to 10 photos/year.
Making Contact & Terms: Call to arrange an appointment, submit portfolio or send mailer. Reports in 1 week. SASE. Pays $25 minimum/hour.
Specs: Uses 5×7, 8×10 semigloss b&w prints; contact sheet OK. Also uses color prints; and 35mm, 2¼×2¼, 4×5 and 11×14 transparencies.

■**CRAMER PRODUCTION CENTER**, Dept. PM, 355 Wood Rd., Braintree MA 02184. (617)849-3350. Fax: (617)849-6165. Film/video production company. Operations Manager: Matt McHugo. Estab. 1982. Types of clients: industrial, financial, fashion, retail and food. Examples of recent projects: "Boston Garden Banner Years" (video); "Tufts National Fundraiser" (video); "Progress Softwear Users Conference" (event support); "Indigo" (CD-ROM).

Audiovisual Needs: Works with 3-8 freelance filmmakers and/or videographers/month for P-O-P displays and audiovisual. Subjects include: industrial to broadcast/machines to people. Reviews stock film or video footage. Uses film and videotape.

Making Contact & Terms: Send demo of work, ¾″ or VHS videotape. Query with résumé of credits. Works on assignment only. Keeps samples on file. Reports in 1 month. Pays $175-560/day, depending on job and level of expertise needed. Pays 30 days from receipt of invoice. Buys all rights. Model/property release required. Credit line sometimes given, depending on how the program is used.

Tips: Looks for experience in commercial video production. "Don't be discouraged if you don't get an immediate response. When we have a need, we'll call you."

***DAVID FOX PHOTOGRAPHY**, 59 Fountain St., Framingham MA 01701. (508)820-1130. Fax: (508)820-0558. President: David Fox. Estab. 1983. Video production/post production photography company. Approximate annual billing: $120,000. Number of employees: 2. Types of clients: consumer, industrial and corporate. Examples of recent projects: Mathworks (training/marketing video); Chariot Publishing (marketing video); "Making Strides Against Breast Cancer March," American Cancer Society (documentary).

Needs: Works with 2-4 freelance photographers/videographers/month. Subjects include: executive portraiture, fine art, stock, children, families. Reviews area footage. Model/property release required. Captions preferred.

Audiovisual Needs: Uses videotape; photos, all media related materials. "We are primarily producers of video and photography images."

Specs: Uses 35mm and 2¼×2¼ transparencies, slides and ½″, SVHS, Hi 8mm and 8mm formats of videotape.

Making Contact & Terms: Arrange personal interview to show portfolio. Provide résumé, business card, brochure, flier or tearsheets to be kept on file for possible future assignments. Portfolio and references required. Works on assignment only. Looking for wedding photographers and freelancers. Works closely with freelancers. Buys all rights; negotiable.

Tips: Looks for style, abilities, quality and commitment similar to ours. "We have expanded our commercial photography. We tend to have more need in springtime and fall, than other times of the year. We're very diversified in our services—projects come along and we use people on an as-need basis."

FUESSLER GROUP INC., 324 Shawmut Ave., Boston MA 02118. (617)262-3964. Fax: (617)266-1068. E-mail: 73060.1633@compuserve.com. President: Rolf Fuessler. Estab. 1984. Member of Society for Marketing Professional Services, Public Relations Society of America. Marketing communications firm. Types of clients: industrial, professional services. Has done work for Ogden Yorkshire, Earth Tech Inc.

Needs: Works with 2 freelancers/month; rarely works with videographers. Uses photos for trade magazines, collateral advertising and direct mail pieces. Subjects include: industrial and environmental. Reviews stock photos. Model/property release required, especially with hazardous waste photos. Captions preferred.

Specs: Uses 35mm transparencies.

Making Contact & Terms: Interested in receiving work from newer, lesser-known photographers. Query with résumé of credits. Query with samples. Works with local freelancers on assignment only. Keeps samples on file. SASE. Reports in 3 weeks. NPI. Pays on receipt of invoice. Credit line given. Buys first rights, one-time rights, all rights and has purchased unlimited usage rights for one client; negotiable.

***GRAPHIC COMMUNICATIONS**, 3 Juniper Lane, Dover MA 02030-2146. (508)785-1301. Fax: (508)785-2072. Owner: Richard Bertucci. Estab. 1970. Member of Art Directors Club, Graphic Artists Guild. Ad agency. Approximate annual billing: $1 million. Number of employees: 5. Types of clients: industrial, consumer, finance. Examples of recent projects: campaigns for Avant Incorporated; JBF Scientific; and Marketrieve Company.

Needs: Works with 3 freelancers/month. Uses photos for consumer magazines, trade magazines, catalogs, direct response and annual reports. Subjects include: products, models. Reviews stock photos. Model/property release required. Captions preferred.

Specs: Uses 8×10 glossy color and b&w prints; 2¼×2¼, 4×5 transparencies.

Making Contact & Terms: Interested in receiving work from newer, lesser-known photographers. Query with stock photo list. Provide résumé, business card, brochure, flier or tearsheets to be kept on file for possible future assignments. Works with local freelancers on assignment only. Keeps samples on file. Cannot return material. Reports as needed. NPI. Pays on receipt of invoice. Credit line not given. Buys all rights.

HILL HOLLIDAY CONNORS COSMOPULOS INC., John Hancock Tower, 200 Clarendon St., Boston MA 02116. Prefers not to share information.

■**JEF FILMS INC**, 143 Hickory Hill Circle, Osterville MA 02655-1322. (508)428-7198. Fax: (508)428-7198. President: Jeffrey H. Aikman. Estab. 1973. AV firm. Member of American Film Marketing Association, National Association of Television Programmers and Executives. Types of clients: retail. Examples of projects: "Yesterday Today & Tomorrow," JEF Films (video box); "M," Aikman Archive (video box).
Needs: Works with 5 freelance photographers, 5-6 filmmakers and 5-6 videographers/month. Uses photos for billboards, consumer magazines, trade magazines, direct mail, P-O-P displays, catalogs, posters, newspapers and audiovisual. Subjects include glamour photography. Reviews stock photos of all types. Model release preferred. Property release required. Captions preferred.
Audiovisual Needs: Uses slides, films and/or video for videocassette distribution at retail level.
Specs: Uses 35mm transparencies.
Making Contact & Terms: Interested in receiving work from newer, lesser-known photographers. Submit portfolio for review. Works on assignment only. Keeps samples on file. Cannot return material. Reports in 1 month. Pays $25-300/job. Pays on publication. Credit line is not given. Buys all rights.

*■**RUTH MORRISON ASSOCIATES**, 22 Wendell St., Cambridge MA 02138. (617)354-4536. Fax: (617)354-6943. Account Executive: Marinelle Hervas. Estab. 1972. PR firm. Types of clients: specialty foods, housewares, home furnishings and general business.
Needs: Works with 1-2 freelance photographers and/or videographers/month. Uses photos for consumer and trade magazines, P-O-P displays, posters, newspapers, signage and audiovisual.
Audiovisual Needs: Uses photos and videotape.
Specs: Specifications vary according to clients' needs. Typically uses b&w prints and transparencies.
Making Contact & Terms: Arrange personal interview to show portfolio. Provide résumé, business card, brochure, flier or tearsheets to be kept on file for possible future assignments. Works with freelancers on assignment only. Reports "as needed." Pays $100-1,000 depending upon client's budget. Credit line sometimes given, depending on use. Rights negotiable.

*■**MULLEN**, 36 Essex St., Wenham MA 01984. (508)468-1155. Fax: (508)468-1133. Art Buyers: Tanya Mathis, Tracy Maidmen. Estab. 1970s. Ad agency, PR firm. Examples of recent projects: "Model People," Timberland (portrait testimonial); and "Grit . . ," Gitano (fashion).
Needs: Works with 15 freelancers/month. Uses photos for billboards, consumer magazines, trade magazines, P-O-P displays, posters and newspapers. Subjects include: still life and location. Reviews stock photos. Model/property release required.
Specs: Uses all sizes color and b&w prints; 35mm, 2¼×2¼, 4×5, 8×10 transparencies.
Making Contact & Terms: Interested in receiving work from newer, lesser-known photographers. Send unsolicited photos by mail for consideration. Query with samples. Works with freelancers on assignment only. Keeps samples on file. SASE. Reports in 1-2 weeks. NPI. Pays on receipt of invoice. Credit line given for low-budget assignments and public services pro bono only. Rights purchased vary, depending on job; negotiable.
Tips: Looks for special attention to detail, conceptualization, experimentation, strong lighting and styling. Notices a trend toward "select focus" photography in still life and portraits.

*■**RSVP MARKETING, INC.**, 450 Plain St., Marshfield MA 02050. (617)837-2804. Fax: (617)837-5389. E-mail: rsvpmktg@aol.com. President: Edward G. Hicks. Estab. 1981. Member of NEDMA, DMA, AMA. Ad agency and AV firm. Types of clients: industrial, financial, fashion, retail and construction. Examples of recent projects: "Landfill Reclamation," RETECH (trade shows); "Traffic," Taylor (print media); and "Fund Raising," CHF (newsletter).
Needs: Works with 1-2 freelance photographers and 1-2 videographers/month. Uses photos for trade magazines, direct mail, catalogs, newspapers and audiovisual. Subjects include: environment and people. Model release required.
Audiovisual Needs: Uses slides and videotape for advertising and trade shows.
Specs: Uses 5×7 color and b&w prints; 35mm, 2¼×2¼, 4×5, 8×10 transparencies.
Making Contact & Terms: Query with stock photo list. Query with samples. Works with freelancers on assignment only. Keeps samples on file. Reports in 1 month. NPI. Pays net 30. Buys all rights.

■**TR PRODUCTIONS**, 1031 Commonwealth Ave., Boston MA 02215. (617)783-0200. Executive Vice President: Ross P. Benjamin. Types of clients: industrial, commercial and educational.
Needs: Works with 1-2 freelance photographers/month. Uses photographers for slide sets and multimedia productions. Subjects include: people shots, manufacturing/sales and facilities.
Specs: Uses 35mm transparencies.
Making Contact & Terms: Provide résumé, business card, self-promotion piece or tearsheets to be kept on file for possible future assignments. Works with local freelancers by assignment only; interested in stock photos/footage. Does not return unsolicited material. Reports "when needed." Pays $600-1,500/day. Pays "14 days after acceptance." Buys all AV rights.

Michigan

***COMMUNICATIONS ELECTRONICS JOURNAL**, P.O. Box 1045-PM, Ann Arbor MI 48106. (313)996-8888. Fax: (313)663-8888. Editor-in-Chief: Ken Ascher. Estab. 1969. Ad agency. Approximate annual billing: $7 million. Number of employees: 38. Types of clients: industrial, financial, retail. Examples of recent projects: Super Disk (computer ad); Eaton Medical (medical ad); Ocean Tech Group (scuba diving ad); and Weather Bureau (weather poster ad).
Needs: Works with 45 freelance photographers, 4 filmmakers and 5 videographers/month. Uses photos for consumer magazines, trade magazines, direct mail, P-O-P displays, catalogs, posters and newspapers. Subjects include: merchandise. Reviews stock photos of electronics, hi-tech, scuba diving, disasters, weather. Model/property release required. Captions required; include location.
Audiovisual Needs: Uses videotape for commercials.
Specs: Uses various size glossy color prints; 35mm, 2¼×2¼, 4×5 transparencies.
Making Contact & Terms: Interested in receiving work from newer, lesser-known photographers. Query with résumé of credits. Provide résumé, business card, brochure, flier or tearsheets to be kept on file for possible future assignments. Cannot return material. Reports in 1 month. Pays $100-2,000/ job; $15-1,000/color photo. Pays on publication. Credit line sometimes given depending on client. Buys one-time rights.

■CREATIVE HOUSE ADVERTISING, INC., 30777 Northwestern Hwy., Suite 301, Farmington Hills MI 48334. (810)737-7077. Executive Vice President/Creative Director: Robert G. Washburn. Senior Art Director: Denise McCormick. Art Director: Amy Hepner. Ad agency. Types of clients: retail, industry, finance and commercial products.
Needs: Works with 4-5 freelance photographers/year on assignment only. Also produces TV commercials and demo film. Uses photos for brochures, catalogs, annual reports, billboards, consumer and trade magazines, direct mail, newspapers, P-O-P displays, radio and TV. Model release required.
Audiovisual Needs: Uses 35mm and 16mm film.
Specs: Uses b&w and color prints; transparencies.
Making Contact & Terms: Arrange personal interview to show portfolio. Query with résumé of credits, samples or list of stock photo subjects. Submit portfolio for review. "Include your specialty and show your range of versatility." Send material by mail for consideration. Provide résumé, business card, brochure, flier and anything to indicate the type and quality of photos to be kept on file for future assignments. Local freelancers preferred. SASE. Reports in 2 weeks. Pays $100-200/hour or $800-1,600/day; negotiates payment based on client's budget and photographer's previous experience/reputation. Pays in 1-3 months, depending on the job. Does not pay royalties. Buys all rights.

HEART GRAPHIC DESIGN, 501 George St., Midland MI 48640. (517)832-9710. Owner: Clark Most. Estab. 1982. Ad agency. Approximate annual billing: $250,000. Number of employees: 3. Types of clients: industrial.
Needs: Works with 1 freelancer/month. Uses photos for consumer magazines, catalogs and posters. Subjects include: product shots. Reviews stock photos. Model/property release preferred. Captions preferred.
Specs: Uses 8×10, 11×14 color and b&w prints; 2¼×2¼, 4×5 and 8×10 transparencies.
Making Contact & Terms: Interested in receiving work from newer, lesser-known photographers. Send unsolicited photos by mail for consideration. Provide résumé, business card, brochure, flier or tearsheets to be kept on file for possible future assignments. Works with local freelancers only. Keeps samples on file. SASE. Reports in 1-2 weeks. Pays $200-2,500/job. Pays on receipt of invoice. Credit line not given. Rights negotiated depending on job.
Tips: "Display an innovative eye, ability to creatively compose shots and have interesting techniques."

■MESSAGE MAKERS, 1217 Turner St., Lansing MI 48906. (517)482-3333. Fax: (517)482-9933. Executive Director: Terry Terry. Estab. 1977. Member of LRCC, NSPI, AIVF, ITVA. AV firm. Number of employees: 4. Types of clients: broadcast, industrial and retail.
Needs: Works with 2 freelance photographers, 1 filmmaker and 2 videographers/month. Uses photos for direct mail, posters and newspapers. Subjects include: people or products. Model release preferred. Property release required. Captions preferred.
Audiovisual Needs: Uses slides, film, video and CD.
Specs: Uses 4×5 color and b&w prints; 35mm, 2¼×2¼ transparencies; Beta SP videotape.
Making Contact & Terms: Interested in receiving work from newer, lesser-known photographers. Provide résumé, business card, brochure, flier or tearsheets to be kept on file for possible future assignments. Keeps samples on file. Cannot return material. Reports only if interested. NPI. **Pays on receipt of invoice.** Credit line sometimes given depending upon client. Buys all rights; negotiable.

***■PHOTO COMMUNICATION SERVICES, INC.**, 6055 Robert Dr., Traverse City MI 49684-8645. (616)943-8800. E-mail: lesnmore@aol.com. President: M'Lynn Hartwell. Estab. 1970. Commer-

cial/Illustrative and AV firm. Types of clients: commercial/industrial, fashion, food, general, human interest.

Needs: Works with variable number of freelance photographers/month. Uses photos for catalogs, P-O-P displays, AV presentations, trade magazines and brochures. Photos used for a "large variety of subjects." Sometimes works with freelance filmmakers. Model release required.

Audiovisual Needs: Primarily industrial multi-image and video.

Specs: Uses 8×10 (or larger) gloss and semigloss b&w and color prints; 35mm, 2¼×2¼, 4×5 and 8×10 transparencies; 16mm film; VHS/SVHS; Hi8 and ¾" videotape.

Making Contact & Terms: Query with résumé of credits, samples or list of stock photo subjects. Works with freelance photographers on assignment basis only. SASE. Reports in 1 month. Payment determined by private negotiation. Pays 30 days from acceptance. Credit line given "whenever possible." Rights negotiated.

Tips: Looks for professionalism in portfolio or demos. "Be professional and to the point. If I see something I can use I will make an appointment to discuss the project in detail. We also have a library of stock photography."

VARON & ASSOCIATES, INC., 31333 Southfield Rd., Beverly Hills MI 48025. (810)645-9730. Fax: (810)642-1303. President: Jerry Varon. Estab. 1963. Ad agency. Types of clients: industrial and retail.

Needs: Uses photos for trade magazines, catalogs and audiovisual. Subjects include: industrial. Reviews stock photos. Model/property release required. Captions preferred.

Audiovisual Needs: Uses slides and videotape for sales and training. Subjects include: industrial.

Specs: Uses 8×10 color prints; 4×5 transparencies.

Making Contact & Terms: Interested in receiving work from newer, lesser-known photographers. Arrange personal interview to show portfolio. Works with freelancers on assignment only. Keeps samples on file. Cannot return material. Reports in 1-2 weeks. Pays $1,000/day. **Pays on acceptance.** Credit line sometimes given. Buys all rights.

Minnesota

***■CARMICHAEL-LYNCH, INC.,** 800 Hennepin Ave., Minneapolis MN 55403. (612)334-6000. Fax: (612)334-6085. E-mail: kdalager@clynch.com. Member of American Association of Advertising Agencies. Ad agency. Executive Creative Director: Jack Supple. Send print information to: Kathy Dalager and Karen Kuhn, Art Buyers. Broadcast information to Jack Steinmann. Types of clients: finance, healthcare, sports and recreation, agriculture, beverage. Examples of recent projects: Harley-Davidson (ads, motor clothes and literature); Rollerblade (ads and collateral); Minnesota Lottery (print and TV ads), Mack Trucks, American Standard.

Needs: Uses many freelance photographers/month. Uses photos for billboards, consumer and trade magazines, direct mail, P-O-P displays, brochures, posters, newspapers, and other media as needs arise. Also works with freelance filmmakers to produce TV commercials.

Specs: Uses all formats for print; 16mm and 35mm film and videotape for broadcast.

Making Contact & Terms: Interested in receiving work from newer, lesser-known photographers. Provide résumé, business card, brochure, flier or tearsheets to be kept on file for possible future assignments. Submit portfolio for review. Arrange a personal interview to show portfolio. Works with freelance photographers on assignment basis only. NPI. Pay depends on contract. Buys all rights, one-time rights or exclusive product rights, "depending on agreement." Model/property release required for all visually recognizable subjects.

Tips: "No 'babes on bikes'! In a portfolio, we prefer to see the photographer's most creative work—not necessarily ads. Show only your most technically, artistically satisfying work."

FALLON MCELLIGOTT, 901 Marquette Ave., #3200, Minneapolis MN 55402. Prefers not to share information.

MARTIN-WILLIAMS ADVERTISING INC., 60 South Sixth St., Suite 2800, Minneapolis MN 55402. (612)340-0800. Fax: (612)342-9716. Production Coordinator/Buyer: Lyle Studt. Estab. 1947. Ad agency. Approximate annual billing: $150 million. Number of employees: 220. Types of clients: industrial, retail, fashion, finance, agricultural, business-to-business and food. Client list free with SASE.

● This agency negotiates with photographers to establish time periods for "unlimited uses" of material.

Needs: Works with 6-12 photographers/month. Uses photos for billboards, consumer and trade magazines, direct mail, catalogs, posters and newspapers. Subject matter varies. Model/property release required.

Specs: Uses 8 × 10 and larger b&w and color prints; 35mm, 2¼ × 2¼, 4 × 5 and 8 × 10 transparencies.
Making Contact & Terms: Arrange a personal interview to show portfolio. Provide résumé, business card, flier or tearsheets to be kept on file for possible future assignments. Works with freelance photographers on an assignment basis only. SASE. Reports in 2 weeks. Payment individually negotiated. Pays $700-3,500/b&w or color photo; $100-475/hour; $1,000-3,500/day; $1,000-14,500/complete job. **Pays on receipt of invoice.** Buys one-time, electronic and all rights.
Tips: Looks for "high quality work, imagination."

***TAKE 1 PRODUCTIONS**, 5325 W. 74th St., Minneapolis MN 55439. (612)831-7757. Fax: (612)831-2193. E-mail: take1@take1productions.com. Producer: Bob Hewitt. Estab. 1985. Member of ITVA, IICS. AV firm. Approximate annual billing: $1 million. Number of employees: 10. Types of clients: industrial. Examples of recent projects: USWest and Kraft (industrial); Paramount (broadcast).
Needs: Works with 2 photographers and 4 videographers/month. Uses photos for direct mail and audiovisual. Subjects include: industrial. Reviews stock photos. Model/property release required. Captions preferred.
Audiovisual Needs: Uses slides and/or video.
Specs: Uses 35mm transparencies; Betacam videotape.
Making Contact & Terms: Interested in receiving work from newer, lesser-known photographers. Provide résumé, business card, brochure, flier or tearsheets to be kept on file for possible future assignments. Works with freelancers on assignment only. Keeps samples on file. Cannot return material. Reports in 1 month. NPI. Pays on receipt of invoice, net 30 days. Credit line not given. Buys all rights.

Mississippi

***■VON SUTHOFF & COMPANY ADVERTISING INC.**, P.O. Box 690, Pascagoula MS 39568. (601)762-9674. President/Creative Director: Eric Suthoff. Estab. 1986. Member of AAF. Ad agency. Number of employees: 4. Types of clients: industrial, financial, retail and health care. Example of recent projects: "Dreams Do Come True," Ingaus Employees Credit Union (radio/TV/print).
Needs: Works with 1-2 photographers, 2-4 filmmakers and 2-4 videographers/month. Uses photos for consumer and trade magazines, catalogs, posters, audiovisual. Subjects include people, some product. Reviews stock photos. Model release required. Property release and captions preferred; include format and costs.
Audiovisual Needs: Uses slides and/or film or video.
Specs: All sizes color and b&w prints; 2¼ × 2¼, 4 × 5 transparencies; 16 or 35mm film; Beta SP or digital series videotape. Accepts IBM PC formated photo disc samples on 3¼ HD disc or CD-ROM.
Making Contact & Terms: Interested in receiving work from newer, lesser-known photographers. Query with stock photo list. Send unsolicited photos by mail for consideration. Query with samples. Provide résumé, business card, brochure, flier or tearsheets to be kept on file for possible future assignments. Works with freelancers on assignment only. SASE. Keeps samples on file. Reports in 1-2 weeks. Pays by project; amount negotiable. **Pays on receipt of invoice.** Credit line sometimes given depending on client. Buys first, one-time, electronic and all rights; negotiable.
Tips: "Creativity, uniqueness of composition, capturing the essence of human emotion are important."

Missouri

***EVERETT, KLAMP & BERNAUER, INC.**, Suite 200, 1805 Grand Ave., Kansas City MO 64108. (816)421-0000. Fax: (816)421-1069. Contact: James A. Everett. Estab. 1967. Member Public Relations Society of America. Ad agency. Approximate annual billing: $1.3 million. Number of employees: 6. Types of clients: construction, finance, industrial, auto dealership, agribusiness, insurance, health services, schools, pet food accounts. Examples of recent projects: "School Services and Learning" (4-color brochure); "Extended Care/Retirement Americare" (ads); and Public Radio and Jack Miller Auto (magazine and newspaper ads).
● Everett, Klamp & Bernauer received a 1995 Silver Prism Award from the Public Relations Society of America.
Needs: Works with 1-2 freelance photographers/month on assignment basis only. Buys 25 photos/year. Uses photos in brochures, newsletters, annual reports, PR releases, AV presentations, sales literature, consumer and trade magazines. Model release required.
Specs: Uses 5 × 7 b&w and color prints; transparencies.
Making Contact & Terms: Interested in receiving work from newer, lesser-known photographers. Arrange a personal interview to show portfolio. Provide résumé and business card to be kept on file

for possible future assignments. Prefers to work with local freelancers. SASE. Reports in 1 week. NPI; negotiates payment based on client's budget and amount of creativity required from photographer. Buys all rights; negotiable.

Tips: "We have a good working relationship with three local photographers and would rarely go outside of their expertise unless work load or other factors change the picture."

▪GEILE/REXFORD CREATIVE ASSOCIATES, 135 N. Meramec, St. Louis MO 63105. (314)727-5850. Fax: (314)727-5819. Creative Director: David Geile. Estab. 1989. Member of American Marketing Association, BPAA. Ad agency. Approximate annual billing: $3 million. Number of employees: 12. Types of clients: industrial and financial. Recent clients include: Texas Boot Company; First Bank; and Monsanto.

Needs: Works with 2-3 freelance photographers/month, 3 filmmakers and 5 videographers/year. Uses photos for billboards, consumer and trade magazines, direct mail, P-O-P displays, catalogs, posters and newspapers. Subjects include: product shots. Model/property release preferred.

Audiovisual Needs: Uses slides and video for sales meetings.

Specs: Uses color and b&w prints; 35mm, 2¼×2¼, 4×5 transparencies; 16mm film; 1″ videotape.

Making Contact & Terms: Interested in receiving work from newer, lesser-known photographers. Provide résumé, business card, brochure, flier or tearsheets to be kept on file for possible future assignments. Keeps samples on file. Cannot return material. Reports when approval is given from client. Pays $800-1,200/day; $300-500/b&w photo; also accepts bids for jobs. Pays net 30-45 days. Buys one-time and all rights.

KUPPER PARKER COMMUNICATIONS INC., 8301 Maryland Ave., St. Louis MO 63105. (314)727-4000. Fax: (314)727-3034. Advertising, public relations and direct mail firm. Executive Creative Director: Peter A.M. Charlton. Creative Directors: Lew Cohn and Joe Geis. Estab. 1992. Types of clients: retail, fashion, automobile dealers, consumer, broadcast stations, health care marketing, sports and entertainment, business-to-business sales and direct marketing.

Needs: Works with 12-16 freelance photographers/month. Uses photos for billboards, consumer and trade magazines, direct mail, P-O-P displays, catalogs, posters, signage and newspapers. Model release required; captions preferred.

Making Contact & Terms: Query with résumé of credits or with list of stock photo subjects. Provide résumé, business card, brochure, flier or tearsheets to be kept on file for possible future assignments. Works on assignment only. Does not return unsolicited material. Reports in 2 weeks. Pays $50-2,500/b&w photo; $250-5,000/color photo; $50-300/hour; $400-2,500/day. Buys one-time rights, exclusive product rights, all rights, and limited-time or limited-run usage. Pays upon receipt of client payment.

Montana

▪CONTINENTAL PRODUCTIONS, 118 Sixth St. S., Great Falls MT 59405. (406)761-5536. Executive in Charge of Production: Cheryl Cordeiro. Types of clients: industrial, educational, retail and broadcast.

Needs: Works with 3-15 videographers/month. Uses video for films and videotapes. Subjects include: television commercials, educational/informational programs. All video is shot "film-style" (lighted for film, etc.). Reviews stock photos/footage. Model release required.

Specs: Uses U-matic ¾″ SP, prefers 1″ C-format or Beta SP.

Making Contact & Terms: Provide résumé, business card, self-promotion piece or tearsheets to be kept on file for possible future assignments. Works with freelancers on assignment only. SASE. Reports in 1 month. NPI. **Pays upon completion of final edit.** Credit line not given. Buys all rights.

Tips: "Send the best copy of your work on ¾″ cassette. Describe your involvement with each piece of video shown."

Nebraska

▪J. GREG SMITH, 1004 Farnam, Suite 102, Burlington on the Mall, Omaha NE 68102. (402)444-1600. Art Director: Mike Briardy. Ad agency. Types of clients: finance, banking institutions, national and state associations, agriculture, insurance, retail, travel.

 THE ASTERISK before a listing indicates that the market is new in this edition. New markets are often the most receptive to freelance submissions.

Needs: Works with 10 freelance photographers/year on assignment only basis. Uses photographers for consumer and trade magazines, brochures, catalogs and AV presentations. Special subject needs include outer space, science and forest scenes, also high tech.
Making Contact & Terms: Arrange interview to show portfolio. Looks for "people shots (with expression), scenics (well known, bright colors)." Pays $500/color photo; $60/hour; $800/day; varies/job. Buys all rights, one-time rights or others, depending on use.
Tips: Considers "composition, color, interest, subject and special effects when reviewing a portfolio or samples."

■**SWANSON, RUSSELL AND ASSOCIATES**, 1222 P St., Lincoln NE 68508. (402)475-5191. Creative Director: John Kloefkorn. Ad agency. Types of clients: primarily industrial, outdoor recreation and agricultural; client list provided on request.
Needs: Works with 10 freelance photographers/year on assignment only basis. Uses photos for consumer and trade magazines, direct mail, brochures, catalogs, newspapers and AV presentations.
Making Contact & Terms: Query first with small brochure or samples along with list of clients freelancer has done work for. NPI. Negotiates payment according to client's budget. Rights are negotiable.

Nevada

■**DAVIDSON & ASSOCIATES**, 3940 Mohigan Way, Las Vegas NV 89119. (702)871-7172. President: George Davidson. Full-service ad agency. Types of clients: beauty, construction, finance, entertainment, retailing, publishing, travel.
Needs: Photos used in brochures, newsletters, annual reports, PR releases, AV presentations, sales literature, consumer and trade magazines.
Making Contact & Terms: Arrange a personal interview to show portfolio. Query with samples or submit portfolio for review. Provide résumé, brochure and tearsheets to be kept on file for possible future assignments. Offers 150-200 assignments/year. Pays $15-50/b&w photo; $25-100/color photo; $15-50/hour; $100-400/day; $25-1,000 by the project. Pays on production. Buys all rights. Model release required.

New Hampshire

■**PORRAS & LAWLOR ASSOCIATES**, 15 Lucille Ave., Salem NH 03079. (603)893-3626. Fax: (603)898-1657. Ad agency, PR and AV firm. Contact: Alix Lawlor. Estab. 1980. Types of clients: industrial, educational, financial and service. Examples of projects: "You Can Get There from Here," MBTA; "Annual Giving," N.E. Telephone.
Needs: Works with 1-2 freelance photographers/month. Uses photographs for direct mail, catalogs, posters, signage and audiovisual uses. Subjects include: people and studio photography.
Specs: Uses all glossy and matte color and b&w prints; 35mm transparencies.
Making Contact & Terms: Interested in receiving work from newer, lesser-known photographers. Query with résumé of credits, list of stock photo subjects and samples. Provide résumé, business card, brochure, flier or tearsheets to be kept on file for possible future assignments. Works with local freelancers on assignment only. Pays $800-1,500/day; $200-800/color photo; $150-500/b&w photo. **Pays on receipt of invoice.** Buys one-time and exclusive product rights; negotiable. Model release and captions preferred.
Tips: In samples, looks for "product photography, people, architectural, landscape, or other depending on brochure or promotion we are working on. We don't buy photos too often. We use photographers for product, architectural or diverse brochure needs. We buy stock photography for interior graphic projects and others—but less often." To break in with this firm, "stay in touch, because timing is essential."

New Jersey

■**AM/PM ADVERTISING, INC.**, 196 Clinton Ave., Newark NJ 07108. (212)755-0860. Fax: (212)755-0115. President: Robert A. Saks. Estab. 1962. Member of Art Directors Club, Illustrators Club, National Association of Advertising Agencies and Type Directors Club. Ad agency. Approximate annual billing: $250 million. Number of employees: 1,100. Types of clients: food, pharmaceuticals, health and beauty aids and entertainment industry. Examples of recent projects: AT&T (TV commer-

cials); Nabisco (print ads for Oreo cookies); and Revlon (prints ads for lipstick colors).
Needs: Works with 6 freelance photographers/month. Uses photos for consumer and trade magazines, direct mail, P-O-P displays, catalogs, posters, newspapers and audiovisual. Subjects include: fashion, still life and commercials. Reviews stock photos of food and beauty products. Model release required. Captions preferred.
Audiovisual Needs: "We use multimedia slide shows and multimedia video shows."
Specs: Uses 8×10 color and/or b&w prints; 35mm, 2¼×2¼, 4×5, 8×10 transparencies; 8×10 film; broadcast videotape.
Making Contact & Terms: Arrange personal interview to show portfolio. Send unsolicited photos by mail for consideration. Provide résumé, business card, brochure, flier or tearsheets to be kept on file for possible future assignments. Works on assignment only. Keeps samples on file. Reports in 1-2 weeks. Pays $50-250/hour; $500-2,000/day; $2,000-5,000/job; $50-500/color or b&w photo. Pays on receipt of invoice. Credit line sometimes given, depending upon client and use. Buys one-time, exclusive product, electronic and all rights; negotiable.
Tips: In portfolio or samples, wants to see originality. Sees trend toward more use of special lighting.

***ARDREY INC.**, 505 Main St., Metuchen NJ 08840. (908)549-1300. Fax: (908)549-1127. E-mail: ardreyco@aol.com. PR firm. Office Manager: Lisa Fania. Number of employees: 8. Types of clients: industrial. Client list provided on request.
Needs: Works with 10-15 freelance photographers/month throughout US. Uses photographers for trade magazines, direct mail, brochures, catalogs, newspapers. Subjects include trade photojournalism.
Specs: Uses 35mm, 2¼×2¼ and 4×5 transparencies.
Making Contact & Terms: Provide résumé, business card, brochure, flier or tearsheets to be kept on file for possible future assignments. Works with freelance photographers on assignment basis only. SASE. Pays $150-450/day; $300-500/job. "travel distance of location work—time and travel considered." Pays 30-45 days after acceptance. Buys all rights and negatives. Model release required.
Tips: Prefers to see "imaginative industrial photojournalism. Identify self, define territory you can cover from home base, define industries you've shot for industrial photojournalism; give relevant references and samples. Regard yourself as a business communication tool. That's how we regard ourselves, as well as photographers and other creative suppliers."

■CREATIVE ASSOCIATES, 44 Park Ave., Madison NJ 07940. (201)377-4440. Producer: Harrison Feather. Estab. 1975. AV firm. Types of clients: industrial, cosmetic and pharmaceutical.
Needs: Works with 1-2 photographers, filmmakers and/or videographers/month. Uses photos for trade magazines and audiovisual uses. Subjects include product and general environment. Reviews stock photos or videotape. Model release required. Property release preferred. Captions preferred.
Audiovisual Needs: Uses photos/video for slides and videotape.
Specs: Uses 35mm, 4×5 and 8×10 transparencies; videotape.
Making Contact & Terms: Provide résumé, business card, brochure, flier or tearsheets to be kept on file for possible future assignments. Works on assignment only. Reports as needed. Pays $500-1,000/day; $1,500-3,000/job. Pays on publication. Credit line sometimes given, depending on assignment. Rights negotiable; "depends on budget."

■CREATIVE PRODUCTIONS, INC., 200 Main St., Orange NJ 07050. (201)676-4422. Contact: Gus Nichols. AV producer. Types of clients: industry, advertising, pharmaceuticals and business. Produces film, video, slide presentations, multimedia programs and training programs.
Needs: Subjects include sales training, industrial and medical topics. No typical school portfolios that contain mostly artistic or journalistic subject matter. Must be 3:4 horizontal ratio for film, video and filmstrips; 2:3 horizontal ratio for slides. Model release required.
Specs: Uses color prints, slides and transparencies. Produces video and industrial, training, medical and sales promotion films. Possible assignments include shooting "almost anything that comes along—industrial sites, hospitals, etc." Interested in some occasional stock footage.
Making Contact & Terms: Provide résumé and letter of inquiry to be kept on file for future assignments. Query first with résumé of credits and rates. Works with freelance photographers on assignment basis only. SASE. Reports in 1 week. NPI. Payment negotiable based on photographer's previous experience and client's budget. **Pays on acceptance.** Buys all rights.
Tips: "We would use freelancers out-of-state for part of a production when it isn't feasible for us to travel, or locally to supplement our people on overload basis."

DIEGNAN & ASSOCIATES, 3 Martens, Lebanon NJ 08833. President: N. Diegnan. Ad agency/PR firm. Types of clients: industrial, consumer.
Needs: Commissions 15 photographers/year; buys 20 photos/year from each. Uses photos for billboards, trade magazines and newspapers. Model release preferred.
Specs: Uses b&w contact sheet or glossy 8×10 prints. For color, uses 5×7 or 8×10 prints; also 2¼×2¼ transparencies.

Making Contact & Terms: Arrange a personal interview to show portfolio. Local freelancers preferred. SASE. Reports in 1 week. NPI. Negotiates payment based on client's budget and amount of creativity required from photographer. Pays by the job. Buys all rights.

■**INSIGHT ASSOCIATES**, 14 Rita Lane, Oak Ridge NJ 07438. (201)697-0880. Fax: (201)697-6904. President: Raymond Valente. Types of clients: major industrial companies.
Needs: Works with 4 freelancers/month. Uses freelancers for slide sets, multimedia productions, videotapes and print material—catalogs. Subjects include: industrial productions. Examples of clients: Matheson (safety); Witco Corp. (corporate image); Volvo (sales training); P.S.E.&G.; Ecolab Inc. Interested in stock photos/footage. Model release preferred.
Specs: Uses 35mm, 2¼×2¼ and 4×5 transparencies.
Making Contact & Terms: Arrange a personal interview to show portfolio. SASE. Reports in 1 week. Pays $450-750/day on acceptance. Credit line given. Buys all rights.
Tips: "Freelance photographers should have knowledge of business needs and video formats. Also, versatility with video or location work. In reviewing a freelancer's portfolio or samples we look for content appropriate to our clients' objectives. Still photographers interested in making the transition into film and video photography should learn the importance of understanding a script."

■**JANUARY PRODUCTIONS**, P.O. Box 66, 210 Sixth Ave., Hawthorne NJ 07507. (201)423-4666. Fax: (201)423-5569. Art Director: Karen Sigler. Estab. 1973. AV firm. Number of employees: 12. Types of clients: schools, teachers and public libraries. Audience consists of primary, elementary and intermediate-grade school students. Produces children's books, videos and CD-ROM. Subjects are concerned with elementary education—science, social studies, math and conceptual development.
Audiovisual Needs: Uses 35mm color transparencies and b&w photographs of products for company catalogs.
Making Contact & Terms: Interested in receiving work from newer, lesser-known photographers. Call or send résumé and samples of work "for us to keep on file." SASE. NPI. Payment amounts "depend on job." Buys all rights.
Tips: Wants to see "clarity, effective use of space, design, etc. We need clear photographs of our products for catalog use. The more pictures we have in the catalogs, the better they look and that helps to sell the product."

■**KJD TELEPRODUCTIONS, INC.**, 30 Whyte Dr., Voorhees NJ 08043. (609)751-3500. Fax: (609)751-7729. E-mail: mactoday@ios.com. President: Larry Scott. Estab. 1989. Member of National Association of Television Programming Executives. AV firm. Approximate annual billing: $500,000. Number of employees: 2. Types of clients: industrial, fashion, retail professional, service and food. Examples of projects: Marco Island Florida Convention, ICI Americas (new magazine show); "More Than Just a Game" (TV sports talk show); and "Rukus," Merv Griffin Productions (TV broadcast).
Needs: Works with 2 photographers, filmmakers and/or videographers/month. Uses photos for trade magazines and audiovisual. Model/property release required.
Audiovisual Needs: Primarily videotape, also slides and film.
Specs: Uses ½", ¾", Betacam/SP 1" videotape.
Making Contact & Terms: Send unsolicited photos by mail for consideration. Works on assignment only. Keeps samples on file. Reports in 1 month. Pays $50-300/day. **Pays on acceptance.** Credit lines sometimes given. Buys one-time, exclusive product, all and electronic rights; negotiable.
Tips: "We are seeing more use of freelancers, less staff. Be visible!"

■**KOLLINS COMMUNICATIONS, INC.**, 425 Meadowlands Pkwy., Secaucus NJ 07094. (201)617-5555. Fax: (201)319-8760. Manager: R.J. Martin. Estab. 1992. Types of clients: Fortune 1000 pharmaceuticals, consumer electronics. Examples of projects: Sony (brochures); CBS Inc. (print ads); TBS Labs (slides).
Needs: Works with 2-4 freelance photographers/month. Uses photos for product shots, multimedia productions and videotapes. Subjects are various. Model release required.
Specs: Uses 35mm, 2¼×2¼, 4×5, 8×10 transparencies; Hi 8, ½" Betacam and 1" videotape.
Making Contact & Terms: Interested in receiving work from newer, lesser-known photographers. Submit portfolio by mail. Provide résumé, business card, self-promotion piece or tearsheets to be kept on file for possible future assignments. Works on assignment only. Cannot return material. Reports in 2 weeks. NPI. Pays per day or per job. Pays by purchase order 30 days after work completed. Credit line given "when applicable." Buys all rights.
Tips: "Be specific about your best work (what areas), be flexible to budget on project—represent our company when on business."

■**SORIN PRODUCTIONS, INC.**, 919 Hwy. 33, Suite 46, Freehold NJ 07728. (908)462-1785. President: David Sorin. Type of client: corporate.

Needs: Works with 2 freelance photographers/month. Uses photographers for slide sets, multimedia productions, films and videotapes. Subjects include people and products.
Specs: Uses b&w and color prints; 35mm and 2¼×2¼ transparencies.
Making Contact & Terms: Query with stock photo list. Provide résumé, business card, self-promotion piece or tearsheets to be kept on file for possible future assignments. Works with freelancers by assignment only; interested in stock photos/footage. Does not return unsolicited material. Reports in 2 weeks. NPI. Pays per piece or per job. **Pays on acceptance.** Buys all rights. Captions and model releases preferred. Credit line given by project.

New Mexico

■**FOCUS ADVERTISING**, 4002 Silver Ave. SE, Albuquerque NM 87108. (505)255-4355. Fax: (505)266-7795. President: Al Costanzo. Ad agency. Types of clients: industry, politics, government, law. Produces overhead transparencies, slide sets, motion pictures, sound-slide sets, videotape, print ads and brochures.
Needs: Works with 1-2 freelance photographers/month on assignment only basis. Buys 70 photos and 5-8 films/year: health, business, environment and products. No animals or flowers. Length requirements: 80 slides or 15-20 minutes, or 60 frames, 20 minutes.
Specs: Produces ½″ and ¾″ video for broadcasts; also b&w photos or color prints and 35mm transparencies, "and a lot of 2¼ transparencies and some 4×5 transparencies."
Making Contact & Terms: Arrange personal interview or query with résumé. Provide résumé, flier and brochure to be kept on file for possible future assignments. Prefers to see a variety of subject matter and styles in portfolio. Does not return unsolicited material. Pays $40-60/hour, $350-750/day, $40-800/job. Negotiates payment based on client's budget and photographer's previous experience/reputation. Pays on job completion. Buys all rights. Model release required.

New York

■**A-1 FILM AND VIDEO WORLD WIDE DUPLICATION**, 4650 Dewey Ave., Rochester NY 14612. (716)663-1400. Fax: (716)663-0246. President: Michael Gross Ordway. Estab. 1976. AV firm. Approximate annual billing: $1 million. Number of employees: 7. Types of clients: industrial and retail.
Needs: Works with 4 freelance photographers, 1 filmmaker and 4 videographers/month. Uses photos for trade magazines, direct mail, catalogs and audiovisual uses. Reviews stock photos or video. Model release required.
Audiovisual Needs: Uses slides, film and video.
Specs: Uses color prints; 35mm transparencies; 16mm film and all types of videotape.
Making Contact & Terms: Fax or write only. Works with local freelancers only. Pays $12/hour; $96/day. **Pays on receipt of invoice.** Credit line not given. Buys all rights.

■**CL&B ADVERTISING, INC.**, 100 Kinloch Commons, Manlius NY 13104-2484. (315)682-8502. Fax: (315)682-8508. President: Richard Labs. Creative Director: Adam Rozum. Estab. 1937. Advertising, PR and research. Types of clients: industrial, fashion, finance and retail. Examples of recent projects: "Charges, Choices and Familiar Faces" (ads and literature); "Girl, dogs, Volvo, fall foliage classics" (posters for retail); and "Glamor shots of donuts" (point of purchase).
Needs: Works with 4-6 freelance photographers/year. Uses photos for billboards, consumer and trade magazines, P-O-P displays, catalogs and newspapers. Subjects include: industrial, consumer, models, location and/or studio. Model/property release required.
Audiovisual Needs: "Wish we could find a low cost, high quality 35mm panavision film team."
Specs: Uses all formats.
Making Contact & Terms: "Send bio and proof sheet (if available) first; we will contact you if interested." Works on assignment only. Also uses stock photos. Does not return unsolicited material. Pays $10-1,000/b&w photo; $10-2,500/color photo; $10-100/hour; $200-3,000/day; $100-10,000/job. Pays in 30 days. Credit line seldom given. Buys all rights.
Tips: "We review your work and will call if we think a particular job is applicable to your talents."

MARKET CONDITIONS are constantly changing! If you're still using this book and it's 1998 or later, buy the newest edition of *Photographer's Market* at your favorite bookstore or order directly from Writer's Digest Books.

■**FINE ART PRODUCTIONS**, 67 Maple St., Newburgh NY 12550-4034. Phone/fax: (914)561-5866. E-mail: richie.suraci@bbs.mhv.net. Website: http://www.geopages.com/hollywood/1077. Résumé Website: http://www.lookup.com/homepages/61239/home.html. Director: Richie Suraci. Estab. 1989. Ad agency, PR firm and AV firm. Types of clients: industrial, financial, fashion, retail, food—all industries. Examples of previous projects: "Great Hudson River Revival," Clearwater, Inc. (folk concert, brochure); feature articles, Hudson Valley News (newspaper); and "Wheel and Rock to Woodstock," MS Society (brochure); Network Erotica (Website).

Needs: Uses photos for billboards, consumer and trade magazines, direct mail, P-O-P displays, catalogs, posters, Web Pages, brochures, newspapers, signage and audiovisual. Especially needs erotic art, adult erotica, science fiction, fantasy, sunrises, waterfalls, beautiful nude women and men, futuristic concepts. Reviews stock photos. Model/property release required. Captions required; include basic information.

Audiovisual Needs: Uses slides, film (all formats) and videotape.

Specs: Uses color and b&w prints, any size or finish; 35mm, 2¼×2¼, 4×5, 8×10 transparencies; film, all formats; ½", ¾" or 1" Beta videotape; and computer disks in Mac format.

Making Contact & Terms: Submit portfolio for review. Query with résumé of credits. Query with list of stock photo subjects. Send unsolicited photos by mail for consideration. Query with samples. Provide résumé, business card, brochure, flier or tearsheets to be kept on file for possible future assignments. Keeps samples on file. SASE. Reports in 1 month or longer. NPI: "All payment negotiable relative to subject matter." Pays on acceptance, publication or on receipt of invoice; "varies relative to project." Credit line sometimes given, "depending on project or if negotiated." Buys first, one-time and all rights; negotiable.

Tips: "We are also requesting any fantasy, avant-garde, sensuous or classy photos, video clips, PR data, short stories, adult erotic scripts, résumé, fan club information, PR schedules, etc. for use on our Website. Nothing will be posted unless accompanied by a release form. We will post this free of charge on the Website and give you free advertising for the use of your submissions We will make a separate agreement for usage for any materials besides ones used on the Website and/or any photos or filming sessions we create together in the future. If you would like to make public appearances in our network and area, send a return reply and include PR information for our files."

HARRINGTON ASSOCIATES INC., 57 Fairmont Ave., Kingston NY 12401-5221. (914)331-7136. Fax: (914)331-7168. President: Gerard Harrington. Estab. 1988. PR firm. Types of clients: industrial, high technology, retail, fashion, finance, transportation, architectural, artistic and publishing. Examples of recent clients include: Plato Software Systems (product/service brochure); Ulster Performing Arts Center (PR, brochures, advertising).

 • This company has received the Gold Eclat Award, Hudson Valley Area Marketing Association, for best PR effort.

Needs: Number of photographers used on a monthly basis varies. Uses photos for consumer and trade magazines, P-O-P displays, catalogs and newspapers. Subjects include: general publicity including head shots and candids. Also still lifes. Model release required.

Specs: Uses b&w prints, any size and format. Also uses 4×5 color transparencies; and ¾" videotape.

Making Contact & Terms: Interested in receiving work from newer, lesser-known photographers. Provide résumé, business card, brochure, flier or tearsheets to be kept on file for possible future assignments. Works with freelancers on assignment only. Cannot return material. Reports only when interested. NPI; payment negotiable. Pays on receipt of invoice. Credit line given whenever possible, depending on use. Buys all rights; negotiable.

■**MCANDREW ADVERTISING CO.**, 2125 St. Raymond Ave., P.O. Box 254, Bronx NY 10462. Phone/fax: (718)892-8660. Contact: Robert McAndrew. Estab. 1961. Ad agency, PR firm. Approximate annual billing: $250,000. Number of employees: 2. Types of clients: industrial and technical. Examples of recent projects: trade advertising and printed material illustrations. Trade show photography.

Needs: Works with 1 freelance photographer/month. Uses photos for trade magazines, direct mail, brochures, catalogs, newspapers, audiovisual. Subjects include: technical products. Reviews stock photos of science subjects. Model release required for recognizable people. Property release required.

Audiovisual Needs: Uses slides and videotape.

Specs: Uses 8×10 glossy b&w or color prints; 35mm, 4×5 transparencies.

Making Contact & Terms: Interested in working with local photographers. Query with résumé of credits. Provide résumé, business card, brochure, flier, tearsheets or non-returnable samples to be kept on file for possible future assignments. Reports when appropriate. Pays $65/b&w photo; $150/color photo; $700/day. "Prices dropping because business is bad." Pays 30 days after receipt of invoice. Credit line sometimes given. Buys all rights; negotiable.

Tips: Photographers should "let us know how close they are, and what their prices are. We look for photographers who have experience in industrial photography." In samples, wants to see "sharp, well-lighted" work.

MCCUE ADVERTISING & PR INC., 91 Riverside Dr., Binghamton NY 13905. (607)723-9226. President: Donna McCue. Ad agency and PR firm. Types of clients: industrial, retail, all types.
Needs: Works with 5 freelance photographers/month. Uses photos for consumer and trade magazines, direct mail, P-O-P displays, catalogs, signage and newspapers. Model release required.
Specs: Uses 8×10 prints; 35mm, 4×5 transparencies.
Making Contact & Terms: Provide résumé, business card, brochure, flier or tearsheets to be kept on file for possible future assignments. Cannot return material. Reports when assignment comes up. NPI; payment negotiable. Pays in 30 days. Credit line sometimes given. Buys all rights.

■**ROGER MALER, INC.**, 264 North Hwy., South Hampton NY 11968. Ad agency. President: Roger Maler. Types of clients: industrial, pharmaceutical.
Needs: Works with 3 freelance photographers/month. Uses photographers for trade magazines, direct mail, P-O-P displays, brochures, catalogs, newspapers and AV presentations.
Audiovisual Needs: Works with freelance filmmakers.
Making Contact & Terms: Send résumé, business card, brochure, flier or tearsheets to be kept on file for possible future assignments. Works with freelance photographers on assignment only. Does not return unsolicited material. NPI. Pays on publication. Model release required. Credit line sometimes given.

■**NATIONAL TEACHING AIDS, INC.**, 1845 Highland Ave., New Hyde Park NY 11040. (516)326-2555. Fax: (516)326-2560. President: A. Becker. Estab. 1960. AV firm. Types of clients: schools. Produces filmstrips.
Needs: Buys 20-100 photos/year. Science subjects; needs photomicrographs and space photography.
Specs: Uses 35mm transparencies.
Making Contact & Terms: Cannot return material. Pays $50 minimum. Buys one-time rights; negotiable.

■**PARAGON ADVERTISING**, 43 Court St., Suite 1111, Buffalo NY 14202. (716)854-7161. Fax: (716)854-7163. Senior Art Director: Leo Abbott. Estab. 1988. Ad agency. Types of clients: industrial, retail, food and medical.
Needs: Works with 0-5 photographers, 0-1 filmmakers and 0-1 videographers/month. Uses photos for billboards, consumer and trade magazines, P-O-P displays, catalogs, posters, newspapers, signage and audiovisual. Subjects include: location. Reviews stock photos. Model release required. Property release preferred.
Audiovisual Needs: Uses film and videotape for on-air.
Specs: Uses 8×10 prints; 2¼×2¼ or 4×5 transparencies; 16mm film; and ¾", 1" Betacam videotape.
Making Contact and Terms: Interested in receiving work from newer, lesser-known photographers. Submit portfolio for review. Query with stock photo list. Send unsolicited photos by mail for consideration. Works on assignment only. Keeps samples on file. SASE. Reports in 1-2 weeks. Pays $500-2,000 day; $100-5,000 job. Pays on receipt of invoice. Credit line sometimes given. Buys all rights; negotiable.

PRO/CREATIVES, 25 W. Burda Pl., New City NY 10956-7116. President: David Rapp. Ad agency. Uses all media except billboards and foreign. Types of clients: package goods, fashion, men's entertainment and leisure magazines, sports and entertainment.
Specs: Send any size b&w prints. For color, send 35mm transparencies or any size prints.
Making Contact & Terms: Submit material by mail for consideration. Reports as needed. SASE. NPI. Negotiates payment based on client's budget.

*****JACK SCHECTERSON ASSOCIATES**, 5316 251 Place, Littleneck NY 11362-1711. (718)225-3536. Fax: (718)423-3478. Principal: Jack Schecterson. Estab. 1965. Member of Package Design Council. Ad agency specializing in package graphic design. Types of clients: industrial, food, HBA, hardware, housewares and leisure.
Needs: Uses photos for trade magazines, direct mail, catalogs and package design. Subjects vary depending on work inhouse. Reviews stock photos. Model/property release required. Captions preferred.
Specs: Uses color and b&w prints; 35mm, 2¼×2¼, 4×5, 8×10 transparencies.
Making Contact & Terms: Interested in receiving work from newer, lesser-known photographers. Provide résumé, business card, brochure, flier or tearsheets to be kept on file for possible future assignments. Works with local freelancers only. Keeps samples on file. Reports ASAP once given clients OK. NPI; depends on job budget. Pays on receipt of invoice. Credit line sometimes given depending on client's preference. Buys all rights.

■**TOBOL GROUP, INC.**, 14 Vanderventer Ave., Port Washington NY 11050. (516)767-8182. Fax: (516)767-8185. Ad agency/design studio. President: Mitch Tobol. Estab. 1981. Types of clients: high-

tech, industrial, business-to-business and consumer. Examples of ad campaigns: Weight Watchers (instore promotion); Eutectic & Castolin; Mainco (trade ad); and Light Alarms.

Needs: Works with up to 4 photographers/videographers/month. Uses photos for billboards, consumer and trade magazines, direct mail, P-O-P displays, catalogs, posters, newspapers and audiovisual. Subjects are varied; mostly still-life photography. Reviews business-to-business and commercial video footage. Model release required.

Audiovisual Needs: Uses videotape.

Specs: Uses 4×5, 8×10, 11×14 b&w prints; 35mm, 2¼×2¼ and 4×5 transparencies; and ½″ videotape.

Making Contact & Terms: Send unsolicited photos by mail for consideration. Query with samples. Provide résumé, business card, brochure, flier or tearsheets to be kept on file for possible future assignments: follow-up with phone call. Works on assignment only. SASE. Reports in 3 weeks. Pays $100-10,000/job. Pays net 30. Credit line sometimes given, depending on client and price. Rights purchased depend on client.

Tips: In freelancer's samples or demos, wants to see "the best they do—any style or subject as long as it is done well. Trend is photos or videos to be multi-functional. Show me your *best* and what you enjoy shooting. Get experience with existing company to make the transition from still photography to audiovisual."

■**VISUAL HORIZONS**, 180 Metro Park, Rochester NY 14623. (716)424-5300. Fax: (716)424-5313. E-mail: 73730.2512@compuserve.com. or slides1@aol.com. President: Stanley Feingold. AV firm. Types of clients: industrial.

Audiovisual Needs: Works with 1 freelance photographer/month. Uses photos for AV presentations. Also works with freelance filmmakers to produce training films. Model release required. Captions required.

Specs: Uses 35mm transparencies and videotape.

Making Contact & Terms: Provide résumé, business card, brochure, flier or tearsheets to be kept on file for possible future assignments. Works on assignment only. Reports as needed. NPI. Pays on publication. Buys all rights.

*■**WOLFF ASSOCIATES INC.**, 500 East Ave., Rochester NY 14607. (716)461-8300. Fax: (716)461-0835. Creative Services Manager: Adele Simmons. Promotional communications agency. Types of clients: industrial, fashion, consumer, packaged goods.

Needs: Works with 3-4 freelance photographers/month. Uses photos for billboards, consumer magazines, direct mail, P-O-P displays, brochures, catalogs, posters, newspapers, AV presentations. Also works with freelance filmmakers to produce TV commercials.

Making Contact & Terms: Provide résumé, business card, brochure, flier or tearsheets to be kept on file for possible future assignments. Does not return unsolicited material. Pays $800-3,500/day.

New York City

ALLY & GARGANO, 805 Third Ave., New York NY 10022. Prefers not to share information.

AMMIRATI PURIS LINTAS, 1 Dag Hammarskjold Plaza, New York NY 10017. (212)605-8000. Art Buyers: Jean Wolff, Julie Rosenoff, Betsy Thompson, Jose Pouso, Helaina Buzzeo. Member of AAAA. Ad agency. Approximate annual billing: $500 million. Number of employees: 750. Types of clients: financial, food, consumer goods. Examples of recent projects: Four Seasons Hotels, Compaq Computers, RCA, Burger King, Epson, Johnson & Johnson.

Needs: Works with 50 freelancers/month. Uses photos for billboards, trade magazines, direct mail, P-O-P displays, catalogs, posters, newspapers. Reviews stock photos. Model/property release required for all subjects.

Making Contact & Terms: Interested in receiving work from newer, lesser-known photographers. Contact through rep. Arrange personal interview to show portfolio. Submit portfolio for review. Provide résumé, business card, brochure, flier or tearsheets to be kept on file for possible future assignments. Works on assignment only. Keeps samples on file. SASE. Reports in 1-2 weeks. NPI; open. Pays extra for electronic usage of images. **Pays on receipt of invoice.** Credit line not given. Buys all rights.

AVRETT FREE & GINSBURG, 800 Third Ave., New York NY 10022. Prefers not to share information.

NW AYER INC., Worldwide Plaza, 825 Eighth Ave., New York NY 10019. Prefers not to share information.

BACKER SPIELVOGEL BATES, 405 Lexington Ave., New York NY 10174. Prefers not to share information.

BBDO WORLDWIDE INC., 1285 Avenue of the Americas, 6th Floor, New York NY 10019-6095. Prefers not to share information.

BOZELL, 40 W. 23rd St., New York NY 10010. Prefers not to share information.

■ANITA HELEN BROOKS ASSOCIATES, 155 E. 55th St., New York NY 10022. (212)755-4498. Contact: Anita Helen Brooks. PR firm. Types of clients: beauty, entertainment, fashion, food, publishing, travel, society, art, politics, exhibits and charity events.
Needs: Photos used in PR releases, AV presentations and consumer and trade magazines. Buys "several hundred" photos/year. Most interested in fashion shots, society, entertainment and literary celebrity/personality shots. Model release preferred.
Specs: Uses 8×10 glossy b&w or color prints; contact sheet OK.
Making Contact & Terms: Provide résumé and brochure to be kept on file for possible future assignments. Query with résumé of credits. No unsolicited material; cannot return unsolicited material. Works on assignment only. Pays $50 minimum/job; negotiates payment based on client's budget. Credit line given.

THE EARL PALMER BROWN CO., 345 Hudson St., New York NY 10014. Prefers not to share information.

■COX ADVERTISING, (formerly Cox & Marshall Advertising), 379 W. Broadway, New York NY 10012. (212)334-9141. Fax: (212)334-9179. Ad agency. Associate Creative Director: Marc Rubin. Types of clients: industrial, retail, fashion and travel.
Needs: Works with 2 freelance photographers—videographers/month. Uses photographers for billboards, consumer magazines, trade magazines, direct mail, P-O-P displays, catalogs, posters, newspapers, signage and audiovisual. Reviews stock photos or video.
Audiovisual Needs: Uses photos for slide shows; also uses videotapes.
Specs: Uses 16×20 b&w prints; 35mm, 2¼×2¼, 4×5 and 8×10 transparencies.
Making Contact & Terms: Arrange personal interview to show portfolio. Works on assignment only. Cannot return material. Reports in 1-2 weeks. Pays minimum of $1,500/job; higher amounts negotiable according to needs of client. Pays within 30-60 days of receipt of invoice. Buys all rights when possible. Model release required. Credit line sometimes given.

■D.C.A./DENTSU CORPORATION OF AMERICA, 666 Fifth Ave., New York NY 10103. (212)397-3333. Fax: (212)397-3322. Art Buyer: Hedy Sikora. Estab. 1971. Ad agency. Types of clients: Canon, U.S.A., Shiseido and Sanyo.
Needs: Works with 5-10 freelance photographers, 1-2 filmmakers. Uses photos for billboards, consumer magazines, trade magazines, direct mail, P-O-P displays, catalogs, posters, newspapers, signage for annual reports, sales and marketing kits. Reviews stock photos. All subjects with a slant on business and sports. Model/property release required. Captions preferred; include location, date and original client.
Audiovisual Needs: Uses slides and videotape for presentations.
Specs: Uses 8×10 to 16×20 color and b&w prints; 35mm, 4×5, 8×10 transparencies.
Making Contact & Terms: Interested in receiving work from newer, lesser-known photographers. Query with samples. Provide résumé, business card, brochure, flier or tearsheets to be kept on file for possible future assignments. Works with local freelancers on assignment only. Keeps samples on file. Reporting time depends on the quality of work; calls will be returned as they apply to ongoing projects. NPI. Pays 60 days from assignment completion. Credit line sometimes given depending on placement of work. Buys one-time and all rights.
Tips: "Your capabilities must be on par with top industry talent."

D'ARCY MASIUS BENTON & BOWLES, 1675 Broadway, New York NY 10019. Prefers not to share information.

DDB NEEDHAM WORLDWIDE INC., 437 Madison Ave., 5th Floor, New York NY 10022. Prefers not to share information.

DEUTSCH, INC., 215 Park Ave. S., New York NY 10014. Prefers not to share information.

■RICHARD L. DOYLE ASSOC., INC., RLDA COMMUNICATIONS, 15 Maiden Lane, New York NY 10038. (212)349-2828. Fax: (212)619-5350. Ad agency. Client Services: R.L. Stewart, Jr.

Estab. 1979. Types of clients: primarily insurance/financial services and publishers. Client list free with SASE.

Needs: Works with 3-4 freelance photographers/month. Uses photographers for consumer and trade magazines, direct mail, newspapers, audiovisual, sales promotion and annual reports. Subjects include people—portrait and candid. Model release required. Captions required.

Audiovisual Needs: Typically uses prepared slides—in presentation formats, video promotions and video editorials.

Specs: Uses b&w and color prints; 35mm and 2¼×2¼ transparencies.

Making Contact & Terms: Query with résumé of credits and samples. Prefers résumé, business card, brochure, flier or tearsheets to be kept on file for possible future assignments. SASE. Reports in 2 weeks. NPI. **Pays on acceptance** or receipt of invoice. Buys all rights.

Tips: Prefers to see photos of people; "good coverage/creativity in presentation. Be perfectly honest as to capabilities; be reasonable in cost and let us know you'll work *with us* to satisfy the client."

■**EMMERLING POST INC., ADVERTISING**, 415 Madison Ave., New York NY 10017-1163. (212)753-4700. Executive Vice President/Associate Creative Director: Art Gilmore. Senior Vice President/Associate Creative Director: Stuart Cohen. Vice President/Art Director: Paul Shields. Types of clients: magazines, banks, aviation and computers. Current clients: *Readers' Digest*, IBM, Magazine Publishers of America, New York Eye Surgery Center, Falcon Jet, Phoenix Home Life, Long Island Savings Bank, Cowles Magazines, Swiss Bank Corp., U.S. Coast Guard, White Plains Hospital.

Needs: Works with 5 photographers and videographers/month. Uses photographs for billboards, consumer and trade magazines, direct mail, P-O-P displays, posters, newspapers, audiovisual and other. Subjects include: reportage, people, still life.

Audiovisual Needs: Uses slides, film and videotape.

Specs: Uses b&w prints; 35mm, 2¼×2¼, 4×5 and 8×10 transparencies; 35mm film; 1", ¾", ½" videotape.

Making Contact & Terms: Mail samples. Local freelancers may call to arrange personal interview to show portfolio. Submit portfolio for review. Provide business card, brochure, flier or tearsheets to be kept on file for possible future assignments. Keeps samples on file. Cannot return material. Reports only as needed. NPI. **Pays on receipt of invoice.** Rights negotiable. Model release required. Credit line sometimes given depending upon fee schedule.

Tips: Looks for original work.

*****EPSTEIN & WALKER ASSOCIATES**, #5A, 65 W. 55 St., New York NY 10019. Phone/fax: (212)246-0565. President/Creative Director: Lee Epstein. Member of Art Directors Club of New York. Ad agency. Types of clients: retail, publication, consumer. Examples of ad campaigns: *Woman's World Magazine*, (trade campaign to media buyers); Northville Gas, (radio/TV campaign to drivers); and Bermuda Shop, (woman's retail-image/fashion).

Needs: Works with 2-3 freelance photographers/year. Uses photos for consumer and trade magazines, direct mail and newspapers. Subjects include still life, people, etc.; "depends on concept of ads." Model release required.

Specs: Any size or format b&w prints; also 35mm, 2¼×2¼ transparencies.

Making Contact & Terms: Arrange personal interview to show portfolio. Provide résumé, business card, brochure, flier or tearsheets to be kept on file for possible future assignments. Works with local freelancers on assignment only. Cannot return material. Reports "as needed." Pays minimum of $250/ b&w photo or negotiates day rate for multiple images. Pays 30-60 days after receipt of invoice. No credit line given. Usually buys rights for "1 year usage across the board."

Tips: Trend within agency is "to solve problems with illustration, and more recently with type/copy only, more because of budget restraints regarding models and location expenses." Is receptive to working with new talent. To break in, show "intelligent conceptual photography with exciting ideas and great composition."

GREY ADVERTISING, 777 Third Ave., New York NY 10017. Prefers not to share information.

■**IMAGE ZONE, INC.**, 101 Fifth Ave., New York NY 10003. (212)924-8804. Fax: (212)924-5585. Managing Director: Doug Ehrlich. Estab. 1986. AV firm. Types of clients: industrial, financial, fashion. Examples of recent projects: SIBA Animal Health; Orth-Pharmaceutical Division, Pfizer (exhibit).

Needs: Works with 1 freelance photographer, 2 filmmakers and 3 videographers/month. Uses photos for audiovisual projects. Subjects vary. Reviews stock photos. Model/property release preferred. Captions preferred.

Audiovisual Needs: Uses slides, film and videotape. Subjects include: "original material."

Specs: Uses 35mm transparencies; ¾" or ½" videotape.

Making Contact & Terms: Query with résumé of credits. Provide résumé, business card, brochure, flier or tearsheets to be kept on file for possible future assignments. Works with local freelancers on assignment only. Keeps samples on file. Cannot return material. Reports when needed. Pays $500-

1,500/job; also depends on size, scope and budget of project. Pays within 30 days of receipt of invoice. Credit line not given. Buys one-time rights; negotiable.

***◼LIPPSERVICE**, 305 W. 52nd St., New York NY 10019. (212)956-0572. President: Ros Lipps. Estab. 1985. Celebrity consulting firm. Types of clients: industrial, financial, fashion, retail, food; "any company which requires use of celebrities." Examples of recent projects: Projects for United Way of Tri-State, CARE, AIDS benefits, Child Find of America, League of American Theatres & Producers, *Celebrate Broadway.*
Needs: Works with 6 freelance photographers and/or videographers/month. Uses photos for billboards, trade magazines, P-O-P displays, posters, audiovisual. Subjects include: celebrities only. Model/property release required.
Audiovisual Needs: Uses videotape.
Specs: Uses videotape.
Making Contact & Terms: Provide résumé, business card, brochure, flier or tearsheets to be kept on file for possible future assignments. Works on assignment only. Keeps samples on file. Cannot return material. Reports in 3 weeks. NPI; pays per job. Credit line given. Rights purchased depend on job; negotiable.
Tips: Looks for "experience in photographing celebrities. Contact us by mail only."

McCANN-ERICKSON WORLDWIDE, 750 Third Ave., 17th Floor, New York NY 10017. Prefers not to share information.

◼MARSDEN, 30 E. 33rd St., New York NY 10016. (212)725-9220. Art Directors: Russell Campbell and Victor Mearini. Types of clients: corporate, nonprofit, Fortune 500.
Needs: Works with photographers as needed. Uses photographers for filmstrips, slide sets, multimedia productions, films and videotapes. Subjects include industrial, technical, office, faces, scenics, special effects, etc.
Specs: Uses 35mm, 2¼×2¼, 4×5 and 8×10 transparencies; 16mm film; U-matic ¾", 1" and 2" videotapes.
Making Contact & Terms: Query with samples or a stock photo list. Provide résumé, business card, self-promotion piece or tearsheets to be kept on file for possible future assignments. Works with local freelancers only; interested in stock photos/footage. "We call when we have a need—no response is made on unsolicited material." Pays $25-1,000/color photo; $150-600/day. **Pays on acceptance.** Buys one-time rights. Model release preferred. Credit line rarely given.

***MIZEREK ADVERTISING INC.**, 318 Lexington Ave., New York NY 10016. (212)689-4885. President: Leonard Mizerek. Estab. 1974. Types of clients: fashion, jewelry and industrial.
● Received a 1994 Readex Award for having the most recognized ad in a trade journal.
Needs: Works with 2 freelance photographers/month. Uses photographs for trade magazines. Subjects include: still life and jewelry. Reviews stock photos of creative images showing fashion/style. Model release required. Property release preferred.
Specs: Uses 8×10 glossy b&w prints; 4×5 and 8×10 transparencies.
Making Contact & Terms: Interested in receiving work from newer, lesser-known photographers. Submit portfolio for review. Provide résumé, business card, brochure, flier or tearsheets to be kept on file for possible future assignments. SASE. Reports in 2 weeks. Pays $500-1,500/job; $1,500-2,500/day; $600/color photo; $400/b&w photo. **Pays on acceptance.** Credit line sometimes given. Buys all rights; negotiable.
Tips: Looks for "clear product visualization. Must show detail and have good color balance." Sees trend toward "more use of photography and expanded creativity." Likes a "thinking" photographer.

***NOSTRADAMUS ADVERTISING**, #1128A, 250 W. 57th, New York NY 10107. (212)581-1362. Fax: (212)581-1369. President: Barry Sher. Estab. 1974. Ad agency. Types of clients: politicians, nonprofit organizations and small businesses.
Needs: Uses freelancers occasionally. Uses photos for consumer and trade magazines, direct mail, catalogs and posters. Subjects include: people and products. Model release required.
Specs: Uses 8×10 glossy b&w and color prints; transparencies, slides.
Making Contact & Terms: Provide résumé, business card, brochure. Works with local freelancers only. Cannot return material. Pays $50-100/hour. Pays 30 days from invoice. Credit line sometimes given. Buys all rights (work-for-hire).

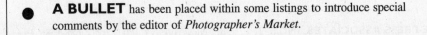

● **A BULLET** has been placed within some listings to introduce special comments by the editor of *Photographer's Market.*

OMNICOM GROUP INC., 437 Madison Ave., 9th Floor, New York NY 10022. Prefers not to share information.

PETER ROTHHOLZ ASSOCIATES, INC., 3860 Lexington Ave., 3rd Floor, New York NY 10017. (212)687-6565. Contact: Peter Rothholz. PR firm. Types of clients: pharmaceuticals (health and beauty), government, travel.
Needs: Works with 2 freelance photographers/year, each with approximately 8 assignments. Uses photos for brochures, newsletters, PR releases, AV presentations and sales literature. Model release required.
Specs: Uses 8×10 glossy b&w prints; contact sheet OK.
Making Contact & Terms: Provide letter of inquiry to be kept on file for possible future assignments. Query with résumé of credits or list of stock photo subjects. Local freelancers preferred. SASE. Reports in 2 weeks. NPI; negotiates payment based on client's budget. Credit line given on request. Buys one-time rights.
Tips: "We use mostly standard publicity shots and have some 'regulars' we deal with. If one of those is unavailable we might begin with someone new—and he/she will then become a regular."

SAATCHI & SAATCHI ADVERTISING, 375 Hudson St., 15th Floor, New York NY 10014-3660. (212)463-2000. Art Buyers: Joanne DeCarlo (Senior Manager), Marity Brody, Jim Hushon, Amy Salzman, Francis Timoney.
• This market says its photo needs are so varied that photographers should contact individual art buyers about potential assignments.

■**SPENCER PRODUCTIONS, INC.**, 234 Fifth Ave., New York NY 10001. General Manager: Bruce Spencer. Estab. 1961. PR firm. Types of clients: business, industry. Produces motion pictures and videotape.
Needs: Works with 1-2 freelance photographers/month on assignment only. Buys 2-6 films/year. Satirical approach to business and industry problems. Freelance photos used on special projects. Length: "Films vary—from a 1-minute commercial to a 90-minute feature." Model/property release required. Captions required.
Specs: 16mm color commercials, documentaries and features.
Making Contact & Terms: Interested in receiving work from newer, lesser-known photographers. Provide résumé and letter of inquiry to be kept on file for possible future assignments. Query with samples and résumé of credits. "Be brief and pertinent!" SASE. Reports in 3 weeks. Pays $50-150/color and b&w photos (purchase of prints only; does not include photo session); $5-15/hour; $500-5,000/job; negotiates payment based on client's budget. Pays a royalty of 5-10%. **Pays on acceptance.** Buys one-time rights and all rights; negotiable.
Tips: "Almost all of our talent was unknown in the field when hired by us. For a sample of our satirical philosophy, see paperback edition of *Don't Get Mad . . . Get Even* (W.W. Norton), by Alan Abel which we promoted, or *How to Thrive on Rejection* (Dembner Books, Inc.), or rent the home video *Is There Sex After Death?*, an R-rated comedy featuring Buck Henry."

■**TALCO PRODUCTIONS**, 279 E. 44th St., New York NY 10017. (212)697-4015. Fax: (212)697-4827. President: Alan Lawrence. Vice President: Marty Holberton. Estab. 1968. Public relations agency and TV, film, radio and audiovisual production firm. Types of clients: industrial, legal, political and nonprofit organizations. Produces motion pictures, videotape and radio programs.
Needs: Works with 1-2 freelancers/month. Model/property release required.
Audiovisual Needs: Uses 16mm and 35mm film. Beta videotape. Filmmaker might be assigned "second unit or pick-up shots."
Making Contact & Terms: Query with résumé of credits. Provide résumé, flier or brochure to be kept on file for possible future assignments. Prefers to see general work or "sample applicable to a specific project we are working on." Works on assignment only. SASE. Reports in 3 weeks. Payment negotiable according to client's budget and where the work will appear. **Pays on receipt of invoice.** Buys all rights.
Tips: Filmmaker "must be experienced—union member is preferred. We do not frequently use free-lancers except outside the New York City area when it is less expensive than sending a crew." Query with résumé of credits only—don't send samples. "We will ask for specifics when an assignment calls for particular experience or talent."

■**TBWA ADVERTISING**, 292 Madison Ave., New York NY 10017. Prefers not to share information.

■**TELE-PRESS ASSOCIATES, INC.**, 321 E. 53rd., New York NY 10022. (212)688-5580. President: Alan Macnow. Project Director: Devin Macnow. PR firm. Uses brochures, annual reports, press

releases, AV presentations, consumer and trade magazines. Serves beauty, fashion, jewelry, food, finance, industrial and government clients.
Needs: Works with 3 freelance photographers/month on assignment only.
Specs: Uses 8×10 glossy b&w prints; 35mm, 2¼×2¼, 4×5 or 8×10 transparencies. Works with freelance filmmakers in production of 16mm documentary, industrial and educational films.
Making Contact & Terms: Provide résumé, business card and brochure to be kept on file for possible future assignments. Query with résumé of credits or list of stock photo subjects. SASE. Reports in 2 weeks. Pays $100-200/b&w photo; $100-200/color photo; $800-1,500/day; negotiates payment based on client's budget. Buys all rights. Model release and captions required.
Tips: In portfolio or samples, wants to see still life, and fashion and beauty, shown in dramatic lighting. "Send intro letter, do either fashion and beauty or food and jewelry still life."

J WALTER THOMPSON COMPANY, 466 Lexington Ave., New York NY 10017. Prefers not to share information.

WARWICK BAKER & FIORE, 100 Avenue of the Americas, New York NY 10013. Prefers not to share information.

YOUNG & RUBICAM INC., 285 Madison Ave., New York NY 10017. Prefers not to share information.

North Carolina

***■CHISHOLM & ASSOCIATES**, 4505 Falls of Neuse Rd., Suite 650, Raleigh NC 27609. (919)876-2065. Fax: (919)876-2344. E-mail: chisassoc@aol.com. Vice President: David Markovsky. Estab. 1993. Ad agency. Approximate annual billing: $10 million. Number of employees: 20. Types of clients: industrial, financial and food. Example of recent projects: Coopertools Worldwide.
Needs: Works with 2-4 freelancers/month and 2 filmmakers/year. Uses photos for consumer magazines, trade magazines, direct mail, P-O-P displays, posters, newspapers and audiovisual. Model/property release preferred.
Audiovisual Needs: Uses slides and film or video. Subjects include health care and industrial.
Specs: Uses color prints; 4×5 transparencies; Mac CD digital format.
Making Contact & Terms: Interested in receiving work from newer, lesser-known photographers. Query with résumé of credits. Provide résumé, business card, brochure, flier or tearsheets to be kept on file for possible future assignments. Works with freelancers on assignment only. Keeps samples on file. Cannot return material. Reports in 3-4 weeks. NPI. **Pays on receipt of invoice.** Credit line sometimes given depending upon piece, price, etc. Buys first, one-time, electronic and all rights; negotiable.

■EPLES ASSOCIATES, 6302 Fairview Rd., Suite 200, Charlotte NC 28210. (704)442-9100. Vice President: Lamar Gunter. Estab. 1968. Types of clients: industrial and others.
Needs: Works with 1-2 freelance photographers and/or videographers/month. Subjects include: photojournalism. Model/property release required.
Audiovisual Needs: Uses slides and videotape.
Specs: "Specifications depend on situation."
Making Contact & Terms: Works on assignment only. NPI. **Pays on receipt of invoice**. Buys various rights. Credit line sometimes given, "depends on client circumstance."

■HODGES ASSOCIATES, INC., P.O. Box 53805, 912 Hay St., Fayetteville NC 28305. (910)483-8489. Fax: (910)483-7197. Art Director: Jeri Allison. Estab. 1974. Ad agency. Types of clients: industrial, financial, retail, food. Examples of projects: House of Raeford Farms (numerous food packaging/publication ads); The Esab Group, welding equipment (publication ads/collateral material).
Needs: Works with 1-2 freelancers/month. Uses photos for consumer magazines, trade magazines, direct mail, P-O-P displays, catalogs, posters, newspapers, signage, audiovisual uses. Subjects include: food, welding equipment, welding usage, financial, health care, industrial fabric usage, agribusiness

THE SOLID, BLACK SQUARE before a listing indicates that the market uses various types of audiovisual materials, such as slides, film or videotape.

products, medical tubing. Reviews stock photos. Model/property release required.
Audiovisual Needs: Uses slides and video. Subjects include: slide shows, charts, videos for every need.
Specs: Uses 4×5, 11×14, 48×96 color and b&w prints; 35mm, $2\frac{1}{4} \times 2\frac{1}{4}$, 4×5, 8×10 transparencies.
Making Contact & Terms: Interested in receiving work from newer, lesser-known photographers. Submit portfolio for review. Keeps samples on file. SASE. Reports in 1-2 weeks. Pays $100/hour; $800/day. **Pays on receipt of invoice.** Credit line given depending upon usage PSAs, etc. but not for industrial or consumer ads/collateral. Buys all rights; negotiable.
Tips: Looking for "all subjects and styles." Also, the "ability to shoot on location in adverse conditions (small cramped spaces). For food photography a kitchen is a must, as well as access to food stylist. Usually shoot both color and b&w on assignment. For people shots . . . photographer who works well with talent/models." Seeing "less concern about getting the 'exact' look, as photo can be 'retouched' so easily in Photoshop or on system at printer. Electronic retouching has enabled art director to 'paint' the image he wants. But by no means does this mean he will accept mediocre photographs."

HOWARD, MERRELL & PARTNERS ADVERTISING, INC., 8521 Six Forks Rd., Raleigh NC 27615. (919)848-2400. Fax: (919)676-1035. Art Buyer/Broadcast Business Supervisor: Jennifer McFarland. Estab. 1976. Member of Affiliated Advertising Agencies International, American Association of Advertising Agencies, American Advertising Federation. Ad agency. Approximate annual billing: $70 million. Number of employees: 65. Types of clients: various.
Needs: Works with 6-10 freelancers/month. Uses photos for consumer and trade magazines, direct mail, catalogs and newspapers. Reviews stock photos. Model/property release required.
Specs: Uses 8×10 glossy b&w prints; 35mm, $2\frac{1}{4} \times 2\frac{1}{4}$, 4×5, 8×10 transparencies.
Making Contact & Terms: Interested in receiving work from newer, lesser-known photographers. Arrange personal interview to show portfolio. Provide résumé, business card, brochure, flier or tearsheets to be kept on file for possible future assignments. Works on assignment only. Keeps samples on file. SASE. Reports in 3 weeks. NPI; payment individually negotiated. **Pays on receipt of invoice.** Buys one-time and all rights (1-year or 2-year unlimited use); negotiable.

■**IMAGE ASSOCIATES**, 4909 Windy Hill Dr., Raleigh NC 27609-4929. (919)876-6400. Fax: (919)876-7064. AV firm. Estab. 1984. Creative Director: John Wigmore. Types of clients: industrial, financial and corporate. Examples of projects: "The American Dream," GECAP (multi-image); CTT (multi-image); and Exide Electronics (print).
Needs: Works with 3 freelance photographers/month for audiovisual uses. Interested in reviewing stock photos. Model/property release and captions required.
Audiovisual Needs: Uses photos for multi-image slide presentation and multimedia.
Making Contact & Terms: Interested in receiving work from newer, lesser-known photographers. Provide résumé, business card, brochure, flier or tearsheets to be kept on file for possible future assignments. Works with freelancers on assignment only. Cannot return material. Reports in 1 month. Pays $100 maximum/hour; $800 minimum/day; $50/color photo; $100/stock photo. Pays within 30 days of invoice. Buys all rights; negotiable. Credit line given sometimes; negotiable.
Tips: "We have a greater need to be able to scan photos for multimedia computer programs."

■**SMITH ADVERTISING & ASSOCIATES**, P.O. Drawer 2187, Fayetteville NC 28302. (910)323-0920. Fax: (910)323-3328. Creative Director: Ron Sloan. Estab. 1974. Ad agency, PR firm. Types of clients: industrial, medical, financial, retail, tourism, resort, real estate. Examples of recent projects: mild side-image, Sarasota Convention & Visitors Bureau (newspaper/magazine/brochure); collateral-image, NC Ports Authority (brochure); 401-K sign-ups, BB&T (posters).
Needs: Works with 0-10 photographers, 0-3 filmmakers, 0-3 videographers/month. Uses photos for billboards, consumer and trade magazines, direct mail, P-O-P displays, catalogs, posters, newspapers, signage, audiovisual. Subjects include: area, specific city, specific landmark. Model release preferred for identifiable people in photos for national publications. Property release preferred. Photo captions preferred.
Audiovisual Needs: Uses slides, film, videotape for slide shows, TVC. Subjects include: archive, early years.
Specs: Uses 5×7 glossy color and b&w prints; 35mm, $2\frac{1}{4} \times 2\frac{1}{4}$, 4×5 transparencies; $\frac{1}{2}$" VHS film; $\frac{1}{2}$" VHS videotape.
Making Contact & Terms: Interested in receiving work from newer, lesser-known photographers. Provide résumé, business card, brochure, flier or tearsheets to be kept on file for possible future assignments. Samples are kept on file "for limited time." SASE. Reports in 1-2 weeks. NPI; payment negotiable according to client's budget. Pays on publication. Credit lines sometimes given depending on subject and job. Buys all rights; negotiable.

North Dakota

***∎FLINT COMMUNICATIONS**, 101 10th St. N., Fargo ND 58102. (701)237-4850. Fax: (701)234-9680. Art Director: Gerri Lien. Estab. 1946. Ad agency. Approximate annual billing: $9 million. Number of employees: 30. Types of clients: industrial, financial, agriculture and health care.
Needs: Works with 2-3 freelance photographers, 1-2 filmmakers and 1-2 videographers/month. Uses photos for direct mail, P-O-P displays, posters and audiovisual. Subjects include: agriculture, health care and business. Reviews stock photos. Model release preferred.
Audiovisual Needs: Uses slides and film.
Specs: Uses 35mm, 2¼×2¼, 4×5 transparencies; CD-ROM digital format.
Making Contact & Terms: Interested in receiving work from newer, lesser-known photographers. Submit portfolio for review. Query with stock photo list. Provide résumé, business card, brochure, flier or tearsheets to be kept on file for possible future assignments. Keeps samples on file. Reports in 1-2 weeks. Pays $50-100/hour; $400-800/day; $100-1,000/job. Pays on receipt of invoice. Buys one-time rights.

∎KRANZLER, KINGSLEY COMMUNICATIONS LTD., P.O. Box 693, Bismarck ND 58502. (701)255-3067. Ad agency. Contact: Art Director. Types of clients: wide variety.
Needs: Works with 1 freelance photographer/month. Uses photos for consumer and trade magazines, direct mail, P-O-P displays, catalogs, posters and newspapers. Subjects include local and regional. Model release required. Captions preferred.
Audiovisual Needs: Uses "general variety" of materials.
Specs: Uses 8×10 glossy b&w and color prints; 35mm, 2¼×2¼ and 4×5 transparencies.
Making Contact & Terms: Interested in receiving work from newer, lesser-known photographers. Query with list of stock photo subjects. Provide résumé, business card, brochure, flier or tearsheets to be kept on file for possible future assignments. Works with freelance photographers on assignment basis only; 90% local freelancers. SASE. Reports in 2 weeks. Pays $50/b&w photo; $50/color photo; $40/hour; $100/day. Pays on publication. Credit line given. Buys exclusive product and one-time rights; negotiable.
Tips: In reviewing a photographer's portfolio or samples, prefers to see "people—working, playing—various views of each shot, including artistic angles, etc., creative expressions using emotions." Looking for "small clean portfolio; basic skills; no flashy work. We are exclusively using photos in an electronic mode—all photos used are incorporated into our desktop publishing system."

Ohio

∎AD ENTERPRISE ADVERTISING AGENCY, 6617 Maplewood Dr., Suite 203, Cleveland OH 44124. (216)461-5566. Fax: (216)461-8139. Art Director: Jim McPherson. Estab. 1953. Ad agency and PR firm. Types of clients: industrial, financial, retail and food.
Needs: Works with 1 freelance photographer, 1 filmmaker and 1 videographer/month. Uses photos for consumer and trade magazines, direct mail, P-O-P displays, catalogs and newspapers. Subjects vary to suit job. Reviews stock photos. Model release required with identifiable faces. Captions preferred.
Audiovisual Needs: Uses slides, film and videotape.
Specs: Uses 4×5, 8×10 glossy color and b&w prints; 35mm, 2¼×2¼ and 4×5 transparencies.
Making Contact & Terms: Interested in receiving work from newer, lesser-known photographers. Provide résumé, business card, brochure, flier or tearsheets to be kept on file for possible future assignments. Works with freelancers on assignment only. Keeps samples on file. SASE. Reports in 1-2 weeks. Pays $50-100/hour; $400-1,000/day. Pays after billing client. Credit line sometimes given, depending on agreement. Buys one-time rights and all rights; negotiable.
Tips: Wants to see industrial, pictorial and consumer photos.

∎BARON ADVERTISING, INC., 1422 Euclid Ave., Suite 645, Cleveland OH 44115-1901. (216)621-6800. President: Selma Baron. Incorporated 1973. Ad agency. Types of clients: food, industrial, electronics, telecommunications, building products, architectural. In particular, serves various manufacturers of tabletop and food service equipment.
Needs: Uses 20-25 freelance photographers/month. Uses photos for direct mail, catalogs, newspapers, consumer magazines, P-O-P displays, posters, trade magazines, brochures and signage. Subject matter varies. Model/property release required.
Audiovisual Needs: Works with freelance filmmakers for AV presentations.
Making Contact & Terms: Arrange a personal interview to show portfolio. Query with list of stock photo subjects. Provide résumé, business card, brochure, flier or tearsheets to be kept on file for possible future assignments. Works with freelancers on assignment only. Cannot return material. NPI.

Payment "depends on the photographer." Pays on completion. Buys all rights.
Tips: Prefers to see "food and equipment" photos in the photographer's samples. "Samples not to be returned."

■**FUNK/LUETKE, INC.**, Dept. PM, 405 Madison Ave., 12th Floor, Toledo OH 43604. (419)241-1244. Fax: (419)241-5210. PR, advertising and marketing firm. Video Supervisor: Ed Hunter. Estab. 1985. Types of clients: corporate, industrial, finance, health/hospitals.
Needs: Works with 20 freelance photographers. Uses photos for newspapers, audiovisual, employee newsletter. Subjects include: photojournalism (b&w), hospitals, corporate communications, industrial, location assignments and video newsletters.
Audiovisual Needs: Uses photos and/or film or video for broadcast quality videotape.
Specs: Uses 8×10, b&w prints; 35mm transparencies; BetaCam SP/broadcast quality.
Making Contact & Terms: Provide résumé, business card, brochure, flier or tearsheets to be kept on file for possible future assignments. Works with freelancers on assignment only. Reports in 1-2 weeks. Pays $50-100/hour; $500-1,000/day; $50-1,500/job; $100/color photo; $75/b&w photo. Pays 45 days after receipt of invoice. Model release required or preferred depending on project. Credit line sometimes given depending upon project.
Tips: In samples and queries, wants to see "photojournalism (b&w), ability to cover location assignments, ability to work independently and represent firm professionally, enthusiasm for work, service-oriented, deadline-oriented, available on short notice and willing to travel." Sees trend toward "more use of freelancers because of the need to match the right person with the right job." To break in with this firm, "be enthusiastic, eager to work and flexible. Be willing to research the client. Be a part of the assignment. Make suggestions; go beyond the assignment given. Be a partner in the job."

GRISWOLD ESHLEMAN INC., (formerly Griswold, Inc.) 101 Prospect Ave. W., Cleveland OH 44115. (216)696-3400. Creative Director: Joe McNeil. Ad agency. Types of clients: consumer and industrial firms; client list provided upon request.
Needs: Works with freelance photographers on assignment only basis. Uses photographers for billboards, consumer and trade magazines, direct mail, P-O-P displays, brochures, catalogs, posters, newspapers out-of-home and AV presentations.
Making Contact & Terms: Provide brochure to be kept on file for possible future assignments. Works primarily with local freelancers but occasionally uses others. Arrange interview to show portfolio. NPI. Payment is per day or project; negotiates according to client's budget. Pays on production.

■**INSTRUCTIONAL VIDEO**, P.O. Box 21, Maumee OH 43537. (419)865-7670. Fax: (419)866-3718. Director: Laurence Jankowski. Estab. 1983. Member of Radio-Television News Directors Association. AV firm. Approximate annual billing: $200,000. Number of employees: 3. Types of clients: industrial and food. Examples of recent projects: "Quality Assurance" for Campbell Soup Co. (employee video); "When is Michigan?" for Midland Art Museum (museum display); and "Weathering & Erosion" for Scott Resources (educational video).
Needs: Works with 2 freelance photographers and 2 videographers/month. Uses photos for audiovisual uses and computer animation. Subjects include computer animation.
Audiovisual Needs: Uses film and video for producing educational videotapes for instruction.
Specs: Uses 16mm film and ¾" videotape.
Making Contact & Terms: Interested in receiving work from newer, lesser-known photographers. Query with résumé of credits. Query with stock photo list. Works on assignment only. Does not keep samples on file. SASE. Reports in 1 month. Pays $1.50-2/second of video. Pays on receipt of invoice. Credit line given. Buys all rights; negotiable.

■**JONES, ANASTASI, BIRCHFIELD ADVERTISING INC.**, 6065 Frantz Rd., Suite 204, Dublin OH 43017. (614)764-1274. Creative Director/VP: Joe Anastasi. Ad agency. Types of clients: telecommunications, hospitals, insurance, food and restaurants and financial.
Needs: Works on assignment basis only. Uses photographers for billboards, consumer and trade magazines, brochures, posters, newspapers and AV presentations.
Making Contact & Terms: Arrange interview to show portfolio. NPI. Payment is per hour, per day, and per project; negotiates according to client's budget.

■**LAUERER MARKIN GROUP, INC.**, 1700 Woodlands Dr., Maumee OH 43537. (419)893-2500. Fax: (419)893-1050. Associate Creative Director: Mike Roberts. Estab. 1971. Ad agency and PR firm. Types of clients: industrial, financial and retail.
Needs: Works with 3-10 freelance photographers, 1 filmmaker and 1 videographer/month. Uses photos for consumer and trade magazines, direct mail, P-O-P displays and newspapers. Subject matter varies. Model/property release required.

Audiovisual Needs: Uses film and videotape for television and corporate videos.
Specs: Uses color and b&w prints; 35mm, 2¼×2¼, 4×5 and 8×10 transparencies; 16mm, 35mm film; and Beta ¾" videotape.
Making Contact & Terms: Interested in receiving work from newer, lesser-known photographers. Provide résumé, business card, brochure, flier or tearsheets to be kept on file for possible future assignments. Works on assignment only. Does not keep samples on file. Cannot return material. Reporting time varies. Pays on receipt of invoice or net 30 days. Buys all rights; negotiable.

***LERNER ET AL, INC.**, 392 Morrison Rd., Columbus OH 43213. (614)864-8554. Fax: (614)755-5402. President: Frank Lerner. Estab. 1987. Ad agency and design firm with inhouse photography. Approximate annual billing: $1.5 million. Number of employees: 10. Types of clients: industrial, financial and manufacturers.
Needs: Works with 1-2 freelancers/month. Uses photos for consumer magazines, trade magazines, direct mail, P-O-P displays, catalogs, posters, annual reports and packaging. Subjects include: commercial products. Reviews stock photos of all subjects—medical, industrial, science, lifestyles. Model release required. Property release preferred. Captions preferred.
Spec: Uses all sizes color and b&w prints; 35mm, 2¼×2¼, 4×5 transparencies.
Making Contact & Terms: Interested in receiving work from newer, lesser-known photographers. Arrange personal interview to show portfolio. Submit portfolio for review. Send unsolicited photos by mail for consideration. Query with samples. Provide résumé, business card, brochure, flier or tearsheets to be kept on file for possible future assignments. Keeps samples on file. SASE. Reports depending on the job. Pays $150-350/day (in-studio). Pays net 30 days. Credit line not given. Buys all rights.
Tips: Looks for skill with lifestyles (people), studio ability, layout/design ability, propping/setup speed and excellent lighting techniques.

LOHRE & ASSOCIATES INC., 2330 Victory Pkwy., Suite 701, Cincinnati OH 45206. (513)961-1174. Ad agency. President: Charles R. Lohre. Types of clients: industrial.
Needs: Works with 1 photographer/month. Uses photographers for trade magazines, direct mail, catalogs and prints. Subjects include: machine-industrial themes and various eye-catchers.
Specs: Uses 8×10 glossy b&w and color prints; 4×5 transparencies.
Making Contact & Terms: Query with résumé of credits. Provide résumé, business card, brochure, flier or tearsheets to be kept on file for possible future assignments. Works with local freelancers only. SASE. Reports in 1 week. Pays $60/b&w photo; $250/color photo; $60/hour; $275/day. Pays on publication. Buys all rights.
Tips: Prefers to see eye-catching and thought-provoking images/non-human. Need someone to take 35mm photos on short notice in Cincinnati plants.

■OLSON AND GIBBONS, INC., 1501 Euclid Ave., Suite 518, Cleveland OH 44115-2108. (216)623-1881. Fax: (216)623-1884. Executive Vice-President/Creative Director: Barry Olson. Estab. 1991. Ad agency, PR/marketing firm. Types of clients: industrial, financial, medical, retail and food. Examples of recent projects: The Cleveland Clinic Foundation (collateral); Ansell Edmont (ads, collateral, direct mail); Rubbermaid Home Products (ads).
Needs: Works with 10 freelancers/month. Uses photos for billboards, trade magazines, consumer newspapers and magazines, direct mail and P-O-P displays. Model/property release required.
Audiovisual Needs: Uses film and videotape.
Specs: Uses color and/or b&w prints; 35mm, 2¼×2¼, 4×5, 8×10 transparencies; 16mm, 35mm film.
Making Contact & Terms: Interested in receiving work from newer, lesser-known photographers. Arrange personal interview to show portfolio. Provide résumé, business card, brochure, flier or tearsheets to be kept on file for possible future assignments. Works with local freelancers on assignment only. Keeps samples on file. SASE. Reports in 1-2 weeks. NPI. **Pays on receipt of invoice**, payment by client. Credit line not given. Buys one-time or all rights; negotiable.

***PIHERA ADVERTISING ASSOCIATES, INC.**, 1605 Ambridge Rd., Dayton OH 45459. (513)433-9814. President: Larry Pihera. Estab. 1970. Ad agency. Number of employees: 4. Types of clients: industrial, fashion and retail. Examples of recent projects: Arkay Industries (20-page brochure); The Elliott Company (series of brochures); Remodeling Designs for Elegance in Remodeling (newspaper/TV campaign).
Needs: Works with 3 freelance photographers and filmmakers or videographers/month. Uses photos for consumer magazines, trade magazines, direct mail, catalogs and newspapers. Subjects include: people and industrial/retail scenes with glamour. Reviews stock photos. Model/property release required.
Audiovisual Needs: Uses slides and film or video for corporate films (employee orientation/training). Subjects include: all types.

Specs: Uses 8×10 color and b&w prints; 35mm, 2¼×2¼, 4×5 transparencies.
Making Contact & Terms: Interested in receiving work from newer, lesser-known photographers. Query with stock photo. Works with freelancers on assignment only. Cannot return material. Reports in 1-2 weeks. NPI. Pays on receipt of invoice. Credit line given. Buys all rights.

SMILEY/HANCHULAK, INC., 47 N. Cleveland-Massillon Rd., Akron OH 44333. (330)666-0868. Ad agency. V.P./Associate Creative Director: Dominick Sorrent, Jr. Clients: all types.
Needs: Works with 1-2 photographers/month. Uses freelance photos for consumer and trade magazines, direct mail, P-O-P displays, catalogs, posters and sales promotion. Model release required. Captions preferred.
Specs: Uses 11×14 b&w and color prints, finish depends on job; 35mm or 2¼×2¼ (location) or 4×5 or 8×10 (usually studio) transparencies, depends on job.
Making Contact & Terms: Arrange a personal interview to show portfolio. Query with résumé of credits, list of stock photo subjects or samples. Send unsolicited photos by mail for consideration or submit portfolio for review. Provide résumé, business card, brochure, flier or tearsheets to be kept on file for possible future assignments. If a personal interview cannot be arranged, a letter would be acceptable. Works with freelance photographers on assignment basis only. SASE. Report depends on work schedule. NPI. Pays per day or per job. Buys all rights unless requested otherwise.
Tips: Prefers to see studio product photos. "Jobs vary—we need to see all types with the exception of fashion. We would like to get more contemporary, but photo should still do the job."

WATT, ROOP & CO., 1100 Superior Ave., Cleveland OH 44114. (216)566-7019. Vice President/ Manager of Design Operations: Thomas Federico. Estab. 1981. Member of AIGA, PRSA, Press Club of Cleveland, Cleveland Ad Club. PR firm. Approximate annual billing: $3 million. Number of employees: 30. Types of clients: industrial, manufacturing and health care. Examples of recent projects: AT&T (magazine insert); City of Cleveland Division of Water (annual report); Cleveland State University (development publication); MicroXperts (ad sales).
Needs: Works with 4 freelance photographers/month. Uses photos for magazines and corporate/ capabilities brochures, annual reports, catalogs and posters. Subjects include: corporate. Reviews stock photos. Model/property release required. Captions preferred.
Specs: Uses 35mm, 2¼×2¼, 4×5 transparencies.
Making Contact & Terms: Interested in receiving work from newer, lesser-known photographers. Provide résumé, business card, brochure, flier or tearsheets to be kept on file for possible future assignments. Works with local freelancers on assignment only. Reports "as needed." Pays $50-1,500/ b&w photo; $100-2,500/color photo; $50-200/hour; $150-2,000/day. **Pays on receipt of invoice.** Credit line sometimes given. Buys all rights (work-for-hire); one-time rights; negotiable.
Tips: Wants to see "variety, an eye for the unusual. Be professional."

Oregon

■ADFILIATION ADVERTISING, 323 W. 13th, Eugene OR 97401. (541)687-8262. Fax: (541)687-8576. Creative Director: Gary Schubert. Estab. 1976. Ad agency. Types of clients: industrial, food, computer, medical.
Needs: Works with 2 freelance photographers, filmmakers and/or videographers/month. Uses photos for billboards, consumer and trade magazines, P-O-P displays, catalogs and posters. Interested in reviewing stock photos/film or video footage. Model/property release required. Captions preferred.
Audiovisual Needs: Uses slides, film and videotape.
Specs: Uses color and b&w prints and 35mm transparencies.
Making Contact & Terms: Submit portfolio for review. Query with résumé of credits. Query with stock photo list. Provide résumé, business card, brochure, flier or tearsheets to be kept on file for possible future assignments. Works on assignment only. Keeps samples on file. SASE. Reports in 1-2 weeks. NPI; depends on job and location. Pays on receipt of invoice. Credit line sometimes given, depending on project and client. Rights purchased depends on usage; negotiable.

■CREATIVE COMPANY, 3276 Commercial St. SE, Salem OR 97302. (503)363-4433. Fax: (503)363-6817. President: Jennifer L. Morrow. Creative Director: Rick Yurk. Estab. 1978. Member of American Institute of Graphic Artists, Portland Ad Federation. Marketing communications firm. Types of clients: food products, manufacturing, business-to-business. Examples of recent projects: "Gardenburger," Wholesome & Hearty Foods (trade ads, P-O-P); "Tec Labs Oak'n Ivy Brand," Tec Labs (collateral direct mail); and "Share the Wind," PGE (direct mail).
Needs: Works with 1-2 freelancers/month. Uses photos for direct mail, P-O-P displays, catalogs, posters, audiovisual and sales promotion packages. Model release preferred.

Specs: Uses 5×7 and larger glossy color or b&w prints; 2¼×2¼, 4×5 transparencies.
Making Contact & Terms: Arrange personal interview to show portfolio. Provide résumé, business card, brochure, flier or tearsheets to be kept on file for possible future assignments. Works with local freelancers only. SASE. Reports "when needed." Pays $75-300/b&w photo; $200-1,000/color photo; $20-75/hour; $700-2,000/day, $200-15,000/job. Credit line not given. Buys one-time, one-year and all rights; negotiable.
Tips: In freelancer's portfolio, looks for "product shots, lighting, creative approach, understanding of sales message and reproduction." Sees trend toward "more special effect photography, manipulation of photos in computers." To break in with this firm, "do good work, be responsive and understand what color separations and printing will do to photos."

WIEDEN & KENNEDY INC., 320 SW Washington, Portland OR 97204. Prefers not to share information.

Pennsylvania

***BELLMEDIA CORPORATION**, P.O. Box 18053, Pittsburgh PA 15236-0053. (412)469-0307, ext. 107. Fax: (412)469-8244. President: Paul Beran. Estab. 1994. Member of MMTA (Multimedia Telecommunications Association). Specialized production house. Approximate annual billing: $500,000-1 million. Types of clients: all, including airlines, utility companies, manufacturers, distributors and retailers.
Needs: Uses photos for direct mail, P-O-P displays, catalogs, signage and audiovisual. Subjects include: communications, telecommunications and business. Reviews stock photos. Model release preferred. Property release required.
Audiovisual Needs: Uses slides and printing and computer files.
Specs: Uses 4×5 matte color and b&w prints; 4×5 transparencies; VHS videotape; PCX, TIFF digital format.
Making Contact & Terms: Interested in receiving work from newer, lesser-known photographers. Query with stock photo list. Send unsolicited photos by mail for consideration. Query with samples. Provide résumé, business card, brochure, flier or tearsheets to be kept on file for possible future assignment. Works with local freelancers only. Keeps samples on file. Cannot return material. Reporting time varies; "I travel a lot." NPI. Pays on receipt of invoice, net 30 days. Rights negotiable.
Tips: Looks for ability to mix media—video, print, color, b&w.

KEENAN-NAGLE ADVERTISING, 1301 S. 12th St., Allentown PA 18103-3814. (610)797-7100. Fax: (215)797-8212. Ad agency. Art Director: Donna Lederach. Types of clients: industrial, retail, finance, health care and high-tech.
Needs: Works with 7-8 freelance photographers/month. Uses photos for billboards, consumer magazines, trade magazines, direct mail, posters, signage and newspapers. Model release required.
Specs: Uses b&w and color prints; 35mm, 2¼×2¼, 4×5 and 8×10 transparencies.
Making Contact & Terms: Query with samples. Provide résumé, business card, brochure, flier or tearsheets to be kept on file for possible future assignments. Does not return unsolicited material. NPI. Pays on receipt of invoice. Credit line sometimes given.

KETCHUM COMMUNICATIONS INC., 6 PPG Place, Pittsburgh PA 15222. Prefers not to share information.

***PERCEPTIVE MARKETERS AGENCY, LTD.**, 1100 E. Hector St., Suite 301, Conshohocken PA 19428. (610)825-8710. Fax: (610)825-9186. E-mail: perceptmkt@aol.com. Contact: Jason Solovitz. Estab. 1972. Member of AANI, Philadelphia Ad Club, Philadelphia Direct Marketing Association. Ad agency. Number of employees: 8. Types of clients: industrial, financial, fashion, retail and food. Examples of recent projects: "TCM Direct Mail" campaign, AT&T; "Model 150" Launch, OPEX Corp; and "1-800-IBM 4 You" launch, IBM.
Needs: Works with 3 freelance photographers, 1 filmmaker and 1 videographer/month. Uses photos for consumer magazines, trade magazines, direct mail, P-O-P displays, catalogs, posters, newspapers, signage and audiovisual. Reviews stock photos. Model release required; property release preferred. Captions preferred.
Audiovisual Needs: Uses slides and film or video.
Specs Uses 8×12 and 11×14 glossy color and b&w prints; 2¼×2¼, 4×5 transparencies.
Making Contact & Terms: Interested in receiving work from newer, lesser-known photographers. Query with stock photo list. Provide résumé, business card, brochure, flier or tearsheets to be kept on file for possible future assignments. Works on assignment only. Keeps samples on file. Pays minimum $75/hour; $800/day. Pays on receipt of invoice. Credit line not given. Buys all rights; negotiable.

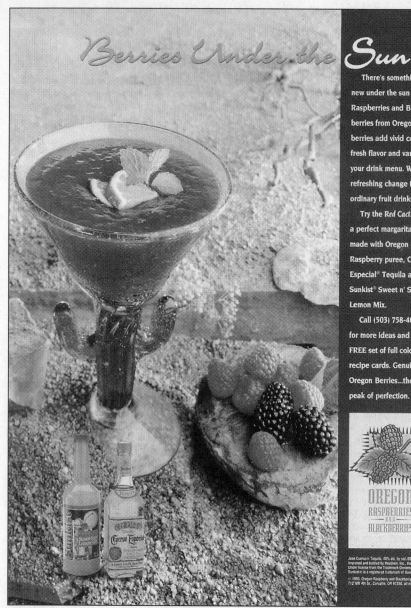

Berries Under the Sun

There's something new under the sun with Raspberries and Blackberries from Oregon. Our berries add vivid color, fresh flavor and variety to your drink menu. What a refreshing change from ordinary fruit drinks!

Try the *Red Cactus*; a perfect margarita made with Oregon Raspberry puree, Cuervo Especial® Tequila and Sunkist® Sweet n' Sour Lemon Mix.

Call (503) 758-4043 for more ideas and a FREE set of full color recipe cards. Genuine Oregon Berries...the peak of perfection.

OREGON RASPBERRIES AND BLACKBERRIES

Carol Murphy of the Creative Company combined the work of two Portland photographers for this inviting ad for Genuine Oregon Berries. Murphy hired Gene Faulkner (paid $550 for the bottle product shot) for his "ability to handle reflective problems of glass." Edward Gowans's propped shot, "intended to convey an appetizing treat in a desert environment" was used in the ad as well as in other promotion and publicity, and recipe cards. It was one of a series of multi-use images by Gowans, who specializes in food and beverage photography.

ROSEN-COREN AGENCY, 2381 Philmont Ave., Suite 117, Huntingdon PA 19006. (215)938-1017. Fax: (215)938-7634. Office Administrator: Ellen R. Coren. PR firm. Types of clients: industrial, retail, fashion, finance, entertainment, health care.
Needs: Works with 4 freelance photographers/month. Uses photos for PR shots.
Specs: Uses b&w prints.
Making Contact & Terms: "Follow up with phone call." Works with local freelancers only. Reports when in need of service. Pays $35-85/hour for b&w and color photos. Pays when "assignment completed and invoice sent—45 days."

■**DUDLEY ZOETROPE PRODUCTIONS**, 19 E Central Ave., Paoli PA 19301. (610)644-4991. Producer: David Speace. Types of clients: corporate.
Needs: Works with 1-2 photographers/month. Uses freelance photographers for slide sets, multi-image productions, films and videotapes. Subject depends on client.
Specs: Uses 35mm transparencies; videotape; 16mm and 35mm film.
Making Contact & Terms: Arrange a personal interview to show portfolio. Provide résumé, business card, self-promotion piece or tearsheets to be kept on file for possible future assignments. Works with freelancers on assignment only. Cannot return material. Reports in 1 week. NPI. Pays per day. **Pays on acceptance.** Credit line sometimes given. Buys all rights.
Tips: "Make your approach straight forward. Don't expect an assignment because someone looked at your portfolio. We are interested in photographers who can shoot for AV. They must be able to shoot from varied angles and present sequences that can tell a story."

Rhode Island

■**MARTIN THOMAS, INC.**, Advertising & Public Relations, 26 Bosworth St., Unit 4, Barrington RI 02806. (401)245-8500. Fax: (401)245-1242. President: Martin K. Pottle. Estab. 1987. Ad agency, PR firm. Types of clients: industrial and business-to-business. Examples of ad campaigns: D&S Plastics International (brochures, PR); Battenfeld of America (ad series); Hysol Adhesives (direct mail).
Needs: Works with 3-5 freelance photographers/month. Uses photos for trade magazines. Subjects include: location shots of equipment in plants and some studio. Model release required.
Audiovisual Needs: Uses videotape for 5-7 minute capabilities or instructional videos.
Specs: Uses 8×10 color and b&w prints; 35mm and 4×5 transparencies.
Making Contact & Terms: Send stock photo list. Provide résumé, business card, brochure, flier or tearsheets to be kept on file for possible future assignments. Send materials on pricing, experience. Works with local freelancers on assignment only. Cannot return material. Pays $1,000/day. Pays 30 days following receipt of invoice. Buys exclusive product rights; negotiable.
Tips: To break in, demonstrate you "can be aggressive, innovative, realistic and can work within our clients' parameters and budgets. Be responsive, be flexible."

South Carolina

■**BROWER, LOWE & HALL ADVERTISING, INC.**, 215 W. Stone Ave., P.O. Box 3357, Greenville SC 29602. (803)242-5350. President: Ed Brower. Estab. 1945. Ad agency. Uses photos for billboards, consumer and trade magazines, direct mail, newspapers, P-O-P displays, radio and TV. Types of clients: consumer and business-to-business.
Needs: Commissions 6 freelancers/year; buys 50 photos/year. Model release required.
Specs: Uses 8×10 b&w and color semigloss prints; also videotape.
Making Contact & Terms: Interested in receiving work from newer, lesser-known photographers. Arrange personal interview to show portfolio or query with list of stock photo subjects; will review unsolicited material. SASE. Reports in 2 weeks. NPI. Buys all rights; negotiable.

LESLIE ADVERTISING AGENCY, 874 S. Pleasantburg Dr., Greenville SC 29607. (803)271-8340. Broadcast Producer: Marilyn Neves. Ad agency. Types of clients: industrial, retail, finance, food and resort.
Needs: Works with 1-2 freelance photographers/month. Uses photos for consumer and trade magazines and newspapers. Model release preferred.
Specs: Varied.
Making Contact & Terms: Query with résumé of credits, list of stock photo subjects and samples. Submit portfolio for review "only on request." Provide résumé, business card, brochure, flier or tearsheets to be kept on file for possible future assignments. Occasionally works with freelance photographers on assignment basis only. SASE. Reports ASAP. Pays $150-3,000/b&w photo; $150-3,000/

color photo; $500-3,000/day. **Pays on receipt of invoice**. Buys all rights or one-time rights.

Tips: "We always want to see sensitive lighting and compositional skills, conceptual strengths, a demonstration of technical proficiency and proven performance. Send printed promotional samples for our files. Call or have rep call for appointment with creative coordinator. Ensure that samples are well-presented and demonstrate professional skills."

"The photographer made a 'boring' product interesting," says Martin Pottle, president of Martin Thomas, Inc., of the work of George Lavoie of Lavoie Photography, East Providence, Rhode Island. Lavoie understands the objective of such assignments, says Pottle, "to take one or more technical products, not in context with the final produced part, and give them interesting 'life.'" Lavoie was paid $350 for the job.

© Martin Thomas, Inc.

■**SOUTH CAROLINA FILM OFFICE**, P.O. Box 7367, Columbia SC 29202. (803)737-0490. Director: Isabel Hill. Types of clients: motion picture and television producers.

Needs: Works with 8 freelance photographers/month. Uses photos to recruit feature films/TV productions. Subjects include location photos for feature films, TV projects, and national commercials.

Specs: Uses 3×5 color prints; 35mm film.

Making Contact & Terms: Submit portfolio by mail. Provide résumé, business card, self-promotion piece or tearsheets to be kept on file for possible future assignments. Works with local freelancers on assignment only. Does not return unsolicited material. NPI. Pays per yearly contract, upon completion of assignment. Buys all rights.

Tips: "Experience working in the film/video industry is essential. Ability needed to identify and photograph suitable structures or settings to work as a movie location."

South Dakota

LAWRENCE & SCHILLER, 3932 S. Willow Ave., Sioux Falls SD 57105. (605)338-8000. Ad agency. Senior Art Director: Dan Edmonds. Types of clients: industrial, financial, manufacturing, medical.

Needs: Works with 3-4 freelance photographers/month. Uses photographers for consumer and trade magazines, direct mail, P-O-P displays, catalogs, posters and newspapers.

Specs: Uses 8×10 b&w prints; 35mm, 2¼×2¼ and 4×5 transparencies.

Making Contact & Terms: Arrange a personal interview to show portfolio; submit portfolio for review. Provide résumé, business card, brochure, flier or tearsheets to be kept on file for possible future assignments. Works with freelance photographers on assignment basis only. Cannot return material. Reports as needed. Pays $500 maximum/day plus film and processing. **Pays on acceptance.** Buys all rights. Model release required. Captions preferred.

Tips: In reviewing photographer's portfolios wants to see a "good selection of location, model, table-top/studio examples—heavily emphasizing their forté. The best way for freelancers to begin working with us is to fill a void in an area in which we have either underqualified or overpriced talent—then

handle as many details of production as they can. We see a trend in using photography as a unique showcase for products—not just a product (or idea) display."

Texas

■**DYKEMAN ASSOCIATES INC.**, 4115 Rawlins, Dallas TX 75219. (214)528-2991. Fax: (214)528-0241. Contact: Alice Dykeman. Estab. 1974. PR and AV firm. Types of clients: industrial, financial, sports, varied.
Needs: Works with 4-5 photographers and/or videographers. Uses photos for publicity, billboards, consumer and trade magazines, direct mail, P-O-P displays, catalogs, posters, newspapers, signage, and audiovisual uses. "We handle model and/or property releases."
Audiovisual Needs: "We produce and direct video. Just need crew with good equipment and people and ability to do their part."
Specs: Uses 8½×11 and glossy b&w transparencies or color prints; ¾″ or Beta videotape.
Making Contact & Terms: Arrange personal interview to show portfolio. Provide résumé, business card, brochure, flier or tearsheets to be kept on file for possible future assignments. Works on assignment only. Cannot return material. Pays $800-1,200/day; $250-400/1-2 days. "Currently we work only with photographers who are willing to be part of our trade dollar network. Call if you don't understand this term." Pays 30 days after receipt of invoice. Credit line sometimes given, "maybe for lifestyle publications—especially if photographer helps place." Buys exclusive product rights.
Tips: Reviews portfolios with current needs in mind. "If PSA, we would want to see examples. If for news story, we would need to see photojournalism capabilities. Show portfolio, state pricing, remember that either we or our clients will keep negatives or slide originals."

■**EDUCATIONAL VIDEO NETWORK**, 1401 19th St., Huntsville TX 77340. (409)295-5767. Fax: (409)294-0233. Chief Executive Officer: George H. Russell. Estab. 1953. AV firm. Types of clients: "We produce for ourselves in the education market."
Needs: Works with 2-3 videographers/month.
Audiovisual Needs: Uses videotape for all projects; slides.
Specs: Uses ½″ videotape.
Making Contact & Terms: Query with program proposal. SASE. Reports in 3 weeks. NPI. Pays in royalties or flat fee based on length, amount of post-production work and marketability; royalties paid quarterly. Credit line given. Buys all rights; negotiable.
Tips: In freelancer's demos, looks for "literate, visually accurate, curriculum-oriented video programs that could serve as a class lesson in junior high, high school or college classroom. The switch from slides and filmstrips to video is complete. The schools need good educational material."

■**GK&A ADVERTISING, INC.**, 8200 Brookriver Dr., Suite 510, Dallas TX 75247. (214)634-9486. Fax: (214)634-9490 or (214)638-4984. Production Manager: Kelly Crane. Estab. 1982. Approximate annual billing: $2 million. Number of employees: 4. Member of AAAA. Ad agency, PR firm. Approximate annual billing: $3 million. Number of employees: 5. Types of clients: financial, service, retail.
 ● This agency is using computer manipulation and stock photos on CD.
Needs: Works with 1 freelance photographer, 2 filmmakers and 2 videographers/month. Uses photos for billboards, direct mail, P-O-P displays, posters, newspapers, audiovisual uses. Reviews stock photos. Model/property release required. Captions preferred.
Audiovisual Needs: Uses slides, film and video.
Specs: Uses 35mm transparencies; ½″ VHS videotape.
Making Contact & Terms: Submit portfolio for review. Works on assignment only. Keeps samples on file. Cannot return material. Reports in 3 weeks. NPI. Pays net 30 days. Credit line not given. Buys one-time rights.

■**HEPWORTH ADVERTISING CO.**, 3403 McKinney Ave., Dallas TX 75204. (214)220-2415. Fax: (214)220-2416. President: S.W. Hepworth. Estab. 1952. Ad agency. Uses all media except P-O-P displays. Types of clients: industrial, consumer and financial. Examples of recent projects: Houston General Insurance, Holman Boiler, Hillcrest State Bank.
Needs: Uses photos for trade magazines, direct mail, P-O-P displays, newspapers and audiovisual. Model/property release required. Captions required.
Specs: Uses 8×10 glossy color prints, 35mm transparencies.
Making Contact & Terms: Submit portfolio by mail. Works on assignment only. Cannot return material. Reports in 1-2 weeks. Pays $350 minimum/job; negotiates payment based on client's budget and photographer's previous experience/reputation. **Pays on acceptance.** Credit line sometimes given. Buys all rights.

Tips: "For best relations with the supplier, we prefer to seek out a photographer in the area of the job location." Sees trend toward machinery shots. "Contact us by letter or phone."

■**CARL RAGSDALE ASSOC., INC.**, 4725 Stillbrooke, Houston TX 77035. (713)729-6530. President: Carl Ragsdale. Types of clients: industrial and documentary film users.
Needs: Uses photographers for multimedia productions, films, still photography for brochures. Subjects include industrial subjects—with live sound—interiors and exteriors.
Specs: Uses 35mm, 2¼×2¼, 4×5 transparencies; 16mm, 35mm film.
Making Contact & Terms: Provide résumé to be kept on file for possible future assignments. Works on assignment only. Does not return unsolicited material. Reports as needed. Pays $350-800/day; negotiable. Pays upon delivery of film. Buys all rights.
Tips: "Do not call. We refer to our freelance file of résumés when looking for personnel. Swing from film to video is major change—most companies are now hiring inhouse personnel to operate video equipment. Resurgence of oil industry should improve the overall use of visuals down here." Photographer should have "ability to operate without supervision on location. Send samples of coverage of the same type of assignment for which they are being hired."

*****TED ROGGEN ADVERTISING AND PUBLIC RELATIONS**, 5050 Westheimer, Suite 309, Houston TX 77056-5608. (713)960-9069. Fax: (713)789-6216. Contact: Ted Roggen. Estab. 1945. Ad agency and PR firm. Types of clients: construction, entertainment, food, finance, publishing and travel.
Needs: Buys 25-50 photos/year; offers 50-75 assignments/year. Uses photos for billboards, direct mail, radio, TV, P-O-P displays, brochures, annual reports, PR releases, sales literature and trade magazines. Model release required. Captions required.
Specs: Uses 5×7 glossy or matte b&w prints; 4×5 transparencies; 5×7 color prints. Contact sheet OK.
Making Contact & Terms: Interested in receiving work from newer, lesser-known photographers. Provide résumé to be kept on file for possible future assignments. Pays $75-250/b&w photo; $125-300/color photo; $150/hour. **Pays on acceptance.** Rights negotiable.

■**SANDERS, WINGO, GALVIN & MORTON ADVERTISING**, 4050 Rio Bravo, Suite 230, El Paso TX 79902. (915)533-9583. Creative Director: Kerry Jackson. Ad agency. Uses photos for billboards, consumer and trade magazines, direct mail, foreign media, newspapers, P-O-P displays, radio and TV. Types of clients: retailing and apparel industries. Free client list.
Needs: Works with 5 photographers/year. Model release required.
Specs: Uses b&w photos and color transparencies. Works with freelance filmmakers in production of slide presentations and TV commercials.
Making Contact & Terms: Query with samples, list of stock photo subjects. Send material by mail for consideration. Submit portfolio for review. SASE. Reports in 1 week. Pays $65-500/hour, $600-3,500/day, negotiates pay on photos. Buys all rights.

TRACY-LOCKE/A DDB NEEDHAM AGENCY, 200 Crescent Court, Dallas TX 75201. (214)969-9000. Ad agency. Manager, Art Buying: Susan McGrane. Estab. 1913. Serves diverse client base.
Needs: Works with 50 freelance photographers/month. Uses photographs for consumer and trade magazines, newspapers, outdoor signage, point of purchase, direct mail and collateral. General subject matter according to client needs.
Making Contact & Terms: Mail promotional pieces. Portfolio showings arranged per approval of Art Buying Department. Personal interviews arranged by phone. Works with freelance photographers on assignment only. Pays after receipt of invoice. Rights negotiated per job. Model release required. No credit line given.

■**EVANS WYATT ADVERTISING & PUBLIC RELATIONS**, 346 Mediterranean Dr., Corpus Christi TX 78418. (512)939-7200. Fax: (512)939-7999. Owner: E. Wyatt. Estab. 1975. Ad agency, PR firm. Types of clients: industrial, real estate, financial, health care, automotive, educational and retail.
Needs: Works with 3-5 freelance photographers and/or videographers/month. Uses photos for consumer and trade magazines, direct mail, catalogs, posters and newspapers. Subjects include: people and industrial. Reviews stock photos/video footage of any subject matter. Model release required. Captions preferred.
Audiovisual Needs: Uses slide shows and videos.
Specs: Uses 5×7 glossy b&w and color prints; 35mm, 2¼×2¼ transparencies; ½" videotape (for demo or review) VHS format.
Making Contact & Terms: Query with résumé of credits, list of stock photo subjects and samples. Submit portfolio for review. Provide résumé, business card, brochure, flier or tearsheets to be kept on file for possible future assignments. Works on assignment only. Reports in 1 month. Pays $500-

1,000/day; $100-700/job; negotiated in advance of assignment. Pays on receipt of invoice. Credit line sometimes given, depending on client's wishes. Buys all rights.

Tips: Resolution and contrast are expected. Especially interested in industrial photography. Wants to see "sharpness, clarity and reproduction possibilities." Also, creative imagery (mood, aspect, view and lighting). Advises freelancers to "do professional work with an eye to marketability. Pure art is used only rarely."

■**ZACHRY ASSOCIATES, INC.**, 709 N. 2nd St., Abilene TX 79601. (915)677-1342. Creative Director: Bob Nutt. Types of clients: industrial, institutional, religious service, commercial.

Needs: Works with 2 photographers/month. Uses photos for slide sets, videotapes and print. Subjects include: industrial location, product, model groups, lifestyle. Model release required.

Specs: Uses 5×7, 8×10 b&w prints; 8×10 color prints; 35mm, 2¼×2¼, 4×5 transparencies; VHS videotape.

Making Contact & Terms: Query with samples and stock photo list. Provide résumé, business card, self-promotion piece or tearsheets to be kept on file for possible future assignments. Works with freelancers on assignment only; interested in stock photos/footage. SASE. Reports as requested. NPI; payment negotiable. **Pays on acceptance.** Buys one-time and all rights.

Utah

*■**BROWNING ADVERTISING**, One Browning Place, Morgan UT 84050. (801)876-2711, ext. 336. Fax: (801)876-3331. Senior Art Director: Brent Evans. Estab. 1878. Ad agency. Approximate annual billing: $4 million. Number of employees: 23. Types of clients: retail. Examples of recent projects: "Game/Health Food," Browning (national ads for wild game recipes); "Adventure Continues," Winchester (national ads); and "Competition Hates Our Guts," Browning/Pro-Steel (national ads).

Needs: Works with 1-2 photographers, 1-2 filmmakers, 1-2 videographers/month. Uses photos for consumer magazines, trade magazines, catalogs, posters and audiovisual. Subjects include: wildlife, hunting, outdoor. Reviews stock photos. Model/property release required for people. Captions preferred; include location, species, season.

Audiovisual Needs: Uses slides, film and videotape for corporate and dealer training and motivation.

Specs: Uses 35mm, 2¼×2¼, 4×5 transparencies, 16 and 35mm film, Beta SP and D2 videotape.

Making Contact & Terms: Interested in receiving work from newer, lesser-known photographers. Provide résumé, business card, brochure, flier or tearsheets to be kept on file for possible future assignments. Keeps samples on file. SASE. Reports in 1-2 weeks. NPI. Pays on receipt of invoice. Credit line sometimes given depending upon payment negotiated. Buys first, one-time, electronic and all rights; negotiable.

Tips: Looking for "unusual and real-world situations."

■**HARRIS & LOVE, INC.**, 630 E. South Temple, Salt Lake City UT 84102. (801)532-7333. Fax: (801)532-6029. Senior Art Director: Preston Wood. Art Directors: Kathy Leach and Heather Hall. Estab. 1938. Member of AAAA. Approximate annual billing: $8 million. Number of employees: 35. Types of clients: industrial, retail, tourism, finance and winter sports. Types of clients: tourism, industrial, retail, fashion, health care. Examples of recent projects: Utah travel summer campaign (national magazines); "HMO Blue," Blue Cross & Blue Shield (regional newspaper).

● This agency is storing images on CD, using computer manipulation and accessing images through computer networks.

Needs: Works with 4 freelance photographers—filmmakers—videographers/month. Uses photos for billboards, consumer magazines, trade magazines, newspapers and audiovisual. Needs mostly images of Utah (travel and winter sports) and people. Interested in reviewing stock photos/film or video footage on people, science, health care and industrial.

Audiovisual Needs: Contact Creative Director, Bob Wassom, by phone or mail.

Specs: Uses 35mm, 2¼×2¼, 4×5 transparencies.

Making Contact & Terms: Interested in receiving work from newer, lesser-known photographers. Send unsolicited photos by mail for consideration. Submit portfolio for review. Provide résumé, business card, brochure, flier or tearsheets to be kept on file for possible future assignments. Works with freelancers on assignment basis only. Pays $150-1,000/b&w photo; $200-2,000/color photo; $600-1,200/day. Rights negotiable depending on project. Model and property releases required. Credit line given sometimes, depending on client, outlet or usage.

Tips: In freelancer's portfolio or demos, wants to see "craftsmanship, mood of photography and creativity." Sees trend toward "more abstract" images in advertising. "Most of our photography is a total buy out (work-for-hire). Photographer can only reuse images in his promotional material."

■SOTER ASSOCIATES INC., 209 N. 400 West, Provo UT 84601. (801)375-6200. Fax: (801)375-6280. Ad agency. President: N. Gregory Soter. Types of clients: industrial, financial, hardware/software and other. Examples of projects: boating publications ad campaign for major boat manufacturer; consumer brochures for residential/commercial mortgage loan company; private school brochure; software ads for magazine use; various direct mail campaigns.
Needs: Uses photos for consumer and trade magazines, direct mail and newspapers. Subjects include product, editorial or stock. Reviews stock photos/videotape. Model/property release required.
Audiovisual Needs: Uses photos for slides and videotape.
Specs: Uses 8×10 b&w prints; 2¼×2¼, 4×5 transparencies; videotape.
Making Contact & Terms: Arrange personal interview to show portfolio. Query with samples. Provide résumé, business card, brochure, flier or tearsheets to be kept on file for possible future assignments. Works on assignment only. Keeps samples on file. SASE. Reports in 1-2 weeks. NPI; payment negotiable. **Pays on receipt of invoice**. Credit line not given. Buys all rights; negotiable.

Virginia

■AMERICAN AUDIO VIDEO, 28762 Hartland Rd., Falls Church VA 22043. (703)573-6910. Fax: (703)573-3539. President: John Eltzroth. Estab. 1972. Member of ICIA and MPI. AV firm. Types of clients: industrial, information systems and financial.
Needs: Works with 1 freelance photographer and 2 videographers/month. Uses photos for catalogs and audiovisual uses. Subjects include: "inhouse photos for our catalogs and video shoots for clients." Reviews stock photos.
Audiovisual Needs: Uses slides and videotape.
Specs: Uses 35mm transparencies; ¾″ Beta videotape.
Making Contact & Terms: Interested in receiving work from newer, lesser-known photographers. Arrange personal interview to show portfolio. Send unsolicited photos by mail for consideration. Provide résumé, business card, brochure, flier or tearsheets to be kept on file for possible future assignments. SASE. Reports in 1 month. NPI. **Pays on acceptance and receipt of invoice**. Credit line not given. Buys all rights; negotiable.

***DEADY ADVERTISING**, 17 E. Cary St., Richmond VA 23219. (804)643-4011. Fax: (804)643-4043. President: Jim Deady. Member of Richmond Ad Club, Richmond Metro Business, MCGAN. Approximate annual billing: $2 million. Number of employees 5. Types of clients: industrial, financial and food. Examples of recent projects: "Reynolds," Reynolds Metals (with distributors and direct sales); "Holiday 1995," Padow's (Christmas catalog); and "OK Foundry" (presentation folder with direct sales and information requests).
Needs: Works with 3-5 freelancers/month. Uses photos for billboards, consumer magazines, trade magazines, direct mail, P-O-P displays, catalogs, posters, newspapers and signage. Subjects include: equipment, products and people. Reviews stock photos. Model/property release preferred.
Audiovisual Needs: Uses video for custom corporate videos.
Specs: Uses color and b&w prints; 35mm, 4×5 transparencies.
Making Contact & Terms: Interested in receiving work from newer, lesser-known photographers. Arrange personal interview to show portfolio. Query with stock photo list. Works on assignment only. Keeps samples on file. Cannot return material. Reports in 1-2 weeks. NPI. **Pays on receipt of invoice**. Credit line sometimes given. Buys all rights.

Washington

***AUGUSTUS BARNETT ADVERTISING/DESIGN**, 632 St. Helens Ave. S., Tacoma WA 98402. (206)627-8508. Fax: (206)593-2116. Creative Director: Charlie Barnett. Estab. 1981. Member of AAF, TAC. Ad agency and design firm. Approximate annual billing: $1 million. Number of employees: 3. Types of clients: industrial, retail and food.
Needs: Works with 1-2 freelancers/month. Uses photos for consumer magazines, trade magazines, direct mail, P-O-P displays and brochures. Subjects include: food, beverage, industry, business-to-business. Model/property release required. Captions preferred.
Making Contact & Terms: Interested in receiving work from newer, lesser-known photographers. Query with résumé of credits. Provide résumé, business card, brochure, flier or tearsheets to be kept on file for possible future assignments. Works on assignment only. Keeps samples on file. SASE. Reports in 1 month. NPI. Pays on receipt of invoice, net 30 days. Credit line sometimes given depending on client, publication, etc. Buys first, one-time and all rights.

MATTHEWS ASSOC. INC., 603 Stewart St., Suite 1018, Seattle WA 98101. (206)340-0680. PR firm. President: Dean Matthews. Types of clients: industrial.
Needs: Works with 0-3 freelance photographers/month. Uses photographers for trade magazines, direct mail, P-O-P displays, catalogs and public relations. Frequently uses architectural photography; other subjects include building products.
Specs: Uses 8×10 b&w and color prints; 35mm, 2¼×2¼ and 4×5 transparencies.
Making Contact & Terms: Arrange a personal interview to show portfolio if local. If not, provide résumé, business card, brochure, flier or tearsheets to be kept on file for possible future assignments. SASE. Works with freelance photographers on assignment only. NPI. Pays per hour, day or job. Pays on receipt of invoice. Buys all rights. Model release preferred.
Tips: Samples preferred depends on client or job needs. "Be good at industrial photography."

West Virginia

■**CAMBRIDGE CAREER PRODUCTS**, 90 MacCorkle Ave., SW, South Charleston WV 25303. (800)468-4227. Fax: (304)744-9351. President: E.T. Gardner, Ph.D. Managing Editor: Amy Pauley. Estab. 1981.
Needs: Works with 2 still photographers and 3 videographers/month. Uses photos for multimedia productions, videotapes and catalog still photography. "We buy b&w prints and color transparencies for use in our 11 catalogs." Reviews stock photos/footage on sports, hi-tech, young people, parenting, general interest topics and other. Model release required.
Specs: Uses 5×7 or 8×10 b&w prints; 35mm, 2¼×2¼, 4×5, and 8×10 transparencies and videotape.
Making Contact & Terms: Interested in receiving work from newer, lesser-known photographers. Video producers arrange a personal interview to show portfolio. Still photographers submit portfolio by mail. SASE. Reports in 2 weeks. Pays $20-80/b&w photo, $250-850/color photo and $8,000-45,000 per video production. Credit line given. "Color transparencies used for catalog covers and video production, but not for b&w catalog shots." Buys one-time and all rights (work-for-hire); negotiable.
Tips: "Still photographers should call our customer service department and get a copy of *all* our educational catalogs. Review the covers and inside shots, then arrange a meeting to show work. Video production firms should visit our headquarters with examples of work. For still color photographs we look for high-quality, colorful, eye-catching transparencies. Black & white photographs should be on sports, home economics (cooking, sewing, child rearing, parenting, food, etc.), and guidance (dating, sex, drugs, alcohol, careers, etc.). We have stopped producing educational filmstrips and now produce only full-motion video. Always need good b&w or color still photography for catalogs."

Wisconsin

AGA COMMUNICATIONS, (formerly Greinke, Eiers and Associates), 2557C N. Terrace Ave., Milwaukee WI 53211-3822. (414)962-9810. Fax: (414)456-0886. CEO: Arthur Greinke. Estab. 1984. Member of Public Relations Society of America, International Association of Business Communicators, Society of Professional Journalists. Number of employees: 9. Ad agency, PR firm and marketing. Types of clients: entertainment, special events, music business, adult entertainment, professional sports, olympic sports. Examples of recent projects: "Brett Farve Chase Football," Fomation, Green Bay Packers, Ad Cetra Sports (display ads, newspaper PR, sales, P.O.P); "IBM Aptiva," IBM (display, newspaper PR, catalog); and "Adult Maid Service," Bare Bottom Maids (display ad, flyers).
Needs: Works with 6-12 freelance photographers, 2 filmmakers, 4-8 videographers/year. Uses photos for billboards, direct mail, P-O-P displays, posters, newspapers, signage, audiovisual. Most photos come from special events. Reviews stock photos of anything related to entertainment/music industry, model photography. Model/property release preferred. Captions preferred; include who, what, where, why, how.
Audiovisual Needs: Uses slides, film, videotape. Subjects include: special events and model work.
Specs: Uses 5×7 or 8×10 color and b&w prints; 2¼×2¼, 4×5 transparencies; 16mm and 35mm film; ½" and ¾" videotape.
Making Contact & Terms: Interested in receiving work from newer, lesser-known photographers. Query with résumé of credits. Query with stock photo list. Query with samples. Provide résumé, business card, brochure, flier or tearsheets to be kept on file for possible future assignments. Keeps samples on file. Cannot return material. "We respond when we need a photographer or a job becomes available for their special skills." NPI. **Pays on acceptance.** Credit line sometimes given depending on client. Buys all rights; negotiable.
Tips: "Search for a specific style or look, and make good use of light and shade."

BVK/MCDONALD, INC., (formerly Birdsall-Voss & Kloppenburg, Inc.), 250 W. Coventry Court, Milwaukee WI 53217. (414)228-1990. Ad agency. Art Director: Scott Krahn. Estab. 1984. Types of clients: travel, health care, financial, industrial and fashion clients such as U.S. Air Vacations, Flyjet Vacations, Robert W. Baird, Covenant HealthCare, Waukesha Memorial Hospital, Care Network Inc., Cousins Subs and Alverno College.
Needs: Uses 5 freelance photographers/month. Uses photos for billboards, consumer magazines, trade magazines, direct mail, catalogs, posters and newspapers. Subjects include travel and health care. Interested in reviewing stock photos of travel scenes in Carribean, California, Nevada, Mexico and Florida. Model release required.
Specs: Uses 35mm, 2¼×2¼, 4×5, 8×10 transparencies.
Making Contact & Terms: Arrange a personal interview to show portfolio or query with résumé of credits or list of stock photo subjects. Provide résumé, business card, brochure, flier or tearsheets to be kept on file for possible future assignments. Cannot return material. NPI. Pays 30 days on receipt of invoice. Buys all rights.
Tips: Looks for "primarily cover shots for travel brochures; ads selling Florida, the Caribbean, Mexico, California and Nevada destinations."

■NELSON PRODUCTIONS, INC., 1533 N. Jackson St., Milwaukee WI 53202. (414)271-5211. Fax: (414)271-5235. President: David Nelson. Estab. 1968. Produces motion pictures, videotapes, and slide shows. Types of clients: industry, advertising.
Needs: Industrial, graphic art and titles.
Audiovisual Needs: Video stock, slides, computer graphics.
Specs: Uses transparencies, computer originals.
Making Contact & Terms: Interested in receiving work from newer, lesser-known photographers. Query with résumé of credits or send material by mail for consideration. "We're looking for high quality photos with an interesting viewpoint." Pays $250-1,200/day. Buys one-time rights. Model release required. Captions preferred.
Tips: Send only top quality images.

WALDBILLIG & BESTEMAN, INC., 7633 Ganser Way, Madison WI 53719. (608)829-0900. Creative Director: Tom Senatori. Types of clients: industrial, financial and health care.
Needs: Works with 4-8 freelance photographers/month. Uses photos for consumer and trade magazines, direct mail, P-O-P displays, catalogs, posters, newspapers, brochures and annual reports. Subject matter varies. Model release required. Captions required.
Specs: Uses 8×9 glossy b&w and color prints; 35mm, 2¼×2¼, 4×5 transparencies.
Making Contact & Terms: Provide résumé, business card, brochure, flier or tearsheets to be kept on file for possible future assignments. Works with freelance photographers on assignment basis only. Reports in 2 weeks. Pays $100-200/b&w photo; $200-400/color photo. **Pays on receipt of invoice.** Buys all rights.
Tips: "Send unsolicited samples that do *not* have to be returned. Indicate willingness to do *any* type job. Indicate if you have access to full line of equipment."

Canada

■✤CABER COMMUNICATIONS, 160 Wilkinson Rd., Unit #39, Brampton, Ontario L6T 4Z4 Canada. (905)454-5141. Fax: (905)454-5936. Producers: Chuck Scott and Christine Rath. Estab. 1988. AV firm, film and video producer. Types of clients: industrial, financial, retail. Examples of recent projects: "Inhaled Steroids," Glaxo Canada (educational); "Access Control," Chubb Security (sale promotion).
Needs: Works with 2-3 freelance photographers and 3-5 videographers/month. Uses photos for posters, newsletters, brochures. Model/property release required.
Audiovisual Needs: Uses film or video. "We mainly shoot our own material for our projects."
Specs: 35mm, 2¼×2¼, 4×5 transparencies; videotape (Betacam quality or better).
Making Contact & Terms: Interested in receiving work from newer, lesser-known photographers. Contact through rep. Query with résumé of credits. Provide résumé, business card, brochure, flier or tearsheets to be kept on file for possible future assignments. Works with local freelancers on assignment only. Keeps samples on file. SASE. Reports in 1-2 weeks. Pays $250/3-hour day. **Pays on receipt of invoice.** Credit line sometimes given depending upon project. Rights vary; negotiable.

■✤JACK CHISHOLM FILM PRODUCTIONS LTD., 99 Atlantic Ave., #50, Toronto, Ontario M6K 3J8 Canada. (416)588-5200. Fax: (416)588-5324. President: Mary Di Tursi. Estab. 1956. Production house and stock shot, film and video library. Types of clients: finance, industrial, government, TV networks and educational TV/multimedia.

Needs: Supplies stock film and video footage on consignment.
Making Contact & Terms: Works with freelancers on an assignment basis only. Rights negotiable.
Tips: Starting to see more CD-ROM and multimedia applications.

■❧**WARNE MARKETING & COMMUNICATIONS**, 111 Avenue Rd., Suite 810, Toronto, Ontario M5R 3J8 Canada. (416)927-0881. Fax: (416)927-1676. President: Keith Warne. Estab. 1979. Ad agency. Types of clients: business-to-business.
Needs: Works with 5 photographers/month. Uses photos for trade magazines, direct mail, P-O-P displays, catalogs and posters. Subjects include: in-plant photography, studio set-ups and product shots. Special subject needs include in-plant shots for background use. Model release required.
Audiovisual Needs: Uses both videotape and slides for product promotion.
Specs: Uses 8×10 glossy b&w prints; 4×5 transparencies and color prints.
Making Contact & Terms: Send letter citing related experience plus 2 or 3 samples. Works on assignment only. Cannot return material. Reports in 2 weeks. Pays $1,000-1,500/day. Pays within 30 days. Buys all rights.
Tips: In portfolio/samples, prefers to see industrial subjects and creative styles. "We look for lighting knowledge, composition and imagination." Send letter and three samples, and wait for trial assignment.

Foreign

*‡**ALONSO Y ASOCIADOS, S.A.**, Lancaster #17 Col. Juarez, D.F. 06600 Mexico. (525)525-1640/44. President: Manuel Alonso Coratella. PR firm. Types of clients: industrial, fashion, financial. Client list free with SAE and IRC.
Needs: Works with 4 freelance photographers/month. Uses photos for consumer and trade magazines, P-O-P displays, catalogs, posters, signage and newspapers. Subjects include: client events or projects, portraits, models. Model release preferred. Captions preferred.
Specs: Uses 5×7 glossy color prints; 35 mm or 4×5 transparencies.
Making Contact & Terms: Send unsolicited photos by mail for consideration. Works with freelance photographers on an assignment basis only. SAE and IRCs. Reports in 2 weeks. NPI; payment depends on client budget. Payment made 15 days after receipt of invoice. Credit line sometimes given. Buys all rights.
Tips: Prefers to see portraits, product shots, landscapes, people. "Freelance photographers should provide recommendations, complete portfolio, good prices. Trends include journalism-type photography, audiovisuals."

*‡**AWY ASSOCIATES**, Peten 91, Col. Narvarte, D.F. 03020 Mexico. (525)530-3439. Fax: (525)538-1261. Creative Director: Isaac Ajzen. Estab. 1982. Ad agency and PR firm. Number of employees: 6. Types of clients: industrial, financial, fashion, retail, food. Examples of recent projects: ads and printing for Grupo Textil Mazal and MCM de Mexico; TV ads for Teatra La Hora.
Needs: Works with 2-3 photographers and 1 videographer/month. Uses photos for comsumer magazines, direct mail, catalogs, posters. Subjects include: fashion, food, science and technology. Reviews stock photos. Model/property release preferred. Captions preferred.
Audiovisual Needs: Uses slides for technology product presentations.
Specs: Uses prints; 35mm, 4×5 transparencies; VHS videotape.
Making Contact & Terms: Interested in receiving work from newer, lesser-known photographers. Submit portfolio for review. Send unsolicited photos by mail for consideration. Provide résumé, business card, brochure, flier or tearsheets to be kept on file for possible future assignments. Works on assignment only. Keeps samples on file. SASE. Reports in 3 weeks. NPI. Pays 2 weeks after photo session. Credit line sometimes given, depending on client and kind of work. Buys one-time rights; negotiable.
Tips: Looks for "creativity, new things, good focus on the subject and good quality."

 THE MAPLE LEAF before a listing indicates that the market is Canadian.

Art/Design Studios

Image is everything for corporations in need of design work for annual reports, inhouse publications, catalogs, package design, brochures and other collateral pieces. Company CEOs know that a positive image portrayed to shareholders, employees or clients can stem from the visual appeal of a well-thought out design. Therefore, many companies hire top studios to conceptualize and execute projects.

For photographers this opens doors to a lot of design jobs. But if you intend to work in the design field, it is important to understand how the industry operates. For example, many designers perform tasks, such as buying media space, that used to be in the domain of ad agencies. The practice has created a rivalry for jobs and removed boundary lines between the two industries. It used to be that the two industries worked hand-in-hand with each other on projects.

Trade magazines such as *HOW*, *Print*, *Communication Arts* and *Graphis* are good places to start when learning about design firms. These magazines not only provide information about how designers operate, but they also explain how creatives use photography. You can find these magazines in bookstores or flip to the section Recommended Books & Publications in the back of this book. The section provides addresses for all of these periodicals if you wish to order them.

CONCENTRATE ON STRENGTHS

For photographers, finding work with studios is much like seeking work with advertising agencies. When preparing your portfolio, concentrate on strengths and find those studios which have an interest in your area of expertise. Photographers who have mastered computer software, such as Adobe Photoshop or programs involving 3-D imaging, also should seriously consider approaching design firms. Studios are quickly adapting these image manipulating programs to their everyday jobs and freelancers can benefit greatly from such computer knowledge.

One photographer whose unique style is attracting attention in Canada is Derek Shapton of Toronto. Shapton shares insight into photography as our Insider Report subject on page 101.

***A.T. ASSOCIATES**, 63 Old Rutherford Ave., Charlestown MA 02129. (617)242-8595. Fax: (617)242-0697. Contact: Dan Kovacevic. Estab. 1980. Member of IDSA. Design firm. Approximate annual billing: $200,000. Number of employees: 30. Specializes in publication design, display design, packaging, signage and product. Types of clients: industrial, financial and retail. Examples of recent projects: real estate brochures (city scapes); and sales brochure (bikes/bikers).
Needs: Works with 1 freelancer/month. Uses photos for catalogs, packaging and signage. Reviews stock photos as needed. Model/property release preferred. Captions preferred.
Specs: Uses 35mm, 4×5 transparencies; and film (specs vary).
Making Contact & Terms: Interested in receiving work from newer, lesser-known photographers. Provide résumé, business card, brochure, flier or tearsheets to be kept on file for possible future assignments. Works with local freelancers only. Keeps samples on file. Cannot return material. Reports only if interested. NPI. **Pays on receipt of invoice.** Credit line sometimes given. Buys all rights; negotiable.

ELIE ALIMAN DESIGN, INC., 134 Spring St., New York, NY 10012. (212)925-9621. Fax: (212)941-9138. Creative Director: Elie Aliman. Estab. 1981. Design firm. Specializes in annual reports, publication design, display design, packaging, direct mail. Types of clients: industrial, financial, publishers, nonprofit. Examples of projects: First Los Angeles Bank, Equitable Capital Investment and NYU State Business School.

Needs: Works with 4 freelancers/month. Uses photos for annual reports, consumer and trade magazines, direct mail, posters. Model release required. Property release preferred. Photo captions preferred.
Specs: Uses 35mm, 2¼×2¼, 4×5, 8×10 color transparencies.
Making Contact & Terms: Interested in receiving work from newer, lesser-known photographers. Query with résumé of credits. Provide résumé, business card, brochure, flier or tearsheets to be kept on file for possible future assignments. Keeps samples on file. Cannot return material. Reports in 1-2 weeks. NPI. **Pays on receipt of invoice.** Credit line sometimes given. Buys first rights, one-time rights and all rights; negotiable.
Tips: Looking for "creative, new ways of visualization and conceptualization."

***AMERICA HOUSE COMMUNICATIONS**, 2 Marlborough St., Newport RI 02840. (401)849-9600. Fax: (401)846-1379. E-mail: jribera@amaltd.com. Design Director: Jeanie Ribera. Estab. 1992. Design, advertising, marketing and PR firm. Specializes in annual reports, publication design, display design, packaging, direct mail, signage and advertising. Types of clients: industrial, financial, retail, publishers and health care. Examples of recent projects: "Out of This World," Bess Eaton Donuts (sales campaign); and Senex (corporate brochure).
Needs: Works with 1 freelancer/month. Uses photos for annual reports, direct mail, P-O-P displays, catalogs and destination guides. Reviews stock photos of New England scenics, people and medical/health care. Model/property release preferred. Captions preferred.
Specs: Uses 8×10 prints; 35mm, 2¼×2¼, 4×5 transparencies.
Making Contact & Terms: Interested in receiving work from newer, lesser-known photographers. Submit portfolio for review. Provide résumé, business card, brochure, flier or tearsheets to be kept on file for possible future assignments. Keeps samples on file. Cannot return material. Reporting time varies depending on project. Pays $800-1,100/day. Pays on receipt of invoice, net 30 days. Credit line given depending on usage. Buys one-time rights unless client photo shoot.
Tips: Looks for composition and impact.

ART ETC., 316 W. 4th St., Cincinnati OH 45202. (513)621-6225. Fax: (513)621-6316. Art Director: Doug Carpenter. Estab. 1971. Art Studio. Specializes in industrial, financial, food and OTC drugs.
Needs: Works with 1-2 freelance photographers/month. Uses photos for consumer and trade magazines, direct mail, P-O-P displays, catalogs and posters. Subjects include: musical instruments, OTC drugs, pet food, people and skin products. Reviews stock photos. Model/property release required. Photo captions preferred.
Specs: Uses 4×5, 8×10 color and b&w prints; 35mm, 2¼×2¼, 4×5, 8×10 transparencies.
Making Contact & Terms: Contact through rep. Arrange personal interview to show portfolio. Query with list of stock photo subjects. Provide résumé, business card, brochure, flier or tearsheets to be kept on file for possible future assignments. Works with local freelancers on assignment only. Keeps samples on file. SASE. Reports in 1-2 weeks. Pays $40-250/hour; $600-2,000/day; $150-3,500/job; $150/color photo; $50/b&w photo. **Pays on receipt of invoice.** Buys all rights; negotiable. Credit line sometimes given depending upon marketing target.
Tips: Wants to see food, people and product shots.

***AYERS/JOHANEK PUBLICATION DESIGN, INC.**, 4750 Rolling Hills Dr., Bozeman MT 59715. (406)585-8826. Fax: (406)585-8837. E-mail: johanek@aol.com. Partner: John Johanek. Estab. 1986. Design firm. Number of employees: 8. Specializes in publication design. Types of clients: trade, consumer and association publications. Examples of recent projects: issue design for *Professional Safety* (cover and inside); *Chicago Home & Garden (cover and inside); Bird Watcher's Digest* (inside design); *Mining and Engineering* (redesign); and *JMNR* (on-going art direction).
● This design firm has won Ozzies and Creativity and Apex awards.
Needs: Works with 4-6 freelancers/month. Uses photos for magazines. Reviews stock photos. Model release required. Property release preferred.
Specs: Uses all sizes/any finish color and b&w prints; 35mm, 2¼×2¼ transparencies.
Making Contact & Terms: Interested in receiving work from newer, lesser-known photographers. Query with résumé of credits. Query with stock photo list. Query with samples. Keeps samples on file. SASE. Reports in 1 month. Pays $25-150/b&w photo; $50-300/color photo; $300-650/day; $250-700/job. Payment for electronic usage varies by client. **Pays on receipt of invoice.** Credit line given. Rights vary by client.

THE ASTERISK before a listing indicates that the market is new in this edition. New markets are often the most receptive to freelance submissions.

BACHMAN DESIGN GROUP, 6001 Memorial Dr., Dublin OH 43017. (614)793-9993. Fax: (614)793-1607. E-mail: bachmand.@aol.com. Principal: Deb Miller. Estab. 1988. Member of American Bankers Association, Bank Administration Institute, Bank Marketing Association, American Center of Design, Design Management Institute. Design firm. Approximate annual billing: $2 million. Number of employees: 15. Specializes in display design, packaging, retail environments. Types of clients: financial, retail. Examples of recent projects: Corestates Financial Corp.; Wells Fargo Bank (print, P-O-P materials); Fidelity Investments (investment account opening package); Nationwide Insurance (catalog, print materials); and Western Canada Lottery.
Needs: Works with 1 freelancer/month. Uses photos for P-O-P displays, posters. Subjects include: lifestyle, still. Reviews stock photos. Model/property release required. Photo captions preferred.
Specs: Uses color and b&w prints; 2¼×2¼, 4×5 transparencies.
Making Contact & Terms: Interested in receiving work from newer, lesser-known photographers. Query with résumé of credits and samples. Provide résumé, business card, brochure, flier or tearsheets to be kept on file for possible future assignments. Works on assignment only. Keeps samples on file. Cannot return material. Reports in 1-2 weeks. NPI. **Pays on receipt of invoice.** Credit line sometimes given depending on clients' needs/requests. Buys one-time, electronic and all rights; negotiable.

BOB BARRY ASSOCIATES, 4109 Goshen Rd., Newtown Square PA 19073. Phone: (610)353-7333. Fax: (610)356-5759. Contact: Bob Barry. Estab. 1964. Design firm. Approximate annual billing: $300,000. Number of employees: 5. Specializes in annual reports, publication design, displays, packaging, exhibitions, museums, interiors and audiovisual productions. Types of clients: industrial, financial, commercial and government. Examples of recent projects: corporate profile brochure, Zerodec 1 Corporation (text illustration); marketing program, Focht's Inc. (ads, brochures and direct mail); and Mavic Inc. exhibit (large color transparencies in display installations).
Needs: Works with 2-3 freelancers per month. Uses photos for annual reports, consumer and trade magazines, direct mail, P-O-P displays, catalogs, posters, packaging and signage. Subjects include: products, on-site installations, people working. Reviews stock images of related subjects. Model release preferred for individual subjects.
Specs: Uses matte b&w and color prints, "very small to cyclorama (mural) size;" 35mm, 2¼×2¼, 4×5, 8×10 transparencies.
Making Contact & Terms: Provide résumé, business card, brochure, flier or tearsheets to be kept on file for possible future assignments. Works on assignment only. Keeps samples on file. SASE. Reports as needed; can be "days to months." Pays $50-150/hour; $600-1,200/day; other payment negotiable. Pays on variable basis, according to project. Credit lines sometimes given, depending upon "end use and client guidelines." Buys all rights; negotiable.
Tips: Wants to see "creative use of subjects, color and lighting. Also, simplicity and clarity. Style should not be too arty." Points out that the objective of a photo should be readily identifiable. Sees trend toward more use of photos within the firm and in the design field in general. To break in, photographers should "understand the objective" they're trying to achieve. "Be creative within personal boundaries. Be my eyes and ears and help me to see things I've missed. Be available and prompt."

BERSON, DEAN, STEVENS, 65 Twining Lane, Wood Ranch CA 93065. (805)582-0898. Owner: Lori Berson. Estab. 1981. Design firm. Specializes in annual reports, display design, packaging and direct mail. Types of clients: industrial, financial and retail.
Needs: Works with 1 freelancer/month. Uses photos for billboards, trade magazines, direct mail, P-O-P displays, catalogs, posters, packaging and signage. Subjects include: product shots and food. Reviews stock photos. Model/property release required.
Specs: Uses 8×10 b&w prints; 35mm, 2¼×2¼, 4×5, 8×10 transparencies.
Making Contact & Terms: Interested in receiving work from newer, lesser-known photographers. Provide résumé, business card, brochure, flier or tearsheets to be kept on file for possible future assignments. Works on assignment only. Keeps samples on file. SASE. Reports in 1-2 weeks. NPI. Pays within 30 days after receipt of invoice. Credit line not given. Rights negotiable.

***BODZIOCH DESIGN**, 30 Robbins Farm Rd., Dunstable MA 01827. (508)649-2949. Fax: (508)649-2969. Art Director: Leon Bodzioch. Estab. 1986. Design firm. Specializes in annual reports, publication design and direct mail. Types of clients: industrial. Examples of recent projects: direct mail, Analog Devices (electronic circuit photography); product brochure/fact sheet, Genrad Inc. (product photography); and direct mail, Nebs, Inc. (background textures).
Needs: Uses 4 freelancers/month. Uses photos for annual reports and direct mail. Subjects include: high tech issues. Reviews stock photos. Model/property release preferred. Captions required; identify whether straight or computer-manipulated photography.
Specs: Uses 2¼×2¼, 4×5 transparencies and Photoshop CMYX files.
Making Contact & Terms: Interested in receiving work from newer, lesser-known photographers. Query with stock photo list. Query with samples. Send unsolicited photos by mail for consideration.

Keeps samples on file. SASE. Reports when need arises. Pays based on project quote or range of $1,200-2,200/day. Pays net 30 days. Credit line sometimes given depending upon agreement. Buys one-time and all rights; negotiable.

Tips: Looks for "strong artistic composition and unique photographic point-of-view without being trend driven imagery. Photographer's ability to provide digital images on disk is also a benefit."

BOB BOEBERITZ DESIGN, 247 Charlotte St., Asheville NC 28801. (704)258-0316. Owner: Bob Boeberitz. Estab. 1984. Member of American Advertising Federation, Asheville Area Chamber of Commerce, National Federation of Independent Business, National Academy of Recording Arts & Sciences. Graphic design studio. Number of employees: 1. Types of clients: management consultants, retail, recording artists, mail-order firms, industrial, restaurants, hotels and book publishers.

- Awards include the 1995 Arts Alliance/Asheville Chamber Business Support of the Arts Award; Citation of Excellence in Sales Promotion/Packaging; 1995 3rd District AAF ADDY Competition; 1 Addy and 3 Citations of Excellence in the 1995 Greenville Addy Awards.

Needs: Works with 1 freelance photographer every 2 or 3 months. Uses photos for consumer and trade magazines, direct mail, brochures, catalogs and posters. Subjects include: studio product shots, some location, some stock photos. Model/property release required.

Specs: Uses 8×10 b&w glossy prints; 35mm or 4×5 transparencies.

Making Contact & Terms: Interested in receiving work from newer, lesser-known photographers. Provide résumé, business card, brochure, flier or tearsheets to be kept on file for possible future assignments. Cannot return unsolicited material. Reports "when there is a need." Pays $50-200/b&w photo; $100-500/color photo; $50-100/hour; $350-1,000/day. Pays on per-job basis. Buys all rights; negotiable.

Tips: "I usually look for a specific specialty. No photographer is good at everything. I also consider studio space and equipment. Show me something different, unusual, something that sets you apart from any average local photographer. If I'm going out of town for something it has to be for something I can't get done locally."

BRAINWORKS DESIGN GROUP, 2 Harris Court, Suite A-7, Monterey CA 93940. (408)657-0650. Fax: (408)657-0750. President: Al Kahn. Estab. 1986. Design firm. Specializes in publication design and direct mail. Types of clients: education.

Needs: Works with 2 freelancers/month. Uses photographs for direct mail, catalogs and posters. Wants conceptual images. Model release required.

Specs: Uses 35mm, 4×5 transparencies.

Making Contact & Terms: Interested in receiving work from newer, lesser-known photographers. Arrange personal interview to show portfolio. Send unsolicited photos by mail for consideration. Works with freelancers on assignment only. Keeps samples on file. Cannot return material. Reports in 1 month. Pays $500/day; $750/job. Pays on receipt of invoice. Credit line sometimes given, depending on client. Buys first rights, one-time rights and all rights; negotiable.

***CAMBRIDGE PREPRESS**, 215 First St., Cambridge MA 02142. (617)354-1991. Fax: (617)494-6575. E-mail: cindyd@cindydavis.com. Creative Director: Cynthia Davis. Estab. 1968. Design firm. Approximate annual billing: $3½ million. Number of employees: 50. Specializes in publication design and packaging. Types of clients: financial and publishers. Examples of recent projects: "Fidelity Focus," Fidelity Investments (editorial); "Inc. Technology," Goldhirsh Group (editorial); and "Dragon Dictate" Dragon Systems (packaging).

Needs: Works with 5-10 freelancers/month. Uses photos for consumer magazines, trade magazines, catalogs and packaging. Subjects include: people. Reviews stock photos. Model release preferred.

Specs: Uses 35mm, 2¼×2¼ transparencies; film appropriate for project.

Making Contact & Terms: Interested in receiving work from newer, lesser-known photographers. Query with samples. Works on assignment only. Keeps samples on file. Do not submit originals. NPI. Pays 30 days net. Credit line given. Rights purchased depend on project; negotiable.

***CC&L, INC.**, (formerly Chicago Computer & Light, Inc.), 5001 N. Lowell Ave., Chicago IL 60630-2610. (312)283-2749. Fax: (312)283-9972. E-mail: ccl@wwa.com. President: Larry Feit. Estab. 1987. Design firm. Approximate annual billing: $200,000. Number of employees: 4. Specializes in display design, signage and manufacturing. Types of clients: industrial and nonprofit. Examples of recent projects: "Bushman Penny Machine," Field Museum of Natural History (display); "Public Education

● **A BULLET** has been placed within some listings to introduce special comments by the editor of *Photographer's Market*.

at School," Schiller Park City (fire safety); and bottle cap refrigerator ad, *Beverage World* (photos for magazine advertising meeting).

Needs: Works with 1 freelancer/month. Uses photos for billboards, consumer magazines, trade magazines, direct mail, P-O-P displays, posters, packaging and signage. Subjects include products, end products, consumer products. Model release required; property release preferred. Photo captions preferred.

Specs: Uses 4×5 glossy color and b&w prints; 35mm, 4×5 transparencies.

Making Contact & Terms: Interested in receiving work from newer, lesser-known photographers. Send unsolicited photos by mail for consideration. Provide résumé, business card, brochure, flier or tearsheets to be kept on file for possible future assignments. Keeps samples on file. SASE. Reports in 1 month. Pays $20-85/hour; $100-500/job. Pays on receipt of invoice, 30 days net. Credit line not given. Buys all rights; negotiable.

***SANDY CONNOR ART DIRECTION**, 90 Ship St., Providence RI 02903. (401)831-5796. Fax: (401)831-5797. Owner: Sandy Connor. Estab. 1992. Member of Providence Chamber of Commerce. Design firm, advertising/design. Number of employees: 1. Specializes in annual reports, publication design, direct mail. Types of clients: industrial, financial, nonprofit. Examples of recent projects: Washington Trust Company (annual report); Arconium (brochures); and Handy & Hamon (corporate brochures).

Needs: Works with 1 freelancer/month. Uses photos for annual reports, trade magazines, direct mail, P-O-P displays, catalogs. Subjects include: industrial, location and product. Reviews stock photos. Model release required.

Specs: Uses b&w prints; 35mm, 2¼×2¼, 4×5, 8×10.

Making Contact & Terms: Interested in receiving work from newer, lesser-known photographers. Submit portfolio for review. Query with samples. Send unsolicited photos by mail for consideration. Provide résumé, business card, brochure, flier or tearsheets to be kept on file for possible future assignments. Works on assignment only. Keeps samples on file. Reports as need for work arises. Pays $50-200/hour; $1,000-2,000/day. Pays on acceptance; 30 days from receipt of invoice. Buys first, one-time and all rights; negotiable.

CSOKA/BENATO/FLEURANT, INC., 134 W. 26th St., Room 903, New York NY 10001. President: Bob Fleurant. Estab. 1969. Design firm. Number of employees: 5. Specializes in annual reports, packaging and direct mail. Types of clients: industrial, financial and music. Examples of recent projects: "Wonders of Life," Met Life (Epcot Center souvenir); "Power of Music," RCA/BMG (sales kit); and "Booster Cables," Standard Motor Products (package design).

Needs: Uses photos for direct mail, packaging, music packages. Subjects include: still life, holidays, memorabilia, lifestyles and health care. Interested in reviewing stock photos of still life, holidays, memorabilia, lifestyles and health care. Model release required for families, lifestyle, business and health care. Property release preferred.

Specs: Uses 8×10 or larger color and b&w prints; 35mm, 2¼×2¼, 4×5, 8×10 transparencies.

Making Contact & Terms: Interested in receiving work from newer, lesser-known photographers. Query with stock photo list. Provide résumé, business card, brochure, flier or tearsheets to be kept on file for possible future assignments. "Only select material is kept on file." Works on assignment only. Cannot return material. Reports only when interested. NPI. Pays 30 days from receipt of invoice. Credit line sometimes given depending on client requirements, usage. Buys one-time, exclusive product and all rights; negotiable.

DESIGN & MORE, 1222 Cavell, Highland Park IL 60035. (847)831-4437. Fax: (847)831-4462. Creative Director: Burt Bentkover. Estab. 1989. Design and marketing firm. Approximate annual billing: $350,000. Number of employees: 2. Specializes in annual reports, packaging, signage, publication design and food brochures and promotions. Types of clients: industrial research and food service.

Needs: Works with 1 freelancer/month. Uses photos for annual reports, consumer and trade magazines and sales brochures. Subjects include abstracts and food. Reviews stock photos of concepts and food. Property release required.

Specs: Uses 35mm and 2¼×2¼ transparencies.

Making Contact & Terms: Interested in receiving work from newer, lesser-known photographers. Provide résumé, business card, brochure, flier or tearsheets to be kept on file for possible future assignments. Never send originals. Keeps samples on file. Cannot return material. Reports in 1-2 weeks. Pays $500-1,000/day. Pays in 45 days. Cannot offer photo credit. Buys negotiable rights.

***DOWNEY COMMUNICATIONS, INC.**, 4800 Montgomery Lane, Suite 710, Bethesda MD 20814. (301)718-7600. Fax: (301)718-7604. E-mail: milgrocer@aol.com. Art Director: Karen Sulmonetti. Estab. 1969. Member of Art Directors Club of Washington DC, Society of Publication Designers. Specializes in publication design. Types of clients: retail. Examples of recent projects: "Consumer Electronics," *Military Exchange Magazine* (people shot with electronic background); "Personality

Chicago photographer Scott Payne shot this scrumptious-looking feast for an ad produced by Design & More. Payne, who does his own prop styling, conceived the shot with Art Director Burt Bentkover and others weeks before the shoot. They sought an "appetizing, inviting and moody" photo. The photographer considers the piece good for his portfolio and name recognition.

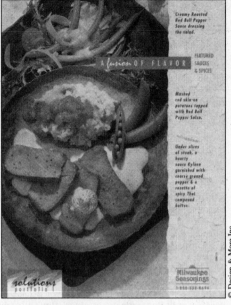

Profile," *Military Grocer Magazine* (person in setting); "Comstore Profile," *Military Grocer Magazine* (variety of shots throughout the store).
Needs: Works with 4 freelancers/month. Uses photos for trade magazines. Subjects include: people and interiors. Model release preferred. Captions required; include name, title, occupation of subject.
Specs: Uses 35mm, 2¼×2¼ transparencies.
Making Contact & Terms: Send unsolicited photos by mail for consideration. Keeps samples on file. SASE. Pays $350-400/day. Pays on publication. Credit line given. Buys one-time rights.
Tips: Looks for composition, style and uniqueness of traditional people shots.

✤**DUCK SOUP GRAPHICS, INC.**, 257 Grandmeadow Crescent, Edmonton, Alberta T6L 1W9 Canada. (403)462-4760. Fax: (403)463-0924. Creative Director: William Doucette. Estab. 1980. Design firm. Specializes in annual reports, publication design, corporate literature/identity, packaging and direct mail. Types of clients: industrial, government, institutional, financial and retail.
Needs: Works with 2-4 freelancers/month. Uses photos for annual reports, billboards, consumer and trade magazines, direct mail, posters and packaging. Subject matter varies. Reviews stock photos. Model release preferred.
Specs: Uses color and b&w prints; 35mm, 4×5, 8×10 transparencies.
Making Contact & Terms: Interested in receiving work from newer, lesser-known photographers. Provide résumé, business card, brochure, flier or tearsheets to be kept on file for possible future assignments. Works on assignment only. Keeps samples on file. SAE and IRC. Reports in 1-2 weeks. Pays $90-130/hour; $600-900/day; $500-6,000/job. **Pays on receipt of invoice**. Credit line sometimes given depending on number of photos in publication. Buys first rights; negotiable.

*****GEREW GRAPHIC DESIGN**, 2623 N. Charles St., Baltimore MD 21218. (410)366-5429. Fax: (410)366-6123. E-mail: clgggd1@aol.com. Owner: Cynthia Gerew. Estab. 1988. Design firm. Approximate annual billing: $150,000. Number of employees: 3. Specializes in publication design and direct mail. Types of clients: financial, publishers and insurance.
Needs: Uses photos for direct mail. Subjects include: families, health, real estate, senior market and credit card usage. Model/property release required.
Specs: Uses 8×10 glossy b&w prints; 35mm, 2¼×2¼, 4×5 transparencies.
Making Contact & Terms: Interested in receiving work from newer, lesser-known photographers. Arrange personal interview to show portfolio. Send unsolicited photos by mail for consideration. Provide résumé, business card, brochure, flier or tearsheets to be kept on file for possible future assignments. Works on assignment only. Keeps samples on file. SASE. Responds if an appropriate assignment is available. Pays $300-900/shot depending on usage. Pays 30 days from receipt of invoice. Credit line not given. Buys one-time rights.
Tips: "I like everyday-type people in the shots with a good cross-market representation."

***■GOLD & ASSOCIATES, INC.**, 100 Executive Way, Ponte Verde Beach FL 32082. (904)285-5669. Fax: (904)285-1579. Creative Director: Keith Gold. Estab. 1988. Member of AIGA. Design firm. Approximate annual billing: $10 million in capitalized billings. Number of employees: 12. Specializes in music, publishing, health care and entertainment industries. Examples of recent projects: Time-Warner (video and video packaging); Harcourt General (book designs); and *Rolling Stone* (music packaging).
Needs: Works with 1-4 freelance photographers and 1-2 filmmakers/month. Uses photos for video, television spots, films and CD packaging. Subjects vary. Reviews stock photos. Tries to buy out images.
Specs: Uses transparencies, film and disks.
Making Contact & Terms: Interested in receiving work from newer, lesser-known photographers. Contact through rep. Provide flier or tearsheets to be kept on file for possible future assignments. Works with freelancers from across the US. Cannot return material. Only reports to "photographers being used." NPI. **Pays on receipt of invoice.** Credit line given only for original work where the photograph is the primary design element; never for spot or stock photos. Buys all rights.

***GRAPHIC ART RESOURCE ASSOCIATES**, 257 W. Tenth St., New York NY 10014-2508. (212)929-0017. Fax: (212)929-0017 (phone first). Principal: Robert Lassen. Estab. 1980. Design firm, photography studio, ad agency, printing brokerage, etc. Specializes in publication design. Types of clients: industrial, financial and academic.
Needs: Works with 2-3 freelancers/year. Uses photos for books. Subjects include: people, table top product, location.
Specs: Uses 35mm b&w contact sheets or 11 × 14 color prints; 35mm transparencies.
Making Contact & Terms: "Just call. If I'm not too busy, I may see you. I'm not interested in dealing with reps." Works on assignment only. Keeps samples on file (but only a few). Will not return material. "If I'm interested I'll call when I have something." Pays $40-60/hour. Pays "when I get paid." Credit lines sometimes given. Buys all rights, may negotiate, depends on client requirements.
Tips: "We supply all film and lab. I myself am a photographer, and virtually all photographic services are done inhouse. Once in a while I need help." Looks for "professional competence, understanding of merchandising and the right equipment for the job. I look at Polaroids for approval."

GRAPHIC DESIGN CONCEPTS, 4123 Wade St., Suite 2, Los Angeles CA 90066. (310)306-8143. President: C. Weinstein. Estab. 1980. Design firm. Specializes in annual reports, publication design, display design, packaging, direct mail and signage. Types of clients: industrial, financial, retail, publishers and nonprofit. Examples of recent projects: "Cosmo Package," Amboy, Inc. (product/package photo); "Aircraft Instruments," General Instruments, Inc. (product/package photo); and "Retirement Residence," Dove, Inc. (pictorial brochure).
Needs: Works with 10 freelancers/month. Uses photos for annual reports, billboards, consumer and trade magazines, direct mail, P-O-P displays, catalogs, posters, packaging and signage. Subjects include: pictorial, scenic, product and travel. Reviews stock photos of pictorial, product, scenic and travel. Model/property release required for people, places, art. Captions required; include who, what, when, where.
Specs: Uses 8 × 10 glossy, color and b&w prints; 35mm, 2¼ × 2¼, 4 × 5, 8 × 10 transparencies.
Making Contact & Terms: Interested in receiving work from newer, lesser-known photographers. Provide résumé, business card, brochure, flier or tearsheets to be kept on file for possible future assignments. Works with freelancers on assignment only. Keeps samples on file. SASE. Reports as needed. Pays $15 minimum/hour; $100 minimum/day; $100 minimum/job; $50 minimum/color photo; $25 minimum/b&w photo. **Pays on receipt of invoice.** Credit line sometimes given depending upon usage. Buys rights according to usage.
Tips: In samples, looks for "composition, lighting and styling." Sees trend toward "photos being digitized and manipulated by computer."

***H. GREENE & COMPANY**, 230 W. Huron, Chicago IL 60610. (312)642-0088. Fax: (312)642-0028. President: Howard Greene. Estab. 1985. Member of AIGA. Design firm. Approximate annual billing: $5 million. Number of employees: 11. Specializes in annual reports, publication design, direct mail and signage. Types of clients: industrial, financial and nonprofit. Examples of recent clients: Motorola, Nalco and Comdisco.

MARKET CONDITIONS are constantly changing! If you're still using this book and it's 1998 or later, buy the newest edition of *Photographer's Market* at your favorite bookstore or order directly from Writer's Digest Books.

Needs: Works with 1 freelancer/month. Uses photos for direct mail, catalogs and posters. Subjects include: people and locations. Reviews stock photos. Model/property release required.
Specs: Uses 35mm, 2¼×2¼, 4×5 transparencies.
Making Contact & Terms: Interested in receiving work from newer, lesser-known photographers. Send unsolicited photos by mail for consideration. Provide résumé, business card, brochure, flier or tearsheets to be kept on file for possible future assignments. Works on assignment only. Keeps samples on file. Cannot return material. NPI. **Pays on receipt of invoice**. Credit line given. Buys one-time and electronic rights; negotiable.

HAMMOND DESIGN ASSOCIATES, 79 Amherst St., Milford NH 03055. (603)673-5253. Fax: (603)673-4297. President: Duane Hammond. Estab. 1969. Design firm. Specializes in annual reports, publication design, display design, packaging, direct mail, signage and non-specialized. Types of clients: industrial, financial, publishers and nonprofit. Examples of projects: Resonetics Capabilities brochure, Micro Lasering (product photos, cover and inside); Christmas card, Transnational Travel (front of card); and Cornerstone Software (data sheets, ads).
Needs: Works with 1 freelancer/month. Uses photos for annual reports, trade magazines, direct mail, catalogs and posters. Subject matter varies. Reviews stock photos. Model release required. Property release preferred. Captions preferred.
Specs: Uses 8×10 and 4×5 matte or glossy, color and b&w prints; 35mm, 2¼×2¼, 4×5 transparencies.
Making Contact & Terms: Interested in receiving work from newer, lesser-known photographers. Send unsolicited photos by mail for consideration. Provide résumé, business card, brochure, flier or tearsheets to be kept on file for possible future assignments. Works with freelancers on assignment only. Cannot return unsolicited material. Pays $25-100/hour; $450-1,000/day; $25-2,000/job; $50-100/color photo; $25-75/b&w photo. Pays on receipt of invoice net 30 days. Credit line sometimes given. Buys one-time, exclusive product and all rights; negotiable.
Tips: Wants to see creative and atmosphere shots, "turning the mundane into something exciting."

***HOWRY DESIGN ASSOCIATES**, 354 Pine St., Suite 600, San Francisco CA 94104. (415)433-2035. Fax: (415)433-0816. Office Manager: Zana Woods. Estab. 1987. Design firm. Number of employees: 8. Specializes in annual reports. Types of clients: industrial, financial and publishers. Examples of recent projects: San Francisco International Airport (annual report); Solectron (annual report); and Cygnus (annual report).
Needs: Works with 2-4 freelancers/month. Uses photos for annual reports. Subjects vary. Reviews stock photos. Model/property release preferred. Captions preferred.
Specs: Uses 35mm, 2¼×2¼, 4×5, 8×10 transparencies.
Making Contact & Terms: Interested in receiving work from newer, lesser-known photographers. Query with samples. Provide résumé, business card, brochure, flier or tearsheets to be kept on file for possible future assignments. Works on assignment only. Keeps samples on file. Reports in 1-2 weeks. NPI. **Pays on receipt of invoice.** Buys one-time rights.

HUTCHINSON ASSOCIATES, INC., 1147 W. Ohio St., Suite 305, Chicago IL 60622-5874. (312)455-9191. Fax: (312)455-9190. E-mail: hutch@hutchinson.com. Website: http://www.hutchinson .com. Design firm. Contact: Jerry Hutchinson. Estab. 1985. Member of American Center for Design, American Institute of Graphic Arts. Number of employees: 3. Specializes in annual reports, marketing brochures, etc. Types of clients: industrial, finance, real estate and medical. Examples of recent projects: annual reports (architectural) and capabilities brochures, multimedia and web page design.
Needs: Works with 1 freelance photographer/month. Uses photographs for annual reports, brochures. Subjects include: still life, real estate.
Specs: Uses 4×5, 8×10 color and b&w prints; 35mm, 4×5 transparencies.
Making Contact & Terms: Arrange personal interview to show portfolio. Provide résumé, business card, brochure, flier or tearsheets to be kept on file for possible future assignments. Keeps samples on file. SASE. Reports in 1-2 weeks. NPI; payment rates depend on the client. Pays within 30 days. Buys one-time, exclusive product and all rights; negotiable. Credit line given.
Tips: In samples "quality and composition count." Sees a trend toward "more abstraction."

ICONS, 76 Elm St., Suite 313, Boston MA 02130. Phone: (617)522-0165. Fax: (617)524-5378. Principal: Glenn Johnson. Estab. 1984. Design firm. Approximate annual billing: $250,000. Number of employees: 2. Specializes in annual reports, publication design, packaging, direct mail and signage. Types of clients: high-tech. Examples of recent clients: SQA Inc., Leaf Systems, Picturetel.
Needs: Works with 2 freelancers/month. Uses photos for annual reports, trade magazines, packaging, direct mail and posters. Subjects include: portraits, photo montage and products. Reviews unusual abstract, non-conventional stock photos. Model/property release preferred for product photography. Captions preferred; include film and exposure information and technique details.

Specs: Uses 4×5 transparencies.

Making Contact & Terms: Interested in receiving work from newer, lesser-known photographers. Query with samples. Works with local freelancers only. Keeps samples on file. SASE. Reports in 3 weeks. Pays $1,200-1,800/day; $750-5,000/job. **Pays on receipt of invoice.** Credit line given. Buys first rights.

***PETER JAMES DESIGN STUDIO**, 7495 NW Fourth St., Plantation FL 33317-2204. (954)587-2842. Fax: (954)587-2866. President/Creative Director: Jim Spangler. Estab. 1980. Design firm. Specializes in advertising design, packaging, direct mail. Types of clients: industrial, corporate. Example of recent project: VSI International (packaging/print).

Needs: Works with 1-2 freelancers/month. Uses photos for consumer and trade magazines, direct mail, P-O-P displays, catalogs, posters and packaging. Subjects include: lifestyle shots and products. Reviews stock photos. Model release required. Captions preferred.

Specs: Uses 8×10, glossy, color prints; 35mm, 2¼×2¼, 4×5 transparencies.

Making Contact & Terms: Arrange personal interview to show portfolio. Query with résumé of credits. Query with samples. Provide résumé, business card, brochure, flier or tearsheets to be kept on file for possible future assignments. Works with freelancers on assignment only. Keeps samples on file. SASE. Reports as needed. Pays $150 minimum/hour; $1,200 minimum/day. Pays net 30 days. Credit line sometimes given depending upon usage.

Tips: Wants to see "specific style, knowledge of the craft, innovation."

LIEBER BREWSTER CORPORATE DESIGN, 324 W. 87th St., #2F, New York NY 10024. (212)874-2874. Principal: Anna Lieber. Estab. 1988. Design firm. Specializes in corporate communications and marketing promotion. Types of clients: health care, financial, publishers and nonprofit.

Needs: Works with freelancers on a per project basis. Uses photos for direct mail, catalogs, brochures, annual report and ads. Subjects include: food and wine, flowers, people, location, still life and corporate.

Specs: Uses 8×10 b&w prints; 35mm, 2¼×2¼, 4×5, 8×10 transparencies.

Making Contact & Terms: Interested in receiving work from newer, lesser-known photographers. Provide résumé, business card, brochure, flier or tearsheets to be kept on file for possible future assignments. Works with freelancers on assignment only. Keeps samples on file. SASE. Reports only on solicited work. Pays $75-150/hour; $250-700/day; $500-2,000/job. **Pays on acceptance or receipt of invoice.** Credit line given. Rights negotiable.

Tips: Wants to see an "extremely professional presentation, well-defined style and versatility. Send professional mailers with actual work for clients, as well as creative personal work."

***LORENC DESIGN**, 724 Longleaf Dr., Atlanta GA 30342. (404)266-2711. Fax: (404)233-5619. Manager: Alicia Cacci. Estab. 1978. Member of SEGD, AIGA, AIA. Design firm. Approximate annual billing: $750,000. Number of employees: 7. Specializes in display design and signage. Types of clients: industrial, financial and retail. Examples of recent projects: "Holiday Inn Worldwide Headquarters," Holiday Inn (exhibit); and "Georgia Pacific Sales Center," Georgia-Pacific (exhibit).

Needs: Works with 1 freelancer/month. Uses photos for P-O-P displays, posters, signage and exhibits. Subjects include: architectural photography, scenery and people. Reviews stock photos.

Specs: Uses 8×10 glossy color and b&w prints; 35mm, 4×5 transparencies.

Making Contact & Terms: Interested in receiving work from newer, lesser-known photographers. Contact through rep. Submit portfolio for review. Keeps samples on file. SASE. Reports in 1-2 weeks. **Pays on receipt of invoice.** Credit line given. Buys all rights; negotiable.

MASI GRAPHICA LTD., 309 N. Justine, Chicago IL 60607. (312)421-7858. Fax: (312)421-7866. Designer: Eric or Kevin Masi. Estab. 1989. Design firm. Approximate annual billing: $200,000-300,000. Number of employees: 4. Specializes in publication design and direct mail. Types of clients: industrial, retail and publishers. Recent clients include: Prime Retail, Spiegal, Kemper.

Needs: Works with 1-2 freelancers/month. Uses photos for direct mail, catalogs, posters and corporate collateral. Reviews stock photos. Model/property release preferred. Captions preferred.

Specs: Uses 4×5 and 8×10 transparencies.

Making Contact & Terms: Interested in receiving work from newer, lesser-known photographers. Query with samples. Provide résumé, business card, brochure, flier or tearsheets to be kept on file for possible future assignments. Works on assignment only. Keeps samples on file. Cannot return material. Reports generally in 1 month. Pays $1,000-1,800/day. **Pays on receipt of invoice.** Credit line sometimes given. Buys one-time rights; negotiable.

Tips: Wants to see conceptual content in the photographer's work. "Style can be just about anything. We're looking for a mind behind the lens."

***MG DESIGN ASSOCIATES CORP.**, 824 W. Superior St., Chicago IL 60622. (312)243-3661. Fax: (312)243-5268. E-mail: mgexhibits@aol.com. Contact: Graphics Designer. Estab. 1959. Member

INSIDER REPORT

"Maintain That Childish Sense of Wow"

Toronto-based photographer Derek Shapton loves scratching film with tools and melting transparencies with fire. He adores breaking the rules of printing by mixing and matching chemicals. He even favors walking on images to increase the dirt content. And the best thing is, clients love it.

© 1996 Eva Milinkovic

Derek Shapton

Shapton's style is unique. There are hints of his interest in illustration and an overriding sense that the work is digitally enhanced. To the contrary, his images are not computer-generated—instead they are perfected through trial and error of different processes. "A lot of things I do I stumbled upon just in screwing around," he says. He has also learned some valuable lessons along the way, such as "the importance of screwing around with dupes instead of originals."

Shapton likes the fact that his work is distinctive. That way clients can't classify him as strictly an advertising, corporate or editorial photographer. And, he likes the idea of transferring, for example, a music industry aesthetic to projects like annual reports. "I'm trying not to close myself off from anything," he says. "Every type of work has fun things about it. I'm still young enough to be sort of starry-eyed. Even if the assignment only pays a couple hundred bucks, if it's cool for a hip magazine or whatever, I'll still say 'Yeah.' "

At 25, Shapton has already cultivated an impressive client list, including Sony Music Canada, Polygram/A&M/Island Records, *Toronto Life Fashion*, and *Saturday Night* magazine. The Canadian Academy of Recording Arts & Sciences nominated him for a 1996 Juno Award, equivalent to a Grammy Award in the U.S. The nomination was for an album cover he completed for A&M Records/Ancient Music.

Shapton attended various schools that helped him develop his visual skills, but he credits much of his career development to Toronto fashion photographer Chris Nicholls. Shapton worked for 1½ years as a studio manager/assistant to Nicholls, who taught Shapton printing techniques and the importance of familiarity with film and calibrating exposures and processing times.

As a result of his association with Nicholls, Shapton came in contact with photo rep Kristina Jansz of Toronto. Jansz, who reps Nicholls, took an interest in Shapton's work and eventually agreed to market his talent. Jansz handles most of Shapton's major clients, including corporations, advertising firms and design studios. "I get a lot of people who say, 'Your stuff is really cool, but we don't

INSIDER REPORT, *continued*

know quite what to do with it right now.' Kristina is good at helping flush out the ways in which they might use it—something I'm not particularly comfortable expressing. I don't want to tell a designer how he can use my work," he says.

How clients use his work often depends on what they like within his portfolio. Once Shapton knows what interests a client, he has a point of departure from which he can create new images. "It always has to be in the service of an idea. Technical wizardry just isn't enough if the picture isn't good to start with and if the concept behind it isn't solidly grounded," he says.

Clients often give Shapton latitude to develop his concepts as he sees fit. This allows him to experiment with new techniques without losing site of the main goal for each project. And, often the new techniques are the ones buyers use. Not only does this give clients more than they expect, but it keeps Shapton interested in his craft. "I've never really become bored, because I've been able to play around a lot. But I've talked to photographers who have one distinct style and

© 1996 Derek Shapton

Derek Shapton of Toronto has a distinctive style that is gaining recognition for his work. Shapton often scratches, steps on, and essentially abuses photos. This image was used on an album cover by A&M Records/Ancient Music, and was nominated for a 1996 Juno Award, Canada's equivalent to a Grammy Award in the U.S.

INSIDER REPORT, *Shapton*

one way of shooting. For some personalities that seems to be a good thing, but for me that wouldn't work. I'd go insane."

To maintain a passion for his work, Shapton surrounds himself with clients, an assistant and even a photo rep he enjoys. He admits that he has even turned down some projects because he had a bad feeling about the people involved. It may seem obvious, but Shapton advises others to understand the importance of getting along with clients and assistants. This includes maintaining an open mind to their ideas. "Some photographers see themselves as artists whose vision precludes the necessity to be good people," he says.

Another recommendation is for newcomers to become students of their peers, he says. Study the work of photographers you admire and try to figure out how they captured special effects and brilliant lighting. "Become addicted to looking at pictures," he says. "Try to retain that sort of childish sense of 'Wow' when you see something you like. Don't be afraid to be impressed."

—Michael Willins

of IEA, EDPA, HCEA. Design firm. Number of employees: 30. Specializes in display design and signage. Types of clients: corporate.
Needs: Subjects include: corporate images and industrial. Model release required. Captions preferred.
Specs: Uses 35mm, 4×5, 8×10 transparencies.
Making Contact & Terms: Query with résumé of credits. Works on assignment only. Does not keep samples on file. Reports in 1 month. NPI; payment negotiable. **Pays on receipt of invoice.** Credit line not given.

***MIRANDA DESIGNS INC.**, 745 President St., Brooklyn NY 11215. (718)857-9839. Owner: Mike Miranda. Estab. 1970. Design firm and publisher. Specializes in publication design, direct mail and product development. Types of clients: industrial, financial, retail and nonprofit.
Needs: Works with 1 freelancer/month. Uses photos for annual reports, consumer magazines, direct mail and catalogs. Subjects include: product and reportage. Model/property release required.
Specs: Uses 8×10, matte, b&w prints; 35mm transparencies.
Making Contact & Terms: Interested in receiving work from newer, lesser-known photographers. Provide résumé, business card, brochure, flier or tearsheets to be kept on file for possible future assignments. Works on assignment only. Keeps samples on file. Cannot return material. Reports in 1-2 weeks. NPI. Credit line sometimes given depending upon client. Rights bought depend on client's needs.

MITCHELL STUDIOS DESIGN CONSULTANTS, 1111 Fordham Lane, Woodmere NY 11598. (516)374-5620. Fax: (516)374-6915. E-mail: mspakdes@aol.com. Principal: Steven E. Mitchell. Estab. 1922. Design firm. Number of employees: 8. Types of clients: corporations with consumer products. Examples of projects: Lipton Cup-A-Soup, Thomas J. Lipton, Inc.; Colgate Toothpaste, Colgate Palmolive Co.; and Chef Boy-Ar-Dee, American Home Foods—all three involved package design.
Needs: Works with variable number of freelancers/month. Uses photographs for direct mail, P-O-P displays, catalogs, posters, signage and package design. Subjects include: still life/product. Reviews stock photos of still life/people. Model release required. Property release preferred. Captions preferred.
Specs: Uses all sizes and finishes of color and b&w prints; 35mm, 2¼×2¼, 4×5, 8×10 transparencies.
Making Contact & Terms: Interested in receiving work from newer, lesser-known photographers. Submit portfolio for review. Provide résumé, business card, brochure, flier or tearsheets to be kept on file for possible future assignments. Cannot return material. Reports as needed. Pays $35-75/hour; $350-1,500/day; $500 and up/job. **Pays on receipt of invoice.** Credit line sometimes given depending on client approval. Buys all rights.
Tips: In portfolio, looks for "ability to complete assignment." Sees a trend toward "tighter budgets." To break in with this firm, keep in touch regularly.

MORRIS BEECHER INC., (formerly Morris Beecher Lord), 1000 Potomac St. NW, Washington DC 20007. (202)337-5300. Fax: (202)333-2659. Contact: Diane Beecher. Estab. 1983. Ad agency. Specializes in publications, P-O-P, display design, direct mail, signage, collateral, ads and billboards. Types of clients: sports, health and nutrition, the environment, real estate, resorts, shopping centers and retail.
Needs: Works with 3-4 freelancers/month. Uses photos for billboards, direct mail, posters, signage, ads and collateral materials. Subjects include real estate, fashion and lifestyle. Reviews stock photos. Model release required. Captions preferred.
Specs: Uses any size or finish of color and b&w prints; 35mm transparencies.
Making Contact & Terms: Arrange personal interview to show portfolio. Provide business card, brochure, flier or tearsheets to be kept on file for possible future assignments. Works on assignment only. Keeps samples on file. SASE. Usually pays per job. Credit line not given. Buys all rights.
Tips: Wants to see "very high quality work." Uses a lot of stock.

***MURRELL DESIGN GROUP**, 1280 W. Peachtree St., Atlanta GA 30309. (404)892-5494. Fax: (404)874-6894. President: James Murrell. Estab. 1992. Member of AIGA. Design firm. Approximate annual billing: $500,000. Specializes in annual reports, publication design, display design, packaging, signage and collateral. Types of clients: retail, publishers and nonprofit. Examples of recent clients: Coca-Cola, Poweraid and ACOG.
Needs: Works with 2 freelancers/month. Uses photos for annual reports, consumer magazines, P-O-P displays, catalogs, posters, packaging and signage. Reviews stock photos. Model release required for P-O-P campaigns. Captions preferred.
Specs: Uses 35mm, 4×5 transparencies.
Making Contact & Terms: Interested in receiving work from newer, lesser-known photographers. Contact through rep. Arrange personal interview to show portfolio. Works on assignment only. SASE. Reports "only if interested." NPI; pays per job. Pays 30 days from invoice. Buys all rights; negotiable.
Tips: Looks for variety.

***NASSAR DESIGN**, 560 Harrison Ave., Boston MA 02146. (617)482-1464. Fax: (617)426-3604. President: Nélida Nassar. Estab. 1980. Member of American Institute of Graphic Arts, Art Guild. Design firm. Approximate annual billing: $1.5 million. Number of employees: 3. Specializes in publication design, signage. Types of clients: publishers, nonprofit and colleges. Examples of recent projects: The Chinese Porcelain Company (illustration of all objects); Metropolitan Museum of Art (illustration of all sculptures); and Harvard University (photography of the campus and the architecture).
Needs: Works with 1-2 freelancers/month. Uses photos for catalogs, posters, signage. Subjects include art objects, architectural sites and products. Reviews stock photos. Model release required; property release preferred. Captions required.
Specs: Uses 8×10 glossy color and b&w prints; 4×5 transparencies.
Making Contact & Terms: Interested in receiving work from newer, lesser-known photographers. Submit portfolio for review. Query with samples. Keeps samples on file. SASE. Reports in 1-2 weeks. Pays $1,500-2,500/day; $30-45/color photo. **Pays on receipt of invoice.** Credit line given. Buys all rights.
Tips: "We always look for the mood created in a photograph that will make it interesting and unique."

■LOUIS NELSON ASSOCIATES INC., 80 University Place, New York NY 10003. (212)620-9191. Fax: (212)620-9194. Design firm. Estab. 1980. Types of clients: corporate, retail, not-for-profit and government agencies.
Needs: Works with 3-4 freelance photographers/year. Uses photographs for consumer and trade magazines, catalogs and posters. Reviews stock photos only with a specific project in mind.
Audiovisual Needs: Occasionally needs visuals for interactive displays as part of exhibits.
Making Contact & Terms: Submit portfolio for review. Provide résumé, business card, brochure, flier or tearsheets to be kept on file for possible future assignments. Works on assignment only. Cannot return material. Does not report; call for response. NPI. **Pays on receipt of invoice.** Credit line sometimes given depending upon client needs.
Tips: In portfolio, wants to see "the usual . . . skill, sense of aesthetics that doesn't take over and ability to work with art director's concept." One trend is that "interactive videos are always being requested."

NOVUS VISUAL COMMUNICATIONS, INC., 18 W. 27th St., New York NY 10001-6904. (212)689-2424. Fax: (212)696-9676. President: Robert Antonik. Estab. 1988. Creative marketing and communications firm. Specializes in advertising, annual reports, publication design, display design, multi-media packaging, direct mail and signage. Types of clients: industrial, financial, retail, publishers health care, telecommunications, entertainment and nonprofit.

Needs: Works with 1 freelancer/month. Uses photos for annual reports, billboards, consumer and trade magazines, direct mail, P-O-P displays, catalogs, posters, packaging and signage. Reviews stock photos. Model/property release required. Captions preferred.
Specs: Uses color and b&w prints; 35mm, 2¼ × 2¼, 4 × 5, 8 × 10 transparencies.
Making Contact & Terms: Interested in receiving work from newer, lesser-known photographers. Arrange personal interview to show portfolio. Works on assignment only. Keeps samples on file. Material cannot be returned. Reports in 1-2 weeks. NPI. Pays upon client's payment. Credit line given. Buys negotiable rights.

***LINDA PATTERSON DESIGN**, 55 Laurel Dr., Needham MA 02192. (617)444-1517. Fax: (617)444-8310. Owner: Linda Patterson. Estab. 1982. Member of New England Women's Business Owners, Women's Business Network. Design firm. Approximate annual billing: $80,000. Number of employees: 1. Specializes in annual reports, publication design and direct mail. Types of clients: industrial, financial, nonprofit and real estate. Examples of recent projects: InfoSoft annual report (portraits); Property Capital Trust annual report (buildings); and John Hancock Investment and Pension Group calendar (people).
Needs: Works with 6 freelancers/year. Uses photos for annual reports, direct mail, catalogs and brochures. Subjects include: people and buildings. Reviews stock photos. Model/property release required. Captions required.
Specs: Uses 8 × 10 b&w prints; 35mm transparencies.
Making Contact & Terms: Interested in receiving work from newer, lesser-known photographers. Provide résumé, business card, brochure, flier or tearsheets to be kept on file for possible future assignments. Keeps samples on file. Reports when interested. NPI. Pays 30 days net. Credit line not given. Buys one-time and all rights; negotiable.

THE PHOTO LIBRARY, INC., P.O. Box 606, Chappaqua NY 10514. (914)238-1076. Fax: (914)238-3177. Vice President: M. Berger. Estab. 1982. Member of ISDA, NCA, ASI. Photo library. Specializes in product design. Types of clients: industrial, retail. Examples of current clients: Canetti Design Group, Atwood Richards, Inc., Infomobile (France).
Needs: Works with 1-2 freelancers/month. Uses photos for annual reports, trade magazines and catalogs. Model/property release required. Captions required.
Making Contact & Terms: Interested in receiving work from newer, lesser-known photographers. Provide résumé, business card, brochure, flier or tearsheets to be kept on file for possible future assignments. Works with local freelancers only. NPI. Pays on publication. Buys all rights.

RICHARD PUDER DESIGN, 2 W. Blackwell St., P.O. Box 1520, Dover NJ 07801. (201)361-1310. Fax: (201)361-1663. E-mail: strongtype@aol.com. Assistant Designer: Suzanne Kersten. Estab. 1985. Member of Type Directors Club. Design firm. Approximate annual billing: $250,000. Number of employees: 3. Specializes in annual reports, publication design, packaging and direct mail. Types of clients: publishers, corporate and communication companies. Examples of recent projects: AT&T (cover head shots); and Prentice Hall (desk shots).
Needs: Works with 1 freelancer/month. Uses photos for annual reports, trade magazines, direct mail, posters and packaging. Subjects include: corporate situations and executive portraits. Reviews stock photos. Model/property release preferred.
Specs: Uses 8 × 10 glossy color and b&w prints; 2¼ × 2¼, 4 × 5 transparencies, digital images.
Making Contact & Terms: Interested in receiving work from newer, lesser-known photographers. Send unsolicited photos by mail for consideration. Provide résumé, business card, brochure, flier or tearsheets to be kept on file for possible future assignments. Works on assignment only. Keeps samples on file. Cannot return material. "We reply on an as needed basis." Pays $500-1,200/day. Pays in 30 days upon receipt of invoice. Credit line sometimes given depending upon client needs and space availability. Buys one-time rights; negotiable.

MIKE QUON DESIGN OFFICE, INC., 568 Broadway, #703, New York NY 10012. (212)226-6024. Fax: (212)219-0331. President: Mike Quon. Estab. 1982. Design firm. Specializes in packaging, direct mail, signage, illustration. Types of clients: industrial, financial, retail, publishers, nonprofit.
Needs: Works with 1-3 freelancers/month. Uses photos for direct mail, P-O-P displays, packaging, signage. Model/property release preferred. Captions required; include company name.

THE CODE NPI (no payment information given) appears in listings that have not given specific payment amounts.

Specs: Uses color, b&w prints; 2¼×2¼, 4×5 transparencies.
Making Contact & Terms: Interested in receiving work from newer, lesser-known photographers. Submit portfolio for review. Send unsolicited photos by mail for consideration. Works on assignment only. Keeps samples on file. Cannot return material. Reports only when interested. Pays $1,000-3,000/day. Pays net 30 days. Credit line given when possible. Buys first rights, one-time rights; negotiable.

***RAINCASTLE COMMUNICATIONS INC.**, 28 Union St., Newton MA 02159. Designer: Janna Leendertse. Estab. 1994. Member of AIGA. Design firm. Approximate annual billing: $500,000. Number of employees: 4. Specializes in annual reports, packaging, collateral, home pages and software. Examples of recent projects: direct mail, home page, product brochure and annual reports for software clients.
Needs: Uses photos for annual reports, packaging and collateral. Subjects include: high-tech to elegant conceptual. Reviews stock photos.
Specs: Uses 35mm transparencies.
Making Contact & Terms: Interested in receiving work from newer, lesser-known photographers. Provide résumé, business card, brochure, flier or tearsheets to be kept on file for possible future assignments. Works with local freelancers on assignment only. Keeps samples on file. NPI. Pays net 30 days. Credit line sometimes given. Rights purchased depend upon project.

PATRICK REDMOND DESIGN, P.O. Box 75430-PM, St. Paul MN 55175-0430. (612)646-4254. Designer/Owner/President: Patrick Michael Redmond, M.A. Estab. 1966. Member of Midwest Independent Publishers Association. Design firm. Specializes in publication design, book covers, books, packaging, direct mail, posters, logos, trademarks, annual reports. Number of employees: 1. Types of clients: publishers, financial, retail, advertising, marketing, education, nonprofit, arts, industrial. Examples of recent projects: Midwest Association of Colleges & Employers, Conference (graphic image development); *Catholic Digest* (design consulting); Abundant Resources, Inc. (book cover and book design).

 • Books designed by Patrick Redmond Design won awards from Midwest Independent Publishers Association, Midwest Book Achievement Awards, Publishers Marketing Association Benjamin Franklin Awards.
Needs: Uses photos for books and book covers, direct mail, P-O-P displays, catalogs, posters, packaging, annual reports. Subject varies with client—may be editorial, product, how-to, etc. May need custom b&w photos of authors (for books/covers designed by PRD). "Poetry book covers provide unique opportunities for unusual images (but typically have miniscule budgets)." Reviews stock photos; subject matter varies with need—like to be aware of resources. Model/property release required; varies with assignment/project. Captions required; include correct spelling and identification of all factual matters, re: images; i.e., names, locations, etc.—to be used optionally—if needed.
Specs: Uses 5×7, 8×10 glossy prints; 35mm, 2¼×2¼, 4×5 transparencies.
Making Contact & Terms: Interested in receiving work from newer, lesser-known photographers, as well as leading, established talent. "Non-returnable—no obligation." Contact through rep. Arrange personal interview to show portfolio. Query with résumé of credits. Query with stock photo list. Provide résumé, business card, brochure, flier, or tearsheets to be kept on file for possible future assignments. "Patrick Redmond Design will not reply unless specific photographer may be needed for respective project." Works with local freelancers on assignment only. Keeps samples on file. Cannot return material. NPI. "Client typically pays photographer directly even though PRD may be involved in photo/photographer selection and photo direction." Payment depends on client. Credit line sometimes given depending upon publication style/individual projects. Rights purchased vary with project; negotiable. "Clients typically involved with negotiation of rights directly with photographer."
Tips: Needs are "open—vary with project . . . location work; studio; table-top; product; portraits; travel; etc." Seeing "use of existing stock images when image/price are right for project and use of b&w how-to photos in low-to-mid budget/price books."

ARNOLD SAKS ASSOCIATES, 350 E. 81st St., New York NY 10028. (212)861-4300. Fax: (212)535-2590. Photo Librarian: Martha Magnuson. Estab. 1968. Member of AIGA. Graphic design firm. Number of employees: 15. Types of clients: industrial, financial, legal, pharmaceutical and utilities. Clients include: 3M, Siemens, Alcoa, Goldman Sachs and MCI.
 • This firm conducts many stock photo searches using computer networks. They also scan images onto CD-ROM.

 THE ASTERISK before a listing indicates that the market is new in this edition. New markets are often the most receptive to freelance submissions.

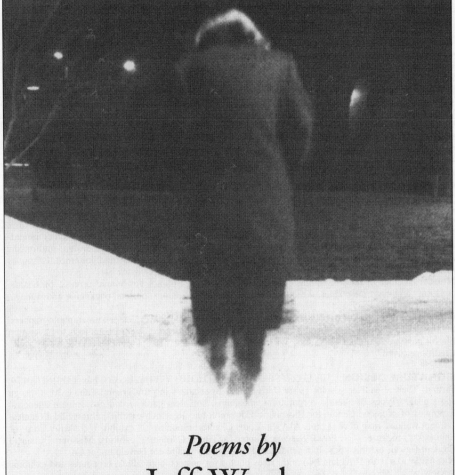

The Only Time There Is

Poems by

Jeff Worley

© Lane Stiles

For the cover of *The Only Time There Is*, Poems by Jeff Worley (Mid-List Press), Patrick Redmond of Patrick Redmond Design needed "a photo that could represent an image from the title poem of the collection—an image of a woman walking at night in the snow." But, according to Minneapolis photographer Lane Stiles, author of the shot, "It never snowed at night, so I used a long exposure and enlarged the image to create a graininess like snow and also the appearance of movement," thus capturing the ambiguity and abstraction desired by Redmond.

Needs: Works with approximately 15 photographers during busy season. Uses photos for annual reports and corporate brochures. Subjects include corporate situations and portraits. Reviews stock photos; subjects vary according to the nature of the annual report. Model release required. Captions preferred.

Specs: Uses b&w prints; 35mm, 2¼×2¼, 4×5, 8×10 transparencies.

Making Contact & Terms: Interested in receiving work from newer, lesser-known photographers. "Appointments are set up during the spring for summer review on a first-come only basis. We have a limit of approximately 30 portfolios each season." Call Anita P. Fioillo to arrange an appointment. Works on assignment only. Reports as needed. Payment negotiable, "based on project budgets. Generally we pay $1,250-2,250/day." Pays on receipt of invoice and payment by client; advances provided. Credit line sometimes given depending upon client specifications. Buys one-time and all rights; negotiable.

Tips: "Ideally a photographer should show a corporate book indicating his success with difficult working conditions and establishing an attractive and vital final product." This "company is well known in the design community for doing classic graphic design. We look for solid, conservative, straightforward corporate photography that will enhance these ideals."

***HENRY SCHMIDT DESIGN**, 3141 Hillway Dr., Boise ID 83702. (208)385-0262. President: Henry Schmidt. Estab. 1976. Design firm. Number of employees: 1. Specializes in display design, packaging, signage and catalog/sales literature. Types of clients: industrial and retail. Examples of recent projects: Marinco-AFI (catalog cover/product); Marinco-AFI (product packaging); Colorado Leisure (product catalog).

Needs: Works with 1-2 freelancers/month. Uses photos for P-O-P displays, catalogs, posters, packaging and signage. Reviews stock photos; subjects are marine/boats and "911" emergencies. Model/property release required. Captions required.

Specs: Uses 35mm, 2¼×2¼, 4×5, 6×7 transparencies.

Making Contact & Terms: Interested in receiving work from newer, lesser-known photographers. Submit portfolio for review. Query with samples. Provide résumé, business card, brochure, flier or tearsheets to be kept on file for possible future assignments. Works with freelancers on assignment only. Keeps samples on file. SASE. Reports in 1 month. NPI. Pays on receipt of invoice, net 30 days. Credit line sometimes given. Buys all rights.

CLIFFORD SELBERT DESIGN COLLABORATIVE, 2067 Massachusetts Ave., Cambridge MA 02140. (617)497-6605. Fax: (617)661-5772. Estab. 1980. Member of AIGA, SEGD. Design firm. Number of employees: 45. Specializes in strategic corporate identity design, environmental communications design, product and packaging design, landscape architecture and urban design, multimedia and CD-ROM design. Types of clients: industrial, financial, retail, publishers and nonprofit. Examples of current clients: Stride Rite, Fidelity, Avid Technology, World Cup U.S.A. '94.

Needs: Number of photos bought each month varies. Uses photos for annual reports, billboards, consumer and trade magazines, direct mail, P-O-P displays, catalogs, posters, packaging and signage. Reviews stock photos.

Making Contact & Terms: Interested in receiving work from newer, lesser-known photographers. Submit portfolio for review. Provide résumé, business card, brochure, flier or tearsheets to be kept on file for possible future assignments. "We have a drop off policy." Keeps samples on file. SASE. NPI. Credit line given.

SIGNATURE DESIGN, 2101 Locust St., St. Louis MO 63103. (314)621-6333. Fax: (314)621-0179. Partner: Therese McKee. Estab. 1988. Design firm. Specializes in print graphics and exhibit design and signage. Types of clients: corporations, museums, botanical gardens and government agencies. Examples of projects: Center for Biospheric Education and Research exhibits, Huntsville Botanical Garden; walking map of St. Louis, AIA, St. Louis Chapter; Flood of '93 exhibit, U.S. Army Corps of Engineers; brochure, U.S. Postal Service; Center for Home Gardening exhibits, Missouri Botanical Garden; Hawaii exhibits, S.S. Independence; Delta Queen Steamboat Development Co.

Needs: Works with 1 freelancer/month. Uses photos for posters, copy shots, brochures and exhibits. Reviews stock photos.

Specs: Uses prints and 35mm, 2¼×2¼ and 4×5 transparencies.

Making Contact & Terms: Interested in receiving work from newer, lesser-known photographers. Arrange personal interview to show portfolio. Send unsolicited photos by mail for consideration. Provide résumé, business card, brochure, flier or tearsheets to be kept on file for possible future assignments. Keeps samples on file. Reports in 1-2 weeks. NPI. Pays 30 days from receipt of invoice. Credit line sometimes given. Buys all rights; negotiable.

SMART ART, 1077 Celestial St., Cincinnati OH 45202. (513)241-9757. President: Fred Lieberman. Estab. 1979. Design firm, advertising art. Specializes in annual reports, display design, packaging, direct mail, signage and advertising art. Types of clients: industrial, retail and health. Examples of

projects: Western Produce sales annual (Chiquita); Jennite corporate sales brochure (Neyra Industries); and corporate capabilities brochure (Leonard Insurance).
Needs: Uses photographs for consumer and trade magazines, direct mail, P-O-P displays, catalogs, posters, packaging and signage for a wide diversity of clients. Reviews stock photos "on a variety of subjects; client list varies." Model/property release required. Captions preferred.
Specs: Uses 8 × 10 color and b&w prints; 2¼ × 2¼, 4 × 5, 8 × 10 transparencies.
Making Contact & Terms: Query with list of stock photo subjects. Provide résumé, business card, brochure, flier or tearsheets to be kept on file for possible future assignments. Works with local freelancers only. Keeps samples on file. Cannot return material. Reporting time "depends entirely on kinds of projects planned." Pays $50-200/hour; $350-1,500/day. **Pays on receipt of invoice.** "Generally client pays directly upon receipt of invoice." Buys all rights; negotiable. Credit lines sometimes given depending on what might be negotiated.

***SPIRIT CREATIVE SERVICES INC.**, 412 Halsey Rd., Annapolis MD 21401. (410)974-9377. President: Alice Yeager. Design firm.
Needs: Works with 1-2 freelancers/year. Subjects vary.
Specs: Uses prints.
Making Contact & Terms: Arrange personal interview to show portfolio. Works with local freelancers only. Keeps samples on file. Reports in 1-2 weeks. NPI. Credit line sometimes given, depending upon client.

STUDIO WILKS, 2148-A Federal Ave., Los Angeles CA 90025. (310)478-44422. Fax: (310)478-0013. Owners: Teri and Richard Wilks. Estab. 1991. Member of American Institute of Graphic Arts. Design firm. Number of employees: 3. Specializes in annual reports, publication design, packaging, signage. Types of clients: corporate, retail.
Needs: Works with 1-2 freelancers/month. Uses photos for annual reports, trade magazines, catalogs, packaging, signage. Reviews stock photos.
Specs: Uses 8 × 10 prints.
Making Contact & Terms: Interested in receiving work from newer, lesser-known photographers. Provide résumé, business card, brochure, flier or tearsheets to be kept on file for possible future assignments. Works with local freelancers only. Keeps samples on file. SASE. Reports in 3 weeks. Pays $300-750/day. **Pays on receipt of invoice.** Credit line given. Buys one-time, exclusive and all rights; negotiable.
Tips: Looking for "interesting, conceptual, experimental."

TRIBOTTI DESIGNS, 22907 Bluebird Dr., Calabasas CA 91302. (818)591-7720. Fax: (818)591-7910. E-mail: bob4149@aol.com. Contact: Bob Tribotti. Estab. 1970. Design firm. Approximate annual billing: $200,000. Number of employees: 2. Specializes in annual reports, publication design, display design, packaging, direct mail and signage. Types of clients: educational, industrial, financial, retail, government, publishers and nonprofit. Examples of projects: school catalog, SouthWestern University School of Law; magazine design, *Knitking*; signage, city of Calabasas.
Needs: Uses photos for annual reports, consumer and trade magazines, direct mail, catalogs and posters. Subjects vary. Reviews stock photos. Model/property release required. Captions preferred.
Specs: Uses 8 × 10, glossy, color and b&w prints; 35mm, 2¼ × 2¼, 4 × 5, 8 × 10 transparencies.
Making Contact & Terms: Interested in receiving work from newer, lesser-known photographers. Contact through rep. Query with résumé of credits. Provide résumé, business card, brochure, flier or tearsheets to be kept on file for possible future assignments. Works with local freelancers only. Keeps samples on file. Cannot return material. Reports in 3 weeks. Pays $500-1,000/day; $75-1,000/job; $50 minimum/b&w photo; $50 minimum/color photo; $50 minimum/hour. **Pays on receipt of invoice.** Credit line sometimes given. Buys one-time, electronic and all rights; negotiable.

UNIT ONE, INC., 950 S. Cherry St., Suite G-16, Denver CO 80222. (303)757-5690. Fax: (303)757-6801. President: Chuck Danford. Estab. 1968. Design firm. Number of employees: 4. Specializes in annual reports, publication design, display design, corporate identity, corporate collateral and signage. Types of clients: industrial, financial, nonprofit and construction/architecture. Examples of projects: Bonfils Blood Center (corporate identity); Western Mobile (plant signage); corporate brochures and marketing materials for companies in the construction industry; fundraising campaign for medical center.
Needs: Works with 1 freelancer/month. Uses photos for annual reports, trade magazines, direct mail, P-O-P displays, catalogs, posters and corporate brochures/ads. Subjects include: construction, architecture, engineering, people and oil and gas. Reviews stock photos "when needed." Model/property release required.
Specs: Reviews 2¼ × 2¼, 4 × 5 transparencies, prints or slides.
Making Contact & Terms: Interested in receiving work from newer, lesser-known photographers. Query with résumé of credits. Provide résumé, business card, brochure, flier or tearsheets to be kept

on file for possible future assignments. Works with local freelancers only. Keeps samples on file. SASE. Reports as needed. Pays $500-1,500/day; $300-450/location for 4×5 building shots. Pays within 30-45 days of completion. Credit line sometimes given, depending on the job, client and price. Buys all rights; negotiable.

Tips: Looks for "quality, style, eye for design, color and good composition."

VISUAL CONCEPTS, 5410 Connecticut Ave., Washington DC 20015. (202)362-1521. Owner: John. Estab. 1980. Design firm, 3-D. Specializes in display design, signage. Types of clients: industrial, retail.

Needs: Works with 3 freelancers/month. Uses photos for annual reports, P-O-P displays, catalogs, posters. Subjects include: fashion and objects. Reviews stock photos of vintage fashion, b&w. Model release preferred.

Specs: Uses prints and transparencies.

Making Contact & Terms: Interested in receiving work from newer, lesser-known photographers. Query with stock photo list. Provide résumé, business card, brochure, flier or tearsheets to be kept on file for possible future assignments. Works on assignment only. Keeps samples on file. Cannot return material. NPI. **Pays on receipt of invoice.** Credit line not given. Rights negotiable.

Tips: Looking for "people, building, postcard style photos, fun. NO landscapes, NO animals."

***WATKINS ADVERTISING DESIGN**, 621 W. 58th Terrace, Kansas City MO 64113-1157. (816)333-6600. Fax: (816)333-6610. E-mail: wadcorp@aol.com. Creative Director: Phil Watkins III. Estab. 1991. Member of Kansas City Advertising Club. Design firm. Number of employees: 1. Specializes in publication design, packaging, direct mail, collateral. Types of clients: industrial, retail, nonprofit, business-to-business. Examples of recent projects: California Health Vitamins, products brochure (shots of product line); Sprint, 1995 international invitation (invitation/golf ... shots); Met Life, agricultural investments brochure (direct mail/people shots).

Needs: Works with 1 freelancer/month. Uses photos for trade magazines, direct mail, P-O-P displays, catalogs, packaging, newspaper, newsletter. Subjects include: location photographs, people. Reviews stock photos. Model release preferred for locations, people shots for retail.

Specs: Uses 8×10 matte b&w prints; 35mm, $2\frac{1}{4} \times 2\frac{1}{4}$ transparencies.

Making Contact & Terms: Interested in receiving work from newer, lesser-known photographers. Arrange personal interview to show portfolio. Works with freelancers on assignment only. Keeps samples on file. SASE. Reports in 1-2 weeks. Pays $1,000-1,500/day. Pays on publication. Credit line sometimes given. Buys one-time or all rights "if usage to span one or more years."

***WAVE DESIGN WORKS**, 560 Harrison Ave., Boston MA 02118. (617)482-4470. Fax: (617)482-2356. Office Manager: Christie Keegan. Estab. 1986. Member of AIGA. Design firm. Approximate annual billing: $650,000-800,000. Number of employees: 5. Specializes in display design, packaging and identity/collateral/product brochures. Types of clients: biotech, medical instrumentation and software manufacturing. Examples of recent projects: brochure, Siemens Medical (to illustrate benefits of medical technology); annual report, United South End Settlements (to illustrate services, clientele); and 1996 catalog, New England Biolabs (environmental awareness).

Needs: Works with 2 freelancers/year. Uses photos for annual reports, trade magazines, catalogs, signage and product brochures. Subjects include product shots. Reviews stock photos, depending upon project. Model/property release preferred. Captions preferred.

Specs: Uses $2\frac{1}{4} \times 2\frac{1}{4}$, 4×5 transparencies.

Making Contact & Terms: Interested in receiving work from newer, lesser-known photographers. Provide résumé, business card, brochure, flier or tearsheets to be kept on file for possible future assignments. Works with local freelancers only. SASE. Reports on unsolicited material only if asked; 1-2 weeks for requested submissions. NPI. Pays on receipt of payment of client. Credit line sometimes given depending on client and photographer. Rights negotiable depending on client's project.

Tips: "Since we use product shots almost exclusively, we look for detail, lighting and innovation in presentation."

WEYMOUTH DESIGN INC., 332 Congress St., Boston MA 02210. (617)542-2647. Fax: (617)451-6233. Office Manager: Judith Hildebrandt. Estab. 1973. Design firm. Specializes in annual reports, publication design, packaging and signage. Types of clients: industrial, financial, retail and nonprofit.

Needs: Uses photos for annual reports and catalogs. Subjects include executive portraits, people pictures or location shots. Subject matter varies. Model/property release required. "Photo captions are written by our corporate clients."

Specs: Uses 35mm, $2\frac{1}{4} \times 2\frac{1}{4}$, 4×5 transparencies.

Making Contact & Terms: Interested in receiving work from newer, lesser-known photographers. Submit portfolio for review. Portfolio reviews April-June only; otherwise send/drop off portfolio for review. Works with freelancers on assignment only. "Mike Weymouth shoots most of the photographs

for our clients." Keeps samples on file. SASE. Pays $125-200/hr.; $1,250-2,000/day. "We give our clients 10-hour days on our day-rate quotes." **Pays on receipt of invoice.** Buys one-time rights; negotiable.

***ZMIEJKO & COMPANIES, INC.**, P.O. Box 126, Freeland PA 18224-0126. (717)636-2304. Fax: (717)636-9878. President: Thomas B.J. Zmiejko. Estab. 1971. Member of ASMP, PPANM, PPA, IPSW, Albuquerque Guild of Professional Photographers. Design firm. Number of employees: 5. Specializes in annual reports, publication design, display design, packaging, direct mail, signage, murals and billboards. Types of clients: industrial, financial, retail, publishers and nonprofit. Examples of recent projects: Pizza Hut House Organ; prep school newsletter; and Public Service New Mexico (murals). **Needs:** Model/property release required. Captions required.
Specs: Uses 8 × 10 flat color and b&w prints; 35mm, 2¼ × 2¼, 4 × 5, 8 × 10 transparencies; Betacam videotape.
Making Contact & Terms: Arrange personal interview to show portfolio. Query with stock photo list. Provide résumé, business card, brochure, flier or tearsheets to be kept on file for possible future assignments. Works with freelancers on assignment only. Keeps samples on file. SASE. Reports in 3 weeks. NPI. Pays on publication. Credit line given. Buys one-time rights.

Book Publishers

The book publishing market for photography can be roughly divided into two sectors. In the first sector, publishers buy individual or groups of photographs for cover art and to illustrate books, especially textbooks, travel books and nonfiction subject books.

For illustration, photographs may be purchased from a stock agency or from a photographer's stock or the publisher may make assignments. Publishers usually pay for photography used in book illustration or on covers on a per-image or per-project basis. Some pay photographers on hourly or day rates. No matter how payment is made, however, the competitive publishing market requires freelancers to remain flexible.

To approach book publishers for illustration jobs, send a query letter and photographs or slides and a stock photo list with prices, if available. If you have published work, tearsheets are very helpful in showing publishers how your work translates to the printed page.

The second sector is created by those publishers who produce photography books. These are usually themed and may feature the work of one or several photographers. It is not always necessary to be well-known to publish your photographs as a book. What you do need, however, is a unique perspective, a saleable idea and quality work.

For entire books, publishers may pay in one lump sum or with an advance plus royalties (a percentage of the book sales). When approaching a publisher for your own book of photographs, query first with a brief letter describing the project and samples. If the publisher is interested in seeing the complete proposal, photographers can send additional information in one of two ways depending on the complexity of the project.

Prints placed in sequence in a protective box, along with an outline, will do for easy-to-describe, straight-forward book projects. For more complex projects, you may want to create a book dummy. A dummy is basically a book model with photographs and print arranged as they will appear in finished book form. Book dummies show exactly how a book will look including the sequence, size, format and layout of photographs and accompanying text. The quality of the dummy is important, but keep in mind the expense can be prohibitive.

To find the right publisher for your work, read the listings in this section carefully. Send for catalogs and guidelines for those publishers that interest you. Also, become familiar with your local bookstore. By examining the books already published, you can find those publishers who produce your type of work. Check for both large and small publishers. While smaller firms may not have as much money to spend, they are often more willing to take risks, especially on the work of new photographers.

When approaching a publisher it also pays to have a unique concept. One photographer whose work typifies the word "unique" is William Wegman. His whimsical weimaraners have been fodder for many projects, including children's books. He discusses his work in an interview on page 127.

AAIMS PUBLISHING COMPANY, (formerly McKinzie Publishing Company), 11000 Wilshire Blvd., P.O. Box 241777, Los Angeles CA 90024-9577. (213)968-1195. Fax: (213)931-7217. Personnel Manager: Samuel P. Elliott. Estab. 1969. Publishes adult trade, "how-to," description and travel, sports, adventure, fiction and poetry. Photos used for text illustration, promotional materials and book covers. Examples of recently published titles: *Family Reunions: How To Plan Yours*; *A Message From Elvis Presley*; and *U.S. Marines Force Recon: A Black Hero's Story*.

Needs: Offers 4 or 5 freelance assignments annually. Shots of sports figures and events. Reviews stock photos. Model/property release required.

Making Contact & Terms: Interested in receiving work from newer, lesser-known photographers. Arrange personal interview to show portfolio. Query with samples. Uses 3×5 glossy b&w/prints. SASE. Reports in 3 weeks. Pays $10-50/b&w photo; $50/hour. Credit line may be given. Buys all rights; negotiable.

ADAMS-BLAKE PUBLISHING, 8041 Sierra St., Fair Oaks CA 95628. Phone/fax: (916)962-9296. Editorial Assistant: Monica Blane. Estab. 1992. Publishes business, career and reference material. Photos used for text illustration, promotional materials and book covers. Examples of published titles: *Computer Money* (promo); *Core 911* (cover/promo); and *Complete Guide to TV Movies* (promo).

Needs: Buys 10-15 photos annually; offers 5 freelance assignments annually. Wants photos of people in office situations. Model/property release required. Captions required; include where and when.

Making Contact & Terms: Interested in receiving work from newer, lesser-known photographers. Query with résumé of credits. Provide résumé, business card, brochure, flier or tearsheets to be kept on file for possible future assignments. Uses 5×7 and 8×10 glossy b&w prints; 35mm transparencies. Keeps samples on file. SASE. Reports in 1 month. Pays $50-100/color photo; $50-100/b&w photo. **Pays on acceptance.** Credit line given. Buys one-time and book rights; negotiable. Simultaneous submissions and previously published work OK.

Tips: "We publish business books and look for subjects using office equipment in meetings and at the desk/work site. Don't send a whole portfolio. We only want your name, number and a few samples. Having an e-mail address and fax number will help you make a sale. Don't phone or fax us. We also look for b&w book covers. They are cheaper to produce and, if done right, can be more effective than color."

AGRITECH PUBLISHING GROUP, P.O. Box 950553, Mission Hills CA 91395-0553. (818)361-8889. Executive Vice President: Eric C. Lightin' Horse. Estab. 1988. Publishes adult trade, juvenile, textbooks. Subject matter includes horses, pets, farm animals/materials, gardening, western art/Americana and agribusiness. Photos used for text illustration, promotional materials, book covers and dust jackets.

Needs: Number of purchases and assignments varies. Reviews stock photos. Model/property release required. Captions preferred.

Making Contact & Terms: Interested in receiving work from newer, lesser-known photographers. Submit portfolio for review. Query with samples. Provide résumé, business card, brochure, flier or tearsheets to be kept on file for possible future assignments. Keeps samples on file. SASE. Subject matter varies. NPI. Pays on publication. Credit line sometimes given depending upon subject and/or photo. Buys book rights and all rights.

Tips: "Limit queries to what we look for and need."

ALLYN AND BACON PUBLISHERS, 160 Gould St., Needham MA 02194. Fax: (617)455-1294. Photo Researcher: Susan Duane. Textbook publisher (college). Photos used in textbook covers and interiors.

Needs: Offers 4 assignments plus 80 stock projects/year. Multi-ethnic photos in education, business, social sciences and good abstracts. Reviews stock photos. Model/property release required.

Making Contact & Terms: Provide self-promotion piece or tearsheets to be kept on file for possible future assignments. "Do not call or send stock lists." Uses 8×10 or larger, matte b&w prints; 35mm, $2\frac{1}{4} \times 2\frac{1}{4}$, 4×5, 8×10 transparencies. Keeps samples on file. Cannot return material. Reports back in "24 hours to 4 months." Pays $100-500/job; $300-500/color photo; $50-200/photo. Pays on usage. Credit line given. Buys one-time rights; negotiable.

Tips: "Watch for our photo needs listing in photo bulletin. Send tearsheets and promotion pieces. Need bright, strong, clean abstracts and unstaged, nicely lit people photos."

***ALPINE PUBLICATIONS, INC.**, 225 S. Madison Ave., Loveland CO 80537. (303)667-9317. Publisher: B.J. McKinney. Estab. 1975. Publishes how-to, training and breed books for dogs, cats, horses, pets. Photos used for text illustration and book covers.

Needs: Wants photos of dogs, horses, cats, (singly and in combination), working and training photos, how-to series on assignment. Reviews stock photos. Model release required for people and animals. Captions preferred; include breed and registered name.

Making Contact & Terms: Interested in receiving work from newer, lesser-known photographers. Query with samples. Query with stock photo list. Works on assignment only. Uses 5×7, 8×10 glossy color and b&w prints; 35mm, $2\frac{1}{4} \times 2\frac{1}{4}$, 4×5 transparencies. Keeps samples on file. SASE. Reports in 1 month. Pays $25-300/color photo; $15-50/b&w photo. Pays on publication. Credit line given. Buys book rights; negotiable. Simultaneous submissions and previously published work OK.

Tips: "We look for clear, very sharp-focused work and prefer purebred, excellent-quality specimens. Natural behavior-type shots are very desirable. Be flexible in rates—we're small and growing. We

actively seek lesser-known talents, believing your work will sell our product, not your name. Be patient.''

AMERICAN & WORLD GEOGRAPHIC PUBLISHING, P.O. Box 5630, Helena MT 59604. (406)443-2842. Fax: (406)443-5480. Photo Librarian: Alexander Sweeney. Estab. 1973. Publishes material relating to geography, weather, photography—scenics and adults and children at work and play. Photos used for text illustration, promotional materials, book covers and dust jackets (inside: alone and with supporting text). Examples of published titles: *Wisconsin from the Sky* (aerial coffee table book); *The Quad-Cities and the People* (text, illustration); and *Oklahoma: The Land and Its People* (text, illustration). Photo guidelines free with SASE.
Needs: Buys 1,000 photos annually; offers 1-10 freelance assignments annually. Looking for photos that are clear with strong focus and color—scenics, wildlife, people, landscapes. Captions required; include name and address on mount. Package slides in individual protectors, then in sleeves.
Making Contact & Terms: Interested in receiving work from newer, lesser-known photographers. Query with samples. Query with stock photo list. Uses 35mm, 2¼×2¼, 4×5 and 8×10 transparencies. SASE. Reporting time depends on project. Pays $75-350/color photo. Pays on publication. Buys one-time rights. Simultaneous submissions and/or previously published work OK.
Tips: "We seek bright, heavily saturated colors. Focus must be razor sharp. Include strong seasonal looks, scenic panoramas, intimate close-ups. Of special note to *wildlife* photographers, specify shots taken in the wild or in a captive situation (zoo or game farm). We identify shots taken in the wild.''

AMERICAN ARBITRATION ASSOCIATION, 140 W. 51st St., New York NY 10020-1203. (212)484-4000. Editorial Director: Jack A. Smith. Publishes law-related materials on all facets of resolving disputes in the labor, commercial, construction and insurance areas. Photos used for text illustration. Examples of published titles: *Dispute Resolution Journal* (cover and text); *Dispute Resolution Times* (text); and *AAA Annual Report* (text).
Needs: Buys 10 photos annually; assigns 5 freelance projects annually. General business and industry-specific photos. Reviews stock photos. Model release and photo captions preferred.
Making Contact & Terms: Provide résumé, business card, brochure, flier or tearsheets to be kept on file for possible future assignments. Uses 8×10 glossy b&w prints; 35mm transparencies. SASE. Reports "as time permits.'' Pays $250-400/color photo, $75-100/b&w photo, $75-100/hour. Credit lines given "depending on usage.'' Buys one-time rights. Also buys all rights "if we hire the photographer for a shoot.'' Simultaneous submissions and previously published work OK.

AMERICAN BAR ASSOCIATION PRESS, 750 N. Lake Shore Dr., Chicago IL 60611. (312)988-6094. Fax: (312)988-6081. Photo Service Coordinator: Craig Jobson. "The ABA Press publishes 10 magazines, each addressing various aspects of the law. Readers are members of the sections of the American Bar Association.'' Photos used for text illustration, promotional materials, book covers. Examples of published titles: *Business Law Today*, portrait shot of subject of story; *Criminal Justice*, photo for story on crack. Photo guidelines free with SASE.
Needs: Buys 3-5 photos/issue. Rarely gives freelance assignments. "We are looking for serious photos that illustrate various aspects of the law, including courtroom scenes and still life law concepts. Photos of various social issues are also needed, e.g., crime, AIDS, homelessness, families, etc. Photos should be technically correct. Photos should show emotion and creativity. Try not to send any gavels or Scales of Justice. We have plenty of those.'' Reviews stock photos. Model/property release preferred; "required for sensitive subjects.'' Photo captions preferred.
Making Contact & Terms: Interested in receiving work from newer, lesser-known photographers. Query with stock photo list. Send unsolicited photos by mail for consideration. Provide résumé, business card, brochure, flier or tearsheets with SASE to be kept on file for possible future assignments. Uses 5×7, 8×10 b&w prints; 35mm, 2¼×2¼, 4×5, 8×10 transparencies. Keeps samples on file. Reports in 4-6 weeks. Pays $100-350. Assignment fees will be negotiated. When photos are given final approval, photographers will be notified to send an invoice. Credit line given. Buys one-time rights; negotiable. "We reserve the right to republish if publication is used on the Internet.'' Simultaneous submissions and/or previously published works OK.
Tips: "Be patient, present only what is relevant.''

AMERICAN BIBLE SOCIETY, 1865 Broadway, New York NY 10023. (212)408-1441. Fax: (212)408-1435. Product Development: Christina Murphy. Estab. 1816. Publishes Bibles, New Testa-

THE ASTERISK before a listing indicates that the market is new in this edition. New markets are often the most receptive to freelance submissions.

ments and illustrated scripture booklets and leaflets on religious and spiritual topics. Photos used for text illustration, promotional materials and book covers. Examples of published titles: *Hospital Scripture Tray Cards*, series of 7 (covers); *God Is Our Shelter and Strength*, booklet on natural disasters; and *God's Love for Us Is Sure and Strong*, booklet on Alzheimer's disease (cover and text).

Needs: Buys 10-25 photos annually; offers 10 freelance assignments annually. Needs scenic photos, people (multicultural), religious activities, international locations (particularly Israel, Jerusalem, Bethlehem, etc.). Reviews stock photos. Model release required. Property release preferred. Releases needed for portraits and churches. Captions preferred; include location and names of identifiable persons.

Making Contact & Terms: Interested in receiving work from new, lesser-known photographers. Query with samples. Provide résumé, business card, brochure, flier or tearsheets to be kept on file for possible future assignments. Uses any size glossy color and b&w prints; 35mm, 2¼×2¼, 4×5, 8×10 transparencies. Keeps samples on file. SASE. Reports within 2 months. Pays $100-800/color photo; $50-500/b&w photo. **Pays on receipt of invoice.** Credit line sometimes given depending on nature of publication. Buys one-time and all rights; negotiable. Simultaneous and/or previously published work OK.

Tips: Looks for "special sensitivity to religious and spiritual subjects and locations; contemporary, multicultural people shots are especially desired."

***AMERICAN MANAGEMENT ASSOCIATION**, 1601 Broadway, New York NY 10019. (212)903-8058. Fax: (212)903-8083. E-mail: s.newton@amanet.org. Art & Production Director: Seval Newton. Estab. 1923. Publishes trade books and magazines on management. Photos used for text illustration, book covers, magazine articles and covers. Examples of recently published titles: *Management Review*, July '95 issue (cover, inside journalistic photos) and February '96 issue (cover photo, ergonomics article).

Needs: Buys 10 photos annually; offers 3-5 freelance assignments annually. Needs business and office photos. Reviews stock photos of management, business, office and professions. Model/property release required for people and locations. Captions required; include name, title of person, location and date.

Making Contact & Terms: Provide résumé, business card, brochure, flier or tearsheets to be kept on file for possible future assignments. Works with freelancers on assignment only. Uses 8×10 color prints; 2¼×2¼, 4×5 transparencies. Negatives and Kodak digital format OK. Keeps samples on file. SASE. Reports only if interested. Pays $350-500/day; 25% more for electronic usage. Pays on publication. Credit line given. Buys all rights; negotiable. Simultaneous submissions OK.

Tips: "Appreciate photographers who know and use Photoshop for enhancement and color correction. Delivery on a disk with excellent color is a big plus."

***AMERICAN PLANNING ASSOCIATION**, 122 S. Michigan, Suite 1600, Chicago IL 60603. (312)431-9100. Fax: (312)431-9985. Art Director: Richard Sessions. Publishes planning and related subjects. Photos used for text illustration, promotional materials, book covers, dust jackets. Photo guidelines and sample for $1 postage.

Needs: Buys 33 photos annually; offers 8-10 freelance assignments annually. Needs planning related photos. Captions required; include what's in the photo and credit information.

Making Contact & Terms: Interested in receiving work from newer, lesser-known photographers. Provide résumé, business card, brochure, flier or tearsheets to be kept on file for possible future assignments. Uses 8×10 glossy color or b&w prints. Keeps samples on file. SASE. Reports in 1-2 weeks. Pays $80-100/b&w photo. **Pays on receipt of invoice**. Credit line given. Buys one-time, electronic rights (CD-ROM and online). Simultaneous submissions and previously published work OK.

AMHERST MEDIA INC., 418 Homecrest Dr., Amherst NY 14226. (716)874-4450. Fax: (716)874-4508. Publisher: Craig Alesse. Estab. 1979. Publishes how-to photography and videography books. Photos used for text illustration and book covers. Examples of published titles: *The Freelance Photographer's Handbook*; *Basic Camcorder Guide* (illustration); and *Lighting for Imaging* (illustration).

Needs: Buys 25 photos annually; offers 6 freelance assignments annually. Model release required. Property release preferred. Captions preferred.

Making Contact & Terms: Interested in receiving work from newer, lesser-known photographers. Query with résumé of credits. Uses 5×7 prints; 35mm transparencies. Does not keep samples on file. SASE. Reports in 1 month. Pays $30-100/color photo; $30-100/b&w photo. Pays on publication. Credit line sometimes given depending on photographer. Rights negotiable. Simultaneous submissions OK.

AMPHOTO BOOKS, 1515 Broadway, New York NY 10036. (212)764-7300. Senior Editor: Robin Simmen. Publishes instructional and how-to books on photography. Photos usually provided by the author of the book.

Needs: Submit model release with photos. Photo captions explaining photo technique required.
Making Contact & Terms: Query with résumé of credits and book idea, or submit material by mail for consideration. SASE. Reports in 1 month. NPI. Pays on royalty basis. Buys one-time rights. Simultaneous submissions and previously published work OK.
Tips: "Submit focused, tight book ideas in form of a detailed outline, a sample chapter, and sample photos. Be able to tell a story in photos and be aware of the market."

ARDSLEY HOUSE PUBLISHERS INC., 320 Central Park West, New York NY 10025. (212)496-7040. Fax: (212)496-7146. Publishing Assistant: Linda Jarkesy. Estab. 1981. Publishes college textbooks—music, film, history, philosophy, mathematics. Photos used for text illustration and book covers. Examples of published titles: *Ethics in Thought and Action* (text illustration); *Music Melting Round* (text illustration, book cover); and *Greek & Latin Roots of English* (text illustration).
Needs: Buys various number of photos annually; offers various freelance assignments annually. Needs photos that deal with music, film and history. Reviews stock photos. Model/property release preferred.
Making Contact & Terms: Interested in receiving work from newer, lesser-known photographers. Query with samples. Query with stock photo list. Provide résumé, business card, brochure, flier or tearsheets to be kept on file for possible future assignments. Uses color and b&w prints. Keeps samples on file. SASE. Reports in 1 month. Pays $25-50/color photo; $25-50/b&w photo. **Pays on acceptance.** Credit line given. Buys book rights; negotiable.

ARJUNA LIBRARY PRESS, 1025 Garner St., D, Space 18, Colorado Springs CO 80905. Director: Prof. Joseph A. Uphoff, Jr. Estab. 1979. Publishes proceedings and monographs, surrealism and meta-mathematics (differential logic, symbolic illustration) pertaining to aspect of performance art (absurdist drama, martial arts, modern dance) and culture (progressive or mystical society). Photos used for text illustration and book covers. Example of published title: *English is a Second Language.*
Needs: Surrealist (static drama, cinematic expressionism) suitable for a general audience, including children. Model release and photo captions preferred.
Making Contact & Terms: Interested in receiving work from newer, lesser-known photographers. Query with samples. Send unsolicited photos by mail for consideration. Submit portfolio for review. Provide résumé, business card, brochure, flier or tearsheets to be kept on file for possible future assignments. Uses 5×7 glossy (maximum size) b&w and color prints. Cannot return material. Reports in "one year." Payment is 1 copy of published pamphlet. Credit line given. Rights dependent on additional use. Simultaneous submissions and previously published work OK.
Tips: "Realizing that photography is expensive, it is not fair to ask the photographer to work for free. Nevertheless, it should be understood that, if the publisher is operating on the same basis, a trade might establish a viable business mode, that of advertising through contributions of historic significance. We are not soliciting the stock photography market. We are searching for examples that can be applied as illustrations to conceptual and performance art. These ideas can be research in the contemporary context, new media, unique perspectives, animate (poses and gestures), or inanimate (landscapes and abstracts). Our preference is for enigmatic, obscure or esoteric compositions. This material is presented in a forum for symbolic announcements, *The Journal of Regional Criticism.* We prefer conservative and general audience compositions." It's helpful "to translate color photographs in order to examine the way they will appear in black & white reproduction of various types. Make a photocopy. It is always a good idea to make a photocopy of a color work for analysis."

***■❖ARNOLD PUBLISHING LTD.**, 10301-104 St., #101, Edmonton, Alberta T5J 1B9 Canada. (403)426-2998. Fax: (403)426-4607. Contact: Production Coordinator. Publishes social studies textbooks and related materials. Photos used for text illustration and CD-ROM. Examples of recently published titles: *Russia Then and Now, Canada Revisited* and *A New World Emerges* (photos used to illustrate content of the books).
Needs: Buys hundreds of photos annually; offers 2-3 freelance assignments annually. Looking for photos of history of Canada, world geography, geography of Canada. Reviews stock photos. Model/property release required. Captions preferred; include description of photo and setting.
Making Contact & Terms: Interested in receiving work from newer, lesser-known photographers. Query with stock photo list. Provide résumé, business card, brochure, flier or tearsheets to be kept on file for possible future assignments. Uses 2¼×2¼ transparencies and broadcast quality videotape. Does not keep samples on file. Cannot return material. Reports in 1 month. NPI; payment negotiated with photographer; varies with assignment. **Pays on receipt of invoice.** Credit line given. Buys book and all rights; negotiable. Simultaneous submissions and previously published work OK.

ART DIRECTION BOOK CO., INC., 456 Glenbrook Rd., Stamford CT 06906. (203)353-1441 or (203)353-1355. Fax: (203)353-1371. Contact: Art Director. Estab. 1939. Publishes advertising art, design, photography. Photos used for dust jackets.

Needs: Buys 10 photos annually. Needs photos for advertising.
Making Contact & Terms: Submit portfolio for review. Works on assignment only. SASE. Reports in 1 month. Pays $200 minimum/b&w photo; $500 minimum/color photo. Credit line given. Buys one-time and all rights.

ASSOCIATION OF AMERICAN COLLEGES AND UNIVERSITIES, 1818 R St., NW, Washington DC 20009. (202)387-3760. Fax: (202)265-9532. E-mail: olson@aacu.nw.dc.us. Production Editor: Cindy Olson. Estab. 1915. Publishes higher education journal: subject matter—educational trends focusing on curriculum, teaching and learning; research reports and monographs. Photos used for text illustration and book covers. Examples of recently published titles: *Drama of Diversity & Democracy* (cover and inside); *Liberal Learning and the Arts of Connection* (cover).
Needs: Buys 15-25 photos annually; offers 1-5 freelance assignments annually. Needs photographs depicting American college life, especially interaction between students, and students and professors, also architecture, cultural events, etc. Reviews stock photos. Model/property release required. Captions required; include name of person, event and/or location.
Making Contact & Terms: Interested in newer, lesser-known photographers. Provide résumé, business card, brochure, flier or tearsheets to be kept on file for possible future assignments. Do not send unsolicited work. Uses 5×7, 8×10 b&w prints; b&w or color transparencies. Keeps samples on file. Reports in 1 month. Pays $25-200/color photo; $25-200/b&w photo; negotiable. Pays on publication. Credit line given. Buys one-time rights. Simultaneous submissions and previously published work OK.
Tips: "We look for close-up, expressive photographs of people, and crisp, detailed shots of architecture, events. We are a small, nonprofit organization primarily interested in working with photographers who have some flexibility in their rates."

ASSOCIATION OF BREWERS, INC., 736 Pearl St., Boulder CO 80302. (303)447-0816. Fax: (303)447-2825. Graphic Production Director: Tyra Segars. Art Director: Vicki Hopewell. Estab. 1978. Publishes how-to, cooking, adult trade, hobby, brewing and beer-related books. Photos used for text illustration, promotional materials, book covers, magazines. Examples of published titles: *Great American Beer Cook Book* (front/back covers and inside); *Scotch Ale* (cover front/back).
Needs: Buys 15-50 photos annually; offers 8 freelance assignments annually. Needs still lifes and events. Reviews stock photos. Model/property release preferred.
Making Contact & Terms: Interested in receiving work from newer, lesser-known photographers. Submit portfolio for review. Query with samples. Provide résumé, business card, brochure, flier or tearsheets to be kept on file for possible future assignments. Uses color and b&w prints, 35mm transparencies. Keeps samples on file. SASE. Reports in 1-2 weeks. NPI; all jobs done on a quote basis. **Pays on receipt of invoice.** Credit line given. Preferably buys all rights, but negotiable. Simultaneous submissions and previously published works OK.
Tips: Looking for "still lifes, food and beer, equipment, event photography. Be flexible on price."

ATRIUM PUBLISHERS GROUP, 3356 Coffey Lane, Santa Rosa CA 95403. (707)542-5400. Fax: (707)542-5444. Production Manager: Steve Graydon. Estab. 1983. Publishes trade books for book and audio outlets and wholesalers.
Needs: Works with 4-5 freelancers/year, 1 videographer/year. Looking for nature, landscape, food, abstract and artistic. Reviews stock photos.
Making Contact & Terms: Interested in receiving work from newer, lesser-known photographers. Provide résumé, business card, brochure, flier or tearsheets to be kept on file for possible future assignments. Uses 4×5 transparencies. Keeps samples on file. SASE. Reports in 3 weeks. Pays $500-1,000/color photo. **Pays on receipt of invoice.** Credit line given. Buys one-time rights and all rights; negotiable.
Tips: "We purchase 12 or more original photos per year for use as catalog covers. We look for creative, even abstract, images that relate to the areas of food, health and fitness, religion and sacred places, nature or landscapes, animals. We prefer to work with individual photographers whose unique styles will draw attention to our catalogs—rather than choosing stock photos. We like to brainstorm with an artist and give an assignment for a mutually agreed-upon subject area."

AUGSBURG FORTRESS, PUBLISHERS, P.O. Box 1209, Minneapolis MN 55440. (612)330-3300. Fax: (612)330-3455. Contact: Photo Secretary. Publishes Protestant/Lutheran books (mostly adult trade), religious education materials, audiovisual resources and periodicals. Photos used for text illustration, book covers, periodical covers and church bulletins. Guidelines free with SASE.
Needs: Buys 1,000 color photos and 250 b&w photos annually. No assignments. People of all ages, variety of races, activities, moods and unposed. "Always looking for church scenarios—baptism, communion, choirs, acolites, ministers, Sunday school, etc." In color, wants to see nature, seasonal, church year and mood. Model release required.
Making Contact & Terms: Send material by mail for consideration. "We are interested in stock photos." Provide tearsheets to be kept on file for possible future assignments. Uses 8×10 glossy or

semiglossy b&w prints, 35mm and 2¼ × 2¼ color transparencies. SASE. Reports in 6-8 weeks. "Write for guidelines, then submit on a regular basis." Pays $25-75/b&w photo; $40-125/color photo. Credit line nearly always given. Buys one-time rights. Simultaneous submissions and previously published work OK.

***AUTONOMEDIA**, P.O. Box 568, Brooklyn NY 11211. Phone/fax: (718)963-2603. Editor: Jim Fleming. Estab. 1974. Publishes books on radical culture and politics. Photos used for text illustration and book covers. Examples of recently published titles: *TAZ* (cover illustration); *Cracking the Movement* (cover illustration); and *Zapatistas* (cover and photo essay).
Needs: The number of photos bought annually varies, as does the number of assignments offered. Model/property release preferred. Captions preferred.
Making Contact & Terms: Interested in receiving work from newer, lesser-known photographers. Query with samples. Send unsolicited photos by mail for consideration. Works on assignment only. Does not keep samples on file. SASE. Reports in 1 month. NPI; payment varies. Pays on publication. Buys one-time and electronic rights.

BEACON PRESS, 25 Beacon St., Boston MA 02108. (617)742-2110. Fax: (617)742-2290. Art Director: Sara Eisenman. Estab. 1854. Publishes adult nonfiction trade and scholarly books; African-American, Jewish, Asian, Native American, gay and lesbian studies; anthropology; philosophy; women's studies; environment/nature. Photos used for book covers and dust jackets. Examples of published titles: *Straight Talk about Death for Teenagers* (½-page cover photo, commissioned); *The Glory and the Power* (full-bleed cover photo, stock); and *Finding Home* (full-bleed cover photo, stock).
Needs: Buys 5-6 photos annually; offers 1-2 freelance assignments annually. "We look for photos for specific books, not any general subject or style." Model/property release required. Captions preferred.
Making Contact & Terms: Interested in receiving work from newer, lesser-known photographers. Provide résumé, business card, brochure, flier or tearsheets to be kept on file for possible future assignments. Uses 8 × 10 glossy b&w prints; 35mm, 2¼ × 2¼ transparencies. Keeps samples on file. SASE. Reports in 1 month. Pays $500-750/color photo; $150-250/b&w photo. **Pays on receipt of invoice.** Credit line given. Buys English-language rights for all (paperback and hardcover) editions; negotiable. Previously published work OK.
Tips: "I only contact a photographer if his area of expertise is appropriate for particular titles for which I need a photo. I do not 'review' portfolios because I'm looking for specific images for specific books. Be willing to negotiate. We are a nonprofit organization, so our fees are not standard for the photo industry."

BEAUTIFUL AMERICA PUBLISHING COMPANY, 9725 SW Commerce Circle, P.O. Box 646, Wilsonville OR 97070. (503)682-0173. Librarian: Jaime Thoreson. Estab. 1986. Publishes nature, scenic, pictorial and history. Photos used for text illustration, pictorial. Examples of recently published titles: *Beautiful America's Alaska*, by George Wuerthner (cover); *Fishing with Peter*, children's book (cover and text); and calendars (regional scenic).
Needs: Assigns 4-8 freelance projects annually; buys small number of additional freelance photos. Nature and scenic. Model release required. Captions required; include location, correct spelling of topic in caption.
Making Contact & Terms: Interested in receiving work from newer, lesser-known photographers. Provide résumé, business card, brochure, flier or tearsheets to be kept on file for possible future assignments. Uses 35mm, 2¼ × 2¼, 4 × 5, and 8 × 10 transparencies. Payment varies based on project; $100 minimum/color photo. Credit line given. Buys one-time rights. Simultaneous submissions and previously published work OK.
Tips: "Do not send unsolicited photos! Please do not ask for guidelines. We are using very little freelance, other than complete book or calendar projects."

BEDFORD BOOKS OF ST. MARTIN'S PRESS, 75 Arlington St., Boston MA 02116. (617)426-7440. Fax: (617)426-8582. Advertising and Promotion Manager: Donna Lee Dennison. Estab. 1981. Publishes college textbooks (freshman composition, literature and history). Photos used for text illustration, promotional materials and book covers. Examples of recently published titles: *Where the Domino Fell: America and Vietnam, 1945-1995, 2nd Edition* (stock photo used on cover); *Europe Since 1945: A Concise History, 4th Edition* (stock photo used on cover); *Our Times: Readings for Recent Periodicals, 4th Edition* (commissioned cover photo); *The Bedford Reader, 5th Edition* (cover photo).
Needs: Buys 12 photos annually; offers 2 freelance assignments annually. "We use photographs editorially, tied to the subject matter of the book (generally historic period pieces)." Also artistic, abstract, conceptual photos; nature or city; people—America or other cultures, multiracial often preferred. Also uses product shots for promotional material. Reviews stock photos. Model/property release required.
Making Contact & Terms: Interested in receiving work from newer, lesser-known photographers. Query with samples. Query with list of stock photo subjects. Provide résumé, business card, brochure,

flier or tearsheets to be kept on file for possible future assignments. Prefers artwork, such as promo cards, that doesn't need to be returned. Works with local freelancers only for product shots. Uses 8×10 b&w and color prints; 35mm, 2¼×2¼, 4×5 transparencies. SASE. Reports in 3 weeks. Pays $50-500/color photo; $50-500/b&w photo; $250-1,000/job; $500-1,800/day. Credit line sometimes given; "always covers, never promo." Buys one-time rights and all rights; depends on project; negotiable. Simultaneous submissions and/or previously published work OK.
Tips: "We are always looking for multicultural works that are nonviolent and nonsexist. We also want artistic, abstract, conceptual photos, computer-manipulated works, collages, etc."

BEHRMAN HOUSE INC., 235 Watchung Ave., West Orange NJ 07052. (201)669-0447. Fax: (201)669-9769. Editor: Ms. Ruby G. Strauss. Estab. 1921. Publishes Judaica textbooks. Photos used for text illustration, promotional materials and book covers.
Needs: Interested in stock photos of Jewish content, particularly holidays, with children. Model/property release required.
Making Contact & Terms: Interested in receiving work from newer, lesser-known photographers. Query with résumé of credits. Query with samples. Provide résumé, business card, brochure, flier or tearsheets to be kept on file for possible future assignments. Interested in stock photos. SASE. Reports in 3 weeks. Pays $50-500/color photo; $20-250/b&w photo. Credit line given. Buys one-time rights; negotiable.
Tips: Company trend is increasing use of photography.

ROBERT BENTLEY, AUTOMOTIVE PUBLISHERS, 1033 Massachusetts Ave., Cambridge MA 02138. (617)547-4170. Fax: (617)876-9235. E-mail: mbentley@rb.com. President: Michael Bentley. Estab. 1950. Publishes professional, technical, consumer how-to books. Photos used for text illustration, promotional materials, book covers, dust jackets. Examples of published titles: *Toyota Truck Owner's Bible*; *Ford F-Series Truck Owner's Bible*; *Think To Win: The New Approach to Fast Driving*.
Needs: Buys 50-100 photos annually; offers 5-10 freelance assignments annually. Looking for motorsport, automotive technical and engineering photos. Reviews stock photos. Model/property release required. Captions preferred.
Making Contact & Terms: Interested in receiving work from newer, lesser-known photographers. Query with samples. Send unsolicited photos by mail for consideration. Provide résumé, business card, brochure, flier or tearsheets to be kept on file for possible future assignments. Works on assignment only. SASE. Reports in 2 months. NPI. Payment negotiable. Credit line given. Buys electronic and all rights. Simultaneous submissions OK.

BLACKBIRCH PRESS/BLACKBIRCH GRAPHICS, INC., 260 Amity Rd., Woodbridge CT 06525. Contact: Sonja Glassman. Estab. 1979. Publishes juvenile nonfiction. Photos used for text illustration, promotional materials, book covers and dust jackets. Example of published titles: *Our Living World*, nature series of 12 volumes.
Needs: Buys 300 photos annually; offers 50 freelance assignments annually. Interested in set up shots of kids, studio product/catalog photos and location shots. Reviews stock photos of nature, animals and geography. Model release required. Property release preferred. Captions required.
Making Contact & Terms: Interested in receiving work from newer, lesser-known photographers. Query with résumé of credits. Query with samples. Query with stock photo list. Works on assignment only. Uses 35mm, 2¼×2¼, 4×5 transparencies. Keeps samples on file. Cannot return material. Reports in 1 month. Pays $50-100/hour; $500-800/day; $100-200/color photo; $60-80/b&w photo. Pays on acceptance or publication. Credit line given. Buys one-time, book, all rights; negotiable. Simultaneous submissions and previously published work OK.
Tips: "We're looking for photos of people, various cultures and nature."

BLUE BIRD PUBLISHING, 2266 S. Dobson, Mesa AZ 85202. Publisher: Cheryl Gorder. Estab. 1985. Publishes adult trade books on home education, home business, social issues (homelessness), etc. Photos used for text illustration. Examples of recently published titles: *Road School* and *Divorced Dad's Handbook*. In both, photos used for text illustration.
Needs: Buys 40 photos annually; offers 3 freelance assignments annually. Types of photos "depends on subject matter of forthcoming books." Reviews stock photos. Model release required; photo captions preferred.

LISTINGS THAT USE IMAGES electronically can be found in the Digital Markets Index located at the back of this book.

Making Contact & Terms: Query with list of stock photo subjects. Provide résumé, business card, brochure, flier or tearsheets to be kept on file for possible future assignments. Pays $25-150/color photo, $25/150/b&w photo; also pays flat fee for bulk purchase of stock photos. Buys book rights. Simultaneous submissions and previously published work OK.

Tips: "We will continue to grow rapidly in the coming years and will have a growing need for stock photos and freelance work. Send a list of stock photos for our file. If a freelance assignment comes up in your area, we will call."

BONUS BOOKS, INC., 160 E. Illinois St., Chicago IL 60611. (312)467-0580. Fax: (312)467-9271. Managing Editor: Deborah Flapan. Estab.1980. Publishes adult trade: sports, consumer, self-help, how-to and biography. Photos used for text illustration and book covers. Examples of recently published titles: *Stuck in the 70s* (cover); *What Will My Mother Say* (cover, interior); and *Hanging Out on Halsted* (cover).

Needs: Buys 1 freelance photo annually; gives 1 assignment annually. Model release required. Property release preferred with identification of location and objects or people. Captions required.

Making Contact & Terms: Interested in receiving work from newer, lesser-known photographers. Query with résumé of credits, query with samples. Provide résumé, business card, brochure, flier or tearsheets to be kept on file for possible future assignments. Uses 8×10 matte b&w prints and 35mm transparencies. Solicits photos by assignment only. Does not return unsolicited material. Reports in 1 month. Pays in contributor's copies and $150 maximum for color transparency. Credit line given if requested. Buys one-time rights.

Tips: "Don't call. Send written query. In reviewing a portfolio, we look for composition, detail, high quality prints, well-lit studio work. We are not interested in nature photography or greeting-card type photography."

♣BOSTON MILLS PRESS, 132 Main St., Erin, Ontario N0B 1T0 Canada. (519)833-2407. Fax: (519)833-2195. Publisher: John Denison. Estab. 1974. Publishes coffee table books, local guide books. Photos used for text illustration, book covers and dust jackets. Examples of recently published titles: *Union Pacific: Salt Lake Route*; *Gift of Wings*; and *Superior: Journey on an Inland Sea*.

Needs: "We're looking for book length ideas *not* stock. We pay a royalty on books sold plus advance."

Making Contact & Terms: Interested in receiving work from established and newer, lesser-known photographers. Query with résumé of credits. Uses 35mm transparencies. Does not keep samples on file. SASE and IRC. Reports in 3 weeks. NPI; payment negotiated with contract. Credit line given. Simultaneous submissions OK.

BROOKS/COLE PUBLISHING COMPANY, 511 Forest Lodge Rd., Pacific Grove CA 93950. (408)373-0728. Photo Manager, Digital Design and Image Technology: Larry Molmud. Publishes college textbooks only—child development, social psychology, family, marriage, chemistry, computers, etc. Photos used for text illustration, book covers and dust jackets.

Needs: Interested in stock photos. Model release preferred.

Making Contact & Terms: Query with list of stock photo subjects. Provide résumé, business card, brochure, flier or tearsheets to be kept on file for possible future assignments. "Also looking for photo researchers." Uses 8×10 glossy b&w prints; also transparencies, any format. SASE. Reports in 2-3 months. Pays $75-200/b&w or color photo. Credit line given. Buys one-time rights.

***WILLIAM C. BROWN PUBLISHERS**, (formerly William C. Brown Communications Inc.), Times Mirror Higher Education Group, Inc., 2460 Kerper Blvd., Dubuque IA 52001. (319)588-1451. Contact: Photo Research Department. Estab. 1944. Publishes college textbooks for the following disciplines: biology, geology, chemistry, physics, astronomy, human anatomy, microbiology, environmental science, botany. In all cases, photos used for covers and/or interiors.

Making Contact & Terms: Submit material by mail for consideration. Provide business card, brochure or stock list to be kept on file for possible future use. Direct material to Photo Research. Uses 8×10 glossy or matte prints; slides and transparencies. Reports in 1-2 months. SASE. Pays up to $90/b&w interior photo; up to $135/color interior photo. Cover photos negotiable. **Pays on acceptance.** Buys one-time rights; also all editions derivative works, electronic and custom. Previously published work OK.

Tips: "We prefer to note your areas of specialties for future reference. We need *top quality* photography. To break in, be open to lower rates."

***THE BUREAU FOR AT-RISK YOUTH**, 645 New York Ave., P.O. Box 670, Huntington NY 11743. (516)673-4584. Editor-in-Chief: Sally Germain. Estab. 1990. Publishes educational materials for teachers, mental health professionals, social service agencies on children's issues such as building self-esteem, substance abuse prevention, parenting information, etc. Photos used for text illustration, promotional materials, book covers, dust jackets. Began publishing books that use photos in 1994.

Needs: Interested in photos for use as posters of children and adults in family and motivational situations. Model release required.

Making Contact & Terms: Interested in receiving work from newer, lesser-known photographers. Send unsolicited photos by mail for consideration. Provide résumé, business card, brochure, flier or tearsheets to be kept on file for possible future assignments. "Please call if you have questions." Uses 2¼ × 2¼ transparencies. Keeps samples on file. SASE. Reports in 3-6 months. NPI; "Fees have not yet been established." Will pay on a per project basis. Pays on publication or receipt of invoice. Credit line sometimes given, depending upon project. Rights purchased depend on project; negotiable. Simultaneous submissions and/or previously published work OK.

***CELO VALLEY BOOKS**, 346 Seven Mile Ridge Rd., Burnsville NC 28714. Production Manager: D. Donovan. Estab. 1987. Publishes all types of books. Photos used for text illustration, book covers and dust jackets. Examples of published titles: *Foulkeways: A History* (text illustraton and color insert); *Tomorrow's Mission* (historical photos); *River Bends and Meanders* (cover and text photos).

Making Contact & Terms: Provide résumé, business card, brochure, flier or tearsheets to be kept on file for possible future assignments. Keeps samples on file. Uses various sizes b&w prints. Reports only as needed. NPI; negotiates with photographer. Credit line not given. Buys one-time rights and book rights. Simultaneous submissions OK.

Tips: "Send listing of what you have. We will contact you if we have a need."

***CENTER PRESS**, Box 16473, Encino CA 91416-6473. (818)754-4410. Art Director: Richelle Bixler. Estab. 1980. Publishes mostly little/literary, some calendars, and a joint venture European "*Esquire*-type" magazine. Photos used for text illustration, promotional, magazine, posters and calendars. Example of recently published title: *La Lectrice* (cultural/literary magazine distributed in Europe for liberal men and women).

Needs: Buys hundreds of photos annually. Looking for female erotica and art photos. Model/property release required prior to payment and use. Captions required; editors create this from a questionnaire the photographer supplies.

Making Contact & Terms: Interested in receiving work from newer, lesser-known photographers. Query with samples. Send unsolicited photos by mail for consideration. Uses 5 × 7, 8 × 10 glossy color and b&w prints; 35mm, 2¼ × 2¼, 4 × 5, 8 × 10 transparencies; VHS videotape. Keeps samples on file if requested and résumé included. SASE; doesn't return photos without adequate postage. Reporting time depends on workload. Pays $10-100/color photo; $10-50/b&w photo. Pays on publication. Credit line given. Buys one-time, book and all rights; negotiable. Simultaneous submissions and previously published work OK.

Tips: "The photos we use are primarily female nudes, art-type and erotic. We'd like to see more photos of women by women and even self-portraits."

CENTERSTREAM PUBLICATION, P.O. Box 17878, Anaheim CA 92807. Phone/fax: (714)779-9390. Owner: Ron Middlebrook. Estab. 1982. Publishes music history (guitar—drum), music instruction all instruments, adult trade, juvenile, textbooks. Photos used for text illustration, book covers. Examples of published titles: *Dobro Techniques, History of Leedy Drums, History of National Guitars*.

Needs: Reviews stock photos of music. Model release preferred. Captions preferred.

Making Contact & Terms: Interested in receiving work from newer, lesser-known photographers. Query with samples. Query with stock photo list. Send unsolicited photos by mail for consideration. Provide résumé, business card, brochure, flier or tearsheets to be kept on file for possible future assignments. Works on assignment only. Uses color b&w prints; 35mm, 2¼ × 2¼, 4 × 5 transparencies. Keeps samples on file. Reports in 1 month. NPI. Pays on receipt of invoice. Credit line given. Buys all rights. Simultaneous submissions and/or previously published works OK.

CHATHAM PRESS, Box A, Old Greenwich CT 06870. (203)531-7755. Editor: Roger Corbin. Estab. 1971. Publishes New England and ocean-related topics. Photos used for text illustration, book covers, art and wall framing.

Needs: Buys 25 photos annually; offers 5 freelance assignments annually. Preferably New England and ocean-related topics. Model release preferred; photo captions required.

Making Contact & Terms: Query with samples. Uses b&w prints. SASE. Reports in 1 month. NPI. Credit line given. Buys all rights.

Tips: To break in with this firm, "produce superb b&w photos. There must be an Ansel Adams-type of appeal—which is instantaneous to the viewer!"

CLEANING CONSULTANT SERVICES, P.O. Box 1273, Seattle WA 98111. (206)682-9748. Fax: (206)622-6876. Publisher: William R. Griffin. "We publish books on cleaning, maintenance and self-employment. Examples are related to janitorial, housekeeping, maid services, window washing, carpet cleaning, etc." Photos are used for text illustration, promotional materials, book covers and all

uses related to production and marketing of books. Photo guidelines free with SASE. Sample issue $3.

Needs: Buys 20-50 freelance photos annually; offers 5-15 freelance assignments annually. Photos of people doing cleaning work. Reviews stock photos. Model release preferred. Captions preferred.

Making Contact & Terms: Query with résumé of credits, samples, list of stock photo subjects or send unsolicited photos by mail for consideration. Provide résumé, business card, brochure, flier or tearsheets to be kept on file for possible future assignments. Uses 5×7 and 8×10 glossy b&w and color prints. SASE. Reports in 3 weeks. Pays $5-50/b&w photo; $5/color photo; $10-30/hour; $40-250/job; negotiable depending on specific project. Credit lines generally given. Buys all rights; depends on need and project; rights negotiable. Simultaneous submissions and previously published work OK.

Tips: "We are especially interested in color photos of people doing cleaning work in other countries, for use on the covers of our quarterly magazine, *Cleaning Business*. Be willing to work at reasonable rates. Selling two or three photos does not qualify you to earn top-of-the-line rates. We expect to use more photos, but they must be specific to our market, which is quite select. Don't send stock sample sheets. Send photos that fit our specific needs. Call if you need more information or would like specific guidance."

***CLEIS PRESS**, Box 14684, San Francisco CA 94114. (415)864-3385. Fax: (415)864-5602. E-mail: sfcleis@aol.com. Art Director: Frédérique Delacoste. Estab. 1979. Publishes fiction, nonfiction, trade and lesbian/gay erotica. Photos used for book covers. Examples of recently published titles: *Best Lesbian Erotica 1996*, *Best Gay Erotica 1996*, and *Dark Angels* (all fiction collections).

Needs: Buys 10 photos annually. Reviews stock photos.

Making Contact & Terms: Interested in receiving work from newer, lesser-known photographers. Provide résumé, business card, brochure, flier or tearsheets to be kept on file for possible future assignments. Works with local freelancers on assignment only. Uses color and b&w prints; 35mm transparencies. Keeps samples on file. SASE. Reports in 3 weeks. Pays $150/photo for all uses in conjunction with book. **Pays on acceptance.** Credit line given. Buys book rights; negotiable.

COMPASS AMERICAN GUIDES, 5332 College Ave., Oakland CA 94618. (510)547-7233. Fax: (510)547-2145. Creative Director: Christopher C. Burt. Estab. 1990. Publishes travel guide series for every state in the U.S. and 15 major cities, also Canadian provinces and cities. Photos used for text illustration and book covers. Examples of recently published titles: *Compass American Guide to Santa Fe*, *Compass American Guide to Texas*, and *Compass American Guide to the Southwest*.

Needs: Buys 1,000-1,500 photos annually; offers 8-10 freelance assignments annually. Reviews stock photos (depends on project). Model release required, especially with prominent people. Property release preferred. Captions required.

Making Contact & Terms: Interested in receiving work from newer, lesser-known photographers as well as seasoned professionals. Provide résumé, business card, brochure, flier or tearsheets to be kept on file for possible future assignments. "Do not phone; fax OK." Works on assignment only. Uses 35mm, 2¼×2¼, 4×5, 8×10 transparencies. Keeps samples on file. Cannot return unsolicited material. Reports in "one week to five years." Pays $5,000/job. Pays ⅓ advance, ⅓ acceptance, ⅓ publication. Buys one-time and book rights. Photographer owns copyright to images. Simultaneous submissions and previously published work OK.

Tips: "Our company works only with photographers native to, or currently residing in, the state or city in which we are publishing the guide. We like creative approaches that capture the spirit of the place being covered. We need a mix of landscapes, portraits, things and places."

CONSERVATORY OF AMERICAN LETTERS, P.O. Box 298, Thomaston ME 04861. (207)354-0998. Fax: (207)354-8953. President: Robert Olmsted. Estab. 1986. Publishes "all types of books except porn and evangelical." Photos used for promotional materials, book covers and dust jackets. Examples of recently published titles: *Dan River Stories* and *Dan River Anthology* (cover); *After the Light* (covers).

Needs: Buys 2-3 photos annually. Model release required if people are identifiable. Photo captions preferred.

Making Contact & Terms: Uses 3×5 to 8×10 b&w glossy prints, also 5×7 or 6×9 color prints, vertical format. SASE. Reports in 1 week. Pays $5-50/b&w photo; $35-200/color photo; per job payment negotiable. Credit line given. Buys one-time and all rights; negotiable.

Tips: "We are a small market. We need *few* photos, but can never find them when we do need them."

CORNERSTONE PRODUCTIONS INC., P.O. Box 55229, Atlanta GA 30308. (770)621-2514. President/CEO: Ricardo A. Scott J.D. Estab. 1985. Publishes adult trade, juvenile and textbooks. Photos used for text illustration, promotional materials and book covers. Examples of published titles: *A Reggae Education* (illustrative); and *Allied Health Risk-Management* (illustrative).

Needs: Buys 10-20 photos annually; offers 50% freelance assignments annually. Photos should show life in all its human and varied forms—reality! Reviews stock photos of life, nature, medicine, science, the arts. Model/property release required. Captions required.

Making Contact & Terms: Interested in receiving work from newer, lesser-known photographers. Submit portfolio for review. Send unsolicited photos by mail for consideration. Uses 5×7, 10×12 glossy color and b&w prints; 4×5, 8×10 transparencies; VHS videotape. Keeps samples on file. SASE. Reports in 1 month. NPI. Pays on publication. Credit line sometimes given depending upon the particular projects and arrangements, done on an individual basis. Buys all rights; negotiable. Simultaneous submissions and previously published work OK.

Tips: "The human aspect and utility value is of prime importance. Ask 'How can this benefit the lives of others?' Let your work be a reflection of yourself. Let it be of some positive value and purpose towards making this world a better place."

CRABTREE PUBLISHING COMPANY, 350 Fifth Ave., Suite 3308, New York NY 10118. (905)262-5814. Fax: (905)262-5890. Contact: Editorial (Dept.). Estab. 1978. Publishes juvenile nonfiction, library and trade—natural science, history, geography (including cultural geography), 18th and 19th-century America, ecology. Photos used for text illustration, book covers. Examples of recently published titles: *Peru: the Land* (text illustration, cover); *Old-Time Toys* (text illustration); and A...B...-Sea (text illustration, cover).

Needs: Buys 400-600 photos annually; offers 3-6 freelance assignments annually. Wants photos of children, cultural events around the world, animals (exotic and domestic). Model/property release required for children, photos of artwork, etc. Captions preferred; include place, name of subject, date photographed.

Making Contact & Terms: Interested in receiving work from newer, lesser-known photographers. Unsolicited photos will be considered but not returned. Provide résumé, business card, brochure, flier or tearsheets to be kept on file for possible future assignments. Works with local freelancers only. Uses color prints; 35mm, $2\frac{1}{4}\times2\frac{1}{4}$, 4×5, 8×10 transparencies. Keeps samples on file. SASE. Reports in 1-2 weeks. Pays $40-75/color photo. Pays on publication. Credit line given. Buys non-exclusive rights. Simultaneous submissions and/or previously published works OK.

Tips: When reviewing a portfolio, this publisher looks for bright, intense color and clarity. "Since books are for younger readers, lively photos of children and animals are always excellent." Portfolio should be "diverse and encompass several subjects, rather than just one or two; depth of coverage of subject should be intense, so that any publishing company could, conceivably, use all or many of a photographer's photos in a book on a particular subject."

CROSS CULTURAL PUBLICATIONS, INC., P.O. Box 506, Notre Dame IN 46556. (219)272-0889. Fax: (219)273-5973. General Editor: Cy Pullapilly. Estab. 1980. Publishes nonfiction, multicultural books. Photos used for book covers and dust jackets. Examples of published titles: *Night Autopsy Room*, *Red Rum Punch*, and *Boots from Heaven*.

Needs: Buys very few photos annually; offers very few freelance assignments annually. Model release preferred. Captions preferred.

Making Contact & Terms: Interested in receiving work from newer, lesser-known photographers. Provide résumé, business card, brochure, flier or tearsheets to be kept on file for possible future assignments. Works on assignment only. Does not keep samples on file. Cannot return material. Reports in 3 weeks. NPI; varies depending on individual agreements. **Pays on acceptance.** Credit line given. Simultaneous submissions and previously published work OK.

CROSSING PRESS, P.O. Box 1048, Freedom CA 95019. (408)722-0711. Fax: (408)722-2749. Publisher: Elaine Gill. Art Director: Amy Sibiga. Estab. 1971. Publishes adult trade, cooking, calendars, health, humor and New Age books. Photos used for text illustration, book covers. Examples of recently published titles: *Natural Healing for Babies and Children*, (cover); *The Great Turkey Cookbook* (cover); and *The Great Barbecue Companion* (cover, text illustration).
 • Crossing Press books were judged Best Covers on Display at the 1995 ABA by the *Small Press Literary Review.*

Needs: Buys 70-100 photos annually; offers 3-6 freelance assignments annually. Looking for photos of food, people, how-to steps for health books. Reviews stock photos of food, people, avant-garde material (potential book covers). Model/property release required. Captions preferred.

Making Contact & Terms: Interested in receiving work from newer, lesser-known photographers. Submit portfolio for review. Query with samples. Provide résumé, business card, brochure, flier or tearsheets to be kept on file for possible future assignments. Works on assignment only. Uses color and b&w. Keeps samples on file. SASE. Pays $50-500/b&w photo; $50-700/color photos; $50-5,000/job. **Pays on acceptance**/comp copies of book. Credit line given. Buys one-time and book rights; negotiable. Simultaneous submissions and previously published works OK.

Tips: Looking for photos which are "unique, stylish but not overdone—tight closeups of food—portraits of interesting everyday people—quirky scenes that can be utilized for different reasons. We are

a mid-size independent press with limited budgets, but can offer unique opportunities for photographers willing to work closely with us. Increasing rapidly—a desire for style without predictability."

***■CRUMB ELBOW PUBLISHING**, P.O. Box 294, Rhododendron OR 97049. (503)622-4798. Publisher: Michael P. Jones. Estab. 1979. Publishes juvenile, educational, environmental, nature, historical, multicultural, travel and guidebooks. Photos used for text illustration, promotional materials, book covers, dust jackets and educational videos. "We are just beginning to use photos in books and videos." Photo guidelines free with SASE.
Needs: Looking for nature, wildlife, historical, environmental, folklife, historical re-enactments, ethnicity and natural landscapes. Model/property release preferred for individuals posing for photos. Captions preferred.
Making Contact & Terms: Submit portfolio for review. Query with résumé of credits. Query with samples. Query with stock photo list. Send unsolicited photos by mail for consideration. Provide résumé, business card, brochure, flier or tearsheets to be kept on file for possible future assignments. Works on assignment only. Uses 3×5, 5×7, 8×10 color or b&w prints; 35mm transparencies; videotape. Keeps samples on file. SASE. Reports in 1 month depending on work load. Pays in contributor's copies. Pays on publication. Credit line given. Buys one-time rights. Simultaneous submissions OK.
Tips: "Publishers are still looking for black & white photos due to high production costs for color work. Don't let opportunities slip by you. Use two cameras—one for black & white and one for color. Multimedia is the coming thing and more opportunities for freelancers will result."

***DANCING JESTER PRESS**, 3411 Garth Rd., Baytown TX 88521. (713)427-95960. Fax: (713)428-8685. Art Director: Gabriel Thomson. Estab. 1995. Publishes children's art and mystery, adult mystery, cooking, adult trade, fiction, poetry and nonfiction. Photos used for text illustration, promotional materials, book covers, dust jackets. Examples of recently published titles: *The Third Millennium Spicery & Herbal Handbook* (dust jacket); *Let's Draw in Perspective* (dust jacket); and *Driver without Brakes*.
Needs: Buys 25 photos annually. Herbs and spices, animals in natural poses; painterly style. Subject depends on the book. Always needs authors' photos. Reviews stock photos. Model/property release preferred. Captions preferred.
Making Contact & Terms: Interested in receiving work from newer, lesser-known photographers. Query with samples. Query with stock photo list. Send unsolicited photos by mail for consideration. Works on assignment only. Uses 4×5, 8×10 glossy color and b&w prints; 2¼×2¼, 4×5, 8×10 transparencies. Keeps samples on file. SASE. Reports in 1 month. Pays $50-100/day; $100-200/job; $10-50/color photo; $10-50/b&w photo. Pays on publication. Credit line given. Buys book and all rights; negotiable. Simultaneous submissions and previously published work OK.
Tips: "We are looking for creativity and imagination. Send the most exciting photographs you have taken. Learn to use the computer; we are adding CD-ROM in the late summer and will be open to photographers with large collections from that point on."

DIAL BOOKS FOR YOUNG READERS, 375 Hudson St., New York NY 10014. (212)366-2803. Fax: (212)366-2020. Senior Editor: Toby Sherry. Publishes children's trade books. Photos used for text illustration, book covers. Examples of published titles: *How Many* (photos used to teach children how to count); and *Jack Creek Cowboy*.
Making Contact & Terms: Photos are only purchased with accompanying book ideas. Works on assignment only. Does not keep samples on file. NPI. Credit line given.

***DOCKERY HOUSE PUBLISHING INC.**, 1720 Regal Row, Suite 228, Dallas TX 75235. (214)630-4300. Fax: (214)638-4049. Art Director: Janet Todd. Photos used for text illustration, promotional material, book covers, catalogs. Example of recently published title: *Celebration of America* (scenery of travel spots).
Needs: Looking for food, scenery, people. Needs vary. Reviews stock photos. Model release preferred.
Making Contact & Terms: Interested in receiving work from newer, lesser-known photographers. Query with samples. Provide résumé, business card, brochure, flier or tearsheets to be kept on file for possible future assignments. Works on assignment only. Uses all sizes and finishes of color, b&w prints; 35mm, 2¼×2¼, 4×5 transparencies. Keeps samples on file. Cannot return material. Reports in 1 month. NPI. Payment varies. Pays net 30 days. Credit line sometimes given depending upon type of book. Buys all rights; negotiable.

DPG/BROWN & BENCHMARK, (formerly Dushkin Publishing Group, Inc.), Sluice Dock, Guilford CT 06437. (203)453-4351. Managing Art Editor: Pamela Carley. Estab. 1971. Publishes college textbooks. Photos used for text illustration, book covers. Examples of published titles: *Sexuality Today*, *Cultural Anthropology*, *International Politics on the World Stage*.

Needs: Varies according to subject. "I tend to use the work of freelance photographers I see in other sources and in some cases, the work of those who contact me." Reviews stock photos. Model release preferred. Captions preferred.

Making Contact & Terms: Interested in receiving work from newer, lesser-known photographers. Query with stock photo list. Send unsolicited photocopies or tearsheets by mail for consideration. Provide résumé, business card, brochure, flier or tearsheets to be kept on file for possible future assignments. Uses 8×10 glossy b&w prints; 35mm, 2¼×2¼, 4×5, 8×10 transparencies. Keeps samples on file. Reporting time "varies from project to project. Often takes 2-3 months if we seriously consider. If not interested we can respond quickly." NPI. Pays on publication. Credit line given. Buys one-time rights; negotiable. Previously published works OK.

Tips: "Subjects include: psychology, anthropology, education, human sexuality, international politics, American government, health. Looking for good quality current material. Mostly b&w, but some color. Looking especially for good, recent people shots that relate to the above subjects. Ethnic variety."

EASTERN PRESS, INC., P.O. Box 881, Bloomington IN 47402. Publisher: Don Lee. Estab. 1981. Publishes university-related Asian subjects: language, linguistics, literature, history, archaeology. Teaching English as Second Language (TESL); Teaching Korean as Second Language (TKSL); Teaching Japanese as Second Language (TJSL); Chinese, Arabic. Photos used for text illustration. Examples of recently published titles: *An Annotated Bibliography on South Asia* and *An Annotated Prehistoric Bibliography on South Asia.*

Needs: Depends upon situation. Looking for higher academic. Captions for photos related to East Asia/Asian higher academic.

Making Contact & Terms: Interested in receiving work from newer, lesser-known photographers. Provide résumé, business card, brochure, flier or tearsheets to be kept on file for possible future assignments. Uses 6×9 book transparencies. Keeps samples on file. Reports in 1 month (sometimes 1-2 weeks). Payment negotiable. **Pays on acceptance.** Credit line sometimes given. Rights negotiable.

Tips: Looking for "East Asian/Arabic textbook-related photos. However, it depends on type of book to be published. Send us résumé and about two samples. We keep them on file. Photos on, for example, drama, literature or archaeology (Asian) will be good, also TESL."

ELLIOTT & CLARK PUBLISHING, 1745 Kalorama Rd. NW, Suite B1, Washington DC 20009. (202)387-9805. Fax: (202)483-0355. E-mail: ecp@dgsys.com. Vice President: Carolyn Clark. Estab. 1991. Looking for illustrated book projects, not single stock images.

Needs: Interested in natural history, Americana, history and music. Does not want to see "cute and fuzzy" subjects. Model/property release preferred. Captions preferred.

Making Contact & Terms: Interested in receiving work from newer, lesser-known photographers. Query with samples. Provide résumé, business card, brochure, flier or tearsheets to be kept on file for possible future assignments. Uses 35mm, 2¼×2¼, 4×5 transparencies. Keeps samples on file. SASE. Reports in 4-6 weeks. Royalties paid on gross sales of books. Single photographers get cover credit. Buys one-time rights and rights for hard and soft covers, and foreign language editions; negotiable.

Tips: "We like to feature one photographer's work. The photography must tell a story and the photographer must be able to relay the concept and know possible markets."

ELYSIUM GROWTH PRESS, 814 Robinson Rd., Topanga CA 90290. (310)455-1000. Fax: (310)455-2007. Director of Marketing: Chris Moran. Estab. 1961. Publishes adult trade books on nudist/naturist/clothing-optional resorts, parks and camps. Photos used for text illustration, promotional, book covers and dust jackets. Examples of published titles: *Nudist Nudes, Shameless Nude.* Photos used for cover and text in both. Photo guidelines free with SASE; catalog, with SASE, 55¢ postage.

Needs: Buys 50 photos annually. Reviews stock photos. Model release required. Captions required.

Making Contact & Terms: Provide résumé, business card, brochure, flier or tearsheets to be kept on file for possible future assignments. Uses 5×7 glossy b&w and color prints; 35mm and 2¼×2¼ transparencies. SASE. Reports in 2 weeks. Pays $50-100/color photo, $35-50/b&w photo. Credit line given. Buys all rights; negotiable. Simultaneous submissions OK.

Tips: In samples, looking for "nudist/naturist lifestyle photos only."

ENCYCLOPAEDIA BRITANNICA, 310 S. Michigan Ave., 3rd Floor, Chicago IL 60604. (312)347-7000. Fax: (312)347-7914. Art Director: Bob Ciano. Estab. 1768. Publishes encyclopedia/ yearbooks. Photos used for text illustration, promotional materials. Examples of published titles: *Encyclopedia Britannica* (text illustration); *Britannica Book of the Year* (text illustration); *Yearbook of Science and the Future* (text illustration); *Medical & Health Annual*; Britannica On-Line; Britannica CD.
 ● Encyclopaedia Britannica has begun seeking nonexclusive world print and electronic rights. For these added rights they have paid $175-200 per image.
Needs: Buys hundreds of photos annually. Needs photos of natural history, personalities, breakthroughs in science and medicine, art, geography, history, architecture. Reviews stock photos. Captions required. "This is very important to us! Captions must be very detailed."
Making Contact & Terms: Interested in receiving work from newer, lesser-known photographers. Query only with stock photo list. Uses any size or finish color and b&w prints; 35mm, 2¼×2¼, 4×5, 8×10 transparencies. Keeps samples on file. Cannot return unsolicited material. "We only contact when needed." NPI. **Pays on receipt of invoice.** Credit line given. Buys one-time world rights; negotiable.
Tips: "Photos must be well-lighted and sharply focused. The subject must be clearly visible. We prefer photographers who have a solid knowledge of their subject matter. Submissions should be tightly edited. Loosely edited submissions take up valuable time! Ultimately, the photos must be informative. Space is limited, so pictures must literally speak a thousand words! Stock lists and samples will be routed through the department. We are always looking for new sources of material."

ENTRY PUBLISHING, INC., 27 W. 96th St., New York NY 10025. (212)662-9703. President: Lynne Glasner. Estab. 1981. Publishes education/textbooks, secondary market. Photos used for text illustrations.
Needs: Number of freelance photos bought and freelance assignments given vary. Often looks for shots of young teens in school settings. Reviews stock photos. Model release required. Captions preferred.
Making Contact & Terms: Interested in receiving work from newer, lesser-known photographers. Query with list of stock photo subjects. Provide résumé, business card, brochure, flier or tearsheets to be kept on file for possible future assignments. Uses b&w prints. SASE. Reports in 3 weeks. NPI; payment depends on job requirements. Credit line given if requested. Buys one-time rights; negotiable. Simultaneous submissions and previously published work OK.
Tips: "Have wide range of subject areas for review and use. Stock photos are most accessible and can be available quickly during the production of a book."

***FAIRCHILD BOOKS**, 7 W. 34th St., New York NY 10001. (212)630-3664. Fax: (212)630-3868. Art Director: David Jaenisch. Estab. 1892. Publishes textbooks (mostly fashion-related) including how-to books on sewing, draping, etc. Examples of recently published titles: *A Guide to Fashion Sewing* (2nd Ed.); *Changing Appearances*; and *Visual Merchandising and Display* (3rd Ed.). All photos used for cover and text illustration.
Needs: Buys 100 photos annually; offers 5-10 freelance assignments annually. Fashion-related; how-to (instructional); still life for covers.
Making Contact & Terms: Interested in receiving work from newer, lesser-known photographers. Query with résumé of credits. Provide résumé, business card, brochure, flier or tearsheets to be kept on file for possible future assignments. Works on assignment only. Uses 8×10, 5×7 b&w prints; 35mm, 2¼×2¼, 4×5 transparencies. Keeps samples on file. Cannot return material. Reports when photo needs arise. Pays $300-600/day; $300-600/job. **Pays on receipt of invoice.** Credit line given. Buys one-time, book and all rights; negotiable. Previously published work OK.
Tips: Wants "photos that communicate an idea or subject matter in a very creative way (for covers); photos that are clear and well-composed for instructional, how-to books. Send promo card or good photocopies of work (especially previously published work). We seek people whom we can can rely on for consistently high quality work. Lesser-known talents are desirable."

FIVE CORNERS PUBLICATIONS, HCR 70 Box 2, Plymouth VT 05056. (802)672-3868. Fax: (802)672-3296. Editor: Donald Kroitzsh. Estab. 1990. Publishes adult trade (such as coffee table photo books), a travel newsletter and how-to books about travel. Photos used for text illustration. Examples of published titles: *American Photographers at the Turn of the Century: People & Our World* and *American Photographers at the Turn of the Century: Nature & Landscape*.
Needs: Buys 20 photos annually. Interested in complementary photos to articles, showing technical matter and travel scenes. Model release preferred. Captions required.
Making Contact & Terms: Interested in receiving work from newer, lesser-known photographers. Query with résumé of credits. Works with freelancers only. Uses color and b&w prints; 35mm,

INSIDER REPORT

Wegman's career develops into a fairy "tail"

William Wegman remembers a time early in his career when he traveled through Europe carrying all his work in "three little 11 × 14 photo boxes." His entire body of work consisted of roughly 30 pieces and he was eager to show them off. "I'm the type of person who likes to say, 'See what I did,'" says Wegman. "Other artists are very protective. They only show a couple things and let them out slowly."

William Wegman

© 1995 Arnie Hernandez

Times have changed. Wegman no longer needs to struggle for acclaim. He has become one of today's foremost photographers. He is a two-time winner of the Guggenheim Fellowship (1975 and 1986); he has exhibited in premier galleries, such as The Corcoran Gallery of Art in Washington D.C., The Museum of Modern Art and the Whitney Museum of American Art in New York City; and, in recent years, he has played off the popularity of his anthropomorphic weimaraners to create numerous children's books, such as *Cinderella* and *Little Red Riding Hood* (both published by Hyperion Books for Children).

And, he has much more work to show. "Now I've done more things than any one person can look at. There are caves and walls of photos. I get that bloated feeling," says Wegman from his home in Maine.

For the rest of us, Wegman's bloated feeling is something to cherish. It means there is plenty of work to admire and analyze—from his early conceptual work of the 1960s when he floated Styrofoam commas down the Milwaukee River, to the kids' books and videos of today that showcase his weimaraners.

His mastery comes from his ability to evolve and convey various messages. This is one area that seems to strike a chord with Wegman when considering advice for newcomers. "They really ought to look at their pictures to see what the photos are saying. When I go to schools to talk, there's so much crap that people say about their work that just isn't emanating from the surface of the paper. It's all in their heads, like little stories about what they're doing."

Since graduating from the Massachusetts College of Art in Boston in 1965, Wegman has kept his subject matter fresh. "My later work is more seduced by how the dogs look—how beautiful they are, where they are looking, what they appear to be thinking. In the old work, the dogs are more stoic. The dogs are there on the box, or in the box, looking left, looking right, doing really simple, very strong gestures."

INSIDER REPORT, *continued*

© 1992 William Wegman. Courtesy Pace/MacGill Gallery.

William Wegman loves to photograph his weimaraners in all sorts of playful and zany situations. In recent years his projects have included children's books, such as adaptations of *Cinderella* and *Little Red Riding Hood*, and video work for the kids' show *Sesame Street*.

INSIDER REPORT, *Wegman*

His playful, comedic approach fits nicely with his more recent projects. Wegman says he began working on children's books when Hyperion asked him to recreate some fairy tales. "Once I got started I got kind of addicted to it. I like the process of having a photograph end up, not just in a gallery or in a museum or on somebody's wall, but in another form."

Wegman retold the fairy tales by dressing up the weimaraners as characters and placing them in intricate scenes. The cast included one of his favorite subjects, Fay Ray, who died in 1995. "As soon as I made Fay tall, it seemed to make the characters more believable as mythological figures," he says. "When people dress up dogs and they're little, they look like beer ads. There's something demeaning about them. When I made Fay tall, and I put her up on something and put a dress over her, she became really quite profound looking. Then the anthropomorphic possibilities became really strong."

In creating the books, Wegman wanted to match the dogs' personalities with the characters they were playing. He also tried to influence the character of the dogs by the types of gowns they wore. "I noticed in one picture that Fay looked rather evil in her wig, so she became the stepmother to Cinderella. I noticed that Battina, no matter how I dressed her up, always looked sweet and forlorn. She became a good choice for Cinderella."

Along with the fairy tales, Wegman has produced fun and educational material for children, such as his books *ABC* and *1,2,3* (both by Hyperion). There also are videos for the home, such as *Alphabet Soup* and *Fay's Twelve Days of Christmas*; and any pre-schooler can tell you about Wegman's videos that appear on the TV show *Sesame Street*. His relationship with *Sesame Street* evolved after the show's producers sent him a book "the size of the Manhattan Yellow Pages" with concepts that he could tackle.

"It's fun to work on something that gets nursed along, like videos. You have to do voice-overs, music, editing, some set building, scriptwriting. So many parts to it involve so many people, and it just takes time. It's very operatic," he says.

Often, however, completing the opera is not as easy as it seems when looking at the finished product. Wegman's weimaraners are attentive to what he wants, but they are not trained. "In still photography it's easy. You can get a moment that's magical and it transcends what you're thinking about. In film work you have to think up new ways to get it to happen. If you want the dogs to look in four different directions, you can do it once, but the next time they're going to look directly at you. . . . To make Chundo (the Big Bad Wolf) look mean, I had to go away from him about 100 feet so that he would squint to see me. When I approached him he would look kind and happy."

One would think that Wegman might grow tired of his four-legged subjects, but actually they revitalize him. He also doesn't mind being labeled as "The Dog Guy" because the dogs have given him so much. "When you're signing books and 200 people come up to you with stories about their dogs, it can get repetitive. But it's also incredibly lovely. You'd have to really be kind of an ogre to not like that. People feel like telling me about their dogs that they just lost, or the new puppy they have. I feel kind of like the Bishop of Dogs."

—Michael Willins

2¼×2¼, 4×5, 8×10 transparencies. SASE. Reports in 1-2 weeks. Pays $25/color photo; $25/b&w photo. Pays on publication. Credit line given. Buys one-time rights. Simultaneous submissions and/or previously published work OK.

MICHAEL FRIEDMAN PUBLISHING GROUP, INC., 15 W. 26th St., New York NY 10010. (212)685-6610. Photography Director: Christopher Bain. Estab. 1979. Publishes adult trade: science and nature series; sports; food and entertainment; design; and gardening. Photos used for text illustration, promotional materials, book covers and dust jackets.
Needs: Buys 7,500 freelance photos annually; offers 20-30 freelance assignments annually. Reviews stock photos. Captions preferred.
Making Contact & Terms: Query with specific list of stock photo subjects. Uses 35mm, 120, 4×5 and 8×10 transparencies. Pays $50-100/color stock photo; $350-500/day. Payment upon publication of book for stock photos; within 30-45 days for assignment. Credit line always given. Buys rights for all editions. Simultaneous submissions and previously published work OK.

***GASLIGHT PUBLICATIONS**, 2809 Wilmington Way, Las Vegas NV 89102-5989. (703)221-8495. Fax: (702)221-8297. E-mail: 71604.511@compuserve.com. Publisher: Jack Tracy. Estab. 1979. Publishes adult trade and Victorian literature studies books. Photos used for text illustration, promotional materials, book covers and dust jackets.
Needs: Buys very few photos annually. Uses some copy photography; very rarely a cover photo. Model/property release required. Captions preferred.
Making Contact & Terms: Interested in receiving work from newer, lesser-known photographers. Query. Works on assignment only. Uses 8×10 glossy b&w prints; 35mm, 2¼×2¼, 4×5 transparencies. Keeps samples on file. Reports in 1-2 weeks. Pays $200/color photo; copy photography batch jobs negotiable. **Pays on receipt of invoice.** Acknowledgements sometimes given. Buys all rights; negotiable.

GLENCOE PUBLISHING/MACMILLAN/MCGRAW HILL, 15319 Chatsworth St., Mission Hills CA 91345. Attention: Photo Editor. Publishes elementary and high school textbooks, religion, careers, business, office automation, social studies and fine arts. Photos used for text illustration and book covers. Examples of published titles: *Art Talk*, *Career Skills* and *Marketing Essentials*.
Needs: Buys 500 photos annually. Occasionally offers assignments. Children and teens at leisure, in school, in Catholic church; interacting with others: parents, siblings, friends, teachers; Catholic church rituals; young people (teens, early 20s) working, especially in jobs that go against sex-role stereotypes. Model release preferred.
Making Contact & Terms: Send stock photo list. List kept on file for future assignments. Uses 8×10 glossy b&w prints and 35mm slides. Pays $50/b&w photo, $100/color photo (¼ page). Buys one-time rights, but prefers to buy all rights on assignment photography with some out takes available to photographer. Simultaneous submissions and previously published work OK.
Tips: "A good ethnic mix of models is important. We look for a contemporary, unposed look."

GRAPHIC ARTS CENTER PUBLISHING COMPANY, P.O. Box 10306, Portland OR 97210. (503)226-2402. Fax: (503)223-1410. Photo Editor: Diana Eilers. Publishes adult trade photographic essay books. Photos used for photo essays.
Needs: Offers 5 freelance assignments annually. Needs photos of landscape, nature, people, historic architecture and other topics pertinent to the essay. Captions preferred.
Making Contact & Terms: Uses 35mm, 2¼×2¼ and 4×5 transparencies (35mm as Kodachrome 25 or 64). NPI; pays by royalty—amount varies based on project; minimum, but advances against royalty are given. Credit line given. Buys book rights. Simultaneous submissions OK.
Tips: "Photographers must be previously published in book form, and have a minimum of five years fulltime professional experience to be considered for assignment. Prepare an original idea as a book proposal. Full color essays are expensive to publish, so select topics with strong market potential."

GRAPHIC ARTS PUB INC., 3100 Bronson Hill Rd., Livonia NY 14487. Estab. 1979. Publishes textbooks, adult trade—how-to quality and reproduction of color for printers and publishers. Photos used for text illustration, promotional materials, book covers. Examples of published titles: *Color Separation on the Desktop* (cover and illustrations); *Quality & Productivity in the Graphic Arts*.
Needs: Varies; offers 1-2 freelance assignments annually. Looking for technical photos. Model release preferred.
Making Contact & Terms: Works on assignment only. Uses color prints; 35mm transparencies.

GREAT QUOTATIONS PUBLISHING CO., 1967 Quincy Ct., Glendale Heights IL 60139. (708)582-2800. Fax: (708)582-2813. Senior Marketing Manager: Patrick Caton. Estab. 1985. Publishes gift books.

Needs: Buys 10-20 photos annually; offers 10 freelance assignments annually. Looking for inspirational or humorous. Reviews stock photos of inspirational, humor, family. Model/property release preferred.

Making Contact & Terms: Interested in receiving work from newer, lesser-known photographers. Provide résumé, business card, brochure, flier or tearsheets to be kept on file for possible future assignments. Works on assignment only. Uses color and b&w prints; 35mm, 2¼×2¼, 4×5 transparencies. Keeps samples on file. SASE. "We prefer to maintain a file of photographers and contact them when appropriate assignments are available." NPI. Pays on publication. "We will work with artist on rights to reach terms all agree on." Simultaneous submissions and previously published work OK.

Tips: "We intend to introduce 30 new books per year. Depending on the subject and book format, we may use photographers or incorporate a photo image in a book cover design. Unfortunately, we decide on new product quickly and need to go to our artist files to coordinate artwork with subject matter. Therefore, more material and variety of subjects on hand is most helpful to us."

GROLIER, INC., Sherman Turnpike, Danbury CT 06816. (203)797-3500. Fax: (203)797-3344. Chief Photo Researcher: Lisa Grize. Estab. 1829. Publishes encyclopedias and yearbooks. Photos used for text illustration. Examples of published titles: *The New Book of Knowledge Annual*; *Academic American Encyclopedia*; and *Health and Medicine Annual* (all photos used for text illustration). All photo use is text illustration unless otherwise negotiated.

● This publisher is using more color images, but they also see a decrease in quality news photos as a result of digital transmission of images. "We also are saddled with shorter deadlines and therefore we rely on those photographers and agencies who put together tight edits in no time. We have less time to track down specialists."

Needs: Buys 2,000 freelance photos/year; offers 5 assignments/year. Interested in unposed photos of the subject in its natural habitat that are current and clear. Model/property release preferred for any photos used in medical articles, education articles, etc. Captions required; include dates, specific locations and natural history subjects should carry Latin identifications.

Making Contact & Terms: Interested in working with newer, lesser-known photographers. Query with list of stock photo subjects. Provide résumé, business card, brochure, flier or tearsheets to be kept on file for possible future assignments. Uses 8×10 glossy b&w/color prints; 35mm, 4×5, 8×10 (reproduction quality dupes preferred) transparencies. Cannot return unsolicited material. Pays $65-100/b&w photo; $150-200/color photo. No assignments. Very infrequent freelance photography is negotiated by the job. Credit line given "either under photo or on illustration credit page." Buys one-time and foreign language rights; negotiable. Occasional foreign language rights.

Tips: "Send subject lists and small selection of samples for file. Photocopy or printed samples *only* please. In reviewing samples we consider the quality of the photographs, range of subjects and editorial approach. Keep in touch but don't overdo it. Keep us notified of recent assignments/coverage by sending stock lists or printed samples. We continue to use about 50% b&w photos but have an increasingly hard time finding good photos in our price range. Color use will increase and we see a trend toward increasing use of computerized images."

***GRYPHON HOUSE**, P.O. Box 207, Beltsville MD 20704. (301)595-9500. Fax: (301)595-0051. E-mail: kcharner@gryphonhouse.com. Editor-in-Chief: Kathy Charner. Estab. 1970. Publishes educational resource materials for teachers and parents of young children. Examples of recently published titles: *Crisis Manual for Teachers* (text illustration); and *Toddlers Together* (book cover).

Needs: Looking for b&w and color photos of young children, (birth-6 years.) Reviews stock photos. Model release required.

Making Contact & Terms: Query with samples. Query with stock photo list. Uses 5×7 glossy color (cover only) and b&w prints. Keeps samples on file. Reports in 1 month. NPI. **Pays on receipt of invoice.** Credit line given. Buys book rights. Simultaneous submissions OK.

❖GUERNICA EDITIONS, INC., P.O. Box 117, Station P, Toronto, Ontario M5S 2S6 Canada. (416)657-8885. Editor: Antonio D'Alfonso. Estab. 1978. Publishes adult trade (literary). Photos used for book covers. Examples of recently published titles: *Approaches to Absence* (cover); *Breaking the Mould* (cover).

Needs: Buys various number of photos annually; "often" assigns work. Life events, including characters; houses. Photo captions required. "We use authors' photo everywhere."

Making Contact & Terms: Interested in receiving work from newer, lesser-known photographers. Query with samples. Uses color and/or b&w prints. Sometimes keeps samples on file. Cannot return material. Reports in 1-2 weeks. Pays $100-150 for cover. Pays on publication. Credit line given. Buys book rights. "Photo rights go to photographers. All we need is the right to reproduce the work."

HARMONY HOUSE PUBLISHERS, P.O. Box 90, Prospect KY 40059 or 1008 Kent Rd., Goshen KY 40026. (502)228-4446. Fax: (502)228-2010. Owner: William Strode. Estab. 1984. Publishes photographic books on specific subjects. Photos used for text illustration, promotion materials, book covers

and dust jackets. Examples of published titles: *Country U.S.A.*, *Emblems of Southern Valor*, *Georgia Tech* and *Farming Comes of Age*.

Needs: Number of freelance photos purchased varies. Assigns 30 shoots each year. Captions required.

Making Contact & Terms: Query with résumé of credits along with business card, brochure, flier or tearsheets to be kept on file for possible future assignments. Query with samples or stock photo list. Submit portfolio for review. Works on assignment mostly. Uses 35mm, 2¼×2¼, 4×5 or 8×10 transparencies. NPI; payment negotiable. Credit line given. Buys one-time rights and book rights. Simultaneous submissions and previously published work OK.

Tips: To break in, "send in book ideas to William Strode, with a good tray of slides to show work."

HERALD PRESS, 616 Walnut Ave., Scottdale PA 15683. (412)887-8500. Fax: (412)887-3111. Contact: James Butti. Estab. 1908. Photos used for book covers and dust jackets. Examples of published titles: *Lord, Teach Us to Pray*, *Starting Over* and *Amish Cooking* (all cover shots).

Needs: Buys 5 photos annually; offers 10 freelance assignments annually. Subject matter varies. Reviews stock photos of people and other subjects. Model/property release required. Captions preferred (identification information).

Making Contact & Terms: Interested in receiving work from newer, lesser-known photographers. Query with samples. Provide résumé, business card, brochure, flier or tearsheets to be kept on file for possible future assignments. Works on assignment only or select from file of samples. Uses varied sizes of glossy color and/or b&w prints; 35mm transparencies. Keeps samples on file. SASE. Reports in 1 month. Pays $150-200/color photo. **Pays on acceptance.** Credit line given. Buys book rights; negotiable. Simultaneous submissions and previously published work OK.

Tips: "Put your résumé and samples on file."

HOLLOW EARTH PUBLISHING, P.O. Box 1355, Boston MA 02205-1355. Phone/fax: (603)433-8735. President/Publisher: Helian Yvette Grimes. Publishes adult trade, mythology, computers (Macintosh), science fiction and fantasy. Photos used for text illustration, promotional materials, book covers, dust jackets and magazines. Examples of published titles: *Complete Guide to B&B's and Country Inns (USA)*, *Complete Guide to B&B's and Country Inns (worldwide)*, and *Software Guide for the Macintosh Power Book*. Photo guidelines free with SASE.

Needs: Buys 150-300 photos annually. Needs photos of bed & breakfasts, country inns, Macintosh Powerbook and computer peripherals. Reviews stock photos of bed & breakfasts, country inns, Macintosh Powerbook and computer peripherals. Model/property release required. Captions required; include what it is, where and when.

Making Contact & Terms: Interested in receiving work from newer, lesser-known photographers. Query with samples. No unsolicited photographs. Works with local freelancers on assignment only. Uses 5×7, 8½×11 glossy or matte color and b&w prints; 35mm, 2¼×2¼, 4×5 transparencies. Also accepts images on disk in EPS, TIFF, or Adobe Photoshop formats. Keeps samples on file. SASE. Reports in 1 month. Pays $50-600/color photo; $50-600/b&w photo. **Pays on acceptance.** Credit line given. Buys all rights "but photographer can use photographs for other projects after contacting us." Rights negotiable. No simultaneous submissions.

Tips: Wants to see portfolios with strong content, impact, graphic design. "Be unique and quick in fulfilling assignments, and pleasant to work with."

HOLT, RINEHART AND WINSTON, 1120 Capital of Texas Hwy. S., Austin TX 78746. (512)314-6500. Fax: (512)314-6590. Manager of Photo Research: Tim Taylor. Estab. 1866. "The Photo Research Department of the HRW School Division in Austin obtains photographs for textbooks in subject areas taught in secondary schools." Photos are used for text illustration, promotional materials and book covers. Examples of published titles: *Elements of Writing*, *Science Plus*, *People and Nations*, *World Literature*, *Biology Today* and *Modern Chemistry*.

Needs: Buys 3,500 photos annually. Photos to illustrate mathematics, the sciences—life, earth and physical—chemistry, history, foreign languages, art, English, literature, speech and health. Reviews stock photos. Model/property releases preferred. Photo captions required that include scientific explanation, location and/or other detailed information.

Making Contact & Terms: Interested in receiving work from newer, lesser-known photographers. Query with résumé of credits. Query with stock photo list. Query with samples. Send a letter and printed flier with a sample of work and a list of subjects in stock. Do not call! Uses any size glossy b&w prints and color transparencies. Cannot return unsolicited material. Reports as needed. Pays $125-180/b&w photo; $150-225/color photo; $75-125/hour and $700-1,000/day. Credit line given. Buys one-time rights.

Tips: "We use a wide variety of photos, from portraits to studio shots to scenics. We like to see slides displayed in sheets. We especially like photographers who have specialties . . . limit themselves to one/two subjects." Looks for "natural looking, uncluttered photographs, labeled with exact descriptions, technically correct, and including no evidence of liquor, drugs, cigarettes or brand names." Photography should be specialized, with photographer showing competence in 1 or more areas.

HOME PLANNERS, INC., 3275 W. Ina Road, Suite 110, Tucson, AZ 85741. (602)297-8200. Fax: (602)297-6219. Art Director: Cindy J. Coatsworth Lewis. Estab. 1946. Publishes material on home building and planning and landscape design. Photos used for text illustration, promotional materials and book covers. Examples of recently published titles: *Home Planners Gold*, *Homes Filled with Natural Light* and *Easy-Care Landscape Plans*. In all 3, photos used for cover and text illustrations.
Needs: Buys 25 freelance photos; offers 10 freelance assignments annually. Homes/houses—"but for the most part, it must be a specified house built with one of our plans." Property release required.
Making Contact & Terms: Provide résumé, business card, brochure, flier or tearsheets to be kept on file for possible assignments. Works on assignment only. Uses 4×5 transparencies. SASE. Reports in 1 month. Pays $25-100/color photo; $500-750/day; maximum $500/4-color cover shots. Credit line given. Buys all rights. Simultaneous submissions and previously published work OK.
Tips: Looks for "ability to shoot architectural settings and convey a mood. Looking for well-thought, professional project proposals."

© Dick Dietrich

Dick Dietrich of Dietrich Stock Photos in Phoenix sought to capture the splendor of the Grand Canyon in this photo. He was obviously successful, as the striking shot has sold ten times for use in books, magazines, postcards and calenders. Holt, Rinehart and Winston used the shot full-page, full-color in a textbook entitled *World Geography Today*.

HOMESTEAD PUBLISHING, Box 193, Moose WY 83012. Editor: Carl Schreier. Publishes 20-30 titles per year in adult and children's trade, natural history, guidebooks, fiction, Western American and art. Photos used for text illustration, promotional, book covers and dust jackets. Examples of published titles: *Yellowstone: Selected Photographs*, *Field Guide to Yellowstone's Geysers, Hot Springs and Fumaroles*, *Field Guide to Wildflowers of the Rocky Mountains*, *Rocky Mountain Wildlife* and *Grand Teton Explorers Guide*.
Needs: Buys 100-200 photos annually; offers 6-8 freelance assignments annually. Natural history. Reviews stock photos. Model release preferred. Photo captions required; accuracy very important.
Making Contact & Terms: Query with samples. Provide résumé, business card, brochure, flier or tearsheets to be kept on file for possible future assignments. Uses 8×10 glossy b&w prints; 35mm, 2¼×2¼, 4×5 and 6×7 transparencies. SASE. Reports in 4-6 weeks. Pays $70-300/color photo, $50-300/b&w photo. Credit line given. Buys one-time and all rights; negotiable. Simultaneous submissions and previously published work OK.

Tips: In freelancer's samples, wants to see "top quality—must contain the basics of composition, clarity, sharp, in focus, etc. Looking for well-thought out, professional project proposals."

HOWELL PRESS, INC., 1147 River Road, Suite 2, Charlottesville VA 22901. (804)977-4006. Fax: (804)971-7204. President: Ross A. Howell, Jr. Estab. 1986. Publishes illustrated books, calendars and posters. Examples of recently published titles: *Sunday Drivers: NASCAR Winston Cup Stock Car Racing, Mustang: North American P-51* and *The Soldier* (photos used for illustration, jackets and promotions for all books).
Needs: Aviation, military history, gardening, maritime history, motorsports, cookbooks only. Model/property release preferred. Captions required; clearly identify subjects.
Making Contact & Terms: Interested in receiving work from newer, lesser-known photographers. Photographer's guidelines available; query. Uses b&w and color prints. Keeps samples on file. SASE. Reports in 1 month. NPI; payment varies. Buys one-time rights. Simultaneous submissions and previously published work OK.
Tips: When submitting work, please "provide a brief outline of project, including cost predictions and target market for project. Be specific in terms of numbers and marketing suggestions."

***HUMANICS,** 1482 Mecaslin St., Atlanta GA 30309. (404)874-2176. Fax: (404)877-1976. E-mail: humanics@aol.com. Photo Manager: Gary B. Wilson. Estab. 1976. Publishes early childhood, psychology and Eastern philosophy, adult trade and textbooks. Photos used for text illustration, promotional materials, book covers and dust jackets. Examples of recently published titles: *Toa Women*; *Aerospace Projects* and *Lives of Families*.
Needs: Buys 100 photos annually; offers 20 freelance assignments annually. Needs photos of children, landscapes and seascapes. Reviews stock photos. Model/property release required. Captions required.
Making Contact & Terms: Arrange personal interview to show portfolio. Submit portfolio for review. Query with résumé of credits. Query with samples. Query with stock photo list. Send unsolicited photos by mail for consideration. Provide résumé, business card, brochure, flier or tearsheets to be kept on file for possible future assignments. Uses color and b&w prints; 35mm, 2¼×2¼, 4×5 transparencies. Keeps samples on file. Reports in 1 month. **Pays on receipt of invoice.** Credit line given. Buys book, electronic and all rights; negotiable.

♣I.G. PUBLICATIONS LTD., 999-8 St. SW, Suite 222, Calgary, Alberta T2R 1J5 Canada. (403)244-7343. Fax: (403)229-2470. Property Coordinator: Elizabeth Hrappstead. Estab. 1977. Publishes travel magazines/books of local interest to include areas/cities of Vancouver, Victoria, Banff/Lake Louise, Calgary. Photos used for text illustration, book covers. Examples of published titles: *International Guide* and *Visitor's Choice*, text illustration and covers. Photo guidelines free with SASE.
Needs: Buys 50-100 photos annually. Looking for photos of mountains, lakes, views, lifestyle, buildings, festivals, people, sports and recreation, specific to each area as mentioned above. Reviews stock photos. Model release required. Property release is preferred. Captions required "detailed but brief."
Making Contact & Terms: Interested in receiving work from newer, lesser-known photographers. Query with samples. Works with local freelancers only. Uses 4×5 to 8×10 color prints; 35mm transparencies. Keeps samples on file. SASE. Reports in 3 weeks. Pays $35-65/color photo. Pays on publication. Credit line given. Previously published works OK.
Tips: "Please submit photos that are relative to our needs only. Photos should be specific, clear, artistic, colorful."

***ICS BOOKS INC.,** 1370 E. 86th Place, Merrillville IN 46410. (219)769-0585. Fax: (219)769-6085. E-mail: booksics@aol.com. Art Director: James Putrus. Estab. 1980. Publishes adult trade, camping, rock climbing, water sports, outdoor. Photos used for book covers. Examples of recently published titles: *No Shit There I Was . . Again* (cover); *Campfire Stories*, Volume 3 (cover); *Parent's Little Book of Wisdom* (cover).
Needs: Buys 5-10 photos annually; offers 1-2 freelance assignments annually. Wants outdoor photos. Model release required. Captions required.
Making Contact & Terms: Interested in receiving work from newer, lesser-known photographers. Send unsolicited photos by mail for consideration. Provide résumé, business card, brochure, flier or tearsheets to be kept on file for possible future assignments. Uses color prints; 35mm, 2¼×2¼, 4×5 transparencies. Keeps samples on file. Cannot return material. Reports in 1-2 weeks. Pays $20-25/hour; $500-600/day; $350-400/job; $350-400/color photo; $150-200/b&w photo. Pays on publication

 THE MAPLE LEAF before a listing indicates that the market is Canadian.

or within 30 days receipt of invoice. Credit line given. Buys all rights; negotiable. Simultaneous submissions and previously published work OK.

Tips: "Send tearsheets with photo in ad or book cover."

***INNER TRADITIONS INTERNATIONAL**, 1 Park St., Rochester VT 05767. (802)767-3174. Fax: (802)767-3726. E-mail: gotoit.com. Art Director: Tim Jones. Estab. 1975. Publishes adult trade: New Age, health, self-help, esoteric philosophy. Photos used for text illustration and book covers. Examples of recently published titles: *Great Book of Hemp* (cover, interior); *Birth Without Violence* (cover); and *Aroma Therapy: Scent and Psyche* (cover).
Needs: Buys 10-50 photos annually; offers 10-50 freelance assignments annually. Reviews stock photos. Model/property release required. Captions preferred.
Making Contact & Terms: Interested in receiving work from newer, lesser-known photographers. Provide résumé, business card, brochure, flier or tearsheets to be kept on file for possible future assignments. Works with freelancers on assignment only. Uses 35mm, 4×5 transparencies. Keeps samples on file. SASE. Reports in 1 month. Pays on publication. Credit line given. Buys book rights; negotiable. Simultaneous submissions OK.

***INTERNATIONAL VOYAGER MEDIA**, 11900 Biscayne Blvd., #300, Miami FL 33181. (305)892-6644. Fax: (305)892-1005. Photography Director: Robin Hill. Estab. 1975. Publishes travel books, cruise line magazines, commemorative books. "We publish 120 different travel publications annually." Photos used for text illustration and book covers. Example of recently published title: *Carribean Vacation Planner*. Photo guidelines free with SASE.
Needs: Buys thousands of photos annually; offers 10 freelance assignments annually. Needs photos that promote a destination in a positive light. Reviews stock photos. Captions required; include where, who, what, when.
Making Contact & Terms: Interested in receiving work from newer, lesser-known photographers. Arrange personal interview to show portfolio. Submit portfolio for review. Query with résumé of credits. Query with stock photo list. Provide résumé, business card, brochure, flier or tearsheets to be kept on file for possible future assignments. Uses 35mm, 2¼×2¼, 4×5 transparencies. Keeps samples on file. Cannot return material. Reports in 3 weeks. Pays $75-1,000/color photo. **Pays on receipt of invoice.** Credit line given. Buys one-time rights. Simultaneous submissions OK.
Tips: "There are only two criteria in succeeding: talent and tenacity. Both are needed in large quantities to succeed in a very competitive marketplace. I look for original ideas and consider it very important to evaluate work of new/less-known photographers."

KALEIDOSCOPIX, INC., P.O. Box 389, Franklin MA 02038. (508)528-3242. Art Director: Jason Kruz. Estab. 1982. Publishes children's New Englandiana, historical, nautical, cooking. Photos used for text illustration, book covers and dust jackets. Photo guidelines free with SASE.
Needs: Subjects depend upon manuscript needs. For example, *ABC's of Covered Bridges* will require action-type photos of specific New England and Ohio covered bridges. Model release required when people included. Captions preferred.
Making Contact & Terms: Query with samples. Works on assignment only. Uses 7×10 b&w prints; 11×14 color prints; 35mm transparencies. SASE. Reports in 1 month. Pays $50/color photo; $25/b&w photo. Credit line given. Buys all rights; usually reassigns rights after 1 year of publication. Previously published work OK.
Tips: In samples, wants to see contact sheet of related subjects or 3×5 prints, not original slides or full size prints. Show some samples or brochure of style and techniques.

B. KLEIN PUBLICATIONS., P.O. Box 6578, Delray Beach FL 33482. (407)496-3316. Fax: (407)496-5546. President: Bernard Klein. Estab. 1953. Publishes adult trade, reference and who's who. Photos used for text illustration, promotional materials, book covers, dust jackets. Examples of published titles: *1933 Chicago World's Fair*, *1939 NY World's Fair* and *Presidential Ancestors*.
Needs: Reviews stock photos.
Making Contact & Terms: Interested in receiving work from newer, lesser-known photographers. Query with résumé of credits. Query with samples. Send unsolicited photos by mail for consideration. Works on assignment only. Cannot return material. Reports in 1-2 weeks. NPI.
Tips: "We have several books in the works that will need extensive photo work in the areas of history and celebrities."

KREGEL PUBLICATIONS, P.O. Box 2607, Grand Rapids MI 49501-2607. (616)451-4775. Fax: (616)451-9330. E-mail: kregelpub@aol.com. Director of Graphic & Print Production: Alan G. Hartman. Publishes books for Christian and Bible colleges, reference works and commentaries, sermon helps and adult trade books. Photos used for book covers and dust jackets. Examples of recently published titles: *Prodigal People*, by Don Hawkins and Woodrow Kroll (full cover); *Testimony of*

This striking photo of a lotus flower by Woodlawn, New York, photographer Albert Squillace appeared in *The American Garden Guides: Water Gardening*, from Layla Productions, part of a garden series from the publisher. Layla's Lori Stein needed a photo capturing "the physical characteristics of the plant, as well as its beauty." The assignment gave Squillace, who photographed the plant life at Longwood Gardens, Pennsylvania, "an opportunity to learn and expand my knowledge and files on horticulture, which presently cover roses, perennials, annuals, trees, tropical plants and water plants."

Evangelists, by Simon Greenleaf (full cover); and *Guide to Gospels*, by W. Graham Scroggie (inset box).

● Kregel received the Gold Medallion Ecpa award for *Spanish Romanus Commentary*.

Needs: Buys 12-40 photos annually. Scenic and/or biblical. Holy Land, scenery and inhabitants sometimes used; religious symbols, stained glass and church activities of non-Catholic origin may be submitted. Reviews stock photos. Model release preferred.

Making Contact & Terms: Query with phone call to approve photo submission before sending. Uses 35mm, 2¼×2¼ and 4×5 transparencies. Keeps duplicates on file. SASE. Reports in 1 month. Pays $200-400/color photo. Credit line given. Buys book rights and one-time rights with allowances for reproductions. Previously published work OK.

Tips: "Prior submission approval a must! High quality scenics of 'inspirational calendar' type preferred."

LAYLA PRODUCTION INC., 340 E. 74, New York NY 10021. (212)879-6984. Fax: (212)879-6399. Manager: Lori Stein. Estab. 1980. Publishes adult trade, how-to gardening and cooking books. Photos used for text illustration and book covers. Examples of recently published title: *American Garden Guides*, 12 volumes (commission or stock, over 4,000 editorial photos).

Needs: Buys over 150 photos annually; offers 6 freelance assignments annually. Gardening and cooking. Buys all rights.

Making Contact & Terms: Provide résumé, business card, brochure, flier or tearsheets to be kept on file for possible future assignments. Specifications for submissions are very flexible. SASE. Reports in 1 month; prefers no unsolicited material. Pays $25-200/color photo; $10-100/b&w photo; $30-75/hour; $250-400/day. Other methods of pay depends on job, budget and quality needed. Simultaneous submissions and previously published work OK.

Tips: "We're usually looking for a very specific subject. We *do* keep all résumés/brochures received on file—but our needs are small, and we don't often use unsolicited material. We will be working on a series of gardening books through 1997."

LERNER PUBLICATIONS COMPANY, 241 First Ave. N., Minneapolis MN 55401. (612)332-3344. Fax: (612)332-7615. Senior Photo Researcher: Lynn Olsen. Estab. 1959. Publishes educational

books for young people covering a wide range of subjects, including animals, biography, ecology, geography and sports. Photos used for text illustration, promotional materials, book covers, dust jackets. Examples of recently published titles: *Alberta*; *Steve Young*; and *Hurricanes* (all text and cover).
Needs: Buys over 1,000 photos annually; rarely offers assignments. Model/property release preferred when photos are of social issues (i.e., the homeless). Captions required; include who, where, what and when.
Making Contact & Terms: Interested in receiving work from newer, lesser-known photographers. Query with stock photo list. Provide résumé, business card, brochure, flier or tearsheets to be kept on file. Uses any size glossy color and b&w prints; 35mm, 2¼×2¼, 4×5 transparencies. Cannot return material. Reports only when interested. Pays $50/color photo; $35/b&w photo; negotiable. **Pays on receipt of invoice.** Credit line given. Buys one-time rights. Previously published works OK.
Tips: Prefers crisp, clear images that can be used editorially. "Send in as detailed a stock list as you can, and be willing to negotiate use fees. We are using freelance photographers more and more."

LITTLE, BROWN & CO., 41 Mt. Vernon St., Boston MA 02108. (617)227-0730. Art Assistant: Kelly Gagnon. Publishes adult trade. Photos used for book covers and dust jackets.
Needs: Reviews stock photos. Model release required.
Making Contact & Terms: Provide tearsheets to be kept on file for possible future assignments. "Samples should be nonreturnable." SASE. Reporting time varies. NPI. Credit line given. Buys one-time rights.

LITURGY TRAINING PUBLICATIONS, 1800 N. Hermitage, Chicago IL 60622. (312)486-8970. Fax: (312)486-7094. Prepress Director: Diana Kodner. Estab. 1964. Publishes materials that assist parishes, institutions and households in the preparation, celebration and expression of liturgy in Christian life. Photos used for text illustration, book covers. Examples of published titles: *Infant Baptism, a Parish Celebration* (text illustration); *The Postures of the Assembly During the Eucharistic Prayer* (cover); and *Teaching Christian Children about Judaism* (text illustration).
Needs: Buys 30 photos annually; offers 5 freelance assignments annually. Needs photos of processions, assemblies with candles in church, African-American worship, sacramental/ritual moments. Reviews stock photos. Model/property release preferred. Captions preferred.
Making Contact & Terms: Interested in receiving work from newer, lesser-known photographers. Arrange personal interview to show portfolio. Submit portfolio for review. Query with résumé of credits. Query with samples. Query with stock photo list. Send unsolicited photos by mail for consideration. Provide résumé, business card, brochure, flier or tearsheets to be kept on file for possible future assignments. Uses 5×7 glossy b&w prints; 35mm transparencies. Keeps samples on file. SASE. Reports in 1-2 weeks. Pays $50-225/color photo; $25-200/b&w photo. Pays on publication. Credit line given. Buys one-time rights; negotiable. Simultaneous submissions; previously published work.
Tips: "Please realize that we are looking for very specific things—people of mixed age, race, socio-economic background; shots in focus; post-Vatican II liturgical style; candid photos; photos that are not dated. We are not looking for generic religious photography. We're trying to use more photos, and will if we can get good ones at reasonable rates."

LLEWELLYN PUBLICATIONS, P.O. Box 64383, St. Paul MN 55164. Art Director: Lynne Menturweck. Publishes consumer books (mostly adult trade paperback) with astrology, psychology, mythology and New Age subjects, geared toward an educated audience. Also publishes book catalogs. Uses photos for book covers. Examples of recently published titles: *Crystal Balls & Crystal Bowls*, *1996 Daily Planetary Guide*, *Whispers of the Moon* and *Advanced Candle Magic* (all covers).
Needs: Buys 5-10 freelance photos annually. Science/fantasy, sacred sites, gods and goddesses (statues, etc.), high-tech and special effects. Reviews stock photos. Model release preferred.
Making Contact & Terms: Query with samples. Uses 8×10 glossy color prints; 35mm or 4×5 transparencies. Provide slides, brochure, flier or tearsheets to be kept on file for possible future assignments. SASE. Reports in 5 weeks. Pays $125-600/color cover photo. Pays on publication. Credit line given. Buys all rights.
Tips: "Send materials that can be kept on file."

LOOMPANICS UNLIMITED, P.O. Box 1197, Port Townsend WA 98368. (360)385-5087. Fax: (360)385-7785. E-mail: loompanx@well.com. Editorial Director: Dennis P. Eichhorn. Estab. 1975. Publishes how-to and nonfiction for adult trade. Photos used for book covers. Examples of published titles: *Free Space!* (color photos on cover and interior); *Secrets of a Superhacker* (photo collage on cover); and *Stoned Free* (interior photos used as line-drawing guide).
Needs: Buys 2-3 photos annually; offers 1-2 freelance assignments annually. "We're always interested in photography documenting crime and criminals." Reviews stock photos. Model/property release preferred. Captions preferred.
Making Contact & Terms: Query with samples. Query with stock photo list. Provide tearsheets to be kept on file for possible future assignments. Uses b&w prints. Samples kept on file. SASE. Reports

in 1 month. Pays $10-250 for cover photo; $5-20 interior photo. Credit lines given. Buys all rights. Simultaneous submissions and previously published work OK.

Tips: "We look for clear, high contrast b&w shots that *clearly* illustrate a caption or product. Find out as much as you can about what we are publishing and tailor your pitch accordingly."

***■MEDIA BRIDGE TECHNOLOGIES**, 2280 Grass Valley, Hwy. #181, Auburn CA 95603. (916)889-4438. Fax: (916)888-0690. E-mail: mbgamekids@aol.com. Publisher: Rennie Mau. Estab. 1991. Publishes textbooks and multicultural, juvenile and teen modeling books. Photos used for text illustration, promotional materials, book covers, dust jackets and world-wide web. Examples of recently published titles: *Home No More (cover, illustrations); GAME KIDS Rope and Strings*; and *Telling* (cover). Photo guidelines free with SASE.
Needs: Buys over 150 photos annually; offers 5-8 freelance assignments annually. Needs children, teens and multicultural photos. Reviews stock photos of children, teens—modeling, action and fashion. Model/property release required for children and teens. Captions preferred.
Making Contact & Terms: Interested in receiving work from newer, lesser-known photographers. Query with résumé of credits. Query with samples. Provide résumé, business card, brochure, flier or tearsheets to be kept on file for possible future assignments. Works with freelancers on assignment only. Uses glossy 5×7, 4×5, 8×10 color and b&w prints; Hi-8, SVHS videotape; photo CD digital format. Keeps samples on file. SASE. Reports in 1 month. Pays $10-300/job; $25-300/color photo; $10-200/b&w photo; electronic barter; extra for electronic usage. Pays on publication. Credit line sometimes given depending upon project. Buys all rights; negotiable. Simultaneous submissions OK.

METAMORPHOUS PRESS, Box 10616, Portland OR 97210. (503)228-4972. Editor: Lori Stephens. "We publish books and tapes in the subject areas of communication, health and fitness, education, business and sales, psychology, women and children. Photos used for text illustration, promotional materials, book covers and dust jackets. Examples of published titles: *The Challenge of Excellence*; *Re-Creating Your Self*; and *The Professional ACT: Acting, Communication, Technique*. Photos used for cover and/or text illustration.
Needs: Reviews stock photos.
Making Contact & Terms: Query with list of stock photo subjects. Provide résumé, business card, brochure, flier or tearsheets to be kept on file for possible future assignments. Works on assignment only. Cannot return material. Reports as soon as possible. NPI; payment negotiable. Credit line given. Buys one-time and book rights. Also buys all rights, but willing to negotiate. Simultaneous submissions and previously published work OK.
Tips: "Let us have samples of specialties so we can match contents and styles to particular projects."

MOON PUBLICATIONS, INC., P.O. Box 3040, Chico CA 95927-3040. (916)345-5473. Fax: (916)345-6751. Photo Buyer: Carey Wilson. Estab. 1973. Publishes travel material. Photos used for text illustration, promotional materials and book covers. Examples of recently published titles: *Indonesia Handbook*, 6th Edition; *Nepal Handbook (2nd Edition)* and *Tasmania Handbook* (1st Edition). All photos used for cover and text illustration. Photo guidelines free with SASE.
Needs: Buys 25-30 photos annually. People, clothing and activity typical of area being covered, landscape or nature. Reviews stock photos. Photo captions preferred; include location, description of subject matter.
Making Contact & Terms: Interested in receiving work from newer, lesser-known photographers. Query with stock photo list. Provide résumé, business card, brochure, flier or tearsheets to be kept on file for possible future assignments. Uses 35mm, 2¼×2¼, 4×5, 8×10 transparencies. Keeps samples on file. SASE. Reports in 1 month. Pays $200-300/cover photo. Pays on publication. Credit line given. Buys book rights; negotiable. Previously published work OK.
Tips: Wants to see "sharp focus, visually interesting (even unusual) compositions portraying typical activities, styles of dress and/or personalities of indigenous people of area covered in handbook. Unusual land or seascapes. Don't send snapshots of your family vacation. Try to look at your own work objectively and imagine whether the photograph you are submitting really deserves consideration for the cover of a book that will be seen worldwide. We continue to refine our selection of photographs that are visually fascinating, unusual."

 THE SOLID, BLACK SQUARE before a listing indicates that the market uses various types of audiovisual materials, such as slides, film or videotape.

MOUNTAIN AUTOMATION CORPORATION, P.O. Box 6020, Woodland Park CO 80866. (719)687-6647. President: Claude Wiatrowski. Estab. 1976. Publishes souvenir books. Photos used for text illustration, promotional materials and book covers. Examples of published titles: *Colorado's Black Canyon* (throughout); *Pike's Peak By Rail* (extra illustrations in video) and *Georgetown Loop RR* (extra illustrations in video).

Needs: Complete projects for illustrated souvenir books, not individual photos. Model release required. Property release preferred. Captions required.

Making Contact & Terms: Interested in receiving work from newer, lesser-known photographers. Query with book project. Uses 35mm, $2\frac{1}{4} \times 2\frac{1}{4}$, 4×5 transparencies. "Although we will deal with larger formats if necessary, we prefer 35mm for transfer to Kodak Photo CD." Keeps samples on file. SASE. Reports in 1 month. NPI; royalty on complete book projects. Credit lines given. Buys all rights. Simultaneous submissions OK.

Tips: "Provide a contact with a tourist attraction, chamber of commerce or other entity willing to purchase souvenir books. We *only* are interested in complete illustrated book projects for the souvenir market with very targeted markets."

JOHN MUIR PUBLICATIONS, P.O. Box 613, Santa Fe NM 87504. (505)982-4078. Fax: (505)988-1680. Graphics Manager: Sarah Horowitz. Estab. 1969. Publishes adult travel (trade), juvenile nonfiction (science, inter-cultural). Photos used for text illustration and book covers. Examples of recently published titles: *Europe 101*, *Extremely Weird Frogs* and *Unique Oregon*.

• This publisher scans photos and places them electronically and outputs from disk.

Needs: Buys more than a hundred photos annually. Reviews stock photos. Model/property release preferred.

Making Contact & Terms: Query with samples. Query with stock photo list. Uses 35mm, 4×5 transparencies. Provide résumé, business card, brochure, flier or tearsheets to be kept on file for possible future assignments. Keeps samples on file. SASE. Reports back "only if we wish to use material or photographer." NPI. Credit line given. Buys one-time rights; rights negotiable. Simultaneous submissions and previously published work OK.

Tips: "After sending list or samples follow up regularly."

***NEGATIVE CAPABILITY**, 62 Ridgelawn Dr. E., Mobile AL 36608. (334)343-6163. Fax: (334)344-8478. Editor: S. Walker. Estab. 1981. Publishes books of poetry, fiction, essays and articles. Photos used for text illustration, book covers and dust jackets. Examples of recently published titles: *Negative Capability* (journal) and *Little Dragons* (book).

Needs: Buys over 10 photos annually. Captions required.

Making Contact & Terms Interested in receiving work from newer, lesser-known photographers. Query with samples. Send unsolicited photos by mail for consideration. Provide résumé, business card, brochure, flier or tearsheets to be kept on file for possible future assignments. Uses 5×7 b&w prints. Keeps samples on file. SASE. Reports in 1 month. Pays in copies or by arrangement for covers. Credit line given. Buys one-time rights.

***NEW LEAF PRESS, INC.**, Box 311, Green Forest AR 72638. (501)438-5288. Production Manager: Janell Robertson. Publishes adult trade, cooking, fiction of religious nature, catalogs and general trade. Photos used for book covers and dust jackets. Example of published title: *Moments for Sisters*.

Needs: Buys 20 freelance photos annually. Landscapes, dramatic outdoor scenes, "anything that could have an inspirational theme." Reviews stock photos. Model release required. Captions preferred.

Making Contact & Terms: Query with samples and list of stock photo subjects. Does not assign work. Uses 35mm slides. SASE. Reports in 4-6 weeks. Pays $100-175/color photo and $50-100/b&w photo. Credit line given. Buys one-time and book rights. Simultaneous submissions and previously published work OK.

Tips: In order to contribute to the company, send "quality, crisp photos." Trend in book publishing is toward much greater use of photography.

W.W. NORTON AND COMPANY, 500 Fifth Ave., New York NY 10110. (212)354-5500. Fax: (212)869-0856. Trade and College Department: Ruth Mandel and Veil Hoos. Estab. 1923. Photos used for text illustration, book covers and dust jackets. Examples of published titles: *Biology: An Exploration of Life*, 4th Edition, and *Abnormal Psychology*, 3rd Edition.

Needs: Variable. Photo captions preferred.

Making Contact & Terms: Interested in receiving work from newer, lesser-known photographers. Send stock photo list. Do not enclose SASE. Reports as needed. NPI. Credit line given. Buys one-time rights; negotiable. Simultaneous submissions and previously published work OK.

Tips: "Competitive pricing and minimal charges for electronic rights are a must."

THE OLIVER PRESS, Charlotte Square, 5707 W. 36th St., Minneapolis MN 55416-2510. (612)926-8981. Fax: (612)926-8965. Associate Editor: Teresa Faden. Estab. 1991. Publishes history books and

collective biographies for the school and library market. Photos used for text illustration, promotional materials and book covers. Examples of published titles: *Women of the U.S. Congress* (9 freelance photos in the book, 1 on the back cover); *Women Who Reformed Politics* (7 freelance photos in the book); and *Amazing Archaeologists and Their Finds* (8 freelance photos in the book, 3 on the front cover).

Needs: Buys 15 freelance photos annually, but "we would like to increase this number." Photographs of people in the public eye: politicians, business people, activists, etc. Reviews stock photos. Captions required; include the name of the person photographed, the year, and the place/event at which the picture was taken.

Making Contact & Terms: Interested in receiving work from newer, lesser-known photographers. Query with stock photo list. Uses 8 × 10 glossy b&w prints. Keeps samples on file. SASE. Reports in 1 month. Pays $35-50/b&w photo. Pays on publication. Credit line given. Buys book rights, including the right to use photos in publicity materials; negotiable. Simultaneous submissions and previously published work OK.

Tips: "We are primarily interested in photographs of public officials, or people in other fields (science, business, law, etc.) who have received national attention. We are not interested in photographs of athletes and entertainers. Do not send unsolicited photos. Instead, send us a list of the major subjects you have photographed in the past."

C. OLSON & CO., P.O. Box 100-PM, Santa Cruz CA 95063-0100. (408)458-9004. E-mail: clayolson @aol.com. Editor: C. L. Olson. Estab. 1977. Examples of published titles: *World Health, Carbon Dioxide & the Weather* (cover).

Needs: Uses 2 photos/year—b&w or color; all supplied by freelance photographers. "Photos of well-known natural hygienists. Also, photos of fruit and nut trees (in blossom or with fruit) in public access locations like parks, schools, churches, streets, businesses. You should be able to see the fruits up close with civilization in the background." Also needs photos of people under stress from loud noise, photos relating to male circumcision, photos showing people (children and/or adults) wounded in war. Model/property release required for posed people and private property. Captions preferred.

Making Contact & Terms: Interested in receiving work from newer, lesser-known photographers. Query with samples. SASE, plus #10 window envelope. Reports in 2 weeks. NPI; "all rates negotiable." Pays on acceptance or publication. Credit line given on request. Buys all rights. Simultaneous submissions and previously published work OK.

Tips: Open to both amateur and professional photographers. "To ensure that we buy your work, be open to payment based on a royalty for each copy of a book we sell."

RICHARD C. OWEN PUBLISHERS, INC., P.O. Box 585, Katonah NY 10536. (914)232-3903. Fax: (914)232-3977. Editor (Children's Books): Janice Boland. Editor (Professional Books): Amy Haggblom. Publishes picture/storybook fiction and nonfiction for 5- to 7-year-olds; author autobiographies for 7- to 10-year-olds; professional books for educators. Photos used for text illustration, promotional materials and book covers of professional books. Examples of recently published titles: *Pigs Peek* (cover and interior photos); *Once Upon A Time* (cover and interior photos).

Needs: Number of photos bought annually varies; offers 3-10 freelance assignments annually. Needs unposed people shots and nature photos that suggest storyline. "For children's books, must be child-appealing with rich, bright colors and scenes, no distortions or special effects. For professional books, similar, but often of classroom scenes, including teachers. Nothing posed, should look natural and realistic." Reviews stock photos of children involved with books and classroom activities, age ranging from kindergarten to sixth grade, "not posed or set up, not portrait type photos. Realistic!" Model release required for children and adults. Children (under the age of 21) must have signature of legal guardian. Property release preferred. Captions required. Include "any information we would need for acknowledgements, including if special permission was needed to use a location."

Making Contact & Terms: Interested in receiving work from newer, lesser-known photographers. Submit portfolio by mail for review. Provide résumé, business card, brochure, flier, or tearsheets to be kept on file for possible future assignments. Include a cover letter with name, address, and daytime phone number, and indicate *Photographer's Market* as a source for correspondence. Works with freelancers on assignment only. "For samples, we like to see any size color prints (or color copies). For materials that are to be used, we need 35mm mounted transparencies. We usually use full-color photos." Keeps samples on file "if appropriate to our needs." Reports in 1 month. Pays $50-150/color photo; $800-2,500/job. "Each job has its own payment rate and arrangements." **Pays on acceptance.** Credit line given sometimes, depending on the project. "Photographers' credits appear in children's books, and in professional books, but not in promotional materials for books or our company." For children's books, publisher retains ownership, possession and world rights, and applies to first and all subsequent editions of a particular title, and to all promotional materials. Simultaneous submissions OK.

Tips: Wants to see "real people in natural, real life situations. No distortion or special effects. Bright, clear images with jewel tones and rich colors. Keep in mind what would appeal to children. Be familiar with what the publishing company has already done. Listen to the needs of the company."

PAPIER-MACHÉ PRESS, 135 Aviation Way, #14, Watsonville CA 95076. (408)763-1420. Fax: (408)763-1421. Editor: Sandra Haldeman Martz. Estab. 1984. Publishes adult trade paperbacks and hardcovers focusing on issues of interest to midlife and older women and for men and women on aging. Photos used for text illustration and promotional materials. Examples of published titles: *When I Am an Old Woman I Shall Wear Purple* (19 photos); *If I Had My Life to Live Over I Would Pick More Daisies* (17 photos); and *Time for Love* (6 photos). "Guidelines for current theme anthologies are available with #10 SASE."
- *I Am Becoming the Woman I've Wanted*, published by Paper-Maché Press, won a 1995 American Book Award from the Before Columbus Foundation.

Needs: Buys 20-40 photos annually. Human interest, usually women in "doing" role; sometimes couples, families, etc. Sometimes reviews stock photos. Model/property release preferred. "Generally we do not caption photos except for photographer's name."

Making Contact & Terms: Interested in receiving work from newer, lesser-known photographers. Query with samples (including photocopies). Provide résumé, business card, brochure, flier or tearsheets to be kept on file for possible future assignments. Uses 8 × 10 semigloss b&w prints. Keeps samples on file. SASE. Reports in 3-6 months. "Guidelines for current theme anthologies are available with #10 SASE." Pays $25-50/b&w photo; $300-500/job; photographers also receive "copies of books, generous discount on books." Credit line given. Buys one-time rights and rights to use photos in promo material for books, e.g. fliers, ads, etc.; negotiable. Simultaneous submissions and previously published work OK.

Tips: "We are generally looking for photos to complement a specific theme anthology or poetry collection. It is essential for photographers to know what those current themes are."

***PARADIGM PUBLISHING INC.**, 300 York Ave., St. Paul MN 55101. (612)771-1555. Fax: (612)772-5196. E-mail: publish@emcp.com. Production Director: Joan Silver. Estab. 1989. Publishes textbooks on business, office and computer information systems. Photos used for text illustration, promotional materials and book covers. Examples of recently published titles: *Psychology: Realizing Human Potential* (250 photos); *Business Communication* (120 photos); and *Business Math* (70 photos).

Needs: Buys 500 photos annually; offers 10 freelance assignments annually. Needs photos of people in high-tech business settings. Model/property release preferred. Captions preferred; technical equipment may need to be tagged.

Making Contact & Terms: Interested in receiving work from newer, lesser-known photographers. Provide résumé, business card, brochure, flier or tearsheets to be kept on file for possible future assignments. Uses 35mm transparencies. Keeps samples on file. SASE. Reports in 1 month. Pays $25-300/color photo; $25-300/b&w photo. **Pays on receipt of invoice.** Credit line given. Buys one-time, book and all rights; negotiable. Simultaneous submissions and previously published work OK.

***PAULINE BOOKS & MEDIA**, 50 St. Paul's Ave., Boston MA 02130. (617)522-8911. Fax: (617)541-9805. Contact: Sr. Helen Rita Lane, fsp. Estab. 1942. Publishes adult trade, juvenile, children's, nonfiction, religious, educational. Photos used for text illustration, book covers and 2 magazines (*My Friend* for children and young people and *The Family*). Examples of recently published book titles: *Jesus: Son & Savior* (cover); *God: Father & Creator* (cover); and *Holy Spirit: Giver of Life & Love*. Photo guidelines available.

Needs: Buys 4-5 photos annually. Offers 4-5 freelance assignments annually. Symbolic and conceptual photos of people, including children and families; nature (scenics, landscapes, seasonal); animals; religious (biblical, ecumenical, saints, Blessed Mother, etc.); inspirational (meditative, symbolic, reflective, abstract); sports (close-ups, equipment, action, practicing, competition, all kinds); famous people, places and things. Model/property release required. Captions preferred; include names, places, events.

Making Contact & Terms: Interested in receiving work from newer, lesser-known photographers. Query with samples. Query with stock photo list. Send unsolicited photos by mail for consideration. Provide résumé, business card, brochure, flier or tearsheets to be kept on file for possible future assignments. Works with local freelancers only. Uses b&w and color prints, slides and transparencies. Keeps samples on file. SASE. Reports in 1-2 months. Pays per reproduction size: $15-40 (b&w half-page or less); $25-50 (b&w half-page to full-page); $90-100 (b&w cover); $25-50 (color half-page or less); $90-150 (color half-page to full-page); $120-250 (color cover). Reusage fees: 50-75% of original payment. Pays on publication. Credit line given. Buys one-time, book, electronic and all rights; negotiable. Previously published work OK.

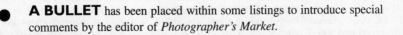 **A BULLET** has been placed within some listings to introduce special comments by the editor of *Photographer's Market*.

PEANUT BUTTER PUBLISHING, 226 2nd Ave. W., Seattle WA 98119. (206)281-5965. Publisher: Elliott Wolf. Estab. 1971. Publishes cookbooks (primarily gourmet); restaurant guides; novels, children's books, assorted adult trade books. Photos used for promotional materials and book covers.
Needs: Buys 24-36 photos/year; offers up to 5 freelance assignments/year. "We are primarily interested in shots displaying a variety of foods in an appealing table or buffet setting. Good depth of field and harmonious color are important. We are also interested in cityscapes that capture one or another of a city's more pleasant aspects. No models." Reviews stock photos.
Making Contact & Terms: Arrange a personal interview to show portfolio. Query with samples or send unsolicited photos by mail for consideration. Uses 2¼×2¼ or 4×5 slides. SASE. Reports in 2 weeks. Pays $50-300/color photo. Credit line given. Buys one-time, exclusive product and all rights. Simultaneous submissions and previously published work OK.

PELICAN PUBLISHING CO., 1101 Monroe St., Gretna LA 70053. (504)368-1175. Fax: (504)368-1195. Production Manager: Cynthia Welch. Publishes adult trade, juvenile, textbooks, how-to, cooking, fiction, travel, science and art books. Photos used for book covers. Examples of published titles: *Maverick Hawaii* (cover), *Maverick Berlin* and *Coffee Book*.
Needs: Buys 8 photos annually; offers 3 freelance assignments annually. Wants to see travel (international) shots of locations and people and cooking photos of food. Reviews stock photos of travel subjects. Model/property release required. Captions required.
Making Contact & Terms: Interested in receiving work from newer, lesser-known photographers. Query with stock photo list. Provide résumé, business card, brochure, flier or tearsheets to be kept on file for possible future assignments. Uses 8×10 glossy color prints; 35mm, 4×5 transparencies. Keeps samples on file. SASE. Reports as needed. Pays $100-500/color photo; negotiable with option for books as payment. **Pays on acceptance.** Credit line given. Buys one-time rights and book rights; negotiable.
Tips: "Be flexible on price. Keep publisher up on new materials."

THE PHOTOGRAPHIC ARTS CENTER, 163 Amsterdam Ave., #201, New York NY 10023. (212)838-8640. Fax: (212)873-7065. Publisher: Robert S. Persky. Estab. 1980. Publishes books on photography and art, emphasizing the business aspects of being a photographer, artist and/or dealer. Photos used for book covers. Examples of recently published titles: *Publishing Your Art as Cards, Posters & Calendars* (cover illustration); *The Photographer's Complete Guide to Getting & Having an Exhibition* and *Creating Successful Advertising* (text illustration).
Needs: Business of photography and art. Model release required.
Making Contact & Terms: Query with samples and text. Uses 5×7 glossy b&w or color prints; 35mm transparencies. SASE. Reports in 3 weeks. Pays $25-100/b&w and color photos. Credit line given. Buys one time rights.
Tips: Sees trend in book publishing toward "books advising photographers how to maximize use of their images by finding business niches such as gallery sales, stock and cards and posters." In freelancer's submissions, looks for "manuscript or detailed outline of manuscript with submission."

PLAYERS PRESS INC., P.O. Box 1132, Studio City CA 91614. Vice President: David Cole. Estab. 1965. Publishes entertainment books including theater, film and television. Photos used for text illustration, promotional materials, book covers and dust jackets. Examples of recently published titles: *Period Costume for Stage and Screen: Medieval-1500*, *Men's Garments 1830-1900* and *Clown Tales*.
Needs: Buys 50-1,000 photos annually. Needs photos of entertainers, actors, directors, theaters, productions, actors in period costumes, scenic designs and clowns. Reviews stock photos. Model release required for actors, directors, productions/personalities. Photo captions preferred for names of principals and project/production.
Making Contact & Terms: Interested in receiving work from newer, lesser-known photographers. Query with list of stock photo subjects. Send unsolicited photos by mail for consideration. Uses 8×10 glossy or matte b&w prints; 5×7 glossy color prints; 35mm, 2¼×2¼ transparencies. SASE. Reports in 3 weeks. Pays $100 maximum/color photo; $100 maximum/b&w photo. Credit line sometimes given, depending on book. Buys all rights; negotiable in "rare cases." Simultaneous submissions and previously published work OK.
Tips: Wants to see "photos relevant to the entertainment industry. Do not telephone; submit only what we ask for."

PRAKKEN PUBLICATIONS, INC., 275 Metty Dr., Suite 1, P.O. Box 8623, Ann Arbor MI 48107. (313)769-1211. Fax: (313)769-8383. Production & Design Manager: Sharon K. Miller. Estab. 1934. Publishes *The Education Digest* (magazine), *Tech Directions* (magazine for technology and vocational/technical educators), text and reference books for technology and vocational/technical education and general education reference. Photos used for text illustration, promotional materials, book covers, magazine covers and text. Examples of published titles: *Chisels on a Wheel: Modern Woodworking Tools and Materials* (cover and text, marketing); *Managing the Occupational Education Laboratory*

(text and marketing); and *The Education Digest, Tech Directions* (covers and marketing). No photo guidelines available.

Needs: Education "in action" and especially technology and vocational-technical education. Photo captions necessary; scene location, activity.

Making Contact & Terms: Query with samples. Send unsolicited photos by mail for consideration. Uses any size image and all media. Keeps sample on file. SASE. NPI. Methods of payment to be arranged. Credit line given. Rights negotiable.

Tips: Wants to see "experience in education and knowledge of high-tech equipment" when reviewing portfolios. Send inquiry with relevant samples to be kept on file. "We buy very few freelance photographs."

PROSTAR PUBLICATIONS LTD., 13468 Beach Ave., Marina del Rey CA 90292. (310)577-1975. Fax: (310)577-9272. Editor: Peter L. Griffes. Estab. 1989. Publishes how-to, nonfiction. Photos used for book covers. Examples of published titles: *Pacific Boating Almanac* (aerial shots of marinas); and *Pacific Northwest Edition*. Photo guidelines free with SASE.

Needs: Buys less than 100 photos annually; offers very few freelance assignments annually. Reviews stock photos of nautical (sport). Model/property release required. Captions required.

Making Contact & Terms: Interested in receiving work from newer, lesser-known photographers. Query with stock photo list. Uses color and b&w prints. Does not keep samples on file. SASE. Reports in 1 month. Pays $10-50/color or b&w photo. Pays on publication. Credit line given. Buys book rights; negotiable. Simultaneous submissions and previously published work OK.

***‡QUARTO PUBLISHING PLC.**, 6 Blundell St., London N7 9BH England. (0171)700-6700. Fax: (0171)700-4191. Picture Manager: Giulia Hetherington. Publishes nonfiction books on a wide variety of topics including art, natural history, home and garden, and reference. Photos used for text illustration. Examples of recently published titles: *Birdhouses Around the World* (text illustration); *Marine Fish* (text illustration) and *Regional Cuisine: Normandy*. Photo guidelines free when projects come up.

Needs: Buys 1,000 photos annually. "Subjects depend on books being worked on." Model/property release required. Photo captions required; include full details of subject and name of photographer.

Making Contact & Terms: Interested in receiving work from newer, lesser-known photographers. Provide résumé, business card, brochure, flier or tearsheets to be kept on file for possible future assignments. Uses all types of prints. Pays $30-600/b&w photo; $60-150/color photo. Pays on publication. Credit line given. Buys one-time rights; negotiable. Simultaneous submissions and/or previously published work OK.

Tips: "Be prepared to negotiate!"

❖REIDMORE BOOKS INC., 10109 106th St., Suite 1200, Edmonton, Alberta T5J 3L7 Canada. (403)424-4420. Fax: (403)441-9919. Contact: Visuals Editor. Estab. 1979. Publishes textbooks for K-12; textbooks published cover all subject areas. Photos used for text illustration and book covers. Examples of published titles: *Greece: Discovering the Past*; *China: Our Pacific Neighbour*; and *Canada's Atlantic Neighbours*. Photo guidelines available.

Needs: Buys 250 photos annually; offers 1-3 freelance assignments annually. "Photo depends on the project, however, images should contain unposed action." Reviews stock photos. Model/property release preferred. Captions required; "include scene description and photographer's control number."

Making Contact & Terms: Interested in receiving work from newer, lesser-known photographers. Arrange personal interview to show portfolio. Submit portfolio for review. Query with résumé of credits. Query with samples. Query with stock photo list. Provide résumé, business card, brochure, flier or tearsheets to be kept on file for possible future assignments. Keeps samples of tearsheets, etc. on file. Cannot return material. Reports in 1 month. Pays $50-200/color photo; $50-200/b&w photo. Credit line given. Buys one-time rights and book rights; negotiable. Simultaneous submissions and previously published work OK.

Tips: "I look for unposed images which show lots of action. Please be patient when you submit images for a project. The editorial process can take a long time and it is in your favor if your images are at hand when last minute changes are made."

***THE ROSEN PUBLISHING GROUP, INC.**, 29 E. 21st St., New York NY 10010. (212)777-3017. Fax: (212)777-0277. E-mail: rosenpub@tribeca.ios.com. Art Director: Kim Sonsky. Estab. 1950. Publishes juvenile and young adult nonfiction books. Photos used for text illustration and book covers.

‡ **THE DOUBLE DAGGER** before a listing indicates that the market is located outside the United States and Canada.

Examples of recently published titles: *Drugs and Your Friends*; *Everything You Need to Know About Sports Injuries*; and *Let's Talk About Your Parents' Divorce*.
Neeeds: Buys 2,000 photos annually; offers 80-100 freelance assignments annually. Needs photos of teens or juveniles in coping and self-help situations; also religious photos. Reviews stock photos. Model release required for subjects in photo. Captions preferred.
Making Contact & Terms: Interested in receiving work from newer, lesser-known photographers. Arrange personal interview to show portfolio. Query with résumé of credits. Provide résumé, business card, brochure, flier or tearsheets to be kept on file for possible future assignments. Works with freelancers on assignment only. Buys 5×7, 8×10 color and b&w prints; 35mm, 2¼×2¼ transparencies; 35mm or medium format film. Keeps samples on file. SASE. Reports in 1-2 weeks. Pays $250-1,000/job. **Pays on acceptance.** Credit line given. Buys all rights; negotiable. Simultaneous submissions and previously published work OK.

THE SPEECH BIN INC., 1965 25th Ave., Vero Beach FL 32960. (407)770-0007. Fax: (407)770-0006. Senior Editor: Jan J. Binney. Estab. 1984. Publishes textbooks and instructional materials for speech-language pathologists, audiologists and special educators. Photos used for book covers, instructional materials and catalogs. Examples of published title: *Talking Time* (cover); also catalogs.
Needs: Scenics are currently most needed photos. Also needs children; children with adults; school scenes; elderly adults; handicapped persons of all ages. Model release required.
Making Contact & Terms: Interested in receiving work from newer, lesser-known photographers. Provide résumé, business card, brochure, flier or tearsheets to be kept on file for possible future assignments. Works on assignment plus purchases stock photos from time to time. Uses 8×10 glossy b&w prints. Full-color scenics for catalog. SASE. Reports in 3 weeks. NPI; negotiable. Credit line given. Buys all rights; negotiable. Previously published work OK.

***SPINSTERS INK**, 3201 Columbus Ave. S., Minneapolis MN 55407-2030. (612)827-6177. Fax: (612)827-4417. E-mail: tufte004@gold.tc.umn.edu. Production Manager: Liz Tufte. Estab. 1978. Publishes feminist books by women. Photos used for book covers. Examples of recently published title: *Give Me Your Good Ear* (cover). Photo guidelines free on request.
Needs: Buys 1 photo annually; offers 6 freelance assignments annually. Wants positive images of women in all their diversity. "We work with photos of women by women." Model release required. Captions preferred.
Making Contact & Terms: Interested in receiving work from newer, lesser-known photographers. Query with samples. Works with freelancers on assignment only. Uses 5×7, 8×10 color or b&w prints; 4×5 transparencies; Macintosh disk; 88 or 44mb SyQuest; photo CD. Keeps samples on file. SASE. Reports in 3 weeks. Pays $150-250/job. **Pays on acceptance.** Credit line given. Buys book rights; negotiable. Simultaneous submissions OK.
Tips: "Spinsters Ink books are produced electronically, so we prefer to receive a print as well as a digital image when we accept a job. Please ask for guidelines before sending art."

THE SPIRIT THAT MOVES US PRESS, P.O. Box 720820PH, Jackson Heights NY 11372-0820. (718)426-8788. Editor/Publisher: Morty Sklar. Estab. 1975. Publishes adult trade fiction, poetry and essays. Photos used for book covers, dust jackets, and as art (not as illustrations). Examples of recently published titles: *Editor's Choice III* (text pages); *Speak to Me* (cover and text); and *Patchwork of Dreams* (cover and text). "However, we're behind in our schedule at present, so please do not query until January 1997."
Needs: Buys 10-20 photos annually; offers 10-20 freelance assignments annually. Subject matter varies with book, but "expressive" images are preferred over formal shots.
Making Contact & Terms: Interested in receiving work from newer, lesser-known photographers. "95% of what we publish is unsolicited." Query *after January 1997* with SASE for needs. Uses 8×10 glossy b&w prints. Keeps samples on file if interested. SASE. Reports in 1-2 weeks. Pays $100 for cover; same as writers for text photos and copies of book. Pays on publication. Credit line given. Buys one-time and possible repeat (anthology) rights; negotiable. Simultaneous submissions and previously published work OK "if they let us know at time of submission."
Tips: "Send us what you love best. Don't try to give us what you think we want at the exclusion of your own tastes. We always love and depend on photographs."

STAR PUBLISHING COMPANY, 940 Emmett Ave., Belmont CA 94002. (415)591-3505. Fax: (415)591-3898. Managing Editor: Stuart Hoffman. Estab. 1978. Publishes textbooks, regional history, professional reference books. Photos used for text illustration, promotional materials and book covers. Examples of recently published titles: *Applied Food Microbiology* and *Medical Mycology*.
Needs: Biological illustrations, photomicrographs, business, industry and commerce. Reviews stock photos. Model release required. Captions required.
Making Contact & Terms: Query with samples and list of stock photo subjects. Provide résumé, business card, brochure, flier or tearsheets to be kept on file for possible future assignments. Uses

5×7 minimum b&w and color prints; 35mm transparencies. SASE. Reports within 90 days when a response is appropriate. NPI; payment variable "depending on publication, placement and exclusivity." Credit line given. Buys one-time rights; negotiable. Previously published submissions OK.

Tips: Wants to see photos that are technically (according to book's subject) correct, showing photographic excellence.

***STRANG COMMUNICATIONS COMPANY**, 600 Rinehart Rd., Lake Mary FL 32746. (407)333-0600. Fax: (407)333-7100. E-mail: markp@strang.mhs.compuserve.com. Design Assistant: Donna Morano. Estab. 1975. Publishes religious magazines and books for Sunday School and general readership. Photos used for text illustration, promotional materials, book covers and dust jackets. Examples of recently published titles: *Charisma Magazine*, *New Man Magazine* and *Ministries Today Magazine* (all editorial, cover). Photo guidelines free with SASE.

Needs: Buys 75-100 photos annually; offers 75-100 freelance assignments annually. People, environmental portraits, situations. Reviews stock photos. Model/property release preferred for all subjects. Captions preferred; include who, what, when, where.

Making Contact & Terms: Interested in receiving work from newer, lesser-known photographers. Arrange personal interview to show portfolio. Submit portfolio for review. Query with samples. Provide résumé, business card, brochure, flier or tearsheets to be kept on file for possible future assignments. Call and arrange to send portfolio. Works with freelancers on assignment only. Uses 8×10 prints; 35mm, 2¼×2¼, 4×5 transparencies; Mac digital format (floppy, zip, 88mg). Keeps samples on file. SASE. NPI; negotiable with each photographer. Pays on publication and receipt of invoice. Credit line given. Buys one-time, first-time, book, electronic and all rights; negotiable. Simultaneous submissions and previously published work OK.

Tips: "Be flexible. Listen to the needs of the client and cultivate a long-term relationship."

♣THISTLEDOWN PRESS LTD., 633 Main St., Saskatoon, Saskatchewan S7H 0J8 Canada. (306)244-1722. Fax: (306)244-1762. Director of Production: A.M. Forrie. Publishes adult/young adult fiction and poetry. Photos used for text illustration, promotional materials, book covers.

Needs: Looking for realistic color or b&w photos.

Making Contact & Terms: Query with samples. Include SASE. "Project oriented—rates negotiable."

***TRUTH CONSCIOUSNESS/DESERT ASHRAM**, 3403 W. Sweetwater Dr., Tucson AZ 85745-0384. (520)743-0384. Editor: Sita Stuhlmiller. Estab. 1974. Publishes books and a periodical, *Light of Consciousness, A Journal of Spiritual Awakening*.

● *Also see listing for Sarcred Mountain Ashram in the Paper Products section of this book.*

Needs: Buys/assigns about 45 photos annually. Looking for "universal spiritual, all traditions that in some way illustrate or evoke upliftment, reverence, devotion or other spiritual qualities." Art is used that relates to or supports a particular article.

Making Contact & Terms: Send b&w and color slides, cards, prints. Include self-addressed, stamped mailer for return of work. NPI. Prefers gratis; negotiable. Model release preferred. Captions preferred. Credit line given; also, artist's name/address/phone (if wished) printed in separate section in magazine.

U.S. NAVAL INSTITUTE, 118 Maryland Ave., Annapolis MD 21402. (410)268-6110. Fax: (410)269-7940. Picture Editor: Charles L. Mussi. Estab. 1873. Publishes naval and maritime subjects, novels. Photos used for text illustration, promotional materials, book covers and dust jackets. Examples of published titles: *The Hunt for Red October* (book cover); *The U.S.N.I. Guide to Combat Fleet* (70% photos); and *A Year at the U.S. Naval Academy* (tabletop picture book). Photo guidelines free with SASE.

Needs: Buys 240 photos annually; offers 12 freelance assignments annually. "We need dynamic cover-type images that are graphic and illustrative." Reviews stock photos. Model release preferred. Captions required.

Making Contact & Terms: Interested in receiving work from newer, lesser-known photographers. Query with résumé of credits. Uses 8×10 glossy color and b&w prints; 35mm, 2¼×2¼, 4×5, 8×10 transparencies. Keeps samples on file. SASE. Reports in 1-2 weeks. Pays $25-200/color and b&w photos. Pays on publication or receipt of invoice. Credit line given. Buys one-time rights; negotiable. Simultaneous submissions and previously published work OK.

Tips: "Be familiar with publications *Proceedings* and *Naval History* published by U.S. Naval Institute."

LISTINGS THAT USE IMAGES electronically can be found in the Digital Markets Index located at the back of this book.

***UNITY SCHOOL OF CHRISTIANITY**, 1901 NW Blue Pkwy., Unity Village MO 64065-0001. (816)524-3550. Fax: (816)251-3552. Product Publicist: Diana Trott. Estab. 1889. Publishes books on adult and juvenile spirituality, *Unity Magazine* and *Daily Word Magazine*. Photos used for book and magazine covers, audio packaging, dust jackets. Examples of recently published titles: *Creating Healthier Relationships, UP Thoughts for Down Moments* and *Open the Doors to Your Soul* (all audio packaging).
Needs: Buys 10 photos annually for book covers and hundreds of photos annually for magazine covers. Needs inspirational photos of happy people, landscapes, nature, etc. Reviews stock photos. Model/property release is required for individuals and identifiable institutions or locations. Captions preferred.
Making Contact & Terms: Interested in receiving work from newer, lesser-known photographers. Query with stock photo list. Provide résumé, business card, brochure, flier or tearsheets to be kept on file for possible future assignments. Prefers 35mm, 2¼×2¼, 4×5 transparencies. Keeps samples on file. SASE. Reports in 1 month. NPI; negotiable. **Pays on receipt of invoice.** Credit line given. Rights negotiable. Simultaneous submissions and previously published work OK.

UNIVELT, INC., P.O. Box 28130, San Diego CA 92198. (619)746-4005. Manager: Robert H. Jacobs. Estab. 1970. Publishes technical books on astronautics. Photos used for text illustration, book covers and dust jackets. Examples of recently published titles: *History of Rocketry and Astronautics* and *Strategies for Mars: A Guide to Human Exploration.*
Needs: Uses astronautics; most interested in photographer's concept of space, and photos depicting space flight and related areas. Reviews stock photos; space related only. Captions required.
Making Contact & Terms: Generally does not use freelance photos. Call before submitting. Uses 6×9 or 4½×6 b&w photos. Reports in 1 month. Pays $25-100/b&w photo. Credit line given, if desired. Buys one-time rights. Simultaneous submissions and previously published work OK.
Tips: "Photos should be suitable for front cover or frontispiece of space books."

VERNON PUBLICATIONS INC., 3000 Northup Way, Suite 200, Bellevue WA 98004. Fax: (206)822-9372. Editorial Director: Michele A. Dill. Estab. 1960. Publishes travel guides, a travel magazine for RVers, relocation guides, homeowner guides. Photos used for text illustration, promotional materials and book covers. Examples of published titles: *The Milepost; RV West* (magazine); and *Info Guide* (annual guide). Photo guidelines free with SASE.
● This publisher likes to see high-resolution, digital images.
Needs: Buys 200-300 photos annually. Model release required. Property release preferred. Captions required; include place, time, subject, and any background information.
Making Contact & Terms: Interested in receiving work from newer, lesser-known photographers. Query with samples. Provide résumé, business card, brochure, flier or tearsheets to be kept on file for possible future assignments. Include SASE for return. Uses b&w prints; 35mm, 2¼×2¼ transparencies. SASE. Reporting time varies. NPI. Pays on publication. Credit line given. Buys one-time, book and all rights; negotiable. Simultaneous submissions and previously published work OK; however, it depends on where the images were previously published.

***VICTOR BOOKS**, 1825 College Ave., Wheaton IL 60187. (708)260-6472. Fax: (708)668-3806. Senior Graphic Designer: Scott Rattray. Estab. 1934. Publishes CBA trade fiction, nonfiction, children's juvenile and reference books. Photos used for book covers and dust jackets. Examples of recently published titles: *Rediscovering the Soul of Leadership, Desert Water* and *Truth Seed Series.*
Needs: Buys 20 photos annually; offers 20 freelance assignments annually. Creative concepts, people, backgrounds. Reviews stock photos. Model/property release required.
Making Contact & Terms: Submit portfolio for review. Query with stock photo list. Uses 2¼×2¼, 4×5 transparencies. Keeps samples on file. Reports in 1-2 weeks. NPI. **Pays on receipt of invoice.** Credit line given. Buys book rights.
Tips: "Keep subject matter simple and with cutting edge style."

***VICTORY PRODUCTIONS**, 581 Pleasant St., Paxton MA 01612. (508)755-0051. Fax: (508)755-0025. Contact: S. Littlewood. Publishes children's books. Example of recently published title: *Language Arts* (theater photos) for Harcourt Brace.
Needs: Children and animals. Model/property release required.
Making Contact & Terms: Interested in receiving work from newer, lesser-known photographers. Provide résumé, business card, brochure, flier or tearsheets to be kept on file for possible future assignments. Works on assignment only. Keeps samples on file. Reports in 1-2 weeks. NPI; varies by project. Credit line usually given, depending upon project. Rights negotiable.

***VOYAGEUR PRESS**, 123 N. Second St., Stillwater MN 55082. Fax: (612)430-2211. Editor: Todd R. Berger. Estab. 1972. Publishes mostly adult trade books; specializes in natural history and travel guides. Photos used for text illustration, book covers, dust jackets, calendars. Examples of recently

published titles: *Loons: Song of the Wild* (text illustration/cover); *Sea Turtles* (text illustration, cover); and *1997 Gun Dogs Calendar* (interior, cover). Photo guidelines free with SASE.

Needs: Buys 200 photos annually. Primarily natural history; artistic angle is crucial—books often emphasize high-quality photos. Model/property release required. Captions preferred; include location, species, interesting nuggets, depending on situation.

Making Contact & Terms: Interested in receiving work from newer, lesser-known photographers. Query with résumé of credits. Query with nonreturnable samples. Query with stock photo list. Provide résumé, business card, brochure, flier or tearsheets to be kept on file for possible future assignments. Uses 35mm, 2¼×2¼, 4×5, some 8×10 transparencies. Keeps samples on file. SASE. Reports in 1 month. NPI. Pays on publication. Credit line given. Buys one-time or all rights; negotiable.

Tips: "We are often looking for specific material (crocodile in the Florida Keys; farm scenics in the Southwest; wolf research in Yellowstone) so subject matter is important. But outstanding color and angles, interesting patterns and perspectives, are strongly preferred whenever possible. If you have the capability and stock to put together an entire book, your chances with us are much better. Though we use some freelance material, primarily for calendars, we publish many more single-photographer works."

***WAITE GROUP PRESS**, 200 Tamal Plaza, Corte Madera CA 94925. (415)924-2575. Fax: (415)924-8738. Production Director: Julianne Ososke. Estab. 1991. Publishes computer programming books. Photos used for book covers. Examples of recently published titles: *Delphi How-to*, *Master C#*, *Visual Basic Database How-to* (all book covers).

Needs: Buys 25-50 photos annually; offers 25-50 freelance assignments annually. Needs abstract photos. Model/property release preferred. Captions preferred; include photographer's name.

Making Contact & Terms: Interested in receiving work from newer, lesser-known photographers. Query with samples. Query with stock photo list. Provide résumé, business card, brochure, flier or tearsheets to be kept on file for possible future assignments. Works on assignment only. Uses 4×5 transparencies. Keeps samples on file. SASE. Reports in 1 month. Pays $600-1,000/color photo. **Pays on receipt of invoice.** Buys book rights; negotiable. Simultaneous submissions and previously published work OK.

Tips: "Make sure the image is submitted in the correct format. Do your homework before you approach a publication—look at cover images used on previous titles."

WARNER BOOKS, 1271 Avenue of the Americas, 9th Floor, New York NY 10020. (212)522-7200. Vice President & Publisher/Warner Treasures, Creative Director/Warner Books: Jackie Merri Meyer. Publishes "everything but text books." Photos used for book covers and dust jackets.

Needs: Buys approximately 50 freelance photos annually; offers approximately 30 assignments annually. Needs photos of people, food still life, glamourous women and couples. Reviews stock photos. Model release required. Captions preferred.

Making Contact & Terms: Send brochure, flier or tearsheets to be kept on file for possible future assignments. Cannot return unsolicited material. Uses color prints/transparencies; also some b&w and hand-tinting. Pays $800 and up/color photo; $1,200 and up/job. Credit line given. Buys one-time rights. Simultaneous submissions and previously published work OK.

Tips: "Printed and published work (color copies are OK, too) are very helpful. Do not call, we do not remember names—we remember samples. Be persistent."

WAVELAND PRESS, INC., P.O. Box 400, Prospect Heights IL 60070. (847)634-0081. Fax: (847)634-9501. Photo Editor: Jan Weissman. Estab. 1975. Publishes college textbooks. Photos used for text illustration and book covers. Examples of published titles: *Our Global Environment*, Fourth Edition (inside text); *Africa & Africans*, Fourth Edition (chapter openers and cover); and *Principles of Agribusiness Management*, Second Edition (chapter openers).

Needs: Number of photos purchased varies depending on type of project and subject matter. Subject matter should relate to college disciplines: criminal justice, anthropology, speech/communication, sociology, archaeology, etc. Model/property release required. Captions preferred.

Making Contact & Terms: Interested in receiving work from newer, lesser-known photographers. Query with stock photo list. Provide résumé, business card, brochure, flier or tearsheets to be kept on file for possible future assignments. Uses 5×7, 8×10 glossy b&w prints. Keeps samples on file. SASE. Reports in 2-4 weeks. Pays $25-200/color photo; $25-100/b&w photo. Pays on publication. Credit line given. Buys one-time and book rights. Simultaneous submissions and previously published work OK.

♣WEIGL EDUCATIONAL PUBLISHERS LIMITED, 1902 11th St. SE, Calgary, Alberta T2G 3G2 Canada. (403)233-7747. Fax: (403)233-7769. Attention: Editorial Department. Estab. 1979. Publishes textbooks and educational resources: social studies, life skills, environment/science studies, multicultural, language arts and geography. Photos used for text illustration and book covers. Example

of published titles: *Career Connections* (cover and inside) and *Alberta, Its People in History* (cover and inside).

Needs: Buys 15-25 photos annually; offers 2-3 freelance assignments annually. Social issues and events, politics, education, technology, people gatherings, multicultural, environment, science, agriculture, life skills, landscape, wildlife and people doing daily activities. Reviews stock photos. Model/property release required. Captions required.

Making Contact & Terms: Interested in receiving work from newer, lesser-known photographers. Query with samples. Query with stock photo list. Provide tearsheets to be kept on file for possible future assignments. Tearsheets or samples that don't have to be returned are best. Keeps samples on file. Uses 5×7, 3×5, 4×6, 8×10 color/b&w prints; 35mm, 2¼×2¼ transparencies. SASE. "We generally get in touch when we actually need photos." Price is negotiable. Credit line given (photo credits as appendix). Buys one-time, book and all rights; negotiable. Simultaneous submissions and previously published work OK.

Tips: Need "clear, well-framed shots that don't look posed. Action, expression, multicultural representation are important, but above all, education value is sought. People must know what they are looking at. Please keep notes on what is taking place, where and when. As an educational publisher, our books use specific examples as well as general illustrations."

SAMUEL WEISER INC., P.O. Box 612, York Beach ME 03910. (207)363-4393. Fax: (207)363-5799. Art Director: Ed Stevens. Estab. 1956. Publishes books on esoterica, Oriental philosophy, alternative health and mystery traditions. Photos used for book covers. Examples of published titles: *Modern Mysticism*, by Micheal Gellert (Nicolas Hays imprint); *Foundations of Personality*, by Hamaker-Zondag. Photo guidelines free with SASE.

Needs: Buys 2-6 photos annually. Needs photos of flowers, abstracts (such as sky, paths, roads, sunsets) and inspirational themes. Reviews stock photos.

Making Contact & Terms: Interested in receiving work from newer, lesser-known photographers. Query with samples. Send unsolicited photos by mail for consideration. Provide résumé, business card, brochure, flier or tearsheets to be kept on file for possible future assignments. "We'll take color snapshots to keep on file, or color copies." Keeps samples on file. Uses color prints, 2¼×2¼ and 4×5 transparencies. SASE. Reports in 1 month. Pays $100-150/color and b&w photos. Credit line given. Buys one-time rights. "We pay once for life of book because we do small runs." Simultaneous submissions and previously published work OK.

Tips: "We don't pay much and we don't ask a lot. We have to keep material on file or we won't use it. Color photocopies, cheap Kodak prints, something that shows us an image that we assume is pristine on a slide and we can call you or fax you for it. We do credit line on back cover, and on copyright page of book, in order to help artist/photographer get publicity. We like to keep inexpensive proofs because we may see a nice photo and not have anything to use it on now. We search our files for covers, usually on tight deadline. We don't want to see goblins and Halloween costumes."

✦WHITECAP BOOKS LTD., 351 Lynn Ave., North Vancouver, British Columbia V7J 2C4 Canada. (604)980-9852. Fax: (604)980-8197. Editorial Director: Robin Rivers. Estab. 1978. Publishes adult trade, color books, natural history, scenic, gardening; some juvenile nonfiction. Photos used for text illustration, book covers, dust jackets, calendars. Examples of published titles: *Canadian Birds*; *Canadian Wildlife*; *Emerald Sea*; all photo essays.

Needs: Buys 500 photos annually. Looking for scenics, wildlife, calendar material. Model release required. Captions required; include basic identification, photographer's name.

Making Contact & Terms: Interested in receiving work from newer, lesser-known photographers. Query with stock photo list. Provide résumé, business card, brochure, flier or tearsheets to be kept on file for possible future assignments. Uses 35mm, 2¼×2¼, 4×5 transparencies. SASE. $90-100/color photo. Pays on publication. Credit line sometimes given (not usually in text—always a photo credit page). Buys one-time and book rights; negotiable. Simultaneous submissions and/or previously published works OK.

Tips: "We look for wildlife and scenics with good composition, color and a creative approach to conventional subjects. Don't expect to be paid the same rates as in other industries. We are continuing to use freelance photographers on a regular basis."

JOHN WILEY & SONS, INC., 605 Third Ave., New York NY 10158. (212)850-6731. Fax: (212)850-6450. Director, Photo Department: Stella Kupferberg. Estab. 1807. Publishes college texts in hard sciences. Photos used for text illustration. Examples of published titles: *Dynamic Earth*, by Skinner; *Blue Planet*, by Skinner; *Biology*, by Brown (all covers and interior photos).

Needs: Buys 4,000 photos/year; 200 photos used for text and cover illustration. Uses b&w and color photos for textbooks in psychology, business, computer science, biology, physics, chemistry, geography, geology and foreign languages. Captions required.

Making Contact & Terms: Query with list of stock photo subjects. Uses 8×10 glossy and semigloss b&w prints; also 35mm, electronic, and large format transparencies. SASE. "We return all photos

securely wrapped between double cardboard by FedX." Pays $100-150/b&w print and $100-225/ color transparency. Credit line given. Buys one-time rights. Simultaneous submissions and previously published work OK.

Tips: "Initial contact should spell out the material photographer specializes in, rather than a general inquiry about our photo needs. Tearsheets and fliers welcome."

***WILLOWISP PRESS**, 801 94th Ave. N., St. Petersburg FL 33702-2426. (813)578-7600 ext. 2280. Fax: (813)578-3105. Art Director: Michael Petty. Estab. 1981. Publishes nonfiction, fiction, how-to, calendars, posters, etc. for juveniles. Photos used for text illustration, book covers, calendars, picture books and posters. Examples of recently published titles: *Jane Goodall* (cover, back cover, inside text photos); *Cute'n Cuddly Kitten Calendar* (cover and 12 images, 1 for each month); and *The Black Cat* (cover).

Needs: Buys 100 photos annually; offers 6 freelance assignments annually. Needs appealing photos of cute animals, children, etc. Reviews stock photos. Model/property release preferred. Captions preferred.

Making Contact & Terms: Interested in receiving work from newer, lesser-known photographers. Query with samples. Provide résumé, business card, brochure, flier or tearsheets to be kept on file for possible future assignments. Works on assignment only. Uses 35mm, $2\frac{1}{4} \times 2\frac{1}{4}$, 4×5, 8×10 transparencies. Keeps samples on file. SASE. Reports in 1 month. Pays $25-500/color photo; $25-250/b&w photo. **Pays on acceptance.** Credit line sometimes given depending upon project. Buys book and all rights; negotiable. Simultaneous and previously published work OK.

Tips: "We are using a lot of digital imagery recently attained from our new CD-stock photo library."

WORD PUBLISHING, 1501 LBJ Freeway, Suite 650, Dallas TX 75234. (214)488-9673. Senior Art Director: Tom Williams. Estab. 1951. Publishes Christian books. Photos used for book covers, publicity, brochures, posters and product advertising. Examples of recently published titles: *The End of the Age*, by Pat Robertson; *Angels*, by Billy Graham; and *Miracle Man: Nolan Ryan Autobiography*. Photos used for covers. "We do not provide want lists or photographer's guidelines."

Needs: Needs photos of people, studio shots and special effects. Model release required; property release preferred.

Making Contact & Terms: Provide brochure, flier or tearsheets to be kept on file for possible future assignments. "Please don't call." SASE. Reports in 1 month. Assignment photo prices determined by the job. Pays for stock $350-1,000. Credit line given. Rights negotiable.

Tips: In portfolio or samples, looking for strikingly lighted shots, good composition, clarity of subject. Something unique and unpredictable. "We use the same kinds of photos as the secular market. I don't need crosses, church windows, steeples, or wheat waving in the sunset. Don't send just a letter. Give me something to look at, not to read about." Opportunity is quite limited: "We have hundreds of photographers on file, and we use about 5-10% of them."

♣WUERZ PUBLISHING LTD., 895 McMillan Ave., Winnipeg, Manitoba R3M 0T2 Canada. (204)453-7429. Fax: (204)453-6598. Director: Steve Wuerz. Estab. 1989. Publishes university-level science textbooks, especially in environmental sciences (chemistry, physics and biology). Photos used for text illustration, book covers to accompany textbooks in diskettes or CD-ROM materials. Examples of published titles: *Mathematical Biology*; *Energy Physics & the Environment*; and *Environmental Chemistry* (all cover and text illustration). Photo guidelines free with SASE.

Needs: Buys more than 100 photos annually; offers 4 assignments and research combined. Reviews stock photos. Model/property release "as appropriate." Captions required; include location, scale, genus/species.

Making Contact & Terms: Interested in receiving work from newer, lesser-known photographers. Query with résumé of credits. Query with samples. Query with stock photo list. Provide résumé, business card, brochure, flier or tearsheets to be kept on file for possible future assignments. Works on assignment only. SASE. Reports usually in 1 month. NPI; negotiable. Credit line given. Buys book rights. Simultaneous submissions and previously published work OK.

Tips: "In all cases, the scientific principle or the instrument being displayed must be clearly shown in the photo. In the past we used photos of smog in Los Angeles and Denver, tree frogs from Amazonia, wind turbines from California, a plasma reactor at Harwell United Kingdom, fireworks over London, and about 50 different viruses. Summarize your capabilities. Summarize your collection of 'stock' photos, preferably with quantities. Outline your 'knowledge level,' or how your collection is organized, so that searches will yield answers in reasonable time."

ZOLAND BOOKS, 384 Huron Ave., Cambridge MA 02138. (617)864-6252. Fax: (617)661-4998. Design Director: Lori K. Pease. Publishes adult trade, some juvenile, mostly fiction, some photography, poetry. Photos used for book covers and dust jackets. Examples of recently published title: *Talking Pictures*, by Rudy Burckhardt and Simon Pettet (photography book). Photo guidelines free with SASE.

Needs: Buys 3-5 photos annually; offers 3-5 freelance assignments annually. Subject matter varies greatly with each book. "We do like a painterly style and always need author photos, nature, people." Subject matter depends on book. Captions preferred.

Making Contact & Terms: Interested in receiving work from newer, lesser-known photographers. Query with samples. Provide résumé, business card, brochure, flier or tearsheets to be kept on file for possible future assignments. Mostly work with freelancers only. Use 4 × 5 glossy, b&w prints; 2¼ × 2¼, 4 × 5 transparencies. Keeps samples on file. SASE. Reports in 1-2 months. NPI. **Pays on acceptance.** Credit lines given. Rights vary with project; negotiable. Simultaneous submissions and previously published work OK.

Tips: Looks for work with a unique vision. Hand-painted work is of interest, as is nature, people. "We are a literary publishing company, not looking for commercial-advertising sorts of photography."

Businesses and Organizations

You will find a wide range of markets in this section, from major corporations such as insurance companies to public interest and trade associations to universities and arts organizations. In all, there are approximately 60 markets. The types of photography these listings require overlap somewhat with advertising markets. However, unlike that work which is largely directed toward external media or audiences, the photography for listings in this section tends to be more for specialized applications. Among these are employee or membership commmunications, annual reports, and documentary purposes such as recording meetings, group functions or theatrical presentations.

A fair number of these listings are receptive to stock images, while many have rather specific needs for which they assign photographers. These projects will sometimes require studio-type skills (again similar to the advertising/PR market), particularly in shooting corporate interiors and portraits of executives for annual reports. However, much of the coverage of meetings, events and performances calls for a different set of skills involving use of available light and fill flash. In particular, coverage of sporting events or theatrical performances may require agility with extreme or rapidly changing light conditions.

Unless these businesses and organizations are active at the national level, they typically prefer to work with local freelancers. Rates vary widely depending upon the individual client's budget. We have tried to list current rates of payment where possible, but some listings only indicate "negotiable terms," or a per-shot, per-hour or per-day basis. Listings which have not provided a specific dollar amount include the code NPI, for "no payment information given." When quoting a price, especially for assigned work, remember to start with a basic day rate plus expenses and negotiate for final number of images, types of usage and time period for usage.

In particular, many of these clients wish to buy all rights to the images since they are often assigned for specific needs. In such cases, negotiate so that these clients get all the rights they need but that you ultimately retain copyright.

***∎ABBY LOU ENTERTAINMENT**, 1411 Edgehill Place, Pasadena CA 91103. (818)795-7334. Fax: (818)795-4013. President: George LeFave. Estab. 1987. Children's TV, toys, video production. Photos used in brochures, posters, catalogs and video production.
Needs: Buys 10-110 photos/year; offers 5-10 freelance assignments/year. Uses freelancers for children, toys. Examples of recent uses: video, catalog, brochure. Model/property release required. Captions preferred.
Audiovisual Needs: Uses slides and videotape. Subjects include: children and toys.
Making Contact & Terms: Interested in receiving work from newer, lesser-known photographers. Query with samples. Provide résumé, business card, brochure, flier or tearsheets to be kept on file for possible future assignments. Works with local freelancers only. Uses transparencies and videotape. Keeps samples on file. Cannot return material. Reports in 1 month. NPI. **Pays on acceptance** or usage. Credit lines sometimes given; "depends on job." Buys all rights; negotiable.
Tips: "Know your craft. Be flexible in negotiations." Concerned that "quality is not what it used to be."

AMATEUR SOFTBALL ASSOCIATION, 2801 NE 50th St., Oklahoma City OK 73111. (405)424-5266. Director of Communications: Ronald A. Babb. Promotion of amateur softball. Photos used in newsletters, newspapers, association magazine.

Needs: Buys 10-12 photos/year; offers 5-6 assignments annually. Subjects include action sports shots. Model release required. Captions required.
Making Contact & Terms: Contact ASA national office first before doing any work. Uses prints or transparencies. SASE. Reports in 2 weeks. Pays $50 for previously published photo. Assignment fees negotiable. Credit line given. Buys all rights.

■AMERICAN ALLIANCE FOR HEALTH, PHYSICAL EDUCATION, RECREATION AND DANCE, 1900 Association Dr., Reston VA 22091. (703)476-3400. Fax: (703)476-9527. E-mail: dlewin@aahperd.org. Director of Publications: Debra H. Lewin. Estab. 1885. Photos used in brochures, newsletters, magazines and catalogs.
Needs: Buys 50 photos/year; offers 2-3 assignments/year. Wants photos of sports, recreation, outdoor activities, health practices, physical education and other education-specific settings; also interested in handicapped and special populations. Reviews stock photos. Model/property release preferred, especially for children and handicapped.
Audiovisual Needs: Uses slides.
Making Contact & Terms: Query with stock photo list. Provide résumé, business card, self-promotion piece or tearsheets to be kept on file for possible future assignments. Call. Keeps samples on file. SASE. Reports in 1-2 weeks. Pays $100/color photo; $25/b&w photo. Pays upon usage. Credit line given. Buys one-time rights; negotiable.
Tips: "We are always looking for strong action or emotion. We usually need vertical formats for magazine covers with color work."

■AMERICAN FUND FOR ALTERNATIVES TO ANIMAL RESEARCH, 175 W. 12th St., Suite 16-G, New York NY 10011. Phone/fax: (212)989-8073. Contact: Dr. E. Thurston. Finances research to develop research methods which will not need live animals. Also informs the public of this and about current methods of experimentation. Photos used in reports, advertising and publications.
Needs: Buys 10 freelance photos/year; offers 5 freelance assignments/year. Needs b&w or color photos of laboratory animal experimentation and animal use connected with fashions (trapping) and cosmetics (tests on animals). Model release preferred.
Making Contact & Terms: Arrange a personal interview to show portfolio. Query with samples and list of stock photo subjects. Provide brochure and flier to be kept on file for possible future assignments. Notifies photographer if future assignments can be expected. Uses 5×7 b&w prints; also uses 16mm film for educational films. SASE. Reports in 2 weeks. Pays $5 minimum/b&w photo; $5 or more/color photo; $30 minimum/job. Credit line given. Buys one-time rights and exclusive product rights; arranged with photographer.
Tips: In portfolios or samples wants to "see clear pictures of animals in cosmetic tests or testing labs, or fur ranches, and in the wilds."

AMERICAN MUSEUM OF NATURAL HISTORY LIBRARY, PHOTOGRAPHIC COLLECTION, Library Services Department, Central Park West, 79th St., New York NY 10024. (212)769-5419. Fax: (212) 769-5009. E-mail: speccol@amnh.org. Senior Special Collections Librarian: Thomas Baione. Estab. 1869. Provides services for advertisers, authors, film and TV producers, general public, government agencies, picture researchers, publishers, scholars, students and teachers who use photos for brochures.
Needs: Model release required. Captions required.
Making Contact & Terms: "We accept only donations with full rights (nonexclusive) to use; we offer visibility through credits." Credit line given. Buys all rights.
Tips: "We do not review portfolios. Unless the photographer is willing to give up rights and provide images for donation with full rights (credit lines are given), the museum is not willing to accept work."

***■AMERICAN POWER BOAT ASSOCIATION**, 17640 E. Nine Mile Rd., Box 377, Eastpointe MI 48021. Fax: (810)773-6490. Executive and Publications Editor: Michele Weston. Estab. 1903. Sanctioning body for US power boat racing; monthly magazine. Majority of assignments made on annual basis. Photos used in monthly magazine, brochures, audiovisual presentations, press releases and programs.
● All photos used by APBA are scanned for placement in electronic page file.

THE SOLID, BLACK SQUARE before a listing indicates that the market uses various types of audiovisual materials, such as slides, film or videotape.

Needs: Power boat racing—action and candid. Captions required.
Making Contact & Terms: Interested in receiving work from newer, lesser-known photographers. Initial personal contact preferred. "Suggests initial contact by phone possibly to be followed by evaluating samples." Send unsolicited photos by mail for consideration; provide résumé, business card, brochure, flier or tearsheets to be kept on file for possible future assignments. Uses 5×7 and up, b&w prints and b&w contact sheets. 35mm slides for cover. SASE. Reports in 2 weeks when needed. Payment varies. Standard is $50/cover; $15/b&w inside; $25/color. Credit line given. Buys one-time rights; negotiable. Photo usage must be invoiced by photographer within the month incurred.
Tips: Prefers to see selection of shots of power boats in action or pit shots, candids, etc., (all identified). Must show ability to produce clear b&w action shots of racing events.

AMERICAN SOCIETY FOR THE PREVENTION OF CRUELTY TO ANIMALS (ASPCA), 424 E. 92nd St., New York NY 10128. (212)876-7700, ext. 4441. Fax: (212)410-0087. Art Director: Amber Alliger. Estab. 1866. Photos used in quarterly color magazine, pamphlets, booklets. Publishes *ASPCA Animal Watch Magazine.*
Needs: Photos of animals (domestic and wildlife): farm, domestic, lab, stray and homeless animals, endangered, trapped, injured, fur animals, marine and wildlife, rain forest animals. Example of recent uses: *ASPCA Animal Watch Magazine.* Model/property release preferred.
Making Contact & Terms: Interested in receiving work from newer, lesser-known photographers. Please send a detailed, alphabetized stock list that can be kept on file for future reference. SASE. Reports when needed. Pays $50/b&w photo (inside use); $50/color photo (inside use); $100/cover. Prefers color. Credit line given. Buys one-time rights; negotiable.
Tips: "I like exciting pictures: strong colors, interesting angles, unusual light."

AQUINO PRODUCTIONS, P.O. Box 15760, Stamford CT 06901. (203)967-9952. Fax: (203)353-9661. E-mail: aaquinoint@aol.com. BBS: (203)353-9841. Publisher: Andres Aquino. Estab. 1983. Publishes posters, magazines and calendars. Photos used in posters, newspapers, magazines, catalogs and online BBS.
Needs: Uses freelancers for travel, fashion, beauty, glamour, people. Examples of recent uses: Westchester County Limousine (brochure); Bella Magazine (cover). Reviews stock photos. Model/property release required for people and private property. Captions required; include location and year (if applicable).
Making Contact & Terms: Query with stock photo list. Uses 8×10 glossy or matte b&w prints; 35mm, 2¼×2¼, 4×5 transparencies. Keeps samples on file. SASE. Pays $2-50/b&w or color photo. "We either buy in bulk or resell and pay photographer 30% of sale." Reports in 3 weeks. NPI. Credit line given. Buys exclusive product, electronic and all rights; negotiable.
Tips: "Call our BBS line and see the kind of images we are promoting. We offer a complete set of guidelines, sample photo requests and catalog of publications for $4." Looking for "sharp, well-exposed images from uncommon perspective covering people and places around the world." Sees trend toward more "computer-enhanced images."

***ARGUS COMMUNICATIONS**, 200 E. Bethany, Allen TX 75002. (214)390-6300. Fax: (214)390-6555. Contact: Photo Department. Estab. 1963. Publishes posters, postcards, calendars and other "socially expressive" products.
Needs: Buys at least 200 photos/year, usually purchases stock photography. Subjects include animals, sports, scenics, the arts and contemporary shots (such as still lifes, abstracts). Reviews stock photos. Model release required. Captions required; include photo identification, name, address, phone number, subject description.
Making Contact & Terms: Request guidelines. Selections and purchases made on a project by project basis. Send 35mm, 2¼×2¼, 4×5, 8×10 duplicate transparencies. Keeps tearsheets and category listings on file if work acceptable. SASE. Reports in 1 month to 6 weeks. "Do not phone." Pays flat fee per image beginning at $350/photo. **Pays on acceptance.** Rights vary depending on needs; negotiable.
Tips: "Please request our guidelines before submitting work."

***ARISTOPLAY**, 334 E. Washington St., Ann Arbor MI 48104. (313)995-4353. Fax: (313)995-4611. Product Development Director: Lorraine Hopping Egan. Estab. 1979. Publishes educational board and card games. Photos used for catalogs and board and card games.
Needs: Bought 50-100 photos in last two years; purchase volume varies depending on game subjects. Offers 6-10 freelance assignments/year for local photographers. Has assigned photos dealing with science, kids playing Aristoplay games, product shots and others. Reviews stock photos. "We will send out wish lists. Do not send unsolicited photos and please do not call; fax with questions or queries." Model release required for children; get permission from parents. Photo captions preferred; identify science subjects.

Making Contact & Terms: Interested in receiving work from newer, lesser-known photographers. Query with stock photo list. Provide résumé, business card, self-promotion piece or tearsheets to be kept on file for possible future assignments. Works on assignment only. Uses 35mm, 2¼×2¼ transparencies. Keeps samples on file. Cannot return material. Reports in 1 month. Pays $35-65/color photo; other rates vary. Credit line given. Buys one-time rights.

Tips: "We publish 2-9 products per year. Each one is very different and may or may not require photos. If you are local, tell us your hourly, half day and day rate, and whether you've worked with children."

BEDOL INTERNATIONAL GROUP, INC., P.O. Box 1268, Claremont CA 91711. (909)626-0388. President: Mark A. Bedol. Estab. 1982. Produces stationery items, picture frames, calculators, calendars, etc. Photos used in brochures, press releases and picture frames.

Needs: Buys 300 photos/year; offers 6 freelance assignments/year. Uses product photos for catalogs and advertising, photos of female models, female models with children and babies, cars. Examples of uses: catalog sheets, frames, product pictures. Reviews stock photos. Model release required. Property release preferred.

Making Contact & Terms: Interested in receiving work from newer, lesser-known photographers. Provide résumé, business card, brochure, flier or tearsheets to be kept on file for possible future assignments. Works on assignment only. Uses various size color, b&w prints; 2¼×2¼ transparencies. Keeps samples on file. Cannot return material. Reports only when needed. Pays $50-85/hour; $50-100/color photo; $50-100/b&w photo. Pays on usage. Credit line not given. Buys all rights.

Tips: "Please send work in for review."

BERRY & HOMER INC., 2035 Richmond St., Philadelphia PA 19125. (215)425-0888. Fax: (215)425-2702. Technical Sales Rep: Lynn Charlton. Estab. 1898. Custom photographic digital imaging lab. Photos used in posters, magazines, catalogs, billboards, direct mail, P-O-P displays, signage.

Needs: Uses 30 photographers/month. Uses freelancers for product shots. Model/property release required. Captions preferred.

Making Contact & Terms: Interested in receiving work from newer, lesser-known photographers. Submit portfolio for review. Works on assignment only. Uses 8½×11 color and b&w prints; 35mm, 2¼×2¼, 4×5, 8×10 transparencies. Keeps samples on file. SASE. Reports in 1 month. NPI; depends on assignment. **Pays on receipt of invoice.** Credit line sometimes given depending upon subject. Buys all rights; negotiable.

■**BETHUNE THEATREDANSE**, 8033 Sunset Blvd., Suite 221, Los Angeles CA 90046. (213)874-0481. Fax: (213)851-2078. Managing Director: Beatrice Ballance. Estab. 1979. Dance company. Photos used in posters, newspapers, magazines.

Needs: Number of photos bought annually varies; offers 2-4 freelance assignments annually. Photographers used to take shots of dance productions, dance outreach classes (disabled children's program) and performances, and graphics and scenic. Examples of uses: promotional pieces for the dance production "Cradle of Fire" and for a circus fundraiser performance (all shots in 35mm format). Reviews stock photos if they show an ability to capture a moment. Captions preferred, include company or name of subject, date, and equipment shown in photo.

Audiovisual Needs: Uses slides and videotape. "We are a multimedia company and use videos and slides within our productions. We also use video for archival purposes." Subject matter varies.

Making Contact & Terms: Interested in receiving work from newer, lesser-known photographers. Provide résumé, business card, self-promotion piece or tearsheets to be kept on file for possible future assignments. Uses 8×10 color or b&w prints; 35mm transparencies and videotape. Keeps samples on file. Cannot return material. Reports only when in need of work. NPI; payment for each job is negotiated differently. Credit line sometimes given depending on usage. "We are not always in control of newspapers or magazines that may use photos for articles." Buys all rights; negotiable.

Tips: "We need to see an ability to see and understand the aesthetics of dance—its lines and depth of field. We also look for innovative approaches and personal signature to each individual's work. Our productions work very much on a collaborative basis and a videographer's talents and uniqueness are very important to each production. It is our preference to establish ongoing relationships with photographers and videographers."

■**BROWNING**, One Browning Place, Morgan UT 84050. (801)876-2711, ext. 328. Fax: (801)876-3331. Senior Art Director: Bonnie Cazier. Estab. 1878. Photos used in posters, magazines, catalogs. Uses photos to promote sporting good products.

Needs: Works with 2 freelancers/month; 3 filmmakers/year. Outdoor, wildlife, hunting, shooting sports and archery. Reviews stock photos. Model/property release required. Captions preferred; include location, types of props used, especially brand names (such as Winchester and Browning).

Audiovisual Needs: Uses slides and/or film for multimedia and motion presentations.
Making Contact & Terms: Interested in receiving work from newer, lesser-known photographers. Query with samples. Provide résumé, business card, self-promotion piece or tearsheets to be kept on file for possible future assignments. Works on assignment only. Uses 35mm, 2¼×2¼, 4×5, 8×10 transparencies; 16mm film. Keeps samples on file. SASE. Reports in 1 month. NPI. **Pays on receipt of invoice.** Credit line given depending upon design. Buys one-time rights, all rights; negotiable.
Tips: "We look for dramatic lighting, exceptional settings, preferably masculine but feminine settings at times are desirable. We see more photographers who negotiate terms of photo electronic retouching and imaging."

CALIFORNIA REDWOOD ASSOCIATION, 405 Enfrente Dr., Suite 200, Novato CA 94949. (415)382-0662. Fax: (415)382-8531. Publicity Manager: Pamela Allsebrook. Estab. 1916. "We publish a variety of literature, a small black and white periodical, run color advertisements and constantly use photos for magazine and newspaper publicity. We use new, well-designed redwood applications—residential, commercial, exteriors, interiors and especially good remodels and outdoor decks, fences, shelters."
Needs: Gives 40 assignments/year. Prefers photographers with architectural specialization. Model release required.
Making Contact & Terms: Send query material by mail for consideration for assignment or send finished speculation shots for possible purchase. Uses b&w prints. For color, uses 2¼×2¼ and 4×5 transparencies; contact sheet OK. Reports in 1 month. NPI; payment based on previous use and other factors. Credit line given whenever possible. Usually buys all but national advertising rights. Simultaneous submissions and previously published work OK if other uses are made very clear.
Tips: "We like to see any new redwood projects showing outstanding design and use of redwood. We don't have a staff photographer and work only with freelancers. We generally look for justified lines, true color quality, projects with style and architectural design, and tasteful props. Find and take 'scout' shots or finished pictures of good redwood projects and send them to us."

CASCADE GEOGRAPHIC SOCIETY, P.O. Box 294, Rhododendron OR 97049. (503)622-4798. Curator: Michael P. Jones. Estab. 1979. "Our photographs are for exhibits, educational materials, fliers, posters, etc., including historical artifact catalogs. We are a nonprofit organization." Photo guidelines free with SASE.
Needs: Buys 20 photos annually; offers 20 freelance assignments annually. Needs American history, wildlife, old buildings, Civil War, Revolutionary War, Indian Wars, Oregon Trail, pioneer history, living history, historical re-enactment, nature and environmental. Examples of recent uses: Indian Life Exhibit (b&w prints/color prints used with artifacts); Northwest Wildlife Exhibit (color prints/slides used with artifacts); Village of Salmon Exhibit of color and b&w prints. Reviews stock photos of American history and nature subjects. Model release preferred. Captions preferred.
Making Contact & Terms: Interested in receiving work from newer, lesser-known photographers. Query with résumé of credits. Send unsolicited photos by mail for consideration. Submit portfolio for review. Provide résumé, business card, brochure, flier or tearsheets to be kept on file for possible future assignments. Works on assignment only. Uses 5×7, 8×10 b&w or color prints; 35mm, 2¼×2¼, 4×5, 8×10 transparencies; videotape. Keeps samples on file. SASE. Reports in 3 weeks. Pays in published copies. Offers copies of published images in place of payment. Credit line given. Buys one-time rights. Simultaneous submissions and previously published work OK.
Tips: "We want photos that bond people to the earth and history. Send us enough samples so that we can really understand you and your work. Be patient. More and more doors are being opened for photographers due to multimedia. We are moving in that direction."

CINCINNATI OPERA, Music Hall, 1241 Elm St., Cincinnati OH 45210. (513)621-1919. Fax: (513)621-4310. Public Relations Director: Robin Carey Wilson. Estab. 1920. Produces grand opera during 4-week summer season; outreach throughout year. Photos used in newsletters, press releases. "Have a company photographer, but occasionally need photographer for special events, social scene or projects."
Needs: Offers 8-10 assignments/year. Black & white head shots; backstage rehearsal/costume fittings; flash photos at parties; group and individual portraits of out-reach staff artists for publicity use. Examples of uses: board member photos/head shots release for business papers; backstage photos of on-stage extras for news release; candids at outdoor party for newsletter/release to papers.
Making Contact & Terms: Interested in receiving work from newer, lesser-known photographers. Provide résumé, business card, self-promotion piece or tearsheets to be kept on file for possible future assignments. Works with local freelancers on assignment only. Uses 5×7 or 8×10 glossy color or b&w prints (depends on assignment). Does not keep samples on file. SASE. "I will respond if asked for a response; if it's busy season, better for them to make follow-up call. We ask photographer to tell us normal charges before negotiations. Pay by the hour plus film costs; negotiable—give us a price sheet." Credit line given. Buys all rights.

Tips: "Please keep in mind that we have a company photographer, plus an art photographer with whom we work on brochures and posters. Our need for extra photographers comes up at a moment's notice (if someone is ill or busy, for instance), when we need photos taken at an event or performance during the summer. The best thing to do is send a card, a tearsheet, maybe a short letter for us to keep on file. I do refer back to my files, as often I am looking for a photographer at the last minute. Also, keep in mind: We give only 8-10 assignments/year. Seeing more color shots of on-stage work—almost always get requests from newspapers and agents for color photos of our operas. Also, getting away from the open-mouthed-singer shot, and going for more intense, dramatic facial expressions and body language in our on-stage photos with a more contemporary style."

***■COST OF WISCONSIN, INC.**, W172, N13050 Division Rd., Germantown WI 53022. (414)255-4220. Fax: (414)255-0096. Project Administrator: Jack Beatty. Estab. 1957. Designers/contractors for zoos, amusement parks, museums. Photos used in brochures, magazines, press releases, catalogs, trade shows and presentations.
Needs: Offers 5-6 freelance assignments/year. Uses freelancers for brochure/magazine advertising (2¼ or larger); mounted 16×20 prints for trade shows (2¼ or larger); 8×10 prints for photocopying for hand-outs, advertising (2¼ or larger). Examples of recent uses: exhibits for Kansas City Zoo, Fort Wayne Children's Zoo and Bavarian Inn, Frankenmoth, Michigan (all 2¼ print and transparencies).- Model/property release preferred where face is very distinguishable.
Audiovisual Needs: Videotape for presentations, seminars. Subjects include: amusement park construction, development.
Making Contact & Terms: Interested in receiving work from newer, lesser-known photographers. Provide résumé, business card, brochure, flier or tearsheets to be kept on file for possible future assignments. Work on assignment only. Uses contact sheets of color prints; 2¼×2¼, 4×5 transparencies; ½" videotape. Keeps samples on file. SASE. Reports only when interested in 5-6 weeks. Pays $3,000 maximum/day. **Pays on acceptance.** Credit line given. Buys all rights; negotiable.
Tips: "We do very specialized work throughout the US. We will direct the type of shots required for our use. Color is very important. We try to create a mood. Listen to our needs for each photo. We use photos in many diverse mediums and we have a very diverse client base to direct our advertising to."

■DAYTON CONTEMPORARY DANCE COMPANY, 126 N. Main St., Suite 200, Dayton OH 45402-1710. (513)228-3232. Fax: (513)223-6156. Marketing Director: Monica Turner. Estab. 1968. Nonprofit arts organization specializing in modern and contemporary dance. Photos used in brochures, posters, newspapers, press releases, table tents and stickers.
Needs: Number of photos purchased varies. Subjects are always dancers, headshots, dance company photos. Examples of uses: season brochure, poster and media requests/performance venue requests.
Audiovisual Needs: Uses videotape for public service announcements.
Making Contact & Terms: Interested in receiving work from newer, lesser-known photographers. Arrange a personal interview to show portfolio. Query with résumé of credits. Query with samples. Provide résumé, business card, self-promotion piece or tearsheets to be kept on file for possible future assignments. Works with local freelancers on assignment only. NPI. Credit line given.

GARY PLASTIC PACKAGING CORP., 530 Old Post Rd., No. 3, Greenwich CT 06830. (203)629-1480. Marketing Director: Marilyn Hellinger. Estab. 1963. Manufacturers of custom injection molding, thermoforming and stock rigid plastic packaging. Photos used in brochures, catalogs and fliers.
Needs: Buys 10 freelance photos/year; offers 10 assignments/year. Product photography. Model release required.
Making Contact & Terms: Query with résumé of credits or with samples. Follow up with a call to set up an appointment to show portfolio. Prefers to see b&w and color product photography. Solicits photos by assignment only. Provide résumé to be kept on file for possible future assignments. Works with local freelancers only. Uses 8×10 b&w and color prints; 2¼×2¼ slides; and b&w or color negatives. Notifies photographer if future assignments can be expected. Does not return unsolicited material. Reports in 2 weeks. Pays up to $150/color photo; up to $900/day. Pays by the job and the number of photographs required. Buys exclusive product rights.
Tips: The photographer "has to be willing to work with our designers."

GEI INTERNATIONAL, INC., 100 Ball St., P.O. Box 6849, Syracuse NY 13217. (315)463-9261. Fax: (315)463-9034. President: Peter Anderson. Estab. 1988. Manufacturer of stainless steel rulers

THE ASTERISK before a listing indicates that the market is new in this edition. New markets are often the most receptive to freelance submissions.

and graphic accessories. Photos used in brochures, press releases and catalogs.

Needs: Buys 18,000 photos/year. Uses freelancers for photos of "our stocked items."

Making Contact & Terms: Provide résumé, business card, brochure, flier or tearsheets to be kept on file for possible future assignments. Works with local freelancers only. Uses various size glossy b&w photos. Does not keep samples on file. SASE. Reports in 1-2 weeks. NPI. Pays upon usage. Buys all rights.

***GENERAL STORE INC.**, 7920 NW 76 Ave., Medley FL 33166. (305)885-7670. Fax: (305)888-7616. Executive Vice President: Ed Mangones. Estab. 1988. Decorative accessories, furniture. Photos used in press releases, catalogs and source material for design work.

Needs: Buys 100-120 photos/year; offers 2-4 freelance assignments/year. Uses freelancers for art objects, subjects for art work, etc. Examples of recent uses: *Gift Decorative Accessories*, *Atlanta Highlights*, *Furniture Today* (advertising). Reviews stock photos of farm animals, florals. Property release preferred. Captions required.

Making Contact & Terms: Interested in receiving work from newer, lesser-known photographers. Query with samples. Query with stock photo list. Works with local freelancers only. Uses 5×7 glossy color prints and transparencies. SASE. Reports in 1-2 weeks. Pays $85-180/color photo; $85-180/b&w photo. Also pays royalties on sales. **Pays on acceptance.** Credit line not given. Buys exclusive product rights; negotiable.

Tips: "Be flexible."

GREAT SMOKY MOUNTAINS NATURAL HISTORY ASSOCIATION, 115 Park Headquarters Rd., Gatlinburg TN 37738. Fax: (423)436-6884. Publications Specialist: Steve Kemp. Estab. 1953. Produces publications on Great Smokies. Photos used for brochures, newsletters, newspapers and books.

Needs: Buys 150 photos/year; offers 2 freelance assignments/year. Wants to see b&w of people enjoying park. Examples of uses: *Smokies Guide* (park newspaper), b&w. Reviews stock photos. Model/property release preferred. Captions preferred; include location of shot.

Making Contact & Terms: Interested in receiving work from newer, lesser-known photographers. Query with stock photo list. Provide résumé, business card, self-promotion piece or tearsheets. Uses 5×7 b&w prints. Does not keep samples on file. SASE. Reports in 1 month. Pays $35-50/b&w photo; sometimes works on royalties. Pays upon usage. Credit line given. Buys one-time rights.

Tips: "Take b&w photos of people hiking, looking at wildflowers, big trees, waterfalls in Great Smokies. We always need nature b&w's (black bear, wildflowers, deer, fox); nobody shoots b&w."

■HUBBARD MILLING COMPANY, 424 N. Riverfront Dr., P.O. Box 8500, Mankato MN 56002. (507)388-9535. Fax: (507)388-9453. Marketing Communications Specialists: Theresa Hoen and Pat Haugen. Estab. 1878. The Hubbard Feed Division manufactures animal feeds, pet foods and animal health products. Photos used in brochures, newsletters, posters and audiovisual presentations.

Needs: Buys 20 freelance photos/year; offers 10 freelance assignments/year. Livestock—beef cattle, dairy cattle, pigs, horses, sheep, dogs, cats. Model release required.

Making Contact & Terms: Query with samples. Query with list of stock photo subjects. Submit portfolio for review. Provide résumé, business card, brochure, flier or tearsheets to be kept on file for possible future assignments. Works on assignment only. Uses 3×5 and 5×7 matte b&w and color prints; 2¼×2¼ and 4×5 transparencies; and b&w and color negatives. SASE. Reports in 2 weeks. Pays $50-100/b&w photo; $200/color photo; $50-300/job. Buys one-time and all rights; negotiable.

Tips: Prefers "to see the types of work the photographer does and what types of subjects done. We look for lots of agricultural photos in a more serious setting. Keep up with modern farming methods and use confinement shots when deemed necessary. Stay away from 'cutesy' shots."

■THE IMAGE MAKERS, 12 Miliche Lane, New City NY 10956. (914)638-4332. Director: Mark Schimmel. Estab. 1990. Specializes in filmmaking/video production of documentaries, shorts, 30-second spots, public service announcements. Photos used in brochures and press releases.

Needs: Offers 3-6 assignments annually. Uses freelancers for interior shots and portraits. Reviews stock photos. Model/property release required.

Audiovisual Needs: Uses film and videotape as insert footage for a given project.

Making Contact & Terms: Interested in receiving work from newer, lesser-known photographers. Query with samples. Provide business card, self-promotion piece to be kept on file for possible future assignments. Do not call. SASE. Reports when client has made decision. NPI. Pays on usage. Credit

line depends on client and usage. Rights purchased depend on client's needs; negotiable.

INTERNATIONAL PUBLISHING MANAGEMENT ASSOCIATION, 1205 W. College St., Liberty MO 64068-3733. (816)781-1111. Fax: (816)781-2790. E-mail: 71674.1647@compuserve.com. Membership association for corporate publishing professionals. Photos used in brochures and newsletters.
Needs: Buys 5-10 photos/year. Subject needs: equipment photos, issues (i.e., soy ink, outsourcing), people. Reviews stock photos. Captions preferred (location).
Making Contact & Terms: Interested in receiving work from newer, lesser-known photographers. Query with stock photo list. Provide résumé, business card, brochure, flier or tearsheets to be kept on file for possible future assignments. Uses 5×7 b&w prints. Keeps samples on file. SASE. Reports in 3 weeks. NPI. Pays on usage. Credit line given. Buys one-time rights.

■**INTERNATIONAL RESEARCH & EDUCATION (IRE)**, 21098 IRE Control Center, Eagan MN 55121-0098. (612)888-9635. Fax: (612)888-9124. IP Director: George Franklin, Jr. IRE conducts in-depth research probes, surveys, and studies to improve the decision support process. Company conducts market research, taste testing, brand image/usage studies, premium testing, and design and development of product/service marketing campaigns. Photos used in brochures, newsletters, posters, audiovisual presentations, annual reports, catalogs, press releases, and as support material for specific project/survey/reports.
Needs: Buys 75-110 photos/year; offers 50-60 assignments/year. "Subjects and topics cover a vast spectrum of possibilities and needs." Model release required.
Audiovisual Needs: Uses freelance filmmakers to produce promotional pieces for 16mm or videotape.
Making Contact & Terms: Provide résumé, business card, brochure, flier or tearsheets to be kept on file for possible future assignments. "Materials sent are put on optic disk for options to pursue by project managers responsible for a program or job." Works on assignment only. Uses prints (15% b&w, 85% color), transparencies and negatives. Cannot return material. Reports when a job is available. NPI; pays on a bid, per job basis. Credit line given. Buys all rights.
Tips: "We look for creativity, innovation and ability to relate to the given job and carry out the mission accordingly."

*****JUVENILE DIABETES FOUNDATION INTERNATIONAL**, 120 Wall St., New York NY 10005. (212)785-9500. Publications Manager: Julie Mettenburg. Estab. 1970. Produces 4-color, 32-page quarterly magazine to deliver research information to a lay audience; also produces brochures, pamphlets, annual report and audiovisual presentations.
Needs: Buys 40 photos/year; offers 20 freelance assignments/year. Needs "mostly portraits of people, but always with some environmental aspect." Reviews stock photos. Model release preferred. Captions preferred.
Making Contact & Terms: Query with samples. Provide résumé, business card, brochure, flier or tearsheets to be kept on file for possible future assignments. Uses $2\frac{1}{4} \times 2\frac{1}{4}$ transparencies. Cannot return material. Reports as needed. Pays $500/color photo; $500-700/day. Also pays by the job—payment "depends on how many days, shots, cities, etc." Credit line given. Buys one-time rights.
Tips: Looks for "a style consistent with commercial magazine photography—upbeat, warm, personal, but with a sophisticated edge. Call and ask for samples of our publications before submitting any of your own samples so you will have an idea what we are looking for in photography. Nonprofit groups have seemingly come to depend more and more on photography to get their message across. The business seems to be using a variety of freelancers, as opposed to a single inhouse photographer."

■**KOSS CORPORATION**, 4129 N. Port Washington Rd., Milwaukee WI 53212. (414)964-5000. Fax: (414)964-0506. Marketing Assistant: Mary Grittinger. Estab. 1953. Stereophone manufacturer. Photos used in catalogs, direct mail, P-O-P displays, packaging.
Needs: Uses 1 photographer/month. Action shots in which stereophones can be used in activity. Reviews stock photos.
Audiovisual Needs: Uses slides and video for sales presentations. Subjects include: company specific.
Making Contact & Terms: Interested in receiving work from newer, lesser-known photographers. Query with samples. Query with stock photo list. Send unsolicited photos by mail for consideration.

LISTINGS THAT USE IMAGES electronically can be found in the Digital Markets Index located at the back of this book.

Works on assignment only. Media used are project specific. Keeps samples on file. Cannot return material. Reports back as needs arise. NPI.
Tips: Looking for very simple, clean product and action shots.

■**NEAL MARSHAD PRODUCTIONS**, 76 Laight St., New York NY 10013-2046. (212)925-5285. E-mail: neal@marshad.com. Website: http://www.marshad.com. Owner: Neal Marshad. Estab. 1983. Video, motion picture and multimedia production house.
Needs: Buys 20-50 photos/year; offers 5-10 assignments/year. Freelancers used for food, travel, production stills for publicity purposes. Examples of recent uses: "Conspiracy of Silence" (TV documentary/website using 35mm film); BBC Website (35mm); Estee Lauder (35mm video). Model release required. Property release preferred. Captions preferred.
Audiovisual Needs: Uses slides, film, video, Photo CD for multimedia CD-ROM. Subjects include: travel and food.
Making Contact & Terms: Provide résumé, business card, self-promotion piece or tearsheets to be kept on file for possible future assignments. "No calls!" Works with local freelancers on assignment only. Uses 35mm, 2¼×2¼, 4×5 prints; 16mm film; Beta SP, 1″ videotape. Keeps samples on file. SASE. Pays $50-100/hour; $150-300/day; $300-500/job; $10-100/color photo. Pays on usage. Credit line depends on client. Buys all rights; negotiable.
Tips: "Show high quality work, be on time, expect to be hired again if you're good." Expects "explosive growth in photography in the next two to five years as in the past five years."

MASEL INDUSTRIES, 2701 Bartram Rd., Bristol PA 19007. (215)785-1600. Fax: (215)785-1680. Marketing Manager: Richard Goldberg. Estab. 1906. Catalog producer. Photos used in posters, magazines, press releases, catalogs and trade shows.
 ● This company scans all photos and stores them. Photos are manipulated on PhotoShop.
Needs: Buys over 250 photos/year; offers 15-20 assignments/year. Examples of recent uses: colorful spill shots of products on interesting backgrounds (trade show duratrans, 4×5 format) and teenage football player (catalog cover, 2¼×2¼ format). Reviews stock photos. Needs children and adults with braces on their teeth. Model release required.
Making Contact & Terms: Interested in receiving work from newer, lesser-known photographers. Provide résumé, business card, self promotion piece or tearsheets to be kept on file for possible future assignments. Works with local freelancers on assignment only. Uses 4×5 glossy b&w prints; 35mm, 2¼×2¼, 4×5 transparencies. Keeps samples on file. SASE. Reports in 2 weeks if interested. Pays $100/color or b&w photo; $250-500/cover shot; $800 maximum/day. Volume work is negotiated. **Pays on acceptance.** Credit line depends on terms and negotiation. Buys all rights.
Tips: "We're an interesting company with great layouts. We are always looking for new ideas. We invite input from our photographers and expect them to get involved."

***MID AMERICA DESIGNS, INC.**, P.O. Box 1368, Effingham IL 62401. (217)347-5591. Fax: (217)347-2952. Catalog Production Manager: Cheryl Habing. Estab. 1975. Provides mail order catalog for Corvette parts & accessories.
Needs: Buys 300 freelance photos/year; offers 6 freelance assignments/year. Apparel and automotive parts. Reviews stock photos. Model release required. Property release preferred.
Making Contact & Terms: Provide résumé, business card, brochure, flier or tearsheets to be kept on file for possible future assignments. Works on assignment. Uses 2¼×2¼, 4×5 and 8×10 transparencies. Cannot return material. Reports in 2 weeks. Pays $75/b&w or color photo. Buys all rights; negotiable.

BRUCE MINER POSTER CO. INC., Box 709, Peabody MA 01960. (508)741-3800. Fax: (508)741-3880. President: Bruce Miner. Estab. 1971. Photos used in posters.
Needs: Number of photos bought "varies." Wildlife photos. Reviews stock photos of wildlife. Model release preferred.
Making Contact & Terms: Interested in receiving work from newer, lesser-known photographers. Query with stock photo list. Provide résumé, business card, brochure, flier or tearsheets to be kept on file for possible future assignments. Uses 8×10 prints; 2¼×2¼ transparencies. Keeps samples on file. SASE. Reports in 1 month. NPI. Pays advance against royalties. Pays on usage. Credit line given. Buys one-time and all rights; negotiable.
Tips: Looking for "quality" submissions.

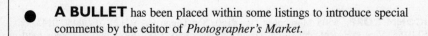

● **A BULLET** has been placed within some listings to introduce special comments by the editor of *Photographer's Market.*

***THE MINNESOTA OPERA**, 620 N. First St., Minneapolis MN 55401. (612)333-2700. Marketing: Kaylen Whitmore. Produces five opera productions, including 1-2 new works each year. Photos used in brochures, posters and press releases/publicity.

Needs: Buys 50 photos/year; offers 10 assignments/year. Operatic productions. Model release preferred.

Making Contact & Terms: Send unsolicited photos by mail for consideration. Provide résumé, business card, brochure, flier or tearsheets to be kept on file for possible future assignments. Works with local freelancers only. Uses 5×7 glossy b&w prints and 35mm slides. Cannot return material. Reporting time depends on needs. Pays $6-12/b&w photo; $8-15/color photo; $60-85/hour. Credit line given. Buys all rights; negatives remain with photographer.

Tips: "We look for photography that dynamically conveys theatrical/dramatic quality of opera with clear, crisp active pictures. Photographers should have experience photographing theater and have a good sense of dramatic timing."

NATIONAL BLACK CHILD DEVELOPMENT INSTITUTE, 1023 15th St. NW, Suite 600, Washington DC 20005. (202)387-1281. Fax: (202)234-1738. Deputy Director: Vicki D. Pinkston. Estab. 1970. Photos used in brochures, newsletters, newspapers, annual reports and annual calendar.

Needs: Candid action photos of black children and youth. Reviews stock photos. Model release required.

Making Contact & Terms: Query with samples. Send unsolicited photos by mail for consideration. Uses 5×7 or 8×10 color and glossy b&w prints and color slides or b&w contact sheets. SASE. Reports in 1 month. Pays $70/cover photo and $20/inside photo. Credit line given. Buys one-time rights.

Tips: "Candid action photographs of one black child or youth or a small group of children or youths. Most color photos selected are used in annual calendar and are placed beside an appropriate poem selected by organization. Therefore, photograph should communicate a message in an indirect way. Black & white photographs are used in quarterly newsletter and reports. Obtain sample of publications published by organization to see the type of photographs selected."

■NORTHERN VIRGINIA YOUTH SYMPHONY ASSOCIATION, 4026 Hummer Rd., Annandale VA 22003. (703)642-8051. Fax: (703)642-1773. Director of Public Relations: Paco Martinez. Estab. 1964. Nonprofit organization that promotes and sponsors 4 youth orchestras. Photos used in newsletters, posters and audiovisual uses and other forms of promotion.

Needs: Photographers usually donate their talents. Offers 8 assignments annually. Photos taken of orchestras, conductors and soloists. Captions preferred.

Audiovisual Needs: Uses slides and videotape.

Making Contact & Terms: Interested in receiving work from newer, lesser-known photographers. Arrange a personal interview to show portfolio. Works with local freelancers on assignment only. Uses 5×7 glossy color and b&w prints. Keeps samples on file. SASE. NPI. "We're a résumé-builder, a nonprofit that can cover expenses but not service fees." **Pays on acceptance.** Credit line given. Rights negotiable.

NORTHWORD PRESS, INC., 7520 Hwy. 51 S., P.O. Box 1360, Minocqua WI 54548. (715)356-7644. Fax: (715)356-6066. Photo Editor: Larry Mishkar. Estab. 1984. Specializes in nature and wildlife books, calendars, nature audio (CD and tape covers).

Needs: Buys more than 1,500 photos/year. World nature, wildlife and outdoor related activities. Tack sharp images. All transparency formats and 70mm repro-quality dupes. Model/property releases where needed is photographer's responsibility. Captions required.

Making Contact & Terms: Photo guidelines with SASE. Guidelines require the following: photographer's bio, published credits, stock list, tearsheets (will return, but to photographer's benefit to have on file). Biz cards not needed. Can read Photo CD or SyQuest 44 meg type disks. Quick return on outs. Published work is duped for printer use. Pays $100-2,000/color photo. Pays within 30 days of publication. Credit line and sample copies given. Buys one-time rights and project rights. Simultaneous submissions and previously published work OK.

Tips: "Tack sharp, well composed images. Do not include multiples. Edit submissions carefully. Credit line on slide. Put slides in Kimac-type sleeves, please." Photographers are contacted by mail or phone on upcoming projects. Update your tearsheets and stocklist regularly. "Newer photographers please present a professional, well-packaged submission that is pertinent to our product."

■OPTICOMM CORP., 5505 Morehouse Dr., #150, San Diego CA 92121. (619)450-0143. Fax: (619)450-0155. Vice President Marketing: David Caidar. Estab. 1987. Fiber optics. Photos used in posters, magazines, catalogs and P-O-P displays.

Needs: Uses 1 photographer/month. Reviews stock photos. Model release required.
Audiovisual Needs: Uses videotape for fiber optic videos.
Making Contact & Terms: Interested in receiving work from newer, lesser-known photographers. Query with samples. Works on assignment only. Uses 35mm, 8×10 transparencies. Keeps samples on file. SASE. Reports in 1-2 weeks. Pays $55/hour; $40/b&w photos. **Pays on receipt of invoice.** Credit line given. Buys all rights.

PHI DELTA KAPPA, Eighth & Union Sts., P.O. Box 789, Bloomington IN 47402. Design Director: Carol Bucheri. Estab. 1915. Produces *Phi Delta Kappan* magazine and supporting materials. Photos used in magazine, fliers and subscription cards.
Needs: Buys 10 photos/year; offers 1 assignment/year. Education-related subjects: innovative school programs, education leaders at state and federal levels, social conditions as they affect education. Reviews stock photos. Model release required. Photo captions required; include who, what, when, where.
Making Contact & Terms: Query with list of education-related stock photo subjects. Provide photocopies, brochure or flier to be kept on file for possible future assignments. Uses 8×10 b&w prints, b&w contact sheets. SASE. Reports in 3 weeks. Pays $20-100/b&w photo; $30-400/color photo; $30-500/job. Credit line and tearsheets given. Buys one-time rights.
Tips: "Don't send photos that you wouldn't want to hang in a gallery. Just because you do a photo for publications does not mean you should lower your standards. Spots should be touched up (not with a ball point pen), the print should be good and carefully done, subject matter should be in focus. Send me photocopies of your b&w prints that we can look at. We don't convert slides and rarely use color."

PHILADELPHIA T-SHIRT MUSEUM, 235 N. 12th St., Philadelphia PA 19107. (215)625-9230. Fax: (215)625-0740. President: Marc Polish. Estab. 1972. Specializes in T-shirts.
Needs: Number of images bought varies; most supplied by freelancers. Interested in humor, resorts and nature. Model/property release required.
Making Contact & Terms: Interested in receiving work from newer, lesser-known photographers. Query with samples. Uses color and b&w prints. Keeps samples on file. SASE. Reports in 1-2 weeks. Pays 6% royalties on sales. Pays on usage. Credit line given. Buys exclusive product rights; negotiable.

POSEY SCHOOL OF DANCE, INC., Box 254, Northport NY 11768. (516)757-2700. E-mail: 74534.1660@compuserve.com. President: Elsa Posey. Estab. 1953. Sponsors a school of dance and a regional dance company. Photos used in brochures, news releases and newspapers.
Needs: Buys 10-12 photos/year; offers 4 assignments/year. Special subject needs include children dancing, ballet, modern dance, jazz/tap (theater dance) and classes including women and men. Reviews stock photos. Model release required.
Making Contact & Terms: Interested in receiving work from newer, lesser-known photographers. "Call us." Works on assignment only. Uses 8×10 glossy b&w prints. SASE. Reports in 1 week. NPI; payment negotiable. Pays $25-200/b&w or color photo. Credit line given if requested. Buys one-time rights; negotiable.
Tips: "We need photos of REAL dancers doing, not posing, dance. We need photos of children dancing. We receive 'cute' photos often portraying dancers as shadows!"

■PROMOTIVISION, INC., 5929 Baker Rd., Suite 460, Minnetonka MN 55345. (612)933-6445. Fax: (612)933-7491. President: Daniel G. Endy. Estab. 1984. Photos used in TV commercials, sports, corporate image and industrial.
Audiovisual Needs: Uses film and video. Subjects include legal, medical, industrial and sports.
Making Contact & Terms: Interested in receiving work from professional photographers. Provide résumé, business card, self-promotion piece or tearsheets to be kept on file for possible future assignments. Works with freelancers on occasion. Uses 16mm color neg; Betacam SP videotape. Keeps samples on file. SASE. Pays $500-1,000/day. **"We pay immediately.** Weekly shows we roll credits." Buys all rights; negotiable.
Tips: "We are only interested in quality work. At times, in markets other than ours, we solicit help and send a producer/director to work with local photo crew. Film is disappearing and video continues to progress. We are only 12 years old and started as an all film company. Now film comprises less than 5% of our business."

THE QUARASAN GROUP, INC., 214 W. Huron, Chicago IL 60610-3616. (312)787-0750. Fax: (312)787-7154. E-mail: quarasan@aol.com. Photography Coordinator: Renee Calabrese. A complete book publishing service and design firm. Offers design of interiors and covers to complete editorial and production stages, art and photo procurement. Photos used in brochures, books and other print products.
Needs: Buys 1,000-5,000 photos/year; offers 75-100 assignments/year. "Most products we produce are educational in nature. The subject matter can vary. For textbook work, male-female/ethnic/handi-

capped/minorities balances must be maintained in the photos we select to ensure an accurate representation." Reviews stock photos and CD-ROM. Model release required. Captions required.

Making Contact & Terms: Interested in receiving work from new, lesser-known photographers. Query with stock photo list or nonreturnable samples (photocopies OK). Provide résumé, business card, brochure, flier or tearsheets to be kept on file for possible future assignments. Prefers 8×10 b&w glossy prints; 35mm, 2¼×2¼, 4×5, or 8×10 transparencies, or b&w contact sheets. Cannot return material. "We contact once work/project requires photos." NPI; payment based on final use size. Pays on a per photo basis or day rate. Credit line given, but may not always appear on page. Usually buys all rights or sometimes North American rights.

Tips: "Learn the industry. Analyze the products on the market to understand *why* those photos were chosen. Clients still prefer work-for-hire, but this is changing. We are always looking for experienced photo researchers and top-notch photographers local to the Chicago area."

REVERE/LIFEDANCE CO. INC., 3479 NW Yeon Ave., Portland OR 97210. (503)228-9430. Fax: (503)228-5039. President: Morris McClellan. Estab. 1982. Record company and distribution company. Photos used in catalogs, CD and cassette packaging.

Needs: Buys 3-8 photos/year. Uses photos of "nature, mostly." Examples of recent use: annual catalog of recordings (cover), CD/cassette (cover). Reviews stock photos of nature subjects. Photo captions should include: description of subject matter.

Making Contact & Terms: Interested in receiving work from newer, lesser-known photographers. Query with samples. Uses color prints; 35mm, 2¼×2¼, 4×5 transparencies. SASE. Reports only when interested. Pays $300-500/color photo. Pays on usage. Credit line given. Buys one-time rights; negotiable.

Tips: "We require nature photos that reflect relaxation, peace and beauty."

◼RIPON COLLEGE, P.O. Box 248, Ripon WI 54971. (414)748-8364. Contact: Director of College Relations. Estab. 1851. Photos used in brochures, newsletters, posters, newspapers, audiovisual presentations, annual reports, magazines and press releases.

Needs: Offers 3-5 assignments/year. Formal and informal portraits of Ripon alumni, on-location shots, architecture. Model/property release preferred. Captions preferred.

Making Contact & Terms: Interested in receiving work from newer, lesser-known photographers. Provide résumé, business card, brochure, flier or tearsheets to be kept on file for possible future assignments. Works on assignment only. SASE. Reports in 1 month. Pays $10-25/b&w photo; $10-50/color photo; $30-40/hour; $300-500/day; $300-500/job; negotiable. Buys one-time and all rights; negotiable.

***SAN FRANCISCO CONSERVATORY OF MUSIC**, 1201 Ortega St., San Francisco CA 94122. (415)564-8086. Publications Editor: Daphne Powell. Estab. 1917. Provides publications about the Conservatory programs, concerts and musicians. Photos used in brochures, posters, newspapers, annual reports, catalogs, magazines and newsletters.

Needs: Offers 10-15 assignments/year. Musical photos—musicians. Prefers to see in-performance shots and studio shots of musicians connected to the Conservatory. "Rarely uses stock shots."

Making Contact & Terms: Interested in working with newer, lesser-known photographers. "Contact us only if you are experienced in photographing performing musicians." Works with local freelancers only. Uses 5×7 b&w prints and color slides. Payment varies by photographer; "credit line" to $25/b&w photo; $100-300/job. Credit line given "most of the time." Buys one-time rights and all rights; negotiable.

SANGRE DE CRISTO CHORALE, P.O. Box 4462, Santa Fe NM 87502. (505)662-9717. Fax: (505)665-4433. Business Manager: Hastings Smith. Estab. 1978. Producers of chorale concerts. Photos used in brochures, posters, newspapers, press releases, programs and advertising.

Needs: Buys one set of photos every two years; offers 1 freelance assignment every two years. Photographers used to take group shots of performers. Examples of recent uses: newspaper feature (5×7, b&w); concert posters (5×7, b&w); and group pictures in a program book (5×7, b&w).

Making Contact & Terms: Interested in receiving work from newer, lesser-known photographers. Provide résumé, business card, self-promotion piece or tearsheets to be kept on file for possible future assignments. Works with local freelancers only. Uses 8×10, 5×7 glossy b&w prints. Keeps samples

 THE ASTERISK before a listing indicates that the market is new in this edition. New markets are often the most receptive to freelance submissions.

on file. SASE. Reports in 1 month, or sooner. NPI. **Pays on acceptance**. Credit line given. Buys all rights; negotiable.

Tips: "We are a small group—36 singers with a $25,000/year budget. We need promotional material updated about every two years. We prefer photo sessions during rehearsal, to which we can come dressed. We find that the ability to provide usable action photos of the group makes promotional pieces more acceptable."

■SCAN VIDEO ENTERTAINMENT, P.O. Box 183, Willernie MN 55090-0183. (612)426-8492. Fax: (612)426-2022. President: Mats Ludwig. Estab. 1981. Distributors of Scandinavian video films, books, calendars, cards.

Needs: Buys 100 photos; 5-10 films/year. Wants any subject related to the Scandinavian countries. Examples of recent uses: travel videos, feature films and Scandinavian fairy tales, all VHS. Reviews stock photos. Model/property release required.

Audiovisual Needs: Uses videotape for marketing and distribution to retail and video stores. Subjects include everything Scandinavian: travel, history, feature, children's material, old fashion, art, nature etc.

Making Contact & Terms: Interested in receiving work from newer, lesser-known photographers. Query with stock photo list. Uses color prints; 35mm transparencies; film and videotape. Does not keep samples. Cannot return material. Replies only if interested. Pays royalties on sales. Pays upon usage. Credit line not given. Buys all rights; negotiable.

Tips: Wants professionally made and edited films with English subtitles or narrated in English. Seeks work which reflects an appreciation of Scandinavian life, traditions and history.

■SPECIAL OLYMPICS INTERNATIONAL, 1325 G St. NW, Suite 500, Washington DC 20005. (202)628-3630. Fax: (202)824-0200. Media Production Manager: Jill Dixon. Estab. 1968. Provides sports training/competition to people with mental retardation. Photos used in brochures, newsletters, posters, annual reports, media and audiovisual.

Needs: Buys 500 photos/year; offers 3-5 assignments/year. Sports action and special events. Examples of recent uses: Awards banquet (prints used in newsletters and momentos); sports training clinic (slides used for training presentation); sports exhibition (prints used for newsletter and momentos). Model/property release preferred for athletes and celebrities.

Audiovisual Needs: Uses slides and videotape.

Making Contact & Terms: Interested in receiving work from newer, lesser-known photographers. Provide résumé, business card, self-promotion piece or tearsheets to be kept on file for possible future assignments. Uses 3×5, 5×7 and 8×10 glossy color or b&w prints; 35mm transparencies; VHS, U-matic, Betacam, 1" videotape. Keeps samples on file. SASE. Reports in 1 month. Pays $50-100/hour; $300-500/job. Processing additional. "Many volunteer time and processing because we're a not-for-profit organization." **Pays on acceptance**. Credit line depends on the material it is used on (no credit on brochure/credit in magazines). Buys one-time and all rights; negotiable.

Tips: Specific guidelines can be given upon request. Looking for "good action and close-up shots. Send example of work related to our organization's needs (i.e. sports photography, etc.). The best way to judge a photographer is to see the photographer's work."

***STARRION PRODUCTIONS**, P.O. Box 31-555, San Francisco CA 94131. (415)861-3100. Fax: (415)861-4212. Creative Director: Ron Lakis. Estab. 1985. Integrated marketing/advertising firm. Photos used in brochures, newspapers, magazines and audiovisual presentations.

Needs: Buys 6-12 photos/year; offers 3-6 assignments/year. Subjects include lifestyle, fashion, fitness, corporate image, sport, kids. Reviews stock photos. Model/property release preferred.

Audiovisual Needs: Uses film/video.

Making Contact & Terms: Interested in receiving work from newer, lesser-known photographers. Provide résumé, business card, brochure, flier or tearsheets to be kept on file for possible future assignments. Uses 4×5, 8×10 b&w prints; 35mm, $2\frac{1}{4} \times 2\frac{1}{4}$, 4×5 transparencies; 35mm film shot at golden hour. Keeps samples on file. SASE. Reports in 1 month. NPI. Rights negotiable, depending on project.

♣■SUN.ERGOS, A Company of Theatre and Dance, 2203, 700 Ninth St., SW, Calgary, Alberta T2P 2B5 Canada. (403)264-4621. Fax: (403)269-1896. Artistic and Managing Director: Robert Greenwood. Estab. 1977. Company established in theater and dance, performing arts, international touring. Photos used in brochures, newsletters, posters, newspapers, annual reports, magazines, press releases, audiovisual uses and catalogs.

Needs: Buys 10-30 photos/year; offers 3-5 assignments/year. Performances. Examples of recent uses: souvenir program, performance programs, brochures. Reviews theater and dance stock photos. Property release required for performance photos for media use. Captions required; include subject, date, city, performance title.

Audiovisual Needs: Uses slides, film and videotape for media usage, showcases and international conferences. Subjects include performance pieces/showcase materials.
Making Contact & Terms: Interested in receiving work from newer, lesser-known photographers. Arrange a personal interview to show portfolio. Query with résumé of credits. Provide résumé, business card, self-promotion piece or tearsheets to be kept on file for possible future assignments. Works on assignment only. Uses 8×10, 8½×11 color and b&w prints; 35mm, 2¼×2¼ transparencies; 16mm film; NTSC/PAL/SECAM videotape. Keeps samples on file. SASE. Reporting time depends on project. Pays $100-150/day; $150-300/job; $2.50-10/color photo; $2.50-10/b&w photo. Pays on usage. Credit line given. Buys all rights.
Tips: "You must have experience shooting dance and *live* theater performances."

TEXAS LOTTERY PLAYERS ASSOCIATION, P.O. Box 270942, Dallas TX 75227-0942. Operations Manager: Bill Flum. Estab. 1993. Membership organization, advertising, marketing. Photos used in newsletters and magazines.
Needs: Photos of persons who have won reasonable amounts from the Texas lottery. Model/property release required for lottery winners. Captions required.
Making Contact & Terms Interested in receiving work from newer, lesser-known photographers. Send unsolicited photos by mail for consideration. "To register as a T.L.P.A. associated photographer and receive photo assignments, apply to: T.L.P.A. Photo Associates, % Photographer Roster-Texas at above address. Photo associates are guaranteed to receive assignment requirements of T.L.P.A. job availabilities monthly. Send résumé, 2 non-returnable samples of color/b&w work (no originals). Include $25 registration/application fee; fee non-refundable. All persons accepted must be experienced and 18 years of age or older." Uses 5×7 glossy color and b&w prints. Keeps samples on file. Reports in 1 month. Pays $10-50/color photo; $15-50/b&w photo; photo credit and copies of publication. Credit line given. Buys all rights; negotiable.
Tips: "Looking for lottery photos about Texas winners of small and large amounts; photos with story lines. Not interested in any other subjects or capabilities. Requests for copy of *T.L.P.A. News* and work guidelines must be accompanied by check/money order of $3.29; no copies will be mailed otherwise. We expect to have a network of photographers in Texas who can get shots/stories (personal) of/from lottery winners, in addition to other lotto info derived from individuals on a creditable basis."

■**THIEL COLLEGE**, 75 College Ave., Greenville PA 16125. (412)589-2855. Fax: (412)589-2856. Director of Information Services: Mark A. Meighen. Estab. 1866. Provides education; undergraduate and community programs. Photos of campus settings used in brochures, newsletters, newspapers, audiovisual presentations, annual reports, catalogs and news releases.
Needs: Buys 10-20 photos/year; offers 1-3 assignments/year. "Basically we have an occasional need for photography depending on the job we want done."
Making Contact & Terms: Interested in receiving work from newer, lesser-known photographers. Query with résumé of credits. Works on assignment only. Uses 35mm transparencies. Reports as needed. NPI; payment negotiable. Credit line given depending on usage. Buys all rights; negotiable.

***TOPS NEWS**, % TOPS Club, Inc., Box 07360, Milwaukee WI 53207. Editor: Kathleen Davis. Estab. 1948. TOPS is a nonprofit, self-help, weight-control organization. Photos used in membership magazine.
Needs: "Subject matter to be illustrated varies greatly." Reviews stock photos.
Making Contact & Terms: Query with stock photo list. Provide résumé, business card, brochure, flier or tearsheets to be kept on file for possible future assignments. Uses any size transparency or print. SASE. Reports in 1 month. Pays $75-135/color photo. Buys one-time rights.
Tips: "Send a brief, well-composed letter along with a few selected samples with a SASE."

■**UNION INSTITUTE**, 440 E. McMillan St., Cincinnati OH 45206. (513)861-6400. Fax: (513)861-0779. Director of University Communications: Anu Mitra. Provides alternative higher education, baccalaureate and doctoral programs. Photos used in brochures, newsletters, magazines, posters, audiovisual presentations, annual reports, catalogs and news releases.
Needs: Uses photos of the Union Institute community involved in their activities. Also, photos that portray themes. Model release required.
Making Contact & Terms: Arrange a personal interview to show portfolio. Uses 5×7 glossy b&w and color prints; b&w and color contact sheets. SASE. Reports in 3 weeks. NPI; payment negotiable. Credit line given.

 THE MAPLE LEAF before a listing indicates that the market is Canadian.

Tips: Prefers "good closeups and action shots of alums/faculty, etc. Our quarterly alumni magazine reaches an international audience concerned with major issues. Illustrating its stories with quality photos involving our people is our constant challenge. We welcome your involvement."

UNITED AUTO WORKERS (UAW), 8000 E. Jefferson Ave., Detroit MI 48214. (313)926-5291. Fax: (313)331-5120. E-mail: 71112.363@compuserv.com. Editor: David Elsila. Trade union representing 800,000 workers in auto, aerospace, and agricultural-implement industries. Publishes *Solidarity* magazine. Photos used for brochures, newsletters, posters, magazines and calendars.
• The publications of this organization have won International Labor Communications Association journalism excellence contest and two photography awards.
Needs: Buys 85 freelance photos/year and offers 12-18 freelance assignments/year. Needs photos of workers at their place of work and social issues for magazine story illustrations. Reviews stock photos. Model releases preferred. Captions preferred.
Making Contact & Terms: Arrange a personal interview to show portfolio. In portfolio, prefers to see b&w and color workplace shots. Query with samples and send material by mail for consideration. Prefers to see published photos as samples. Provide résumé and tearsheets to be kept on file for possible future assignments. Uses 8×10 prints; contact sheets OK. Notifies photographer if future assignments can be expected. SASE. Reports in 2 weeks. Pays $50-100/b&w or color photo; $250/half-day; $475/ day. Credit line given. Buys one-time rights and all rights; negotiable.

UNITED STATES SAILING ASSOCIATION, 15 Maritime Dr., P.O. Box 1260, Portsmouth RI 02871-6015. (401)683-0800. Fax: (401)683-0840. Editor: Dana Marnane. Estab. 1897. *American Sailor Magazine* provided to members of United States Sailing Association. Photos used in brochures, posters and magazines.
Needs: Buys 20-30 photos/year. Examples of uses: *American Sailor* (cover, color slide); "US Sailing Directory" (cover); and membership brochure, (b&w and color). Reviews stock photos, action sailing/ racing shots; close-up face shots. Captions preferred; include boat type/name, regatta name.
Making Contact & Terms: Prefers slides, accepts prints, color only. Pays $25-100/color cover. Buys one-time rights.

WILLIAM K. WALTHERS, INC., 5601 W. Florist Ave., Milwaukee WI 53218. (414)527-0770. Fax: (414)527-4423. Publications Manager: Don Gulbrandsen. Estab. 1932. Importer/wholesaler of hobby products. Photos used in catalogs, text illustration and promotional materials.
Needs: Buys 50-100 photos/year; offers 20 assignments/year. Interested in any photos relating to historic or model railroading. Reviews stock photos. Model/property release required. Captions preferred; include brief overview of action, location, any unusual spellings, names of photographer and model builder.
Making Contact & Terms: Interested in receiving work from newer, lesser-known photographers. Send unsolicited photos by mail for consideration. Uses 4×5, 8½×11 color and b&w prints; 35mm, 2¼×2¼ transparencies. Keeps samples on file. SASE. Reports in 1-2 weeks. NPI; payment negotiated based on usage. Pays on publication or receipt of invoice. Credit line given. Buys all rights.
Tips: "Knowledge of railroading is essential since customers consider themselves experts on the subject. With model railroad shots, it should be difficult to see that the subject is a miniature."

■WORCESTER POLYTECHNIC INSTITUTE, 100 Institute Rd., Worcester MA 01609. (508)831-5609. Fax: (508)831-5604. University Editor: Michael Dorsey. Estab. 1865. Publishes periodicals and promotional, recruiting and fund-raising printed materials. Photos used in brochures, newsletters, posters, audiovisual presentations, annual reports, catalogs, magazines and press releases.
Needs: On-campus, comprehensive and specific views of all elements of the WPI experience. Relations with industry, alumni. Reviews stock photos. Captions preferred.
Making Contact & Terms: Interested in receiving work from newer, lesser-known photographers. Arrange a personal interview to show portfolio or query with stock photo list. Provide résumé, business card, brochure, flier or tearsheets to be kept on file for possible future assignments. "No phone calls." Uses 5×7 (minimum) glossy b&w prints; 35mm, 2¼×2¼, 4×5 transparencies; b&w contact sheets. SASE. Reports in 2 weeks. NPI. Rates negotiable. Credit line given in some publications. Buys onetime or all rights; negotiable.

ZOLAN FINE ART STUDIO, Dept. PM, P.O. Box 656, Hershey PA 17033-2173. (717)534-2446. Fax: (717)534-1095. E-mail: donaldz798@aol.com. President/Art Director: Jennifer Zolan. Commercial and fine art business. Photos used for artist reference in oil paintings.
Needs: Buys 16-24 photos/year; assignments vary on need. Interested in candid, heart-warming, and endearing photos of children with high emotional appeal between the ages of two through five capturing the golden moments of early childhood. Reviews stock photos. Model release preferred.
Making Contact & Terms: Interested in receiving work from newer, lesser-known photographers. Write and send for photo guidelines by mail, fax or America Online. Uses any size color or b&w

prints; 35mm, 2¼×2¼, 4×5, 8×10 transparencies. Does not keep samples on file. SASE. Queries on guidelines 2-3 weeks; photo returns or acceptances up to 45 days. Pays $200-500/b&w photo; $200-500/color photo; $1,000 for all rights. **Pays on acceptance**. Buys exclusive rights only for use as artist reference (prefers) or all rights; negotiable.

Tips: "Photos should have high emotional appeal and tell a story. Children should be involved with activity or play. Photos should look candid and capture a child's natural mannerisms. Write for free photo guidelines before submitting your work. We are happy to work with amateur and professional photographers. We are always looking for human interest type of photographs on early childhood, ages two to five."

Galleries

There has been enormous growth in the popularity of photography as a collectible art form. The reasons for this vary. Prices for outstanding images are not out of reach; the value of limited editions makes photography a worthy investment; and, photographers such as Ansel Adams, Henri Cartier-Bresson and Helmut Newton are becoming well known to collectors.

The fine art photo industry also has benefited from an increase in gallery space, and a sampling of these galleries is in this section. There are 152 galleries listed here, 44 new ones, and all offer exhibition opportunities for new talent.

When trying to rouse interest from collectors and gallery directors, it's important to establish your own style. Purchases are made mainly because a viewer feels something for the work, whether it's a limited edition print or a $10 poster. Even the truly serious collectors are ones who not only recognize the investment value of photos, but also get attached to the beauty of the work.

Peter MacGill of the Pace/Willenstein/MacGill Gallery in New York City says the important thing about fine art photography is that the work should change the way viewers perceive the world. His interview on page 196 can help you learn more about the gallery market.

HOW GALLERIES OPERATE

Although there are a growing number of all-photography galleries, most are still primarily art galleries which may either hold annual photography shows or special solo and group photography exhibits throughout the year. Some also include photography as part of their permanent collections and exhibit photos at all times.

The largest group of galleries are retail, for-profit operations. These galleries usually cater to both private and corporate collectors. Depending on the location, the clientele may include everyone from tourists and first-time buyers, to sophisticated, long-time collectors and professional interior designers. The emphasis is on what sells and these galleries are interested only in work they feel will fit the needs of their clientele. Before approaching a retail gallery, be sure you have a very clear understanding of its clientele's interests and needs.

Art consultancies work primarily with professional art buyers, including interior decorators, interior designers, developers, architects and corporate art collectors. Some include a viewing gallery open to the public, but they are most interested in being able to show their clients a wide variety of work. Consultancies maintain large slide files to match the needs of their clients in almost any situation. Photographers interested in working with consultants must have a body of work readily available.

Nonprofit galleries and alternative spaces offer photographers the most opportunities, especially if their work is experimental. Often sponsored by an educational facility or by a cooperative, the aim of these galleries is to expose the public to a variety of art forms and new artists. Since sales are secondary, profits from sales in these galleries will be lower than in retail outlets. Cooperatives offer artists (and photographers) the opportunity to have a say in how the gallery is operated. Most require a small membership fee and a donation of time. In exchange they take a very low commission on sales.

Read the listings carefully to determine which galleries interest you most. Some

provide guidelines or promotional information about the gallery's recent exhibits for a self-addressed, stamped envelope. Whenever possible, visit those galleries that interest you to get a real feel for their particular needs and outlook. Do not, however, try to show a portfolio without first making an appointment. Most galleries will look at transparencies, prints, tearsheets, bios, résumés and other material first. If interested, they will request to see a portfolio.

Most galleries operate on a commission basis. Galleries take a percentage commission for works sold. Retail galleries usually take 40-50 percent commission, while nonprofits usually charge 20-30 percent. A few also take a rental fee for space used. Prices may be set by either the gallery or the artist, but quite often by mutual agreement.

Most galleries provide insurance on-site and will handle promotional costs. Shipping costs often are shared with the gallery paying for shipment one-way. Galleries also provide written contracts outlining their expectations. Photographers should study the contract carefully and treat the gallery as any other business partner.

A.O.I. GALLERY, 634 Canyon Rd., Santa Fe NM 87501. (505)982-3456. Fax: (505)982-2040. Director: Frank Aoi. Estab. 1992.
Exhibits: Requirements: Must be involved with fine art photography. No students' work. Interested in contemporary/avant garde photography or videos. Very coherent content and professional presentation. Examples of recent exhibitions: "A Box of Ku," by Masao Yamamoto (silver prints with mixed media); "Unique Exhibits of Contemporary Japanese Photographic Artists," by various artists; and "Rediscovery of a New Vision," by Ernst Haas (dye-transfer prints). Presents 5 shows/year. Shows last 1 month. Sponsors openings. Photographer's presence at opening and during show preferred.
Making Contact & Terms: Commission varies. Buys photos outright. General price range: $500-15,000. Call for size limits. Cannot return material.
Tips: "Be extremely polite and professional."

ADIRONDACK LAKES CENTER FOR THE ARTS, Rt. 28, P.O. Box 205, Blue Mt. Lake NY 12812. (518)352-7715. Fax: (518)352-7333. Program Coordinator: Susan Mitchell. Estab. 1967.
Exhibits: Requirements: send résumé, artist's statement, slides or photos. Interested in contemporary Adirondack and nature photography. Examples of recent exhibitions: "Rt. 30," by Mark Kurtz (hand-colored panoramic photographs); "Adirondack Visions," by Rod Maciver (color photographs); "Abstract Florals," by Walter Carstens; "Adirondack Park—Exposures of Color," by Brian Morris. Presents 6-8 exhibits/year. Shows last 1 month. Sponsors openings. Provides wine and cheese receptions, bulk mailings of announcements may also be arranged if artist can provide postcard. Photographer's presence at opening preferred.
Making Contact & Terms: Interested in receiving work from newer, lesser-known photographers. Charges 30% commission. General price range: $100-250. "Pricing is determined by photographer. Payment made to photographer at end of exhibit." Reviews transparencies. Interested in framed and matted work. Send material by mail for consideration. SASE. Reports in 1 month.
Tips: "Our gallery is open during all events taking place at the Arts Center, including concerts, films, workshops and theater productions. Guests for these events are often customers seeking images from our gallery for their own collections or their places of business. Customers are often vacationers who have come to enjoy the natural beauty of the Adirondacks. For this reason, landscape and nature photographs sell well here."

AKRON ART MUSEUM, 70 E. Market St., Akron OH 44308. (330)376-9185. Curator: Barbara Tannenbaum.
• This gallery annually awards the Knight Purchase Award to a living artist working with photographic media.
Exhibits: Requirements: To exhibit, photographers must possess "a notable record of exhibitions, inclusion in publications, and/or a role in the historical development of photography. We also feature local photographers (Akron area)." Interested in innovative works by contemporary photographers; any subject matter. Example of recent exhibition: "A Retrospective, Dorothea Lange." Presents 3-5 exhibits/year. Shows last 2 months. Sponsors openings; provides light food, beverages and sometimes entertainment. Photographer's presence at opening preferred. Presence during show is not required, but willingness to give a gallery talk is appreciated.
Making Contact & Terms: NPI; buys photography outright. Will review transparencies. Send material by mail for consideration. SASE. Reports in 1-2 months, "depending on our workload."
Tips: "Prepare a professional looking packet of materials including high-quality slides, and always send a SASE. Never send original prints."

This untitled work from Japanese photographer/ artist Masao Yamamoto comes from his series "A Box of Ku," postcard-size work shown at Santa Fe's A.O.I Gallery. ("Ku" is a Zen word meaning "void" or "emptiness.") Yamamoto's photos of mundane items such as a ball on the ground, a bird on a branch, or this globe are intentionally damaged, stained or painted to look aged. "We tend, selfishly, to remember only the strongest feelings as a memory and quickly forget the rest," says Yamamoto. "An old and faded photograph, after shedding things not necessary, retains its clear memory and essence."

© Masao Yamamoto

ALBER GALLERIES, 3300 Darby Rd., #5111, Haverford PA 19041. (610)896-9297. Director: Howard Alber. Estab. 1977.
 ● This is a private gallery with a very limited operation.
Exhibits: Requirements: Professional presentation, well priced for sales, consistent quality and willingness to deliver promptly. Interested in Philadelphia subjects, land conservation, wetlands, artful treatments of creative presentation. Has shown work by Michael Hogan, Harry Auspitz (deceased), Barry Slavin, Joan E. Rosenstein, Ken Roberts (computer-restoration), and Joan Z. Rough. Photographer's presence at opening is not required. "Cooperative show space only. We do not have our own gallery space."
Making Contact & Terms: Charges 40% commission. General price range: $75-1,000. Reviews transparencies; only as requested by us. Not interested in new presentations. Slides only on first presentation.
Tips: "Give us copies of all reproduced photos, calendars, etc., only if we can retain them permanently."

THE ALBUQUERQUE MUSEUM, 2000 Mountain Rd. NW, Albuquerque NM 87104. (505)243-7255. Fax: (505)764-6546. Curator of Art: Ellen Landis. Estab. 1967.
Exhibits: Requirements: Send photos, résumé and artist's statement. Interested in all subjects. Examples of previous exhibitions: "Gus Foster," by Gus Foster (panoramic photographs); "Santiago," by Joan Myers (b&w 16×20); and "Frida Kahlo," by Lola Alvaraz Bravo (b&w various sizes). Presents 3-6 shows/year. Shows last 8-12 weeks. Photographer's presence at opening preferred, presence during show preferred.
Making Contact & Terms: Buys photos outright. Reviews transparencies. Interested in framed or unframed work, mounted or unmounted work, matted or unmatted work. Arrange a personal interview to show portfolio. Submit portfolio for review. Send material by mail for consideration. "Sometimes we return material; sometimes we keep works on file." Reports in 1 month.

AMERICAN SOCIETY OF ARTISTS, INC., Box 1326, Palatine IL 60078. (847)991-4748 or (312)751-2500. Membership Chairman: Helen Del Valle.
Exhibits: Members and nonmembers may exhibit. "Our members range from internationally known artists to unknown artists—quality of work is the important factor. We have about 25 shows throughout the year which accept photographic art."
Making Contact & Terms: NPI; price range varies. Interested in framed, mounted or matted work only. Send SASE for membership information and application (state media). Reports in 2 weeks.

Accepted members may participate in lecture and demonstration service. Member publication: *ASA Artisan.*

***ARKANSAS RIVER VALLEY ARTS CENTER**, P.O. Box 2112, 1001 E. B St., Russellville AR 72811. (501)968-2452. Fax: (501)968-6181. E-mail: arvac@aol.com. Executive Director: Greg Boyd.
Exhibits: Requirements: Work must be reviewed by the Visual Arts Committee. Considers anything except nudes. Examples of recent exhibitions: "Landscapes," by Walter Carr (photo b&w); "Assortment," by Russ Hancock (mixed and photo); and "Styles," by Dan Pierce (b&w). Presents 1-2 shows/year. Shows last 1 month. Sponsors openings; provides all arrangements. Photographer's presence at opening preferred.
Making Contact & Terms: Interested in receiving work from newer, lesser-known photographers. Charges 25% commission. General price range: $100-500. Reviews transparencies. Interested in framed work only. Query with samples. Send material by mail for consideration. Reports in 3 weeks.
Tips: "We are just starting with CD-ROM and online networking."

THE ART CENTER, 125 Macomb Place, Mount Clemens MI 48043. (810)469-8666. Fax: (810)469-4529. Exhibit Coordinator: Colleen Brunton. Executive Director: Jo-Anne F. Wilkie.
Exhibits: Interested in landscapes, still life, portraiture, abstracts, architecture and fashion. Examples of recent exhibitions: "Through the Lens," by Steve Jensen and Fernando Diaz (male nudes and nature scenes); Mary Keithan (barns and school houses); and G.L. Klayman (solarized silver prints). Presents 1 show/year. Shows last 3-4 weeks. Sponsors openings. Provides refreshments and food, publicity for opening reception. Photographer's presence at opening and during show preferred.
Making Contact & Terms: Interested in receiving work from newer, lesser-known and well-known photographers. Charges 30% commission. General price range: $175-300. Reviews slides. Interested in framed work only. Large scale submissions accepted based on available gallery space. Query with samples. Send material by mail for consideration. SASE. Reports in 1-2 months.

***ART FORMS**, 16 Monmouth St., Red Bank NJ 07701. (908)530-4330. Fax: (908)530-9791. Director: Charlotte T. Scherer. Estab. 1985.
Exhibits: Requirements: work must be original. Examples of recent exhibitions: works by Vincent Serbin (b&w manipulative photography); Valentine (b&w photography); Joseph Paduano (infra red photography); Jeff Gross (Polaroid image transfers/Cibachrome prints); and Michael Neuhaus (platinum prints). Photography is exhibited all year long. Shows last 6 weeks. Photographer's presence at opening and during show preferred.
Making Contact & Terms: Interested in receiving work from newer, lesser-known photographers. Charges 50% commission. General price range: $250-1,500. Reviews transparencies. Interested in framed or unframed, mounted or unmounted, matted or unmatted work. Requires exclusive representation locally. Query with samples. SASE. Reports in 1 month.

ART INSTITUTE OF PHILADELPHIA, 1622 Chestnut St., Philadelphia PA 19103. (215)567-7080. Fax: (215)246-3339. Gallery Director: Alicia A. Bruno. Estab. 1973.
Exhibits: Requirements: All work must be ready to hang under glass or Plexiglas; no clip frames. Interested in fine and commercial art. Examples of recent exhibitions: George Krause (fine art, b&w); Lisa Goodman (commercial, b&w/color); Enrique Bostelmann (documentary, b&w/color). Presents 4 exhibits/year. Shows last 30 days. Photographer's presence at opening and during show is preferred.
Making Contacts & Terms: Interested in receiving work from newer, lesser-known photographers. Sold in gallery. General price range: $150-2,000. Reviews transparencies. Interested in matted or unmatted work. Query with samples. Include 10-20 slides and a résumé. SASE. Reports in 1 month.
Tips: "The gallery's concern is that artists must demonstrate the ability to present a mature body of work in any photography genre. In this area there are currently very few commercial galleries that show photography. We are open to showing the best photographic work that is submitted."

ARTISTS' COOPERATIVE GALLERY, 405 S. 11th St., Omaha NE 68102. (402)342-9617. President: Robin Davis. Estab. 1974.
Exhibits: Requirements: Fine art photography only. Artist must be willing to work 13 days per year at the gallery or pay another member to do so. "We are a member-owned and -operated cooperative. Artist must also serve on one committee." Interested in all types, styles and subject matter. Examples of exhibitions: works by Ulla Gallagher (sabattier, hand coloring), Pam King (photograms), and Margie

● **A BULLET** has been placed within some listings to introduce special comments by the editor of *Photographer's Market.*

Schimenti (Cibachrome prints). Presents 14 shows/year. Shows last one month. Sponsors openings. Gallery sponsors 1 all-member exhibit and outreach exhibits, individual artists sponsor their own small group exhibits throughout the year. Photographer's presence at opening and during show required.

Making Contact & Terms: Interested in receiving work from newer, lesser-known photographers. Charges no commission. General price range: $100-300. Reviews transparencies. Interested in framed work only. Query with résumé of credits. SASE. Reports in 2 months.

Tips: "Write for membership application. Membership committee screens applicants Aug. 1-15 each year. Reports back by Sept. 1. New membership year begins Oct. 1. Members must pay annual fee of $300. Will consider well-known artists of regional or national importance for one of our community outreach exhibits. Membership is not required for outreach program and gallery will host one-month exhibit with opening reception."

***ARTSPACE, INC.**, 201 East Davie St., Raleigh NC 27601. (919)821-2787. Fax: (919)839-6002. Executive Director: Meg Rader. Estab. 1986.

Exhibits: Works are reviewed by the Artspace Gallery Committee for invitational exhibitions; Artspace sponsors juried shows periodically that are open to all artists and photographers. Send slides, résumé and SASE." Interested in all types, styles and subjects. Examples of recent exhibitions: "1,001 Chairs," by Karl Larsen (b&w serial work, framed); "West Art and the Law," by Mary Ellen Mark (b&w, framed); "New Works," Doug van de Zande (color, framed). Presents 1 show/2-3 years. Shows last 5-7 weeks. Sponsors openings; provides reception, invitations, refreshments, publicity, exhibition, installation. Photographer's presence at opening and during show preferred.

Making Contact & Terms: Interested in receiving work from newer, lesser-known photographers. Charges 30% commission. General price range: $100-600. Reviews transparencies. Send material by mail for consideration. SASE. Reports in 60 days.

ASCHERMAN GALLERY/CLEVELAND PHOTOGRAPHIC WORKSHOP, 23500 Mercantile Rd., Suite D, Beachwood OH 44122. (216)464-4944. Fax: (216)464-3188. Director: Herbert Ascherman, Jr. Estab. 1977. Sponsored by Cleveland Photographic Workshop. Subject matter: all forms of photographic art and production. "Membership is not necessary. A prospective photographer must show a portfolio of 40-60 slides or prints for consideration. We prefer to see distinctive work—a signature in the print, work that could only be done by one person, not repetitive or replicative of others."

Exhibits: Presents 5 shows/year. Shows last about 10 weeks. Openings are held for some shows. Photographers are expected to contribute toward expenses of publicity. Photographer's presence at show "always good to publicize, but not necessary."

Making Contact & Terms: Interested in receiving work from newer, lesser-known photographers. Charges 25-40% commission, depending on the artist. Sometimes buys photography outright. Price range: $100-1,000. "Photos in the $100-300 range sell best." Will review transparencies. Matted work only for show.

Tips: "Photographers should show a sincere interest in photography as fine art. Be as professional in your presentation as possible; identify slides with name, title, etc.; matte, mount, box prints. We are a Midwest gallery and for the most part, people here respond to competent, conservative images more so than experimental or trendy work, though we are always looking for innovative work that best represents the artist (all subject matter). This does not mean that every show is landscape. We enjoy a variety of images and subject matters. Know our gallery; call first; find out something about us, about our background or interests. Never come in cold."

***TAMARA BANC GALLERY**, 8025 Melrose, Los Angeles CA 90046. (310)205-0555. Fax: (310)205-0794. Vice President: Tamara Banc. Estab. 1983.

Exhibits: Requirements: Must be experienced and published photographer. Examples of recent exhibitions: work of Dean Karr and Todd Friedman. Interested in nudes or erotic/provocative work. Also represents various vintage erotic photography. Presents 2 shows/year. Shows last 6 weeks. Sponsors openings; provides invitations, advertising, beverages and food. Photographer's presence at opening required; presence during show preferred.

Making Contact & Terms: Charges 50% commission. Buys photos outright. General price range: $200-5,000. Reviews transparencies. Interested in framed or unframed work. Requires exclusive representation locally. Submit portfolio for review. Query with résumé of credits. Query with samples. Send material by mail for consideration. SASE. Reports in 1 month.

✳ THE ASTERISK before a listing indicates that the market is new in this edition. New markets are often the most receptive to freelance submissions.

BARLETT FINE ARTS GALLERY, 77 W. Angela St., Pleasanton CA 94566. (510)846-4322. Owner: Dorothea Barlett. Estab. 1982.

Exhibits: Interested in landscape, dramatic images. Example of exhibitions: "Photography 1994," by Al Weber. Shows last 1 month. Sponsors openings. Artists contribute a fee to cover printing, mailing and reception. Group exhibits keep cost low. Photographer's presence at opening preferred.

Making Contact & Terms: Photography sold in gallery. General price range: $125-500. Reviews transparencies. Interested in matted work only. Requires exclusive representation locally. Works are limited to 8 × 10 (smallest). Query with samples. Send material by mail for consideration. SASE.

Tips: Submit work that has high marketable appeal, as well as artistic quality."

BARRON ARTS CENTER, Dept. PM, 582 Rahway Ave., Woodbridge NJ 07095. (908)634-0413. Director: Stephen J. Kager. Estab. 1975.

Exhibits: Examples of recent exhibitions: New Jersey Print Making Council. Photographer's presence at opening required.

Making Contact & Terms: Photography sold in gallery. Charges 20% commission. General price range: $150-400. Reviews transparencies but prefers portfolio. Submit portfolio for review. Cannot return material. Reports "depending upon date of review, but in general within a month of receiving materials."

Tips: "Make a professional presentation of work with all pieces matted or treated in a like manner." In terms of the market, we tend to hear that there are not enough galleries existing that will exhibit photography." One trend is that there is a fair amount of "both representational and art and photography."

BATON ROUGE GALLERY, INC., 1442 City Park Ave., Baton Rouge LA 70808. (504)383-1470. Fax: (504)336-0943. E-mail: brgal@intersurf.com. Director: Kathleen L. Sunderman. Estab. 1966.
 • This gallery is the oldest artist co-op in the US.

Exhibits: Professional artists with established exhibition history—must submit 20 slides and résumé to programming committee for approval. Open to all types, styles and subject matter. Examples of recent exhibitions: "Stories of the Truth," by Jennifer Simmons (portraits everyday life); and "Animal Dance," by Lori Waselchuk (photographic essay on Cajun Mardi Gras). Presents approximately 3 exhibits/year. Shows last 4 weeks. Sponsors openings; provides publicity, liquid refreshments. Photographer's presence at opening is preferred.

Making Contact & Terms: Interested in receiving work from newer, lesser-known photographers. Charges 33.3% commission. General price range: $200-600. Reviews transparencies and artwork on CD-ROM. Interested in "professional presentation." Send material by mail for consideration. SASE. Reports in 2-3 months. Accepts submissions in March and September.

***BELIAN ART CENTER**, 5980 Rochester Rd., Troy MI 48098. (810)828-1001. Fax: (810)828-1905. Director: Zabel Belian. Estab. 1985.

Exhibits: Requirements: originality, capturing the intended mood, perfect copy, limited edition. Examples of exhibitions: "Ommagio," by Robert Vigilatti (people in motion); "Parian," by Levon Parian (reproduced on brass); and "Santin," by Lisa Santin (architectural). Presents 1-2 shows/year. Shows last 3 weeks. Sponsors openings. Photographer's presence at opening and during show preferred.

Making Contact & Terms: Interested in receiving work from newer, lesser-known photographers. Charges 40-50% commission. Buys photos outright. General price range: $200-2,000. Reviews transparencies. Interested in framed or unframed, matted or unmatted work. Requires exclusive representation locally. No size limit. Arrange a personal interview to show portfolio. Query with résumé of credits. SASE. Reports in 1-2 weeks.

BENHAM STUDIO GALLERY, 1216 First Ave., Seattle WA 98101. (206)622-2480. Owners: Marita or Lisa. Estab. 1987.

Exhibits: Requirements: Call in December for review appointment in February. Examples of recent exhibitions: works by Michael Gesinger (handcolored nudes); b&w landscapes by Bruce Barnbaum and "Bodies of Work" (group show). Presents 12 shows/year. Shows last 1 month. Photographer's presence at opening preferred.

Making Contact & Terms: Interested in receiving work from newer, lesser-known photographers. Charges 40% commission. General price range: $175-2,000.

BERKSHIRE ARTISANS GALLERY, Lichtenstein Center for the Arts, 28 Renne Ave., Pittsfield MA 01201. (413)499-9348. Fax: (413)442-8043. Artistic Director: Daniel M. O'Connell. Estab. 1975.
 • This gallery was written up in a *Watercolors* magazine article, by Daniel Grant, on galleries that do open-jury selections.

Exhibits: Requirements: Professionalism in portfolio presentation, professionalism in printing photographs, professionalism. Examples of previous exhibitions: "The Other Side of Florida," by Woody Walters (b&w prints); "Radicals," by David Ricci (color prints); "Postcard Invitational," worldwide

Jennifer Simmons first sent this photo to Baton Rouge Gallery for judging as part of her application to become a member of the gallery. The photo, in which she sought to capture the "tension between the child's desire and the dog's need to run free," as well as "the general mood of Santa Fe Plaza at lunchtime," was later featured in a gallery show.

call for entries. Presents 10 shows/year. Sponsors openings; "we provide publicity announcements, artist provides refreshments." Artist's presence at opening and during shows preferred.
Making Contact & Terms: Interested in receiving work from newer, lesser-known photographers. Charges 20% commission. General price range: $50-1,500. Will review transparencies of photographic work. Interested in seeing framed, mounted, matted work only. "Photographer should send SASE with 20 slides or prints and résumé by mail only to gallery." SASE.
Tips: To break in, "Send portfolio, slides and SASE. We accept all art photography. Work must be professionally presented. Send in by July 1, each year. Expect exhibition 4-6 years from submission date. We have a professional juror look at slide entries once a year (usually July-September). Expect that work to be tied up for 6-8 months in jury." Sees trend toward "b&w and Cibachrome architectural photography."

MONA BERMAN FINE ARTS, 78 Lyon St., New Haven CT 06511. (203)562-4720. Fax: (203)787-6855. Director: Mona Berman. Estab. 1979.
 • "We are primarily art consultants serving corporations, architects and designers. We also have private clients. We hold very few exhibits, we mainly show work to our clients for consideration and sell a lot of photographs."
Exhibits: Requirements: "Photographers must have been represented by us for over 2 years. Interested in all except figurative, although we do use some portrait work." Examples of previous exhibits: "Suite Juliette," by Tom Hricko (b&w still life). Presents 0-1 exhibits/year. Shows last 1 month. Sponsors openings; provides all promotion. Photographer's presence at opening is required.
Making Contact & Terms: Interested in receiving work from newer, lesser-known photographers. Charges 50% commission. General price range: $300 and up. Reviews 35mm transparencies only. Interested in seeing unframed, unmounted, unmatted work only. Submit portfolio for review (35mm slides only). Query with résumé of credits. Send material by mail for consideration (35mm slides with retail prices and SASE). Reports in 1 month.
Tips: "Have a variety of sizes and a good amount of work available."

BOSTON CORPORATE ART, 470 Atlantic Ave., Boston MA 02210. Contact: Assistant to the Gallery Director. Estab. 1987. "The gallery shows group shows and doesn't follow conventional formats. We are an art consulting firm with a large open gallery space that is accessible to the public and our clients." Number of shows varies. Length of shows varies.

Making Contact & Terms: Charges 50% commission. General price range: $150-6,000. "In the event of a sale, the artist will be issued a purchase order which indicates to whom the art was sold. Payment will be issued in full when BCA receives payment from our client." Prefers slides. "When reviewing slides we look for work in all media, sizes and price ranges. We look for work that is appropriate for our corporate client market." Send slides by mail for consideration. Provide all necessary information with slides including all the sizes you can produce and the corresponding artist's price in writing for each dimension. SASE. Reports in 6-8 weeks.

Tips: "We curate some of the largest and most prestigious collections in New England and can provide terrific opportunities for artists." Boston Corporate Art is an advisory and consulting firm working with the corporate community in the areas of acquisition of fine art and commissioning of site-specific work. Boston Corporate Art's client listing is diverse, representing large and small corporate collections, academic, restaurant and health care communities, as well as private collectors.

BROMFIELD GALLERY, 107 South St., Boston MA 02111. (617)451-3605. Director: Christina Lanzl. Estab. 1974.
 • Bromfield Gallery is Boston's oldest artist-run institution.

Exhibits: Requirements: Usually shows New England artists. Interested in "programs of diversity and excellence." Examples of exhibitions: "Process and Product," juried by Barbara Hitchcock and Jim Dow. Presents various number of shows/year. Shows last 1 month. Photographer's presence at opening required.

Making Contact & Terms: Interested in receiving work from newer, lesser-known photographers. Rents gallery to artists ($750-900). Charges 50% commission. General price range: $200-2,000. Reviews transparencies. Interested in framed or unframed, mounted or unmounted, matted or unmatted work. Submit portfolio for review. Send material by mail for consideration. Reports in 1 month.

Tips: "We are looking to expand our presentation of photographers." There is a "small percentage of galleries handling photographers."

J.J. BROOKINGS GALLERY, 669 Mission St., San Francisco CA 94105. (415)546-1000. Director: Timothy C. Duran.

Exhibits: Requirements: Professional presentation, realistic pricing, numerous quality images. Interested in photography created with a painterly eye. Examples of exhibitions: Ansel Adams, James Crable, Lisa Gray, Duane Michals, Eberhard Grames, Misha Grodin, Irving Penn, Ben Schonzeit, Sandy Skoglund and Todd Watts. Presents rotating group shows. Sponsors openings. Photographer's presence at opening preferred.

Making Contact & Terms: Charges 50% commission. General price range: $500-8,000. Reviews transparencies. Send material by mail for consideration. Reports in 3-5 weeks; "if not acceptable, reports immediately."

Tips: Interested in "whatever the artist thinks will impress us the most. 'Painterly' work is best. No documentary or politically-oriented work."

C.A.G.E., 1416 Main St., Cincinnati OH 45210-2603. (513)381-2437. Director: Alan Bratton. Estab. 1978.

Exhibits: Accepts proposals from artists/curators on a continual basis. Recent exhibits by Thomas Tulos, Clattis Moorer and Lee Zellars. Presents 15-20 exhibits/year. Shows last 6 weeks. Sponsors openings; announcements sent to public and media. Photographer's presence at opening is preferred.

Making Contact & Terms: Interested in receiving work from newer, lesser-known photographers. Charges 25% commission. General price range: $100-1,000. Reviews transparencies. Send SASE for prospectus.

Tips: "Submit good quality slides with a clear proposal for show. Also, we are a nonprofit gallery and exhibition is more important than sales."

CALIFORNIA MUSEUM OF PHOTOGRAPHY, University of California, Riverside CA 92521. (714)787-4787. Director: Jonathan Green.

Exhibits: The photographer must have the "highest quality work." Presents 12-18 shows/year. Shows last 6-8 weeks. Sponsors openings; inclusion in museum calendar, reception.

Making Contact & Terms: Curatorial committee reviews transparencies and/or matted or unmounted work. Query with résumé of credits. SASE. Reports in 90 days.

Tips: "This museum attempts to balance exhibitions among historical, technology, contemporary, etc. We do not sell photos but provide photographers with exposure. The museum is always interested in newer, lesser-known photographers who are producing interesting work. We can show only a small

percent of what we see in a year. The CMP has moved into a renovated 23,000 sq. ft. building. It is the largest exhibition space devoted to photography in the West."

THE CANTON MUSEUM OF ART, 1001 Market Ave., Canton OH 44702. (216)453-7666. Executive Director: M.J. Albacete.

Exhibits: Requirements: "The photographer must send preliminary letter explaining desire to exhibit; send samples of work (upon our request); have enough work to form an exhibition; complete *Artist's Form* detailing professional and academic background, and provide photographs for press usage. We are interested in exhibiting all types of quality photography, preferably using photography as an art medium, but we will also examine portfolios of other types of photography work as well: architecture, etc." Presents 2-5 shows/year. Shows last 6 weeks. Sponsors openings. Major exhibits (in galleries), postcard or other type mailer, public reception.

Making Contact & Terms: Charges commission. General price range: $50-500. Interested in exhibition-ready work. No size limits. Query with samples. Submit letters of inquiry first, with samples of photos. SASE. Reports in 2 weeks.

Tips: "We look for photo exhibitions which are unique, not necessarily by 'top' names. Anyone inquiring should have some exhibition experience, and have sufficient materials; also, price lists, insurance lists, description of work, artist's background, etc. Most photographers and artists do little to aid galleries and museums in promoting their works—no good publicity photos, confusing explanations about their work, etc. We attempt to give photographers—new and old—a good gallery exhibit when we feel their work merits such. While sales are not our main concern, the exhibition experience and the publicity can help promote new talents. If the photographer is really serious about his profession, he should design a press-kit type of package so that people like me can study his work, learn about his background, and get a pretty good concept of his work. This is generally the first knowledge we have of any particular artist, and if a bad impression is made, even for the best photographer, he gets no exhibition. How else are we to know? We have a basic form which we send to potential exhibitors requesting all the information needed for an exhibition. My article, 'Artists, Get Your Act Together If You Plan to Take it on the Road,' shows artists how to prepare self-promoting kits for potential sponsors, gallery exhibitors, etc. Copy of article and form sent for $2 and SASE."

***CAPITOL COMPLEX EXHIBITIONS**, Florida Division of Cultural Affairs, Department of State, The Capitol, Tallahassee FL 32399-0250. (904)487-2980. Fax: (904)922-5259. Arts Consultant: Katie Dempsey.

Exhibits: "The Capitol Complex Exhibitions Program is designed to showcase Florida artists and art organizations. Exhibition spaces include the Capitol Gallery (22nd floor), the Cabinet Meeting Room, the Old Capitol Gallery, the Secretary of State's Reception Room, and the Division of Cultural Affairs Gallery. Exhibitions are selected based on quality, diversity of medium, and regional representation." Examples of recent exhibitions: Rick Wagner (b&w); Lee Dunkel (b&w); and Barbara Edwards (color). Shows last 3 months. Provides announcements and staff assistance for openings. Photographer's presence at opening is required.

Making Contact & Terms: Interested in receiving work from newer, lesser-known photographers. Does not charge commission. Interested in framed work only. Request an application. SASE. Reports in 3 weeks.

***SANDY CARSON GALLERY**, 1734 Wazee, Denver CO 80202. (303)297-8585. Fax: (303)297-8933. Director: Brenda Hull. Estab. 1975.

Exhibits: Requirements: Professional, committed, body of work and continually producing new work. Interests vary. Examples of recent exhibitions: "We the People," by Rimma & Valeriy Gerlovin (color); "3 Artists," by Carolyn Kinca (color chromogenic prints); "Recent Exposures," by Peter de Lory and others (b&w and color); photography by Carolyn Krieg, David Teplica, Rimma & Valeriy Gerlovin, Gary Isaacs (June 1996). Shows last 6 weeks. Sponsors openings; reception and invitations. Photographer's presence at opening preferred; "Doesn't matter."

Making Contact & Terms: Interested in receiving work from newer, lesser-known photographers. Charges 50% commission. Reviews transparencies. Interested in framed or unframed, matted or unmatted work. Requires exclusive representation locally. Send material by mail for consideration. SASE. Reports in 1 month.

MARKET CONDITIONS are constantly changing! If you're still using this book and it's 1998 or later, buy the newest edition of *Photographer's Market* at your favorite bookstore or order directly from Writer's Digest Books.

Tips: "We like an original point of view. Properly developed prints. Seeing more photography being included in gallery shows."

***KATHARINE T. CARTER & ASSOCIATES**, P.O. Box C, St. Leo FL 33574. (352)523-1948. Fax: (352)523-1949. New York: 24 Fifth Ave., Suite 703, New York NY 10011. (212)903-4650. Fax: (212)533-9530. Executive Director: Katharine T. Carter. Estab. 1985.
Exhibits: Requirements: Strong body of work, thematically developed over 2 year period; 30-40 works minimum in one area of investigation. Prefers "mature (40+) artists with statewide/regional reputations." Interested in all subject matter—traditional to innovative/experimental. Examples of recent exhibitions: James Hughson (b&w); Joan Rough (Cibachrome); and Sally Crooks (Polaroid). Presents 4 shows/year. Shows last 2-3 months. Sponsors openings; provides press and color announcement mailed to over 1,000 art professionals and collectors statewide/regionally. Artist must cover all round-trip shipping and insurance costs. Photographer's presence at opening preferred, not required.
Making Contact & Terms: Interested in receiving work from lesser-known photographers. Charges 50% commission. Buys photos outright. General price range: $500-2,000. Reviews transparencies. Send résumé and slides. SASE.
Tips: "Katharine T. Carter & Associates is committed to the development of the careers of their artist/clients. Gallery space is primarily used to exhibit the work of artists with whom long standing relationships have been built over several years."

CENTER FOR EXPLORATORY AND PERCEPTUAL ART, 700 Main St., Fourth Floor, Buffalo NY 14202. (716)856-2717. Fax: (716)856-2720. E-mail: cepa@aol.com. Curator: Robert Hirsch. Estab. 1974. "CEPA is an artist-run space dedicated to presenting photographically based work that is underrepresented in traditional cultural institutions."
Exhibits: Requirements: slides with detailed and numbered checklist, résumé, artist's statement, project proposal and SASE. The total gallery space is approximately 5,000 square feet. Interested in political, culturally diverse, contemporary and conceptual works. Examples of recent exhibitions: "Akin & Ludwig," by Gwen Akin and Allan Ludwig (diptyes, sequences, landscapes); "Multiple Affinities," a group show by 15 artists (convergence of printmaking and photographic practice); "Face to Face with the Bomb," by Paul Shambroom (nuclear reality after the cold war). Presents 5-6 shows/year. Shows last 6 weeks. Sponsors openings; reception with lecture.
Making Contact & Terms: Extremely interested in exhibiting work of newer, lesser-known photographers. Charges 20% commission. General price range: $200-3,500. Reviews transparencies. Interested in framed or unframed, mounted or unmounted, matted or unmatted work. Query with résumé of credits. Send material by mail for consideration. SASE. Reports in 3 months.
Tips: "We review CD-ROM portfolios and encourage digital imagery. We will be showcasing work on our website currently under construction."

CENTER FOR PHOTOGRAPHY AT WOODSTOCK, 59 Tinker St., Woodstock NY 12498. (914)679-9957. Fax: (914)679-6337. Exhibitions Director: Kathleen Kenyon. Estab. 1977.
Exhibits: Interested in all creative photography. Examples of previous exhibitions: "Social Studies/ Public Monument"; "Mirror-Mirror"; and "Picturing Ritual" (all were group shows). Presents 5 shows/year. Shows last 6 weeks. Sponsors openings.
Making Contact & Terms: Interested in receiving work from newer, lesser-known photographers. Charges 25% sales commission. Send 20 slides plus cover letter, résumé and artist's statement by mail for consideration. SASE. Reports in 4 months.
Tips: "We are closed Mondays and Tuesdays. Interested in contemporary and emerging photographers."

***THE CENTRAL BANK GALLERY,** (formerly The Gallery at Central Bank), Box 1360, Lexington KY 40590. In U.S. only (800)637-6884. In Kentucky (800)432-0721. Fax: (606)253-6244. Curator: John G. Irvin. Estab. 1987.
Exhibits: Requirements: No nudes and only Kentucky photographers. Interested in all types of photos. Examples of recent exhibitions: "Covered Bridges of Kentucky," by Jeff Rogers; "Portraits of Children in Black and White," by Jeanne Walter Garvey; and "The Desert Storm Series," by Brother Paul of the Abbey of Gethsemane. Presents 2-3 photography shows/year. Shows last 3 weeks. Sponsors openings. "We pay for everything, invitations, receptions and hanging. We give the photographer 100 percent of the proceeds."
Making Contact & Terms: Interested in receiving work from newer, lesser-known photographers. Charges no commission. General price range: $75-1,500. "If you can get it in the door we can hang it." Query with telephone call. Reports back probably same day.

CHARLENE'S FRAMING AND GALLERY TEN, (formerly Gallery Ten), 514 E. State St., Rockford IL 61104. (815)963-1113. President: Charlene Berg. Estab. 1986.

Exhibits: "We look for quality in presentation; will review any subject or style. However, we are located in a conservative community so artists must consider that when submitting. We may show it, but it may not sell if it is of a controversial nature." Interested in fine art. Example of exhibitions: "Johnson Center Series," by Beth Jersild. Number of exhibits varies. Shows last 6 weeks. Sponsors openings; provides publicity, mailer and opening refreshments. Photographer's presence at opening preferred.

Making Contact & Terms: Very receptive to exhibiting work of newer, lesser-known photographers. Charges 40% commission. General price range: $50-300. Reviews transparencies. Interested in mounted or unmounted work, matted work. "We prefer 20×24 or smaller." Send material by mail for consideration. SASE. Reports in 1 month.

Tips: "Quality in framing and presentation is paramount. We cannot accept work to sell to our clients that will self destruct in a few years."

CLEVELAND STATE UNIVERSITY ART GALLERY, 2307 Chester Ave., Cleveland OH 44114. (216)687-2103. Fax: (216)687-2275. Director: Robert Thurmer. Estab. 1973.

Exhibits: Requirements: Photographs must be of superior quality. Interested in all subjects and styles. Looks for professionalism, creativity, uniqueness. Examples of recent exhibitions: "Re-Photo Construct," with Lorna Simpson; "El Salvador," by Steve Cagan; "In Search of the Media Monster," with Jenny Holzer; and "Body of Evidence: The Figure in Contemporary Photography," by Dieter Appelt, Cindy Sherman, Joel Peter Witkin and others, curated by Robert Thurmer (1995). Presents 0-1 show/year. Shows last 1 month. Sponsors openings; provides publicity, catalog or brochure, wine and cheese. Photographer's presence at opening and during show preferred.

Making Contact & Terms: Interested in receiving work from newer, lesser-known photographers. Charges 25% commission. General price range: $100-1,000. Reviews transparencies. Interested in framed or unframed, mounted or unmounted, matted or unmatted work. Send material by mail for consideration. SASE. Reports within 3 months.

Tips: "Write us! Do not submit oversized materials. This gallery is interested in new, challenging work—we are not interested in sales (sales are a service to artists and public)."

***COASTAL CENTER FOR THE ARTS, INC.**, 2012 Demere Rd., St. Simons Island GA 31522. Phone/fax: (912)634-0404. Executive Director: Mittie B. Hendrix. Estab. 1946.

Exhibits: Requirements: Unframed work must be shrink-wrapped for bin; framed work must be ready for hanging. Looking for "photo art rather than 'vacation' photos." Examples of recent exhibitions: "Impressions of the Italian Countryside," by Judy Wallin (general, color); "Slow Leap," by John Couper (large frame b&w nature abstract); and "Land of Light and Shadows," by Suzanne Jachson (underwater landscapes). Presents 2 shows/year. Shows last 3 weeks. Sponsors openings.

Making Contact & Terms: Interested in receiving work from newer, lesser-known photographers. Charges 30% commission to members; 40% to nonmembers. General price range: $25-625. Reviews transparencies. Interested in framed or unframed work. "We have seven galleries and can show photos of all sizes." Send slides and résumé of credits. SASE. Reports in 3-4 weeks.

Tips: "In 1995 a national juror selected computer art to be hung in our 42nd Artists' National, considered the year's premiere exhibit for the region. If framed, use a simple frame. Know what the gallery mission is—more fine art (as we are) or walk-in tourists (as others in the area). Use a good printer. Do not substitute other work for work selected by the gallery."

COLLECTOR'S CHOICE GALLERY, 20352 Laguna Canyon Rd., Laguna Beach CA 92651-1164. Phone/fax: (714)494-8215 (call before faxing). Director: Beverly Inskeep. Estab. 1979.

Exhibits: Interested in portraiture (young, old, individual, groups); and surrealism and computer-enhanced works. Examples of recent exhibitions: works by Jennifer Griffiths (hand-tints); Kornelius Schorle (Cibachrome); David Richardson (b&w); and Glenn Aaron (b&w).

Making Contact & Terms: Interested in receiving work from newer, lesser-known photographers. Charges 40% commission. Buys photos outright. General price range: $15-2,000. Interested in unframed, unmounted and unmatted work only. Works are limited to unmounted 13'×16' largest. No minimum restrictions. Send material by mail for consideration. SASE. Reports in 3 weeks.

***CONCEPT ART GALLERY**, 1031 S. Braddock, Pittsburgh PA 15218. (412)242-9200. Fax: (412)242-7443. Director: Sam Berkovitz. Estab. 1972.

Exhibits: Desires "interesting, mature work." Work that stretches the bounds of what is percieved as typical photography. Examples of exhibitions: "Home Earth Sky," by Seth Dickerman and "Luke Swank," selected photos.

Making Contact & Terms: Very interested in receiving work from newer, lesser-known photographers. NPI. Reviews transparencies. Interested in unmounted work only. Requires exclusive representation within metropolitan area. Send material by mail for consideration. SASE.

Tips: "Mail portfolio with SASE for best results. Will arrange appointment with artist if interested." Sees trend toward "crossover work."

***THE CONTEMPORARY ARTS CENTER**, Dept. PR, 115 E. Fifth St., Cincinnati OH 45202. (513)721-0390. Contact: Curator. Nonprofit arts center.
Exhibits: Requirements: photographer must be selected by the curator and approved by the board. Interested in avant garde, innovative photography. Examples of recent exhibits: "Warhol/Makos," the work of New York photographer Christopher Makos; "Images of Desire," contemporary advertising photography; "The Perfect Moment: Robert Mapplethorpe"; and "Songs of My People." Presents 1-3 shows/year. Shows last 6-12 weeks. Sponsors openings; provides printed invitations, music, refreshments, cash bar. Photographer's presence at opening preferred.
Making Contact & Terms: Photography sometimes sold in gallery. Charges 15% commission. General price range: $200-500. Reviews transparencies. Send query with résumé and slides of work. SASE. Reports in 2 months.

THE COPLEY SOCIETY OF BOSTON, 158 Newbury St., Boston MA 02116. (617)536-5049. Gallery Manager: Jason M. Pechinski. Estab. 1879. A nonprofit institution.
Exhibits: Requirements: Must apply and be accepted as an artist member. Once accepted, artists are eligible to compete in juried competitions. Guaranteed showing once a year in small works shows. There is a possibility of group or individual shows, on an invitational basis, if merit exists. Interested in all styles. Examples of exhibitions: portraiture by Al Fisher (b&w, platinum prints); landscape/exotic works by Eugene Epstein (b&w, limited edition prints); and landscapes by Jack Wilkerson (b&w). Presents various number of shows/year. Shows last 2-4 weeks. Sponsors openings for juried shows by providing refreshments. Does not sponsor openings for invited artists. Photographer's presence at opening required. Photographer's presence during show required for invited artists, preferred for juried shows. Workshops and critiques offered.
Making Contact & Terms: Interested in receiving work from newer, lesser-known photographers. Charges 40% commission. General price range: $100-10,000. Reviews transparencies. Interested in framed work only. Request membership application. Quarterly review deadlines.
Tips: Wants to see "professional, concise and informative completion of application. The weight of the judgment for admission is based on quality of slides. Only the strongest work is accepted."

***CREATIONS INTERNATIONAL FINE ARTS GALLERY**, 48 E. Granada Blvd., Ormond Beach FL 32176. (904)673-8778. Fax: (904)673-8778 (with advance notice). E-mail: 103221.654@compuserve.com. zbhy42a@prodigy.com. Website: http://ourworld.compuserve.com/homepages/creations_International_Gallery. Owner: Benton Ledbetter. Director: Vickie Haer. Estab. 1984.
Exhibits: Requirements: Submit bio indicating past shows, awards, collectors, education, and any other information that will help present the artist and the work. "There are no limits in the world of art, but we do keep it clean here due to the large numbers of children and families that visit Creations International each year." Examples of recent exhibitions: "Mission Art," by John F. Hodgson (nature unfettered by man); "Art Experience," by Vickie L. Haer (nature at its finest); nature photos by Brian K. Neely; and "Art Attack," by Tony Lee Better (real life awareness). Presents 12 shows/year. Shows last 1 month. Sponsors openings; hosted by international award winner Benton Ledbetter along with the participating artists. Refreshments supplied. Photographers presense at opening and during show preferred.
Making Contact & Terms: Interested in receiving work from newer, lesser-known photographers. Charges 25% commission. General price range: $50 and up. Reviews transparencies. Interested in framed or unframed, mounted or unmounted, matted or unmatted work. Send material by mail for consideration. Send in any way possible. SASE. Reports in 1 month.
Tips: "We currently have 30 Web pages and are up to date with the new computer trends. We represent work by slide registry and disk registry and train other businesses to use computers for their market needs. Be faithful to your work as an artist and keep working at it no matter what."

CROSSMAN GALLERY, University of Wisconsin-Whitewater, 800 W. Main St., Whitewater WI 53190. (414)472-5708. Director: Michael Flanagan. Estab. 1971.
Exhibits: Requirements: Résumé, artist's statement, list insurance information, 10-20 slides, work framed and ready to mount and have 4×5 transparencies available. Interested in all types, especially Cibachrome as large format and controversial subjects. Examples of recent exhibitions: "Color Photography Invitational," by Regina Flanagan, Leigh Kane and Janica Yoder. Presents 1 show biannually. Shows last 3-4 weeks. Sponsors openings; provides food, beverage, show announcement, mailing, shipping (partial) and possible visiting artist lecture/demo. Photographer's presence at opening preferred.
Making Contact & Terms: Buys photos outright. General price range: $250-2,800. Reviews transparencies. Interested in framed and mounted work only. Send material by mail for consideration. SASE. Reports in 1 month.
Tips: "The Crossman Gallery's main role is to teach. I want students to learn about themselves and others in alternative ways; about social and political concerns through art."

CUMBERLAND GALLERY, 4107 Hillsboro Circle, Nashville TN 37215. (615)297-0296. Director: Carol Stein. Estab. 1980.
Exhibits: Limited editions should not exceed 50. Examples of exhibitions: works by Peter Laytin (b&w silver gelatin prints); Jack Spencer (b&w silver gelatin prints); Susan Bryant (hand-colored, silver gelatin prints); and Meryl Truett (hand-colored, silver gelatin prints). Presents 1 photography show/year. Shows last 4-5 weeks. Sponsors openings; provides invitations, mailing list, wine and cheese, publicity. Photographer's presence at opening preferred.
Making Contact & Terms: Interested in receiving work from newer, lesser-known photographers. Charges 50% commission. General price range: $175-1,200. Reviews transparencies. Interested in matted or unmatted work. Requires exclusive representation locally. Send material by mail for consideration. Send résumé and slides. SASE.
Tips: "Please present labeled slides and a professional résumé. Work should be current and readily available. Please do not submit slides of work that is not available. Work should be presented in a professional manner (conservation). Sales in photography are increasing. Due to the high cost of art, photography represents an opportunity for collectors to buy at an affordable price."

DALLAS VISUAL ART CENTER, 2917 Swiss Ave., Dallas TX 75204. (214)821-2522. Fax: (214)821-9103. Executive Director: Katherine Wagner. Estab. 1981.
Exhibits: Requirements: a résumé, cover letter, slides and a SASE; photographer must be from Texas. Interested in all types. Examples of recent exhibitions: Mosaics series by Pablo Esparza (b&w/airbrushed). Presents variable number of shows (2-3)/year. Shows last 3-6 weeks.
Making Contact & Terms: Charges no commission (nonprofit organization). Reviews transparencies. Send material by mail for consideration. SASE. Reports in 1 month.
Tips: "We have funding from Exxon Corporation to underwrite exhibits for artists who have incorporated their ethnic heritage in their work; they should make a note that they are applying for the Mosaics series. (We have a Collector series which we underwrite expenses. All submissions are reviewed by committee.) Other gallery space is available for artists upon slide review. We have a resource newsletter that is published bimonthly and contains artist opportunities (galleries, call for entries, commissions) available to members (membership starts at $35)."

DE HAVILLAND FINE ART, 39 Newbury St., Boston MA 02116. (617)859-3880. Fax: (617)859-3973. Gallery Director: Jennifer Gilbert. Estab. 1989.
Exhibits: Interested in mixed media, photo manipulation, Polaroid transfers, etc. Presents 10 shows/year. Shows last 2 weeks. Sponsors openings. Photographer's presence at opening preferred.
Making Contact & Terms: Interested in receiving work from newer, lesser-known photographers. Charges 50% commission. General price range: $100-800. Reviews transparencies. Interested in framed, mounted or matted work. "We prefer work that is matted and framed. Shape and size is of no particular consideration." Submit portfolio for review. SASE. Reports in 1 month.
Tips: "The public is becoming more interested in photography. It must be unique, consistant and outstanding. We are extremely competitive for representation. Located in the first block of Boston's exclusive Newbury Street, our gallery has been featured in dozens of publications as well as on NBC News for it's innovative support of emerging artists."

***TIBOR DE NAGY GALLERY**, 41 W. 57th St., New York NY 10019. (212)421-3780. Fax: (212)421-3731. Directors: Eric Brown and Andrew Arnot. Estab. 1950.
Exhibits: Interested in figures, nature, collages. Examples of recent exhibitions: "Photographs," by Allen Ginsberg and "A Photo Retrospective," by Rudy Burckhardt. Presents 2 shows/year. Shows last 1 month. Sponsors openings for gallery artists only. Photographer's presence at opening and during show preferred.
Making Contact & Terms: Charges 50% commission. General price range: $900-2,600. Not currently reviewing photographs. Requires exclusive representation locally. SASE.

***CATHERINE EDELMAN GALLERY**, Lower Level, 300 W. Superior, Chicago IL 60610. (312)266-2350. Fax: (312)266-1967. Director: Catherine Edelman. Estab. 1987.
Exhibits: "We exhibit works ranging from traditional landscapes to painted photo works done by artists who use photography as the medium through which to explore an idea." Requirements: "The work must be engaging and honest." Examples of recent exhibitions: work of Joel-Peter Witkin;

LISTINGS THAT USE IMAGES electronically can be found in the Digital Markets Index located at the back of this book.

Michael Kenna; Lynn Geesman. Presents 9-10 exhibits/year. Shows last 4 weeks. Sponsors openings; free drinks. Photographer's presence at opening preferred.

Making Contact & Terms: Charges 50% commission. General price range: $500-8,000. Reviews transparencies. Interested in matted or unmatted work. Requires exclusive representation within metropolitan area. Send material by mail for consideration. SASE. Reports in 2 weeks.

Tips: Looks for "consistency, dedication and honesty. Try to not be overly eager and realize that the process of arranging an exhibition takes a long time. The relationship between gallery and photographer is a partnership—there must be open lines of communication."

PAUL EDELSTEIN GALLERY, 519 N. Highland, Memphis TN 38122-4521. (901)454-7105. Director/Owner: Paul R. Edelstein. Estab. 1985.

Exhibits: Interested in 20th century photography "that intrigues the viewer"—figurative still life, landscape, abstract—by upcoming and established photographers. Examples of exhibitions: "Mind Visions," by Vincent de Gerlando (figurative); "Eudora Welty Portfolio," by Eudora Welty (figurative); and "Still Lives," by Lucia Burch Dogrell. Shows are presented continually throughout the year.

Making Contact & Terms: Interested in receiving work from newer, lesser-known photographers. Charges 30-40% commission. Buys photos outright. General price range: $400-5,000. Reviews transparencies. Interested in framed or unframed, mounted or unmounted, matted or unmatted work. There are no size limitations. Submit portfolio for review. Query with samples. Cannot return material. Reports in 1 month.

ELEVEN EAST ASHLAND (Independent Art Space), 11 E. Ashland, Phoenix AZ 85004. (602)257-8543. Director: David Cook. Estab. 1986.

Exhibits: Requirements: Contemporary only (portrait, landscape, genre, mixed media in b&w, color, non-silver, etc.); photographers must represent themselves, complete exhibition proposal form and be responsible for own announcements. Interested in "all subjects in the contemporary vein—manipulated, straight and non-silver processes." Examples of recent exhibitions: works by Jon Gipe, Jack Stuler, Len Harris, David Cook, Jeffrey Huffman and Eric Kronengold. Presents 13 shows/year. Shows last 3 weeks. Sponsors openings; two inhouse juried/invitational exhibits/year. Photographer's presence during show preferred.

Making Contact & Terms: Very receptive to exhibiting work of newer, lesser-known photographers. Charges 25% commission. General price range: $100-500. Reviews transparencies. Interested in framed or unframed, mounted or unmounted, matted or unmatted work. Shows are limited to material able to fit through the front door and in the $4' \times 8'$ space. Query with résumé of credits. Query with samples. SASE. Reports in 2 weeks.

Tips: "Sincerely look for a venue for your art, and follow through. Search for traditional and nontraditional spaces."

***AMOS ENO GALLERY**, 594 Broadway, #404, New York NY 10012. (212)226-5342. Director: Anne Yearsley. Estab. 1974.

Exhibits: "This is a nonprofit cooperative gallery. Generally, we only exhibit the work of our members except for our annual small works juried exhibition and selected exchanges and invitationals. We only represent 3 photographers out of 34 artists at this time." Open to all styles. Examples of recent exhibitions: "Watershed Investigations II," by Mark Abrahamson (aerial landscape, Cibachrome prints); "Paper" (group show of b&w photos); "Nothing Serious" (group show of b&w and color prints). Presents 1 photography show/year. Shows last 3 weeks. Photographer's presence at opening required.

Making Contact & Terms: Interested in receiving work from newer, lesser-known photographers. Charges 20% commission. General price range: $250-600. Interested in framed work only. Request information sheet first. If interested in applying for membership, send slides, résumé, statement and cover letter. Reviews slides on the third Saturdays of January, March, May, July and September.

FAHEY/KLEIN GALLERY, 148 N. La Brea Ave., Los Angeles CA 90036. (213)934-2250. Fax: (213)934-4243. Co-Director: David Fahey. Estab. 1986.

Exhibits: Requirements: Must be established for a minimum of 5 years; preferably published. Interested in established work. Fashion/documentary/nudes/portraiture/fabricated to be photographed work. Examples of exhibitions: works by Irving Penn (color work), Henri Cartier-Bresson and McDermott & McGough. Presents 10 shows/year. Shows last 5 weeks. Sponsors openings; provides announcements and beverages served at reception. Photographer's presence at opening and during show preferred.

Making Contact & Terms: Charges 50% commission. Buys photos outright. General price range: $600-200,000. Reviews transparencies. Interested in unframed, unmounted and unmatted work only. Requires exclusive representation within metropolitan area. Send material by mail for consideration. SASE. Reports in 2 months. Interested in seeing mature work with resolved photographic ideas and viewing complete portfolios addressing 1 idea.

Tips: "Have a comprehensive sample of innovative work."

***FAVA (Firelands Association for the Visual Arts)**, 80 S. Main St., Oberlin OH 44074. (216)774-7158. Fax: (216)774-7158. Gallery Director: Susan Jones. Estab. 1979.
Exhibits: Presents 1 regional juried photo show/year. Apply for "Six-State Photography." Open to residents of Ohio, Kentucky, West Virginia, Pennsylvania, Indiana, Michigan. Send annual application for invitational show by November 1 of each year; include 12 slides, résumé, slide list. Shows last 1 month. Sponsors openings; produces and mails announcements and provides refreshments. Photographer's presence at opening preferred.
Making Contact & Terms: Interested in receiving work from newer, lesser-known photographers. Charges 30% commission. General price range: $100-1,000. Interested in framed or unframed, mounted, matted work. Send SASE for "Exhibition Opportunity" flier or Six-State Show entry form.
Tips: "As a nonprofit gallery, we do not represent artists except during the show."

FOCAL POINT GALLERY, 321 City Island Ave., New York NY 10464. (718)885-1403. Photographer/Director: Ron Terner. Estab. 1974.
Exhibits: Open to all subjects, styles and capabilities. "I'm looking for the artist to show me a way of seeing I haven't seen before." Nudes and landscapes sell best. Examples of recent exhibitions: Robert Forlini (winner of 6th annual juried exhibition); Anna D. Shaw, James Brozek, Jill Waterman (photos of New Year's Eve celebration in different countries and cities); Gregory Ilich, Steve Jensen, Penny Harris, Vincent Serbin and Ron Terner. Photographer's presence at opening preferred.
Making Contact & Terms: Very receptive to exhibiting work of newer, lesser-known photographers. Charges 30% sales commission. General price range: $175-700. Artist should call for information about exhibition policies.
Tips: Sees trend toward more use of alternative processes. "The gallery is geared toward exposure—letting the public know what contemporary artists are doing—and is not concerned with whether it will sell. If the photographer is only interested in selling, this is not the gallery for him/her, but if the artist is concerned with people seeing the work and gaining feedback, this is the place. Most of the work shown at Focal Point Gallery is of lesser-known artists. Don't be discouraged if not accepted the first time. But continue to come back with new work when ready."

***ADRIENNE FORD GALLERY**, 115 E. Mobile St., Florence AL 35630. (205)764-8366. Fax: (205)381-1283. Art Consultant: Virginia Kingsley. Estab. 1993.
Exhibits: Requirements: Must be under exclusive contract in Lauderdale, Colbert and Franklin counties in Alabama and must pass jury selection. Interested in all types of work appropriate for north Alabama market, including landmarks, landscapes, humor, people (with release only), animals and mixed media. Examples of recent exhibitions: "Art for Your Ears," by Michael McCrackin (b&w of musicians); "Mind Station," by Shannon Wells (b&w, b&w hand-colored). Presents 1 show/year. Shows last 1 month. Sponsors openings; provides press, publicity, food, invitations for 50% show commission. Photographer's presence at opening preferred.
Making Contact & Terms: Interested in receiving work from newer, lesser-known photographers. Charges 40% commission after show. General price range: $25-250. Reviews transparencies. Interested in framed, matted or unmatted work. Shrink wrap if accepted. Requires exclusive representation locally. No size limits. Arrange a personal interview to show portfolio. Submit portfolio for review. Query with résumé of credits. Query with samples. Send material by mail for consideration. Call before you send slides and send résumé with slides. Make an appointment with appropriate gallery personnel at least 1 week in advance to show work. Bring a good representation of work. Bring résumé and biography to appointment. SASE. Reports in 3 weeks.
Tips: "We prefer to meet the photographer and see actual work, preferably a solid representation of a complete body of work." CD-ROM, video OK.

***FRAGA FRAMING & ART GALLERY**, 4532 Magazine St., New Orleans LA 70115. (504)899-7002. Fax: (504)834-5045. President: Grace Fraga. Estab. 1992.
Exhibits: Requirements: Must be established for a minimum of 3 years. Interested in any kind of subject matter and style, especially unique, innovative styles. Examples of recent exhibitions: erotic photography by Michael White (distorted color images); Jim Fairchild (11×14 b&w Cibachrome nudes); and Steven Snyder (11×14 b&w nudes and documentary). Presents 1-3 shows/year. Shows last 1-2 months. Sponsors openings; artist provides announcements and gallery provides advertising and refreshments. Photographer's presence at opening and during show required.

 THE ASTERISK before a listing indicates that the market is new in this edition. New markets are often the most receptive to freelance submissions.

Making Contact & Terms: Interested in receiving work from newer, lesser-known photographers. Charges 50% commission. General price range: $200-600. Reviews transparencies. Interested in framed or unframed work. Requires exclusive representation locally. Works are limited to maximum 16×20 image. SASE. Reports in 2-3 months.

FREEPORT ART MUSEUM & CULTURAL CENTER, 121 N. Harlem Ave., Freeport IL 61032. Phone/fax: (815)235-9755. Director: Becky Connors. Estab. 1976.
Exhibits: Interested in general, especially landscapes, portraits and country life. Examples of exhibitions: "Between Black and White: Photographs by Carol House" and "Archie Lieberman: The Corner of My Eye." Presents 1 or 2 shows/year. Shows last 2 months. Sponsors openings on Friday evenings. Pays mileage. Photographer's presence at opening required. Solo shows for Illinois artists only.
Making Contact & Terms: Exhibits works by established or lesser-known photographers. Charges 20% commission. Reviews transparencies or photographs. Interested in framed work only. Send material by mail for consideration. SASE. Reports in 3 months.

***FULLER LODGE ART CENTER AND GALLERY**, 2132 Central Ave., Los Alamos NM 87544. (505)662-9331. Director: Gloria Gilmore-House. Estab. 1977.
Exhibits: Presents 10-11 shows/year, 3 of which are juried, one exclusively for photography. Shows last 4-5 weeks. For more information and prospectus send SASE. Examples of recent juried exhibitions: "Que Pasa: Art in New Mexico," T.K. Thompson (gelatin silver prints) and Marcia Reifman (photo transfer); "1995 Biennial: Regional Art (Texas, Oklahoma, Colorado, Arizona, Utah and New Mexico)," first prize and Grumbacher medal to photographer Virginia Lee Lierz (photo transfer)." Annual exhibit exclusively for photography is Through the Looking Glass. Initiated in 1993 as a national show, the 1995 exhibit attracted 150 entrants, of which 51 photographs representing 30 artists were accepted. Cash awards and ribbons are presented. 1995 jurors included Liz Bensley (New Mexican newpaper), Kris Elrick (WESTAF) and Richard C. Sandoval (New Mexican magazine). Exhibit juried from transparencies; awards decided upon actual pieces. Interested in all styles and genres.
Making Contact & Terms: Interested in receiving work from newer, lesser-known photographers. Charges 30% commission. General price range: $75-300. Interested in framed or unframed, mounted or unmounted work. Query with résumé of credits. SASE. Reports in 3 weeks.
Tips: "Be aware that we never do one person shows—artists will be used as they fit into scheduled shows. Work should show impeccable craftsmanship."

***GAIER CONTEMPORARY GALLERY**, 1104 N. Mills Ave., Orlando FL 32803. Phone/fax: (407)897-6669. Assistant Curator: Phil Bailey. Estab. 1993.
Exhibits: Requirements: Must have a body of strong work and previous experience showing in a gallery. Interested in b&w and color nudes, still life, landscapes, portraits, alternative process and mixed media. Recent group shows have included work by Slayton Underhill, Charity Barton and Anna Tomczak. Presents 1-2 shows/year. Shows last 1 month. Sponsors openings.
Making Contact & Terms: Interested in receiving work from newer, lesser-known photographers. Charges 40% commission. General price range: $100-1,000. Reviews transparencies. Interested in framed work only. Arrange personal interview to show portfolio. Query with résumé of credits. Query with samples. SASE. Reports in 1 month.

GALERIA MESA, P.O. Box 1466, 155 N. Center, Mesa AZ 85211-1466. (602)644-2056. Fax: (602)644-2901. Contact: Curator. Estab. 1980.
Exhibits: Interested in contemporary photography as part of its national juried exhibitions in any and all media. Examples of recent exhibitions: "Image Conscious," by 35 artists (nationally juried); "Out and About Landscape," by Tom Strich, Chris Burkett, Laurie Lundquist (internationally juried); and "Reality Check," by several artists (nationally juried). Presents 7-9 national juried exhibits/year. Shows last 4-6 weeks. Sponsors openings; refreshments and sometimes slide lectures (all free).
Making Contact & Terms: Interested in receiving work from emerging photographers. Charges 25% commission. General price range: $300-800. Interested in seeing slides of all styles and aesthetics; wants more shots of everyday life, Hispanic/Native American themes, mixed media. Slides are reviewed by changing professional jurors. Must fit through a standard size door and be ready for hanging. Enter national juried shows; awards total $1,500. SASE. Reports in 1 month.
Tips: "We do invitational or national juried exhibits only. Only submit professional quality work."

***GALMAN LEPOW ASSOCIATES, INC.**, Unit #12, 1879 Old Cuthbert Rd., Cherry Hill NJ 08034. (609)354-0771. Fax: (609)428-7559. Principals: Elaine Galman and Judith Lepow. Estab. 1979.
Making Contact & Terms: Interested in reviewing work from newer, lesser-known photographers. General price range is open. Reviews transparencies. Interested in seeing matted or unmatted work. No size limit. Query with résumé of credits. Visual imagery of work is helpful. SASE. Reports in 3 weeks.
Tips: "We are corporate art consultants and use photography for our clients."

***FAY GOLD GALLERY**, 247 Buckhead Ave., Atlanta GA 30305. (404)233-3843. Fax: (404)365-8633. Owner/Director: Fay Gold. Estab. 1981.
Exhibits: Interested in surreal, nudes, allegorical, landscape (20th century); strong interest in contemporary color and b&w photography. The photographer must be inventive, speak a new language, and present something not seen before of quality, historical importance. Examples of recent exhibits: photographs by Jan Soudek; "From Zonskal to Tibet," photographs by Richard Gere; "A Retrospective of Works by O. Winston Link," photoconstructions by Micah Lexier; "Africa," photographs by Herb Ritts; and "Untitled," recent photographs by George Tice. Presents 12 shows/year. Shows last 4 weeks. Sponsors openings; provides invitation, mailing, press releases to all media, serves wine, contacts all private and corporate collectors. Photographer's presence at opening preferred.
Making Contact & Terms: Very interested in receiving work from newer, lesser-known photographers. Charges 50% commission. General price range: $350-15,000. Reviews transparencies. Interested in framed and unframed work, mounted work and matted work only. Generally requires exclusive representation within metropolitan area. Send slides and résumé. SASE.
Tips: Interested in seeing "unusual, avant-garde" work.

GOMEZ GALLERY, 836 Leadenhall St., Baltimore MD 21230. (410)752-2080. Fax: (410)752-2082. Website: http://www.gomez.com. Directors: Walter Gomez and Diane DiSalvo. Director of photography: Jessica Mendels. Estab. 1988.
Exhibits: Interested in work exploring human relationships or having psychological dimensions. Provocative work accepted. "We are a full-scope gallery (paintings, prints, sculpture, photography). One specialty is male and female figurative photography. Work must be contemporary, experimental, innovative. We will not accept traditional nude or portraiture work." Photographers represented include: Connie Imboden, Robert Flynt, Stephen John Phillips, Jose Villarrubia, Mary Wagner, Frank Yamrus, Jeanmane Cost, John McGarity and Ian Green. Presents 10 photo shows/year. Shows last 1 month. Sponsors openings; provides advertising, mailings, opening receptions.
Making Contact & Terms: Interested in reviewing work from newer, lesser-known photographers and from established photographers. Charges 50% commission. General price range: $150-3,000. "Initially will only review transparencies and résumé; may later request to see actual work." Requires exclusive representation within metropolitan area or Mid-Atlantic region." No "walk-ins" please. SASE. Reports 1-2 months.
Tips: "We currently are redesigning our gallery to devote a room exclusively to photography and are looking for new work. If it's already been done, or is traditional nudes, or lacks a focus or purpose, we are not the gallery to contact! We find that more provocative figurative work sells best. For all our top figurative photographers, we are their top selling gallery in the world."

WELLINGTON B. GRAY GALLERY, East Carolina University, Greenville NC 27858. (919)328-6336. Fax: (919)328-6441. Director: Gilbert Leebrick. Estab. 1978.
Exhibits: Requirements: For exhibit review, submit 20 slides, résumé, catalogs, etc., by November 15th annually. Exhibits are booked the next academic year. Work accepted must be framed or ready to hang. Interested in fine art photography. Examples of exhibitions: "A Question of Gender," by Angela Borodimos (color C-prints) and "Photographs from America," by Marsha Burns (gelatin silver prints). Presents 1 show/year. Shows last 1-2 months. Sponsors openings; provides invitations, publicity and a reception. Photographer's presence at opening and during show preferred.
Making Contact & Terms: Interested in receiving work from newer, lesser-known photographers. Charges 20% commission. General price range: $200-1,000. Reviews transparencies. Interested in framed work for exhibitions; send slides for exhibit committee's review. Send material by mail for consideration. SASE. Reports 1 month after slide deadline (November 15th).

***R. GRODEN GALLERY**, P.O. Box 1733, Hot Springs National Park AR 71902-1733. (501)623-4545. Owner: Randy Groden. Estab. 1989.
Exhibits: Interested in fashion, nude and portraiture. Examples of recent exhibitions: "Female Images" (b&w and color); "Women" (color); and "The Female Form" (color), all by R. Groden. Presents 6 shows/year. Shows last 2 months. Photographer's presence at opening and during show preferred.
Making Contact & Terms: Interested in receiving work from newer, lesser-known photographers. Charges 33% commission. General price range: $600-11,000. Reviews transparencies. Interested in framed or unframed, mounted or unmounted, matted or unmatted work. Query with samples of slides or prints. Reports in 3 weeks only if interested.

HALLWALLS CONTEMPORARY ARTS CENTER, 2495 Main St., Suite 425, Buffalo NY 14214. (716)835-7362. Fax: (716)835-7364. E-mail: hallwall@localnet.com. Visual Arts Director: Sara Kellner. Estab. 1974.
Exhibits: Hallwalls is a nonprofit multimedia organization. "While we do not focus on the presentation of photography alone, we present innovative work by contemporary photographers in the context of contemporary art as a whole." Interested in work which expands the boundaries of traditional photogra-

phy. No limitations on type, style or subject matter. Examples of recent exhibitions: "Feed," by Heidi Kumao (zoetrope, mixed media); "Amendments," including Ricardo Zulveta (b&w performance stills); and "Consuming Passions," including Annie Lopez (b&w photos of food). Presents 10 shows/ year. Shows last 6 weeks. Sponsors openings; provides invitations, brochure and refreshments. Photographer's presence at opening and during show preferred.

Making Contact & Terms: Interested in receiving work from newer, lesser-known photographers. Photography sold in gallery. Reviews transparencies. Send material by mail for consideration. Do not send work. Work may be kept on file for additional review for 6 months.

Tips: "We're looking for photographers with innovative work; work that challenges the boundaries of the medium."

THE HALSTED GALLERY INC., 560 N. Woodward, Birmingham MI 48009. (810)644-8284. Fax: (810)644-3911. Contact: Wendy Halsted or Thomas Halsted.

Exhibits: Interested in 19th and 20th century photographs and out-of-print photography books. Examples of recent exhibitions: "Edna's Nudes," by Edna Bullock (nudes in landscapes); "JP Atterberry: A 15 Year Retrospective," by JP Atterberry; and "The Rouge," by Michael Kenna (the Rouge Steel Plant—industrial). Sponsors openings. Presents 5 shows/year. Shows last 2 months.

Making Contact & Terms: Charges 50% sales commission or buys outright. General price range: $500-25,000. Call to arrange a personal interview to show portfolio only. Prefers to see 10-15 prints overmatted. Send no slides or samples. Unframed work only.

Tips: This gallery has no limitations on subjects. Wants to see creativity, consistency, depth and emotional work.

***LEE HANSLEY GALLERY**, 16 W. Martin St., #201, Raleigh NC 27601. (919)828-7557. Gallery Director: Lee Hansley. Estab. 1993.

Exhibits: Interested in new images using camera as a tool of manipulation; also minimalist works. Looks for top-quality work and a unique vision. Examples of recent exhibitions: "Portrait of America," by Marsha Burns (large framed silver prints); "Landscapes," by Nona Short (b&w prints); "Paris at Night," by Ed Martin (8×10 silver prints). Presents 1 show/year. Show lasts 4-6 weeks. Sponsors openings; gallery provides everything. Photographer's presence at opening and during show preferred.

Making Contact & Terms: Interested in receiving work from newer, lesser-known photographers. Charges 50% commission. General price range: $250-800. Reviews transparencies. Interested in framed or unframed work. No mural-size works. Send material by mail for consideration. SASE. Reports in 1 month.

HAYDON GALLERY, 335 N. Eighth St., Suite A, Lincoln NE 68508. (402)475-5421. Director: Anne Pagel. Estab. 1987 (part of Sheldon Art & Gift Shop for 20 years prior to that).

Exhibits: Requirements: Must do fine-quality, professional-level art. "Interested in any photography medium or content, so long as the work is of high quality." Example of recent exhibition: photographs by Joel Sartore (a *National Geographic* photographer). Presents 1 or 2 (of 9 solo exhibitions) plus group exhibitions/year. Shows last 1 month. Hors d'oeuvres provided by host couple, cost of beverages split between gallery and artist. (Exhibitions booked through 1998.) Artist presents gallery talk 1 week after the opening. Photographer's presence at opening required.

Making Contact & Terms: Interested in receiving work from newer, lesser-known photographers "if high quality." Charges 45% commission. General price range: $150-1,000. Reviews transparencies. Interested in seeing framed or unframed, mounted or unmounted, matted or unmatted work. "Photos in inventory must be framed or boxed." Requires exclusive representation locally. Arrange a personal interview to show portfolio. Submit portfolio for review. SASE. Reports in 1 month.

Tips: "Submit a professional portfolio, including résumé, statement of purpose and a representative sampling from a cohesive body of work." Seeing opportunities for photographers through galleries becoming more competitive. "The public is still very conservative in its response to photography. My observation has been that although people express a preference for b&w photography, they purchase color."

***HEMPHILL FINE ARTS**, 1027 33rd St. NW, Washington DC 20007. (202)342-5610. Fax: (202)342-2107. E-mail: hemphill@aol.com. Owner: George Hemphill. Estab. 1993.

Exhibits: Requirements: "Must present a quality product and make art that is innovative, fresh and interesting. Personality is a big factor us well." Interested in wide-ranging art of all periods. Examples of recent exhibitions: Robert Frank (street photography/gelatin silver); Colby Caldwell (hand-manipulated/gelatin silver); and "Timeless Style: Ageless Photographs of Fashion from Bellocq to Newton." Shows last 5 weeks. Sponsors openings. Photographer's presence at opening and during show preferred.

Making Contact & Terms: Interested in receiving work from newer, lesser-known photographers. Receives variable commission. Buys photos outright. General price range: $400-200,000. Reviews transparencies. Requires exclusive representation locally. Arrange a personal interview to show portfolio. Send material by mail for consideration. SASE. Reporting time varies.

HERA EDUCATIONAL FOUNDATION AND ART GALLERY, P.O. Box 336, Wakefield RI 02880. (401)789-1488. Director: Alexandra Broches. Estab. 1974.
Exhibits: Requirements: Must show a portfolio before attaining membership in this co-operative gallery. Interested in all types of innovative contemporary art which explores social and artistic issues. Examples of exhibitions: "Ordinary Places," by Alexandra Broches (b&w photos), and "Digital Collage," by Patti Fitzmaurice (computer generated). The number of photo exhibits varies each year. Shows last 3-4 weeks. Sponsors openings; provides refreshments and entertainment or lectures, demonstrations and symposia for some exhibits.
Making Contact & Terms: Interested in receiving work from newer, lesser-known photographers. Charges 25% commission. Prices set by artist. Reviews transparencies. Works must fit inside a 6' 6"×2'6" door. Reports in 2-3 weeks. Inquire about membership and shows. Membership guidelines mailed on request.
Tip: Hera exhibits a culturally diverse range of visual artists, particularly women and emerging artists.

HUGHES FINE ARTS CENTER, Dept. of Visual Arts, Box 7099, Grand Forks ND 58202-7099. (701)777-2906. Director: Brian Paulsen. Estab. 1979.
Exhibits: Interested in any subject; mixed media photos, unique technique, unusual subjects. Examples of exhibitions: works by James Falkofske and Alexis Schaefer. Presents 11-14 shows/year. Shows last 2-3 weeks. "We pay shipping costs."
Making Contact & Terms: Very interested in receiving work of newer, lesser-known photographers. Does not charge commission; sales are between artist-buyer. Reviews transparencies. "Works should be framed and matted." No size limits or restrictions. Send 10-20 transparencies with résumé. SASE. Reports in 2 weeks.
Tips: "Send slides of work . . . we will dupe originals and return ASAP and contact you later." Needs "fewer photos imitating other art movements. Photographers should show their own inherent qualities."

***HUNTSVILLE MUSEUM OF ART**, 700 Monroe St. SW, Huntsville AL 35801. (205)535-4350. Fax: (205)532-1743. Chief Curator: Peter J. Baldaia. Estab. 1970.
Exhibits: Requirements: Must have professional track record and résumé, slides, critical reviews in package (for curatorial review). Regional connection preferred. No specific stylistic or thematic criteria. Examples of recent exhibitions: "Still Time," by Sally Mann (b&w/color); "Salvation on Sand Mountain," by Melissa Springer/Jim Neel (b&w documentary); and "Encounters," by John Reese (b&w Alabama subjects). Presents 1-2 shows/year. Shows last 6-8 weeks. Sponsors openings; provides announcement card, mailing and food and drink at reception. Photographer's presence at opening and during show preferred.
Making Contact & Terms: Interested in receiving work from newer, lesser-known photographers. Buys photos outright. Reviews transparencies. Interested in framed or unframed, mounted or unmounted, matted or unmatted work. Send material by mail for consideration. SASE. Reports in 1-3 months.

HYDE PARK ART CENTER, 5307 S. Hyde Park Blvd., Chicago IL 60615. (312)324-5520. Contact: Exhibition Committee. Estab. 1939.
Exhibits: Receptive but selective with new work. "The gallery has a history of showing work on the cutting edge—and from emerging artists. Usually works with Chicago-area photographers who do not have gallery representation." Examples of exhibitions: "Humor," curated by C. Thurow and E. Murray; "Private Relations," curated by Jay Boersma. Shows last 4-5 weeks. Photography included in 1-2 shows/year. Exclusively photo shows rare.
Making Contact & Terms: Charges 25% commission. Send up to 6 slides and résumé to exhibition committee. SASE. Reports quarterly.
Tips: "Don't make solicitations by phone; the exhibition committee does not have office hours. Please do not bring work in for review."

ICEBOX QUALITY FRAMING & GALLERY, 2401 Central Ave. NE, Minneapolis MN 55418. (612)788-1790. Contact: Howard Christopherson. Exhibition, promotion and sales gallery. Estab. 1988. Represents photographers and fine artists in all media. Specializes in "thought-provoking art work and photography, predominantly Minnesota artists." Markets include: corporate collections; interior decorators; museums; private collections.
Exhibits: Fine art and fine art photographs of "artists with serious, thought-provoking work who find it hard to fit in with the more commercial art gallery scene. A for-profit alternative gallery, Icebox sponsors installations and exhibits in the gallery's intimate black-walled space." Exhibit expenses and promotional materials paid by the artist.
Making Contact & Terms: NPI. Sliding sales commission. Send letter of interest telling why you would like to exhibit at Icebox. Include slides and other appropriate materials for review. "At first, send materials that can be kept at the gallery and updated as needed."

Tips: "We are also experienced with the out-of-town artist's needs."

ILLINOIS ART GALLERY, 100 W. Randolph, Suite 2-100, Chicago IL 60601. (312)814-5322. Director: Kent Smith. Assistant Administrator: Jane Stevens. Estab. 1985.
Exhibits: Must be an Illinois photographer. Interested in contemporary and historical photography. Examples of exhibitions: "Poetic Vision," by Joseph Jachna (landscape, large-format); "New Bauhaus Photographs 1937-1940," by James Hamilton Brown, Nathan Lerner, Gyorgy Kepes, Laszlo Moholy-Nagy and Arthur Siegel (photograms). Presents 2-3 shows/year. Shows last 2 months. Sponsors openings; provides refreshments at reception and sends out announcement cards for exhibitions.
Making Contact & Terms: Interested in receiving work from newer, lesser-known photographers, as well as established photographers. Reviews transparencies. Interested in mounted or unmounted work. Send résumé, artist's statement and slides (10). SASE. Reports in 1 month.

INDIANAPOLIS ART CENTER, 820 E. 67th St., Indianapolis IN 46220. (317)255-2464. Fax: (317)254-0486. Exhibitions Curator: Julia Moore. Estab. 1934.
Exhibits: Requirements: Preferably live within 250 miles of Indianapolis. Interested in very contemporary work, preferably unusual processes. Examples of exhibitions: works by Nancy Hutchinson (b&w hand-colored: surreal); Yasha Persson (altered using Adobe Photoshop: social commentary); Ken Gray (overprinted: social commentary); and Stephen Marc (documentary/digital montages). Presents 1-2 photography shows/year out of 13-20 shows in a season. Shows last 4-6 weeks. Sponsors openings. Provides food and mailers. "We mail to our list and 50 names from photographer's list. You mail the rest." Photographer's presence at opening and during show preferred.
Making Contact & Terms: Interested in receiving work from newer, lesser-known photographers. Charges 35% commission. General price range: $100-1,000. Reviews transparencies. Interested in framed (or other finished-presentation formatted) work only for final exhibition. Works are limited to 96″ maximum any direction. Send material by mail for consideration. Send minimum 10 slides with résumé, reviews, artist's statement by December 31. No wildlife or landscape photography. Interesting color work is appreciated. SASE.

INTERNATIONAL CENTER OF PHOTOGRAPHY, 1130 Fifth Ave., New York NY 10128. Contact: Department of Exhibitions. Estab. 1974.
Making Contact & Terms: Portfolio reviews are held the first Monday of each month. Submit portfolio to the receptionist by noon and pick up the following afternoon. Call Friday prior to drop-off date to confirm. "This is strictly drop-off."

ISLIP ART MUSEUM, 50 Irish Lane, Islip NY 11730. (516)224-5402. Director: M.L. Cohalan. Estab. 1973.
Exhibits: Interested in contemporary or avant-garde works. Has exhibited work by Robert Flynt, Skeet McAuley and James Fraschetti. Shows last 6-8 weeks. Sponsors openings. Photographer's presence at opening preferred.
Making Contact & Terms: Interested in reviewing work from newer, lesser-known photographers. Charges 30% commission. General price range: $200-3,000. Reviews transparencies. Send slides and résumé; no original work. Reports in 1 month.
Tips: "Our museum exhibits theme shows. We seldom exhibit work of individual artists. Themes reflect ideas and issues facing current avant-garde art world. We are a museum. Our prime function is to exhibit, not promote or sell, work."

***JACKSON FINE ART**, 3115 E. Shadowlawn Ave., Atlanta GA 30305. (404)233-3739. Fax: (404)233-1205. President: Jane Jackson. Estab. 1990.
Exhibits: Requirements: "Photographers must be established, preferably published in books or national art publications. They must also have a strong biography, preferably museum exhibitions, either one-person or group." Interested in innovative photography and photo-related art: nudes, landscape, fashion, portraiture. Exhibition schedule includes mix of classic vintage work and new contemporary work. Examples of recent exhibitions: Sally Mann (20x24 silver prints); William Wegman (20x24 Polaroid); and John Dugdale (8x10 Cyanotype). Presents 14 shows/year in 2 gallery spaces. Shows last 6 weeks. Sponsors openings; provides invitations, food and beverages. Photographer's presence at opening preferred.

 A BULLET has been placed within some listings to introduce special comments by the editor of *Photographer's Market.*

Making Contact & Terms: Only buys vintage photos outright. General price range: $600-150,000. Reviews transparencies. Requires exclusive representation locally. Send material by mail for consideration. "Send slides first. We will not accept unsolicited original work, and we are not responsible for slides. We also review portfolios on CD-ROM and sell work through CD-ROM." SASE. Reports in 2-3 months.

Tips: "Be organized. Galleries are always looking for exciting fresh work. The work should be based on a single idea or theme."

KENT STATE UNIVERSITY SCHOOL OF ART GALLERY, Dept. PM, KSU, 201 Art Building, Kent OH 44242. (330)672-7853. Director: Fred T. Smith.

Exhibits: Interested in all types, styles and subject matter of photography. Photographer must present quality work. Presents 1 show/year. Exhibits last 3 weeks. Sponsors openings; provides hors d'oeuvres, wine and non-alcoholic punch. Photographer's presence at opening preferred.

Making Contact & Terms: Photography can be sold in gallery. Charges 20% commission. Buys photography outright. Will review transparencies. Write a proposal and send with slides. Send material by mail for consideration. SASE. Reports usually in 4 months, but it depends on time submitted.

***ROBERT KLEIN GALLERY,** 38 Newbury St., Boston MA 02116. (617)267-7997. Fax: (617)267-5567. President: Robert L. Klein. Estab. 1978.

Exhibits: Requirements: Must be established a minimum of 5 years; preferably published. Interested in fashion, documentary, nudes, portraiture, and work that has been fabricated to be photographs. Examples of recent exhibitions: work by William Wegman, Tom Baril and Atget. Presents 10 exhibits/year. Shows last 5 weeks. Sponsors openings; provides announcements and beverages served at reception. Photographer's presence at opening and during show preferred.

Making Contact & Terms: Charges 50% commission. Buys photos outright. General price range: $600-200,000. Reviews transparencies. Interested in unframed, unmatted, unmounted work only. Requires exclusive representation locally. Send material by mail for consideration. SASE. Reports in 2 months.

***PAUL KOPEIKIN GALLERY,** 170 S. La Brea Ave., Los Angeles CA 90036. (213)937-0765. Fax: (213)937-5974. Associate Director: Kristin Worthe. Estab. 1990.

Exhibits: Requirements: Must be highly professional. Quality and unique point of view also important. No restriction on type, style or subject. Examples of recent exhibitions: Lee Friedlander (b&w 35mm); Karen Hallerson (color landscapes); and Andrea Modica (platinum large format). Presents 7-9 shows/year. Shows last 1-2 months. Sponsors openings. Photographer's presence at opening and availability during show preferred.

Making Contact & Terms: Interested in receiving work from newer, lesser-known photographers, "if they're serious." Charges 50% commission. General price range: $400-4,000. Reviews transparencies. Interested in slides. Requires exclusive representation locally. Submit slides and support material. SASE. Reports in 1-2 weeks.

Tips: "Don't waste people's time by showing work before you're ready to do so."

LA MAMA LA GALLERIA, 6 E. First Street, New York NY 10003. (212)505-2476. Director/Curator: Lawry Smith. Estab. 1982.

Exhibits: Interested in all types of work. Looking for "movement, point of view, dimension." Examples of exhibitions: "Jocks in Frocks," by Charles Justina; "Styles & Aesthetics," group show. Presents 2 shows/year. Shows last 3 weeks. Sponsors openings. Photographer's presence at opening required.

Making Contact & Terms: Very receptive to exhibiting work of newer, lesser-known photographers. Charges 20% commission. General price range: $200-2,000. Prices set by agreement between director/curator and photographer. Reviews transparencies. Interested in framed or unframed, mounted, matted or unmatted work. Requires exclusive representation within metropolitan area. Arrange a personal interview to show portfolio. Send material by mail for consideration. SASE. Reports in 1 month.

Tips: "Be patient; we are continuously booked 18 months-2 years ahead."

LBW GALLERY, Northview Mall, 1724 E. 86th St., Indianapolis IN 46240-2360. (317)848-2787. Director: Linda B. Walsh.

Exhibits: Requirements: Must appeal to clients (homeowners, collectors). Interested in landscapes, flowers, architecture, points and places of interest. Examples of recent exhibitions: "Indiana Scenes," by Robert Cook; and "Indiana Scenery," by Robert Wallis. Presents 10 shows/year. Shows last 1 month. Sponsors openings; provides refreshments, press releases, direct mail. Photographer's presence at opening preferred, but not necessary.

Making Contact & Terms: Interested in receiving work from newer, lesser-known photographers. Charges 50% commission. General price range: $150-250. Reviews transparencies. Interested in framed and matted work only. Works are limited to up to 18 × 24. Query with résumé of credits. Query with samples. SASE. Reports in 1-2 weeks.

Tips: "Be realistic in dealing with subject matter that would be interesting and sell to the public. Also, be realistic as to the price you desire out of your work."

***ELIZABETH LEACH GALLERY**, 207 SW Pine, Portland OR 97204. (503)224-0521. Fax: (503)224-0844. Gallery Director: Miriam Rose.
Exhibits: Requirements: Photographers must meet museum conservation standards. Interested in "high quality and fine craftmanship." Examples of recent exhibitions: Terry Toedtemeier (landscape/gelatin silver prints); Christopher Rauschenberg (landscape/gelatin silver print collage); and Richard Misrach (Extacolor photographs). Presents 1-2 shows/year. Shows last 1 month. Sponsors openings. "The gallery has extended hours every first Thursday of the month for our openings. Beer and wine are available for patrons and artists." Photographer's presence at opening and during show preferred.
Making Contact & Terms: Interested in receiving work from newer, lesser-known photographers. Charges 50% commission. General price range: $300-5,000. Reviews transparencies. Interested in framed or unframed, matted work. Requires exclusive representation locally. Submit slides with resume, artist statement, articles and SASE. Reports every 4 months.

LEHIGH UNIVERSITY ART GALLERIES, 17 Memorial Dr. E., Bethlehem PA 18015. (610)758-3615. Fax: (610)758-4580. Director/Curator: Ricardo Viera.
Exhibits: Interested in all types of works. The photographer should "preferably be an established professional." Presents 5-8 shows/year. Shows last 4-6 weeks. Sponsors openings. Photographer's presence at opening and during the show preferred.
Making Contact & Terms: NPI. Reviews transparencies. Arrange a personal interview to show portfolio. SASE. Reports in 1 month.
Tips: Don't send more than 20 (top) slides.

LEWIS LEHR INC., Box 1008, Gracie Station, New York NY 10028. (212)288-6765. Director: Lewis Lehr. Estab. 1984. Private dealer. Buys vintage photos.
Making Contact & Terms: Charges 50% commission. Buys photography outright. General price range: $500 plus. Reviews transparencies. Interested in mounted or unmounted work. Requires exclusive representation within metropolitan area. Query with résumé of credits. SASE. Member AIPAD.
Tips: Vintage American sells best. Sees trend toward "more color and larger" print sizes. To break in, "knock on doors." Do not send work or slides.

■THE LIGHT FACTORY PHOTOGRAPHIC ARTS CENTER, P.O. Box 32815, Charlotte NC 28232. (704)333-9755. Fax: (704)333-5910. Executive Director: Bruce Lineker. Nonprofit. Estab. 1972.
Exhibits: Requirements: Photographer must have a professional exhibition record for main gallery. Interested in contemporary and documentary photography, any subject matter. Presents 8-10 shows/year. Shows last 1-2 months. Sponsors openings; reception (3 hours) with food and beverages, artist lecture following reception. Photographer's presence at opening preferred.
Making Contact & Terms: Photography sold in the gallery. "Artists price their work." Charges 33% commission. Rarely buys photography outright. General price range: $500-12,000. Reviews transparencies. Write for gallery guidelines. Query with résumé of credits and slides. Artist's statement required. SASE. Reports in 2 months.
Tips: Among various trends in contemporary art, "we are seeing more mixed media using photography, painting, sculpture and videos. We have several galleries to show work by emerging and established photographic artists. We are interested in cohesive bodies of work that reflect a particular viewpoint or idea. The Light Factory is committed to stimulating dialogue and inquiry about contemporary photography, related visual arts and their relationship to social, psychological, historical and political issues."

LIZARDI/HARP GALLERY, 8678 Melrose Ave., Los Angeles CA 90069. (310)358-5840. Fax: (310)358-5683. Director: Grady Harp. Estab. 1981.
Exhibits: Requirements: Must have more than one portfolio of subject, unique slant and professional manner. Interested in figurative, nudes, "maybe" manipulated work, documentary and mood landscapes. Examples of exhibitions: "The Rome Series," by Christopher James (Diana camera documentary/portraits); self portraits, by Robert Stivers (self portraits in staged settings); and "L.A. Gangs," by Della Rossa (documentary on Echo Park). Presents 3-4 shows/year. Shows last 4-6 weeks. Sponsors openings; provides announcements, reception costs. Photographer's presence at opening preferred.
Making Contact & Terms: Interested in receiving work from newer, lesser-known photographers. Charges 50% commission. General price range: $500-4,000. Reviews transparencies. Interested in unframed, unmounted and matted or unmatted work only. Submit portfolio for review. Query with résumé of credits. Query with samples. Send material by mail for consideration. SASE. Reports in 1 month.

M.C. GALLERY, 400 First Ave. N., Minneapolis MN 55401. (612)339-1480. Fax: (612)339-1480. Director: M.C. Anderson. Estab. 1984.
Exhibits: Interested in avant-garde work. Examples of recent exhibitions: works by Gloria Dephilips Brush, Ann Hofkin and Catherine Kemp. Shows last 6 weeks. Sponsors openings; attended by 2,000-3,000 people. Photographer's presence preferred at opening and during show.
Making Contact & Terms: Interested in receiving work from newer, lesser-known photographers. Charges 50% commission. General price range: $300-1,200. Reviews transparencies. Interested in framed or unframed work. Requires exclusive representation within metropolitan area. Submit portfolio for review. Query with résumé of credits. Send material by mail for consideration. Material will be returned, but 2-3 times/year. Reports in 1-2 weeks if strongly interested, or it could be several months.

MAINE COAST ARTISTS, P.O. Box 147, Rockport ME 04856. (207)236-2875. Fax: (207)236-2490. Director: John Chandler. Estab. 1952.
 ● This gallery has received a National Endowment for the Arts grant.
Exhibits: Requirements: Photographer must work part of the year in Maine; work should be recent and not previously exhibited in the area. Examples of recent exhibitions: "Two Generations," by Paul and John Caparigro; "Belfast," by Patricia McLean and Liv Robinson; and "Pothos," by Jonathan Bailey and Tillman Crane. Number of shots varies. Shows last 1 month. Sponsors openings; provides refreshments. Photographer's presence at opening is preferred.
Making Contact & Terms: Interested in receiving work from newer, lesser-known photographers. Charges 40% commission. General price range: $200-2,000. Reviews transparencies. Query with résumé of credits. Query with samples. Send material by mail for consideration. SASE. Reports in 2 months.
Tips: "A photographer can request receipt of application for our annual juried exhibition (May 27-end of June), as well as apply for solo or group exhibitions. MCA is exhibiting more and more photography."

***MARBLE HOUSE GALLERY**, 44 Exchange Place, Salt Lake City UT 84111. (801)532-7332. Fax: (801)532-7338, "call first." Owner: Dolores Kohler. Estab. 1988.
Exhibits: Requirements: Professional presentation, realistic pricing and numerous quality images. Interested in painterly, abstract and landscapes. No documentary or politically-oriented work. No nudes. Examples of recent exhibitions: "Wildlife," by Paul Garvey; "Ducks and Cacti," by Dolores Kohler; and photographic scenes by Mark Smith. Presents 2 shows/year. Shows last 1 month. As a member of the Salt Lake Gallery Association, there are monthly downtown gallery strolls. Also provides public relations, etc.
Making Contact & Terms: Interested in receiving work from newer, lesser-known photographers. Charges 50% commission. Buys photos outright. General price range: $50-1,000. Reviews transparencies. Interested in framed or unframed, mounted or unmounted, matted or unmatted work. Requires exclusive representation within metropolitan area. No size limits. Arrange a personal interview to show a portfolio. Submit portfolio for review. Query with résumé of credits. Query with samples. Send material by mail for consideration. SASE. Reports in 1 month.

MARLBORO GALLERY, Prince George's Community College, 301 Largo Road, Largo MD 20772-2199. (301)322-0967. Gallery Curator: John Krumrein. Estab. 1976.
Exhibits: Not interested in commercial work. "We are looking for fine art photos, we need between 10 to 20 to make assessment, and reviews are done every 6 months. We prefer submissions during February-April." Examples of recent exhibitions: "Blues Face/Blues Places," John Belushi's blues collection photos (various photographers); "Blues Face/Blues Places," the David Spitzer collection of blues; and "Greek Influence," photos of Greece by various photographers. Shows last 3-4 weeks. Sponsors openings. Photographer's presence at opening required.
Making Contact & Terms: Interested in receiving work from newer, lesser-known photographers. General price range: $50-5,000. Reviews transparencies. Interested in framed work only. Query with samples. Send material by mail for consideration. SASE. Reports in 3-4 weeks.
Tips: "Send examples of what you wish to display and explanations if photos do not meet normal standards (i.e., in focus, experimental subject matter)."

MARSH ART GALLERY, University of Richmond, Richmond VA 23173. (804)289-8276. Fax: (804)287-6006. E-mail: waller@urvax.urich.edu. Website: http://www.urich.edu/. Director: Richard Waller. Estab. 1966.
Exhibits: Interested in all subjects. Examples of recent exhibitions: "Van McElwee: Reconstructions, the Video Image Outside of Time"; "Builder Levy: Images of Appalachian Coalfields"; "The Encompassing Eye: Photography as Drawing." Presents 8-10 shows/year. Shows last 1 month. Photographer's presence at opening preferred.
Making Contact & Terms: Charges 10% commission. Reviews transparencies. Interested in framed or unframed, mounted or unmounted, matted or unmatted work. Work must be framed for exhibition.

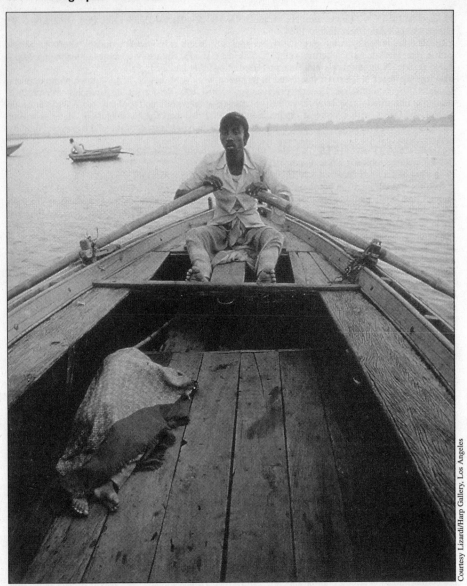

Christopher James's "arresting compositional aspects which open a stage for mysterious story telling," attracted Grady Harp of Lizardi/Harp Gallery to the photographer's work. "He uses his camera to unravel serial novels," says Harp, "capturing strange peoples in their own environs apparently undisturbed by his presence," evident in this photo of an Indian boatman on the Ganges River. The image has sold twice in a 20 × 16 format at $1,200.

Query with résumé of credits. Query with samples. Send material by mail for consideration. Reports in 1 month.
Tips: If possible, submit material which can be left on file and fits standard letter file. "We are a nonprofit university gallery interested in presenting contemporary art."

MORTON J. MAY FOUNDATION GALLERY—MARYVILLE UNIVERSITY, 13550 Conway Rd., St. Louis MO 63141. (314)529-9415. Gallery Director and Art Professor: Nancy N. Rice.
Exhibits: Requirements: Must transcend student work, must have a consistent aesthetic point of view or consistent theme, and must be technically excellent. Examples of recent exhibitions: "Recent Work,"

by Stacey C. Morse (b&w landscapes). Presents 1-3 shows/year. Shows last 1 month. Sponsors openings; provides wine and soda, exhibit announcements and bulk rate mailings. Photographer's presence at opening required.

Making Contact & Terms: Interested in receiving work from newer, lesser-known photographers. Photographer is responsible for all shipping costs to and from gallery. Gallery takes no commission; photographer responsible for collecting fees. General price range: $25-500. Interested in framed or unframed, mounted or unmounted, matted or unmatted work (when exhibited, work must be framed or suitably presented.) Send material by mail for consideration. SASE. Reports in 3-4 months.

ERNESTO MAYANS GALLERIES LTD., 601 Canyon Rd., Santa Fe NM 87501. (505)983-8068. Fax: (505)982-1999. E-mail: arte@eworld.com. Owner: Ernesto Mayans. Associate: Ava Minghu. Estab. 1977.

Exhibits: Examples of exhibitions: "Cholos/East L.A.," by Graciela Iturbide (b&w); "Fresson Images," by Doug Keats (Fresson), "Selected Works," by André Kertész (b&w) and Willis Lee (photogravures); Manuel Alvarez Bravo; and Diane Kaye. Publishes books, catalogs and portfolios.

Making Contact & Terms: Charges 50% commission. Buys photos outright. General price range: $200-5,000. Reviews transparencies. Interested in framed or unframed, mounted or unmounted work. Requires exclusive representation within area. Size limited to 11×20 maximum. Arrange a personal interview to show portfolio. Send material by mail for consideration. SASE. Reports in 1-2 weeks.

Tips: "Please call before submitting."

R. MICHELSON GALLERIES, 132 Main St., Northampton MA 01060. (413)586-3964. Owner and President: Richard Michelson. Estab. 1976.

Exhibits: Interested in contemporary, landscape and/or figure, generally realistic work. Examples of exhibitions: Works by Michael Jacobson-Hardy (landscape), Jim Wallace (landscape), and Robin Logan (still life/floral). Presents 1 show/year. Show lasts 6 weeks. Sponsors openings. Photographer's presence at opening required, presence during show preferred.

Making Contact & Terms: Sometimes buys photos outright. General price range: $100-1,000. Reviews transparencies. Interested in framed or unframed, mounted or unmounted, matted or unmatted work. Requires exclusive representation locally. Send material by mail for consideration. SASE. Reports in 1-2 weeks.

PETER MILLER GALLERY, 740 N. Franklin, Chicago IL 60610. (312)951-0252. Fax: (312)951-2628. Director: Peter Miller. Estab. 1979.

Exhibits: "We have not exhibited photography but we are interested in adding photography to the work currently exhibited here." Sponsors openings.

Making Contact & Terms: Interested in receiving work from newer, lesser-known photographers. Charges 50% commission. Reviews transparencies. Interested in framed or unframed, mounted or unmounted, matted or unmatted work. Requires exclusive representation locally. Send 20 slides of the most recent work with SASE. Reports in 1-2 weeks.

MINOT ART GALLERY, P.O. Box 325, Minot ND 58701. (701)838-4445. Executive Director: Jeanne Rodgers. Estab. 1970.

Exhibits: Example of exhibitions: "Wayne Jansen: Photographs," by Wayne Jansen (buildings and landscapes). Presents 3 shows/year. Shows last about 1 month. Sponsors openings.

Making Contact & Terms: Very receptive to work of newer, lesser-known photographers. Charges 30% commission. General price range: $25-150. Submit portfolio or at least 6 examples of work for review. Prefers transparencies. SASE. Reports in 1 month.

Tips: "Wildlife, landscapes and floral pieces seem to be the trend in North Dakota. The new director likes the human figure and looks for high quality in photos. We get many slides to review for our three photography shows a year. Do something unusual, creative, artistic. Do not send postcard photos."

***MOBILE MUSEUM OF ART**, (formerly Fine Arts Museum of the South), P.O. Box 8426, Mobile AL 36689 or 4850 Museum Dr., Mobile AL 36608. (334)343-2667. Fax: (334)343-2680. Executive Director: Joe Schenk. Estab. 1964.

● The Mobile Museum of Art was the Silver winner of the 1995 SEMC publication design competition for "Alabama Impact: Contemporary Artists with Alabama Ties" with the Huntsville Museum of Art.

Exhibits: Open to all types and styles. Examples of recent exhibits: "Generations in Black and White: Photography by Carl Van Vechten from the James Weldon Johnson Memorial Collection"; and "Medicine's Great Journey: 100 Years of Healing." Presents 1-2 shows/year. Shows last about 6 weeks. Sponsors openings; provides light hors d'oeuvres and wine. Photographer's presence at opening is preferred.

Making Contact & Terms: Photography sold in gallery. Charges 20% commission. Occasionally buys photos outright. Reviews transparencies. Interested in framed work only. Arrange a personal

interview to show portfolio; send material by mail for consideration. Returns material when SAE is provided "unless photographer specifically points out that it's not required."
Tips: "We look for personal point of view beyond technical mystery."

MONTPELIER CULTURAL ARTS CENTER, 12826 Laurel-Bowie Rd., Laurel MD 20708. (301)953-1993. Director: Richard Zandler. Estab. 1979.
Exhibits: Open to all photography. Examples of exhibitions: "Photographs by Jason Horowitz" (panoramic b&w); "In The Shadow of Crough Patrick," photos by Joan Rough (color landscapes of Ireland); photos by Robert Houston (b&ws of urban life); "Images in Time," by Andrea Davidhazy. Shows last 1-2 months. Sponsors openings. "We take care of everything." Photographer's presence at opening preferred.
Making Contact & Terms: Interested in receiving work from newer, lesser-known photographers. "We do not sell much." Charges 25% commission. Reviews transparencies. Interested in framed work only. "Send 20 slides, résumé and exhibit proposal for consideration. Include SASE for return of slides. Work must be framed and ready for hanging if accepted." Reports "after scheduled committee meeting; depends on time of year."

***MORGAN GALLERY**, 412 Delaware, Suite A, Kansas City MO 64105. (816)842-8755. Fax: (816)842-3376. Director: Dennis Morgan. Estab. 1969.
Exhibits: Examples of recent exhibitions: photos by Holly Roberts; Dick Arentz (platinum); and Linda Conner (b&w). Presents 1-2 shows/year. Shows last 4-6 weeks. Sponsors openings.
Making Contact & Terms: Interested in receiving work from newer, lesser-known photographers. Charges 50% commission. General price range: $250-5,000. Reviews transparencies. Submit portfolio for review. Send material by mail for consideration. SASE. Reports in 3 months.

***MORRIS-HEALY GALLERY**, 530 W. 22nd St., New York NY 10011. (212)243-3753. Fax: (212)243-3668. Gallery Assistant: Stephanie Maley. Estab. 1995.
Exhibits: "The photographers hopefully will have shown at some other galleries and have work that fits the conceptual ideology of our gallery. We are open to many different types and styles, however, the work must be provocative and strong technically." Example of recent exhibitions: Esco Männikkö (representational). Presents 1-2 shows/year. Shows last 1 month. Sponsors openings; depending on situation, generally provides installation costs, shipping, reception and marketing. Photographer's presence at opening required; presence during show preferred.
Making Contact & Terms: Interested in receiving work from newer, lesser-known photographers. Commission depends on individual situation. General price range: $1,000-2,000. Reviews transparencies if requested. Interested in framed or unframed work. Requires exclusive representation locally. Arrange a personal interview to show portfolio. SASE.
Tips: "Get a contact person in the gallery, develop a relationship with that person and then invite him/her to your studio."

MTSU PHOTOGRAPHIC GALLERY, P.O. Box 305, Murfreesboro TN 37132. (615)898-2085. Fax: (615)898-5682. Curator: Tom Jimison. Estab. 1971.
Exhibits: Interested in all styles and genres, including landscapes, Americana, documentary and figurative work. Presents 6 shows/year. Shows last 5 weeks.
Making Contact & Terms: Interested in receiving work also from newer, lesser-known photographers. General price range: $300-2,000. Interested in framed work in any size and matted work in standard sizes (11×14, 14×17, 16×20, 20×24). Query with résumé of credits. Call or write for portfolio review. Reports in 4-6 weeks.

MUSEUM OF PHOTOGRAPHIC ARTS, 1649 El Prado, Balboa Park, San Diego CA 92101. (619)238-7559. Fax: (619)238-8777. Executive Director: Arthur Ollman. Curator: Diana Gaston. Estab. 1983.
Exhibits: "The criteria is simply that the photography be the finest and most interesting in the world, relative to other fine art activity. MoPA is a museum and therefore does not sell works in exhibitions. There are no fees involved." Examples of recent exhibitions featuring contemporary photographers from the U.S. and abroad include: "Informed by Film," "A Shadow Born of Earth: New Photography in Mexico," "Photography and Beyond: New Expressions in France" and "Points of Entry: Tracing Cultures." Presents 6-8 exhibitions annually from 19th century to contemporary. Each exhibition lasts approximately 2 months. Exhibition schedules planned 2-3 years in advance. Holds a private Members' Opening Reception for each exhibition.
Making Contact & Terms: "For space, time and curatorial reasons, there are few opportunities to present the work of newer, lesser-known photographers." Send résumé of credits with a portfolio (unframed photographs) or slides. Portfolios may be submitted for review with advance notification. Files are kept on contemporary artists for future reference. Send return address and postage. Reports in 2 months.

Tips: "Exhibitions presented by the museum represent the full range of artistic and journalistic photographic works." There are no specific requirements."The executive director and curator make all decisions on works that will be included in exhibitions. There is an enormous stylistic diversity in the photographic arts. The Museum does not place an emphasis on one style or technique over another."

MUSEUM OF THE PLAINS INDIAN & CRAFTS CENTER, Junction of Highways 2 and 89, Browning MT 59417. (406)338-2230. Fax: (406)338-7404. Curator: Loretta Pepion. Estab. 1941.
Exhibits: Requirements: Must be a Native American of any tribe within the 50 states, proof required. Shows last 6 weeks. Sponsors openings. Provides refreshments and a weekend opening plus a brochure.
Making Contact & Terms: Interested in receiving work from newer, lesser-known photographers. Charges 25% commission. Reviews transparencies. Interested in framed and matted work. Query with samples. Send material by mail for consideration.

NEW ORLEANS MUSEUM OF ART, Box 19123, City Park, New Orleans LA 70179. (504)488-2631. Fax: (504)484-6662. Curator of Photography: Steven Maklansky. Collection estab. 1973.
Exhibits: Requirements: "Send thought-out images with originality and expertise. Do not send commercial looking images." Interested in all types of photography. Examples of exhibitions: "Double Exposure," "Photoglyphs," and "Asserting Equality" (all photos by various photographers). Presents shows continuously. Shows last 1-3 months.
Making Contact & Terms: Buys photography outright; NPI. Present budget for purchasing contemporary photography is very small. Sometimes accepts donations from established artists, collectors or dealers. Query with color photocopies (preferred) or slides and résumé of credits. SASE. Reports in 1-3 months.

NICOLAYSEN ART MUSEUM & DISCOVERY CENTER, 400 E. Collins, Casper WY 82601. (307)235-5247. Fax: (307)235-0923. Director: Karen R. Mobley. Estab. 1967.
Exhibits: Requirements: Artistic excellence and work must be appropriate to gallery's schedule. Interested in all subjects and media. Examples of exhibitions: works by Gerry Spence (b&w); Devendra Shirkehande (color); and Susan Moldenhauer (color). Presents 2 shows/year. Shows last 2 months. Sponsors openings. Photographer's presence at opening and during show is preferred.
Making Contact & Terms: Interested in receiving work from newer, lesser-known photographers. Charges 40% commission. General price range: $250-1,500. Reviews transparencies. Interested in framed or unframed work. Send material by mail for consideration (slides, vita, proposal). SASE. Reports in 1 month.
Tips: "We have a large children/youth audience and gear some of what we do to them."

THE NOYES MUSEUM, Lily Lake Rd., Oceanville NJ 08231. (609)652-8848. Fax: (609)652-6166. Curator: Stacy Smith. Estab. 1983.
Exhibits: Works must be ready for hanging, framed preferable. Interested in all styles. Examples of recent exhibitions: "Wind, Water and Sand," by Henry Troup (gelatin silver prints); "Fields of Vision," by Leonard Balish (color); "Atlantic City," by William Suttle (hand colored). Presents 2-3 shows/year. Shows last 6-12 weeks. Sponsors openings; provides invitation, public relations, light refreshments. Photographer's presence at opening preferred.
Making Contact & Terms: Interested in receiving work from newer, lesser-known photographers. Charges 10% commission. Infrequently buys photos for permanent collection. General price range: $150-1,000. Reviews transparencies. Any format OK for initial review. Send material by mail for consideration, include résumé and slide samples. Reports in 1 month.
Tips: "Send challenging, cohesive body of work. May include photography and mixed media."

O.K. HARRIS WORKS OF ART, 383 W. Broadway, New York NY 10012. (212)431-3600. Director: Ivan C. Karp. Estab. 1969.
● This gallery is closed from mid-July to after Labor Day.
Exhibits: Requirements: "The images should be startling or profoundly evocative. No rock, dunes, weeds or nudes reclining on any of the above or seascapes." Interested in urban and industrial subjects and cogent photojournalism. Examples of exhibitions: "Vernacular Church Architecture of the South," by Dennis O'Kain; "Second Story Windows," by A. Roy Greer; and "Neighbors, 1974-1990," by Noel Jones-Sylvester. Presents 5-8 shows/year. Shows last 3 weeks.

LISTINGS THAT USE IMAGES electronically can be found in the Digital Markets Index located at the back of this book.

Making Contact & Terms: Charges 40% commission. General price range: $350-1,200. Interested in matted or unmatted work. Appear in person, no appointment: Tuesday-Friday 10-6. SASE. Reports back immediately.
Tips: "Do not provide a descriptive text."

OLIN FINE ARTS GALLERY, Washington & Jefferson College, Washington PA 15301. (412)222-4400. Contact: Paul Edwards. Estab. 1982.
Exhibits: Requirements: Photographer must be at least 18 years old, American citizen and artists assume most show costs. Interested in large format, experimental, traditional photos. Examples of previous exhibitions: one-person show by William Wellman; "The Eighties," by Mark Perrott. Presents 1 show/year. Shows last 3 weeks. Sponsors openings; pays for non-alcoholic reception if artist attends. Photographer's presence at opening preferred.
Making Contact & Terms: Charges 20% commission. General price range: $50-1,500. Reviews transparencies. Interested in framed work only. Shows are limited to works that are no bigger than 6 feet and not for publication. Send material by mail for consideration. SASE. Reports in 1 month.

OLIVER ART CENTER-CALIFORNIA COLLEGE OF ARTS & CRAFTS, 5212 Broadway, Oakland CA 94618. (510)597-3605. Fax: (510)547-8612. Director-Exhibitions/Public Programming: Dyana Curreri. Estab. 1989.
Exhibits: Requirements: must be professional photographer with at least a 2-year exhibition record. Interested in contemporary photography in all formats and genres. Examples of recent exhibitions: "Landscape: A Concept," by Andy Goldsworthy, Vito Accenci, Catherine Wagner, Judy Fiskin and others; "Cultural Identities and Immigration-Changing Images of America in the 90's," by Larry Sultain, Young Kim, Su-Chen Hung and others; and MFA graduate exhibition. Presents 1-2 exhibits/year. Shows last 6-8 weeks. Photographer's presence at opening and at show preferred.
Making Contact & Terms: Interested in receiving work from newer, lesser-known photographers. "All subjects and styles are accepted for our slide registry." NPI. Reviews transparencies. Query with résumé of credits. SASE. Reports in 1 month.
Tips: "Know the types of exhibitions we have presented and the audience which we serve."

***ONLINEGALLERY**, Internet Marketing Corporation, P.O. Box 280, Chalfont PA 18914-0280. (215)997-1234. Fax: (215)997-1991. Website: http://www.OnLineGallery.com. President: R.C. Horsch. Estab. 1996. Gallery that "exists only electronically on the Internet." Requirements: "The work must be artistically defensible and of the highest quality, must be available in a limited, signed edition, and, if possible, should have been previously exhibited or published by a gallery or museum." Needs all types and styles, including erotic.
Exhibits: "We are similar to traditional galleries in that we 'mount' cohesive one-man shows of artists' work. However, we differ considerably in that we exist only on the Internet. This confers some advantages by providing an unlimited amount of exhibition space and allowing our artists' shows to remain permanently mounted. Also, we breach the regional barriers of physical galleries by reaching a potential audience of 60 milliion in over 150 countries worldwide. We have two special gallery sections: FineArtPhoto and CommercialPhoto. Photographers can utilize either or both depending on the nature of their work. Each artist has an individual 'exhibition space' in the form of a dedicated OnLineGallery Webpage. Within that space, art is grouped and presented as a body of work by the individual artist along with biographical information, promotional material, reviews and other pertinent data."
Making Contact & Terms: "Contact us in any way you choose for information. Include your address and phone number, or the address and phone number of your gallery or representative. Your 'exhibition space' will contain an e-mail form that people browsing your work can use to leave comments, messages and to contact you electronically. Every image will contain your name and copyright information in both visible and encoded form and cannot legally be sold or distributed without violating Federal copyright law." Charges for a basic listing with 6 images: $75/month for a 1-year contract; $50/month for a 2-year contract; $40/month prepaid for a 24 month contract. Additional images: $6 each/month for a 1-year contract; $4 each/month for a 2-year contract; $5 and $3.20 each/month for prepaid 1- and 2-year contracts.
Tips: "We have taken over the traditional 'Rated X' photography show that has been an industry tradition hosted by Marjorie Neikrug of Neikrug Photographica, Ltd. in her New York gallery for the past 20 years. This show will continue with us and open this summer as a permanently mounted exhibition of the world's finest erotic photography. Interested photographers may purchase exhibition

space in this exhibition under the same terms as other OnLineGallery areas,"

❧OPEN SPACE ARTS SOCIETY, 510 Fort St., Victoria, British Columbia V8W 1E6 Canada. (604)383-8833. E-mail: openare@islandenet.com. Director: Sue Donaldson. Estab. 1972.
Exhibits: Interested in photographs as fine art in an experimental context, as well as interdisciplinary works involving the photograph. No traditional documentary, scenics, sunsets or the like. Examples of recent exhibitions: "Inter View," by Cheryl Paguerek (3-D installation with projections and large-scale color photo manipulations); "Search Image and Identity," by 10 Prairie photographers (2-D and 3-D photo-based work); and "Bounce: A Dutch/Canadian Artists Exchange," by six Rotterdam artists (photo and mixed media). Presents 5 shows/year. Shows last 3-4 weeks. Sponsors openings.
Making Contact & Terms: Interested in receiving work from newer, lesser-known photographers. General price range: $100-1,000. Pays the C.A.R.F.A.C. fees; no commission. SASE. Reports once a year after annual call for submissions in fall.
Tips: "Submit 10-20 slides and artist statement of what the work is about or how you feel about it. Send for information about Open Space to give you an idea of how large the space is." Sees trend in multimedia installation work where photography is used as part of a larger artwork.

ORGANIZATION OF INDEPENDENT ARTISTS, 19 Hudson St., #402, New York NY 10013. (212)219-9213. Fax: (212)219-9216. Website: http://www.arts-online.com/oia.htm. Estab. 1976.
● OIA is a non-profit organization that helps sponsor group exhibitions at the OIA office and in public spaces throughout New York City.
Exhibits: Presents 2 shows/year. Shows last 1 month. Photographer's presence at opening preferred.
Making Contact & Terms: Interested in receiving work from newer, lesser-known photographers. NPI. Submit slides with proposal. Send material by mail for consideration according to guidelines only. Write for information on membership. SASE. "We review 3 times/year."
Tips: "It is not required to be a member to submit a proposal, but interested photographers may want to become OIA members to be included in OIA's active slide file that is used regularly by curators and artists. You must be a member to have your slides in the registry to be considered for exhibits 'Selections from the Slide File' at the OIA office."

ORLANDO GALLERY, Dept. PM, 14553 Ventura Blvd., Sherman Oaks CA 91403. (818)789-6012. Directors: Robert Gino, Don Grant. Estab. 1958.
Exhibits: Interested in photography demonstrating "inventiveness" on any subject. Examples of recent exhibitions: landscapes by Steve Wallace; personal images by Fred Skupenski; platinum prints by Joseph Orsillo; and landscapes and nudes by Kevin Lynch and Chris Voelken. Shows last 1 month. Sponsors openings. Photographer's presence at opening and during show is preferred.
Making Contact & Terms: Very receptive to work of newer photographers. Charges 50% commission. Price range: $600-3,000. Query with résumé of credits. Send material by mail for consideration. SASE. Framed work only. Reports in 1 month. Requires exclusive representation in area.
Tips: Make a good presentation. "Make sure that personality is reflected in images. We're not interested in what sells the best—just good photos."

PACE/MACGILL GALLERY, Dept. PM, 32 E. 57th St., 9th Floor, New York NY 10022. (212)759-7999. Contact: Assistant to the Director. Estab. 1983.
● This gallery has a second location in Los Angeles, Pace/Wildenstein/MacGill.
Exhibits: "We like to show original work that changes the direction of the medium." Presents 18 shows/year. Shows last 3-5 weeks. Sponsors openings. Photographer's presence at opening preferred.
Making Contact & Terms: Photography sold in gallery. Commission varies. On occasion, buys photos outright. General price range: $1,000-300,000. Reviews transparencies with a letter of recommendation from an established, reputable third party. Requires exclusive representation. No size limits. Please include SASE. Reports in 3 weeks.
Tips: "Review our exhibitions and ask, 'Does my work make a similar contribution to photography?' If so, seek third party to recommend your work."

PALO ALTO CULTURAL CENTER, 1313 Newell Rd., Palo Alto CA 94303. (415)329-2366. Contact: Exhibitions Dept. Estab. 1971.
Exhibits: "Exhibit needs vary according to curatorial context." Seeks "imagery unique to individual artist. No standard policy. Photography may be integrated in group exhibits." Shows last 1-3 months. Sponsors openings. Photographer's presence at opening preferred.
Making Contact & Terms: Reviews transparencies. Interested in framed work only. Send material by mail for consideration; include transparencies, slides, bio and artistic statement. SASE.

THE PEORIA ART GUILD, 1831 N. Knoxville Ave., Peoria IL 61603. (309)685-7522. Fax: (309)685-7446. Director: Tyson Joye. Estab. 1969.
● The Guild has a successful first annual Digital Photo Competition. Write for details.

INSIDER REPORT

Focus on Creativity in the Fine Art Market

As gallery professional Peter MacGill knows from personal experience, there's a lot of hard work behind the glamour of fine art photography.

Known best for his work with the recently-merged Pace/Wildenstein/MacGill Galleries in New York City and Los Angeles, this 20-plus-year veteran of the photo gallery world, says he once aspired to be a fine art photographer. However, while in graduate school in Tucson, Arizona, and working in the Center for Creative Photography, he soberly realized that he was better suited to marketing photography than creating it.

"In two years of graduate school, I made one especially good picture. But it took a lot of trial and error to get that great one," says MacGill. "At the same time, I was handling the work of Harry Callahan and Paul Strand at the Center, and they [appeared to be] able to make great pictures whenever they felt like it. So I began to see there was a major difference between their work and what I was doing, and I stopped kidding myself."

© Joel Sternfeld

Peter MacGill

The field requires photographers to be ruthlessly objective in their self-evaluations—just as MacGill was 23 years ago. As he explains, success in fine art photography demands a high level of talent and originality. In fact, those are the chief criteria that gallery owners and photo buyers look for in photographers.

"Whether you're an artist or a viewer, what you're always left with is the image itself," says MacGill. "An image has to be an original work of art, one that somehow changes the way the viewer thinks about the world. If the image has that kind of impact, then I think it's successful, exciting, and interesting. And so will buyers."

Offering a few examples of photographers who have consistently produced stunning work, MacGill names acclaimed contemporary photographers Edward Weston, the brothers Doug and Mike Starns, and Kiki Smith, who is represented by PWM's Los Angeles location. MacGill adds that aspiring photographers in the process of defining their own visions should observe the work of such accomplished photographers.

"There are very few people who make a major contribution that should be on the walls of galleries and museums," MacGill says. "Yet there are lots of people who try. I don't think they should stop trying, but I don't believe photographers should persist in thinking they deserve a show when their work isn't ready."

INSIDER REPORT, *MacGill*

Working with a mentor can aid in defining one's personal vision, says MacGill. A mentor can not only offer objective feedback about a photographer's work, but also provide encouragement and advice in breaking into the gallery market. The mentor can be an instructor, a more experienced photographer, or, if possible, someone in the gallery field.

MacGill says having a mentor in the gallery field can be especially advantageous because that person can coach the photographer on gallery business practices, become an exhibitor of the photographer's work, and even help to introduce him or her to others in the gallery network.

"Photographers should use galleries to do the work for them," MacGill explains. While a gallery does the work of marketing a photographer's images, including coordinating off-site exhibitions and corporate placement, the photographer is free to concentrate on his or her craft. "As an artist, the photographer should be busy creating, not dealing with museums, corporations, or the public."

Whether a photographer decides to work with a mentor, he still must monitor his creative progress and decide on the right time to exhibit work, says MacGill. He adds that this is usually after a photographer has produced a sizable body of work and can clearly see that it makes an original, personal statement.

"When you show good work, gallery owners will be excited by it and want to show it," says MacGill. "Photographers shouldn't have to do the 'hustle' or 'two-step' to get their work into a gallery or museum. They should just keep working, and when they produce fresh, exciting work, gallery owners will want to show it."

—*Sam A. Marshall*

Peter MacGill believes that aspiring photographers should scrutinize the work of top professionals, such as Edward Weston, Doug and Mike Starns, and Kiki Smith. Viewing outstanding photos, such as this untitled piece by Smith, can teach young photographers the importance of creating images with impact.

© 1995 Kiki Smith. Courtesy Pace/Wildenstein/MacGill, New York.

Exhibits: Requirements: submit slides, résumé and artist's statement. Examples of recent exhibitions: "Digital Photography '96"; a Fine Art Fair and a Fine Art Show & Sale with photography included. Presents 1-2 shows/year. Shows last 1 month. Sponsors openings; provides food and drink, occasionally live music. Photographer's presence at opening preferred.

Making Contact & Terms: Interested in receiving work from newer, lesser-known photographers. Charges 40% commission. General price range: $75-500. Reviews transparencies. Interested in framed or unframed work. Submit portfolio for review. Query with résumé of credits. Send material by mail for consideration. SASE. Reports in 1 month.

***PHILLIPS GALLERY**, 444 E. 200 S., Salt Lake City UT 84111. (801)364-8284. Fax: (801)364-8293. E-mail: phillips@thoughtport.com. Director/Curator: Meri Ploety. Estab. 1965.

Exhibits: Requirements: Must be actively pursuing photography. Interested in all types and styles. Examples of recent exhibitions: "A Western View," by John Telford (color photography); "What I did on My Summer Vacation," by Ruth Gier (b&w photography); and "What I did on My Summer Vacation," by Laurel Casjens (b&w and color photography). Shows last 4-6 weeks. Sponsors openings; provides advertisement, half of mailing costs and refreshments. Photographer's presence at opening and during show preferred.

Making Contact & Terms: Interested in receiving work from newer, lesser-known photographers. Charges 50% commission. General price range: $300-700. Reviews transparencies. Interested in framed or unframed, matted or unmatted work. Requires exclusive representation locally. Submit portfolio for review. SASE. Reports in 1-2 weeks.

THE PHOTO LOUNGE, Truckee Meadows Community College, 7000 Danoini Blvd, Reno NV 89512. (702)673-7084. Director: Professor Erik Lauritzen. Estab. 1993.

Exhibits: Requirements: Send 15 slides of recent work, résumé, artist's statement and SASE for return of slides. Annual deadline April 1. Examples of recent exhibitions: "Watershed Investigations," by Mark Abrahamson; "Siberia," by George Vago (b&w photographs); and "The Face of God," by Hal Honigsberg (mixed media photos). Presents 8-9 shows/year. Shows last 1 month. Sponsors openings; provides full color announcement and catered reception—wine, cheese, breads, fruit, etc. Photographer's presence at opening preferred.

Making Contact & Terms: Interested in receiving work from newer, lesser-known photographers. Charges 20% commission. General price range: $150-1,500. Reviews transparencies. Interested in matted work only. Works are limited to 30×40 maximum. Send material by mail for consideration. SASE. Reports in 2-4 months.

Tips: Slides submitted should be sharp, in focus, color correct and show entire image. "Ours is a nonprofit educational space. Students and community rarely purchase work, but appreciate images shown. In Reno, exposure to art is valuable as the community is somewhat removed from the artworld."

PHOTOGRAPHIC IMAGE GALLERY, 240 SW First St., Portland OR 97204. (503)224-3543. Fax: (503)224-3607. Director: Guy Swanson. Estab. 1984.

Exhibits: Interested in primarily mid-career to contemporary Master-Traditional Landscape in color and b&w. Examples of recent exhibitions: "Erotica," by Charles Gatewood; "Group," by Rowell, Neil, Ketchum (landscapes); "Nudes," by Jenny Velsmann. Presents 12 shows/year. Shows last 1 month. Sponsors openings. Photographer's presence at opening preferred.

Making Contact & Terms: Charges 50% commission. General price range: $300-1,500. Reviews transparencies. Requires exclusive representation within metropolitan area. Query with résumé of credits. SASE. Reports in 1 month.

Tips: Current opportunities through this gallery are fair. Sees trend toward "more specializing in imagery rather than trying to cover all areas."

■PHOTOGRAPHIC RESOURCE CENTER, 602 Commonwealth Ave., Boston MA 02215. (617)353-0700. Fax: (617)353-1662. Curator: Robert E. Seydel. "The PRC is a nonprofit gallery."

Exhibits: Interested in contemporary and historical photography and mixed-media work incorporating photography. "The photographer must meet our high quality requirements." Examples of previous exhibitions: "The Silence of the Passing Time," by Vistan (Wieslaw Brzoska); "Message Carriers," (Contemporary Native American); "Camera As Weapon: Worker Photography Between the Wars." Presents 5-6 group thematic exhibitions in the David and Sandra Bakalar Gallery and 5-6 one- and two-person shows in the Natalie G. Klebenov Gallery/year. Shows last 6-8 weeks. Sponsors openings; provides receptions with refreshments for the Bakalar Gallery shows.

Making Contact & Terms: Interested in receiving work from newer, lesser-known photographers. Will review transparencies. Interested in matted or unmatted work. Query with samples or send material by mail for consideration. SASE. Reports in 2-3 months "depending upon frequency of programming committee meetings. We are continuing to consider new work, but because the PRC's exhibitions are currently scheduled into 1997, we are not offering exhibition dates."

***PRAKAPAS GALLERY**, 1 Northgate 6B, Bronxville NY 10078. (914)961-5091. Fax: (914)961-5192. Director: Eugene J. Prakapas.
Making Contact & Terms: Commission "depends on the particular situation." General price range: $500-100,000.
Tips: "We are concentrating primarily on vintage work, especially from between the World Wars, but some as late as the 70s. We are not currently doing exhibitions."

QUEENS COLLEGE ART CENTER, Benjamin S. Rosenthal Library, Queens College, Flushing NY 11367-6701. (718)997-3770. Fax: (718)997-3753. E-mail: adlqc@cunyvm.cuny.edu. Website: http://www.qc.edu/library/aexhibit.htm. Director: Suzanna Simor. Curator: Alexandra de Luise. Estab. 1952.
Exhibits: Requirements: Open to all types, styles, subject matter; decisive factor is quality. Photographer must be ready to deliver all the work in ready-to-be-exhibited condition and is responsible for installation, removal, transportation. Examples of recent exhibitions: "Meliton Rodriguez (1875-1942): Photographs of Medellin Colombia"; "Tony Velez: Photographs"; and "Lenore Seroka: Imag-in-ations" (computer graphics). Shows last 1 month. Sponsors openings. Photographer is responsible for providing/arranging, refreshments and cleanup. Photographer's presence at opening required, presence during show preferred.
Making Contact & Terms: Charges 40% commission. General price range: $100-500. Interested in framed or unframed, mounted or unmounted, matted or unmatted work. Arrange a personal interview to show portfolio. Query with résumé of credits. Query with samples. Send material by mail for consideration. Submit portfolio for review. SASE. Reports in 2-4 weeks.

RANDOLPH STREET GALLERY, 756 N. Milwaukee Ave., Chicago IL 60622. (312)666-7737. Fax: (312)666-8966. E-mail: randolph@merle.acns.nwu.edu. Website: fileroom.aaup.vic.edu/RSG/rsg home.html. Exhibitions Director: Paul Brenner. Estab. 1979.
Exhibits: Exhibits work in all media, mostly in group exhibitions dealing with a specific topic, theme, social issue or aesthetic concept. Examples of exhibitions: "Telling. . . Stories," group show (photographic autobiography); "Lousy Fear," Andrew Bush, Harlen Wallach, et al. (marketing of fear); and "Minefield of Memory," Rosy Martin (lesbian identity). Presents 7 shows/year. Shows last 5 weeks. Sponsors openings; provides publicity brochure for exhibition. Photographer's presence at opening preferred.
Making Contact & Terms: NPI. Reviews slides. Interested in framed or unframed, mounted or unmounted, matted or unmatted work. Send material by mail for consideration. SASE. Reports in 1-4 months, depending on when the slides are received.
Tips: "We review quarterly and view slides only. We are a nonprofit arts center, therefore we do not represent artists, but can facilitate sales through the artist's gallery or directly through artist."

RED MOUNTAIN GALLERY, Truckee Meadows Community College, 7000 Dandini Blvd., Reno NV 89512. (702)673-7084. Fax: (702)673-7221. E-mail: eml@scs.unr.edu. Gallery Director: Erik Lauritzen. Estab. 1990.
Exhibits: Interested in all styles, subject matter, techniques—less traditional, more innovative and/or cutting edge. Examples of recent exhibits: "Tents," by Wendy Erickson (16×20 Cibachrome prints); "Other Spaces—Chaos to Zen," by Misako Akimoto; "Watershed Investigations," by Mark Abrahamson; and "Mackaig's Kafe Klatche," by Janet Mackaig (photo laser transfers/acrylic or canvas). Number of photography exhibits presented each year depends on jury. Shows last 1 month. Sponsors openings; catered through school food service. Photographer's presence at opening is preferred, but not mandatory.
Making Contact & Terms: Interested in reviewing work from known photographers. Possible honorarium. Charges 20% commission; artist sets price. General price range: $100-4,000. Reviews transparencies. Interested in exhibiting matted work only. Send 15 slides, résumé and SASE for consideration (35mm glassless dupes). Work is reviewed once a year; deadline is April 1st.
Tips: "Slides submitted should be sharp, accurate color and clearly labeled with name, title, dimensions, medium—the clearer the vitae the better. Statements optional." Sees trend toward mixed media concerns and explorations."

ANNE REED GALLERY, P.O. Box 597, 620 Sun Valley Rd., Ketchum ID 83340. (208)726-3036. Fax: (208)726-9630. Director: Jennifer Gately. Estab. 1980.
Exhibits: Requirements: Work must be of exceptional quality. Interested in platinum, palladium prints, landscapes, still lifes and regional material (West). Examples of recent exhibitions: "An Unerring Eye," by Kenro Izu (still life, floral) and Bruce Barnbaum (b&w, silver image). Presents 1-2 shows/year. Shows last 1 month. Sponsors openings; provides installation of exhibition, public relations and opening reception. Photographer's presence at opening preferred.
Making Contact & Terms: Interested in receiving work from newer, lesser-known photographers. Charges 50% commission. General price range: $400-4,000. Reviews transparencies. Interested in

framed or unframed, mounted or unmounted, matted or unmatted work. Requires exclusive representation locally. Submit portfolio for review. Query with résumé of credits. Query with samples. Send material by mail for consideration. "It helps to have previous exhibition experience." SASE. Reports in 1-3 weeks.

Tips: "We're interested only in fine art photography. Work should be sensitive, social issues are difficult to sell. We want work of substance, quality in execution and uniqueness. Exhibitions are planned one year in advance. Photography is still a difficult medium to sell, however there is always a market for exceptional work!"

REFLECTIONS OF COLOR GALLERY, 18951 Livernois, Detroit MI 48221. (313)342-7595. Director: Marla Wellborn. Estab. 1988.
Exhibits: Requirements: Must be a minority (African-American, Hispanic, Native American). Interested in images expressing lifestyles, living environments; images expressing or capturing individual strengths. (Not interested in depressing subjects). Art exhibits last 30 days. Sponsors openings; provides promotion of event. Photographer's presence at opening preferred.
Making Contact & Terms: Interested in receiving work from newer, lesser-known photographers. Charges 50% commission. Buys photos outright. General price range: $50-300. Reviews transparencies. Interested in framed or unframed, matted work only. Works are limited to 30×36 maximum. Query with samples. SASE. Reports in 3 weeks.
Tips: Images should be creative and interesting, not commercial. "Galleries are realizing that photography is a true art form to be explored as customers demand more unique and fresh expressions of life!"

ROBINSON GALLERIES, 2800 Kipling, Houston TX 77098. (713)521-2215. Fax: (713)526-0763. Director: Thomas V. Robinson. Estab. 1969.
• Robinson Galleries, through Art Travel Studies, has developed various travel programs whereby individual photographers provide their leadership and expertise to travel groups of other photographers, artists, museum personnel, collectors, ecologists and travelers in general. Ecuador and Mexico are the featured countries, however, the services are not limited to any one destination. Artists/photographers are requested to submit biographies and proposals for projects that would be of interest to them, and possibly to others that would pay the expenses and an honorarium to the photographer leader.
Exhibits: Requirements: Archivally framed and ready for presentation. Limited editions only. Work must be professional. Not interested in pure abstractions. Examples of recent exhibitions: works by Pablo Corral (Cibachrome); Ron English (b&w and hand-colored silver gelatin prints); and Blair Pittman (audiovisual with 35mm slides in addition to Cibachrome and b&w framed photographs). Presents 1 show every other year. (Photographs included in all media exhibitions one or two times per year.) Shows last 4-6 weeks. Sponsors openings; provides invitations, reception and traditional promotion.
Making Contact & Terms: Charges 50% commission. General price range $100-400. Reviews transparencies. Interested in framed or unframed, matted or unmatted work. Requires exclusive representation within metropolitan or state area. Arrange a personal interview to show portfolio. Submit portfolio for review. Query with résumé of credits. SASE. Reports in 1-2 weeks.
Tips: "Robinson Galleries is a fine arts gallery first, the medium is secondary."

ROCKRIDGE CAFE, 5492 College Ave., Oakland CA 94618. (510)653-1567. Fax: (510)653-6806. Manager: Bill Chung. Estab. 1973.
Exhibits: "Rockridge Cafe is a popular restaurant in North Oakland that has existed for twenty years. We are flexible and willing to work with upstart artists. We show what we like, the only restrictions having to do with the fact that this is a family restaurant." Presents 7 exhibits/year. Shows last 2 months. "We will accommodate a reception."
Making Contact & Terms: Very interested in receiving work from newer, lesser-known photographers. NPI. Reviews transparencies. Interested in framed or unframed, mounted, matted or unmatted work. Accepts photos up to 3×6 feet. Query with samples. Send material by mail for consideration. Submit portfolio for review–"2 or 3 pieces as would be shown plus slides." SASE. Reports after receiving sample. Reports promptly.
Tips: Does not buy photos outright. Interested buyers will be referred to photographers. "Artists are responsible for hanging and taking down their work."

THE ROLAND GALLERY, 601 Sun Valley Rd., P.O. Box 221, Ketchum ID 83340. (208)726-2333. Fax: (208)726-6266. Contact: Roger Roland. Estab. 1990.
Exhibits: Example of exhibitions: works by Al Wertheimer (1956 original Elvis Presley prints). Presents 5 shows/year. Shows last 1 month. Sponsors openings; provides advertising and reception. Photographer's presence at opening and during show preferred.
Making Contact & Terms: Interested in receiving work from newer, lesser-known photographers. Charges 50% commission. General price range: $100-1,000. Reviews transparencies. Interested in

matted or unmatted work. Submit portfolio for review. SASE. Reports in 1 month.

THE ROTUNDA GALLERY, 33 Clinton St., Brooklyn NY 11201. (718)875-4047. Fax: (718)488-0609. Director: Janet Riker.
Exhibits: Requirements: Must live in, work in or have studio in Brooklyn. Interested in contemporary works. Examples of previous exhibitions: "All That Jazz," by Cheung Ching Ming (jazz musicians); "Undiscovered New York," by Stanley Greenberg (hidden New York scenes); "To Have and to Hold," by Lauren Piperno (ballroom dancing). Presents 1 show/year. Shows last 5 weeks. Sponsors openings. Photographer's presence at opening preferred.
Making Contact & Terms: Interested in receiving work from newer, lesser-known photographers. Charges 20% commission. Reviews transparencies. Interested in framed or unframed, mounted or unmounted, matted or unmatted work. Shows are limited by walls that are 22 feet high. Arrange a personal interview to show portfolio. Send material by mail for consideration. Join artists slide registry, call for form. SASE.

SANGRE DE CRISTO ARTS CENTER, 210 N. Santa Fe Ave., Pueblo CO 81003. (719)543-0130. Fax: (719)543-0134. Curator of Visual Arts: Jennifer Cook. Estab. 1972.
Exhibits: Requirements: Work must be artistically and technically superior; all displayed works must be framed. It is preferred that emerging and mid-career artists be regional. Examples of exhibitions: "Photographs by Karsh," by Yousef Karsh (b&w, large format); "Seeing The Unseen," by Harold Edgerton (high speed); "A Legacy of Beauty," by Laura Gilpin (photos of the Southwest). Presents 3 shows/year. Shows last 2 months. Sponsors openings; provides hors d'oeuvres, cash bar and live musical entertainment. Photographer's presence at opening preferred.
Making Contact & Terms: Interested in receiving work from newer, lesser-known photographers, particularly regional. Charges 30% commission. General price range: $200-800. Reviews transparencies. Interested in framed or unframed, matted or unmatted work. Arrange a personal interview to show portfolio. Submit portfolio for review. Query with résumé of credits. Query with samples. Send material by mail for consideration. Reports in 2 months.

MARTIN SCHWEIG STUDIO AND GALLERY, 4658 Maryland Ave., St. Louis MO 63108. (314)361-3000. Gallery Director: Christine Flavin.
Exhibits: Requirements: Photographs must be matted to standard frame sizes. Interested in all types, expecially interested in seeing work that pushes the boundaries of photography, in technique and subject. Examples of recent exhibitions: "Celebrations," by Paul Dahlquist (20 year retrospective); "Emulsion Media," by various artists (annual alternative photographic processes); and "Redux," by Herb Wetman (retrospective, lifetime work). Presents 8 shows/year. Shows last 1 month. Sponsors openings. Photographer's presence at opening preferred.
Making Contact & Terms: Interested in receiving work from newer, lesser-known photographers. Charges 40% commission. General price range: $200-1,200. Interested in mounted or matted work. Submit portfolio for review. Query with samples. Usually a portfolio must be submitted twice. Portfolio should include 12-15 matted pieces. SASE. Reports in 1 month.
Tips: Looks for technical expertise, creativity and simplicity. "Ours is the longest continuing gallery in St. Louis. Our show schedule is decided by a panel of jurors (professional photographers and educators)."

SELECT ART, 10315 Gooding Dr., Dallas TX 75229. (214)353-0011. Fax: (214)350-0027. Owner: Paul Adelson. Estab. 1986.
 • This market deals fine art photography to corporations and sells to collectors.
Exhibits: Interested in architectural pieces and landscapes.
Making Contact & Terms: Interested in receiving work from newer, lesser-known photographers. Charges 50% commission. General price range: $250-600. Retail price range: $100-1,000. Reviews transparencies. Interested in unframed and matted work only. Send material by mail for consideration. SASE. Reports in 1 month.
Tips: Make sure the work you submit is fine art photography, not documentary/photojournalistic or commercial photography. No nudes.

SHAPIRO GALLERY, 250 Sutter St., 3rd Floor, San Francisco CA 94108. (415)398-6655. Owners: Michael Shapiro and Heather Shapiro. Estab. 1980.
Exhibits: Interested in "all subjects and styles. Superior printing and presentation will catch our attention." Examples of exhibitions: Aaron Siskind (b&w); Andre Kertesz (b&w); and Vernon Miller (platinum). Shows last 2 months. Sponsors openings.
Making Contact & Terms: Very interested in receiving work from newer, lesser-known photographers. General price range: $500-50,000. Weekly portfolio drop off for viewing on Wednesdays. No personal interview or review is given. "No slides please." SASE.
Tips: "Classic, traditional" work sells best.

***THE SILVER IMAGE INC.**, 425, 300 Queen Anne Ave. N., Seattle WA 98109. (206)233-8585. Director: Dan Fear. Estab. 1973.
Exhibits: Interested in traditional landscapes, nudes and hand colored photographs.
Making Contact & Terms: Interested in established photographers. General price range: $350 and up.
Tips: "A 'business-like' attitude is important. A good artist has mastered his/her technical skills and has a unique vision. I also try to figure out if the artist has any idea about the realities of selling photographs and making a living at it. The buying public is most interested in high quality, large format, beautiful prints." Subjects include landscape, nudes, still lifes, plants. "We have published a book on the business of art, *Creating a Successful Career In Photography*." Computer disk with 40 business forms also available (PC or Macintosh computers). Book and disk, $34.95; disk version, $16.95.

***SLIDETEC GALLERY OF PHOTOGRAPHIC ARTS**, 4376 Park Blvd., Pinellas Park FL 34665. (813)541-9772. Director: Mark Wilcox. Estab. 1992.
Exhibits: Requirements: Must pass gallery director's acceptance, provide enough work to form an exhibition and price each work or provide price sheets. Presents 10-12 shows/year. Shows last 4-6 weeks. Provides advertising, promotion and press release information. Artist provides promotion photos. Photographer's presence at opening and during show preferred.
Making Contact & Terms: Interested in receiving work from newer, lesser-known photographers. Charges 20% commission from show, 25% from bins. General price range: $25-900. Prices set by the artist to include gallery commissions. Works not for sale are listed as N.F.S. Reviews transparencies. All works must be framed, mounted or matted. Arrange a personal interview to show portfolio. Submit portfolio for review. Query with résumé of credits. Query with samples. Send material by mail for consideration. SASE. Reports in 1 month.
Tips: "The photographer is solely responsible for the packing, delivery and return shipping of all works. The photographer is not responsible for hanging the show. Although every precaution will be made to safeguard the artist's work, Slidetec will not be responsible for any damages while on exhibit due to shipping and handling, fire or theft."

***NANCY SOLOMON GALLERY**, 1037 Monroe Dr., Atlanta GA 30306. (404)875-7150. Fax: (404)875-0270. Gallery Manager: Wendy Giren. Estab. 1994.
Exhibits: Requirements: Must supply full set (20 or more) of slides for review with biography and résumé. Interested in contemporary, large format, pin-hole and international work. Examples of recent exhibition: "Fantastic Imagery," by Lawrence Beck (b&w large format); and works by "Skeet McAuley." Presents 3-4 shows/year. Shows last 5 weeks. Sponsors openings; provides invitations and food and drink. Photographer's presence at opening preferred.
Making Contact & Terms: Interested in receiving work from newer, lesser-known photographers. Charges 50% commission. General price range: $500-3,000. Reviews transparencies. Interested in framed or unframed work. Requires exclusive representation locally. Submit portfolio for review. Send material by mail for consideration. "Only portfolios reviewed." SASE. Reports in 3 weeks.

SPIRIT SQUARE CENTER FOR THE ARTS, 345 N. College St., Charlotte NC 28202. (704)372-9664. Fax: (704)377-9808. Curator of Exhibitions: Alan Prokop. Estab. 1975.
Exhibits: Requirements: must be able to present a cogent body of work and be responsible for effective presentation. Interested in wide ranging work; no tourism. Presents 3-4 shows/year in each of 6 different galleries. Shows last 8-10 weeks. Sponsors openings. Photographer's presence at opening preferred.
Making Contact & Terms: Interested in receiving work from newer, lesser-known photographers. Charges 40% commission. General price range: $80-1,500. Reviews transparencies. Interested in framed or unframed, mounted or unmounted. Submit portfolio for review. Send material by mail for consideration. SASE. Reports quarterly.
Tips: "The work has to be able to maintain its strength within the presence of other media—painting, sculpture, fiber arts. Installation-based work is a plus."

B. J. SPOKE GALLERY, (formerly Northport/B.J. Spoke Gallery), 299 Main Street, Huntington NY 11743. (516)549-5106. Director: Patricia James.

MARKET CONDITIONS are constantly changing! If you're still using this book and it's 1998 or later, buy the newest edition of *Photographer's Market* at your favorite bookstore or order directly from Writer's Digest Books.

Exhibits: Requirements: juried shows; send for prospectus or deadline. Interested in "all styles and genres, photography as essay, as well as 'beyond' photography." Examples of recent exhibitions: "Expo XIV," by Howard Steinberg (winner of juried show); "Photo '95 Invitational," 8 photographers; and "Reflections on China," by Constance Wain. Shows last 1 month. Sponsors openings. Photographer's presence at opening preferred.
Making Contact & Terms: Interested in receiving work from newer, lesser-known photographers. Charges 25% commission. General price range: $200-800; photographer sets price. Reviews transparencies. Interested in framed or unframed, matted or unmatted work. Arrange a personal interview to show portfolio. Query with résumé of credits. Send material by mail for consideration. SASE. Reports back in 2 months.
Tips: Offers biennial photography invitational in odd years. Curatorial fee: $50.

THE STATE MUSEUM OF PENNSYLVANIA, P.O. Box 1026, Third & North Streets, Harrisburg PA 17108-1026. (717)787-4980. Fax: (717)783-1073. Senior Curator, Art Collections: N. Lee Stevens. Museum estab. 1905; Current Fine Arts Gallery opened in 1993.
Exhibits: Requirements: Photography must be created by native or resident of Pennsylvania, or relevant subject matter. Art photography is a new area of endeavor for The State Museum, both collecting and exhibiting. Interested in works produced with experimental techniques. Examples of exhibitions: "Art of the State: PA '94," by Bruce Fry (manipulated, sepia-toned, b&w photo), and works by Norinne Betjemann (gelatin silver print with paint), and David Lebe (painted photogram). Number of exhibits varies. Shows last 2 months. Photographer's presence at opening preferred.
Making Contact & Terms: Interested in receiving work from newer, lesser-known photographers. Work is sold in gallery, but not actively. General price range: $50-500. Reviews transparencies. Interested in framed work. Send material by mail for consideration. SASE. Reports in 1 month.

***THREAD WAXING SPACE**, 476 Broadway, New York NY 10013. (212)966-9520. Fax: (212)274-0792. Exhibition Coordinators: Danielle Chang and Corey McCorkle. Estab. 1991.
Exhibits: "We are a nonprofit exhibition and performance space and do not sell or represent work. We have no set parameters, but, generally, we exhibit emerging artists' work or work that is not ordinarily accessible to the public." Examples of recent exhibitions: "Pence Springs Resort," by Stefan Roloff (photographic installation); "Solo Exhibition," by Pico Harnden; and "Collaboration B&W," by Nancy Spero and Abe Frapndlich. Shows last 6 weeks. Sponsors openings. Photographer's presence at opening and during show preferred.
Making Contact & Terms: Interested in receiving work from newer, lesser-known photographers. Reviews transparencies. Send slides with SASE.

***UNIVERSITY ART GALLERY, NEW MEXICO STATE UNIVERSITY**, Dept. 3572, P.O. Box 30001, Las Cruces NM 88003. (505)646-2545. Fax: (505)646-8036. Director: Charles M. Lovell. Estab. 1973.
Exhibits: Examples of recent exhibitions: "Breath Taken," by Bill Ravanesz (documentary of asbestos workers; "Celia Munoz," by Celia Munoz (conceptual); and "Close to the Border," group exhibition including photography. Presents 1 show/year. Shows last 2 months. Sponsors openings; provides curatorial, registration and shipping. Photographer's presence at opening preferred.
Making Contact & Terms: Buys photos outright. General price range: $100-1,000. Interested in framed or unframed work. Arrange a personal interview to show portfolio. Submit portfolio for review. Query with samples. Send material by mail for consideration by end of October, 1996. SASE. Reports in 2 months.
Tips: Looks for "quality fine art photography. The gallery does mostly curated, thematic exhibitions. Very few one-person exhibitions."

URBAN PARK-DETROIT ART CENTER, 508 Monroe St., Detroit MI 48226-2944. (313)963-5445. Director: Dave Roberts. Estab. 1991.
Exhibits: Requirements: Artist or designate must assist in staffing gallery 32 hours over course of exhibition. Interested in landscape, still life, figurative. Examples of recent exhibitions: "Retrospective," by Ray Rohr (landscape and still life); "Noir Contour," by Gosden (black male nudes); and Manequin Series, by Elaine Redmond (antique wax manequins). Presents 8 shows/year. Shows last 5 weeks. Sponsors openings; provides mailed announcements, refreshments. Photographer's presence at opening preferred; presence during show required.
Making Contact & Terms: Interested in receiving work from newer, lesser-known photographers. Charges 40% commission. General price range: $150-800. Reviews transparencies. Interested in framed work only. Arrange a personal interview to show portfolio. Submit portfolio for review. Query with résumé of credits. Query with samples. SASE. Reports in 1 month.
Tips: "Photographers should present a solid body of work with resolved ideas. Subjects can range from landscape still life or figurative to totally abstract. We are looking for comprehensive series within a particular style."

VALENCIA COMMUNITY COLLEGE EAST CAMPUS GALLERIES, P.O. Box 3028, Orlando FL 32802. (407)299-5000 ext. 2298. Fax: (407)299-5000 ext. 2270. Gallery Curator: Robin Ambrose. Estab. 1982.
Exhibits: Interested in innovative, documentary, straight-forward style. Examples of recent exhibitions: "Figure/Ground Relationships," by Margaret Steward and Amelia Pierney (landscape/figurative paintings, drawings, photos); and "Picture Element," by Kenneth Sean Golden and others (electronic imaging). Shows last 6-8 weeks. Sponsors openings; provides food. Photographer's presence at opening required, presence during show preferred.
Making Contact & Terms: Interested in receiving work from newer, lesser-known photographers. Does not charge commission. General price range: $175-1,500. Reviews transparencies. Interested in matted work only. Send material by mail for consideration. SASE. Reports as needed.
Tips: Photography is usually exhibited with other mediums. Looks for "fresness and personal vision. Professional presentation is most helpful; display a willingness to participate in group shows." Sees a renewed interest in documentary photography, also in contemporary materials and methods.

VIRIDIAN GALLERY, 24 W. 57 St., New York NY 10019. (212)245-2882. Director: Joan Krawczyk. Estab. 1968.
Exhibits: Interested in eclectic. Member of Cooperative Gallery. Examples of recent exhibitions: works by Susan Hockaday, Jennifer Warner, Carol Crawford and Robert Smith. Presents 1-2 shows/ year. Shows last 3 weeks. Photographer's presence at opening preferred.
Making Contact & Terms: Is receptive to exhibiting work of newer photographers, but they must pass board acceptance. Charges 30% commission. General price range: $300-600. Will review transparencies only if submitted as membership application. Interested in framed or unframed, mounted, and matted or unmatted work. Request membership application details. Send materials by mail for consideration. SASE. Reports in 3 weeks.
Tips: Opportunities for photographers in galleries are "improving." Sees trend toward "a broad range of styles" being shown in galleries. "Photography is getting a large audience that is seemingly appreciative of technical and aesthetic abilities of the individual artists."

SANDE WEBSTER GALLERY, 2018 Locust St., Philadelphia PA 19103. (215)732-8850. Fax: (215)732-7850. E-mail: swgpa@aol.com. Gallery Director: Michael Murphy.
● The gallery will review the work of emerging artists, but due to a crowded exhibition schedule, may defer in handling their work.
Exhibits: Requirements: Must be established fine artist with experience exhibiting. Interested in contemporary, fine art photography in limited editions. "We encourage the use of non-traditional materials in the pursuit of expression, but favor quality as the criterion for inclusion in exhibits." Examples of exhibitions: "Dust Shaped Hearts," by Don Camp (photo sensitized portraits); works by Norrine Betjenzon (hand-tinted); and Kevin Reilly (documentary landscape and automotive images). Presents 1 show/year. Shows last 1 month. Sponsors openings; covers all costs for the event. The artist is responsible for travel and accommodations. Photographer's presence at opening and during show preferred.
Making Contact & Terms: Interested in receiving work from newer, lesser-known photographers. Charges 50% commission. General price range: $200-2,000. Reviews transparencies. Interested in framed or unframed work. Send material by mail for consideration. SASE. Reports in 1 month.

WESTCHESTER GALLERY, 196 Central Ave., County Center, White Plains NY 10606. (914)684-0094. Fax: (914)684-0608. Gallery Coordinator: Christine Jewell.
Exhibits: Requirements: submit 10 slides or actual work to be juried by panel of artists. Example of exhibition: works by Tim Keating and Alan Rokach. Presents 2 photo shows/year (usually). Shows last 1 month. Sponsors openings; gallery covers cost of space, light, insurance, mailers (printing and small mailing list) and modest refreshments. Photographer's presence at opening preferred.
Making Contact & Terms: Interested in receiving work from newer, lesser-known photographers. Charges 33⅓% commission. General price range $150-3,750. Reviews transparencies. Interested in any presentable format ready to hang. Arrange a personal interview to show portfolio. Submit portfolio for review. Query with résumé of credits. Send material by mail for consideration. SASE. Reports in 1 month.
Tips: "Most sales are at low end, $150. Gallery space is flexible and artists are encouraged to do their own installation."

WHITE GALLERY-PORTLAND STATE UNIVERSITY, Box 751/SD Portland OR 97207. (503)725-5656 or (800)547-8887. Fax: (503)725-4882. Associate Director: Dulcinea Myers-Newcomb. Estab. 1969.
Exhibits: Examples of previous exhibitions: "invisible No More," by Orville Robertson (b&w); "In the City Streets," by Edis Lurchis (b&w); and Collection of Opera Photographs," by Christine Sale

Award-winning photographer Don Camp's distinctive style is evident in this photo of jazz pianist and composer Dave Burrell, from Camp's suite "Men Who Hear Music," part of his one-man exhibit at Sande Webster Gallery entitled "Dust-Shaped Hearts." Camp works with earth pigment and casein monoprint process to achieve the painterly look of his portraits. His work has appeared in countless exhibitions and received a number of grants including a 1995-96 Guggenheim Fellowship.

(b&w). Presents 12 shows/year. Exhibits last 1 month. Sponsors openings. Photographer's presence at opening and during show is preferred.

Making Contact & Terms: Charges 20% commission. General price range: $175-400. Interested in framed or unframed, mounted, matted work. "We prefer matted work that is 16×20." Send material by mail for consideration. SASE. Reports in 1 month.

Tips: "Best time to submit is September-October of the year prior to the year show will be held. We only go by what we see, not the name. We see it all and refrain from the trendy. Send slides. Do something different . . . view life upside down."

WYCKOFF GALLERY, 648 Wyckoff Ave., Wyckoff NJ 07481. (201)891-7436. Director: Sherry Cosloy. Estab. 1978.

Exhibits: Requirements: prior exhibition schedule, mid-career level. Interested in all styles except depressing subject matter (e.g. AIDS, homelessness). Example of exhibitions: Works by Jorge Hernandez (landscapes). Presents 1 exhibit/year. Shows last 1 month. Sponsors openings; arrangements discussed with photographer. Photographer's presence at opening is required, presence during show preferred.

Making Contact & Terms: General price range: $200-2,000. Reviews transparencies. Interested in framed or unframed, mounted or unmounted, matted or unmatted work. Requires exclusive presentation locally. Query with résumé of credits. Query with samples. SASE. Reports in 1-2 weeks.

Tips: "I am predominantly a fine arts (paintings and sculptures) gallery so photography is not the prime focus. People like photography that is hand-colored and/or artistic in composition and clarity."

YESHIVA UNIVERSITY MUSEUM, 2520 Amsterdam Ave., New York NY 10033. (212)960-5390. Fax: (212)960-5406. Director: Sylvia A. Herskowitz. Estab. 1973.

Exhibits: Seeks work focusing on Jewish themes and interest. Examples of recent exhibitions: "Sacred Realm: The Emergence of the Synagogue in the Ancient World"; "In a Golub: The Work of the Weavers in Color." Presents 3-4 shows/year. Shows last 4-8 months. Sponsors openings; provides invitations and light refreshments. Photographer's presence at opening preferred.

Making Contact & Terms: Interested in receiving work from newer, lesser-known photographers. Photography sold in museum shop. NPI; commission negotiable. General price range: $100 and up. Interested in framed work. Send material by mail for consideration. Reports following meeting of exhibits committee.

Tips: "We exhibit the contemporary art and photography that is based on a Jewish theme. We look for excellent quality; individuality; and especially look for unknown artists who have not widely exhibited either in the New York area or at all. Send a slide portfolio of ten slides, an exhibition proposal, a résumé, and other pertinent information with a SASE. We conduct portfolio reviews three times a year."

Paper Products

The greeting card industry is dominated by the big three—American Greetings, Gibson Greetings and Hallmark Cards. These giants consistently corner over 80 percent of the market. But if you are having trouble breaking into these three markets, don't despair. There is plenty of room for photo sales to the smaller players.

There are more than 1,000 greeting card companies in the United States which sell over 7 billion cards annually. Many of these companies produce low-priced cards that fill a niche in the market. Some, such as West Graphics in San Francisco, focus on risqué subjects, while others, like Cardmakers in Lyme, New Hampshire, prefer seasonal topics. Many of the 48 listings in this section produce not only greeting cards, but calendars, posters, games and gift items.

BUILDING A RAPPORT

The important thing is to research the industry to know what is being bought and sold. After your initial research, query companies you are interested in working with and send a stock photo list. Since these companies receive large volumes of submissions, they often appreciate knowing what is available rather than actually receiving it. This kind of query can lead to future sales even if your stock inventory doesn't meet their immediate needs. Buyers know they can request additional submissions as their needs change. Some listings in this section advise sending quality samples along with your query while others specifically request only a list. As you plan your queries, follow their instructions. It will help you establish a better rapport with companies from the start.

Some larger companies have staff photographers for routine assignments, but also look for freelance images. Usually, this is in the form of stock, and images are especially desirable if they are of unusual subject matter or remote scenic areas for which assignments—even to staff shooters—would be too costly. Freelancers are usually offered assignments once they have established a track record and demonstrate a flair for certain techniques, subject matters or locations. Also, smaller companies are more receptive to working with freelancers, though they are less likely to assign work because of smaller budgets for photography.

The pay in this market can be quite lucrative if you provide the right image at the right time for a client desperately in need of it, or if you develop a working relationship with one or a few of the better paying markets. You should be aware, though, that one reason for higher rates of payment in this market is that these companies may want to buy all rights to images. With changes in the copyright law, many companies are more willing to negotiate sales which specify all rights for limited time periods or exclusive product rights rather than complete surrender of copyright.

Another key consideration is that an image with good market value is effectively taken out of the market during the selection process. Many paper product companies work on lead times of up to two years before products are ready to market. It can be weeks, months or as much as a year before buyers contact photographers. In addition, some companies will pay only on publication or on a royalty basis after publication. For these reasons, as well as the question of rights, you may want to reconsider selling images with high multiple resale potential in this market. Certainly, you will want to

pursue selling to companies which do not present serious obstacles in these ways or which offer exceptionally good compensation when they do.

Keep in mind the varying degrees of professionalism among companies. For instance, some smaller companies can be a source of headaches in a number of ways, including failing to report in a timely manner on submissions, delaying return of submissions or using images without authorization. This sometimes happens with the seemingly more established companies, too, though it's less common. Typically, many smaller companies have started as one- or two-person operations, and not all have acquired adequate knowledge of industry practices which are standard among the more established firms.

***ACME GRAPHICS, INC.**, Box 1348, Cedar Rapids IA 52406. (319)364-0233. Fax: (319)363-6437. President: Stan Richardson. Estab. 1913. Specializes in printed merchandise for funeral directors. **Needs:** Religious, nature. Reviews stock photos.
Making Contact & Terms: Interested in receiving work from newer, lesser-known photographers. Query with samples. Send unsolicited photos by mail for consideration. Uses 35mm transparencies; color contact sheets; color negatives. SASE. Reports in 2 weeks. Pays $50/b&w photo; $50/color photo. Also, pays according to price set by photographer. **Pays on acceptance.** Buys all rights.

***ADVANCED GRAPHICS**, P.O. Box 8517, 941 Garcia Ave., Pittsburg CA 94565. (510)432-2262. Fax: (510)432-9259. Photo Editor: Steve Henderson. Estab. 1985. Specializes in life-size standups and cardboard displays.
Needs: Buys 20 images annually; number supplied by freelancers varies. Interested in celebrities (movie and TV stars, entertainers). Reviews stock photos.
Making Contact & Terms: Interested in receiving work from newer, lesser-known photographers. Query with stock photo list. Uses 4×5, 8×10 transparencies. Keeps samples on file. SASE. Reports in 1 month. NPI; negotiable. **Pays on acceptance.** Credit line given. Buys exclusive product rights; negotiable. Simultaneous submissions and/or previously published work OK.
Tips: "We specialize in publishing life-size standups which are cardboard displays of celebrities. Any pictures we use must show the entire person, head to toe. We must also obtain a license for each image that we use from the celebrity pictured or from that celebrity's estate. The image should be vertical and not too wide."

AMERICAN GREETINGS, 10500 American Rd., Cleveland OH 44144. Prefers not to share information.

***ANGLER'S CALENDARS**, 4955 E. 2900 N., Murtaugh ID 83344. Phone/fax: (208)432-6625. Editor: Barbara Wolverton. Estab. 1975. Specializes in calendars.
Needs: Buys 250 photos/year. Fly fishing; saltwater fishing; wildlife; waterfowl; whitetail deer; upland birds; sporting dogs; bass, muskie, walleye, pike; and "scantily-clad" women fishing, hunting, camping, canoeing, hiking. Examples of recently published calendars: "Angler's Calendar," "Decoy Calendar" and "Saltwater Fishing Calendar" (monthly photos). Reviews stock photos. Model release preferred. Captions required—include location and species of fish or animal.
Making Contact & Terms: Query first. Submit no more than 100 slides at one time in January. Uses 35mm, 2¼×2¼ and 4×5 transparencies. SASE. Reports in 2 weeks. Pays $60-200/color photo. Pays on publication. Credit line given. Buys one-time rights. Previously published work OK if advised of previous publication and date.
Tips: Interested in action shots; no dead fish or animals. "Look at past calendars to see style and format." In portfolios or samples, make a "neat presentation—clean and insured."

ART RESOURCE INTERNATIONAL LTD./BON ART, Fields Lane, Brewster NY 10509. (914)277-8888. Fax: (914)277-8602. Vice President: Robin Bonnist. Estab. 1980. Specializes in posters and fine art prints. Photo guidelines free with SASE.
Needs: Buys 500 images/year. Interested in all types but does not wish to see regional. Accepts seasonal material anytime. Model release required. Captions preferred.

 THE ASTERISK before a listing indicates that the market is new in this edition. New markets are often the most receptive to freelance submissions.

Making Contact & Terms: Interested in receiving work from newer, lesser-known photographers. Send unsolicited photos by mail for consideration. Submit portfolio for review. Works on assignment only. Uses 35mm, 4×5 and 8×10 transparencies. SASE. Reports in 1 month. Pays $50-250/photo. Pays on publication. Credit line given if required. Buys all rights; exclusive reproduction rights. Simultaneous submissions and previously published work OK.

Tips: Looks for "new and exciting material; subject matter with universal appeal."

***THE AVALON HILL GAME CO.**, 4517 Harford Rd., Baltimore MD 21214. (410)254-9200. Fax: (410)254-0991. E-mail: j4d@1x.netcom.com. President: Jack Doff. Estab. 1949. Specializes in playing cards.

Needs: Buys 50 images annually; 50% supplied by freelancers. Offers 15 assignments annually. Specializes in military subjects. Submit seasonal material 3 months in advance. Reviews stock photos of military subjects. Model/property release required for models, etc. Captions preferred.

Making Contact & Terms: Interested in receiving work from newer, lesser-known photographers. Query with stock photo list. Works on assignment only. Uses 5×8, 8½×11 color and b&w prints; 35mm, 4×5 transparencies. Keeps samples on file. SASE. Reports in 3 weeks. Pays $50-500/job. Pays on usage. Credit line given. Buys exclusive product rights. Simultaneous submissions and/or previously published work OK.

AVANTI PRESS INC., 134 Spring St., Suite 602, New York NY 10012. (212)941-9000. Fax: (212)941-8008. Attention: Art Submissions. Estab. 1980. Specializes in photographic greeting cards, posters and note cards. Photo guidelines free with SASE.

Needs: Buys approximately 250 images annually; all supplied by freelancers. Offers 75 assignments annually. Interested in humorous, narrative, colorful, simple, to the point; also babies, children, animals (in humorous situations). Has specific deadlines for seasonal material. Does NOT want travel, sunsets, landscapes, nudes, high-tech. Reviews stock photos. Model/property release required. Now have an alternative, multi-occasion line—4U. Personal, artistic, expressive, friendly, intimate, mysterious are words which describe the types of images needed for this line.

Making Contact & Terms: Interested in receiving work from newer, lesser-known photographers. Arrange personal interview to show portfolio. Query with stock photo list. Please do not submit original material. Will work with all mediums and formats. Reports quarterly. NPI. Pays on license. Credit line given. Buys 5-year worldwide, exclusive card rights.

Tips: "Know our card lines. Stretch the boundaries of creativity."

BEAUTYWAY, Box 340, Flagstaff AZ 86002. (602)526-1812. President: Kenneth Schneider. Estab. 1979. Specializes in postcards, note cards and posters.

Needs: Buys 100-200 freelance photos/year (fee pay and Joint Venture). "Joint Venture is a program within Beautyway in which the photographer invests in his own images and works more closely in overall development. Through Joint Venture, photographers may initiate new lines or subjects with Beautyway." Interested in (1) nationwide landscapes emphasizing subjects of traveler interest and generic scenes of sea, lake and river; (2) animals, birds and sealife, with particular interest in young animals, eyes and interaction; (3) air, water and winter sports; (4) the most important attractions and vistas of major cities, emphasizing sunset, storm, cloud and night settings. Model release required.

Making Contact & Terms: Query with samples, stock list and statement of interests or objectives. All transparency formats OK. Ship in protective sleeves with photographer name, title and location of image on frame. SASE. First report averages two weeks, others vary. Pays $45 for up to 2,400 postcards; $70 for up to 4,800 postcards; $120 for up to 9,600 postcards; $8 per 1,200 postcards thereafter. Previously published work OK if not potentially competitive.

Tips: Looks for "very sharp photos with bright colors and good contrast. Subject matter should be easily identified at first glance. We seek straightforward, basic scenic or subject shots. Obvious camera manipulation such as juxtaposing shots or unnatural filter use is almost always rejected. When submitting transparencies, the person's name, address and name and location of subject should be upon each transparency sleeve."

BLUE SKY PUBLISHING, 6395 Gunpark Dr., M, Boulder CO 80301. (303)530-4654. Fax: (303)530-4627. Art Director: Theresa Brown. Estab. 1989. Specializes in greeting cards.

Needs: Buys 24-48 images annually; all supplied by freelancers. Interested in Rocky Mountain winter landscapes, seasonal and Christmas. Submit seasonal material 1 year in advance. Reviews stock photos. Model/property release preferred.

Making Contact & Terms: Interested in receiving work from newer, lesser-known photographers. Submit portfolio for review. Query with samples. Provide résumé, business card, self-promotion piece or tearsheets to be kept on file for possible future assignments. Uses 35mm, 4×5 (preferred) transparencies. Keeps samples on file. SASE. "We try to respond within 1 month—sometimes runs 2 months." Pays $150-250/color photo; 3-5% royalties. **Pays on acceptance**. Credit line given. Buys exclusive

product rights for 5 years; negotiable. Simultaneous submissions and/or previously published work OK.

***BRISTOL GIFT CO. INC.**, P.O. Box 425, Washingtonville NY 10992. (914)496-2821. Fax: (914)496-2859. Marketing Director: Allen Ropiecki. Estab. 1988. Specializes in framing prints and wall decor.
Needs: Interested in religious, nature, still life. Submit seasonal material 6 months in advance. Reviews stock photos. Model/property release preferred.
Making Contact & Terms: Interested in receiving work from newer, lesser-known photographers. Query with samples. Uses 4×5, 8×10 color prints; 4×5 transparencies. Keeps samples on file. SASE. Reports in 1 month. NPI; depends on agreement. Buys exclusive product rights. Previously published work OK.

CARDMAKERS, High Bridge Rd., P.O. Box 236, Lyme NH 03768. (603)795-4422. Fax: (603)795-4222. Owner: Peter D. Diebold. Estab. 1978. Specializes in greeting cards (Christmas).
● This company expects photo cards to be a growing portion of their business.
Needs: Buys stock and assigns work. Nautical scenes which make appropriate Christmas card illustrations. Model/property release preferred.
Making Contact & Terms: Interested in receiving work from newer, lesser-known photographers. Provide self-promotion piece to be kept on file for possible future assignments. Uses color prints; 35mm, 4×5, 8×10 transparencies. Keeps samples on file. SASE. Reports in 3 weeks. Pays $100/b&w and color photos. **Pays on acceptance.** Credit line negotiable. Buys exclusive product rights and all rights; negotiable. Simultaneous submissions and previously published work OK.
Tips: "We are seeking photos primarily for our nautical Christmas card line but would also be interested in any which might have potential for business to business Christmas greeting cards. Emphasis is on humorous situations. A combination of humor and nautical scenes is best. Please do not load us up with tons of stuff. We have yet to acquire/publish designs using photos but are very active in the market presently. The best time to approach us is during the first nine months of the year (when we can spend more time reviewing submissions)."

CEDCO PUBLISHING CO., 2955 Kerner Blvd., San Rafael CA 94901. (415)457-3893. Fax: (415)457-1226. E-mail: sales@cedco.com. Website: http://www.cedco.com. Contact: Art Dept. Estab. 1980. Specializes in calendars and picture books. Photo guidelines free with SASE.
Needs: Buys 1,500 images/year; 1,000 supplied by freelancers. Wild animals, domestic animals, America, Ireland, inspirational, beaches, islands, whales, general stock and studio stock. Especially needs 4×5 photos of the East Coast and South—beaches, music, flowers. New ideas welcome. Model/property release required. Captions required.
Making Contact & Terms: Interested in receiving work from newer, lesser-known photographers. Query with non-returnable samples and a list of stock photo subjects. "Do not send any returnable material unless requested." Uses 35mm, 2¼×2¼, 4×5, 8×10 transparencies. Keeps samples on file. Reports as needed. Pays $200/b&w photo; $200/color photo; payment negotiable. Pays the December prior to the year the calendar is dated (i.e., if calendar is 1998, photographers are paid in December 1997). Credit line given. Buys one-time rights. Simultaneous submissions and previously published work OK.
Tips: No phone calls.

COMSTOCK CARDS, 600 S. Rock Blvd., #15, Reno NV 89502. Phone/fax: (702)856-9400. Production Manager: David Delacroix. Estab. 1986. Specializes in greeting cards, invitations, notepads, magnets. Photo guidelines free with SASE.
Needs: Buys/assigns 20 photos/year. Wild, outrageous and shocking adult humor only! "Do not waste our time, or yours, submitting hot men or women images." Definitely does not want to see traditional, sweet, cute, animals or scenics. "If it's appropriate to show your mother, we don't want it!" Submit seasonal material 9-10 months in advance. Model/property release required.
Making Contact & Terms: Interested in receiving work from newer, lesser-known photographers. Query with samples. Uses 35mm, 6cm×6cm, 6cm×7cm or 4×5 color transparencies. SASE. Reports in 3 weeks. Pays $50-150/color photo. **Pays on acceptance.** Credit line given if requested. Buys all rights; negotiable. Simultaneous submissions OK.
Tips: "Submit with SASE if you want material returned."

● **A BULLET** has been placed within some listings to introduce special comments by the editor of *Photographer's Market*.

DeBOS PUBLISHING COMPANY, P.O. Box 36182, Canton OH 44735. Phone/fax: (216)833-5152. Editor of Photography: Brian Gortney. Estab. 1990. Specializes in calendars, posters and aviataion reference books. Photo guidelines free with SASE.
Needs: Buys 24 images/year. Offers 24 assignments/year. Interested in civilian and military helicopters, in operation, all seasons. "We promote public interest in the helicopter industry." Reviews stock photos of any helicopter relating to historical or newsworthy events. Model/property release required (owner of the helicopter, property release; pilot of aircraft, model release). Captions preferred; include name and address of operation and pilot (optional); date and location of photograph(s) are recommended. DeBos Publishing Company will supply all releases.
Making Contact & Terms: Interested in receiving work from newer, lesser-known photographers. Provide résumé, business card, self-promotion piece or tearsheets to be kept on file for possible future assignments. Works with freelancers on assignment only. Uses color prints; 35mm, 2¼×2¼, 4×5 and 6×7 transparencies. Keeps samples on file. Pays $10-175/color photo. Pays when proper releases returned. Credit line given. Buys all rights; negotiable.
Tips: "Every company in the market for photography has its own view on what photographs should look like. Their staff photographers have their favorite lens, angle and style. The freelance photographer is their answer to a fresh look at the subject. Shoot the subject in your best point-of-view, and shoot it in a different way, a way people are not used to seeing. Everyone owns a camera, but the one who puts it to use is the one who generates the income. The amount of money made should not take priority at first, but the quality and amount of work published should be your goal. If your work is good, your client will call on you again. Due to today's economy, companies are keeping fewer photographers on staff and buying less photographs from the high priced stock photo agencies. *Photographer's Market* allows us to successfully do so, using freelance photographers for some of our needs. This also gives experience and income to photographers who like to work independently and on numerous subjects. This is an essential tool to both employer and employee."

DESIGN DESIGN, INC., P.O. Box 2266, Grand Rapids MI 49501. (616)774-2448. Fax: (616)774-4020. Creative Director: Tom Vituj. Estab. 1986. Specializes in greeting cards, gift wrap, T-shirts, gift bags and invitations.
Needs: Buy stock images from freelancers and assigns work. Specializes in humorous, seasonal and traditional topics. Submit seasonal material one year in advance. Model/property release required.
Making Contact & Terms: Submit portfolio for review. Provide résumé, business card, self-promotion piece or tearsheets to be kept on file for possible future assignments. Do not send original work. Uses color prints. Samples kept on file. SASE. Pays royalties. Pays upon sales. Credit line given.

FLASHCARDS, INC., 1211A NE Eighth Ave., Fort Lauderdale FL 33304. (305)467-1141. Photo Researcher: Micklos Huggins. Estab. 1980. Specializes in postcards, greeting cards, notecards and posters.
Needs: Buys 500 images/year. Humorous, human interest, animals in humorous situations, nostalgic looks, male nudes, Christmas material, valentines, children in interesting and humorous situations. No traditional postcard material; no florals or scenic. "If the photo needs explaining, it's probably not for us." Submit seasonal material 8 months in advance. Reviews stock photos. Model release required.
Making Contact & Terms: Interested in receiving work from newer, lesser-known photographers. Query with sample. Send photos by mail for consideration. Provide résumé, business card, brochure, flier or tearsheets to be kept on file for possible future assignments. Uses any size color or b&w prints, transparencies and color or b&w contact sheets. SASE. Reports in 5 weeks. Pays $100 for exclusive product rights. Pays on publication. Credit line given. Buys exclusive product rights. Simultaneous and previously published submissions OK.

GIBSON GREETINGS, 2100 Section Rd., Cincinnati OH 45222. Prefers not to share information.

***GLOBAL EDITIONS INC.**, 2450 Central Ave., Suite C, Boulder CO 80301. (303)447-3388. Fax: (303)440-6423. President: James Gritz. Estab. 1990. Specializes in greeting cards and postcards. Photo guidelines free with SASE.
Needs: Buys 30-40 images annually; most supplied by freelancers. Interested in nature, wildlife, marine life. Submit seasonal material 3-6 months in advance. Does not want people photos. Reviews stock photos. Photo captions required.
Making Contact & Terms: Interested in receiving work from newer, lesser-known photographers. Submit portfolio for review. Provide résumé, business card, brochure, flier or tearsheets to be kept on file for possible future assignments. Uses 35mm, 2¼×2¼, 4×5 transparencies; Velvia, Provia preferred. Keeps samples on file. SASE. Reports in 1 month. Pays $300/color photo and royalties. Pays on usage. Credit line given. Buys one-time and 5-year world rights.

***‡GREETWELL**, D-24, M.I.D.C., Satpur., Nasik 422 007 India. Phone: 30181. Chief Executive: Ms. V.H. Sanghavi. Estab. 1974. Specializes in greeting cards and calendars.

Photographer Paul DeGruccio was paid $100 by Flashcards, Inc. for use of this amusing photo on a postcard. Flashcards' Micklos Higgins was attracted to the "cute facial expression and natural look" captured by DeGruccio. The caption on the back of the card reads "pump up the volume."

Needs: Buys approx. 100 photos/year. Landscapes, wildlife, nudes. No graphic illustrations. Submit seasonal material anytime throughout the year. Reviews stock photos. Model release preferred.
Making Contact & Terms: Query with samples. Uses any size color prints. SASE. Reports in 1 month. Pays $25/color photo. Pays on publication. Credit line given. Previously published work OK.
Tips: In photographer's samples, "quality of photo is important; would prefer nonreturnable copies. No originals please."

HALLMARK CARDS, INC., 2501 McGee, Drop #152, Kansas City MO 64108. Not accepting freelance submissions at this time.

HEALTHY PLANET PRODUCTS INC., 1129 N. McDowell Blvd., Petaluma CA 94954. (707)778-2280. Fax: (707)778-7518. E-mail: hppi@aol.com. Vice President/Sales and Marketing: M. Scott Foster. Specializes in greeting cards, stationery, and gift products such as magnets and journals.
Needs: "We have expanded several of our Healthy Planet Products lines. Our Sierra Club line of wildlife and wilderness cards has been a great success and we continue to look for more shots to expand this line. Wildlife in pairs, interacting in a nonthreatening manner are popular, as well as dramatic shots of man in nature. Non-West Coast shots are always in demand, as well as shots that could be used in our boxed Christmas line. Our underwater line, Sea Dreams, is comprised of only sea-related shots. Vibrant colors are a real plus. Sea mammals are very popular. Submit seasonal material 1 year in advance; all-year-round review; "include return postage."
Making Contact & Terms: Submit by mail. Provide business card and tearsheets to be kept on file for possible future assignments. "Due to insurance requirements, we cannot accept responsibility for original transparencies so we encourage you to submit dupes. Should we select a shot from your original submission for further review, we will at that time request the original and accept responsibility for that original up to $1,500 per transparency." Uses 35 mm, 2¼×2¼, 4×5 transparencies. SASE. Reports in 4-6 weeks. Simultaneous submissions and previously published work OK. Pays $300 for 5-year, worldwide greeting card rights which include electronic online greeting cards; separate fees for other rights. "We do not pay research fees." Credit line given. Buys exclusive product rights.
Tips: "Please hold submissions for our Healthy Planet Products line to your best 100-120 shots. A portion of the proceeds from the sales of our lines goes to the Sierra Club and/or other environmentally conscious organizations."

IMAGE CONNECTION AMERICA, INC., 456 Penn St., Yeadon PA 19050. (610)626-7770. Fax: (610)626-2778. President: Michael Markowicz. Estab. 1988. Specializes in postcards and posters.
Needs: Contemporary. Model release required. Captions preferred.
Making Contact & Terms: Query with samples. Send unsolicited photos by mail for consideration. Uses 8×10 b&w prints and 35mm transparencies. SASE. NPI. Pays quarterly or monthly on sales. Credit line given. Buys exclusive product rights; negotiable.

IMPACT, 4961 Windplay Dr., El Dorado Hills CA 95762. (916)939-9333. Fax: (916)939-9334. Estab. 1975. Specializes in calendars, bookmarks, magnets, postcard packets, postcards, posters and books for the tourist industry. Photo guidelines and fee schedule free with SASE.
 ● This company sells to specific tourist destinations; their products are not sold nationally. They
 need material that will be sold for at least a 6-8 year period.
Needs: Buys stock and assigns work. Buys 3,000 photos/year. Offers 10-15 assignments/year. Wildlife, scenics, US travel destinations, national parks, theme parks and animals. Submit seasonal material 4-5 months in advance. Model/property release required. Captions preferred.
Making Contact & Terms: Query with samples. Query with stock photo list. Provide résumé, business card, self-promotion piece or tearsheets to be kept on file for possible future assignments. Uses 35mm, 2¼×2¼, 4×5, 8×10 transparencies. Keeps samples on file. SASE. Reports in 1 month. NPI; request fee schedule; rates vary by size. Pays on usage. Credit line and printed samples of work given. Buys one-time and nonexclusive product rights; negotiable. Simultaneous submissions and previously published work OK.

ARTHUR A. KAPLAN CO., INC., 460 W. 34th St., New York NY 10001. (212)947-8989. Art Director: Elizabeth Tuckman. Estab. 1956. Specializes in posters, wall decor and fine prints and posters for framing.

LISTINGS THAT USE IMAGES electronically can be found in the Digital Markets Index located at the back of this book.

Needs: Buys 50-100 freelance photos/year. Flowers (no close-ups), scenics, animals, still life, Oriental motif, musical instruments, Americana, hand-colored and *unique* imagery. Reviews stock photos. Model release required.
Making Contact & Terms: Send unsolicited photos or transparencies by mail for consideration. Uses any size color prints; 35mm, 2¼×2¼, 4×5 and 8×10 transparencies. Reports in 1-2 weeks. Royalty 5-10% on sales. Offers advances. Pays on publication. Buys exclusive product rights. Simultaneous submissions OK.
Tips: "Our needs constantly change, so we need diversity of imagery. We are especially interested in images with international appeal."

KOGLE CARDS, INC., 1498 S. Lipan St., Denver CO 80223. (303)698-9007. Fax: (303)698-9242. President: Patricia Koller. Send submissions Attn: Photo Director. Estab. 1982. Specializes in greeting cards and postcards for all business occasions.
Needs: Buys about 300 photos/year. Thanksgiving, Christmas and other holidays, also humorous. Submit seasonal material 9 months in advance. Reviews stock photos. Model release required.
Making Contact & Terms: Query with samples. Will work with color only. SASE. Reports in 4 weeks. NPI; works under royalty with no advance. "The photographer makes more that way." Monthly royalty check. Buys all rights; negotiable.

***LAJOHN DISTRIBUTORS**, 262 Beachview Ave., #3, Pacifica CA 94044. (415)359-6931. Fax: (415)359-6821. Owner: Lily Ann Hainline. Estab. 1985. Specializes in greeting cards, postcards, stationery, gift wrap.
Needs: Does not want nude or risqué. Reviews stock photos. Model/property release preferred.
Making Contact & Terms: Interested in receiving work from newer, lesser-known photographers. Query with samples. Uses 35mm, 4×5 transparencies. Keeps samples on file. SASE. Reports in 1-2 weeks. Pays in royalties. Pays on usage. Buys all and exclusive product rights; negotiable. Simultaneous submissions and previously published work OK.

LANDMARK CALENDARS, 51 Digital Dr., P.O. Box 6105, Novato CA 94948-6105. (415)898-8523. Fax: (415)883-6725. Contact: Photo Editor. Estab. 1979. Specializes in calendars. Photo guidelines free with SASE.
 • Images for this market must be super quality. In the next two years Landmark plans to implement digital pre-press of images and line art. They encourage freelancers to submit images on CD.
Needs: Buys/assigns 3,000 photos/year. Interested in scenic, nature, travel, sports, automobiles, collectibles, animals, food, people, miscellaneous. No nudes. "We accept *solicited* submissions only, from November through February two years prior to the calendar product year. Photos must be accompanied by our submission agreement, and be sent only within the terms of our guidelines." Reviews stock photos. Model/property release required especially when shooting models and photos containing trademarked property or logos. Captions required; include specific breed of animal, if any; specific location of scene (i.e. gray wolf, Kalispell, Montana).
Making Contact & Terms: Unsolicited submissions are not accepted. Send list of published credits and/or non-returnable samples. Will send guidelines if work fits our needs. Uses transparencies from 35mm to 8×10. Pays $50-200/photo depending on product. Pays in April of year preceding product year (i.e. would pay in April 1996 for 1997 product). Credit line given. Buys one-time and exclusive product rights, plus rights to use photo in sales material and catalogs. Previously published work OK.
Tips: Looks for "tack-sharp focus, good use of color, interesting compositions, correct exposures. Most of our calendars are square or horizontal, so work should allow cropping to these formats. For 35mm slides, film speeds higher than ASA 100 are generally unacceptable due to the size of the final image (up to 12×12)."

LOVE GREETING CARDS, INC., 1717 Opa Locka Blvd., Opa Locka FL 33054. (305)685-LOVE. Vice President: Norman Drittel. Specializes in greeting cards, postcards and posters.
Needs: Buys 75-100 photos/year. Nature, flowers, boy/girl (contemporary looks). Submit seasonal material 6 months in advance. Reviews stock photos. Model release preferred.
Making Contact & Terms: Query with samples or stock photo list. Send unsolicited photos by mail for consideration. Provide résumé, business card, brochure, flier or tearsheets to be kept on file for possible future assignments. Uses 5×7 or 8×10 color prints; 35mm, 2¼×2¼ and 4×5 transparencies; color contact sheets, color negatives. SASE. Reports in 1 month. Pays $75-150/color photo. Pays on publication. Credit line given. Buys exclusive product rights. Previously published work OK.
Tips: "We are looking for outstanding photos for greeting cards and New Age posters." There is a "larger use of photos in posters for commercial sale."

***MADISON PARK GREETINGS**, 1407 11th Ave., Seattle WA 98122-3901. (206)324-5711. Fax: (206)324-5822. Art Director: Mark Jacobsen. Estab. 1984. Specializes in greeting cards, stationery, gift wrap.

Needs: Buys 100 images annually; all supplied by freelancers. Offers 100 assignments annually. Interested in everyday greeting card images. Submit seasonal material 10 months in advance. Reviews stock photos. Model release required.
Making Contact & Terms: Interested in receiving work from newer, lesser-known photographers. Query with samples. Works with local freelancers on assignment only. Uses 4×5 transparencies; TIFF or EPS digital formats. Keeps samples on file. SASE. Reports in 6 weeks. Pays $350-500 flat fee or royalty on occasion. Pays on product release date. Credit line given. Buys exclusive product rights. Simultaneous submissions and previously published work OK.
Tips: "Send images appropriate for greeting cards. 50% of greeting card images are birthday related."

MARCEL SCHURMAN COMPANY, 2500 N. Watney Way, Fairfield CA 94533. (800)333-6724, ext. 3055 or (707)428-0200. Fax: (707)428-0641. Art Director: Maria Magistro. Estab. 1950. Specializes in greeting cards, stationery, gift wrap. Guidelines free with SASE.
Needs: Buys 75 images annually; all supplied by freelancers. Offers 50 assignments annually. Interested in humorous, seasonal, art/contemporary, some nature, still life. Submit seasonal material 1 year in advance. Does not want technical, medical, or industrial shots. Model/property release required. Captions preferred.
Making Contact & Terms: Interested in receiving work of newer photographers. Submit portfolio for review. Query with samples. Provide résumé, business card, self-promotion piece or tearsheets to be kept on file for possible future assignments. Works with local freelancers only. Uses 8×10, 11×14 matte b&w prints; 35mm, 2¼×2¼, 4×5 transparencies. Keeps samples on file. SASE. Reports in 6 weeks. Pays flat fee or royalties on sales in some cases. **Pays on acceptance.** Credit line given. Buys 3-5 year worldwide exclusive rights to greeting cards/gift wraps. Simultaneous submissions OK.
Tips: "In terms of greeting cards, I advise any interested artists to familiarize themselves with the company's line by visiting a retailer. It is the fastest and most effective way to know what kind of work the company is willing to purchase or commission. Photography, in all forms, is very marketable now, specifically in different areas of technique, such as hand-colored, sepia/etc. toning, Polaroid transfer, b&w art photography."

PALM PRESS, INC., 1442A Walnut St., Berkeley CA 94709. (510)486-0502. Fax: (510)486-1158. E-mail: palmpress@aol.com. Assistant Photo Editor: Theresa McCormick. Estab. 1980. Specializes in greeting cards.
Needs: Buys stock images from freelancers. Buys 200 photos/year. Wildlife, humor, nostalgia, unusual and interesting b&w and color, Christmas and Valentine. Does not want abstracts or portraits. Submit seasonal material 1 year in advance. Model/property release required. Captions required.
• Palm Press has received Louie Awards from the Greeting Card Association.
Making Contact & Terms: Query with résumé of credits. Query with samples. Uses b&w and color prints; 35mm transparencies. SASE. Reports in 2-3 weeks. NPI; pays royalty on sales. Credit line given. Buys one-time and exclusive worldwide product rights; negotiable.
Tips: Sees trend in increased use of "occasion" photos.

***PAPER ANIMATION DESIGN**, 33 Richdale Ave., Cambridge MA 02140. Phone/fax: (617)441-9600. Art Director: David Whittredge. Estab. 1993. Specializes in animated greeting cards and tridimensional paper promotional pieces.
Needs: Buys 150 images annually; supplied by freelancers or licensed from publishers. Offers 4 assignments annually. "We buy photos of animals, insects, toys and funny or endearing pets. We value color and clarity. Backgrounds are not used." Does not want landscapes. Reviews stock photos of animals, insects, toys. Property release preferred. Photo captions preferred (any information pertinent to the subject that cannot be obtained through standard fact-checking sources).
Making Contact & Terms: Interested in receiving work from newer, lesser-known photographers. Query with samples. Query with stock photo list. Provide résumé, business card, self-promotion piece or tearsheets to be kept on file for possible future assignments. Call. Uses all photo image media. Keeps samples on file. SASE. Reports in 3 weeks. Pays $100-450/color photo; $800-1,200/day. **Pays on acceptance.** Credit line given. Buys one-time, repeat use and exclusive product rights; negotiable. Simultaneous submissions and/or previously published work OK.
Tips: "I see more creative computer alterations of photographs used to enhance the message in specific applications. Stay focused on providing your clients with precisely the work that will make their product the best."

THE SUBJECT INDEX, located at the back of this book, can help you find publications interested in the topics you shoot.

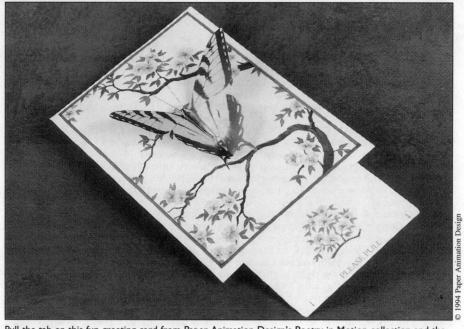

© 1994 Paper Animation Design

Pull the tab on this fun greeting card from Paper Animation Design's Poetry in Motion collection and the photo of a Tiger Swallowtail butterfly flutters as if it's the real thing. The butterfly's photo, taken by Wakefield, Massachusetts, photographer Bob Wilson (an expert on butterflies and employee of a butterfly farm) is attached to an illustrated floral background.

PHOTOFILE, P.O. Box 8138, Springfield MO 65801. Estab. 1994. Specializes in greeting cards, postcards, posters, calendars and photo art. Photo guidelines free with SASE.
Needs: Buys 100 photos/year. Interested in photos of sexy women in swimwear, sportswear, fashion, glamour, lingerie, boudoir, sensuous nude and semi-nude (no porn). Also needs hot car and motorcycle shots that include models; modern military jets, big game animals. Model/property release required.
Making Contact & Terms: Interested in receiving work from newer, lesser-known photographers. Query with samples. Send unsolicited material by mail for consideration. Send duplicate slides or prints. Do not send originals. Uses glossy b&w, color prints; 35mm, 2¼×2¼, 4×5 transparencies. SASE. Reports in 1 month. Pays $25-100/photo per thousand printed; payment negotiable. **Pays on acceptance**. Rights negotiable. Simultaneous submissions and previously published work OK.
Tips: "We need submissions from photographers who can provide consistant quality material."

PREFERRED STOCK, INC., 6667 W. Old Shakopee Rd., Suite 112, Bloomington MN 55438. (612)947-9319. Fax: (612)947-9322. Art/Production Director: Kevin Hughes. Estab. 1984. Specializes in gift wrap and gift totes.
Needs: Buys 4-5 images annually; 100% supplied by freelancers. Interested in floral, still life images for seasonal use—very few human and animal images. Does not want to see nudes. Reviews stock photos of still life and natural images. Property release required.
Making Contact & Terms: Interested in receiving work from newer, lesser-known photographers. Query with samples. Provide résumé, business card, self-promotion piece or tearsheets to be kept on file for possible future assignments. Works with local freelancers only. Uses 4×5 transparencies. Does not keep samples on file. SASE. Reports in 1 month. Pays $100-250/color photo. Pays on usage. Buys exclusive product rights; negotiable.
Tips: "Image must create immediate response. We are not interested in 'art' pieces that require thought."

***PUNKIN' HEAD PETS**, 1025 N. Central Expy., Suite 300-349, Plano TX 75075-8806. (214)491-2435. Owner: Lyn Skaggs. Estab. 1995. Specializes in greeting cards and gift wrap. Photo guidelines free.
Needs: Interested in cat and dog photos. Submit seasonal material 3 months in advance.
Making Contact & Terms: Interested in receiving work from newer, lesser-known photographers. Query with samples. Uses 3×5 (any finish) color prints; 4×5 transparencies. Keeps samples on file.

SASE. Reports in 1 month. Pays $20-50/color photo. Credit line given. Buys all rights; negotiable. Simultaneous submissions OK.

Tips: "Send cute and creative photos of cats and dogs. I do not want pictures with people in them."

***RENAISSANCE GREETING CARDS, INC.**, P.O. Box 845, Springvale ME 04083-0845. (207)324-4153. Fax: (207)324-9564. Photo Editor: Wendy Crowell. Estab. 1977. Photo guidelines free with SASE.

• Renaissance is doing more manipulation of images and adding of special effects.

Needs: Buys/assigns 25-50 photos/year. "We're interested in photographs that are artsy, quirky, nostalgic, dramatic, innovative and humorous. Special treatment such as hand-tinted b&w images are also of interest." No animals in clothing, risqué or religious. Reviews occur in November and June. Limit slides/images to less than 100 per submission. Reviews stock photos. Model release preferred. Captions required; include location and name of subject if animal or plant.

Making Contact & Terms: Interested in receiving work from newer, lesser-known photographers. Uses b&w 35mm, 2¼×2¼, 4×5 transparencies; b&w, color contact sheets. SASE. Reports in 2 months. Rates negotiable. Pays $175-350 flat fee/color or b&w photo, or $150 advance against royalties. Credit line given. Buys all rights or exclusive product rights; negotiable.

Tips: "We strongly suggest starting with a review of our guidelines, which indicate what we are looking for during the November and June submission reviews."

ROCKSHOTS, INC., 632 Broadway, New York NY 10012. Fax: (212)353-8756. Art Director: Bob Vesce. Estab. 1978. Specializes in greeting cards.

Needs: Buys 20-50 photos/year. Sexy (including nudes and semi-nudes), outrageous, satirical, ironic, humorous photos. Submit seasonal material at least 6 months in advance. Model release required.

Making Contact & Terms: Interested in receiving work from newer, lesser-known photographers, in addition to established, well-known photographers. Send SASE requesting photo guidelines. Provide flier and tearsheets to be kept on file for possible future assignments. Uses b&w and color prints; 35mm, 2¼×2¼ and 4×5 slides. "Do not send originals!" SASE. Reports in 8-10 weeks. Pays $50-125/b&w, $125-300/color photo; other payment negotiable. **Pays on acceptance.** Rights negotiable. Simultaneous submissions and previously published work OK.

Tips: Prefers to see "greeting card themes, especially birthday, Christmas, Valentine's Day. Remember, nudes and semi-nudes are fantasies. Models should definitely be better built than average folk. Also, have fun with nudity, take it out of the normal boundaries. It's much easier to write a gag line for an image that has a theme and/or props. We like to look at life with a very zany slant, not holding back because of society's imposed standards. We are always interested in adding freelance photography because it broadens the look of the line and showcases different points of view. We shoot extensively inhouse."

***SACRED MOUNTAIN ASHRAM**, 10668 Gold Hill Rd., Boulder CO 80302-9716. (303)459-3538 or 447-1637. Editor: Sita Stuhlmiller. Estab. 1974. Specializes in books and calendars.

• Also see listing for Truth Consciousness/Desert Ashram in the Book Publishers section of this book.

Needs: Buys/assigns 30-35 photos/year. Religious (universal); prayer/meditation. "Devotional and reverential mood plus spontaneity are important." Submit seasonal material 3 months in advance. Reviews stock photos. Model release preferred. Captions preferred.

Making Contact & Terms: Query with stock photo list. Uses b&w, color prints; 35mm, 2¼×2¼, 8×10 transparencies; color contact sheets; color negatives. SASE. Reports in 3 weeks. Pays $25-100/b&w; $50-200/color photo. "Rates are negotiable, depending on photograph and specific publication." **Pays on acceptance.** Credit line given. Buys one-time rights. Simultaneous submissions and previously published work OK.

Tips: Wants to see shots of "people in prayer or meditation."

SCANDECOR INC., 430 Pike Rd., Southampton PA 18966. (215)355-2410. Fax: (215)364-8737. Product Manager: Lauren H. Karp. Estab. 1972. Specializes in posters, framing prints, wall decor and calendars.

MARKET CONDITIONS are constantly changing! If you're still using this book and it's 1998 or later, buy the newest edition of *Photographer's Market* at your favorite bookstore or order directly from Writer's Digest Books.

Sharon Eide and Elizabeth Flynn of Novato, California, sent this image in a submission package to Renaissance Greeting Cards after reading about the company in *Photographer's Market* and sending for guidelines. "The image has a sweet innocence that we thought would have wide appeal," says Art Director Janice Keefe. "The photo is a perfect example of the re-awakening of spring, so we thought it would make a great Easter Card—and it does!" Eide and Flynn received a $125 advance with 5% royalties.

© Sharon Eide/Elizabeth Flynn. Courtesy of Renaissance Greeting Cards

Needs: Buys stock and assigns work. Buys 400 photos/year. Needs studio and wild animals, men and women, cute children, trendy subjects, marine animals, humorous images. Model/property release required. Captions preferred.

Making Contact & Terms: Query with samples. Uses color prints; 35mm, 2¼×2¼, 4×5, 8×10 transparencies. Samples not kept on file. SASE required for return of samples. Reports in 1 month. Pays $150 minimum/b&w photo; $250 minimum/color photo; $300 minimum/job. Pays upon usage. Credit line given. Buys exclusive product rights; negotiable. Simultaneous submissions and previously published work OK.

***SEABRIGHT PRESS**, P.O. Box 7285, Santa Cruz CA 95061. (408)457-1568. Photo Editor: Jim Thompson. Estab. 1990. Specializes in greeting cards.

Needs: Buys stock images from freelancers. Licenses 25-35 photos/year from freelancers. Southwestern US landscapes, seasonal images, Southern France scenics, still life and hand-tinted photographs. Submit seasonal material 6 months in advance. Model/property release preferred. Captions preferred.

Making Contact & Terms: Query with samples. Uses 4×6 glossy color prints; 35mm transparencies. SASE. Reports in 4-6 weeks. Pays 5-7% royalties on sales. Buys exclusive product rights; negotiable. Simultaneous submissions and previously published work OK.

SUNRISE PUBLICATIONS, INC., P.O. Box 4699, Bloomington IN 47402. (812)336-9900. Fax: (812)336-8712. Administrative Assistant for Artistic Resources: Amy Kellams. Estab. 1974. Specializes in greeting cards, posters, stationery. Photo guidelines free with SASE.

Needs: Buys approximately 30 images/year supplied by freelancers. Interested in interaction between people/children/animals evoking a mood/feeling, nature, endangered species (color or b&w photography). Does not want to see sexually suggestive or industry/business photos. Reviews stock photos. Model release required. Property release preferred.

Making Contact & Terms: Interested in receiving work from newer, lesser-known photographers. Submit portfolio for review. Works on assignment only. Uses 35mm; 4×5 transparencies. Keeps samples on file. Reports in 3 months. NPI. **Pays on acceptance.** Credit line given. Buys exclusive product rights; negotiable. Simultaneous submissions and previously published work OK.

Tips: "Look for Sunrise cards in stores; familiarize yourself with quality and designs before making a submission."

SYRACUSE CULTURAL WORKERS, Box 6367, Syracuse NY 13217. (315)474-1132. Research/ Development Director: Dik Cool. Art Director: Linda Malik. Specializes in posters, cards and calendars.
Needs: Buys 15-25 freelance photos/year. Images of social content, reflecting a consciousness of peace/social justice, environment, liberation, etc. Model release preferred. Captions preferred.
Making Contact & Terms: Interested in receiving work from newer, lesser-known photographers. Send unsolicited photos by mail for consideration. Uses any size b&w; 35mm, 2¼×2¼, 4×5 or 8×10 color transparencies. SASE. Reports in 2-4 months. Pays $75-100/b&w or color photo plus free copies of item. Credit line given. Buys one-time rights.
Tips: "We are interested in photos that reflect a consciousness of peace and social justice, that portray the experience of people of color, disabled, elderly, gay/lesbian—must be progressive, feminist, nonsexist. Look at our catalog (available for $1)—understand our philosophy and politics. Send only what is appropriate and socially relevant. We are looking for positive, upbeat and visionary work."

TELDON CALENDARS, A Division of Teldon International Inc., Box 8110, 800-250 H St., Blaine WA 98231-2107. (206)945-1211. Fax: (206)945-0555. Photo Editor: Monika Vent. Estab. 1968. Publishes high quality scenic and generic calendars. Photos used for one time use in calendars. Photo guidelines free with SASE (9×11) or stamps only for return postage.
• Teldon will start working on photo CD this year.
Needs: Buys 800-1,000 photos annually. Looking for travel (world), wildlife (North America), classic automobiles, golf, scenic North America photos and much more. Reviews stock photos. Model/property release required for residential houses, people. Photo captions required that include complete detailed description of destination, i.e., Robson Square, Vancouver, British Columbia, Canada. "Month of picture taken also required as we are 'seasonal driven.' "
Making Contact & Terms: Interested in receiving work from newer, lesser-known photographers. Query with stock photo list. Works with freelancers and stock agencies. Uses 35mm, 2¼×2¼, 4×5, 6×7, 8×10 horizontal only transparencies. "We are making duplicates of what we think is possible material and return the originals within a given time frame. Originals are recalled once final selection has been made." SASE. Reports in 1 month, depending on work load. Pays $100 for one-time use. Pays in September of publication year. Credit line and complementary calendar copies given. Simultaneous submissions and/or previously published works OK.
Tips: Horizontal transparencies only, dramatic and colorful nature/scenic/wildlife shots. City shots to be no older than one year. For scenic and nature pictures avoid "man made" objects, even though an old barn captured in the right moment can be quite beautiful. "Examine our catalogs and fliers carefully and you will see what we are looking for. Capture the beauty of nature and wildlife as long as it's still around—and that's the trend."

TIDE MARK PRESS, Box 280311, East Hartford CT 06128-0311. Editor: Scott Kaeser. Art Director: C. Cote. Estab. 1979. Specializes in calendars.
Needs: Buys 400-500 photos/year; few individual photos; all from freelance stock. Complete calendar concepts which are unique, but also have identifiable markets; groups of photos which could work as an entire calendar; ideas and approach must be visually appealing and innovative but also have a definable audience. No general nature or varied subjects without a single theme. Submit seasonal material in spring for next calendar year. Reviews stock photos. Model release preferred. Captions required.
Making Contact & Terms: "Contact us to offer specific topic suggestion which reflect specific strengths of your stock." Uses 35mm, 2¼×2¼, 4×5 and 8×10 transparencies. SASE. Reports in 1 month. Pays $125-150/color photo; royalties on sales if entire calendar supplied. Pays on publication or per agreement. Credit line given. Buys one-time rights.
Tips: "We tend to be a niche publisher and we rely on niche photographers to supply our needs."

***TORA INTERNATIONAL ASSOCIATES**, P.O. Box 1009, Southport CT 06490. (203)254-2451. Fax: (203)254-0579. Photo Editor: Ryan Tortora. Estab. 1970. Specializes in calendars, posters.
Needs: Buys 96 images annually; 100% supplied by freelancers. Offers 8 assignments annually. Interested in college-related, high school-related, sports, academics and semi-nudes and nudes. Submit seasonal material 2 years in advance. Reviews stock photos. Model/property release required. Captions required.
Making Contact & Terms: Interested in receiving work from newer, lesser-known photographers. Query with samples. Works with local freelancers only. Uses 8×10 color prints; 35mm, 2¼×2¼, 4×5 transparencies. Reports in 1 month. Pays $100/color photo. **Pays on acceptance.** Buys all rights.

***U.S. ALLEGIANCE, INC.**, P.O. Box 12000, Eugene OR 97440; 955 Overpark, Eugene OR 97401. (541)484-7250. Fax: (541)484-7279. E-mail: usa500@aol.com. Creative Director: Steve Crawford. Estab. 1981. Specializes in greeting cards and postcards.
• U.S. Allegiance is the largest publisher of military postcards in the United States.

© Howard Ande

"I've specialized in railroad photography ever since picking up a camera," says Streamwood, Illinois, photographer Howard Ande. This shot of a train emerging from a tunnel, which Ande submitted unsolicited, was used in a calender by Tidemark Press, for which he was paid $65. "There's a high demand for winter railroad photos," says Ande, who found Tidemark in *Photographer's Market.*

Needs: Buys 50 images annually; all supplied by freelancers. Interested in military, Korea, Germany, Japan, Okinawa. Reviews stock photos. Model release required. Captions required.

Making Contact & Terms: Interested in receiving work from newer, lesser-known photographers. Query with samples. Uses 5×7 glossy color prints; 35mm, 2¼×2¼, 4×5 transparencies. Does not keep samples on file. SASE. Reports in 1-2 weeks. Pays $100/color photo. Pays on usage. Credit line given. Buys exclusive product rights. Simultaneous submissions and/or previously published work OK.

VAGABOND CREATIONS, INC., 2560 Lance Dr., Dayton OH 45409. (513)298-1124. President: George F. Stanley, Jr. Specializes in greeting cards.

Needs: Buys 2 photos/year. Interested in general Christmas scenes . . . non-religious. Submit seasonal material 9 months in advance. Reviews stock photos.

Making Contact & Terms: Query with stock photo list. Uses 35mm transparencies. SASE. Reports in 1 week. Pays $100/color photo. **Pays on acceptance.** Buys all rights. Simultaneous submissions OK.

WEST GRAPHICS, 385 Oyster Point Blvd., Unit 7, South San Francisco CA 94080. (800)648-9378. Contact: Production Department. Specializes in humorous greeting cards. Photo guidelines free with SASE.

Needs: Buys 10-20 freelance photos/year. Humorous, animals, people in outrageous situations or anything of an unusual nature; prefers color. Does not want to see scenics. Submit seasonal material 1 year in advance. Model release required. Captions preferred; include model's/photographer's name.

Making Contact & Terms: Interested in receiving work from newer, cutting edge photographers. Query with samples. Send unsolicited photos by mail for consideration. Uses 8×10 b&w glossy prints; 35mm, 2¼×2¼ and 4×5 transparencies. Do not send originals. SASE. Reports in 6 weeks. Pays $50-300/color or b&w photo and/or 5% royalty on sales. Pays 30 days after publication. Buys exclusive product rights; negotiable. Simultaneous submissions and previously published work OK.

Tips: "Our goal is to publish cards that challenge the limits of taste and keep people laughing. Using the latest in computer graphic technology we can creatively combine photographic images with settings and objects from a variety of resources. Computers and scanners have expanded the range of photographs we accept for publication."

***WISCONSIN TRAILS**, Box 5650, Madison WI 53705. (608)231-2444. Photo Editor: Nancy Mead. Estab. 1960. Specializes in calendars (horizontal and vertical) portraying seasonal scenics, some books and activities from Wisconsin.

Needs: Buys 35 photos/issue. Needs photos of nature, landscapes, wildlife and Wisconsin activities. Makes selections in January for calendars, 6 months ahead for issues. Captions required.

Making Contact & Terms: Submit material by mail for consideration or submit portfolio. Uses 35mm, 2¼×2¼ and 4×5 transparencies. Reports in 1 month. Pays $25-100/b&w photo; $50-200/ color photo. Buys one-time rights. Simultaneous submissions OK "if we are informed, and if there's not a competitive market among them." Previously published work OK.

Tips: "Be sure to inform us how you want materials returned and include proper postage. Calendar scenes must be horizontal to fit 8½×11 format, but we also want vertical formats for engagement calendars. See our magazine and books and be aware of our type of photography. Submit only Wisconsin scenes."

Publications

There is no doubt that somewhere among the hundreds of listings in this section you can find a publication interested in your work. These magazines, newspapers and newsletters are too far ranging in style and content not to have viable markets for you. Some, such as *Life*, *Playboy* and *Vanity Fair* require more experience from freelancers, but many publications are willing to take a chance on an unknown talent. Your task is to find your niche. Find those markets that fit your style and might be interested in your photographs.

First, do your homework. This section consists of four main categories—Consumer Publications, Newspapers & Newsletters, Special Interest Publications and Trade Publications. Many of these listings offer photo guidelines and sample copies. Send for this information and use it to your advantage. Photo guidelines tell you what editors prefer in the way of formats and content. They might provide tips regarding upcoming needs and tell you when to drop off portfolios. Also, sample copies can give you a better indication of what the publication needs and they can show you how your work is likely to be presented.

Whenever possible try to get feedback regarding your work. If an editor hated the images in your portfolio, ask him why. Also, try not to take a love-it-or-leave-it attitude regarding your work. Be willing to accept criticism and learn from the suggestions of editors. However, if you ask for an assessment of your work and an editor gives you a vague response, be a little suspicious. There are times when editors are too busy and don't look at portfolios. Without being too confrontational, see if you can submit your portfolio again in the near future.

The important thing is to be persistent without being a pest. Sending a new promotional piece often can be enough to keep your name in the mind of an editor. Constant phone calls from freelancers often bother editors who may be working on deadlines and don't have time to talk. If you get on an editor's bad side your chances of making a sale or getting an assignment for that publication drastically decrease.

To make your search for markets easier, there is a Subject Index at the back of this book. This index is divided into 24 topics, and markets are listed according to the types of photographs they want to see. For example, if you shoot environmental photos there are numerous markets wanting to receive this type of material.

Every year we update all our listings to include new information, such as changes in photo needs, adjustments in pay rates, and replacement of old addresses with new ones. However, throughout the year some of this information can be found in photo industry newsletters and trade magazines. Addresses for these and other publications are located in the back of this book under Recommended Books & Publications.

Throughout this section you also will find bullets (●) inside some listings. These comments were written by the editor of *Photographer's Market* and they are designed to provide additional information about listings. The comments usually center on awards won by markets, design changes that have taken place, or specific submission requirements.

CONSUMER PUBLICATIONS

The consumer publications that follow make up the largest section in *Photographer's*

Market. This year there are more than 440 markets, 46 of which are new. If you want to work with these magazines you should realize that some of them are taking a good look at the way information is presented. For example, as the general public gets more acquainted with online networks, publishers are adopting such technology. Photos eventually will be viewed by editors on a computer screen rather than on a light table. Be prepared for such advances and do what you can to protect your copyright.

This section contains three interviews that should be extremely helpful to you. The subjects are major players in the magazine market and they know what you must do to sell your photos. To gain insight from photographers, we interviewed 1996 Magazine Photographer of the Year Eugene Richards (page 238) and *Sport's Illustrated* photographer John McDonough (page 293). From the editorial side, we have *Life* Picture Editor Barbara Baker Burrows (page 277).

When dealing with editors you will notice that many maintain strict fees. Photographers often consider editorial prices to be fairly low, so newcomers should not anticipate large sums for unsolicited photographs. If you are just beginning to build a client base, expect to pay your dues for awhile. Once you are established you will acquire photo assignments which pay more than standard stock fees.

If you feel an image is unique don't be afraid to ask for more money. Many editors and photographers report that they often see photographers losing income because they don't ask for it.

ACCENT ON LIVING, P.O. Box 700, Bloomington IL 61702. (309)378-2961. Fax: (309)378-4420. Editor: Betty Garee. Circ. 20,000. Estab. 1955. Quarterly magazine. Emphasizes successful disabled young adults (18 and up) who are getting the most out of life in every way and *how* they are accomplishing this. Readers are physically disabled individuals of all ages and socioeconomic levels and professions. Sample copy $3.50 with 5×7 SAE and 5 first-class stamps. Free photo/writers guidelines; enclose SASE.
Needs: Uses 40-50 photos/issue; 95% supplied by freelancers. Needs photos for Accent on People department, "a human interest photo column on disabled individuals who are gainfully employed or doing unusual things." Also uses occasional photo features on disabled persons in specific occupations: art, health, etc. Manuscript required. Photos depict handicapped persons coping with the problems and situations particular to them: how-to, new aids and assistive devices, news, documentary, human interest, photo essay/photo feature, humorous and travel. "All must be tied in with physical disability. We want essentially action shots of disabled individuals doing something interesting/unique or with a new device they have developed. Not photos of disabled people shown with a good citizen 'helping' them." Model release preferred. Captions preferred.
Making Contact & Terms: Interested in receiving work from newer, lesser-known photographers. Query first with ideas, get an OK, and send contact sheet for consideration. Uses glossy prints and color photos, transparencies preferred. Provide letter of inquiry and samples to be kept on file for possible future assignments. Cover is usually tied in with the main feature inside. SASE. Reports in 3 weeks. Pays $50-up/color cover; pays $15-up/color inside photo; pays $5-up/b&w inside photo. Pays on publication. Credit line given if requested. Previously published work OK.
Tips: "Concentrate on improving photographic skills. Join a local camera club, go to photo seminars, etc. We find that most articles are helped a great deal with *good* photographs—in fact, good photographs will often mean buying a story and passing up another one with very poor or no photographs at all." Looking for *good* quality photos depicting what article is about. "We almost always work on speculation."

ADVENTURE WEST MAGAZINE, P.O. Box 3210, Incline Village NV 89450. (702)832-3700. Fax: (702)832-1640. Editor: Marianne Porter. Circ. 165,000. Estab. 1992. Bimonthly magazine. Emphasizes travel and adventure in the 13 western states, including Hawaii, Alaska, Western Canada and Western Mexico. Sample copy free with 10×13 SAE and 11 first-class stamps. Photo guidelines free with SASE.
Needs: Uses 65-70 photos/issue; 100% supplied by freelancers. Needs photos of action, sports, animal/wildlife, scenics. Special photo needs include scuba/underwater, hiking, camping, biking, climbing, kayaking, sailing, caving, skiing. Property release preferred. Captions preferred; include where and what.
Making Contact & Terms: Interested in receiving work from newer, lesser-known photographers. Query with stock photo list. Send unsolicited photos by mail for consideration. Send 35mm color

transparencies. Keeps samples on file; "not originals but business cards and stock lists." SASE. Reports in 6 weeks. Pays $300/color cover photo; $35-100/color inside photo. Pays on publication. Credit line given. Buys one-time rights. Simultanous submissions OK.

Tips: "Always ask about payment before agreeing to send photos."

AFTER FIVE MAGAZINE, P.O. Box 492905, Redding CA 96049. (800)637-3540. Fax: (916)335-5335. Publisher: Craig Harrington. Monthly tabloid. Emphasizes news, arts and entertainment. Circ. 32,000. Estab. 1986. Sample copy $1.

Needs: Uses 8-12 photos/issue; 10% supplied by freelance photographers. Needs photos of scenics of northern California. Model release and captions preferred.

Making Contact & Terms: Provide résumé, business card, brochure, flier or tearsheets to be kept on file for possible assignments. Accepts digital images on disk or SyQuest 270MB. SASE. Reports in 1-2 weeks. Pays $50/color cover photo; $50/b&w cover photo; $20/b&w inside photo; $60/b&w page rate. Pays on publication. Credit line given. Buys one-time rights. Previously published work OK.

Tips: "Need photographs of subjects north of Sacramento to Oregon-California border, plus southern Oregon. Query first."

In this cover photo for *Accent on Living*, photographer Mike Matthews successfully conveys the idea "that people with disabilities can enjoy summer action sports." Kim Meyling, the skier in the photo (on a tri-ski rig), is quadriplegic. Matthews was paid $165 for use of the photo and an essay accompanying it. The image has been sold at least four times—to other magazines, for use on displays and for a calendar.

AIM MAGAZINE, P.O. Box 20554, Chicago IL 60620. (312)874-6184. Editor: Myron Apilado. Circ. 7,000. Estab. 1974. Quarterly magazine. Magazine dedicated to promoting racial harmony and peace. Readers are high school and college students, as well as those interested in social change. Sample copy for $4 with 9×12 SAE and 5 first-class stamps.

Needs: Uses 10 photos/issue. Needs "ghetto pictures, pictures of people deserving recognition, etc." Needs photos of "integrated schools with high achievement." Model release required.

Making Contact & Terms: Send unsolicited photos by mail for consideration. Send b&w prints. SASE. Reports in 1 month. Pays $25/color cover photo; $10/b&w cover photo. **Pays on acceptance.** Credit line given. Buys one-time rights. Simultaneous submissions OK.

Tips: Looks for "positive contributions."

ALABAMA LIVING, P.O. Box 244014, Montgomery AL 36124. (334)215-2732. Fax: (334)215-2733. Editor: Darryl Gates. Circ. 315,000. Estab. 1948. Publication of the Alabama Rural Electric Association. Monthly magazine. Emphasizes rural life and rural electrification. Readers are older males and females living in rural areas and small towns. Sample copy free with 9×12 SAE and 4 first-class stamps.

Needs: Uses 6-12 photos/issue; 1-3 supplied by freelancers. Needs photos of nature/wildlife, travel—southern region, some scenic and Alabama specific. Special photos needs include vertical scenic cover shots. Captions preferred; include place and date.

Making Contact & Terms: Interested in receiving work from newer, lesser-known photographers. Query with stock photo list or transparencies ("dupes are fine") in negative sleeves. Keeps samples on file. SASE. Reports in 1 month. Pays $40-50/color cover photo; $60-75/photo/text package. Pays on publication. Credit line given. Buys one-time rights; negotiable. Simultaneous submissions OK. Previously published work OK "if previously published out-of-state."

Alive Now! MAGAZINE, 1908 Grand Ave., P.O. Box 189, Nashville TN 37202. (615)340-7218. Associate Editor: Beth A. Richardson. Circ. 80,000. Estab. 1975. Bimonthly magazine published by The Upper Room. "*Alive Now!* uses poetry, short prose, photography and contemporary design to present material for personal devotion and reflection. It reflects on a chosen Christian concern in each issue. The readership is composed of primarily college-educated adults." Sample copy free with 6×9 SAE and 3 first-class stamps. Themes list free with SASE; photo guidelines available.

Needs: Uses about 25-30 b&w prints/issue; 90% supplied by freelancers. Needs b&w photos of "family, friends, people in positive and negative situations, scenery, celebrations, disappointments, ethnic minority subjects in everyday situations—Native Americans, Hispanics, Asian-Americans and African-Americans." Model release preferred.

Making Contact & Terms: Query with samples. Send 8×10 glossy b&w prints by mail for consideration. Send return postage with photographs. Submit portfolio for review. SASE. Reports in 6 months; "longer to consider photos for more than one issue." Pays $25-35/b&w inside photo; no color photos. Pays on publication. Credit line given. Buys one-time rights. Simultaneous and previously published submissions OK.

Tips: Looking for high reproduction, quality photographs. Prefers to see "a variety of photos of people in life situations, presenting positive and negative slants, happy/sad, celebrations/disappointments, etc. Use of racially inclusive photos is preferred."

ALLURE, 360 Madison Ave., New York, NY 10017. Prefers not to share information.

ALOHA, THE MAGAZINE OF HAWAII AND THE PACIFIC, P.O. Box 3260, Honolulu HI 96801. (808)593-1191. Fax: (808)593-1327. Assistant Editor: Joyce Akamine. Circ. 90,000. Estab. 1978. Bimonthly. Emphasizes culture, arts, history of Hawaii and its people. Readers are "affluent, college-educated people from all over the world who have an interest in Hawaii." Sample copy $2.95 with 9×11 SAE and 9 first-class stamps. Photo guidelines free with SASE.

Needs: Uses about 50 photos/issue; 90% supplied by freelance photographers. Needs "scenics, travel, people, florals, strictly about Hawaii. We buy primarily from stock. Assignments are rarely given and when they are, they are usually given to one of our regular local contributors. Subject matter must be Hawaiian in some way." Model release required if the shot is to be used for a cover. Captions required.

Making Contact & Terms: Interested in receiving work from newer, lesser-known photographers. Submit portfolio for review. Query with stock photo list. Send unsolicited photos by mail for consideration. Provide résumé, business card, brochure, flier or tearsheets. SASE. Reports in 3 weeks. Pays $25/b&w photo; $75/color transparency; $125/photo running across a two-page spread; $250/cover shot. Pays on publication. Credit line given. Buys one-time rights.

Tips: Prefers to see "a unique way of looking at things, and of course, well-composed images. Generally, we are looking for outstanding scenic photos that are not standard sunset shots printed in every Hawaii publication. We need to see that the photographer can use lighting techniques skillfully, and we want to see pictures that are sharp and crisp." Competition is fierce, and it helps if a photographer can first bring in his portfolio to show to our art director. Then the art director can give him ideas regarding our needs."

AMERICAN HORTICULTURIST, 7931 E. Boulevard Dr., Alexandria VA 22308. (703)768-5700. Fax: (703)768-7533. Editor: Kathleen Fisher. Circ. 25,000. Estab. 1927. Bi-monthly. 4-color. Emphasizes horticulture. Readers are advanced amateur gardeners. Sample copy $3. Photo guidelines free with SASE.

Needs: Uses 30-40 photos/issue; all supplied by freelancers. "Assignments are rare; 2-3/year for portraits to accompany profiles." Needs primarily close-ups of particular plant species showing detail. "We only review photos to illustrate a particular manuscript which has already been accepted." Sometimes uses seasonal cover shots. Model release preferred. Captions required, must include genus, species and/or cultivar names; "tulip" or "rose" is not enough. "We are science-based, not a garden design magazine."

Making Contact & Terms: Interested in receiving work from newer, lesser-known photographers. Query with list of stock photo subjects, photo samples. Provide résumé, business card, brochure, flier or tearsheets to be kept on file for possible future assignments or requests. SASE. Reports in 3 weeks. Pays $50-65/color inside photo; $100/cover photo. Pays on publication. Buys one-time rights.

Tips: Wants to see "ability to identify precise names of plants, clarity and vibrant color."

AMERICAN SKATING WORLD, 1816 Brownsville Rd., Pittsburgh PA 15210-3908. (412)885-7600. Fax: (412)885-7617. Managing Editor: H. Kermit Jackson. Circ. 15,000. Estab. 1981. Monthly tabloid. Emphasizes ice skating—figure skating primarily, speed skating secondary. Readers are figure skating participants and fans of all ages. Sample copy $3.25 with 8×12 SAE and 3 first-class stamps. Photo guidelines free with SASE.
Needs: Uses 20-25 photos/issue; 4 supplied by freelancers. Needs performance and candid shots of skaters and "industry heavyweights." Reviews photos with or without manuscript. Model/property release preferred for children and recreational skaters. Captions required; include name, locale, date and move being executed (if relevant).
Making Contact & Terms: Interested in receiving work from newer, lesser-known photographers. Query with résumé of credits. Keeps samples on file. SASE. Report on unsolicited submissions could take 3 months. Pays $25/color cover photo; $5/b&w inside photo. Pays 30 days after publication. Buys one-time rights color; all rights b&w; negotiable. Simultaneous submissions and/or previously published work OK.
Tips: "Pay attention to what's new, the newly emerging competitors, the newly developed events. In general, be flexible!" Photographers should capture proper lighting in performances and freeze the action instead of snapping a pose.

ARIZONA HIGHWAYS, 2039 W. Lewis Ave., Phoenix AZ 85009. Prefers not to share information.

ASTRONOMY, 21027 Crossroads Circle, Waukesha WI 53187. (414)796-8776. Fax: (414)796-1142. Photo Editor: David J. Eicher. Circ. 175,000. Estab. 1973. Monthly magazine. Emphasizes astronomy, science and hobby. Median reader: 40 years old, 85% male, income approximately $68,000/yr. Sample copy $3. Photo guidelines free with SASE.
Needs: Uses approximately 100 photos/issue; 70% supplied by freelancers. Needs photos of astronomical images. Model/property release preferred. Captions required.
Making Contact & Terms: Interested in receiving work from newer, lesser-known photographers. Send unsolicited photos by mail for consideration. Send 8×10 glossy color and b&w photos; 35mm, 2¼×2¼, 4×5, 8×10 transparencies. Keeps samples on file. SASE. Reports in 2 weeks. Pays $150/cover photo; $25 for routine uses. Pays on publication. Credit line given.

ATLANTA PARENT, 4330 Georgetown Square II, Suite 506, Atlanta GA 30338. (770)454-7599. Fax: (770)454-7699. Assistant to Publisher: Peggy Middendorf. Circ. 65,000. Estab. 1983. Monthly tabloid. Emphasizes parents, families, children, babies. Readers are parents with children ages 0-16. Sample copy $2.
Needs: Uses 4-8 photos/issue; all supplied by freelancers. Needs photos of babies, children in various activities, parents with kids. Model/property release required. Captions preferred.
Making Contact & Terms: Interested in receiving work from newer, lesser-known photographers. Query with stock photos or photocopies of photos. Send unsolicited photos by mail for consideration. Send 3×5 or 4×6 b&w prints. Keeps samples on file. SASE. Reports in 3 months. Pays $20-75/color photo; $20/b&w photo. Pays on publication. Credit line given. Buys one-time rights; negotiable. Simultaneous and/or previously published work OK.

ATLANTIC CITY MAGAZINE, Dept. PM, Box 2100, Pleasantville NJ 08232. (609)272-7900. Art Director: Michael Lacy. Circ. 50,000. Monthly. Sample copy $2 plus 4 first-class stamps.
Needs: Uses 50 photos/issue; all supplied by freelance photographers. Prefers to see b&w and color portraits in photographic essays. Model release required. Captions required.
Making Contact & Terms: Query with portfolio/samples. Cannot return material. Provide tearsheets to be kept on file for possible future assignments. Payment negotiable; usually $35-50/b&w photo; $50-100/color; $250-450/day; $175-300 for text/photo package. Pays on publication. Credit line given. Buys one-time rights.
Tips: "We promise only exposure, not great fees. We're looking for imagination, composition, sense of design, creative freedom and trust."

AUDUBON MAGAZINE, 700 Broadway, New York NY 10003. Prefers not to share information.

THE SUBJECT INDEX, located at the back of this book, can help you find publications interested in the topics you shoot.

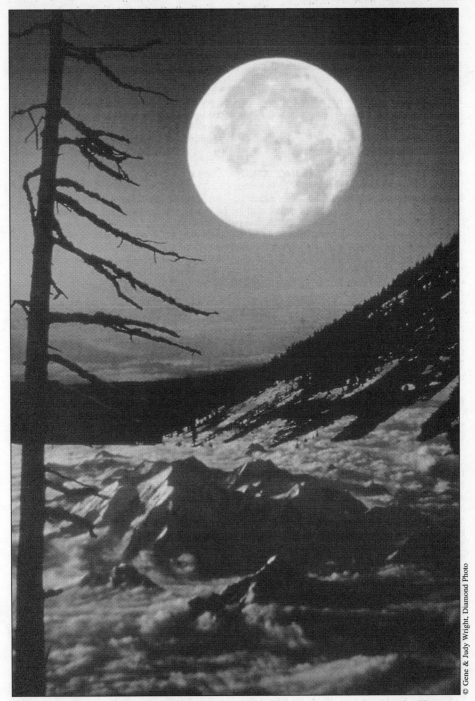

Gene and Judy Wright of Diamond Photo in Diamond, Illinois, were in the portrait business for 25 years before switching to slide film and submitting work to magazines and greeting card companies, with help from *Photographer's Market*. This image, which sold as an *Adventure West* magazine cover, is a triple exposure. "The tree and mountain to the right were taken in Washington, the moon was taken in Illinois, and the snow-covered mountains were taken from an airplane over Alaska," explain the Wrights.

***AUTOGRAPH COLLECTOR MAGAZINE**, 510-A S. Corona Mall, Corona CA 91719-1420. (909)734-9636. Fax: (909)371-7139. Editors: Bill Miller and Darrell Talbert. Circ. 5,000. Estab. 1986. Magazine published 12 times/year. Emphasizes autograph collecting. Readers are all ages and occupations. Sample copy $6.

Needs: Uses 30-40 photos/issue; all supplied by freelancers. Needs photos of "autograph collectors with collections, autographs and VIPs giving autographs, historical documents in museums, etc." Model/property release required. Photo captions preferred.

Making Contact & Terms: Interested in receiving work from newer, lesser-known photographers. Send unsolicited photos by mail for consideration. Provide résumé, business card, brochure, flier or tearsheets to be kept on file for possible assignments. Send 4×5, 8×10 glossy b&w or color prints. SASE. Reports in 3 weeks. NPI. Pays on publication. Credit line given. Buys first North American serial rights; negotiable. Simultaneous submissions OK.

AWARE COMMUNICATIONS INC., 2720 NW Sixth St., Suite A, Gainesville FL 32609-2931. (352)378-3879. Fax: (352)378-2481. Vice President-Creative: Scott Stephens. Publishes quarterly and annual magazines and poster. Emphasizes education—medical, pre-natal, sports safety and job safety. Readers are high school males and females, medical personnel, pregnant women, new home owners.

● This company produces numerous consumer publications: *Student Aware*, *Technology Education*, *Sports Safety*, *Medaware*, *New Homeowner*, *Help Yourself*, *Perfect Prom* and *Insect Protect!*.

Needs: Uses 20-30 photos/issue; 10% supplied by freelancers. Needs photos of medical, teenage sports and fitness, pregnancy and lifestyle (of pregnant mothers), home interiors. Model/property release required.

Making Contact & Terms: Interested in reviewing work from newer, lesser-known photographers. Submit portfolio for review. Send unsolicited photos by mail for consideration. Send 35mm, 2¼×2¼, 4×5, 8×10 transparencies. Keeps samples on file. SASE. Reports only when interested. Pays $400/ color cover photo; $100/color inside photo; $200-1,000/complete job. Pays on publication. Credit line given. Buys one time rights; negotiable. Simultaneous submissions and/or previously published work OK.

Tips: Looks for quality of composition and color sharpness. "Photograph people in all lifestyle situations."

BACK HOME IN KENTUCKY, P.O. Box 681629, Franklin TN 37068-1629. (615)794-4338. Fax: (615)790-6188. Editor: Nanci Gregg. Circ. 13,000. Estab. 1977. Bimonthly magazine. Emphasizes subjects in the state of Kentucky. Readers are interested in the heritage and future of Kentucky. Sample copy $3 with 9×12 SAE and 5 first-class stamps.

● This publication performs its own photo scans and has stored some images on Photo CD. "We have done minor photo manipulation of photos for advertisers."

Needs: Uses 25 photos/issue; all supplied by freelance photographers, less than 10% on assignment. Needs photos of scenic, specific places, events, people. Reviews photos solo or with accompanying ms. Also seeking vertical cover (color) photos. Special needs include winter, fall, spring and summer in Kentucky; Christmas; the Kentucky Derby sights and sounds. Model release required. Captions required.

Making Contact & Terms: Interested in receiving work from newer, lesser-known photographers. Send any size, glossy b&w and color prints, 35mm transparencies by mail for consideration. Reports in 2 weeks. Pays $10-25/b&w photo; $20-50/color photo; $50 minimum/cover photo; $15-100/text/ photo package. Pays on publication. Credit line given. Usually buys one-time rights; also all rights; negotiable. Simultaneous submissions and previously published work OK.

Tips: "We look for someone who can capture the flavor of Kentucky—history, events, people, homes, etc. Have a great story to go with the photo—by self or another."

BACKPACKER MAGAZINE, 135 N. Sixth St., Emmaus PA 18049. Prefers not to share information.

BALLOON LIFE, 2145 Dale Ave., Sacramento CA 95815. (916)922-9648. Fax: (916)922-4730. E-mail: 73232.1112@compuserve.com. Editor: Tom Hamilton. Circ. 4,000. Estab. 1986. Monthly magazine. Emphasizes sport ballooning. Readers are sport balloon enthusiasts. Sample copy free with 9×12 SAE and 6 first-class stamps. Photo guidelines free with #10 SASE.

● 95% of artwork is scanned digitally inhouse by this publication, then color corrected and cropped for placement.

Needs: Uses about 15-20 photos/issue; 90% supplied by freelance photographers on assignment. Needs how-to photos for technical articles, scenic for events. Model/property release preferred. Captions preferred.

Making Contact & Terms: Interested in receiving work from newer, lesser-known photographers. Send b&w or color prints; 35mm transparencies by mail for consideration. "We are now scanning our

own color and doing color separations in house. As such we prefer 35mm transparencies above all other photos." SASE. Reports in 1 month. Pays $50/color cover photo; $15-50/b&w or color inside photo. Pays on publication. Credit line given. Buys one-time and first North American serial rights. Simultaneous submissions and previously published work OK.

Tips: "Photographs, generally, should be accompanied by a story. Cover the basics first. Good exposure, sharp focus, color saturation, etc. Then get creative with framing and content. Often we look for one single photograph that tells readers all they need to know about a specific flight or event. We're evolving our coverage of balloon events into more than just 'pretty balloons in the sky.' I'm looking for photographers who can go the next step and capture the people, moments in time, unusual happenings, etc. that make an event unique. Query first with interest in sport, access to people and events, experience shooting balloons or other outdoor special events."

BASSIN', Dept. PM, 2448 E. 81st St., 5300 CityPlex Tower, Tulsa OK 74137-4207. (918)491-6100. Executive Editor: Mark Chesnut. Circ. 275,000 subscribers, 100,000 newsstand sales. Published 8 times/year. Emphasizes bass fishing. Readers are predominantly male, adult; nationwide circulation with heavier concentrations in South and Midwest. Sample copy $2.95. Photo guidelines free.

Needs: Uses about 50-75 photos/issue; "almost all of them" are supplied by freelance photographers. "We need both b&w and Kodachrome action shots of bass fishing; close-ups of fish with lures, tackle, etc., and scenics featuring lakes, streams and fishing activity." Captions required.

Making Contact & Terms: Query with samples. SASE. Reports in 6 weeks. Pays $400-500/color cover photo; $25/b&w inside photo; $75-200/color inside photo. Pays on publication. Credit line given. Buys first North American serial rights.

Tips: "Don't send lists—I can't pick a photo from a grocery list. In the past, we used only photos sent in with stories from freelance writers. However, we would like freelance photographers to participate."

✦BC OUTDOORS, 202-1132 Hamilton St., Vancouver, British Columbia V6B 2S2 Canada. (604)687-1581. Fax: (604)687-1925. Editor: Karl Bruhn. Circ. 42,000. Estab. 1945. Emphasizes fishing, both fresh water and salt; hunting; RV camping; wildlife and management issues. Published 8 times/year (January/February, March, April, May, June, July/August, September/October, November/December). Free sample copy with $2 postage.

Needs: Uses about 30-35 photos/issue; 99% supplied by freelance photographers on assignment. "Fishing (in our territory) is a big need—people in the act of catching or releasing fish. Hunting, canoeing and camping. Family oriented. By far most photos accompany mss. We are always on lookout for good covers—fishing, wildlife, recreational activities, people in the outdoors—vertical and square format, primarily of British Columbia and Yukon. Photos with mss must, of course, illustrate the story. There should, as far as possible, be something happening. Photos generally dominate lead spread of each story. They are used in everything from double-page bleeds to thumbnails. Column needs basically supplied inhouse." Model/property release preferred. Captions or at least full identification required.

Making Contact & Terms: Interested in receiving work from newer, lesser-known photographers. Send by mail for consideration actual 5×7 or 8×10 b&w prints; 35mm, 2¼×2¼, 4×5 or 8×10 color transparencies; color contact sheet. If color negative, send jumbo prints and negatives only on request. Query with list of stock photo subjects. SASE, Canadian stamps. Reports in 1-2 weeks normally. Pays $20-75/b&w photo; $25-200/color photo; and $250/cover photo. Pays on publication. Credit line given. Buys one-time rights inside; with covers "we retain the right for subsequent promotional use." Simultaneous submissions not acceptable if competitor; previously published work OK.

Tips: "We see a trend toward more environmental/conservation issues."

BEAUTY HANDBOOK: NATIONAL WOMEN'S BEAUTY MAGAZINE, 75 Holly Hill Lane, Third Floor, Greenwich CT 06830. (203)869-5553, ext. 305. Fax: (203)869-3971. Editor-in-Chief: Sara Fiedelholtz. Circ. 1.1 million. Quarterly magazine. Emphasizes beauty, health, fitness, hair, cosmetics, nails. Readers are female, ages 25-45, interested in improving appearance. Sample copy free with 9×12 SAE and 4 first-class stamps.

Needs: Uses 12-14 photos/issue; almost all supplied by freelancers. Needs photos of studio and natural setting shots of attractive young women. Model/property release preferred.

Making Contact & Terms: Interested in receiving work from newer, lesser-known photographers. Send unsolicited photos by mail for consideration. Contact through rep. Query with stock photo list. Send 8×10 glossy b&w or color prints; 35mm, 2¼×2¼, 4×5. Keeps samples on file. SASE. Reports in 2 weeks. Photographers must be willing to work for tearsheets only. Rights negotiable. Simultaneous submissions and previously published work OK.

BETTER NUTRITION, Argus Business, 6151 Powers Ferry Rd., Atlanta GA 30339-2941. (770)955-2500. Fax: (770)618-0348. Art Director: Scott Upton. Circ. 465,000. Monthly magazine. Emphasizes "health food, healthy people." Readers are 30-60. Sample copy or editorial calendar free with 9×12 SAE and 2 first-class stamps. Free guideline sheet with SASE.

Needs: Uses 8-10 photos/issue; 6 supplied by freelancers. Needs photos of "healthy people exercising (skiing, running, etc.), food shots, botanical shots." Model release preferred.
Making Contact & Terms: Interested in receiving work from newer, lesser-known photographers. Send unsolicited photos by mail for consideration. Send 35mm transparencies. SASE. Reports in 1 month. Pays $400/color cover photo; $150/color inside photo. Pays on publication. Credit line given. Buys one-time rights. Simultaneous submissions and previously published work OK.
Tips: "We are looking for photos of healthy people (all ages) usually in outdoor settings. We work on a limited budget, so do not send submissions if you cannot work within it. Review past issues for photo style."

BIBLICAL ARCHAEOLOGY SOCIETY, 4710 41st St. NW, Washington DC 20016. (202)364-3300. Fax: (202)364-2636. Contact: Lisa Josephson. Estab. 1975. Magazine. Emphasizes archaeology, Biblical subjects.
Needs: Needs photos of archaeology, Biblical. Captions preferred.
Making Contact & Terms: Interested in receiving work from newer, lesser-known photographers. Query with samples. Send 35mm, 2¼ × 2¼, 4 × 5 transparencies. Does not keep samples on file. SASE. Reports in 3 weeks. Pays $50-250/color inside photo; $25-100/b&w inside photo. Pays on publication. Buys one-time rights.

BIRD WATCHER'S DIGEST, Dept. PM, Box 110, Marietta OH 45750. (614)373-5285. Editor/ Photography and Art: Bill Thompson III. Circ. 99,000. Bimonthly. Emphasizes birds and bird watchers. Readers are bird watchers/birders (backyard and field, veterans and novices). Digest size. Sample copy $3.50.
Needs: Uses 25-35 photos/issue; all supplied by freelance photographers. Needs photos of North American species. For the most part, photos are purchased with accompanying ms.
Making Contact & Terms: Query with list of stock photo subjects and samples. SASE. Reports in 2 months. Pays $50-up/color inside. Pays on publication. Credit line given. Buys one-time rights. Previously published work in other bird publications should not be submitted.

***BLACK CHILD MAGAZINE,** Interrace Publications, P.O. Box 12048, Atlanta GA 30355. (404)364-9195. Fax: (404)364-9965. Associate Publisher: Gabe Grosz. Circ. 50,000. Estab. 1995. Bimonthly magazine. Emphasizes black children, with or without family, of heritage, birth to early teens. Also, transracial adoptees. Sample copies $2 with 9 × 12 SAE and 4 first-class stamps. Photo guidelines free with SASE.
 • *Black Child* was launched by Interrace Publications, publisher of *Child of Colors* also listed in this section.
Needs: Uses 15-20 photos/issue; 12-15 supplied by freelancers. Needs photos of children and their families. Must be of African-American heritage. Special photo needs include children playing, serious shots, schooling, athletes, arts, entertainment. Model/property release preferred. Captions preferred.
Making Contact & Terms: Interested in receiving work from newer, lesser-known photographers. Submit portfolio for review. Query with résumé of credits. Query with stock photo list. Send unsolicited photos by mail for consideration. Provide résumé, business card, brochure, flier or tearsheets to be kept on file for possible assignments. Send 3 × 5, 8 × 10 color or b&w prints; any transparencies. Keeps samples on file. SASE. Reports in 1 month or less. Pays $25/photo for less than ½ page; $35/ photo for ½ page-full page; $50/cover photo. Pays on publication. Credit line given. Buys one-time rights. Simultaneous submissions and/or previously published work OK.
Tips: "We're looking for kids in all types of settings and situations! Family settings are also needed."

BLUE RIDGE COUNTRY, P.O. Box 21535, Roanoke VA 24018. (540)989-6138. Art Director: Tim Brown. Circ. 70,000. Estab. 1988. Bimonthly magazine. Emphasizes outdoor scenics of Blue Ridge Mountain region. Readers are upscale couples, ages 30-70. Sample copy free with 9 × 12 SAE and 7 first-class stamps. Photo guidelines free with SASE.
Needs: Uses up to 20 photos/issue; all supplied by freelance photographers; 10% assignment and 90% freelance stock. Needs photos of travel, scenics and wildlife. Seeking more scenics with people in them. Future photo needs include themes of the Blue Ridge region. Model release preferred. Captions required.
Making Contact & Terms: Query with list of stock photo subjects. Send unsolicited photos by mail for consideration. Uses 35mm, 2¼ × 2¼, 4 × 5 transparencies. Also accepts digital images on Kodak

✱ THE ASTERISK before a listing indicates that the market is new in this edition. New markets are often the most receptive to freelance submissions.

CD. SASE. Reports in 2 months. Pays $100/color cover photo; $25/b&w photo; $25-50/color photo. Pays on publication. Credit line given. Buys one-time rights.

Tips: In photographer's samples looks for "photos of Blue Ridge region, color saturated, focus required and photo abilities. Freelancer should present him/herself neatly and organized."

***THE B'NAI B'RITH INTERNATIONAL JEWISH MONTHLY**, 1640 Rhode Island Ave. NW, Washington DC 20036. (202)857-6645. Fax: (202)296-1092. E-mail: jrubin@bnaibrith.org. Website: http://bnaibrith.org/ijm. Editor: Jeff Rubin. Circ. 200,000. Estab. 1886. Monthly magazine. Emphasizes Jewish religion, cultural and political concerns worldwide.

Needs: Buys 100 photos/year, stock and on assignment. Occasionally publishes photo essays.

Making Contact & Terms: Present samples and text (if available). SASE. Reports in 6 weeks. Pays $25-300/b&w or color photo (cover); $300/day; $100-500/photo/text package. Pays on publicaiton. Buys first serial rights.

Tips: "Be familiar with our format and offer suggestions or experience relevant to our needs." Looks for "technical expertise, ability to tell a story within the frame."

BODY, MIND & SPIRIT MAGAZINE, P.O. Box 701, Providence RI 02901. (401)351-4320. Fax: (401)272-5767. Publisher: Jim Valliere. Associate Publisher: Jane Kuhn. Circ. 150,000. Estab. 1982. Bimonthly. Focuses on spirituality, meditation, alternative healing, and the body/mind connection. Targeted to all who are interested in personal transformation and growth. Sample copy free with 9×12 SAE.

Needs: Uses 10-15 photos/issue. Photographs for different areas of magazine which include; natural foods, holistic beauty and skin care, alternative healing, herbs, meditation, spirituality, and the media section which includes; reviews of books, audio tapes, videos and music. "Photos should show creativity, depth of feeling, positive energy, imagination and a light heart." Model release required. Captions required.

Making Contact & Terms: Interested in receiving work from newer, lesser-known photographers. Query with samples/portfolio. Provide résumé, business card, brochure, price requirements if available, flier or tearsheets to be kept on file for possible future assignments. SASE. Reports in 3 months. Pays up to $150/b&w photo and up to $400/color photo. Pays on publication. Credit line given. Buys one-time rights. Previously published work OK.

BODYBOARDING MAGAZINE, 950 Calle Amanecer, Suite C, San Clemente CA 92673. (714)492-7873. Fax: (714)498-6485. E-mail: surfing@netcom.com. Photo Editor: Scott Winer. Bimonthly magazine. Emphasizes hardcore bodyboarding action and bodyboarding beach lifestyle photos and personalities. Readers are 15-24 years old, mostly males (96%). Circ. 40,000. Photo guidelines free with SASE.

Needs: Uses roughly 70 photos/issue; 50-70% supplied by freelancers. Needs photos of hardcore bodyboarding action, surf lineups, beach scenics, lifestyles and bodyboarding personalities. Special needs include bodyboarding around the world; foreign bodyboarders in home waves, local beach scenics.

Making Contact & Terms: Send unsolicited photos by mail for consideration. Uses 35mm and 2¼×2¼ transparencies; b&w contact sheets & negatives. SASE. Reports in 2 weeks. Pays $20-110/b&w photo; $20-575/color photo; $575/color cover photo; $40/b&w page rate; $110/color page rate. Pays on publication. Credit line given. Buys one-time rights.

Tips: "We look for clear, sharp, high-action bodyboarding photos preferably on Fuji Velvia 50. We like to see a balance of land and water shots. Be able to shoot in not so perfect conditions. Be persistent and set high standards."

BOSTONIA MAGAZINE, 10 Lenox St., Brookline MA 02146. (617)353-9711. Editor: Jerrold Hickey. Art Director: Doug Parker. Circ. 150,000. Estab. 1900. Quarterly. Sample copy $3.50.

Needs: Uses 100 photos/issue; many photos are supplied by freelance photographers. Works with freelance photographers on assignment only. Needs include documentary photos and international travel photos; photo essay/photo features and human interest; and possibly art photos presented in long portfolio sections. Also seeks feature articles on people and the New England area accompanied by photos. Model releases required. Captions required.

Making Contact & Terms: Provide résumé, brochure and samples to be kept on file for possible future assignments. Call for appointment or send photos by mail for consideration; send actual 5×7 b&w glossies for inside. SASE. Reports in 2 weeks. Pays $50-400 for b&w photo; $300-600/color photo; 10¢/word or flat fee (depending on amount of preparation) for feature articles. **Pays on acceptance.** Credit line given. Buys all rights. No simultaneous submissions or previously published work.

BOW & ARROW HUNTING, 34249 Camino Capistrano, Box 2429, Capistrano Beach CA 92624. (714)493-2101. Fax: (714)240-8680. Editor: Jack Lewis. Circ. 150,000. Bimonthly magazine. For archers and bowhunters. "We emphasize bowhunting—with technical pieces, how-tos, techniques,

bowhunting tips, personality profiles and equipment tests." Writer's guidelines included with photo guidelines.

Needs: "We buy approximately 4 text/photo packages per issue." Technical pieces, personality profiles, humor, tournament coverage, how-to stories, bowhunting stories (with tips), equipment tests and target technique articles. Needs photos of animals (for bowhunting stories); celebrity/personality (if the celebrity is involved in archery); head shot ("occasionally used with personality profiles, but we prefer a full-length shot with the person shooting the bow, etc."); how-to (must be step-by-step); human interest; humorous; nature, travel and wildlife (related to bowhunting); photo essay/photo feature; product shot (with equipment tests); scenic (only if related to a story); sport (of tournaments); and sports news. "No snapshots (particularly color snapshots), and no photos of animals that were not hunted by the rules of fair chase." Photos purchased with accompanying ms; rarely without. Captions required; include location, species and month taken.

Making Contact & Terms: Interested in receiving work from newer, lesser-known photographers. Query with samples OK, but prefers to see completed material by mail on speculation. Uses 5×7 or 8×10 glossy color and b&w prints; 35mm or 2¼×2¼ transparencies. SASE. Reports in 4-6 weeks. Pays $50-300 for text/photo package or on a per-photo basis for photos without accompanying ms. **Pays on acceptance.** Credit line given. Buys one-time rights.

Tips: "Send us a good, clean manuscript with good-quality b&w glossies (our use of color is limited). Most cover shots are freelance. Review the magazine before you submit anything."

BOWHUNTER, 6405 Flank Dr., P.O. Box 8200, Harrisburg PA 17105. (717)657-9555. Editor: M.R. James. Publisher: Dave Canfield. Editorial Director: Richard Cochran. Circ. 200,000. Estab. 1971. Published 8 times/year. Emphasizes bow and arrow hunting. Sample copy $2. Writer's guidelines free with SASE.

Needs: Buys 50-75 photos/year. Scenic (showing bowhunting) and wildlife (big and small game of North America). No cute animal shots or poses. "We want informative, entertaining bowhunting adventure, how-to and where-to-go articles." Photos purchased with or without accompanying ms.

Making Contact & Terms: Send material by mail for consideration. Query with samples. SASE. Reports on queries in 2 weeks; on material in 6 weeks. Uses 5×7 or 8×10 glossy b&w and color prints, both vertical and horizontal format; 35mm and 2¼×2¼ transparencies, vertical format; vertical format preferred for cover. Pays $50-125/b&w photo; $75-250/color photo; $300/cover photo, occasionally "more if photo warrants it." **Pays on acceptance.** Credit line given. Buys one-time publication rights.

Tips: "Know bowhunting and/or wildlife and study several copies of our magazine before submitting any material. We're looking for better quality and we're using more color on inside pages. Most purchased photos are of big game animals. Hunting scenes are second. In b&w we look for sharp, realistic light, good contrast. Color must be sharp; early, late light is best. We avoid anything that looks staged; we want natural settings, quality animals. Send only your best, and if at all possible let us hold those we indicate interest in. Very little is taken on assignment; most comes from our files or is part of the manuscript package. If your work is in our files it will probably be used."

BOWLING MAGAZINE, 5301 S. 76th St., Greendale WI 53129. (414)423-3232. Fax: (414)421-7977. Editor: Bill Vint. Circ. 150,000. Estab. 1934. Publication of the American Bowling Congress. Bimonthly magazine. Emphasizes ten-pin bowling. Readers are males, ages 30-55, in a cross section of occupations. Sample copy free with 9×12 SAE and 5 first-class stamps. Photo guidelines free with SASE.

Needs: Uses 30-40 photos/issue; 5-10 supplied by freelancers. Needs photos of outstanding bowlers or human interest features. Model release preferred. Captions required.

Making Contact & Terms: Interested in receiving work from newer, lesser-known photographers. Provide résumé, business card, brochure, flier or tearsheets to be kept on file for possible assignments. Deadline discussed on case basis. SASE. Reports in 1-2 weeks. Pays $25-50/hour; $100-150/day; $50-150/job; $50-150/color cover photo; $25-50/color inside photo; $20-30/b&w inside photo; $150-300/photo/text package. **Pays on acceptance.** Credit line given. Buys all rights.

BOY'S LIFE, 1325 Walnut Hill Lane, Irving TX 75038. (214)580-2358. Fax: (214)580-2079. Photo Editor: Brian Payne. Circ. 1.3 million. Estab. 1910. Monthly magazine. General interest youth publication. Readers are primarily boys, ages 8-18. Photo guidelines free with SASE.

Needs: Uses 50-80 photos/issue; 99% supplied by freelancers. Needs photos of all categories. Captions required.

Making Contact & Terms: "We're interested in all photographers, but please do not send work." Arrange personal interview to show portfolio. Does not keep samples on file. Cannot return material. Reports in 3 weeks. NPI. Pays extra for electronic usage of images. Pays on acceptance or publication. Buys one-time rights. Previously published work OK.

Tips: "A portfolio shows me 20% of a person's ability. We use new people regularly. Show an ability to work quickly with people in tough situations. Learn and read our publications before submitting anything."

✦**BRIARPATCH**, 2138 McIntyre St., Regina, Sasketchewan S4P 2R7 Canada. (306)525-2949. Fax: (306)565-3430. Managing Editor: George Martin Manz. Circ. 2,000. Estab. 1973. Magazine published 10 times per year. Emphasizes Canadian and international politics, labor, environment, women, peace. Readers are left-wing political activists. Sample copy $3.
Needs: Uses 15-30 photos/issue; 15-30 supplied by freelancers. Needs photos of Canadian and international politics, labor, environment, women, peace and personalities. Model/property release preferred. Captions preferred; include name of person(s) in photo, etc.
Making Contact & Terms: Interested in receiving work from newer, lesser-known photographers. Query with stock photo list. Send unsolicited photos by mail for consideration. Do not send slides! Provide résumé, business card, brochure, flier or tearsheets to be kept on file for possible assignments. Send (minimum 3×5) color and b&w prints. Keeps samples on file. SASE. Reports in 1 month. "We cannot pay photographers for their work since we do not pay any of our contributors (writers, photo, illustrators). We rely on volunteer submissions. When we publish photos, etc., we send photographer 5 free copies of magazine." Credit line given. Buys one-time rights. Simultaneous submissions and previously published work OK.
Tips: "We keep photos on file and send free magazines when they are published."

BRIDE'S & YOUR NEW HOME, 140 E. 45th St., New York NY 10017. (212)880-8530. Fax: (212)880-8331. Art Director: Phyllis Richmond Cox. Produced by Conde Nast Publications. Bimonthly magazine. Emphasizes bridal fashions, home furnishings, travel. Readers are mostly female, newly engaged; ages 21-35.
Needs: Needs photos of home furnishings, tabletop, lifestyle, fashion, travel. Model release required.
Making Contact & Terms: Interested in receiving work from newer, lesser-known photographers. Submit portfolio for review. Provide résumé, business card, brochure, flier or tearsheets to be kept on file for possible assignments. Keeps samples on file. SASE. Reports in 3 weeks. NPI. Pays after job is complete. Credit line given. Buys one-time rights, all rights; negotiable.

BRIGADE LEADER, P.O. Box 150, Wheaton IL 60189. (708)665-0630. Fax: (708)665-0372. Managing Editor: Deborah Christensen. Art Director: Robert Fine. Circ. 9,000. Estab. 1959. Quarterly 2-color magazine for Christian men. Seeks "to make men aware of their leadership responsibilities toward boys in their families, churches and communities." Sample copy $1.50 with 9×12 SAE and 4 first-class stamps. Photo guidelines free with SASE.
Needs: Buys 2-7 photos/issue; 50% freelance photography/issue comes from assignment and 50% from freelance stock. Needs photos of men at work, camping with their sons, with boys in sports, recreation and hobbies.
Making Contact & Terms: Interested in receiving work from newer, lesser-known photographers. Send 8×10 photos or photocopies for consideration. Reports in 6 weeks. Pays $50-100/inside b&w photo; $75-100/b&w cover photo. Pays on publication. Buys one-time rights. Simultaneous submissions and previously published work OK.
Tips: "Study the magazine before submitting. Submit sharp photos with good contrast; 8×10 prints preferred."

BRITISH CAR, Dept. PM, P.O. Box 1683, Los Altos CA 94023-1683. (415)949-9680. Fax: (415)949-9685. Editor: Gary G. Anderson. Circ. 30,000. Estab. 1985. Bimonthly magazine. Publication for owners and enthusiasts of British motor cars. Readers are US citizens, male, 40 years old and owners of multiple cars. Sample copy $5. Photo guidelines free for SASE.
Needs: Uses 100 photos/issue; 50-75% (75% are b&w) supplied by freelancers. "Photos with accompanied manuscripts required. However, sharp uncluttered photos of different British marques may be submitted for file photos to be drawn on as needed." Photo captions required that include description of vehicles, owner's name and phone number, interesting facts, etc.
Making Contact & Terms: Send unsolicited photos by mail for consideration. Send 5×7 and larger b&w prints. Does not keep samples on file unless there is a good chance of publication. SASE. "Publisher takes all reasonable precautions with materials, however cannot be held liable for damaged or lost photos." Reports in 6-8 weeks. Pays $25-100/color inside photo; $10-35/b&w inside photo. Payment negotiable, however standard rates will be paid unless otherwise agreed in writing prior to publication." Pays on publication. Buys world rights; negotiable.
Tips: "Find a journalist to work in cooperation with."

BUGLE MAGAZINE, P.O. Box 8249, Missoula MT 59807-8249. (406)523-4573. Fax: (406)523-4550. Photo Coordinator: Mia McGreevey. Circ. 200,000. Estab. 1984. Publication of the Rocky Mountain Elk Foundation. Quarterly magazine. Nonprofit organization that specializes in elk, elk

habitat and hunting. Readers are 98% hunters, both male and female; 54% are 35-54; 48% have income over $50,000. Sample copy $5. Photo guidelines free with SASE.

Needs: Uses 50 photos/issue; all supplied by freelancers. "*Bugle* editor sends out quarterly letter requesting specific images for upcoming issue." Model/property release required. Captions preferred; include name of photographer, location of photo, information on what is taking place.

Making Contact & Terms: Interested in receiving work from newer, lesser-known photographers. Send unsolicited photos by mail for consideration. Send 3×5 glossy prints; 35mm, 2¼×2¼, 4×5 transparencies. Deadlines: February 8 for summer issue; May 3 for fall issue; August 2 for winter issue; November 1 for spring issue. Does not keep samples on file. SASE. Reports in 1-2 weeks. Pays $250/cover photo; $150/spread; $100/full-page; $50/half page. Pays on publication. Credit line given. Rights negotiable. Previously published work OK.

Tips: "We look for high quality, unusual, dramatic and stimulating images of elk and other wildlife. Photos of elk habitat and elk in unique habitat catch our attention, as well as those depicting specific elk behavior. We are also interested in habitat project photos involving trick tanks, elk capture and release, etc. And images showing the effects of human development on elk habitat. Outdoor recreation photos are also welcome. Besides *Bugle* we also use images for billboards, brochures and displays. We work with both amateur and professional photographers, with the bulk of our editorial material donated."

BUSINESS IN BROWARD, P.O. Box 7375, Ft. Lauderdale FL 33338-7375. (305)563-8805. Publisher: Sherry Friedlander. Circ. 30,000. Estab. 1986. Magazine published 8 times/year. Emphasizes business. Readers are male and female executives, ages 30-65. Sample copy $4.

● This company also publishes *Broward Realtors®*.

Needs: Uses 30-40 photos/issue; 75% supplied by freelancers. Needs photos of local sports, local people, ports, activities and festivals. Model/property release required. Photo captions required.

Making Contact & Terms: Contact through rep. Submit portfolio for review. Reports in 2 weeks. Pays $150/color cover photo; $75/color inside photo. Pays on publication. Buys one-time rights; negotiable. Previously published work OK.

Tips: "Know the area we service."

BUSINESS PHILADELPHIA, 260 S. Broad St., 3rd Floor, Philadelphia PA 19102. (215)735-6969. Fax: (215)735-6965. Design Director: Nicole Ruhl. Monthly magazine. Emphasizes business through the eyes of business people. Readers are CEO's, presidents, vice presidents and other top-level business executives.

Needs: Uses 10-15 photos/issue; 5-10 supplied by freelancers. Needs portrait photos, studio and location shots and still lifes. Reviews photos with or without a manuscript. Model release preferred.

Making Contact & Terms: Interested in receiving work from newer, lesser-known photographers. Submit portfolio for review. Provide résumé, business card, brochure, flier or tearsheets to be kept on file for possible assignments. Keeps samples on file. Reports in 1-2 weeks. Pays $75-200/job; $100-200/feature story, plus expenses. Pays 30 days after acceptance. Credit line given. Buys one-time rights; negotiable. Previously published work OK.

Tips: "Photographers should work well with CEOs, presidents and other executives whose portraits they are taking, while providing unique and avante-garde concepts or styles to their photographs. While we do not offer much monetarily, *Business Philadelphia* offers photographers opportunities to experiment and create more artistic images than most business publications. Photographers should base the worth of an assignment using the amount of artistic control they have, as well as the dollar amounts being offered."

BUSINESS WEEK, 1221 Avenue of the Americas, 39th Floor, New York NY 10020-1001. Prefers not to share information.

CAGED BIRD HOBBYIST, 7-L Dundas Circle, Greensboro NC 27407-1645. (910)292-4047. Fax: (910)292-4272. Editor: Phyllis K. Martin. Bimonthly magazine plus one special issue printed annually. Emphasizes primarily pet birds, plus some feature coverage of birds in nature. Sample copy $5 and 9×12 SASE. Photo guidelines free with SASE.

Needs: Needs photos of pet birds. Special needs arise with story schedule. Write for photo needs list. Common pet birds are always in demand (cockatiels, parakeets, etc.) Captions required; include common and scientific name of bird; additional description as needed.

Making Contact & Terms: Interested in receiving work from newer, lesser-known photographers. Send unsolicited photos by mail for consideration. Query with stock photo list. We cannot assure liability for originals. Photographers may wish to send duplicates. Send 4×6, 8×10 glossy color prints; 35mm, 2¼×2¼ transparencies. Deadlines: 3 months prior to issue of publication. Keeps samples on file. SASE. Reports in 2 months. Pays $150-250/color cover photo; $25-50/color inside photo. Pays on publication. Buys all rights; negotiable.

Tips: "We are looking for pet birds primarily; although we do feature some wildlife/nature/conservation bird articles. We look for good composition (indoor or outdoor). Photos must be professional and of publication quality—in focus and with proper contrast. We work regularly with a few excellent freelancers, but are always on the lookout for new contributors. Because we are a bimonthly, we do need to retain submissions on file for at least a few months."

CALLIOPE, World History for Young People, Cobblestone Publishing, Inc., 7 School St., Peterborough NH 03458. (603)924-7209. Fax: (603)924-7380. Managing Editor: Denise L. Babcock. Circ. 10,500. Estab. 1990. Magazine published 5 times/year, September-May. Emphasis on non-United States history. Readers are children, ages 8-14. Sample copies $4.50 with 9×12 or larger SAE and 5 first-class stamps. Photo guidelines free with SASE.
Needs: Uses 40-45 photos/issue; 15% supplied by freelancers. Needs contemporary shots of historical locations, buildings, artifacts, historical reenactments and costumes. Reviews photos with or without accompanying ms. Model/property release preferred. Captions preferred.
Making Contact & Terms: Query with stock photo list. Send unsolicited photos by mail for consideration. Provide résumé, business card, brochure, flier or tearsheets to be kept on file for possible future assignments. Send b&w or color prints; 35mm transparencies. Samples kept on file. SASE. Reports in 1 month. Pays $15-100/inside b&w photo; cover (color) photo negotiated. Pays on publication. Credit line given. Buys one-time rights; negotiable. Simultaneous submissions and/or previously published work OK.
Tips: "Given our young audience, we like to have pictures which include people, both young and old. Pictures must be dynamic to make history appealing. Submissions must relate to themes in each issue."

✹CAMPUS CANADA, 287 MacPherson Ave., Toronto, Ontario M4V 1A4 Canada. (416)928-2909. Fax: (416)928-1357. Managing Editor: Sarah Moore. Circ. 125,000. Estab. 1983. Quarterly magazine. Emphasizes university students and lifestyle. Readers are primarily students 18-25. Free sample copy.
Needs: Uses 10 photos/issue; all supplied by freelancers. Needs photos of entertainment, travel, lifestyle, etc. Model release preferred.
Making Contact & Terms: Interested in receiving work from newer, lesser-known photographers. Query with résumé of credits. Keeps samples on file. SASE. Reports in 2 weeks. Pays on publication. Credit line given. Simultaneous submissions OK.

CAMPUS LIFE, 465 Gundersen Dr., Carol Stream IL 60188. Editor: Harold Smith. Art Director: Doug Johnson. Circ. 100,000. Estab. 1943. Bimonthly magazine. "*Campus Life* is a magazine for high school and college-age youth. We emphasize balanced living—emotionally, spiritually, physically and mentally." Sample copy $2. Photo guidelines free with SASE.
Needs: Buys 15 photos/issue; 10 supplied by freelancers, most are assigned. Head shots (of teenagers in a variety of moods); humorous, sport and candid shots of teenagers/college students in a variety of settings. "We look for diverse racial teenagers in lifestyle situations, and in many moods and expressions, at work, play, home and school. No travel, how-to, still life, travel scenics, news or product shots. Shoot for a target audience of 17-year-olds." Photos purchased with or without accompanying ms. Special needs include "Afro-American males/females in positive shots." Model/property release preferred for controversial stories. Captions preferred.
Making Contact & Terms: Interested in reviewing work from newer, lesser-known photographers. Submit portfolio for review. Query with résumé of credits. Provide brochure, tearsheets, résumé, business card or flier to be kept on file for possible assignments. Uses 6×9 glossy b&w prints and 35mm or larger transparencies. Keeps samples on file. SASE. Reports in 2 months. Pays $100-150/b&w photo; $100-300/color photo. Pays on publication. Credit line given. Buys one-time rights; negotiable. Simultaneous submissions and previously published work OK if marked as such.
Tips: "Look at a few issues to get a feel for what we choose. Ask for copies of past issues of *Campus Life*. Show work that fits our editorial approach. We choose photos that express the contemporary teen experience. We look for unusual lighting and color. Our guiding philosophy: that readers will 'see themselves' in the pages of our magazine." Looks for "ability to catch teenagers in real-life situations that are well-composed but not posed. Technical quality, communication of an overall mood or emotion or action."

✹CANADIAN RODEO NEWS, 2116 27th Ave. NE, #223, Calgary, Alberta T2E 7A6 Canada. (403)250-7292. Fax: (403)250-6926. Editor: P. Kirby Meston. Circ. 4,000. Estab. 1964. Monthly tabloid. Emphasizes professional rodeo in Canada. Readers are male and female rodeo contestants and

fans—all ages. Sample copy and photo guidelines free with SASE (9×12).

Needs: Uses 20-25 photos/issue; 3 supplied by freelancers. Needs photos of professional rodeo action or profiles. Captions preferred; include identity of contestant/subject.

Making Contact & Terms: Interested in receiving work from newer, lesser-known photographers. Send unsolicited photos by mail for consideration. Phone to confirm if usable. Send any color/b&w print. Keeps samples on file. SASE. Reports in 1 month. Pays $15/color cover photo; pays $10/color inside photo; pays $10/b&w inside photo; pays $60-70/photo/text package. Pays on publication. Credit line given. Rights negotiable. Simultaneous submissions and/or previously published work OK.

Tips: "Photos must be from or pertain to professional rodeo in Canada. Phone to confirm if subject/material is suitable before submitting. *CRN* is very specific in subject."

✦**CANADIAN YACHTING**, 395 Matheson Blvd. E., Mississauga, Ontario L4Z 2H2 Canada. (905)890-1846. Fax: (905)890-5769. Editor: Graham Jones. Circ. 15,800. Estab. 1976. Bimonthly magazine. Emphasizes sailing (no powerboats). Readers are mostly male, highly educated, high income, well read. Sample copy free with 9×12 SASE.

Needs: Uses 28 photos/issue; all supplied by freelancers. Needs photos of all sailing/sailing related (keelboats, dinghies, racing, cruising, etc.). Model/property release preferred. Captions preferred.

Making Contact & Terms: Interested in receiving work from newer, lesser-known photographers. Submit portfolio for review. Query with stock photo list. Send unsolicited photos by mail for consideration. Send transparencies. SASE. Reports in 1 month. Pays $150-250/color cover photo; $30-70/color inside photo; $30-70/b&w inside photo. Pays 60 days after publication. Buys one-time rights. Simultaneous submissions and previously published work OK.

CANOE & KAYAK, Dept. PM, P.O. Box 3146, Kirkland WA 98083. (206)827-6363. Fax: (206)827-1893. Editor: Jan Nesset. Circ. 63,000. Estab. 1973. Bimonthly magazine. Emphasizes a variety of paddle sports, as well as how-to material and articles about equipment. For upscale canoe and kayak enthusiasts at all levels of ability. Also publishes special projects/posters. Free sample copy with 9×12 SASE.

Needs: Uses 30 photos/issue: 90% supplied by freelancers. Canoeing, kayaking, ocean touring, canoe sailing, fishing when compatible to the main activity, canoe camping but not rafting. No photos showing disregard for the environment, be it river or land; no photos showing gasoline-powered, multi hp engines; no photos showing unskilled persons taking extraordinary risks to life, etc. Accompanying mss for "editorial coverage strives for balanced representation of all interests in today's paddling activity. Those interests include paddling adventures (both close to home and far away), camping, fishing, flatwater, whitewater, ocean kayaking, poling, sailing, outdoor photography, how-to projects, instruction and historical perspective. Regular columns feature paddling techniques, conservation topics, safety, interviews, equipment reviews, book/movie reviews, new products and letters from readers." Photos only occasionally purchased without accompanying ms. Model release preferred "when potential for litigation." Property release required. Captions are preferred, unless impractical.

Making Contact & Terms Interested in reviewing work from newer, lesser-known photographers. Query or send material. "Let me know those areas in which you have particularly strong expertise and/or photofile material. Send best samples only and make sure they relate to the magazine's emphasis and/or focus. (If you don't know what that is, pick up a recent issue first, before sending me unusable material.) We will review dupes for consideration only. Originals required for publication. Also, if you have something in the works or extraordinary photo subject matter of interest to our audience, let me know! It would be helpful to me if those with substantial reserves would supply indexes by subject matter." Uses 5×7 and 8×10 glossy b&w prints; 35mm, $2\frac{1}{4} \times 2\frac{1}{4}$ and 4×5 transparencies; color transparencies for cover; vertical format preferred. SASE. Reports in 1 month. Pays $300/cover color photo; $150/half to full page color photos; $100/full page or larger b&w photos; $75/quarter to half page color photos; $50/quarter or less color photos; $75/half to full page b&w photos; $50/quarter to half page b&w photos; $25/less than quarter b&w photos. NPI for accompanying ms. Pays on publication. Credit line given. Buys one-time rights, first serial rights and exclusive rights. Simultaneous submissions and previously published work OK, in noncompeting publications.

Tips: "We have a highly specialized subject and readers don't want just any photo of the activity. We're particularly interested in photos showing paddlers' *faces*; the faces of people having a good time. We're after anything that highlights the paddling activity as a lifestyle and the urge to be outdoors." All photos should be "as natural as possible with authentic subjects. We receive a lot of submissions from photographers to whom canoeing and kayaking are quite novel activities. These photos are often clichéd and uninteresting. So consider the quality of your work carefully before submission if you are not familiar with the sport. We are always in search of fresh ways of looking at our sport."

CAPE COD LIFE INCLUDING MARTHA'S VINEYARD AND NANTUCKET, P.O. Box 1385, Pocasset MA 02559-1385. Phone/fax: (508)564-4466. E-mail: capecod@capecodlife.com. Website: http://www.capecodlife.com. Publisher: Brian F. Shortsleeve. Circ. 35,000. Estab. 1979. Bimonthly magazine. Emphasizes Cape Cod lifestyle. "Readers are 55% female, 45% male, upper in-

come, second home, vacation homeowners." Sample copy for $3.75. Photo guidelines free with SASE.
Needs: Uses 30 photos/issue; all supplied by freelancers. Needs "photos of Cape and Island scenes, people, places; general interest of this area." Reviews photos with or without a ms. Model release required. Property release preferred. Photo captions required; include location. Reviews photos with or without a ms.
Making Contact & Terms: Interested in receiving work from newer, lesser-known photographers. Submit portfolio for review. Send unsolicited photos by mail for consideration. Send 35mm, 2¼×2¼, 4×5 transparencies. Keeps samples on file. SASE. Pays $225/color cover photo; $25-225/b&w/color photo, depending on size. Pays 30 days after publication. Credit line given. Buys one-time rights; reprint rights for *Cape Cod Life* reprints; negotiable. Simultaneous submissions and previously published work OK.
Tips: Looks for "clear, somewhat graphic slides. Show us scenes we've seen hundreds of times with a different twist and elements of surprise."

THE CAPE ROCK, Southeast Missouri State University, Cape Girardeau MO 63701. (314)651-2156. Editor-in-Chief: Harvey Hecht. Circ. 1,000. Estab. 1964. Emphasizes poetry and poets for libraries and interested persons. Semiannual. Free photo guidelines.
Needs: Uses about 13 photos/issue; all supplied by freelance photographers. "We like to feature a single photographer each issue. Submit 25-30 thematically organized b&w glossies (at least 5×7), or send 5 pictures with plan for complete issue. We favor a series that conveys a sense of place. Seasons are a consideration too: we have spring and fall issues. Photos must have a sense of place: e.g., an issue featuring Chicago might show buildings or other landmarks, people of the city (no nudes), travel or scenic. No how-to or products. Sample issues and guidelines provide all information a photographer needs to decide whether to submit to us." Model release not required "but photographer is liable." Captions not required "but photographer should indicate where series was shot."
Making Contact & Terms: Send by mail for consideration actual b&w photos. Query with list of stock photo subjects. Submit portfolio by mail for review. SASE. Reporting time varies. Pays $100 and 10 copies on publication. Credit line given. Buys "all rights, but will release rights to photographer on request." Returns unused photos.
Tips: "We don't make assignments, but we look for a unified package put together by the photographer. We may request additional or alternative photos when accepting a package."

CAR CRAFT MAGAZINE, 6420 Wilshire Blvd., Los Angeles CA 90048. (213)782-2320. Fax: (213)782-2263. Editor: Charles Schifsky. Circ. 500,000. Estab. 1953. Monthly magazine. Emphasizes street machines, muscle cars and modern, high-tech performance cars. Readership is mostly males, ages 18-34.
Needs: Uses 100 photos/issue. Uses freelancers occasionally; all on assignment. Model/property release required. Captions preferred.
Making Contact & Terms: Interested in receiving work from newer, lesser-known photographers. Query with résumé of credits. Provide résumé, business card, brochure, flier or tearsheets to be kept on file for possible assignments. Send 35mm and 8×10 b&w prints; 35mm and 2¼×2¼ transparencies by mail for consideration. SASE. Reports in 1 month. Pays $35-75/b&w photo; $75-250/color photo, cover or text; $60 minimum/hour; $250 minimum/day; $500 minimum/job. Payment for b&w varies according to subject and needs. Pays on publication. Credit line given. Buys all rights.
Tips: "We use primarily b&w shots. When we need something special in color or see an interesting color shot, we'll pay more for that. Review a current issue for our style and taste."

CAREER FOCUS, Dept. PM, 250 Mark Twain Tower, 106 W 11th St., Kansas City MO 64105. (816)221-4404. Fax: (816)221-1112. Circ. 250,000. Estab. 1988. Bimonthly magazine. Emphasizes career development. Readers are male and female African-American and Hispanic professionals, ages 21-45. Sample copy free with 9×12 SAE and 4 first-class stamps. Photo guidelines free with SASE.
Needs: Uses approximately 40 photos/issue. Needs technology photos and shots of personalities; career people in computer, science, teaching, finance, engineering, law, law enforcement, government, hi-tech, leisure. Model release preferred. Captions required; include name, date, place, why.
Making Contact & Terms: Query with résumé of credits and list of stock photo subjects. Keeps samples on file. SASE. Reports in 1 month. Pays $10-50/color photo; $5-25/b&w photo. Pays on publication. Credit line given. Buys one-time rights. Simultaneous submissions and previously published work OK.
Tips: "Freelancer must be familiar with our magazine to be able to submit appropriate manuscripts and photos."

CAREERS & COLLEGES MAGAZINE, 989 Avenue of Americas, New York NY 10018. (212)563-4688. Fax: (212)967-2531. Art Director: Michael Hofmann. Circ. 500,000. Estab. 1980. Biannual magazine. Emphasizes college and career choices for teens. Readers are high school juniors and seniors, male and female, ages 16-19. Sample copy $2.50 with 9×12 SAE and 5 first-class stamps.

INSIDER REPORT

Embrace the Serious Issues

When you talk with Eugene Richards you might be fooled into thinking that his soft-spoken demeanor is a sign of timidity. It's hard to comprehend how someone with such a mild disposition can become such a master at entering the lives of strangers to photograph serious social issues. What you might not immediately grasp is that these social issues have made him angry about injustices in the world. Angry enough to tackle projects that most people ignore.

Eugene Richards

© Paul Fusco. Magnum Photos Inc.

A native of Brooklyn, New York, Richards won the 1996 Magazine Photographer of the Year Award given out by the National Press Photographer's Association. He says his inconspicuous demeanor is key to being a good journalist. It's what allows him into the homes of hardcore drug addicts, some even willing to trade sex for drugs (see his book *Cocaine True, Cocaine Blue*, published by Aperture). He takes us into a Denver emergency room to view the carnage of a failed life-saving effort (*The Knife and Gun Club: Scenes from an Emergency Room*, published by Grove/ Atlantic). He even shares with us the struggle of his former mate, Dorothea Lynch, as she comes to terms with having breast cancer and becomes politically active despite the disease (*Exploding Into Life*, Aperture).

So what causes someone to tackle such heavy issues? "I don't think it's a choice," says Richards. "I see very little photography that's done of the more serious nature. I see a huge amount of violence in our media. I think people mistake that for seriousness. . . . In terms of really embracing the serious issues in any kind of depth, I think there's very little that's done."

To cover subjects as he believes they should be covered, Richards spends approximately a third of his time on book projects. However, "books are a love, not an income," he says. The remainder of his time is spent shooting editorial assignments for such top magazines as *Life*, *The New York Times Magazine* and *The London Telegraph*. He also occasionally completes advertising jobs for clients such as Levi Strauss and Nike.

A graduate of Northeastern University and former student of Minor White, Richards developed a taste for documenting social issues in 1968 when he became a health advocate for VISTA in eastern Arkansas. He documented life there and, in 1973, published his first book *Few Comforts or Surprises: The Arkansas Delta*.

In all his stories is an intimacy between Richards and his subjects reminiscent of such masters as Walker Evans, Gordon Parks and Mary Ellen Mark. Richards's closeness to subjects is genuine, but often there are twinges of discomfort. "I'm

INSIDER REPORT, *Richards*

put in the position where most of the time I feel like I'm intruding. It's a very uncomfortable feeling." However, he doesn't back off. It's his job to tell a story.

Experience in covering such difficult issues has taught Richards plenty. He covers stories as assigned, but he also stretches the limits to give editors more than they expect. "Any editor is going to test you out and see if you can produce. The better you are at production, the more you're trusted. It's as simple as that."

Richards estimates that 50 percent of his magazine assignments are his own ideas, while the rest are generated by editors. He finds that reading newspapers helps him uncover new ideas. He adds that aspiring photographers should not anticipate unlimited budgets and lengthy magazine assignments. Those days are gone. Instead, photographers should expect about two weeks to complete most assignments.

When Richards is on an assignment he prefers a straightforward approach. In some cases—for instance his coverage of the drug scene in a Brooklyn housing project called Red Hook—being upfront is the only way to gain access. "You know why Red Hook worked? Red Hook worked because we (Richards and *Life*

© Eugene Richards

For his book *Cocaine True, Cocaine Blue,* Eugene Richards entered the lives of hardcore drug addicts to find out how they survive day by day. Like many of his projects, the book examines a serious issue that other photographers might shy away from. "I see very little photography that's done of the more serious nature. I see a huge amount of violence in our media. I think people mistake that for seriousness," he says.

Needs: Uses 4 photos/issue; 80% supplied by freelancers. Needs photos of teen situations, study or career related, some profiles. Model release preferred. Property release required. Captions preferred. **Making Contact & Terms:** Interested in receiving work from newer, lesser-known photographers. Send tearsheets and promo cards. Keeps samples on file. SASE. Reports in 3 weeks. Pays $800-1,000/ color cover photo; $350-450/color inside photo; $600-800/color page rate. **Pays on acceptance.** Credit line given. Buys one-time rights; negotiable. **Tips:** "Must work well with teen subjects, hip, fresh style, not too corny. Promo cards or packets work the best, business cards are not needed unless they contain your photography."

CARIBBEAN TRAVEL AND LIFE MAGAZINE, 8403 Colesville Rd., #830, Silver Spring MD 20910. (301)588-2300. Fax: (301)588-2256. Production/Photo Editor: Sara Perez. Circ. 125,000. Estab. 1985. Published bimonthly. Emphasizes travel, culture and recreation in islands of Caribbean, Bahamas and Bermuda. Readers are male and female frequent Caribbean travelers, age 32-52. Sample copy $4.95. Photo guidelines free with SASE. **Needs:** Uses about 100 photos/issue; 90% supplied by freelance photographers: 10% assignment and 90% freelance stock. "We combine scenics with people shots. Where applicable, we show interiors, food shots, resorts, water sports, cultural events, shopping and wildlife/underwater shots." Special needs include "cover shots—attractive people on beach; striking images of the region, etc." Captions preferred. "Provide thorough caption information. Don't submit stock that is mediocre." **Making Contact & Terms:** Query with list of stock photo subjects. Uses 4-color photography. SASE. Reports in 3 weeks. Pays $400/color cover photo; $150/color full page; $125/color ¾ page; $100/color ½ page and $75/color ¼ page; $75-400/color photo; $1,200-1,500 per photo/text package. Pays after publication. Buys one-time rights. Does not pay research or holding fees. **Tips:** Seeing trend toward "fewer but larger photos with more impact and drama. We are looking for particularly strong images of color and style, beautiful island scenics and people shots—images that are powerful enough to make the reader want to travel to the region; photos that show people doing things in the destinations we cover; originality in approach, composition, subject matter. Good composition, lighting and creative flair. Images that are evocative of a place, creating story mood. Good use of people. Submit stock photography for specific story needs, if good enough can lead to possible assignments. Let us know exactly what coverage you have on a stock list so we can contact you when certain photo needs arise."

CAROLINA QUARTERLY, Greenlaw Hall, CB#3520, University of North Carolina, Chapel Hill NC 27599-3520. Editor: Amber Vogel. Circ. 1,500. Estab. 1948. Emphasizes "current poetry, short fiction." Readers are "literary, artistic—primarily, though not exclusively, writers and serious readers." Sample copy $5. **Needs:** Sometimes uses 1-8 photos/issue; all supplied by freelance photographers from stock. Often photos are chosen to accompany the text of the magazine. **Making Contact & Terms:** Interested in receiving work from newer, lesser-known photographers. Send b&w prints by mail for consideration. SASE. Reports in 3 months, depending on deadline. NPI. Credit line given. Buys one-time rights.

Tips: "Look at a recent issue of the magazine to get a clear idea of its contents and design."

CASINO PLAYER, Bayport One, 8025 Black Horse Pike, Suite 470, West Atlantic City NJ 08232. Photo Editor: Rick Greco. Circ. 200,000. Estab. 1988. Monthly magazine. Emphasizes casino gambling. Readers are frequent gamblers, age 35 and up. Sample copy free with 9×12 SAE and $2 postage.
Needs: Uses 40-60 photos/issue; 5 supplied by freelancers. Needs photos of casinos, gambling, casino destinations, money, slot machines. Reviews photos with or without ms. Model release required for gamblers. Captions required; include name, hometown, titles.
Making Contact & Terms: Interested in receiving work from newer, lesser-known photographers. Query with résumé of credits. Reports in 3 months. Pays $200/color cover photo; $40/color inside photo; $20/b&w inside photo. Pays on publication. Credit line given. Buys all rights; negotiable.
Tips: "Know the magazine before submission."

CAT FANCY, Fancy Publications, Inc., P.O. Box 6050, Mission Viejo CA 92690. (714)855-8822. Editor-in-Chief: Debbie Phillips-Donaldson. Circ. 303,000. Estab. 1965. Readers are "men and women of all ages interested in all phases of cat ownership." Monthly. Sample copy $5.50. Photo guidelines and needs free with SASE.
Needs: Uses 20-30 photos/issue; all supplied by freelancers. "For purebred photos, we prefer shots that show the various physical and mental attributes of the breed. Include both environmental and portrait-type photographs. We also need good-quality, interesting b&w and color photos of mixed-breed cats for use with feature articles and departments." Model release required.
Making Contact & Terms: Send by mail for consideration actual 8×10 b&w photos; 35mm or $2\frac{1}{4} \times 2\frac{1}{4}$ color transparencies. No duplicates. SASE. Reports in 8-10 weeks. Pays $35-100/b&w photo; $50-250/color photo; and $50-450 for text/photo package. Credit line given. Buys first North American serial rights.
Tips: "Nothing but sharp, high contrast shots, please. We prefer color photos and action shots to portrait shots. We look for photos of all kinds and numbers of cats doing predictable feline activities—eating, drinking, grooming, being groomed, playing, scratching, taking care of kittens, fighting, being judged at cat shows and accompanied by people of all ages."

CATHOLIC NEAR EAST MAGAZINE, 1011 First Ave., New York NY 10022-4195. Fax: (212)838-1344. Editor: Michael LaCività. Circ. 110,000. Estab. 1974. Bimonthly magazine. A publication of Catholic Near East Welfare Association, a papal agency for humanitarian and pastoral support. *Catholic Near East* informs Americans about the traditions, faiths, cultures and religious communities of Middle East, Northeast Africa, India and Eastern Europe. Sample copy and guidelines available with SASE.
Needs: 60% supplied by freelancers. Prefers to work with writer/photographer team. Evocative photos of people—not posed—involved in activities; work, play, worship. Also interested in scenic shots and photographs of art objects and the creation of crafts, etc. Liturgical shots also welcomed. Extensive captions required if text is not available.
Making Contact & Terms: Interested in receiving work from newer, lesser-known photographers. Query first. "Please do not send an inventory, rather, send a letter explaining your ideas." SASE. Reports in 3 weeks; acknowledges receipt of material immediately. Credit line given. "Credits appear on page 3 with masthead and table of contents." Pays $50-150/b&w photo; $75-300/color photo; $20 maximum/hour; $60 maximum/day. Pays on publication. Buys first North American serial rights. Simultaneous submissions and previously published work OK, "but neither is preferred. If previously published please tell us when and where."
Tips: Stories should weave current lifestyles with issues and needs. Avoid political subjects, stick with ordinary people. Photo essays are welcomed.

CATS MAGAZINE, P.O. Box 290037, Port Orange FL 32129. (904)788-2770. Fax: (904)788-2710. Editor: Tracey Copeland. Circ. 150,000. Estab. 1945. Monthly magazine. For cat enthusiasts of all types. Sample copy $3. Photo guidelines free with SASE.
Needs: Buys 50-60 photos/year; 70% of photography per issue is assigned; 30% from freelance. Felines of all types: photos depicting cats in motion and capturing feline expression are preferred; celebrities with their cats; head shots of cats; human interest on cats; humorous cats; feature photography; sport (cat shows); travel with cats; and wildlife (wild cats). No shots of clothed cats or cats doing tricks. Photos must not be over-propped (hats, bows, baskets, flowers etc.). Model/property release preferred. Photo captions preferred.
Making Contact & Terms: Submit sample photos to be kept on file for possible future assignments. Samples are reviewed upon arrival. Photos accepted are kept on file, the rest are returned. Send to Roy Copeland, Art Director. 35mm slides, $2\frac{1}{4} \times 2\frac{1}{4}$ or 4×5 transparencies are preferred for feature photos and cover. SASE. Reports in 2 months. Pays $200-250/cover; $75/breed of the month; $25-200/various other, depending on size. Pays on publication. Buys first serial rights.

Tips: Label material clearly with name, address, phone, and breed/name of cats. "Do not send oversized submissions. If purebred cats are used as subjects, they must be a high quality specimen of their breed. Photos must be clear, well composed and in focus. Our most frequent causes for rejection: not preferred format; out of focus; cat image too small; backgrounds cluttered; too posed; too many props; uninteresting; poor quality purebred cats; dirty or scruffy cats; shot wrong shape for cover (must be vertical); colors untrue; exposure incorrect. Cats should be portrayed in a realistic manner. Submit your specialty (ie: outdoor cat scenes, portraits or realistic shots)."

CD REVIEW, 86 Elm St., Peterborough NH 03458. (603)924-7271. Fax: (603)924-7013. Editor-in-Chief: Robert Baird. Circ. 100,000. Estab. 1984. Monthly magazine. Emphasizes music and music/audio industries. Readers are primarily male, 80% college educated, average age 34. Sample copy $3.95.
Needs: Uses 20 photos/issue; 5-10 supplied by freelancers. Needs photos of musicians, recording artists. Special photo needs include greater emphasis on topical, cutting edge musicians. Captions preferred; include names of all appropriate individuals.
Making Contact & Terms: Interested in receiving work from newer, lesser-known photographers. Query with résumé of credits. Send unsolicited photos by mail for consideration. Provide résumé, business card, brochure, flier or tearsheets to be kept on file for possible assignments. Send 35mm, 2¼×2¼, 4×5, 8×10 transparencies. Keeps samples on file. SASE. Reports in 1 month. NPI. Pays on publication. Credit line given. Buys one-time rights; negotiable.

***CHANGING MEN: Issues in Gender, Sex & Politics**, P.O. Box 3121, Kansas City KS 66103. (816)374-5969. Publisher: Frank Mauro. Estab. 1978. Triquarterly. Emphasizes men's issues, feminist, male politics, gay and heterosexual personal and political issues. Readers are anti-sexist men, feminists, gay and political activists. Circ. 8,000. Sample copy $7 (4-issue subscriptions $24).
Needs: Uses 6-8 photos/issue; all supplied by freelance photographers. Needs art photography: male body shots (not standard "nudes" or explicit sexual poses); non-stereotypical images of men at work, play, in social and emotional relationships, etc.; artistic compositions encouraged, as well as photojournalism. Special needs include features on all aspects of men's issues, AIDS, relationships with women, lives of men of all colors, men's health, gay issues, antiporn, third world masculinities, gender, spirituality, etc. Model release preferred.
Making Contact & Terms: Interested in receiving work from newer, lesser-known photographers. Query with list of sample relevant stock photo subjects. Send b&w prints (photocopies acceptable) and contact sheets. SASE. Reports in 2 months. Pays $10-25/b&w inside photo; $35-50/color covers; plus 2 sample copies. Pays after publication. Credit line given. Buys one-time rights.
Tips: "Display sensitivity to subject matter. Provide political photos showing conscience, strong journalism on pro-feminist and gay issues." In samples, wants to see "emotional content of image; non-stereotypical or strong statements about a man's situation or in relation to others around him; or humor/irony in 'changing' situations." To break in, shoot "well-composed images that stand on their own, by showing emotional feeling or mood or by making a statement."

CHARISMA MAGAZINE, 600 Rinehart Rd., Lake Mary FL 32746. (407)333-0600. Design Manager: Mark Poulalion. Circ. 200,000. Monthly magazine. Emphasizes Christians. General readership. Sample copy $2.50.
Needs: Uses approximately 20 photos/issue; all supplied by freelance photographers. Needs editorial photos—appropriate for each article. Model release required. Captions preferred.
Making Contact & Terms: Send unsolicited photos by mail for consideration. Provide brochure, flier or tearsheets to be kept on file for possible assignments. Send color 35mm, 2¼×2¼, 4×5 or 8×10 transparencies. Cannot return material. Reports ASAP. Pays $300/color cover photo; $150/b&w inside photo; $50-150/hour or $400-600/day. Pays on publication. Credit line given. Buys all rights; negotiable. Simultaneous submissions and previously published work OK.
Tips: In portfolio or samples, looking for "good color and composition with great technical ability. To break in, specialize; sell the sizzle rather than the steak!"

THE CHESAPEAKE BAY MAGAZINE, 1819 Bay Ridge Ave., Annapolis MD 21403. (410)263-2662, (DC)261-1323. Fax: (410)267-6924. Art Director: Christine Gill. Circ. 37,000. Estab. 1972. Monthly. Emphasizes boating—Chesapeake Bay only. Readers are "people who use Bay for recreation." Sample copy available.
 ● *Chesapeake Bay* has just become CD-ROM equipped and has begun to do corrections and manipulate photos inhouse.
Needs: Uses "approximately" 45 photos/issue; 60% supplied by freelancers; 40% by freelance assignment. Needs photos that are Chesapeake Bay related (must); vertical powerboat shots are badly needed (color). Special needs include "vertical 4-color slides showing boats and people on Bay."
Making Contact & Terms: Interested in reviewing work from newer, lesser-known photographers. Query with samples or list of stock photo subjects. Send 35mm, 2¼×2¼, 4×5 or 8×10 transparencies

by mail for consideration. SASE. Reports in 3 weeks. Pays $300/color cover photo; $25-75/b&w photo; $35-250/color photo; $150-1,000/photo/text package. Pays on publication. Credit line given. Buys one-time rights. Simultaneous submissions OK.

Tips: "We prefer Kodachrome over Ektachrome. Looking for: boating, bay and water-oriented subject matter. Qualities and abilities include: fresh ideas, clarity, exciting angles and true color. We're using larger photos—more double-page spreads. Photos should be able to hold up to that degree of enlargement. When photographing boats on the Bay—keep the 'safety' issue in mind. (People hanging off the boat, drinking, women 'perched' on the bow are a no-no!)"

CHICAGO BEAR REPORT, 112 Market St., Sun Prairie WI 53590. (608)837-5161. Fax: (608)825-3053. Managing Editor: Larry Mayer. Circ. 15,000. Estab. 1976. Published by Royal Publication Group. Tabloid published 26 times/year, weekly during NFL season and off-season issues. Emphasizes Chicago Bears and the NFL. Readers are male 25-45, professionals and manufacturers. Sample copy free with 9×12 SASE and 4 first-class stamps.

Needs: Uses 10-12 photos/issue; all supplied by freelancers. Needs photos of NFL games, player action shots, Chicago Bears action and posed shots. Captions preferred; include where, when, who, what.

Making Contact & Terms: Interested in receiving work from newer, lesser-known photographers. Arrange personal interview to show portfolio. Submit portfolio for review. Send unsolicited photos by mail for consideration. Send any size glossy color or b&w prints; 35mm, 2¼×2¼, 4×5, 8×10 transparencies. Keeps samples on file. SASE. Reports in 3 weeks. Pays $50/color cover photo; $50/color inside photo; $15-20/b&w inside photo. Pays on publication. Credit line given. Buys all rights; negotiable. Simultaneous submissions and previously published work OK.

CHICAGO'S AMATEUR ATHLETE MAGAZINE, (formerly *Chicago Runner Magazine*), 7840 N. Lincoln Ave., Suite 204, Skokie IL 60077. (708)675-0200. Fax: (708)675-2903. Publisher: Eliot Wineberg. Circ. 50,000. Estab. 1991. Bimonthly magazine. Emphasizes Chicago running. Readers are male and female, ages 25-55. Sample copies available.

Needs: Uses 40 photos/issue. 90% supplied by freelancers. Needs photos of people running in Chicago. Reviews photos with or without ms. Model/property release is preferred. Captions preferred.

Making Contact & Terms: Interested in reviewing work from newer, lesser-known photographers. Send unsolicited photos by mail for consideration. Send any size b&w prints. Keeps samples on file. SASE. Reports in 1-2 weeks. NPI. **Pays on acceptance**. Credit line given. Simultaneous submissions and/or previously published work OK.

✿**CHICKADEE MAGAZINE**, 179 John St., Suite 500, Toronto, Ontario M5T 3G5 Canada. (416)971-5275. Fax: (416)971-5294. Website: http://www.owl.on.ca. Researcher: Ekaterina Gitlin. Circ. 125,000. Estab. 1979. Published 10 times/year, 1 summer issue. A natural science magazine for children under 8 years. Sample copy for $4.28 with 9×12 SAE and $1.50 money order to cover postage. Photo guidelines free.

● *Chickadee* has received Magazine of the Year, Parents' Choice and The Educational Association of America awards.

Needs: Uses about 3-6 photos/issue; 1-2 supplied by freelance photographers. Needs "crisp, bright, close-up shots of animals in their natural habitat." Model/property release required. Captions required.

Making Contact & Terms: Interested in receiving work from newer, lesser-known photographers. Request photo package before sending photos for review. Send 35mm transparencies; submit digital images on Zip disk or SyQuest hard disk scanned at high resolution (300 dpi) as a TIFF or EPS file (prefer CMYK format, separations included). Reports in 6-8 weeks. Pays $325 Canadian/color cover; $200 Canadian/color page; text/photo package negotiated separately. **Pays on acceptance.** Credit line given. Buys one-time rights. Previously published work OK.

CHILD OF COLORS, (formerly *Biracial Child*), Interrace Publications P.O. Box 12048, Atlanta GA 30355. (404)364-9690. Fax: (404)364-9965. Associate Publisher: Gabe Grosz. Circ. 5,000. Estab. 1994. Quarterly magazine. Emphasizes children, with or without family, of black, Hispanic, Asian, American-Indian and mixed-race heritage, 1 month to 17 years old. Also, transracial adoptees. Readers are parents of children of all races/ethnicity, including biracial/multiracial; transracial adoption parents. Sample copies $2 with 9×12 SAE and 4 first-class stamps. Photo guidelines free with SASE.

● See listing in this section for *Black Child Magazine* also published by Interrace Publications.

LISTINGS THAT USE IMAGES electronically can be found in the Digital Markets Index located at the back of this book.

Needs: Uses 15-20 photos/issue; 12-15 supplied by freelancers. Needs photos of children and their families. Must be mixed-race or transracial adoptees. All racial, ethnic background. Special photo needs include children playing, serious shots, schooling, athletes, arts, entertainment. Model/property release preferred. Captions preferred.

Making Contact & Terms: Interested in receiving work from newer, lesser-known photographers. Submit portfolio for review. Query with résumé of credits. Query with stock photo list. Send unsolicited photos by mail for consideration. Provide résumé, business card, brochure, flier or tearsheets to be kept on file for possible assignments. Send 3×5, 8×10 color or b&w prints; any transparencies. Keeps samples on file. SASE. Reports in 1 month or less. Pays $15-25/hour; $15-75/job; $35/color cover photo; $35/b&w cover photo; $20/color inside photo; $20/b&w inside photo; $20-35/color page rate. Pays on publication. Credit line given. Buys one-time rights. Simultaneous submissions and/or previously published work OK.

Tips: "We're looking for kids of all ethnic/racial make up. Cute, upbeat kids are a plus. Photos with family are also needed."

CHILDREN'S DIGEST, P.O. Box 567, Indianapolis IN 46206. (317)636-8881. Fax: (317)684-8094. Photo Editor: Mary Stropoli. Circ. 106,000. Estab. 1950. Magazine published 8 times/year. Emphasizes health and fitness. Readers are preteens—kids 10-13. Sample copy $1.25. Photo guidelines free with SASE.

Needs: "We have featured photos of wildlife, children in other countries, adults in different jobs, how-to projects." *Reviews photos with accompanying ms only.* "We would like to include more photo features on nature, wildlife or anything with an environmental slant." Model release preferred.

Making Contact & Terms: Send complete manuscript and photos on speculation; 35mm transparencies. SASE. Reports in 10 weeks. Pays $50-100/color cover photo; $20/color inside photo; $10/b&w inside photo. Pays on publication. Buys one-time rights.

CHILDREN'S MINISTRY MAGAZINE, % Group Publishing, Inc., 2890 N. Monroe Ave., P.O. Box 481, Loveland CO 80538. (970)669-3836. Fax: (970)669-3269. Photo Editor: Joel Armstrong. Art Director: Rich Martin. Circ. 30,000. Estab. 1991. Bimonthly magazine. Provides ideas and support to adult workers (professional and volunteer) with children in Christian churches. Sample copy $1 with 9×12 SAE. Photo guidelines free with SASE.

• This publication is interested in receiving work on Photo CD.

Needs: Uses 20-25 photos/issue; 1-3 supplied by freelancers. Needs photos of children (infancy—6th grade) involved in family, school, church, recreational activities; with or without adults; generally upbeat and happy. Reviews photos with or without a manuscript. Especially needs good portrait-type shots of individual children, suitable for cover use; colorful, expressive. Model release required when people's faces are visible and recognizable and could be used to illustrate a potentially embarrassing subject. Captions not needed.

Making Contact & Terms: Interested in reviewing work from newer, lesser-known photographers, "if they meet our stated requirements." Query with list of stock photo subjects. Send unsolicited photos by mail for consideration. Send 8×10 glossy b&w prints; 35mm, 2¼×2¼ transparencies. SASE. Reports in 1 month. Pays minimum $150/color cover photo; minimum $75/color inside photo; $40-60/b&w inside photo. Pays on publication. Credit line given. Buys one-time rights. Simultaneous submissions and previously published work OK.

Tips: Wants to see "sharp, well-composed and well-exposed shots of children from all walks of life; emphasis on the active, upbeat colorful; ethnic mix is highly desirable." To be considered, "photos must appear current and contemporary. Professionalism must be evident in photos and their presentation. No under- or overexposed 'snapshot'-style photos, please."

CHILDREN'S PLAYMATE, Dept. PM, P.O. Box 567, Indianapolis IN 46206. (317)636-8881. Editor: Terry Harshman. Circ. 117,820. Published 8 times/year. Emphasizes better health for children. Readers are children between the ages of 6-8. Sample copy $1.25 with 5×7 SASE. Photo guidelines free with SASE.

Needs: Number of photos/issue varies; all supplied by freelancers. *Reviews photos with accompanying ms only.* Model release required. Captions preferred.

Making Contact & Terms: Send unsolicited photos, accompanied by ms. Uses b&w prints and 35mm transparencies. SASE. Reports in 2-3 months. Pays $5 minimum/b&w inside photo; $15 minimum/color inside photo. Pays on publication. Credit line given. Buys one-time rights.

CHILE PEPPER, P.O. Box 80780, Albuquerque NM 87198. (505)266-8322. Fax: (505)266-2127. Art Director: Lois Bergthold. Bimonthly magazine. Emphasizes world cuisine, especially hot, spicy foods and chile peppers. Readers are male and female consumers of spicy food, age 35-55. Circ. 70,000. Estab. 1986. Sample copy $3.95. Photo guidelines not available.

Needs: Uses 8-12 photos/issue; 10-20% supplied by freelancers. Needs photos of still life ingredients, location shots specifically of locales which are known for spicy cuisine, shots of chiles. Reviews

photos with or without a ms. "We will be doing features on the cuisine of India, Africa, Malaysia, Louisiana, Mexico, Arizona and the Caribbean." Model/property release preferred. Captions required; include location and species of chile (if applicable).

Making Contact & Terms: Query with stock photo list. Send unsolicited photos by mail for consideration. Provide résumé, business card, brochure, flier or tearsheets to be kept on file for possible assignments. Send b&w/color prints; 35mm, 4×5, 8×10 transparencies. Keeps samples on file. SASE. Reports in 3 weeks. Pays $150/color cover photo; $50/color inside photo; $25/b&w inside photo. Pays on publication. Credit line given. Buys one-time rights. Simultaneous submissions and/or previously published work OK.

Tips: "Looking for shots that capture the energy and exotica of locations, and still-life food shots that are not too classical, with a 'fresh eye' and interesting juxtapositions."

THE CHRISTIAN CENTURY, 407 S. Dearborn St., Chicago IL 60605. (312)427-5380. Fax: (312)427-1302. Production Coordinator: Matthew Giunti. Circ. 32,000. Estab. 1884. Weekly journal. Emphasis on religion. Readers are clergy, scholars, laypeople, male and female, ages 40-85. Sample copy $2. Photo guidelines free with SASE.

Needs: Buys 50 photos/year; all supplied by freelancers; 75% comes from stock. People of various races and nationalities; celebrity/personality (primarily political and religious figures in the news); documentary (conflict and controversy, also constructive projects and cooperative endeavors); scenic (occasional use of seasonal scenes and scenes from foreign countries); spot news; and human interest (children, human rights issues, people "in trouble," and people interacting). Photos with or without accompanying ms. For accompanying mss seeks articles dealing with ecclesiastical concerns, social problems, political issues and international affairs. Model/property release preferred. Captions preferred; include name of subject and date.

Making Contact & Terms: Interested in reviewing work from newer, lesser-known photographers. "Send crisp black-and-white images. We will consider a stack of photos in one submission. Send cover letter with prints. Don't send negatives or color prints." Also accepts digital files on floppy disk in Photoshop or TIFF format (EPS also if it's not too large). Uses 8×10 b&w prints. Does not keep samples on file. SASE. Reports in 1 month. Pays $50-150/photo (b&w or color). Pays on publication. Credit line given. Buys one-time rights; negotiable. Simultaneous submissions and previously published work OK.

Tips: Looks for diversity in gender, race, age and religious settings. Photos should reproduce well on newsprint.

THE CHRONICLE OF THE HORSE, P.O. Box 46, Middleburg VA 22117. (540)687-6341. Fax: (540)687-3937. Editor: John Strassburger. Circ. 23,000. Estab. 1937. Weekly magazine. Emphasizes English horse sports. Readers range from young to old. "Average reader is a college-educated female, middle-aged, well-off financially." Sample copy for $2. Photo guidelines free with SASE.

Needs: Uses 10-25 photos/issue; 90% supplied by freelance photographers. Needs photos from competitive events (horse shows, dressage, steeplechase, etc.) to go with news story or to accompany personality profile. "A few stand alone. Must be cute, beautiful or newsworthy. Reproduced in b&w." Prefers purchasing photos with accompanying ms. Captions required with every subject identified.

Making Contact & Terms: Interested in receiving work from newer, lesser-known photographers. Query with idea. Send b&w and color prints (reproduced b&w). SASE. Reports in 3 weeks. Pays $15-30/photo/text package. Pays on publication. Credit line given. Buys one-time rights. Prefers first North American rights. Simultaneous submissions and previously published work OK.

Tips: "We do not want to see portfolio or samples. Contact us first, preferably by letter. Know horse sports."

CIRCLE K MAGAZINE, 3636 Woodview Trace, Indianapolis IN 46268. (317)875-8755. Executive Editor: Nicholas K. Drake. Circ. 15,000. Published 5 times/year. For community service-oriented college leaders "interested in the concept of voluntary service, societal problems, leadership abilities and college life. They are politically and socially aware and have a wide range of interests."

Needs: Assigns 0-5 photos/issue. Needs general interest photos, "though we rarely use a nonorganization shot without text. Also, the annual convention requires a large number of photos from that area." Prefers ms with photos. Seeks general interest features aimed at the better-than-average college student. "Not specific places, people topics." Captions required, "or include enough information for us to write a caption."

Making Contact & Terms: Works with freelance photographers on assignment only basis. Provide calling card, letter of inquiry, résumé and samples to be kept on file for possible future assignments. Send query with résumé of credits. Uses 8×10 glossy b&w prints or color transparencies. Uses b&w and color covers; vertical format required for cover. SASE. Reports in 3 weeks. Pays up to $225-350 for text/photo package, or on a per-photo basis—$15 minimum/b&w print and $70 minimum/cover. **Pays on acceptance.** Credit line given. Previously published work OK if necessary to text.

CLASSIC AUTO RESTORER, P.O. Box 6050, Mission Viejo CA 92690. (714)855-8822. Fax: (714)855-3045. Editor: Dan Burger. Circ. 75,000. Estab. 1989. Monthly magazine. Emphasizes restoration of collector cars and trucks. Readers are male (98%), professional/technical/managerial, ages 35-55. Sample copy $5.50.
Needs: Uses 100 photos/issue; 95% supplied by freelancers. Needs photos of auto restoration projects and restored cars. Reviews photos with accompanying ms only. Model/property release preferred. Captions required; include year, make and model of car; identification of people in photo.
Making Contact & Terms: Interested in receiving work from newer, lesser-known photographers. Submit inquiry and portfolio for review. Provide résumé, business card, brochure, flier or tearsheets to be kept on file for possible assignments. Prefers transparencies, mostly 35mm, 2¼×2¼. Does not keep samples on file. SASE. Reports in 1 month. Pays $200-300/color cover photo; $100/color page rate; $100/b&w page rate; $100/page for photo/test package; $30-100/color or b&w photo. Pays on publication. Credit line given. Buys first North American serial rights; negotiable. Simultaneous submissions OK.
Tips: Looks for "technically proficient or dramatic photos of various automotive subjects, auto portraits, detail shots, action photos, good angles, composition and lighting. We're also looking for photos to illustrate how-to articles such as how-to repair a damaged fender or how-to repair a four-barrel carburetor."

CLASSIC TOY TRAINS, 21027 Crossroads Circle, Waukesha WI 53187. (414)796-8776. Fax: (414)796-1383. Editor: Roger Carp. Circ. 75,000. Estab. 1987. Magazine published 8 times/year (Jan., Feb., Mar., May, July, Sept., Nov., Dec.). Emphasizes collectible toy trains (O scale, S scale, Standard gauge, G scale) Lionel, American Flyer, Marx, Dorfan. Readers are high-income male professionals, average age mid-40s. Sample copy $3.95 plus shipping and handling. Photo guidelines free with SASE.
Needs: Uses 35 photos/issue; number supplied by freelancers varies. Needs photos of toy train collections and layouts. Captions preferred; include toy train scale, manufacturer, model number, collector's name and address.
Making Contact & Terms: Interested in receiving work from newer, lesser-known photographers. Send unsolicited photos by mail for consideration. Send 5×7 glossy color prints; 35mm, 4×5 transparencies. Does not keep samples on file. SASE. Reports in 1 month. Pays $75/page; $200/cover ($15 minimum). Pays on acceptance. Credit line given. Buys all rights; negotiable.
Tips: "Reviewing a couple back issues of *Classic Toy Trains* will give the best idea of the material we're interested in. Familiarity with toy train subject is very helpful."

CLUB MODÈLE MAGAZINE, P.O. Box 15760, Stamford CT 06901-0760. (203)967-9952. Fax: (203)353-9661. BBS: (203)353-9841. E-mail: aaquinoInt@aol.com. Monthly magazine. Emphasizes modeling, fashion and entertainment. Readers are male and female, ages 18-55 (agents, managers, producers, fashion designers, models, talents, photographers). Sample copy $4. Photo guidelines free with SASE.
Needs: Uses 50 photos/issue; 35-45% supplied by freelancers. Needs photos of personalities, models and entertainers. Model/property release required. Captions required.
Making Contact & Terms: Interested in receiving work from newer, lesser-known photographers. Query with stock photo list. Send unsolicited photos by mail for consideration. Send any size, any finish color and b&w prints; 35mm, 2¼×2¼, 4×5, 8×10 transparencies. Also accepts digital images on Photo CD or computer diskettes (CPC). Keeps samples on file. SASE. Reports in 1 month. Pays $25-150/b&w inside photo; $25-150/color page rate; purchases of 20-1,000 are negotiated. **Pays on acceptance**. Credit line given. Buys one-time rights, first North American serial rights, all rights; negotiable. Simultaneous submissions OK.
Tips: Make sure your work captures the essence and personality of the model. Send creative images—beauty and glamour with a special touch. Become familiar with the content of the publication and offer better images than those published.

***COAST MAGAZINE**, 943 A 33rd Ave., Gulfport MS 39501. (601)868-1182. Fax: (601)867-2986. Creative Director: Belinda Mallery. Circ. 25,000. Estab. 1993. Bimonthly magazine. Emphasizes lifestyle. Readers are mostly female (59%), ages 34-46, affluent ($35,000 plus income). Sample copy free with 10×13 SAE and $2.90 first-class postage.
Needs: Uses 60-80 photos/issue; 40 supplied by freelancers. Needs photos of travel, people, vacation spots, scenics. Model/property release required. Captions required; include pertinent information.
Making Contact & Terms: Interested in receiving work from newer, lesser-known photographers. Arrange personal interview to show portfolio. Query with stock photo list. Send 35mm transparencies. Does not keep samples on file. SASE. Reports in 1 month. Pays $50-500/job. Pays on publication. Credit line given.

COBBLESTONE: THE HISTORY MAGAZINE FOR YOUNG PEOPLE, Cobblestone Publishing, Inc., 7 School St., Peterborough NH 03458. (603)924-7209. Editor: Meg Chorlian. Circ.

36,000. Estab. 1980. Publishes 10 issues/year, September-June. Emphasizes American history; each issue covers a specific theme. Readers are children 8-14, parents, teachers. Sample copy for $4.50 and 9 × 12 SAE with 5 first-class stamps. Photo guidelines free with SASE.

Needs: Uses about 40 photos/issue; 5-10 supplied by freelance photographers. "We need photographs related to our specific themes (each issue is theme-related) and urge photographers to request our themes list." Model release required. Captions preferred.

Making Contact & Terms: Query with samples or list of stock photo subjects. Send 8 × 10 glossy b&w prints, or 35mm or 2¼ × 2¼ transparencies. SASE. "Photos must pertain to themes, and reporting dates depend on how far ahead of the issue the photographer submits photos. We work on issues 6 months ahead of publication." Cover photo (color) negotiated; $15-100/inside b&w use. Pays on publication. Credit line given. Buys one-time rights. Simultaneous submissions and previously published work OK.

Tips: "In general, we use few contemporary images; most photos are of historical subjects. However, the amount varies with each monthly theme."

COLLAGES & BRICOLAGES, P.O. Box 86, Clarion PA 16214. Editor: Marie-José Fortis. Estab. 1986. Annual magazine. Emphasizes literary works, avant-garde, poetry, fiction, plays and nonfiction. Readers are writers and the general public in the US and abroad. Sample copy $7.50.

Needs: Uses 5-10 photos/issue; all supplied by freelancers. Needs photos that make a social statement, surrealist photos and photo collages. Reviews photos (only in fall, August-December) with or without a ms. Photo captions preferred; include title of photo and short biography of artist/photographer.

Making Contact & Terms: Send unsolicited photos by mail for consideration. Send matte b&w prints. SASE. Reports in 3 months. Pays in copies. Simultaneous submissions and/or previously published work OK.

Tips: "*C&B* is primarily meant for writers. It will include photos if: a) they accompany or illustrate a story, a poem, an essay or a focus *C&B* might have at the moment; b) they constitute the cover of a particular issue; or c) they make a statement (political, social, spiritual)."

COLLECTOR EDITIONS, 170 Fifth Ave., 12th Floor, New York NY 10010. (212)989-8700. Fax: (212)645-8976. Art Director: Caroline Meyers. Circ. 100,000. Estab. 1973. Magazine published 7 times/year. Emphasizes collectibles: glass, plates, cottages, dolls, figurines, antiques, prints, etc. Readers are females, 45 years old and over. Sample copy $4.

Needs: Uses 200 photos/issue; less than 10% assigned to freelancers. Photo assignments of collectible items (product shots). Model/property release required for interior arrangements with props or on location.

Making Contact & Terms: Interested in assigning work to newer, lesser-known photographers. Provide résumé, business card, brochure, flier or tearsheets to be kept on file for possible assignments. Deadlines discussed at time of assignment. Keeps samples on file. SASE. Reports in 2 weeks. Pays up to $500/day plus expenses. Pays 4-6 weeks after assignment is completed. Credit line given. Buys first North American serial rights.

COLLEGE PREVIEW, 106 W. 11th St., #250, Kansas City MO 64105-1806. (816)221-4404. Fax: (816)221-1112. Editor: Neoshia Michelle Paige. Circ. 600,000. Bimonthly magazine. Emphasizes college and college-bound African-American and Hispanic students. Readers are African-American, Hispanic, ages 16-24. Sample copy free with 9 × 12 SAE and 4 first-class stamps.

Needs: Uses 30 photos/issue. Needs photos of students in class, at work, in interesting careers, on-campus. Special photo needs include computers, military, law and law enforcement, business, aerospace and aviation, health care. Model/property release required. Captions required; include name, age, location, subject.

Making Contact & Terms: Interested in receiving work from newer, lesser-known photographers. Query with résumé of credits. Query with ideas and SASE. Reports in 1 month, "usually less." Pays $10-50/color photo; $5-25/b&w inside photo. Pays on publication. Buys first North American serial rights. Simultaneous submissions and/or previously published work OK.

COLLISION, P.O. Box M, Franklin MA 02038-0912. (508)528-6211. Editor: J.A. Kruza. Circ. 15,000. Magazine published 6 times a year. Readers are auto dealers, body shops and tow truck operators in northeastern US. Photo guidelines free.

Needs: Uses 100 photos/issue; usually 30% supplied by freelance photographers. "We are looking for feature stories on specific business or technological aspects of work." Captions required.

Making Contact & Terms: Query with samples. SASE. Reports in 2 weeks. Pays $25 first photo; $10 for each additional photo; buys 5-6 photos in a series. **Pays on acceptance.** Credit line given. Reassigns rights to photographer after use. Simultaneous submissions and previously published work OK.

***COLONIAL HOMES MAGAZINE**, Dept. PM, 1790 Broadway, New York NY 10019. (212)830-2950. Editor: Annette Stramesi. Bimonthly. Circ. 600,000. Focuses on traditional American architecture, interior design, antiques and crafts. Sample copy available.
Needs: All photos supplied by freelance photographers. Needs photos of "American architecture and interiors of 18th century or 18th century style." Special needs include "American food and drink; private and museum homes; historic towns in America." All art must be identified.
Making Contact & Terms: Submit portfolio for review. Send 4×5 or 2¼×2¼ transparencies by mail for consideration. Provide résumé, business card, brochure, flier or tearsheets to be kept on file for possible future assignments. SASE. Reports in 1 month. Pays a flat fee. Pays on publication. Credit line given. Buys all rights. Previously published work OK.

COLORADO HOMES & LIFESTYLES MAGAZINE, 7009 S. Potomac, Englewood CO 80112. (303)397-7600. Fax: (303)397-7619. Art Director: Elaine St. Louis. Circ. 45,000. Estab. 1980. Bimonthly magazine. Emphasizes interior design, architecture of homes and lifestyles of people in Colorado. Readers are mostly women, 35-55, the majority of them homeowners. Sample copies available.
Needs: Uses approximately 100 photos/issue; roughly one-third supplied by freelancers. Needs photos of home interiors, architecture, people (by assignment only), travel, food and entertaining, gardening, home products, etc. Reviews photos with accompanying ms only. "We will review photographers' books for possible future assignments." Model/property release required for private homes and people. Captions required; include what and where.
Making Contact & Terms: Interested in receiving work from newer, lesser-known photographers. Arrange personal interview to show portfolio. Send unsolicited photos by mail for consideration with SASE if you would like them returned. Provide résumé, business card, brochure, flier or tearsheets to be kept on file for possible assignments. Send 5×7 or larger prints; 35mm, 2¼×2¼, 4×5, 8×10 transparencies. Keeps samples on file. Reports within 3 months. Pays $75-400/job for a feature story with 5 shots; $50-200/color photo; $50-75/b&w photo. **Pays on acceptance.** Credit line given. Rights negotiable. Simultaneous submissions and/or previously published work OK.
Tips: "Our primary subject matter is homes. With very rare exceptions, subjects must be in Colorado. Particular attention to refined talent with subtle, controlled lighting, both tungsten and daylight/strobe. If you shoot homes for another (Colorado) client—interior designer, architect, etc.—consider submitting to us; that's a good way to break in because we don't have to pay, and we're *very* budget-conscious."

COMBO MAGAZINE, 5 Nassau Blvd. S., Garden City South NY 11530. (516)292-6000. Fax: (516)349-9516. Managing Editor: Ian Seller. Circ. 150,000. Estab. 1992. Monthly. Emphasizes movies, outer space, science fiction, super heroes, cartoons, fantasy art. Readers are male and female, ages 9-99. Free sample copy.
Needs: Uses 1-2 photos/issue; all supplied by freelancers. Needs studio shots, graphics (computerized), shots of famous personalities, movie stars, music stars, etc. Special photo needs include studio shots, action shots. Property release required.
Making Contact & Terms: Interested in receiving work from newer, lesser-known photographers. Send unsolicited photos by mail for consideration. Send 8×10 glossy color prints. Cannot return material. Reports in 2 weeks. Pays $75-150/job. Pays on publication. Credit line given. Buys all rights; negotiable. Simultaneous submissions OK.

COMPLETE WOMAN, 875 N. Michigan Ave., Suite 3434, Chicago IL 60611-1901. (312)266-8680. Art Director: Sheri L. Darnall. Estab. 1980. Bimonthly magazine. General interest magazine for women. Readers are "females, 21-40, from all walks of life."
 ● *Complete Woman* has increased its payment for b&w and color photos.
Needs: Uses 50-60 photos/issue. Needs "high-contrast shots of attractive women, how-to beauty shots, women with men, etc." Model release required. Captions preferred.
Making Contact & Terms: Interested in receiving work from newer, lesser-known photographers. Query with list of stock photo subjects. Send unsolicited photos by mail for consideration. Provide résumé, business card, brochure, flier or tearsheets to be kept on file for possible assignments. Send b&w, color prints; 35mm transparencies. SASE. Reports in 1 month. Pays $100/color inside photo; $50-100/b&w inside photo. Pays on publication. Credit line given. Buys one-time rights. Simultaneous and previously published work OK.

***COMPUTER CURRENTS**, 5720 Hollis St., Emeryville CA 94608. (510)547-6800. Fax: (510)547-4613. E-mail: ccgen@compcurr.com. Managing Editor: Cheryl Masse. Circ. 600,000. Estab. 1983. Magazine: biweekly in Bay Area; monthly in Los Angeles, New York City, Chicago, Boston, Atlanta and Texas. Emphasizes personal computing (PCs and Macs). Readers are PC and Mac users with 4-5 years experience; mostly male, 25-55. Sample copy for 10½×12½ SAE and $3 postage. Photo guidelines free with SASE.

Needs: Uses 1 cover photo/issue; all supplied by freelancers. Needs illustrative photos representing a given concept. Reviews photos purchased with accompanying ms only. Model/property release required.

Making Contact & Terms: Interested in receiving work from newer, lesser-known photographers. Send unsolicited photos by mail for consideration. Provide résumé, business card, brochure, flier or tearsheets to be kept on file for possible future assignments. Send 2¼×2¼, 4×5 transparencies; SyQuest in TIFF Photoshop, Illustrator digital formats. Keeps samples on file. SASE. Reports in 1 month. Pays $800-1,000/color cover photo. **Pays on acceptance.** Credit line given. Buys first North American serial, electronic and nonexclusive rights. Simultaneous submissions and previously published work OK.

Tips: "Photographers wishing to work with us should have Photoshop and QuarkXPress awareness or experience."

CONDE NAST TRAVELER, 360 Madison Ave., New York NY 10017. Has very specific needs and contacts a stock agency when seeking shots.

CONFRONTATION: A LITERARY JOURNAL, English Dept., C.W. Post of L.I.U., Brookville NY 11548. (516)299-2391. Fax: (516)299-2735. Editor: Martin Tucker. Circ. 2,000. Estab. 1968. Semiannual magazine. Emphasizes literature. Readers are college-educated lay people interested in literature. Sample copy $3.

Needs: Reviews photos with or without a manuscript. Captions preferred.

Making Contact & Terms: Interested in reviewing work from newer, lesser-known photographers. Query with résumé of credits. Query with stock photo list. Reports in 1 month. Pays $25-100/b&w photo; $50-100/color cover photo; $20-40/b&w page rate; $100-300/job. Pays on publication. Credit line given. Buys first North American serial rights; negotiable. Simultaneous submissions OK.

THE CONNECTION PUBLICATION OF NJ, INC., P.O. Box 2122, Teaneck NJ 07666. (201)692-1512. Fax: (201)692-1655. Editor: Ms. Kelly. Weekly tabloid. Readers are male and female executives, ages 18-62. Circ. 25,000. Estab. 1982. Sample copy $1.50 with 9×12 SAE.

Needs: Uses 12 photos/issue; 4 supplied by freelancers. Needs photos of personalities. Reviews photos with accompanying ms only. Photo captions required.

Making Contact & Terms: Send unsolicited photos by mail for consideration. Send b&w prints. Keeps samples on file. SASE. Reports in 2 weeks. NPI; negotiable. Pays on publication. Credit line given. Buys one-time rights; negotiable. Previously published work OK.

Tips: "Work with us on price."

COSMOPOLITAN, 224 W. 57th St., 8th Floor, New York NY 10019. Prefers not to share information.

COUNTRY, 5925 Country Lane, Greendale WI 53129. (414)423-0100. Fax: (414)423-8463. Photo Coordinator: Trudi Bellin. Estab. 1987. Bimonthly magazine. "For those who live in or long for the country." Readers are rural-oriented, male and female. "*Country* is supported entirely by subscriptions and accepts no outside advertising." Sample copy $2. Photo guidelines free with SASE.

Needs: Uses 150 photos/issue; 20% supplied by freelancers. Needs photos of scenics—country only. Model/property release required. Captions preferred; include season, location.

Making Contact & Terms: Interested in receiving work from newer, lesser-known photographers. Query with list of stock photo subjects. Send unsolicited photos by mail for consideration. Send 35mm, 2¼×2¼, 4×5 and 8×10 transparencies. Tearsheets kept on file but not dupes. SASE. Reports "as soon as possible; sometimes days, other times months." Pays $300/color cover photo; $75-150/color inside photo; $150/color page (full-page bleed); $10-100/b&w photo. Pays on publication. Credit line given. Buys one-time rights. Previously published work OK.

Tips: "Technical quality is extremely important: focus must be sharp, no soft focus; colors must be vivid so they 'pop off the page.' Study our magazine thoroughly—we have a continuing need for sharp, colorful images, and those who can supply what we need can expect to be regular contributors."

COUNTRY JOURNAL, 4 Highridge Park, Stamford CT 06905. (203)321-1709. Art Director: Robin Demougeot. Circ. 166,000. Estab. 1974. Bimonthly magazine. Emphasizes practical concerns and

rewards of life in the country. Sample copy for $4. Photo guidelines free with SASE.
Needs: Uses 40 photos/issue; 95% supplied by freelance photographers. Needs photos of animal/wildlife, country scenics, vegetable and flower gardening, home improvements, personality profiles, environmental issues and other subjects relating to rural life. Model release required. Captions required.
Making Contact & Terms: Provide résumé, business card, brochure, flier or tearsheets to be kept on file for possible assignments. Send b&w prints and 35mm, 2¼×2¼, 4×5 and 8×10 prints with SASE by return mail for consideration. Reports in 1 month. Pays $500/color and b&w cover photo; $135/quarter page color and b&w page inside photo; $235/color and b&w page rate; $275-325/day. Pays on publication. Credit line given. Buys one-time rights. Simultaneous submissions OK.
Tips: "Know who you are submitting to. You can waste time, money and a possible opportunity by sending inappropriate samples and queries. If you can't find samples of the publication, call or send for them."

COUNTRY WOMAN, Dept. PM, P.O. Box 643, Milwaukee WI 53201. Managing Editor: Kathy Pohl. Emphasizes rural life and a special quality of living to which country women can relate; at work or play in sharing problems, etc. Sample copy $2. Free photo guidelines with SASE.
Needs: Uses 75-100 photos/issue, most supplied by readers, rather than freelance photographers. "We're always interested in seeing good shots of farm, ranch and country women (in particular) and rural families (in general) at work and at play." Uses photos of farm animals, children with farm animals, farm and country scenes (both with and without people) and nature. Want on a regular basis scenic (rural), seasonal, photos of rural women and their family. "We're always happy to consider cover ideas. Covers are often seasonal in nature and *always* feature a country woman. Additional information on cover needs available." Photos purchased with or without accompanying ms. Good quality photo/text packages featuring interesting country women are much more likely to be accepted than photos only. Captions are required. Work 6 months in advance. "No poor-quality color prints, posed photos, etc."
Making Contact & Terms: Send material by mail for consideration. Uses transparencies. Provide brochure, calling card, letter of inquiry, price list, résumé and samples to be kept on file for possible future assignments. SASE. Reports in 3 months. Pays $100-150 for text/photo package depending on quality of photos and number used; pays $200 for front cover; $150 for back cover; partial page inside $50-125, depending on size. Many photos are used at ¼ page size or less, and payment for those is at the low end of the scale. No b&w photos used. **Pays on acceptance.** Buys one-time rights. Previously published work OK.
Tips: Prefers to see "rural scenics, in various seasons; emphasis on farm women, ranch women, country women and their families. Slides appropriately simple for use with poems or as accents to inspirational, reflective essays, etc."

THE COVENANT COMPANION, 5101 N. Francisco Ave., Chicago IL 60625. (312)784-3000. Editor: John E. Phelan, Jr. Managing Editor: Jane K. Swanson-Nystrom. Art Director: David Westerfield. Circ. 23,500. Monthly denominational magazine of The Evangelical Covenant Church. Emphasizes "gathering, enlightening and stimulating the people of our church and keeping them in touch with their mission and that of the wider Christian church in the world."
Needs: Mood shots of home life, church life, church buildings, nature, commerce and industry and people. Also uses fine art, scenes, city life, etc.
Making Contact & Terms: "We need to keep a rotating file of photos for consideration." Send 5×7 and 8×10 glossy prints; color slides for cover only. Also accepts digital images in TIFF files. SASE. Pays $20/b&w photo; $50-75/color cover. Pays within 2 months of publication. Credit line given. Buys one-time rights. Simultaneous submissions OK.
Tips: "Give us photos that illustrate life situations and moods. We use b&w photos which reflect a mood or an aspect of society—wealthy/poor, strong/weak, happiness/sadness, conflict/peace. These photos or illustrations can be of nature, people, buildings, designs and so on. Give us a file from which we can draw."

THE CREAM CITY REVIEW, University of Wisconsin-Milwaukee, English Dept., Box 413, Milwaukee WI 53201. (414)229-4708. Art Director: Laurie Buman. Circ. 2,000. Estab. 1975. Bienniel journal. Emphasizes literature. Readers are mostly males and females with Ph.D's in English, ages 18-over 70. Sample copy $5. Photo guidelines free with SASE.
Needs: Uses 6-20 photos/issue; most supplied by freelancers. Needs photos of fine art and other works of art. Captions preferred.
Making Contact & Terms: Interested in reviewing work from newer, lesser-known photographers. Send unsolicited photos by mail for consideration. Send all sizes b&w and color prints; 35mm, 2¼×2¼, 4×5, 8×10 transparencies. SASE. Reports in 2 months. Pays $50/color cover photo; $50/b&w cover photo; $5/b&w inside photo; $5/b&w page rate. Pays on publication. Credit line given. Buys one-time rights. Simultaneous submissions and/or previously published work OK.

Tips: "We currently receive very few unsolicited submissions, and would like to see more. Though our primary focus is literary, we are dedicated to producing a visually exciting journal. The artistic merit of submitted work is important. We have been known to change our look based on exciting work submitted. Take a look at *Cream City Review* and see how we like to look. If you have things that fit, send them."

CRUISE TRAVEL, 990 Grove St., Evanston IL 60201. (708)491-6440. Managing Editor: Charles Doherty. Circ. 200,000. Estab. 1979. Bimonthly magazine. Emphasizes cruise ships, ports, vacation destinations, travel tips, ship history. Readers are "those who have taken a cruise, plan to take a cruise, or dream of taking a cruise." Sample copy $3.50 with 9×12 SAE and 6 first-class stamps. Photo guidelines free with SASE.
Needs: Uses about 50 photos/issue; 75% supplied by freelance photographers. Needs ship shots, interior/exterior, scenic shots of ports, shopping shots, native sights, etc. Photos rarely purchased without accompanying ms. Model release preferred. Captions required.
Making Contact & Terms: Query with samples. "We are not seeking overseas contacts." Uses color prints; 35mm (preferred), 2¼×2¼, 4×5, 8×10 transparencies. SASE. Reports in 2 weeks. Pays variable rate for color cover; $25-150/color inside photo; $200-500/text/photo package for original work. Pays on acceptance or publication; depends on package. Credit line usually given, depends on arrangement with photographer. Buys one-time rights. Simultaneous submissions and previously published work OK.
Tips: "We look for bright, colorful travel slides with good captions. Nearly every purchase is a photo/ms package, but good photos are key. We prefer 35mm originals for publication, all color."

CRUISING WORLD MAGAZINE, 5 John Clark Rd., Newport RI 02840. (401)847-1588. Fax: (401)848-5048. Art Director: William Roche. Circ. 130,000. Estab. 1974. Emphasizes sailboat maintenance, sailing instruction and personal experience. For people interested in cruising under sail. Sample copy free for 9×12 SAE.
Needs: Buys 25 photos/year. Needs "shots of cruising sailboats and their crews anywhere in the world. Shots of ideal cruising scenes. No identifiable racing shots, please." Also wants exotic images of cruising sailboats, people enjoying sailing, tropical images, different perspectives of sailing, good composition, bright colors. For covers, photos "must be of a cruising sailboat with strong human interest, and can be located anywhere in the world." Prefers vertical format. Allow space at top of photo for insertion of logo. Model release preferred. Property release required. Captions required; include location, body of water, make and model of boat.
Making Contact & Terms: Interested in receiving work from newer, lesser-known photographers "as long as their subjects are marine related." Send 35mm color transparencies. "We rarely accept miscellaneous b&w shots and would rather they not be submitted unless accompanied by a manuscript." For cover, "submit original 35mm slides. *No* duplicates. Most of our editorial is supplied by author. We look for good color balance, very sharp focus, the ability to capture sailing, good composition and action. Always looking for *cover shots*." Reports in 2 months. Pays $50-300/inside photo; $500/cover photo. Pays on publication. Credit line given. Buys all rights, but may reassign to photographer after publication; first North American serial rights; or one-time rights.

CUPIDO, % Red Alder Books, P.O. Box 2992, Santa Cruz CA 95063. (408)426-7082. Fax: (408)425-8825. E-mail: eronat@aol.com. Photo Representative: David Steinberg. Circ. 60,000. Estab. 1984. Monthly magazine. Emphasizes quality erotica. Sample copy $10 (check payable to Red Alder Books).
Needs: Uses 50 photos/issue. Needs quality erotic and sexual photography, visually interesting, imaginative, showing human emotion, tenderness, warmth, humor OK, sensuality emphasized. Reviews photos only (no manuscripts, please).
Making Contact & Terms: Contact through rep. Arrange personal interview to show portfolio or submit portfolio for review. Query with stock photo list. Send unsolicited photos by mail for consideration. Send 8×10 or 11×14 b&w, color prints; 35mm, 2¼×2¼, 4×5, 8×10 transparencies. Keeps samples on file. SASE. Reports in 1 month. Pays $500-800/color cover photo; $60/color or b&w inside photo. Pays on publication. Credit line given. Buys one-time rights. Simultaneous submissions and/or previously published work OK.
Tips: "Not interested in standard, porn-style photos. Imagination, freshness, emotion emphasized. Glamor OK, but not preferred."

CYCLE WORLD MAGAZINE, Dept. PM, 1499 Monrovia Ave., Newport Beach CA 92663. (714)720-5300. Editor-in-Chief: David Edwards. VP/Editorial Director: Paul Dean. Monthly magazine. Circ. 350,000. For active motorcyclists who are "young, affluent, educated and very perceptive." For motorcycle enthusiasts.
Needs: "Outstanding" photos relating to motorcycling. Buys 10 photos/issue. Prefers to buy photos with mss. For Slipstream column see instructions in a recent issue.

Making Contact & Terms: Buys all rights. Send photos for consideration. Pays on publication. Reports in 6 weeks. SASE. Send 8 × 10 glossy prints. "Cover shots are generally done by the staff or on assignment." Uses 35mm color transparencies. Pays $50-100/b&w photo; $150-225/color photo.
Tips: Prefers to buy photos with mss. "Read the magazine. Send us something good. Expect instant harsh rejection. If you don't know our magazine, don't bother us."

DAKOTA OUTDOORS, P.O. Box 669, Pierre SD 57501. (605)224-7301. Fax: (605)224-9210. E-mail: 73613,3456@cis.com. Managing Editor: Rachel Engbrecht. Circ. 6,900. Estab. 1978. Monthly magazine. Emphasizes hunting and fishing in the Dakotas. Readers are sportsmen interested in hunting and fishing, ages 35-45. Sample copy free for 9 × 12 SAE and 3 first-class stamps. Photo guidelines free with SASE.
 ● All photos for *Dakota Outdoors* are scanned and reproduced digitally. They now store photos on CD and do computer manipulation.
Needs: Uses 15-20 photos/issue; 8-10 supplied by freelancers. Needs photos of hunting and fishing. Reviews photos with or without ms. Special photo needs include: scenic shots of sportsmen. Model/property release required. Captions preferred.
Making Contact & Terms: Interested in receiving work from newer, lesser-known photographers. Send 3 × 5 b&w prints; 35mm b&w transparencies by mail for consideration. Also accepts digital files on disk or online. Keeps samples on file. SASE. Reports in 3 weeks. Pays $50-150/b&w cover photo; $25-75/b&w inside photo; payment negotiable. Pays on publication. Credit line given. Usually buys one-time rights; negotiable.
Tips: "We want good quality outdoor shots, good lighting, identifiable faces, etc.—photos shot in the Dakotas. Use some imagination and make your photo help tell a story. Photos with accompanying story are accepted."

DANCING USA, 10600 University Ave. NW, Minneapolis MN 55448-6166. (612)757-4414. Fax: (612)757-6605. Managing Editor: Patti P. Johnson. Circ. 20,000. Estab. 1982. Bimonthly magazine. Emphasizes romance of ballroom dance and big bands, techniques, personal relationships, dance music reviews. Readers are male and female, all backgrounds, with ballroom dancing and band interest, age over 45. Sample copy free with 9 × 12 SAE and 4 first-class stamps.
Needs: Uses 25 photos/issue; 1-3 supplied by freelancers. Prefer action dancing/band photos. Non-dance competitive clothing, showing romance and/or fun of dancing. Model/property release preferred. Captions preferred; include who, what, when, where, how if applicable.
Making Contact & Terms: Interested in receiving work from newer, lesser-known photographers. Send unsolicited photos by mail for consideration. Send 4 × 5 matte color or b&w prints. Keeps samples on file. SASE. Reports in 1 month. Pays $50-100/color cover photo; $25/color inside photo; $10/b&w inside photo; $10-125/photo/text package. Pays on acceptance. Credit line given. Buys one-time rights. Simultaneous submissions and previously published work OK.

DAS FENSTER, 1060 Gaines School Rd., B-3, Athens GA 30605. (706)548-4382. Owner/Business Manager: Alex Mazeika. Circ. 18,000. Estab. 1904. Monthly magazine. Emphasizes general topics written in the German language. Readers are German, ages 35 years plus. Sample copy free with SASE.
Needs: Uses 25 photos/issue; 20-25 supplied by freelancers. Needs photos of German scenics, wildlife and travel. Captions preferred.
Making Contact & Terms: Interested in receiving work from newer, lesser-known photographers. Send unsolicited photos by mail for consideration. Send 4 × 5 glossy b&w prints. Keeps samples on file. SASE. Reports in 3 weeks. Pays $40/b&w page rate. Pays on publication. Credit line given. Buys one-time rights; negotiable. Previously published work OK.

DEER AND DEER HUNTING, 700 E. State St., Iola WI 54990. (715)445-2214. Editor: Pat Durkin. Distribution 200,000. Estab. 1977. 8 issues/year. Emphasizes white-tailed deer and deer hunting. Readers are "a cross-section of American deer hunters—bow, gun, camera." Sample copy and photo guidelines free with 9 × 12 SAE with 7 first-class stamps.
Needs: Uses about 25 photos/issue; 20 supplied by freelance photographers. Needs photos of deer in natural settings. Model release and captions preferred.
Making Contact & Terms: Query with résumé of credits and samples. "If we judge your photos as being usable, we like to hold them in our file. It is best to send us duplicates because we may hold the photo for a lengthy period." SASE. Reports in 2 weeks. Pays $500/color cover; $50/b&w inside; $75-250/color inside. Pays within 10 days of publication. Credit line given. Buys one-time rights. Simultaneous submissions and previously published work OK.
Tips: Prefers to see "adequate selection of b&w 8 × 10 glossy prints and 35mm color transparencies, action shots of whitetail deer only as opposed to portraits. We also need photos of deer hunters in action. We are currently using almost all color—very little b&w. Submit a limited number of quality

photos rather than a multitude of marginal photos. Have your name on all entries. Cover shots must have room for masthead."

DIRT RIDER, 6420 Wilshire Blvd., Los Angeles CA 90048-5515. (213)782-2390. Fax: (213)782-2372. Moto Editor: Ken Faught. Circ. 185,000. Estab. 1982. Monthly magazine. Covers off-road motorcycles, specializing in product tests, race coverage and rider interviews. Readers are predominantly male blue-collar/white-collar, between the ages of 20-35 who are active in motorcycling. Sample copy $3.
Needs: Uses 125 photos/issue; 40 supplied by freelancers. "We need everything: technical photos, race coverage and personality profiles. Most subject matter is assigned. Any photo aside from race coverage or interview needs a release." Captions preferred.
Making Contact & Terms: Interested in receiving work from newer, lesser-known photographers. Phone Ken Faught. Deadlines vary from month to month. Keeps samples on file. Cannot return material. Reports in 2 weeks. Pays $200/color cover photo; $200/b&w cover photo; $50/color inside photo; $25/b&w inside photo; $50/color page rate; $25/b&w page rate. Pays on publication. Credit line given. Simultaneous submissions OK.
Tips: "Familiarize yourself with *Dirt Rider* before submitting photos for review or making initial contact. Pay strict attention to deadlines."

THE DIVER, Dept. PM, P.O. Box 54788, Saint Petersburg FL 33739-4788. (813)866-9856. Publisher/Editor: Bob Taylor. 6 issues/year. Emphasizes springboard and platform diving. Readers are divers, coaches, officials and fans. Circ. 1,500. Sample copy $2 with 9×12 SAE and 4 first-class stamps.
Needs: Uses about 10 photos/issue; 30% supplied by freelance photographers. Needs action shots, portraits of divers, team shots and anything associated with the sport of diving. Special needs include photo spreads on outstanding divers and tournament coverage. Captions required.
Making Contact & Terms: Send 4×5 or 8×10 b&w glossy prints by mail for consideration; "simply query about prospective projects." SASE. Reports in 1 month. Pays $25/b&w cover photo; $10/b&w inside photo; $50 for text/photo package. Pays on publication. Credit line given. Buys one-time rights. Simultaneous submissions and previously published work OK.
Tips: "Study the field, stay busy."

DOG FANCY, P.O. Box 6050, Mission Viejo CA 92690. Editor: Kim Thornton. Circ. 270,000. Estab. 1970. Monthly. Readers are "men and women of all ages interested in all phases of dog ownership." Sample copy $5.50; photo guidelines available with SASE.
Needs: Uses 20-30 photos/issue, 100% supplied from freelance stock. Specific breed featured in each issue. Prefers "photographs that show the various physical and mental attributes of the breed. Include both environmental and portrait-type photographs. Dogs must be well groomed and, if purebred, good examples of their breed. By good example, we mean a dog that has achieved some recognition on the show circuit and is owned by a serious breeder or exhibitor. We also have a major need for good-quality, interesting photographs of any breed or mixed breed in any and all canine situations (dogs with veterinarians; dogs eating, drinking, playing, swimming, etc.) for use with feature articles." Model release required. Captions preferred (include dog's name and breed and owner's name and address).
Making Contact & Terms: Interested in receiving work from newer, lesser-known photographers. Send by mail for consideration actual 35mm or 2¼×2¼ color transparencies. Present a professional package: 35mm slides in sleeves, labeled, numbered or otherwise identified; a run sheet listing dog's name, titles (if any) and owner's name; and a return envelope of the appropriate size with the correct amount of postage. Reports in 6 weeks. Pays $15-35/b&w photo; $50-75/color photo; $100-400 per text/photo package. Credit line given. Buys first North American serial rights; buys one-time rights.
Tips: "Nothing but sharp, high contrast shots. Send SASE for list of photography needs. We're looking more and more for good quality photo/text packages that present an interesting subject both editorially and visually. Bad writing can be fixed, but we can't do a thing with bad photos. Subjects should be in interesting poses or settings with good lighting, good backgrounds and foregrounds, etc. We are very concerned with sharpness and reproducibility; the best shot in the world won't work if it's fuzzy, and it's amazing how many are. Submit a variety of subjects—there's always a chance we'll find something special we like."

***DOUBLETAKE MAGAZINE**, 1317 W. Pettigrew St., Durham NC 27705. (919)660-3669. Fax: (919)681-7600. E-mail: dtmag@aol.com. Assistant Editor: Caroline Nasrallah. Circ. 35,000. Estab. 1995. Quarterly magazine covering all writing (fiction, nonfiction and poetry) and photography, mostly documentary. General interest, 18 and over. Sample copy for $12. Photo guidelines free with SASE.
Needs: Uses photos on approximately half of the pages (50+ pages/issue); 80% supplied by freelancers. Needs completed photo essays. "We also accept works in progress and some proposals for projects. We are usually interested in work that is in the broad photo-journalistic/humanistic tradition." Model release preferred for children. Captions preferred; date and location are helpful, but not necessary.

Making Contact & Terms: Interested in receiving work from newer, lesser-known photographers. Send unsolicited photos by mail for consideration. Send SASE for guidelines. "We prefer copy slides, no more than 60." Send 35mm transparencies. "We have an ongoing review process. We do not keep samples from every photographer." Keeps samples on file. SASE. Reports in 4-5 weeks usually (varies). Pays $1,000 cover; $250/full published page; $125/half page; etc. Minimum is $75. Pays on publication. Credit line given. Buys first North American serial rights. Simultaneous submissions OK.

***DOWN BEAT MAGAZINE**, Dept. PM, Jazz Blues & Beyond, 102 N. Haven Rd., Elmhurst IL 60126. (708)941-2030. Editorial Director: Frank Alkyer. Monthly. Emphasizes jazz musicians. Circ. 90,000. Estab. 1934. Sample copy available for SASE.
Needs: Uses about 30 photos/issue; 95% supplied by freelancers. Needs photos of live music performers/posed musicians/equipment, "primarily jazz and blues." Captions preferred.
Making Contact & Terms: Query with list of stock photo subjects; send 8×10 b&w prints; 35mm, 2¼×2¼, 4×5, 8×10 transparencies; b&w or color contact sheets by mail. Unsolicited samples for consideration will not be returned unless accompanied by SASE. Provide résumé, business card, brochure, flier or tearsheets to be kept on file for possible future assignments. "Send us two samples of your best work and a list of artists photographed." Reports only when needed. Pays $35/b&w photo; $75/color photo; $175/complete job. Credit line given. Buys one-time rights. Simultaneous submissions and previously published work OK.
Tips: "We prefer live shots and interesting candids to studio work."

***DUNE BUGGIES AND HOT VWS MAGAZINE**, P.O. Box 2260, Costa Mesa CA 92628. (714)979-2560. Fax: (714)979-3998. Editor: Michael Sommer. Circ. 95,000. Estab. 1968. Monthly magazine. Emphasizes Volkswagen features, technical, how-to, race events and reports, product information relating to VWs. Readers are male and female, ages 18-65, seeking general VW-related information. Sample copy $5. Photo guidelines free with SASE.
Needs: Uses 150 photos/issue; 20 supplied by freelancers. Needs photos of feature cars, technical/how-to articles and event coverage. Special photo needs include photos relating to new/cutting edge VW news and/or production of VW automobiles worldwide. Model release required; models must be over 18 years old and photos must be accompanied by a signed release form. Captions preferred.
Making Contact & Terms: Interested in receiving work from newer, lesser-known photographers. Send unsolicited photos by mail for consideration. Provide résumé, business card, brochure, flier or tearsheets to be kept on file for possible future assignments. Send 5×7 glossy b&w prints; 35mm, 2¼×2¼, 4×5 transparencies. Deadlines: 10th of each month, 3 months preceeding cover date. Keeps samples on file. SASE. Reports in 1-2 weeks. Pays $100-125/color page; $100-125/b&w page. Higher rates available depending on quality. Credit line given. Buys one-time rights.
Tips: "We will not accept photos of any vehicle used in careless, dangerous, illegal or other unsafe manner."

E MAGAZINE, 28 Knight St., Dept. PM, Norwalk CT 06851. (203)854-5559. Fax: (203)866-0602. E-mail: emagazine@prodigy.com. Assistant Editor: Anne W. Wilke. Circ. 70,000. Estab. 1990. Nonprofit consumer magazine. Emphasizes environmental issues. Readers are environmental activists; people concerned about the environment. Sample copy for 9×12 SAE and $5. Photo guidelines free with SASE.
Needs: Uses 42 photos/issue; 55% supplied by freelancers. Needs photos of threatened landscapes, environmental leaders, people and the environment and coverage of when environmental problem figures into background of other news. Model and/or property release preferred. Photo captions required: location, identities of people in photograph, date, action in photograph.
Making Contact & Terms: Query with résumé of credits and list of stock photo subjects. Keeps printed samples on file. Reports in 6 weeks. Pays free—$150/color photo; negotiable. Pays several weeks after publication. Credit line given. Buys one-time rights. Simultaneous submissions and previously published work OK.
Tips: Wants to see "straightforward, journalistic images. Abstract or art photography or landscape photography is not used." In addition, "please do not send manuscripts with photographs. These can be addressed as queries to the managing editor."

EARTH MAGAZINE, 21027 Crossroads Circle, Waukesha WI 53186-4055. (414)796-8776. Fax: (414)796-1142. Editorial Assistant: Diane Pinkalla. Circ. 85,000. Estab. 1992. Bimonthly magazine.

THE SUBJECT INDEX, located at the back of this book, can help you find publications interested in the topics you shoot.

Emphasizes earth science for general audience. Sample copy $6.95 ($3.95 plus $3 shipping and handling). Photo guidelines free with SASE for amateurs.
Needs: Uses 70 photos/issue; 25% supplied by freelancers. Needs photos of earth science: landforms, air and water phenomena, minerals, fossils, researchers at work, geologic processes. Model/property release preferred. Captions required; include location, feature and date.
Making Contact & Terms: Interested in receiving work from newer, lesser-known photographers. Send stock list and samples for file. Pays $25-200/color or b&w inside photo. Pays on publication. Credit line given. Buys one-time rights. Previously published work OK.
Tips: Wants to see excellent technical quality in photos of real earth science, not just pretty pictures.

EASYRIDERS MAGAZINE, Dept. PM, P.O. Box 3000, Agoura Hills CA 91376-3000. (818)889-8740. Fax: (818)889-4726. Editorial Director: Keith R. Ball. Estab. 1971. Monthly. Emphasizes "motorcycles (Harley-Davidsons in particular), motorcycle women, bikers having fun." Readers are "adult men who own, or desire to own, custom motorcycles—the individualist—a rugged guy who enjoys riding a custom motorcycle and all the good times derived from it." Free sample copy. Photo guidelines free with SASE.
Needs: Uses about 60 photos/issue; "the majority" supplied by freelance photographers; 70% assigned. Needs photos of "motorcycle riding (rugged chopper riders), motorcycle women, good times had by bikers, etc." Model release required. Also interested in technical articles relating to Harley-Davidsons.
Making Contact & Terms: Send b&w prints, 35mm transparencies by mail for consideration. SASE. Reports in 2 months. Pays $30-100/b&w photo; $40-250/color photo; $30-2,500/complete package. Other terms for bike features with models to satisfaction of editors. For usage on cover, gatefold and feature. Pays 30 days after publication. Credit line given. Buys all rights. All material must be exclusive.
Tips: Trend is toward "more action photos, bikes being photographed by photographers on bikes to create a feeling of motion." In samples, wants photos "clear, in-focus, eye-catching and showing some emotion. Read magazine before making submissions. Be critical of your own work. Check for sharpness. Also, label photos/slides clearly with name and address."

ELLE, MIRABELLA, (formerly *Elle*), 1633 Broadway, 44th Floor, New York NY 10019. Director of Photography: Alison Morely. "We use all freelance work, but rarely unsolicited work. If you are interested in submitting work, please send a 2 or 3 paragraph query in writing. Do not send slides or other artwork—your work will not be returned. Portfolios may be dropped off for review on Wednesdays."

ELLERY QUEEN'S MYSTERY MAGAZINE, 1540 Broadway, New York NY 10036. (212)782-8547. Fax: (212)782-8309. Art Director: Terri Czeczko. Monthly magazine. Readers are female and male, ages 40 and over. Circ. 250,000. Estab. 1941. Photo guidelines free with SASE.
Needs: Uses 1 cover shot/issue. Needs photos of famous authors and personalities. Model/property release required.
Making Contact & Terms: Submit portfolio for review. Keeps samples on file. NPI. Pays on publication. Credit line given. Buys all rights. Rights negotiable.

ENERGY TIMES, 548 Broad Hollow Rd., Melville NY 11747. (516)777-7773. Fax: (516)293-0349. Art Director: Ed Canavan. Circ. 575,000. Estab. 1992. Published 10 times/year. Emphasizes health food industry. Readers are 72% female, 28% male, average age 42.3, interested in supplements and alternative health care, exercise 3.2 times per week. Sample copy $1.25.
Needs: Uses 25 photos/issue; 5 supplied by freelancers. Needs photos of herbs, natural lifestyle, food. Model/property release required. Captions preferred.
Making Contact & Terms: Interested in receiving work from newer, lesser-known photographers. Provide résumé, business card, brochure, flier or tearsheets to be kept on file for possible assignments. Deadlines ongoing. Keeps samples on file. SASE. Reports in 2 weeks. Pays $250/color cover photo; $85/color inside photo; "inside rates negotiable based on size." Pays on publication. Rights negotiable. Previously published work OK.
Tips: "Photos must clearly illustrate the editorial context. Photos showing personal energy are highly regarded. Sharp, high-contrast photos are the best to work with. Bright but non-tacky colors will add vibrance to a publication. When shooting people, the emotion captured in the subject's expression is often as important as the composition."

ENTREPRENEUR, Dept. PM, 2392 Morse Ave., Irvine CA 92714. (714)261-2325. Fax: (714)755-4211. Photo Editor: Chrissy Borgatta. Publisher: Lee Jones. Editor: Rieva Lesonsky. Design Director: Richard R. Olson. Circ. 435,000. Estab. 1977. Monthly. Emphasizes business. Readers are existing and aspiring small business owners.
Needs: Uses about 30 photos/issue; many supplied by freelance photographers; 60% on assignment; 40% from stock. Needs "people at work: home office, business situations. I want to see colorful shots

in all formats and styles." Model/property release preferred. Captions required; include names of subjects.

Making Contact & Terms: Interested in reviewing work from newer, lesser-known photographers. Arrange a personal interview to show portfolio. Query with sample or list of stock photo subjects. Provide résumé, business card, brochure, flier or tearsheets to be kept on file for possible future assignments; "follow-up for response." Pays $75-200/b&w photo; $125-225/color photo; $125-225/color stock. Pays "depending on photo shoot, per hour or per day. We pay $250-300 plus all expenses for assignments." Pays on publication. Credit line given. Buys one-time rights; negotiable.

Tips: "I am looking for photographers who use the environment creatively; I do not like blank walls for backgrounds. Lighting is also important. I prefer medium format for most shoots. I think photographers are going back to the basics—a good clean shot, different angles and bright colors. I am extremely tired of a lot of motion-blurred effect with gelled lighting. I prefer examples of your work—promo cards and tearsheets along with business cards and résumés. Portfolios are always welcome."

ENVIRONMENT, Dept. PM, 1319 18th St. NW, Washington DC 20036. (202)296-6267. Fax: (202)296-5149. Editor: Barbara T. Richman. Editorial Assistant: Nathan Borchelt. Circ. 12,500. Estab. 1958. Magazine published 10 times/year. Covers science and science policy from a national, international and global perspective. "We cover a wide range of environmental topics—acid rain, tropical deforestation, nuclear winter, hazardous waste disposal, energy topics and environmental legislation." Readers include libraries, colleges and universities and professionals in the field of environmental science and policy. Sample copy $7.

Needs: Uses 15 photos/issue; varying number supplied by freelance photographers; 90% comes from stock. "Our needs vary greatly from issue to issue—but we are always looking for good photos showing human impact on the environment worldwide—industrial sites, cities, alternative energy sources, pesticide use, disasters, third world growth, hazardous wastes, sustainable agriculture and pollution. Interesting and unusual landscapes are also needed." Model release required. Captions required, include location and subject.

Making Contact & Terms: Interested in receiving work from newer, lesser-known photographers. Query with list of stock photo subjects. Provide business card, brochure, flier or tearsheets to be kept on file for possible future assignments. Pays $50-150/b&w photo; $50-300/color photo; $350/color cover photo. Pays on publication. Credit line given. Buys one-time rights. Simultaneous submissions and previously published work OK.

Tips: "We are looking for international subject matter—especially environmental conditions in developing countries. Provide us with a stock list, and if you are going someplace specific to shoot photos let us know. We might have some specific request."

❧EQUINOX MAGAZINE, 25 Sheppard Ave. W., Suite 100, North York, Ontario M2N 6S7 Canada. Fax: (416)218-3633. E-mail: letters@equinox.ca. Website: www.equinox.ca. Editor: Jim Cormier. Circ. 175,000. Bimonthly. Emphasizes "Canadian subjects of a general 'discovery' nature." Sample copy $5 with 8½×14 SAE; photo guidelines free with SAE and IRC.

Needs: Uses 80-100 photos/issue; all supplied by stock agencies and freelance photographers. Needs "photo stories of interest to a Canadian readership as well as occasional stock photos required to supplement assignments. Story categories include wildlife, international travel and adventure, science, Canadian arts and architecture and Canadian people and places." Captions required.

 • *Equinox Magazine* has won numerous national magazine awards (Canadian).

Making Contact & Terms: Query with samples. "Submit story ideas and complete photo essays rather than vague invitations." SASE. Reports in 6 weeks. "Most stories are shot on assignment basis—average $2,000 price. We also pay expenses for people on assignment. We also buy packages at negotiable prices and stock photography at about $250 a page if only one or two shots used." **Pays on acceptance.** Credit line given.

Tips: We look for "excellence and in-depth coverage of a subject, technical mastery and an ability to work intimately with people. Many of the photographs we use are of people, so any story idea should emphasize people involved in some activity. Stick to Kodachrome/Ektachrome transparencies."

ESQUIRE, 1790 Broadway, 12th Floor, New York NY 10019. (212)459-7500. Fax: (212)582-7067. Prefers not to share information.

EVANGELIZING TODAY'S CHILD, Child Evangelism Fellowship Inc., P.O. Box 348, Warrenton MO 63383. (314)456-4321. Fax: (314)456-2078. Editor: Mrs. Elsie Lippy. Circ. 20,000. Estab. 1975. Bimonthly magazine. Written for people who work with children, ages 5-12, in Sunday schools, Bible clubs and camps. Sample copy for $2. Photo guidelines free with SASE.

Needs: Buys 1-4 photos/issue; 20% from freelance asssignment; 80% from freelance stock. Children, ages 6-11; unique, up-to-date. Candid shots of various moods and activities. If full color, needs to include good color combination. "We use quite a few shots with more than one child and some with

an adult, mostly closeups. The content emphasis is upon believability and appeal. Religious themes may be especially valuable." No nudes, scenery, fashion/beauty, glamour or still lifes.
Making Contact & Terms: Prefers to retain good-quality photocopies of selected glossy prints and duplicate slides in files for future use. Send material by mail with SASE for consideration; 35mm or larger transparencies. Publication is under no obligation to return materials sent without SASE. Pays on a per-photo basis. Pays $45 minimum/color inside photo; $125/color cover shot. Credit line given. Buys one-time rights. Simultaneous submissions and previously published work OK.

FACES: The Magazine About People, Cobblestone Publishing Inc., 7 School St., Peterborough NH 03458. (603)924-7209. Fax: (603)924-7380. Freelance Picture Editor: Francelle Carapetyan. Circ. 13,500. Estab. 1984. 9 issues/year, September-May. Emphasizes cultural anthropology for young people ages 8-14. Sample copy $4.50 with 8×11 SASE and 5 first-class stamps. Photo guidelines free with SASE.
Needs: Uses about 30-35 photos/issue; about 75% supplied by freelancers. "Photos (b&w) for text must relate to themes; cover photos (color) should also relate to themes." Send SASE for themes. Photos purchased with or without accompanying ms. Model release preferred. Captions preferred.
Making Contact & Terms: Query with stock photo list and/or samples. SASE. Reports in 1 month. Pays $15-100/inside b&w use; cover (color) photos negotiated. Pays on publication. Credit line given. Buys one-time rights. Simultaneous submissions and previously published work OK.
Tips: "Photographers should request our theme list. Most of the photographs we use are of people from other cultures. We look for an ability to capture people in action—at work or play. We primarily need photos showing people, young and old, taking part in ceremonies, rituals, customs and with artifacts and architecture particular to a given culture. Appropriate scenics and animal pictures are also needed. All submissions must relate to a specific future theme."

FAMILY CIRCLE, 110 Fifth Ave., New York NY 10011. Prefers not to share information.

FARM & RANCH LIVING, 5400 S. 60th St., Greendale WI 53129. (414)423-0100. Fax: (414)423-8463. Associate Editor: Trudi Bellin. Estab. 1978. Bimonthly magazine. "Concentrates on farming and ranching as a way of life." Readers are full-time farmers and ranchers. Sample copy $2. Photo guidelines free with SASE.
Needs: Uses about 130 photos/issue; about 30% from freelance stock; 40% assigned. Needs agricultural and scenic photos. "We assume you have secured releases. If in question, don't send the photos." Captions should include season, location.
Making Contact & Terms: Interested in receiving work from newer, lesser-known photographers. Query with samples or list of stock photo subjects. Send 35mm, $2\frac{1}{4} \times 2\frac{1}{4}$, 4×5, 8×10 transparencies by mail for consideration. SASE. "We only want to see one season at a time; we work one season in advance." Reporting time varies; "ASAP: can be a few days, may be a few months." Pays $300/color cover photo; $75-150/color inside photo; $150/color page (full-page bleed); $10-100/b&w photo. Pays on publication. Buys one-time rights. Previously published work OK.
Tips: "Technical quality extremely important. Colors must be vivid so they pop off the page. Study our magazines thoroughly. We have a continuing need for sharp, colorful images. Those who supply what we need can expect to be regular contributors."

FIELD & STREAM, 2 Park Ave., New York NY 10016. (212)779-5364. Photo Editor: Scott Wm. Hanrahan. Circ. 2 million. This is a broad-based service magazine. The editorial content ranges from very basic "how it's done" filler stories that tell in pictures and words how an outdoor technique is accomplished or device is made, to feature articles of penetrating depth about national conservation, game management, and resource management issues; and recreational hunting, fishing, travel, nature and outdoor equipment. Photographer's guidelines available.
Needs: Photos using action and a variety of subjects and angles in color and occasionally b&w. "We are always looking for cover photographs, in color, which may be vertical or horizontal. Remember: a cover picture must have room at the left for cover lines." Needs photo information regarding subjects, the area, the nature of the activity and the point the picture makes.
Making Contact & Terms: Send 35mm slides. Will also consider $2\frac{1}{4} \times 2\frac{1}{4}$ and 4×5 transparencies, but "majority of color illustrations are made from 35mm or slides." Submit photos by registered mail. Send slides in $8\frac{1}{2} \times 11$ plastic sheets, and pack slides and/or prints between cardboard. SASE. Pays $75/b&w photo, $450/color photo depending on size used on single page; $700/partial color spread; $900/full-color spread; $1,000/color cover. Buys first North American serial rights returned after publication.

FIFTY SOMETHING MAGAZINE, 1168 Beachview Rd., Mentor OH 44060. (216)951-2468. Editor: Linda L. Lindeman. Circ. 25,000. Estab. 1990. Bimonthly magazine. Emphasizes lifestyles for the fifty-and-better-reader. Readers are men and women, age 50 and up. Sample copy free with 9×12 SAE and 4 first-class stamps. Photo guidelines free with SASE.

Needs: Uses 25-40 photos/issue; 30 supplied by freelancers. Needs "anything pertaining to mature living—travel, education, health, fitness, money, etc." Model release preferred. Captions preferred.
Making Contact & Terms: Interested in receiving work from newer, lesser-known photographers. Query with list of stock photo subjects. Send unsolicited photos by mail for consideration. Submit portfolio for review. Provide résumé, business card, brochure, flier or tearsheets to be kept on file for possible assignments. Send b&w, color prints; 35mm, 2¼×2¼, 4×5, 8×10 transparencies. SASE. Reports in 6 months. Pays $100/color cover photo; $10/color inside photo; $5/b&w inside photo; $25-75/hour; $100-400/day; $25-125/photo/text package. Pays on publication. Credit line given. Buys one-time rights. Simultaneous submissions and previously published work OK.
Tips: "We are an upbeat publication with the philosophy that life begins at 50. Looking for stories/pictures that show this lifestyle. Also, use a lot of travel/photo essays."

FIGHTING WOMAN NEWS, P.O. Box 741221, New Orleans LA 70131-1221. (504)394-3965. Fax: (504)394-3973. E-mail: FightWomn@aol.com. Website: http://www.gstand.com/pwn. Editor: Sabrina B. Marin. Quarterly. Circ. 5,000. Estab. 1975. Quarterly. Covers women's martial arts. Readers are "adult females actively practicing the martial arts or combative sports." Sample copy $4.00 postpaid. Photo guidelines free with SASE.
Needs: Uses several photos/issue; most supplied by freelance photographers. Needs powerful images of female martial artists; "action photos from tournaments and classes/demonstrations; studio sequences illustrating specific techniques and artistic constructions illustrating spiritual values. Obviously, photos illustrating text have a better chance of being used. We have little space for fillers. We are always short of photos suitable to our magazine." Model release preferred. Captions required; include identification information.
Making Contact & Terms: Interested in reviewing work from newer, lesser-known photographers. Query with résumé of credits or with samples. Send 8×10 glossy b&w prints or b&w contact sheet by mail for consideration. Provide résumé, business card, brochure, flier or tearsheets to be kept on file for possible future assignments. Also accepts digital files in TIFF, GIF or JPEG. SASE. Reports "as soon as possible." NPI. Payment for text/photo package "to be negotiated." Pays on publication. Credit line given. Buys one-time rights. Simultaneous submissions and previously published work OK; "however, we insist that we are *told* concerning these matters. We don't want to publish a photo that is in the current issue of another martial arts magazine."
Tips: Prefers to see "technically competent b&w photos of female martial artists in action; good solid images of powerful female martial artists. We don't print color. No glamour, no models; no cute little kids unless they are also skilled. Get someone knowledgeable to caption your photos or at least tell you what you have—or don't have if you are not experienced in the art you are photographing. We are a poor alternative publication chronically short of material, yet we reject 90% of what is sent because the sender obviously never saw the magazine and has no idea what it's about. Five of our last seven covers were live action photos and we are using fewer enhancements than previously. Best to present yourself and your work with samples and a query letter indicating that you have *seen* our publication. The cost of buying sample copies is a lot less than postage these days."

FINE GARDENING, 63 S. Main St., P.O. Box 5506, Newtown CT 06470. (203)426-8171. Fax: (203)426-3434. Editor: Carole Turner. Circ. 195,000. Estab. 1988. Bimonthly magazine. Emphasizes gardening. Readers are male and female gardeners, all ages (30-60 mostly). Sample copy $5. Photo guidelines free with SASE.
Needs: Uses 80 photos/issue; 30-40 supplied by freelancers. Needs photos of landscape, gardens, individual plants, how-tos. Property release required for private gardens. Captions required, include complete names of plants (common and botanic).
Making Contact & Terms: Interested in receiving work from newer, lesser-known photographers. Send unsolicited photos by mail for consideration. Send color prints; 35mm transparencies. SASE. Reports in 1 month. Pays $300/color cover photo; $50-200/color inside photo; $200/color page rate. Pays on publication. Credit line given. Buys one-time rights. Simultaneous submissions OK.

FINESCALE MODELER, 21027 Crossroads Circle, P.O. Box 1612, Waukesha WI 53187. (414)796-8776. Fax: (414)796-1383. Editor: Bob Hayden. Photo Editor: Paul Boyer. Circ. 85,000. Published 10 times/year. Emphasizes "how-to-do-it information for hobbyists who build nonoperating scale models." Readers are "adult and juvenile hobbyists who build nonoperating model aircraft, ships, tanks and military vehicles, cars and figures." Sample copy $3.50. Photo guidelines free with SASE.
Needs: Uses more than 50 photos/issue; "anticipates using" 10 supplied by freelance photographers. Needs "in-progress how-to photos illustrating a specific modeling technique; photos of full-size aircraft, cars, trucks, tanks and ships." Model release required. Captions required.
Making Contact & Terms: Provide résumé, business card, brochure, flier or tearsheets to be kept on file for possible future assignments. "Phone calls are OK." Reports in 2 months. Pays $25 minimum/color cover photo; $5 minimum/b&w inside photo; $7.50 minimum/color inside photo; $30/b&w page; $45/color page; $50-500 for text/photo package. Pays for photos on publication, for text/photo package

on acceptance. Credit line given. Buys one-time rights. "Will sometimes accept previously published work if copyright is clear."
Tips: Looking for "clear b&w glossy 5×7 or 8×10 prints of aircraft, ships, cars, trucks, tanks and sharp color positive transparencies of the same. In addition to photographic talent, must have comprehensive knowledge of objects photographed and provide copious caption material. Freelance photographers should provide a catalog stating subject, date, place, format, conditions of sale and desired credit line before attempting to sell us photos. We're most likely to purchase color photos of outstanding models of all types for our regular feature, 'Showcase.' "

FIRST OPPORTUNITY, 106 W. 11th St., #250, Kansas City MO 64105-1806. (816)221-4404. Fax: (816)221-1112. Editor: Neoshia Michelle Paige. Circ. 500,000. Semi-annual magazine. Emphasizes advanced vocational/technical education opportunities, career prospects. Readers are African-American, Hispanic, ages 16-22. Sample copy free with 9×12 SAE and 4 first-class stamps.
Needs: Uses 30 photos/issue. Needs photos of students in class, at work, in vocational/technical training, in health field, in computer field, in technology, in engineering, general interest. Model/property release required. Captions required; include name, age, location, action.
Making Contact & Terms: Interested in receiving work from newer, lesser-known photographers. Query with résumé of credits. Query with ideas and SASE. Reports in 1 month, "usually less." Pays $10-50/color photo; $5-25/b&w inside photo. Pays on publication. Buys first North American serial rights. Simultaneous submissions and/or previously published work OK.

FIRST VISIT, 8003 Old York Rd., Elkins Park PA 19027. (215)635-1700. Fax: (215)635-6455. Project Coordinator: Deana C. Jamroz. Circ. 2.25 million/year. Estab. 1991. Magazine published 3 times/year. Emphasizes postnatal care for infants. Readers are new parents who have just taken baby to first pediatrician visit. Sample copy free with 6×9 SAE and 2 first-class stamps. Photo guidelines free with SASE.
Needs: Uses 2-10 photos/issue; 80% supplied by freelancers. Needs photos of neonates, parents with new babies, grandparents with new babies, baby items/products, babies being fed, babies being bathed, etc. Reviews photos with or without ms. Model/property release required.
Making Contact & Terms: Interested in receiving work from newer, lesser-known photographers. Query with stock photo list. Does not keep samples on file. SASE. Pays $800/half day; $300-600/color inside photo; $100-500/b&w inside photo. **Pays on acceptance.** Credit line not given. Buys all rights.
Tips: "Payment for photos is negotiable depending upon degree of difficulty/technical difficulty of pictures."

FLORIDA KEYS MAGAZINE, 3299 SW Ninth Ave., P.O. Box 22748, Ft. Lauderdale FL 33335-2748. (305)764-0604. Fax: (305)760-9949. Art Director: Roschelle Gonzalez. Circ. 10,000. Estab. 1978. Bimonthly magazine. Emphasizes Florida Keys lifestyle. Readers are male and female, Keys residents and frequent visitors, ages 30-55. Sample copy free with 9×12 SAE and 3 first-class stamps. Photo guidelines free with SASE.
Needs: Uses 20-30 photos/issue; 20% supplied by freelancers. Needs photos of wildlife, scenic, personalities, food, architecture, sports. Special photo needs include holiday and special event locations in the Keys. Model/property release preferred. Captions required; include location, names of subjects.
Making Contact & Terms: Interested in receiving work from newer, lesser-known photographers. Send unsolicited photos by mail for consideration. Send any size color or b&w prints; 35mm, 2¼×2¼, 4×5, 8×10 transparencies. Keeps samples on file. SASE. Reports in 1 month. Pays $50/color cover photo; $25/color inside photo; $25/b&w inside photo. Pays on publication. Credit line given. Buys one-time rights; negotiable. Simultaneous submissions and/or previously published work OK.
Tips: Wants to see a "fresh viewpoint on familiar subjects."

FLORIDA MARINER, P.O. Box 1220, Venice FL 34284. (941)488-9307. Fax: (941)488-9309. Publisher: Ken Brothwell. Editor: Stacey Fulgieri. Circ. 25,000. Estab. 1984. Biweekly tabloid. Readers are recreational boaters, both power and sail. Sample copy free with 9×12 SAE and 7 first-class stamps.
Needs: Uses cover photo each issue—24 a year; 100% supplied by freelance photographers. Needs photos of boating related fishing, water skiing, racing and shows. Use of swimsuit-clad model or fisherman with boat preferred. All photos must have *vertical* orientation to match our format. Model release required. Captions preferred.
Making Contact & Terms: Interested in receiving work from newer, lesser-known photographers. Send 35mm transparencies by mail for consideration. SASE. Reports in 2 weeks. Pays $50/color cover photo. **Pays on acceptance.** Credit line optional. Rights negotiable. May use photo more than once for cover. Simultaneous submissions and previously published work OK.
Tips: "We are willing to accept outtakes from other assignments which is why we pay only $50. We figure that is better than letting an unused shot go to waste or collect dust in the drawer."

FLOWER AND GARDEN MAGAZINE, 700 W. 47th St., Suite 310, Kansas City MO 64112. (816)531-5730. Fax: (816)531-5730. Staff Editor: Brent Shepherd. Executive Editor: Kay Melchisedech Olson. Estab. 1957. "We publish 6 times a year and require several months of lead time." Emphasizes home gardening. Readers are male and female homeowners with a median age of 47. Sample copy $3.50. Photo guidelines free with SASE.

Needs: Uses 25-50 photos/issue; 75% supplied by freelancers. "We purchase a variety of subjects relating to home lawn and garden activities. Specific horticultural subjects must be accurately identified."

Making Contact & Terms: Interested in receiving work from newer, lesser-known photographers. To make initial contact, "Do not send great numbers of photographs, but rather a good selection of 1 or 2 specific subjects. We do not want photographers to call. We return photos by certified mail— other means of return must be specified and paid for by the individual submitting them. It is not our policy to pay holding fees for photographs." Pays $25-100/b&w photo; $100-500/color photo. Pays on publication. Buys one-time and non-exclusive reprint rights. Model/property release preferred. Captions preferred; please provide exact name of plant (botanical), variety name and common name.

Tips: Wants to see "clear shots with crisp focus. Also, appealing subject matter—good lighting, technical accuracy, depictions of plants in a home garden setting rather than individual close-ups. Let us know what you've got, we'll contact you when we need it. We see more and more freelance photographers trying to have their work published. In other words, supply is greater than demand. Therefore, a photographer who has too many conditions and provisions will probably not work for us."

FLY FISHERMAN, Cowles Magazines, Inc., 6405 Flank Dr., P.O. Box 8200, Harrisburg PA 17112. (717)657-9555. Editor and Publisher: John Randolph. Managing Editor: Philip Hanyok. Circ. 150,000. Published 6 times/year. Emphasizes all types of fly fishing for readers who are "100% male, 83% college educated, 98% married. Average household income is $81,800 and 49% are managers or professionals; 68% keep their copies for future reference and spend 35 days a year fishing." Sample copy $3.95 with 9×12 SAE and 4 first-class stamps. Photo/writer guidelines for SASE.

Needs: Uses about 45 photos/issue, 80% of which are supplied by freelance photographers. Needs shots of "fly fishing and all related areas—scenics, fish, insects, how-to." Captions required.

Making Contact & Terms: Send 35mm, 2¼×2¼, 4×5 or 8×10 color transparencies by mail for consideration. SASE. Reports in 6 weeks. NPI. Pays on publication. Credit line given. Buys one-time rights.

FLY ROD & REEL: THE MAGAZINE OF AMERICAN FLY-FISHING, Dept. PM, P.O. Box 370, Camden ME 04843. (207)594-9544. Fax: (207)594-5144. Editor: Jim Butler. Magazine published 6 times/year, irregular intervals. Emphasizes fly-fishing. Readers are primarily fly fishermen ages 30-60. Circ. 62,000. Estab. 1979. Free sample copy with SASE. Photo guidelines free with SASE.

Needs: Uses 25-30 photos/issue; 15-20 supplied by freelancers. Needs "photos of fish, scenics (preferrably with anglers in shot), equipment." Photo captions preferred that include location, name of model (if applicable).

Making Contact & Terms: Query with list of stock photo subjects. Send unsolicited photos by mail for consideration. Provide résumé, business card, brochure, flier or tearsheets to be kept on file for possible assignments. Send glossy b&w, color prints; 35mm, 2¼×2¼, 4×5 transparencies. Keeps samples on file. SASE. Reports in 1 month. Pays $600/color cover photo; $75/color inside photo; $75/ b&w inside photo; $150/color page rate; $150/b&w page rate. Pays on publication. Credit line given. Buys one-time rights.

Tips: "Photos should avoid appearance of being too 'staged.' We look for bright color (especially on covers), and unusual, visually appealing settings. Trout and salmon are preferred for covers. Also looking for saltwater fly-fishing subjects."

FOOD & WINE, Dept. PM, 1120 Avenue of the Americas, New York NY 10036. (212)382-5600. Photo Editor: Palli Wilson. Monthly. Emphasizes food and wine. Readers are an "upscale audience who cook, entertain, dine out and travel stylishly." Circ. 850,000. Estab. 1978.

Needs: Uses about 25-30 photos/issue; freelance photography on assignment basis 85%, 15% freelance stock. "We look for editorial reportage specialists who do restaurants, food on location and travel photography." Model release and captions required.

Making Contact & Terms: Drop-off portfolio on Tuesdays. Call for pickup. Submit fliers, tearsheets, etc. to be kept on file for possible future assignments and stock usage. Pays $450/color page; $100-450 color photo. **Pays on acceptance.** Credit line given. Buys one-time world rights.

FORTUNE, Dept. PM, Rockefeller Center, Time-Life Bldg., 1271 Avenue of the Americas, New York NY 10020. (212)522-3803. Managing Editor: John Huey. Picture Editor: Michele F. McNally. Picture Editor reviews photographers' portfolios on an overnight drop-off basis. Emphasizes analysis of news in the business world for management personnel. Photos purchased on assignment only. Day

rate on assignment (against space rate): $400; page rate for space: $400; minimum for b&w or color usage: $150. Pays extra for electronic rights.

FOUR WHEELER MAGAZINE, 3330 Ocean Park Blvd., Suite 115,, Santa Monica CA 90405. (310)392-2998. Editor: John Stewart. Circ. 325,000. Monthly magazine. Emphasizes four-wheel drive vehicles and enthusiasts. Photo guidelines free with SASE.
Needs: Uses 100 color/100 b&w photos/issue; 2% supplied by freelance photographers. Needs how-to, travel/scenic/action (off-road 4×4s only) photos. Travel pieces also encouraged. Reviews photos with accompanying ms only. Model release required. Captions required.
Making Contact & Terms: Provide résumé, business card, brochure, flier or tearsheets to be kept on file for possible future assignments. Does not return unsolicited material. Reports in 1 month. Pays $10-50/inside b&w photo; $20-100/inside color photo; $100/b&w and color page; $200-600/text/photo package. Pays on publication. Credit line given. Buys all rights.

‡FRANCE MAGAZINE, Dormer House, The Square, Stow-on-the-Wold, Gloucestershire GL54 1BN England. (0451)831398. Fax: (0451)830869. E-mail: editors@francehouse.co.uk. Assistant Editor: Jon Stackpool. Circ. 43,121. Estab. 1990. Quarterly magazine. Emphasizes France. Readers are male and female, ages over 45; people who holiday in France. Sample copy $9.
Needs: Uses 250 photos/issue; 200 supplied by freelancers. Needs photos of France and French subjects: people, places, customs, curiosities, produce, towns, cities, countryside. Captions required; include location and as much information as is practical.
Making Contact & Terms: Interested in receiving work on spec: themed sets very welcome. Send unsolicited photos by mail for consideration. Also accepts digital files on ISDN: 4sight compatible 300 DPI or similar. Send 35mm, 2¼×2¼ transparencies. Keep samples on file. SASE. Reports in 1 month. Pays £100/color cover photo; £50/color full page; £25/¼ page and under. Pays quarterly following publication. Credit line given. Buys one-time rights. Previously published work OK.

FUN IN THE SUN, Dept. PM, 5436 Fernwood Ave., Los Angeles CA 90027. (213)465-7121. Publisher: Dana Lange-Newman. Circ. 10,000. Quarterly. Emphasizes nudism/naturism/alternative lifestyles. Photo guidelines free with SASE.
Needs: Uses about 50 photos/issue; 20 supplied by freelance photographers. Needs photos of "nudity; fun in sun (nonsexist)." Nudist, naturist, body self-acceptance. Model release required. Captions required.
Making Contact & Terms: Query with samples. SASE. Reports in 3 weeks. Pays $50/b&w cover photo; $100/color cover photo; $25/b&w or color inside photo. **Pays on acceptance.** Credit line given. Buys one-time or all rights. Previously published work OK.

GALLERY MAGAZINE, FOX MAGAZINE, POCKETFOX MAGAZINE, 401 Park Ave. S., New York NY 10016-8802. Photo Editor: Judy Linden. Estab. 1972. Emphasizes men's interests. Readers are male, collegiate, middle class. Photo guidelines free with SASE.
Needs: Uses 80 photos/issue; 10% supplied from freelancers (no assignments). Needs photos of nude women and celebrities, plus sports, adventure pieces. Model release with photo ID required.
Making Contact & Terms: Send at least 100 35mm transparencies by mail for consideration. SASE. Reports in 1 month. Pays $85-100/b&w photo. Girl sets: pays $1,500-1,800; cover extra. Buys first North American serial rights plus nonexclusive international rights. Also operates Girl Next Door contest: $250 entry photo; $2,500 monthly winner; $25,000 yearly winner (must be amateur!). Photographer: entry photo/receives 1-year free subscription, monthly winner $500; yearly winner $2,500. Send *by mail* for contest information.
Tips: In photographer's samples, wants to see "beautiful models and good composition. Trend in our publication is outdoor settings—avoid soft focus! Send complete layout."

GAME & FISH PUBLICATIONS, 2250 Newmarket Pkwy., Suite 110, Marietta GA 30067. (404)953-9222. Fax: (404)933-9510. Photo Editor: Tom Evans. Editorial Director: Ken Dunwoody. Combined circ. 525,000. Estab. 1975. Publishes 31 different monthly outdoors magazines: *Alabama Game & Fish, Arkansas Sportsman, California Game & Fish, Florida Game & Fish, Georgia Sportsman, Great Plains Game & Fish, Illinois Game & Fish, Indiana Game & Fish, Iowa Game & Fish, Kentucky Game & Fish, Louisiana Game & Fish, Michigan Sportsman, Mid-Atlantic Game & Fish, Minnesota Sportsman, Mississippi Game & Fish, Missouri Game & Fish, New England Game & Fish, New York Game & Fish, North Carolina Game & Fish, Ohio Game & Fish, Oklahoma Game & Fish, Pennsylvania Game & Fish, Rocky Mountain Game & Fish, South Carolina Game & Fish, Tennessee Sportsman, Texas Sportsman, Virginia Game & Fish, Washington-Oregon Game & Fish, West Virginia Game & Fish, Wisconsin Sportsman,* and *North American Whitetail.* All magazines (except *Whitetail*) are for experienced fishermen and hunters and provide information about where, when and how to enjoy the best hunting and fishing in their particular state or region, as well as articles about game and

fish management, conservation and environmental issues. Sample copy $2.50 with 10×12 SAE. Photo guidelines free with SASE.

Needs: 50% of photos supplied by freelance photographers; 5% assigned. Needs photos of live game animals/birds in natural environment and hunting scenes; also underwater game fish photos and fishing scenes. Model release preferred. Captions required; include species identification and location. Number slides/prints. In captions, identify species and location.

Making Contact & Terms: Query with samples. Send 8×10 glossy b&w prints or 35mm transparencies (preferably Kodachrome) with SASE for consideration. Reports in 1 month. Pays $250/color cover photo; $75/color inside photo; $25/b&w inside photo. Pays 75 days prior to publication. Tearsheet provided. Credit line given. Buys one-time rights. Simultaneous submissions not accepted.

Tips: "Study the photos that we are publishing before sending submission. We'll return photos we don't expect to use and hold remainder in-house so they're available for monthly photo selections. Please do not send dupes. Photos will be returned upon publication or at photographer's request."

GARDEN DESIGN, 100 Avenue of the Americas, 7th Floor, New York NY 10013. (212)334-1212. Fax: (212)334-1260. Photography Editor: Susan Goldberger. Bimonthly. Emphasizes residential landscape architecture and garden design. Readers are gardeners, home owners, architects, landscape architects, garden designers and garden connoisseurs. Estab. 1982. Sample copy $5.

Needs: Uses about 80 photos/issue; nearly all supplied by freelance photographers; 80% from assignment and 20% from freelance stock. Needs photos of "public and private gardens that exemplify professional quality design." Needs to see both the design intent and how garden subspaces work together. Model release and captions required.

Making Contact & Terms: Interested in receiving work from newer, lesser-known photographers. Submit proposal with résumé and samples. Reports in 2 months or sooner if requested. Publishes color primarily, and uses original transparencies only for separation—do not send dupes. Pays $150/inside photo over ⅓ page; $75/⅓ page or smaller. Credit line given. Buys one-time first North American magazine publication rights. Previously published work may be acceptable but is not preferred.

Tips: "Show both detailed and comprehensive views that reveal the design intent and content of a garden, as well as subjective, interpretive views of the garden. A letter and résumé are not enough— must see evidence of the quality of your work, in samples or tearsheets. Need excellent depth of field and superior focus throughout. The quality of light, original framing and point of view are important."

***‡GAY TIMES**, Worldwide House, 116-134 Bayham St., London NWI OBA United Kingdom (071)482-2576. Fax: (071)284-0329. Editor: David Smith. Circ. 50,000. Estab. 1983. Monthly magazine. Emphasizes news and culture from a lesbian and gay perspective. Readers are lesbians and gay men of all ages. Sample copy for £2.50.

Needs: Uses 50 photos/issue. Needs photos of personalities, lesbian and gay news and events. Reviews photos with or without manuscript. Model release preferred. Captions required; include who it is, what they're doing, where, photographer's details.

Making Contact & Terms: Interested in receiving work from newer, lesser-known photographers. Send unsolicited photos by mail for consideration with introductory letter. Send 8×10 b&w prints; 35mm transparencies. Does not keep samples on file. SASE. Reports in 1 month. Pays £25 per photo and £60-80 commission. Pays on publication. Credit line given. Buys one-time rights; negotiable. Previously published work OK.

Tips: Looks for a "good grasp of news stories and ability to show this through photography. Unique coverage of lesbian and gay themes."

GENERAL LEARNING COMMUNICATIONS, 60 Revere Dr., Northbrook IL 60062-1563. (708)205-3000. Supervisor/Photography: Candace H. Johnson. Estab. 1969. Publishes four monthly school magazines running September through May. *Current Health I* is for children aged 9-13. *Current Health II*, *Writing!*, *Career World* are for high school teens. An article topics list and photo guidelines will be provided free with 9×12 SASE.

Needs: Color photos of children aged 11-13 for *Current Health II*, all other publications for teens aged 13-18, geared to our topic themes for inside use and cover; 35mm or larger transparencies only. Model release preferred. Captions preferred.

Making Contact & Terms: Interested in receiving work from newer, lesser-known photographers who produce exceptional quality photographs. Label all photos with name and address for easy return.

‡ **THE DOUBLE DAGGER** before a listing indicates that the market is located outside the United States and Canada.

Pays $75/inside photo; $200/cover photo. Pays on publication. Credit line given. Buys one-time rights. Simultaneous submissions and previously published work OK.

Tips: "We are looking for contemporary photos of children and teens, including minorities. Do not send outdated or posed photos. When sending photos for a particular article or magazine be as specific as possible in stating the name of the magazine, issue and title of article (example: *Career World*, March 1997, "Managing Stress").

GENESIS MAGAZINE, 110 E. 59th St., Suite 3100, New York NY 10022. (212)644-8800. Fax: (212)644-9212. Creative Director: Tony Perrotti. Circ. 250,000. Estab. 1973. Monthly magazine. Emphasizes nude women. Readers are male, ages 25-45. Photo guidelines free with SASE.
Needs: Uses 100 photos/issue. Needs photos of nudes. Special photo needs include surreal photojournalism and artistic nudes. Model release required (2 pieces of identification).
Making Contact & Terms: Interested in receiving work from newer, lesser-known photographers. Send unsolicited photos by mail for consideration. Send 35mm, 2¼×2¼ transparencies. SASE. Reports in 1 month. Pays $200-500/color photo; $1,000-3,000/girl pictorials. Pays 90 days after acceptance. Credit line given.
Tips: "On girl pictorials we need to see very beautiful, vibrant models and great color on flesh tones. We need all indoor sets, no outdoor."

GENRE, 7080 Hollywood Blvd., Suite 1104, Hollywood CA 90028. (213)896-9778. Publisher: Richard Settles. Editor: Ron Kraft. Circ. 45,000. Estab. 1990. Monthly. Emphasizes gay life. Readers are gay men, ages 24-35. Sample copy $5.
Needs: Uses 140 photos/issue. Needs photos of fashion, celebrities, scenics. Model/property release required. Captions preferred.
Making Contact & Terms: Interested in receiving work from newer, lesser-known photographers. Provide résumé, business card, brochure, flier or tearsheets to be kept on file for possible assignments. Cannot return material. Reports only if interested. "We pay only film processing." Pays on publication. Credit line given. Buys all rights; negotiable.

***GENT**, 14411 Commerce Way, Suite 420, Miami Lakes FL 33016. (305)557-0071. Editor: Steve Dorfman. Circ. 150,000. Monthly magazine. Showcases full-figured, D-cup nude models. Sample copy $6 (postpaid). Photo guidelines free with SASE.
Needs: Buys in sets, not by individual photos. "We publish manuscripts on sex, travel, adventure, cars, racing, sports, gambling, grooming, fashion and other topics that traditionally interest males. Nude models must be extremely large breasted (minimum 38" bust line). Sequence of photos should start with woman clothed, then stripped to brassiere and then on to completely nude. Bikini sequences also recommended. Cover shots must have nipples covered. Chubby models also considered if they are reasonably attractive and measure up to our 'D-Cup' image." Model release and photocopy or photograph of picture ID required.
Making Contact & Terms: Send material by mail for consideration. Send transparencies. Prefer Kodachrome or large format; vertical format required for cover. SASE. Reports in 4-6 weeks. Pays $1,200 minimum per set (first rights); $600 (second rights); $300/cover photo; $250-500 for text and photo package. Pays on publication. Credit line given. Buys one-time rights or second serial (reprint) rights. Previously published work OK.

✤GEORGIA STRAIGHT, 1770 Burrard St., 2nd Floor, Vancouver, British Columbia V6J 3G7 Canada. (604)730-7000. Fax: (604)681-0272. Managing Editor: Charles Campbell. Circ. 100,000. Estab. 1967. Weekly tabloid. Emphasizes entertainment. Readers are generally well-educated people between 20 and 45 years old. Sample copy free with 10×12 SAE.
Needs: Uses 20 photos/issue; 35% supplied by freelance photographers on assignment. Needs photos of entertainment events and personalities. Captions preferred.
Making Contact & Terms: Query with list of stock photo subjects. Include résumé, business card, brochure, flier or tearsheets to be kept on file for possible assignments. Reports in 1 month. Pays $200/b&w cover photo and $125/b&w inside photo. Pays on publication. Credit line given. Buys one-time rights. Simultaneous submissions and previously published work OK.
Tips: "Almost all needs are for in-Vancouver assigned photos, except for high-quality portraits of film stars."

GLAMOUR, Conde Nast Building, 350 Madison Ave., New York NY 10017-3704. Prefers not to share information.

GOLF TRAVELER, 2575 Vista del Mar Dr., Ventura CA 93001. (805)667-4000. Fax: (805)667-4217. Editor: Valerie Law. Bimonthly magazine. Emphasizes golf; senior golfers. Readers are "avid golfers who have played an average of 24 years." Circ. 130,000. Estab. 1976. Sample copy $2.50 and SASE.

Needs: Uses 10-20 photos/issue; all supplied by freelancers. Needs photos of "affiliated golf courses associated with Golf Card;" personality photos of Senior Tour golfers; general interest golf photos. Model release required for cover images. Photo captions preferred that include who and where.
Making Contact & Terms: Send stock list. Does not keep samples on file. SASE. Reports in 1 month. Pays $475/color cover photo; $150/color inside ¼ page photo. **Pays on acceptance**. Credit line given. Buys one-time rights. Previously published work OK.
Tips: Looks for "good color-saturated images."

THE GOLFER, 21 E. 40th St., New York NY 10016. (212)768-8360. Fax: (212)768-8365. Contact: Gina Falco. Circ. 250,000. Estab. 1994. Bimonthly magazine. Emphasizes golf, resort, travel, sporting fashion. Readers are affluent males and females, ages 35 and up. Sample copy $5.50.
Needs: Uses 30-50 photos/issue; all supplied by freelancers. Needs photos of golf action, resorts, courses, and still life photography.
Making Contact & Terms: Interested in receiving work from newer, lesser-known photographers. Query with résumé of credits. Provide résumé, business card, brochure, flier or tearsheets to be kept on file for possible assignments. Query with stock photo list. Keeps samples on file. SASE. Reports in 1 month. NPI. Pays on publication. Buys one-time rights. Simultaneous submissions and previously published work OK.

GOOD HOUSEKEEPING, 959 Eighth Ave., New York NY 10019-3795. Prefers not to share information.

♣GOSPEL HERALD, 4904 King St., Beamsville, Ontario L0R 1B6 Canada. (905)563-7503. Fax: (905)563-7503. Co-editor: Wayne Turner. Managing Editor: Eugene Perry. Circ. 1,420. Estab. 1936. Consumer publication. Monthly magazine. Emphasizes Christianity. Readers are primarily members of the Churches of Christ. Sample copy free with SASE.
Needs: Uses 2-3 photos/issue; percentage supplied by freelancers varies. Needs scenics, shots, especially those relating to readership—moral, religious and nature themes.
Making Contact & Terms: Send unsolicited photos by mail for consideration. Send b&w, any size and any format. Payment not given, but photographer receives credit line.
Tips: "We have never paid for photos. Because of the purpose of our magazine, both photos and stories are accepted on a volunteer basis."

GRAND RAPIDS MAGAZINE, 549 Ottawa Ave. NW, Grand Rapids MI 49503-1444. (616)459-4545. Fax: (616)459-4800. Publisher: John H. Zwarensteyn. Editor: Carole R. Valade. Estab. 1963. Monthly magazine. Emphasizes community-related material of Western Michigan; local action and local people.
Needs: Animal, nature, scenic, travel, sport, fashion/beauty, photo essay/photo feature, fine art, documentary, human interest, celebrity/personality, humorous, wildlife, vibrant people shots and special effects/experimental. Wants on a regular basis western Michigan photo essays and travel-photo essays of any area in Michigan. Model release required. Captions required.
Making Contact & Terms: Interested in receiving work from newer, lesser-known photographers. Freelance photos assigned and accepted. Provide business card to be kept on file for possible future assignments; "only people on file are those we have met and personally reviewed." Arrange a personal interview to show portfolio. Query with résumé of credits. Send material by mail for consideration. Submit portfolio for review. Send 8×10 or 5×7 glossy b&w prints; contact sheet OK; 35mm, 120mm or 4×5 transparencies or 8×10 glossy color prints; Uses 2¼×2¼ and 4×5 color transparencies for cover, vertical format required. SASE. Reports in 3 weeks. Pays $25-35/b&w photo; $35-50/color photo; $100-150/cover photo. Buys one-time rights, exclusive product rights, all rights; negotiable.
Tips: "Most photography is by our local freelance photographers, so freelancers should sell us on the unique nature of what they have to offer."

GUEST INFORMANT, 21200 Erwin St., Woodland Hills CA 91367. (800)275-5885. Contact: Photo Editor. Quarterly and annual city guide books. Emphasizes city-specific photos for use in guide books distributed in upscale hotel rooms in approximately 30 U.S. cities.
Needs: "We review people-oriented, city-specific stock photography that is innovative and on the cutting edge." Categories include: major attractions, annual events, local recreation, lifestyle, pro sports, regional food and cultural color. Captions required; include city, location, event, etc.
Making Contact & Terms: Interested in seeing new as well as established photographers. Provide promo, business card and list of cities covered. Send transparencies with a delivery memo stating the number and format of transparencies you are sending. All transparencies must be clearly marked with photographer's name and caption information. They should be submitted in slide pages with similar images grouped together. Rates: Cover $250. Inside $100-200, depending on size. 50% reuse rate. Pays on publication, which is about 60 days from initial submission. Credit line given.

Tips: Contact photo editor at (800)275-5885 for guidelines and submission schedule before sending your work.

GUIDE FOR EXPECTANT PARENTS, 8003 Old York Rd., Elkins Park PA 19027. (215)635-1700. Fax: (215)635-6455. Project Coordinator: Deana C. Jamroz. Circ. 1.85 million. Estab. 1973. Biannual magazine. Emphasizes prenatal care for pregnant women and their partners. Sample copy free with 9×12 SAE and 4 first-class stamps. Photo guidelines free with SASE.
Needs: Uses 2-8 photos/issue; 80% supplied by freelancers. Needs photos of pregnant women with their spouses and physicians, nurses with pregnant women, pregnant women in classroom (prenatal) situations, pictures of new families. Reviews photos with or without ms. Model/property release required.
Making Contact & Terms: Interested in receiving work from newer, lesser-known photographers. Query with stock photo list. Does not keep samples on file. SASE. Reports in 3 weeks. Pays $300-600/color inside photo; $100-500/b&w inside photo. **Pays on acceptance.** Credit line not given. Buys all rights.

GUIDEPOSTS, Dept. PM, 16 E. 34th St., 21st Floor, New York NY 10016. (212)251-8124. Fax: (212)684-0679. Photo Editor: Candice Smilow. Circ. 4 million. Estab. 1945. Monthly magazine. Emphasizes tested methods for developing courage, strength and positive attitudes through faith in God. Free sample copy and photo guidelines with 6×9 SAE and 3 first-class stamps.
● This company has begun using digital manipulation and retouching when necessary.
Needs: Uses 85% assignment, 15% stock (variable). "Photos mostly used are of an editorial reportage nature or stock photos, i.e., scenic landscape, agriculture, people, animals, sports. We work four months in advance. It's helpful to send stock pertaining to upcoming seasons/holidays. No lovers, suggestive situations or violence." Model release preferred.
Making Contact & Terms: Interested in receiving work from newer, lesser-known photographers. Send photos or arrange a personal interview. Send 35mm transparencies; vertical format required for cover, usually shot on assignment. SASE. Reports in 1 month. Pays by job or on a per-photo basis; pays $150-400/color photo; $750/cover photo; $400-600/day; negotiable. **Pays on acceptance.** Credit line given. Buys one-time rights. Simultaneous submissions OK.
Tips: "I'm looking for photographs that show people in their environment. I like warm, saturated color for portraits and scenics. We're trying to appear more contemporary. We want to stimulate a younger audience and yet maintain a homey feel. For stock—scenics; graphic images with intense color. *Guideposts* is an 'inspirational' magazine. NO violence, nudity, sex. No more than 60 images at a time. Write first and ask for a photo guidelines/sample issue; this will give you a better idea of what we're looking for. I will review transparencies on a light box. I am interested in the experience as well as the photograph. I am also interested in the photographer's sensibilities—Do you love the city? Mountain climbing? Farm life?"

GUITAR SCHOOL, 1115 Broadway, New York NY 10010. (212)807-7100. Fax: (212)627-4678. Managing Editor: Tom Beaujour. Circ. 127,000. Bimonthly. Emphasizes guitar playing. Readers are male and female fans and students of guitar.
Needs: Uses 25 photos/issue; all supplied by freelancers.
Making Contact & Terms: Interested in receiving work from newer, lesser-known photographers. Query with stock photo list. Cannot return materials. Reports in 1-2 weeks. NPI. Pays on publication. Credit line given. Buys one-time rights.

✿HARROWSMITH, 25 Sheppard Ave. W., Suite 100, North York, Ontario M2N 6S7 Canada. (416)733-7600. Assistant Editor: Robin Bates. Estab. 1976. Magazine published 6 times/year. Circ. 154,000. Emphasizes self-reliance, energy conservation, organic gardening, solar energy. Sample copy $5 with 8½×14 SAE.
Needs: Buys 400 photos/year, 50 photos/issue; 40% assigned. Animal, how-to, nature, North American rural life, wildlife (North American), horticulture, organic gardening.
Making Contact & Terms: Anyone wishing to submit photographs should contact the Editorial Assistant. "We are interested in seeing portfolios of both published and personal work." NPI. Payment varies with assignment.
Tips: Prefers to see portfolio with credits and tearsheets of published material. Samples should be subject-oriented. In portfolio or samples, wants to see "clarity, ability to shoot people, nature and horticulture photo essays."

✻HEALTH & BEAUTY MAGAZINE, P.O. Box 841224, Pembroke Pines FL 33024. (954)434-3885. Fax: (954)434-3829. Publisher: Marie Provenciano. Circ. 50,000. Estab. 1996. Magazine published 10 times/year. Emphasizes health, beauty and fashion. Readers are "savvy Floridians," ages 35-55. Sample copy free with SASE.

Needs: Model release required.
Making Contact & Terms: Interested in receiving work from newer, lesser-known photographers. Send unsolicited photos by mail for consideration. Keeps samples on file. Pays on publication. Rights negotiable. Simultaneous submissions and previously published work OK.

***‡HEALTH & BEAUTY MAGAZINE**, 10 Woodford, Brewery Rd., Blackrock, Dublin, Ireland. (01)2954095. Mobile: 088-531566. Fax: (01)8745682. Advertising Manager: David Briggs. Circ. 11,000. Estab. 1985. Bimonthly magazine. Emphasizes all body matters. Readers are male and female, ages 17-50 (all keen on body matters). Sample copy free with A4 SASE.
Needs: Uses approximately 100 photos/issue; 50% supplied by freelancers. Needs photos related to health, hair, fashion, beauty, food, drinks. Reviews photos with or without ms. Model/property release preferred. Captions preferred; include photo description.
Making Contact & Terms: Interested in receiving work from newer, lesser-known photographers. Send unsolicited photos by mail for consideration. Provide résumé, business card, brochure, flier or tearsheets to be kept on file for possible assignments. Send any size glossy color and b&w prints; 35mm, 2¼×2¼, 4×5, 8×10 transparencies; prints preferred. Keeps samples on file. SASE. Reports in 1 month. NPI. Credit line given. Buys all rights; negotiable. Simultaneous submissions and/or previously published work OK.
Tips: Looks for "male and female models of good body shape, shot in interesting locations with interesting body and facial features. Continue on a regular basis to submit good material for review."

HEALTHY OUTLOOK, 2601 Ocean Park Blvd., #200, Santa Monica CA 90405. (310)399-9000. Fax: (310)399-1722. Art Director: Howard Maat. Publication of Oxford Health Plans. Quarterly magazine. Emphasizes senior health issues, senior travel, finance, etc. Readers are 65 and older, mostly retired seniors from East Coast.
Needs: Needs photos of healthy/active senior citizens, healthy food preparations/ingredients, East Coast scenics, famous senior personalities. Special photo needs include senior celebrities (60+) with release. Model/property release preferred. Captions required.
Making Contact & Terms: Interested in receiving work from newer, lesser-known photographers. Provide résumé, business card, brochure, flier or tearsheets to be kept on file for possible assignments. Submit portfolio for review. Keeps samples on file. Reports in 1 month. NPI. Pays on publication. Credit line given. Buys one-time rights, all rights. Previously published work OK.
Tips: "Show specific strengths; be upfront with prices; be flexible and responsible with regards to deadlines."

HEARTLAND BOATING, P.O. Box 1067, Martin TN 38237. (901)587-6791. Fax: (901)587-6893. Editor: Molly Lightfoot Blom. Circ. 20,000. Estab. 1989. Magazine published 7 times/year (during boating season). Emphasizes recreational boating on the inland lakes and rivers. Readers are recreational boaters, primarily affluent middle-aged males. Sample copy $5. Photo guidelines free with SASE.
Needs: Needs photos of boating—places, people, technical. Model release preferred. Captions preferred.
Making Contact & Terms: Interested in receiving work from newer, lesser-known photographers. Provide résumé, business card, brochure, flier or tearsheets to be kept on file for possible assignments. Keeps samples on file. Reports 2 months. NPI. Pays on publication. Credit line given. Buys one-time rights, first North American serial rights. Previously published work OK.

HIGH SOCIETY MAGAZINE, 801 Second Ave., New York NY 10017. (212)661-7878. Fax: (212)692-9297. Photo Editor: Vivienne Maricevic. Circ. 400,000. Estab. 1976. Monthly magazine. Emphasis on "everything of sexual interest to the American male." Readers are young males, ages 21-40. SASE. Photo guidelines available.
Needs: Uses 300 photos/issue; 50% supplied by freelancers. Needs sexually stimulating, nude photos of gorgeous women, ages 21-35. Reviews photos with or without accompanying ms. Special needs include outdoor and indoor scenes of nude women. Model/property release required. Captions preferred.
Making Contact & Terms: Interested in receiving work from newer, lesser-known photographers. Send color prints; 35mm, 2¼×2¼ transparencies by mail for consideration. Does not keep samples on file. SASE. Pays $300/color cover photo; $150/color inside photo; $100/b&w inside photo; $800/

THE CODE NPI (no payment information given) appears in listings that have not given specific payment amounts.

color page rate; $400/b&w page rate; $1,500/photo-text package. **Pays on acceptance.** Credit line given. Buys one-time rights; negotiable. Simultaneous submissions and previously published work OK.

Tips: Looks for "clear, concise color, interesting set preparation and props, strong contrast, backgrounds and settings, and knock-'em-out models. Look at our previous published issues and see what we buy."

HIGHLIGHTS FOR CHILDREN, Dept. PM, 803 Church St., Honesdale PA 18431. (717)253-1080. Photo Essay Editor: Kent L. Brown, Jr. Circ. nearly 3 million. Monthly magazine. For children, ages 2-12. Free sample copy.

Needs: Buys 20 or more photos annually. "We will consider outstanding photo essays on subjects of high interest to children." Photos purchased with accompanying ms. Wants no single photos without captions or accompanying ms.

Making Contact & Terms: Interested in receiving work from newer, lesser-known photographers. Send photo essays for consideration. Prefers transparencies. SASE. Reports in 7 weeks. Pays $30 minimum/b&w photo; $55 minimum/color photo. Pays $100 minimum for ms. Buys all rights.

Tips: "Tell a story which is exciting to children. We also need mystery photos, puzzles that use photography/collage, special effects, anything unusual that will visually and mentally challenge children."

HOCKEY ILLUSTRATED, 233 Park Ave. S., New York NY 10003. (212)780-3500. Fax: (212)780-3555. Editor: Stephen Ciacciarelli. Circ. 50,000. Published 4 times/year, in season. Emphasizes hockey superstars. Readers are hockey fans. Sample copy $2.95 with 9 × 12 SASE.

Needs: Uses about 60 photos/issue; all supplied by freelance photographers. Needs color slides of top hockey players in action. Captions preferred.

Making Contact & Terms: Query with action color slides. SASE. Pays $150/color cover photo; $75/color inside photo. **Pays on acceptance.** Credit line given. Buys one-time rights.

HOME EDUCATION MAGAZINE, P.O. Box 1083, Tonasket WA 98855. (509)486-1351. E-mail: homeedmag@aol.com. Managing Editor: Helen Hegener. Circ. 8,900. Estab. 1983. Bimonthly magazine. Emphasizes homeschooling. Readers are parents of children, ages 2-18. Sample copy for $4.50. Photo guidelines free with SASE.

Needs: Number of photos used/issue varies based on availability; 50% supplied by freelance photographers. Needs photos of parent/child or children. Special photo needs include homeschool personalities and leaders. Model/property releases preferred. Captions preferred.

Making Contact & Terms: Interested in receiving work from newer, lesser-known photographers. Send unsolicited b&w prints by mail for consideration. Prefers b&w prints in normal print size (3 × 5). "Enlargements not necessary for inside only—we need enlargements for cover submissions." Uses 35mm transparencies. SASE. Reports in 1 month. Pays $50/color cover photo; $10/b&w inside photo; $50-150/photo/text package. **Pays on acceptance.** Credit line given. Buys first North American serial rights; negotiable.

Tips: In photographer's samples, wants to see "sharp clear photos of children doing things alone, in groups or with parents. Know what we're about! We get too many submissions that are simply irrelevant to our publication."

THE HOME SHOP MACHINIST, P.O. Box 1810, Traverse City MI 49685. (616)946-3712. Fax: (616)946-3289. Editor: Joe D. Rice. Circ. 30,000. Estab. 1982. Bimonthly. Emphasizes "machining and metal working." Readers are "amateur machinists, small commercial machine shop operators and school machine shops." Sample copy free with 9 × 12 SAE and 4 first-class stamps. Photo guidelines free with SASE.

Needs: Uses about 30-40 photos/issue; "all are accompanied by text"; 30% from assignment; 70% from stock." Needs photos of "machining operations, how-to-build metal projects." Special needs include good quality machining operations in b&w. "No SASE, no response."

Making Contact & Terms: Interested in receiving work from newer, lesser-known machinist photographers. Send 4 × 5 or larger glossy b&w prints by mail for consideration. SASE. Reports in 3 weeks. Pays $40/b&w cover photo; $9/b&w inside photo; $30 minimum for text/photo package (depends on length). Pays on publication. Credit line given. Buys one-time rights.

Tips: "Photographer should know about machining techniques or work with a machinist. Subject should be strongly lit for maximum detail clarity."

HORIZONS MAGAZINE, P.O. Box 2639, Bismarck ND 58502. (701)222-0929. Fax: (701)222-1611. Editor: Lyle Halvorson. Estab. 1971. Quality regional magazine. Photos used in magazines, audiovisual and calendars.

Needs: Buys 50 photos/year; offers 25 assignments/year. Scenics of North Dakota events, places and people. Examples of recent uses: "Scenic North Dakota" calendar, *Horizons Magazine* (winter edition)

and "North Dakota Bad Lands." Model/property release preferred. Captions preferred.
Making Contact & Terms: Query with samples. Query with stock photo list. Works on assignment only. Uses 8×10 glossy b&w prints; 35mm, 2¼×2¼, 4×5 transparencies. Does not keep samples on file. SASE. Reports in 2 weeks. Pays $150-250/day; $200-300/job. Pays on usage. Credit line given. Buys one-time rights; negotiable.
Tips: "Know North Dakota events, places. Have strong quality of composition and light."

HORSE ILLUSTRATED, Dept. PM, P.O. Box 6050, Mission Viejo CA 92690. (714)855-8822. Fax: (714)855-3045. Editor: Moira C. Harris. Readers are "primarily adult horsewomen between 18-40 who ride and show mostly for pleasure and who are very concerned about the well being of their horses." Circ. 180,000. Sample copy $4.50; photo guidelines free with SASE.
Needs: Uses 20-30 photos/issue, all supplied by freelance photographers; 50% from assignment and 50% from freelance stock. Specific breed featured every issue. Prefers "photos that show various physical and mental aspects of horses. Include environmental, action and portrait-type photos. Prefer people to be shown only in action shots (riding, grooming, treating, etc.). We like riders—especially those jumping—to be wearing protective headgear."
Making Contact & Terms: Send by mail for consideration actual 8×10 b&w photos or 35mm and 2¼×2¼ color transparencies. "We generally use color transparencies and have them converted to b&w as needed." Reports in 2 months. Pays $25/b&w photo; $60-200/color photo and $100-350 per text/photo package. Credit line given. Buys one-time rights.
Tips: "Nothing but sharp, high-contrast shots. Looks for clear, sharp color and b&w shots of horse care and training. Healthy horses, safe riding and care atmosphere is the current trend in our publication. Send SASE for a list of photography needs and for photo guidelines and submit work (prefer color transparencies) on spec."

HORTICULTURE MAGAZINE, 98 N. Washington St., Boston MA 02114. (617)742-5600. Fax: (617)367-6364. Photo Editor: Tina Schwinder. Circ. 350,000. Estab. 1904. Monthly magazine. Emphasizes gardening. Readers are all ages. Sample copy $2.50 with 9×12 SAE with $2 postage. Photo guidelines free with SASE.
Needs: Uses 25-30 photos/issue; 100% supplied by freelance photographers. Needs photos of gardening, individual plants. Model release preferred. Captions required.
Making Contact & Terms: Arrange a personal interview to show portfolio. Query with samples. Send 35mm color transparencies by mail for consideration. Submit portfolio for review. Provide résumé, business card, brochure, flier or tearsheets to be kept on file for possible future assignments. SASE. Reports in 1 month. Pays $500/color cover photo; $50-250/color page. Pays on publication. Credit line given. Buys one-time rights. Simultaneous submissions OK.
Tips: Wants to see gardening images, i.e., plants and gardens.

***HOST COMMUNICATIONS, INC.**, 904 N. Broadway, Lexington KY 40505. (606)226-4510. Fax: (606)226-4575. Production Manager: Craig Baroncelli. Estab. 1971. Weekly magazine. Emphasizes collegiate athletics. Includes football, basketball and Texas football sections and NCAA Basketball Championship Guide. Readers are predominantly male, ages 18-49. Sample copy free with 9×12 SAE and $2.90 postage.
Needs: Uses 30 photos/issue; 25 supplied by freelancers. Needs action photography. Model release preferred; photo captions preferred.
Making Contact & Terms: Interested in receiving work from newer, lesser-known photographers. Submit portfolio for review. Send unsolicited photos by mail for consideration. Provide résumé, business card, brochure, flier or tearsheets to be kept on file for possible future assignments. Send color prints; 35mm transparencies. Deadlines vary depending on publication. SASE. Pays $50-100/color cover photo; $50-100/color inside photo; $25-100/color page. Pays on publication. Credit line given. Buys one-time rights.
Tips: Looks for crispness, clarity of photography, action captured in photography.

HOT BOAT, 8484 Wilshire Blvd., Suite 900, Beverly Hills CA 90211. (213)651-5400. Editor: Brett Bayne. Circ. 70,000. Estab. 1964. Monthly magazine. Emphasizes performance boating. Readers are mostly male, ages 19-55. Sample copy free with SASE.
Needs: Uses 40 photos/issue; 20 supplied by freelancers. "We use photography to illustrate our tech stories, travel and boat tests, competition, too." Captions required.
Making Contact & Terms: Interested in receiving work from newer, lesser-known photographers "as long as they know the subject." Submit portfolio for review (copies OK). Send color prints; 35mm, 2¼×2¼ transparencies. Does not keep samples on file. SASE. Reports in 1-2 weeks. Pays $100-200/ color page rate. Pays on publication. Credit line given. Buys first North American serial rights; negotiable. Simultaneous submissions OK.
Tips: "I look for an understanding of performance boating. We aren't interested in sailboats or fishing! The best way to break into this magazine is to shoot a feature (multiple photos—details and overall

action) of a 'hot boat.' Check out the magazine if you don't know what a custom performance boat is."

I LOVE CATS, 950 Third Ave., 16th Floor, New York NY 10022. (212)888-1855. Fax: (212)838-8420. Editor: Lisa A. Sheets. Circ. 200,000. Bimonthly magazine. Emphasizes cats. Readers are male and female ages 10-100. Sample copy $4. Photo guidelines free with SASE.
Needs: Uses 30-40 photos/issue; all supplied by freelancers. Needs color shots of cats in any environment. "Pay attention to details. Don't let props overplay cat." Model/property release preferred for children. Caption preferred.
Making Contact & Terms: Interested in receiving work from newer, lesser-known photographers. Send unsolicited photos by mail for consideration. Provide résumé, business card, brochure, flier or tearsheets to be kept on file for possible assignments. Send any size, any finish, color and b&w prints; 35mm transparencies. Deadlines: 6 months ahead of any holiday. SASE. Reports in 2 months. Pays $100-400/color cover photo; $25-50/color inside photo; $25/b&w inside photo; $100-200/photo/text package. Pays on publication. Credit line given. Buys all rights but, photos are returned after use.
Tips: Wants to see "crisp, clear photos with cats as the focus. Big eyes on cats looking straight at the viewer for the cover. Inside photos can be from the side with more props, more soft, creative settings. Don't send cats in dangerous situations. Keep the family perspective in mind. Always include a SASE with enough postage. Don't bug an editor, as editors are very busy. Keep the theme, intent and purpose of the publication in mind when submitting material. Be patient and submit material that is appropriate. Get a copy of the magazine."

IDAHO WILDLIFE, P.O. Box 25, Boise ID 83707. (208)334-3748. Fax: (208)334-2148. E-mail: dronayne@idfg.state.id.us. Website: http://www.state.id.us/fishgame/fishgame.html. Editor: Diane Ronayne. Circ. 27,000. Estab. 1978. Bimonthly magazine. Emphasizes wildlife, hunting, fishing. Readers are aged 25-70, 80% male, purchase Idaho hunting or fishing licenses; ⅖ nonresident, ⅗ resident. Sample copy $1. Photo guidelines free with SASE.
Needs: Uses 20-40 photos/issue; 30-60% supplied by freelancers. Needs shots of "wildlife, hunting, fishing in Idaho; habitat management." Photos of wildlife/people should be "real," not too "pretty" or obviously set up. Model release preferred. Captions required; include species and location.
Making Contact & Terms: Interested in receiving work from newer, lesser-known photographers. Query with list of stock photo subjects. SASE. Reports in 1 month. Pays $80/color cover photo; $40/color or b&w inside photo; $40/color or b&w page rate. Pays on publication. Credit line given. Buys one-time rights. Simultaneous submissions and previously published work OK.
Tips: "Write first for want list. 99% of photos published are taken in Idaho. Seldom use scenics. Love action hunting or fishing images but must look 'real' (i.e., natural light). Only send your *best* work. We don't pay as much as the 'Big Three' commercial hunting/fishing magazines but our production quality is as high or higher and we value photography and design as much as text. We began placing information, including the *Idaho Wildlife* table of contents and selected back-issue articles on the Internet in early 1996. The potential use of these technologies to enhance freelancer-editor communication is great."

IDEALS MAGAZINE, Ideals Publications Incorporated, P.O. Box 305300, Nashville TN 37230-5300. (615)333-0478. Editor: Lisa Ragan. Circ. 200,000. Estab. 1944. Magazine published 6 times/year. Emphasizes an idealized, nostalgic look at America through poetry and short prose, using "seasonal themes—bright flowers and scenics for Thanksgiving, Christmas, Easter, Mother's Day, Friendship and Country—all thematically related material. Issues are seasonal in appearance." Readers are "mostly women who live in rural areas, aged 50 and up." Sample copy $4. Photo guidelines free with SASE.
Needs: Uses 20-25 photos/issue; all supplied by freelancers. Needs photos of "bright, colorful flowers, scenics, still life, children, pets, home interiors; subject-related shots depending on issue. We regularly send out a letter listing the photo needs for our upcoming issue." Model/property release required. No research fees.
Making Contact & Terms: Submit tearsheets to be kept on file. No color copies. Will send photo needs list if interested. Do not submit unsolicited photos or transparencies. Work only with 2¼×2¼, 4×5, 8×10 transparencies; no 35mm. Keeps samples on file. NPI; rates negotiable. Pays on publication. Credit line given. Buys one-time rights. Simultaneous and previously published work OK.
Tips: "We want to see *sharp* shots. No mood shots, please. No filters. Would suggest the photographer purchase several recent issues of *Ideals* magazine and study photos for our requirements."

ILLINOIS ENTERTAINER, 124 W. Polk, #103, Chicago IL 60605-2069. (312)922-9333. Fax: (312)922-9369. E-mail: ieeditors@aol.com. Editor: Michael C. Harris. Circ. 80,000. Estab. 1975. Monthly magazine. Emphasizes music, theater, entertainment. Readers are male and female, 16-40, music/clubgoers. Sample copy $5.

Needs: Uses 20 photos/issue; approximately 5 supplied by freelancers on assignment or from stock. Needs "live concert photos; personality head shots—crisp, clean, high-contrast b&ws." Model/property release required; "releases required for any non-approved publicity photos or pics with models." Captions required.

Making Contact & Terms: Interested in receiving work from newer, lesser-known photographers. Query with résumé of credits and list of stock photo subjects. Send unsolicited photos by mail for consideration. Send 8×10 or 5×7 b&w prints. Does not keep samples on file. SASE. Reports in 1 month. Pays $100-125/color cover photo; $20-30/b&w inside photo. Pays no sooner than 60 days after publication. Buys one-time rights. Simultaneous submissions and previously published work OK.

Tips: Send high-contrast b&w photos. "We print on newsprint paper. We are seeing some more engaging publicity photos, though still fairly straightforward stuff abounds. We are able to make simple images infinitely more interesting via Mac-based program manipulation."

INCOME OPPORTUNITIES, 1500 Broadway, 6th Floor, New York NY 10036. (212)642-0631. Fax: (212)302-8269. Website: http://www.incomeopps.com. Art Director: Andrew Bass. Circ. 350,000. Estab. 1956. Monthly magazine. Readers are individuals looking for ways to start low-cost businesses. Sample copy free with 9×12 SASE.
 • This publication uses Photoshop for manipulation to achieve certain effects.

Needs: Uses 10-30 photos/issue; 10-15 supplied by freelancers. Needs editorial shots with people, location shots. Special photo needs include special effect, location, portraiture photos.

Making Contact & Terms: Interested in receiving work from newer, lesser-known photographers. Provide résumé, business card, brochure, flier or tearsheets to be kept on file for possible assignments; or send 300 dpi Photoshop TIFF files in CMYK mode. Keeps samples on file. Cannot return material. Reports in 2 weeks. Pays maximum prices of $2,000/color cover photo; $500/color inside photo. Pays in 30 days. Credit line given. Buys first North American serial rights; negotiable.

INDIANAPOLIS BUSINESS JOURNAL, 431 N. Pennsylvania St., Indianapolis IN 46204. (317)634-6200. Fax: (317)263-5060. Picture Editor: Robin Jerstad. Circ. 17,000. Estab. 1980. Weekly newspaper/monthly magazine. Emphasizes Indianapolis business. Readers are male, 28 and up, middle management to CEO's.

Needs: Uses 15-20 photos/issue; 3-4 supplied by freelancers. Needs portraits of business people. Model release preferred. Captions required; include who, what, when and where.

Making Contact & Terms: Interested in receiving work from newer, lesser-known photographers. Query with résumé and credits. Query with stock photo list. Cannot return material. Reports in 3 weeks. Pays $50-75/color inside photo; $25-50/b&w inside photo. Pays on publication. Credit line given. Buys one-time rights. Simultaneous submissions and/or previously published work OK.

Tips: "We generally use local freelancers (when we need them). Rarely do we have needs outside the Indianapolis area."

INDIANAPOLIS MONTHLY, Dept. PM, 950 N. Meridian, Suite 1200, Indianapolis IN 46204. Art Director: Craig Arive. Monthly. Emphasizes regional/Indianapolis. Readers are upscale, well-educated. Circ. 50,000. Sample copy for $3.05 and 9×12 SASE.
 • *Indianapolis Monthly* was a 1994 Gold Medal Winner of the White Award for best city magazine under 50,000 circulation.

Needs: Uses 50-60 photos/issue; 10-12 supplied by freelance photographers. Needs seasonal, human interest, humorous, regional; subjects must be Indiana- or Indianapolis-related. Model release and captions preferred.

Making Contact & Terms: Query with samples; send 5×7 or 8×10 glossy b&w prints or 35mm or 2¼×2¼ transparencies by mail for consideration. Also accepts digital files. SASE. Reports in 1 month. Pays $50-100/b&w inside photo; $75-250/color inside photo. Pays on publication. Credit line given. Buys first North American serial rights. Previously published work on occasion OK, if different market.

Tips: "Read publication. Send photo similar to those you see published. If we do nothing like what you are considering, we probably don't want to."

INDIANAPOLIS WOMAN, 9000 Keystone Crossing, Suite 939, Indianapolis IN 46240. (317)580-0939. Fax: (317)581-1329. Art Director: Christina Hill. Circ. 32,000. Estab. 1994. Monthly magazine. Readers are females, ages 20-55. Sample copy free with 9×12 SASE. Photo guidelines free with SASE.

Needs: Uses 48 photos/issue. Needs photos of beauty, fashion, dining out. Model relese preferred. Property release required. Captions preferred; include subject, date, photographer.

Making Contact & Terms: Interested in receiving work from newer, lesser-known photographers. Provide résumé, business card, brochure, flier or tearsheets to be kept on file for possible assignments. Keeps samples on file. SASE. Reports on an as needed basis. NPI. Credit line given. Rights negotiable. Previously published work OK.

INLINE: THE SKATER'S MAGAZINE, 2025 Pearl St., Boulder CO 80302. (303)440-5111. Fax: (303)440-3313. Photo Editor: Annelies Cunis. Circ. 40,000. Estab. 1991. Bimonthly tabloid. Emphasizes inline skating (street, speed, vertical, fitness, hockey, basics). Readers are male and female skaters of all ages. Sample copy free with 11 × 14 SASE.
Needs: Uses 20-50 photos/issue; 75% supplied by freelancers. Needs photos of skating action, products; scenics, personalities, how-to. Captions preferred; include location and model.
Making Contact & Terms: Interested in receiving work from newer, lesser-known photographers. Provide résumé, business card, brochure, flier or tearsheets to be kept on file for possible assignments. Keeps samples on file. SASE. Reports in 3 weeks. Pays $50-500/job; 200-300/color cover photo; $50-125/color inside photo; $25-100/b&w inside photo; $100/color page rate; $75/b&w page rate. Pays on publication. Credit line given. Buys one-time rights; negotiable. Simultaneous submissions and previously published work OK.
Tips: "Freelancers should get in touch to arrange any kind of submission before sending it. However, I am always interested in seeing new work from new photographers."

***INTERNATIONAL VOYAGER MEDIA**, 11900 Biscayne Blvd., Suite 300, Miami FL 33181-2726. (305)892-6644. Fax: (305)892-1005. Photography Director: Mr. Robin Hill. Estab. 1978. Mainly annual and biannual hotel books and cruise magazines. Emphasizes travel. "We have 120 different publications. Most are called *Vacation* or *Time Out*. We also publish the *Caribbean Vacation Planner*." Readers are affluent travelers, ages 35-70. Sample $14-95/book. Photo guidelines free with SASE.
Needs: Uses various numbers of photos/issue; all supplied by freelancers. Needs photos of travel scenics, people enjoying themselves, aerials. Model release preferred; photo captions required (whereabouts, who, what, any pertinent information regarding location of photo).
Making Contact & Terms: Arrange personal interview to show portfolio. Submit portfolio for review. Query with résumé of credits. Provide résumé, business card, brochure, flier or tearsheets to be kept on file for possible future assignments. Keeps samples on file. Reports in 1 month. Payment depends on circulation of publication which varies from 6,000-750,000. Pays $250 minimum/color cover photo; $75-350/color page; $125 minimum/b&w page. Pays on publication. Credit line given. Buys one-time rights. Simultaneous submissions and/or previously published work OK.
Tips: "Our publications emphasize travel with a positive outlook—photos that make a location look attractive, to aid in attracting tourists to an area. Photographers need to show versatility as our assignment work involves still lifes, people, aerials and travel scenics. Good captions are very important. We are looking for photographers with a professional attitude, a willingness to travel at short notice and an interest in travel photography as their foremost specialty. Photographers need to understand that the editorial process is not just dependent on the photo buyer, but is dependent on the budgets that the photo buyer is given for each photo project, which is usually flexible but not always. Persistence and quality work are the main ingredients for success."

INTERNATIONAL WILDLIFE PHOTO SUBMISSIONS, 8925 Leesburg Pike, Vienna VA 22184. Photo Editor: John Nuhn. Circ. 375,000. Estab. 1970. Bimonthly magazine. Emphasizes world's wildlife, nature, environment, conservation. Readers are people who enjoy viewing high-quality wildlife and nature images, and who are interested in knowing more about the natural world and man's interrelationship with animals and environment on all parts of the globe. Sample copy $3 from National Wildlife Federation Membership Services (same address). Send separate SASE for free photo guidelines to Photo Guidelines, Wildlife Editorial (same address).
● This photo editor looks for the ability to go one step farther to make a common shot unique and creative.
Needs: Uses about 45 photos/issue; all supplied by freelance photographers; 30% on assignment, 70% from stock. Needs photos of world's wildlife, wild plants, nature-related how-to, conservation practices, conservation-minded people (tribal and individual), environmental damage, environmental research, outdoor recreation. Special needs include single photos for cover possibility (primarily wildlife but also plants, scenics, people); story ideas (with photos) from Canada, Europe, former Soviet republics, Pacific, China; b&w accompanying unique story ideas that have good reason not to be in color. Model release preferred. Captions required.
Making Contact & Terms: "No unsolicited submissions from photographers whose work has not been previously published or considered for use in our magazine. Instead, send nonreturnable samples (tearsheets or photocopies) to Photo Queries (same address)." Interested in seeing work from newer, lesser-known photographers with high-quality transparencies only. Send 35mm, 2¼ × 2¼, 4 × 5, 8 × 10 transparencies (magazine is 95% color) or 8 × 10 glossy b&w prints for consideration. SASE. Reports in 1 month. Pays $500-800/color cover photo; $300-750/color and b&w inside photo; negotiable/text photo package. **Pays on acceptance.** Credit line given. Buys one-time rights with limited magazine promotion rights. Previously published work OK.
Tips: Do not send submissions or samples without studying a copy of the magazine. Looking for a variety of images that show photographer's scope and specialization, organized in loose slide sheets (no binders), along with tearsheets of previously published work. "Study our magazine; note the type

of images we use and send photos equal or better. Think editorially when submitting story queries or photos. Assure that package is complete—sufficient return postage (no checks), proper size return envelope, address inside and do not submit photos in glass slides, trays or small boxes."

INTERRACE MAGAZINE, P.O. Box 12048, Atlanta GA 30355. (404)364-9690. Fax: (404)364-9965. Associate Publisher: Gabe Grosz. Circ. 25,000. Estab. 1989. Bimonthly magazine. Emphasizes interracial couples and families, mixed-race people. Readers are male and female, ages 18-70, of all racial backgrounds. Sample copies $2 with 9×12 SAE and 4 first-class stamps. Photo guidelines free with SASE.
Needs: Uses 20-30 photos/issue; 15-20 supplied by freelancers. Needs photos of people/couples/personalities; must be interracial couple or interracially involved; biracial/multiracial people. Model/property release optional. Captions preferred, identify subjects.
Making Contact & Terms: Interested in receiving work from newer, lesser-known photographers. Submit portfolio for review. Query with résumé of credits. Query with stock photo list. Send unsolicited photos by mail for consideration. Provide résumé, business card, brochure, flier or tearsheets to be kept on file for possible assignments. Send 3×5, 8×10 color or b&w prints; any transparencies. Keeps samples on file. SASE. Reports in 1 month or less. Pays $15-25/hour; $15-100/job; $35/color cover photo; $35/b&w cover photo; $20/color inside photo; $20/b&w inside photo; $20/color page rate. Pays on publication. Credit line given. Buys one-time rights. Simultaneous submissions and/or previously published work OK.
Tips: "We're looking for unusual, candid, upbeat, artistic, unique photos. We're looking for not only black and white couples/people. All racial make ups are needed."

THE IOWAN MAGAZINE, 108 Third St., Suite 350, Des Moines IA 50309. (515)282-8220. Fax: (515)282-0125. Editor: Mark Ingebretsen. Circ. 25,000. Estab. 1952. Quarterly magazine. Emphasizes "Iowa—its people, places, events and history." Readers are over 30, college-educated, middle to upper income. Sample copy $4.50 with 9×12 SAE and 8 first-class stamps. Photo guidelines free with SASE.
Needs: Uses about 80 photos/issue; 50% by freelance photographers on assignment and 50% freelance stock. Needs "Iowa scenics—all seasons." Model/property releases preferred. Captions required.
Making Contact & Terms: Interested in receiving work from newer, lesser-known photographers. Send b&w prints; 35mm, 2¼×2¼ or 4×5 transparencies; or b&w contact sheet by mail for consideration. SASE. Reports in 1 month. Pays $25-50/b&w photo; $50-200/color photo; $200-500/day. Pays on publication. Credit line given. Buys one-time rights; negotiable.

JAZZTIMES, 7961 Eastern Ave., Suite 303, Silver Spring MD 20910. (301)588-4114. Fax: (301)588-2009. Editor: Mike Joyce. Circ. 80,000. Estab. 1969. Monthly glossy magazine (10 times/year). Emphasizes jazz. Readers are jazz fans, record consumers and people in the music industry, ages 15-75.
Needs: Uses about 50 photos/issue; 30 supplied by freelance photographers. Needs performance shots, portrait shots of jazz musicians. Model release required. Captions preferred.
Making Contact & Terms: Interested in receiving work from newer, lesser-known photographers. Send 5×7 b&w prints by mail for consideration. "If possible, we keep photos on file till we can use them." SASE. Reports in 2 weeks. Pays $50/color; $15-20/b&w inside photo. Negotiates fees for cover photo. Pays on publication. Credit line given. Buys one-time or reprint rights; negotiable. Simultaneous submissions and previously published work OK.
Tips: "Send whatever photos you can spare. Name and address should be on back."

JUNIOR SCHOLASTIC, 555 Broadway, New York NY 10012. (212)343-6295. Editor: Lee Baier. Senior Photo Researcher: Donna Frankland. Circ. 500,000. Biweekly educational school magazine. Emphasizes middle school social studies (grades 6-8): world and national news, US and world history, geography, how people live around the world. Sample copy $1.75 with 9×12 SAE.
Needs: Uses 20 photos/issue. Needs photos of young people ages 11-14; non-travel photos of life in other countries; US news events. Reviews photos with accompanying ms only. Model release required. Captions required.
Making Contact & Terms: Arrange a personal interview to show portfolio. "Please do not send samples—only stock list or photocopies of photos." Reports in 1 month. Pays $200/color cover photo; $75/b&w inside photo; $150/color inside photo. **Pays on acceptance.** Credit line given. Buys one-time rights. Simultaneous submissions OK.

 THE ASTERISK before a listing indicates that the market is new in this edition. New markets are often the most receptive to freelance submissions.

Tips: Prefers to see young teenagers; in US and foreign countries, especially "personal interviews with teenagers worldwide with photos."

KALLIOPE, A Journal of Women's Art, 3939 Roosevelt Blvd., Jacksonville FL 32205. Contact: Art Editor. Circ. 1,500. Estab. 1978. Journal published 3 times/year. Emphasizes art by women. Readers are interested in women's issues. Sample copy $7. Photo guidelines free with SASE.
Needs: Uses 18 photos/issue; all supplied by freelancers. Needs art and fine art that will reproduce well in b&w. Needs photos of nature, people, fine art by excellent sculptors and painters, and shots that reveal lab applications. Model release required. Photo captions preferred. Artwork should be titled.
Making Contact & Terms: Interested in receiving work from newer, lesser-known photographers as well as established photographers. Send unsolicited photos by mail for consideration. Send 5×7 b&w prints. SASE. Reports in 1 month. Pays contributor 3 free issues or 1-year free subscription. Buys one-time rights. Credit line given.
Tips: "Send excellent quality photos with an artist's statement (50 words) and résumé."

KANSAS, 700 SW Harrison, Suite 1300, Topeka KS 66603. (913)296-3479. Editor: Andrea Glenn. Circ. 54,000. Estab. 1945. Quarterly magazine. Emphasizes Kansas scenery, arts, recreation and people. Photos are purchased with or without accompanying ms or on assignment. Free sample copy and photo guidelines.
Needs: Buys 60-80 photos/year; 75% from freelance assignment, 25% from freelance stock. Animal, human interest, nature, photo essay/photo feature, scenic, sport, travel and wildlife, all from Kansas. No nudes, still life or fashion photos. Model/property release preferred. Captions required.
Making Contact & Terms: Interested in receiving work from newer, lesser-known photographers. Send material by mail for consideration. No b&w. Transparencies must be identified by location and photographer's name on the mount. Uses 35mm, 2¼×2¼ or 4×5 transparencies. Photos are returned after use. Pays $50 minimum/color photo; $150 minimum/cover photo. **Pays on acceptance.** Credit line given. Not copyrighted. Buys one-time rights. Previously published work OK.
Tips: Kansas-oriented material only. Prefers Kansas photographers. "Follow guidelines, submission dates specifically. Shoot a lot of seasonal scenics."

KASHRUS MAGAZINE—The Guide for the Kosher Consumer, P.O. Box 204, Parkville Station, Brooklyn NY 11204. (718)336-8544. Editor: Rabbi Yosef Wikler. Circ. 10,000. Bimonthly. Emphasizes kosher food and food technology. Readers are kosher food consumers, vegetarians and producers. Sample copy for 9×12 SAE with $1.24 postage.
Needs: Uses 3-5 photos/issue; all supplied by freelance photographers. Needs photos of travel, food, food technology, seasonal nature photos and Jewish holidays. Model release preferred. Captions preferred.
Making Contact & Terms: Send unsolicited photos by mail for consideration. Provide résumé, business card, brochure, flier or tearsheets to be kept on file for possible future assignments. Uses 2¼×2¼, 3½×3½ or 7½×7½ matte b&w prints. SASE. Reports in 1 week. Pays $40-75/b&w cover photo; $25-50/b&w inside photo; $75-200/job; $50-200/text/photo package. Pays part on acceptance; part on publication. Buys one-time rights, first North American serial rights, all rights; negotiable. Simultaneous submissions and previously published work OK.

♣KEY PACIFIC PUBLISHERS CO. LTD., 1001 Wharf St., 3rd Floor, Victoria, British Columbia V8W 1T6 Canada. (604)388-4324. Fax: (604)388-6166. Editor: Gloria Russo. Estab. 1986. Publishes travel/Victoria visitor information. Photos used for text illustration. Examples of recently published titles: *Essential Victoria*, text illustration and covers; *Where Victoria*, text illustration.
Needs: Buys 30-40 photos annually. Looking for photos of Victoria sights, attractions, shops, restaurants, city life. Reviews stock photos of Victoria scenes only. Model release required. Property release preferred. Restaurant with people needs model release. Captions preferred; include what and where.
Making Contact & Terms: Interested in receiving work from newer, lesser-known photographers. Arrange personal interview to show portfolio. Query with stock photo list. Works with local freelancers only. Uses any glossy/matte color b&w prints; 35mm, 4×5 transparencies. Keeps samples on file. SASE. Reports in 3 weeks. Pays $0-350/color photo; $0-100/b&w photo; photo credit when demanded. Pays on publication, receipt of invoice. Buys one-time rights; negotiable. Simultaneous submissions and/or previously published works OK.
Tips: Looking for "generic shopping—someone/couple shopping; generic dining—shot of food/table settings; Victoria sights—coastal scenes; Victoria attractions—museums, gardens, etc. Pick up magazines to see what we use. Tend to use photos for summer issues more than winter." Accepting artist submissions for covers.

KEYBOARD, 411 Borel Ave., Suite 100, San Mateo CA 94402. (415)358-9500. Editor: Tom Darter. Art Director: Paul Martinez. Monthly magazine. Circ. 82,000. Emphasizes "biographies and how-to feature articles on keyboard players (pianists, organists, synthesizer players, etc.) and keyboard-related

material. It is read primarily by musicians to get background information on their favorite artists, new developments in the world of keyboard instruments, etc.''

Needs: Buys 10-15 photos/issue. Celebrity/personality (photos of keyboard players at their instruments). Prefers shots of musicians with their instruments. Photos purchased with or without accompanying ms and infrequently on assignment. Captions required for historical shots only.

Making Contact & Terms: Interested in receiving work from newer, lesser-known photographers. Query with list of stock photo subjects. Send first class to Paul Martinez. Uses 8×10 b&w glossy prints; 35mm color, 120mm, 4×5 transparencies for cover shots. SASE. Reports in 1 month. Pays on a per-photo basis. Pays expenses on assignment only. Pays $35-150/b&w inside photo; $300-500/photo for cover; $75-250/ color inside photo. Pays on publication. Credit line given. Buys rights to one-time use with option to reprint. Simultaneous submissions OK.

Tips: ''Send along a list of artist shots on file. Photos submitted for our files would also be helpful—we'd prefer keeping them on hand, but will return prints if requested. We prefer live shots at concerts or in clubs. Keep us up to date on artists that will be photographed in the near future. Freelancers are vital to us.''

KIPLINGER'S PERSONAL FINANCE MAGAZINE, 1729 H St. NW, Washington DC 20006. (202)887-6492. Fax: (202)331-1206. Photography Editor: Marc Turkel. Circ. 1.2 million. Estab. 1935. Monthly magazine. Emphasizes personal finance.

Needs: Uses 15-25 photos/issue; 90% supplied by freelancers. Needs ''business portraits and photo illustration dealing with personal finance issues (i.e. investing, retirement, real estate). Model release required. Property release preferred. Captions required.

Making Contact & Terms: Interested in receiving work from newer, lesser-known and established photographers. Arrange personal interview to show portfolio. Provide business card, brochure, flier or tearsheets to be kept on file for possible assignments. Keeps samples on file. SASE. Reports in 2 weeks. Pays $1,200/color and b&w cover photo; $350-1,200/day against space rate per page. **Pays on acceptance.** Credit line given. Buys one-time rights.

KITE LINES, P.O. Box 466, Randallstown MD 21133-0466. (410)922-1212. Fax: (410)922-4262. E-mail: 102365.1060@compuserve.com. Publisher-Editor: Valerie Govig. Circ. 13,000. Estab. 1977. Quarterly. Emphasizes kites and kite flying exclusively. Readers are international adult kiters. Sample copy $5. Photo guidelines free with SASE.

Needs: Uses about 45-65 photos/issue; ''up to about 50% are unassigned or over-the-transom—but nearly all are from *kiter*-photographers.'' Needs photos of ''unusual kites in action (no dimestore plastic kites), preferably with people in the scene (not easy with kites). Needs to relate closely to *information* (article or long caption).'' Special needs include major kite festivals; important kites and kiters. Captions required. ''Identify *kites*, kitemakers and kitefliers as well as location and date.''

Making Contact & Terms: Query with samples or send 2-3 b&w 8×10 uncropped prints or 35mm or larger transparencies (dupes OK) by mail for consideration. Provide relevant background information, i.e., knowledge of kites or kite happenings. SASE. Reports in ''2 weeks to 2 months (varies with work load, but any obviously unsuitable stuff is returned quickly—in 2 weeks.'' Pays $0-30/inside photo; $0-50/color photo; special jobs on assignment negotiable; generally on basis of film expenses paid only. ''We provide extra copies to contributors. Our limitations arise from our small size. However, *Kite Lines* is a quality showcase for good work.'' Pays within 30 days after publication. Buys one-time rights; usually buys first world serial rights. Previously published work considered.

Tips: In portfolio or samples wants to see ''ability to select important, *noncommercial* kites. Just take a great kite picture, and be patient with our tiny staff. Considers good selection of subject matter; good composition—angles, light, background and sharpness. But we don't want to look at 'portfolios'—just *kite* pictures, please.''

LADIES HOME JOURNAL, Dept. PM, 125 Park Ave., New York NY 10017. (212)557-6600. Fax: (212)351-3650. Contact: Photo Editor. Monthly magazine. Features women's issues. Readership consists of women with children and working women in 30s age group. Circ. 6 million.

Needs: Uses 90 photos per issue; 100% supplied by freelancers. Needs photos of children, celebrities and women's lifestyles/situations. Reviews photos only without ms. Model release and captions preferred. No photo guidelines available.

Making Contact & Terms: Provide résumé, business card, brochure, flier or tearsheet to be kept on file for possible assignment. ''Do not send slides or original work; send only promo cards or disks.'' Reports in 3 weeks. Pays $200/b&w inside photo; $200/color page rate. **Pays on acceptance.** Credit line given. Buys one-time rights.

LAKE SUPERIOR MAGAZINE, Lake Superior Port Cities, Inc., P.O. Box 16417, Duluth MN 55816-0417. (218)722-5002. Fax: (218)722-4096. Editor: Paul L. Hayden. Circ. 20,000. Estab. 1979. Bimonthly magazine. ''Beautiful picture magazine about Lake Superior.'' Readers are ages 35-55, male and female, highly educated, upper-middle and upper-management level through working. Sample

copy $3.95 with 9×12 SAE and 5 first-class stamps. Photo guidelines free with SASE.
● This publication now uses a desktop system for color scanning and storage of high resolution files.
Needs: Uses 30 photos/issue; 70% supplied by freelance photographers. Needs photos of scenic, travel, wildlife, personalities, underwater, all photos Lake Superior-related. Photo captions preferred.
Making Contact & Terms: Interested in receiving work from newer, lesser-known photographers. Send unsolicited photos by mail for consideration. Provide résumé, business card, brochure, flier or tearsheets to be kept on file for possible assignments. Uses b&w prints; 35mm, 2¼×2¼, 4×5 transparencies. SASE. Reports in 3 weeks. Pays $75/color cover photo; $35/color inside photo; $20/b&w inside photo. Pays on publication. Credit line given. Buys first North American serial rights; reserves second rights for future use. Simultaneous submissions OK.
Tips: "Be aware of the focus of our publication—Lake Superior. Photo features concern only that. Features with text can be related. We are known for our fine color photography and reproduction. It has to be 'tops.' We try to use images large, therefore detail quality and resolution must be good. We look for unique outlook on subject, not just snapshots. Must communicate emotionally."

LAKELAND BOATING MAGAZINE, 1560 Sherman Ave., Suite 1220, Evanston IL 60201. (708)869-5400. Editor: Randall W. Hess. Circ. 45,000. Estab. 1945. Monthly magazine. Emphasizes powerboating in the Great Lakes. Readers are affluent professionals, predominantly men over 35. Sample copy $6 with 9×12 SAE and 10 first-class stamps.
Needs: Needs shots of particular Great Lakes ports and waterfront communities. Model release preferred. Captions preferred.
Making Contact & Terms: Query with list of stock photo subjects. Provide résumé, business card, brochure, flier or tearsheets to be kept on file for possible assignments. SASE. Pays $20-100/b&w photo; $25-100/color photo. **Pays on acceptance.** Credit line given. Buys one-time rights.

✦**LEISURE WORLD**, 1253 Ouellette Ave., Windsor, Ontario N8X 1J3 Canada. (519)971-3207. Fax: (519)977-1197. Editor-in-Chief: Doug O'Neil. Circ. 321,214. Estab. 1988. Bimonthly magazine. Emphasizes travel and leisure. Readers are members of the Canadian Automobile Association, 50% male, 50% female, middle to upper middle class. Sample copy $2.
Needs: Uses 9-10 photos/issue; 25-30% supplied by freelance photographers. "*Leisure World* is looking for travel and destination features that not only serve as accurate accounts of real-life experiences, but are also dramatic narratives, peopled by compelling characters. Nonfiction short stories brought home by writers who have gone beyond the ordinary verities of descriptive travel writing to provide an intimate glimpse of another culture." Special needs include exotic travel locales. Model release preferred. Captions required.
Making Contact & Terms: Send unsolicited photos by mail for consideration. Provide business card, brochure, flier or tearsheets to be kept on file for possible assignments. Send b&w or color 35mm, 2¼×2¼, 4×5, or 8×10 transparencies. SASE. Reports in 2 weeks. Pays $100/color cover photo; $50/color inside photo; $50/b&w inside photo; or $150-300/photo/text package. Pays on publication. Credit line given. Buys one-time rights.
Tips: "We expect that the technical considerations are all perfect—frames, focus, exposure, etc. Beyond that we look for a photograph that can convey a mood or tell a story by itself. We would like to see more subjective and impressionistic photographs. Don't be afraid to submit material. If your first submissions are not accepted, try again. We encourage talented and creative photographers who are trying to establish themselves."

*****LIBIDO: THE JOURNAL OF SEX AND SENSIBILITY**, 5318 N. Paulina St., Chicago IL 60640. (312)275-0842. Fax: (312)275-0752. E-mail: rune@mcs.com. Photo Editor: Marianna Beck. Circ. 9,000. Estab. 1988. Quarterly journal. Emphasizes erotic photography. Subscribers are 60% male, 40% female, generally over 30, college educated professionals. Sample copy $8. Photo guidelines free with SASE.
Needs: Uses 30-35 photos/issue; 30 supplied by freelancers. Needs erotic photos (need not be nude, but usually it helps); nude figure-studies and couples. Reviews photos with or without ms. Model release required. "Besides dated releases, all photos taken after July 5, 1995 must comply with federal record keeping requirements."
Making Contact & Terms: Interested in receiving work from newer, lesser-known photographers. Send unsolicited photos by mail for consideration. Send 4×5, 8×10 matte or glossy b&w prints. Keeps samples on file. Reports in 1 month. Pays $75/b&w cover photo; $25/b&w inside photo. Pays on publication. Credit line given. Buys one-time and electronic rights. Previously published work OK.
Tips: "Fit your work to the style and tone of the publication."

LIFE, Dept. PM, Time-Life Bldg., Rockefeller Center, New York NY 10020. (212)522-1212. Photo Editor: Barbara Baker Burrows. Circ. 1.4 million. Monthly magazine. Emphasizes current events,

cultural trends, human behavior, nature and the arts, mainly through photojournalism. Readers are of all ages, backgrounds and interests.

Needs: Uses about 100 photos/issue. Prefers to see topical and unusual photos. Must be up-to-the minute and newsworthy. Send photos that could not be duplicated by anyone or anywhere else. Especially needs humorous photos for last page article "Just One More."

Making Contact & Terms: Send material by mail for consideration. SASE. Uses 35mm, 2¼×2¼, 4×5 and 8×10 slides. Pays $500/page; $1,000/cover. Credit line given. Buys one-time rights.

Tips: "Familiarize yourself with the topical nature and format of the magazine before submitting photos and/or proposals."

LIVE STEAM MAGAZINE, Dept. PM, P.O. Box 629, Traverse City MI 49685. (616)941-7160. Fax: (616)946-3289. Editor-in-Chief: Joe D. Rice. Circ. 12,000. Bimonthly. Emphasizes "steam-powered large scale models (i.e., locomotives, cars, boats, stationary engines, etc.)." Readers are "hobbyists—many are building scale models." Sample copy free with 9×12 SAE and 4 first-class stamps. Photo guidelines free with SASE.

Needs: Uses about 80 photos/issue; "most are supplied by the authors of published articles." Needs "how-to-build (steam models), historical locomotives, steamboats. Unless it's a cover shot (color), we only use photos with ms." Special needs include "strong transparencies of model steam locomotives, steamboats or stationary steam engines. No SASE, no response."

Making Contact & Terms: Query with samples. Send 3×5 glossy b&w or color prints by mail for consideration. SASE. Reports in 3 weeks. Pays $40/color cover photo; $8/b&w inside photo; $30/page plus $8/photo; $25 minimum for text/photo package (maximum payment "depends on article length"). Pays on publication. Credit line given. Buys one-time rights. Simultaneous submissions OK.

Tips: "Be sure that mechanical detail can be seen clearly. Try for maximum depth of field."

THE LIVING CHURCH, 816 E. Juneau Ave., P.O. Box 92936, Milwaukee WI 53202. (414)276-5420. Fax: (414)276-7483. Managing Editor: John Schuessler. Circ. 9,000. Estab. 1878. Weekly magazine. Emphasizes news of interest to members of the Episcopal Church. Readers are clergy and lay members of the Episcopal Church, predominantly ages 35-70. Sample copies available.

Needs: Uses 8-10 photos/issue; almost all supplied by freelancers. Needs photos to illustrate news articles. Always in need of stock photos—churches, scenic, people in various settings. Captions preferred.

Making Contact & Terms: Interested in receiving work from newer, lesser-known photographers. Send unsolicited photos by mail for consideration. Send 5×7 or larger glossy b&w prints. Also accepts color/b&w TIFF files, resolution 72 and 300 dpi. SASE. Reports in 1 month. Pays $25-50/b&w cover photo; $10-25/b&w inside photo. Pays on publication. Credit line given.

LOG HOME LIVING, 4451 Brookfield Corp. Dr., Suite 101, Chantilly VA 22021. (703)222-9411. Fax: (703)222-3209. Managing Editor: Janice Brewster. Circ. 100,000. Estab. 1989. Bimonthly magazine. Emphasizes buying and living in log homes. Sample copy $3.50/issue. Photo guidelines free with SASE.

Needs: Uses over 100 photos/issue; 10 supplied by freelancers. Needs photos of homes—living room, dining room, kitchen, bedroom, bathroom, exterior, portrait of owners, design/decor—tile sunrooms, furniture, fireplaces, lighting, porch and decks, doors. Model release preferred. Caption required.

Making Contact & Terms: Interested in receiving work from newer, lesser-known photographers. Send unsolicited photos by mail for consideration. Keeps samples on file. SASE. Reports back only if interested. Pays $200-300/color cover photo; $50-100/color inside photo; $100/color page rate; $500-600/photo/text package. **Pays on acceptance.** Credit line given. Buys first North American serial rights; negotiable. Previously published work OK.

LUSTY LETTERS, OPTIONS, BEAU, Box 470, Port Chester NY 10573. Photo Editor: Wayne Shuster. Circ. 60,000. Periodical magazines. Emphasizes "sexually oriented situations. We emphasize good, clean sexual fun among liberal-minded adults." Readers are mostly male; ages 18-65. Sample copy $2.95 with 6×9 SAE and 5 first-class stamps.

Needs: Color transparencies of single girls, girl-girl and single boys for cover; "present in a way suitable for newsstand display." Also transparencies of sexual situations among gay males, lesbians, male-female. Model release required.

Making Contact & Terms: Query with samples. Send 35mm, 2¼×2¼, 4×5 transparencies by mail for consideration. SASE. Reports in 2 weeks. Pays $250 maximum/color cover photo. Pays on publication. Buys one-time rights on covers.

Tips: "Please examine copies of our publications before submitting work. In reviewing samples we consider composition of color photos for newsstand display and look for recent b&w photos for inside."

LUTHERAN FORUM, P.O. Box 327, Delhi NY 13753. (607)746-7511. Editor: Leonard Klein. Circ. 3,500. Quarterly. Emphasizes "Lutheran concerns, both within the church and in relation to the wider society, for the leadership of Lutheran churches in North America."

INSIDER REPORT

Learn From *Life*'s Experiences

"I always tell young photographers that if they don't have a passion for this field, then find another business—because this is a way of life, it's not a job." Coming from Barbara Baker Burrows, picture editor of *Life* magazine, photographers should heed this advice.

Burrows has been with *Life* for almost 30 years, beginning work at the publication when it was still a weekly. She's had the privilege of knowing legendary photographers like Gordon Parks, Alfred Eisenstaedt and Larry Burrows (her father-in-law), and participating in some exciting events in recent American history.

© Photo Courtesy Time, Inc.

Barbara Baker Burrows

Burrows arrived at *Life* at a very exciting time— the late '60s. During the heyday of the space program she covered the Apollo 9, 10 and 11 missions. She was threatened at gunpoint while covering a murder case. She hung out of a helicopter while helping a photographer shoot the fires on the East Coast after Martin Luther King, Jr. was killed.

When Bobby Kennedy was assassinated in 1968, *Life* photographer Bill Eppridge was there. "I had the photos and negatives and hid them under the blotter (on my desk) because the FBI came in looking for pictures." If she hadn't hidden them, America would never have seen that famous image of Kennedy lying on the ground after the shooting. "I didn't realize the significance at the time, but here I was, a kid, hiding pictures from the FBI."

Burrows settled in New York City, not to work for *Life*, but to be a dancer. She didn't have any money saved so a friend who worked at *Life* got her a job there. "I thought I'd save up enough money to go into the theater. And after I was at *Life* for a week I realized that being there was the most exciting thing that had ever happened to me. I had to pinch myself every morning to be sure I was working for *Life*. I just fell completely in love with everything about the magazine," says Burrows.

Life, which began in 1936, discontinued as a weekly in 1972, at which time Burrows and six other staff members put out two issues a year plus a special year-in-review edition. Finally in 1977, *Life* returned as a monthly. By the early '80s Burrows had become picture editor.

"We all know the '80s was the decade of greed. I think some of the things that were wrong in the '80s were reflected in the style of photography," says Burrows. "It was trendy to photograph glitzy, over-lit, over-produced, one-shot photographs. And many of the photographers from then on into today are carrying

INSIDER REPORT, *continued*

far too much equipment, too many lights, too much film. They're depending on one or more assistants." This extraneous paraphernalia, says Burrows, makes it difficult for photographers to successfully shoot *Life*-caliber photos.

"[In the past] great photographers went out with a limited amount of film, they looked around them, they observed, they started thinking about what it was they wanted to produce." The most successful photographers to Burrows are "the thinking photographers"— the ones who learn to observe and think about the kind of picture they want to make before they shoot. Observation, patience and anticipation are essential.

"My father-in-law [Larry Burrows] who was in the jungles of Vietnam would sit for days without shooting. Photographers around him had used up all their film and they were very nervous. Larry hadn't shot a thing. And then all of a sudden, he'd pick up his camera. He'd seen before his eyes what he wanted all along, and he'd shoot it. There it was on one roll of film, because he was thinking all the while."

That's why Burrows admires photographers who approach subjects with minimal equipment. "If you're going into a delicate situation, or you're doing a real photo essay, you should go in quietly, like a fly on the wall. You're going to get more back in the end. Photographers can get muddled up in their own magnification and lose sight of waiting and watching, and capturing a moment to be preserved on film forever."

The problem nowadays, though, is that photographers don't have as much time because magazines like *Life* have more limited budgets and can't afford to send photographers out for days on end. "It's a shame. And it's incredibly frustrating for photographers and picture editors alike. Because you know in your heart what is possible and you're not allowed to do it."

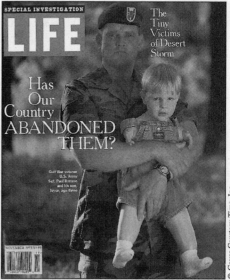

Photographer Derek Hudson snapped this cover shot of young Jayce Hanson and his father as part of a photo essay for a *Life* story called "The Tiny Victims of Desert Storm." The photos featured a number of children born with a variety of birth defects, all to parents who served in the Gulf War. "Hudson is a very caring photographer," says Picture Editor Barbara Baker Burrows. "There's a sensitivity and tenderness in the photographs. You see it in their faces."

INSIDER REPORT, *Burrows*

Life, of course, is synonymous with the photo essay. And a great photo essay requires time. "It's just like the written word. It's like a book or a story. There's a beginning, there's a middle and there's an end. You don't go into somebody's life and get their story in one day. You should build up confidence and trust with the subjects you're shooting."

This confidence and trust come through in a photographer's pictures, and it's something Burrows looks for when reviewing portfolios along with the hundreds of submissions *Life* receives each month from photographers and newspapers. And she looks at everything. "I know this is unusual, but often a simple little picture for the 'Just One More' page or even 'The Big Picture' will come in through the mail. I would be afraid not to look at everything."

Although the competition is very stiff it's still realistic to dream of being published in *Life*. For Burrows, consistency in a photographer's work is important. "I'm not impressed with a Pulitzer Prize winner if that was his only moment. If you can't go out and perform on a daily basis, what good is it? It's just a nice thing to put on your wall."

Life has portfolio drop off Tuesday-Thursday with 24-hour turn-around, but Burrows often sees photographers in person on the recommendation of others in the business. She discourages photographers from cold-calling magazine editors and asking for appointments. "I get hundreds of calls from photographers saying, 'Hi, I'm in town for the day.' You and a thousand other photographers are just in town for the day."

Burrows also cautions photographers from going overboard on the presentation of the photos in their portfolios, such as laminating work. Laminated photos are not attractive and they're heavy to lug around, she says. Extremely large photos also aren't necessary. Obviously presentation is important, but any good editor can look at smaller prints and decide the quality of your work. "I always advise photographers not to bother to laminate and do all that fancy stuff because you don't need it."

Photographers having work reviewed shouldn't expect to get an assignment from an editor right away, says Burrows. But she has pulled photos from portfolios she was reviewing and used them in the magazine. "It's those moments that give me enormous satisfaction, just to see the stunned expression on the face of a totally unsuspecting photographer—watching him exit minus one photograph, dazed in total disbelief. This is why my job is worth all the unwanted stress at other times."

Burrows urges photographers to be sure they have enough knowledge about the magazines they're approaching. "Editors are busy people. Submit when you feel confident you have something of value to offer. Study the magazine and ask yourself, 'Do I match up to what I see in print? Are my photos strong enough to fit in the context of a particular magazine?' I feel you have to have a passion for what you're doing. More and more we are becoming a visual society. And as a photographer, it is your responsibility to teach people through your vision."

—*Alice P. Buening*

Needs: Uses cover photo occasionally. "While subject matter varies, we are generally looking for photos that include people, and that have a symbolic dimension. We use *few* purely 'scenic' photos. Photos of religious activities, such as worship, are often useful, but should not be 'cliches'—types of photos that are seen again and again." Captions "may be helpful."

Making Contact & Terms: Query with list of stock photo subjects. SASE. Reports in 2 months. Pays $15-25/b&w photo. Pays on publication. Credit line given. Buys one-time rights. Simultaneous submissions or previously published work OK.

***♣MACLEAN'S MAGAZINE**, 777 Bay St., Toronto, Ontario M5W 1A7 Canada. (416)596-5379. Fax: (416)596-7730. E-mail: bregg@plink.geis.com. Photo Editor: Peter Bregg. Circ. 500,000. Estab. 1905. Weekly magazine. Emphasizes news/editorial. Readers are a general audience. Sample copy $3 with 9×12 SASE.

Needs: Uses 50 photos/issue. Needs a variety of photos similar to *Time* and *Newsweek*. Captions required; include who, what, where, when, why.

Making Contact & Terms: Interested in receiving work from newer, lesser-known photographers. Send business card. Uses color prints; transparencies; 266 dpi, 6×8 average digital formats. Deadline each Friday. Cannot return material. Don't send originals. Reports in 3 weeks. Pays $350/day; $600/ color cover photo; $200/color inside photo; $50 extra for electronic usage. Pays on publication. Credit line given. Buys one-time and electronic rights. Simultaneous submissions and previously published work OK.

THE MAGAZINE ANTIQUES, 575 Broadway, New York NY 10012. (212)941-2800. Fax: (212)941-2819. Editor: Allison E. Ledes. Circ. 56,700. Estab. 1922. Monthly magazine. Emphasizes art, antiques, architecture. Readers are male and female collectors, curators, academics, interior designers, ages 40-70. Sample copy $10.50.

Needs: Uses 60-120 photos/issue; 40% supplied by freelancers. Needs photos of interiors, architectural exteriors, objects. Reviews photos with or without ms.

Making Contact & Terms: Interested in receiving work from newer, lesser-known photographers. Submit portfolio for review. Send 8×10 glossy prints; 4×5 transparencies. Does not keep samples on file. SASE. Reports in 2 weeks. NPI; rates negotiated on an individual basis. Pays on publication. Credit line given. Buys one-time rights; negotiable. Previously published work OK.

MAINSTREAM, Magazine of the Able-Disabled, 2973 Beech St., San Diego CA 92102. (619)234-3138. Editor: William G. Stothers. Circ.19,400. Estab. 1975. Published 10 times per year. Emphasizes disability rights. Readers are upscale, active men and women who are disabled. Sample copy $5 with 9×12 SAE and 6 first-class stamps.

Needs: Uses 3-4 photos/issue. Needs photos of disabled people doing things—sports, travel, working, etc. Reviews photos with accompanying ms only. Model/property release preferred. Captions required.

Making Contact & Terms: Provide résumé, business card, brochure, flier or tearsheets to be kept on file for possible assignments. Keeps samples on file. SASE. Reports in 2 months. Pays $85/color cover photo; $35/b&w inside photo. Pays on publication. Credit line given. Buys all rights; negotiable. Previously published work OK "if not in one of our major competitors' publications."

Tips: "We definitely look for signs that the photographer empathizes with and understands the perspective of the disability rights movement."

MARLIN MAGAZINE, P.O. Box 2456, Winter Park FL 32790. (407)628-4802. Fax: (407)628-7061. E-mail: marlin@gate.net. Editor: David Ritchie. Circ. 30,000 (paid). Estab. 1981. Bimonthly magazine. Emphasizes offshore big game fishing for billfish, sharks and tuna and other large pelagics. Readers are 94% male, 75% married, average age 43, very affluent businessmen. Free sample copy with 8×10 SAE. Photo guidelines free with SASE.

• This publication is using more high resolution enhancements, blends, collages, etc. Also, at *Photographer's Market* press time, *Marlin* was in the process of creating a policy for purchasing electronic rights to images.

Needs: Uses 40-50 photos/issue; 98% supplied by freelancers. Needs photos of fish/action shots, scenics and how-to. Special photo needs include big game fishing action and scenics (marinas, landmarks etc.). Model release preferred. Captions preferred.

Making Contact & Terms: Interested in receiving work from newer, lesser-known photographers. Send unsolicited photos by mail for consideration. Send 35mm transparencies. Also accepts high resolution images on CD (Mac). SASE. Reports in 1 month. Pays $750/color cover photo; $50-300/ color inside photo; $35-150/b&w inside photo; $150-200/color page rate. Pays on publication. Buys first North American rights. Simultaneous submissions OK, with notification.

♣MARQUEE ENTERTAINMENT MAGAZINE, 77 Mowat Ave., #621, Toronto, Ontario M6K 3E3 Canada. (416)538-1000. Fax: (416)538-0201. Editors: Jack Gardner and Alexandra Lenhoff. Circ. 730,000. Estab. 1975. Magazine published 9 times/year. Emphasizes movies, music. Sample copy $3.

Needs: Uses 25-30 photos/issue. Needs photos of personalities. Captions preferred.
Making Contact & Terms: Interested in receiving work from newer, lesser-known photographers. Contact through rep. Does not keep samples on file. Reports in 3 weeks. Pays on publication. Credit line given. Rights negotiable.
Tips: Looking for "shots that relate to movies/personalities."

MARTIAL ARTS TRAINING, P.O. Box 918, Santa Clarita CA 91380-9018. (805)257-4066. Fax: (805)257-3028. Editor: Douglas Jeffrey. Circ. 40,000. Bimonthly. Emphasizes martial arts training. Readers are martial artists of all skill levels. Sample copy free. Photo guidelines free with SASE.
Needs: Uses about 100 photos/issue; 90 supplied by freelance photographers. Needs "photos that pertain to fitness/conditioning drills for martial artists. Photos purchased with accompanying ms only. Model release required. Captions required.
Making Contact & Terms: Send 5×7 or 8×10 b&w prints; 35mm transparencies; b&w contact sheet or negatives by mail for consideration. SASE. Reports in 1 month. Pays $50-150 for text/photo package. Pays on publication. Credit line given. Buys all rights.
Tips: Photos "must be razor-sharp, b&w. Technique shots should be against neutral background. Concentrate on training-related articles and photos."

MEDIPHORS, P.O. Box 327, Bloomsburg PA 17815. Editor: Eugene D. Radice, MD. Circ. 800. Estab. 1993. Semiannual magazine. Emphasizes literary/art in medicine and health. Readers are male and female adults in the medical fields and literature. Sample copy $5.50. Photo guidelines free with SASE.
Needs: Uses 5-7 photos/issue; all supplied by freelancers. Needs artistic photos related to medicine and health. Also photos to accompany poetry, essay, and short stories. Special photo needs include single photos, cover photos, and photos accompanying literary work. Releases usually not needed—artistic work. Photographers encouraged to submit titles for their artwork.
Making Contact & Terms: Interested in receiving work from newer, lesser-known photographers. Send unsolicited photos by mail for consideration. Send minimum 3×4 any finish b&w prints. Keeps samples on file. SASE. Reports in 1 month. Pays on publication 2 copies of magazines. Credit line given. Buys first North American serial rights.
Tips: Looking for "b&w artistic photos related to medicine & health. Our goal is to give new artists an opportunity to publish their work. Prefer photos where people CANNOT be specifically identified. Examples: Drawings on the wall of a Mexican Clinic, an abandoned nursing home, an old doctor's house, architecture of an old hospital."

MENNONITE PUBLISHING HOUSE, 616 Walnut Ave., Scottdale PA 15683. (412)887-8500. Fax: (412)887-3100. Photo Secretary: Debbie Cameron. Publishes *Story Friends* (ages 4-9), *On The Line* (ages 10-14), *Christian Living*, *Gospel Herald*, *Purpose* (adults).
Needs: Buys 10-20 photos/year. Needs photos of children engaged in all kinds of legitimate childhood activities (at school, at play, with parents, in church and Sunday School, at work, with hobbies, relating to peers and significant elders, interacting with the world); photos of youth in all aspects of their lives (school, work, recreation, sports, family, dating, peers); adults in a variety of settings (family life, church, work, and recreation); abstract and scenic photos. Model release preferred.
Making Contact & Terms: Send 8½×11 b&w photos by mail for consideration. Provide résumé, business card, brochure, flier or tearsheets to be kept on file for possible assignments. SASE. Reports in 1 month. Pays $20-50/b&w photo. Credit line given. Buys one-time rights. Simultaneous submissions and/or previously published work OK.

MICHIGAN NATURAL RESOURCES MAGAZINE, 30600 Telegraph Rd., Suite 1255, Bingham Farms MI 48025-4531. (810)642-9580. Fax: (810)642-5290. Editor: Richard Morscheck. Creative Director: Kathleen Kolka. Circ. 100,000. Estab. 1931. Bimonthly. Emphasizes natural resources in the Great Lakes region. Readers are "appreciators of the out-of-doors; 15% readership is out of state." Sample copy $4. Photo guidelines free with SASE.
Needs: Uses about 40 photos/issue; freelance photography in given issue—25% from assignment and 75% from freelance stock. Needs photos of Michigan wildlife, Michigan flora, how-to, travel in Michigan, outdoor recreation. Captions preferred.
Making Contact & Terms: Interested in receiving work from newer, lesser-known photographers. Query with samples or list of stock photo subjects. Send original 35mm color transparencies by mail

LISTINGS THAT USE IMAGES electronically can be found in the Digital Markets Index located at the back of this book.

for consideration. SAE. Reports in 1 month. Pays $50-250/color page; $500/job; $800 maximum for text/photo package. Pays on publication. Credit line given. Buys one-time rights.

Tips: Prefers "Kodachrome 64 or 25 or Fuji 50 or 100, 35mm, *razor-sharp in focus!* Send about 20 slides with a list of stock photo topics. Be sure slides are sharp, labeled clearly with subject and photographer's name and address. Send them in plastic slide filing sheets. Looks for unusual outdoor photos. Flora, fauna of Michigan and Great Lakes region. Strongly recommend that photographer look at past issues of the magazine to become familiar with the quality of the photography and the overall content. We'd like our photographers to approach the subject from an editorial point of view. Every article has a beginning, middle and end. We're looking for the photographer who can submit a complete package that does the same thing."

MICHIGAN OUT-OF-DOORS, P.O. Box 30235, Lansing MI 48909. (517)371-1041. Fax: (517)371-1505. Editor: Kenneth S. Lowe. Circ. 130,000. Estab. 1947. Monthly magazine. For people interested in "outdoor recreation, especially hunting and fishing; conservation; environmental affairs." Sample copy $2; free editorial guidelines.

Needs: Use 1-6 freelance photos/issue. Animal, nature, scenic, sport (hunting, fishing and other forms of noncompetitive recreation), and wildlife. Materials must have a Michigan slant. Captions preferred.

Making Contact & Terms: Send any size glossy b&w prints; 35mm or 2¼×2¼ transparencies. SASE. Reports in 1 month. Pays $15 minimum/b&w photo; $150/cover photo; $25/inside color photo. Credit line given. Buys first North American serial rights. Previously published work OK "if so indicated."

Tips: Submit seasonal material 6 months in advance. Wants to see "new approaches to subject matter."

***MODERN DRUMMER MAGAZINE**, 12 Old Bridge Rd., Cedar Grove NJ 07009. (201)239-4140. Fax: (201)239-7139. Editor: Ron Spagnardi. Photo Editor: Scott Bienstock. Circ. 100,000. Magazine published 12 times/year. For drummers at all levels of ability: students, semiprofessionals and professionals. Sample copy $3.95.

Needs: Buys 100-150 photos annually. Needs celebrity/personality, product shots, action photos of professional drummers and photos dealing with "all aspects of the art and the instrument."

Making Contact & Terms: Submit freelance photos with letter. Send for consideration b&w contact sheet, b&w negatives, or 5×7 or 8×10 glossy b&w prints; 35mm, 2¼×2¼, 8×10 color transparencies. Uses color covers. SASE. Pays $200/cover; $30-150/color photo; $15-75/b&w photo. Pays on publication. Credit line given. Buys one-time international usage rights per country. Previously published work OK.

MONDO 2000, PO Box 10171, Berkeley CA 94708. (510)845-9018. Fax: (510)649-9630. Art Director: Heide Foley. Circ. 100,000. Estab. 1989. Quarterly magazine. Emphasizes lifestyle, high-tech computer and communication fields. Readers are professionals, 70% male, 30% female, median age of 29. Sample copies $7.

• This publication lives on bizarre artwork and stories. Creativity is a must when submitting work to this market.

Needs: Uses approximately 25-30 photos/issue; around 70% supplied by freelancers. Needs photos of technology, portraits, fashion. Experimental and fringe art preferred. Reviews photos with or without ms. Model/property release preferred. No captions are necessary, provide description and details if they are not obvious.

Making Contact & Terms: Submit portfolio for review. Provide résumé, business card, brochure, flier or tearsheets to be kept on file for possible assignments. Keeps samples on file. SASE. Reports in 3 weeks to 3 months. NPI. Pays 30 days to 1 year after publication. Also interested in receiving work from newer, lesser-known photographers. Previously unpublished work preferred.

Tips: "Put your name, address and phone number on everything. Call us often and tell us it's OK if we don't have a lot of money to pay." Wants to see sharp images with "disturbing composition and lots of creativity. We seek images from the darker side of the mind."

MONEY, Time-Life Bldg., 1271 Avenue of the Americas, New York NY 10020. Prefers not to share information.

***MOPAR MUSCLE MAGAZINE**, 3816 Industry Blvd., Lakeland FL 33811. (941)644-0449. Fax: (941)648-1187. Editor Greg Rager. Circ. 100,000. Estab. 1988. Bimonthly magazine. Emphasizes Chrysler products—Dodge, Plymouth, Chrysler (old and new). Readers are Chrysler product enthusiasts of all ages. Guidelines free with SASE.

Needs: Uses approximately 120 photos/issue; 50% supplied by freelancers. Needs photos of automotive personalities, automobile features. Reviews photos with or without ms. Model release required. Property release required of automobile owners. Captions required; include all facts relating to the automotive subject.

Making Contact & Terms: Interested in receiving work from newer, lesser-known photographers. Send unsolicited photos by mail for consideration. Send 35mm, 2¼×2¼, 4×5 color transparencies. Keeps samples on file. Reports in 3 weeks. NPI. Pays on publication. Credit line given. Buys all rights; negotiable.

MOTHER EARTH NEWS, Sussex Publishers, 49 E. 21st St., 11th Floor, New York NY 10010. (212)260-3214. Fax: (212)260-7445. Photo Editor: Jennifer Lipshy. Estab. 1992. Bimonthly magazines. Readers are male and female, highly educated, active professionals. Photo guidelines free with SASE.
 • Sussex also publishes *Psychology Today* and *Spy* listed in this section.
Needs: Uses 19-25 photos/issue; all supplied by freelancers. Needs photos of humor, photo montage, symbolic, environmental, portraits, conceptual. Model/property release preferred.
Making Contact & Terms: Interested in receiving work from "upcoming" photographers. Submit portfolio for review. Send promo card with photo. Also accepts Mac files. Call before you drop off portfolio. Keeps samples on file. Cannot return material. Reports back only if interested. For assignments, pays $1,000/cover plus expenses; $350-750/inside photo plus expenses; for stock, pays $150/¼ page; $300/full page.

MOTHERING MAGAZINE, P.O. Box 1690, Santa Fe NM 87504. (505)984-8116. Fax: (505)986-8335. Photo Editor: Madeleine Tilin. Circ. 70,000. Estab. 1976. Quarterly magazine. Emphasizes parenting. Readers are progressive parents, primarily aged 25-40, with children of all ages, racially mixed. Sample copy $3. Free photo guidelines and current photo needs.
Needs: Uses about 40-50 photos/issue; nearly all supplied by freelance photographers. Needs photos of children of all ages, mothers, fathers, breastfeeding, birthing, education. Model/property release required.
Making Contact & Terms: Interested in receiving work from newer, lesser-known photographers. Please send duplicates of slides. Send only 8×10 b&w prints by mail for consideration. "Provide a well-organized, carefully packaged submission following our guidelines carefully. Send SASE for return of pictures please." Reports in 2 months. Pays $500/color cover photo; $100 for full page, $50 for less than full page/b&w inside photo. Pays on publication. Credit line given. Buys one-time rights.
Tips: "For cover: we want technically superior color slides only of sharply focused images evoking a strong feeling or mood, spontaneous and unposed; unique and compelling. Eye contact with subject will often draw in viewer. For inside: b&w prints, sharply focused, action or unposed shots; 'doing' pictures—family, breastfeeding, fathering, midwifery, birth, reading, drawing, crawling, climbing, etc. No disposable diapers, no bottles, no pacifiers. We are being flooded with submissions from photographers acting as their own small stock agency—when the reality is that they are just individual freelancers selling their own work. As a result, we are using fewer photos from just one photographer, giving exposure to more photographers."

♣MOVING PUBLICATIONS LIMITED, 44 Upjohn Rd., #100, Don Mills, Ontario M3B 2W1 Canada. Administrative Assistant: Anne Laplante. Circ. 225,000. Estab. 1973. Annual magazines. Emphasizes moving to a geographic area. Readers are male and female, ages 35-55.
Needs: Uses 20 photos/issue. Needs photos of housing shots, attractions, leisure. Special photo needs include cover shots. Model/property release required. Captions should include location.
 • This publisher produces guides to locations such as Alberta, San Francisco Bay area and Greater Sacramento; Vancouver & British Columbia; Winnipeg and Manitoba; Montreal; Toronto and area; Saskatchewan; Ottawa/Hull; Greater Hamilton area.
Making Contact & Terms: Only free photographs accepted. Do not send unsolicited material. Phone/fax to determine requirements.
Tips: "For front covers, we look for general scenic shots."

***MULTINATIONAL MONITOR**, P.O. Box 19405, Washington DC 20036. (202)387-8030. Fax: (202)234-5176. E-mail: monitor@essential.org. Website: http://www.essential.org/monitor. Editor: Robert Weissman. Circ. 6,000. Estab. 1978. Monthly magazine. "We are a political-economic magazine covering operations of multinational corporations." Emphasizes multinational corporate activity. Readers are in business, academia and many are activists. Sample copy free with 9×12 SAE.
Needs: Uses 12 photos/issue; number of photos supplied by freelancers varies. "We need photos of industry, people, cities, technology, agriculture and many other business-related subjects." Captions required, include location, your name and description of subject matter.
Making Contact & Terms: Interested in receiving work from newer, lesser-known photographers. Query with list of stock photo subjects. SASE. Reports in 3 weeks. Pays $0-35/color and b&w photos and transparencies. Pays on publication. Credit line given. Buys one-time rights.

♣MUSCLEMAG INTERNATIONAL, 6465 Airport Rd., Mississauga, Ontario L4V 1E4 Canada. (905)678-7311. Fax: (905)678-9236. Editor: Johnny Fitness. Circ. 300,000. Estab. 1974. Monthly magazine. Emphasizes male and female physical development and fitness. Sample copy $6.

Needs: Buys 3,000 photos/year; 50% assigned; 50% stock. Needs celebrity/personality, fashion/beauty, glamour, swimsuit, how-to, human interest, humorous, special effects/experimental and spot news. "We require action exercise photos of bodybuilders and fitness enthusiasts training with sweat and strain." Wants on a regular basis "different" pics of top names, bodybuilders or film stars famous for their physique (i.e., Schwarzenegger, The Hulk, etc.). No photos of mediocre bodybuilders. "They have to be among the top 100 in the world or top film stars exercising." Photos purchased with accompanying ms. Captions preferred.

Making Contact & Terms: Send material by mail for consideration; send $3 for return postage. Uses 8 × 10 glossy b&w prints. Query with contact sheet. Send 35mm, 2¼ × 2¼ or 4 × 5 transparencies; vertical format preferred for cover. Reports in 1 month. Pays $85-100/hour; $500-700/day and $1,000-3,000/complete package. Pays $13-35/b&w photo; $25-500/color photo; $500/cover photo; $85-300/accompanying ms. **Pays on acceptance.** Credit line given. Buys all rights.

Tips: "We would like to see photographers take up the challenge of making exercise photos look like exercise motion." In samples wants to see "sharp, color balanced, attractive subjects, no grain, artistic eye. Someone who can glamorize bodybuilding on film." To break in, "get serious: read, ask questions, learn, experiment and try, try again. Keep trying for improvement—don't kid yourself that you are a good photographer when you don't even understand half the attachments on your camera. Immerse yourself in photography. Study the best; study how they use light, props, backgrounds, best angles to photograph."

MUSTANG MONTHLY, P.O. Box 7157, Lakeland FL 33807-7157. (813)646-5743. Fax: (813)648-1187. Senior Editor: Rob Reaser. Circ. 80,000. Estab. 1978. Monthly magazine. Emphasizes 1964 through current model Mustangs. Readers are male and female, ages 18-65, who span all occupations and income brackets. They have a deep passion for the preservation, restoration and enjoyment of all Mustangs, from the '60s classics to the current models. Free sample copy. Photo guidelines free.

Needs: 15% of photos supplied by freelancers. Needs technical "how-to" and feature car photography. "Query first." Reviews photos with or without ms. Special photo needs include 1969-73 and 1979-current model Mustangs. Property release required for feature cars. Captions preferred.

Making Contact & Terms: Interested in receiving work from newer, lesser-known photographers. Currently looking to expand our freelance base. Submit portfolio for review. Query with stock photo list. Send unsolicited photos by mail for consideration. "Anything containing automobile subject matter." Send 35mm, 2¼ × 2¼, 4 × 5 transparencies. Does not keep samples on file. SASE. Reports in 1 month. Pays $200-250/color cover photo; $10/b&w inside photo; $150-300/photo/text package. Pays on publication. Credit line given. Buys one-time rights; first North American serial rights.

Tips: Wants to see "command of lighting and composition. *Mustang Monthly* is a showcase of the best Mustangs in the world. Photographer should have a working knowledge of Mustangs and automotive photography skills. We feature only pristine and correctly restored cars. Study past issues for style."

NATIONAL GEOGRAPHIC, Prefers not to share information.

NATIONAL GEOGRAPHIC TRAVELER, Prefers not to share information.

NATIONAL GEOGRAPHIC WORLD, Prefers not to share information.

NATIONAL PARKS MAGAZINE, 1776 Massachusetts Ave. NW, Washington DC 20036. (202)223-6722. Editor: Sue Dodge. Circ. 450,000. Estab. 1919. Bimonthly magazine. Emphasizes the preservation of national parks and wildlife. Sample copy $3. Photo guidelines free with SASE.

Needs: Photos of wildlife and people in national parks, scenics, national monuments, national recreation areas, national seashores, threats to park resources and wildlife.

Making Contact & Terms: Send stock list with example of work if possible. *National Parks* does not accept unsolicited mss or photos. Uses 4 × 5 or 35mm transparencies. SASE. Reports in 1 month. Pays $100-200/color photos; $250 full-bleed color covers. Pays on publication. Buys one-time rights.

Tips: "Photographers should be specific about national park system areas they have covered. We are a specialized publication and are not interested in extensive lists on topics we do not cover."

NATIONAL WILDLIFE, Photo Submissions, Wildlife Editorial, 8925 Leesburg Pike, Vienna VA 22184. (703)790-4419. Fax: (703)442-7332. Photo Editor: John Nuhn. Circ. 700,000. Estab. 1962. Bimonthly magazine. Emphasizes wildlife, nature, environment and conservation. Readers are people who enjoy viewing high-quality wildlife and nature images from around the world, and who are interested in knowing more about the natural world and man's interrelationship with animals and environment. Sample copy $3; send to National Wildlife Federation Membership Services (same address). Send separate SASE only for free photo guidelines, to Photo Guidelines Wildlife Editorial (same address).

Needs: Uses 45 photos/issue; all supplied by freelance photographers; 80% stock, 20% assigned. Photo needs include worldwide photos of wildlife, wild plants, nature-related how-to, conservation

practices, environmental damage, environmental research, outdoor recreation. Subject needs include single photos for cover possibility (primarily wildlife but also plants, scenics, people); b&w accompanying unique story ideas that have good reason not to be in color. Model release preferred. Captions required.

Making Contact & Terms: No unsolicited submissions from photographers whose work has not been previously published or considered for use in our magazine. Instead, send nonreturnable samples (tearsheets or photocopies) to Photo Queries (same address). Interested in seeing work from newer, lesser-known photographers with high quality transparencies only. Do not send submissions or samples without studying a copy of the magazine. Send 35mm, 2¼×2¼, 4×5, 8×10 transparencies (magazine is 95% color) or 8×10 glossy b&w prints for consideration. SASE. Reports in 1 month. Pays $300-750/b&w inside photo; $500-800/color cover photo; $300-750/color inside photo; text/photo negotiable. **Pays on acceptance.** Credit line given. Buys one-time rights with limited magazine promotion rights. Previously published work OK.

Tips: Interested in a variety of images that show photographer's scope and specialization. Organize in loose slide sheets (no binders), along with tearsheets of previously published work. "Study our magazine; note the types of images we use and send photos equal or better. We look for imagination (common subjects done creatively, different views of animals and plants); technical expertise (proper exposure, focusing, lighting); and the ability to go that one step further and make the shot unique. Think editorially when submitting stories, queries or photos; assure that package is complete—sufficient return postage (no checks), proper size return envelope, address inside, and do not use tape, slide boxes or glass mounts."

NATIVE PEOPLES MAGAZINE, 5333 N. Seventh St., Suite C-224, Phoenix AZ 85014. (602)252-2236. Fax: (602)265-3113. E-mail: native_peoples@amcolor.com. Website: http://www.atiin.com/native_peoples. Editor: Gary Avey. Circ. 115,000. Estab. 1987. Quarterly magazine. Dedicated to the sensitive protrayal of the arts and lifeways of the native peoples of the Americas. Readers are primarily upper-demographic members of affiliated museums (i.e. National Museum of the American Indian/Smithsonian). Sample copy free with SASE. Photo guidelines free with SASE.

Needs: Uses 50-60 photos/edition; 100% supplied by freelancers. Needs Native American lifeways photos. Model/property release preferred. Captions preferred; include names, location and circumstances.

Making Contact & Terms: Interested in receiving work from newer, lesser-known photographers. Submit portfolio for review. Send unsolicited photos by mail for consideration. Send transparencies, all formats. Also accepts digital files on disk with proof copy. SASE. Reports in 1 month. Pays $250/color cover photo; $250/b&w cover photo; $45-150 color inside photo; $45-150/b&w inside photo. Pays on publication. Buys one-time rights.

Tips: "We prefer to send magazine and guidelines rather than pour over general portfolio."

***NATURAL HISTORY MAGAZINE,** Central Park W. at 79th St., New York NY 10024. (212)769-5500. Editor: Bruce Stutz. Picture Editor: Kay Zakariasen. Circ. 520,000. Monthly magazine. For primarily well-educated people with interests in the sciences. Free photo guidelines.

Needs: Buys 400-450 photos/year. Animal behavior, photo essay, documentary, plant and landscape. "We are interested in photoessays that give an in-depth look at plants, animals, or people and that are visually superior. We are also looking for photos for our photographic feature, 'The Natural Moment.' This feature focuses on images that are both visually arresting and behaviorally interesting." Photos used must relate to the social or natural sciences with an ecological framework. Accurate, detailed captions required.

Making Contact & Terms: Query with résumé of credits. "We prefer that you come in and show us your portfolio, if and when you are in New York. Please don't send us any photographs without a query first, describing the work you would like to send. No submission should exceed 30 original transparencies or negatives. However, please let us know if you have additional images that we might consider. Potential liability for submissions that exceed 30 originals shall be no more than $100 per slide." Uses 8×10 glossy, matte and semigloss b&w prints; and 35mm, 2¼×2¼, 4×5, 6×7 and 8×10 color transparencies. Covers are always related to an article in the issue. SASE. Reports in 2 weeks. Pays (for color and b&w) $400-600/cover; $350-500/spread; $300-400/oversize; $250-350/full-page; $200-300/¾ page; $150-225/½ page; $125-175/¼ page; $100-125/¹⁄₁₆ page or less. Pays $50 for usage on contents page. Pays on publication. Credit line given. Buys one-time rights. Previously published work OK but must be indicated on delivery memo.

Tips: "Study the magazine—we are more interested in ideas than individual photos. We do not have the time to review portfolios without a specific theme in the social or natural sciences."

NATURE PHOTOGRAPHER, P.O. Box 2037, West Palm Beach FL 33402. (407)586-3491. Fax: (407)586-9521. Photo Editor: Helen Longest-Slaughter. Circ. 25,000. Estab. 1990. Bimonthly 4-color high-quality magazine. Emphasizes "conservation-oriented, low-impact nature photography" with

strong how-to focus. Readers are male and female nature photographers of all ages. Sample copies free with 10×13 SAE with 6 first-class stamps.

Needs: Uses 25-35 photos/issue; 90% supplied by freelancers. Needs nature shots of "all types—abstracts, animal/wildlife shots, flowers, plants, scenics, environmental images, etc." Shots must be in natural settings; no set-ups, zoo or captive animal shots accepted. Reviews photos with or without ms twice a year, May (for fall/winter issues) and November (for spring/summer). Captions required; include description of subject, location, type of equipment, how photographed. "This information published with photos."

Making Contact & Terms: Interested in receiving work from newer, lesser-known photographers. Prefers to see 35mm, 2¼×2¼ and 4×5 transparencies. Does not keep samples on file. SASE. Reports within 4 months, according to deadline. Pays $100/color cover photo; $25-40/color inside photo; $20/b&w inside photo; $75-150/photo/text package. Pays on publication. Credit line given. Buys one-time rights. Simultaneous submissions and previously published work OK.

Tips: Recommends working with "the best lens you can afford and slow speed slide film." Suggests editing with a 4× or 8× lupe (magnifier) on a light board to check for sharpness, color saturation, etc. Color prints are not used for publication in magazine, except from photographers under the age of 18 for the "Young People's" column.

NATURIST LIFE INTERNATIONAL, P.O. Box 300-F, Troy VT 05868-0300. (802)744-6565. Editor-in-chief: Jim C. Cunningham. Circ. 2,000. Estab. 1987. Quarterly magazine. Emphasizes nudism. Readers are male and female nudists, age 30-80. Sample copy $5. Photo guidelines free with SASE.

Needs: Uses approximately 45 photos/issue; 80% supplied by freelancers. Needs photos depicting family-oriented, nudist/naturist work and recreational activity. Reviews photos with or without ms. Model release required. Property release preferred for recognizable nude subjects. Captions preferred.

Making Contact & Terms: Interested in receiving work from newer, lesser-known photographers. Query with résumé of credits. Send unsolicited photos by mail for consideration. Provide résumé, business card, brochure, flier or tearsheets to be kept on file for possible assignments. Send 8×10 glossy color and b&w prints; 35mm, 2¼×2¼, 4×5, 8×10 (preferred) transparencies. Does not keep samples on file. SASE. Reports in 2 weeks. Pays $50 color photo; $25/color inside photo; $25/b&w inside photo. Only pays $10 if not transparency or 8×10 glossy. Pays on publication. Credit line given. "Prefer to own all rights but sometimes agree to one-time publication rights."

Tips: "The ideal *NLI* photo shows ordinary-looking people of all ages doing everyday activities, in the joy of nudism."

***NAUGHTY NEIGHBORS**, 13360 SW 128th St., Miami FL 33186. (305)238-5040. Fax: (305)238-6716. E-mail: quad@netrunner.net. Assistant Editor: Douglas Covin. Circ. 250,000. Estab. 1995. Monthly magazine. Emphasizes "nude glamor with a voyeuristic focus—amateurs and the swinging scene." Readers are male, 18 and over. Sample copy $7. Photo guidelines free with SASE.

Needs: Uses approximately 200 photos/issue; all supplied by freelancers. Needs photos of nude females; "amateurs, not professional models." Model release required.

Making Contact & Terms: Interested in receiving work from newer, lesser-known photographers. Send unsolicited photos by mail for consideration. Send 4×6 or 7×10 glossy color prints; 35mm transparencies. Keeps samples on file. SASE. Reports in 1-2 weeks. NPI; "rates negotiated per individual sets." Pays on publication. Buys one-time and other negotiated rights. Simultaneous submissions OK.

Tips: "Study samples of the magazine for insights into what we are looking for."

NEVADA MAGAZINE, 1800 Hwy. 50 E., Suite 200, Carson City NV 89710. (702)687-6158. Fax: (702)687-6159. Art Director: Denise Barr. Estab. 1936. Circ. 100,000. Bimonthly. State tourism magazine devoted to promoting tourism in Nevada, particularly for people interested in travel, people, history, events and recreation; age 30-70. Sample copy $3.50.

Needs: Buys 40-50 photos/issue; 30-35 supplied by freelance photographers. Buys 10% freelance on assignment, 20% from freelance stock. (Nevada stock photos only—not generic). Towns and cities, scenics, outdoor recreation with people, events, state parks, tourist attractions, travel, wildlife, ranching, mining and general Nevada life. Must be Nevada subjects. Captions required; include place, date, names if available.

Making Contact & Terms: Interested in receiving work from newer, lesser-known photographers. Send samples of Nevada photos. Send 8×10 glossy prints; 35mm, 2¼×2¼, 4×5, 8×10 transparencies; prefers vertical format for cover. Send 35mm slides in 8×10 see-through slide sleeves. Must be labeled with name, address and captions on each. SASE. Reports in 4 months. Pays $20-100/inside photo; $150-300/cover photo; $50 minimum/job. Pays on publication. Credit line given. Buys first North American serial rights.

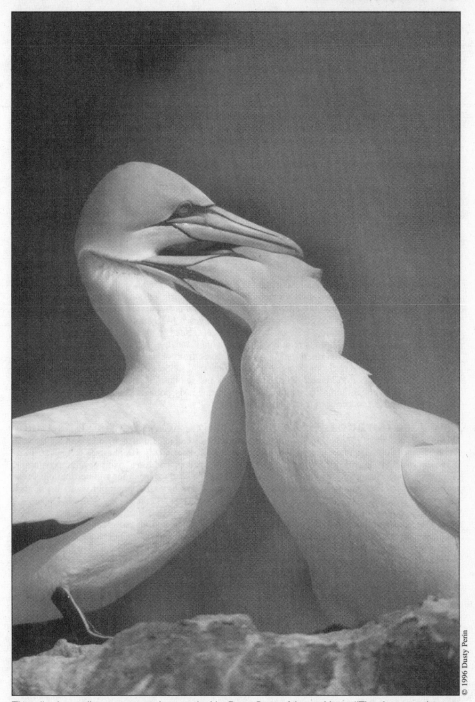

These "embracing" gannets were photographed by Dusty Perin of Acton, Maine. "This shot was taken at the Black Reef gannet colony on Cape Kidnappers, New Zealand," explains Perin. "It was a wonderful experience to be the only person surrounded by hundreds of gannets. I was trying hard to capture their unique interaction on film." When Perin heard photographer Helen Longest-Slaughter had started *Nature Photographer* magazine, he looked it up in *Photographer's Market* and submitted his work. The photo appeared on the table of contents page of the magazine. Perin has also successfully sold the image as a gallery print.

Tips: "Send variety of good-quality Nevada photos, well-labeled. Self-edit work to 20-40 slides maximum. We are increasing our use of events photos from prior years' events. We have a real need for current casino shots."

NEW MEXICO MAGAZINE, Dept. PM, 495 Old Santa Fe Trail, Santa Fe NM 87503. (505)827-7447. Fax: (505)827-6496. Art Director: John Vaughan. Circ. 123,000. Monthly magazine. For affluent people age 35-65 interested in the Southwest or who have lived in or visited New Mexico. Sample copy $2.95 with 9×12 SAE and 3 first-class stamps. Photo guidelines free with SASE.
Needs: Uses about 60 photos/issue; 90% supplied by freelancers. Needs New Mexico photos only—landscapes, people, events, architecture, etc. "Most work is done on assignment in relation to a story, but we welcome photo essay suggestions from photographers." Cover photos usually relate to the main feature in the magazine. Model release preferred. Captions required; include who, what, where.
Making Contact & Terms: Interested in receiving work from newer, lesser-known photographers. Submit portfolio to John Vaughan; uses transparencies. SASE. Pays $450/day; $300/color cover photo; $300/b&w cover photo; $60-100/color inside photo; $60-100/b&w inside photo. Pays on publication. Credit line given. Buys one-time rights.
Tips: Prefers transparencies submitted in plastic pocketed sheets. Interested in different viewpoints, styles not necessarily obligated to straight scenic. "All material must be taken in New Mexico. Representative work suggested. If photographers have a preference about what they want to do or where they're going, we would like to see that in their work. Transparencies or dupes are best for review and handling purposes."

***NEW MOON PUBLISHING**, P.O. Box 3620, Duluth MN 55803-3620. (218)728-5507. Fax: (218)728-0314. E-mail: newmoon@newmoon.duluth.mn.us. Girls Editorial Board: %Tya Ward or Barbara Stretchberry. Circ. 22,000. Estab. 1993. Bimonthly magazine. Emphasizes girls, ages 8-14; *New Moon* is edited by girls for girls. Readers are girls, ages 8-14. Sample copy $6.50.
Needs: Uses 15-25 photos/issue; 5 supplied by freelancers. Needs photos for specific stories. Model/property release required. Captions required; include names, location, ages of kids.
Making Contact & Terms: Interested in receiving work from newer, lesser-known photographers. Submit portfolio for review. Send 4×6 glossy color b&w prints; 35mm transparencies. Keeps samples on file. SASE. Reports in 6 months. Pays $15-30/b&w inside photo. Pays on publication. Credit line given. Buys all rights. Simultaneous submissions and previously published work OK.
Tips: "Read and get to know style of magazine first!"

NEW YORK OUTDOORS, Allsport Publishing Corp., 51 Atlantic Ave., Floral Park NY 11001. (516)352-9700. Fax: (516)437-6841. E-mail: hattie38@aol.com. Publisher/Editor-in-Chief: Scott Shane. Editor: John Tsaousis. Circ. 50,000. Published 8 times annually. Emphasizes technique, locations and products for all outdoor activities including: cycling, paddling, fishing, hiking, camping, climbing, diving, skiing and boating. Also features adventure outdoor locations and destinations in the northeastern US. Free sample copy and photo guidelines. "Ask to be placed on our wants list or send us your stock list."
Needs: Buys one color cover and 5-10 inside shots per issue. Photo from freelance stock. Photos purchased with accompanying ms; covers purchased separately. Captions required.
Making Contact & Terms: Interested in receiving work from newer, lesser-known photographers. Send original transparencies. Send photos for consideration. Also accepts digital files in Mac format—TIFF, GIF or EPS. SASE. Reports in 3 weeks. Pays: $25-100/color or b&w inside; $350/color cover. Pays on publication. Buys first North American serial rights.
Tips: "If it looks like fun, it's for us. Any sport, but background must be or look like Northeast United States, New York state a bonus. We are tabloid size, so pictures need to hold a blow-up. People in sport—including families—are always good."

NEW YORK SPORTSCENE, 990 Motor Pkwy., Central Islip NY 11722. (516)435-8890. Fax: (516)435-8925. Editor-in-Chief: Keith Loria. Circ. 125,000. Estab. 1995. Monthly magazine. Emphasizes professional and major college sports in New York. Readers are 95% male; median age: 30; 85% are college educated. Sample copy $3.
Needs: Uses 30 photos/issue; all supplied by freelancers. Needs photos of sports action, fans/crowd reaction.
Making Contact & Terms: Interested in receiving work from newer, lesser-known photographers. Send unsolicited photos by mail for consideration. Send color prints; 35mm transparencies. Keeps samples on file. SASE. Reports in 3 weeks. NPI. Pays several weeks after publication.
Tips: "Slides should capture an important moment or event and tell a story. There are numerous sports photographers out there—your work must stand out to be noticed."

NEW YORK STATE CONSERVATIONIST MAGAZINE, (formerly *Conservationist Magazine*) Editorial Office, NYSDEC, 50 Wolf Rd., Albany NY 12233-4502. (518)457-5547. Contact: Photo

Editor. Circ. 110,000. Estab. 1946. Bimonthly nonprofit, New York State government publication. Emphasizes natural history, environmental, and outdoor interests pertinent to New York State. Readers are people interested in nature and environmental quality issues. Sample copy $3.50 and 8½×11 SASE. Photo guidelines free with SASE.

Needs: Uses 40 photos/issue; 80% supplied by freelance photographers. Needs wildlife shots, people in the environment, outdoor recreation, forest and land management, fisheries and fisheries management, environmental subjects (some pollution shots), effects of pollution on plants, buildings, etc. Model release preferred. Captions required.

Making Contact & Terms: Interested in reviewing work from newer, lesser-known photographers. Query with samples. Send 35mm, 2¼×2¼, 4×5 or 8×10 transparencies by mail for consideration. Submit portfolio for review. Provide résumé, business card, brochure, flier or tearsheets to be kept on file for possible future assignments. Reports in 3 weeks. Pays $15/b&w or color photo. Pays on publication. Buys one-time rights. Simultaneous submissions and previously published work OK.

Tips: Looks for "artistic interpretation of nature and the environment, unusual ways of picturing environmental subjects (even pollution, oil spills, trash, air pollution, etc.); wildlife and fishing subjects at all seasons. Try for unique composition, lighting. Technical excellence a must."

NEWSWEEK, 251 W. 57th St., New York NY 10019-6999. Prefers not to share information.

NORTHEAST OUTDOORS, P.O. Box 2180, Waterbury CT 06722. (203)755-0158. Fax: (203)755-3480. Editorial Director: John Florian. Circ. 14,000. Estab. 1968. Monthly tabloid. Emphasizes camping in the Northeast. Sample copy free with SASE.

Needs: Reviews photos with accompanying manuscript *only*. Model release required. Photo captions preferred.

Making Contact & Terms: Query with story ideas and résumé. SASE. Reports in approximately 2 weeks. Pays $40-80/photo text package. Pays on publication. Credit line given. Buys one-time rights, first North American serial rights. Previously published work OK if not in competing publication.

NORTHERN OHIO LIVE, Dept. PM, 11320 Juniper Rd., Cleveland OH 44106. (216)721-1800. Art Director: James Weber. Circ. 35,000. Estab. 1980. Monthly magazine. Emphasizes arts, entertainment and lifestyle. Readers are upper income, ages 25-60, professionals. Sample copy $2 with 9×12 SAE.

Needs: Uses 30 photos/issue; 20-100% supplied by freelance photographers. Needs photos of people in different locations, fashion and locale. Model release preferred. Captions preferred (names only are usually OK).

Making Contact & Terms: Arrange a personal interview to show portfolio. Send b&w and color prints; 35mm or 2¼×2¼ transparencies by mail for consideration. Provide résumé, business card, brochure, flier or tearsheet to be kept on file for possible assignments. Follow up phone call OK. SASE. Reports in 3 weeks. Pays $250/color cover photo; $250/b&w cover photo; $100/color inside photo; $50/b&w inside photo; $30-50/hour; $250-500/day. Pays on publication. Credit line given. Buys one-time rights. Previously published work OK.

Tips: In photographer's portfolio wants to see "good portraits, people on location, photojournalism strengths, quick turn-around and willingness to work on *low* budget. Mail sample of work, follow up with phone call. Portfolio review should be short—only *best quality* work!"

NORTHWEST TRAVEL, 1525 12th St., P.O. Box 18000, Florence OR 97439. (800)348-8401. Fax: (541)997-1124. E-mail: rob@preferred-syspresys.com. Website: http://www.presys.com/highway. Art Director: Barbara Grano. Circ. 50,000. Estab. 1991. Bimonthly magazine. Emphasizes Pacific Northwest travel—Alaska, Oregon, Washington, Idaho and British Columbia (southern). Readers are middle-age male and female, upper income/middle income. Sample copy $4.50 includes postage. Photo guidelines free with SASE.

Needs: Uses 8-12 (full page) photos/issue; all supplied by freelancers. Needs photos of travel, scenics. Model release preferred. Photo captions required.

Making Contact & Terms: Send unsolicited photos by mail for consideration. Uses 35mm, 2¼×2¼, 4×5 transparencies. SASE. Reports in 1 month. Pays $325/color cover photo; $25-75/color inside photo; $25-50/b&w inside photo; $100-250/photo/text package. Pays on publication. Credit line given. Buys one-time rights.

Tips: "Mainly interested in scenics. Avoid colored filters. Use only film that can enlarge without graininess."

 THE MAPLE LEAF before a listing indicates that the market is Canadian.

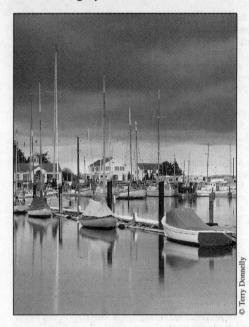

In shooting this photo Terry Donnelly sought "a feeling of a storm or rain—weather typical for winter in the Northwest." His "dramatic lighting, nice contrast in texture and color and excellent focus" caught the eye of *Northwest Travel* Photo Editor Barbara Grano. The photo depicting Point Hudson Marina in Port Townsend, Washington, appeared in a pictorial in the magazine. Donnelly then sold a 20 × 24 print of the image to the owner of the marina, who saw the shot in *Northwest Travel*.

© Terry Donnelly

NORTHWOODS PUBLICATIONS INC., 430 N. Front St., P.O. Box 90, Lemoyne PA 17043. (717)761-1400. Fax: (717)761-4579. Publishes *Pennsylvania Sportsman*, *New York Sportsman*, *Michigan Hunting & Fishing*. Publisher: Sherry Ritchey. Circ. 140,000. Estab. 1977. Published 8 times/year. Emphasizes outdoor hunting and fishing. Readers are of all ages and backgrounds. Sample copy $2.95. Photo guidelines free with SASE.
Needs: Uses 40-70 photos/issue; 30% supplied by freelancers. Needs photos of wildlife. Special photo needs include deer, turkey, bear, trout, pike, walleye and panfish. Captions preferred.
Making Contact & Terms: Interested in receiving work from newer, lesser-known photographers. Query with stock photo list. Send unsolicited photos by mail for consideration. Send 35mm transparencies. Keeps samples on file. SASE. Pays $150/color cover photo; $25-75/color inside photo; $10-50/ b&w inside photo. Pays on publication. Credit line given. Buys first North American serial rights.
Tips: "Look at the magazine to become familiar with needs."

‡**NORWAY AT YOUR SERVICE**, Drammensveien 40, 0243, Oslo, Norway. (47)22926300. Fax: (47)22926400. Editor: Peggy Schoen. Circ. 35,000. Estab. 1984. Publication of the Norwegian Trade Council, in cooperation with the Norwegian Tourist Board, the Ministry of Foreign Affairs and other national organizations. Annual magazine. Emphasizes Norwegian business, culture and tourism. Readers are tourists interested in visiting Norway and business/organizations interested in Norwegian products and companies. Sample copy free with European C4 SAE and International postal voucher. Photo guidelines free with SASE.
Needs: Uses 60-80 photos/issue; 50% freelance, 50% photo agency. Needs photos of Norwegian travel destinations (festivals, places, nature); modern Norwegian culture and lifestyle; Norwegian companies and products; Norwegian personalities. Model/property release preferred. Captions required; include when/where taken, context of photo.
Making Contact & Terms: Interested in receiving work from newer, lesser-known photographers. Query with stock photo list. Send unsolicited photos by mail for consideration. Provide résumé, business card, brochure, flier or tearsheets to be kept on file for possible assignments. "We prefer transparencies but can take 5×7 prints. Keeps samples on file. Returns unsolicited material if SASE is an international postal order. Reports in 2 months if of interest. Pays $150-300/color cover photo; $70-200/color inside photo; $275-600/photo/text package. Pays on publication. Credit line given. Buys one-time rights. Simultaneous submissions and previously published work OK.
Tips: "Photos must be professional and high quality. Freelance submissions need to have a specific focus to be considered, as general Norwegian landscape shots, etc., are easily obtained from photo agencies. The magazine markets contemporary Norway, so submissions should have a contemporary, rather than a historical, focus. Tourist articles should have a specific focus as tourist destinations/ attractions such as the coastal express, Lofoten, Flamsbanen are already well covered."

NOR'WESTING, 6044 Seaview Ave. NW, Seattle WA 98107. (206)783-8939. Fax: (206)783-9011. Editor: Gloria Kruzner. Monthly magazine. Emphasis on cruising destinations in the Pacific Northwest. Readers are male and female boat owners ages 40-65 (on average) who own 32'-42' boats (mostly powerboats). Sample copy free with SASE. Photo guidelines available.
Needs: Uses 20 photos/issue; 75% supplied by freelancers. Interested in scenic Northwest destination shots, boating, slice-of-life nautical views. Model release preferred for anyone under age 18. Captions required; include location, type of boat, name of owner, crew (if available).
Making Contact & Terms: Interested in receiving work from newer, lesser-known photographers. "We're looking for active outdoor photographers in the Pacific Northwest." Send unsolicited photos by mail for consideration. Provide résumé, business card, brochure, flier or tearsheets to be kept on file for possible assignments. Send 3×5 glossy b&w prints; 35mm transparencies. Deadlines: the 10th of each month. Keeps samples on file. SASE. Reports in 2 months. Pays $100-250/color cover photo; $25-50/b&w inside photo. Pays 2 months after publication. Credit line given. Buys first North American rights; negotiable. Simultaneous submissions and/or previously published work OK.
Tips: "We want the Pacific Northwest boating scene to come alive through photography. No posed shots; wait for moment to happen."

NUGGET, 14411 Commerce Way, Suite 420, Miami Lakes FL 33016. (305)557-0071. Editor-in-Chief: Christopher James. Circ. 100,000. Magazine published 10 times a year. Emphasizes sex and fetishism for men and women of all ages. Sample copy $5 postpaid; photo guidelines free with SASE.
Needs: Uses 100 photos/issue. Interested only in nude sets—single woman, female/female or male/female. All photo sequences should have a fetish theme (sadomasochism, leather, bondage, transvestism, transsexuals, lingerie, infantilism, wrestling—female/female or male/female—women fighting women or women fighting men, amputee models, etc.). Also seeks accompanying mss on sex, fetishism and sex-oriented products. Model release required.
Making Contact & Terms: Submit material for consideration. Buys in sets, not by individual photos. No Polaroids or amateur photography. Send 8×10 glossy b&w prints, contact sheet OK; transparencies, prefers Kodachrome or large format; vertical format required for cover. SASE. Reports in 2 weeks. Pays $250 minimum/b&w set; $400-600/color set; $200/cover photo; $250-350/ms. Pays on publication. Credit line given. Buys one-time rights or second serial (reprint) rights. Previously published work OK.

ODYSSEY, Science That's Out of This World, Cobblestone Publishing, Inc., 7 School St., Peterborough NH 03458. (603)924-7209. Fax: (603)924-7380. Senior Editor: Elizabeth Lindstrom. Circ. 29,000. Estab. 1979. Monthly magazine, September-May. Emphasis on astronomy and space exploration. Readers are children, ages 8-14. Sample copy $4.50 with 9×12 or larger SAE and 5 first-class stamps. Photo guidelines free with SASE.
Needs: Uses 30-35 photos/issue. Needs photos of astronomy and space exploration from NASA and observatories, museum shots and others illustrating activities from various organizations. Reviews photos with or without ms. Model/property release required. Captions preferred.
Making Contact & Terms: Query with stock photo list. Send unsolicited photos by mail for consideration. Provide résumé, business card, brochure, flier or tearsheets to be kept on file for possible future assignments. Send color prints or transparencies. Samples kept on file. SASE. Reports in 1 month. Payment negotiable for color cover photo; $25-100/inside color use. Pays on publication. Credit line given. Buys one-time and all rights; negotiable.
Tips: "We like photos that include kids in reader-age range and plenty of action. Each issue is devoted to a single theme. Photos should relate to those themes."

***OFF DUTY MAGAZINE**, 3303 Harbor Blvd., Suite C-2, Costa Mesa CA 92626. Fax: (714)549-4222. E-mail: oduty_edit@aol.com. Managing Editor: Gary Burch. Circ. 507,000. Estab. 1970. Published 8 times/year. Emphasizes the military community. Readers are military members and their spouses, ages 20-45. Sample copy $1.75 with 9×12 SAE and 6 first-class stamps.
Needs: Uses 25 photos/issue; 5 supplied by freelancers. "We're looking solely for freelancers to handle occasional assignments around the U.S." Model/property release preferred. Captions required.
Making Contact & Terms: Provide résumé, business card, brochure, flier or tearsheets to be kept on file for possible assignments. Also accepts digital files in TIFF preferably on Mac-formatted disk; 44MB SyQuest OK. Keeps samples on file. Pays $300/color cover photo; up to $75-200/color inside photo. **Pays on acceptance**. Credit line given. Buys one-time rights.
Tips: "I don't want to receive unsolicited photos for consideration, just résumés and brochure/samples for filing. Send good samples and you have a good shot at an assignment if something comes up in your area."

***OFFSHORE**, 220-9 Reservoir St., Needham MA 02194. (617)449-6204, ext. 26. Fax: (617)449-9702. Editor: Peter Serratore. Monthly magazine. Emphasizes boating in the Northeast region, from Maine to New Jersey. Sample copy free with 9×12 SASE.

Needs: Uses 30 photos/issue; 10 supplied by freelancers. Needs photos of boats, water, ocean—New Jersey to Maine. Captions required; include location.
Making Contact & Terms: Interested in receiving work from newer, lesser-known photographers. Please call before sending photos. Cover photos should be vertical format and have strong graphics and/or color. Pays $300/color cover photo; $15-150/color and b&w inside photo. Pays on publication. Credit line given. Buys one-time rights. Simlultaneous submissions and/or previously published work OK.

OHIO MAGAZINE, 62 E. Broad St., Columbus OH 43215. (614)461-5083. Photo Editor: Brooke Wenstrup. Estab. 1979. Magazine published 10 times/year. Emphasizes features throughout Ohio for an educated, urban and urbane readership. Sample copy $4 postpaid.
Needs: Travel, photo essay/photo feature, b&w scenics, personality, sports and spot news. Photojournalism and concept-oriented studio photography. Model/property releases preferred. Captions required.
Making Contact & Terms: Interested in receiving work from newer, lesser-known photographers. Send material by mail for consideration. Query with samples. Arrange a personal interview to show portfolio. Send 8 × 10 b&w glossy prints; contact sheet requested. Also uses 35mm, 2¼ × 2¼ or 4 × 5 transparencies; square format preferred for covers. SASE. Reports in 1 month. Pays $30-250/b&w photo; $30-250/color photo; $350/day; and $150-350/job. Pays within 90 days after acceptance. Credit line given. Buys one-time rights; negotiable.
Tips: "Please look at magazine before submitting to get an idea of what type of photographs we use. Send sheets of slides and/or prints with return postage and they will be reviewed. Dupes for our files are always appreciated—and reviewed on a regular basis. We are leaning more toward well-done documentary photography and less toward studio photography. Trends in our use of editorial photography include scenics, single photos that can support an essay, photo essays on cities/towns, more use of 180° shots. In reviewing a photographer's portfolio or samples we look for humor, insight, multi-level photos, quirkiness, thoughtfulness; stock photos of Ohio; ability to work with subjects (i.e., an obvious indication that the photographer was able to make subject relax and forget the camera—even difficult subjects); ability to work with givens, bad natural light, etc.; creativity on the spot—as we can't always tell what a situation will be on location."

OLD WEST, P.O. Box 2107, Stillwater OK 74076. (405)743-3370. Fax: (405)743-3374. Editor: John Joerschke. Circ. 30,000. Estab. 1964. Quarterly magazine. Emphasizes history of the Old West (1830 to 1915). Readers are people who like to read the history of the West, mostly male, age 45 and older. Sample copy free with 9 × 12 SAE and 7 first-class stamps.
Needs: Uses 100 or more photos/issue; "almost all" supplied by freelance photographers. Needs mostly Old West historical subjects, some travel, some scenic (ghost towns, old mining camps, historical sites). Prefers to have accompanying ms. Special needs include western wear, cowboys, rodeos, western events. Captions required; include name and location of site.
Making Contact & Terms: Interested in receiving work from newer, lesser-known photographers. Query with samples, b&w only for inside, color covers. SASE. Reports in 1 month. Pays $75-150/ color cover photos; $10/b&w inside photos. **Payment on acceptance**; cover photos on publication. Credit line given. Buys first North American serial rights.
Tips: "We are looking for transparencies of existing artwork as well as scenics for covers, pictures that tell stories associated with Old West for the inside. Most of our photos are used to illustrate stories and come with manuscripts; however, we will consider other work (scenics, historical sites, old houses). Scenics should be free of modern intrusions such as buildings, power line, highways, etc."

ON-DIRT MAGAZINE, P.O. Box 6246, Woodland Hills CA 91365. (818)340-5750. Fax: (818)348-4648. Photo Editor: Lonnie Peralta. Circ. 120,000. Estab. 1984. Monthly magazine. Emphasizes all forms of off-roading and racing. Readers are male and female off-road enthusiasts, ages 15-65. Sample copy $3.
Needs: Uses 100-135 photos/issue; 50% supplied by freelancers. Needs photos of off-road action from events, races or fun. Reviews photos with or without a manuscript. Special needs are "fun" drives, "jamborees" and how-to articles with photos. Model/property release preferred. Captions required.
Making Contact & Terms: Send unsolicited photos by mail for consideration. Send 5 × 7, 8 × 10 glossy with border b&w, color prints; 35mm transparencies. Keeps samples on file. SASE. Reports as needed. Pays $50/cover photo; $7/b&w inside photo; $7/color page rate; $7/b&w page rate; $7/hour. Pays on publication. Credit line given. Buys all rights; negotiable.

***OPEN WHEEL MAGAZINE**, P.O. Box 715, 47 S. Main St., Ipswich MA 01938. (508)356-7030. Fax: (508)356-2492. Editor: Dick Berggren. Circ. 135,000. Estab. 1981. Monthly. Emphasizes sprint car, supermodified, Indy and midget racing. Readers are fans, owners and drivers of race cars and those with business in racing. Photo guidelines free for SASE.
Needs: Uses 100-125 photos/issue supplied by freelance photographers; almost all come from freelance stock. Needs documentary, portraits, dramatic racing pictures, product photography, special ef-

INSIDER REPORT

Act Like a Pro to Cover the Pros

Sports photographers dream of days when they can rub elbows with sports legends. They love being close to the stars, even if those moments are fleeting.

John McDonough

Over 10 years ago, while on assignment for *Sport* magazine, photographer John McDonough entered Muhammed Ali's home prepared to shoot a quick portrait of the legendary, yet ailing boxer. Instead, he and Ali read some of the hundreds of letters that arrive for Ali every day, mainly from people seeking money. Then McDonough was treated to a magic show by the former heavyweight champ. "He just came alive," says McDonough. "Then he showed us how each trick was done. Being a Muslim, he didn't want to deceive anyone."

Like Ali with his magic tricks, McDonough doesn't like deception, especially when discussing his profession. "I guess there is some glamour associated with photographing sports, but once you start working sports you see how little glamour there really is," he says.

McDonough lives in San Diego, California, and has spent more than eight years on contract with *Sports Illustrated*. He started his photographic career while working as a sports writer for the *Banner-Graphic* in Greencastle, Indiana. He was given a camera to shoot high school football, but returned from his first assignment with no pictures. The film wasn't properly loaded. "I was completely intimidated by the camera and didn't want to have anything to do with it," he says. After solving his technical difficulties and seeing his first images materialize in the darkroom, McDonough fell in love with the process.

He worked for various papers either as an intern or fulltime, completed assignments for United Press International, and managed some freelance assignments for NFL Properties. In 1979 he was chosen as California Photographer of the Year and in 1980 he won an NFL Hall of Fame photo contest.

McDonough credits his early career with developing his skills, not just as a photographer, but also as a journalist. His initial portfolio contained a mix of color and black & white images. He estimates that sports made up 40 percent of his book, while the rest were editorial shots and picture essays. Editors hired him for such diversity. "I could go out and take on an assignment and understand the story behind the assignment. Action is only a part of sports. Being able to take portraits and being able to tell a story are also very important."

Storytelling is a skill that can be honed while employed on weekly or daily newspapers, a notion that McDonough wholeheartedly supports. Newspapers give photographers a chance to learn from other professionals and gain valuable

INSIDER REPORT, *continued*

Covering professional basketball stars like Grant Hill of the Detroit Pistons may seem like a dream job to some, but photographer John McDonough quickly dispells such misconceptions about "the glamour" of his profession. "There are a lot of people who come straight out of school and start freelancing and say, 'I want to work for *Sports Illustrated*.' They don't want to pay any dues and it just blows my mind."

INSIDER REPORT, *continued*

experience covering diverse subjects. "I believe very strongly that sports photographers should get out there and get a well-rounded foundation of experience before they go out and work for national magazines. There are a lot of people who come straight out of school and start freelancing and say, 'I want to work for *Sports Illustrated*.' They don't want to pay any dues and it just blows my mind."

The issue of experience is only part of the package sports photographers must consider if they plan to succeed. They also must take into account the limitations that are being placed upon them by professional sports associations like the National Basketball Association, Major League Baseball and the National Football League.

McDonough, whose specialty is covering professional basketball, must often work within tight boundaries established by the NBA. For example, on-court access is extremely limited. Photographers usually must sit on the end of the court throughout each game. "It's pretty limiting, but I try to do anything I can to get off-court and shoot from a different position. And I stretch everybody's patience by trying to get into different positions."

During the 1995 NBA Finals, McDonough found himself behind security guards and police officers for the last two minutes of the final game. He wanted a game-ending celebration shot, but was not allowed on court. He decided to negotiate with NBC to get a tiny corner of a TV camera platform. His foresight paid off with a cover shot of Houston Rockets star Hakeem Olajuwon celebrating with teammate Clyde Drexler. "You have to separate yourself from the masses. What are you going to shoot that's different, unique and better?"

Sometimes, as in the aforementioned scenario, the limitations can be overcome. However, sports photographers have other uphill battles. For instance, the NBA must license any photos of pro basketball players if the images are to be used to sell products, such as in advertising or on trading cards, says McDonough. Other sports, such as auto racing, baseball and golf, have similar restrictions, he says.

Such constraints make joining professional organizations, such as the American Society of Media Photographers, extremely important. McDonough recommends that photographers join the Sports Photography Specialty Group, which is part of ASMP, so that they can learn how to properly conduct business.

Once you've learned to be a professional, you should also be willing to take some risks to be successful, McDonough says. "You have to get out there and fail and learn from your failures. You really have to be assertive about what you want to do, what direction you want to go in. Above and beyond everything, you have to be a pro with everyone you deal with."

—Michael Willins

fects, crash. Photos purchased with or without accompanying ms. Model release required for photos not shot in pit, garage or on tractk. Captions required.

Making Contact & Terms: Send by mail for consideration 8×10 glossy b&w or color prints and any size slides. Kodachrome 64 preferred. SASE. Reports in 6 weeks. Pays $20/b&w inside; $35-250/ color inside. Pays on publication. Buys all rights.

Tips: "Send the photos. We get dozens of inquiries but not enough pictures. We file everything that comes in and pull 80% of the pictures used each issue from those files. If it's on file, the photographer has a good shot."

***OPERA NEWS**, Dept. PM, 70 Lincoln Center, New York NY 10023-6593. (212)769-7080. Fax: (212)769-7007. Senior Editor: Jane L. Poole. Circ. 125,000. Published by the Metropolitan Opera Guild. Biweekly (December-April) and monthly (May-November) magazine. Emphasizes opera performances and personalities for opera-goers, members of opera and music professionals. Sample copy $4.

Needs: Uses about 45 photos/issue; 15 supplied by freelance photographers. Needs photos of "opera performances, both historical and current; opera singers, conductors and stage directors." Captions preferred.

Making Contact & Terms: Query with samples. Provide résumé, business card, brochure, flier or tearsheets to be kept on file for possible future assignments. SASE. Reporting time varies. NPI. Payment negotiated. Pays on publication. Credit line given. Buys one-time rights. Simultaneous submissions OK.

OREGON COAST MAGAZINE, P.O. Box 18000, Florence OR 97439. (800)348-8401. Fax: (541)997-1124. E-mail: rob@preferred-syspresys.com. Website: http://www.presys.com/highway. Art Director: Barbara Grano. Circ. 40,000. Estab. 1982. Bimonthly magazine. Emphasizes Oregon coast life. Readers are middle class, middle age. Sample copy $4.50, including postage. Photo guidelines available with SASE with 2 first-class stamps.

Needs: Uses 6-10 photos/issue; all supplied by freelancers. Needs scenics. Especially needs photos of typical subjects—waves, beaches, lighthouses—but from a different angle. Needs mostly vertical format. Model release required. Captions required; include specific location and description. "Label all slides and transparencies with captions and photographer's name."

Making Contact & Terms: Interested in receiving work from newer, lesser-known photographers. Send unsolicited 35mm, 2¼×2¼, 4×5 transparencies by mail for consideration. SASE. Reports in 2 weeks; 1 month for photo-text package. Pays $325/color cover photo; pays $100 for calendar usage; pays $25-75/color inside photo; $25-50/b&w inside photo; $100-250/photo/text package. Credit line given. Buys one-time rights.

Tips: "Send only the very best. Use only slide film that can be enlarged without graininess. An appropriate submission would be 20-60 slides. Don't use color filters. Protect slides with sleeves— put in plastic holders. Don't send in little boxes."

OREGON OUTSIDE, (formerly *Northwest Parks and Wildlife*), 1525 12th St., P.O. Box 18000, Florence OR 97439. (800)348-8401. Fax: (541)997-1124. E-mail: rob@preferred-syspresys.com. Website: http://www.presys.com/highway. Art Director: Barbara Grano. Circ. 15,000. Estab. 1991. Bimonthly magazine. Emphasizes state and national parks in Oregon. Readers are middle-age male and female, upper income/middle income. Sample copy $4.50 includes postage. Photo guidelines free with SASE.

Needs: Uses 8-12 (full page) vertical or horizontal photos/issue; all supplied by freelancers. Needs photos of outdoor activities, scenics. Model release preferred. Photo captions required.

Making Contact & Terms: Send unsolicited photos by mail for consideration. Uses 35mm, 2¼×2¼, 4×5 transparencies. SASE. Reports in 2 weeks; 1 month for photo/text packages. Pays $325/color cover photo; $25-75/color inside photo; $25-50/b&w inside photo; $100-250/photo/text package. Pays on publication. Credit line given. Buys one-time rights.

Tips: "Mainly interested in scenics and activity shots. Avoid colored filters. Use only film that can enlarge without graininess."

THE OTHER SIDE, 300 W. Apsley St., Philadelphia PA 19144. (215)849-2178. Art Director: Cathleen Benberg. Circ. 17,000. Estab. 1965. Bimonthly magazine. Emphasizes social justice issues from a Christian perspective. Sample copy $4.

● This publication is an Associated Church Press and Evangelical Press Association award winner.

Needs: Buys 6 photos/issue; 95-100% from stock, 0-5% on assignment. Documentary, human interest and photo essay/photo feature. "We're interested in human-interest photos and photos that relate to current social, economic or political issues, both here and in the Third World." Model/property release preferred. Captions preferred.

Making Contact & Terms: Interested in receiving work from newer, lesser-known photographers. Send samples of work to be photocopied for our files and/or photos; a list of subjects is difficult to judge quality of work by. Send 8×10 glossy b&w prints; transparencies for cover, vertical format required. Materials will be returned on request. SASE. Pays $20-30/b&w photo; $50-75/cover photo. Credit line given. Buys one-time rights. Simultaneous submissions and previously published work OK.
Tips: In reviewing photographs/samples, looks for "sensitivity to subject, creativity, and good quality darkroom work."

✣**OUR FAMILY**, P.O. Box 249, Battleford, Saskatchewan, S0M 0E0 Canada. Fax: (306)937-7644. Editor: Nestor Gregoire. Circ. 10,000. Estab. 1949. Monthly magazine. Emphasizes Christian faith as a part of daily living for Roman Catholic families. Sample copy $2.50 with 9×12 SAE and $1.10 Canadian postage. Free photo and writer's guidelines with SAE and 52¢ Canadian postage.
Needs: Buys 5 photos/issue; cover by assignment, contents all freelance. Head shot (to convey mood); human interest ("people engaged in the various experiences of living"); humorous ("anything that strikes a responsive chord in the viewer"); photo essay/photo feature (human/religious themes); and special effects/experimental (dramatic—to help convey a specific mood). "We are always in need of the following: family (aspects of family life); couples (husband and wife interacting and interrelating or involved in various activities); teenagers (in all aspects of their lives and especially in a school situation); babies and children; any age person involved in service to others; individuals in various moods (depicting the whole gamut of human emotions); religious symbolism; and humor. We especially want people photos, but we do not want the posed photos that make people appear 'plastic,' snobbish or elite. In all photos, the simple, common touch is preferred. We are especially in search of humorous photos (human and animal subjects). Stick to the naturally comic, whether it's subtle or obvious." Photos are purchased with or without accompanying ms. Model release required if editorial topic might embarrass subject. Captions required when photos accompany ms.
Making Contact & Terms: Send material by mail for consideration or query with samples after consulting photo spec sheet. Provide letter of inquiry, samples and tearsheets to be kept on file for possible future assignments. Send 8×10 glossy b&w prints; transparencies or 8×10 glossy color prints are used on inside pages, but are converted to b&w. SAE and IRC. (Personal check or money order OK instead or IRC.) Reports in 1 month. Pays $35/b&w photo; 7-10¢/word for original mss; 5¢/word for nonoriginal mss. **Pays on acceptance.** Credit line given. Buys one-time rights and simultaneous rights. Simultaneous submissions or previously published work OK.
Tips: "Send us a sample (20-50 photos) of your work after reviewing our Photo Spec Sheet. Looks for "photos that center around family life—but in the broad sense — i.e., our elderly parents, teenagers, young adults, family activities. Our covers (full color) are a specific assignment. We do not use freelance submissions for our cover."

OUT MAGAZINE, 110 Greene St., Suite 600, New York NY 10012. (212)334-9119. Fax: (212)334-9227. E-mail: outmag@aol.com. Website: http://www.out.com. Art Director: David O'Connor. Photo Editor: Amy Steiner. Circ. 150,000. Estab. 1992. Published 11 times/year. Emphasizes gay and lesbian lifestyle. Readers are gay men and lesbians of all ages and their friends.
Needs: Uses 100 photos/issue; 50 supplied by freelancers. Needs portraits, photojournalism and fashion photos. Reviews photos with or without ms. Model release required. Captions required.
Making Contact & Terms: Submit portfolio every Wednesday for review. Also accepts digital images in SyQuest and images via the Internet. Accepts "visual dispatch" and party photos from around the country; return postage required. Unsolicited material is not returned. Payment negotiated directly with photographer. Pays on publication. Credit line given. Buys all rights; negotiable. Simultaneous submissions and/or previously published work OK.
Tips: "Don't ask to see layout. Don't call every five minutes. Turn over large portion of film."

✣**OUTDOOR CANADA**, 703 Evans Ave., Suite 202, Toronto, Ontario M9C 5E9 Canada. (416)695-0311. Fax: (416)695-0381. Editor: James Little. Circ. 95,000. Estab. 1972. Magazine published 8 times a year. Free writers' and photographers' guidelines "with SASE or SAE and IRC only."
Needs: Buys 70-80 photos annually. Needs Canadian photos of people fishing, hunting, hiking, wildlife, camping, ice-fishing, action shots. Captions required including identification of fish, bird or animal.
Making Contact & Terms: Interested in receiving work from newer, lesser-known photographers. Send transparencies for consideration. No phone calls, please. For cover allow undetailed space along left side of photo for cover lines. SAE and IRC for American contributors, SASE for Canadians *must* be sent for return of materials. Reports in 3 weeks. Pays $400 maximum/cover photo; $30-225/inside color photo depending on size used. Pays on publication. Buys first serial rights.
Tips: "Study the magazine and see the type of articles we use and the types of illustration used" and send a number of pictures to facilitate selection. "We are using more photos. We are looking for pictures that tell a story. We especially need photos of people in the outdoors. A photo that captures

the outdoor experience and shows the human delight in it. Take more fishing photos. It's the fastest-growing outdoor pastime in North America."

***OUTDOOR PHOTOGRAPHER**, 12121 Wilshire Blvd., Suite 1220, Los Angeles CA 90025. (310)820-1500. Editor: Rob Sheppard. Circ. 200,000. Estab. 1984. Magazine published 10 times per year. Emphasizes professional and semi-professional scenic, travel, wildlife and sports photography. Readers are photographers of all ages and interests. Photo guidelines free with SASE.
Needs: Uses about 50-60 photos/issue; 90% supplied by freelance photographers. Interested in outdoor photography, how-tos on flash, difficult light, composition, wildlife photography, equipment and tips; rare, natural phenomenon; scenics with a how-to angle or special time of day that is best; sports and interesting ways to shoot them; something unusually funny in the natural outdoor world. Model release preferred. Captions required, include location, camera, lens, f-stop, speed, film—conditions shot was achieved under and any other helpful or amusing descriptive information.
Making Contact & Terms: Interested in receiving work from newer, lesser-known photographers. Query with samples; send b&w prints or duplicate color transparencies by mail for consideration. SASE. Reports in 60 days. Pays $25-50/b&w photo; $75-200/color photo. Pays on publication. Credit line given. Buys one time rights; negotiable. Previously published work OK.
Tips: "A special angle or how-to type text to accompany photos, or even a proposed idea with photos, will be more carefully considered than isolated beautiful photos without explanation."

OUTDOOR TRAVELER MID-ATLANTIC, P.O. Box 2748, Charlottesville VA 22902. (804)984-0655. Fax: (804)984-0656. Editor: Marianne Marks. Circ. 30,000. Estab. 1993. Quarterly magazine. Emphasizes outdoor recreation, travel, nature—all in the mid-Atlantic region. Readers are male and female outdoor enthusiasts and travelers, ages 20-50. Sample copy $4.
Needs: Uses 20-25 photos/issue; 95% supplied by freelancers. Needs photos of outdoor recreation, nature/wildlife, travel, scenics—all in the region. Reviews photos with or without ms. Special photo needs include seasonal photos related to outdoor recreation and scenery. Property release is preferred. Captions preferred.
Making Contact & Terms: Interested in receiving work from newer, lesser-known photographers. Query with résumé of credits, slides or printed samples and a stock list. Keeps samples on file. SASE. Reports in 2 months. Pays $250/color cover photo; $50/color quarter-page; $75/color half page; $100/ color full page; $150/color spread. Pays on publication. Credit line given. Buys one-time rights. Simultaneous submissions and previously published work OK.
Tips: Interested in "action-oriented, scenic photos of people engaged in outdoor recreation (hiking, bicycling, skiing, rafting, canoeing, rock climbing, etc.)."

OUTSIDE, 400 Market St., Santa Fe NM 87501-9999. Prefers not to share information.

OVER THE BACK FENCE, P.O. Box 756, Chillicothe OH 45601. (614)772-2165. Fax: (614)773-7626. Contact: Photo Editor. Estab. 1994. Quarterly magazine. "This is a regional magazine serving Southern Ohio. We are looking for photos of interesting people, events, and history of our area." Sample copy $4. Photo guidelines free with SASE.
Needs: Uses 50-70 photos/issue; 80% supplied by freelance assignment; 20% by freelance stock. Needs photos of scenics, attractions, food (specific to each issue), historical locations in our region (call for specific counties). Model release required for identifiable people. Captions preferred; include locations, description, names, date of photo (year); and if previously published, where and when.
Making Contact & Terms: Interested in receiving work from newer, lesser-known photographers. Provide résumé, business card, brochure, flier or tearsheets to be kept on file for possible assignments. Query with stock photo list and résumé of credits. Deadlines: 6 months minimum before each issue. SASE. Reports in 3 months. Pays $100/color cover photo; $100/b&w cover photo; $25-100/color inside photo; $25-100/b&w inside photo. "We pay mileage fees to photographers on assignments. Request our photographer's rates and guidelines for specifics." Pays on publication. Credit line given except in the case of ads, where it may or may not appear. Buys one-time rights. Simultaneous submissions and previously published work OK, "but must identify photos used in other publications."
Tips: "We are looking for sharp, colorful images and prefer using color transparencies over color prints when possible. Nostalgic and historical photos are usually in black & white."

♥OWL MAGAZINE, 179 John St., Suite 500, Toronto, Ontario M5T 3G5 Canada. (416)971-5275. Fax: (416)971-5294. Website: http://www.owl.on.ca. Researcher: Ekaterina Gitlin. Circ. 150,000.

THE SUBJECT INDEX, located at the back of this book, can help you find publications interested in the topics you shoot.

Estab. 1976. Published 10 times/year; 1 summer issue. A science and nature magazine for children ages 8-13. Sample copy $4.28 and 9×12 SAE. Photo guidelines with SAE.

• For cover and article design, *Owl* was awarded The Educational Press Association of America Distinguished Achievement Award for 1995 given for excellence in educational journalism.

Needs: Uses approximately 15 photos/issue; 50% supplied by freelancers. Needs photos of animals/wildlife, science, technology, scientists working in the field (i.e. with animals). Model/property release preferred. Captions required.

Making Contact & Terms: Interested in receiving work from newer, lesser-known photographers. Request photo package before sending photos for review. Send 35mm transparencies. Also accepts digital files scanned on to Zip disk or SyQuest-type hard disk, at high resolution (300 dpi) as a TIFF or EPS file (prefers CMYK format, separations included). Keeps samples on file. SAE and IRCs. Reports in 6-8 weeks. Pays $325 Canadian/color cover photo; $100 Canadian/color inside photo; $200 Canadian/color page rate; $125-500 US/color photo. **Pays on acceptance.** Credit line given. Buys one-time rights. Previously published work OK.

Tips: "Photos should be sharply focused with good lighting showing animals in their natural environment. It is important that you present your work as professionally as possible. Become familiar with the magazine—study back issues."

✷PACIFIC YACHTING MAGAZINE, 1132 Hamilton St., #202, Vancouver, British Columbia V6B 2S2 Canada. (604)687-1581. Fax: (604)687-1925. Editor: Duart Snow. Circ. 25,000. Estab. 1968. Monthly magazine. Emphasizes boating on West Coast. Readers are male, ages 35-60, boaters, power and sail. Sample copy free with 8½×11 SAE with IRC.

Needs: Uses 125 photos/issue; 125 supplied by freelancers. Needs photos of all kinds. Reviews photos with accompanying ms only.

Making Contact & Terms: Interested in receiving work from newer, lesser-known photographers. Keeps samples on file. NPI. Payment negotiable. Credit line given. Buys one-time rights. Simultaneous submissions and/or previously published work OK.

PADDLER MAGAZINE, P.O. Box 5450, Steamboat Springs CO 80477. Phone/fax: (970)879-1450. Editor: Eugene Buchanan. Circ. 85,000. Estab. 1990. Bimonthly magazine. Emphasizes kayaking, rafting, canoeing and sea kayaking. Sample copy $3.50. Photo guidelines free with SASE.

Needs: Uses 30-50 photos/issue; 90% supplied by freelancers. Needs photos of scenics and action. Model/property release preferred. Captions preferred; include location.

Making Contact & Terms: Interested in receiving work from newer, lesser-known photographers. Query with stock photo list. Send unsolicited photos by mail for consideration. Send 35mm transparencies. Keeps samples on file. SASE. Reports in 2 months. Pays $25-150/color photo; $150/color cover photo; $50/inset color cover photo; $75/color full page inside photo. Pays on publication. Credit line given. Buys first North American serial rights; negotiable.

Tips: "Send dupes and let us keep them on file."

PALM BEACH ILLUSTRATED MAGAZINE, 1016 N. Dixie Hwy., West Palm Beach FL 33401. (407)659-0210. Fax: (407)659-1736. Creative Director: Meg Seville. Circ. 30,000. Estab. 1952. Magazine published 10 times a year. Emphasizes upscale, first-class living. Readers are highly influential, established people, ages 35-54.

Needs: Needs photos of travel. Reviews photos with or without a ms. Model/property release required. Captions preferred.

Making Contact & Terms: Send color prints; 35mm, 2¼×2¼ transparencies. SASE. Reports in 1 month. NPI; payment made on individual basis. Pays on publication. Credit line given. Buys one-time rights. Simultaneous submissions OK.

Tips: Looks for "travel and related topics such as resorts, spas, yacht charters, trend and lifestyle topics. Materials should appeal to affluent readers: e.g., budget travel is not of interest. Editorial material on the latest best investments in the arts would be appropriate; editorial material on investing in a mobile home would not."

PALM SPRINGS LIFE MAGAZINE, P.O. Box 2724, 303 N. Indian Canyon Ave., Palm Springs CA 92263. (619)325-2333. Fax: (619)325-7008. Art Director: Bill Russom. Editor: Stewart Weiner. Circ. 20,000. Estab. 1957. Monthly magazine. Emphasizes Palm Springs/California desert area upscale resort living. Readers are extremely affluent, 35 years and older. "Primarily for our readers, Palm Springs may be second/vacation home." Sample copy $6. Photo guidelines free with SASE.

Needs: Uses 100 photos/issue; 30% supplied by freelance photographers; 70% from assignment. Needs desert photos, scenic wildlife, gardening, fashion, beauty, interior design, travel, personalities and people (all local). Special needs include photo essays, art photography. Model release preferred. Property release required. Captions preferred; include who, what, when, where, why.

Making Contact & Terms: Interested in receiving work from newer, lesser-known photographers. Arrange personal interview to show portfolio. Submit portfolio for review. Query with résumé of

credits. Query with stock photo list. Uses 35mm, 2¼×2¼, 4×5 or 8×10 transparencies. Deadlines: 3 months prior to publication. SASE. Reports as soon as possible. Pays $300-500/color cover photo; $25-200/color inside photo; $125/color page; $25-100/b&w photo; $50-325/color photo; payment/job, negotiable. Pays on publication. Credit line given. Buys all rights; negotiable. Simultaneous submissions and previously published work OK.

Tips: In reviewing photographer's portfolio, "we look for published photographs. The 'unusual' bend to the 'usual' subject. We will try anything new photographically as long as it's gorgeous! Present a professional-looking portfolio. Please don't submit photos of subjects I'd never use. Know your market!"

PARENTING, 301 Howard St., 17th Floor, San Francisco CA 94105. Fax: (415)546-0578. Picture Editor: Lisa Hilgers. Circ. 1.1 million. Estab. 1987. Monthly magazine. Emphasizes parenting skills and child rearing, pregnancy through pre-teen. Readers are primarily female approximately 22-35 years old, middle to upper-middle income. Sample copy $3. Photo guidelines free with SASE.

Needs: Uses 75-100 photos/issue; 90% supplied by freelancers. Needs photos of all subject areas related to parents, families and children. Model release required for anything of a potentially controversial subject, or which might be used in a controversial context. Captions preferred; include when shot, context of photo, etc. Primarily a concern with journalistic work.

Making Contact & Terms: Interested in receiving work from newer, lesser-known photographers. Arrange personal interview to show portfolio. Submit portfolio for review. Provide résumé, business card, brochure, flier or tearsheets to be kept on file for possible assignments. Also accepts digital files in SyQuest or other disk formats. Reports in 3 weeks depending on interest in material, etc. Pays $300-500/day; other payment varies. Pays on acceptance. Credit line given. Buys one-time rights, first North American serial rights. Simultaneous submissions and previously published work OK.

Tips: "Subject area is not always most important, but 'how' a photographer approaches any subject and how well the photographer captures an original or creative image (is important). Technique is secondary often to 'vision.' Submit good samples and portfolio. Try to show quality, not the 'I can shoot anything/everything' type of book. Know who you're submitting your work to. Look at the publication and have some knowledge of how we use photography, and how your work might apply. We prefer to see your more personal work since we're more likely to use it than strictly commercial imagery."

PASSENGER TRAIN JOURNAL, P.O. Box 379, Waukesha WI 53187. (414)542-4900. Fax: (414)542-7595. E-mail: 76307.1175@compuserve.com. Editor: Carl Swanson. Circ. 14,000. Estab. 1968. Monthly magazine. Emphasizes rail passenger equipment and travel. Readers are mostly male, well-educated, ages 35-60. Photo guidelines free with SASE.

Needs: Uses 12-15 photos/issue; all supplied by freelancers. Needs photos of North American passenger trains, depots and rail transit systems in the United States. Reviews photos with or without ms. Special photo needs include general photos of Amtrak long-distance trains. Model/property release preferred for any recognizable person in the photo. Captions required; include name of train, direction of travel, date, location.

Making Contact & Terms: Interested in receiving work from newer, lesser-known photographers. Send unsolicited photos by mail for consideration. Send 5×7 glossy b&w prints; 35mm, 2¼×2¼ transparencies. Does not keep samples on file. SASE. Reports in 1 month. Pays $100/color cover photo; $50/b&w cover photo; $10-50/color inside photo; $10-50/b&w inside photo. Pays on publication. Credit line given. Buys one-time rights.

Tips: "We look for people who can convey the drama of passenger railroading through their pictures. Although our payment rates are fairly low, we feel this magazine is a good way for unknown photographers to see their work in print and get their name before the public."

PENNSYLVANIA, P.O. Box 576, Camp Hill PA 17011. (717)697-4660. Editor: Matthew K. Holliday. Circ. 40,000. Bimonthly. Emphasizes history, travel and contemporary issues and topics. Readers are 40-60 years old, professional and retired; average income is $59,000. Sample copy $2.95. Photo guidelines free with SASE.

• If you want to work with this publication make sure you review several past issues and obtain photo guidelines.

Needs: Uses about 40 photos/issue; most supplied by freelance photographers. Needs include travel and scenic. All photos must be in Pennsylvania. Reviews photos with or without accompanying ms. Captions required.

Making Contact & Terms: Query with samples. Send 5×7 and up b&w and color prints; 35mm and 2¼×2¼ transparencies (duplicates only, no originals) by mail for consideration. SASE. Reports in 2 weeks. Pays $100/color cover photo; $15-25/inside photo; $50-400/text/photo package. Credit line given. Buys one-time rights. Simultaneous submissions and previously published work OK.

PENNSYLVANIA SPORTSMAN, P.O. Box 90, Lemoyne PA 17043. (717)761-1400. Publisher: Sherry Ritchey. Regional magazine, published 8 times/year. Circ. 68,000. Estab. 1971. Features fiction, nonfiction, how-to's, where-to's, various game and wildlife in Pennsylvania. Readers are men and women of all ages and occupations. Sample copy for $2. Photo guidelines free with SASE.

Needs: Uses 40 photos/issue; 5 supplied by freelancers. Primarily needs animal/wildlife shots. Especially interested in shots of deer, bear, turkeys and game fish such as trout and bass. Photo captions preferred.

Making Contact & Terms: Query with list of stock photo subjects. SASE. Reports in 1 month. NPI; negotiable. **Pays on acceptance.** Credit line given. Buys one-time rights. Simultaneous submissions OK.

Tips: "Read the magazine to determine needs."

PENTHOUSE, 1965 Broadway, New York NY 10023. Prefers not to share information.

PEOPLE MAGAZINE, Time & Life Bldg., Rockefeller Center, New York NY 10024. Photo Editor: M.C. Marden. Circ. 1.9 million subscribers; 1.5 million newsstand buyers. Estab. 1974. Weekly. "We are concerned with people, from the celebrity to the person next door. We have a dual audience, men and women, primarily under 40."

• *People* now accesses images through computer networks.

Needs: Uses approximately 100 photos/issue. "We have no staff photographers, therefore all work in *People* is done by freelancers. About 75% is from assignments, the rest of the material is from photo agencies and pickups from freelancers, movie companies, and networks, record companies and publishers. We are always looking for recent *lively* photojournalistic photos. We are less interested in studio portraits than in photo reportage. Our needs are specific people rather than generic people." Model release and captions required.

Making Contact & Terms: "*People* has a portfolio drop-off system. This enables them to let *People* see their work. They should call and make a drop-off appointment. "Pays $125-375/b&w photo; $150-500/color photo; $1,250/b&w or color cover photo; "space rates: minimum $125 to $375 for full page depending or color or black and white usage"; $400-500/day. "Bills should be submitted to the magazine for assignments and pick-ups." Credit line given.

Tips: "Our photographs must tell a story. In a portfolio, I have to see reportage, not portraits. I am looking for pictures with impact, pictures that move one, make one laugh. It is valuable to include contact sheets and color to show how the photographer really works a story. It is also important to have a portfolio that relates to the appropriate market, i.e. advertising for advertising, editorial for editorial. Submit newsworthy recent photos. They really should be timely and exclusive."

PETERSEN'S PHOTOGRAPHIC, 6420 Wilshire Blvd., Los Angeles CA 90048-5515. (213)782-2200. Fax: (213)782-2465. Editor: Geoff Engel. Circ. 225,000. Estab. 1972. Monthly magazine. Emphasizes photography. Sample copies available on newsstands. Photo guidelines free with SASE.

Needs: No assignments. All queries, outlines and mss must be accompanied by a selection of images that would illustrate the article.

Making Contact & Terms: Interested in receiving work from newer, lesser-known photographers as well as established pros. Submit portfolio for review. Send unsolicited photos by mail for consideration. Send unmounted glossy color or b&w prints no larger than 8×10; 35mm, 2¼×2¼, 4×5, 8×10 transparencies preferred. All queries and mss must be accompanied by sample photos for the article. Deadlines: 6 months in advance for seasonal photos. SASE. Reports in 2 months. NPI. Pays per published page (text and photos). Pays on publication. Credit line given. Buys one-time rights. Previously published work OK.

Tips: "We need images that are visually exciting and technically flawless. The articles mostly cover the theme 'We Show You How.' Send great photographs with an explanation of how to create them."

PHOENIX MAGAZINE, 5555 N. Seventh Ave., Suite B-200, Phoenix AZ 85013. (602)207-3750. Managing Editor: Beth Deveny. Art Director: James Forsmo. Monthly magazine. Circ. 60,000. Emphasizes "subjects that are unique to Phoenix: its culture, urban and social achievements and problems, its people and the Arizona way of life. We reach a professional and general audience of well-educated, affluent visitors and long-term residents."

Needs: Buys 10-35 photos/issue. Wide range, all dealing with life in metro Phoenix. Generally related to editorial subject matter. Wants on a regular basis photos to illustrate features, as well as for regular columns on arts. No "random shots of Arizona scenery, etc. that can't be linked to specific stories in the magazine." Photos purchased with or without an accompanying ms.

Making Contact & Terms: Query. Works with freelance photographers on assignment only basis. Provide résumé, samples, business card, brochure, flier and tearsheets to be kept on file for possible future assignments. SASE. Reports in 3-4 weeks. Black and white: $25-75; color: $50-200; cover: $400-1,000. Pays within 2 weeks of publication. Payment for manuscripts includes photos in most cases. Payment negotiable for covers and other photos purchased separately.

Tips: "Study the magazine, then show us an impressive portfolio."

PHOTO EDITORS REVIEW/PHOTO EDITORS INTERNATIONAL, 1201 Montego Way, Suite #4, Walnut Creek CA 94598-2819. Phone/fax: (510)935-7406. Photo Editor: Bob Shepherd. Circ. 5,000. Estab. 1994. Bimonthly newsletter. Emphasis on photo editing. Readers are mostly professional photo editors and magazine photographers. Sample copies free with 9×12 envelope and 3 first-class stamps. Photo guidelines free with SASE.

Needs: Uses 6-10 photos/issue; almost all supplied by photo editors and professional photographers. About 25% supplied by talented amateur photographers. Needs all kinds of photos, but photos must meet criteria listed under Tips, below. Special photo needs include photographic illustrations with universal themes. Model/property release required for identifiable private property and portraits. Captions required; include camera model, lens used, shutter speed; f-stop and lighting information if applicable.

Making Contact & Terms: Always interested in receiving work from newer, lesser-known photographers. Query with résumé of credits. Query with stock photo list. Send 3×5 to 8×10 glossy b&w prints by mail for consideration. Provide return envelope and postage if photos are to be returned. Provide résumé, business card, brochure, flier or tearsheets to be kept on file for possible assignments. Keeps photo samples on file. SASE. Reports in 1 month. Pays $50/b&w photo; up to $200 for photo assignment. **Pays on acceptance.** Credit line given and portrait of photo editor or photographer published. Buys one-time rights; negotiable. Simultaneous submissions and previously published work OK.

Tips: "We are a trade publication that caters to the needs of professional photo editors; therefore, marketable photos that exhibit universal themes will be given top priority. Universal themes are represented by images that are meaningful to people everywhere. We look for five basic characteristics by which we judge photographic materials: sharp exposures (unless the image was intended as a soft-focus shot), impact, easily identifiable theme or subject, emphasis of the theme or subject, and simplicity."

♣PHOTO LIFE, Apex Publications, Toronto Dominion Center, Suite 2550, P.O. Box 77, Toronto, Ontario M5K 1E7 Canada. (416)287-6357. Fax: (416)287-6359. Editor: Jacques Thibault. Circ. 65,000. Magazine published 6 times/year. Readers are advanced amateur and professional photographers. Sample copy or photo guidelines free with SASE.

• This publication was acquired by Apex Publications in January 1996.

Needs: Uses 50 photos/issue; 100% supplied by freelance photographers. Needs animal/wildlife shots, travel, scenics and so on. Only by Canadian photographers on Canadian subjects.

Making Contact & Terms: Query with résumé of credits. SASE. Reports in 1 month. Pays $75-100/color photo; $400 maximum/complete job; $700 maximum/photo/text package. **Pays on acceptance.** Buys first North American serial rights and one-time rights.

Tips: "Looking for good writers to cover any subject interesting to the advanced photographer. Fine art photos should be striking, innovative. General stock, outdoor and travel photos should be presented with a strong technical theme."

PHOTOGRAPHER'S MARKET, 1507 Dana Ave., Cincinnati OH 45207. (513)531-2690, ext. 286. Fax: (513)531-7107. E-mail: MikeW99722@aol.com. Editor: Michael Willins. Circ. 30,000. Annual hardbound directory for freelance photographers. Photo guidelines free with SASE.

Needs: Publishes 35-40 photos per year. Uses general subject matter. Photos must be work sold to listings in *Photographer's Market*. Photos are used to illustrate to readers the various types of images being sold to photo buyers listed in the book. "We receive a lot of photos for our Publications section. Your chances of getting published are better if you can supply images for sections other than Publications." Captions should explain how the photo was used by the buyer, why it was selected, how the photographer sold the photo or got the assignment, how much the buyer paid the photographer, what rights were sold to the buyer and any self-marketing advice the photographer can share with readers. Look at book for examples.

Making Contact & Terms: Interested in receiving work from newer, lesser-known photographers. Submit photos for inside text usage in fall and winter to ensure sufficient time to review them by deadline (end of January). All photos are judged according to subject uniqueness in a given edition, as well as technical quality and composition within the market section in the book. Photos are held and reviewed at close of deadline. Uses b&w glossy prints, any size and format; 5×7 or 8×10

preferred. Also uses tearsheets and transparencies, all sizes. Reports are immediate if a photo is selected; photos not chosen are returned within 2 months of selection deadline. Pays $50 plus complimentary copy of book. Pays when book goes to printer (May). Book forwarded in September upon arrival from printer. Credit line given. Buys second reprint and promotional rights. Simultaneous submissions and previously published work OK.

Tips: "Send photos with brief cover letter describing the background of the sale. If sending more than one photo, make sure that photos are clearly identified with name and a code that corresponds to a comprehensive list. Slides should be enclosed in plastic slide sleeves, and original prints should be reinforced with cardboard. Cannot return material if SASE is not included. Tearsheets will be considered disposable unless SASE is provided and return is requested. Because photos are printed in black and white on newsprint stock, some photos, especially color shots, may not reproduce well. Photos should have strong contrast and not too much fine detail that will fill in when photo is reduced to fit our small page format."

PLAYBOY, 680 North Lake Shore Dr., Chicago IL 60611. (312)751-8000. Fax: (312)587-9046. Photography Director: Gary Cole. Circ. 3.15 million US Edition; 5 million worldwide. Estab. 1954. Monthly magazine. Readers are 75% male and 25% female, ages 18-70; come from all economic, ethnic and regional backgrounds.

● This is a premiere market that demands photographic excellence. *Playboy* does not use freelance photographers per se, but if you send images they like they may use your work and/or pay a finder's fee.

Needs: Uses 50 photos/issue. Needs photos of glamour, fashion, merchandise, travel, food, personalities and glamour. Model release required. Models must be at least 18 years old.

Making Contact & Terms: Interested in receiving work from newer, lesser-known photographers. Contact through rep. Submit portfolio for review. Query with résumé of credits. Send unsolicited photos by mail for consideration. Provide résumé, business card, brochure, flier or tearsheets to be kept on file for possible assignments. Send color 35mm, 2¼ × 2¼, 4 × 5, 8 × 10 transparencies. Reports in 1-2 weeks. Pays $300 and up/job. Pays on acceptance. Buys all rights.

Tips: Lighting and attention to detail is most important when photographing women, especially the ability to use strobes indoors. Refer to magazine for style and quality guidelines.

POLO MAGAZINE, 656 Quince Orchard Rd., Gaithersburg MD 20878. (301)977-0200. Fax: (301)990-9015. Editor: Ami Shinitzky. Circ. 7,000. Estab. 1975. Publishes monthly magazine 10 times/year with combined issues for January/February and June/July. Emphasizes the sport of polo and its lifestyle. Readers are primarily male; average age is 40. 90% of readers are professional/managerial levels, including CEO's and presidents. Sample copy free with 10 × 13 SASE. Photo guidelines free with SASE.

Needs: Uses 50 photos/issue; 70% supplied by freelance photographers; 20% of this by assignment. Needs photos of polo action, portraits, travel, party/social and scenics. Most polo action is assigned, but freelance needs range from dynamic action photos to spectator fashion to social events. Photographers may write and obtain an editorial calendar for the year, listing planned features/photo needs. Captions preferred, where necessary include subjects and names.

Making Contact & Terms: Query with list of stock photo subjects. Provide résumé, business card, brochure, flier or tearsheets to be kept on file for possible assignments. SASE. Reports in 2 weeks. Pays $25-150/b&w photo, $30-300/color photo, $150/half day, $300/full day, $200-500/complete package. Pays on publication. Credit line given. Buys one-time or all rights; negotiable. Simultaneous submissions and previously published work OK "in some instances."

Tips: Wants to see tight focus on subject matter and ability to capture drama of polo. "In assigning action photography, we look for close-ups that show the dramatic interaction of two or more players rather than a single player. On the sidelines, we encourage photographers to capture emotions of game, pony picket lines, etc." Sees trend toward "more use of quality b&w images." To break in, "send samples of work, preferably polo action photography."

♣POOL & SPA LIVING MAGAZINE, 270 Esna Park Dr., Unit 12, Markham, Ontario L3R 1H3 Canada. (905)513-0090. Editor: David Barnsley. Circ. 40,000. Published twice a year. Emphasizes swimming pools, spas, hot tubs, outdoor entertaining, landscaping (patios, decks, gardens, lawns, fencing). Readers are homeowners and professionals 30-55 years old. Equally read by men and women.

Needs: Uses 20-30 photos/issue; 30% supplied by freelance photographers. Looking for shots of models dressed in bathing suits, people swimming in pools/spas, patios. Plans annual bathing suit issue late in year. Model release required.

Making Contact & Terms: Send unsolicited photos by mail for consideration. Send 8 × 10 glossy color prints; 35mm transparencies. SASE. Reports in 2 weeks. NPI; will negotiate payment. Pays on publication. Credit line given. Buys all rights; negotiable. Simultaneous submissions and previously published work OK.

Tips: Looking for "photos of families relaxing outdoors around a pool, spa or patio. We are always in need of visual material, so send in whatever you feel is appropriate for the magazine. Photos will be returned."

PORTLAND-THE UNIVERSITY OF PORTLAND MAGAZINE, 5000 N. Willamette Blvd., Portland OR 97203. (503)283-7202. Fax: (503)283-7110. Editor: Brian Doyle. Estab. 1985. 40-page magazine published quarterly.
Needs: Buys 20 photos/year; offers 3 assignments/year. Subjects include people. Model release preferred.
Making Contact & Terms: Interested in receiving work from newer, lesser-known photographers. Query with résumé of credits. Query with list of stock photo subjects. Solicits photos by assignment only. Uses 8×10 glossy b&w prints; b&w contact sheets; 35mm and 2½×2½ transparencies. SASE. Reports in 2 weeks. Pays $100-300/b&w and color photo. Credit line given. Buys one-time rights.
Tips: "Our needs are fairly specific. Tell me how you can help me. We want strong, creative photos. No mugs and 'grip and grins.' " In portfolio of samples wants to see "interpretive ability more than photojournalistic work. Also show work with other magazines. Strong composition and color is important. We often buy already completed work. University magazines are a growing market for first-rate photography. Our best work in recent years has been on assignment. There are more than 500 university and college magazines—a little-known niche. Our needs are not extensive. A good promotional brochure gives me someone to contact in various areas on various subjects."

PRAYING, P.O. Box 419281, Kansas City MO 64141. (816)531-0538. Editor: Art Winter. Photo Editor: Rich Heffern. Circ. 15,000. Estab. 1986. Bimonthly. Emphasizes spirituality for everyday living. Readers include mostly Catholic laypeople. Sample copy and photo guidelines free with SASE.
Needs: Uses 1 photo/issue; all supplied by freelance photographers. Needs quality photographs which stand on their own as celebrations of people, relationships, ordinary events, work, nature, etc. "We are looking for photos for a feature called Prayer-Starter. The pictures should lead readers to reflect on an aspect of their lives. The images can be abstract, but they must be natural—we don't go for 'trick' photography. Close-ups tend to work better than panoramic shots." Reviews photos with or without accompanying ms.
Making Contact & Terms: Query with samples. Send 8×10 b&w prints by mail for consideration. SASE. Reports in 2 weeks. Pays $50/b&w photo. **Pays on acceptance.** Credit line given. Buys one-time rights. Simultaneous submissions and previously published work OK.
Tips: Looking for "good *printing* composition. We get a lot of really *poor* stuff! Know how to take and print a quality photograph. Don't try to add holy element or reflective moment. Natural, to us, is holy. We have one rule: never to run a picture of someone praying."

***PREVENTION MAGAZINE**, 33 E. Minor St., Emmaus PA 18098. (215)967-5171. Executive Art Director: Wendy Ronga. Circ. 2.5 million. Monthly magazine. Emphasizes health. Readers are mostly female, 35-50, upscale.
Needs: Uses 20-25 photos/issue; 90% on assignment, 10% from stock, but seeing trend toward "more assignment work than usual." Photo needs very specific to editorial, health, beauty, food. Model release required. Captions required.
Making Contact & Terms: Provide résumé, business card, brochure, flier or tearsheets to be kept on file for possible future assignments; tearsheets and/or dupes very important. Cannot return unsolicited material. Reports in 1 month. Pays $100-300/b&w photo; $150-600/color photo; $250-1,000/day. Pays on publication. Credit line given. Buys one-time rights.
Tips: Prefers to see ability to do one thing very well. "Good lighting technique is a must." Wants to see "something different, taking an unusual twist to an ordinary subject."

PRIMAVERA, Box 37-7547, Chicago IL 60637. (312)324-5920. Contact: Board of Editors. Annual magazine. "We publish original fiction, poetry, drawings, paintings and photographs that deal with women's experiences." Sample copy $5. Photo guidelines free with SASE.
Needs: Uses 2-12 photos/issue; all supplied by freelancers.
Making Contact & Terms: Interested in receiving work from newer, lesser-known photographers. Send unsolicited photos or photocopies by mail for consideration. Send b&w prints. SASE. Reports in 1 month. Pays on publication 2 copies of volume in which art appears. Credit line given. Buys one-time rights.

PRIME TIME SPORTS & FITNESS, Dept. PM, P.O. Box 6097, Evanston IL 60204. (708)864-8113. Fax: (708)864-1206. Editor: Dennis Dorner. Magazine publishes 8 times/year. Emphasizes sports, recreation and fitness. Readers are professional males (50%) and females (50%), 19-45. Photo guidelines on request.
Needs: Uses about 70 photos/issue; 60 supplied by freelancers. Needs photos concerning women's fitness and fashion, swimwear and aerobic routines. Special photo needs include women's workout and

swimwear photos. Upcoming short-term needs: summer swimwear, women's aerobic wear, portraits of women in sports. "Don't send any photos that would be termed photobank access." Model/property release required. Captions preferred; include names, the situation and locations.

Making Contact & Terms: Interested in reviewing work from newer, lesser-known photographers. Send unsolicited photos by mail for consideration. SASE. Reports in 2 months. Pays $200/color and b&w cover photo; $20/color and b&w inside photo; $20/color page rate; $50/b&w page rate; $30-60/hour. Time of payment negotiable. Credit line given. Buys all rights; negotiable. Simultaneous submissions and previously published work OK.

Tips: Wants to see "tight shots of personalities, people, sports in action, but only tight close ups." There are a "plethora of amateur photographers who have trouble providing quality action or fashion shots and yet call themselves professionals. However, bulk of photographers are sending in a wider variety of photos. Photographers can best present themselves by letting me see their work in our related fields (both published and unpublished) by sending us samples. Do not drop by or phone, it will not help."

PRISON LIFE MAGAZINE, 200 Varick St., Suite 901, New York NY 10014. (212)229-1169. Fax: (212)967-7101. Photo Editor: Chris Cozzone. Circ. 100,000. Estab. 1992. Bimonthly magazine. Emphasizes prison life and prison-related topics. Readers are male and female prisoners ages 16-80, and families of the incarcerated. Sample copy $3.95 with #10 SAE and 1 first-class stamp. Photo guidelines available.

Needs: Uses 40-50 photos/issue; 10-20 supplied by freelancers. Needs photos of prison. Model/property release preferred for prisoners. Captions preferred.

Making Contact & Terms: Interested in receiving work from newer, lesser-known photographers. Send unsolicited photos by mail for consideration. Send any size color or b&w prints; 35mm transparencies. Keeps samples on file. SASE. Reports in 2 weeks. Pays $200/color cover photo; $100/b&w cover photo; $50/color inside photo; $40/b&w inside photo; $200/photo/text package. Pays on publication. Credit line given. Buys one-time rights; negotiable. Previously published work OK.

PRIVATE PILOT, P.O. Box 6050, Mission Viejo CA 92690. (714)855-8822. Fax: (714)855-3045. Managing Editor: Morga Fritze. Circ. 90,000. Estab. 1965. Monthly magazine. Emphasizes general aviation, aircraft, avionics, aviation-related materials. Readers are 90% male, age 45 and over. Sample copy free with SASE. Photo guidelines free with SASE.

Needs: Uses 40-50 photos/issue; 75% supplied by freelancers. Needs photos of aircraft—air-to-air and details. Model/property release preferred. Captions required; include date, location, names of people, aircraft model names and number.

Making Contact & Terms: Interested in receiving work from newer, lesser-known photographers. Submit portfolio for review. Query with résumé of credits. Query with stock photo list. Send unsolicited photos by mail for consideration. Provide résumé, business card, brochure, flier or tearsheets to be kept on file for possible assignments. Send 35mm transparencies. Keeps samples on file. SASE. Reports in 2 weeks. Pays $350/color cover photo; $25-50/inside photo; $75-100/page photo/text package. Pays on publication. Credit line given. Buys first North American rights..

PSYCHOLOGY TODAY, Sussex Publishers, 49 E. 21st St., 11th Floor, New York NY 10010. (212)260-3214. Fax: (212)260-7445. Photo Editor: Jennifer Lipshy. Estab. 1992. Bimonthly magazine. Readers are male and female, highly educated, active professionals. Photo guidelines free with SASE.
 ● Sussex also publishes *Mother Earth News* and *Spy* listed in this section.

Needs: Uses 19-25 photos/issue; all supplied by freelancers. Needs photos of humor, photo montage, symbolic, environmental, portraits, conceptual. Model/property release preferred.

Making Contact & Terms: Interested in receiving work from "upcoming" photographers. Submit portfolio for review. Send promo card with photo. Also accepts Mac files. Call before you drop off portfolio. Keeps samples on file. Cannot return material. Reports back only if interested. For assignments, pays $1,000/cover plus expenses; $350-750/inside photo plus expenses; for stock, pays $150/¼ page; $300/full page.

***PYX PRESS**, Box 922648, Sylmar CA 91392-2648. Contact: C. Darren Butler. Circ. 700. Estab. 1990. Quarterly journal. Emphasizes magic-realism fiction and related creative works. Readers are a general, educated audience. Sample copy: $5.95 (recent issue); $4.95 (back issue). Magazine guidelines available.

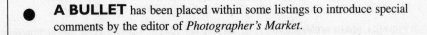

● **A BULLET** has been placed within some listings to introduce special comments by the editor of *Photographer's Market*.

Needs: Uses 0-2 photos/issue; all supplied by freelancers. Needs photos that are double-exposure, magic realism or lightly surreal. Model release preferred. Captions preferred.

Making Contact & Terms: Interested in receiving work from newer, lesser-known photographers. Submit portfolio for review. Query with stock photo list. Send unsolicited photos by mail for consideration. Provide résumé, business card, brochure, flier or tearsheets to be kept on file for possible assignments. Send 4½×8 color or b&w prints. Keeps samples on file. SASE. Reports in 1 month for queries, 2-6 months for submissions. Pays $100/color cover photo; $50/b&w cover photo; $2-10/ b&w inside photo; $10/b&w page. **Pays on acceptance.** Credit line given. Buys one-time, first North American serial and reprint rights. Simultaneous submissions and previously published work OK.

RACQUETBALL MAGAZINE, 1685 W. Uintah, Colorado Springs CO 80904-2921. (719)635-5396. Fax: (719)635-0685. Production Manager: Rebecca Maxedon. Circ. 45,000. Estab. 1990. Publication of American Amateur Racquetball Association. Bimonthly magazine. Emphasizes racquetball. Sample copy $4. Photo guidelines available.
Needs: Uses 20-40 photos/issue; 20-40% supplied by freelancers. Needs photos of action racquetball. Model/property release preferred. Captions required.
Making Contact & Terms: Interested in receiving work from newer, lesser-known photographers. Provide résumé, business card, brochure, flier or tearsheets to be kept on file for possible assignments. Deadlines: 1 month prior to each publication date. Keeps samples on file. SASE. Reports in 1 month. Pays $200/color cover photo; $25-75/color inside photo; $3-5/b&w inside photo. Pays on publication. Credit line given. Buys all rights; negotiable. Previously published work OK.

RADIANCE, The Magazine for Large Women, P.O. Box 30246, Oakland CA 94604. Phone/ fax: (510)482-0680. Publisher/Editor: Alice Ansfield. Circ. 10,000. Estab. 1984. Quarterly magazine. "We're a positive/self-esteem magazine for women all sizes of large. We have diverse readership, 90% women, ages 25-70 from all ethnic groups, lifestyles and interests." Sample copy $3.50. Writer's guidelines free with SASE. Photo guidelines not available.
Needs: Uses 20 photos/issue; all supplied by freelance photographers. Needs portraits, cover shots, fashion photos. Model release preferred. Captions preferred.
Making Contact & Terms: Send unsolicited photos by mail for consideration. Provide résumé, business card, brochure, flier or tearsheets to be kept on file for possible assignments. SASE. Reports in 4 months. Pays $50-200/color cover photo; $15-25/b&w inside photo; $8-20/hour; $400/day. Pays on publication. Credit line given. Buys one-time rights. Simultaneous submissions OK.
Tips: In photographer's portfolio or samples wants to see "clear, crisp photos, creativity, setting, etc." Recommends freelancers "get to know the magazine. Work with the publisher (or photo editor) and get to know her requirements. Try to help the magazine with its goals."

RAG MAG, Box 12, Goodhue MN 55027. (612)923-4590. Editor: Beverly Voldseth. Circ. 300. Estab. 1982. Magazine. Emphasizes poetry and fiction, but is open to good writing in an genre. Sample copy $6 with 6¼×9¼ SAE and 4 first-class stamps.
 • *Rag Mag* will only publish theme issues through 1997, request guidelines. Regular, non-theme submissions will be accepted beginning January 1998.
Needs: Uses 3-4 photos/issue; all supplied by freelancers. Needs photos that work well in a literary magazine; faces, bodies, stones, trees, water, etc. Reviews photos without a manuscript. Uses photos on covers.
Making Contact & Terms: Interested in receiving work from newer, lesser-known photographers. Send up to 8 unsolicited photocopies of photos by mail for consideration; include name on back of copies with brief bio. Always supply your name and address and add an image title or number on each photo for easy reference. Do not send originals. 6×9 vertical shots are best. Does not keep samples on file. SASE. Reports in 2 weeks-2 months. Pays in copies. Pays on publication. Buys one-time rights. Simultaneous submissions and previously published work OK.
Tips: "I do not want anything abusive, sadistic or violent."

REAL PEOPLE, 950 Third Ave., 16th Floor, New York NY 10022. (212)371-4932. Fax: (212)838-8420. Editor: Alex Polner. Circ. 130,000. Estab. 1988. Bimonthly magazine. Emphasizes celebrities. Readers are women 35 and up. Sample copy $3.50 with 6×9 SAE.
Needs: Uses 30-40 photo/issue; 10% supplied by freelancers. Needs celebrity photos. Reviews photos with accompanying ms. Model release preferred where applicable. Photo captions preferred.
Making Contact & Terms: Interested in receiving work from newer, lesser-known photographers. Query with résumé of credits and/or list of stock photo subjects. Provide résumé, business card, brochure, flier or tearsheets to be kept on file for possible assignments. Send samples or tearsheets, perhaps even an idea for a photo essay as it relates to entertainment field. SASE. Reports only when interested. Pays $100-200/day. Pays on publication. Credit line given. Buys one-time rights.

***RECREATIONAL HAIR NEWS**, 246 Greenfield Park NY 12435. (914)647-4198. E-mail: bfitzge rald@zelacom.com. Editor: Bob Fitzgerald. Circ. 2,000. Monthly newsletter. Emphasizes "unusual,

radical, bizarre hairstyles and fashions, such as a shaved head for women, waist-length hair or extreme transformations from very long to very short." Sample copy $3. Photo guidelines free with SASE.

Needs: Celebrity/personality, documentary, fashion/beauty, glamour, head shots, nudes, photo essay/ photo feature, spot news, travel, fine art, special effects/experimental, how-to and human interest "directly related to hairstyles and innovative fashions. We are also looking for old photos showing hairstyles of earlier decades—the older the better. If it's not related to hairstyles in the broadest sense, we're not interested." Model release preferred. Captions preferred.

Making Contact & Terms: Uses 5×7, 8×10 color and b&w prints; 35mm transparencies; and "accompanying manuscripts that are interviews/profiles of individuals with radical or unusual hair- cuts." Vertical format preferred. Send material by mail for consideration. Include samples of work and description of experience. SASE. Reports in 3 weeks. Pays: $10-100/b&w or color photo; $50 mini- mum/job; $50 minimum/manuscript. Credit line given. Buys one-time and all rights. Simultaneous submissions and previously published work OK.

Tips: "The difficulty in our publication is finding the subject matter, which is unusual and fairly rare. Anyone who can overcome that hurdle has an excellent chance of selling to us."

RELIX MAGAZINE, P.O. Box 94, Brooklyn NY 11229. (718)258-0009. Fax: (718)692-4345. Editor: Phyllis Antoniello. Circ. 60,000-70,000. Estab. 1974. Bimonthly. Emphasizes rock and roll music and classic rock. Readers are music fans, ages 13-50. Sample copy $4.

Needs: Uses about 50 photos/issue; "about 30%" supplied by freelance photographers; 20% on assignment; 80% from stock. Needs photos of "music artists—in concert and candid, backstage, etc." Special needs: "photos of rock groups, especially the Grateful Dead, San Francisco-oriented groups and sixties related bands." Captions preferred.

Making Contact & Terms: Interested in receiving work from newer, lesser-known photographers. Send 5×7 or larger b&w and color prints by mail for consideration. SASE. Reports in 1 month. "We try to report immediately; occasionally we cannot be sure of use." Pays $25-75/b&w photo; $25-300/ color. Pays on publication. Credit line given. Buys all rights; negotiable. Simultaneous submissions and previously published work OK.

Tips: "Black and white photos should be printed on grade 4 or higher for best contrast."

REMINISCE, 5400 S. 60th St., Greendale WI 53129. (414)423-0100. Fax: (414)423-8463. Photo Coordinator: Trudi Bellin. Estab. 1990. Bimonthly magazine. "For people who love reliving the good times." Readers are male and female, interested in nostalgia, ages 55 and over. "*Reminisce* is supported entirely by subscriptions and accepts no outside advertising." Sample copy $2. Photo guidelines free with SASE.

Needs: Uses 100 photos/issue; 40% supplied by freelancers. Needs photos with people interest—"we need high-quality color shots with nostalgic appeal, as well as good quality b&w vintage photography." Model/property release required. Captions preferred; season, location.

Making Contact & Terms: Interested in receiving work from newer, lesser-known photographers. Query with list of stock photo subjects. Send unsolicited photos by mail for consideration. Send 35mm, $2\frac{1}{4} \times 2\frac{1}{4}$, 4×5, 8×10 transparencies. Submit seasonally. Tearsheets filed but not dupes. SASE. Reports ASAP; "anywhere from a few days to a couple of months." Pays $300/color cover photo; $75-150/color inside photo; $150/color page (full page bleed); $10-100/b&w photo. Pays on publica- tion. Credit line given. Buys one-time rights. Previously published work OK.

Tips: "We are continually in need of authentic color taken in the 40s, 50s and 60s and b&w stock photos. Technical quality is extremely important; focus must be sharp, no soft focus; colors must be vivid so they 'pop off the page.' Color photos of nostalgic subjects stand the best chance of making our covers. Study our magazine thoroughly—we have a continuing need for sharp, colorful images, and those who can supply what we need can expect to be regular contributors."

REPTILE & AMPHIBIAN MAGAZINE, RD3, Box 3709-A, Pottsville PA 17901. (717)622-6050. Fax: (717)622-5858. E-mail: eramus@postoffice.ptd.net. Website: http://petstation.com/repamp.html. Editor: Erica Ramus. Circ. 14,000. Estab. 1989. Bimonthly magazine. Specializes in reptiles and amphibians only. Readers are college-educated, interested in nature and animals, familiar with basics of herpetology, many are breeders and conservation oriented. Sample copy $5. Photo guidelines with SASE.

Needs: Uses 50 photos/issue; 80% supplied by freelance photographers. Needs photos of related subjects. Photos purchased with or without ms. Model/property releases preferred. Captions required; clearly identify species with common and/or scientific name on slide mount.

Making Contact & Terms: Interested in receiving work from newer, lesser-known photographers. Send cover letter describing qualifications with representative samples. Must identify species pictured. Provide résumé, business card, brochure, flier or tearsheets to be kept on file for possible assignments. Send b&w and glossy prints; 35mm transparencies. Originals returned in 3 months. SASE. Reports in 1 month. Pays $25-50/color cover photo; $25/color inside photo; and $10/b&w inside photo. Pays on

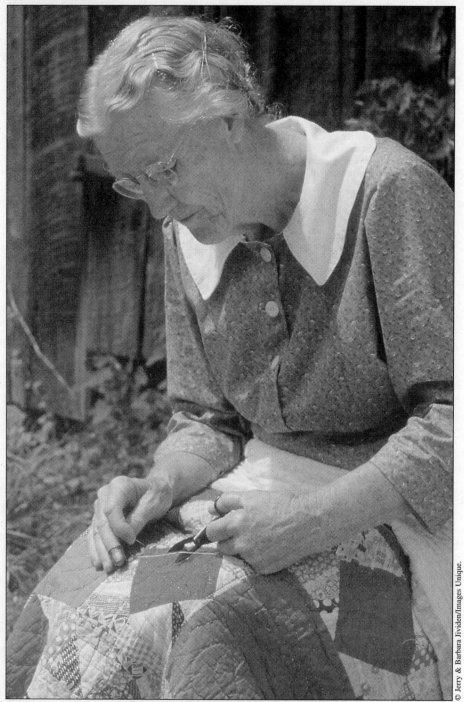

Jerry and Barbara Jividen staged this shot outdoors in overcast light using reflectors and fill flash to create a look appropriate for *Reminisce* magazine. "This photo typifies our search for sharp-focus images with an old-time feel," says Trudi Bellin of *Reminisce*. The image appeared as a full-page with text—a nostalgic poem by Barbara Jividen entitled "Grandma's Quilt." The Jividens found *Reminisce* through *Photographer's Market*, and have continued a working relationship with the company since selling them rights to this stock photo.

acceptance if needed immediately, or publication if the photo is to be filed for future use. Credit line given. Buys one-time rights. Previously published work OK.

Tips: In photographer's samples, looks for quality—eyes in-focus; action shots—animals eating, interacting, in motion. "Avoid field-guide type photos. Try to get shots with action and/or which have 'personality.' " All animals should be clearly identified with common and/or scientific name.

REVIEW OF OPTOMETRY, 201 King of Prussia Rd., Radnor PA 19089. (610)964-4370. Editor: Rich Kirkner. Circ. 31,500. Estab. 1891. Monthly. Emphasizes optometry. Readers include 31,000 practicing optometrists nationwide; academicians, students.
Needs: Uses 40 photos/issue; 3-8 supplied by freelance photographers. "Most photos illustrate news stories or features. Ninety-nine percent are solicited. We rarely need unsolicited photos. We will need top-notch freelance news photographers in all parts of the country for specific assignments." Model and property releases preferred; captions required.
Making Contact & Terms: Provide résumé, business card, brochure, flier or tearsheets to be kept on file for possible assignments; tearsheets and business cards or résumés preferred. NPI; payment varies. Credit line given. Rights negotiable. Simultaneous submissions and previously published work OK.

RHODE ISLAND MONTHLY, 95 Chestnut St., Providence RI 02903. (401)421-2552. Fax: (401)831-5624. Art Director: Donna Chludzinski. Circ. 32,000. Estab. 1988. Monthly magazine. Emphasizes local personalities, current events, consumer pieces, beautiful photo essays. Readers are predominantly affluent women, ages 40-55. Sample copy $1.
Needs: Uses 35-45 photos/issues; 30-40 supplied by freelancers. Needs photos of scenics, local personalities. Captions required; include identify names (correct spelling) and places.
Making Contact & Terms: Send unsolicited photos by mail for consideration. Send 35mm, 2¼×2¼, 4×5, 8×10 transparencies. Keeps samples on file. SASE. Reports in 3 weeks. Pays $200-800/job; $300-500/color cover photo; $75-300/color inside photos. The above amounts are an average. Pays on publication. Credit line given. Buys one-time rights. Simultaneous submissions and previously published work OK.
Tips: "We need photographers who have a good rapport with people as we photograph many Rhode Islanders from politicians, celebrity personalities, business men and women. We also need good nature photographers, Rhode Island has many beautiful natural resources, especially its 300 mile coastline. Looking at our magazine will give you an idea of our needs."

***RIDER**, 2575 Vista Del Mar Dr., Ventura CA 93001. Editor: Mark Tuttle. Circ. 120,000. Monthly magazine. For dedicated motorcyclists with emphasis on long-distance touring, with coverage also of general street riding, commuting and sport riding. Sample copy $2.50 with 9×12 SAE. Guidelines free.
Needs: Needs human interest, novelty and technical photos; color photos to accompany feature stories about motorcycle tours. Photos are rarely purchased without accompanying ms. Captions required.
Making Contact & Terms: Query first. Send 8×10 glossy or matte prints; 35mm transparencies. SASE. Reports in 2 months. NPI. Pay is included in total purchase price with ms. Pays on publication. Buys first-time rights.
Tips: "We emphasize quality graphics and color photos with good visual impact. Photos should be in character with accompanying ms and should include motorcyclists engaged in natural activities. Read our magazine before contacting us."

RIFLE & SHOTGUN SPORT SHOOTING, 2448 E. 81st St., 5300 CityPlex Tower, Tulsa OK 74137-4207. (918)491-6100. Fax: (918)491-9424. Executive Editor: Mark Chesnut. Circ. 100,000. Estab. 1994. Bimonthly magazine. Emphasizes shooting sports, including hunting. Readers are primarily male over 35. Sample copy $2.50. Photo guidelines free with SASE.
Needs: Uses 40-50 photos/issue; all supplied by freelancers. Needs photos of various action shots of shooting sports. Special photo needs include wildlife shots for cover; skeet, trap, sporting clays, rifle shooting and hunting shots for inside use. Model/property release preferred. Captions preferred.
Making Contact & Terms: Interested in receiving work from newer, lesser-known photographers. Send unsolicited photos by mail for consideration. Send 35mm, 2¼×2¼ transparencies. Keeps samples on file. SASE. Reports in 3 weeks. Pays $400-600/color cover photo; $75-200/color inside photo; $300-450/photo/text package. **Pays on acceptance**. Credit line given. Buys first North American serial rights.

THE ROANOKER, P.O. Box 21535, Roanoke VA 24018. (540)989-6138. Fax: (540)989-7603. Editor: Kurt Rheinheimer. Circ. 14,000. Estab. 1974. Monthly. Emphasizes Roanoke and western Virginia. Readers are upper income, educated people interested in their community. Sample copy $2.50.

Needs: Uses about 40 photos/issue; most are supplied on assignment by freelance photographers. Needs "travel and scenic photos in western Virginia; color photo essays on life in western Virginia." Model/property releases preferred. Captions required.

Making Contact & Terms: Interested in receiving work from newer, lesser-known photographers. Send any size glossy b&w or color prints and transparencies (preferred) by mail for consideration. SASE. Reports in 1 month. Pays $15-25/b&w photo; $20-35/color photo; $100/day. Pays on publication. Credit line given. Rights purchased vary; negotiable. Simultaneous submissions and previously published work OK.

ROCK & ICE, P.O. Box 3595, Boulder CO 80307. (303)499-8410. E-mail: rockandice@nite.com. Website: http://www.rscomm.comladsports/rock/index.html. Editor-in-Chief: George Bracksieck. Circ. 45,000. Estab. 1984. Bimonthly magazine. Emphasizes rock and ice climbing and mountaineering. Readers are predominantly professional, ages 10-80. Sample copy for $6.50. Photo guidelines free with SASE.
 • Photos in this publication usually are outstanding action shots. Make sure your work meets the magazine's standards. Do not limit yourself to climbing shots from the U.S.

Needs: Uses 90 photos/issue; all supplied by freelance photographers; 20% on assignment, 80% from stock. Needs photos of climbing action, personalities and scenics. Buys photos with or without ms. Captions required.

Making Contact & Terms: Interested in receiving work from newer, lesser-known photographers. Query with list of stock photo subjects. Send unsolicited photos by mail for consideration. Send b&w prints; 35mm, 2¼×2¼ and 4×5 transparencies. Also accepts digital images in SyQuest or on CD-ROM. SASE. Pays $500/cover photo; $200/color and b&w page rate; $25/Website image. Pays on publication. Credit line given. Buys one-time rights and first North American serial rights. Previously published work OK.

Tips: "Samples must show some aspect of technical rock climbing, ice climbing, mountain climbing or indoor climbing, scenics of places to climb or images of people who climb or who are indigenous to the climbing area. Climbing is one of North America's fastest growing sports."

ROLLER HOCKEY, 12327 Santa Monica Blvd., Los Angeles CA 90025. (310)442-6660. Fax: (310)442-6663. Editor: Michael Scarr. Circ. 20,000. Estab. 1992. Magazine published 9 times/year. Emphasizes roller hockey, specifically inline hockey. Readers are male and female, ages 12-45. Sample copy $2.95. Photo guidelines free with SASE.

Needs: Uses 50 photos/issue; 35 supplied by freelancers. Needs photos of roller hockey. Special photo needs include play from local and professional roller hockey leagues. Model/property release preferred for professionals in staged settings. Captions preferred; include who, what, where, when, why, how.

Making Contact & Terms: Interested in receiving work from newer, lesser-known photographers. Send unsolicited photos by mail for consideration. Query with stock photo list. Send 3×5, 5×7 glossy color b&w prints; 35mm transparencies. Deadlines: 3 months prior to any season. SASE. Reports in 1 month. Pays $100/color cover photo; $25/color inside photo; $15/b&w inside photo. Pays on publication. Credit line given. Buys all rights; negotiable. Previously published work OK.

ROLLING STONE, Dept. PM, 1290 Avenue of the Americas, New York NY 10104. (212)484-1616. Associate Photo Editor: Jodi Peckman. Emphasizes all forms of entertainment (music, movies, politics, news events).

Making Contact & Terms: "All our photographers are freelance." Provide brochure, calling card, flier, samples and tearsheet to be kept on file for future assignments. Needs famous personalities and rock groups in b&w and color. No editorial repertoire. SASE. Reports immediately. Pays $150-350/day.

Tips: "Drop off portfolio at mail room any Wednesday between 10 am and noon. Pickup same day between 4 pm and 6 pm or next day. Leave a card with sample of work to keep on file so we'll have it to remember."

RUNNER'S WORLD, 135 N. Sixth St., Emmaus PA 18098. (610)967-5171. Fax: (610)967-7725. Executive Editor: Amby Burfoot. Photo Editor: Chuck Johnson. Circ. 435,000. Monthly magazine. Emphasizes running. Readers are median aged: 37, 65% male, median income $40,000, college-educated. Photo guidelines free with SASE.

Needs: Uses 100 photos/issue; 25% freelance, 75% assigned; features are generally assigned. Needs photos of action, features, photojournalism. Model release and captions preferred.

Making Contact & Terms: Query with samples. Contact photo editor before sending portfolio or submissions. Pays as follows: color—$350/full page, $250/half page, $210/quarter page, $580/2-page spread. Cover shots are assigned. Pays on publication. Credit line given. Buys one-time rights. Simultaneous submissions and previously published work OK.

Tips: "Become familiar with the publication and send photos in on spec. Also send samples that can be kept in our source file. Show full range of expertise; lighting abilities—quality of light—whether

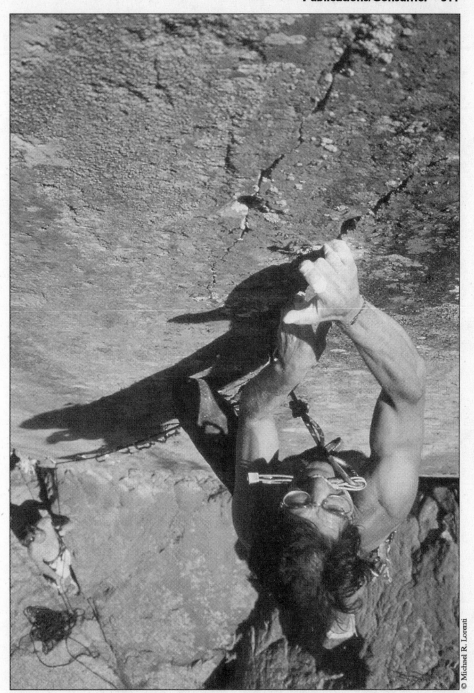

© Michael R. Lorenti

Boulder, Colorado, photographer Michael Lorenti has sold this shot of courageous climber Rob Candelaria three times—to *Rock & Ice* magazine for their 1994 media kit cover; to *Climbing* magazine for their news section; and most recently to *Rock & Ice* for an article on hard crack climbs. "The image is striking enough in the climbing community that people associate me with the image," says Lorenti, who also works part-time as photo editor of *Rock & Ice*, providing him with "knowledge of the magazine industry as well as increasing my professionalism when dealing with clients in the freelance world."

strobe sensitivity for people—portraits, sports, etc.. Both action and studio work if applicable, should be shown." Current trend is non-traditional treatment of sports coverage and portraits. Call prior to submitting work. Be familiar with running as well as the magazine."

RURAL HERITAGE, 281 Dean Ridge Lane, Gainesboro TN 38562-5039. (615)268-0655. Editor: Gail Damerow. Circ. 2,500. Estab. 1975. Bimonthly magazine. Readers live the rural lifestyle and maintain its traditional values in the modern world. Sample copy $6 ($6.50 outside the U.S.).
Needs: "Most of the photos we purchase illustrate stories or poems. Exceptions are back cover, for which we need well-captioned, humorous scenes related to rural life, and front cover where we use draft animals in harness."
Making Contact & Terms: Interested in receiving work from newer, lesser-known photographers. "For covers we prefer color horizontal shots, 5×7 glossy (color or 35mm slide). Interior is b&w. Please include SASE for the return of your material, and put your name and address on the back of each piece. Pays $10/photo to illustrate a story or poem; $15/photo for captioned humor; $25/back cover, $50/front cover. Also provides 2 copies of issue in which work appears. Pays on publication.
Tips: "Animals usually look better from the side than from the front. We like to see all the animal's body parts, including hooves, ears and tail. For animals in harness, we want to see the entire implement or vehicle. We prefer action shots (plowing, harvesting hay, etc.). Look for good contrast that will print well in black and white; watch out for shadows across animals and people. Please include the name of any human handlers involved, the farm, the town (or county), state, and the animal's names (if any) and breeds."

***RUSSIAN LIFE MAGAZINE**, 89 Main St., #2, Montpelier VT 05602. (802)223-4955. (802)223-6105. E-mail: 74754.3234@compuserve.com. Executive Editor: Mikhail Ivanov. Estab. 1990. Monthly magazine.
Needs: Uses 25-35 photos/issue. Offers 10-15 freelance assignments annually. Needs photojournalism related to Russian culture, art and history. Model/property release preferred.
Making Contact & Terms: Interested in receiving work from newer, lesser-known photographers. Works with local freelancers only. Query with samples. Send 35mm, 2¼×2¼, 4×5, 8×10 transparencies; 35mm film; Kodak CD digital format. SASE "or material not returned." Reports in 1 month. Pays $25-200 (color photo with accompanying story), depending on placement in magazine. Pays on publication. Credit line given. Buys one-time and electronic rights.

SACRAMENTO MAGAZINE, Dept. PM, 4471 D St., Sacramento CA 95819. (916)452-6200. Fax: (916)452-6061. Editor: Krista Hendricks Minard. Managing Editor: Darlena Belushin. Art Director: Debra Hurst. Circ. 30,000. Monthly magazine. Emphasizes culture, food, outdoor recreation, home and garden and personalities for middle to upper middle class, urban-oriented Sacramento residents with emphasis on women.
Needs: Uses about 40-50 photos/issue; most supplied by freelance photographers. "Photographers are selected on the basis of experience and portfolio strength. No work assigned on speculation or before a portfolio showing. Photographers are used on an assignment only basis. Stock photos used only occasionally. Most assignments are to area photographers and handled by phone. Photographers with studios, mobile lighting and other equipment have an advantage in gaining assignments. Darkroom equipment desirable but not necessary." Needs news photos, essay, avant-garde, still life, landscape, architecture, human interest and sports. All photography must pertain to Sacramento and environs. Captions required.
Making Contact & Terms: Arrange a personal interview to show portfolio. Also query with résumé of photo credits. Pays $5-45/hour. Average payment is $15-20/hour; all assignments are negotiated to fall within that range. **Pays on acceptance.** Credit line given. Buys one-time rights. Will consider simultaneous submissions and previously published work, providing they are not in the northern California area.

SAIL MAGAZINE, 275 Washington St., Newton MA 02158-1630. (617)630-3726. Fax: (617)630-3737. Photo Editor: Allison Peter. Circ. 200,000. Estab. 1970. Monthly magazine. Emphasizes all aspects of sailing. Readers are managers and professionals, average age 44. Photo guidelines free with SASE.
Needs: Uses 40 photos/issue; 100% supplied by freelancers. "We are particularly interested in photos for our 'Under Sail' section. Photos for this section should be original 35mm transparencies only and should humorously depict some aspect of sailing." Photo captions preferred.
Making Contact & Terms: Interested in receiving work from newer, lesser-known photographers. Send unsolicited 35mm and 2¼×2¼ transparencies by mail for consideration. SASE. Pays $600/cover

photo; $75-250/color inside photo; also negotiates prices on a per day, per hour, and per job basis. Pays on publication. Credit line given. Buys one-time rights.

SAILING, Dept. PM, 125 E. Main St., Box 248, Port Washington WI 53074. (414)284-3494. Editor: Micca L. Hutchins. Circ. 50,000. Monthly magazine. Emphasizes sailing. Our theme is "the beauty of sail." Readers are sailors with great sailing experience—racing and cruising. Sample copy free with 11 × 15 SAE and 9 first-class stamps. Photo guidelines free with SASE.

Needs: "We are a photo journal-type publication so about 50% of issue is photos." Needs photos of exciting sailing action, onboard deck shots; sailor-type boat portraits seldom used. Special needs include high-quality color—mainly good *sailing*. Captions required. "We must have area sailed, etc., identification."

Making Contact & Terms: Query with samples. Send 35mm transparencies by mail for consideration. "Request guidelines first—a big help." SASE. Reports in 1 month. Payment varies from $150 and up. Pays 30 days after publication. Credit line given. Buys one-time rights. Simultaneous submissions and previously published work OK "if not with other sailing publications who compete with us."

Tips: "We are looking for good, clean, sharp photos of sailing action—exciting shots are for us. Please request a sample copy to become familiar with format. Knowledge of the sport of sailing a requisite for good photos for us."

SAILING WORLD, 5 John Clarke Rd., Newport RI 02840. (401)847-1588. Fax: (401)848-5048. Asst. Art Director: Maureen Mulligan. Circ. 62,000. Estab. 1962. Monthly magazine. Emphasizes sailboat racing and performance cruising for sailors, upper income. Readers are males 35-45, females 25-35 who are interested in sailing. Sample copy $5. Photo guidelines free with SASE.

Needs: "We will send an updated photo letter listing our needs on request." Freelance photography in a given issue: 20% assignment and 80% freelance stock. Covers most sailing races.

Making Contact & Terms: Uses 35mm and 2¼ × 2¼ transparencies for covers. Vertical and square (slightly horizontal) formats. Reports in 1 month. Pays $500 for cover shot; regular color $50-300 (varies with use). Pays on publication. Credit line given. Buys first N.A. serial rights.

Tips: "We look for photos that are unusual in composition, lighting and/or color that feature performance sailing at its most exciting. We would like to emphasize speed, skill, fun and action. Photos must be of high quality. We prefer Fuji Velvia or Kodachrome 64 film. We have a format that allows us to feature work of exceptional quality. A knowledge of sailing and experience with on-the-water photography is really a requirement. Please call with specific questions or interests. We cover current events and generally only use photos taken in the past 30-60 days."

SALT WATER SPORTSMAN, 77 Franklin St., Boston MA 02110. (617)338-2300. Fax: (617)338-2309. Editor: Barry Gibson. Circ. 150,000. Estab. 1939. Monthly magazine. Emphasizes all phases of salt water sport fishing for the avid beginner-to-professional salt water angler. "Number-one monthly marine sport fishing magazine in the US." Sample copy free with 9 × 12 SAE and 7 first-class stamps. Free photo and writer's guidelines.

Needs: Buys photos (including covers) without ms; 20-30 photos/issue with ms. Needs salt water fishing photos. "Think scenery, mood, fishing action, storytelling close-ups of anglers in action. Make it come alive—and don't bother us with the obviously posed 'dead fish and stupid fisherman' back at the dock. Wants, on a regular basis, cover shots (verticals depicting salt water fishing action)." For accompanying ms needs fact/feature articles dealing with marine sportfishing in the US, Canada, Caribbean, Central and South America. Emphasis on how-to.

Making Contact & Terms: Send material by mail for consideration or query with samples. Provide résumé and tearsheets to be kept on file for possible future assignments. Holds slides for 1 year and will pay as used. Also accepts digital images on an 88mg SyQuest disk with proof of image. Uses 35mm or 2¼ × 2¼ transparencies; cover transparency vertical format required. SASE. Reports in 1 month. Pay included in total purchase price with ms, or pays $50-400/color photo; $1,000 minimum/cover photo; $250-up/text-photo package. **Pays on acceptance.**

Tips: "Prefers to see a selection of fishing action and mood; must be sport fishing oriented. Read the magazine! Example: no horizontal cover slides with suggestions it can be cropped, etc. Don't send Ektachrome. We're using more 'outside' photography—that is, photos not submitted with ms package. Take lots of verticals and experiment with lighting. Most shots we get are too dark."

LISTINGS THAT USE IMAGES electronically can be found in the Digital Markets Index located at the back of this book.

SAN DIEGO FAMILY PRESS, P.O. Box 23960, San Diego CA 92193. (619)685-6970. Editor: Sharon Bay. Circ. 74,000. Estab. 1982. Monthly magazine. Emphasizes families with children. Readers are mothers, ages 25-45. Sample copy 10×13 SAE and $3.50 postage/handling.
Needs: Uses 4-6 photos/issue. Needs photos of children and families participating in all activities.
Making Contact & Terms: Send unsolicited photos by mail for consideration. Query with stock photo list. Send 3×5, 4×5, 5×7 color b&w prints. Deadlines: first of each month. Keeps samples on file. SASE. Reports in 1 month. Pays $5-10/b&w inside photo. Pays on publication. Credit line given. Buys one-time rights; negotiable. Simultaneous submissions and previously published work OK.

SANDLAPPER MAGAZINE, P.O. Box 1108, Lexington SC 29071. (803)359-9941. Fax: (803)957-8226. Managing Editor: Dan Harmon. Estab. 1989. Quarterly magazine. Emphasizes South Carolina topics.
Needs: Uses about 5 photographers/issue. Needs photos of South Carolina subjects. Model release preferred. Captions required; include places and people.
Making Contact & Terms: Interested in receiving work from newer, lesser-known photographers. Query with samples. Send 8×10 color and b&w prints; 35mm, 2¼×2¼, 4×5, 8×10 transparencies. Keeps samples on file. SASE. Reports in 1 month. Pays $25-100/color inside photo; $25-75/b&w inside photo. Pays on publication. Credit line given. Buys first rights plus right to reprint.
Tips: Looking for any South Carolina topic—scenics, people, action, mood, etc.

SANTA BARBARA MAGAZINE, Dept. PM, 2064 Alameda Padre Serra, Suite 120, Santa Barbara CA 93103. (805)965-5999. Fax: (805)965-7627. Publisher: Daniel Denton. Photo Editor: Kimberly Kavish. Editor: Michael Smith. Circ. 14,000. Estab. 1975. Quarterly magazine. Emphasizes Santa Barbara community and culture. Sample copy $3.77 with 9×12 SAE.
Needs: Uses 50-60 photos/issue; 40% supplied by freelance photographers. Needs portrait, environmental, architectural, travel, celebrity, et al. Reviews photos with accompanying ms only. Model release required. Captions preferred.
Making Contact & Terms: Provide résumé, business card, brochure, flier or tearsheets to be kept on file for possible future assignments; "portfolio drop off Thursdays, pick up Fridays." Cannot return unsolicited material. Reports in 4-6 weeks. Pays $75-250/b&w or color photo. Pays on publication. Credit line given. Buys first North American serial rights.
Tips: Prefers to see strong personal style and excellent technical ability. "Work needs to be oriented to our market. Know our magazine and its orientation before contacting me."

THE SATURDAY EVENING POST SOCIETY, Dept. PM, Benjamin Franklin Literary & Medical Society, 1100 Waterway Blvd., Indianapolis IN 46202. (317)634-1100. Editor: Cory SerVaas, M.D. Photo Editor: Patrick Perry. Magazine published 6 times annually. For family readers interested in travel, food, fiction, personalities, human interest and medical topics—emphasis on health topics. Circ. 500,000. Sample copy $4; free photo guidelines with SASE.
Needs: Prefers the photo essay over single submission. Model release required.
Making Contact & Terms: Send photos for consideration; 8×10 b&w glossy prints; 35mm or larger transparencies. Provide business card to be kept on file for possible future assignments. SASE. Reports in 1 month. Pays $50 minimum/b&w photo or by the hour; pays $150 minimum for text/photo package; $75 minimum/color photo; $300/color cover photo. Pays on publication. Prefers all rights. Simultaneous submissions and previously published work OK.

SCHOLASTIC MAGAZINES, 555 Broadway, New York NY 10012. (212)343-6100. Fax: (212)343-6185. Manager of Picture Services: Grace How. Estab. 1920. Publication of magazine varies from weekly to monthly. "We publish 25 titles per year on topics from current events, science, math, fine art, literature and social studies. Interested in featuring high-quality well-composed images of students of all ages and all ethnic backgrounds." Sample copy free with 9×12 SAE with 3 first-class stamps.
Needs: Uses 15 photos/issue. Needs photos of various subjects depending upon educational topics planned for academic year. Model release preferred. Captions required.
Making Contact & Terms: Interested in receiving work from newer, lesser-known photographers. Query with résumé, business card, brochure, flier or tearsheets to be kept on file for possible assignments. Accepts digital images in SyQuest or downloads off of the Internet. Material cannot be returned. Pays $400/color cover photo; $100/b&w inside photo (⅛ page); $125/color inside photo (¼ page). Pays on publication. Buys one-time rights. Previously published work OK.

SCIENTIFIC AMERICAN, 415 Madison Ave., New York NY 10017. (212)754-0474. Fax: (212)755-1976. E-mail: geller@sciam.com. Photography Editor: Nisa Geller. Circ. 600,000. Estab. 1854. Emphasizes science technology and people involved in science. Readers are mostly male, 15-55.

Needs: Uses 100 photos/issue; all supplied by freelancers. Needs photos of science and technology, personalities, photojournalism and how-to shots; especially "amazing science photos." Model release required. Property release preferred. Captions required.

Making Contact & Terms: Interested in receiving work from newer, lesser-known photographers. Arrange personal interview to show portfolio. "Do not send unsolicited photos." Provide résumé, business card, brochure, flier or tearsheets to be kept on file for possible assignments. Keeps samples on file. Cannot return material. Reports in 1 month. Pays $350/day; $1,000/color cover photo. Pays on publication. Credit line given. Buys one-time and electronic rights; negotiable.

Tips: Wants to see strong natural and artificial lighting, location portraits and location shooting. "Send business cards and promotional pieces frequently when dealing with magazine editors. Find a niche."

***SCORE**, 13360 S.W. 128 St., Miami FL 33186. (305)238-5040. Fax: (305)238-6716. E-mail: quad@ netrunner.net. Editor: John Fox. Circ. 150,000. Estab. 1992. Monthly magazine. Emphasizes large-busted models. Readers are males between 18-50 years of age.

Needs: Uses 150 photos/issue; 100% supplied by freelancers. Model release required for photo identification (such as a driver's license) is also required and/or copy of model's birth certificate.

Making Contact & Terms: Interested in receiving work from newer, lesser-known photographers. Query with stock photo list. Send unsolicited photos by mail for consideration. Photo submissions should consist of a minimum of 100 transparencies of one model. Send 35mm transparencies. SASE. Reports in 3 weeks. Pays $150/color page rate; photo sets of individual models—$1,500-2,500. Pays on publication. Credit line given (if requested). Buys one-time rights; negotiable.

Tips: "Study samples of our publication. We place a premium on—and pay a premium for—new discoveries and exclusives."

***SCORE, Canada's Golf Magazine**, 287 MacPherson Ave., Toronto, Ontario M4V 1A4 Canada. (416)928-2909. Fax: (416)928-1357. Managing Editor: Bob Weeks. Circ. 125,000. Estab. 1980. Magazine published 8 times/year. Emphasizes golf. "The foundation of the magazine is Canadian golf and golfers." Readers are affluent, well-educated, 80% male, 20% female. Sample copy $2 (Canadian). Photo guidelines free with SAE with IRC.

Needs: Uses between 30 and 40 photos/issue; approximately 95% supplied by freelance photographers. Needs "professional-quality, golf-oriented color and b&w material on prominent Canadian male and female pro golfers on the US PGA and LPGA tours, as well as the European and other international circuits, scenics, travel, close-ups and full-figure." Model releases (if necessary) required. Captions required.

Making Contact & Terms: Query with samples and with list of stock photo subjects. Send 8×10 or 5×7 glossy b&w prints and 35mm or 2¼×2¼ transparencies by mail for consideration. Provide résumé, business card, brochure, flier or tearsheets to be kept on file for possible future assignments. SASE with IRC. Reports in 3 weeks. Pays $75-100/color cover photo; $30/b&w inside photo; $50/ color inside photo; $40-65/hour; $320-520/day; and $80-2,000/job. **Pays on acceptance.** Credit line given. Buys all rights. Simultaneous submissions OK.

Tips: "When approaching *Score* with visual material, it is best to illustrate photographic versatility with a variety of lenses, exposures, subjects and light conditions. Golf is not a high-speed sport, but invariably presents a spectrum of location puzzles: rapidly changing light conditions, weather, positioning, etc. Capabilities should be demonstrated in query photos. Scenic material follows the same rule. Specific golf hole shots are certainly encouraged for travel features, but wide-angle shots are just as important, to 'place' the golf hole or course, especially if it is located close to notable landmarks or particularly stunning scenery. Approaching *Score* is best done with a clear, concise presentation. A picture is absolutely worth a thousand words, and knowing your market and your particular strengths will prevent a mutual waste of time and effort. Sample copies of the magazine are available and any photographer seeking to work with *Score* is encouraged to investigate prior to querying."

***SCUBA TIMES MAGAZINE**, 14110 Perdido Key Dr., Suite 16, Pensacola FL 32507. (904)492-7805. Fax: (904)492-7807. Art Director: Scott Bieberich. Circ. 42,000. Estab. 1979. Bimonthly magazine. Emphasizes scuba diving. Sample copy $3. Photo guidelines free with SASE. Provides an editorial schedule with SASE.

● The editorial staff at this magazine likes to work with photographers who can write as well as shoot outstanding images. Don't be afraid to deviate from "blue" photos when submitting work. Other vibrant colors can make you stand out.

Needs: Uses 50-60 photos/issue; all supplied by freelance photographers; 80% comes from assignments. Needs animal/wildlife shots, travel, scenics, how-to, all with an underwater focus. Model release preferred. Captions preferred; include description of subject and location.

Making Contact & Terms: Interested in receiving work from newer, lesser-known photographers. "Send a sample (20 dupes) for our stock file with each slide labelled according to location rather than creature. Send a complete list of destinations you have photographed. We will build a file from which we can make assignments and order originals." Send 35mm or large format transparencies. SASE.

Reports in 1-2 months. Pays $150/color cover photo; $75/color page rate; $75/b&w page rate. Pays 30 days after publication. Credit line given. Buys one-time rights. Previously published work OK "under certain circumstances."

Tips: Looks for underwater and "topside" shots of dive destinations around the world, close-ups of marine creatures, divers underwater with creatures or coral. "We look for photographers who can capture the details that, when combined, create not only a physical description, but also capture the spirit of a dive destination. In portfolio or samples, likes to see "broad range of samples, majority underwater."

SEA KAYAKER, P.O. Box 17170, Seattle WA 98107. (206)789-1326. Fax: (206)781-1141. Editor: Christopher Cunningham. Circ. 20,000. Estab. 1984. Bimonthly magazine. Emphasizes sea kayaking—kayak cruising on coastal and inland waterways. Sample copy $5.75. Photo guidelines free with SASE.

Needs: Uses 50 photos/issue; 85% supplied by freelancers. Needs photos of sea kayaking locations, coastal camping and paddling techniques. Reviews photos with or without ms. Always looking for cover images (some to be translated into paintings, etc.). Model/property release preferred. Captions preferred.

Making Contact & Terms: Interested in receiving work from newer, lesser-known photographers. Submit portfolio for review. Send unsolicited photos by mail for consideration. Send 5×7 color and b&w prints; 35mm transparencies. Keeps samples on file. SASE. Reports in 1 month. Pays $250/color cover photo; $25-50/color inside photo; $15-35/b&w inside photo. Pays on publication. Credit line given. Buys one-time rights, first North American serial rights.

Tips: Subjects "must relate to sea kayaking and cruising locations."

SEA, The Magazine of Western Boating, 17782 Cowan, Suite C, Irvine CA 92714. (714)660-6150. Fax: (714)660-6172. Senior Editor: Eston Ellis. Art Director: Jeffrey Fleming. Circ. 60,000. Monthly magazine. Emphasizes "recreational boating in 13 western states (including some coverage of Mexico and British Columbia) for owners of recreational power boats." Sample copy and photo guidelines free with 10×13 SAE.

Needs: Uses about 50-75 photos/issue; most supplied by freelance photographers; 10% assignment; 70% requested from freelancers existing photo files or submitted unsolicited. Needs "people enjoying boating activity and scenic shots; shots which include parts or all of a boat are preferred." Special needs include "vertical-format shots involving power boats for cover consideration." Photos should have West Coast angle. Model release required. Captions required.

Making Contact & Terms: Query with samples. SASE. Reports in 1 month. Pays $250/color cover photo; inside photo rate varies according to size published. Range is from $25 for b&w and $50-150 for color. Pays on publication. Credit line given. Buys one-time North American rights.

Tips: "We are looking for sharp color transparencies with good composition showing pleasure boats in action, and people having fun aboard boats in a West Coast location. We also use studio shots of marine products and do personality profiles. Black & white also accepted, for a limited number of stories. Color preferred. Send samples of work with a query letter and a résumé or clips of previously published photos."

***SECURE RETIREMENT**, 2000 K St. NW, Washington DC 20006. (202)822-9459. Fax: (202)822-9612. E-mail: secure_retirement@ncpssm.org. Editor: Denise Fremeau. Circ. 2 million. Estab. 1992. Publication of the National Committee to Preserve Social Security and Medicare. Magazine published 6 times yearly. Emphasizes aging and senior citizen issues. Readers are male and female retirees/non-retirees, ages 50-80. Sample copy free with 9×12 SASE.

● *Secure Retirement* now buys all its photos from freelancers.

Needs: Uses 20-25 photos/issue; all supplied by freelancers. Needs photos of generic, healthy lifestyle seniors, intergenerational families. Model release required. Captions preferred.

Making Contact & Terms: Interested in receiving work from newer, lesser-known photographers. Arrange personal interview to show portfolio. Provide résumé, business card, brochure, flier or tear-sheets to be kept on file for possible assignments. "Do not send unsolicited 35mm or 4×5 slides; color or b&w prints OK. SASE. Pays $100-500/day; $100-500/color and b&w inside photo. Pays on publication. Credit line given. Buys one-time rights; negotiable. Simultaneous submissions and/or previously published work OK.

Tips: "We are interested in hiring freelancers to cover events for us across the nation (approximately 3-7 events/month)."

 THE DOUBLE DAGGER before a listing indicates that the market is located outside the United States and Canada.

SENTIMENTAL SOJOURN, 11702 Webercrest, Houston TX 77048. (713)733-0338. Editor: Charlie Mainze. Circ. 1,000. Estab. 1993. Annual magazine. Sample copy $12.50.

Needs: Uses photos on almost every page. Needs sensual images evocative of sentimental emotions, usually including at least one human being, suitable for matching with sentimental poetry. "Delicate, refined, romantic, nostalgic, emotional idealism can be erotic, but must be suitable for a general readership." Model/property release required for any model not shot in public places.

Making Contact & Terms: Interested in receiving work from newer, lesser-known photographers. Send unsolicited photos by mail for consideration. Provide résumé, business card, brochure, flier or tearsheets to be kept on file for possible assignments. Send color and b&w prints; 35mm, 2¼ × 2¼, 4 × 5 transparencies. Keeps samples on file. SASE, but generally keep for a few years. Reports when need for work arises, could be 2 years. Pays $50-200/color cover photo; $50-200/b&w cover photo; $10-100/color inside photo; $10-100/b&w inside photo; also pays a percentage of page if less than full page. Credit line given. Buys one-time rights, first North American serial rights. Previously published work OK.

Tips: "Symbols of the dead and dying had better be incomparably delicate. Send a celebration of emotions."

SEVENTEEN MAGAZINE, 850 Third Ave., 9th Floor, New York NY 10022. Prefers not to share information.

SHOWBOATS INTERNATIONAL, 1600 SE 17th St., Suite 200, Ft. Lauderdale FL 33316. (305)525-8626. Fax: (305)525-7954. Executive Editor: Marilyn Mower. Circ. 60,000. Estab. 1981. Bimonthly magazine. Emphasizes exclusively large yachts (100 feet or over). Readers are mostly male, 40 plus years of age, incomes above $1 million, international. Sample copy $5.

● This publication has received 18 Florida Magazine Association Awards plus two Ozzies since 1989.

Needs: Uses 90-150 photos/issue; 80-90% supplied by freelancers. Needs photos of very large yachts and exotic destinations. "Almost all shots are commissioned by us." Model/property releases required. Color photography only. Captions preferred.

Making Contact & Terms: Arrange personal interview to show portfolio. Submit portfolio for review. Query with résumé of credits. Provide résumé, business card, brochure, flier or tearsheets to be kept on file for possible assignments. Does not keep samples on file. SASE. Reports in 3 weeks. Pays $500/color cover photo; $75-350/color page rate; $550-850/day. Pays on publication. Credit line given. Buys first serial rights, all rights; negotiable. Previously published work OK, however, exclusivity is important.

Tips: Looking for excellent control of lighting; extreme depth of focus; well-saturated transparencies. Prefer to work with photographers who can supply both exteriors and beautiful, architectural quality interiors. "Don't send pictures that need any excuses. The larger the format, the better. Send samples. Exotic location shots should include yachts."

SIMPLY SEAFOOD, 5305 Shilshole Ave. NW, Suite 200, Seattle WA 98107. (206)789-6506. Fax: (206)789-9193. Photo Editor: Scott Wellsandt. Estab. 1991. Quarterly magazine. Emphasizes seafood recipes, step-by-step cooking of seafood, profiles of chefs. Sample copy $1.95.

Needs: Uses 40 photos/issue; 25% supplied by freelancers. Needs "mainly food shots, a few travel, historic and fishing shots, chefs in different locations." Model/property release preferred. Captions preferred.

Making Contact & Terms: Interested in receiving work from newer, lesser-known photographers. Query with list of stock photo subjects. Provide résumé, business card, brochure, flier or tearsheets to be kept on file for possible assignments. Keeps samples on file. SASE. Reports as needed. Pays $100/color cover photo; $50/color inside photo. Pays on publication. Credit line given. Buys one-time rights; negotiable. Simultaneous submissions and previously published work OK.

Tips: Review the magazine before contacting.

***SINISTER WISDOM**, P.O. Box 3252, Berkeley CA 94703. Contact: Editor. Circ. 3,000. Estab. 1976. Published 3 times/year. Emphasizes lesbian/feminist themes. Readers are lesbians/women, ages 20-90. Sample copy $6.50. Photo guidelines free with SASE.

Needs: Uses 3-6 photos/issue. Needs photos relevant to specific theme, by lesbians only. Reviews photos with or without a ms. Model/property release required. Captions preferred.

Making Contact & Terms: Send unsolicited photos by mail for consideration. Provide résumé, business card, brochure, flier or tearsheets to be kept on file for possible assignments. Send all sizes or finishes. Reports in 2-9 months. Pays in copies. Pays on publication. Credit line given. Buys one-time rights; negotiable.

Tips: "Read at least one issue of *Sinister Wisdom*."

SKATING, 20 First St., Colorado Springs CO 80906-3697. (719)635-5200. Fax: (719)635-9548. Editor: Jay Miller. Circ. 40,000. Estab. 1923. Publication of The United States Figure Skating Association. Monthly magazine. Emphasizes competitive figure skating. Readers are primarily pre-teen and teenage girls who spend up to 15 hours a week skating. Sample copy $3.

Needs: Uses 25 photos/issue; 90% supplied by freelancers. Needs sports action shots of national and world-class figure skaters; also casual, off-ice shots of skating personalities. Model/property release required. Captions preferred; include who, what, when where. Send unsolicited photos by mail for consideration. Send 3½×5, 4×6, 5×7 glossy color prints; 35mm transparencies. Deadlines: 15th of every month. Keeps samples on file. Cannot return material. Reports in 2 weeks. Pays $50/color cover photo; $35/color inside photo; $15/b&w inside photo. Pays on publication. Credit line given. Buys one-time rights; negotiable.

Tips: "We look for a mix of full-body action shots of skaters in dramatic skating poses and tight, close-up or detail shots that reveal the intensity of being a competitor. Shooting in ice arenas can be tricky. Flash units are prohibited during skating competitions, therefore, photographers need fast, zoom lenses that will provide the proper exposure, as well as stop the action."

❦**SKI CANADA**, 117 Indian Rd., Toronto, Ontario M6R 2V5 Canada. (416)538-2293. Fax: (416)538-2475. E-mail: skicanada@shift.com. Editor: Iain MacMillan. Monthly magazine published 7 times/year, September through February. Readership is 65% male, ages 25-44, with high income. Circ. 55,000. Sample copy free with SASE.

Needs: Uses 40 photos/issue; 100% supplied by freelance photographers. Needs photos of skiing—travel (within Canada and abroad), competition, equipment, instruction, news and trends. Model release required; photo captions preferred.

Making Contact & Terms: Send unsolicited photos by mail for consideration. Provide résumé, business card, brochure, flier or tearsheets to be kept on file for possible assignments. Send color and 35mm transparencies. SASE. Reports in 1 month. Pays $100/photo/page; cover $350; rates are for b&w or color. Pays within 30 days of publication. Credit line given. Simultaneous submissions OK.

Tips: "Please request in writing (or by fax), an editorial lineup, available in late fall for the following year's publishing schedule. Areas covered: travel, equipment, instruction, competition, fashion and general skiing stories and news."

SKIPPING STONES: A Multicultural Children's Magazine, P.O. Box 3939, Eugene OR 97403. (541)342-4956. Managing Editor: Arun N. Toke. Circ. 3,000. Estab. 1988. Magazine published 5 times/year. Emphasizes multicultural and ecological issues. Readers are youth ages 8-15, their parents and teachers, schools and libraries. Sample copy $5 (including postage). Photo guidelines free with SASE.

Needs: Uses 25-40 photos/issue; most supplied by freelancers. Needs photos of animals, wildlife, children 8-16, cultural celebrations, international, travel, school/home life in other countries or cultures. Model release preferred. Captions preferred; include site, year, names of people in photo.

Making Contact & Terms: Interested in receiving work from newer, lesser-known photographers. Send unsolicited photos by mail for consideration. Send 4×6, 5×7 glossy color or b&w prints. Keeps samples on file. SASE. Reports in 1 month. Pays contributor's copy; "we're a labor of love." For photo essays; "we provide 5 copies to contributors. Additional copies at a 25% discount. Sometimes, a small honorarium of up to $50. Credit line given. Buys one-time and first North American serial rights; negotiable. Simultaneous submission OK.

Tips: "We publish only b&w. Should you send color photos, choose the ones with good contrast which can translate well into b&w photos. We are seeking meaningful, humanistic and realistic photographs."

SMITHSONIAN, Arts & Industrial Building, 900 Jefferson Dr., Washington DC 20560. Prefers not to share information.

SNOW COUNTRY MAGAZINE, 5520 Park Ave., Trumbull CT 06611. (203)373-7296 Fax: (203)373-7111. E-mail: scountry@msn.com. Photo Editor: Susan Lampe-Wilson. Circ. 465,000. Estab. 1988. Magazine published 8 times/year. Emphasizes skiing, mountain sports and living. Readers are 70% male, 39 years old, professional/managerial with average household income of $90,000. Sample copy $5.

Needs: Uses 90 photos/issue; 95% supplied by freelancers. Needs photos of downhill skiing, cross-country skiing, telemark skiing, snowboarding, mountain biking, in-line skating, hiking, scenic drives, ski area resorts, ice/rock climbing, people profiles, Heli skiing, snowcat skiing, rafting, camping. Special photo needs include good ski area resort shots showing family interaction, scenic drives going into white-capped mountains. Also b&w and color photos to be used as a photo essay feature in each issue. The photos should have a theme and relate to the mountains. Model/property release preferred. Captions preferred.

Making Contact & Terms: Interested in receiving work from newer, lesser-known photographers. Query with stock photo list. Provide résumé, business card, brochure, flier or tearsheets to be kept on

file for possible assignments. Also accepts digital images on CD. Keeps samples on file. SASE. Reports in 1 month. Pays $250/½ day; $400/day; $800/color cover photo; $100-400/color space rate. Pays on publication. Buys first North American serial rights; negotiable. Simultaneous submissions and/or previously published work OK.

Tips: "Looking for unique shots that put our readers in snow country, a place in the mountains."

SOAP OPERA DIGEST, 45 W 25th St., New York NY 10010. (212)229-8400. Fax: (212)645-0683. Editor-in Chief: Lynn Leahey. Art Director: Catherine Connors. Photo Editor: Tammy Roth. Circ. 1 million. Estab. 1975. Biweekly. Emphasizes daytime and nighttime TV serial drama. Readers are mostly women, all ages. Sample copy free with 5×7 SAE and 3 first-class stamps.

Needs: Needs photos of people who appear on daytime and nighttime TV soap operas; special events in which they appear. Uses mostly color and some b&w photos.

Making Contact & Terms: Interested in receiving work from new photographers. Query with résumé of credits to photo editor. Provide business card and promotional material to be kept on file for possible future assignments. SASE. Reports in 1 month. Pays $50-175/b&w photo; $100-400/color photo; $350-1,000/complete package. Pays on publication. Credit line given. Buys all rights; negotiable.

Tips: "Have photos of the most popular stars and of good quality." Sharp color quality is a must. "I look for something that's unusual in a picture, like a different pose instead of head shots. We are not interested in people who happened to take photos of someone they met. Show variety of lighting techniques and creativity in your portfolio."

***SOARING SPIRIT**, (formerly *Master of Life Winners*), P.O. Box 38, Malibu CA 90265. Editor: Dick Sutphen. Art Director: Jason D. McKean. Circ. 120,000. Estab. 1976. Quarterly magazine. Emphasizes metaphysical, psychic development, reincarnation, self-help with tapes. Everyone receiving the magazine has attended a Sutphen Seminar or purchased Valley of the Sun Publishing books or tapes from a line of over 300 titles: video and audio tapes, subliminal/hypnosis/meditation/New Age music/seminars on tape, etc. Sample copy free with 12×15 SAE and 5 first-class stamps.

Needs: "We purchase about 20 photos per year for the magazine and also for cassette album covers, videos and CDs. We are especially interested in surrealistic photography which would be used as covers, to illustrate stories and for New Age music cassettes. Even seminar ads often use photos that we purchase from freelancers." Model release required.

Making Contact & Terms: Interested in receiving work from newer, lesser-known photographers. Send b&w and color prints; 35mm transparencies by mail for consideration. SASE. Reports in 2 weeks. Pays $100/color photo; $50/b&w photo. Pays on publication. Credit line given if desired. Buys one-time rights; negotiable. Simultaneous submissions and previously published work OK.

SOCCER MAGAZINE, 5211 S. Washington Ave., Titusville FL 32780. (407)268-5010. Fax: (407)267-1894. Photo Editor: J. Brett Whitesell. Circ. 30,000. Estab. 1993. Magazine published 9 times/year. Emphasizes soccer. Readers are male and female, ages 15-50, players, fans, coaches, officials. Photo guidelines free with SASE.

Needs: Uses 45-50 photos/issue; 25-30% supplied by freelancers. Needs photos of game action. Reviews photos purchased with accompanying ms only. Captions required; include player identification, event.

Making Contact & Terms: Provide résumé, business card, brochure, flier or tearsheets to be kept on file for possible assignments. Keeps samples on file. SASE. Reports in 2 weeks. Pays $300/color cover photo; $75-100/color inside photo; $50/b&w inside photo; photo/text package rate negotiated. Pays on publication. Credit line given. buys one-time rights.

Tips: "The photographers I use know the sport of soccer. They are not just sports photographers. I will know the difference. I use photographer's files who keep me informed on events they are covering. Rarely do I give specific assignments. Those that are given out go to proven photographers."

SOCIETY, Rutgers University, New Brunswick NJ 08903. (201)932-2280. Fax: (201)932-3138. Editor: Irving Louis Horowitz. Circ. 31,000. Estab. 1962. Bimonthly magazine. Readers are interested in the understanding and use of the social sciences and new ideas and research findings from sociology, psychology, political science, anthropology and economics. Free sample copy and photo guidelines.

Needs: Buys 75-100 photos/annually. Human interest, photo essay and documentary. Needs photo essays—"no random photo submissions." Essays (brief) should stress human interaction; photos

THE ASTERISK before a listing indicates that the market is new in this edition. New markets are often the most receptive to freelance submissions.

should be of people interacting (not a single person) or of natural surroundings. Include an accompanying explanation of photographer's "aesthetic vision."

Making Contact & Terms: Send 8×10 b&w glossy prints for consideration. SASE. Reports in 3 months. Pays $250/photo essay. Pays on publication. Buys all rights to one-time usage.

SOLDIER OF FORTUNE MAGAZINE, P.O. Box 693, Boulder CO 80306. (303)449-3750. Editor: Dwight Swift. Deputy Editor: Tom Reisinger. Monthly magazine. Emphasizes adventure, combat, military units and events. Readers are mostly male—interested in adventure and military related subjects. Circ. 175,000. Estab. 1975. Sample copy $5.

Needs: Uses about 60 photos/issue; 33% on assignment, 33% from stock. Needs photos of combat—under fire, or military units, military—war related. "We always need front-line combat photography." Not interested in studio or still life shots. Model/property release preferred. Captions required; "include as much tech information as possible."

Making Contact & Terms: Contact Tom Reisinger by phone with queries; send 8×10 glossy b&w, color prints, 35mm transparencies, b&w contact sheets by mail for consideration. SASE. Reports in 3 weeks. Pays $50-150/b&w photo; $50-500/color cover; $150-2,000/complete job. Will negotiate a space-rate payment schedule for photos alone. **Pays on acceptance.** Credit line given. Buys one-time rights.

Tips: "Combat action photography gets first consideration for full-page and cover layouts. Photo spreads on military units from around the world also get a serious look, but stay away from 'man with gun' shots. *Give us horizontals and verticals!* The horizontal-shot syndrome handcuffs our art director. *Get close!* Otherwise, use telephoto. Too many photographers send us long distance shots that just don't work for our audience. *Give us action!* People sitting, or staring into the lens, mean nothing. *Consider using b&w* along with color. It gives us options in regard to layout; often, b&w better expresses the combat/military dynamic."

SOUTHERN BOATING, 1766 Bay Rd., Miami Beach FL 33139. (305)538-0700. Executive Editor: David Strickland. Circ. 30,000. Estab. 1972. Monthly magazine. Emphasizes "boating (mostly power, but also sail) in the southeastern US and the Caribbean." Readers are "concentrated in 30-50 age group; male and female; affluent—executives mostly." Sample copy $4.

Needs: Number of photos/issue varies; all supplied by freelancers. Needs "photos to accompany articles about cruising destinations, the latest in boats and boat technology, boating activities (races, rendezvous); cover photos of a boat in a square format (a must) in the context of that issue's focus (see editorial calendar)." Model release preferred. Captions required.

Making Contact & Terms: Query with list of stock photo subjects. SASE. Reporting time varies. Pays $150 minimum/color cover photo; $50 minimum/color inside photo; $25 minimum/b&w inside photo; $75-150/photo/text package. Pays on publication. Credit line given. Buys one-time rights. Simultaneous submissions and previously published work OK.

Tips: "Photography on the water is very tricky. We are looking for first-rate work, preferably Kodachrome or Fujichrome, and prefer to have story *and* photos together, except in the case of cover material."

SOUTHERN EXPOSURE, P.O. Box 531, Durham NC 27702. (919)419-8311. Fax: (919)419-8315. Editor: Pat Arnow. Estab. 1972. Quarterly. Emphasizes the politics and culture of the South, with special interest in women's issues, African-American affairs and labor. Sample copy $5 with 9×12 SASE. Photo guidelines free with SASE.

Needs: Uses 30 photos/issue; most supplied by freelance photographers. Needs news and historical photos; photo essays. Model/property release preferred. Captions required.

Making Contact & Terms: Interested in receiving work from newer, lesser-known photographers. Query with samples. Send glossy b&w prints by mail for consideration. SASE. Reports in 6 weeks. Pays $25-100/color photo; $100/color cover photo; $25-50/b&w inside photo. Pays on publication. Credit line given. Buys all rights "unless the photographer requests otherwise." Simultaneous submissions and previously published work OK.

SPARE TIME MAGAZINE, 5810 W. Oklahoma Ave., Milwaukee WI 53219. (414)543-8110. Fax: (414)543-9767. Publisher: Dennis Wilk. Circ. 301,500. Estab. 1955. Published 11 times yearly (monthly except July). Emphasizes income-making opportunities. Readers are income opportunity seekers with small capitalization. People who want to learn new techniques to earn extra income. Sample copy $2.50 with 9 first-class stamps.

• *Spare Time Magazine* has increased its publication from 9 to 11 issues.

Needs: Uses one photo/issue. Needs photos that display money-making opportunities. Model/property release required.

Making Contact & Terms: Interested in receiving work from newer, lesser-known photographers. Send unsolicited photos by mail for consideration. Send color or b&w prints; 2¼×2¼ transparencies. Keeps samples on file. Contacts photographer if photo accepted. Pays $15-50/color or b&w photo. Pays

on publication. Buys one-time rights, all rights; negotiable. Simultaneous submissions and previously published work OK.

SPORT FISHING, 330 W. Canton, Winter Park FL 32789. (407)628-4802. Fax: (407)628-7061. E-mail: sportfsh@gate.net. Website: sportsfsh@gate.net. Photo Editor: Doug Olander. Circ. 110,000 (paid). Estab. 1986. Publishes 9 issues/year. Emphasizes off-shore fishing. Readers are upscale boat owners and off shore fishermen. Sample copy $2.50 with 9×12 SAE and 6 first-class stamps. Photo guidelines free with SASE.
Needs: Uses 50 photos/issue; 85% supplied by freelance photographers. Needs photos of salt water fish and fishing—especially big boats/big fish, action shots. "We are working more from stock—good opportunities for extra sales on any given assignment." Model release preferred; releases needed for subjects (under "unusual" circumstances) in photo. Captions preferred.
Making Contact & Terms: Interested in receiving work from newer, lesser-known photographers. Query with samples. Send unsolicited photos by mail for consideration. Provide résumé, business card, brochure, flier or tearsheets to be kept on file for possible future assignments. Send 35mm, 2¼×2¼ and 4×5 transparencies by mail for consideration. "Kodachrome 64 and Fuji 100 are preferred." Also accepts digital images. Reports in 3 weeks. Pays $20-100/b&w page; $50-500/color page; $750/cover; $50-200/b&w or color photo. Buys one-time rights unless otherwise agreed upon.
Tips: "Tack-sharp focus critical; avoid 'kill' shots of big game fish, sharks; avoid bloody fish in/at the boat. The best guideline is the magazine itself. Get used to shooting on, in or under water. Most of our needs are found there. If you have first rate photos and questions: call."

SPORTS CARD TRADER, 5 Nassau Blvd. S., Garden City South NY 11530. (516)292-6000. Fax: (516)292-6007. Editor: Doug Kale. Circ. 225,000. Estab. 1990. Monthly magazine. Emphasizes baseball cards, basketball, football, hockey sports cards, memorabilia, all sports. Readers are male ages 9-99. Free sample copy.
Needs: Uses 1-2 photos/issue; all supplied by freelancers. Needs photos of studio shots, action shots. Model/property release required.
Making Contact & Terms: Interested in receiving work from newer, lesser-known photographers. Send unsolicited photos by mail for consideration. Send 8×10 glossy color prints. Keeps samples on file. Cannot return material. Reports in 2 weeks. Pays $100-150/job. Pays on publication. Credit line given. Buys all rights; negotiable. Simultaneous submissions OK.

SPORTS ILLUSTRATED, Time Life Building, 1271 Avenue of the Americas, New York NY 10020. Prefers not to share information.

SPOTLIGHT MAGAZINE, 126 Library Lane, Mamaroneck NY 10543. (914)381-4740. Fax: (914)381-4641. Publisher: Susan Meadow. Circ. 500,000. Monthly magazine. Readers are largely upscale, about 60% female. Sample copy $2.50.
Needs: Uses 25-30 photos/issue; 5-10 supplied by freelancers. Model release required. Captions required.
Making Contact & Terms: Interested in receiving work from newer, lesser-known photographers. Query with résumé of credits. Also accepts digital files on SyQuest disk in TIFF format. Keeps samples on file. SASE. Reports in 1 month. Pays $25-75/photo. Pays on publication. Credit line given. Buys all rights "but flexible on reuse."

***SPY**, Sussex Publishers, 49 E. 21st St., 11th Floor, New York NY 10010. (212)260-3214. Fax: (212)260-7445. Photo Editor: Jennifer Lipshy. Estab. 1992. Bimonthly magazine. Readers are male and female, highly educated, active professionals. Photo guidelines free with SASE.
● Sussex also publishes *Mother Earth News* and *Psychology Today* listed in this section.
Needs: Uses 19-25 photos/issue; all supplied by freelancers. Needs photos of humor, photo montage, symbolic, environmental, portraits, conceptual. Model/property release preferred.
Making Contact & Terms: Interested in receiving work from "upcoming" photographers. Submit portfolio for review. Send promo card with photo. Also accepts Mac files. Call before you drop off portfolio. Keeps samples on file. Cannot return material. Reports back only if interested. For assignments, pays $1,000/cover plus expenses; $350-750/inside photo plus expenses; for stock, pays $150/¼ page; $300/full page.

STAR, 660 White Plains Rd., Tarrytown NY 10591. (914)332-5000. Editor: Phillip Bunton. Photo Director: Alistair Duncan. Circ. 2.8 million. Weekly. Emphasizes news, human interest and celebrity stories. Sample copy and photo guidelines free with SASE.
Needs: Uses 100-125 photos/issue; 75% supplied by freelancers. Reviews photos with or without accompanying ms. Model release preferred. Captions required.
Making Contact & Terms: Interested in receiving work from newer, lesser-known photographers. Query with samples and with list of stock photo subjects. Send 8×10 b&w prints; 35mm, 2¼×2¼

transparencies by mail for consideration. SASE. Reports in 2 weeks. NPI. Pays on publication. Credit line sometimes given. Simultaneous submissions and previously published work OK.

THE STATE: Down Home in North Carolina, 128 S. Tryon St., Suite 2200, Charlotte NC 28202. (704)371-3268. Editor: Scott Smith. Circ. 25,000. Estab. 1933. Monthly magazine. Regional publication, privately owned, emphasizing travel, history, nostalgia, folklore, humor, all subjects regional to North Carolina for residents of, and others interested in, North Carolina. Sample copy $3. "Send for our photography guidelines."

Needs: Freelance photography used; 5% assignment and 5% stock. Photos on travel, history and human interest in North Carolina. Captions required.

Making Contact & Terms: Send material by mail for consideration. Uses 5×7 and 8×10 glossy b&w prints; also glossy color prints and slides. Uses b&w and color cover photos, vertical preferred. SASE. Pays $25/b&w photo; $25-150/cover photo; $125-150/complete job. Credit line given. Pays on publication.

Tips: Looks for "North Carolina material; solid cutline information."

STOCK CAR RACING MAGAZINE, 47 S. Main St., P.O. Box 715, Ipswich MA 01938. (508)356-7030. Fax: (508)356-2492. Editor: Dick Berggren. Circ. 400,000. Estab. 1966. Monthly magazine. Emphasizes all forms of stock car competition. Read by fans, owners and drivers of race cars and those with racing businesses. Photo guidelines free with SASE.

Needs: Buys 50-70 photos/issue. Documentary, head shot, photo essay/photo feature, product shot, personality, crash pictures, special effects/experimental, technical and sport. No photos unrelated to stock car racing. Photos purchased with or without accompany ms and on assignment. Model release required unless subject is a racer who has signed a release at the track. Captions required.

Making Contact & Terms: Send material by mail for consideration. Uses 8×10 glossy b&w prints; 35mm or 2¼×2¼ transparencies. Kodachrome 64 or Fuji 100 preferred. Pays $35-250/color photo; $250/cover photo. Pays on publication. Credit line given. Buys one-time rights.

Tips: "Send the pictures. We will buy anything that relates to racing if it's interesting, if we have the first shot at it, and it's well printed and exposed. Eighty percent of our rejections are for technical reasons—poorly focused, badly printed, too much dust, picture cracked, etc. We get far fewer cover submissions than we would like. We look for full-bleed cover verticals where we can drop type into the picture and position our logo."

STRAIGHT, 8121 Hamilton Ave., Cincinnati OH 45231. (513)931-4050. Fax: (513)931-0904. Editor: Heather E. Wallace. Circ. 35,000. Estab. 1950. Weekly. Readers are ages 13-19, mostly Christian; a conservative audience. Sample copy free with SASE and 2 first-class stamps. Photo guidelines for SASE.

Needs: Uses about 4 photos/issue; all supplied by freelance photographers. Needs color photos of teenagers involved in various activities such as sports, study, church, part-time jobs, school activities, classroom situations. Outside nature shots, groups of teens having good times together are also needed. "Try to avoid the sullen, apathetic look—vital, fresh, thoughtful, outgoing teens are what we need. Any photographer who submits a set of quality color transparencies for our consideration, whose subjects are teens in various activities and poses, has a good chance of selling to us. This is a difficult age group to photograph without looking stilted or unnatural. We want to purport a clean, healthy, happy look. No smoking, drinking or immodest clothing. We especially need masculine-looking guys and minority subjects." Submit photos coinciding with the seasons (i.e., winter scenes in December through February, spring scenes in March through May, etc.). Model release required. Photo captions preferred.

Making Contact & Terms: Interested in receiving work from newer, lesser-known photographers. Send color transparencies by mail for consideration. Enclose sufficient packing and postage for return of photos. Reports in 6 weeks. Pays $75-125/color photo. **Pays on acceptance.** Credit line given. Buys one-time rights. Simultaneous submissions and previously published work OK.

Tips: "Our publication is almost square in shape. Therefore, 5×7 or 8×10 prints that are cropped closely will not fit our proportions. Any photo should have enough 'margin' around the subject that it may be cropped square. This is a simple point, but absolutely necessary. Look for active, contemporary teenagers with light backgrounds for photos. For our publication, keep up with what teens are interested in. Subjects should include teens in school, church, sports and other activities. Although our rates may be lower than the average, we try to purchase several photos from the same photographer to help absorb mailing costs. Review our publication and get a feel for our subjects."

SUMMIT, The Mountain Journal, P.O. Box 182, Boulder CO 80306. Editor: Sally Moser. Circ. 30,000. Estab. 1990. Quarterly magazine. Features news related to the world of mountains. Readers are mostly male professionals, ages 35-45. Sample copy for $6 with 10×13 SAE and 7 first-class stamps.

Needs: Uses up to 40 photos/issue; all supplied by freelancers. Needs "landscape shots of mountains, flowers, mountain people, animals and mountain environments from all over the world. All imagery must have strong interpretative element as well as being graphically powerful. Both abstract and figurative photos welcome." Photos must be high-quality b&w or color only. Model release preferred (when applicable). Captions required.

Making Contact & Terms: Interested in receiving work from newer, lesser-known photographers. Query with list of stock photo subjects. Provide résumé, business card, brochure, flier or tearsheets to be kept on file for possible assignment. Reports in 3 weeks. NPI. Pays on publication. Credit line given. Buys one-time rights.

THE SUN, 107 N. Roberson, Chapel Hill NC 27516. (919)942-5282. Editor: Sy Safransky. Circ. 25,000. Estab. 1974. Monthly magazine. Sample copy $3.50. Photo guidelines free with SASE.
 • *The Sun* has doubled its payment.
Needs: Uses about 8 photos/issue; all supplied by freelance photographers. Model release preferred.
Making Contact & Terms: Interested in receiving work from newer, lesser-known photographers. Send cover letter and b&w prints by mail for consideration. SASE. Reports in 2 months. Pays $50-200/ b&w cover and inside photos. Pays on publication. Credit line given. Buys one-time rights; negotiable. Previously published work OK.
Tips: Looks for "artful and sensitive photographs that are not overly sentimental. We use many photos of people. All the photographs we publish come to us as unsolicited submissions."

***SUNFLOWER BOTANICAL PHOTO MAGAZINE**, P.O. Box 19002, Lenexa KS 66285-9002. (316)343-7162. Fax: (316)343-7249. E-mail: botatogra@aol.com. Editor: Amy Bersh. Circ. 11,000. Estab. 1994. Quarterly newsletter. Emphasizes botanicals. Readers are male and female, ages 25-60. Sample copy free with #10 SASE. Photo guidelines available.
Needs: Uses 4-10 photos/issue; all supplied by freelancers. Needs floral and botanical photos. Model/ property release required. Photo captions preferred.
Making Contact & Terms: Interested in receiving work from newer, lesser-known photographers. Query with résumé of credits. Send unsolicited photos by mail for consideration. Send 35mm, 2¼×2¼, 4×5 transparencies. Does not keep samples on file. Cannot return material. Reports in 1 month. NPI. Pays on publication. Credit line given. Buys one-time rights. Simultaneous submissions OK.

SUPER FORD, 3816 Industry Blvd., Lakeland FL 33811. (941)644-0449. Managing Editor: Steve Turner. Circ. 65,000. Estab. 1977. Monthly magazine. Emphasizes high-performance Ford automobiles. Readers are males, ages 18-40, all occupations. Sample copy free with 11×14 SASE and 8 first-class stamps.
Needs: Uses 75 photos/issue; 30-40 supplied by freelancers. Needs photos of high performance Fords. Model/property release preferred. Captions required.
Making Contact & Terms: Interested in receiving work from newer, lesser-known photographers. Send unsolicited photos by mail for consideration. Provide résumé, business card, brochure, flier or tearsheets to be kept on file for possible assignments. Send 5×7 glossy color or b&w prints; 35mm, 2¼×2¼ transparencies. Does not keep samples on file. SASE. Reports in 1 month, "can be longer." Pays $200/day; $65/color inside photo; $45/b&w inside photo. Pays on publication. Credit line given. Buys one-time rights; negotiable.
Tips: "Do not park/pose cars on grass."

SURFING MAGAZINE, P.O. Box 3010, San Clemente CA 92672. (714)492-7873. Photo Editor: Larry Moore. Monthly magazine. Circ. 120,000. Emphasizes "surfing and bodyboarding action and related aspects of beach lifestyle. Travel to new surfing areas covered as well. Average age of readers is 18 with 92% being male. Nearly all drawn to publication due to high quality, action packed photographs." Free photo guidelines with SASE. Sample copy free with legal size SAE and 9 first-class stamps.
Needs: Uses about 80 photos/issue; 35% supplied by freelance photographers. Needs "in-tight, front-lit surfing and bodyboarding action photos as well as travel-related scenics. Beach lifestyle photos always in demand."
Making Contact & Terms: Send by mail for consideration 35mm or 2¼×2¼ transparencies; b&w contact sheet and negatives. SASE. Reports in 1 month. Pays $750/color cover photo; $30-225/color inside photo; $20-100/b&w inside photo; $600/color poster photo. Pays on publication. Credit line given. Buys one-time rights.
Tips: Prefers to see "well-exposed, sharp images showing both the ability to capture peak action as well as beach scenes depicting the surfing and bodyboarding lifestyle. Color, lighting, composition and proper film usage are important. Ask for our photo guidelines prior to making any film/camera/ lens choices."

SWANK, 210 Route 4 East, Paramus NJ 07652. (201)843-4004. Fax: (201)843-8636. Circ. 350,000. Estab. 1954. Published 13 times a year magazine. Emphasizes adult entertainment. Readers are mostly male of all backgrounds, ages 22 to 55. Sample copy $5.95. Photo guidelines free with SASE.
Needs: Needs photos of new models for explicit, all nude photo shoots. Reviews photos with or without a manuscript. Model/property release required.
Making Contact & Terms: Send unsolicited photos by mail for consideration. Send color prints, 35mm transparencies. SASE. Reports in 2 weeks. Average pay for one set $1,800. Rates vary. Pays on publication. Buys all rights.
Tips: "We mostly work with established erotic photographers, but always looking for new talent. Make sure there are enough photos submitted for us to have a good idea of your ability."

TAMPA REVIEW, The University of Tampa, 19F, Tampa FL 33606-1490. (813)253-3333, ext. 6266. Editor: Richard B. Mathews. Circ. 500. Estab. 1988. Semiannual literary magazine. Emphasizes literature and art. Readers are intelligent, college level. Sample copy $5. Photo guidelines free with SASE.
 • *Tampa Review* currently reproduces all images via in-house scans, stores images on SyQuest removable hard disks and color-corrects or retouches with Photoshop.
Needs: Uses 6 photos/issue; 100% supplied by freelancers. Needs photos of artistic, museum-quality images. Photographer must hold right, or release. "We have our own release form if needed." Photo captions required.
Making Contact & Terms: Interested in receiving work from newer, lesser-known photographers. Provide résumé, business card, brochure, flier or tearsheets to be kept on file for possible assignments. Send b&w, color prints "suitable for vertical 6×8 or 6×9 reproduction." SASE. Reports by end of April. Pays $10/image. Pays on publication. Credit line given. Buys first North American serial rights.
Tips: "We are looking for artistic photography, not for illustration, but to generally enhance our magazine. We will consider paintings, prints, drawings, photographs, or other media suitable for printed reproduction. Submissions should be made in February and March for publication the following year."

TENNIS WEEK, 341 Madison Ave., New York NY 10017. (212)808-4750. Publisher: Eugene L. Scott. Managing Editors: Heather Holland, Kim Kodl and Merrill Shafer. Circ. 80,000. Biweekly. Readers are "tennis fanatics." Sample copy $3.
Needs: Uses about 16 photos/issue. Needs photos of "off-court color, beach scenes with pros, social scenes with players, etc." Emphasizes originality. Subject identification required.
Making Contact & Terms: Send actual 8×10 or 5×7 b&w photos by mail for consideration. SASE. Reports in 2 weeks. Pays $25/b&w photo; $50/cover; $100/color cover. Pays on publication. Credit line given. Rights purchased on a work-for-hire basis.

TEXAS FISH & GAME, 7600 W. Tidwell, Suite 708, Houston TX 77040. (713)690-3474. Fax: (713)690-4339. Editor: Marvin Spivey. Circ. 120,000. Estab. 1983. Magazine published 10 times/year; November/December and June/July are double issues. Features all types of hunting and fishing. Must be Texas only. Photo guidelines free with SASE.
Needs: Uses 20-30 photos/issue; 95% supplied by freelance photographers. Needs photos of fish: action, close up of fish found in Texas; hunting: Texas hunting and game of Texas. Model release preferred. Captions required.
Making Contact & Terms: Interested in receiving work from newer, lesser-known photographers. Query with list of stock photo subjects. SASE. Reports in 1 month. Pays $200-300/color cover photo and $50-100/color inside photos. Pays on publication. Credit line given. Buys one-time rights.
Tips: "Query first. Ask for guidelines. No b&w used. For that 'great' shot, prices will go up. Send best shots and only subjects the publication you're trying to sell uses."

TEXAS GARDENER, P.O. Box 9005, Waco TX 76714. (817)772-1270. Fax: (817)772-9696. Editor/Publisher: Chris S. Corby. Circ. 35,000. Bimonthly. Emphasizes gardening. Readers are "65% male, home gardeners, 98% Texas residents." Sample copy $2.95.
Needs: Uses 20-30 photos/issue; 90% supplied by freelance photographers. Needs "color photos of gardening activities in Texas." Special needs include "cover photos shot in vertical format. Must be taken in Texas." Model release preferred. Captions required.
Making Contact & Terms: Query with samples. SASE. Reports in 3 weeks. Pays $100-200/color cover photo; $5-15/b&w inside photo; $25-100/color inside photo. Pays on publication. Credit line given. Buys one-time rights.
Tips: "Provide complete information on photos. For example, if you submit a photo of watermelons growing in a garden, we need to know what variety they are and when and where the picture was taken. Also, ask for a copy of our editorial calendar. Then use it in selecting images to send us on speculation."

TEXAS HIGHWAYS, P.O. Box 141009, Austin TX 78714. (512)483-3675. Editor: Jack Lowry. Photo Editor: Michael A. Murphy. Circ. 430,000. Monthly. *"Texas Highways* interprets scenic, recreational, historical, cultural and ethnic treasures of the state and preserves the best of Texas heritage. Its purpose is to educate and entertain, to encourage recreational travel to and within the state, and to tell the Texas story to readers around the world." Readers are 45 and over (majority); $24,000 to $60,000/year salary bracket with a college education. Sample copy and photo guidelines free.
Needs: Uses about 60-70 photos/issue; 50% supplied by freelance photographers. Needs "travel and scenic photos in Texas only." Special needs include "fall, winter, spring and summer scenic shots and wildflower shots (Texas only)." Captions required; include location, names, addresses and other useful information.
Making Contact & Terms: Interested in receiving work from newer, lesser-known photographers. Query with samples. Provide business card and tearsheets to be kept on file for possible future assignments. "We take only color originals, 35mm or larger transparencies. No negatives." SASE. Reports in 1 month. Pays $120/half-page color inside photo; $170/full-page color photo; $400/front cover photo. Pays on publication. Credit line given. Buys one-time rights. Simultaneous submissions OK.
Tips: "Know our magazine and format. We accept only high-quality, professional level work—no snapshots. Interested in a photographer's ability to edit their own material and the breadth of a photographer's work. Look at 3-4 months of the magazine. Query not just for photos but with ideas for new/unusual topics."

TEXAS MONTHLY, P.O. Box 1569, Austin TX 78767. Prefers not to share information.

THANATOS, P.O. Box 6009, Tallahassee FL 32314. (904)224-1969. Fax: (904)224-7965. Editor: Jan Scheff. Circ. 6,000. Estab. 1975. Quarterly journal. Covers death, dying and bereavement. Readers include health-care professionals, thanatologists, clergy, funeral directors, counselors, support groups, volunteers, bereaved family members, students, et al. Photo guidelines free with SASE.
Needs: Uses 6 photos/issue; all supplied by freelancers. Needs many b&w scenic and people shots to accompany articles. Also, full-color scenics to illustrate seasons for each quarterly edition. Model release required. Captions preferred.
Making Contact & Terms: Query with list of stock photo subjects. Provide résumé, business card, brochure, flier or tearsheets to be kept on file for possible assignment. Cannot return material. Reports in 1 month. Pays $100/color cover photo; $50/b&w inside photo. Buys all rights. Simultaneous submissions OK.

***THIS: A SERIAL REVIEW**, 6600 Clough Pike, Cincinnati OH 45244-4090. Fine Arts Editor: Phillip Roberto. Estab. 1994. Literary/arts quarterly magazine. Emphasizes poetry, fiction, essays, reviews, photography, art, design. Sample copy $7. Photo guidelines free with SASE.
Needs: "We seek submissions of black and white photography."
Making Contact & Terms: Interested in receiving work from newer, lesser-known photographers. Send unsolicited photos by mail for consideration. Uses 35mm transparencies. Does not keep samples on file. SASE Reports in 2-4 months. Pays 1 copy of issue in which photo appeared. Rights negotiable. Simultaneous submissions OK.

THRASHER MAGAZINE, P.O. Box 884570, San Francisco CA 94188-4570. (415)822-3083. Fax: (415)822-8359. Photo Editor: Bryce Kanights. Circ. 250,000. Estab. 1981. Monthly magazine. Emphasizes skateboarding, snowboarding and alternative music. Readers are primarily male between ages 12-24. Sample copy $3.25. Photo guidelines free with SASE.
 • *Thrasher* scans 35mm b&w negatives and color transparencies in-house and uses Photoshop 3.0 to correct color, density and manipulate images to be published.
Needs: Uses 55 photos/issue; 20 supplied by freelancers. Needs photos of skateboarding, snowboarding and alternative music. Reviews photos with or without a manuscript. Special needs are b&w action sequences. Model/property release preferred; release needed for minors. Captions preferred; include name of subject, location and date of shoot.
Making Contact & Terms: Interested in receiving work from newer, lesser-known photographers. Send unsolicited photos by mail for consideration. Send 5×7, 8×10 b&w prints; 35mm, 2¼×2¼ transparencies. Keeps samples on file. SASE. Reports in 2 weeks. Pays $250/color cover photo; $200/b&w cover photo; $65/color inside photo; $50/b&w inside photo; $110/color page rate; $85/b&w page rate. Pays on publication. Credit line given. Buys all rights.
Tips: "Get to know the sports of skateboarding and snowboarding, the lifestyles and current trends."

TIDE MAGAZINE, 4801 Woodway, Suite 220 W, Houston TX 77056. (713)626-4222. Fax: (713)961-3801. Editor: Doug Pike. Circ. 45,000. Estab. 1979. Publication of the Coastal Conservation Association. Bimonthly magazine. Emphasizes coastal fishing, conservation issues. Readers are mostly male, ages 25-50, coastal anglers and professionals.

Needs: Uses 16-20 photos/issue; 12-16 supplied by freelancers. Needs photos of Gulf and Atlantic coastal activity, recreational fishing and coastal scenics, tight shots of fish (saltwater only). Model/property release preferred. Captions not required, but include names, dates, places and specific equipment or other key information.
Making Contact & Terms: Interested in receiving work from newer, lesser-known photographers. Query with stock photo list. SASE. Reports in 1 month. Pays $100/color cover photo; $50/color inside photo; $25/b&w inside photo; $250/photo/text package. Pays on publication. Credit line given. Buys one-time rights; negotiable. Simultaneous submissions and/or previously published work OK.
Tips: Wants to see "fresh twists on old themes—unique lighting, subjects of interest to my readers. Take time to discover new angles for fishing shots. Avoid the usual poses, i.e. man holding fish. We see too much of that already."

TIME, Time/Life Building, 1271 Avenue of the Americas, New York NY 10020. Prefers not to share information.

TODAY'S MODEL, P.O. Box 205-454, Brooklyn NY 11220. (718)439-0889. Fax: (718)439-0226. Publisher: Sumit Arya. Circ. 100,000. Estab. 1993. Monthly newspaper. Emphasizes modeling and performing arts. Readers are male and female ages 13-28, parents of kids 1-12. Sample copy $3 with 9×12 SAE and 10 first-class stamps.
Needs: Uses various number photos/issue. Needs photos of fashion—studio/on location/runway; celebrity models, performers, beauty and hair—how-to; photojournalism—modeling, performing arts. Reviews photos with or without ms. Needs models of all ages. Model/property release required. Captions preferred; include name and experience (résumé if possible).
Making Contact & Terms: Interested in receiving work from newer, lesser-known photographers. Provide résumé, business card, brochure, flier or tearsheets to be kept on file for possible future assignments. Keeps samples on file. Reports only when interested. NPI. Pays on publication. Buys all rights; negotiable. Considers simultaneous submissions and/or previously published work.

TODAY'S PHOTOGRAPHER INTERNATIONAL, P.O. Box 18205, Washington DC 20036. (910)945-9867. Photography Editor: Vonda H. Blackburn. Circ. 131,000. Estab. 1986. Bimonthly magazine. Emphasizes making money with photography. Readers are 90% male photographers. For sample copy, send 9×12 SAE. Photo guidelines free with SASE.
Needs: Uses 40 photos/issue; all supplied by freelance photographers. Model release required. Photo captions preferred.
Making Contact & Terms: Send 35mm, 2¼×2¼, 4×5, 8×10 b&w and color prints or transparencies by mail for consideration. SASE. Reports at end of the quarter. NPI; payment negotiable. Credit line given. Buys one-time rights, per contract. Simultaneous submissions and previously published work OK.
Tips: Wants to see "consistently fine-quality photographs and good captions or other associated information. Present a portfolio which is easy to evaluate—keep it simple and informative. Be aware of deadlines. Submit early."

TODAY'S TRAVELER, 68 E. Wacker Place, Suite 800, Chicago IL 60601. (312)853-4775. Fax (312)782-7367. Associate Editor: Lisa Smith. Circ. 65,000. Estab. 1991. Bimonthly magazine. Emphasizes travel. Readers are of all ages and backgrounds. Sample $4 with 9×12 SASE. Photo guidelines free with SASE.
Needs: Uses 40-50 photos; 20-25 supplied by freelancers. Needs photos of travel, scenics, personalities, how-to (i.e., how to pack luggage; how to dress for certain climates, cruises, safaris, etc.). Model release required for children, close-up shots of people; celebrities. Property release preferred. Captions preferred.
Making Contact & Terms: Interested in receiving work from newer, lesser-known photographers. Query with résumé of credits, stock photo list. Provide résumé, business card, brochure, flier or tearsheets to be kept on file for possible assignments. Does not keep samples on file. SASE. Reports in 1 month. Pays $500-1,000/color cover photo. **Pays on acceptance**. Credit line given. Buys first North American serial rights; negotiable. Previously published work OK.
Tips: Looking for photo essays, character studies, candid shots, mood shots, unusual angles, creativity, action shots. "Since we are relatively new and small in size, we naturally look for highly creative people who do not command high fees. We want people who are willing to grow with us."

THE SUBJECT INDEX, located at the back of this book, can help you find publications interested in the topics you shoot.

***TOTAL TV**, 475 Fifth Ave., New York NY 10017. (212)683-6116, ext. 328. Fax: (212)683-8051. Photo Editor: Cherie Cincilla. Weekly magazine. Emphasizes movie and TV personalities, sports figures, musicians, nature.
• *Total TV* is online on Prodigy and launched its own Website in January '96.
Needs: Uses 30 photos/issue; all supplied by freelancers. Needs photos of personalities or TV and movie coverage. Reviews photos with or without ms. Model/property release preferred. Captions preferred.
Making Contact & Terms: Interested in receiving work from newer, lesser-known photographers. Accepts digital files in SyQuest. SASE. Reports in 1-2 weeks. Pays $75 minimum/photo (b&w or color); $500-2,000/job. **Pays on acceptance.** Credit line given. Simultaneous submissions and/or previously published work OK.

TRACK AND FIELD NEWS, 2570 El Camino Real, Suite 606, Mountain View CA 94040. (415)948-8417. Fax: (415)948-9445. Associate Editor (Features/Photography): Jon Hendershott. Circ. 35,000. Estab. 1948. Monthly magazine. Emphasizes national and world-class track and field competition and participants at those levels for athletes, coaches, administrators and fans. Sample copy free with 9×12 SAE. Free photo guidelines.
Needs: Buys 10-15 photos/issue; 75% of freelance photos on assignment, 25% from stock. Wants on a regular basis, photos of national-class athletes, men and women, preferably in action. "We are always looking for quality pictures of track and field action as well as offbeat and different feature photos. We always prefer to hear from a photographer before he/she covers a specific meet. We also welcome shots from road and cross-country races for both men and women. Any photos may eventually be used to illustrate news stories in *T&FN*, feature stories in *T&FN* or may be used in our other publications (books, technical journals, etc.). Any such editorial use will be paid for, regardless of whether material is used directly in *T&FN*. About all we don't want to see are pictures taken with someone's Instamatic or Polaroid. No shots of someone's child or grandparent running. Professional work only." Captions required; include subject name, meet date/name.
Making Contact & Terms: Interested in receiving work from newer, lesser-known photographers. Query with samples or send material by mail for consideration. Uses 8×10 glossy prints; contact sheet preferred; 35mm transparencies. SASE. Reports in 1 week. Pays $20/b&w inside photo; $50/color inside photo; $150/color cover photo. Payment is made bimonthly. Credit line given. Buys one-time rights.
Tips: "No photographer is going to get rich via *T&FN*. We can offer a credit line, nominal payment and, in some cases, credentials to major track and field meets to enable on-the-field shooting. Also, we can offer the chance for competent photographers to shoot major competitions and competitors up close as well as being the most highly regarded publication in the track world as a forum to display a photographer's talents."

TRAILER BOATS MAGAZINE, Poole Publications Inc., 20700 Belshaw Ave., Carson CA 90746. (310)537-6322. Fax: (310)537-8735. Editor: Randy Scott. Circ. 90,000. Estab. 1971. Monthly magazine. "We are the only magazine devoted exclusively to legally trailerable boats and related activities" for owners and prospective owners. Sample copy $1.25. Free writer's guidelines.
Needs: Uses 15 photos/issue with ms. 95-100% of freelance photography comes from assignment; 0-5% from stock. Scenic (with ms), how-to, humorous (monthly "Over-the-Transom" funny or weird shots in the boating world), travel (with ms). For accompanying ms, articles related to trailer boat activities. Photos purchased with or without accompanying ms. "Photos must relate to trailer boat activities. No long list of stock photos or subject matter not related to editorial content." Captions preferred; include location of travel pictures.
Making Contact & Terms: Interested in receiving work from newer, lesser-known photographers. Query or send photos or contact sheet by mail for consideration. Uses transparencies. SASE. Reports in 1 month. Pays per text/photo package or on a per-photo basis. Pays $25-200/color photo; $150-400/ cover photo; additional for mss. **Pays on acceptance.** Credit line given. Buys one-time and all rights; negotiable.
Tips: "Shoot with imagination and a variety of angles. Don't be afraid to 'set-up' a photo that looks natural. Think in terms of complete feature stories; photos and mss. It is rare any more that we publish freelance photos without accompanying manuscripts; with one exception, 'Over the Transom'—a comical, weird or unusual boating shot."

TRANSITIONS ABROAD, 18 Hulst Rd., P.O. Box 1300, Amherst MA 01004. Fax: (413)256-0373. E-mail: trabroad@aol.com. Editor: Clay Hubbs. Circ. 20,000. Estab. 1977. Bimonthly magazine. Emphasizes special interest travel. Readers are people interested in cultural travel and learning, living, or working abroad, all ages, both sexes. Sample copy $6.25. Photo guidelines free with SASE.
Needs: Uses 10 photos/issue; all supplied by freelancers. Needs photos of travelers in international settings or the people of other countries. Each issue has an area focus: January/February—Asia and the Pacific Rim; March/April—Europe and the former Soviet Union; May/June—The Americas and

Africa (South of the Sahara); November/December—The Mediterranean Basin and the Near East. Captions preferred.

Making Contact & Terms: Interested in receiving work from newer, lesser-known photographers. Query with list of stock photo subjects. Send unsolicited 8×10 b&w prints by mail for consideration. Prefers b&w; sometimes uses color photos; rarely uses transparencies. SASE. Reports in 6 weeks. Pays $25-50/inside photo; $125/b&w cover photo. Pays on publication. Credit line given. Buys one-time rights. Simultaneous submissions and previously published work OK.

Tips: In freelance photographer's samples, wants to see "mostly people in action shots—travelers and people of other countries. We use very few landscapes or abstract shots."

TRAVEL & LEISURE, 1120 Avenue of the Americas, New York NY 10036. (212)382-5600. Editor: Nancy Novogrod. Art Director: Pamela Berry. Circ. 1.2 million. Monthly magazine. Emphasizes travel destinations, resorts, dining and entertainment. Free photo guidelines with SASE.

Needs: Nature, still life, scenic, sport and travel. Model release required. Captions required.

Making Contact & Terms: Uses 8×10 semigloss b&w prints; 35mm, 2¼×2¼, 4×5 and 8×10 transparencies, vertical format required for cover. Pays $200-500/b&w photo; $200-500/color photo; $1,000/cover photo or negotiated. Sometimes pays $450-1,200/day; $1,200 minimum/complete package. Pays on publication. Credit line given. Buys first world serial rights, plus promotional use. Previously published work OK.

Tips: Seeing trend toward "more editorial/journalistic images that are interpretive representations of a destination."

‡TRAVELLER, 45-49 Brompton Road, London SW3 1DE Great Britain. (0171)581-4130. Fax: (0171)581-1357. Managing Editor: Caroline Brandenburger. Circ. 35,000. Quarterly. Readers are predominantly male, professional, age 35 and older. Sample copy £2.50.

Needs: Uses 30 photos/issue; all supplied by freelancers. Needs photos of travel, wildlife. Reviews photos with or without ms. Captions preferred.

Making Contact & Terms: Interested in receiving work from newer, lesser-known photographers. Arrange personal interview to show portfolio. Submit portfolio for review. Send 35mm transparencies. Does not keep samples on file. SASE. Reports in 1 month. Pays £50/color cover photo; £25/color inside photo. Pays on publication. Buys one-time rights.

Tips: Looks for "original, quirky shots with impact, which tell a story."

TROUT: The Voice of America's Trout and Salmon Anglers, 1500 Wilson Blvd., Suite 310, Arlington VA 22209-2310. (703)522-0200. Fax: (703)284-9400. E-mail: troutu@aol.com. Website: http://www.tu.org/trout. Editor: Peter Rafle. Circ. 75,000. Estab. 1959. Quarterly magazine. Emphasizes conservation and restoration of America's trout and salmon species and the streams and rivers they inhabit. Readers are conservation-minded anglers, primarily male, with an average age of 46. Sample copy free with 9×12 SASE and 4 first-class stamps. Photo guidelines free with SASE.

Needs: Uses 25-50 photos/issue; 100% supplied by freelancers. Needs photos of trout and salmon, trout and salmon angling, conservation issues. Special photo needs include endangered species of trout and salmon; Pacific and Atlantic salmon. Model/property release required. Captions preferred; include species of fish; if angling shot: location (river/stream, state, name of park or wilderness area).

Making Contact & Terms: Interested in receiving work from newer, lesser-known photographers. Query with résumé of credits. Deadlines: Spring, 2/1; Summer, 5/1; Fall, 8/1; Winter, 11/1. Does not keep samples on file. SASE. Reports in 2 months. Pays $500/color cover photo; $500/b&w cover photo; $150-350/color inside photo; $150-350/b&w inside photo. Pays on publication. Credit line given. Buys first North American serial rights; negotiable. Simultaneous submissions OK.

Tips: "If the fish in the photo could not be returned to the water alive with a reasonable expectation it would survive, we will not run the photo. The exception is when the photo is explicitly intended to represent 'what not to do.' "

TRUE WEST, P.O. Box 2107, Stillwater OK 74076. (405)743-3370. Fax: (405)743-3374. Editor: John Joerschke. Circ. 30,000. Estab. 1953. Monthly magazine. Emphasizes "history of the Old West (1830 to about 1915)." Readers are "people who like to read the history of the West, mostly male, age 45 and older." Sample copy $2 with 9×12 SAE. Photo guidelines free with SASE.

Needs: Uses about 50 or more photos/issue; almost all are supplied by freelance photographers. Needs "mostly Old West historical subjects, some travel, some scenic, (ghost towns, old mining camps, historical sites). We prefer photos with ms." Special needs include western wear; cowboys, rodeos, western events. Captions required; include name and location of site.

Making Contact & Terms: Interested in receiving work from newer, lesser-known photographers. Query with samples—b&w only for inside; color for covers. Query with stock photo list. Send unsolicited photos by mail for consideration. SASE. Reports in 1 month. Pays $100-175/color cover photo; $10-25/color inside photo; $10-25/b&w inside photo. **Pays on acceptance**; cover photos on publication. Credit line given. Buys first North American serial rights.

Tips: Prefers to see "transparencies of existing artwork as well as scenics for cover photos. Scenics should be free of modern intrusions such as buildings, powerlines, highways, etc. Inside photos need to tell story associated with the Old West. Most of our photos are used to illustrate stories and come with manuscripts; however, we will consider other work, scenics, historical sites, old houses. Even though we are Old West history, we do need current photos, both inside and for covers—so don't hesitate to contact us."

TV GUIDE, Four Radnor Corporate Center, Radnor PA 19088. Did not want to be listed. Uses staff members to shoot photos.

TWINS MAGAZINE, 6740 Antioch, Suite 155, Merriam KS 66204. (913)722-1090. Fax: (913)722-1767. Editor: Barbara Unell. Art Director: Cindy Himmelberg. Circ. 55,000. Estab. 1984. Bimonthly magazine. Emphasizes parenting twins, triplets, quadruplets, or more and being a twin, triplet, quadruplet or more. Readers include the parents of multiples. Sample copy $5. Free photo guidelines with SASE.
Needs: Uses about 10 photos/issue; all supplied by freelance photographers. Needs family related—children, adults, family life. Usually needs to have twins, triplets or more included as well. Reviews photos with or without accompanying ms. Model release required. Property release preferred. Captions preferred.
Making Contact & Terms: Interested in receiving work from newer, lesser-known photographers. Query with résumé of credits and samples. Provide résumé, business card, brochure, flier or tearsheets to be kept on file for possible assignments. SASE. Reports in 1 month. Pays $100 minimum/cover photo. Pays on publication. Credit line given. Buys all rights. Simultaneous submissions OK.

U. THE NATIONAL COLLEGE MAGAZINE, 1800 Century Park E., Suite 820, Los Angeles CA 90067. (310)551-1381. Fax: (310)551-1659. E-mail: editor@umagazine.com.; umagazine@aol.com. Website: http://www.umagazine.com. Editor: Frances Huffman. Circ. 1.5 million. Estab. 1987. Monthly magazine. Emphasizes college. Readers are college students at 400 schools nationwide. Sample copy free for 9×12 SAE with 3 first-class stamps.
Needs: Uses 15 photos/issue; all supplied by student freelancers. Needs color feature shots of students, college life and student-related shots. Model release preferred. Captions required that include name of subject, school.
Making Contact & Terms: Interested in receiving work from newer, lesser-known photographers. Send unsolicited photos by mail for consideration. Provide résumé or tearsheets to be kept on file for possible assignments. Send any size color prints; 35mm, 2¼×2¼, 4×5, 8×10, but prefers color slides. Also uses photo illustrations, collages, etc. Accepts digital images on disk (Mac) or via e-mail, Illustrator or Photoshop. Files should be 220 dpi minimum TIFF or EPS format, CMYK color. Must include all fonts if any used. "Send samples and we will commission shots as needed." Keeps sample on file. Reports in 3 weeks. Pays $100/color cover photo; $25/color inside photo. Pays on publication. Credit line given. Buys all rights. Simultaneous submissions and previously published work OK.
Tips: "We look for photographers who can creatively capture the essence of life on campus. Also, we need light, bright photos since we print on newspaper. We are looking for photographers who are college students."

***UNDERWATER USA**, 3185 Lackawanna Ave., Bloomsburg PA 17815. (717)784-6081. Fax: (717)784-9226. Executive Editor: Cathie Cush. Circ. 47,000. Estab. 1984. Monthly tabloid. Emphasizes scuba diving. Sample copy free with 9×12 SAE and 8 first-class stamps.
Needs: Uses 35 photos/issue; 95% supplied by freelancers. Needs travel and underwater photos, mainly news shots that involve scuba divers. Reviews photos with accompanying ms only. Model/property release preferred. Captions required (any recognizable individuals, where they're from, where shot was taken, sea life in photo).
Making Contact & Terms: Query with stock photo list. Provide résumé, business card, brochure, flier or tearsheets to be kept on file for possible future assignments. Keeps samples on file. SASE. Reports in 1 month. Pays $50/color inside photo; $25/b&w inside photo. Pays on publication. Credit line given. Buys one-time rights.
Tips: "We need sharp shots with good contrast—we run on newsprint and use more black & white than color. We are less interested in 'fine art' than in news photos that tell a story—we're the only newspaper in the scuba market."

 THE DOUBLE DAGGER before a listing indicates that the market is located outside the United States and Canada.

UNITY MAGAZINE, 1901 NW Blue Pkwy., Unity Village MO 64065. Editor: Philip White. Associate Editor: Janet McNamara. Circ. 120,000. Estab. 1889. Monthly magazine. Emphasizes spiritual, metaphysical, self-help, healing articles and poetry. Free sample copy and photo guidelines for 6×9 SASE.
Needs: Uses 6-10 photos/issue. Buys 100 photos/year, 10% from freelancers. Wants on a regular basis people and nature scenics. Model release required. Captions required, include location for scenics and ethnic clothed people. Stock numbers required.
Making Contact & Terms: Interested in receiving work from newer, lesser-known photographers. Send insured material by mail for consideration. No calls in person or by phone. Uses 4×5 or 2×2 color transparencies. Vertical format required for cover. **Send SAE and check or money order for return postage. Do not send stamps or stamped envelopes.** Return postage must be included for photographs to be returned. There is a 7-8 month lead time for seasonal material. Reports in 2 months. Pays $220/cover, $110 inside color photo. **Pays on acceptance.** Credit line given. Buys first North American serial rights.
Tips: "Don't overwhelm us with hundreds of submissions at a time. We look for nature scenics, human interest, photos of active people. We are looking for photos with a lot of color and contrast."

♣UP HERE, P.O. Box 1350, Yellowknife, Northwest Territories X1A 2N9 Canada. (403)920-4652. Fax: (403)873-2844. Editor: R. Allerston. Circ. 35,000. Estab. 1984. Bimonthly magazine. Emphasizes Canada's north. Readers are white collar men and women ages 30 to 60. Sample copy $3 and 9×12 SAE. Photo guidelines free with SASE.
Needs: Uses 20-30 photos/issue; 90% supplied by freelance photographers. Purchases photos with and without accompanying ms. Captions required.
Making Contact & Terms: Provide résumé, business card, brochure, flier or tearsheets to be kept on file for possible assignments. SASE. Reports in 2 months. Pays $35-100/b&w photo; $50-150/color photo; $150-500/cover. Pays on publication. Credit line given. Buys one-time rights.
Tips: "We are a *people* magazine. We need northern subjects—lots of faces. We're moving more into outdoor adventure—soft type, as they say in the industry—and wildlife. Few scenics as such. We approach local freelancers for given subjects, but are building a library. We can't always make use of photos alone, but a photographer could profit by sending sheets of dupes for our stock files." Wants to see "sharp, clear photos, good color and composition. We always need verticals to consider for the cover, but they usually tie in with an article inside."

UPSIDE MAGAZINE, 143 11th Ave., San Mateo CA 94401. (415)570-5193. Fax: (415)570-5083. Art Director: Amparo del Rio. Circ. 50,000. Estab. 1978. Monthly magazine. Emphasizes people who build companies in the computer industry. Readers are male executives.
Needs: Uses 10 photos/issue; 10 supplied by freelancers. Wants photos of people only. "We use only strong, unique, photos of executives. We run a full page plus 3 small photos on each issue each month."
Making Contact & Terms: Interested in receiving work from newer, lesser-known photographers. Send unsolicited photos by mail for consideration. Accepts images in digital format. Keeps samples on file. Cannot return material. Pays $650 maximum/job (includes materials). Credit line given. Buys one-time rights.
Tips: Make sure your work is creative and has strong composition with impact.

VANITY FAIR, Condé Nast Building, 350 Madison Ave., New York NY 10017. (212)880-8800. Photography Director: Susan White. Monthly magazine.
Needs: 50% of photos supplied by freelancers. Needs portraits. Model/property release required for everyone. Captions required for photographer, styles, hair, makeup, etc.
Making Contact & Terms: Interested in receiving work from newer, lesser-known photographers. Contact through rep. Submit portfolio for review. Provide résumé, business card, brochure, flier or tearsheets to be kept on file for possible assignments. Reports in 1-2 weeks. NPI. Pays on publication.
Tips: "We solicit material after a portfolio drop. So really we don't want unsolicited material."

VENTURE, P.O. Box 150, Wheaton IL 60189. (708)665-0630. Fax: (708)665-0372. Editor: Deborah Christensen. Art Director: Robert Fine. Circ. 20,000. Estab. 1959. Magazine published 5 times/year. "We aim to inform, entertain and challenge from a Christian perspective. Our readers are boys 8-11 years old." Sample copy $1.85 with 9×12 SAE and 4 first-class stamps. Photo guidelines available (SASE).
Needs: Buys 2-10 color photos/issue; all from freelance stock. Photos of boys involved in sports, hobbies, camping, family life and just having fun. Also need photos of interest to boys: ecology, nature, adventure, occupations, etc.
Making Contact & Terms: Fax your stock list to Art Director or send photos for consideration. Send 8×10 color prints or duplicate transparencies with. SASE. Also accepts digital images: Photo CD or Mac Photoshop 3.0/JPEG. Advance inquiry requested. Reports in 6 weeks. Pays $50-150/b&w

photo; $50-250/color photo. Pays on publication. Buys one-time rights. Simultaneous submissions and previously published work OK.

VERMONT LIFE, 6 Baldwin St., Montpelier VT 05602. (802)828-3241. Editor: Tom Slayton. Circ. 95,000. Estab. 1946. Quarterly magazine. Emphasizes life in Vermont: its people, traditions, way of life, farming, industry and the physical beauty of the landscape for "Vermonters, ex-Vermonters and would-be Vermonters." Sample copy $4 with 9×12 SAE. Free photo guidelines.
Needs: Buys 30 photos/issue; 90-95% supplied by freelance photographers, 5-10% from stock. Wants on a regular basis scenic views of Vermont, seasonal (winter, spring, summer, autumn), submitted 6 months prior to the actual season; animal; documentary; human interest; humorous; nature; photo essay/photo feature; still life; travel; and wildlife. "We are using fewer, larger photos and are especially interested in good shots of wildlife, birds." No photos in poor taste, nature close-ups, cliches or photos of places other than Vermont. Model/property releases preferred. Captions required.
Making Contact & Terms: Interested in receiving work from newer, lesser-known photographers. Query first. Send 35mm or 2¼×2¼ color transparencies. SASE. Reports in 3 weeks. Pays $75-200/ b&w photo; $75-200/color photo; $250/day; $400-800 job. Pays on publication. Credit line given. Buys one-time rights; negotiable. Simultaneous submissions OK.
Tips: "We look for clarity of focus; use of low-grain, true film (Kodachrome or Fujichrome are best); unusual composition or subject."

VERMONT MAGAZINE, P.O. Box 288, 14 School St., Bristol VT 05443. (802)453-3200. Photo Editor: Regan Eberhart. Circ. 50,000. Estab. 1989. Bimonthly magazine. Emphasizes all facets of Vermont and nature, politics, business, sports, restaurants, real estate, people, crafts, art, architecture, etc. Readers are people interested in Vermont, including residents, tourists and summer home owners. Sample copy $3 with 9×12 SAE and 5 first-class stamps. Photo guidelines free with SASE.
Needs: Uses 30-40 photos/issue; 75% supplied by freelance photographers. Needs animal/wildlife shots, travel, Vermont scenics, how-to, portraits, products and architecture. Special photo needs include Vermont activities such as skiing, ice skating, biking, hiking, etc. Model release preferred. Captions required.
Making Contact & Terms: Interested in receiving work from newer, lesser-known photographers. Query with résumé of credits and samples of work. Send 8×10 b&w prints or 35mm or larger transparencies by mail for consideration. Submit portfolio for review. Provide tearsheets to be kept on file for possible assignments. SASE. Reports in 2 months. Pays $450/color cover photo; $200/color page rate; $75-200/color or b&w photo; $275/day. Pays on publication. Credit line given. Buys one-time rights and first North American serial rights; negotiable. Previously published work OK, depending on "how it was previously published."
Tips: In portfolio or samples, wants to see tearsheets of published work, and at least 40 35mm transparencies. Explain your areas of expertise. Looking for creative solutions to illustrate regional activities, profiles and lifestyles. "We would like to see more illustrative photography/fine art photography where it applies to the articles and departments we produce."

VICTORIA MAGAZINE, 224 W. 57th St., New York NY 10019. Fax: (212)757-6109. Photography Editor: Susan Maher. Circ. 900,000. Estab. 1987. Monthly magazine. Emphasizes women's interests, lifestyle. Readers are females, 60% married, average age 37. Photo guidelines free with SASE.
Needs: Uses "hundreds" of photos/issue; most supplied by freelancers. "We hire freelancers to shoot 99% of our stories. Occasionally a photographer will submit work that we consider exceptional and wish to publish. This is rare, and an exception to the rule." Needs beauty, fashion, home furnishings, lifestyle, children's corner, gardens, food, collections. Model/property release required.
Making Contact & Terms: Interested in receiving work from newer, lesser-known photographers. Submit portfolio for review. Provide tearsheets to be kept on file for possible future assignments. SASE. Reports in 2 weeks. Pays $750-850/day. **Pays on acceptance**. Credit line given. Usually buys all rights, one-time rights; negotiable. Previously published work OK.
Tips: Looking for "beautiful photos, wonderful lighting, elegance of style, simplicity."

***VIRGINIA BUSINESS**, 411 E. Franklin St., Suite 105, Richmond VA 23219. (804)649-6999. Managing Editor: Leigh Anne Larance. Circ. 35,500. Estab. 1986. Monthly magazine. Emphasizes industry and the economy of Virginia. Readers are government leaders and executives, ages 40-55. Sample copy $3.50.
Needs: Uses 8-10 photos/issue; all supplied by freelancers.
Making Contact & Terms: Interested in receiving work from newer, lesser-known photographers. Query with résumé of credits. Provide résumé, business card, brochure, flier or tearsheets to be kept on file for possible future assignments. Send 35mm, 2¼×2¼ transparencies. Keeps samples on file. SASE. Pays $100/color inside photo, plus some expenses. **Pays on acceptance and receipt of invoice.** Buys one-time and electronic rights. Simultaneous submissions and previously published work OK.

VISIONS, 106 W. 11th St., #250, Kansas City MO 64105-1806. (816)221-4404. Fax: (816)221-1112. Editor: Neoshia Michelle Paige. Circ. 100,000. Semi-annual magazine. Emphasizes Native Americans in high school, college, vocational-technical, careers. Readers are Native American students 16-22. Sample copy free with 9×12 SAE and 5 first-class stamps.
Needs: Uses 30 photos/issue. Needs photos of students in-class, at work, on campus, in vocational/technical training in health, engineering, technology, computers, law, science, general interest. Model/property release required. Captions required; include name, age, location, what's going on in photo.
Making Contact & Terms: Interested in receiving work from newer, lesser-known photographers. Query with ideas and SASE. Reports in 1 month. Pays $10-50/color photo; pays $5-25/b&w inside photo. Pays on publication. Buys first North American serial rights. Simultaneous submissions and previously published work OK.

VISTA, 999 Ponce de Leon Blvd., Suite 600, Coral Gables FL 33134. (305)442-2462. Fax: (305)443-7650. Editor: Julia Bencomo Lobaco. Circ. 1.2 million. Estab. 1985. Monthly newspaper insert. Emphasizes Hispanic life in the US. Readers are Hispanic-Americans of all ages. Sample copy available.
Needs: Uses 10-50 photos/issue; all supplied by freelancers. Needs photos mostly of personalities with story only. No "stand-alone" photos. Reviews photos with accompanying ms only. Special photo needs include events in the Hispanic American communities. Model/property release preferred. Captions required.
Making Contact & Terms: Provide résumé, business card, brochure, flier or tearsheets to be kept on file for possible assignments. Keeps samples on file. SASE. Reports in 3 weeks. Pays $300/color cover photo; $150/color inside photo; $75/b&w inside photo; day assignments are negotiated. Pays on publication. Credit line given. Buys one-time rights. Previously published work OK.
Tips: "Build a file of personalities and events. Hispanics are America's fastest-growing minority."

VOGUE, 350 Madison Ave., New York NY 10017-3799. Prefers not to share information.

VOICE OF SOUTH MARION, P.O. Box 700, Belleview FL 34421. (904)245-3161. Editor: Jim Waldron. Circ. 1,800. Estab. 1969. Weekly tabloid. Readers are male and female, ages 12-65, working in agriculture and various small town jobs. Sample copy $1.
Needs: Uses 15-20 photos/issue; 2 supplied by freelance photographers. Features pictures that can stand alone with a cutline. Captions required.
Making Contact & Terms: Send b&w or color prints by mail for consideration. SASE. Reports in 2 weeks. Pays $10/b&w cover photo; $5/b&w inside photo. Pays on publication. Credit line given. Buys one-time rights.

***VOLUPTUOUS**, 13360 S.W. 128 St., Miami FL 33186. (305)238-5040. Fax: (305)238-6716. Editor: Bruce Arthur. Circ. 110,000. Estab. 1994. Monthly magazine. *Voluptuous* specializes in nude pictorials of Rubenesque models. Readers are males, 18-50 years of age.
Needs: Uses 250 photos/issue; all supplied by freelancers. Model release required; also requires photo identification and/or birth certificate for models.
Making Contact & Terms: Interested in receiving work from newer, lesser-known photographers. Query with stock photo list. Send unsolicited photos by mail for consideration. Send 35mm transparencies. SASE. Reports in 3 weeks. Pays $150/color page rate. Pays on publication. Credit line given (if requested). Buys one-time rights with reprint option; negotiable. Previously published work OK, but pays at a lesser, second rights page rate—$80/page.
Tips: "Study sample copies of our magazine before submitting. Pre-edit your material before submitting. We're impressed by quality of photos and variety of poses—not just quantity."

WASHINGTONIAN, 1828 L St. NW, Suite 200, Washington DC 20036. (202)296-3600. Fax: (202)785-1822. Photo Editor: Jay Sumner. Monthly city/regional magazine emphasizing Washington metro area. Readers are 40-50, 54% female, 46% male and middle to upper middle professionals. Circ. 160,000. Estab. 1965.
Needs: Uses 75-150 photos/issue; 100% supplied by freelance photographers. Needs photos for illustration, portraits, reportage; tabletop of products, food; restaurants; nightlife; house and garden; fashion; and local and regional travel. Model release preferred; captions required.
Making Contact & Terms: Submit portfolio for review. Provide résumé, business card, brochure, flier or tearsheets to be kept on file for possible assignments. Pays $125-250/b&w photo; $150-300/color photo; $175-$350/day. Credit line given. Buys one-time rights ("on exclusive shoots we share resale").
Tips: "Read the magazine you want to work for. Show work that relates to its needs. Offer photo-story ideas. Send samples occasionally of new work."

***WATERCRAFT WORLD**, (formerly *Waterfront World*), 601 Lakeshore Pkwy, #600, Minnetonka MN 55305. (612)476-2200. Fax: (612)476-8065. E-mail: wtrcrftwrl@aol.com. Managing Editor:

Glenn R. Hansen. Circ. 70,000. Estab. 1987. Published 9 times/year. Emphasizes personal watercraft (jet skis). Readers are 95% male, average age 35, boaters, outdoor enthusiasts. Sample copy $3.

• This publication is doing more storing of images on CD and computer manipulation of photos.

Needs: Uses 30-50 photos/issue; 25% supplied by freelancers. Needs photos of jet ski travel, action, technology, race coverage. Model/property release required. Captions preferred.

Making Contact & Terms: Query with résumé of credits. Provide résumé, business card, brochure, flier or tearsheets to be kept on file for possible future assignments. Also accepts digital images in SyQuest and Photo CD. SASE. Reports in 1 month. Pays $20/b&w photo; $40/color photo; $200/color cover photo. Pays on publication. Credit line given. Rights negotiable.

WATERFRONT SOUTHERN CALIFORNIA NEWS, 17782 Cowan, Suite C, Irvine CA 92714. (714)660-6150. Fax: (714)660-6172. Associate Editor: Erin McNiff. Circ. 40,000. Estab. 1979. Monthly magazine. Emphasizes sailing and power boating in Southern California. Sample copy $5. Photo guidelines free with SASE.

Needs: Uses 15-20 photos/issue; 5-10 supplied by freelancers. Needs photos of people having fun in boats for cover; current boating events. Special photo needs include America's Cup. Model release required. Captions preferred; include place, date, identify people if possible.

Making Contact & Terms: Interested in receiving work from newer, lesser-known photographers. Query with résumé of credits. Provide résume, business card, brochure, flier or tearsheets to be kept on file for possible assignments. Query with stock photo list. Deadlines: 15th of the month preceeding publication. SASE. Reports in 1-2 months. Pays $30/color cover photo; $15/b&w inside photo. Pays on publication. Credit line given. Buys first North American serial rights. Simultaneous submissions OK.

WATERSKI MAGAZINE, 330 W. Canton Ave., Winter Park FL 32789. (407)628-4802. Fax: (407)628-7061. Editor: Rob May. Circ. 105,000. Estab. 1978. Published 10 times/year. Emphasizes water skiing instruction, lifestyle, competition, travel. Readers are 31-year-old males, average household income $65,000. Sample copy $2.95. Photo guidelines free with SASE.

Needs: Uses 75 photos/issue; 20 supplied by freelancers. 30% of photos in each issue comes from assigned work; 30% from freelance stock. Needs photos of instruction, travel, personality. Special photo needs include travel, personality. Model/property release preferred. Captions preferred; include person, trick described.

Making Contact & Terms: Interested in receiving work from newer, lesser-known photographers. Arrange a personal interview to show portfolio. Keeps samples on file. Reports in 1 month. Pays $150-300/day; $500/color cover photo; $75-200/color inside photo; $50-75/b&w inside photo; $75-250/color page rate; $50-75/b&w page rate. Pays on publication. Credit line given. Buys first North American serial rights.

Tips: "Clean, clear, large images. Plenty of vibrant action, colorful travel scenics and personality. Must be able to shoot action photography."

WATERWAY GUIDE, 6151 Powers Ferry Rd. NW, Atlanta GA 30339. Fax: (404)618-0349. Editor: Judith Powers. Circ. 50,000. Estab. 1947. Cruising guides with 3 annual regional editions. Emphasizes recreational boating. Readers are men and women ages 25-65, management or professional, with average income $95,000 a year. Sample copy $33.95 and $3 shipping. Photo guidelines free with SASE.

Needs: Uses 10-15 photos/issue; all supplied by freelance photographers. Needs photos of boats, Intracoastal Waterway, bridges, landmarks, famous sights and scenic waterfronts. Expects to use more coastal shots from Maine to the Bahamas; also, Hudson River, Lake Champlain and Gulf of Mexico. Model release required. Captions required.

Making Contact & Terms: Send unsolicited photos by mail for consideration. Send b&w and color prints or 35mm transparencies. SASE. Reports in 2 months. Pays $600/color cover photo; $25/b&w inside photo; $50/color photo. Pays on publication. Credit line given. Buys first North American serial rights.

WEEKENDS, 481 Bronson Rd., Southport CT 06490. (203)255-0064. Fax: (203)255-4281. Associate Publisher: Zach Chouteau. Circ. 260,000. Estab. 1991. Bimonthly magazine. Emphasizes travel—primarily in the Northeast and Mid-Atlantic regions, with occasional exotic escapes. Readers are top executives, male and female, with an average age of 43.6. Sample copy free with 9 × 12 SASE and 6 first-class stamps.

Needs: Uses 10-15 photos/issue; 0-10 supplied by freelancers. Needs photos primarily of travel. Special photo needs include Bar Harbor, ME; Atlanta, GA; Detroit, MI. Property release preferred. Captions preferred; include what it is, where it is.

Making Contact & Terms: Interested in receiving work from newer, lesser-known photographers. Query with stock photo list. Send unsolicited photos by mail for consideration. Send color or b&w prints; 35mm transparencies. SASE. Reports in 3 weeks. Pays $50-75/color cover photo; $25-50/b&w

cover photo; $25-35/color inside photo; $20-40/b&w inside photo. Pays on publication. Credit line given. Buys one-time rights. Simultaneous submissions and previously published work OK.

Tips: "Extreme clarity is a necessity; lighting is also crucial." Suggests that photographers who want to sell to publications should "look over the periodicals you are considering submitting photos to. Be willing to work for whatever you can get in order to build portfolio/résumé etc."

WESTERN HORSEMAN, P.O. Box 7980, Colorado Springs CO 80933. (719)633-5524. Editor: Pat Close. Monthly magazine. Circ. 230,000. Estab. 1936. Readers are active participants in horse activities, including pleasure riders, ranchers, breeders and riding club members. Model/property release preferred. Captions required; include name of subject, date, location.

Needs: Articles and photos must have a strong horse angle, slanted towards the western rider—rodeos, shows, ranching, stable plans, training. "We do not buy single photographs/slides; they must be accompanied by an article. The exception: We buy 35mm color slides for our annual cowboy calendar. Slides must depict ranch cowboys/cowgirls at work."

Making Contact & Terms: Interested in receiving work from newer, lesser-known photographers. Submit material by mail for consideration. Pays $20/b&w photo; $50-75/color photo; $400-500 maximum for articles. For the calendar, pays $100-250/slide. "We buy mss and photos as a package." Payment for 1,500 words with b&w photos ranges from $100-400. Buys one-time rights; negotiable.

Tips: "For color, we prefer 35mm slides. For b&w, either 5×7 or 8×10 glossies. We can sometimes use color prints if they are of excellent quality. In all prints, photos and slides, subjects must be properly dressed. Baseball caps, T-shirts, tank tops, shorts, tennis shoes, bare feet, etc., are unacceptable."

WESTERN OUTDOORS, 3197-E Airport Loop, Costa Mesa CA 92626. (714)546-4370. E-mail: woutdoors@aol.com. Editor: Jack Brown. Circ. 131,000. Estab. 1961. Magazine published 9 times/year. Emphasizes fishing and boating for Far West states. Sample copy $2 OWAA members, $1. Editorial and photo guidelines free with SASE.

Needs: Uses 80-85 photos/issue; 70% supplied by freelancers; 25% comes from assignments, 75% from stock. Cover photos of fishing in California, Oregon, Washington, Baja. "We are moving toward 100% four-color books, meaning we are buying only color photography. A special subject need will be photos of boat-related fishing, particularly small and trailerable boats and trout fishing cover photos." Most photos purchased with accompanying ms. Model/property release preferred for women and men in brief attire. Captions required.

Making Contact & Terms: Interested in receiving work from newer, lesser-known photographers. Query or send photos for consideration. Send 35mm Kodachrome II transparencies. SASE. Reports in 3 weeks. Pays $50-150/color photo; $250/cover photo; $400-600 for text/photo package. **Pays on acceptance**. Buys one-time rights; negotiable.

Tips: "Submissions should be of interest to Western fishermen, and should include a 1,120-1,500 word ms; a Trip Facts Box (where to stay, costs, special information); photos; captions; and a map of the area. Emphasis is on fishing and hunting how-to, somewhere-to-go. Submit seasonal material 6 months in advance. Make your photos tell the story and don't depend on captions to explain what is pictured. Avoid 'photographic cliches' such as 'dead fish with man.' Get action shots, live fish. In fishing, we seek individual action or underwater shots. For cover photos, use vertical format composed with action entering picture from right; leave enough left-hand margin for cover blurbs, space at top of frame for magazine logo. Add human element to scenics to lend scale. Get to know the magazine and its editors. Ask for the year's editorial schedule (available through advertising department) and offer cover photos to match the theme of an issue. In samples, looks for color saturation, pleasing use of color components; originality, creativity; attractiveness of human subjects as well as fish or game; above all—sharp, sharp, sharp focus! Send duplicated transparencies as samples, but be prepared to provide originals." Sees trend toward electronic imagery, computer enhancement and electronic transmission of images.

WHERE CHICAGO MAGAZINE, 1165 N. Clark St., Chicago IL 60610. (312)642-1896. Fax: (312)642-5467. Editor: Margaret Doyle. Circ. 100,000. Estab. 1985. Monthly magazine. Emphasizes shopping, dining, nightlife and entertainment available in Chicago and its suburbs. Readers are male and female traveling executives and tourists, ages 25-55. Sample copy $4.

Needs: Uses 1 photo/issue; 90% supplied by freelancers. Needs scenic, seasonal shots of Chicago; "must include architecture or landmarks that identify a photo as being shot in Chicago." Reviews photos with or without ms. "We look for seasonal shots on a monthly basis." Model/property release required. Captions required.

Making Contact & Terms: Send unsolicited photos by mail for consideration. Provide résumé, business card, brochure, flier or tearsheets to be kept on file for possible assignments. Send 35mm, 2¼×2¼, 4×5, 8×10 transparencies. SASE. Reports in 1 month. Pays $300/color cover photo. **Pays on acceptance.** Credit line given. Buys one-time rights; negotiable. Simultaneous submissions and previously published work OK.

Tips: "We only consider photos of downtown Chicago, without people in them. Shots should be colorful and current, in a vertical format. Keep our deadlines in mind. We look for covers two months in advance of issue publication."

WHERE MAGAZINE, 475 Park Ave. S., Suite 2100, New York NY 10016. (212)725-8100. Fax: (212)725-3412. Editor-in-Chief: Lois Anzelowitz-Tanner. Circ. 119,000. Estab. 1936. Monthly. Emphasizes points of interest, shopping, restaurants, theater, museums, etc. in New York City (specifically Manhattan). Readers are visitors to New York staying in the city's leading hotels. Sample copy available in hotels.
Needs: Buys cover photos only. Covers showing New York scenes; color photos only. Vertical compositions preferred. Model release preferred. Captions preferred.
Making Contact & Terms: Interested in receiving work from newer, lesser-known photographers. Arrange a personal interview to show portfolio. Does not return unsolicited material. Pays $300-500/ color photo. Pays on publication. Credit line given. Rights purchased vary. Simultaneous submissions and previously published work OK.

THE JAMES WHITE REVIEW, P.O. Box 3356, Butler Quarter Station, Minneapolis MN 55403. (612)339-8317. Art Editor: Ed Mikola. A gay men's literary quarterly. Emphasizes gay men's writing, poetry and artwork. Readers are mostly gay men. Estab. 1983. Sample copy $3.
Needs: Uses 8-10 photos/issue; 100% supplied by freelancers. Reviews photos with or without a manuscript. Photo captions preferred; include title of work and media used.
Making Contact & Terms: Send unsolicited photos by mail for consideration. Send 5×7 or 8×10 glossy b&w prints. Keeps samples on file. SASE. Reports in 1 month. Pays $25/b&w cover photo; $25-50/photo package. Pays on publication. Credit line given. Buys one-time rights. Simultaneous submissions and previously published work OK.
Tips: "We are seeking work by emerging and established gay male artists, any style and theme. Please include biographical information."

WINDSURFING, 330 W. Canton Ave., Winter Park FL 32789. (407)628-4802. Fax: (407)628-7061. Editor: Tom James. Circ. 75,000. Monthly magazine published 8 times/year. Emphasizes board-sailing. Readers are all ages and all income groups. Sample copy free with SASE. Photo guidelines free with SASE.
Needs: Uses 80 photos/issue; 60% supplied by freelance photographers. Needs photos of boardsailing, flat water, recreational travel destinations to sail. Model/property release preferred. Captions required; include who, what, where, when, why.
Making Contact & Terms: Query with samples. Send unsolicited photos by mail for consideration. Provide résumé, business card, brochure, flier or tearsheets to be kept on file for possible future assignments. Send 35mm, 2¼×2¼ and 4×5 transparencies by mail for consideration. Kodachrome and slow Fuji preferred. SASE. Reports in 3 weeks. Pays $450/color cover photo; $40-150/color inside; $25-100/b&w inside. Pays on publication. Credit line given. Buys one-time rights unless otherwise agreed on. Previously published work OK.
Tips: Prefers to see razor sharp, colorful images. The best guideline is the magazine itself. "Get used to shooting on, in or under water. Most of our needs are found there."

WINE & SPIRITS, 1 Academy St., RD #6, Princeton NJ 08540. (609)921-1060. Fax: (609)921-2566. Art Director: John Thompson. Circ. 55,000. Estab. 1985. Bimonthly magazine. Emphasizes wine. Readers are male, ages 39-60, married, parents, children, $70,000 plus income, wine consumers. Sample copy $2.95; September and November special issues $3.95.
Needs: Uses 6-15 photos/issue; all supplied by freelancers. Needs photos of food, wine, travel, people. Captions preferred; include date, location.
Making Contact & Terms: Interested in receiving work from newer, lesser-known photographers. Submit portfolio for review. Provide résumé, business card, brochure, flier or tearsheets to be kept on file for possible assignments. Reports in 1-2 weeks, if interested. Pays $250-600/job; $250/color cover photo. Pays on publication. Credit line given. Buys one-time rights. Simultaneous submissions OK.
Tips: "I prefer working with natural light whenever possible and I find these photographers very hard to come by."

♣WINE TIDINGS, 5165 Sherbrooke St. W., #414, Montreal, Quebec H4A 1T6 Canada. (514)481-5892. Editor: Tony Aspler. Circ. 16,000. Estab. 1973. Published 8 times/year. Emphasizes "wine for Canadian wine lovers, 85% male, average age 45, high education and income levels." Sample copy free on request.
Needs: Uses about 10 photos/issue; occasionally supplied by freelance photographers. Needs "wine scenes, grapes, vintners, pickers, vineyards, bottles, decanters, wine and food; from all wine producing countries of the world." Photos usually purchased with accompanying ms. Captions preferred.

Making Contact & Terms: Send any size color prints; 35mm or 2¼ × 2¼ transparencies by mail for consideration. SAE and IRC. Reports in 6 weeks. Pays $300 (Canadian)/color cover photo; $25-100/color used inside. Pays on publication. Credit line given. Buys "all rights for one year from date of publication."

WISCONSIN SNOWMOBILE NEWS, P.O. Box 182, Rio WI 53960-0182. (414)992-6370. Editor: Cathy Hansen. Circ. 23,000. Estab. 1960. Publication of the Wisconsin Snowmobile Clubs. Magazine published 7 times/year. Emphasizes snowmobiling. Sample copy free with 9 × 12 SAE and 4 first-class stamps.
Needs: Uses 20-24 photos/issue; 85% supplied by freelancers. Needs photos of snowmobile action, posed snowmobiles, travel, new products. Model/property release preferred. Captions preferred; include where, what, when.
Making Contact & Terms: Interested in receiving work from newer, lesser-known photographers. Submit portfolio for review. Send unsolicited photos by mail for consideration. Provide résumé, business card, brochure, flier or tearsheets to be kept on file for possible assignments. Send 8 × 10 glossy color and b&w prints; 35mm, 2¼ × 2¼, 4 × 5, 8 × 10 transparencies. Keeps samples on file. SASE. Reports in 1-2 weeks. NPI. Pays on publication. Credit line given. Buys one-time rights, all rights; negotiable. Simultaneous submissions and/or previously published work OK.

WITH, The Magazine for Radical Christian Youth, P.O. Box 347, Newton KS 67114. (316)283-5100. Fax: (316)283-0454. E-mail: withllp@aol.com. Co-editors: Eddy Hall, Carol Duerksen. Circ. 6,200. Estab. 1968. Magazine published eight times a year. Emphasizes "Christian values in lifestyle, vocational decision making, conflict resolution for US and Canadian high school students." Sample copy free with 9 × 12 SAE and 4 first-class stamps. Photo and writer's guidelines free with SASE.
Needs: Buys 70 photos/year; 8-10 photos/issue. Buys 65% of freelance photography from assignment; 35% from stock. Documentary (related to concerns of high school youth "interacting with each other, with family and in school environment; intergenerational"); head shot; photo essay/photo feature; scenic; human interest; humorous. Particularly interested in action shots of teens, especially of ethnic minorities. We use some mood shots and a few nature photos. Prefers candids over posed model photos. Few religious shots, e.g., crosses, steeples, etc. Photos purchased with or without accompanying ms and on assignment. For accompanying mss wants issues involving youth—school, peers, family, hobbies, sports, community involvement, sex, dating, drugs, self-identity, values, religion, etc. Model release preferred.
Making Contact & Terms: Interested in receiving work from newer, lesser-known photographers. Send material by mail for consideration. Uses 8 × 10 glossy b&w prints. SASE. Reports in 2 months. Pays $35-40/b&w inside photo; $40-50/b&w cover photo; 5¢/word for text/photo packages, or on a per-photo basis. **Pays on acceptance.** Credit line given. Buys one-time rights. Simultaneous submissions and previously published work OK.
Tips: "Candid shots of youth doing ordinary daily activities and mood shots are what we generally use. Photos dealing with social problems are also often needed. Needs to relate to teenagers—either include them in photos or subjects they relate to; using a lot of 'nontraditional' roles, also more ethnic and cultural diversity. Use models who are average-looking, not obvious model-types. Teenagers have enough self-esteem problems without seeing 'perfect' teens in photos."

WOMAN ENGINEER, Equal Opportunity Publications, Inc., 1160 E. Jericho Turnpike, Suite 200, Huntington NY 11743. (516)421-9478. Fax: (516)421-0359. Editor: Anne Kelly. Circ. 16,000. Estab. 1979. Published three times a year. Emphasizes career guidance for women engineers at the college and professional levels. Readers are college-age and professional women in engineering. Sample copy free with 9 × 12 SAE and 6 first-class stamps.
Needs: Uses at least one photo per issue (cover); planning to use freelance work for covers and possibly editorial; most of the photos are submitted by freelance writers with their articles. Model release preferred. Captions required.
Making Contact & Terms: Query with list of stock photo subjects or call to discuss our needs. SASE. Reports in 6 weeks. Pays $25/color cover photo; $15/b&w photo; $15/color photo. Pays on publication. Credit line given. Buys one-time rights. Simultaneous submissions and previously published work OK, "but not in competitive career-guidance publications."
Tips: "We are looking for strong, sharply focused photos or slides of women engineers. The photo should show a woman engineer at work, but the background should be uncluttered. The photo subject should be dressed and groomed in a professional manner. Cover photo should represent a professional

woman engineer at work, convey a positive and professional image. Read our magazine, and find actual women engineers to photograph. We're not against using cover models, but we prefer cover subjects to be women engineers working in the field."

WOMEN'S SPORTS AND FITNESS MAGAZINE, 2025 Pearl St., Boulder CO 80302. (303)440-5111. Fax: (303)440-3313. Photo Editor: Laurie Russo. Art Director: Janis Llewelyn. Circ. 200,000. Estab. 1974. Published 8 times/year. Readers want to celebrate an active lifestyle through the spirit of sports. Recreational interests include participation in two or more sports, particularly cycling, running and swimming. Sample copy and photo guidelines free with SASE.
Needs: 80% of photos supplied by freelance photographers. Needs photos of indoor and outdoor fitness, product shots (creative approaches as well as straight forward), outdoor action and location. Model release preferred. Captions preferred.
Making Contact & Terms: Write before submitting material to receive photo schedule. Provide business card, brochure, flier or tearsheets to be kept on file for possible future assignments. "I prefer to see promo cards and tearsheets first to keep on file. Then follow up with a call for specific instructions." SASE. Reports in 1 month. Pays $125-400/b&w or color photo; $200-400/day; $200-3,000 (fees and expenses)/job. Pays on publication. Credit line given. Buys one-time rights.
Tips: Looks for "razor sharp images and nice light. Check magazine before submitting query. We look especially for photos of women who are genuinely athletic in active situations that actually represent a particular sport or activity. We want to see less set-up, smiling-at-the-camera shots and more spontaneous, real-action shots. We are always interested in seeing new work and new styles of photography."

WOODENBOAT MAGAZINE, P.O. Box 78, Brooklin ME 04616. (207)359-4651. Fax: (207)359-8920. Editor: Matthew P. Murphy. Circ. 105,000. Estab. 1974. Bimonthly magazine. Emphasizes wooden boats. Sample copy $4.95. Photo guidelines free with SASE.
Needs: Uses 100-125 photos/issue; 95% supplied by freelancers. Needs photos of wooden boats: in use, under construction, maintenance, how-to. Captions required; include identifying information, name and address of photographer on each image.
Making Contact & Terms: Interested in receiving work from newer, lesser-known photographers. Query with stock photo list. Keeps samples on file. SASE. Reports in 1 month. Pays $350/day; $350/ color cover photo; $25-125/color inside photo; $15-75/b&w page rate. Pays on publication. Credit line given. Buys first North American serial rights. Simultaneous submissions and/or previously published work OK with notification.

WORKBENCH MAGAZINE, 700 W. 47th St., Suite 310, Kansas City MO 64112. (816)531-5730. Fax: (816)531-3873. Executive Editor: A. Robert Gould. Senior Editor: Lawrence F. Okrend. Managing Editor: Kip Chin. Circ. 750,000. Estab. 1957. Bimonthly magazine. Emphasizes do-it-yourself projects for the woodworker and home remodeler. Free sample copy. Free photo guidelines and writer's guidelines.
Needs: Looks for residential architecture (interiors and exteriors of homes), wood crafts, furniture, wood toys and folk art. How-to; needs step-by-step shots. Photos are purchased with accompanying ms. "We also purchase photos to illustrate articles, including 'beauty' lead photographs." Model/ property release required for product shots, homeowner's or craftspeople's projects and profile shots. Captions required; include people's names and what action is shown in photo.
Making Contact & Terms: Interested in receiving work from newer, lesser-known photographers. Ask for guidelines, then send material by mail for consideration. Uses 5×7 or 8×10 glossy b&w prints; 2¼×2¼ or 4×5 transparencies and 8×10 glossy color prints; 4×5 color transparencies for cover, vertical format required. SASE. Reports in 1 month. Pay for b&w photos included in purchase price of ms: $125 minimum/color photo; $450 minimum/cover photo; $150-300/published page. **Pays on acceptance.** Credit line given with ms. Buys all rights; negotiable.
Tips: Prefers to see "sharp, clear photos; they must be accompanied by story with necessary working drawings. See copy of the magazine. We are happy to work with photographers in developing story ideas."

THE WORLD & I, 3600 New York Ave. NE, Washington DC 20002. (202)635-4037. Fax: (202)269-9353. Photo Essay Editor: Linda Forristal. Contact department editors. Circ. 30,000. Estab. 1986. Monthly magazine. Sample copy $10. Photo guidelines free with 9×12 SASE.
Needs: Uses 250 photos/issue; 50% supplied by freelancers. Needs news photos, head shots of important political figures; important international news photos of the month; scientific photos, new products, inventions, research; reviews of concerts, exhibitions, museums, architecture, photography shows, fine art; travel; gardening; adventure; food; human interests; personalities; activities; groups; organizations; anthropology, social change, folklore, Americana; photo essay: Life and Ideals, unsung heroes doing altruistic work. Reviews photos with or without ms—depends on editorial section. Model release required for special features and personalities. Captions required.

Making Contact & Terms: Interested in receiving work from newer, lesser-known photographers. "Send written query or call photo essay editor before sending photos. Photographers should direct themselves to editors of different sections (Current Issues, Natural Science, Arts, Life, Book World, Modern Thought, and Photo Essays). If they have questions, they can ask the photo director or the photo essay editor for advice. All unsolicited material must be accompanied by a SASE and unsolicited delivery memos will not be honored. We will try to give you a quick reply, within 2 weeks." For color, pays $75/¼ page, $125/½ page, $135/¾ page, $200/full page, $225/1¼ page, $275/1½ page, $330/1¾ page, $375/double page; for b&w, pays $45/¼ page, $95/½ page, $110/¾ page, $150/full page, $165/ 1¼ page, $175/1½ page, $185/1¾ page, $200/double page. Commissioned photo essays are paid on package deal basis. Pays on publication. Buys one-time rights. Previously published work OK.

Tips: "To be considered for the Photo Essay department, study the guidelines well and then make contact as described above. You must be a good and creative photographer who can tell a story with sufficient attention paid to details and the larger picture. Images must work well with the text, but all tell their own story and add to the story with strong captions. Do NOT submit travel pieces as Patterns photo essays, nor sentimental life stories as Life & Ideals photo essays."

WRESTLING WORLD, Sterling/MacFadden, 233 Park Ave. S. New York NY 10003. (212)780-3500. Fax: (212)780-3555. Editor: Stephen Ciacciarelli. Circ. 50,000. Bimonthly magazine. Emphasizes professional wrestling superstars. Readers are wrestling fans. Sample copy $3.50 with 9×12 SAE and 3 first-class stamps.

Needs: Uses about 60 photos/issue; all supplied by freelance photographers. Needs photos of wrestling superstars, action and posed, color slides and b&w prints.

Making Contact & Terms: Query with representative samples, preferably action. SASE. Reports ASAP. Pays $150/color cover photo; $75/color inside photo; $50-125/text/photo package. **Pays on acceptance.** Credit line given on color photos. Buys one-time rights.

YANKEE MAGAZINE, Main St., Dublin NH 03444. (603)563-8111. Fax: (603)563-8252. Picture Editor: Ann Card. Circ. 700,000. Estab. 1935. Monthly magazine. Emphasizes general interest within New England. Readers are of all ages and backgrounds, majority are actually outside of New England. Sample copy $1.95. Photo guidelines free with SASE.

Needs: Uses 50 photos/issue; 70% supplied by freelancers (on assignment). Needs environmental portraits, travel, food, still lifes, photojournalistic essays. "Always looking for outstanding photo packages shot in New England." Model/property release preferred. Captions required; include name, locale, pertinent details.

Making Contact & Terms: Submit portfolio for review. Keeps samples on file. SASE. Reports in 1 month. Pays $300/day; $100-400/color inside photo; $100-400/b&w inside photo; $200/color page rate; $200/b&w page rate. Credit line given. Buys one-time rights; negotiable. Simultaneous submissions and previously published work OK.

Tips: "Submit only top-notch work. I don't need to see development from student to pro. Show me you can work with light to create exciting images."

YELLOW SILK: Journal of Erotic Arts, P.O. Box 6374, Albany CA 94706. (510)644-4188. Editor: Lily Pond. Circ. 16,000. Quarterly magazine. Emphasizes literature, arts and erotica. Readers are well educated, creative, liberal. Sample copy $7.50

Needs: Uses about 15-20 photos "by one artist" per issue. Have published the work of Jan Saudek, Judy Dater, Tee Corinne, Stephen John Phillips and Sandra Russell Clark. "All photos are erotic; none are cheesecake or sexist. No porn. We define 'erotic' in its widest sense. They are fine arts." Model release required.

Making Contact & Terms: Query with samples. Send prints, transparencies, contact sheets or photocopies by mail for consideration. Submit portfolio for review. SASE. Reports in 3 months. NPI; payment to be arranged. Pays on publication. Credit line given. Buys one-time and additional rights; "use for promotional and/or other rights arranged."

Tips: "Get to know the publication you are submitting work to and enclose SASE in all correspondence. Interested in color and black & white work at this time."

YOGA JOURNAL, 2054 University Ave., Berkeley CA 94704. (510)841-9200. Fax: (510)644-3101. Art Director: Jonathan Wieder. Circ. 80,000. Estab. 1975. Bimonthly magazine. Emphasizes yoga, holistic health, bodywork and massage, meditation, and Eastern spirituality. Readers are female, college educated, median income, $60,000, and median age, 42. Sample copy $5.

Needs: Uses 20-30 photos/issue; 5-10 supplied by freelancers. Needs photos of travel, editorial by assignment. Special photo needs include botanicals, foreign landscapes. Model release preferred. Captions preferred; include name of person, location.

Making Contact & Terms: Interested in receiving work from newer, lesser-known photographers. Send unsolicited photos by mail for consideration. Provide samples or tearsheets for files. Send all sizes and finishes color b&w prints. 35mm, 2¼×2¼, 4×5, 8×10 transparencies. Keeps samples on

file. SASE. Reports in 1 month only if requested. Pays $800/color cover photo; $100-250/color inside photo; $100/b&w inside photo. **Pays on acceptance**. Buys one-time rights. Previously published work OK.

Tips: Seeking electronic files. Also "searching for photographers who use exceptional lighting and exceptional outdoor scenes when photographing models. Photographers should be familiar with shooting human form in yoga poses."

***YOU! MAGAZINE**, 31194 La Baya Dr., #200, Westlake Village CA 91362. (818)991-1813. Fax: (818)991-2024. Managing Editor: Juliette Buerkle. Circ. 100,000. Estab. 1987. Monthly tabloid. Emphasizes teen social and moral issues from a Christian/Catholic perspective. Readers are male and female, 13-21. Sample copy $2. Photo guidelines available.

Needs: Uses 50 photos/issue; 20-30 supplied by freelancers. Needs photos of teens in every situation imaginable, close ups, goofy shots, outrageous or funky shots, artsy shots. Mixed ethnic backgrounds. Model release preferred for close-ups.

Making Contact & Terms: Interested in receiving work from newer, lesser-known photographers. Send unsolicited photos by mail for consideration. Send any size color or b&w matte or glossy prints; 35mm, 2¼ × 2¼, 4 × 5 transparencies. Keeps samples on file. SASE. Reports in 1 month. Pays $25-200/color cover photo; $25-50/color inside photo; $10-35/b&w inside photo. Pays on publication. Credit line given. Rights negotiable. Simultaneous submissions and/or previously published work OK.

Tips: "Upbeat, hip, teen-oriented up close, clear people shots, and action shots. Look at our magazine; give us a call."

YOUR HEALTH, 5401 NW Broken Sound Blvd., Boca Raton FL 33487. (800)749-7733, (407)997-7733. E-mail: yhealth@aol.com. Editor: Susan Gregg. Photo Editor: Judy Browne. Circ. 40,000. Estab. 1963. Biweekly magazine. Emphasizes healthy lifestyles: aerobics, sports, eating, celebrity fitness plans, plus medical advances and the latest technology. Readers are consumer audience; males and females 20-70. Sample copy free with 9 × 12 SASE. Call for photo guidelines.

Needs: Uses 40-45 photos/issue; all supplied by freelance photographers. Needs photos depicting nutrition and diet, sports (runners, tennis, hiking, swimming, etc.), food, celebrity workout, pain and suffering, arthritis and bone disease, skin care and problems. Also any photos illustrating exciting technological or scientific breakthroughs. Model release required.

Making Contact & Terms: Interested in receiving work from newer, lesser-known photographers. Provide résumé, business card, brochure, flier or tearsheets to be kept on file for possible future assignments, and call to query interest on a specific subject. SASE. Reports in 2 weeks. Pay depends on photo size and color. Pays $25-75/b&w photo; $75-200/color photo; $75-150/photo/text package. Pays on publication. Buys one-time rights. Simultaneous submissions and previously published work OK.

Tips: "Pictures and subjects should be interesting; bright and consumer-health oriented. We are using both magazine-type mood photos, and hard medical pictures. We are looking for different, interesting, unusual ways of illustrating the typical fitness, health nutrition story; e.g. an interesting concept for fatigue, insomnia, vitamins. Send prints or dupes to keep on file. Our first inclination is to use what's on hand."

YOUR MONEY MAGAZINE, 5705 N. Lincoln Ave., Chicago IL 60659. Art Director: Beth Ceisel. Circ. 450,000. Estab. 1979. Bimonthly magazine. Emphasizes personal finance.

Needs: Uses 18-25 photos/issue, 130-150 photos/year; all supplied by freelance assignment. Considers all styles depending on needs. "Always looking for quality location photography, especially environmental portraiture. We need photographers with the ability to work with people in their environment, especially people who are not used to being photographed." Model/property release required.

Making Contact & Terms: Interested in receiving work from newer, lesser-known photographers. Arrange a personal interview to show portfolio. Provide a business card, flier or tearsheets to be kept on file. Transparencies, slides, proofs or prints returned after publication. Samples not filed are returned with SASE. Reports only when interested. Pays up to $1,000/color cover photo; $450/b&w page; $200-500/b&w photo; $500/color page. **Pays on acceptance.** Credit line given.

Tips: "Show your best work. Include tearsheets in portfolio."

NEWSPAPERS & NEWSLETTERS

When working with newspapers always remind yourself that time is of the essence. Newspapers have various deadlines for each section that is produced. An interesting feature or news photo has a better chance of getting in the next edition if the subject is timely and has a local appeal. Most of the markets in this section are interested in regional coverage. Find publications near you and contact editors to get an understanding of their deadline schedules.

Also, ask editors if they prefer certain types of film or if they want color slides or
b&w prints. Many smaller newspapers do not have the capability to run color images,
so b&w prints are preferred. However, color slides can be converted to b&w. Editors
who have the option of running color or b&w photos often prefer color film because
of its versatility.

One of the best photojournalists working today is Carol Guzy of the *Washington
Post*. A two-time winner of the Pulitzer Prize (1986 and 1995), Guzy gives insight into
the field as our Insider Report subject on page 347.

Although most newspapers rely on staff photographers, some hire freelancers as
stringers for certain stories. Act professionally and build an editor's confidence in you
by supplying innovative images. For example, don't get caught in the trap of shooting
"grip-and-grin" photos when a corporation executive is handing over a check to a
nonprofit organization. Turn the scene into an interesting portrait. Capture some sponta-
neous interaction between the recipient and the donor. By planning ahead you can be
creative.

When you receive assignments think about the image before you snap your first
photo. If you are scheduled to meet someone at a specific location, arrive early and
scout around. Find a proper setting or locate some props to use in the shoot. Do whatever
you can to show the editor that you are willing to make that extra effort.

Always try to retain resale rights to shots of major news events. High news value
means high resale value, and strong news photos can be resold repeatedly. If you have
an image with a national appeal, search for those larger markets, possibly through the
wire services. You also may find buyers among national news magazines, such as *Time*
or *Newsweek*.

While most newspapers offer low payment for images, they are willing to negotiate
if the image will have a major impact. Front page artwork often sells newspapers, so
don't underestimate the worth of your images.

ADVOCATE/PKA'S PUBLICATIONS, 301A Rolling Hills Park, Prattsville NY 12468. (518)299-
3103. Art Editor: C.J. Karlie. Circ. 12,000. Estab. 1987. Bimonthly tabloid. Literary arts-oriented
magazine geared toward the pre-professional. Readers are male and female, ages 12-90, all professions.
Sample copy $4. Photo guidelines free with SASE.
Needs: Uses 5-10 photos/issue; 100% supplied by freelancers. Needs photos of animals, wildlife,
scenics, humor. Special needs include horses. Reviews photos with or without ms. Model/property
release required. Captions required; include where shot, people and subject of photo, location, anything
which describes shot.
Making Contact & Terms: Interested in receiving work from newer, lesser-known photographers.
Send unsolicited photos by mail for consideration. Send prints no larger than 8×10, color and b&w.
Does not keep samples on file. SASE. Reports in 3-6 weeks. Pays contributor's copy and byline. Pays
on publication. Credit line given. Buys first North American serial rights.
Tips: "We like to publish pretty, positive and expressive photos. Work should look good in black and
white format. We do not print in color, but do accept both b&w and color prints. Just send prints with
SASE, unpublished and not simultaneous submissions."

AMERICAN METAL MARKET, 825 Seventh Ave., New York NY 10019. (212)887-8574. Fax:
(212)887-8520. Del-Capital Cities/ABC, Inc., Chilton Publications, Inc., Diversified Publishing Group.
Editor-in-chief and Associate Publisher: Michael G. Botta. Contact: Bob Manus, Senior Editor. Circ.
11,500. Estab. 1882. Daily newspaper. Emphasizes metals production and trade. Readers are top level
management (CEOs, chairmen, and presidents) in metals and metals-related industries. Sample copies
free with 10×13 SASE.
Needs: 90% of photos supplied by freelancers. Needs photos of press conferences, executive inter-
views, industry action shots and industry receptions. Photo captions required.
Making Contact & Terms: Provide résumé, business card, brochure, flier or tearsheets to be kept on
file for possible assignments. Cannot return material. NPI. Credit line given. Buys all rights; negotiable.
Simultaneous submissions OK.
Tips: "We tend to avoid photographers who are unwilling to release all rights. We produce a daily
newspaper and maintain a complete photo file. We cover events worldwide and often need to hire

freelance photographers. Best bet is to supply business card, phone number and any samples for us to keep on file. Keep in mind action photos are difficult to come by. Much of the metals industry is automated and it has become a challenge to find good 'people' shots."

■AMERICAN SPORTS NETWORK, Box 6100, Rosemead CA 91770. (818)292-2222. President: Louis Zwick. Associate Producer: Tim Edwards. Circ. 793,420. Publishes 4 newspapers covering "general collegiate, amateur and professional sports, i.e., football, baseball, basketball, track and field, wrestling, boxing, hockey, powerlifting and bodybuilding, fitness, health contests, etc."
Needs: Uses about 10-85 photos/issue in various publications; 90% supplied by freelancers. Needs "sport action, hard-hitting contact, emotion-filled photos. Have special bodybuilder annual calendar, collegiate and professional football pre- and post-season editions." Model release and captions preferred.
Making Contact & Terms: Send 8×10 glossy b&w prints and 4×5 transparencies or video demo reel or film work. by mail for consideration. Provide résumé, business card, brochure, flier or tearsheets to be kept on file for possible future assignments. SASE. Reports in 1 week. Pays $1,250/color cover photo; $300/inside b&w photo; negotiates rates by the job and hour. Pays on publication. Buys first North American serial rights. Simultaneous submissions and previously published work OK.

ANCHORAGE DAILY NEWS, Dept. PM, 1001 Northway Dr., Anchorage AK 99508. (907)257-4347. Editor: Kent Pollock. Photo Editor: Richard Murphy. Daily newspaper. Emphasizes all Alaskan subjects. Readers are Alaskans. Circ. 71,000 weekdays, 94,000 Sundays. Estab. 1946. Sample copy free with 11×14 SAE and 8 first-class stamps.
Needs: Uses 10-50 photos/issue; 0-5% supplied by freelance photographers; most from assignment. Needs photos of all subjects, primarily Alaskan subjects. In particular, looking for freelance images for travel section; wants photos of all areas, especially Hawaii. Model release preferred. Captions required.
Making Contact & Terms: Contact photo editor with specific ideas. SASE. Reports in 1-3 weeks. Interested only in color submissions. Pays $35 minimum/color photo: photo/text package negotiable. Pays on publication. Credit line given. Buys one-time rights. Simultaneous submissions OK.
Tips: "We, like most daily newspapers, are primarily interested in timely topics, but at times will use dated material." In portfolio or samples, wants to see "eye-catching images, good use of light and active photographs."

***ARIZONA BUSINESS GAZETTE**, Box 1950, Phoenix AZ 85001. (602)271-7300. Fax: (602)271-7364. General Manager: Stephanie Pressly. Circ. 16,000. Estab. 1880. Weekly newspaper.
Needs: 25% of photos come from assignments. Interested in business subjects, portraits and an ability to illustrate business series and concepts. Model release preferred. Captions required; include name, title and photo description.
Making Contact & Terms: Interested in receiving work from newer, lesser-known photographers. Provide résumé, business card, brochure, flier or tearsheets to be kept on file for possible assignments. Cannot return unsolicited material. Reports when possible. Pays $95/color photo; $85/assignment; $125/day. Pays on publication. Buys one-time rights. Does not consider simultaneous submissions or previously published work.
Tips: Wants to see an "ability to shoot environmental portraits, creatively illustrate stories on business trends and an ability to shoot indoor, outdoor and studio work." Photographers should live in Arizona with some newspaper experience.

AVSC NEWS, 79 Madison Ave., New York NY 10016. (212)561-8000. Fax: (212)779-9439. Director of Communications: Pam Harper. Circ. 7,000. Estab. 1962. Publication of the AVSC International. Quarterly newsletter. Emphasizes health care, contraception. Readers are health care professionals in the US and abroad. Sample copies for 4×9 SASE.
Needs: Uses 2-3 photos/issue; 1 supplied by freelancer. Needs photos of mothers and fathers with children in US and developing worlds. Photos only; does not accept mss. Special needs include annual report 15-20 photos, brochures throughout the year. Model release required. Captions preferred.
Making Contact & Terms: Interested in receiving work from newer, lesser-known photographers. Query with list of stock photo subjects. Reports in 2 weeks. Pays $200 maximum/b&w cover photo; $50-150/b&w inside photo. Pays on publication. Buys one-time rights. Previously published work OK.

 THE SOLID, BLACK SQUARE before a listing indicates that the market uses various types of audiovisual materials, such as slides, film or videotape.

Tips: Prefers to see a "sharp, good range of tones from white through all greys to black, and appealing pictures of people."

CALIFORNIA SCHOOL EMPLOYEE, P.O. Box 640, San Jose CA 95106. (408)263-8000, ext. 298. Fax: (408)954-0948. Senior Designer: Lisa Yordy. Publication of the California School Employees Association (CSEA labor union). Monthly (October-July) newspaper. Circ. 100,000. Estab. 1932. Sample copy free upon request.
Needs: Uses freelance photos on assignment (70%) and from stock (30%). Needs photos of people and kids. Special photo needs include school work sites; classroom shots; crowds; elementary, middle and high school and college related. Wants to see facial emotion, action—cultural diversity, different ethnic backgrounds. "California subject matter only; no out-of-state photographers." Model release required; captions required including subject names.
Making Contact & Terms: Interested in receiving work from newer, lesser-known photographers. Prefers b&w, candid style photos. Provide résumé, business card, brochure, flier or tearsheets to be kept on file for possible assignments. "Call before sending samples." SASE. NPI; payment negotiable. Pays on publication. Credit line given. Rights purchased are negotiable. Simultaneous submissions and previously published work OK.
Tips: "Know publisher's subject matter."

THE CALLER, P.O. Box 530, Edgefield SC 29824. (803)637-3106. Fax: (803)637-0034. Editor: Dana W. Todd. Circ. 120,000. Estab. 1990. Publication of National Wild Turkey Federation, Inc. Quarterly tabloid. Emphasizes wildlife conservation, hunting (turkey). Sample copy free with 9 × 12 SASE and 4 first-class stamps. Photo guidelines available.
Needs: Uses 15 photos/issue; 50% supplied by freelancers. Accepts photos on wide range of outdoor themes—hunting, camping, wild turkeys, other wildlife, nature scenes, etc. "We have opportunities to cover photo assignments. The NWTF does approximately 1,000 habitat restoration projects each year throughout the U.S." Model release preferred. Captions preferred; include species of animals.
Making Contact & Terms: Interested in receiving work from newer, lesser-known photographers. Provide résumé, business card, brochure, flier or tearsheets to be kept on file for possible assignments. Send 35mm transparencies. SASE. Pays up to $300/color cover photo; $50/color inside photo; $25/b&w inside photo. **Pays on acceptance.** Credit line given. Buys one-time rights. Previously published work OK.
Tips: "We know the difference between truly wild turkeys and pen-raised birds. Don't waste any time photographing a turkey unless it's a wild bird."

✤CANADIAN RODEO NEWS, 2116 27th Ave. NE, #223, Calgary, Alberta T2E 7A6 Canada. (403)250-7292. Fax: (403)250-6926. Editor: P. Kirby Meston. Circ. 4,000. Estab. 1963. Monthly tabloid. Emphasizes professional rodeo in Canada. Readers are male and female rodeo contestants and fans—all ages. Free sample copy. Photo guidelines free with SASE.
Needs: Uses 15-20 photos/issue; 2-5 supplied by freelancers. Needs photos of professional rodeo action or profiles. Captions preferred; include identity of contestant/subject, date taken and place.
Making Contact & Terms: Interested in receiving work from newer, lesser-known photographers. Send unsolicited photos by mail for consideration. Send 4 × 6 or larger, glossy or matte, color or b&w prints. Keeps samples on file. SASE. Reports in 1 month. Pays $15/color cover photo; $10/color inside photo; $10/b&w inside photo; $35-60/photo/text package. Pays on publication. Credit line given. Rights negotiable. Simultaneous submissions and/or previously published work OK.
Tips: "Photos must be from or pertain to professional rodeo in Canada. Phone to confirm if subject/material is suitable before submitting. *CRN* is very specific in subject."

CAPPER'S, 1503 SW 42nd St., Topeka KS 66609-1265. (800)678-5779, ext. 4346. Fax: (800)274-4305. Editor: Nancy Peavler. Circ. 370,000. Estab. 1879. Biweekly tabloid. Emphasizes human-interest subjects. Readers are "mostly Midwesterners in small towns and on rural routes." Sample copy $1.50.
Needs: Uses about 20-25 photos/issue, 3-4 supplied by freelance photographers. "We make no photo assignments. We select freelance photos with specific issues in mind." Needs "35mm color slides or larger transparencies of human-interest activities, nature (scenic), etc., in bright primary colors. We often use photos tied to the season, a holiday or an upcoming event of general interest." Captions preferred.
Making Contact & Terms: Interested in receiving work from newer, lesser-known photographers. "Send for guidelines and a sample copy (SAE, 85¢ postage). Study the types of photos in the publication, then send a sheet of 10-20 samples with caption material for our consideration. Although we do most of our business by mail, a phone number is helpful in case we need more caption information. Phone calls to try to sell us on your photos don't really help." Also accepts digital images through AP Leaf Desk. Reporting time varies. Pays $10-15/b&w photo; $35-40/color photo; only cover photos receive maximum payment. Pays on publication. Credit line given. Buys one-time rights.

Tips: "Generally, we're looking for photos of everyday people doing everyday activities. If the photographer can present this in a pleasing manner, these are the photos we're most likely to use. Season shots are appropriate for Capper's, but they should be natural, not posed. We steer clear of dark, mood shots; they don't reproduce well on newsprint. Most of our readers are small town or rural Midwesterners, so we're looking for photos with which they can identify. Although our format is tabloid, we don't use celebrity shots and won't devote an area much larger than 5×6 to one photo."

CATHOLIC HEALTH WORLD, 4455 Woodson Rd., St. Louis MO 63134. (314)427-2500. Fax: (314)427-0029. Editor: Suzy Farren. Circ. 6,000. Estab. 1985. Publication of Catholic Health Association. Semimonthly newspaper emphasizing healthcare—primary subjects dealing with our member facilities. Readers are hospital and long-term care facility administrators, public relations staff people. Sample copy free with 9×12 SASE.
Needs: Uses 4-15 photos/issue; 1-2 supplied by freelancers. Any photos that would help illustrate health concerns (i.e., pregnant teens, elderly). Model release required.
Making Contact & Terms: Send unsolicited photos by mail for consideration. Uses 5×7 or 8×10 b&w and color glossy prints. SASE. Reports in 2 weeks. Pays $40-60/photo. Pays on publication. Credit line given. Buys one-time rights. Simultaneous submissions OK.

❧**CHILD CARE FOCUS**, 364 McGregor St., Winnipeg, Manitoba R2W 4X3 Canada. (204)586-8587. Fax: (204)589-5613. Communication Officer: Debra Mayer. Circ. 2,200. Estab. 1974. Quarterly newspaper. Trade publication for the child care industry. Emphasizes anything pertaining to child care field. Readers are male and female, 18 years of age and up. Sample copy available. Photo guidelines available.
Needs: Uses 8-10 photos/issue; all supplied by freelancers; 10% from assignments; 90% from stock. Needs photos of children, life shots, how-to, personalities. Make sure work isn't too cute. Material should contain realistic interaction between adults and children. Reviews photos with or without a ms. Model release required. Property release preferred. Captions preferred.
Making Contact & Terms: Interested in receiving work from newer, lesser-known photographers. Send unsolicited photos by mail for consideration. Provide résumé, business card, brochure, flier or tearsheets to be kept on file for possible future assignments. Uses 3×5 or larger b&w prints; 35mm transparencies. Keeps samples on file. SASE. Reports in 1 month. "We do not publish photos we must pay for. We are non-profit and *may* print photos offered for free." Credit line given. Buys one-time rights. Previously published work OK.

COUNSELING TODAY, 5999 Stevenson Ave., Alexandria VA 22304. (703)823-9800, ext. 358. Fax: (703)823-0252. Photo Editor: Mary Morrissey. Circ. 60,000. Estab. 1952. Publication of the American Counseling Association. Monthly tabloid. Emphasizes mental health counseling. Readers are male and female mental health professionals, ages 25 and older. Sample copy $2.
Needs: Uses 5-10 photos/issue; 50% supplied by freelancers. Needs human interest shots (i.e., people in conversation or counseling situations, groups, children, medical professionals, students, people with disabilities). Reviews photos with or without ms. Special photo needs include people with disabilities, group therapy, counseling with professionals. Model/property release preferred. Captions preferred; include names of subjects, location, special circumstances.
Making Contact & Terms: Interested in receiving work from newer, lesser-known photographers. Query with stock photo list. Keeps samples on file. SASE. Reports in 1 month. Pays $75-150/color cover photo; $75-100/b&w cover photo; $50-75/b&w inside photo. Pays on publication. Credit line given. Buys one-time rights/negotiable. Simultaneous submissions and/or previously published work OK.
Tips: "We often write about current popular issues from a mental health angle—gays in the military, the gender and generation gap, familial abuse—and we need photos to accompany those articles. It is easiest for us to evaluate your work if you send a pamphlet with reproductions of your stock photos. We often choose directly from catalogs or pamphlets."

*****CRAIN'S DETROIT BUSINESS**, 1400 Woodbridge, Detroit MI 48207. (313)446-6000. Graphics Editor: Nancy Clark. Weekly tabloid. Emphasizes business. Estab. 1985. Sample copy for 11×14 SAE and 2 first-class stamps.
Needs: Uses 30 photos/issue; 9-10 supplied by freelancers. Needs environmental portraits of business executives illustrating product and/or specialty. Model release preferred; captions required.
Making Contact & Terms: Arrange a personal interview to show a portfolio. Submit portfolio for review. Provide résumé, business card, brochure, flier or tearsheets to be kept on file for possible assignments. SASE. Reports in 2 weeks. NPI. **Pays on acceptance**. Credit line given. Buys one-time rights.

CYCLE NEWS, Dept. PM, P.O. Box 498, Long Beach CA 90801. (310)427-7433. Publisher/Editor: Paul Carruthers. Art Director: Ree Johnson. Weekly tabloid. Emphasizes motorcycle news for enthusiasts and covers nationwide races. Circ. 45,000. Estab. 1964.

Needs: Needs photos of motorcycle racing accompanied by written race reports; prefers more than one bike to appear in photo. Wants current material. Buys 1,000 photos/year. Buys all rights, but may revert to photographer after publication.

Making Contact & Terms: Send photos or contact sheet for consideration or call for appointment. Reports in 3 weeks. SASE. For b&w: send contact sheet, negatives (preferred for best reproduction) or prints (5×7 or 8×10, glossy or matte), captions required, pays $10 minimum. For color: send transparencies. captions required, pays $50 minimum. For cover shots: send contact sheet, prints or negatives for b&w; transparencies for color, captions required, payment negotiable. "Payment on 15th of the month for issues cover-dated the previous month."

Tips: Prefers sharp action photos utilizing good contrast. Study publication before submitting "to see what it's all about." Primary coverage area is nationwide.

DAILY BUSINESS REVIEW, 1 SE Third Ave., Suite 900, Miami FL 33131. (305)347-6622. Art Director: John Rindo. Staff Photographers: Aixa Montero-Green, Melanie Bell. Circ. 11,000. Estab. 1926. Daily newspaper. Emphasizes law, business and real estate. Readers are 25-55 years, average net worth of $750,000, male and female. Sample copy for $3 with 9×11 SASE.

Needs: Uses 8 photos/issue; 10% supplied by freelance photographers. Needs mostly portraits, however we use live news events, sports and building mugs. Photo captions "an absolute must."

Making Contact & Terms: Arrange a personal interview to show portfolio. Submit portfolio for review. Send 35mm, 8×10 b&w and color prints. Accepts all types of finishes. Cannot return unsolicited material. If used, reports immediately. Pays $75-150 for most photos; pays more if part of photo/text package. Credit line given. Buys all rights; negotiable. Previously published work OK.

Tips: In photographer's portfolio, looks for "a good grasp of lighting and composition; the ability to take an ordinary situation and make an extraordinary photograph. We work on daily deadlines, so promptness is a must and extensive cutline information is needed."

DEKALB DAILY CHRONICLE, 1586 Barber Greene Rd., DeKalb IL 60115. (815)756-4841. Head Photographer: Kathleen Fox. Circ. 15,000. Estab. 1869. Daily newspaper. Emphasizes agriculture and features on DeKalb people. Sample copy for 50¢.

Needs: Feature pages run every week on Sunday—must pertain to DeKalb County. Photos purchased with accompanying ms only. Model release preferred; photo captions required.

Making Contact & Terms: Query with résumé of credits. Send unsolicited 8×10 glossy b&w photos by mail for consideration. Also, call to query. Cannot return material. Reports in 1 month. NPI. **Pays on acceptance.** Credit line given. Buys one-time rights.

Tips: "No 'set' pay scale per se; payment negotiable depending on several factors including quality of photo and need."

✦FARM & COUNTRY, 1 Yonge St., Suite 1504, Toronto, Ontario M5E 1E5 Canada. (416)364-5324. Fax: (416)364-5857. E-mail: agpub@magic.ca. Website: http://www.agpub.on.ca. Managing Editor: John Muggeridge. Circ. 56,000. Estab. 1935. Tabloid published 18 times/year. Emphasizes agriculture. Readers are farmers, ages 20-70. Sample copy free with SASE. Photo guidelines available.

Needs: Uses 50 photos/issue; 5 supplied by freelancers. Needs photos of farm livestock, farmers farming, farm activities. *No rural scenes.* Special photo needs include food processing, shoppers, rural development, trade, politics. Captions preferred; include subject name, location, description of activity, date.

Making Contact & Terms: Interested in receiving work from newer, lesser-known photographers. Submit portfolio for review. Query with résumé of credits. Query with stock photo list. Send unsolicited photos by mail for consideration. Provide résumé, business card, brochure, flier or tearsheets to be kept on file for possible assignments. Send $2\frac{1}{4} \times 2\frac{1}{4}$ transparencies. Also accepts images in digital format. Published second and fourth Tuesdays—2 weeks earlier. Keeps samples on file. SASE. Reports in 1 month. Pays $100/inside color photo; $25/inside b&w photo; $100-300/color cover photo. Pays on publication. Buys all rights; negotiable. Previously published work OK.

Tips: Looking for "action, color, imaginative angles, vertical. Be able to offer wide range of color—on disk, if possible."

THE FRONT STRIKER BULLETIN, P.O. Box 18481, Asheville NC 28814. (704)254-4487. Fax: (704)254-1066. Owner: Bill Retskin. Circ. 800. Estab. 1986. Publication of The American Matchcover Collecting Club. Quarterly newsletter. Emphasizes matchcover collecting. Readers are male, blue collar workers, average age 55 years. Sample copy $3.50.

Needs: Uses 2-3 photos/issue; none supplied by freelancers. Needs table top photos of older match covers or related subjects. Reviews photos with accompanying ms only.

Making Contact & Terms: Interested in receiving work from newer, lesser-known photographers. Send unsolicited 5×7 matte b&w prints. Keeps samples on

file. SASE. Reports in 1 month. NPI, negotiable. Pays on publication. Credit line given. Buys one-time rights; negotiable.

FULTON COUNTY DAILY REPORT, Dept. PM, 190 Pryor St. SW, Atlanta GA 30303. (404)521-1227. Art Director: Beverly Davis. Daily newspaper, 5 times/week. Emphasizes legal news and business. Readers are male and female professionals age 25 up, involved in legal field, court system, legislature, etc. Sample copy $1, with 9½×12½ SAE and 6 first-class stamps.
Needs: Uses 5-10 b&w photos/issue; 30% supplied by freelancers. Needs informal environmental photographs of lawyers, judges and others involved in legal news and business. Some real estate, etc. Photo captions preferred; complete name of subject and date shot, along with other pertinent information. Two or more people should be identified from left to right.
Making Contact & Terms: Submit portfolio for review—call first. Query with list of stock photo subjects. Keeps samples on file. SASE. Reports in 1 month. "Freelance work generally done on an assignment-only basis." Pays $100/assignment. Credit line given. Simultaneous submissions and previously published work OK.
Tips: Wants to see ability with "casual, environmental portraiture, people—especially in office settings, urban environment, courtrooms, etc.; and photojournalistic coverage of people in law or courtroom settings." In general, needs "competent, fast freelancers from time to time around the state of Georgia who can be called in at the last minute. We keep a list of them for reference. Good work keeps you on the list." Recommends that "when shooting for FCDR, it's best to avoid law-book-type photos if possible, along with other overused legal cliches."

GLOBE, Dept. PM, 5401 NW Broken Sound Blvd., Boca Raton FL 33487. (407)997-7733. Photo Editor: Ron Haines. Circ. 2 million. Weekly tabloid. "For everyone in the family. *Globe* readers are the same people you meet on the street, and in supermarket lines—average, hard-working Americans."
Needs: Celebrity photos only!!!
Making Contact & Terms: Send transparencies or prints for consideration. Color preferred. SASE. Reports in 1 week. Pays $75/b&w photo (negotiable); $125/color photo (negotiable); day and package rates negotiable. Buys first serial rights. Pays on publication unless otherwise arranged.
Tips: "Do **NOT** write for photo guidelines. Study the publication instead."

GRAND RAPIDS BUSINESS JOURNAL, 549 Ottawa NW, Grand Rapids MI 49503. (616)459-4545. Fax: (616)459-4800. Editor: Carole Valade. Circ. 6,000. Estab. 1983. Weekly tabloid. Emphasizes West Michigan business community. Sample copy $1.
Needs: Uses 10 photos/issue; 100% supplied by freelancers. Needs photos of local community, manufacturing, world trade, stock market, etc. Model/property release required. Captions required.
Making Contact & Terms: Interested in receiving work from newer, lesser-known photographers. Query with résumé of credits. Query with stock photo list. Deadlines: two weeks prior to publication. SASE. Reports in 1 month. Pays $25-35/b&w cover photo; $35/color inside photo; $25/b&w inside photo. Pays on publication. Credit line given. Buys one-time rights, first North American serial rights; negotiable. Simultaneous submissions and previously published work OK.

GULF COAST GOLFER, 9182 Old Katy Rd., Suite 212, Houston TX 77055. (713)464-0308. Editor: Steve Hunter. Circ. 32,000. Monthly tabloid. Emphasizes golf below the 31st parallel area of Texas. Readers average 48.5 years old, $72,406 income, upscale lifestyle and play golf 2-5 times weekly. Sample copy free with SASE and 9 first-class stamps.
Needs: "Photos are bought only in conjunction with purchase of articles." Model release preferred. Captions preferred.
Making Contact & Terms: "Use the telephone." SASE. Reports in 2 weeks. NPI. Pays on publication. Credit line given. Buys one-time rights or all rights, if specified.

INSIDE TEXAS RUNNING, Dept. PM, 9514 Bristlebrook, Houston TX 77083. (713)498-3208. Fax: (713)879-9980. Publisher/Editor: Joanne Schmidt. Circ. 10,000. Estab. 1977. Tabloid published 10 times/year. Emphasizes running and jogging with biking insert. Readers are Texas runners and joggers of all abilities. Sample copy for 9 first-class stamps.
Needs: Uses about 20 photos/issue; 10 supplied by freelancers; 80% percent of freelance photography in issue comes from assignment from freelance stock. Needs photos of "races, especially outside of Houston area; scenic places to run; how-to (accompanying articles by coaches); also triathlon and bike

 THE MAPLE LEAF before a listing indicates that the market is Canadian.

tours and races." Special needs include "top race coverage; running camps (summer); variety of Texas running terrain." Captions preferred.

Making Contact & Terms: Interested in receiving work from newer, lesser-known photographers. Send glossy b&w or color prints by mail for consideration. SASE. Reports in 1 month. Pays $10-15/ b&w or color photo; $25/color cover photo. Pays on publication. Credit line given. Buys one-time rights; negotiable. Simultaneous submissions outside Texas and previously published work OK.

Tips: Prefers to see "human interest, contrast and good composition" in photos. Must use color prints for covers. "Look for the unusual. Race photos tend to look the same." Wants "clear photos with people near front; too often photographers are too far away when they shoot and subjects are a dot on the landscape." Wants to see road races in Texas outside of Houston area.

***JEWISH EXPONENT**, Dept. PM, 226 S. 16th St., Philadelphia PA 19102. (215)893-5740. Executive Editor: Bertram Korn, Jr. Weekly newspaper. Emphasizes news of impact to the Jewish community. Circ. 70,000.

Needs: Buys 15 photos/issue. On a regular basis, wants news and feature photos of a cultural, heritage, historic, news and human interest nature involving Jews and Jewish issues. Query as to photographic needs for upcoming year. No art photos. Photos purchased with or without accompanying mss. Captions required. Uses 8×10 glossy prints; 35mm or 4×5 transparencies. Model release required "where the event covered is not in the public domain."

Making Contact & Terms: Query with résumé of credits or arrange a personal interview. "Telephone or mail inquiries first are essential. Do not send original material on speculation." Provide résumé, business card, letter of inquiry, samples, brochure, flier and tearsheets to be kept on file. SASE. Reports in 1 week. Free sample copy. Pays $50/studio photo assignment; $10/print; $150/color cover photo; $100/b&w cover photo; fee negotiable. Credit line given. Pays on publication. Buys one-time, all, first serial, first North American serial and all rights. Rights are negotiable.

Tips: "Photographers should keep in mind the special requirements of high-speed newspaper presses. High contrast photographs probably provide better reproduction under newsprint and ink conditions."

❖THE LAWYERS WEEKLY, 75 Clegg Rd., Markham, Ontario L6G 1A1 Canada. (905)479-2665. Fax: (905)479-3758. E-mail: amacaulay@butterworths.ca. Copy Coordinator: Ann Macaulay. Circ. 8,000. Estab. 1983. Weekly newspaper. Emphasizes law. Readers are male and female lawyers and judges, ages 25-75. Sample copy $8. Photo guidelines free with SASE.

Needs: Uses 12-20 photos/issue; 5 supplied by freelancers. Needs head shot photos of lawyers and judges mentioned in story.

Making Contact & Terms: Interested in receiving work from newer, lesser-known photographers. Provide résumé, business card, brochure, flier or tearsheets to be kept on file for possible assignments. Deadlines: 1-2 day turnaround time. Does not keep samples on file. SASE. Reports only when interested. Pays $50 maximum/b&w photo. **Pays on acceptance.** Credit line not given.

Tips: "We need photographers across Canada to shoot lawyers and judges on an as-needed basis. Send a résumé and we will keep your name on file. Mostly b&w work."

LONG ISLAND PARENTING NEWS, P.O. Box 214, Island Park NY 11558. (516)889-5510. Fax: (516)889-5513. Director: Andrew Elias. Circulation: 50,000. Estab. 1989. Monthly newspaper. Emphasizes parenting issues and children's media. Readers are mostly women, ages 25-45, with kids, ages 0-12. Sample copy $3 and 9×12 SASE with 5 first-class stamps. Model release required.

Needs: Uses 4-8 photos/issue; 1-2 supplied by freelancers. Needs photos of kids, families, parents. Model release required.

Making Contact & Terms: Interested in receiving work from newer, lesser-known photographers. Send unsolicited photos by mail for consideration. Send 5×7 or 8×10 color or b&w prints. Keeps samples on file. SASE. Reports in 6 weeks. Pays $50/color cover photo; $25-50/color inside photo; $25-50/b&w inside photo. Pays on publication. Credit line given. Buys one-time rights.

METRO, 550 S. First St., San Jose CA 95113. (408)298-8000. Chief Photographer: Christopher Gardner. Circ. 91,000. Alternative newspaper, weekly tabloid format. Emphasis on news, arts and entertainment. Readers are adults ages 25-44, in Silicon Valley. Sample copy $3.

Needs: Uses 15 photos/issue; 10% supplied by freelance photographers. Model release required for model shots. Captions preferred.

Making Contact & Terms: Query with résumé of credits, list of stock photos subjects. Provide résumé, business card, brochure, flier or tearsheets to be kept on file for possible assignments. Also accepts digital images on Zip cartridge, SyQuest, small floppy, CD—all on Mac format. Does not return unsolicited material. Pays $75-100/color cover photo; $50-75/b&w cover photo; $50/b&w inside photo. Pays on publication. Credit line given. Buys one-time rights. Simultaneous submissions and/or previously published work OK "if outside of San Francisco Bay area."

MISSISSIPPI PUBLISHERS, INC., Dept. PM, 801 N. Congress St., P.O. Box 40, Jackson MS 39201. (601)961-7073. Photo Editors: Chris Todd and Jennifer Laird. Circ. 115,000. Daily newspaper.

INSIDER REPORT

Shoot from the Heart

Veteran shooter Carol Guzy recognizes the downside of being a photojournalist. "The hours are lousy, and you'll never get rich, if that's your goal," she says. "But if you have the talent and determination, and want an incredibly fascinating life full of variety, then being a photojournalist is the best job in the world. You get to experience so many life situations that you never would otherwise."

Winner of Pulitzer Prizes for spot news in 1986 and 1995, plus other honors such as two Photographer of the Year awards from the National Press Photographers' Association, Guzy says that the best news pictures arise from observational skills and other related qualities.

"One of my few strengths is that I'm fairly chameleon-like," says Guzy. "I tend to blend in easily wherever I am. I try to understand my subjects and stay open to the 'little' moments. So I really am an observer."

Guzy points out that novice shooters often are too impatient to capture either the dramatic or subtle moments that tell stories. In the rush to record a scene or an event, beginners often overlook details that provide insight for the viewer, she says.

"Less experienced photographers may shoot what they think other people want to see, or they'll try to copy the styles of photographers they recognize, but I think style's a personal matter. People should develop their own eye, and shoot what they think is important or needs to be said. Ultimately, the pictures will be better if the subject is something you shoot from the heart."

Guzy adds that the value of sensitivity is intimately connected with personal viewpoint. "The cliché about journalists is that they're cynical and hard. But most of the people I know and respect in photography are very compassionate. They tend to be sensitive toward the issue, the people or the culture that they're covering. I feel you have to respect people's space and body language, wherever you are. People can tell you in a lot of ways if [photographing them] is not appropriate."

Reflecting on her own path, Guzy says that building a career in news photography is "certainly more difficult now" than when she broke into the business 16 years ago. Immediately upon getting a two-year nursing degree, Guzy went into photography school to find "something more comfortable." She attended the Art Institute in Ft. Lauderdale, Florida, where she got the opportunity to intern twice with the *Miami Herald*. After graduation, she took a photo position with the newspaper. She worked there until 1988, when she joined her current newspaper, the *Washington Post*.

Guzy cites interning as the critical link to her first job and advises aspiring news photographers to pursue such opportunities. "Internships are the way to go. I don't think that school is enough. For photography, you have to shoot. Class work teaches you only so much. But getting an internship, which gives you a chance to build a portfolio in a working situation, is invaluable."

INSIDER REPORT, *continued*

© Carol Guzy/Washington Post

Washington Post photographer Carol Guzy says the best news pictures arise from observational skills. "One of my few strengths is that I'm fairly chameleon-like. I tend to blend in easily wherever I am. I try to understand my subjects and stay open to the 'little' moments. So I really am an observer." These skills helped earn her the 1995 Pulitzer Prize for spot news for her coverage of political unrest in Haiti. In this image, a Haitian woman bleeds after being struck in the head with a brick.

INSIDER REPORT, *Guzy*

Photographers today will find entry into the field much more difficult. "Many papers are folding. And, with so many more photographers trying to break in, there's a lot less work out there," she says. As a result, interning opportunities also have decreased.

"Also, not as many pictures are getting published as they once were," Guzy says. "Most people get their immediate news from TV, so now we're in a different ball game. All of this has made [photojournalism] so competitive that you practically have to have a God-given talent and just be willing to work incredibly hard."

Guzy professes the need for sober self-awareness before embarking on a career in photojournalism. "This business isn't for everyone," she says. "Many people want to be in the business, but they can't always recognize that their talent may lie somewhere else, and not necessarily with photography."

How do you know, then, if you've got what it takes to make it as a photojournalist? Well, photography instructors often recognize photographic talent and recommend students with journalistic potential to internships. Once you've earned an internship, learn from people in the business.

"When interns come to work at the *Post*, everybody offers them tips and feedback on their work," Guzy says. "Evaluating photography is subjective anyway. So, especially for someone just starting out, the more people who look at your work and the more opinions you get, the better you become at evaluating your own abilities."

Getting feedback at this stage, from people you respect, helps when choosing a direction, says Guzy. "If someone has been in the business awhile, then he or she can help to point [you] toward the right path, whether it's in journalism or a different kind of photography."

—Sam A. Marshall

Emphasizes photojournalism: news, sports, features, fashion, food and portraits. Readers are in very broad age range of 18-70 years; male and female. Sample copy for 11 × 14 SAE and 54¢.
Needs: Uses 10-15 photos/issue; 1-5 supplied by freelance photographers. Needs news, sports, features, portraits, fashion and food photos. Special photo needs include food and fashion. Model release and captions required.
Making Contact & Terms: Provide résumé, business card, brochure, flier or tearsheets to be kept on file for possible assignments. Uses 8 × 10 matte b&w and color prints; 35mm, 2¼ × 2¼, 4 × 5, 8 × 10 transparencies. SASE. Reports 1 week. Pays $50-100/color cover photo; $25-50/b&w cover photo; $25/b&w inside photo; $20-50/hour; $150-400/day. Pays on publication. Credit line given. Buys one-time or all rights; negotiable.

MODEL NEWS, 244 Madison Ave., Suite 393, New York NY 10016-2817. (212)683-0244. or (516)764-3856. Publisher: John King. Circ. 288,000. Estab. 1975. Monthly newspaper. Emphasizes celebrities and talented models, beauty and fashion. Readers are male and female, ages 15-80. Sample copy $1.50 with 8 × 10 SAE and 1 first-class stamp. Photo guidelines $1.50.
Needs: Uses 1-2 photos/issue; 1-2 supplied by freelancers. Review photos with accompanying ms only. Special photo needs include new celebrities, famous faces, VIP's, old and young. Model release preferred. Captions preferred.
Making Contact & Terms: Interested in receiving work from newer, lesser-known photographers. Contact through rep. Arrange personal interview to show portfolio. Submit portfolio for review. Send unsolicited photos by mail for consideration. Provide résumé, business card, brochure, flier or tearsheets to be kept on file for possible future assignments. Send 8 × 10 b&w prints. Keeps samples on file. SASE. Reports in 3 weeks. Pays $50-60/b&w cover photo; $30/b&w inside photo. Pays on publication.

Credit line given. Buys all rights. Considers simultaneous submissions.

***THE MOVING WORLD**, 1611 Duke St., Alexandria VA 22314. Fax: (703)548-1845. Editor: Rose S. Talbot. Circ. 3,000. Estab. 1992. Publication of the American Movers Conference. Biweekly newspaper. Emphasizes the household goods moving industry. Readers are owners of businesses of all sizes associated with moving and transportation.
Needs: Uses 3-4 photos/issue. "I need shots of moving vans, transportation and affiliated shots (i.e., roads, bridges, highway signs, maps, etc.)." Reviews photos with or without ms. Also accepts digital images in TIFF files, Mac platform. Model/property release preferred.
Making Contact & Terms: Interested in receiving work from newer, lesser-known photographers. Send unsolicited photos by mail for consideration. Send 5×7 b&w prints. Keeps samples on file. SASE. Reports in 3 weeks. Pays $200/color cover photo; $25-50/b&w inside photo. Pays on publication. Credit line given. Buys one-time rights.

NATIONAL ENQUIRER, 600 S. E. Coast Ave., Lantana FL 33464. (407)586-1111. Photo Editor: Valerie Virga. Weekly tabloid. Readers are mostly female, ages 18-45.
Needs: Uses 150-200 photos/issue; all supplied by freelancers. Needs celebrity shots, funny animal photos, spectacular stunt photos, human interest. Model release required. Captions preferred.
Making Contact & Terms: Interested in receiving work from newer, lesser-known photographers. Arrange personal interview to show portfolio. Submit portfolio for review. Query with résumé of credits. Query with stock photo list. Provide résumé, business card, brochure flier or tearsheets to be kept on file for possible future assignments. SASE. "Must have proper postage." Reports in 3 weeks. NPI. Payment varies according to photo. Credit line sometimes given. Buys one-time rights, first North American serial rights. If work is not published in competitive publication it will be considered.

NATIONAL MASTERS NEWS, P.O. Box 50098, Eugene OR 97405. (503)343-7716. Fax: (503)345-2436. Editor: Al Sheahen. Circ. 8,000. Estab. 1977. Monthly tabloid. Official world and US publication for Masters (age 35 and over) track and field, long distance running and race walking. Sample copy free with 9×12 SASE.
Needs: Uses 25 photos/issue; 20% assigned and 80% from freelance stock. Needs photos of Masters athletes (men and women over age 35) competing in track and field events, long distance running races or racewalking competitions. Captions preferred.
Making Contact & Terms: Send any size matte or glossy b&w print by mail for consideration, "may write for sample issue." SASE. Reports in 1 month. NPI. Pays on publication. Credit line given. Buys one-time rights. Simultaneous submissions and previously published work OK.

NATIONAL NEWS BUREAU, P.O. Box 43039, Philadelphia PA 19129. (215)546-8088. Editor: Andy Edelman. Circ. 300 publications. Weekly syndication packet. Emphasizes entertainment. Readers are leisure/entertainment-oriented, 17-55 years old.
Needs: "Always looking for new female models for our syndicated fashion/beauty columns." Uses about 20 photos/issue; 15 supplied by freelance photographers. Captions required.
Making Contact & Terms: Arrange a personal interview to show portfolio. Query with samples. Submit portfolio for review. Send 8×10 b&w prints, b&w contact sheet by mail for consideration. SASE. Reports in 1 week. Pays $50-1,000/job. Pays on publication. Credit line given. Buys all rights.

NEW HAVEN ADVOCATE, 1 Long Wharf Dr., New Haven CT 06511. (203)789-0010. Publisher: Gail Thompson. Photographer: Kathleen Cei. Circ. 55,000. Estab. 1975. Weekly tabloid. Member of Alternative Association of News Weeklys. Readers are male and female, educated, ages 20-50.
Needs: Uses 7-10 photos/issue; 0-1 supplied by freelancers. Reviews photos with or without ms. Model release required. Captions required.
Making Contact & Terms: Interested in receiving work from newer, lesser-known photographers. Provide résumé, business card, brochure, flier or tearsheets to be kept on file for possible assignments. Does not keep samples on file. SASE. Reports in 1 month. NPI. Pays on publication. Credit line given. Buys one-time rights. Simultaneous submissions and/or previously published work OK.

***NEW YORK TIMES MAGAZINE**, 229 W. 43 St., New York NY 10036. (212)556-7434. Photo Editor: Kathy Ryan. Weekly. Circ. 1.65 million.

MARKET CONDITIONS are constantly changing! If you're still using this book and it's 1998 or later, buy the newest edition of *Photographer's Market* at your favorite bookstore or order directly from Writer's Digest Books.

● This magazine went through a major redesign which increased the size of the editorial space and put color on nearly every page.

Needs: The number of freelance photos varies. Model release and photo captions required.

Making Contact & Terms: Drop off portfolio for review. SASE. Reports in 1 week. Pays $250/ b&w page rate; $300/color page rate; $225/half page; $350/job (day rates); $650/color cover photo. **Pays on acceptance.** Credit line given. Buys one-time rights.

NORTH TEXAS GOLFER, 9182 Old Katy Rd., Suite 212, Houston TX 77055. (713)464-0308. Editor: Steve Hunter. Monthly tabloid. Emphasizes golf in the northern areas of Texas. Readers average 48.5 years old, $72,406 income, upscale lifestyle and play golf 2-5 times weekly. Circ. 29,000. Sample copy $2.50 with SAE.

Needs: "Photos are bought only in conjunction with purchase of articles." Model release and captions preferred.

Making Contact & Terms: "Use the telephone." SASE. Reports in 2 weeks. NPI. Pays on publication. Credit line given. Buys one-time rights or all rights, if specified.

PACKER REPORT, (formerly *Ray Nitschke's Packer Report*), 1317 Lombardi Access Rd., Green Bay WI 54304. (414)490-6500. Fax: (414)497-6519. Contact: Editor. Circ. 35,000. Estab. 1972. Weekly tabloid. Emphasizes Green Bay Packer football. Readers are 94% male, all occupations, ages. Sample copy free with SASE and 3 first-class stamps.

Needs: Uses 6-10 photos/issue; all supplied by freelancers. Needs photos of Green Bay Packer football.

Making Contact & Terms: Interested in receiving work from newer, lesser-known photographers. Query with résumé of credits. Provide résumé, business card, brochure, flier or tearsheets to be kept on file for possible assignments. Does not keep samples on file. SASE. Reports in 1 month. Pays $50/ color cover photo; $10-50/color inside photo; $10-20/b&w page rate. Pays on publication. Credit line given. Buys one-time rights; negotiable. Simultaneous submissions and previously published work OK.

THE PATRIOT LEDGER, 400 Crown Colony Dr., Quincy MA 02169. (617)786-7084. Fax: (617)786-7025. Circ. 100,000. Estab. 1837. "Daily except Sunday" newspaper. General readership. Photo guidelines free with SASE.

Needs: Uses 15-25 photos/issue; most photos used come from staff; some freelance assigned. Needs general newspaper coverage photos—especially spot news and "grabbed" features from circulation area. Model release preferred. Captions required.

Making Contact & Terms: Query with résumé of credits. SASE. Reports as needed. Pays $15-75/ b&w inside photo or more if material is outstanding and especially newsworthy; $10-15/hour. Pays on publication. Credit line given. Rights negotiable. Simultaneous submissions and previously published work OK "depending on time and place."

Tips: Looks for "diversity in photojournalism: use NPPA pictures of the year categories as guidelines. Dynamite grabber qualities: unique, poignant images properly and accurately identified and captioned which concisely tell what happened. We want images we're unable to get with staff due to immediacy of events, shot well and in our hands quickly for evaluation and possible publication. To break in to our publication call and explain what you can contribute to our newspaper that is unique. We'll take it from there, depending on the results of the initial conversation."

PITTSBURGH CITY PAPER, 911 Penn Ave., 6th Floor, Pittsburgh PA 15222. (412)560-2489. Fax: (412)281-1962. Editor: John Hayes. Art Director: Kevin Shepherd. Circ. 80,000. Estab. 1991. Weekly tabloid. Emphasizes Pittsburgh arts, news, entertainment. Readers are active, educated young adults, ages 29-54, with disposable incomes. Sample copy free with 12×15 SASE.

Needs: Uses 6-10 photos, all supplied by freelancers. Model/property release preferred. Captions preferred. Generally supplies film and processing. "We can write actual captions but we need all the pertinent facts."

Making Contact & Terms: Interested in receiving work from newer, lesser-known photographers. Arrange personal interview to show portfolio. Query with résumé of credits. Provide résumé, business card, brochure, flier or tearsheets to be kept on file for possible assignments. Does not keep samples on file. SASE. Reports 2 weeks. Pays $25-125/job. Pays on publication. Credit line given. Previously published work OK.

Tips: Provide "something beyond the sort of shots typically seen in daily newspapers. Consider the long-term value of exposing your work through publication. In negotiating prices, be honest about

your costs, while remembering there are others competing for the assignment. Be reliable and allow time for possible re-shooting to end up with the best pic possible.''

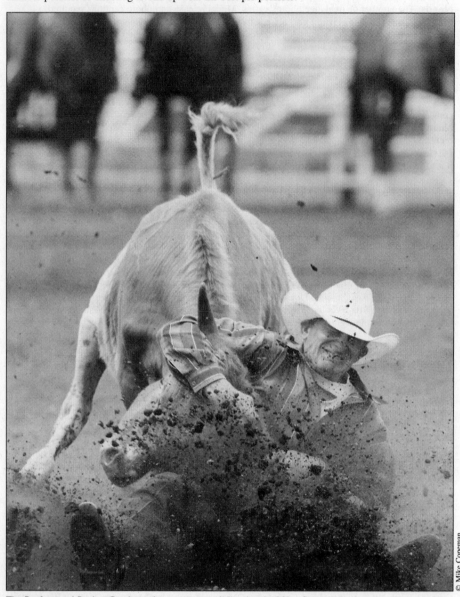

© Mike Copeman

The Professional Rodeo Cowboys Association used this shot by Mike Copeman—depicting "just another day at the office" for a rodeo cowboy—inside *Prorodeo Sports News*. "Mike Copeman is easily the best rodeo photographer in Canada," says PRCA's Clay Gaillard of the Saskatchewan-based photographer. Copeman has been photographing rodeos since 1989 and has sold his work all over North America and the world to rodeo contestants, fans, committees, newspapers, magazines and advertisers. He sold reprint rights to this photo to PRCA for $50.

PRORODEO SPORTS NEWS, 101 Pro Rodeo Dr., Colorado Springs CO 80919. (719)593-8840. Fax: (719)548-4889. Associate Editors: Clay Gaillard and Paul Asay. Circ. 40,000. Publication of Professional Rodeo Cowboys Association. Biweekly newspaper, weekly during summer (12 weeks). Emphasizes professional rodeo. Sample copy free with SAE and 8×10 envelope and 4 first-class stamps. Photo guidelines free with SASE.

● *Prorodeo* scans about 95% of their photos, so *high quality* prints are very helpful.
Needs: Uses about 25-50 photos/issue; all supplied by freelancers. Needs action rodeo photos. Also uses behind-the-scenes photos, cowboys preparing to ride, talking behind the chutes—something other than action. Model/property release preferred. Captions required, including contestant name, rodeo and name of animal.
Making Contact & Terms: Interested in receiving work from newer, lesser-known photographers. Send 5×7, 8×10 glossy b&w and color prints by mail for consideration. Also accepts images in digital format, contact for information. SASE. Pays $85/color cover photo; $35/color inside photo; $15/b&w inside photo. Other payment negotiable. Pays on publication. Credit line given. Buys one-time rights.
Tips: In portfolio or samples, wants to see "the ability to capture a cowboy's character outside the competition arena, as well as inside. In reviewing samples we look for clean, sharp reproduction—no grain. Photographer should respond quickly to photo requests. I see more PRCA sponsor-related photos being printed."

ROLL CALL NEWSPAPER, 900 Second St. NE, Suite 107, Washington DC 20002. (202)289-4900. Fax: (202)289-5337. Photo Editor: Laura Patterson. Circ. 25,000. Estab. 1955. Semiweekly newspaper. Emphasizes US Congress and politics. Readers are politicians, lobbyists and congressional staff. Sample copy free with 9×12 SAE with 4 first-class stamps.
Needs: Uses 20-30 photos/issue; up to 5 supplied by freelancers. Needs photos of anything involving current congressional issues, good or unusual shots of congressmen. Captions required.
Making Contact & Terms: Interested in receiving work from newer, lesser-known photographers. Query with samples or list of stock photo subjects. Send unsolicited photos by mail for consideration. Uses 8×10 glossy b&w prints; 35mm transparencies. Does not return unsolicited material. Reports in 1 month. Pays $50-200/b&w photo; $75-250/color photo (if cover); $50-100/hour; $200-300/day. Pays on publication. Credit line given. Buys one-time rights. Simultaneous submissions OK.
Tips: "We're always looking for unique candids of congressmen or political events. In reviewing photographer's samples, we like to see good use of composition and light for newsprint."

RUBBER AND PLASTICS NEWS, 1725 Merriman Rd., Akron OH 44313. (330)836-9180. Editor: Edward Noga. Circ. 17,000. Weekly tabloid. Emphasizes rubber industry. Readers are rubber product makers. Sample copy free.
Needs: Uses 5-10 photos/issue. Needs photos of company officials, in-plant scenes, etc. to go with stories staff produces.
Making Contact & Terms: Query with samples. SASE. Reports in 2 weeks. Pays $50-200/b&w or color cover photo; $50-100/b&w or color inside photo. Pays on publication. Credit line given. Buys all rights; negotiable. Simultaneous submissions OK.
Tips: Prefers to see "news photos; mood shots suitable for cover; business-related photos. Call us. We'd like to use more freelance photographers throughout the U.S. and internationally to produce photographs that we'd use in stories generated by our staff."

SENIOR VOICE OF FLORIDA, 18860 US Highway 19 N., Suite 151, Clearwater FL 34624-3106. Editor: Nancy Yost. Circ. 70,000. Estab. 1981. Monthly newspaper. Emphasizes lifestyles of senior citizens. Readers are Florida residents and tourists, 50 years old and older. Sample copy $1. Photo guidelines free with SASE.
Needs: Uses 6 photos/issue; 1-2 supplied by freelancers. Needs photos of recreational activities, travel, seasonal, famous persons (only with story). Reviews photos purchased with accompanying ms only. Model/property release required. Captions required.
Making Contact & Terms: Send photos with manuscript. Samples kept on file. SASE. Reports in 2 months. Pays $10/color cover photo; $5/color inside photo; $5/b&w inside photo. Pays on publication. Credit line given. Buys one-time rights; negotiable. Simultaneous submissions and previously published work OK.
Tips: "We look for crisp, clean, clear prints. Photos that speak to us rate special attention. We use photos only to illustrate manuscripts."

SHOW BIZ NEWS, 244 Madison Ave., New York NY 10016-2817. (212)683-0244 or (516)764-3856. Publisher: John King. Circ. 310,000. Estab. 1975. Monthly newspaper. Emphasizes model and talent agencies coast to coast. Readers are male and female, ages 15-80. Sample copy $1.50 with 8×10 SAE and 1 first-class stamp. Photo guidelines $1.50.
Needs: Uses 1-2 photos/issue; 1-2 supplied by freelancers. Reviews photos with accompanying ms only. Needs photos of new celebrities, famous faces, VIP's, old and young. Model release preferred. Captions preferred.
Making Contact & Terms: Interested in receiving work from newer, lesser-known photographers. Contact through rep. Arrange personal interview to show portfolio. Submit portfolio for review. Send unsolicited photos by mail for consideration. Send 8×10 b&w prints. Keeps samples on file. SASE.

Reports in 3 weeks. Pays $50-60/b&w cover photo; $30/b&w inside photo. Pays on publication. Gives credit line. Buys all rights. Considers simultaneous submissions.

SINGER MEDIA CORP., INC., Seaview Business Park, 1030 Calle Cordillera, Unit #106, San Clemente CA 92673. President: Kurt Singer. Worldwide circulation. Estab. 1940. Newspaper syndicate (magazine, journal, books, newspaper, newsletter, tabloid). Emphasizes books and interviews.
 • Singer Media is starting to store images on optical disks.
Needs: Needs photos of celebrities, movies, TV, rock/pop music pictures, fitness, posters, postcards, greeting cards, text features with transparencies (35mm, 2¼×2¼, 4×5). Will use dupes or photocopies, cannot guarantee returns. No models. Usually requires releases on interview photos. Photo captions required.
Making Contact & Terms: Interested in receiving work from newer, lesser-known photographers, depending on subject. Query with list of stock photo subjects or tearsheets of previously published work. Color preferred. Reports in 6 weeks. Pays $25-1,000/b&w photo; $50-1,000/color photo. Pays 50/50% of all syndication sales. Pays after collection. Credit line given. Buys one-time rights, foreign rights; negotiable. Previously published work OK.
Tips: "Worldwide, mass market, text essential. Trend is toward international interest. Survey the market for ideas."

***SKIING TRADE NEWS**, Dept. PM, 2 Park Ave., New York NY 10016. (212)779-5000. Editor: Gregg Reilly. Circ. 22,000. Estab. 1965. Tabloid published 7 times/year. Emphasizes news, retailing and service articles for ski retailers. Free sample copy with 12×24 SASE.
Needs: Uses 2-6 photos/issue; 50% from freelancers. Celebrity/personality; photo essay/photo feature ("if it has to do with skiing and skiwear retailing or snowboarding"); spot news; and humorous. Model release preferred. Captions required; include who, what, when.
Making Contact & Terms: Interested in receiving work from newer, lesser-known photographers. Photos purchased with accompanying ms or caption. Uses 5×7 glossy prints; transparencies. Pays $25-75/b&w photo; $100-150/color photo. Pays on publication. Buys one-time rights. Credit line given. Send material by mail for consideration. SASE. Reports in 1 month.
Tips: "Send some samples, stay in touch. Remember, we only run photos to accompany stories, so most must be assigned."

SOUTHERN MOTORACING, P.O. Box 500, Winston-Salem NC 27102. (910)723-5227. Associate: Greer Smith. Editor/Publisher: Hank Schoolfield. Circ. 15,000. Biweekly tabloid. Emphasizes autoracing. Readers are fans of auto racing.
Needs: Uses about 10-15 photos/issue; some supplied by freelance photographers. Needs "news photos on the subject of Southeastern auto racing." Captions required.
Making Contact & Terms: Query with samples; send 5×7 or larger matte or glossy b&w prints; b&w negatives by mail for consideration. SASE. Reports in 1 month. Pays $25-50/b&w cover photo; $5-50/b&w inside photo; $50-100/page. Pays on publication. Credit line given. Buys first North American serial rights. Simultaneous submissions OK.
Tips: "We're looking primarily for *news* pictures, and staff produces many of them—with about 25% coming from freelancers through long-standing relationships. However, we're receptive to good photos from new sources, and we do use some of those. Good quality professional pictures only, please!"

THE STAR NEWSPAPERS, Dept PM, 1526 Otto Blvd., Chicago Heights IL 60411. (708)755-6161. Fax: (708)755-0095. Photo Director: Carol Dorsett. Publishes 20 weekly newspapers in south suburban Chicago. Circ. 100,000. Estab. 1920.
Needs: Buys 100 stock photos and offers 1,000 assignments annually. Uses photos for features, news, spot news and sports coverage. Captions required; include description of subject, especially of towns or events.
Making Contact & Terms: Arrange personal interview to show portfolio. Accepts color or b&w prints, any size over 5×7. Also uses 35mm and 2¼×2¼ transparencies. Works with local freelancers on assignment only. Does not keep samples on file. SASE. Pays $19-25/assignment. Credit line given. Buys one-time and all rights; negotiable.
Tips: Wants to see "variety of photojournalism categories." Also, show "ability both to utilize and supplement available light." To break in, "be ready to hustle and work lousy hours." Sees a trend toward more use of "a documentary style."

LISTINGS THAT USE IMAGES electronically can be found in the Digital Markets Index located at the back of this book.

STREETPEOPLE'S WEEKLY NEWS (Homeless Editorial), P.O. Box 270942, Dallas TX 75227-0942. Newspaper publisher. Publisher: Lon G. Dorsey, Jr. Estab. 1977. For a copy of the paper send $3 to cover immediate handling (same day as received) and postage.

● *SWN* wishes to establish relationships with corporations interested in homeless issues that can also provide photography regarding what their company is doing to combat the problem.

Needs: Uses photos for newspapers. Subjects include: photojournalism on homeless or street people. Model/property release required. Captions required.

Making Contact & Terms: Interested in receiving work from newer, lesser-known photographers. "Hundreds of photographers are needed to show national view of America's homeless." Send unsolicited photos by mail for consideration with SASE for return of all materials. Reports promptly. Pays $30/b&w photo; $20/color photo; $15/hour; $20-500/job. Pays on acceptance or publication. Credit line sometimes given. Buys all rights; negotiable.

Tips: In freelancer's demos, wants to see "professionalism, clarity of purpose, without sex or negative atmosphere which could harm purpose of paper." The trend is toward "kinder, gentler situations, the 'let's help our fellows' attitude." To break in, "find out what we're about so we don't waste time with exhausting explanations. We're interested in all homeless situations. Inquiries not answered without SASE."

SUN, 5401 NW Broken Sound Blvd., Boca Raton FL 33487. (407)989-1070. Fax: (409)998-0798. Photo Editor: Bella Center. Weekly tabloid. Readers are housewives, college students, middle Americans. Sample copy free with extra large SAE and $1.70 postage.

Needs: Uses about 60 photos/issue; 50% supplied by freelance photographers. Wants varied subjects: amazing sightings (i.e., Jesus, Elvis, angels), action, unusual pets, offbeat medical, human interest, inventions, spectacular sports action; b&w human interest and offbeat pix and stories; and b&w celebrity photos. "Also—we are always in need of interesting, offbeat color photos for the center spread." Model release preferred. Captions preferred.

Making Contact & Terms: Query with stock photo list. Send 8 × 10 b&w prints, 35mm transparencies, b&w contact sheet or b&w negatives by mail for consideration. Also accepts digital images via Mac to Mac W Z modem, ISDN, Leaf Desk. Send through mail with SASE. Reports in 2 weeks. Pays $150-250/day; $150-250/job; $100/b&w cover photo; $200/color cover photo; $50-150/b&w inside photo; $125-200/color inside photo. Pays on publication. Buys one-time rights. Simultaneous submissions and previously published work OK.

Tips: "We are specifically looking for the unusual, offbeat, freakish true stories and photos. *Nothing* is too far out for consideration. We would suggest you send for a sample copy and take it from there."

SUNSHINE: THE MAGAZINE OF SOUTH FLORIDA, 200 E. Las Olas Blvd., Ft. Lauderdale FL 33301-2293. (305)356-4685. Art Director: Greg Carannante. "*Sunshine* is a Sunday newspaper magazine emphasizing articles of interest to readers in the Broward and Palm Beach counties region of South Florida." Readers are "the 800,000 readers of the Sunday edition of the *Sun-Sentinel*." Sample copy and guidelines free with SASE.

Needs: Uses about 12-20 photos/issue; 30% supplied by freelancers. Needs "all kinds of photos relevant to a South Florida readership." Photos purchased with accompanying ms. Model release sometimes required. Captions preferred.

Making Contact & Terms: Query with samples. Provide résumé, business card, brochure, flier or tearsheets to be kept on file for possible future assignments. SASE. Reports in 1 month. "All rates negotiable; the following are as a guide only." Pays $200/color cover photo; $75-150/color inside photo; $500-1,000 for text/photo package. Pays within 2 months of acceptance. Credit line given. Buys one-time rights. Simultaneous and previously published submissions OK.

***❉TORONTO SUN PUBLISHING**, 333 King St., Toronto, Ontario M5A 3X5 Canada. (416)947-2399. Fax: (416)947-3580. Director of Photography: Hugh Wesley. Circ. 300,000. Estab. 1971. Daily newspaper. Emphasizes sports, news and entertainment. Readers are 60% male, 40% female, ages 25-60. Sample copy free with SASE.

Needs: Uses 30-50 photos/issue; 20% supplied by freelancers. Needs photos of Toronto personalities making news out of town. Reviews photos with or without ms. Captions preferred.

Making Contact & Terms: Interested in receiving work from newer, lesser-known photographers. Phone. Send any size color prints; 35mm transparencies; press link digital format. Deadline: 11 p.m. daily. Does not keep samples on file. Reports in 1-2 weeks. Pays $150/job. Pays on publication. Credit line given. Buys one-time and other negotiated rights. Simultaneous submissions and previously published work OK.

Tips: "The squeeky wheel gets the grease when it delivers the goods. Don't try to oversell a questionable photo. Return calls promptly."

***TRIBUNE-REVIEW**, 622 Cabin Hill Dr., Greensburg PA 15601. (800)433-3045. Fax: (412)838-5171. Chief Photographer: Tod Gombar. Circ. 150,000. Estab. 1889. Daily newspaper. Emphasizes

news, features, sports, travel, consumer information and food. Sample copy 50¢.
Needs: Uses 25-35 photos/issue; 10% supplied by freelancers. Model release required; property release preferred. Captions required.
Making Contact & Terms: Interested in receiving work from newer, lesser-known photographers. Arrange personal interview to show portfolio. Provide résumé, business card, brochure, flier or tearsheets to be kept on file for possible future assignments. "All work submitted should be digitized in Mac format on floppy disks or magneto optical disks, using Photoshop." Deadlines: daily. Keeps samples on file. Reports in 1-2 weeks. Pays on publication. Buys one-time and other negotiated rights. Simultaneous submissions OK.
Tips: "Illustration photos are important to us; people-oriented subject material is a must."

U.S. YOUTH SOCCER, 3333 S. Wadsworth, Suite D-321, Lakewood CO 80227. (303)987-3994. Fax: (303)987-3998. Editor: Jon DeStefano. Circ. 110,000. Estab. 1982. Publication of the United States Youth Soccer Association. Quarterly newspaper. Emphasizes soccer and kids. Readers are coaches and club officers.
Needs: Uses 40 photos/issue; 90% supplied by freelancers. Reviews photos with or without ms. Captions required; include names of players and teams.
Making Contact & Terms: Interested in receiving work from newer, lesser-known photographers. Send unsolicited photos by mail for consideration. Send color prints. Does not keep samples on file. Cannot return material. Reports in 2 weeks. NPI. Pays on publication. Buys one-time rights. Considers simultaneous submissions.
Tips: "Have fun, show emotion, humor or intensity."

VELONEWS, 1830 N. 55th St., Boulder CO 80301-2700. (303)440-0601. Fax: (303)444-6788. Senior Editor: Tim Johnson. Paid circ. 48,000. The journal of competitive cycling. Covers road racing, mountain biking and recreational riding. Sample copy free with 9×12 SAE and 4 first-class stamps.
Needs: Bicycle racing and nationally important races. Looking for action shots, not just finish-line photos with the winner's arms in the air. No bicycle touring. Photos purchased with or without accompanying ms. Uses news, features, profiles. Captions and identification of subjects required.
Making Contact & Terms: Send samples of work or tearsheets with assignment proposal. Query first on mss. Send glossy b&w prints and transparencies. SASE. Reports in 3 weeks. Pays $16.50-50/b&w inside photo; $33-100/color inside photo; $75/b&w cover; $150/color cover; $15-100/ms. Credit line given. Pays on publication. Buys one-time rights.
Tips: "We're a newspaper; photos must be timely. Use fill flash to compensate for harsh summer light."

VENTURA COUNTY & COAST REPORTER, Dept. PM, 1563 Spinnaker Dr., #202, Ventura CA 93001. (805)658-2244. Editor: Nancy S. Cloutier. Circ. 35,000. Estab. 1977. Weekly tabloid newspaper.
Needs: Uses 12-14 photos/issue; 40-45% supplied by freelancers. Photos purchased with accompanying ms only. Model release required.
Making Contact & Terms: Send sample b&w or color original photos. SASE. Reports in 2 weeks. Pays $10/b&w or color cover photo; $10/b&w inside photo. Pays on publication. Credit line given. Buys one-time rights. Simultaneous submissions OK.
Tips: "We prefer locally slanted photos (Ventura County, CA)."

THE WASHINGTON BLADE, 1408 U St. NW, Washington DC 20009-3916. (202)797-7000. Fax: (202)797-7040. E-mail: washblade@aol.com. Senior Editor: Lisa M. Keen. Circ. 40,000. Estab. 1969. Weekly tabloid. For and about the gay community. Readers are gay men and lesbians; moderate-to upper-level income; primarily Washington DC metropolitan area. Sample copy free with 9×12 SAE plus 11 first-class stamps.
 • *The Washington Blade* stores images on CD; manipulating size, contrast, etc.—but not content!
Needs: Uses about 6-7 photos/issue; only out-of-town photos are supplied by freelance photographers. Needs "gay-related news, sports, entertainment events; profiles of gay people in news, sports, entertainment, other fields." Photos purchased with or without accompanying ms. Model release preferred. Captions preferred.
Making Contact & Terms: Interested in receiving work from newer, lesser-known photographers. Query with résumé of credits. Provide résumé, business card and tearsheets to be kept on file for possible future assignments. SASE. Reports in 1 month. Pays $25-50/b&w photo; $50-100/color photo; $50 minimum/job. Pays within 45 days of publication. Credit line given. Buys all rights when on assignment, otherwise one-time rights. Simultaneous submissions and previously published work OK.
Tips: "Be timely! Stay up-to-date on what we're covering in the news and call if you know of a story about to happen in your city that you can cover. Also, be able to provide some basic details for a caption (*tell* us what's happening, too)." Especially important to "avoid stereotypes."

WATERTOWN PUBLIC OPINION, Box 10, Watertown SD 57201. (605)886-6903. Fax: (605)886-4280. Editor: Gordon Garnos. Circ. 17,500. Estab. 1887. Daily newspaper. Emphasizes general news of this area, state, national and international news. Sample copy 50¢.

Needs: Uses up to 8 photos/issue. Reviews photos with or without ms. Model release required. Captions required.

Making Contact & Terms: Interested in receiving work from newer, lesser-known photographers. Send unsolicited photos by mail for consideration. Send b&w or color prints. Does not keep samples on file. SASE. Reports in 1-2 weeks. Pays minimum $5/b&w or color cover photo; $5/b&w or color inside photo; $5/color page rate. Pays on publication. Credit line given. Buys one-time rights; negotiable. Simultaneous submissions OK.

WESTART, Box 6868, Auburn CA 95604. (916)885-0969. Editor-in-Chief: Martha Garcia. Circ. 4,000. Emphasizes art for practicing artists, artists/craftsmen, students of art and art patrons, collectors and teachers. Free sample copy and photo guidelines.

Needs: Uses 20 photos/issue, 10 supplied by freelancers. "We will publish photos if they are in a current exhibition, where the public may view the exhibition. The photos must be b&w. We treat them as an art medium. Therefore, we purchase freelance articles accompanied by photos." Wants mss on exhibitions and artists in the western states. Captions required.

Making Contact & Terms: Send 5×7 or 8×10 b&w prints by mail for consideration. SASE. Reports in 2 weeks. Payment is included with total purchase price of ms. Pays $25 on publication. Buys one-time rights. Simultaneous and previously published submissions OK.

♣THE WESTERN PRODUCER, PO Box 2500, Saskatoon, Sasketchewan S7K 2C4 Canada. Fax: (306)934-2401. E-mail: shein@producer.com. Editor: Garry Fairbairn. Circ. 100,000. Estab. 1923. Weekly newspaper. Emphasizes agriculture and rural living in western Canada. Photo guidelines free with SASE.

● This publication accesses images through computer networks and is examining the storage of images on CD.

Needs: Buys up to 10 photos/issue; about 50-80% of photos supplied by freelancers. Livestock, nature, human interest, scenic, rural, agriculture, day-to-day rural life and small communities. Model/property release preferred. Captions required; include person's name and description of activity.

Making Contact & Terms: Interested in receiving work from newer, lesser-known photographers. Send material by mail for consideration. SASE. Pays $20-40/photo; $35-100/color photo; $50-250 for text/photo package. Pays on publication. Credit line given. Buys one-time rights. Previously published work OK.

Tips: Needs current photos of farm and agricultural news. "Don't waste postage on abandoned, derelict farm buildings or sunset photos. We want modern scenes with life in them—people or animals, preferably both. Farm kids are always a good bet." Also seeks mss on agriculture, rural Western Canada, history, fiction and contemporary life in rural western Canada.

YACHTSMAN, Dept. PM, 2033 Clement Ave., Suite 100, Alameda CA 94501. (510)865-7500. Editor: Connie Skoog. Circ. 25,000. Estab. 1965. Monthly tabloid. Emphasizes recreational boating for boat owners of northern California. Sample copy $3. Writer's guidelines free with SASE.

● *Yachtsman* scans b&w or color photos for the inside of its magazine.

Needs: Buys 5-10 photos/issue. Sport; power and sail (boating and recreation in northern California); spot news (about boating); travel (of interest to boaters). Seeks mss about power boats and sailboats, boating personalities, locales, piers, harbors, and how-tos in northern California. Photos purchased with or without accompanying ms. Model release required. Captions preferred.

Making Contact & Terms: Interested in receiving work from newer, lesser-known photographers. "We would love to give a newcomer a chance at a cover." Send material by mail for consideration. Uses any size b&w or color glossy prints. Uses color slides for cover. Vertical (preferred) or horizontal format. SASE. Reports in 1 month. Pays $5 minimum/b&w photo; $150 minimum/cover photo; $1.50 minimum/inch for ms. Pays on publication. Credit line given. Buys one-time rights. Simultaneous submissions or previously published work OK but must be exclusive in Bay Area (nonduplicated).

Tips: Prefers to see action b&w, color slides, water scenes. "We do not use photos as stand-alones; they must illustrate a story. The exception is cover photos, which must have a Bay Area application—power, sail or combination; vertical format with uncluttered upper area especially welcome."

SPECIAL INTEREST PUBLICATIONS

As with most magazines, breaking in with special interest publications will probably happen in stages. You may be assigned smaller projects at first, but once you supply quality material—on time and within budget—you may become a regular contributor.

Editors will ask you to complete larger assignments as they become more comfortable with your talents.

Though the subject matter, readerships and circulations of these publications vary, their photo editors share a need for top-notch images. Normally these publications are affiliated with certain organizations that are trying to reach a clearly defined readership. These associations generally will be described with the phrase, "Publication of the (Name) Association" or "Company publication for the (Name) Corporation."

As you build a rapport with photo editors in these markets, you might find yourself being asked to complete noneditorial projects for a periodical's parent company or association. Among these would be shooting publicity materials, executive portraits, product advertising and documentation of company or organization events. Keep your eyes open for such opportunities and when you approach these editors remember there is potential for some of these higher paying projects.

There also are certain publications interested in text/photo packages and photographers who have an ability to write can benefit from these listings. Editors often turn down photo submissions because they do not have an article to coincide with the artwork. By providing the full package you can make work more attractive to editors. The key is to cover a topic that is unique and focuses on the magazine's audience. If you do not have talent as a writer, team up with writers who need artwork for their stories.

AAA MICHIGAN LIVING, 1 Auto Club Dr., Dearborn MI 48126. (313)336-1506. Fax: (313)336-1344. Executive Editor: Ron Garbinski. Managing Editor: Larry Keller. Circ. 1 million. Estab. 1918. Monthly magazine. Emphasizes auto use, as well as travel in Michigan, US, Canada and foreign countries. Free sample copy and photo guidelines.
Needs: Scenic and travel. "We buy photos without accompanying ms. Only for stories listed on our editorial calendar. Seeks queries about travel in Michigan, US and Canada. We maintain a file on stock photos and subjects photographers have available." Captions required.
Making Contact & Terms: Interested in receiving work from newer, lesser-known photographers. Query with list of stock photo subjects. Uses 35mm, 2¼×2¼ or 4×5 transparencies. For covers in particular, uses 35mm, 4×5 or 8×10 color transparencies. SASE. Reports in 6 weeks. Pays up to $500/color photo depending on quality and size; $350/cover photo; $55-500/ms. Pays on publication for photos, on acceptance for mss. Buys one-time rights. Simultaneous submissions and previously published work not accepted.

ACROSS THE BOARD MAGAZINE, published by The Conference Board, 845 Third Ave., New York NY 10022-6679. (212)339-0454. Picture Editor: Marilyn Stern. Circ. 30,000. Estab. 1976. General interest business magazine with 10 monthly issues (January/February and July/August are double issues). Readers are senior executives in large corporations. Recent articles that used photos covered these topics: US design, the Asian economic boom, business in Eastern Europe, social unrest in Western Europe, natural drugs, workplace depression, technology transfer.
 • *Across the Board Magazine* sometimes requests the right to do computer manipulation, usually montaging or cropping.
Needs: Use 10-15 photos/issue some supplied by freelancers. Wide range of needs, including location portraits, industrial, workplace, social topics, environmental topics, government and corporate projects, foreign business (especially east and west Europe, former USSR and Asia). Needs striking, unusual or humorous photos with newsworthy business themes for "Sightings" department. Captions required.
Making Contact and Terms: Interested in receiving promos from newer, lesser-known photographers. Query *by mail only* with list of stock photo subjects and clients, and brochure or tearsheets to be kept on file. Accepts digital images. Ok for final use but not for portfolio review. Cannot return material. "No phone queries please. We pay $125-300 inside, up to $500 for cover or $300/half-day for assignments. We buy one-time rights, or six-month exclusive rights if we assign the project."
Tips: "Our style is journalistic. We sometimes assign locally around the USA and internationally. We keep a regional file of photographers. Also interested in seeing computer manipulated photo illustration."

ADVENTURE CYCLIST, Box 8308, Missoula MT 59807. (406)721-1776. Editor: Dan D'Ambrosio. Circ. 30,000. Estab. 1974. Publication of Adventure Cycling Association. Magazine published 9 times/year. Emphasizes bicycle touring. Readers are mid-30s, mostly male, professionals. Sample copy free with 9×12 SAE and 4 first-class stamps.

Needs: Covers. Model release preferred. Captions required.
Making Contact & Terms: Submit portfolio for review. SASE. Reports in 3 weeks. NPI; payment negotiable. Pays on publication. Credit line given. Buys one-time rights. Simultaneous submissions and previously published work OK.

***AFSCME PUBLIC EMPLOYEE**, AFSCME, 1625 L St. NW, Washington DC 20036. (202)429-1150. Production Supervisor: Judy Sugar. Circ. 1,300,000. Union publication of American Federation of State, County and Municipal Employees, AFL-CIO. Color magazine published 6 times/year. Emphasizes public employees, AFSCME members. Readers are "our members."
Needs: Uses 35 photos/issue; majority supplied by freelancers. Assignment only.
Making Contact & Terms: Provide résumé, business card, brochure, flier or tearsheets to be kept on file for possible assignments. Will try to return unsolicited material if a SASE is enclosed, but no guarantee. Reports back as needed. NPI; depends on assignment, usually negotiates price. **Pays on acceptance.** Credit line usually given. Buys all rights; negotiable.
Tips: "Color transparencies, no fast film. Show strong photojournalism skills and be skilled in use of flash."

AI MAGAZINE, 445 Burgess Dr., Menlo Park CA 94025. (415)328-3123. Fax: (415)321-4457. Publishing Director: David Hamilton. Circ. 10,000. Estab. 1980. Publication of American Association of Artificial Intelligence (AAAI). Quarterly. Emphasizes artificial intelligence. Readers are research scientists, engineers, high-technology managers, professors of computer science. Sample copy with 9×12 SAE and 9 first-class stamps.
Needs: Uses about 1-2 photos/issue; all supplied by freelancers. Needs photos of specialized computer applications. Model release required. Captions preferred.
Making Contact & Terms: Interested in receiving work from newer, lesser-known photographers. Arrange a personal interview to show portfolio. Query with list of stock photo subjects. Provide résumé, business card, brochure, flier or tearsheets to be kept on file for possible future assignments. SASE. Reports in 6 weeks. Pays $100-800/color cover photo; $25-250/color inside photo. Pays on publication. Credit line given. Buys one-time and first North American serial rights. Simultaneous submissions and previously published work OK.
Tips: Looks for "editorial content of photos, not artistic merit."

AIR LINE PILOT, 535 Herndon Pkwy., Box 1169, Herndon VA 22070. (703)481-4460. Fax: (703)689-4370. Editor-in-Chief: Gary DiNunno. Circ. 65,000. Estab. 1933. Publication of Air Line Pilots Association. Monthly. Emphasizes news and feature stories for commercial airline pilots. Photo guidelines for SASE.
Needs: Uses 12-15 photos/issue; 25% comes from freelance stock. Needs dramatic 35mm Kodachrome transparencies of commercial aircraft, pilots and co-pilots performing work-related activities in or near their aircraft. Special needs include dramatic 35mm Kodachromes technically and aesthetically suitable for full-page magazine covers. Especially needs vertical composition scenes. Model release required. Captions required; include aircraft type, airline, location of photo/scene, description of action, date, identification of people and which airline they work for.
Making Contact & Terms: Interested in receiving work from newer, lesser-known photographers. Query with samples. Send unsolicited photos by mail for consideration. Uses 35mm transparencies. SASE. Pays $35/b&w photo; $35-350/color photo. **Pays on acceptance.** Buys all rights. Simultaneous submissions and previously published work OK.
Tips: In photographer's samples, wants to see "strong composition, poster-like quality and high technical quality. Photos compete with text for space so they need to be very interesting to be published. Be sure to provide brief but accurate caption information and send in only professional quality work. For our publication, cover shots do not need to tie in with current articles. This means that the greatest opportunity for publication exists on our cover."

***AMERICAN BAR ASSOCIATION JOURNAL**, 750 N. Lake Shore Drive, Chicago IL 60611. (312)988-6002. Photo Editor: Beverly Lane. Publication of the American Bar Association. Monthly magazine. Emphasizes law and the legal profession. Readers are lawyers of all ages. Circ. 400,000. Estab. 1915. Photo guidelines available.
Needs: Uses 50-100 photos per month; 80% supplied by freelance photographers. Needs vary; mainly shots of lawyers and clients by assignment only.
Making Contact & Terms: Send non-returnable printed samples with résumé and two business cards with rates written on back. "If samples are good, portfolio will be requested. *ABA Journal* keeps film. However, if another publication requests photos, we will release and send the photos. Then, that publication pays the photographer." NPI. Cannot return unsolicited material. Credit line given.

Tips: "NO PHONE CALLS. The *ABA Journal* does not hire beginners."

AMERICAN CRAFT, 72 Spring St., New York NY 10012. (212)274-0630. Fax: (212)274-0650. Editor/Publisher: Lois Moran. Managing Editor: Pat Dandignac. Circ. 45,000. Estab. 1941. Bimonthly magazine of the American Craft Council. Emphasizes contemporary creative work in clay, fiber, metal, glass, wood, etc. and discusses the technology, materials and ideas of the artists who do the work. Free sample copy with 9×12 SAE and 5 first-class stamps.
Needs: Visual art. Shots of crafts: clay, metal, fiber, etc. Captions required.
Making Contact & Terms: Arrange a personal interview to show portfolio. Uses 8×10 glossy b&w prints; 4×5 transparencies and 35mm film; 4×5 color transparencies for cover, vertical format preferred. SASE. Reports in 1 month. Pays according to size of reproduction; $40 minimum/b&w and color photos; $175-500/cover photos. Pays on publication. Buys one-time rights. Previously published work OK.

AMERICAN FITNESS, Dept. PM, 15250 Ventura Blvd., Suite 200, Sherman Oaks CA 91403. (818)905-0040. Managing Editor: Rhonda J. Wilson. Circ. 30,000. Estab. 1983. Publication of the Aerobics and Fitness Association of America. Publishes 6 issues/year. Emphasizes exercise, fitness, health, sports nutrition, aerobic sports. Readers are fitness enthusiasts and professionals, 75% college educated, 66% female, majority between 20-45. Sample copy $2.50.
Needs: Uses about 20-40 photos/issue; most supplied by freelancers. Assigns 90% of work. Needs action photography of runners, aerobic classes, swimmers, bicyclists, speedwalkers, in-liners, volleyball players, etc. Special needs include food choices, youth and senior fitness, people enjoying recreation, dos and don'ts. Model release required.
Making Contact & Terms: Query with samples or with list of stock photo subjects. Send b&w prints; 35mm, 2¼×2¼ transparencies; b&w contact sheets by mail for consideration. SASE. Reports in 2 weeks. Pays $10-35/b&w or color photo; $50-100 for text/photo package. Pays 4-6 weeks after publication. Credit line given. Buys first North American serial rights. Simultaneous submissions and previously published work OK.
Tips: Looks for "firsthand fitness experiences—we frequently publish personal photo essays." Fitness-oriented outdoor sports are the current trend (i.e. mountain bicycling, hiking, rock climbing). Over-40 sports leagues, youth fitness, family fitness and senior fitness are also hot trends. Wants high-quality, professional photos of people participating in high-energy activities—anything that conveys the essence of a fabulous fitness lifestyle. Also accepts highly stylized studio shots to run as lead artwork for feature stories. "Since we don't have a big art budget, freelancers usually submit spin-off projects from their larger photo assignments."

AMERICAN FORESTS MAGAZINE, Dept. PM, 1516 P St. NW, Washington DC 20005. (202)667-3300. Fax: (202)667-2407. Editor: Michelle Robbins. Circ. 25,000. Estab. 1895. Publication of American Forests. Quarterly. Emphasizes use, enjoyment and management of forests and other natural resources. Readers are "people from all walks of life, from rural to urban settings, whose main common denominator is an abiding love for trees, forests or forestry." Sample copy and free photo guidelines with magazine-sized envelope and 7 first-class stamps.
Needs: Uses about 40 photos/issue, 80% supplied by freelance photographers (most supplied by article authors). Needs woods scenics, wildlife, woods use/management and urban forestry shots. Model release preferred. Captions required, include who, what, where, when and why.
Making Contact & Terms: Interested in receiving work from newer, lesser-known photographers. Query with résumé of credits. SASE. Reports in 2 months. $300/color cover photo; $50-75/b&w inside; $75-200/color inside; $350-800 for text/photo package. Pays on acceptance. Credit line given. Buys one-time rights.
Tips: Seeing trend away from "static woods scenics, toward more people and action shots." In samples wants to see "overall sharpness, unusual conformation, shots that accurately portray the highlights and 'outsideness' of outdoor scenes."

AMERICAN HUNTER, 11250 Waples Mill Rd., Fairfax VA 22030-7400. (703)267-1300. Editor: Tom Fulgham. Circ. 1.4 million. Publication of the National Rifle Association. Monthly magazine. Sample copy and photo guidelines free with 9×12 SAE. Free writer's guidelines with SASE.
Needs: Uses wildlife shots and hunting action scenes. Photos purchased with or without accompanying ms. Seeks general hunting stories on North American game. Captions preferred.

 THE ASTERISK before a listing indicates that the market is new in this edition. New markets are often the most receptive to freelance submissions.

Making Contact & Terms: Send material by mail for consideration. Uses 8×10 glossy b&w prints and 35mm color transparencies. (Uses 35mm transparencies for cover). Vertical format required for cover. SASE. Reports in 1 month. Pays $25/b&w print; $75-275/transparency; $300/color cover photo; $200-500 for text/photo package. Pays on publication for photos. Credit line given. Buys one-time rights.

***AMERICAN LIBRARIES**, 50 E. Huron St., Chicago IL 60611. (312)280-4216. Fax: (312)440-0901. E-mail: american.librariest@ala.org. Website: american.libraries@a 1 a.org. Senior Production Editor: Edith McCormick. Circ. 58,500. Publication of the American Library Association. Magazine published 11 times/year. Emphasizes libraries and librarians. Readers are "chiefly the members of the American Library Association but also subscribing institutions who are not members." Sample copy free with SASE. General guidelines free with SASE.
Needs: Uses about 5-20 photos/issue; 1-3 supplied by freelance photographers.
Making Contacts & Terms: Interested in receiving work from newer, lesser-known photographers. Send transparencies, slides or contact sheet by mail for consideration. SASE. Reports in 2-8 weeks. Pays $200-300/color photo. Credit line given. Buys first North American serial rights.
Tips: "Read or scan at least two issues thoroughly. We look for excellent, focused, well-lit shots, in color, of interesting events strongly related to library context—off-beat and upbeat occurrences in libraries of interest to sophisticated librarian audience."

AMERICAN MOTORCYCLIST, Dept. PM, P.O. Box 6114, Westerville OH 43081-6114. (614)891-2425. Vice President of Communication: Greg Harrison. Managing Editor: Bill Wood. Circ. 183,000. Publication of the American Motorcyclist Association. Monthly magazine. For "enthusiastic motorcyclists, investing considerable time in road riding or competition sides of the sport. We are interested in people involved in, and events dealing with, all aspects of motorcycling." Sample copy and photo guidelines for $1.50.
Needs: Buys 10-20 photos/issue. Subjects include: travel, technical, sports, humorous, photo essay/feature and celebrity/personality. Captions preferred.
Making Contact & Terms: Query with samples to be kept on file for possible future assignments. Reports in 3 weeks. SASE. Send 5×7 or 8×10 semigloss prints; transparencies. Pays $20-50/photo; $30-100/slide; $150 minimum/cover photo. Also buys photos in photo/text packages according to same rate; pays $7/column inch minimum for story. Pays on publication. Buys first North American serial rights.
Tips: Uses transparencies for covers. "The cover shot is tied in with the main story or theme of that issue and generally needs to be with accompanying ms. Show us experience in motorcycling photography and suggest your ability to meet our editorial needs and complement our philosophy."

THE AMERICAN MUSIC TEACHER, 441 Vine St., Suite 505, Cincinnati OH 45202-2814. (513)421-1420. Art Director: Stacy Clark. Circ. 25,000. Publication of Music Teachers National Association. Bimonthly magazine. Emphasizes music teaching. Readers are music teachers operating independently from conservatories, studios and homes.
Needs: Uses about 4 photos/issue; 3 supplied by freelancers. Needs photos of musical subject matter. Model release preferred. Captions preferred.
Making Contact & Terms: Query with résumé of credits. Query with samples. Query with list of stock photo subjects. Send unsolicited photos by mail for consideration. Provide résumé, business card, brochure, flier or tearsheets to be kept on file for possible future assignments. Uses 3×5 to 8×10 glossy b&w prints; 35mm, $2\frac{1}{4} \times 2\frac{1}{4}$, 4×5 and 8×10 transparencies; b&w contact sheets. SASE. Pays $150 maximum/b&w photo; $250 maximum/color photo. **Pays on acceptance.** Credit line given. Buys one-time rights. Simultaneous submissions and previously published work OK.
Tips: In portfolio or samples, wants to see "teaching subjects, musical subject matter from classical to traditional, to computers and electronics, children and adults."

AMERICAN SAILOR, P.O. Box 1260, Portsmouth RI 02871. (401)683-0800. Fax: (401)683-0840. Editor: Dana Marnane. Circ. 30,000. Estab. 1897. Publication of the US Sailing Association. Publishes 10 issues/year. Magazine. Emphasizes sailing. Readers are male and female sailors ages 15-70. Sample copy free with SASE.
Needs: Uses 15 photos/issue; most supplied by freelancers. Needs photos of one-design, big boat, multihull and/or windsurfing. Reviews photos with or without ms. Captions preferred; include date, location of event, name(s) of boats pictured.
Making Contact & Terms: Interested in receiving work from newer, lesser-known photographers. Send unsolicited photos by mail for consideration. Provide résumé, business card, brochure, flier or tearsheets to be kept on file for possible future assignments. Send slides or standard photograph. Does not keep samples on file. SASE. Reports in 1 month. Pays $25-100/color photo. "We are a nonprofit organization."

Tips: Looks for "vertical, colorful shots. No technicals, no power boats, no bikini-clad women; only sailing or sailboats."

ANIMALS, 350 S. Huntington Ave., Boston MA 02130. (617)522-7400. Fax: (617)522-4885. Photo Editor: Detrich Gehring. Publication of the Massachusetts Society for the Prevention of Cruelty to Animals and the American Humane Education Society. Circ. 100,000. Estab. 1868. Bimonthly. Emphasizes animals, both wild and domestic. Readers are people interested in animals, conservation, animal welfare issues, pet care and wildlife. Sample copy $2.95 with 9 × 12 SASE. Photo guidelines free with SASE.
Needs: Uses about 45 photos/issue; approximately 95% supplied by freelance photographers. "All of our pictures portray animals, usually in their natural settings, however some in specific situations such as pets being treated by veterinarians or wildlife in captive breeding programs." Needs vary according to editorial coverage. Special needs include clear, crisp shots of animals, wild and domestic, both close-up and distance shots with spectacular backgrounds, or in the case of domestic animals, a comfortable home or backyard. Model release required in some cases. Captions preferred; include species, location.
Making Contact & Terms: Interested in receiving work from newer, lesser-known photographers. Query with résumé of credits; query with list of stock photo subjects. Provide résumé, business card, brochure, flier or tearsheets to be kept on file for possible future assignments. SASE. Reports in 6 weeks. Fees are usually negotiable; pays $50-150/b&w photo; $75-300/color photo; payment depends on size and placement. Pays on publication. Credit line given. Buys one-time rights.
Tips: Photos should be sent to Detrich Gehring, Photo Editor. Gehring does first screening. "Offer original ideas combined with extremely high-quality technical ability. Suggest article ideas to accompany your photos, but only propose yourself as author if you are qualified. We have a never-ending need for sharp, high-quality portraits of mixed-breed dogs and cats for both inside and cover use. Keep in mind we seldom use domestic cats outdoors; we often need indoor cat shots."

APA MONITOR, American Psychological Association, 750 First St. NE, Washington DC 20002. (202)336-5675. Fax: (202)336-6103. Editor: Sara Martin. Circ. 100,000. Monthly newspaper. Emphasizes "news and features of interest to psychologists and other behavioral scientists and professionals, including legislation and agency action affecting science and health, and major issues facing psychology both as a science and a mental health profession." Sample copy with $3 and 9 × 12 envelope.
Needs: Buys 60-90 photos/year. Photos purchased on assignment. Needs portraits, feature illustrations and spot news.
Making Contact & Terms: Arrange a personal interview to show portfolio or query with samples. Uses 5 × 7 and 8 × 10 glossy b&w prints; contact sheet OK; some 4-color use. Also accepts digital images in TIFF files. SASE. Pays by the job; $75/hour; $175 minimum; $100/stock. **Pays on receipt of invoice.** Credit line given. Buys first serial rights.
Tips: "Become good at developing ideas for illustrating abstract concepts and innovative approaches to clichés such as meetings and speeches. We look for quality in technical reproduction and innovative approaches to subjects."

APERTURE, 20 E. 23rd St., New York NY 10010. (212)505-5555. Executive Editor: Ron Schick. Circ. 16,000. Quarterly. Emphasizes fine art and contemporary photography, as well as social reportage. Readers include photographers, artists, collectors.
Needs: Uses about 60 photos/issue; issues are generally thematic—regular portfolio review. Model release required. Captions required.
Making Contact & Terms: Submit portfolio for review. SASE. Reports in 1 month. No payment. Credit line given.
Tips: "We are a nonprofit foundation and do not pay for photos."

APPALACHIAN TRAILWAY NEWS, Box 807, Harpers Ferry WV 25425. (304)535-6331. Fax: (304)535-2667. Editor: Judith Jenner. Circ. 26,000. Estab. 1939. Publication of the Appalachian Trail Conference. Bimonthly. Emphasizes the Appalachian Trail. Readers are conservationists, hikers. Sample copy $3 (includes postage and guidelines). Guidelines free with SASE.
Needs: Uses about 20-30 b&w photos/issue; 4-5 supplied by freelance photographers (plus 13 color slides each year for calendar). Needs scenes from the Appalachian Trail, specifically of people using or maintaining the trail. Special needs include candids—people/wildlife/trail scenes. Photo information required.
Making Contact & Terms: Query with ideas. Send 5 × 7 or larger glossy b&w prints; b&w contact sheet; or 35mm transparencies by mail for consideration. SASE. Reports in 3 weeks. **Pays on acceptance.** Pays $150/cover photo; $200 minimum/color slide calendar photo; $10-50/b&w inside photo. Credit line given. Rights negotiable. Simultaneous submissions and/or previously published work OK.

ARMY MAGAZINE, 2425 Wilson Blvd., Arlington VA 22201. (703)841-4300. Fax: (703)525-9039. Art Director: Patty Zukerowski. Circ. 110,000. Publication of the U.S. Army. Monthly magazine.

Emphasizes military events, topics, history (specifically U.S. Army related). Readers are male/female military personnel—active and retired; defense industries. Sample copy free with 8×10 SASE.
Needs: Uses 20-40 photos/issue; 10-20% supplied by freelancers. Needs photos of military events, news events, famous people and politicans, military technology. Model release required. Captions required.
Making Contact & Terms: Interested in receiving work from newer, lesser-known photographers. Query with résumé of credits. Send unsolicited photos by mail for consideration. Provide résumé, business card, brochure, flier or tearsheets to be kept on file for possible assignments. Send 5×7—8×10 color or b&w prints; 35mm, 2¼×2¼, 4×5, 8×10 transparencies. Keeps samples on file. SASE. Reports in 3 weeks. Pays $125-600/color cover photo; $100-400/b&w cover photo; $75-250/color inside photo; $50/b&w inside photo; $100-400/color page rate; $75-200/b&w page rate. Pays on publication. Buys one-time rights; negotiable.

ARMY RESERVE MAGAZINE, 1815 N. Fort Myer Dr., Room 305, Arlington VA 22209-1805. (703)696-6212. Fax: (703)696-3745. Editor: Major Mike Burbach. Circ. 570,000. Estab. 1954. Publication for U.S. Army Reserve. Quarterly magazine. Emphasizes training and employment of Army Reservists. Readers are ages 17-60, 60% male, 40% female, all occupations. No particular focus on civilian employment. Sample copy free. Write for guidelines.
 • *Army Reserve Magazine* won the NAGC International "Blue Pencil" award for outstanding governmental magazine.
Needs: Uses 35-45 photos/issue; 85% supplied by freelancers. Needs photos related to the mission or function of the U.S. Army Reserve. "We're looking for well-written feature stories accompanied by high-quality photos." Model release preferred (if of a civilian or non-affiliated person). Captions required.
Making Contact & Terms: Interested in receiving work from newer, lesser-known photographers. "Call the editor to discuss your idea." Uses 5×7 b&w prints; 35mm or 2¼×2¼ transparencies. Reports in 1 month. "No pay for material; credit only since we are a government publication." Unable to purchase rights, but consider as "one-time usage." Simultaneous submissions and previously published work OK.
Tips: "High quality color transparencies and prints of Army Reserve-related training or community activities are in demand."

ARTHRITIS TODAY, 1330 W. Peachtree St. NW, Atlanta GA 30309. (404)872-7100. Fax: (404)872-9559. Art Director: Deb Gaston. Circ. 500,000. Estab. 1987. Bimonthly magazine. Emphasizes arthritis. Readers are primarily female, over 50 with interest in travel, crafts, foods (diets) and research into the cure for arthritis. Sample copy available on a limited basis.
Needs: Uses 7-20 photos/issue; 75-100% supplied by freelancers. Needs photos of people, lifestyles, research, doctor-patient. Model/property release required for people, locations, other publications or photographs.
Making Contact & Terms: Provide résumé, business card, brochure, flier or tearsheets to be kept on file for possible assignments. SASE. Samples are kept on file until a need arises for a particular photographer's location or style. NPI. Payment based on individual assignment and budget. **Pays on acceptance**. Credit line given. Buys first North American serial rights for a period of 4 months and electronic rights with unlimited reprint rights for Arthritis Foundation affiliated publications.

AUTO TRIM & RESTYLING NEWS, (formerly *Auto Trim News*), 6255 Barfield Rd., Suite 200, Atlanta GA 30328-4300. (404)252-8831. Fax: (404)252-4436. Editor: Gregory Sharpless. Circ. 8,503. Estab. 1951. Publication of National Association of Auto Trim and Restyling Shops. Monthly. Emphasizes automobile restyling and restoration. Readers include owners and managers of shops specializing in restyling, customizing, graphics, upholstery, trim, restoration, detailing, glass repairs, and others.
Needs: Uses about 15-20 photos/issue; 10-15 supplied by freelance photographers, all on assignment. Needs "how-to, step-by-step photos; restyling showcase photos of unusual and superior completed work." Special needs include "restyling ideas for new cars in the aftermarket area; soft goods and chrome add-ons to update Detroit." Also needs feature and cover-experienced photographers. Captions required.
Making Contact & Terms: Interested in receiving work from photographers with a minimum of 3 years professional experience. Provide résumé, business card, brochure, flier or tearsheets to be kept on file for possible future assignments. Photographer should be in touch with a cooperative shop locally. SASE. Reports in 2-3 weeks. Pays $35/b&w photo; assignment fees negotiable. Pays on publication. Credit line given if desired. Buys all rights.
Tips: "In samples we look for experience in shop photography, ability to photograph technical subject matter within automotive and marine industries."

***AUTOMOTIVE SERVICE ASSOCIATION (ASA)**, 1901 Airport Freeway, Bedford TX 76021. (817)283-6205. Fax: (817)685-0225. E-mail: monicab@asa.dataorg.com. Website: http://www.asahop.net.

org. Vice President of Communication: Monica Buchholz. Circ. 15,000. Estab. 1952. Publication of Automotive Service Association. Monthly magazine. Emphasizes automotive articles pertinent to members, legislative concerns, computer technology related to auto repair. Readers are male and female, ages 25-60, automotive repair owners, aftermarket. Free sample copy; additional copies $3.
Needs: Uses 20 photos/issue; 50% supplied by freelancers. Needs cover photos, technology photos and photos pertaining to specific articles. Special cover photo needs include late model 1960s automobiles. Model/property release required. Captions required.
Making Contact & Terms: Interested in receiving work from newer, lesser-known photographers. Submit portfolio for review. Send unsolicited photos by mail for consideration. Send 4×5 medium format transparencies. Deadline: 30-40 days prior to publication. Keeps samples on file. SASE. Reports in 3 weeks. NPI. Pays on publication. Buys all rights; negotiable. Previously published work OK.

THE BIBLE ADVOCATE, P.O. Box 33677, Denver CO 80233. (303)452-7973. Fax: (303)452-0657. Editor: Roy A. Marrs. Circ. 13,000. Estab. 1863. Publication of the Church of God (Seventh Day). Monthly magazine; 11 issues/year. Emphasizes Christian and denominational subjects. Sample copy free with 9×12 SAE and 4 first-class stamps.
• *The Bible Advocate* is buying a slide scanner to store and manipulate color slides, but is using CD-ROM art too.
Needs: Needs scenics and some religious shots (Jerusalem, etc.). Captions preferred, include name, place.
Making Contact & Terms: Interested in receiving work from newer, lesser-known photographers. Submit portfolio for review. SASE. Reports as needed. No payment offered. Rights negotiable. Simultaneous submissions and previously published work OK.
Tips: "We especially need fall and winter slides for the front cover." Wants to see "b&w prints for inside and 35mm color transparencies for front cover—religious, nature, people." To break in, "be patient—right now we use material on an as-needed basis. We will look at all work, but please realize we don't pay for photos or cover art. Send samples and we'll review them. We are working several months in advance now. If we like a photographer's work, we schedule it for a particular issue so we don't hold it indefinitely."

BOWLING MAGAZINE, 5301 S. 76th St., Greendale WI 53129. (414)421-6400. Fax: (414)421-1194. Editor: Bill Vint. Circ. 150,000. Estab. 1938. Published by the American Bowling Congress. Bimonthly. Emphasizes bowling for readers who are bowlers, bowling fans or media. Free sample copy. Photo guidelines with SASE.
Needs: Uses about 20 photos/issue, 1 of which, on the average, is supplied by a freelancer. Model/property release preferred. Captions required.
Making Contact & Terms: Interested in receiving work from newer, lesser-known photographers. Provide calling card and letter of inquiry to be kept on file for possible future assignments. "In almost all cases we like to keep photos. Our staff takes almost all photos as they deal mainly with editorial copy published. Rarely do we have a photo page or need freelance photos. No posed action." Send 5×7 or 8×10 b&w or color photos by mail for consideration. SASE. Reports in 2 weeks. Pays $20-25/b&w photo; $25-50/color photo. Pays on publication. Credit line given. Buys one-time rights, but photos are kept on file after use. No simultaneous submissions or previously published work.

CALYPSO LOG, 777 United Nations Plaza, New York NY 10017. (212)949-6290. Fax: (212)949-6296. American Section Editor: Lisa Rao. Circ. 200,000. Publication of The Cousteau Society. Bimonthly. Emphasizes expedition activities of The Cousteau Society; educational/science articles; environmental activities. Readers are members of The Cousteau Society. Sample copy $2 with 9×12 SAE and $1 postage. Photo guidelines free with SASE.
Needs: Uses 10-14 photos/issue; 1-2 supplied by freelancers; 2-3 photos/issue from freelance stock.
Making Contact & Terms: Query with samples and list of stock photo subjects. Uses color prints; 35mm and 2¼×2¼ transparencies (duplicates only). SASE. Reports in 5 weeks. Pays $50-200/color photo. Pays on publication. Buys one-time rights and "translation rights for our French publication." Previously published work OK.
Tips: Sharp, clear, good composition and color; unusual animals or views of environmental features. Prefers transparencies over prints. "We look for ecological stories, food chain, prey-predator interaction and impact of people on environment. Please request a copy of our publication to familiarize yourself

A BULLET has been placed within some listings to introduce special comments by the editor of *Photographer's Market.*

with our style, content and tone and then send samples that best represent underwater and environmental photography."

✤**CANADA LUTHERAN**, 1512 St. James St., Winnipeg, Manitoba R3H 0L2 Canada. (204)786-6707. Fax: (204)783-7548. Art Director: Darrell Dyck. Editor: Kenn Ward. Circ. 22,000. Estab. 1986. Publication of Evangelical Lutheran Church in Canada. Monthly. Emphasizes faith/religious content; Lutheran denomination. Readers are members of the Evangelical Lutheran Church in Canada. Sample copy for $1.50 with 9 × 12 SAE and $1 postage (Canadian).
Needs: Uses 4-10 photos/issue; most supplied though article contributors; 1 or 2 supplied by freelancers. Needs photos of people (in worship/work/play etc.).
Making Contact & Terms: Interested in receiving work from newer, lesser-known photographers. Send 5 × 7 glossy prints or 35mm transparencies by mail for consideration. Also accepts digital files on CD-ROM or floppy ("call for particulars"). SASE. Pays $15-50/b&w photo; $40-75/color photo. Pays on publication. Credit line given. Buys one-time rights.
Tips: "Trend toward more men and women in non-stereotypical roles. Do not restrict photo submissions to just the categories you believe we need. Sometimes a surprise shot works perfectly for a subject. Give us many photos that show your range. We prefer to keep them on file for at least a year. We have a short-term turnaround and turn to our file on a monthly basis to illustrate articles or cover concepts. Changing technology speeds up the turnaround time considerably when assessing images, yet forces publishers to think farther in advance to be able to achieve promised cost savings."

CAR & TRAVEL, 1000 AAA Dr., Heathrow, FL 32746-5063. (407)444-8544. Fax: (407)444-8500. Editor and Publisher: Doug Damerst. Art Director: Emilie Whitcomb. Circ. 4.7 million. Estab. 1995. Member publication of AAA (ABC member). Bimonthly magazine (except monthly in Metro New York and quarterly in Alabama) emphasizing how to drive, car care, how to travel and travel destinations. Readers are above average income and age. Sample copy free.
Needs: Uses 60 photos/issue; 20 supplied by freelancers. Needs photos of people enjoying domestic and international vacation settings. Model release required. Captions preferred.
Making Contact & Terms: Provide résumé, business card, brochure, flier or tearsheets to be kept on file for possible future assignments. Do not send any unsolicited photos. Will only accept queries. Cannot return material. Payment varies according to size and circulation. **Pays on acceptance.** Credit line given. Buys one-time rights.
Tips: "Our need is for travel photos, but not of places as much as of Americans enjoying travel."

*****CATHOLIC LIBRARY WORLD**, 9009 Carter, Allen Park MI 48101. (313)388-7429. Fax: (313)388-6233 (after 6 p.m.). E-mail: allencg@aol.com. Editor: Allen Gruenke. Circ. 1,100. Estab. 1929. Publication of the Catholic Library Association. Quarterly magazine. Emphasizes libraries and librarians (community, school, academic librarians, research librarians, archivists). Readers are librarians who belong to the Catholic Library Association; generally employed in Catholic institutions or academic settings. Sample copy $5.
Needs: Uses 2 photos/issue. Needs photos of authors of children's books and librarians who have done something to contribute to the community at large. Special photo needs include photos of annual/conventions in April 1996 in Philadelphia and 1997 in Minneapolis. Model release preferred for photos of authors. Captions preferred.
Making Contact & Terms: Interested in receiving work from newer, lesser-known photographers. Send 5 × 7 b&w prints. Deadlines: January 15, April 15, July 15, September 15. SASE. Reports in 1-2 weeks. Pays with copies and photo credit. Acquires one-time rights. Previously published work OK.

CEA ADVISOR, Dept. PM, Connecticut Education Association, 21 Oak St., Hartford CT 06106. (860)525-5641. Managing Editor: Michael Lydick. Circ. 30,000. Monthly tabloid. Emphasizes education. Readers are public school teachers. Sample copy free with 6 first-class stamps.
Needs: Uses about 20 photos/issue; 1 or 2 supplied by freelancers. Needs "classroom scenes, students, school buildings." Model release preferred. Captions preferred.
Making Contact & Terms: Send b&w contact sheet by mail for consideration. Provide résumé, business card, brochure, flier or tearsheets to be kept on file for possible future assignments. Cannot return material. Reports in 1 month. Pays $50/b&w cover photo; $25/b&w inside photo. Pays on publication. Credit line given. Buys all rights. Simultaneous submissions and/or previously published work OK.

CHESS LIFE, Dept. PM, 186 Route 9W, New Windsor NY 12553. (914)562-8350. Fax: (914)561-CHES (2437). Editor-in-Chief: Glenn Petersen. Art Director: Jami Anson. Circ. 70,000. Estab. 1939. Publication of the U.S. Chess Federation. Monthly. *Chess Life* covers news of all major national and international tournaments; historical articles, personality profiles, columns of instruction, occasional fiction, humor . . . for the devoted fan of chess. Sample copy and photo guidelines free with SAE and 3 first-class stamps.

• *Chess Life* received several awards in 1994 from the Chess Journalists of America, including Best Layout, Best Regular Magazine, Best Chess Art.

Needs: Uses about 10 photos/issue; 7-8 supplied by freelancers. Needs "news photos from events around the country; shots for personality profiles." Special needs include "Chess Review" section. Model release preferred. Captions preferred.

Making Contact & Terms: Interested in receiving work from newer, lesser-known photographers. Query with samples. Provide business card and tearsheets to be kept on file for possible future assignments. Prefers 35mm transparencies for cover shots. Also accepts digital images on broadcast tape, VHS and Beta. SASE. Reports in "2-4 weeks, depending on when the deadline crunch occurs." Pays $150-300/b&w or color cover photo; $25/b&w inside photo; $35/color inside photo; $15-30/hour; $150-250/day. Pays on publication. Credit line given. Buys one-time rights; "we occasionally purchase all rights for stock mug shots." Simultaneous submissions and previously published work OK.

Tips: Using "more color, and more illustrative photography. The photographer's name and date should appear on the back of all photos." Looks for "clear images, good composition and contrast—with a fresh approach to interest the viewer. Increasing emphasis on strong portraits of chess personalities, especially Americans. Tournament photographs of winning players and key games are in high demand."

***CHILDHOOD EDUCATION**, 11501 Georgia Ave., Suite 315, Wheaton MD 20902. (301)942-2443. Director of Publications/Editor: Anne Bauer. Assistant Editor: Bruce Herzig. Circ. 15,000. Estab. 1924. Publication for the Association for Childhood Education International. Bimonthly journal. Emphasizes the education of children from infancy through early adolescence. Readers include teachers, administrators, day-care workers, parents, psychologists, student teachers, etc. Sample copy free with 9 × 12 SAE and $1.44 postage. Photo guidelines free with SASE.

Needs: Uses 5-10 photos/issue; 2-3 supplied by freelance photographers. Subject matter includes children infancy-14 years in groups or alone, in or out of the classroom, at play, in study groups; boys and girls of all races and in all cities and countries. Wants close-ups of children, unposed. Reviews photos with or without accompanying ms. Special needs include photos of minority children; photos of children from different ethnic groups together in one shot; boys and girls together. Model release required.

Making Contact & Terms: Interested in receiving work from newer, lesser-known photographers. Send unsolicited photos by mail for consideration. Uses 8 × 10 glossy b&w and color prints and color transparencies. SASE. Reports in 1 month. Pays $75-100/color cover photo; $25-50/b&w inside photo. Pays on publication. Credit line given. Buys one-time rights. Simultaneous submissions and previously published work are discouraged but negotiable.

Tips: "Send pictures of unposed children, please."

CHILDREN'S DEFENSE FUND, 25 E St. NW, Washington DC 20001. (202)628-8787. Fax: (202)662-3530. Production Manager: Janis Johnston. Specializes in newsletters and books.

Needs: Buys 50 photos/year. Buys stock and assigns work. Wants to see children of all ages and ethnicity, serious, playful, poor, middle class, school setting, home setting and health setting. Does not want to see studio portraits. Domestic photos only. Model/property release required.

Making Contact & Terms: Provide résumé, business card, self-promotion piece or tearsheets to be kept on file for possible future assignments. Uses b&w prints only. Keeps photocopy samples on file. SASE. Reports in 1-2 weeks. Pays $50-75/hour; $125-500/day; $50-150/b&w photo. Pays on usage. Credit line given. Buys one-time rights. Previously published work OK.

Tips: Looks for "good, clear focus, nice composition, variety of settings and good expressions on faces."

CHRISTIAN HOME & SCHOOL, 3350 E. Paris Ave. SE, Grand Rapids MI 49512-3054. (616)957-1070. Senior Editor: Roger Schmurr. Circ. 57,000. Estab. 1922. Publication of Christian Schools International. Published 6 times a year. Emphasizes Christian family issues. Readers are parents who support Christian education. Sample copy free with 9 × 12 SAE with 4 first-class stamps. Photo guidelines free with SASE.

Needs: Uses 10-15 photos/issue; 7-10 supplied by freelancers. Needs photos of children, family activities, school scenes. Model release preferred.

Making Contact & Terms: Query with samples. Query with list of stock photo subjects. Send b&w prints or contact sheets by mail for consideration. SASE. Reports in 3 weeks. Pays color: $125/inside editorial; $250/cover; b&w: $50/b&w inside spot usage. Pays on publication. Credit line given. Buys one-time rights. Simultaneous submissions and previously published work OK.

Tips: Assignment work is becoming rare. Freelance stock most often used. "Photographers who allow us to hold duplicate photos for an extended period of time stand more chance of having their photos selected for publication than those who require speedy return of submitted photos."

CIVITAN MAGAZINE, P. O. Box 130744, Birmingham AL 35213-0744. (205)591-8910. Editor: Dorothy Wellborn. Circ. 36,000. Estab. 1920. Publication of Civitan International. Bimonthly magazine. Emphasizes work with mental retardation/developmental disabilities. Readers are men and women, college age to retirement and usually managers or owners of businesses. Sample copy free with 9×12 SAE and 2 first-class stamps. Photo guidelines not available.
Needs: Uses 8-10 photos/issue; 50% supplied by freelancers. Always looking for good cover shots (travel, scenic and how-tos). Model release preferred. Captions preferred.
Making Contact & Terms: Send unsolicited 2¼×2¼ or 4×5 transparencies or b&w prints by mail for consideration. Provide résumé, business card, brochure, flier or tearsheets to be kept on file for possible assignments. Reports in 1 month. Pays $50/color cover photo; $10 b&w inside photo. **Pays on acceptance.** Buys one-time rights. Simultaneous submissions and previously published work OK.

COMPANY: A MAGAZINE OF THE AMERICAN JESUITS, Dept. PM, 3441 N. Ashland Ave., Chicago IL 60657. (312)281-1534. Fax: (312)281-2667. Editor: Martin McHugh. Circ. 128,000. Estab. 1983. Published by the Jesuits (Society of Jesus). Quarterly magazine. Emphasizes people; "a human interest magazine about people helping people." Sample copy free with 9×12 SAE and 4 first-class stamps. Photo guidelines free with SASE.
Needs: All photos supplied by freelancers. Needs photo-stories of Jesuit and allied ministries and projects, only photos related to Jesuit works. Photos purchased with or without accompanying ms. Model release required. Captions required.
Making Contact & Terms: Interested in receiving work from newer, lesser-known photographers. Query with samples. Provide résumé, business card, brochure, flier or tearsheets to be kept on file for possible future assignments. SASE. Reports in 1 month. Pays $300/color cover photo; $100-400/job. Pays on publication. Credit line given. Buys one-time rights; negotiable.
Tips: "Avoid large-group, 'smile-at-camera' photos. We are interested in people photographs that tell a story in a sensitive way—the eye-catching look that something is happening."

***THE CONSTRUCTION SPECIFIER**, Dept. PM, 601 Madison St., Alexandria VA 22314. (703)684-0300. Fax: (703)684-0465. Editor/Publisher: Jack Reeder. Circ. 20,000. Estab. 1949. Publication of the Construction Specifications Institute. Monthly magazine. Emphasizes construction. Readers are architects and engineers in commercial construction. Sample copy free with 8½×11 SASE and 1 first-class stamp. Photo guidelines available.
Needs: Uses 40 photos/issue; 15% supplied by freelance photographers; 85% from freelance stock. Needs architectural and construction shots. Model release required. Captions required.
Making Contact & Terms: Provide résumé, business card, brochure, flier or tearsheets to be kept on file for possible assignments. SASE. Pays $25-200/b&w photo; $50-400/color photo. Pays on publication. Credit line given. Buys one-time rights. Simultaneous submissions OK if in unrelated field. Previously published work OK.
Tips: Wants to see "photos depicting commercial construction: job site shots."

DEFENDERS, 1101 14th St. NW, Suite 1400, Washington DC 20005. (202)682-9400. Fax: (202)682-1331. Editor: James G. Deane. Circ. 100,000. Membership publication of Defenders of Wildlife. Quarterly magazine. Emphasizes wildlife and wildlife habitat. Sample copy free with 9×12½ SAE and 6 first-class stamps. Photo guidelines free with SASE.
Needs: Uses 35 or more photos/issue; "many" from freelancers. Captions required.
Making Contact & Terms: Query with list of stock photo subjects. In portfolio or samples, wants to see "wildlife group action and behavioral shots in preference to static portraits. High technical quality." SASE. Reports ASAP. Pays $75-450/color photo. Pays on publication. Credit line given. Buys one-time rights.
Tips: "*Defenders* focuses heavily on endangered species and destruction of their habitats, wildlife refuges and wildlife management issues, primarily North American, but also some foreign. Images must be sharp. Think twice before submitting anything but low speed (preferably Kodachrome) transparencies."

DIVERSION MAGAZINE, 1790 Broadway, 6th Floor, New York NY 10019. (212)969-7542. Fax: (212)969-7557. Photo Editor: Ericka Camastro. Circ. 176,000. Monthly magazine. Emphasizes travel. Readers are doctors/physicians. Sample copy free with SASE.
Needs: Uses varying number of photos/issue; all supplied by freelancers. Needs a variety of subjects, "mostly worldwide travel. Hotels, restaurants and people." Model/property release preferred. Captions preferred; include precise locations.
Making Contact & Terms: Interested in receiving work from newer, lesser-known photographers. Query with list of stock photo subjects. Keeps samples on file. SASE. Reports in 3 weeks. Pays $350/color cover photo; $135/quarter color page inside photo; $225/color full page rate; $200-250/day. Pays on publication. Credit line given. Buys one-time rights. Simultaneous submissions and/or previously published work OK.

Tips: "Send updated stock list and photo samples regularly."

DOLL READER, Cowles Magazines, 6405 Flank Dr., Harrisburg PA 17112. (717)540-6656. Fax: (717)540-6169. Managing Editor: Deborah Thompson. Estab. 1972. Magazine published 9 times/year. Emphasizes doll collecting. Photo guidelines free with SASE.
Needs: Buys 100-250 photos/year; 50 photos/year supplied by freelancers. "We need photos of specific dolls to accompany our articles." Model/property release required. Captions required; include name of object, height, medium, edition size, costume and accessory description; name, address, telephone number of artist or manufacturer; price.
Making Contact & Terms: Interested in receiving work from newer, lesser-known photographers. Send unsolicited photos by mail for consideration. Provide résumé, business card, brochure, flier or tearsheets to be kept on file for possible assignments. Submit portfolio for review. Query with stock photo list. Query with sample. Send 3½×5 glossy color prints; 35mm, 2¼×2¼, 4×5 trapnsparencies. Transparencies are preferred. Keeps samples on file. SASE. Reports in 1 month. NPI. "If photos are accepted, we pay on receipt of invoice." Credit line given. Buys all rights. Simultaneous submissions OK.

THE DOLPHIN LOG, 777 United Nations Plaza, New York NY 10017. (212)949-6290. Fax: (212)949-6296. Editor: Lisa Rao. Circ. 80,000. Estab. 1981. Publication of The Cousteau Society, Inc., a nonprofit organization. Bimonthly magazine. Emphasizes "ocean and water-related subject matter for children ages 8 to 12." Sample copy $2.50 with 9×12 SAE and 3 first-class stamps. Photo guidelines free with SASE.
Needs: Uses about 20 photos/issue; 2-6 supplied by freelancers; 10% stock. Needs "selections of images of individual creatures or subjects, such as architects and builders of the sea, how sea animals eat, the smallest and largest things in the sea, the different forms of tails in sea animals, resemblances of sea creatures to other things. Also excellent potential for cover shots or images which elicit curiosity, humor or interest." No aquarium shots. Model release required if person is recognizable. Captions preferred, include when, where and, if possible, scientifically accurate identification of animal.
Making Contact & Terms: Query with samples or list of stock photos. Send 35mm, 4×5 transparencies or b&w contact sheets by mail for consideration. Send duplicates only. SASE. Reports in 1 month. Pays $75-200/color photo. Pays on publication. Credit line given. Buys one-time rights and worldwide translation rights. Simultaneous and previously published submissions OK.
Tips: Prefers to see "rich color, sharp focus and interesting action of water-related subjects" in samples. "No assignments are made. A large amount is staff-shot. However, we use a fair amount of freelance photography, usually pulled from our files, approximately 45-50%. Stock photos purchased only when an author's sources are insufficient we have need for a shot not in file. These are most often hard-to-find creatures of the sea." To break in, "send a good submission of dupes in keeping with our magazine's tone/content; be flexible in allowing us to hold slides for consideration."

DUCKS UNLIMITED, One Waterfowl Way, Memphis TN 38120. (901)758-3825. Production Coordinator: Diane Jolie. Circ. 515,000. Estab. 1937. Association publication of Ducks Unlimited, a nonprofit organization. Bimonthly magazine. Emphasizes waterfowl conservation. Readers are professional males, ages 40-50. Sample copy $3. Guidelines free with SASE.
Needs: Uses 20-30 photos/issue; 70% supplied by freelance photographers. Needs wildlife shots (waterfowl/waterfowling), scenics and personalities. Special photo needs include dynamic shots of waterfowl interacting in natural habitat.
Making Contact & Terms: Send 20-40 35mm or larger transparencies with ideas for consideration. SASE. Reports in 1 month. Pays $100 for images less than half page; $125/half page; $150/full page; $225/2-page spread; $400/cover photo; $600/photo essay. **Pays on acceptance.** Credit line given. Buys one-time rights plus permission to reprint in our Mexican and Canadian publications. Previously published work OK.

EASTERN CHALLENGE, P.O. Box 14866, Reading PA 19612-4866. (610)375-0300. Fax: (610)375-6862. Editor: Dr. Osborne Buchanan, Jr. Circ. 22,000. Estab. 1967. Publication of the International Missions, Inc. Quarterly magazine. Emphasizes "church-planting ministry in a number of countries." Sample copy free with SASE.
• *Eastern Challenge* is beginning to use photos that are available on CD-ROM discs.

THE SUBJECT INDEX, located at the back of this book, can help you find publications interested in the topics you shoot.

Needs: Uses 2+ photos/issue. Needs photos of scenics and personalties. Reviews photos with or without accompanying ms. Model/property release preferred. Captions preferred.
Making Contact & Terms: Send unsolicited photos by mail for consideration. Provide résumé, business card, brochure, flier or tearsheets to be kept on file for possible assignments. Keeps samples on file. SASE. Reports in 1 month. Pays "minimal or nominal amount; organization is nonprofit." Pays on publication. Credit line given. Buys all rights; negotiable. Simultaneous submissions and/or previously published work OK.
Tips: Looks for "color and contrast; relevance to program of organization."

***EDUCATIONAL LEADERSHIP MAGAZINE**, 1250 N. Pitt St., Alexandria VA 22314. (703)549-9110. Fax: (703)299-8637. E-mail: jconnelly@ascd.org. Designer: Judi Connelly. Circ. 200,000. Publication of the Association for Supervision and Curriculum Development. Magazine; 8 issues/year. Emphasizes schools and children, especially grade school and high school levels, classroom activities. Readers are teachers and educators worldwide.
Needs: Uses 30-40 photos/issue; all supplied by freelancers. Model release required. Property release preferred. Captions preferred.
Making Contact & Terms: Interested in receiving work from newer, lesser-known photographers. Provide résumé, business card, brochure, flier or tearsheets to be kept on file for possible future assignments. Send all size glossy b&w prints; 35mm, 2¼×2¼, 4×5 transparencies. Nonreturnable samples only. Keeps samples on file. Cannot return material. Reports in 3 weeks. Pays $125/color inside photo; $175/color page. Pays on publication. Buys one-time rights. Simultaneous submissions and previously published work OK.

ENVIRONMENTAL ACTION, 6930 Carroll Ave., Suite 600, Takoma Park MD 20912. (301)891-1100. Fax: (301)891-2218.Website: http://www.econet.apc.org/eaf/. Contact: Editor. Circ. 20,000. Estab. 1970. Association publication of Environmental Action Foundation. Quarterly magazine. Emphasizes environmental subjects for activists of all ages. Sample copies $2.50.
Needs: Uses up to 10 photos/issue; 40% supplied by freelancers. 20% of photos come from assignments; 60% from stock. Needs photos that "illustrate environmental problems and issues, including transportation, environmental justice, toxic waste, energy." Model/property release preferred. Captions preferred.
Making Contact & Terms: Interested in receiving work from newer, lesser-known photographers. Query with résumé of credits. Send stock photo list. Provide résumé, business card, brochure, flier or tearsheet to be kept on file for possible assignments. Does not keep samples on file. Cannot return material. Reports in 1 month. Pays $40-150/b&w cover photo; $25-150/color and b&w inside photo. Pays on publication. Credit line given. Buys one-time rights. Simultaneous submissions and previously published work OK.
Tips: "We only publish in b&w, but we will consider both color and b&w original photos. Contact editor for details on accepting images in digital format."

FAMILY MOTOR COACHING, Dept. PM, 8291 Clough Pike, Cincinnati OH 45244. (513)474-3622. Editor: Pamela Wisby Kay. Circ. 104,000. Estab. 1963. Publication of Family Motor Coach Association. Monthly. Emphasizes motor homes. Readers are members of national association of motor home owners. Sample copy $2.50. Writer's/photographer's guidelines free with SASE.
Needs: Uses about 45-50 photos/issue; 40-45 supplied by freelance photographers. Each issue includes varied subject matter—primarily needs travel and scenic shots and how-to material. Photos purchased with accompanying ms only. Model release preferred. Captions required.
Making Contact & Terms: Query with résumé of credits. SASE. Reports in 2 months. Pays $100-500/text/photo package. **Pays on acceptance.** Credit line given if requested. Prefers first North American rights, but will consider one-time rights on photos *only.*

FELLOWSHIP, Box 271, Nyack NY 10960. (914)358-4601. Fax: (914)358-4924. Editor. Richard Deats. Circ. 8,500. Estab. 1935. Publication of the Fellowship of Reconciliation. Publishes 32-page b&w magazine 6 times/year. Emphasizes peace-making, social justice, nonviolent social change. Readers are religious peace fellowships—interfaith pacifists. Sample copy free with SASE.
Needs: Uses 8-10 photos/issue; 90% supplied by freelancers. Needs stock photos of people, monuments, civil disobedience, demonstrations—Middle East, Latin America, Caribbean, prisons, anti-nuclear, children, farm crisis, gay/lesbian, the former Soviet Union. Also natural beauty and scenic; b&w only. Captions required.
Making Contact & Terms: Provide résumé, business card, brochure, flier or tearsheets to be kept on file for possible future assignments. "Call on specs." SASE. Reports in 3 weeks. Pays $27/b&w cover photo; $15/b&w inside photo. Pays on publication. Credit line given. Buys one-time rights. Simultaneous submissions and/or previously published work OK.
Tips: "You must want to make a contribution to peace movements. Money is simply token (our authors contribute without tokens)."

FFA NEW HORIZONS, Box 15160, Alexandria VA 22309. (703)360-3600. Fax: (703)360-5524. Managing Editor: Jim Scott. Circ. 450,000. Estab. 1953. Publication of the National Future Farmers of America Organization. Bimonthly magazine; 4-color. Emphasizes careers in agriculture/agribusiness, members and their successes and topics of general interest to youth. Readers are members of the FFA who are students of agricultural education in high school, ages 14-21. Photo guidelines free with SASE.
Needs: Uses 45 photos/issue; 18 supplied by freelancers. "We need exciting shots of our FFA members in action." Has continuing need for national coverage. Model/property release preferred. Photo captions required; include names, hometowns.
Making Contact & Terms: Provide résumé, business card, brochure, flier or tearsheets to be kept on file for possible assignments. Keeps samples on file. SASE. Reports in 1 month. Pays $100/color cover photo; $35/color inside photo; $20/b&w inside photo. **Pays on acceptance.** Credit line given. Buys all rights.
Tips: "We want to see energy and a sense that the photographer knows how to work with teenagers." Contact editor before doing any work. "We have specific needs and need good shooters."

FIGURINES & COLLECTIBLES, Cowles Enthusiast Media, 6405 Flank Dr., Harrisburg PA 17112. (717)540-6652. Fax: (717)540-6169. Publisher: Dave Miller. Estab. 1994. Bimonthly magazine. Emphasizes figurine collecting. Photo guidelines free with SASE.
Needs: Model/property release required. Captions required; include name of object, height, medium, edition size and accessory description, name, address, telephone number of artist or manufacturer; price.
Making Contact & Terms: Interested in receiving work from newer, lesser-known photographers. Send unsolicited photos by mail for consideration. Provide résumé, business card, brochure, flier or tearsheets to be kept on file for possible assignments. Submit portfolio for review. Query with stock photo list. Query with samples. Send 3½×5 glossy color prints; 35mm, 2¼×2¼, 4×5 transparencies. Transparencies are preferred. Keeps samples on file. SASE. Reports in 1 month. NPI. "If photos are accepted, we pay on receipt of invoice." Credit line given. Buys all rights. Simultaneous submissions OK.

FLORIDA WILDLIFE, 620 S. Meridian St., Tallahassee FL 32399-1600. (904)488-5563. Fax: (904)488-6988. Editor: Dick Sublette. Circ. 29,000. Estab. 1947. Publication of the Florida Game & Fresh Water Fish Commission. Bimonthly magazine. Emphasizes wildlife, hunting, fishing, conservation. Readers are wildlife lovers, hunters and fishermen. Sample copy $2.95. Photo guidelines free with SASE.
Needs: Uses about 20-40 photos/issue; 75% supplied by freelance photojournalists. Needs Florida fishing and hunting, all flora and fauna of Southeastern US; how-to; covers and inside illustration. Do not feature products in photographs. No alcohol or tobacco. Special needs include hunting and fishing activities in Florida scenes; showing ethical and enjoyable use of outdoor resources. "Must be able to ID species and/or provide accurate natural history information with materials." Model release preferred. Captions required; include location and species.
Making Contact & Terms: Interested in receiving work from newer, lesser-known photographers. Query with samples. Send 35mm color transparencies by mail for consideration. "Do not send negatives." SASE. Keeps materials on file, or will review and return if requested. Pays $50-75/color back cover; $100/color front cover; $20-50/color inside photos. Pays on publication. Credit line given. Buys one-time rights; "other rights are sometimes negotiated." Simultaneous submissions OK "but we prefer originals over duplicates." Previously published work OK but must be mentioned when submitted.
Tips: "Study back issues to determine what we buy from freelancers (no saltwater species as a rule, etc.) Use flat slide mounting pages or individual sleeves. Show us your best. Annual photography contest often introduces us to good freelancers. Rules printed in March-April issue. Contest form must accompany entry; available in magazine or by writing/calling; winners receive honorarium and winning entries are printed in September-October and November-December issues."

GREEN BAY PACKER YEARBOOK, P.O. Box 1773, Green Bay WI 54305. (414)435-5100. Publisher: John Wemple. Sample copy free with 9×12 SASE.
Needs: Needs photos of Green Bay Packer football action shots in NFL cities other than Green Bay. Captions preferred.
Making Contact & Terms: Query with résumé of credits. Query with samples. Provide résumé, business card, brochure, flier or tearsheets to be kept on file for possible future assignments. Works on assignment only. SASE. Reports in 2 weeks. Pays $50 maximum/color photo. Pays on acceptance or receipt of invoice. Credit line given on table of contents page. Buys all rights.
Tips: "We are looking for Green Bay Packer pictures when they play in other NFL cities—action photos. Contact me directly." Looks for "the ability to capture action in addition to the unusual" in photos.

THE GREYHOUND REVIEW, P.O. Box 543, Abilene KS 67410. (913)263-4660. Contact: Gary Guccione or Tim Horan. Circ. 6,000. Publication of the National Greyhound Association. Monthly. Emphasizes greyhound racing and breeding. Readers are greyhound owners and breeders. Sample copy with SAE and 11 first-class stamps.
Needs: Uses about 5 photos/issue; 1 supplied by freelance photographers. Needs "anything pertinent to the greyhound that would be of interest to greyhound owners." Captions required.
Making Contact & Terms: Query first. After response, send b&w or color prints and contact sheets by mail for consideration. Submit portfolio for review. Provide résumé, business card, brochure, flier or tearsheets to be kept on file for possible future assignments. Can return unsolicited material if requested. Reports within 1 month. Pays $85/color cover photo; $25-100/color inside photo. **Pays on acceptance.** Credit line given. Buys one-time and North American rights. Simultaneous submissions and previously published work OK.
Tips: "We look for human-interest or action photos involving greyhounds. No muzzles, please, unless the greyhound is actually racing. When submitting photos for our cover, make sure there's plenty of cropping space on all margins around your photo's subject; full bleeds on our cover are preferred."

GUERNSEY BREEDERS' JOURNAL, Dept. PM, P.O. Box 666, Reynoldsburg OH 43068-0666. (614)864-2409. Managing Editor: Becky Goodwin. Associate Editor: Beth Littlefield. Circ. 2,200. Publication of American Guernsey Association. Magazine published 10 times a year. Emphasizes Guernsey dairy cattle, dairy cattle management. Readership consists of male and female dairymen, 20-70 years of age. Sample copy free with 8½×11 SASE.
Needs: Uses 40-100 photos/issue; uses less than 5% of freelance photos. Needs scenic photos featuring Guernsey cattle. Model release preferred. Captions preferred.
Making Contact & Terms: Query with résumé of credits, business card, brochure, flier or tearsheets to be kept on file for possible assignments. SASE. Reports in 1 month. Pays $100/color cover photo and $50/b&w cover photo. Pays on publication. Credit line given. Buys all rights; negotiable. Simultaneous submissions and previously published work OK.

HADASSAH MAGAZINE, 50 W. 58th St., New York NY 10019. (212)688-0558. Fax: (212)446-9521. Editorial Assistant: Chava Boylan. Circ. 300,000. Publication of the Hadassah Women's Zionist Organization of America. Monthly magazine. Emphasizes Jewish life, Israel. Readers are 85% females who travel and are interested in Jewish affairs, average age 59. Photo guidelines free with SASE.
Needs: Uses 10 photos/issue; most supplied by freelancers. Needs photos of travel and Israel. Captions preferred, include where, when, who and credit line.
Making Contact & Terms: Interested in receiving work from newer, lesser-known photographers. Submit portfolio for review. Send unsolicited photos by mail for consideration. Keeps samples on file. SASE. Reports in 1 month. Pays $400/color cover photo; $100-125/¼ page color inside photo; $75-100 ¼ page b&w inside photo. Pays on publication. Credit line given. Buys one-time rights.
Tips: "We're looking for kids of all ethnic/racial make up. Cute, upbeat kids are a plus. We also need photos of families and travel photos, especially of places of Jewish interest."

HOOF BEATS, Dept. PM, 750 Michigan Ave., Columbus OH 43215. (614)224-2291. Fax: (614)222-6791. Executive Editor: Dean Hoffman. Design/Production Manager: Gena Gallagher. Circ. 18,000. Estab. 1933. Publication of the US Trotting Association. Monthly. Emphasizes harness racing. Readers are participants in the sport of harness racing. Sample copy free.
Needs: Uses about 30 photos/issue; about 20% supplied by freelancers. Needs "artistic or striking photos that feature harness horses for covers; other photos on specific horses and drivers by assignment only."
Making Contact & Terms: Query with samples. SASE. Reports in 3 weeks. Pays $25-150/b&w photo; $50-200/color photo; $150 and up/color cover photo; freelance assignments negotiable. Pays on publication. Credit line given if requested. Buys one-time rights. Simultaneous submissions OK.
Tips: "We look for photos with unique perspective and that display unusual techniques or use of light. Send query letter first. Know the publication and its needs before submitting. Be sure to shoot pictures of harness horses only, not Thoroughbred or riding horses." There is "more artistic use of b&w photography instead of color. More use of fill-flash in personality photos. We always need good night racing action or creative photography."

HORSE SHOW MAGAZINE, % AHSA, 220 E. 42nd St., New York NY 10017-5876. (212)972-2472, ext. 237. Fax: (212)983-7286. Editor: Norine Dworkin. Circ. 57,000. Estab. 1937. Publication of National Equestrian Federation of US. Monthly magazine. Emphasizes horses and show trade. Majority of readers are upscale women, median age 31.
Needs: Uses up to 25 photos/issue; most are supplied by equine photographers; freelance 100% on assignment only. Needs shots of competitions. Reviews photos with or without accompanying ms. Especially looking for "excellent color cover shots" in the coming year. Model release required.

Property release preferred. Captions required; include name of owner, rider, name of event, date held, horse and summary of accomplishments.
Making Contact & Terms: Interested in receiving work from newer, lesser-known photographers. Pays $250/color cover photo; $30/color and b&w inside photo. **Pays on acceptance.** Credit line given. Buys one-time rights; negotiable. Previously published work OK.
Tips: "Get best possible action shots. Call to see if we need coverage of an event."

HSUS NEWS, 700 Professional Dr., Gaithersburg MD 20879-3418. Art Director: T. Tilton. Circ. 500,000. Estab. 1954. Publication of The Humane Society of the US Association. Quarterly magazine. Emphasizes animals. Sample copy free with 10×14 SASE.
Needs: Uses 60 photos/issue. Needs photos of animal/wildlife shots. Model release required.
Making Contact & Terms: Query with list of stock photo subjects. Send unsolicited transparencies by mail for consideration. Provide résumé, business card, brochure, flier or tearsheets to be kept on file for possible assignments. Reports in 3 weeks. Pays $500/color cover photo; $225/color inside photo; $150/b&w inside photo. **Pays on acceptance.** Credit line given. Buys one-time rights. Previously published work OK.
Tips: To break in, "don't pester us. Be professional with your submissions."

"IN THE FAST LANE", ICC National Headquarters, 2001 Pittston Ave., Scranton PA 18505. (717)585-4082. Editor: D.M. Crispino. Circ. 2,000. Publication of the International Camaro Club. Bimonthly, 20-page newsletter. Emphasizes Camaro car shows, events, cars, stories, etc. Readers are auto enthusiasts/Camaro exclusively. Sample copy $2.
Needs: Uses 20-24 photos/issue; 90% assigned. Needs Camaro-oriented photos only. "At this time we are looking for photographs and stories on the Camaro pace cars 1967, 1969, 1982 and the Camaro Z28s, 1967-1981." Reviews photos with accompanying ms only. Model release required. Captions required.
Making Contact & Terms: Send 3½×5 and larger b&w or color prints by mail for consideration. SASE. Reports in 2 weeks. Pays $5-25 for text/photo package. Pays on publication. Credit line given. Buys one-time rights. Previously published work OK.
Tips: "We need quality photos that put you at the track, in the race or in the midst of the show. Magazine is bimonthly; timeliness is even more important than with monthly."

INTERNATIONAL OLYMPIC LIFTER, Box 65855, 3602 Eagle Rock, Los Angeles CA 90065. (213)257-8762. Editor: Bob Hise II. Circ. 1,000. Estab. 1973. Bimonthly international magazine. Emphasizes Olympic-style weightlifting. Readers are athletes, coaches, administrators, enthusiasts of all ages. Sample copy $4.50 and 5 first-class stamps.
Needs: Uses 20 or more photos/issue; all supplied by freelancers. Needs photos of weightlifting action. Reviews photos with or without ms. Captions preferred.
Making Contact & Terms: Send unsolicited photos by mail for consideration. Send 5×7, 8×10 b&w prints. Does not keep samples on file. SASE. Reports in 1-2 weeks. Pays $25/b&w cover photo; $2-10/b&w inside photo. **Pays on acceptance.** Credit line given. Rights negotiable.
Tips: "Good, clear, b&w still and action photos of (preferably outstanding) olympic-style (overhead/lifting) weightlifters. Must know sport of weightlifting, not bodybuilding or powerlifting."

INTERVAL INTERNATIONAL TRAVELER, 6262 Sunset Dr., Miami FL 33143. (305)666-1861. Photo Editor: Margaret Swiatek. Circ. 485,000. Estab. 1982. Publication of Interval International. Quarterly. Emphasizes vacation exchange and travel. Readers are members of the Interval International vacation exchange club.
Needs: Uses 50 photos/issue. Needs photos of travel destinations, vacation activities. Model/property release required. Captions required; all relevant to full identification.
Making Contact & Terms: Interested in receiving work from newer, lesser-known photographers. Query with stock photo list. Provide business card, brochure, flier or tearsheets to be kept on file. Keeps samples on file. Cannot return materials. NPI. Pays on publication. Credit line given for editorial use. Buys one-time rights; negotiable. Simultaneous submissions and previously published work OK.
Tips: Looking for beautiful scenics; family-oriented, fun travel shots. Superior technical quality.

ITE JOURNAL, 525 School St. SW, #410, Washington DC 20024. (202)554-8050. Fax: (202)863-5486. Editor: Eduardo F. Dalere. Circ. 11,000. Estab. 1930. Publication of Institute of Transportation Engineers. Monthly journal. Emphasizes surface transportation, including streets, highways and transit. Readers are transportation engineers and professionals.
Needs: One photo used for cover illustration per issue. Needs "strikingly scenic shots of streets, highways, bridges, transit systems." Model release required. Captions preferred; include location, name or number of road or highway and details.
Making Contact & Terms: Interested in receiving work from newer, lesser-known photographers. Query with list of stock photo subjects. Send 35mm or 2¼×2¼ transparencies by mail for consider-

ation. Provide résumé, business card, brochure, flier or tearsheets to be kept on file for possible assignments. "Send originals; no dupes please." Pays $250/color cover photo; $50/b&w inside photo. Pays on publication. Credit line given. Buys multiple-use rights. Simultaneous submissions and/or previously published work OK.

JOURNAL OF PHYSICAL EDUCATION, RECREATION & DANCE, American Alliance for Health, Physical Education, Recreation & Dance, Reston VA 22091. (703)476-3400. Fax: (703)476-9527. Managing Editor: Frances Rowan. Circ. 30,000. Estab. 1896. Monthly magazine. Emphasizes "teaching and learning in public school physical education: youth sports, youth fitness; dance on elementary, secondary or college levels (not performances, classes only); recreation for youth, children, families; girls and women's athletics; and *physical* education and fitness." Sample copy free with 9 × 12 SAE and 7 first-class stamps. Photo guidelines free with SASE.
Needs: Freelancers supply cover photos only; 80% from assignment. Model release required. Captions preferred.
Making Contact & Terms: Interested in receiving work from newer, lesser-known photographers. Query with list of stock photo subjects. Buys 5 × 7 or 8 × 10 color prints; 35mm transparencies. Buys b&w photos by contract. SASE. Reports in 2 weeks. Pays $30/b&w photo; $250/color photo. Credit line given. Buys one-time rights. Previously published work OK.
Tips: "Innovative transparencies relating to physical education, recreation and sport are considered for publication on the cover—vertical format." Looks for "action shots, cooperative games, no competitive sports and classroom scenes. Send samples of *relevant* photos."

JUDICATURE, 180 N. Michigan, Suite 600, Chicago IL 60601-7401. (312)558-6900, ext. 119. Fax: (312)558-9175. Editor: David Richert. Circ. 12,000. Estab. 1917. Publication of the American Judicature Society. Bimonthly. Emphasizes courts, administration of justice. Readers are judges, lawyers, professors, citizens interested in improving the administration of justice. Sample copy free with 9 × 12 SAE and 6 first-class stamps.
Needs: Uses 2-3 photos/issue; 1-2 supplied by freelancers. Needs photos relating to courts, the law. "Actual or posed courtroom shots are always needed." Model/property releases preferred. Captions preferred.
Making Contact & Terms: Interested in receiving work from newer, lesser-known photographers. Send 5 × 7 glossy b&w prints by mail for consideration. Provide résumé, business card, brochure, flier or tearsheets to be kept on file for possible future assignments. SASE. Reports in 2 weeks. Pays $250/b&w cover photo; $125-300/color inside photo; $125-250/b&w inside photo. Pays on publication. Credit line given. Buys one-time rights. Simultaneous submissions and previously published work OK.

KEYNOTER, Dept. PM, 3636 Woodview Trace, Indianapolis IN 46268. (317)875-8755. Fax: (317)879-0204. Art Director: Jim Patterson. Circ. 175,000. Publication of the Key Club International. Monthly magazine through school year (7 issues). Emphasizes teenagers, above average students and members of Key Club International. Readers are teenagers, ages 14-18, male and female, high GPA, college-bound, leaders. Sample copy free with 9 × 12 SAE and 3 first-class stamps. Photo guidelines free with SASE.
Needs: Uses varying number of photos/issue; varying percentage supplied by freelancers. Needs vary with subject of the feature article. Reviews photos purchased with accompanying ms only. Model release required. Captions preferred.
Making Contact & Terms: Query with résumé of credits. Accepts images on disk with high-resolution proof. Pays $700/color cover photo; $500/b&w cover photo; $400/color inside photo; $100/b&w inside photo. **Pays on acceptance.** Credit line given. Buys first North American serial rights and first international serial rights.

KIWANIS MAGAZINE, 3636 Woodview Trace, Indianapolis IN 46268. (317)875-8755. Fax: (317)879-0204. Managing Editor: Chuck Jonak. Art Director: Jim Patterson. Circ. 285,000. Estab. 1915. Published 10 times/year. Emphasizes organizational news, plus major features of interest to business and professional men and women involved in community service. Free sample copy and writer's guidelines with SAE and 5 first-class stamps.
Needs: Uses photos with or without ms.
Making Contact & Terms: Send résumé of stock photos. Provide brochure, business card and flier to be kept on file for future assignments. Assigns 95% of work. Uses 5 × 7 or 8 × 10 glossy b&w prints; accepts 35mm but prefers 2¼ × 2¼ and 4 × 5 transparencies. Pays $50-700/b&w photo; $75-1,000/color photo; $400-1,000/text/photo package. Buys one-time rights.
Tips: "We can offer the photographer a lot of freedom to work *and* worldwide exposure. And perhaps an award or two if the work is good. We are now using more conceptual photos. We also use studio set-up shots. When we assign work, we want to know if a photographer can follow a concept into

finished photo without on-site direction." In portfolio or samples, wants to see "studio work with flash and natural light."

***LACMA PHYSICIAN**, P.O. Box 3465, Los Angeles CA 90051-1465. (213)683-9900. Managing Editor: Janice M. Nagano. Circ. 10,000. Estab. 1875. Published 20 times/year—twice a month except January, July, August and December. Emphasizes Los Angeles County Medical Association news and medical issues. Readers are physicians and members of LACMA.
Needs: Uses about 1-12 photos/issue; from both freelance and staff assignments. Needs photos of association meetings, physician members, association events—mostly internal coverage. Photos purchased with or without accompanying ms. Model release required.
Making Contact & Terms: Arrange a personal interview to show portfolio. Does not return unsolicited material. Pays by hour, day or half day; negotiable. Pays $100/hour. Pays on publication with submission of invoice. Credit line given. Buys one-time rights or first North American serial rights "depending on what is agreed upon."
Tips: "We want photographers who blend in well, and can get an extraordinary photo from what may be an ordinary situation. We need to see work that demonstrates an ability to get it right the first time without a lot of set-up on most shoots."

LANDSCAPE ARCHITECTURE, 4401 Connecticut Ave. NW, 5th Floor, Washington DC 20008. (202)686-8322. Design Director: Jeff Roth. Circ. 35,000. Estab. 1910. Publication of the American Society of Landscape Architects. Monthly magazine. Emphasizes "landscape architecture, urban design, parks and recreation, architecture, sculpture" for professional planners and designers. Sample copy $7. Photo guidelines free with SASE.
Needs: Uses about 75-100 photos/issue; 80% supplied by freelance photographers. Needs photos of landscape- and architecture-related subjects as described above. Special needs include aerial photography and environmental portraits. Model release required. Credit, caption information required.
Making Contact & Terms: Query with samples or list of stock photo subjects. Provide résumé, business card, brochure, flier or tearsheets to be kept on file for possible future assignments. SASE. Reporting time varies. Pays $400/day. Pays on publication. Credit line given. Buys one-time rights. Previously published work OK.
Tips: "We take an editorial approach to photographing our subjects."

LAW PRACTICE MANAGEMENT, Box 11418, Columbia SC 29211-1418. (803)754-3563. Editor/Art Director: Delmar L. Roberts. Circ. 22,005 (BPA). Estab. 1975. Published 8 times/year. Publication of the Section of Law Practice Management, American Bar Association. For practicing attorneys and legal administrators. Sample copy $8 (make check payable to American Bar Association).
Needs: Uses 1-2 photos/issue; all supplied by freelance photographers. Needs photos of some stock subjects such as group at a conference table, someone being interviewed, scenes showing staffed office-reception areas; *imaginative* photos illustrating such topics as time management, employee relations, trends in office technology, alternative billing, lawyer compensation. Computer graphics of interest. Abstract shots or special effects illustrating almost anything concerning management of a law practice. "We'll exceed our usual rates for exceptional photos of this latter type." No snapshots or Polaroid photos. Model release required. Captions required.
Making Contact & Terms: Uses 5×7 glossy b&w prints; 35mm, 2¼×2¼, 4×5 transparencies. Send unsolicited photos by mail for consideration. They are accompanied by an article pertaining to the lapida "if requested." SASE. Reports in 3 months. Pays $200-300/color cover photo (vertical format); $75-100/b&w inside photo; $200-300/job. Pays on publication. Credit line given. Usually buys all rights, and rarely reassigns to photographer after publication.

THE LION, 300 22nd St., Oak Brook IL 60521-8842. (708)571-5466. Fax: (708)571-8890. Editor: Robert Kleinfelder. Circ. 600,000. Estab. 1918. For members of the Lions Club and their families. Monthly magazine. Emphasizes Lions Club service projects. Free sample copy and photo guidelines available.
Needs: Uses 50-60 photos/issue. Needs photos of Lions Club service or fundraising projects. "All photos must be as candid as possible, showing an activity in progress. Please, no award presentations, meetings, speeches, etc. Generally photos purchased with ms (300-1,500 words) and used as a photo

MARKET CONDITIONS are constantly changing! If you're still using this book and it's 1998 or later, buy the newest edition of *Photographer's Market* at your favorite bookstore or order directly from Writer's Digest Books.

story.We seldom purchase photos separately." Model release preferred for young or disabled children. Captions required.

Making Contact & Terms: Interested in receiving work from newer, lesser-known photographers. Works with freelancers on assignment only. Provide résumé to be kept on file for possible future assignments. Query first with résumé of credits or story idea. Send 5×7, 8×10 glossy b&w and color prints; 35mm transparencies. SASE. Reports in 2 weeks. Pays $10-25/photo; $100-600/text/photo package. **Pays on acceptance.** Buys all rights; negotiable.

LOYOLA MAGAZINE, 820 N. Michigan, Chicago IL 60611. (312)915-6407. Fax: (312)915-6450. E-mail: wnoblit@luc.edu. Editor: William F. Noblitt. Circ. 98,500. Estab. 1971. Loyola University Alumni Publication. Magazine published 3 times/year. Emphasizes issues related to Loyola University Chicago. Readers are Loyola University Chicago alumni—professionals, ages 22 and up. Sample copy free with 9×12 SAE and 3 first-class stamps.
Needs: Uses 50 photos/issue; 40% supplied by freelancers. Needs Loyola-related or Loyola alumni-related photos only. Model release preferred. Captions preferred.
Making Contact & Terms: Interested in receiving work from newer, lesser-known photographers. Send unsolicited photos by mail for consideration. Provide résumé, business card, brochure, flier or tearsheets to be kept on file for possible assignments. Send 8×10 b&w/color prints; 35mm and 2¼×2¼ transparencies. SASE. Reports in 3 months. Pays $300/b&w and color cover photo; $85/b&w and color inside photo; $50-150/hour; $400-1,200/day. **Pays on acceptance.** Credit line given. Buys one-time rights. Simultaneous submissions and previously published work OK.
Tips: "Send us information, but don't call."

THE LUTHERAN, 8765 W. Higgins Rd., Chicago IL 60631. (312)380-2540. Fax: (312)380-2751. E-mail: lutheran_magazine.parti@ecunet.org. Website: http://www.elca.orgliu/luthmag.html. Art Director: Michael Watson. Publication of Evangelical Lutheran Church in America. Circ. 800,000. Estab. 1988. Monthly magazine. Sample copy 75¢ with 9×12 SASE.
• *The Lutheran's* entire production is now digitized. They have their own inhouse network so graphics, photo and text are readily accessible to all. They have been online with a worldwide Web edition since July, 1995.
Needs: Assigns 35-40 photos/issue; 4-5 supplied by freelancers. Needs current news, mood shots. "We usually assign work with exception of 'Reflections' section." Model release required. Captions preferred.
Making Contact & Terms: Interested in receiving work from newer, lesser-known photographers. Query with list of stock photo subjects. Also accepts digital images on disk. Provide résumé, brochure, flier or tearsheets to be kept on file for possible future assignments. SASE. Reports in 3 weeks. Pays $50-200/color photo; $175-300/day. Pays on publication. Credit line given. Buys one-time rights.
Tips: Trend toward "more dramatic lighting. Careful composition." In portfolio or samples, wants to see "candid shots of people active in church life, preferably Lutheran. Churches-only photos have little chance of publication. Submit sharp well-composed photos with borders for cropping."

MAINSTREAM—ANIMAL PROTECTION INSTITUTE, P.O. Box 22505, Sacramento CA 95822, or 2831 Fruitridge Rd., Sacramento CA 95820. (916)731-5521. Fax: (916)731-4467. Art Director: Barbara Tugaeff. Circ. 65,000. Estab. 1970. Official Publication of the Animal Protection Institute. Quarterly. Emphasizes "humane education toward and about animal issues and events concerning animal welfare." Readers are "all ages; people most concerned with animals." Sample copy available with 9×12 SAE and 5 first-class stamps.
Needs: Uses approximately 30 photos/issue; 15 supplied by freelancers. Needs images of animals in natural habitats. Especially interested in "one of a kind" situational animal slides. All species, wild and domestic: marine mammals, wild horses, primates, companion animals (pets), farm animals, wildlife from all parts of the world, and endangered species. Animals in specific situations: factory farming, product testing, animal experimentation and their alternatives; people and animals working together; trapping and fur ranching; animal rescue and rehabilitation; animals in abusive situations (used/abused) by humans; entertainment (rodeos, circuses, amusement parks, zoos); etc. *API* also uses high quality images of animals in various publications besides its magazine. Submissions should be excellent quality—sharp with effective lighting. Prefer tight to medium shots with good eye contact. Vertical format required for *Mainstream* covers. Model release required for vertical shots and any recognizable faces.
Making Contact & Terms: Interested in receiving work from newer, lesser-known photographers. Query with résumé, credits, stock list and sample submission of no more than 20 of best slides; originals are preferred unless dupes are *high quality*. Provide business card, brochure, flier or tearsheets for *API* files for future reference. "We welcome all 'excellent quality' contacts with SASE." Black and white rarely used. However, will accept b&w images of outstanding quality of hard-to-get, issue-oriented situations: experimentation, product testing, factory farming etc. Original transparencies or high-quality dupes only; 35mm Kodachrome 64 preferred; larger formats accepted. Reports in 1 month.

Pays $150/color cover; $35-50/b&w (from slide or photo) inside; $50-150/color inside. Pays on publication. Credit line given; please specify. Buys one-time rights. Simultaneous submissions and previously published work OK.

Tips: "The images used in *Mainstream* touch the heart. We see a trend toward strong subject, eye contact, emotional scenes, mood shots, inspirational close-ups and natural habitat shots."

MANAGEMENT ACCOUNTING, 10 Paragon Dr., Montvale NJ 07645. (201)573-9000. Fax: (201)573-0639. Editor: Kathy Williams. Circ. 95,000. Estab. 1919. Publication of Institute of Management Accountants. Monthly. Emphasizes management accounting. Readers are financial executives.
Needs: Uses about 25 photos/issue; 40% from stock houses. Needs stock photos of business, high-tech, production and factory. Model release required for identifiable people. Captions required.
Making Contact & Terms: Query with samples. Provide résumé, business card, brochure, flier or tearsheets to be kept on file for possible future assignments. Uses prints and transparencies. SASE. Reports in 2 weeks. Pays $100-200/b&w photo; $150-250/color photo. **Pays on acceptance.** Credit line given. Buys one-time rights. Simultaneous submissions and previously published work OK.
Tips: Prefers to see "ingenuity, creativity, dramatics (business photos are often dry), clarity, close-ups, simple but striking. Aim for a different slant."

❤THE MANITOBA TEACHER, 191 Harcourt St., Winnipeg, Manitoba R3J 3H2 Canada. (204)888-7961. Fax: (204)831-0877. Communications Officer: Janice Armstrong. Managing Editor: Raman Job. Production Editor/Advertising: Joy Montgomery. Circ. 17,000. Publication of The Manitoba Teachers' Society. Published nine times per year. Emphasizes education in Manitoba—emphasis on teachers' interest. Readers are teachers and others in education. Sample copy free with 10 × 14 SAE and Canadian stamps.
Needs: Uses approximately 4 photos/issue; 80% supplied by freelancers. Needs action shots of students and teachers in education-related settings. "Good cover shots always needed." Model release required. Captions required.
Making Contact & Terms: Send 8 × 10 glossy b&w prints by mail for consideration. Submit portfolio for review. Provide résumé, business card, brochure, flier or tearsheets to be kept on file for possible assignments. SASE. Reports in 1 month. Pays $35/photo for single use.
Tips: "Always submit action shots directly related to major subject matter of publication and interests of readership of that publication."

THE MIDWEST MOTORIST, Dept. PM, Auto Club of Missouri, 12901 N. Forty Dr., St. Louis MO 63141. (314)523-7350. Editor: Michael Right. Circ. 385,000. Bimonthly. Emphasizes travel and driving safety. Readers are "members of the Auto Club of Missouri, ranging in age from 25-65 and older." Free sample copy and photo guidelines with SASE; use large manila envelope.
Needs: Uses 8-10 photos/issue, most supplied by freelancers. "We use four-color photos inside to accompany specific articles. Our magazine covers topics of general interest, historical (of Midwest regional interest), humor (motoring slant), interview, profile, travel, car care and driving tips. Our covers are full color photos mainly corresponding to an article inside. Except for cover shots, we use freelance photos only to accompany specific articles." Captions required.
Making Contact & Terms: Send by mail for consideration 35mm, 2¼ × 2¼ or 4 × 5 color transparencies. Query with résumé of credits. Query with list of stock photo subjects. SASE. Reports in 6 weeks. Pays $100-250/cover; $10-25/photo with accompanying ms; $50-200/color photo; $75-200 text/photo package. Pays on publication. Credit line given. Rights negotiable. Simultaneous submissions and previously published work OK.
Tips: "Send an 8½ × 11 SASE for sample copies and study the type of covers and inside work we use."

MODERN MATURITY, 3200 E. Carson St., Lakewood CA 90712. (310)496-2277. Photo Editor: M.J. Wadolny. Circ. 20 million. Bimonthly. Readers are age 50 and older. Sample copy free with 9 × 12 SASE. Guidelines free with SASE.
Needs: Uses about 50 photos/issue; 45 supplied by freelancers; 75% from assignment and 25% from stock.
Making Contact & Terms: Arrange a personal interview to show portfolio. SASE. Pays $50-200/ b&w photo; $150-1,000/color photo; $350/day. **Pays on acceptance.** Credit line given. Buys one-time and first North American serial rights.
Tips: Portfolio review: Prefers to see clean, crisp images on a variety of subjects of interest. "Present yourself and your work in a professional manner. Be familiar with *Modern Maturity*. Wants to see creativity and ingenuity in images."

MUZZLE BLASTS, P.O. Box 67, Friendship IN 47021. (812)667-5131. Fax: (812)667-5137. Art Director: Sharon Pollard. Circ. 25,000. Estab. 1939. Publication of the National Muzzle Loading Rifle

Association. Monthly magazine emphasizing muzzleloading. Sample copy free. Photo guidelines free with SASE.

Needs: Interested in North American wildlife, muzzleloading hunting, primitive camping. Model/property release required. Captions preferred.

Making Contact & Terms: Interested in receiving work from newer, lesser-known photographers. Query with stock photo list. Deadlines: 15th of the month—4 months before cover date. Keeps samples on file. SASE. Reports in 1-2 weeks. Pays $300/color cover photo; $25/b&w inside photo. Pays on publication. Credit line given. Buys one-time rights. Simultaneous submissions OK.

NACLA REPORT ON THE AMERICAS, 475 Riverside Dr., Room 454, New York NY 10115. (212)870-3146. Photo Editor: Deidre McFadyen. Circ. 11,500. Association publication of North American Congress on Latin America. Bimonthly journal. Emphasizes Latin American political economy; US foreign policy toward Latin America and the Caribbean; and development issues in the region. Readers are academic, church, human rights, political activists, foreign policy interested. Sample copy $5.75 (includes postage).

Needs: Uses about 20 photos/issue; most supplied by freelancers. Model release preferred. Captions preferred.

Making Contact & Terms: Arrange a personal interview to show portfolio or send a query with list of countries and topics covered. Black & white prints preferred. SASE. Reports in 1 month. Pays $35/b&w photo. Pays on publication. Credit line given. Buys one-time rights. Simultaneous submissions and previously published work OK.

NATIONAL GARDENING, Dept. PM, 180 Flynn Ave., Burlington VT 05401. (802)863-1308. Fax: (802)863-5962. Editor: Michael MacCaskey. Managing Editor: Dan Hicky. Circ. 200,000. Estab. 1979. Publication of the National Gardening Association. Bimonthly. Covers fruits, vegetables, herbs and ornamentals. Readers are home and community gardeners. Sample copy $3.50. Photo guidelines free with SASE.

Needs: Uses about 50-60 photos/issue; 80% supplied by freelancers. "Most of our photographers are also gardeners or have an avid interest in gardening or gardening research." Ongoing needs include: "people gardening; special techniques; how to; specific varieties (please label); garden pests and diseases; soils; unusual (or impressive) gardens in different parts of the country. We sometimes need someone to photograph a garden or gardener in various parts of the country for a specific story."

Making Contact & Terms: "We send out a photo needs list for each issue." Query with samples or list of stock photo subjects. SASE. Reports in 1 month. Pays $350/color cover photo; $30/b&w and $50-100/color inside photo. Also negotiates day rate against number of photos used. Pays on publication. Credit line given. Buys first North American serial rights.

Tips: "We need top-quality work. Most photos used are color. We look for general qualities like sharp focus, good color balance, good sense of lighting and composition. Also interesting viewpoint, one that makes the photos more than just a record (getting down to ground level in the garden, for instance, instead of shooting everything from a standing position). Look at the magazine carefully and at the photos used. When we publish a story on growing broccoli, we love to have photos of people planting or harvesting broccoli, in addition to lush close ups. We like to show process, step-by-step, and, of course, inspire people."

THE NATIONAL NOTARY, 8236 Remmet Ave., Box 7184, Canoga Park CA 91309-7184. (818)713-4000. Editor: Charles N. Faerber. Circ. 125,000. Bimonthly. Emphasizes "Notaries Public and notarization—goal is to impart knowledge, understanding and unity among notaries nationwide and internationally." Readers are employed primarily in the following areas: law, government, finance and real estate. Sample copy $5.

Needs: Uses about 20-25 photos/issue; 10 supplied by non-staff photographers. "Photo subject depends on accompanying story/theme; some product shots used." Unsolicited photos purchased with accompanying ms only. Model release required.

Making Contact & Terms: Query with samples. Provide business card, tearsheets, résumé or samples to be kept on file for possible future assignments. Prefers to see prints as samples. Cannot return material. Reports in 6 weeks. Pays $25-300 depending on job. Pays on publication. Credit line given "with editor's approval of quality." Buys all rights. Previously published work OK.

Tips: "Since photography is often the art of a story, the photographer must understand the story to be able to produce the most useful photographs."

THE NATIONAL RURAL LETTER CARRIER, Dept. PM, 1630 Duke St., Alexandria VA 22314-3465. (703)684-5545. Managing Editor: RuthAnn Saenger. Circ. 80,000. Biweekly magazine. Emphasizes Federal legislation and issues affecting rural letter carriers and the activities of the membership for rural carriers and their spouses and postal management. Sample copy 55¢. Photo guidelines free with SASE.

• This magazine uses a limited number of photos in each issue, usually only a cover photograph

and some promotional headshots or group photos. Photo/text packages are used on occasion and if you present an interesting story you should have better luck with this market.

Needs: Photos purchased with accompanying ms. Buys 24 photos/year. Animal; wildlife; sport; celebrity/personality; documentary; fine art; human interest; humorous; nature; scenics; photo essay/photo feature; special effects and experimental; still life; spot news; and travel. Needs scenes that combine subjects of the Postal Service and rural America; "submit photos of rural carriers on the route." Model release required. Captions required.

Making Contact & Terms: Interested in receiving work from newer, lesser-known photographers. Send material by mail for consideration. Query with list of stock photo subjects. Uses 8×10 b&w or color glossy prints, vertical format preferred for cover. SASE. Reports in 1 month. Pays $60/photo. Pays on publication. Credit line given. Buys first serial rights. Previously published work OK.

Tips: "Please submit sharp and clear photos with interesting and pertinent subject matter. Study the publication to get a feel for the types of rural and postal subject matter that would be of interest to the membership. We receive more photos than we can publish, but we accept beginners' work if it is good."

NATURE CONSERVANCY MAGAZINE, 1815 N. Lynn St., Arlington VA 22209. (703)841-8742. Fax: (703)841-9692. E-mail: cgelb@aol.com. Website: cgelb@aol.org. Photo Editor: Connie Gelb. Circ. 820,000. Estab. 1951. Publication of The Nature Conservancy. Bimonthly. Emphasizes "nature, rare and endangered flora and fauna, ecosystems in North and South America, the Caribbean, Indonesia, Micronesia and South Pacific and compatible development." Readers are the membership of The Nature Conservancy. Sample copy free with 9×12 SAE and 5 first-class stamps. Write for guidelines. Articles reflect work of the Nature Conservancy and its partner organizations.

Needs: Uses about 20-25 photos/issue; 70% from freelance stock. The Nature Conservancy welcomes permission to make duplicates of slides submitted to the *Magazine* for use in slide shows and online use. Captions required; include location and names (common and Latin) of flora and fauna. Proper credit should appear on slides.

Making Contact & Terms: Interested in receiving work and photo-driven story ideas from newer, lesser-known photographers. Many photographers contribute the use of their slides. Uses color transparencies. Pays $150-500/hour; $300/color cover photo; $150-300/color inside photo; $75-100/b&w photo; negotiable day rate. Pays on publication. Credit line given. Buys one-time rights; starting to consider all rights for public relations and online purposes; negotiable. Willing to offer free hyperlinks to photographers' web pages.

Tips: Seeing more large-format photography and more interesting uses of motion and mixing available light with flash and b&w. "Photographers must familiarize themselves with our organization. We only run articles reflecting our work or that of our partner organizations in Latin America and Asia/Pacific. Membership in the Nature Conservancy is only $25/year and the state newsletter will keep photographers up to date on what the Conservancy is doing in your area. Many of the preserves are open to the public. We look for rare and endangered species, wetlands and flyways, indigenous/traditional people of Latin America, South Pacific and the Caribbean."

NEVADA FARM BUREAU AGRICULTURE AND LIVESTOCK JOURNAL, 1300 Marietta Way, Sparks NV 89431. (702)358-3276. Contact: Norman Cardoza. Circ. 7,200. Monthly tabloid. Emphasizes Nevada agriculture. Readers are primarily Nevada Farm Bureau members and their families; men, women and youth of various ages. Members are farmers and ranchers. Sample copy free with 10×13 SAE with 3 first-class stamps.

Needs: Uses 5 photos/issue; 30% occasionally supplied by freelancers. Needs photos of Nevada agriculture people, scenes and events. Model release preferred. Captions required.

Making Contact & Terms: Send 3×5 and larger b&w prints, any format and finish by mail for consideration. SASE. Reports in 1 week. Pays $10/b&w cover photo; $5/b&w inside photo. **Pays on acceptance.** Credit line given. Buys one-time rights.

Tips: "In portfolio or samples, wants to see: newsworthiness, 50%; good composition, 20%; interesting action, 20%; photo contrast, resolution, 10%. Try for new angles on stock shots: awards, speakers, etc., We like 'Great Basin' agricultural scenery such as cows on the rangelands and high desert cropping. We pay little, but we offer credits for your résumé."

NEW ERA MAGAZINE, 50 E. North Temple St., Salt Lake City UT 84150. (801)240-2951. Fax: (801)240-5997. Art Director: Lee Shaw. Circ. 203,000. Estab. 1971. Association publication of The

 THE ASTERISK before a listing indicates that the market is new in this edition. New markets are often the most receptive to freelance submissions.

Church of Jesus Christ of Latter-day Saints. Monthly magazine. Emphasizes teenagers who are members of the Mormon Church. Readers are male and female teenagers, who are members of the Latter-day Saints Church. Sample $1 with 9×12 SAE and 2 first-class stamps. Photo guidelines free with SASE.

Needs: Uses 60-70 photos/issue; 35-40 supplied by freelancers. Anything can be considered for "Photo of the Month," most photos of teenage Mormons and their activities. Model/property release preferred. Captions preferred.

Making Contact & Terms: Arrange personal interview to show portfolio. Submit portfolio for review. Query with stock photo list. Send unsolicited photos by mail for consideration. Send any b&w or color print; 35mm, 2¼×2¼, 4×5 transparencies. Keeps samples on file. SASE. Reports in 6-8 weeks. Pays $150-300/day; "rates are individually negotiated, since we deal with many teenagers, non-professionals, etc." Credit line given. Buys all rights; negotiable. "Rights are reassigned on request."

Tips: "Most work consists of assignments given to photographers we know and trust, or of single item purchases for 'Photo of the Month.' "

***THE NEW PHYSICIAN**, 1902 Association Dr., Reston VA 22091. (703)620-6600. Editor: Laura Milani. Art Director: Julie Cherry. Circ. 30,000. Publication of American Medical Student Association. Magazine published 9 times a year. Emphasizes medicine/health. Readers are medical students, interns, residents, medical educators. Sample copy $5 with SASE.

Needs: Needs freelance photos for about 6 stories per year. Needs photos usually on health, medical, medical training. Commissions photos to go with story or photo essay on above topics only. Model release required. Captions required.

Making Contact & Terms: Provide résumé, business card, brochure, flier or tearsheets to be kept on file for possible future assignments. NPI; pay negotiated. Pays 2-4 weeks after acceptance.

NEWS PHOTOGRAPHER, Dept. PM, 1446 Conneaut Ave., Bowling Green OH 43402. (419)352-8175. Fax: (419)354-5435. E-mail: jgordon@bgnet.bgsu.edu. Website: http://sunsite.unc.edu/nppa. Editor: James R. Gordon. Circ. 11,000. Estab. 1946. Publication of National Press Photographers Association, Inc. Monthly magazine. Emphasizes photojournalism and news photography. Readers are newspaper, magazine, television freelancers and photojournalists. Sample copy free with 9×12 SAE and 9 first-class stamps.

 • *News Photographer* is 100% digital—to printer.

Needs: Uses 50 photos/issue. Needs photos of photojournalists at work; photos which illustrate problems of photojournalists. Special photo needs include photojournalists at work, assaulted, arrested; groups of news photographers at work; problems and accomplishments of news photographers. Captions required.

Making Contact & Terms: Send glossy b&w or color prints; 35mm transparencies or negs by mail for consideration. Also accepts JPEG'd to Mac or DOS floppy or 44 or 88 Mb SyQuest cartridge. Provide résumé, business card, brochure, flier or tearsheets to be kept on file for possible assignments; make contact by telephone. "Collect calls accepted." Reports in 3 weeks. Pays $75/color page rate; $50/b&w page rate; $50-150/photo/text package. **Pays on acceptance.** Credit line given. Buys one-time rights. Simultaneous submissions and previously published work OK.

***NFPA JOURNAL**, 1 Batterymarch Park, Quincy MA 02169-9101. (617)984-7566. Art Director: Jane Dashfield. Circ. 65,000. Publication of National Fire Protection Association. Bimonthly magazine. Emphasizes fire protection issues. Readers are fire professionals, engineers, architects, building code officials, ages 20-65. Sample copy free with 9×12 SAE.

Needs: Uses 25-30 photos/issue; 25% supplied by freelance photographers. Needs photos of fires and fire-related incidents. Especially wants to use more photos for Fire Fighter Injury Report and Fire Fighter Fatality Report. Model release preferred. Captions preferred.

Making Contact & Terms: Query with list of stock photo subjects, send unsolicited photos by mail for consideration. Provide résumé, business card, brochure, flier or tearsheets to be kept on file for possible assignments. Send color prints and 35mm transparencies in 3-ring slide sleeve with date. SASE. Reports in 3 weeks or "as soon as I can." Payment negotiated. Pays on publication. Credit line given. Buys rights depending "on article and sensitivity of subject. We are not responsible for damage to photos."

Tips: "Send cover letter, 35mm color slides preferably with manuscripts and photo captions."

NORTH AMERICAN HUNTER, P.O. Box 3401, Minnetonka MN 55343. (612)936-9333. Fax: (612)936-9755. Publisher: Russ Nolan. Editor: Bill Miller. Senior Editor: Michael Faw. Managing Editor: Greg Gutschow. Circ. 750,000. Estab. 1978. Publication of North American Hunting Club. Bimonthly. Emphasizes hunting. Readers are all types of hunters with an eye for detail and an appreciation of wildlife. Sample copy $5.

Needs: Uses about 12-15 photos/issue; all supplied by freelance photographers. For covers, needs "action wildlife centered in vertical format. Inside, needs North American big game, small game,

gamebirds and waterfowl only. Always looking for trophy white-tailed deer." Model release preferred. Captions preferred.

Making Contact & Terms: Interested in receiving work from newer, lesser-known photographers. Send 35mm transparencies by mail for consideration or submit list of photos in your file. SASE. Reports in 1 month. Pays $350/color cover photo; $100/b&w photo; $100-350/color photo; and $325-400 for text/photo package. **"Pays promptly on acceptance."** Credit line given. Buys one-time rights; negotiable.

Tips: "We want close-ups of outdoor people and top-quality photos of North American big game depicting a particular behavior pattern that members of the North American Hunting Club might find useful in pursuing that animal. Action shots are especially sought. Get a copy of the magazine and check out the type of photos we are using."

NORTH AMERICAN WHITETAIL MAGAZINE, P.O. Box 741, Marietta GA 30061. (404)953-9222. Fax: (404)933-9510. Photo Editor: Gordon Whittington. Circ. 170,000. Estab. 1982. Published 8 times/year (July-February) by Game & Fish Publications, Inc. emphasizing trophy whitetail deer hunting. Sample copy $3. Photo guidelines free with SASE.

Needs: Uses 20 photos/issue; 40% supplied by freelancers. Needs photos of large, live whitetail deer, hunter posing with or approaching downed trophy deer, or hunter posing with mounted head. Also use photos of deer habitat and sign. Model release preferred. Captions preferred; include where scene was photographed and when.

Making Contact & Terms: Interested in receiving work from newer, lesser-known photographers. Query with résumé of credits and list of stock photo subjects. Send unsolicited 8×10 b&w prints; 35mm transparencies (Kodachrome preferred). Will return unsolicited material in 1 month if accompanied by SASE. Pays $250/color cover photo; $75/inside color photo; $25/b&w photo. Tearsheets provided. Pays 75 days prior to publication. Credit line given. Buys one-time rights. Simultaneous submissions not accepted.

Tips: "In samples we look for extremely sharp, well-composed photos of whitetailed deer in natural settings. We also use photos depicting deer hunting scenes. Please study the photos we are using before making submission. We'll return photos we don't expect to use and hold the remainder. Please do not send dupes. Use an 8× loupe to ensure sharpness of images and put name and identifying number on all slides and prints. Photos returned at time of publication or at photographer's request."

OAK RIDGE BOYS "TOUR BOOK" AND FAN CLUB NEWSLETTER, 329 Rockland Rd., Hendersonville TN 37075. (615)824-4924. Fax: (615)822-7078. Art Director: Kathy Harris. Circ. newsletter 5,000; tour book 25,000. Publication of The Oak Ridge Boys, Inc. 3 times/year newsletter, tour book published "every 1-3 years." Tour book: 24 pages, full color. Emphasizes The Oak Ridge Boys (music group) exclusively. Readers are fans of Oak Ridge Boys and country music. Free sample copies available of newsletter; tourbook $10.

Needs: Uses 4-5 photos/issue of newsletter, 0-2 supplied by freelance photographers; 20-150/tour book, 1-50 supplied by freelance photographers. Needs current photos of Oak Ridge Boys. Will review photos with or without accompanying ms; subject to change without notice. "We need *great* live shots or candid shots—not interested in just average shots." Model release required. Captions preferred.

Making Contact & Terms: Interested in receiving work from newer, lesser-known photographers. Send 8×10 or smaller color or b&w prints with any finish by mail for consideration. Samples kept on file. Sometimes returns material if SASE is enclosed. Reports vary, 2 months. Newsletter: Pays $50/photo. Tour Book: for color photos, pays $500/page; $250/half page; $125/quarter page. For b&w photos, pays $250/page; $125/half page; $75/quarter page. Price is negotiable depending on usage. Pays on publication. Credit line usually given. Buys all rights; negotiable. Simultaneous submissions and previously published work OK.

Tips: "We are interested in Oak Ridge Boys photos only! Send only a few good shots at one time—send prints only. No original slides or negatives please."

OKLAHOMA TODAY, Box 53384, Oklahoma City OK 73152. (405)521-2496. Fax: (405)522-4588. Editor-in-Chief: Jeanne M. Devlin. Circ. 45,000. Estab. 1956. Bimonthly magazine. "We cover all aspects of Oklahoma, from history to people profiles, but we emphasize travel." Readers are "Oklahomans, whether they live in-state or are exiles; studies show them to be above average in education and income." Sample copy $4.95. Photo guidelines free with SASE.

Needs: Uses about 50 photos/issue; 90-95% supplied by freelancers. Needs photos of "Oklahoma subjects only; the greatest number are used to illustrate a specific story on a person, place or thing in the state. We are also interested in stock scenics of the state." Other areas of focus are adventure—sport/travel, reenactment, historical and cultural activities. Model release required. Captions required.

Making Contact & Terms: Interested in receiving work from newer, lesser-known photographers. Query with samples. Send 8×10 glossy b&w prints; 35mm, 2¼×2¼, 4×5, 8×10 transparencies or b&w contact sheets by mail for consideration. No color prints. Also accepts digital files (Mac compatible). SASE. Reports in 2 months. Pays $50-200/b&w photo; $50-200/color photo; $125-1,000/job.

Pays on publication. Buys one-time rights with a six-month from publication exclusive, plus right to reproduce photo in promotions for magazine, without additional payment with credit line. Simultaneous submissions and/or previously published work OK (on occasion).

Tips: To break in, "read the magazine. Subjects are normally activities or scenics (mostly the latter). I would like good composition and very good lighting. I look for photographs that evoke a sense of place, look extraordinary and say something only a good photographer could say about the image. Look at what Ansel Adams and Eliot Porter did and what Muench and others are producing and send me that kind of quality. We want the best photographs available and we give them the space and play such quality warrants."

♣THE ONTARIO TECHNOLOGIST, 10 Four Seasons Place, Suite 404, Etobicoke, Ontario M9B 6H7 Canada. (416)621-9621. Fax: (416)621-8694. Editor-in-Chief: Ruth M. Klein. Circ. 21,400. Publication of the Ontario Association of Certified Engineering Technicians and Technologists. Bi-monthly. Emphasizes engineering technology. Sample copy free with SAE and IRC.
Needs: Uses 10-12 photos/issue. Needs how-to photos—"building and installation of equipment; similar technical subjects." Model release preferred. Captions preferred.
Making Contact & Terms: Prefers business card and brochure for files. Send 5×7 glossy b&w or color prints for consideration. SASE. Reports in 1 month. Pays $25/b&w photo; $50/color photo. Pays on publication. Credit line given. Buys one-time rights. Previously published work OK.

OUTDOOR AMERICA, 707 Conservation Lane, Gaithersburg MD 20878-2983. (301)548-0150. Fax: (301)548-0146. Editor: Denny Johnson. Circ. 45,000. Estab. 1922. Published quarterly. Empha-sizes natural resource conservation and activities for outdoor enthusiasts, including hunters, anglers, hikers and campers. Readers are members of the Izaak Walton League of America and all members of Congress. Sample copy $2 with 9×12 envelope. Guidelines free with SASE.
Needs: Needs vertical wildlife or shots of anglers or hunters for cover. Buys pictures to accompany articles on conservation and outdoor recreation for inside. Model release preferred. Captions required; include date taken, model info, location and species.
Making Contact & Terms: Query with résumé of photo credits. Send stock photo list. Tearsheets and non-returnable samples only. Uses 35mm and 2¼×2¼ slides. Not responsible for return of unsolicited material. SASE. Pays $200/color cover; $50-100/inside photo. **Pays on acceptance.** Credit line given. Buys one-time rights. Simultaneous and/or previously published work OK.
Tips: "*Outdoor America* seeks vertical photos of wildlife (particular game species); outdoor recreation subjects (fishing, hunting, camping or boating) and occasional scenics (especially of the Chesapeake Bay and Upper Mississippi river). We also like the unusual shot—new perspectives on familiar objects or subjects. We do not assign work. Approximately one half of the magazine's photos are from freelance sources. Our cover has moved from using a square photo format to full bleed."

***PACIFIC DISCOVERY,** California Academy of Sciences, Golden Gate Park, San Francisco CA 94118. (415)750-7116. Fax: (415)750-7106. Art Director: Susan Schneider. Circ. 36,000. Estab. 1948. Publication of California Academy of Sciences. Quarterly magazine. Emphasizes natural history and culture of California, the western US, the Pacific and Pacific Rim countries. Sample copy $1.50 with 9×11 SASE. Photo guidelines free with SASE.
Needs: Uses 50 photos/issue; 90% supplied by freelance photographers and stock photos. Scenics of habitat as well as detailed photos of individual species that convey biological information; wildlife, habitat, ecology, conservation and geology. "Scientific accuracy in identifying species is essential. We do extensive photo searches for every story." Current needs listed in *Guilfoyle Report*, natural history photographers' newsletter published by AG Editions. Model release preferred. "Captions preferred, but captions are generally staff written."
Making Contact & Terms: Interested in receiving work from newer, lesser-known photographers. Query with list of stock photo subjects and file stock lists, but recommend consulting *Guilfoyle Report* and calling first. Uses color prints; 35mm, 2¼×2¼, or 4×5 transparencies; originals preferred. SASE. Reports in 6 weeks. Pays $200/color cover photo; $90-125/color inside photo; $100/color page rate; $125 color 1⅓ pages; $500-1,000 photo/text packages, but payment varies according to length of text and number of photos. Pays on panel selection. Credit line given. Buys one-time rights.
Tips: "*Pacific Discovery* has a reputation for high-quality photo reproduction and favorable layouts, but photographers must be meticulous about identifying what they shoot."

 THE MAPLE LEAF before a listing indicates that the market is Canadian.

PACIFIC UNION RECORDER, Box 5005, Westlake Village CA 91359. (805)497-9457. Editor: C. Elwyn Platner. Circ. 58,500. Estab. 1901. Company publication of Pacific Union Conference of Seventh-day Adventist. Monthly except twice a month in February, April, June, August, October and December. Emphasizes religion. Readers are primarily age 18-90 church members. Sample copy free with 8½ × 11 SAE and 3 first-class stamps. Photo guidelines free with SASE.
Needs: Uses photos for cover only; 80% supplied by freelance photographers. Needs photos of animal/wildlife shots, travel, scenics, limited to subjects within Nevada, Utah, Arizona, California and Hawaii. Model release required. Captions required.
Making Contact & Terms: Send unsolicited 35mm, 2¼ × 2¼, 4 × 5, 8 × 10 vertical transparencies by mail for consideration in October only. Limit of 10 transparencies or less/year per photographer. SASE. Reports in 1-2 months after contest. Pays $75/color cover photo. Pays on publication. Credit line given. Buys first one-time rights.
Tips: "Avoid the trite, Yosemite Falls, Half Dome, etc." Holds annual contest November 1 each year; submit entries in October only.

PENNSYLVANIA ANGLER, Dept. PM, P.O. Box 67000, Harrisburg PA 17106-7000. (717)657-4518. Editor: Art Michaels. Monthly. "*Pennsylvania Angler* is the Keystone State's official fishing magazine, published by the Pennsylvania Fish and Boat Commission." Readers are "anglers who fish in Pennsylvania." Sample copy and photo guidelines free with 9 × 12 SAE and 4 first-class stamps.
Needs: Uses about 25 photos/issue; 80% supplied by freelancers. Needs "action fishing and boating shots." Model release preferred. Captions required.
Making Contact & Terms: Query with résumé of credits. Send 8 × 10 glossy b&w prints; 35mm or larger transparencies by mail for consideration. SASE. Reports in 2 weeks. Pays up to $200/color cover photo; $25-100/b&w inside photo; $25 up/color inside photo; $50-250 for text/photo package. **Pays on acceptance.** Credit line given. Buys variable rights.

***PENNSYLVANIA HERITAGE**, Dept PM, P.O. Box 1026, Harrisburg PA 17108-1026. (717)787-7522. Editor: Michael J. O'Malley, III. Circ. 10,000. Published by the Pennsylvania Historical & Museum Commission. Quarterly magazine. Emphasizes Pennsylvania history, culture and art. Readers are "varied—generally well-educated with an interest in history, museums, travel, etc." Sample copy free with SAE and 65¢ postage. Photo guidelines free with SASE.
Needs: Uses approximately 60 photos/issue; 50% supplied by freelance photographers; 35% on specific assignment, 65% from stock. Needs photos of "historic sites, artifacts, travel, scenic views, objects of material culture, etc." Photos purchased to accompany ms. "We are generally seeking illustrations for specific manuscripts." Captions required.
Making Contact & Terms: Query with samples and list of stock photo subjects. Provide résumé, business card, brochure, flier or tearsheets to be kept on file for possible future assignments. SASE. Reports in 1 month. Pays $25-100/b&w photo and $25-300/color photo. **Pays on acceptance.** Credit line given. Buys all rights. Simultaneous submissions OK.
Tips: "Send query *first* with sample and ideally, a list of Pennsylvania subjects that are available. Quality is everything. Don't bombard an editor or photo buyer with everything—be selective."

PENNSYLVANIAN MAGAZINE, Dept. PM, 2941 N. Front St., Harrisburg PA 17110. (717)236-9526. Fax: (717)236-8164. Editor: T. Michael Mullen. Circ. 7,000. Estab. 1962. Monthly magazine of Pennsylvania State Association of Boroughs (and other local governments). Emphasizes local government in Pennsylvania. Readers are officials in small municipalities in Pennsylvania. Sample copy free with 9 × 12 SAE and 5 first-class stamps.
Needs: Number of photos/issue varies with inside copy. Needs "color photos of scenics (Pennsylvania), local government activities, Pennsylvania landmarks, ecology—for cover photos only; authors of articles supply their own photos." Special photo needs include photos of street and road maintenance work; wetlands scenic. Model release preferred. Captions preferred that include identification of place and/or subject.
Making Contact & Terms: Interested in receiving work from newer, lesser-known photographers. Query with résumé of credits. Query with list of stock photo subjects. Send unsolicited photos by mail for consideration. Provide résumé, business card, brochure, flier or tearsheets to be kept on file for possible assignments. Send color prints and 35mm transparencies. Does not keep samples on file. SASE. Reports in 1 month. Pays $25-30/color cover photo. Pays on publication. Buys one-time rights.
Tips: "We're looking for a variety of scenic shots of Pennsylvania which can be used for front covers of the magazine, especially special issues such as engineering, winter road maintenance or park and recreation. Photographs submitted for cover consideration should be vertical shots; horizontal shots receive minimal consideration."

PENTECOSTAL EVANGEL, 1445 Boonville, Springfield MO 65802. (417)862-2781. Fax: (417)862-0416. E-mail: pevagel@ao.org. Editor: Hal Donaldson. Managing Editor: John T. Maempa. Circ. 280,000. Official voice of the Assemblies of God, a conservative Pentecostal denomination.

Weekly magazine. Emphasizes denomination's activities and inspirational articles for membership. Free sample copy and photographer's/writer's guidelines.

• *Pentecostal Evangel* uses a number of images taken from the Internet and CD-ROMs.

Needs: Uses 25 photos/issue; 5 supplied by freelance photographers. Human interest (very few children and animals). Also needs seasonal and religious shots. "We are interested in photos that can be used to illustrate articles or concepts developed in articles. We are not interested in merely pretty pictures (flowers and sunsets) or in technically unusual effects or photos. We use a lot of people and mood shots." Model release preferred. Captions preferred.

Making Contact & Terms: Interested in receiving work from newer, lesser-known photographers. Send material by mail for consideration. Uses 8×10 b&w and color prints; 35mm or larger transparencies; color 2¼×2¼ to 4×5 transparencies for cover; vertical format preferred. Also accepts digital images in TIFF files. SASE. Reports in 1 month. Pays $35-50/b&w photo; $50-200/color photo; $100-300/job. **Pays on acceptance.** Credit line given. Buys one-time rights; simultaneous rights; or second serial (reprint) rights. Simultaneous submissions and previously published work OK if indicated.

Tips: "Send seasonal material six months to a year in advance—especially color."

PERSIMMON HILL, 1700 NE 63rd, Oklahoma City OK 73111. (405)478-6404. Fax: (405)478-4714. Editor: M. J. Van Deventer. Circ. 15,000. Estab. 1970. Publication of the National Cowboy Hall of Fame museum. Quarterly magazine. Emphasizes the West, both historical and contemporary views. Has diverse international audience with an interest in preservation of the West. Sample copy $8 with 9×12 SAE and 7 first-class stamps. Writers and photography guidelines free with SASE.

• This magazine has received Outstanding Publication honors from the Oklahoma Museums Association, the International Association of Business Communicators and Ad Club.

Needs: Uses 70 photos/issue; 95% supplied by freelancers; 90% of photos in each issue come from assigned work. "Photos must pertain to specific articles unless it is a photo essay on the West." Model release required for children's photos. Photo captions required including location, names of people, action. Proper credit is required if photos are of an historical nature.

Making Contact & Terms: Interested in receiving work from newer, lesser-known photographers. Submit portfolio for review. SASE. Reports in 6 weeks. Pays $350/color cover photo; $50/color inside photo; $25-100/b&w inside photo; $200/photo/text package; $40-60/hour; $250-500/day; $300-750/job. Credit line given. Buys first North American serial rights.

Tips: "Make certain your photographs are high quality and have a story to tell. We are using more contemporary portraits of things that are currently happening in the West and using fewer historical photographs. Work must be high quality, original, innovative. Photographers can best present their work in a portfolio format and should keep in mind that we like to feature photo essays on the West in each issue. Study the magazine to understand its purpose. Show only the work that would be beneficial to us or pertain to the traditional Western subjects we cover."

PLANNING, American Planning Association, 122 S. Michigan Ave, Chicago IL 60603. (312)431-9100. (312)431-9985. Editor: Sylvia Lewis. Photo Editor: Richard Sessions. Circ. 30,000. Estab. 1972. Monthly magazine. "We focus on urban and regional planning, reaching most of the nation's professional planners and others interested in the topic." Free sample copy and photo guidelines with 10×13 SAE and 4 first-class stamps. Writer's guidelines included on photo guidelines sheet.

Needs: Buys 50 photos/year, 95% from freelance stock. Photos purchased with accompanying ms and on assignment. Photo essay/photo feature (architecture, neighborhoods, historic preservation, agriculture); scenic (mountains, wilderness, rivers, oceans, lakes); housing; and transportation (cars, railroads, trolleys, highways). "No cheesecake; no sentimental shots of dogs, children, etc. High artistic quality is very important. We publish high-quality nonfiction stories on city planning and land use. Ours is an association magazine but not a house organ, and we use the standard journalistic techniques: interviews, anecdotes, quotes. Topics include energy, the environment, housing, transportation, land use, agriculture, neighborhoods and urban affairs." Captions required.

Making Contact & Terms: Interested in receiving work from newer, lesser-known photographers. Query with samples. Uses 8×10 glossy and semigloss b&w prints; contact sheet OK; 4-color prints; 35mm or 4×5 transparencies. SASE. Reports in 1 month. Pays $50-100/b&w photo; $50-200/color photo; up to $350/cover photo; $200-600/ms. Pays on publication. Credit line given. Previously published work OK.

Tips: "Just let us know you exist. Eventually, we may be able to use your services. Send tearsheets or photocopies of your work, or a little self-promo piece. Subject lists are only minimally useful. How the work looks is of paramount importance."

PN/PARAPLEGIA NEWS, 2111 E. Highland Ave., Suite 180, Phoenix AZ 85016-4702. (602)224-0500. Fax: (602)224-0507. E-mail: pvapub@aol.com. Director of Art & Production: Susan Robbins. Circ. 27,000. Estab. 1946. Monthly magazine. Emphasizes all aspects of living for people with spinal-chord injuries or diseases. Readers are primarily well-educated males, 40-55, who use wheelchairs for

mobility. Sample copy free with 9×12 SASE and 7 first-class stamps. Photo guidelines free with SASE.
Needs: Uses 30 photos/issue; 10% supplied by freelancers. Articles/photos must deal with accessibility or some aspect of wheelchair living. "We do not accept photos that do not accompany manuscript." Model/property release preferred. Captions required; include who, what, when, where.
Making Contact & Terms: Interested in receiving work from newer, lesser-known photographers. Provide résumé, business card, brochure, flier or tearsheets to be kept on file for possible assignments. "OK to call regarding possible assignments in their locales." Deadlines: will be communicated on contact. Keeps samples on file. SASE. Reports in 1 month. Pays $25-200/color cover photo; $10-25/color inside photo; $10-25/b&w inside photo; $50-200/photo/text package; other forms of payment negotiated with editor. Pays on publication. Credit line given. Buys one-time, all rights; negotiable. Simultaneous submissions and previously published work OK.
Tips: "Feature a person in a wheelchair in photos whenever possible. Person should preferably be involved in some activity."

POPULATION BULLETIN, 1875 Connecticut Ave., Suite 520, Washington D.C. 20009. (202)483-1100. Fax: (202)328-3937. E-mail: shershey@prb.org. Website: http://www.prb.org/prb/. Production Manager: Sharon Hershey. Circ. 15,000. Estab. 1929. Publication of the nonprofit Population Reference Bureau. Quarterly journal. Publishes other population-related publications, including a monthly newsletter. Emphasizes demography. Readers are educators (both high school and college) of sociology, demography and public policy.
Needs: Uses 8-10 photos/issue; 70% supplied by freelancers. Needs vary widely with topic of each edition—international and US people, families, young, old, all ethnic backgrounds. Everyday scenes, closeup pictures of people in developing countries in South America, Asia, Africa and Europe. Model/property release required. Captions preferred.
Making Contact & Terms: Interested in receiving work from newer, lesser-known photographers. Query with list of stock photo subjects. Send unsolicited photos by mail for consideration. Send b&w prints or photocopies. SASE. Reports in 2 weeks. Pays $50-100/b&w photo; $150-250/color photo. **Pays on acceptance.** Buys one-time rights. Simultaneous submissions and previously published work OK.
Tips: "Looks for subjects relevant to the topics of our publications, quality photographs, composition, artistic value and price."

✦PRESBYTERIAN RECORD, 50 Wynford Dr., North York, Ontario M3C 1J7 Canada. (416)441-1111. Fax: (416)441-2825. Editor: Rev. John Congram. Circ. 60,000. Estab. 1875. Monthly magazine. Emphasizes subjects related to The Presbyterian Church in Canada, ecumenical themes and theological perspectives for church-oriented family audience. Photos purchased with or without accompanying ms. Free sample copy and photo guidelines with 9×12 SAE and $1 postage minimum.
Needs: Religious themes related to features published. No formal poses, food, nude studies, alcoholic beverages, church buildings, empty churches or sports. Captions preferred.
Making Contact & Terms: Interested in receiving work from newer, lesser-known photographers. Send photos. Uses prints only for reproduction; 8×10, 4×5 glossy b&w or color prints and 35mm and $2\frac{1}{4} \times 2\frac{1}{4}$ color transparencies. Usually uses 35mm color transparency for cover or ideally, 8×10 transparency. Vertical format used on cover. SAE, IRCs for return of work. Reports in 1 month. Pays $15-35/b&w print; $60 minimum/cover photo; $30-60 for text/photo package. Pays on publication. Credit line given. Buys one-time rights; negotiable. Simultaneous submissions and/or previously published work OK.
Tips: "Unusual photographs related to subject needs are welcome."

PRINCETON ALUMNI WEEKLY, 194 Nassau St., Princeton NJ 08542. (609)258-4722. E-mail: wszola@princeton.ed. Editor-in-Chief: J.I. Merritt. Art Director: Stacy Wszola. Circ. 58,000. Biweekly. Emphasizes Princeton University and higher education. Readers are alumni, faculty, students, staff and friends of Princeton University. Sample copy $1.50 with 9×12 SAE and 2 first-class stamps.
Needs: Uses about 15 photos/issue (not including class notes section); 10 supplied by freelance photographers. Needs b&w photos of "people, campus scenes; subjects vary greatly with content of each issue. Show us photos of Princeton." Captions required.
Making Contact & Terms: Arrange a personal interview to show portfolio. Provide brochure to be kept on file for possible future assignments. SASE. Reports in 1 month. Pays $60-100/hour; $300-1,000/day; $50-450/color photo; $40-300/b&w photo. Pays on publication. Buys one-time rights. Simultaneous submissions and previously published work OK.

PRINCIPAL MAGAZINE, Dept. PM, 1615 Duke St., Alexandria VA 22314-3483. (703)684-3345. Editor: Lee Greene. Circ. 25,000. Estab. 1921. Publication of the National Association of Elementary School Principals. Bimonthly. Emphasizes public education—kindergarten to 8th grade. Readers are mostly principals of elementary and middle schools. Sample copy free with SASE.

Needs: Uses 5-10 b&w photos/issue; all supplied by freelancers. Needs photos of school scenes (classrooms, playgrounds, etc.), teaching situations, school principals at work, computer use and technology and science activities. The magazine sometimes has theme issues, such as back to school, technology and early childhood education. *No posed groups.* Close-ups preferred. Reviews photos with or without accompanying ms. Model release preferred. Captions preferred.

Making Contact & Terms: Interested in receiving work from newer, lesser-known photographers. Query with samples and list of stock photo subjects. Send b&w prints, b&w contact sheet by mail for consideration. SASE. "We hold submitted photos indefinitely for possible stock use, so send dupes or photocopies." Reports in 1 month. Pays $50/b&w photo. Pays on publication. Credit line given. Buys one-time rights; negotiable. Simultaneous submissions and previously published work OK.

PROCEEDINGS/NAVAL HISTORY, US Naval Institute, Annapolis MD 21402. (410)268-6110. Fax: (410)269-7940. Contact: Picture Editor. Circ. 110,000. Estab. 1873. Association publications. *Proceedings* is a monthly magazine and *Naval History* is a bimonthly publication. Emphasizes Navy, Marine Corps, Coast Guard. Readers are age 18 and older, male and female, naval officers, enlisted, retirees, civilians. Sample copy free with 9×12 SASE. Photo guidelines free with SASE.

Needs: Uses 50 photos/issue; 40% supplied by freelancers. Needs photos of foreign and US Naval, Coast Guard and Marine Corps vessels, personnel and aircraft. Captions required.

Making Contact & Terms: Send unsolicited photos by mail for consideration: 8×10 glossy or matte, b&w or color prints; 35mm transparencies. SASE. Reports in 1 month. Pays $200/color or b&w cover photo; $25/color inside photo; $25/b&w page rate; $250-500/photo/text package. Pays on publication. Credit line given. Buys one-time rights. Simultaneous submissions and previously published work OK.

***PUBLIC CITIZEN**, 1600 20th St., NW, Washington DC 20009. (202)588-1000. Editor: Peter Nye. Circ. 100,000. Bimonthly. "*Public Citizen* is the magazine of the membership organization of the same name, founded by Ralph Nader in 1971. The magazine addresses topics of concern to today's socially aware and politically active consumers on issues in consumer rights, safe products and workplaces, a clean environment, campaign finance reform, safe and efficient energy, global trade and corporate and government accountability." Sample copy free with 9×12 SAE and 2 first-class stamps.

Needs: Uses 7-10 photos/issue; 2 usually supplied by freelancers. Needs photos to go along with articles on various consumer issues—assigns for press conference coverage or portrait shot of interview. Buys stock for other purposes.

Making Contact & Terms: Provide résumé, business card, brochure, flier or tearsheets to be kept on file for possible future assignments. Does not return unsolicited material. Pays $50-75/b&w inside photo. Pays on publication. Credit line given. Buys first North American serial rights. Simultaneous submissions and previously published work OK.

Tips: Prefers to see "good photocopies of photos and list of stock to keep on file. Common subjects: nuclear power, presidential administrations, health and safety issues, citizen empowerment, union democracy, etc."

PUBLIC POWER, 2301 M. St. NW, Third Floor, Washington DC 20037. (202)467-2948. Fax: (202)467-2910. E-mail: jlabella@his.com. Editor: Jeanne LaBella. Circ. 12,000. Publication of the American Public Power Association. Bimonthly. Emphasizes electric power provided by cities, towns and utility districts. Circ. 12,000. Sample copy and photo guidelines free.

Needs: "We buy photos on assignment only."

Making Contact & Terms: Query with samples. Provide résumé, business card, brochure, flier or tearsheets to be kept on file for possible future assignments. Accepts ditigal images; call art director (James Bartlett (202)467-2983) to discuss. Reports in 2 weeks. Pay varies—$25-75/photo—more for covers. **Pays on acceptance.** Credit line given. Buys one-time rights. Simultaneous submissions and previously published work OK.

***READING TODAY**, International Reading Association, 800 Barksdale Rd., P.O. Box 8139, Newark DE 19714-8139. (302)731-1600, ext. 250. Fax: (302)731-1057. E-mail: 74673.3641@compuserve. com. Editor: John Micklos, Jr. Circ. 90,000. Estab. 1983. Publication of the International Reading Association. Bimonthly newspaper. Emphasizes reading education. Readers are educators who belong to the International Reading Association. Sample copy available. Photo guidelines free with SASE.

LISTINGS THAT USE IMAGES electronically can be found in the Digital Markets Index located at the back of this book.

Needs: Uses 20 photos/issue; 3 supplied by freelancers. Needs classroom shots and photos of people of all ages reading in various settings. Reviews photos with or without ms. Model/property release preferred. Captions preferred; include names (if appropriate) and context of photo.
Making Contact & Terms: Interested in receiving work from newer, lesser-known photographers. Query with résumé of credits. Query with stock photo list. Send unsolicited photos by mail for consideration. Send 3½×5 or larger color and b&w (preferred) prints. Deadline: 8 weeks prior to publication date for any given issue. SASE. Reports in 1 month. Pays $25-50/b&w inside photo. **Pays on acceptance.** Credit line given. Buys one-time rights. Simultaneous submissions and previously published work OK.

RECREATIONAL ICE SKATING, 355 W. Dundee Rd., Buffalo Grove IL 60089-3500. (847)808-7528. Fax: (847)808-8329. Art Director: Carol Davis. Circ. 40,000. Estab. 1976. A publication of Ice Skating Institute of America. Quarterly magazine. Emphasizes figure skating, hockey and speedskating—recreational aspects of these sports. Readers are male and female skating enthusiasts—all professions; ages 6-80. Sample copy free with 9×12 SASE and 3 first-class stamps.
Needs: Uses 50 photos/issue; 68% supplied by freelancers. Needs photos of travel (ISIA event venues); art with stories—skating, hockey. Model/property release required for skaters, bystanders, organization property (i.e. Disney World, etc.) and any photo not directly associated with story content. Captions preferred; include name(s) of person/people locations, ages of people—where they are from, skate, etc.
Making Contact & Terms: Interested in receiving work from newer, lesser-known photographers. Query with stock photo list. Provide résumé, business card, brochure, flier or tearsheets to be kept on file for possible assignments. Deadlines: July 1, September 1, January 1, February 15. Keeps samples on file. SASE. Reports in 1 month. Pays $25-50/hour; $100-200/day; $100-1,000/job; pays $10-35/color cover photo; $10-15/b&w inside photo; $15-35/color page rate; $10-35/photo/text package. Pays on publication. Credit line given. Buys one-time rights and all rights; negotiable. Previously published work OK.
Tips: Show an ability to produce lean action photos within indoor rinks that have poor lighting conditions.

REFORM JUDAISM, 838 Fifth Ave., New York NY 10021. (212)650-4240. Managing Editor: Joy Weinberg. Circ. 300,000. Estab. 1972. Publication of the Union of American Hebrew Congregations. Quarterly magazine. Emphasizes Reform Judaism. Readers are members of Reform congregations in North America. Sample copy $3.50.
Needs: Uses 35 photos/issue; 10% supplied by freelancers. Needs photos relating to Jewish life or Jewish issues, Israel, politics. Captions required.
Making Contact & Terms: Provide résumé, business card, brochure, flier or tearsheets to be kept on file for possible assignments. Reports in 1 month. Pays on publication. Credit line given. Buys one-time rights; first North American serial rights. Simultaneous submissions and/or previously published work OK.
Tips: Wants to see "excellent photography: artistic, creative, evocative pictures that involve the reader."

RELAY MAGAZINE, P.O. Box 10114, Tallahassee FL 32302-2114. (904)224-3314. Editor: Stephanie Wolanski. Circ. 1,800. Estab. 1957. Association publication of Florida Municipal Electric. Monthly magazine. Emphasizes municipally owned electric utilities. Readers are city officials, legislators, public power officials and employees. Sample copy free with 9×12 SAE and 3 first-class stamps.
 ● *Relay* is purchasing more photos on CD.
Needs: Uses various amounts of photos/issue; various number supplied by freelancers. Needs b&w photos of electric utilities in Florida (hurricane/storm damage to lines, utility workers, etc.). Special photo needs include hurricane/storm photos. Model/property release preferred. Captions required.
Making Contact & Terms: Query with letter, description of photo or photocopy. Uses 3×5, 4×6, 5×7 or 8×10 b&w prints. Also accepts digital images. Keeps samples on file. SASE. Reports in 3 months. NPI. Rates negotiable. **Pays on acceptance.** Credit line given. Buys one-time rights, repeated use (stock); negotiable. Simultaneous submissions and/or previously published work OK.
Tips: "Must relate to our industry. Clarity and contrast important. Query first if possible. Always looking for good black & white hurricane, lightning-storm and Florida power plant shots."

***THE RETIRED OFFICER MAGAZINE**, 201 N. Washington St., Alexandria VA 22314. (800)245-8762. Fax: (703)838-8179. Contact: Senior Editor. Circ. 400,000. Estab. 1945. Monthly. Publication represents the interests of retired military officers from the seven uniformed services: recent military history (particularly Vietnam and Korea), travel, health, second-career job opportunities, military family lifestyle and current military/political affairs. Readers are officers or warrant officers from the Army, Navy, Air Force, Marine Corps, Coast Guard, Public Health Service and NOAA. Free sample copy and photo guidelines with 9×12 SAE and $1.25 postage.

Needs: Uses about 24 photos/issue; 8 (the cover and some inside shots) usually supplied by freelancers. "We're always looking for good color slides of active duty military people and healthy, active mature adults with a young 50s look—our readers are 55-65."

Making Contact & Terms: Interested in receiving work from newer, lesser-known photographers. Query with list of stock photo subjects. Provide résumé, brochure, flier to be kept on file. "Do *not* send original photos unless requested to do so." Uses original 35mm, $2\frac{1}{4} \times 2\frac{1}{4}$ or 4×5 transparencies. Pays $200/color cover photo; $20/b&w inside photo; $50-125 transparencies for inside use (in color); $50-150/quarter-page; complimentary copies. Other payment negotiable. "Photo rates vary with size and position." **Pays on acceptance.** Credit line given. Buys one-time rights.

Tips: "A photographer who can also write and submit a complete package of story and photos is valuable to us. Much of our photography is supplied by our authors as part of their manuscript package. We periodically select a cover photo from these submissions—our covers relate to a particular feature in each issue." In samples, wants to see "good color saturation, well-focused, excellent composition."

ROCKFORD REVIEW, P.O. Box 858, Rockford IL 61105. Editor: David Ross. Association publication of Rockford Writers' Guild. Triquarterly magazine. Circ. 750. Estab. 1982. Emphasizes poetry and prose of all types. Readers are of all stages and ages who share an interest in quality writing and art. Sample copy $5.
 ● This publication is literary in nature and publishes very few photographs. However, the photos on the cover tend to be experimental (e.g. solarized images, photograms, etc.).

Needs: Uses 1-5 photos/issue; all supplied by freelancers. Needs photos of scenics and personalities. Model/property release preferred. Captions preferred; include when and where of the photos and biography.

Making Contact & Terms: Interested in receiving work from newer, lesser-known photographers. Send unsolicited photos by mail for consideration. Send 8×10 or 5×7 glossy b&w prints. Does not keep samples on file. SASE. Reports in 6 weeks. Pays in one copy of magazine, but work is eligible for *Review*'s $25 Editor's Choice prize. Pays on publication. Credit line given. Buys first North American serial rights. Simultaneous submissions OK.

Tips: "Experimental work with a literary magazine in mind will be carefully considered. Avoid the 'news' approach." Sees more opportunities for artsy photos.

THE ROTARIAN, 1560 Sherman Ave., Evanston IL 60201. (847)866-3000. Fax: (847)866-9732. Editor: Willmon L. White. Photo Editor: Judy Lee. Circ. 520,439. Estab. 1911. Monthly magazine. For Rotarian business and professional men and women and their families. Free sample copy and photo guidelines with SASE.

Needs: "Our greatest need is for the identifying face or landscape, one that says unmistakably, 'This is Japan, or Minnesota, or Brazil, or France or Sierra Leone,' or any of the other states, countries and geographic regions this magazine reaches." Captions preferred.

Making Contact & Terms: Interested in receiving work from newer, lesser-known photographers. Query with résumé of credits or send photos for consideration. Uses 8×10 glossy b&w or color prints; contact sheet OK; 8×10 color glossy prints; for cover uses transparencies "generally related to the contents of that month's issue." SASE. Reports in 2 weeks. **Pays on acceptance.** NPI; payment varies. Buys one-time rights; occasionally all rights; negotiable.

Tips: "We prefer vertical shots in most cases. The key words for the freelance photographer to keep in mind are *internationality* and *variety*. Study the magazine. Read the kinds of articles we publish. Think how your photographs could illustrate such articles in a dramatic, story-telling way. Key submissions to general interest, art-of-living material." Plans special pre-convention promotion coverage of June 1996 Rotary International convention in Calgary, Alberta, Canada.

***SCHOOL MATES**, 186 Rt. 9W, New Windsor NY 12553. (914)562-8350, ext. 152. Fax: (914)561-2437. Graphic Designer: Tammy Steinman. Publication of the US Chess Federation. Bimonthly magazine. Emphasizes chess. Readers are male/female, ages 7-18. Sample copy free with 9×12 SAE and 2 first-class stamps.

Needs: Buys 5-30 photos/issue; most supplied by freelancers. Needs photos of children playing chess. Photo captions preferred.

Making Contact & Terms: Interested in receiving work from newer, lesser-known photographers. Send unsolicited photos by mail for consideration. Provide résumé, business card, brochure, flier or tearsheets to be kept on file for possible future assignments. Send color or b&w prints. Keeps samples on file. SASE. Reports in 1 month. Pays $15 minimum for b&w or color inside photo. Pays $100-150/color cover photo. Pays on publication. Credit line given. Rights negotiable.

***SCIENCE AND CHILDREN**, 1840 Wilson Blvd., Arlington VA 22201-3000. (703)243-7100. Assistant Editor: Katherine Marteka. Circ. 24,000. Publication of the National Science Teachers Association. Monthly (September to May) journal. Emphasizes teaching science to elementary school children. Readers are male and female elementary science teachers and other education professionals.

Needs: Uses 40 photos/issue; 10 supplied by freelancers. Needs photos of "a variety of science-related topics, though seasonals, nature scenes and animals are often published. Also children." Special photo needs include children doing science in all settings, especially classroom and science fairs. Model/property release required. Captions required.

Making Contact & Terms: Arrange personal interview to show portfolio. Send stock lists and photocopies of b&w or color prints. Unsolicited material will not be returned. Pays $200/color cover photo; $50/color inside; $35 b&w inside. Pays on publication. Credit line given.

Tips: "We look for candid shots that are sharp in focus and show the excitement of science discovery. We also want photographs that reflect the fact that science is accessible to people of every race, gender, economic background and ability."

***SCRAP,** (formerly *Scrap Processing and Recycling*), 1325 G St. NW, Suite 1000, Washington DC 20005. (202)466-4050. Fax: (202)775-9109. Editor: Elise Browne Hughes. Circ. 6,000. Estab. 1988. Publication of the Institute of Scrap Recycling Industries. Bimonthly magazine. Covers scrap recycling for owners and managers of private recycling operations worldwide. Sample copy $7.50.

Needs: Uses approximately 100 photos/issue; 15% supplied by freelancers. Needs operation shots of companies being profiled and studio concept shots. Model release required. Captions required.

Making Contact & Terms: Arrange personal interview to show portfolio. Query with list of stock photo subjects. Provide résumé, business card, brochure, flier or tearsheets to be kept on file for possible assignment. Reports in 1 month. Pays $500-800/day. Pays on publication. Credit line given. Rights negotiable. Previously published work OK.

Tips: Photographers must possess "ability to photograph people in corporate atmosphere as well as industrial operations; ability to work well with executives as well as laborers. We are always looking for good color photographers to accompany our staff writers on visits to companies being profiled. We try to keep travel costs to a minimum by hiring photographers located in the general vicinity of the profiled company. Other photography (primarily studio work) is usually assigned through freelance art director."

THE SECRETARY, 2800 Shirlington Rd., Suite 706, Arlington VA 22206. (703)998-2534. Managing Editor: Catherine P. O'Keefe. Circ. 45,000. Estab. 1942. Association publication of the Professional Secretaries International. Published 9 times a year. Emphasizes secretarial profession—proficiency, continuing education, new products/methods and equipment related to office administration/communications. Readers include career secretaries, 98% women, in myriad offices, with wide ranging responsibilities. Sample copy free with SASE.

Needs: Uses 1-2 feature photos and several "Product News" photos/issue; freelance photos 100% from stock. Needs secretaries (predominately women, but occasionally men) in appropriate and contemporary office settings using varied office equipment or performing varied office tasks. Must be in good taste and portray professionalism of secretaries. Especially interested in photos featuring members of minority groups. Reviews photos with or without accompanying ms. Model release preferred.

Making Contact & Terms: Interested in receiving work from newer, lesser-known photographers. Query with samples. Send unsolicited photos by mail for consideration. Uses 3½×4½, 8×10 glossy prints; 35mm, 2¼×2¼, 4×5 and 8×10 transparencies. SASE. Reports in 1 month. Pays $150 maximum/b&w photo; $500 maximum/color photo. Pays on publication. Credit line given. Buys first North American serial rights. Simultaneous submissions and previously published work OK.

***THE SENTINEL,** Industrial Risk Insurers, Dept. PM, 85 Woodland St., Hartford CT 06102. (203)520-7300. Editor: Anson Smith. Circ. 59,000. Quarterly magazine. Emphasizes industrial loss prevention for "insureds and all individuals interested in fire protection." Free sample copy and photo guidelines.

Needs: Uses 10-20 photos/issue; "many" supplied by freelance photographers. Needs photos of fires, explosions, floods, windstorm damage and other losses at industrial sites. Prefers to see good industrial fires and industrial process shots, industrial and commercial fire protection equipment. No photos that do not pertain to industrial loss prevention (no house fires) but can use generic shots of natural disaster damage, e.g., floods, hurricanes, tornadoes. Model release preferred.

Making Contact & Terms: Send material by mail for consideration. Uses color glossy prints or slides. Horizontal or vertical format for cover. Reports in 2 weeks. Pays $100/photo. **Pays on acceptance.** Credit line given. Buys unlimited reproduction rights for nonexclusive use. Previously published work OK.

THE CODE NPI (no payment information given) appears in listings that have not given specific payment amounts.

***SHOOTING SPORTS USA**, Dept. PM, 11250 Waples Mill Rd., Fairfax VA 22030. (703)267-1585. Editor: Karen Davey. Circ. 25,000. Publication of the National Rifle Association of America. Monthly. Emphasizes competitive shooting sports (rifle, pistol and shotgun). Readers are mostly NRA-classified competitive shooters including Olympic-level shooters. Sample copy free with 9 × 12 SAE with $1 postage. Editorial guidelines free with SASE.

Needs: Uses 1-10 photos/issue; about half or less supplied by freelance photographers. Needs photos of how-to, shooting positions, specific shooters. Quality photos preferred with ms. Model release required. Captions preferred.

Making Contact & Terms: Query with photo and editorial ideas by mail. Uses 8 × 10 glossy b&w prints. SASE. Reports in 2 weeks. Pays $150-300 for photo/text package; amount varies for photos alone. Pays on publication. Credit line given. Buys first North American serial rights. Previously published work OK when cleared with editor.

Tips: Looks for "generic photos of shooters shooting, obeying all safety rules and using proper eye protection and hearing protection. If text concerns certain how-to advice, photos are needed to illuminate this. Always query first. We are in search of quality photos to interest both beginning and experienced shooters."

SIGNPOST FOR NORTHWEST TRAILS MAGAZINE, Dept. PM, 1305 Fourth Ave., #512, Seattle WA 98101. (206)625-1367. E-mail: dnelson024@aol.com. Editor: Dan Nelson. Circ. 3,800. Estab. 1966. Publication of the Washington Trails Association. Monthly. Emphasizes "backpacking, hiking, cross-country skiing, all nonmotorized trail use, outdoor equipment and minimum-impact camping techniques." Readers are "people active in outdoor activities, primarily backpacking; residents of the Pacific Northwest, mostly Washington; age group: 9-90, family-oriented, interested in wilderness preservation, trail maintenance." Photo guidelines free with SASE.

Needs: Uses about 20-25 photos/issue; 50% supplied by freelancers. Needs "wilderness/scenic; people involved in hiking, backpacking, canoeing, skiing, wildlife, outdoor equipment photos, all with Pacific Northwest emphasis." Captions required.

Making Contact & Terms: Send 5 × 7 or 8 × 10 glossy b&w prints by mail for consideration. SASE. Reports in 1 month. No payment for inside photos. Pays $25/b&w cover photo. Pays on publication. Credit line given. Buys one-time rights. Simultaneous submissions and previously published work OK.

Tips: "We are a b&w publication and prefer using b&w originals for the best reproduction. Photos must have a Pacific Northwest slant. Photos that meet our cover specifications are always of interest to us. Familiarity with our magazine would greatly aid the photographer in submitting material to us. Contributing to *Signpost* won't help pay your bills, but sharing your photos with other backpackers and skiers has its own rewards."

SKYDIVING, 1725 N. Lexington Ave., DeLand FL 32724. (904)736-4793. Fax: (904)736-9786. Editor: Sue Clifton. Circ. 12,400. Estab. 1979. Monthly magazine. Readers are "sport parachutists worldwide, dealers and equipment manufacturers." Sample copy $3. Photo guidelines for SASE.

Needs: Uses 50 photos/issue; 5 supplied by freelancers. Selects photos from wire service, photographers who are skydivers and freelancers. Interested in anything related to skydiving—news or any dramatic illustration of an aspect of parachuting. Model release preferred. Captions preferred; include who, what, why, when, how.

Making Contact & Terms: Interested in receiving work from newer, lesser-known photographers. Send actual 5 × 7 or larger b&w or color photos or 35mm or 2¼ × 2¼ transparencies by mail for consideration. Keeps samples on file. SASE. Reports in 1 month. Pays $50-100/color cover photo; $25-50/color inside photo; $15-50/b&w inside photo. Pays on publication. Credit line given. Buys one-time rights.

SOARING, Box E, Hobbs NM 88241-7504. (505)392-1177. Fax: (505)392-8154. Art Director: Steve Hines. Circ. 16,010. Estab. 1937. Monthly magazine. Emphasizes the sport of soaring in sailplanes and motorgliders. Readership consists of white collar and professional males and females, ages 14 and up. Sample copy and photo guidelines free with SASE.

Needs: Uses 25 or more photos/issue; 95% supplied by freelancers. "We hold freelance work for a period of usually 6 months, then it is returned. If we have to keep work longer, we notify the photographer. The photographer is always updated on the status of his or her material." Needs sharply focused transparencies, any format. Especially needs aerial photography. "We need a good supply of sailplane transparencies for our yearly calendar." Model release preferred. Captions required.

Making Contact & Terms: Send unsolicited photos by mail for consideration. Uses b&w prints, any size and format. Also uses transparencies, any format. SASE. Reports in 2 weeks. Pays $50/color cover photo. Pays $50-100 for calendar photos. Pays on publication. Credit line given. Buys one-time rights. Simultaneous submissions OK.

Tips: "Exciting air-to-air photos, creative angles and techniques are encouraged. We pay only for the front cover of our magazine and photos used in our calendars. We are a perfect market for photographers

that have sailplane photos of excellent quality. Send work dealing with sailplanes only and label all material."

SOUTHERN CALIFORNIA BUSINESS, 350 S. Bixel St., Los Angeles CA 90017. (213)580-7571. Fax: (213)580-7586. Editor: Christopher Volker. Circ. 7,000. Estab. 1898. Association publication of L.A. Chamber of Commerce. Monthly newspaper. Emphasizes business. Readers are mostly business owners, male and female, ages 21-65. Sample copy $2. Photo guidelines not available.
Needs: Uses 10-20 photos/issue; 5-8 supplied by freelance photographers and public relations agencies. Needs photos of events, editorial, technology, business people and new products. Special photo needs include specialty shots on various subjects (mainly business-oriented).
Making Contact & Terms: Interested in receiving work from newer, lesser-known photographers. Query with list of stock photo subjects. Send b&w prints by mail for consideration. Provide résumé, business card, brochure, flier or tearsheets to be kept on file for possible assignments. SASE. Reports in 3 weeks. Pays $4-5/b&w photo; $100/b&w cover photo; $75/hour; $100-150/day; $100-250/photo/text package. Pays on publication. Credit line given. Buys first North American serial rights and all rights; negotiable. Model release required. Captions required. Simultaneous submissions OK.
Tips: In photographer's samples, wants to see "a variety of different subject matter but prefer people shots. Present new ideas, how photography could be more exciting. Send in detailed letter and description of work."

SPORTSCAR, 1371 E. Warner, Suite E, Tustin CA 92680. (714)259-8240. Editor: Rich McCormack. Circ. 50,000. Estab. 1944. Publication of the Sports Car Club of America. Monthly magazine. Emphasizes sports car racing and competition activities. Sample copy $2.95.
Needs: Uses 75-100 photos/issue; 75% from assignment and 25% from freelance stock. Needs action photos from competitive events, personality portraits and technical photos.
Making Contact & Terms: Interested in receiving work from newer, lesser-known photographers. Query with résumé of credits or send 5×7 color or b&w glossy/borders prints or 35mm or 2¼×2¼ transparencies by mail for consideration. Provide résumé, business card, brochure, flier or tearsheets to be kept on file for possible assignments. SASE. Reports in 1 month. Pays $25/color inside photo; $10/b&w inside photo; $250/color cover. Negotiates all other rates. Pays on publication. Credit line given. Buys first North American serial rights. Simultaneous submissions OK.
Tips: To break in with this or any magazine, "always send only the absolute best work; try to accommodate the specific needs of your clients. Have a relevant subject, strong action, crystal sharp focus, proper contrast and exposure. We need good candid personality photos of key competitors and officials."

THE SURGICAL TECHNOLOGIST, 7108-C S. Alton Way, Englewood CO 80112. (303)694-9130. Editor: Sharon Pellowe. Circ. 17,371. Publication of the Association of Surgical Technologists. Monthly. Emphasizes surgery. Readers are "20-60 years old, operating room professionals, well educated in surgical procedures." Sample copy free with 9×12 SASE and 5 first-class stamps. $1.25 postage. Photo guidelines free with SASE.
Needs: Needs "surgical, operating room photos that show members of the surgical team in action." Model release required.
Making Contact & Terms: Query with samples. Submit portfolio for review. Send 5×7 or 8½×11 glossy or matte prints; 35mm, 2¼×2¼ or 4×5 transparencies; b&w or color contact sheets; b&w or color negatives by mail for consideration. Provide résumé, business card, brochure, flier or tearsheets to be kept on file for possible future assignments. SASE. Reports in 4 weeks after review by Editorial Board. Pays $25/b&w inside photo; $50/color inside photo. **Pays on acceptance.** Credit line given. Buys one-time rights. Simultaneous submissions and previously published work OK.

TANK TALK, 570 Oakwood Rd., Lake Zurich IL 60047. (708)438-TANK. Fax: (708)438-8766. Contact: Jon Schwerman. Circ. 9,800. Publication of Steel Tank Institute. Bimonthly. Emphasizes matters pertaining to the underground and aboveground storage tank industry. Readers are tank owners, installers, government officials, regulators, manufacturers, engineers. Sample copy free with 9×12 SAE and 3 first-class stamps.
Needs: Uses about 4-6 photos/issue; 50-75% supplied by freelancers. Needs photos of installations, current developments in the industry, i.e., new equipment and features for tanks, author photos, fiberglass tank leaks. Photos purchased with accompanying ms only. Model/property release required. Captions required.
Making Contact & Terms: Interested in receiving work from newer, lesser-known photographers. "Call if you have photos of interest to the tank industry." Uses at least 5×7 glossy b&w prints. SASE. Reports in 2 weeks. NPI. Pays on publication. Buys all rights; negotiable. Simultaneous submissions and previously published work OK.

TEAM MAGAZINE, P.O. Box 7259, Grand Rapids MI 49510. (616)241-5616. Fax: (616)241-5558. Editor: Judy Blain. Publication of the Young Calvinist Federation. *Team Magazine* is a quarterly digest

for volunteer church youth leaders. It promotes shared leadership for holistic ministry with high school young people. Contributor's guidelines and sample issue of *Team* for SASE.

Needs: Buys 25-30 photos/year. Photos used in magazines and books—"We produce 1-2 books annually for youth leaders, an additional 5-25 pictures." High school young people in groups and as individuals in informal settings—on the street, in the country, at retreats, at school, having fun; racial variety; discussing in two's, three's, small groups; studying the Bible; praying; dating; doing service projects; interacting with children, adults, the elderly.

Making Contact & Terms: Query with samples. Query with list of stock photo subjects. Send unsolicited photos by mail for consideration. "We like to keep those packages that have potential on file for two months. Others (with no potential) returned immediately." Uses 5×7 or 8×10 b&w glossy prints. Also uses color for cover. SASE. Pays $35-75/b&w photo; $50-300/color photo. Credit line given. Buys one-time rights.

Tips: In samples, looks for "more than just faces. We look for activity, unusual situations or settings, symbolic work. No out-of-date fashion or hair." To break in, "send us a selection of photos. We will photocopy and request as needed. We expect good contrast in b&w."

TECHNIQUES, (formerly *Vocational Education Journal*), 1410 King St., Alexandria VA 22314. (703)683-3111. Fax: (703)683-7424. Circ. 42,000. Estab. 1926. Monthly magazine for American Vocational Association. Emphasizes education for work and on-the-job training. Readers are teachers and administrators in high school and colleges. Sample copy free with 10×13 SASE.

• This publication has begun to use computer manipulated images.

Needs: Uses 8-10 photos/issue, 1-2 supplied by freelancers. "Students in classroom and job training settings; teachers; students in work situations." Model release preferred for children. Captions preferred; include location, explanation of situation.

Making Contact & Terms: Interested in receiving work from newer, lesser-known photographers. Query with list of stock photo subjects. Send unsolicited photos by mail for consideration. Provide résumé, business card, brochure, flier or tearsheets to be kept on file for possible assignments. Send 5×7 color prints and 35mm transparencies. Keeps samples on file. SASE. Reports as needed. Pays $400 up/color cover photo; $50 up/color inside photo; $30 up/b&w inside photo; $500-1,000/job. Pays on publication. Credit line given. Buys one-time rights; sometimes buys all rights; negotiable. Simultaneous submissions and previously published work OK.

TEDDY BEAR AND FRIENDS, Cowles Enthusiast Media, 6405 Flank Dr., Harrisburg PA 17112. (717)540-6652. Fax: (717)540-6169. Publisher: David Miller. Estab. 1983. Bimonthly magazine. Emphasizes teddy bear collecting. Photo guidelines free with SASE.

Needs: Buys 100-250 photos/year; 50 photo/year supplied by freelancers. "We need photos of specific teddy bears to accompany our articles." Model/property release required. Captions required; include name of object, height, medium, edition size, costume and accessory description; name, address, telephone number of artist or manufacturer; price.

Making Contact & Terms: Interested in receiving work from newer, lesser-known photographers. Send unsolicited photos by mail for consideration. Provide résumé, business card, brochure, flier or tearsheets to be kept on file for possible assignments. Submit portfolio for review. Query with stock photo list. Query with samples. Send $3\frac{1}{2} \times 5$ glossy color prints; 35mm, $2\frac{1}{4} \times 2\frac{1}{4}$, 4×5 transparencies. Transparencies are preferred. Keeps samples on file. SASE. Reports in 1 month. NPI. "If photos are accepted, we pay on receipt of invoice." Credit line given. Buys all rights. Simultaneous submissions OK.

TEXAS ALCALDE MAGAZINE, P.O. Box 7278, Austin TX 78713. (512)471-3799. Fax: (512)471-8088. Editor: Avrel Seale. Circ. 52,000. Estab. 1913. Publication of the University of Texas Ex-Students' Association. Bimonthly magazine. Emphasizes University alumni. Readers are graduates, former students and friends who pay dues in the Association. Sample copy free with 9×12 SAE and 5 first-class stamps.

Needs: Needs University of Texas (UT) campus shots, professors, students, buildings, city of Austin, UT sports. Will review photos with accompanying ms only. Model release preferred. Captions required.

Making Contact & Terms: Interested in receiving work from newer, lesser-known photographers. Query with list of stock photo subjects. Slides preferred. SASE. Reports in 1 month. Fee negotiable. NPI. Pays on publication. Credit line given. Buys one-time rights. Simultaneous submissions and/or previously published work OK if details of use are supplied.

TEXAS REALTOR MAGAZINE, P.O. Box 2246, Austin TX 78768. (512)370-2286. Fax: (512)370-2390. Art Director: Lauren Levi. Circ. 43,000. Estab. 1972. Publication of the Texas Association of Realtors. Monthly magazine. Emphasizes real estate sales and related industries. Readers are male and female realtors, ages 20-70. Sample copy free with SASE.

Needs: Uses 10 photos/issue; all supplied by freelancers. Needs photos of architectural details, business, office management, telesales, real estate sales, commercial real estate, nature. Especially wants

to see architectural detail and landscape for covers. Property release required.
Making Contact & Terms: Interested in receiving work from newer, lesser-known photographers. Pays $75-300/color photo; $1,500/job. Buys one-time rights; negotiable.

TEXTILE RENTAL MAGAZINE, Dept. PM, P.O. Box 1283, Hallandale FL 33008. (305)457-7555. Editor: Christine Seaman. Circ. 6,000. Publication of the Textile Rental Services Association of America. Monthly magazine. Emphasizes the "linen supply, industrial and commercial laundering industry." Readers are "heads of companies, general managers of facilities, predominantly male audience; national and international readers."
Needs: Photos "needed on assignment basis only." Model release preferred. Captions preferred or required "depending on subject."
Making Contact & Terms: "We contact photographers on an as-needed basis selecting from a directory of photographers." Cannot return material. Pays $350/color cover plus processing; "depends on the job." **Pays on acceptance.** Credit line given if requested. Buys all rights. Previously published work OK.

TIKKUN, 251 W 100 St., New York NY 10025. (212)864-4110. Fax: (212)864-4137. E-mail: tikkun@panix.com. Production Manager: Eric Goldhagen. Circ. 40,000. Estab. 1986. Bimonthly journal. Publication is a political, social and cultural Jewish critique. Readers are 75% Jewish, white, middle-class, literary people ages 30-60.
Needs: Uses 10 photos/issue; 50% supplied by freelancers. Needs political; social; commentary; Middle Eastern; US photos. Reviews photos with or without ms.
Making Contact & Terms: Send unsolicited photos by mail for consideration. Uses b&w "or good photo copy" prints. Keeps samples on file. SASE. Reporting time varies. "Turnaround is 4 months, unless artist specifies other." Pays $40/b&w inside photo. Pays on publication. Credit line given. Buys all rights; negotiable. Simultaneous submissions and/or previously published work OK.
Tips: "Read or look at magazine before sending photos."

TOUCH, P.O. Box 7259, Grand Rapids MI 49510. (616)241-5616. Managing Editor: Carol Smith. Circ. 15,500. Estab. 1970. Publication of Calvinettes. Monthly. Emphasizes "girls 7-14 in action. The magazine is a Christian girls' publication geared to the needs and activities of girls in the above age group." Readers are "Christian girls ages 7-14; multiracial." Sample copy and photo guidelines for $1 with 9×12 SASE. "Also available is a theme update listing all the themes of the magazine for one year."
Needs: Uses about 5-6 photos/issue; 50-75% from freelancers. Needs "photos suitable for illustrating stories and articles: photos of girls aged 7-14 from multicultural backgrounds involved in sports, Christian service and other activities young girls would be participating in." Model/property release preferred.
Making Contact & Terms: Interested in receiving work from newer, lesser-known photographers. Send 5×7 glossy color prints by mail for consideration. SASE. Reports in 2 months. Pays $30-40/b&w photo; $50/cover. Pays on publication. Credit line given. Buys one-time rights. Simultaneous submissions OK.
Tips: "Make the photos simple. We prefer to get a spec sheet rather than photos and we'd really like to hold photos sent to us on speculation until publication. We select those we might use and send others back. Freelancers should write for our annual theme update and try to get photos to fit the theme of each issue." Recommends that photographers "be concerned about current trends in fashions and hair styles and that all girls don't belong to 'families.' " To break in, "a freelancer can present a selection of his/her photography of girls, we'll review it and contact him/her on its usability."

TRAFFIC SAFETY, 1121 Spring Lake Dr., Itasca IL 60143. (708)775-2278. Fax: (708)775-2285. Publisher: Kevin Axe. Editor: John Jackson. Circ. 20,000. Publication of National Safety Council. Bimonthly. Emphasizes highway and traffic safety, accident prevention. Readers are professionals in highway-related fields, including law-enforcement officials, traffic engineers, fleet managers, state officials, driver improvement instructors, trucking executives, licensing officials, community groups, university safety centers.
• *Traffic Safety* uses computer manipulation for cover shots.
Needs: Uses about 10 photos/issue; most supplied by freelancers. Needs photos of road scenes, vehicles, driving; specific needs vary.
Making Contact & Terms: Query with four-color and/or b&w prints. SASE. Reports in 2 weeks. Pays $100-1,000/cover. **Pays on acceptance.** Credit line given.

TRANSPORT TOPICS, 2200 Mill Rd., Alexandria VA 22314. (703)838-1780. Fax: (703)548-3662. Chief Photographer: Michael James. Circ. 31,000. Estab. 1935. Publication of the American Trucking Associations. Weekly tabloid. Emphasizes the trucking industry. Readers are male executives 35-65.

Charles Heiney was assigned this cover photo for a very special issue of *Touch* magazine. "It was the first time the entire issue was to be full four-color, and also marked the 25th anniversary of the publication," explains the photographer. "I wanted the shot to be upbeat, lively, showing kids happy about going back to school." Heiney first learned of *Touch* several years ago through *Photographer's Market* and has maintained a working relationship with them ever since, as they're both based in Grand Rapids, Michigan.

Needs: Uses approximately 12 photos/issue; amount supplied by freelancers "depends on need." Needs photos of truck transportation in all modes. Model/property release preferred. Captions preferred.
Making Contact & Terms: Interested in receiving work from newer, lesser-known photographers. Send unsolicited 35mm or 2¼ × 2¼ transparencies by mail for consideration. Provide résumé, business card, brochure, flier or tearsheets to be kept on file for possible assignments. Does not keep samples on file. SASE. Reports in 1 month. NPI. Pays standard "market rate" for color cover photo. **Pays on acceptance.** Credit line given. Buys one-time rights; negotiable. Simultaneous submissions and previously published work OK.
Tips: "Trucks/trucking must be dominant element in the photograph—not an incidental part of an environmental scene."

***THE TRICKSTER REVIEW OF CULTURAL CENSURE & POLITICAL CENSORSHIP: ART, LITERATURE, POLITICS, COMMUNICATIONS**, (formerly *The Trickster Review of Cultural Censorship: Art, Literature, Politics, Communication*), 122 E. Texas Ave., #1016, Baytown TX 77520. (713)427-9560. Fax: (713)428-8685. E-mail: djpress@aol.com. Photo Acquisitions: Nile Lienad. Circ. 500. Estab. 1994. Publication of The International Citizen's Corps for Free Expression of Art & Thought (TRICC). Biannual journal. Emphasizes the limitation of free speech. Readers are educated adults of both sexes. Sample copy $14.95. Photo guidelines free with SASE.
Needs: Uses 20 photos/issue; all supplied by freelancers. Guidelines outlining the focus of the next year's issues free with SASE. Model release preferred (celebrities, corporation facilities); photo captions preferred.
Making Contact & Terms: Query with stock photo list. (No query by fax.) Send unsolicited photos by mail for consideration. Provide résumé, business card, brochure, flier or tearsheets to be kept on file for possible future assignments. Send color and b&w prints; 4×5, 8×10 transparencies. Keeps samples on file. SASE. Reports in 1 month. Pays $50-100/day; $100-200/job; $10-50/b&w or color cover photo; $10-50/b&w or color inside photo; $50-100/color page; $100-125/b&w page; other forms of payment negotiable. Pays on publication. Credit line given. Buys all rights; negotiable. Simultaneous submissions and/or previously published work OK.
Tips: "*The Trickster Review* looks at modern culture skeptically. Photos which are provocative and insightful could find space in the *Review*. Nothing will shock us. Send your best. If you are overly comfortable in the world as it is, don't bother to contribute."

TURKEY CALL, P.O. Box 530, Edgefield SC 29824. Parcel services: 770 Augusta Rd. (803)637-3106. Fax: (803)637-0034. Publisher: National Wild Turkey Federation, Inc. (nonprofit). Editor: Jay Langston. Circ. 120,000. Estab. 1973. Bimonthly magazine. For members of the National Wild Turkey Federation—people interested in conserving the American wild turkey. Sample copy $3 with 9×12 SASE. Contributor guidelines free with SASE.

Needs: Buys at least 50 photos/year. Needs photos of "wild turkeys, wild turkey hunting, wild turkey management techniques (planting food, trapping for relocation, releasing), wild turkey habitat." Captions required.

Making Contact & Terms: Interested in receiving work from newer, lesser-known photographers. Send copyrighted photos to editor for consideration. Send 8 × 10 glossy b&w prints; color transparencies, any format; prefers originals, 35mm accepted. SASE. Reports in 6 weeks. Pays $35 minimum/ b&w photo; maximum $100/inside color photo; $400/cover. **Pays on acceptance.** Credit line given. Buys one-time rights.

Tips: Wants no "poorly posed or restaged shots, mounted turkeys representing live birds, domestic turkeys representing wild birds or typical hunter-with-dead-bird shots. Photos of dead turkeys in a tasteful hunt setting are considered. Keep the acceptance agreement/liability language to a minimum. It scares off editors and art directors." Sees a trend developing regarding serious amateurs who are successfully competing with pros. "Newer equipment is partly the reason. In good light and steady hands, full auto is producing good results. I still encourage tripods, however, at every opportunity."

V.F.W. MAGAZINE, 406 W. 34th St., Kansas City MO 64111. (816)756-3390. Fax: (816)968-1169. Editor: Richard Kolb. Art Director: Robert Widener. Circ. 2.2 million. Monthly magazine, except July. For members of the Veterans of Foreign Wars (V.F.W.)—men and women who served overseas, and their families. Sample copy free with SAE and 2 first-class stamps.

Needs: Photos illustrating features on current defense and foreign policy events, veterans issues and, accounts of "military actions of consequence." Photos purchased with or without accompanying ms. Present model release on acceptance of photo. Captions required.

Making Contact & Terms: Interested in receiving work from newer, lesser-known photographers. Send 8 × 10 glossy b&w or color prints; transparencies. "Cover shots must be submitted with a ms. Price for cover shot will be included in payment of manuscript." SASE. Reports in 1 month. Pays $250 minimum. Pays $25-50/b&w photo; $35-250/color photo. **Pays on acceptance.** Buys one-time and all rights; negotiable.

Tips: "Go through an issue or two at the local library (if not a member) to get the flavor of the magazine." When reviewing samples "we look for familiarity with the military and ability to capture its action and people. We encourage military photographers to send us their best work while they're still in the service. Though they can't be paid for official military photos, at least they're getting published by-lines, which is important when they get out and start looking for jobs."

VIRGINIA TOWN & CITY, P.O. Box 12164, Richmond VA 23241. (804)649-8471. Fax: (804)343-3759. Editor: David Parsons. Circ. 5,000. Estab. 1965. Monthly magazine of Virginia Municipal League concerning Virginia local government. Readers are state and local government officials in Virginia.

Needs: Wants photos of Virginia locations/topics only. "Black & white photos illustrating scenes of local government and some color work for covers." Special photo needs include "illustrations of environmental issues, computer uses, development, transportation, schools and law enforcement." Captions preferred.

Making Contact & Terms: Query with list of stock photo subjects. Send unsolicited photos by mail for consideration. Send b&w prints. Keeps samples on file. SASE. Reports "when we can." Pays $25-150/b&w photo; $100-300/color photo; $100-125/color cover photo. Pays on publication. Credit line given. Buys one-time rights; negotiable. Simultaneous submissions and previously published work OK.

VIRGINIA WILDLIFE, P.O. Box 11104, Richmond VA 23230. (804)367-1000. Art Director: Emily Pels. Circ. 55,000. Monthly magazine. Emphasizes Virginia wildlife, as well as outdoor features in general, fishing, hunting and conservation for sportsmen and conservationists. Free sample copy and photo/writer's guidelines.

Needs: Buys 350 photos/year; about 95% purchased from freelancers. Photos purchased with accompanying ms. Good action shots relating to animals (wildlife indigenous to Virginia), action hunting and fishing shots, photo essay/photo feature, scenic, human interest outdoors, nature, outdoor recreation (especially boating) and wildlife. Photos must relate to Virginia. Accompanying mss: features on wildlife; Virginia travel; first-person outdoors stories. Pays 15¢/printed word. Model release preferred for children. Property release preferred for private property. Captions required; identify species and locations.

Making Contact & Terms: Send 35mm and 2¼ × 2¼ or larger transparencies. Vertical format required for cover. SASE. Reports (letter of acknowledgment) within 30 days; acceptance or rejection within 45 days of acknowledgement. Pays $30-50/color photo; $125/cover photo; $75/back cover. Pays on publication. Credit line given. Buys one-time rights.

Tips: "We don't have time to talk with every photographer who submits work to us, since we do have a system for processing submissions by mail. Our art director will not see anyone without an appointment. In portfolio or samples, wants to see a good eye for color and composition and both vertical and horizontal formats. We are seeing higher quality photography from many of our photographers. It is

a very competitive field. Show only your best work. Name and address must be on each slide. Plant and wildlife species should also be identified on slide mount. We look for outdoor shots (must relate to Virginia); close-ups of wildlife."

***THE WAR CRY**, Dept. PM, The Salvation Army, 615 Slaters Lane, Alexandria VA 22313. (703)684-5500. Editor-in-Chief: Lt. Colonel Marlene Chase. Circ. 300,000. Publication of The Salvation Army. Biweekly. Emphasizes the inspirational. Readers are general public and membership. Sample copy free with SASE.
Needs: Uses about 6 photos/issue. Needs "inspirational, scenic, general photos."
Making Contact & Terms: Send color prints or color slides by mail for consideration. SASE. Reports in 2 weeks. Pays up to $250/color photo; payment varies for text/photo package. **Pays on acceptance.** Credit line given "if requested." Buys one-time rights. Simultaneous submissions and previously published work OK.

THE WATER SKIER, 799 Overlook Dr., Winter Haven FL 33884. (941)324-4341. Fax: (941)325-8259. E-mail: 76774.1141@compuserve. com. Editor: Don Cullimore. Circ. 30,000. Estab. 1950. Publication of the American Water Ski Association. Magazine published 7 times a year. Emphasizes water skiing. Readers are male and female professionals ages 20-45. Sample copy $2.50. Photo guidelines available.
● *The Water Skier* uses the Gallery Effects program to enhance images.
Needs: Uses 25-35 photos/issue. 1-5 supplied by freelancers. Needs photos of sports action. Model/property release required. Captions required.
Making Contact & Terms: Interested in receiving work from newer, lesser-known photographers. Call first. SASE. Reports in 1 month. Pays $25-50/b&w photo; $50-150/color photo. Pays on publication. Credit line given. Buys all rights.

WOMENWISE, CFHC, Dept. PM, 38 S Main St., Concord NH 03301. (603)225-2739. Fax: (603)228-6255. Editor: Luita Spangler. Circ. 3,000. Estab. 1978. Publication of the Concord Feminist Health Center. Quarterly tabloid. Emphasizes women's health from a feminist perspective. Readers are women, all ages and occupations. Sample copy $2.95.
Needs: All photos supplied by freelancers; 80% assignment; 20% or less stock. Needs photos of primarily women, women's events and demonstrations, etc. Model release required. Captions preferred.
Making Contact & Terms: Interested in receiving work from newer, lesser-known photographers, "if it's excellent quality and supports our editorial stance." Arrange a personal interview to show portfolio. Send b&w prints. Pays $15/b&w cover photo; sub per b&w inside photo. Pays on publication. Credit line given. Buys first North American serial rights.
Tips: "We don't publish a lot of 'fine-arts' photography now. We want photos that reflect our commitment to empowerment of all women. We prefer work by women. Do not send originals to us, even with SASE. We are small (staff of three) and lack the time to return original work."

WOODMEN, 1700 Farnam St., Omaha NE 68102. (402)342-1890. Fax: (402)271-7269. Editor: Scott J. Darling. Assistant Editor: Billie Jo Foust. Circ. 507,000. Estab. 1890. Official publication for Woodmen of the World/Omaha Woodmen Life Insurance Society. Bimonthly magazine. Emphasizes American family life. Free sample copy and photographer guidelines.
Needs: Buys 15-20 photos/year. Historic, animal, fine art, photo essay/photo feature, scenic, human interest, humorous; nature, still life, travel, health and wildlife. Model release required. Captions preferred.
Making Contact & Terms: Send material by mail for consideration. Uses 8×10 glossy b&w prints on occasion; 35mm, 2¼×2¼ and 4×5 transparencies; 4×5 transparencies for cover, vertical format preferred. SASE. Reports in 1 month. Pays $50/b&w inside photo; $75 minimum/color inside photo; $300/cover photo. **Pays on acceptance.** Credit line given on request. Buys one-time rights. Previously published work OK.
Tips: "Submit good, sharp pictures that will reproduce well."

YOUNG CHILDREN, 1509 16th St. NW, Washington DC 20036-1426. (202)232-8777. Photo Editor: Roma White. Circ. 99,000. Bimonthly journal. Emphasizes education, care and development of young children and promotes education of those who work with children. Read by teachers, administra-

● **A BULLET** has been placed within some listings to introduce special comments by the editor of *Photographer's Market*.

tors, social workers, physicians, college students, professors, early childhood education teachers and birth-8 caregivers. Free photo and writer's guidelines.

Needs: Buys color and b&w photos on continuing basis. Also publishes 8 books/year with photos. Children (from birth to age 8) unposed, with/without adults. Wants on a regular basis children engaged in educational activities: dramatic play, scribbling/writing, playing with blocks—typical nursery school activities. Especially needs photos of minority children and children with disabilities engrossed in projects (not separate or looking bored). No posed, "cute" or stereotyped photos; no "adult interference, sexism, unhealthy food, unsafe situations, old photos, children with workbooks, depressing photos, parties, religious observances. Must provide copies of model releases for all individuals in photos." Accompanying mss: professional discussion of early childhood education and child development topics.

Making Contact & Terms: Interested in receiving work from newer, lesser-known photographers. Query with samples. Send glossy b&w and color prints; transparencies. SASE. Pays $25/inside photo; $75/posters and covers; no payment for ms. Pays on publication. Credit line given. Buys one-time rights; negotiable. Simultaneous submissions and/or previously published work OK.

Tips: "Write for our guidelines. We are using more photos per issue and using them in more creative ways, such as collages and inside color." Looks for "photos that depict children actively learning through interactions with the world around them; sensitivity to how children grow, learn and feel."

***YOUTH UPDATE**, St. Anthony Messenger Press, 1615 Republic St., Cincinnati OH 45210. (513)241-5615. Fax: (513)241-0399. Art Director/Youth Update: June Pfaff. Circ. 27,000. Estab. 1982. Company publication. Monthly 4-page, 3-color newsletter. Emphasizes topics for teenagers (13-19) that deal with issues and practices of the Catholic faith but also show teens' spiritual dimension in every aspect of life. Readers are male and female teenagers in junior high and high school. Sample copy free with SASE.

Needs: Uses 2 photos/issue; 2 supplied by freelancers. Needs photos of teenagers in a variety of situations. Model/property release preferred. Captions preferred.

Making Contact & Terms: Interested in receiving work from newer, lesser-known photographers. Query with stock photo list. Send unsolicited photos by mail for consideration. Provide résumé, business card, brochure, flier or tearsheets to be kept on file for possible future assignments. Uses b&w prints. Keeps samples on file. SASE. Reports in 1 month. Pays $75-90/hour; $200/job; $40-50/b&w cover photo; $40-50/b&w inside photo. Pays on publication. Buys one-time rights. Simultaneous submissions and/or previously published work OK.

TRADE PUBLICATIONS

Just as special interest publications fill a specific need, so too do trade magazines. This section contains more than 200 listings with 42 new markets. Most trade publications are directed toward the business community in an effort to keep readers abreast of the ever-changing trends and events in their specific professions. For photographers, shooting for these professions can be financially rewarding and can serve as a stepping stone toward acquiring future jobs.

As often happens with this category, the number of trade publications produced increases or decreases as professions develop or deteriorate. In recent years, for example, magazines involving computers have flourished as the technology continues to grow.

Trade publication readers are usually very knowledgeable about their businesses or professions. The editors and photo editors, too, are often experts in their particular fields. So, with both the readers and the publications' staffs, you are dealing with a much more discriminating audience. To be taken seriously, your photos must not be merely technically good pictures, but also should communicate a solid understanding of the subject and reveal greater insights.

In particular, photographers who can communicate their knowledge in both verbal and visual form will often find their work more in demand. If you have such expertise, you may wish to query about submitting a photo/text package that highlights a unique aspect of working in that particular profession or that deals with a current issue of interest to that field.

Many photos purchased by these publications come from stock—both that of freelance inventories and of stock photo agencies. Generally, these publications are more

conservative with their freelance budgets and use stock as an economical alternative. For this reason, listings in this section will often advise sending a stock list as an initial method of contact. Some of the more established publications with larger circulations and advertising bases will sometimes offer assignments as they become familiar with a particular photographer's work. For the most part, though, stock remains the primary means of breaking in and doing business with this market.

© Joel Radtke/AAP News

The American Academy of Pediatrics assigned this photo to Joel Radtke to accompany an article in their monthly newspaper, *AAP News*, on the damaging effects of ultraviolet rays on the eyes of young people. "I knew that seeing the sunglasses and seeing that the subjects were youths were the most important features," says Radtke of the photo taken at his community swimming pool. The shot was reproduced in full-color with a 12-inch story and caption. The Loveland, Colorado, photographer felt good in "knowing that my photograph may have made a difference in someone's life because they saw it, read the story and now their children are using UV protection sunglasses."

AAP NEWS, 141 Northwest Pt. Blvd., Elk Grove Village IL 60007. (708)981-6755. Fax: (708)228-5097. E-mail: Kidsdocs@aap.org. Art Director/Production Coordinator: Felicia McGurren. Estab. 1985. Publication of American Academy of Pediatrics. Monthly tabloid newspaper.
Needs: Uses 100 photos/year. 15-35 freelance assignments offered/year. Needs photos of children, pediatricians, health care providers—news magazine style. Model/property release required as needed. Captions required; include names, dates, location and explanation of situations.
Making Contact & Terms: Provide résumé, business card, tearsheets to be kept on file (for 1 year) for possible assignments. Also accepts digital files in SyQuest. Cannot return material. Pays $75/hour; $75-125/one-time use of photo. Pays on publication. Buys one-time or all rights; negotiable. Simultaneous submissions and previously published work OK.
Tips: "We want great photos 'real' children in 'real-life' situations, and the more diverse the better."

ABA BANKING JOURNAL, 345 Hudson St., New York NY 10014. (212)620-7256. Art Director: John McLaughlin. Circ. 30,000. Estab. 1909. Monthly magazine. Emphasizes "how to manage a bank better. Bankers read it to find out how to keep up with changes in regulations, lending practices, investments, technology, marketing and what other bankers are doing to increase community standing."
Needs: Buys 12-24 photos/year; freelance photography is 50% assigned, 50% from stock. Personality, and occasionally photos of unusual bank displays or equipment. "We need candid photos of various bankers who are subjects of articles." Photos purchased with accompanying ms or on assignment.

Making Contact & Terms: Query with samples. For color: uses 35mm transparencies and 2¼ × 2¼ transparencies. For cover: uses color transparencies. SASE. Reports in 1 month. Pays $200-500/photo; $100 minimum/job; $200/printed page for photo/text package. **Pays on acceptance**. Credit line given. Buys one-time rights.
Tips: "For portraits, I'm as interested in the subject's environment as the subject."

***A/C FLYER**, Suite 260, 4 International Dr., Rye Brook NY 10573. (914)939-8787. Fax: (914)939-8824. Managing Editor: Mike Perry. Circ. 45,000. Estab. 1979. Company publication for McGraw-Hill. Monthly magazine. Emphasizes resale aircraft. Readers are aircraft owners, pilots, company pilots, company CEOs and presidents. Sample copy $2.
Needs: Uses 125 photos/issue; 1 supplied by freelancers. Needs photos of aircraft (jets, turboprop). Model/property release required for aircraft with 10 numbers showing, hangars and people.
Making Contact & Terms: Provide résumé, business card, brochure, flier or tearsheets to be kept on file for possible assignments. Deadlines: 3rd week of each month. Keeps samples on file. SASE. Reports in 1 month. Pays $1,600/color cover photo. Pays on publication. Credit line given. Buys all rights.
Tips: "Some clients may need photos taken of their aircraft listed for sale. We can refer freelancers to our clients."

ACCOUNTING TODAY, 11 Penn Plaza, New York NY 10001. (212)631-1596. Fax: (212)564-9896. Contact: Managing Editor. Circ. 35,000. Estab. 1987. Biweekly tabloid. Emphasizes finance. Readers are CPAs in public practice.
Needs: Uses 2-3 photos/issue; all supplied by freelancers. "We assign news subjects, as needed." Captions required.
Making Contact & Terms: Interested in receiving work from newer, lesser-known photographers. Provide résumé, business card, brochure, flier or tearsheets to be kept on file for possible assignments. Keeps samples on file. Cannot return material. Pays $250/shoot. **Pays on acceptance**. Credit line given. Buys all rights; negotiable.

***ADAMS MEDIA CORPORATION—THE CAREERS GROUP**, 260 Center St., Holbrook MA 02343. (617)767-8100. Fax: (617)767-5901. E-mail: jennifermost_adamsonline.com. Editor: Jennifer Most. Circ. 20,000. Estab. 1985. Biannual magazine. Emphasizes careers, job-hunting and recruitment pertaining to MBAs, engineers and liberal arts. Readers are 1st and 2nd year MBA students; junior and senior engineering undergraduate students; and junior and senior liberal arts undergraduate students. Sample copy $12.95 and $4.50 p&h.
Needs: Uses 3-4 photos/issue; 3-4 supplied by freelancers and stock photo houses. Needs illustrations and photos of business, job-hunting and technology. Captions preferred.
Making Contact & Terms: Interested in receiving work from newer, lesser-known photographers. Send unsolicited photos by mail for consideration. Provide résumé, business card, brochure, flier or tearsheets to be kept on file for possible future assignments. Send any size, any finish color prints; 35mm, 2¼ × 2¼, 4 × 5, 8 × 10 transparencies; TIFF format for PC. Deadlines: May 1996, August 1996. SASE. Reports in 1 month. Pays $300/color cover photo; $10/color inside photo; $50 extra for electronic usage of cover photo, $5 extra for electronic usage of inside photo. Pays on publication. Credit line given. Buys one-time rights. Simultaneous submissions and previously published work OK.

AG PILOT INTERNATIONAL MAGAZINE, P.O. Box 1607, Mt. Vernon WA 98273. (360)336-9737. Fax: (360)336-2506. Publisher: Tom J. Wood. Circ. 7,200. Estab. 1978. Monthly magazine. Emphasizes agricultural aviation and aerial fire suppression (airborne fire fighting). Readers are male cropdusters, ages 20-70. Sample copy $3.
Needs: Uses 20-30 photos/issue; 20% supplied by freelancers. Needs photos of small, less than 400 hp,ag aircraft suitable for cover shots. Model/property release preferred. Captions preferred; include who, what, where, when, why.
Making Contact & Terms: Interested in receiving work from newer, lesser-known photographers. Send unsolicited photos by mail for consideration. Send 3 × 5 any finish color or b&w prints. Keeps samples on file. SASE. Usually reports in 1 month, but may be 2-3 months. Pays $30-150/color cover photo; $10-30/color inside photo; $5-20/b&w inside photo; $50-250/photo/text package. Pays on publication. Credit line given. Buys all rights; negotiable.
Tips: "Subject must be cropdusting and aerial fire suppression (airborne fire fighting). Learn about the aerial application business before submitting material."

AMERICAN AGRICULTURIST, 2389 N. Triphammer Rd., Ithaca NY 14850. (607)257-8670. Fax: (607)257-8238. Editor: Eleanor Jacobs. Circ. 37,000. Estab. 1842. Monthly. Emphasizes agriculture in the Northeast—specifically New York and New England. Photo guidelines free with SASE.
Needs: Occasionally photos supplied by freelance photographers; 90% on assignment, 25% from stock. Needs photos of farm equipment, general farm scenes, animals. Geographic location: only New

York and New England. Reviews photos with or without accompanying ms. Model release required. Captions preferred.

Making Contact & Terms: Interested in receiving work from newer, lesser-known photographers. Query with samples and list of stock photo subjects. Send 35mm transparencies by mail for consideration. SASE. Reports in 3 months. Pays $200/color cover photo and $75-150/inside color photo. **Pays on acceptance.** Credit line given. Buys one-time rights.

Tips: "We need shots of modern farm equipment with the newer safety features. Also looking for shots of women actively involved in farming and shots of farm activity. We also use scenics. We send out our editorial calendar with our photo needs yearly."

AMERICAN BANKER, Dept. PM, 1 State St. Plaza, New York NY 10004. (212)803-8313. Fax: (212)843-9600. Photo Editor: Lois Wadler. Circ. 17,000. Estab. 1835. Daily tabloid. Emphasizes banking industry. Readers are male and female, senior executives in finance, ages 35-59.
● This publication scans its photos on computer.

Needs: "We are a daily newspaper and we assign a lot of pictures throughout the country. We mostly assign environmental portraits with an editorial, magazine style to them."

Making Contact & Terms: Arrange a personal interview to show portfolio. Send unsolicited b&w or color prints by mail for consideration. Provide résumé, business card, brochure, flier or tearsheets to be kept on file for possible assignments. Keeps samples on file. SASE. Pays $225/assignment plus expenses. Credit line given. Buys one-time rights.

Tips: "We look for photos that offer a creative insight to corporate portraiture and technically proficient photographers who can work well with stuffy businessmen in a limited amount of time—30 minutes or less is the norm. Photographers should send promo cards that indicate their style and ability to work with executives. Portfolio should include 5-10 samples either slides or prints, with well-presented tearsheets of published work. Portfolio reviews by appointment only. Samples are kept on file for future reference."

AMERICAN BEE JOURNAL, Dept. PM, 51 S. 2nd St., Hamilton IL 62341. (217)847-3324. Fax: (217)847-3660. Editor: Joe M. Graham. Circ. 13,000. Estab. 1861. Monthly trade magazine. Emphasizes beekeeping for hobby and professional beekeepers. Sample copy free with SASE.

Needs: Uses about 25 photos/issue; 1-2 supplied by freelance photographers. Needs photos of beekeeping and related topics, beehive products, honey and cooking with honey. Special needs include color photos of seasonal beekeeping scenes. Model release preferred. Captions preferred.

Making Contact & Terms: Interested in receiving work from newer, lesser-known photographers. Query with samples. Send 5×7 or 8½×11 b&w and color prints by mail for consideration. SASE. Reports in 2 weeks. Pays $50/color cover photo; $10/b&w inside photo. Pays on publication. Credit line given. Buys all rights.

AMERICAN BREWER MAGAZINE, Box 510, Hayward CA 94541. (510)538-9500. President: Bill Owens. Circ. 15,000. Estab. 1986. Quarterly magazine. Emphasizes micro-brewing and brewpubs. Readers are males ages 25-35. Sample copy $5.

Needs: Uses 5 photos/issue; 5 supplied by freelancers. Reviews photos with accompanying ms only. Captions required.

Making Contact & Terms: Contact by phone. Reports in 2 weeks. NPI; pays per job. **Pays on acceptance.** Credit line given. Buys one-time rights; negotiable. Simultaneous submissions OK.

***AMERICAN CHAMBER OF COMMERCE EXECUTIVES**, 4232 King St., Alexandria VA 22302. (703)998-0072. Fax: (703)931-5624. Meetings Manager: Kristin Harrison. Circ. 5,000. Monthly trade newsletter. Emphasizes chambers of commerce. Readers are chamber professionals (male and female) interested in developing chambers and securing their professional place. Free sample copy.

Needs: Uses 1-15 photos/issue; 0-10 supplied by freelancers. Special photo needs include coverage of our annual conference in October 1996 in Norfolk, Virginia. Model release required. Captions preferred.

Making Contact & Terms: Interested in receiving work from newer, lesser-known photographers. Query with stock photo list. Provide résumé, business card, brochure, flier or tearsheets to be kept on file for possible future assignments. Send 4×6 matte b&w prints. Keeps samples on file. SASE. Reports in 1-2 weeks. Pays $10-50/hour. **Pays on acceptance** Buys all rights.

AMERICAN FARRIERS JOURNAL, P.O. Box 624, Brookfield WI 53008-0624. (414)782-4480. Fax: (414)782-1252. Editor: Frank Lessiter. Circ. 7,000 (paid). Estab. 1974. Magazine published 7 times/year. Emphasizes horseshoeing and horse health for professional horseshoers. Sample copy free with SASE.

Needs: Looking for horseshoeing photos, documentary, how-to (of new procedures in shoeing), photo/essay feature, product shot and spot news. Photos purchased with or without accompanying ms. Captions required.

Making Contact & Terms: Interested in receiving work from newer, lesser-known photographers. Query with printed samples. Uses 4-color transparencies for covers. Vertical format. Artistic shots. SASE. Pays $25-50/b&w photo; $30-100/color photo; up to $150/cover photo. Pays on publication. Credit line given.

AMERICAN FIRE JOURNAL, Dept. PM, 9072 Artesia Blvd., Suite 7, Bellflower CA 90706. (310)866-1664. Fax: (310)867-6434. Editor: Carol Carlsen Brooks. Circ. 6,000. Estab. 1952. Monthly magazine. Emphasizes fire protection and prevention. Sample copy $3.50 with 10×12 SAE and 6 first-class stamps. Free photo and writer's guidelines.
Needs: Buys 5 or more photos/issue; 90% supplied by freelancers. Documentary (emergency incidents, showing fire personnel at work); how-to (new techniques for fire service); and spot news (fire personnel at work). Captions required. Seeks short ms describing emergency incident and how it was handled by the agencies involved.
Making Contact & Terms: Interested in receiving work from newer, lesser-known photographers. Query with samples. Provide résumé, business card or letter of inquiry. SASE. Reports in 1 month. Uses b&w semigloss prints; for cover uses 35mm color transparencies; covers must be verticals. Pays $10-25/b&w photo, negotiable; $25-100/color photo; $100/cover photo; $1.50-2/inch for ms.
Tips: "Don't be shy! Submit your work. I'm always looking for contributing photographers (especially if they are from outside the Los Angeles area). I'm looking for good shots of fire scene activity with captions. The action should have a clean composition with little smoke and prominent fire and show good firefighting techniques, i.e., firefighters in full turnouts, etc. It helps if photographers know something about firefighting so as to capture important aspects of fire scene. We like photos that illustrate the drama of firefighting—large flames, equipment and apparatus, fellow firefighters, people in motion. Write suggested captions. Give us as many shots as possible to choose from. Most of our photographers are firefighters or 'fire buffs.' "

ANIMAL SHELTERING, (formerly *Shelter Sense*), Humane Society of the US, 2100 L St. NW, Washington DC 20037. (202)452-1100. Fax: (301)258-3081. E-mail: asm@ix.netcom.com. Editor: Geoffrey Handy. Circ. 3,500. Estab. 1978. Bimonthly magazine. Emphasizes animal protection. Readers are animal control and shelter workers, men and women, all ages. Sample copy free.
Needs: Uses 25 photos/issue; 75% supplied by freelance photographers. Needs photos of domestic animals interacting with people/humane workers; animals in shelters; animals during the seasons; animal care and obedience; humane society work and functions; other companion animal shots. "We do not pay for manuscripts." Model release required for cover photos only. Captions preferred.
Making Contact & Terms: Interested in receiving work from newer, lesser-known photographers. Provide résumé, business card, brochure, flier or tearsheets to be kept on file for possible assignments. SASE. Reports in 3 weeks. Pays $45/b&w cover photo; $35/b&w inside photo. "We accept color, but magazine prints in b&w." **Pays on acceptance.** Credit line given. Buys one-time rights.
Tips: "We almost always need good photos of people working with animals in an animal shelter, in the field, or in the home. We do not use photos of individual dogs, cats and other companion animals as much as we use photos of people working to protect, rescue or care for dogs, cats and other companion animals."

APPLIANCE MANUFACTURER, 5900 Harper Rd., Suite 105, Solon OH 44139. (216)349-3060. Fax: (216)498-9121. Editor: Joe Jancsurak. Circ. 38,000. Monthly magazine. Emphasizes design for manufacturing in the global consumer, commercial and business appliance industry. Primary audience is the "engineering community." Sample copy free with 10×12 SASE.
Needs: Uses 20-25 photos/issue. Needs technological photos. Reviews photos purchased with accompanying ms only. Captions preferred.
Making Contact & Terms: Interested in receiving work from newer, lesser-known photographers. Provide résumé, business card, brochure, flier or tearsheets to be kept on file for possible assignments. Keeps samples on file. SASE. Reports in 2 weeks. NPI. Payment negotiable. **Pays on acceptance.** Credit line given.

***ART MATERIALS TODAY MAGAZINE**, 1507 Dana Ave., Cincinnati OH 45207. (513)531-2690, ext. 452. Fax: (513)531-2902. Editor: Lisa Baggerman. Circ. 10,500. Estab. 1993. Bimonthly magazine. Emphasizes art materials industry. Readers are predominantly male, ages 45-65, art material store owners. Sample copy free with 10×13 SAE and 5 first-class stamps.
Needs: Uses 15-20 photos/issue; 1-5 supplied by freelancers. Needs portraits of people and photos of stores. Reviews photos purchased with accompanying ms only. Model/property release preferred. Captions required; include action and names/titles of people in photo.
Making Contact & Terms: Provide résumé, business card, brochure, flier or tearsheets to be kept on file for possible future assignments. Send 3½×5 color prints; 4×5 transparencies. Does not keep samples on file. Reports in 3 weeks. Pays $200-250/color inside photo. **Pays on acceptance.** Credit line

given. Buys first North American serial rights; negotiable. Simultaneous submissions and previously published work OK.

ATHLETIC BUSINESS, % Athletic Business Publications Inc., 1846 Hoffman St., Madison WI 53704. (608)249-0186. Fax: (608)249-1153. Art Directors: Kay Lunn and Michael Roberts. Monthly magazine. Emphasizes athletics, fitness and recreation. "Readers are athletic, park and recreational directors and club managers, ages 30-65." Circ. 45,000. Estab. 1977. Sample copy $5.
Needs: Uses 4 or 5 photos/issue; 50% supplied by freelancers. Needs photos of sporting shots, athletic equipment, recreational parks and club interiors. Model and/or property release and photo captions preferred.
Making Contact & Terms: Send unsolicited color prints or 35mm transparencies by mail for consideration. Does not keep samples on file. SASE. Reports in 1-2 weeks. Pays $250/color cover photo; $75/color inside photos; $125/color page rate. Pays on publication. Credit line given. Buys all rights; negotiable. Simultaneous submissions and previously published work OK, but should be explained.
Tips: Wants to see ability with subject, high quality and reasonable price. To break in, "shoot a quality and creative shot from more than one angle."

***ATHLETIC MANAGEMENT**, 438 W. State St., Ithaca NY 14850. (607)272-0265. Fax: (607)273-0701. Managing Editor: Eleanor Frankel. Circ. 30,000. Estab. 1989. Bimonthly magazine. Emphasizes the management of athletics. Readers are managers of high school and college athletic programs.
Needs: Uses 6-10 photos/issue; 50% supplied by freelancers. Needs photos of athletic events and athletic equipment/facility shots. Model release preferred.
Making Contact & Terms: Interested in receiving work from newer, lesser-known photographers. Submit portfolio for review. Keeps samples on file. SASE. Reports in 1-2 weeks. Pays $150-300/color cover photo; $100-150/b&w cover or color inside photo; $50-100/b&w inside photo. Pays on publication. Credit line given. Buys first North American serial rights; negotiable. Previously published work OK.

ATLANTIC PUBLICATION GROUP INC., 2430 Mall Dr., Suite 160, Charleston SC 29406. (803)747-0025. Fax: (803)744-0816. Editorial Coordinator: Shannon Clark. Circ. 6,500. Estab. 1985. Publication of Chamber of Commerces South of New York and North of Georgia, Visitor Products from Hawaii to the East Coast. Quarterly magazine. Emphasizes business. Readers are male, female business people who are members of chambers of commerce, ages 30-60. Sample copy free with 9×12 SAE and 7 first-class stamps.
Needs: Uses 10 photos/issue; all supplied by freelancers. Needs photos of business scenes, manufacturing, real estate, lifestyle. Model/property release required. Captions preferred.
Making Contact & Terms: Provide résumé, business card, brochure, flier or tearsheets to be kept on file for possible assignment. Query with stock photo list. Unsolicited material will not be returned. Deadlines: quarterly. Keeps samples on file. SASE. Reports in 1 month. Pays $100-400/color cover photo; $100-250/b&w cover photo; $50-100/color inside photo; $50/b&w inside photo. **Pays on acceptance.** Credit line given. Buys one-time rights; negotiable. Simultaneous submissions and previously published work OK.

AUTOMATED BUILDER, Dept. PM, P.O. Box 120, Carpinteria CA 93014. (805)684-7659. Fax: (805)684-1765. E-mail: abmag@autbldrmag.com. Website: http://www.autbldrmag.com. Editor and Publisher: Don Carlson. Circ. 26,000. Estab. 1964. Monthly. Emphasizes home and apartment construction. Readers are "factory and site builders and dealers of all types of homes, apartments and commercial buildings." Sample copy free with SASE.
Needs: Uses about 40 photos/issue; 10-20% supplied by freelance photographers. Needs in-plant and job site construction photos and photos of completed homes and apartments. Photos purchased with accompanying ms only. Captions required.
Making Contact & Terms: Interested in receiving work from newer, lesser-known photographers. "Call to discuss story and photo ideas." Send 3×5 color prints; 35mm or $2\frac{1}{4} \times 2\frac{1}{4}$ transparencies by mail for consideration. Will consider dramatic, preferably vertical cover photos. Send color proof or slide. SASE. Reports in 2 weeks. Pays $300/text/photo package; $150/cover photo. Credit line given "if desired." Buys first time reproduction rights.
Tips: "Study sample copy. Query editor by phone on story ideas related to industrialized housing industry."

AUTOMOTIVE COOLING JOURNAL, P.O. Box 97, E. Greenville PA 18041. (215)541-4500. Fax: (215)679-4977. Managing Editor: Richard Krisher. Circ. 10,500. Estab. 1956. Publication of National Automotive Radiator Service Association/Mobile Air Conditioning Society. Monthly magazine. Emphasizes cooling system repair, mobile air conditioning service. Readers are mostly male shop owners and employees.

Needs: Uses 25-30 photos/issue; 50% supplied by freelancers. Needs shots illustrating service techniques, general interest auto repair emphasizing cooling system and air conditioning service. Model/property release preferred. Captions required.
Making Contact & Terms: Interested in receiving work from newer, lesser-known photographers. Send unsolicited photos by mail for consideration. Provide résumé, business card, brochure, flier or tearsheets to be kept on file for possible assignments. Send any glossy prints; 35mm, 1¼×2¼, 4×5, 8×10 transparencies. Keeps samples on file. SASE. Reports in 1 month. NPI. Pays on publication. Credit line given. Buys one-time rights.

AUTOMOTIVE NEWS, 1400 Woodbridge, Detroit MI 48207-3187. (313)446-6000. Fax: (313)446-0383. Staff Photographer: Joe Wilssens. Circ. 77,000. Estab. 1926. Published by Crain Communications. Weekly tabloid. Emphasizes the global automotive industry. Readers are automotive industry executives including people in manufacturing and retail. Sample copies available.
Needs: Uses 30 photos/issue; 5 supplied by freelancers. Needs photos of automotive executive environmental portraits, auto plants, new vehicles, auto dealer features. Captions required; include identification of individuals and event details.
Making Contact & Terms: Interested in receiving work from newer, lesser-known photographers. Send unsolicited photos by mail for consideration. Provide résumé, business card, brochure, flier or tearsheets to be kept on file for possible assignments. Send 8×10 color or b&w prints; 35mm, 2¼×2¼, 4×5 transparencies. Deadlines: daily. Keeps samples on file. SASE. Reports in 2 weeks. Pays on publication. Credit line given. Buys one-time rights, possible secondary rights for other Crain publications. Simultaneous submissions and previously published work OK.

AVIONICS MAGAZINE, 1201 Seven Locks Rd., Potomac MD 20854. (301)340-7788, ext. 2840. Fax: (301)340-0542. Editor: David Robb. Circ. 24,000. Estab. 1978. Monthly magazine. Emphasizes aviation electronics. Readers are avionics engineers, technicians, executives. Sample copy free with 9×12 SASE.
Needs: Uses 15-20 photos/issue; 10% supplied by freelancers. Reviews photos with or without ms. Captions required.
Making Contact & Terms: Interested in receiving work from newer, lesser-known photographers. Send unsolicited photos by mail for consideration. Provide résumé, business card, brochure, flier or tearsheets to be kept on file for possible assignments. Send 8½×11 glossy color prints; 35mm, 2¼×2¼, 4×5, 8×10 transparencies. Keeps samples on file. SASE. Reports in 1-2 months. Pays $150-200/color cover photo. **Pays on acceptance.** Credit line given. Rights negotiable. Simultaneous submissions OK.

BANK INVESTMENT REPRESENTATIVE, P.O. Box 4364, Logan UT 84323-4364. (801)752-1173. Fax: (801)752-1193. E-mail: bir2@aol.com. Art Director: Tamara Pluth. Circ. 33,000. Estab. 1991. Monthly magazine. Emphasizes interests and concerns of investment representatives working for financial institutions. Readers are male and female investment representatives and managers, ages 30-60. Sample copy $5. Photo guidelines free with SASE.
● This publication is storing images on CD, using computer manipulation, and accessing images through computer networks.
Needs: Uses 5-10 photos/issue; 50% supplied by freelancers. Needs photos of business, finance, personalities in field, insurance. Model/property release preferred.
Making Contact & Terms: Interested in receiving work from newer, lesser-known photographers. Query with résumé of credits. Query with stock photo list. Send unsolicited photos by mail for consideration. Provide résumé, business card, brochure, flier or tearsheets to be kept on file for possible assignments. Also accepts digital files (TIFF or JPEG). Send 2¼×2¼ transparencies. Keeps samples on file. Reports in 3 weeks. Pays $50-100/b&w photo; $150-250/color photo. Pays on publication. Credit line given. Buys one-time rights. Previously published work OK.

BARTENDER MAGAZINE, P.O. Box 158, Liberty Corner NJ 07938. (908)766-6006. Fax: (908)766-6607. Art Director: Erica DeWitte. Circ. 147,000. Estab. 1979. Quarterly magazine. *Bartender Magazine* serves full-service drinking establishments (full-service means able to serve liquor, beer and wine). "We serve single locations including individual restaurants, hotels, motels, bars, taverns, lounges and all other full-service on-premises licensees." Sample copy $2.50.

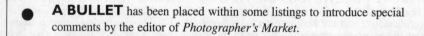

● **A BULLET** has been placed within some listings to introduce special comments by the editor of *Photographer's Market*.

Needs: Number of photos/issue varies. Number supplied by freelancers varies. Needs photos of liquor-related topics, drinks, bars/bartenders. Reviews photos with or without ms. Model/property release required. Captions preferred.
Making Contact & Terms: Interested in receiving work from newer, lesser-known photographers. Provide résumé, business card, brochure, flier or tearsheets to be kept on file for possible assignments. SASE. NPI. Pays on publication. Credit line given. Buys all rights; negotiable. Previously published work OK.

***BEEF**, 7900 International Dr., 3rd Floor, Minneapolis MN 55425. (612)851-4668. Editor: Joe Roybal. Monthly magazine. Emphasizes beef cattle production and feeding. Readers are feeders, ranchers and stocker operators. Sample copy and photo guidelines free with SASE.
Needs: Uses 20 or more photos/issue; 10% supplied by freelance photographers. Needs variety of cow-calf and feedlot scenes. Model release required. Captions required.
Making Contact & Terms: Send 8×10 glossy b&w prints and 35mm transparencies by mail for consideration. SASE. Reports in 1 month. Payment negotiable. **Pays on acceptance.** Buys one-time rights.
Tips: "We buy few photos, since our staff provides most of those needed. Payment negotiable."

BEEF TODAY, Farm Journal Publishing, Inc., Centre Square W., 1500 Market St., 28th Floor, Philadelphia PA 19102-2181. (215)557-8959. Photo Editor: Tom Dodge. Circ. 220,000. Monthly magazine. Emphasizes American agriculture. Readers are active farmers, ranchers or agribusiness people. Sample copy and photo guidelines free with SASE.
● This company also publishes *Farm Journal*, *Top Producer*, *Hogs Today* and *Dairy Today*.
Needs: Uses 20-30 photos/issue; 75% supplied by freelance photographers. "We use studio-type portraiture (environmental portraits), technical, details, scenics." Model release preferred. Captions required.
Making Contact & Terms: Arrange a personal interview to show portfolio. Query with résumé of credits along with business card, brochure, flier or tearsheets to be kept on file for possible assignments. SASE. Reports in 2 weeks. NPI. "We pay a cover bonus." **Pays on acceptance.** Credit line given. Buys one-time rights. Simultaneous submissions OK.
Tips: In portfolio or samples, likes to "see about 20 slides showing photographer's use of lighting and photographer's ability to work with people. Know your intended market. Familiarize yourself with the magazine and keep abreast of how photos are used in the general magazine field."

BETTER ROADS, 6301 Gaston Ave., Suite 541, Dallas TX 75214. (214)827-4630. Fax: (214)827-4758. Associate Publisher: Ruth W. Stidger. Circ. 40,000. Estab. 1935. Monthly magazine. Emphasizes highway and street construction, repair, maintenance. Readers are mostly male engineers and public works managers, ages 30-65. Sample copy for 9×12 SAE and 4 first-class stamps.
Needs: Uses 12 photos/issue; 20% supplied by freelancers. Needs vertical 4-color shots of workers and/or equipment in bridge, street, road repair or maintenance situations. Special photo needs include work-zone photos, winter road maintenance photos, bridge painting, roadside vegetation maintenance. "Releases not needed if photos shot in public locations." Captions preferred; include names of workers in photos, location, highway department and contractor names.
Making Contact & Terms: Interested in receiving work from newer, lesser-known photographers. Send unsolicited photos by mail for consideration. Send 8×10 color prints; 35mm, 2¼×2¼, 4×5, 8×10 transparencies. Keeps samples on file. SASE. Reports in 2 weeks. Pays $200-300/color cover photo; $200-300/color inside photo. **Pays on acceptance**. Buys first North American serial rights; negotiable. Simultaneous submissions and previously published work OK.

BEVERAGE & FOOD DYNAMICS, Dept. PM, 1180 Avenue of the Americas, New York NY 10036. (212)827-4700. Fax: (212)827-4720. Editor: Richard Brandes. Art Director: Paul Viola. Circ. 67,000. Nine times/year magazine. Emphasizes distilled spirits, wine and beer and all varieties of non-alcoholic beverages (soft drinks, bottled water, juices, etc.), as well as gourmet and specialty foods. Readers are national—retailers (liquor stores, supermarkets, etc.), wholesalers, distillers, vintners, brewers, ad agencies and media.
● This magazine received an Ozzie Award in 1994 for Best Overall Design (trade magazine under 50,000 circulation) and also the Graphic Design: USA Award.
Needs: Uses 30-50 photos/issue; 5 supplied by freelance photographers and photo house (stock). Needs photos of retailers, product shots, concept shots and profiles. Special needs include good retail environments; interesting store settings; special effect photos. Model release required. Captions required.
Making Contact & Terms: Interested in receiving work from newer, lesser-known photographers. Query with samples and list of stock photo subjects. Send non-returnable samples, slides, tearsheets, etc. with a business card. "An idea of their fee schedule helps as well as knowing if they travel on a steady basis to certain locations." SASE. Reports in 2 weeks. Pays $550-750/color cover photo; $450-

950/job. Pays on publication. Credit line given. Buys one-time rights or all rights on commissioned photos. Simultaneous submissions OK.

Tips: "We're looking for good location photographers who can style their own photo shoots or have staff stylists. It also helps if they are resourceful with props. A good photographer with basic photographs is always needed. We don't manipulate other artists work, whether its an illustration or a photograph. If a special effect is needed, we hire a photographer who manipulates photographs."

BUILDINGS: The Facilities Construction and Management Magazine, 427 Sixth Ave. SE, P.O. Box 1888, Cedar Rapids IA 52406. (319)364-6167. Fax: (319)364-4278. Editor: Linda Monroe. Circ. 42,000. Estab. 1906. Monthly magazine. Emphasizes commercial real estate. Readers are building owners and facilities managers. Sample copy $6.
Needs: Uses 50 photos/issue; 10% supplied by freelancers. Needs photos of concept, building interiors and exteriors, company personnel and products. Model/property release preferred. Captions preferred.
Making Contact & Terms: Provide résumé, business card, brochure, flier or tearsheets to be kept on file for possible assignments. Send 3×5, 8×10, b&w, color prints; 35mm, 2¼×2¼, 4×5 transparencies upon request only. SASE. Reports as needed. Pays $350/color cover photo; $200/color inside photo. Pays on publication. Credit line given. Rights negotiable. Simultaneous submissions OK.

***BUSINESS CREDIT MAGAZINE**, National Association of Credit Management, 8815 Centre Park Dr., Suite 200, Columbia MD 21045. (410)740-5560. Fax: (410)740-5574. Marketing Director: Katherine Jeschke. Circ. 40,000. Estab. 1896. Publication of the National Association of Credit Management. Monthly magazine. Emphasizes business credit, finance, banking, freight forwarding and customer financial services. Readers are male and female executives, 25-65—VPs, CEOs, CFOs, middle management—and entry-level employees. Free sample copy.
Needs: Uses 1-5 photos/issue. Needs photos of technology, industry, commerce, banking and business (general, international, concepts). Special photo needs include: international; computer technology (Internet, global village); humorous; business-related; and technology-related.
Making Contact & Terms: Interested in receiving work from newer, lesser-known photographers. Query with résumé of credits. Provide résumé, business card, brochure, flier or tearsheets to be kept on file for possible future assignments. Send 4×6 glossy color and b&w prints; 35mm, 2¼×2¼ transparencies. Deadlines: 2 months prior to publication; always 1st of month. SASE. Reports in 1 month. Pays $50-100/hour; $250-500/color cover photo; $250-375/b&w cover photo; $100-375/color inside photo; $100-275/b&w inside photo; $100-200/color page rate; $100-150/b&w page rate. **Pays on acceptance.** Credit line given. Buys one-time and all rights; negotiable. Previously published work OK.
Tips: "Be familiar with publication and offer suggestions. Be available when called and be flexible with nonprofit groups such as NACM."

BUSINESS NH MAGAZINE, 404 Chestnut St., #201, Manchester NH 03101. (603)626-6354. Fax: (603)626-6359. Art Director: Nikki Bonenfant. Circ. 13,000. Estab. 1984. Monthly magazine. Emphasizes business. Readers are male and female—top management, average age 45. Sample copy free with 9×12 SAE and 5 first-class stamps.
Needs: Uses 3-6 photos/issue. Needs photos of people, high-tech, software and locations. Model/property release preferred. Captions required; include names, locations, contact phone number.
Making Contact & Terms: Interested in receiving work from newer, lesser-known photographers. Arrange personal interview to show portfolio. Provide résumé, business card, brochure, flier or tearsheets to be kept on file for possible assignments. Keeps samples on file. SASE. Reports in 3 weeks. Pays $300-500/color cover photo; $60/color inside photo; $40/b&w inside photo. Pays on publication. Credit line given. Buys one-time rights.
Tips: Looks for "people in environment shots, interesting lighting, lots of creative interpretations, a definite personal style. If you're just starting out and want excellent statewide exposure to the leading executives in New Hampshire, you should talk to us."

♣CANADIAN GUERNSEY JOURNAL, 368 Woolwich St., Guelph, Onatrio N1H 3W6 Canada. (519)836-2141. Editor: V.M. Macdonald. Circ. 500. Estab. 1927. Publication of the Canadian Guernsey Association. Bimonthly magazine. Emphasizes dairy cattle, purebred and grade guernseys. Readers are dairy farmers. Sample copy $5.
Needs: Uses 10 photos/issue; 1 supplied by freelancer. Needs photos of guernsey cattle; posed, informal, scenes. Photo captions preferred.
Making Contact & Terms: Interested in receiving work from newer, lesser-known photographers. Contact through rep. Keeps samples on file. SASE (IRCs). Reports in 2 weeks. Pays $10/b&w inside photo. Pays on publication. Credit line given. Rights negotiable. Previously published work OK.

CAREER PILOT MAGAZINE, 4971 Massachusetts Blvd., Atlanta GA 30337. (770)997-8097, ext. 142. Fax: (770)997-8111. Graphic Designer: Kellie Frissell. Circ. 14,000. Estab. 1983. Monthly

magazine. Emphasizes career advancement for pilots. Sample copy available.

● *Career Pilot Magazine* is interested in computer manipulated images as long as the quality is high.

Needs: Uses 2 photos/issue minimum; all supplied by freelancers. Needs photos of airline airplanes, lifestyle, financial and health related topics. Model/property release required.

Making Contact & Terms: Interested in receiving work from newer, lesser-known photographers. Provide résumé, business card, brochure, flier or tearsheets to be kept on file for possible assignments. No phone calls. Keeps samples on file. SASE. Pays $100-500/job; $300/color cover photo; $100-200/color inside photo. Pays on publication. Buys one-time rights. Previously published work OK.

Tips: "No fashion photography, wildlife or scenics. Still-lifes preferred. Let us know if you prefer concepting ideas or if you prefer us to give you the idea. We need both types. Attention to detail and variety of styles are very important."

CASINO JOURNAL, 3100 W. Sahara Ave., #207, Las Vegas NV 89102. (702)253-6230. Fax: (702)253-6804. Editor: Adam Fine. Circ. 35,000. Estab. 1990. Monthly journal. Emphasizes casino operations. Readers are casino executives, employees and vendors. Sample copy free with 11×14 SAE and 9 first-class stamps.

Needs: Uses 40-60 photos/issue; 5-10 supplied by freelancers. Needs photos of gaming tables and slot machines, casinos and portraits of executives. Model release required for gamblers, employees. Captions required.

Making Contact & Terms: Interested in receiving work from newer, lesser-known photographers. Query with résumé of credits. Query with stock photo list. Reports in 2-3 months. Pays $100 minimum/color cover photo; $10-35/color inside photo; $10-25/b&w inside photo. Pays on publication. Credit line given. Buys all rights; negotiable.

Tips: "Read and study photos in current issues."

CED MAGAZINE, 600 S. Cherry St., Suite 400, Denver CO 80222. (303)393-7449. Fax: (303)393-6654. Editor: Roger Brown. Art Director: Don Ruth. Circ. 18,500. Estab. 1975. Monthly magazine. Emphasizes cable TV or video networking. Readers are typically male, ages 30-50, who are technical and engineering oriented.

Needs: Uses 2-3 photos/issue. Needs photos of technology. Model/property release preferred.

Making Contact & Terms: Interested in receiving work from newer, lesser-known photographers. Provide résumé, business card, brochure, flier or tearsheets to be kept on file for possible assignments. Keeps samples on file. SASE. Reports in 3 weeks. Pays $400-1,700/job; $250-600/color cover photo; $50-200/color inside photo. **Pays on acceptance**. Credit line given. Buys one-time rights; negotiable. Previously published work OK.

***CHEMICAL ENGINEERING**, 1221 Avenue of the Americas, New York NY 10020. Phone: (212)512-3377. Fax: (212)512-4762. Art Director: Maureen Gleason. Circ. 80,000. Estab. 1903. Monthly magazine. Emphasizes equipment and technology of the chemical process industry. Readers are mostly male, median age 38. Sample copies available for $7, postage included.

Needs: Occasionally works with freelancers. Needs composite images, CAD (computer-aided design) images, shots of plant personnel at work, high-tech effects, shots of liquids, tanks, drums, sensors, toxic waste, landfills and remediation. Especially wants to see photos of environmental clean up, recycling, plant staff handling bulk solids, thermoplastic pumps, cyclone selection, batch process plants, corrosive gases, valves, flowmeters and strainers. Model/property release required. Captions required; include "when, where and whom."

Making Contact & Terms: Interested in receiving work from newer, lesser-known photographers. Send stock photo list. Provide, résumé, business card, brochure, flier or tearsheets to be kept on file for possible assignments. Keeps samples on file. SASE. Reports in 3 weeks. Pays $1,000/color cover photo; $200/color inside photo; $100/b&w inside photo; $200/color page rate; $100/b&w page rate. Pays on publication. Credit line given. Buys one-time rights; negotiable. Simultaneous submissions and previously published work OK.

Tips: "Please respond ONLY if you are familiar with the chemical processing industry. After technology, our focus is on engineers at work. We want to feature a diversity of ages, ethnic types and both men and women in groups and individually. Pictures must show *current* technology, and identify location with permission of subject. Also, photos must be clean, crisp and have good color saturation for excellent reproduction."

 THE MAPLE LEAF before a listing indicates that the market is Canadian.

THE CHRISTIAN MINISTRY, 407 S. Dearborn St., Chicago IL 60605-1150. (312)427-5380. Fax: (312)427-1302. Managing Editor: Victoria A. Rebeck. Circ. 12,000. Estab. 1969. Bimonthly magazine. Emphasizes religion—parish clergy. Readers are 30-65 years old, 80% male, 20% female, parish clergy and well-educated. Sample copy free with 9×12 SAE and 4 first-class stamps. Photo guidelines free with SASE.

Needs: Uses 8 photos/issue; all supplied by freelancers; 75% comes from stock. Needs photos of clergy (especially female clergy), church gatherings, school classrooms and church symbols. Future photo needs include social gatherings and leaders working with groups. Candids should appear natural. Model release preferred. Captions preferred.

Making Contact & Terms: Interested in receiving work from newer, lesser-known photographers. Send 8×10 b&w prints by mail for consideration. Also accepts digital images. SASE. Reports in 3 weeks. Pays $75/b&w cover photo; $35/b&w inside photo. On solicited photography, pays $50/photo plus expenses and processing. Pays on publication. Credit line given. Buys one-time rights. Will consider simultaneous submissions.

Tips: "We're looking for up-to-date photos of clergy, engaged in preaching, teaching, meeting with congregants, working in social activities. We need photos of women, African-American and Hispanic clergy. We print on newsprint, so images should be high in contrast and sharply focused."

THE CHRONICLE OF PHILANTHROPY, 1255 23rd St. NW, 7th Floor, Washington DC 20037. (202)466-1205. Fax: (202)466-2078. E-mail: sup.lalumia@chronicle.com. Art Director: Sue LaLumia. Circ. 35,000. Estab. 1988. Biweekly tabloid. Readers come from all aspects of the nonprofit world such as charities (large or small grant maker/giving), foundations and relief agencies such as the Red Cross. Sample copy free.

Needs: Uses 20 photos/issue; 50-75% supplied by freelance photographers. Needs photos of people (profiles) making the news in philanthropy and environmental shots related to person(s)/organization. Most shots arranged with freelancers are specific. Model release required. Captions required.

Making Contact & Terms: Arrange a personal interview to show portfolio. Send unsolicited photos by mail for consideration. Send 35mm, 2¼×2¼ transparencies and prints by mail for consideration. Provide résumé, business card, brochure, flier or tearsheets to be kept on file for possible assignments. Will send negatives back via certified mail. Reports in 1-2 days. Pays (color and b&w) $225 plus expenses/half day; $350 plus expenses/full day; $75/b&w reprint; $150/color reprint. Pays on publication. Buys one-time rights. Previously published work OK.

CLAVIER, Dept. PM, 200 Northfield Rd., Northfield IL 60093. (847)446-5000. Editor: Elizabeth Hintch. Circ. 20,000. Estab. 1962. Magazine published 10 times/year. Readers are piano and organ teachers. Sample copy $2.

Needs: Human interest photos of keyboard instrument students and teachers. Special needs include synthesizer photos and children performing.

Making Contact & Terms: Send material by mail for consideration. Uses glossy b&w prints. For cover: Kodachrome, glossy color prints or 35mm transparencies. Vertical format preferred. SASE. Reports in 1 month. Pays $100-150/color cover; $10-25/b&w inside photo. Pays on publication. Credit line given. Buys all rights.

Tips: "We look for sharply focused photographs that show action and for clear color that is bright and true. We need photographs of children and teachers involved in learning music at the piano. We prefer shots that show them deeply involved in their work rather than posed shots. Very little is taken on specific assignment except for the cover. Authors usually include article photographs with their manuscripts. We purchase only one or two items from stock each year."

CLEANING & MAINTENANCE MANAGEMENT MAGAZINE, 13 Century Hill Dr., Latham NY 12110. (518)783-1281. Fax: (518)783-1386. E-mail: cleannet@cleannet.com. Website: http://clean net.com. Senior Editor: Tom Williams. Managing Editor: Anne Dantz. Circ. 40,000. Estab. 1963. Monthly. Emphasizes management of cleaning/custodial/housekeeping operations for commercial buildings, schools, hospitals, shopping malls, airports, etc. Readers are middle- to upper-level managers of in-house cleaning/custodial departments, and managers/owners of contract cleaning companies. Sample copy free (limited) with SASE.

Needs: Uses 10-15 photos/issue. Needs photos of cleaning personnel working on carpets, hard floors, tile, windows, restrooms, large buildings, etc. Model release preferred. Captions required.

Making Contact & Terms: Provide résumé, business card, brochure, flier or tearsheets to be kept on file for possible assignments. "Query with specific ideas for photos related to our field." SASE. Reports in 1-2 weeks. Pays $25/b&w inside photo. Credit line given. Rights negotiable. Simultaneous submissions and previously published work OK.

Tips: "Query first and shoot what the publication needs."

CLIMATE BUSINESS MAGAZINE, P.O. Box 13067, Pensacola FL 32591. (904)433-1166. Fax: (904)435-9174. Publisher: Elizabeth A. Burchell. Circ. 15,000. Estab. 1990. Bimonthly magazine.

Emphasizes business. Readers are executives, ages 35-54, with average annual income of $80,000. Sample copy $4.75.

Needs: Uses 50 photos/issue; 20 supplied by freelancers. Needs photos of Florida topics: technology, government, ecology, global trade, finance, travel and life shots. Model/property release required. Captions preferred.

Making Contact & Terms: Send unsolicited photos by mail for consideration. Provide résumé, business card, brochure, flier or tearsheets to be kept on file for possible assignments. Send 5×7 b&w or color prints; 35mm, 2¼×2¼ transparencies. Keeps samples on file. SASE. Reports in 3 weeks. Pays $75/color cover photo; $25/color inside photo; $25/b&w inside photo; $75/color page. Pays on publication. Buys one-time rights.

Tips: "Don't overprice yourself and keep submitting work."

CLUB INDUSTRY MAGAZINE, 1300 Virginia Dr., Suite 400, Fort Washington PA 19034. (215)643-8036. Fax: (215)643-1705. Art Director: Al Feuerstein. Circ. 35,000. Estab. 1980. Monthly magazine. Readers are energetic, goal-oriented male and female fitness executives, ages 25-60. Sample copy free with SASE.

Needs: Uses 5-10 photos/issue; 1-4 supplied by freelancers. Needs photos of health-fitness related, nutrition, active lifestyle. Model release required. Captions required.

Making Contact & Terms: Interested in receiving work from newer, lesser-known photographers. Provide résumé, business card, brochure, flier or tearsheets to be kept on file for possible assignments. Keeps samples on file. Reports based on interest in samples and current needs. Pays $600-1,000/day. Pays on publication. Credit line given. Buys one-time rights; negotiable. Previously published work OK.

COLLISION, Box M, Franklin MA 02038. (508)528-6211. Editor: Jay Kruza. Circ. 20,000. Magazine published every 2 months. Emphasizes "technical tips and management guidelines" for auto body repairmen and dealership managers in eastern US. Sample copy $3. Photo guidelines free with SASE.

Needs: Buys 100 photos/year; 12/issue. Photos of technical repair procedures, association meetings, etc. A regular column called "Stars and Cars" features a national personality with his/her car. Prefers at least 3 b&w photos with captions as to why person likes this vehicle. If person has worked on it or customized it, photo is worth more. Special needs include: best looking body shops in US, includes exterior view, owner/manager, office, shop, paint room and any special features (about 6-8 photos). In created or set-up photos, which are not direct news, requires photocopy of model release with address and phone number of models for verification. Captions required

Making Contact & Terms: Query with résumé of credits and representational samples (not necessarily on subject) or send contact sheet for consideration. Send b&w glossy or matte contact sheet or 5×7 prints. SASE. Reports in 3 weeks. Pays $25 for first photo; $10 for each additional photo in the series; pays $50 for first photo and $25 for each additional photo for "Stars and Cars" column. Prefers to buy 5 or 7 photos per series. Extra pay for accompanying mss. **Pays on acceptance.** Buys all rights, but may reassign to photographer after publication. Simultaneous submissions OK.

Tips: "Don't shoot one or two frames; do a sequence or series. It gives us choice, and we'll buy more photos. Often we reject single photo submissions. Capture how the work is done to solve the problem."

COMMERCIAL CARRIER JOURNAL, Dept. PM, Chilton Way, Radnor PA 19089. (610)964-4513. Editor-in-Chief: Gerald F. Standley. Managing Editor: Paul Richards. Circ. 85,600. Estab. 1911. Monthly magazine. Emphasizes truck and bus fleet maintenance operations and management.

Needs: Spot news (of truck accidents, Teamster activities and highway scenes involving trucks). Photos purchased with or without accompanying ms, or on assignment. Model release required. *Detailed* captions required.

Making Contact & Terms: Send material by mail for consideration. For color photos, uses prints and 35mm transparencies. For covers, uses color transparencies. Uses vertical cover only. Needs accompanying features on truck fleets and news features involving trucking companies. SASE. Reports in 6 weeks. Payment varies. Pays on a per-job or per-photo basis. **Pays on acceptance.** Credit line given. Buys all rights.

THE COMMERCIAL IMAGE, PTN Publications, 445 Broad Hollow Rd., Melville NY 11747. (516)845-2700. Fax: (516)845-7109. Editorial Director: George Schaub. Editor: Steve Shaw. Circ. 46,000. Monthly magazine. "Our emphasis is on the commercial photographer who produces images for a company or organization." Free sample copy and writer's/photo guidelines.

Needs: All mss and photos must relate to the needs of commercial photographers. Photos purchased with accompanying ms. Seeks mss that offer technical or general information of value to commercial photographers, including applications, techniques, case histories. Model/property release required. Captions required.

Making Contact & Terms: Interested in receiving work from newer, lesser-known photographers. Query with story/photo suggestion. Provide letter of inquiry and samples to be kept on file for possible

future assignments. Uses 4×5, 5×7 or 8×10 glossy b&w and color prints or 35mm transparencies; allows other kinds of photos. SASE. Reports in 1 month. Pays $150 minimum/ms, including all photos and other illustrations. Pays on publication. Credit line given. Buys first North American serial rights except photo with text.

Tips: Trend toward "photo/text packages only." In samples wants to see "technical ability, graphic depiction of subject matter and unique application of technique." To break in, "link up with a writer" if not already a writer as well as photographer. Photographers with previously published work in advertising or public relations campaigns have best chance. "We also are looking for top cover shots."

♣CONSTRUCTION COMMENT, 920 Yonge St., 6th Floor, Toronto, Ontario M4W 3C7 Canada. (416)961-1028. Fax: (416)924-4408. Executive Editor: Lori Knowles. Circ. 5,000. Estab. 1970. Semi-annual magazine. Emphasizes construction and architecture. Readers are builders, contractors, architects and designers in the Ottawa area. Sample copy and photo guidelines available.

Needs: Uses 25 photos/issue; 50% supplied by freelance photographers. Needs "straightforward, descriptive photos of buildings and projects under construction, and interesting people shots of workers at Ottawa construction sites." Model release preferred. Captions preferred.

Making Contact & Terms: Arrange a personal interview to show portfolio. Query with résumé of credits or list of stock photo subjects. Provide résumé, business card, brochure, flier or tearsheets to be kept on file for possible assignments. SASE (IRCs). Reports in 1 month. Pays $125/color cover photo; $75/b&w cover photo; $25/color or b&w inside photo. Pays on publication. Credit line given. Buys all rights to reprint in our other publications; rights negotiable. Simultaneous submissions and previously published work OK.

Tips: Looks for "representative photos of Ottawa building projects and interesting construction-site people shots."

***CONSTRUCTION EQUIPMENT GUIDE**, 2627 Mt. Carmel Ave., Glenside PA 19038. (215)885-2900 or (800)523-2200. Fax: (215)885-2910. E-mail: cegglen@aol.com. Editor: Beth Baker. Circ. 80,000. Estab. 1957. Biweekly trade newspaper. Emphasizes construction equipment industry, including projects ongoing throughout the country. Readers are male and female of all ages. Many are construction executives, contractors, dealers and manufacturers. Free sample copy. Photo guidelines free with SASE.

Needs: Uses 75 photo/issue; 20 supplied by freelancers. Needs photos of construction job sites and special event coverage illustrating new equipment applications and interesting projects. Call to inquire about special photo needs for coming year. Model/property release preferred. Captions required for subject identification.

Making Contact & Terms: Interested in receiving work from newer, lesser-known photographers. Send unsolicited photos by mail for consideration. Provide résumé, business card, brochure, flier or tearsheets to be kept on file for possible future assignments. Send any size matte or glossy b&w prints. Keeps samples on file. SASE. Reports in 3 weeks. NPI. Pays on publication. Credit line given. Buys all rights; negotiable. Simultaneous submissions OK.

CONTEMPORARY DIALYSIS & NEPHROLOGY, 6300 Variel Ave., Suite 1, Woodland Hills CA 91367. (818)704-5555. Fax: (818)704-6500. Associate Publisher: Susan Sommer. Circ. 16,300. Estab. 1980. Monthly magazine. Emphasizes renal care (kidney disease). Readers are medical professionals involved in kidney care. Sample copy $4.

Needs: Uses various number of photos/issue. Model release required. Captions required.

Making Contact & Terms: Interested in receiving work from newer, lesser-known photographers. Contact through rep. Send unsolicited photos by mail for consideration. Send 35mm transparencies. Keeps samples on file. SASE. Reports in 2 weeks. NPI. Credit line given.

***CORPORATE CASHFLOW**, 6151 Powers Ferry Rd., Atlanta GA 30339. (404)618-0198. Editor: Dick Gamble. Art Director: Stacy Celota. Circ. 40,000. Estab. 1980. Monthly magazine. Emphasizes corporate treasury management. Readers are senior financial officers of large and mid-sized US corporations. Sample copy available.

Needs: Uses 1 or 2 photos/issue; all supplied by freelancers.

Making Contact & Terms: Provide résumé, business card, brochure, flier or tearsheets to be kept on file for possible assignments. "Atlanta photographers only." Pays $500/color cover photo. **Pays on acceptance.** Credit line given. Buys one-time rights.

CORPORATE DETROIT MAGAZINE, 3031 W. Grand Blvd., Suite 264, Detroit MI 48202. (313)872-6000. Fax: (313)872-6009. Editor: Claire Hinsberg. Circ. 33,000. Monthly independent circulated to senior executives. Emphasizes Michigan business. Readers include top-level executives. Sample copy free with 9×12 SASE. Call Art Director for photo guidelines.

Needs: Uses variable number of photographs; most supplied by freelance photographers; 40% come from assignments. Needs photos of business people, environmental, feature story presentation, mug

shots, etc. Reviews photos with accompanying ms only. Special needs include photographers based around Michigan for freelance work on job basis. Model/property release preferred. Captions required.
Making Contact & Terms: Interested in receiving work from newer, lesser-known photographers. Arrange a personal interview to show portfolio. Query with résumé of credits and samples. SASE. NPI; pay individually negotiated. Pays on publication.

THE CRAFTS REPORT, 300 Water St., Wilmington DE 19801. (302)656-2209. Fax: (302)656-4894. Art Director: Mike Ricci. Circ. 20,000. Estab. 1975. Monthly. Emphasizes business issues of concern to professional craftspeople. Readers are professional working craftspeople. Sample copy $5.
Needs: Uses 15-25 photos/issue; 0-10 supplied by freelancers. Needs photos of professionally-made crafts, craftspeople at work, studio spaces, craft schools—also photos tied to issue theme; i.e. environment, women, etc. Model/property release required; shots of artists and their work. Captions required; include artist, location.
Making Contact & Terms: Interested in receiving work from newer, lesser-known photographers. Arrange personal interview to show portfolio. Query with résumé of credits. Provide résumé, business card, brochure, flier or tearsheets to be kept on file for possible assignments. Keeps samples on file. SASE. Reports in 3 weeks. Pays $250-400/color cover photo; $25/published photo; assignments negotiated. Pays on publication. Credit line given. Buys one-time and first North American serial rights; negotiable. Simultaneous submissions and previously published work OK.
Tips: "Shots of craft items must be professional-quality images. For all images be creative—experiment. Color, b&w and alternative processes considered."

CRANBERRIES, Dept. PM, P.O. Box 858, South Carver MA 02366. (508)866-5055. Fax: (508)866-9291. Publisher/Editor: Carolyn Gilmore. Circ. 850. Monthly, but December/January is a combined issue. Emphasizes cranberry growing, processing, marketing and research. Readers are "primarily cranberry growers but includes anybody associated with the field." Sample copy free.
Needs: Uses about 10 photos/issue; half supplied by freelancers. Needs "portraits of growers, harvesting, manufacturing—anything associated with cranberries." Captions required.
Making Contact & Terms: Send 4×5 or 8×10 b&w or color glossy prints by mail for consideration; "simply query about prospective jobs." SASE. Pays $25-60/b&w cover photo; $15-30/b&w inside photo; $35-100 for text/photo package. Pays on publication. Credit line given. Buys one-time rights. Simultaneous submissions and previously published work OK.
Tips: "Learn about the field."

DAIRY TODAY, Farm Journal Publishing, Inc., Centre Square West, 1500 Market St., Philadelphia PA 19102-2181. (215)557-8959. Fax: (215)568-3989. Website: http://www.farmjournal.com. Photo Editor: Tom Dodge. Circ. 111,000. Monthly magazine. Emphasizes American agriculture. Readers are active farmers, ranchers or agribusiness people. Sample copy and photo guidelines free with SASE.
 ● This company also publishes *Farm Journal, Beef Today, Hogs Today* and *Top Producer*.
Needs: Uses 10-20 photos/issue; 50% supplied by freelancers. "We use studio-type portraiture (environmental portraits), technical, details, scenics." Model release preferred. Captions required.
Making Contact & Terms: Arrange a personal interview to show portfolio. Query with résumé of credits along with business card, brochure, flier or tearsheets to be kept on file for possible assignments. Accepts digital images. "Portfolios may be submitted via CD-ROM or floppy disk." SASE. Reports in 2 weeks. Pays $75-400/color photo; $200-400/day. Pays extra for electronic usage of images. "We pay a cover bonus." **Pays on acceptance.** Credit line given. Buys one-time rights. Simultaneous submissions OK.
Tips: In portfolio or samples, likes to "see about 40 slides showing photographer's use of lighting and ability to work with people. Know your intended market. Familiarize yourself with the magazine and keep abreast of how photos are used in the general magazine field."

DANCE TEACHER NOW, 3101 Poplarwood Court, Suite 310, Raleigh NC 27604-1010. (919)872-7888. Fax: (919)872-6888. E-mail: dancenow@aol.com. Editor: K.C. Patrick. Circ. 8,000. Estab. 1979. Magazine published 10 times per year. Emphasizes dance, business, health and education. Readers are dance instructors and other related professionals, ages 15-90. Sample copy free with 9×12 SASE. Guidelines free with SASE.
Needs: Uses 20 photos/issue; all supplied by freelancers. Needs photos of action shots (teaching, etc.). Reviews photos with accompanying ms only. Model/property release preferred. Model releases required for minors and celebrities. Captions preferred; include date and location.
Making Contact & Terms: Interested in receiving work from newer, lesser-known photographers. Provide résumé, business card, brochure, flier or tearsheets to be kept on file for possible assignments. Keeps samples on file. SASE. Accepts digital images; call art director. Pays $50 minimum/color cover photo; $20/color inside photo; $20/b&w inside photo. Pays on publication. Credit line given. Buys one-time rights plus publicity rights; negotiable. Simultaneous submissions and/or previously published work OK.

■**DELTA DESIGN GROUP, INC.**, 409 Washington Ave., Box 112, Greenville MS 38702. (601)335-6148. Fax: (601)378-2826. President: Noel Workman. Publishes magazines dealing with cotton marketing, dentistry, health care, casino, travel and Southern agriculture.

Needs: Photos used for text illustration, promotional materials and slide presentations. Buys 25 photos/year; offers 10 assignments/year. Southern agriculture (cotton, rice, soybeans, sorghum, forages, beef and dairy, and catfish); California and Arizona irrigated cotton production; all aspects of life and labor on the lower Mississippi River; Southern historical (old photos or new photos of old subjects); recreation (boating, water skiing, fishing, canoeing, camping), casino gambling. Model release required. Captions preferred.

Making Contact & Terms: Query with samples or list of stock photo subjects or mail material for consideration. SASE. Reports in 1 week. Pays $50 minimum/job. Credit line given, except for photos used in ads or slide shows. Rights negotiable. Simultaneous submissions and previously published work OK.

Tips: "Wide selections of a given subject often deliver a shot that we will buy, rather than just one landscape, one portrait, one product shot, etc."

DENTAL ECONOMICS, Box 3408, Tulsa OK 74101. (918)835-3161. Editor: Dick Hale. Circ. 110,000. Monthly magazine. Emphasizes dental practice administration—how to handle staff, patients and bookkeeping and how to handle personal finances for dentists. Free sample copy. Photo and writer's guidelines free with SASE.

Needs: The mss relate to the business side of a practice: scheduling, collections, consultation, malpractice, peer review, closed panels, capitation, associates, group practice, office design, etc." Also uses profiles of dentists.

Making Contact & Terms: Send material by mail for consideration. Uses 8 × 10 b&w glossy prints; 35mm or 2¼ × 2¼ transparencies. "No outsiders for cover." SASE. Reports in 5-6 weeks. NPI. Pays in 30 days. Credit line given. Buys all rights but may reassign to photographer after publication.

Tips: "Write and think from the viewpoint of the dentist—not as a consumer or patient. If you know of a dentist with an unusual or very visual hobby, tell us about it. We'll help you write the article to accompany your photos. Query please."

***DISPLAY & DESIGN IDEAS**, 6255 Barfield Rd., Suite 200, Atlanta GA 30328. (404)252-8831. Fax: (404)252-4436. Managing Editor: Jennifer Bammer. Circ. 20,000. Estab. 1988. Monthly magazine. Emphasizes retail design, store planning, visual merchandising. Readers are retail chain executives in more than 35 retail catagories. Sample copy available.

Needs: Uses 150 photos/issue; less than 5% supplied by freelancers. Needs photos of architecture, mostly interior. Property release preferred.

Making Contact & Terms: Interested in receiving work from newer, lesser-known photographers. Contact through rep. Arrange personal interview to show portfolio. Submit portfolio for review. Query with résumé of credits. Send unsolicited photos by mail for consideration. Provide résumé, business card, brochure, flier or tearsheets to be kept on file for possible future assignments. Send 8 × 10 glossy color prints; 4 × 5 transparencies. Keeps samples on file. SASE. Reports in 3 weeks. Credit line given. Rights negotiable. Simultaneous submissions and/or previously published work OK.

Tips: Looks for architectural interiors, ability to work with different lighting.

EDUCATION WEEK, Dept. PM, 4301 Connecticut Ave. NW, Suite 250, Washington DC 20008. (202)364-4114. Fax: (202)364-1039. Editor-in-Chief: Ronald A. Wolk. Photo Editor: Benjamin Tice Smith. Circ. 65,000. Estab. 1981. Weekly. Emphasizes elementary and secondary education.

Needs: Uses about 20 photos/issue; most supplied by freelance photographers; 90% on assignment, 10% from stock. Model/property release preferred. Model release usually needed for children (from parents). Captions required; include names, ages, what is going on in the picture.

Making Contact & Terms: Interested in receiving work from newer, lesser-known photographers. Query with samples. Provide résumé and tearsheets to be kept on file for possible future assignments. Cannot return material. Reports in 2 weeks. Pays $50-150/b&w photo; $100-300/day; $50-250/job. **Pays on acceptance.** Credit line given. Buys all rights; negotiable. Simultaneous submissions and previously published work OK.

Tips: "When reviewing samples we look for the ability to make interesting and varied images from what might not seem to be photogenic. Show creativity backed up with technical polish."

 THE SOLID, BLACK SQUARE before a listing indicates that the market uses various types of audiovisual materials, such as slides, film or videotape.

ELECTRIC PERSPECTIVES, 701 Pennsylvania Ave. NW, Washington DC 20004. (202)508-5714. Fax: (202)508-5759. Associate Editor: Eric Blume. Circ. 20,000. Estab. 1976. Publication of Edison Electric Institute. Bimonthly magazine. Emphasizes issues and subjects related to investor-owned electric utilities. Sample copy available on request.

Needs: Uses 20-25 photos/issue; 60% supplied by freelancers. Needs photos relating to the business and operational life of electric utilities—from customer service to engineering, from executive to blue collar. Model release required. Captions preferred.

Making Contact & Terms: Interested in receiving work from all photographers, including newer, lesser-known photographers. Query with stock photo list. Send unsolicited photos by mail for consideration. Provide résumé, business card, brochure, flier or tearsheets to be kept on file for possible assignments. Send 8×10 glossy color prints; 35mm, 2¼×2¼, 4×5 transparencies. Keeps samples on file. SASE. Reports in 1 month. Pays $200-400/color cover photo; $100-300/color inside photo; $200-350/color page rate; $750-1,500/photo/text package. Pays on publication. Buys one-time rights; negotiable (for reprints).

Tips: "We're interested in annual-report quality transparencies in particular. Quality and creativity is often more important than subject."

ELECTRICAL APPARATUS, Barks Publications, Inc., 400 N. Michigan Ave., Chicago IL 60611-4198. (312)321-9440. Associate Publisher: Elsie Dickson. Circ. 17,000. Monthly magazine. Emphasizes industrial electrical machinery maintenance and repair for the electrical aftermarket. Readers are "persons engaged in the application, maintenance and servicing of industrial and commercial electrical and electronic equipment." Sample copy $4.

Needs: "Assigned materials only. We welcome innovative industrial photography, but most of our material is staff-prepared." Photos purchased with accompanying ms or on assignment. Model release required "when requested." Captions preferred.

Making Contact & Terms: Query with résumé of credits. Contact sheet or contact sheet with negatives OK. SASE. Reports in 3 weeks. Pays $25-100/b&w or color. Pays on publication. Credit line given. Buys all rights, but exceptions are occasionally made.

ELECTRICAL WHOLESALING, 9800 Metcalf, Overland Park KS 66212-2215. (913)967-1797. Fax: (913)967-1905. Art Director: Cheri Jones. Monthly magazine. Emphasizes electrical wholesale business. Readers are male and female executives, electrical distributors and contractors, salespeople (ages 30-65) in the electrical wholesale business. Sample copy free with 9×12 SAE and 10 first-class stamps.

Needs: Uses 15 photos/issue; 3 supplied by freelancers. Needs color photos of executive portraits, photo/illustration. Special photos include executive portraits, company profile photos, photo/illustration. Model release required. Property release preferred.

Making Contact & Terms: Interested in receiving work from newer, lesser-known photographers. Provide business card, brochure or tearsheets to be kept on file for possible assignments. Keeps samples on file. SASE. Reports in 3 weeks. Pays $400-1,000/job; $700-900/color cover photo; $450-700/color inside photo. Credit line given. Rights negotiable. Simultaneous submissions and previously published work OK.

Tips: Looks for "a natural sense of working with people, location capability, good color sense, an ability to make mundane subjects seem interesting using mood, color, composition, etc. We only use color photos. We run a small operation, which often forces us to be ingenious and flexible and creative. We look for similar characteristics in the people we hire."

EMERGENCY, The Journal of Emergency Services, 6300 Yarrow Dr., Carlsbad CA 92009. (619)438-2511 or (800)365-7827. Fax: (619)931-5809. E-mail: emergency@aol.com. Editor: Doug Fiske. Circ. 26,000. Estab. 1969. Monthly magazine. Emphasizes prehospital emergency medical and rescue services for paramedics, EMTs and firefighters to keep them informed of latest developments in the emergency medical services field. Sample copy $5.

• *Emergency* customizes photos in PhotoShop.

Needs: Buys 200 photos/year; 12 photos/issue. Documentary and spot news dealing with prehospital emergency medicine. Needs shots to accompany unillustrated articles submitted and cover photos; year's calendar of themes forwarded on request with #10 SASE. "Try to get close to the action; both patient and emergency personnel should be visible. All medics pictured *must* be wearing gloves and using any other necessary universal precautions." Photos purchased with or without accompanying ms. Model and property releases preferred. Captions required; include the name, city and state of the emergency rescue team and medical treatment being rendered in photo. Also needs color transparencies for "Action," a photo department dealing with emergency personnel in action. Accompanying mss: instructional, descriptive or feature articles dealing with emergency medical services.

Making Contact & Terms: Interested in receiving work from newer, lesser-known photographers. Uses 5×7 b&w or color glossy prints; 35mm or larger transparencies. For cover: Prefers 35mm; 2¼×2¼ transparencies OK. Vertical format preferred. Send material by mail for consideration, espe-

AN INTERTEC® PUBLICATION • $5.04 • DECEMBER 1995

ELECTRICAL
WHOLESALING®

Fairmont Supply Co.
W.T. Todd II shares a wealth of experience in integrated supply

Strategic planning
Remembering 1995

© 1995 Mark Portland

Mark Portland was assigned to photograph W.T. Todd II, president of Fairmont Supply Co., for a cover and article in *Electrical Wholesaling* magazine. "(Art Director) Cheri Jones needed a dramatic cover photo of the president. I wanted to relate him to the products his company sells in a subtle way," says Portland, who photographed the man in a bright red jacket with company logo. Working with the magazine helped Portland in building his referral network, "and it's always enjoyable to be with and photograph people."

cially shots of EMTs/paramedics in action. SASE. Pays $30/inside photo; $100/color cover photo; $100-400/ms. Pays for mss/photo package, or on a per-photo basis. **Pays on acceptance.** Credit line given. Buys all rights, "nonexclusive."
Tips: Wants well-composed photos with good overall scenes and clarity that say more than "an accident happened here. We're going toward single-focus, uncluttered photos." Looking for more color photos for articles. "Good closeups of actual treatment. Also, sensitive illustrations of the people in EMS—stress, interacting with family/pediatrics etc. We're interested in rescuers, and our readers like to see their peers in action, demonstrating their skills. Make sure photo is presented with treatment rendered and people involved.

EMPIRE STATE REPORT, 3/F, 4 Central Ave., Albany NY 12210. (518)465-5502. Fax: (518)465-9822. Editor: Victor Schaffner. Circ. 15,000. Estab. 1976. Monthly magazine. Emphasizes New York state politics and public policy. Readers are state policy makers and those who wish to influence them. Sample copy with 8½×11 SAE and 6 first-class stamps.
Needs: Uses 10-20 photos/issue; 5-10 supplied by freelancers. Needs photos of New York state personalities (political, government, business); issues; New York state places, cities, towns. Model/property release preferred. Captions preferred; include subject matter of photo.
Making Contact & Terms: Interested in receiving work from newer, lesser-known photographers. Send unsolicited photos by mail for consideration. Provide résumé, business card, brochure, flier or tearsheets to be kept on file for possible assignments. Keeps samples on file. SASE. Reports in 3 weeks. Pays $150-300/color cover photo; $50-75/b&w inside photo. Pays on publication. Credit line given. Buys one-time rights. Simultaneous submissions and previously published work OK.
Tips: "Subject matter is the most important consideration at ESR. The subject must have a New York connection. But, on some occasions, a state issue can be illustrated with a more general photograph."

ERGONOMICS IN DESIGN, P.O. Box 1369, Santa Monica CA 90406-1369. (310)394-1811. Fax: (310)394-2410. E-mail: 72133.1474@compuserve.com. Website: http://hfes.vt.edu/hfes. Managing Editor: Lois Smith. Circ. 6,000. Estab. 1993. Publication of Human Factors and Ergonomics Society. Quarterly magazine. Emphasizes how ergonomics research is applied to tools, equipment and systems people use. Readers are BA/MA/PhDs in psychology, engineering and related fields. Sample copy $9.
Needs: Needs photos of technology areas such as medicine, transportation, consumer products. Model/property release preferred. Captions preferred.
Making Contact & Terms: Interested in receiving work from newer, lesser-known photographers. Query with stock photo list. Keeps samples on file. SASE. Reports in 2 weeks. Also accepts digital

images; inquire before submitting. Pays on publication. Credit line given. Buys one-time rights. Simultaneous submissions and previously published work OK.

Tips: Wants to see high-quality color work for strong (sometimes subtle) cover that can also be modified in b&w for lead feature opener inside book.

EUROPE, 2300 M St. NW, Washington DC 20037. (202)862-9557. Editor-in-Chief: Robert J. Guttman. Managing Editor: Peter Gwin. Photo Editor: Anne Alvarez. Circ. 25,000. Magazine published 10 times a year. Covers the Europe Union with "in-depth news articles on topics such as economics, trade, US-EU relations, industry, development and East-West relations." Readers are "business people, professionals, academics, government officials." Free sample copy.

Needs: Uses about 20-30 photos/issue, most of which are supplied by stock houses and freelance photographers. Needs photos of "current news coverage and sectors, such as economics, trade, small business, people, transport, politics, industry, agriculture, fishing, some culture, some travel. No traditional costumes. Each issue we have an overview article on one of the 15 countries in the European Union. For this we need a broad spectrum of photos, particularly color, in all sectors. If a photographer queries and lets us know what he has on hand, we might ask him to submit a selection for a particular story. For example, if he has slides or b&ws on a certain European country, if we run a story on that country, we might ask him to submit slides on particular topics, such as industry, transport or small business." Model release preferred. Captions preferred; identification necessary.

Making Contact & Terms: Interested in receiving work from newer, lesser-known photographers. Query with list of stock photo subjects. Initially, a list of countries/topics covered will be sufficient. SASE. Reports in 1 month. Pays $75-150/b&w photo; $100 minimum/color transparency for inside; $400/cover; per job negotiable. Pays on publication. Credit line given. Buys one-time rights. Simultaneous submissions and previously published work OK.

Tips: "For certain articles, especially the Member States' Reports, we are now using more freelance material than previously. We need good photo and color quality, but not touristy or stereotypical. We want to show modern Europe growing and changing. Feature business or industry if possible."

FACILITIES DESIGN & MANAGEMENT, 1 Penn Plaza, New York NY 10109. (212)615-2616. Fax: (212)279-3955. Art Director: Lyndon Lorenz. Circ. 35,000. Estab. 1981. Monthly magazine. Emphasizes corporate space planning, real estate and office furnishings. Readers are executive-level management. Free sample copy.

Needs: Uses 30-50 photos/issue; 3-5 supplied by freelancers. Needs photos of executive-level decision makers photographed in their corporate environments. Special photo needs include monthly photo shots. Model release preferred.

Making Contact & Terms: Interested in receiving work from newer, lesser-known photographers. Arrange personal interview to show portfolio. Keeps samples on file. Cannot return material. Reports in 1-2 weeks. Pays $700-900/day. **Pays on acceptance.** Credit line given. Buys one-time rights. Simultaneous submissions OK.

Tips: Looking for "a strong combination of architecture and portraiture."

FARM CHEMICALS, Dept. PM, 37733 Euclid Ave., Willoughby OH 44094. (216)942-2000. Fax: (216)942-0662. Editorial Director: Charlotte Sine. Editor: Dale Little. Circ. 32,000. Estab. 1894. Monthly magazine. Emphasizes application and marketing of fertilizers and protective chemicals for crops for those in the farm chemical industry. Free sample copy and photo guidelines with 9 × 12 SAE.

Needs: Buys 6-7 photos/year; 5-30% supplied by freelancers. Photos of agricultural chemical and fertilizer application scenes (of commercial—not farmer—applicators). Model release preferred. Captions required.

Making Contact & Terms: Query first with résumé of credits. Uses 8 × 10 glossy b&w and color prints or transparencies. SASE. Reports in 3 weeks. Pays $25-50/b&w photo; $50-125/color photo. **Pays on acceptance.** Buys one-time rights. Simultaneous submissions and previously published work OK.

FARM JOURNAL, INC., Centre Square West, 1500 Market St., Philadelphia PA 19102-2181. (215)557-8959. Fax: (215)568-3989. Editor: Sonja Hillgren. Photo Editor: Tom Dodge. Circ. 800,000. Estab. 1877. Monthly magazine. Emphasizes the business of agriculture: "Good farmers want to know what their peers are doing and how to make money marketing their products." Free sample copy upon request.

 ● This company also publishes *Top Producer, Hogs Today, Beef Today* and *Dairy Today. Farm Journal* has received the Best Use of Photos/Design from the American Agricultural Editors' Association (AAEA).

Needs: Freelancers supply 60% of the photos. Photos having to do with the basics of raising, harvesting and marketing of all the farm commodities. People-oriented shots are encouraged. Also uses human interest and interview photos. All photos must relate to agriculture. Photos purchased with or without accompanying ms. Model release required. Captions required.

Making Contact & Terms: Arrange a personal interview or send photos by mail. Provide calling card and samples to be kept on file for possible future assignments. Uses glossy or semigloss color or b&w prints; 35mm or 2¼×2¼ transparencies, all sizes for covers. SASE. Reports in 1 month. Pays by assignment or photo. Pays $200-400/job. Cover bonus. **Pays on acceptance.** Credit line given. Buys one-time rights; negotiable. Simultaneous submissions OK.

Tips: "Be original, take time to see with the camera. Be selective. Look at use of light—available or strobed—and use of color. I look for an easy rapport between photographer and subject. Take as many different angles of subject as possible. Use fill where needed."

FIRE CHIEF, 35 E. Wacker, Suite 700, Chicago IL 60601. (312)726-7277. Fax: (312)726-0241. E-mail: firechfmag@connectinc.com. Editor: Scott Baltic. Circ. 45,000. Estab. 1956. Monthly magazine. Emphasizes fire department management and operations. Readers are overwhelmingly fire officers and predominantly chiefs of departments. Free sample copy. Photo guidelines free with SASE.

Needs: Uses 1 photo/issue; 1 supplied by freelancers. Needs photos of a fire chief in action at an emergency scene. "Contact us for a copy of our current editorial calendar." Model/property release preferred. Captions required; include names, dates, brief description of incident.

Making Contact & Terms: Interested in receiving work from newer, lesser-known photographers. Send unsolicited photos by mail for consideration. Send any glossy color prints; 35mm, 2¼×2¼ transparencies. Keeps samples on file. SASE. Reports in 1 month. Pays $75/color cover photo; $20-25/color inside photo. Pays on publication. Buys first serial rights; negotiable.

Tips: "We want a photo that captures a chief officer in command at a fire or other incident, that speaks to the emotions (the burden of command, stress, concern for others). Most of our cover photographers take dozens of fire photos every month. These are the guys who keep radio scanners on in the background most of the day. Timing is everything."

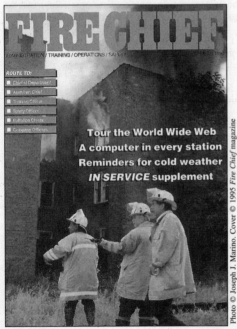

This dramatic cover photo was shot as stock by New Britain, Connecticut, photographer Joseph J. Marino, who sold reprint rights to *Fire Chief* magazine for $75. "I liked the immediacy of the shot, its candid, spontaneous nature," says *Fire Chief* editor Scott Baltic. "The composition also worked well, with room for our logo and cover lines, but with flames still showing clearly."

FIRE ENGINEERING, Park 80 West Plaza 2, 7th Floor, Saddle Brook NJ 07663. (201)845-0800. Fax: (201)845-6275. Editor: Bill Manning. Estab. 1877. Magazine. Training magazine for firefighters. Photo guidelines free with SASE.

Needs: Uses 100 photos/year. Needs action photos of firefighters working. Captions required; include date, what is happening, location and fire department contact.

Making Contact & Terms: Interested in receiving work from newer, lesser-known photographers. Send unsolicited photos by mail for consideration. Send prints; 35mm transparencies. SASE. "We accept scans of photos as long as high-resolution version." Reports in up to 3 months. Pays $50-300/color inside photo; $50-300/b&w inside photo. Pays on publication. Credit line given. Rights negotiable.

Tips: "Firefighters must be doing something. Our focus is on training and learning lessons from photos."

FIREHOUSE MAGAZINE, 445 Broad Hollow Rd., Suite 21, Melville NY 11747. (516)845-2700. Fax: (516)845-7109. Editor-in-Chief: Harvey Eisner. Circ. 110,000. Estab. 1973. Monthly. Emphasizes "firefighting—notable fires, techniques, dramatic fires and rescues, etc." Readers are "paid and volunteer firefighters, EMT's." Sample copy $3 with 9×12 SAE and approximately 6 first-class stamps. Photo guidelines free with SASE.
Needs: Uses about 30 photos/issue; 20 supplied by freelance photographers. Needs photos in the above subject areas. Model release preferred.
Making Contact & Terms: Send 8×10 matte or glossy b&w or color prints; 35mm, $2\frac{1}{4} \times 2\frac{1}{4}$, 4×5, 8×10 transparencies or b&w or color negatives with contact sheet by mail for consideration. "Photos must not be more than 30 days old." SASE. Reports ASAP. Pays $200/color cover photo; $15-45/b&w photo; $15-75/color photo. Pays on publication. Credit line given. Buys one-time rights.
Tips: "Mostly we are looking for action-packed photos—the more fire, the better the shot. Show firefighters in full gear, do not show spectators. Fire safety is a big concern. Much of our photo work is freelance. Try to be in the right place at the right time as the fire occurs."

■**FLORAL MANAGEMENT MAGAZINE**, 1601 Duke St., Alexandria VA 22314. (703)836-8700. Fax: (703)836-8705. Editor and Publisher: Kate Penn. Estab. 1894. National trade association magazine representing growers, wholesalers and retailers of flowers and plants. Photos used in magazine and promotional materials.
Needs: Offers 15-20 assignments/year. Needs photos of floral business owners and employees on location. Reviews stock photos. Model release required. Captions preferred.
Audiovisual Needs: Uses slides (with graphics) for convention slide shows.
Making Contact & Terms: Interested in receiving work from newer, lesser-known photographers. Query with samples. Provide résumé, business card, brochure, flier or tearsheets to be kept on file for possible future assignments. Uses b&w prints, or transparencies. SASE. Reports in 1 week. Pays $400-600/cover shot; $75-150/hour; $125-250/job; $75-500/color photo. Credit line given. Buys one-time rights.
Tips: "We shoot a lot of tightly composed, dramatic shots of people so we look for these skills. We also welcome input from the photographer on the concept of the shot. Our readers, as business owners, like to see photos of other business owners. Therefore, people photography, on location, is particularly popular."

FLORIDA UNDERWRITER, Dept. PM, 9887 Fourth St. N., Suite 230, St. Petersburg FL 33702. (813)576-1101. Editor: James E. Seymour. Circ. 10,000. Estab. 1984. Monthly magazine. Emphasizes insurance. Readers are insurance professionals in Florida. Sample copy free with 9×12 SASE.
Needs: Uses 10-12 photos/issue; 1-2 supplied by freelancers; 80% assignment and 20% freelance stock. Needs photos of insurance people, subjects, meetings and legislators. Captions preferred.
Making Contact & Terms: Query first with list of stock photo subjects. Send b&w prints, 35mm, $2\frac{1}{4} \times 2\frac{1}{4}$, 4×5, 8×10 transparencies by mail for consideration. Provide résumé, business card, brochure, flier or tearsheets to be kept on file for possible assignments. SASE. Reports in 3 weeks. Pays $50-150/b&w cover photo; $15-35/b&w inside photo; $5-20/color page rate. Pays on publication. Credit line given. Buys all rights; negotiable. Simultaneous submissions and previously published work OK (admission of same required).
Tips: "Like the insurance industry we cover, we are cutting costs. We are using fewer freelance photos (almost none at present)."

FOOD & SERVICE, P.O. Box 1429, Austin TX 78767-1429. Art Director: Neil Ferguson. Circ. 6,500. Estab. 1940. Publication of the Texas Restaurant Association. Published 8 times a year. Emphasizes restaurant owners and managers in Texas—industry issues, legislative concerns, management techniques. Readers are restaurant owners/operators in Texas. Sample copy free with 10×13 SAE and 6 first-class stamps. Photo guidelines free with SASE.
Needs: Uses 1-3 photos/issue; 1-3 supplied by freelancers. Needs editorial photos illustrating business concerns (i.e. health care issues, theft in the workplace, economic outlooks, employee motivation, etc.) Reviews photos purchased with or without a manuscript (but prefers with). Model release required for paid models. Property release preferred for paid models.
Making Contact & Terms: Interested in receiving work from newer, lesser-known photographers. Provide résumé, business card, brochure, flier or tearsheets to be kept on file for possible assignments. Accepts digital images in Photoshop 300 DPI RGB files on magnetic optical 230 drive for Macintosh. Deadlines: 2-3 week turnaround from assignment date. Keeps samples on file. SASE. Reports in 2 months. Pays $75-450/job; $200-450/color cover photo; $200-300/b&w cover photo; $200-300/color inside photo; $100-250/b&w inside photo. **Pays on acceptance**. Credit line given. Buys one-time rights. Previously published work OK.

Tips: "Please don't send food shots—even though our magazine is called *Food & Service*. We publish articles about the food service industry that interest association members—restaurant owners and operators (i.e. legislative issues like health care; motivating employees; smokers' vs. non-smokers' rights; proper food handling; plus, occasional member profiles. Avoid clichés and over-used trends. Don't be weird for weird's sake. Photos in our magazines must communicate (and complement the editorial matter)."

***FOOD DISTRIBUTION MAGAZINE**, 406 Water St., Warren RI 02885. (401)245-4500. Fax: (401)245-4699. Art Director: Chris Izzo. Circ. 35,000. Estab. 1959. Monthly magazine. Emphasizes gourmet and specialty foods. Readers are male and female executives, ages 30-60. Sample copy $5.
Needs: Uses 20 photos/issue; 3 supplied by freelancers. Needs photos of food, still-life, human interest, people. Reviews photos with accompanying ms only. Model release required for models only. Captions preferred; include photographer's name, subject.
Making Contact & Terms: Send unsolicited photos by mail for consideration. Send any size color prints and 4×5 transparencies. SASE. Reports in 1-2 weeks. Pays $100 minimum/color cover photo; $50 minimum/color inside photo. Pays on publication. Credit line given. Buys all rights. Simultaneous submissions OK.

FOOD PRODUCT DESIGN MAGAZINE, 3400 Dundee Rd., Suite 100, Northbook IL 60062. (847)559-0385. Fax: (847)559-0389. Art Director: Barbara Weeks. Circ. 26,000. Estab. 1991. Monthly. Emphasizes food development. Readers are research and development people in food industry.
Needs: Needs food shots (4-color). Special photo needs include food shots—pastas, cheese, reduced fat, meat products, sauces, etc.; as well as group shots of people, lab shots, focus group shots.
Making Contact & Terms: Interested in receiving work from newer, lesser-known photographers. Query with stock photo list. Send unsolicited photos by mail for consideration. Call. Send color prints; 35mm, 4×5, 8×10 transparencies. SASE. Reports in 1-2 weeks. Pays on publication. Credit line given. Buys all rights for use in magazine. Simultaneous submissions and/or previously published work OK.
Tips: Prefers to work with local photographers.

FORD NEW HOLLAND NEWS, Dept. PM, P.O. Box 1895, New Holland PA 17557. (717)355-1276. Editor: Gary Martin. Circ. 400,000. Estab. 1960. Published 8 times a year. Emphasizes agriculture. Readers are farm families. Sample copy and photo guidelines free with 9×12 SASE.
Needs: Buys 30 photos/year. 50% freelance photography/issue from assignment and 50% freelance stock. Needs photos of scenic agriculture relating to the seasons, harvesting, farm animals, farm management and farm people. Model release required. Captions required.
Making Contact & Terms: "Show us your work." SASE. Reports in 2 weeks. "Collections viewed and returned quickly." Pays $50-500/color photo, depends on use and quality of photo; $400-1,500/photo/text package; $500/cover. Payment negotiable. **Pays on acceptance.** Buys first North American serial rights. Previously published work OK.
Tips: Photographers "must see beauty in agriculture and provide meaningful photojournalistic caption material to be successful here. It also helps to team up with a good agricultural writer and query us on a photojournalistic idea."

FOREST LANDOWER, (formerly *Forest Farmer*), P.O. Box 95385, Atlanta GA 30347. (404)325-2954. Fax: (404)325-2955. Managing Editor: Steve Newton. Circ. 6,700. Estab. 1950. Publication of Forest Landowners Association. Bimonthly magazine. Emphasizes forest management and forest policy issues for private forest landowners. Readers are forest landowners and consultants, 80% male, average age 55. Sample copy $3 (magazine), $25 (manual).
Needs: Uses 15-25 photos/issue; 3-4 supplied by freelancers. Needs photos of unique or interesting southern forests. Model/property release preferred. Captions preferred.
Making Contact & Terms: Send unsolicited photos by mail for consideration. Query with stock photo list. Send 5×7 color prints; 35mm transparencies. Deadlines: "The 10th of all even numbered months." Keeps samples on file. SASE. Reports in 3 weeks. Pays $200-300/hour; $100-200/b&w cover photo; $75-100/b&w inside photo. Pays on publication. Credit line given. Buys one-time and all rights; negotiable. Simultaneous submissions and previously published work OK.
Tips: "We are a small shop with limited resources. Consequently we use more computer images to save time. Digitized images are acceptable."

FUTURES MAGAZINE, 219 Parkade, Cedar Falls IA 50613. Fax: (319)277-5803. Website: http://www.futuresmag.com. Managing Editor: Kristin Beane-Sullivan. Circ. 70,000. Monthly magazine. Emphasizes futures and options trading. Readers are individual traders, institutional traders, brokerage firms, exchanges. Sample copy $4.50.

Needs: Uses 1-5 photos/issue; 80% supplied by freelance photographers. Needs mostly personality portraits of story sources, some mug shots, trading floor environment. Model release required. Captions preferred.

Making Contact & Terms: Arrange a personal interview to show portfolio. Query with list of stock photo subjects. Provide résumé, business card, brochure, flier or tearsheets to be kept on file for possible future assignments. SASE. Reports in 2 weeks. NPI. Pays on publication. Credit line given.

Tips: All work is on assignment. Be competitive on price. Shoot good work without excessive film use.

GAS INDUSTRIES, 6301 Gaston Ave., Suite 541, Dallas TX 75214. (214)827-4630. Fax: (214)827-4758. Associate Publisher: Ruth W. Stidger. Circ. 11,000. Estab. 1956. Monthly magazine. Emphasizes natural gas utilities and pipelines. Readers are mostly male managers and engineers, ages 30-65. Sample copy free with 9×12 SAE and 4 first-class stamps.

Needs: Uses 12 photos/issue; 20% supplied by freelancers. Needs photos of workers laying, repairing pipelines; gas utility crews on the job. Special photo needs include plastic pipe cover; new gas meter technology cover; assigned industry figure shots. Model release required. "Releases required unless photo is shot in public place. Captions required; include names of people in photos; names of contractors or utilities' crews in pictures.

Making Contact & Terms: Interested in receiving work from newer, lesser-known photographers. Send unsolicited photos by mail for consideration. Send 8×10 color prints; 35mm, 2¼×2¼, 4×5, 8×10 transparencies. Does not keep samples on file. SASE. Reports in 2 weeks. Pays $200-300/color cover photo. **Pays on acceptance.** Credit line given. Buys first North American serial rights; negotiable. Simultaneous submissions and previously published work OK.

***GENERAL AVIATION NEWS & FLYER**, Dept. PM, P.O. Box 39099, Tacoma WA 98439-0099. (206)471-9888. Fax: (206)471-9911. Managing Editor: Kirk Gormley. Circ. 35,000. Estab. 1949. Biweekly tabloid. Emphasizes aviation. Readers are pilots and airplane owners and aviation professionals. Sample copy $3. Photo guidelines free with SASE.

Needs: Uses 30-40 photos/issue; 10-50% supplied by freelancers. Reviews photos with or without ms, but "strongly prefer with ms." Especially wants to see "travel and destinations, special events."

Making Contact & Terms: Interested in receiving work from newer, lesser-known photographers. Query with résumé of credits. Captions preferred. Send unsolicited prints (up to 8×10, b&w or color) or transparencies (35mm or 2¼×2¼) by mail for consideration. Does not keep samples on file. SASE. Reports in 1 month. Pays $35-50/color cover photo; $35/color inside photo; $10/b&w inside photo. Pays on publication. Credit line given. Buys one-time rights.

Tips: Wants to see "sharp photos of planes with good color, airshows not generally used."

GEOTECHNICAL FABRICS REPORT, 345 Cedar St., Suite 800, St. Paul MN 55101. (612)222-2508 or (800)225-4324. Fax: (612)222-8215. Editor: Dawn A. Sawwel. Circ. 14,000. Estab. 1983. Published 9 times/year. Emphasizes geosynthetics in civil engineering application. Readers are civil engineers, professors and consulting engineers. Sample copies available. Photo guidelines available.

Needs: Uses 10-15 photos/issue; various number supplied by freelancers. Needs photos of finished applications using geosynthetics, photos of the application process. Reviews photos with or without ms. Model release required. Captions required; include project, type of geosynthetics used and location.

Making Contact & Terms: Interested in receiving work from newer, lesser-known photographers. Send unsolicited photos by mail for consideration. Send any size color and b&w prints. Keeps samples on file. SASE. Reports in 1 month. NPI. Payment negotiable. Credit line given. Buys all rights; negotiable. Simultaneous submissions OK.

Tips: "Contact manufacturers in the geosynthetics industry and offer your services. We will provide a list, if needed."

***GOVERNMENT IMAGING**, 1738 Elton Rd., #304, Silver Spring MD 20903. (301)445-4405. Fax: (301)445-5722. Editor: R.V. Head. Circ. 32,000. Estab. 1992. Monthly newspaper. Emphasizes document imaging. Readers are federal, state and local government executives. Sample copy free with SASE.

Needs: Uses 10 photos/issue. Needs photos of technology, animals, people. Model/property release preferred. Captions preferred.

Making Contact & Terms: Interested in receiving work from newer, lesser-known photographers. Query with résumé of credits. Send unsolicited photos by mail for consideration. Provide résumé, business card, brochure, flier or tearsheets to be kept on file for possible future assignments. Send color or b&w prints; 35mm transparencies. Keeps samples on file. SASE. Reports in 1 month. NPI. Pays on publication. Credit line given. Buys one-time rights. Simultaneous submissions and/or previously published work OK.

GOVERNMENT TECHNOLOGY, 9719 Lincoln Village, #500, Sacramento CA 95827. (916)363-5000. Fax: (916)363-5197. Creative Director: Michelle MacDonnell. Circ. 55,000. Estab. 1988.

Monthly tabloid. Emphasizes technology in state and local government—no federal. Readers are male and female state and local government executives. Sample copy free with tabloid-sized SAE and 10 first-class stamps.

Needs: Uses 20-30 photos/issue; 1-5 supplied by freelancers. Needs photos of action or aesthetic—technology in use in state and local government, ex: fire department, city hall, etc. Model/property release required; model and government agency. Captions preferred; who, what and where.

Making Contact & Terms: Interested in receiving work from newer, lesser-known photographers. Send unsolicited photos by mail for consideration. Send 35mm, 2¼×2¼, 4×5, 8×10 transparencies. Cannot return materials. Reports back when used. Pays $100-200/color cover photo; $25-75/color inside photo; $10-50/b&w inside photo. Pays on publication. Credit line given. Buys all rights; negotiable. Simultaneous submissions and previously published work OK.

Tips: Looking for "before and after shots. Photo sequences that tell the story. Get copies of our magazine. Tell me their location if they are willing to do assignments on spec."

GRAIN JOURNAL, Dept. PM, 2490 N. Water St., Decatur IL 62526. (217)877-9660. Fax: (217)877-6647. Editor: Ed Zdrojewski. Circ. 11,303. Bimonthly. Emphasizes grain industry. Readers are "elevator managers primarily as well as suppliers and others in the industry." Sample copy free with 10×12 SAE and 3 first-class stamps.

Needs: Uses about 6 photos/issue. "We need photos concerning industry practices and activities. We look for clear, high-quality images without a lot of extraneous material." Captions preferred.

Making Contact & Terms: Query with samples and list of stock photo subjects. SASE. Reports in 1 week. Pays $100/color cover photo; $30/b&w inside photo. Pays on publication. Credit line given. Buys all rights; negotiable.

***GROUP MAGAZINE**, 2890 N. Monroe Ave., Loveland CO 80538. (303)669-3836. Fax: (303)669-3269. Administrative Assistant: Angela Wilson. Circ. 50,000. Estab. 1974. Magazine published 8 times/year. Sample copy $1 and 9×12 SAE with 2 first-class stamps. Photo guidelines free with SASE.

Needs: Uses 20-25 photos/issue; 3-6 supplied by freelancers. Needs photos of activities and settings related to families, teenagers, adults, adults and teenagers together. Model release required.

Making Contact & Terms: Interested in receiving work from newer, lesser-known photographers. Send unsolicited photos by mail for consideration. Send 8×10 b&w prints; 35mm, 2¼×2¼, 4×5 transparencies. Keeps samples on file. SASE. Reports in 1 month. Pays $350 & up/color cover photo; $300 & up/b&w cover photo; $65 & up/color inside photo; $35 & up/b&w inside photo. **Pays on acceptance.** Credit line given. Buys one-time and multimedia rights. Simultaneous submissions and previously published work OK.

Tips: "We seek to portray people in a variety of ethnic cultural and socio-economic backgrounds in our publications and the ability of a photographer to portray emotion in photos. One of our greatest ongoing needs is for good contemporary photos of black, hispanic, Asian American, Native American adults, teenagers and children as well as photos portraying a mix of ethnic groups. Also, candid, real-life shots are highly preferable to posed ones."

THE GROWER, 10901 W. 84th Terrace, Lenexa KS 66214. (913)438-8700. Fax: (913)438-0697. Managing Editor: Steve Buckner. Circ. 27,500. Estab. 1967. Monthly magazine. Emphasizes commercial fruit and vegetable production. "*The Grower* targets male and female fruit and vegetable growers, ages 21 and older." Free sample copy. Photo guidelines free with SASE.

Needs: Uses 15-40 photos/issue; 5-10 supplied by freelancers. Needs vegetable field shots (irrigation, planting, harvesting, packing); orchard-related shots (growing, pruning, harvesting, spraying). Model/property release required for all posed shots. Captions preferred; include where shot was taken, name of crop.

Making Contact & Terms: Interested in receiving work from newer, lesser-known photographers. Provide résumé, business card, brochure, flier or tearsheets to be kept on file for possible assignments. Keeps samples on file. SASE. Reports in 2 weeks. Pays $10-15/hour; $200-300/color cover photo; $50-100/color inside photo. **Pays on acceptance.** Buys all rights.

Tips: "We are looking only for shots pertaining to fruit and vetetable production—not shots of fruit in baskets. We'd consider odd angles, different perspectives. Know our magazine and our audience. Call us with questions or for sample issues."

THE GROWING EDGE, 215 SW Second St., P.O. Box 1027, Corvallis OR 97333. (503)757-2511. Fax: (503)757-0028. E-mail: tcoene@csos.orst.edu. Editor: Trisha Coene. Circ. 20,000. Estab. 1989. Published quarterly. Emphasizes "new and innovative techniques in gardening indoors, outdoors and in the greenhouse—hydroponics, artificial lighting, greenhouse operations/control, water conservation, new and unusual plant varieties." Readers are serious amateurs to small commercial growers.

Needs: Uses about 20 photos per issue; most supplied with articles by freelancers. Occasional assignment work (5%); 80% from freelance stock. Model release required. Captions preferred; include plant types, equipment used.

Making Contact & Terms: Interested in receiving work from newer, lesser-known photographers. Send query with samples. Accepts b&w or color prints; transparencies (any size); b&w or color negatives with contact sheets. SASE. Reports in 6 weeks or will notify and keep material on file for future use. Pays $175/cover photos; $25-50/b&w photos; $25-175/color; $75-400/text/photo package. Pays on publication. Credit line given. Buys first world and one-time anthology rights; negotiable. Simultaneous submissions and/or previously published work OK.

Tips: "Most photographs are used to illustrate processes and equipment described in text. Some photographs of specimen plants purchased. Many photos are of indoor plants under artificial lighting. The ability to deal with tricky lighting situations is important." Expects more assignment work in the future.

HEARTH AND HOME, Dept. PM, P.O. Box 2008, Laconia NH 03247. (603)528-4285. Fax: (603)524-0643. Editor: Richard Wright. Circ. 22,000. Monthly magazine. Emphasizes new and industry trends for specialty retailers and manufacturers of solid fuel and gas appliances, hearth accessories and casual furnishings. Sample copy $5.
 ● This publication scans images and stores them electronically.
Needs: Uses about 30 photos/issue; 30% supplied by freelance photographers. Needs "shots of energy and patio furnishings stores (preferably a combination store), retail displays, wood heat installations, fireplaces, wood stoves and lawn and garden shots (installation as well as final design). Assignments available for interviews, conferences and out-of-state stories." Model release required; captions preferred.
Making Contact & Terms: Interested in receiving work from newer, lesser-known photographers. Query with samples or list of stock photo subjects. Send color glossy prints, transparencies by mail for consideration. Also accepts digital images with color proof in Photoshop, CMYK and SyQuest. SASE. Reports in 2 weeks. Pays $50-300/color photo, $250-750/job. Pays within 60 days. Credit line given. Buys various rights. Simultaneous and photocopied submissions OK.
Tips: "Call and ask what we need. We're *always* on the lookout for material."

❦**HEATING, PLUMBING & AIR CONDITIONING (HPAC)**, 1370 Don Mills Rd., Suite 300, Don Mills, Ontario M3B 3N7 Canada. (416)759-2500. Fax: (416)759-6979. Publisher: Bruce Meacock. Circ. 17,000. Estab. 1927. Bimonthly magazine plus annual buyers guide. Emphasizes heating, plumbing, air conditioning, refrigeration. Readers are predominantly male, mechanical contractors ages 30-60. Sample copy $4.
Needs: Uses 10-15 photos/issue; 2-4 supplied by freelancers. Needs photos of mechanical contractors at work, product shots. Model/property release preferred. Captions preferred.
Making Contact & Terms: Interested in receiving work from newer, lesser-known photographers. Send unsolicited photos by mail for consideration. Send 4×6, glossy/semi-matte color b&w prints; 35mm transparencies. Also accepts digital images. Cannot return material. Reports in 1 month. NPI. Pays on publication. Credit line given. Buys one-time rights; negotiable. Simultaneous submissions and/or previously published work OK.

‡**HELICOPTER INTERNATIONAL**, 75 Elm Tree Rd., Locking, Weston-S-Mare, Avon BS24 8EL England. (0934)822524. Editor: E. aphees. Circ. 23,000. Bimonthly magazine. Emphasizes helicopters and autogyros. Readers are helicopter professionals. Sample copy $4.50.
Needs: Uses 25-35 photos/issue; 50% supplied by freelance photographers. Needs photos of helicopters, especially newsworthy subjects. Model release preferred. Captions required.
Making Contact & Terms: Send unsolicited photos by mail for consideration. Send 8×10 or 4×5 glossy b&w, color prints or slides. Cannot return material. Reports in 1 month. Pays $20/color cover photo; $5/b&w inside photo. Pays on publication. Credit line given. Buys one-time rights. Simultaneous submissions or previously published work OK.
Tips: Magazine is growing. To break in, submit "newsworthy pictures. No arty-crafty pix; good clear shots of helicopters backed by newsworthy captions, e.g., a new sale/new type/new color scheme/accident with dates."

HEREFORD WORLD, (formerly *Polled Hereford World*), P.O. Box 014059, Kansas City MO 64101. (816)842-3757. Editor: Ed Bible. Circ. 14,000. Estab. 1947. Monthly magazine. Emphasizes Hereford cattle for registered breeders, commercial cattle breeders and agribusinessmen in related fields.

LISTINGS THAT USE IMAGES electronically can be found in the Digital Markets Index located at the back of this book.

Making Contact & Terms: Interested in receiving work from newer, lesser-known photographers. Query. Uses b&w prints and color transparencies and prints. Reports in 2 weeks. Pays $5/b&w print; $100/color transparency or print. Pays on publication.

Tips: Wants to see "Hereford cattle in quantities, in seasonal and/or scenic settings."

HISPANIC BUSINESS, 360 S. Hope Ave., Suite 300C, Santa Barbara CA 93105. (805)682-5843. Managing Editor: Hector Cantu. Circ. 200,000. Estab. 1979. Monthly publication. Emphasizes Hispanics in business (entrepreneurs and executives), the Hispanic market. Sample copy $5.

Needs: Uses 25 photos/issue; 20% supplied by freelancers. Needs photos of personalities and action shots. No mug shots. Captions required; include name, title.

Making Contact & Terms: Query with résumé of credits. Keeps samples on file. Reports in 2 weeks. Pays $450/color cover photo; $150/color inside photo. Pays on publication. Credit line given. Rights negotiable.

Tips: Wants to see "unusual angles, bright colors, hand activity. Photo tied to profession."

HOGS TODAY, Farm Journal Publishing, Inc., Centre Square W., 1500 Market St., 28th Floor, Philadelphia PA 19102-2181. (215)557-8959. Photo Editor: Tom Dodge. Circ. 125,000. Monthly magazine. Sample copy and photo guidelines free with SASE.

• This company also publishes *Farm Journal, Beef Today, Dairy Today* and *Top Producer.*

Needs: Uses 20-30 photos/issue; 75% supplied by freelancers. "We use studio-type portraiture (environmental portraits), technical, details, scenics." Model release preferred. Captions required.

Making Contact & Terms: Arrange a personal interview to show portfolio. Query with résumé of credits along with business card, brochure, flier or tearsheets to be kept on file for possible assignments. SASE. Reports in 2 weeks. NPI. "We pay a cover bonus." **Pays on acceptance.** Credit line given. Buys one-time rights. Simultaneous submissions OK.

Tips: In portfolio or samples, likes to "see about 20 slides showing photographer's use of lighting and ability to work with people. Know your intended market. Familiarize yourself with the magazine and keep abreast of how photos are used in the general magazine field."

***HOME LIGHTING & ACCESSORIES**, 1011 Clifton Ave., Clifton NJ 07013. (201)779-1600. Fax: (201)779-3242. Editor-in-Chief: Linda Longo. Circ. 12,000. Estab. 1923. Monthly magazine. Emphasizes outdoor and interior lighting. Readers are small business owners, specifically lighting showrooms and furniture stores. Sample copy free with SASE.

Needs: Uses 50 photos/issue; 10 supplied by freelancers. Needs photos of lighting applications that are unusual—either landscape for residential or some commercial and retail stores. Reviews photos with accompanying ms only. Model/property release preferred. Captions required (location and relevant names of people or store).

Making Contact & Terms: Interested in receiving work from newer, lesser-known photographers. Query with résumé of credits. Send unsolicited photos by mail for consideration. Provide résumé, business card, brochure, flier or tearsheets to be kept on file for possible future assignments. Send 5×7, 8×10 color prints; 4×5 transparencies. Keeps samples on file. SASE. Reports in 1 month. Pays $90/color cover photo; $5-10/color inside photo. Pays on publication. Credit line given. Buys one-time rights. Simultaneous submissions and/or previously published work OK.

***♥HUMAN RESOURCES PROFESSIONAL**, 2 Bloor St. W., Suite 1902, Toronto, Ontario M4W 3E2 Canada. (416)923-2324. Fax: (416)923-8956. Editor: Joanne Eidinger. Circ. 8,200. Estab. 1985. Publication of the Human Resources Professionals Association of Ontario. Monthly magazine. Emphasizes human resources. Readers are male and female senior manager executives, 40-55. Free sample copy.

Needs: Uses 2-3 photos/issue; all supplied by freelancers. Needs photos of people profiles, some abstract shots. Reviews photos purchased with accompanying ms only. Model/property release preferred. Captions required.

Making Contact & Terms: Interested in receiving work from newer, lesser-known photographers. Provide tearsheets to be kept on file for possible assignments. Keeps samples on file. Cannot return materials. Reporting back depends on deadlines. Pays $400-700 Canadian. Pays on publication. Credit line given. Buys one-time rights.

IB (INDEPENDENT BUSINESS): AMERICA'S SMALL BUSINESS MAGAZINE, Group IV Communications, 125 Auburn Court, Suite 100, Thousand Oaks CA 91362. (805)496-6156. Fax: (805)496-5469. Editor: Daniel Kehrer. Editorial Director: Don Phillipson. Photo Editor: Ethan Blumen. Circ. 600,000. Estab. 1990. Bimonthly magazine. Emphasizes small business. All readers are small business owners throughout the US. Sample copy $4. Photo guidelines free with SASE.

Needs: Uses 25-35 photos/issue; all supplied by freelancers. Needs photos of "people who are small business owners. All pictures are by assignment; no spec photos." Special photo needs include dynamic, unusual photos of offbeat businesses and their owners. Model/property release required. Cap-

tions required; include correct spelling on name, title, business name, location.

Making Contact & Terms: Query with résumé of credits. Provide résumé, business card, brochure, flier or tearsheets to be kept on file for possible assignments. Unsolicited original art will not be returned. Pays $350/color inside photo plus expenses. **Pays on acceptance.** Credit line given. Buys first plus nonexclusive reprint rights.

Tips: "We want colorful, striking photos of small business owners that go well above-and-beyond the usual business magazine. Capture the essence of the business owner's native habitat."

IEEE SPECTRUM, 345 E. 47th St., New York NY 10017. (212)705-7568. Fax: (212)705-7453. Website: http://www.spectrum.IEEE.ORG. Art Director: Mark Montgomery. Circ. 300,000. Publication of Institute of Electrical and Electronics Engineers, Inc. (IEEE). Monthly magazine. Emphasizes electrical and electronics field and high technology. Readers are male/female; educated; age range: 24-60.

Need: Uses 3-6 photos/issue; 3 provided by freelancers. Special photo needs include portrait photography and high technology photography. Model/property release required. Captions preferred.

Making Contact & Terms: Interested in receiving work from newer, lesser-known photographers. Arrange personal interview to show portfolio. Provide résume, business card, brochure, flier or tearsheets to be kept on file for possible assignments. Pays $1,000-1,500/color cover photo; $200-400/color inside photo. **Pays on acceptance.** Credit line given. Buys one-time rights. Previously published work OK.

Tips: Wants photographers who are consistent, have an ability to shoot color and b&w, display a unique vision and are receptive to their subjects.

***IGA GROCERGRAM**, 1301 Carolina St., Greensboro NC 27401. (910)378-6065. Fax: (910)275-2864. Managing Editor: Wes Isley. Publication of the Independent Grocers Alliance. Circ. 18,000. Estab. 1926. Monthly magazine, plus special issues. Emphasizes food industry. Readers are IGA retailers, mainly male. Sample copy $2 plus postage.

Needs: Uses 25-35 photos/issue; all supplied by freelancers. Needs in-store shots, food (appetite appeal). Prefers shots of IGA stores. Model/property release preferred. Captions preferred.

Making Contact & Terms: Send unsolicited 35mm transparencies by mail for consideration. Provide résumé, business card, brochure, flier or tearsheets to be kept on file for possible assignments. Keeps samples on file. Reports in 3 weeks. Pay negotiable. **Pays on acceptance.** Credit line given. Buys one-time rights. Simultaneous submissions and previously published work OK.

INDOOR COMFORT NEWS, 454 W. Broadway, Glendale CA 91204. (818)551-1555. Fax: (818)551-1115. Managing Editor: Chris Callard. Circ. 23,000. Estab. 1955. Publication of Institute of Heating and Air Conditioning Industries. Monthly magazine. Emphasizes news, features, updates, special sections on CFC's, Indoor Air Quality, Legal. Readers are predominantly male—25-65, HVAC/R/SM contractors, wholesalers, manufacturers and distributors. Sample copy free with 10×13 SAE and 10 first-class stamps.

Needs: Interested in photos with stories of topical projects, retrofits, or renovations that are of interest to the heating, venting, and air conditioning industry. Property release required. Captions required; include what it is, where and what is unique about it.

Making Contact & Terms: Interested in receiving work from newer, lesser-known photographers. Send unsolicited photos by mail for consideration. Provide résumé, business card, brochure, flier or tearsheets to be kept on file for possible assignments. Send 3×5 glossy color and b&w prints. Deadlines: first of the month, 2 months prior to publication. Keeps samples on file. SASE. Reports in 1-2 weeks. NPI. Credit line given.

Tips: Looks for West Coast material—projects and activities with quality photos of interest to the HVAC industry. "Familiarize yourself with the magazine and industry before submitting photos."

INFOSECURITY NEWS, 498 Concord St., Framingham MA 01701-2357. (508)879-9792. Fax: (508)879-0348. Art Director: Maureen Joyce. Circ. 30,000. Estab. 1988. Bimonthly magazine. Emphasizes computer security. Readers are male and female executives, managers. Sample copy $8.

Needs: Uses 5-15 photos; 1-5 supplied by freelancers. Needs photos of technology (computers), business, people. Model/property release required. Captions preferred.

Making Contact & Terms: Interested in receiving work from newer, lesser-known photographers. Arrange personal interview to show portfolio. Query with résumé of credits. Provide résumé, business card, brochure, flier or tearsheets to be kept on file for possible assignments. Keeps samples on file (printed samples or tearsheets only). Reports in 1 month. Pays $200-1,300 (depending on use, position). Pays on publication. Credit line given. Buys one-time rights.

IN-PLANT PRINTER AND ELECTRONIC PUBLISHER, Dept. PM, P.O. Box 1387, Northbrook IL 60065. (847)564-5940. Editor: Ray Roth. Circ. 41,000. Bimonthly. Emphasizes "in-plant printing; print and graphic shops housed, supported, and serving larger companies and organizations and electronic publishing applications in those locations." Readers are management and production

personnel of such shops. Sample copy $10. Photo guidelines free with SASE.
Needs: Uses about 5-10 photos/issue. Needs "working/shop photos, atmosphere, interesting equipment shots, how-to." Model release required. Captions preferred.
Making Contact & Terms: Query with samples or with list of stock photo subjects. Send b&w and color (any size or finish) prints; 35mm, 2¼×2¼, 4×5, 8×10 slides, b&w and color contact sheet or b&w and color negatives by mail for consideration. SASE. Reports in 1 month. Pays $200 maximum/b&w or color cover photo; $25 maximum/b&w or color inside photo; $200 maximum text/photo package. Pays on publication. Credit line given. Buys one-time rights with option for future use. Previously published work OK "if previous publication is indicated."
Tips: "Good photos of a case study—such as a printshop, in our case—can lead us to doing a follow-up story by phone and paying more for photos. Photographer should be able to bring out the hidden or overlooked design elements in graphic arts equipment." Trends include artistic representation of common objects found in-plant—equipment, keyboard, etc.

***INSIDE AUTOMOTIVES**, 314 Tribble Gap Rd., Suite B, Cumming GA 30130. (770)889-6884. Fax: (770)889-6298. E-mail: autoinfo@atlanta.com. Managing Editor: Sandra Farrer. Circ. 11,200. Estab. 1994. Bimonthly magazine. Emphasizes automotive interiors. Readers are engineers, designers, management OEMS and material and components suppliers. Sample copy $4. Photo guidelines free with SASE.
Needs: Uses 20 photos/issue; 10% supplied by freelancers. Needs photos of technology related to articles. Model/property release preferred for technical information. Captions required; include who and what is in photos.
Making Contact & Terms: Interested in receiving work from newer, lesser-known photographers. Provide résumé, business card, brochure, flier or tearsheets to be kept on file for possible future assignments. Contact editor by letter or fax. Send 3×5, 5×7 color and b&w photos; 35mm transparencies. Keeps samples on file. SASE. NPI; negotiable. Pays on publication. Credit line given. Buys one-time rights. Simultaneous submissions OK.

INSTANT AND SMALL COMMERCIAL PRINTER, Dept. PM, P.O. Box 1387, Northbrook IL 60065. (847)564-5940. Fax: (847)564-8361. Editor: Anne Marie Mohan. Circ. 61,000. Estab. 1982. Published 10 times/year. Emphasizes the "instant and retail printing industry." Readers are owners, operators and managers of instant and smaller commercial (less than 20 employees) print shops. Sample copy $10. Photo guidelines free with SASE.
Needs: Uses about 15-20 photos/issue. Needs "working/shop photos, atmosphere, interesting equipment shots, some how-to." Model release required. Captions preferred.
Making Contact & Terms: Interested in receiving work from newer, lesser-known photographers. Query with samples or with list of stock photo subjects or send b&w and color (any size or finish) prints; 35mm, 2¼×2¼, 4×5 or 8×10 slides; b&w and color contact sheet or b&w and color negatives by mail for consideration. SASE. Reports in 1 month. Pays $300 maximum/b&w and color cover photo; $50 maximum/b&w and color inside photo; $200 maximum text/photo package. Pays on publication. Credit line given. Buys one-time rights with option for future use; negotiable. Previously published work OK "if previous publication is indicated."

***INTERNATIONAL GROUND WATER TECHNOLOGY**, (formerly *Ground Water Age*), 13 Century Hill Dr., Latham NY 12110. (518)783-1281. Fax: (518)783-1386. Editor: Susan Wheeler. Monthly magazine. Circ. 17,000. Estab. 1966. Emphasizes management, marketing and technical information. Readers are international water well drilling contractors, water pump specialists and monitoring well contractors. Free sample copy and photo guidelines.
Needs: Buys 5-10 photos/year. Needs picture stories and photos of water well drilling activity and pump installation.
Making Contact & Terms: Send 5×7 matte b&w prints; 8×10 matte color prints; transparencies; negatives. Uses vertical format for covers. SASE. Reports in 3 weeks. NPI; payment negotiable. **Pays on acceptance**. Buys all rights, but may reassign to photographer after publication. Simultaneous submissions and/or previously published work OK.
Tips: "There is a need for quality photos of on-site, job-related activity in our industry. Many photo sites are outdoors. Some familiarity with the industry would be helpful, of course." In photographer's samples, wants to see "an ability to capture a water well contractor, pump installer or monitoring well contractor in action. We have been improving our color cover shots. We'd appreciate more contributions from freelancers."

***JEMS COMMUNICATIONS**, 1947 Camino Vida Roble, Suite 200, Carlsbad CA 92008. (619)431-9797. Fax: (619)431-8176. E-mail: jems.editor@mosby.com. Managing Editor: Julie Rach. Circ. 45,000. Estab. 1980. Monthly magazine. Emphasizes emergency medical services by out-of-hospital providers. Readers are EMTS and paramedics. Sample copy available. Photo guidelines free with SASE.

Needs: Uses 35-40 photos/month; 15-20 supplied by freelancers. Needs photos of paramedics and EMTs on actual calls following proper procedures with focus on caregivers, not patients. "1996 will be our first-year of all-photo covers. We will pay for excellent EMS action material of paramedics and EMTs at work." Model/property release required for EMS providers, patients and family members. Captions preferred; include city, state, incident and response organizations identified.

Making Contact & Terms: Interested in receiving work from newer, lesser-known photographers. Query with letter requesting rates and guidelines. Send 8×10 glossy color and b&w prints; 35mm $2\frac{1}{4} \times 2\frac{1}{4}$, 4×5, 8×10 transparencies; Macintosh/Photoshop-compatible digital formats. Keeps samples on file. Cannot return material. Reports in 3 weeks. Pays $200-1,100/color cover photo; $25-300/color inside photo; $25-100/b&w inside photo; pays extra for electronic usage of photos. Credit line given. Buys one-time rights.

Tips: "Study samples before submitting. We want the photos to focus on caregivers, not patients. We want providers in a variety of settings and following protocols."

JOURNAL OF PROPERTY MANAGEMENT, 430 N. Michigan Ave., 7th Floor, Chicago IL 60611. (312)329-6059. Fax: (312)661-0217. E-mail: Kwadswor@irem.com. Associate Editor: Kent Wadsworth. Estab. 1934. Bimonthly magazine. Emphasizes real estate management. Readers are mid- and upper-level managers of investment real estate. Sample copy free with SASE. Photo guidelines available.

● This publication is now pulling images off CD-ROM.

Needs: Uses 6 photos/issue; 50% supplied by freelancers. Needs photos of buildings, building operations and office interaction. Model/property release preferred.

Making Contact & Terms: NPI.

JOURNAL OF PSYCHOACTIVE DRUGS, Dept. PM, 612 Clayton St., San Francisco CA 94117. (415)565-1904. Fax: (415)864-6162. Editor: Jeffrey H. Novey. Circ. 1,400. Estab. 1967. Quarterly. Emphasizes "psychoactive substances (both legal and illegal)." Readers are "professionals (primarily health) in the drug abuse treatment field."

Needs: Uses 1 photo/issue; supplied by freelancers. Needs "full-color abstract, surreal, avant garde or computer graphics."

Making Contact & Terms: Query with samples. Send 4×6 color prints or 35mm slides by mail for consideration. SASE. Reports in 2 weeks. Pays $50/color cover photo. Pays on publication. Credit line given. Buys one-time rights. Simultaneous submissions and previously published work OK.

JR. HIGH MINISTRY MAGAZINE, 2890 N. Monroe, Loveland CO 80539. (970)669-3836. Fax: (970)669-3269. Photo Editor: Diane Dickerson. Published 5 times a year. Interdenominational magazine that provides ideas and support to adult workers (professional and volunteer) with junior highers in Christian churches. Sample copy $1 and 9×12 SASE. Photo guidelines free with SASE.

Needs: Uses 20-25 photos/issue; 3-6 supplied by freelancers. Needs photos of activities and settings relating to families, teenagers (junior high school age), adults and junior high youth together. Model release required.

Making Contact & Terms: Interested in receiving work from newer, lesser-known photographers. Send unsolicited photos by mail for consideration. "Must include SASE." Send 8×10 b&w prints; 35mm, $2\frac{1}{4} \times 2\frac{1}{4}$, 4×5 transparencies, will also accept PhotoCD. Reports in 1 month. Pays $300 and up/color cover photo; $300 & up/b&w cover photo; $65 & up/color inside photo; $35 & up/b&w inside photo. **Pays on acceptance**. Credit line given. Buys one-time rights. Simultaneous submissions and previously published work OK.

Tips: "We seek to portray people in a variety of ethnic, cultural and racio-economic backgrounds in our publications and the ability of a photographer to portray emotion in photos. One of our greatest ongoing needs is for good contemporary photos of black, Hispanic and American and Native American, as well as photos portraying a mix of group ethnic. Also candid, real life shots are preferable to posed ones."

***KITCHEN & BATH BUSINESS**, One Penn Plaza, 10th Floor, New York NY 10119. (212)615-2338. Fax: (212)279-3963. E-mail: vcaruso@mfi.com. Editor: Valerie Caruso. Circ. 52,000. Estab. 1955. Monthly magazine. Emphasizes kitchen and bath design, sales and products. Readers are male and female kitchen and bath dealers, designers, builders, architects, manufacturers, distributors and home center personnel. Sample copy free with 9×12 SASE.

Needs: Uses 40-50 photos/issue; 4-8 supplied by freelancers. Needs kitchen and bath installation shots and project shots of never-before-published kitchens and baths. Reviews photos with accompanying ms only. Captions preferred; include relevant information about the kitchen or bath—remodel or new construction, designer's name and phone number.

Making Contact & Terms: Interested in receiving work from newer, lesser-known photographers. Send photos by mail for consideration. Send any size color and b&w prints. Keeps samples

on file. Reports in 3 weeks. NPI. Pays on publication. Buys one-time rights. Simultaneous submissions OK.

LAND LINE MAGAZINE, 311 R.D. Mize Rd., Grain Valley MO 64029. (816)229-5791. Fax: (816)229-0518. Managing Editor: Sandi Laxson. Circ. 110,000. Estab. 1975. Publication of Owner Operator Independent Drivers Association. Bimonthly magazine. Emphasizes trucking. Readers are male and female independent truckers, with an average age of 44. Sample copy $2.
 • This company planned to start using CD-ROM in late 1996.
Needs: Uses 18-20 photos/issue; 50% supplied by freelancers. Needs photos of trucks, highways, truck stops, truckers, etc. "We prefer to have truck owners/operators in photos." Reviews photos with or without ms. Model/property release preferred for company trucks, drivers. Captions preferred.
Making Contact & Terms: Interested in receiving work from newer, lesser-known photographers. Provide résumé, business card, brochure, flier or tearsheets to be kept on file for possible assignments. Send glossy color or b&w prints; 2¼×2¼ transparencies. Pays $100/color cover photo; $50/b&w cover photo; $50/color inside photo; $30/b&w inside photo. Credit line given. Buys one-time rights. Previously published work OK.

LLAMAS MAGAZINE, P.O.Box 100, Herald CA 95638. (209)223-0469. Fax: (209)223-0466. Circ. 5,500. Estab. 1979. Publication of The International Camelid Journal. Magazine published 7 times a year. Emphasizes llamas, alpacas, vicunas, guanacos and camels. Readers are llama and alpaca owners and ranchers. Sample copy $5.75. Photo and editorial guidelines free with SASE.
Needs: Uses 30-50 photos/issue; all supplied by freelancers. Wants to see "any kind of photo with llamas, alpacas, camels in it. Always need good verticals for the cover. Always need good action shots." Model release required. Captions required.
Making Contact & Terms: Send unsolicited b&w or color 35mm prints or 35mm transparencies by mail for consideration. Provide résumé, business card, brochure, flier or tearsheets to be kept on file for possible assignments. SASE. Reports in 2 weeks. Pays $100/color cover photo; $25/color inside photo; $15/b&w inside photo. Pays on publication. Credit line given. Buys one-time rights. Simultaneous submissions and previously published work OK.
Tips: "You must have a good understanding of llamas and alpacas to submit photos to us. It's a very specialized market. Our rates are modest, but our publication is a very slick 4-color magazine and it's a terrific vehicle for getting your work into circulation. We are willing to give photographers a lot of free tearsheets for their portfolios to help publicize their work."

MANAGING OFFICE TECHNOLOGY, 1100 Superior Ave., Cleveland OH 44114. Editor: Lura K. Romei. Circ. 110,000. Estab. 1957. Monthly magazine. Emphasizes office automation, data processing. Readers are middle and upper management and higher in companies of 100 or more employees. Sample copy free with 11×14 SAE and 2 first-class stamps.
Needs: Uses 15 photos/issue; 1 supplied by freelancers. Needs office shots, office interiors, computers, concept shots of office automation and networking; "any and all office shots are welcome." Model/property release preferred. Captions required; include non-model names, positions.
Making Contact & Terms: Interested in receiving work from newer, lesser-known photographers. Provide résumé, business card, brochure, flier or tearsheets to be kept on file for possible future assignments. Reports in 3 weeks. Also accepts digital images in TIFF or EPS. Pays $500/color cover photo; $50-100/b&w; $150-500/color photo. Pays on publication. Credit line given. Buys one-time rights.
Tips: "Good conceptual (not vendor-specific) material about the office and office supplies is hard to find. Crack that and you're in business." In reviewing a photographer's samples, looks for "imagination and humor."

MARKETERS FORUM, 383 E. Main St., Centerport NY 11721. (516)754-5000. Fax: (516)754-0630. Publisher: Martin Stevens. Circ. 70,000. Estab. 1981. Monthly magazine. Readers are entrepreneurs and retail store owners. Sample copy $5.
Needs: Uses 3-6 photos/issue; all supplied by freelancers. "We publish trade magazines for retail variety goods stores and flea market vendors. Items include: jewelry, cosmetics, novelties, toys, etc. (five-and-dime-type goods). We are interested in creative and abstract impressions—not straight-on product shots. Humor a plus." Model/property release required.
Making Contact & Terms: Send unsolicited photos by mail for consideration. Send color prints; 35mm, 4×5 transparencies. Does not keep samples on file. SASE. Reports in 2 weeks. Pays $100/color cover photo; $50/color inside photo. **Pays on acceptance.** Buys one-time rights. Simultaneous submissions and/or previously published work OK.

MARKETING & TECHNOLOGY GROUP, 1415 N. Dayton, Chicago IL 60622. (312)266-3311. Fax: (312)266-3363. Art Director: Neil Ruffolo. Circ. 18,000. Estab. 1993. Publishes 3 magazines: *Carnetec*, *Meat Marketing & Technology*, and *Poultry Marketing & Technology*. Emphasizes meat and

poultry processing. Readers are predominantly male, ages 35-65, generally conservative. Sample copy $4.

Needs: Uses 15-30 photos/issue; 1-3 supplied by freelancers. Needs photos of food, processing plant tours, product shots, illustrative/conceptual. Model/property release preferred. Captions preferred.

Making Contact & Terms: Provide résumé, business card, brochure, flier or tearsheets to be kept on file for possible assignments. Submit portfolio for review. Keeps samples on file. Reports in 1 month. NPI. Pays on publication. Credit line given. Buys all rights; negotiable. Simultaneous submissions and previously published work OK.

Tips: "Work quickly and meet deadlines. Follow directions when given; and when none are given, be creative while using your best judgment."

MASONRY MAGAZINE, 1550 Spring Rd., Oak Brook IL 60521. (708)782-6767. Fax: (708)782-6786. Contact: Editor. Circ. 7,200. Estab. 1960. Publication of the Mason Contractors Association of America and Canadian Masonry Contractors. Bimonthly magazine. Emphasizes masonry contracting. Readers are mason and general contractors, ages 30-70. Free sample copy. Free photo guidelines.

Needs: Uses 15-20 photos/issue; 1-2 supplied by freelancers. Needs photos of technology/how-to masonry buildings/personalities in industry. Model/property release preferred for individuals/plant technologists. Captions required.

Making Contact & Terms: Interested in receiving work from newer, lesser-known photographers. Query with stock photo list. Send unsolicited photos by mail for consideration. Provide résumé, business card, brochure, flier or tearsheets to be kept on file for possible assignments. Send 5×7 or 8×10 color or b&w matte finish prints; 35mm transparencies. SASE. Reports in 1 month. Pays $50 and up/color cover photo; $10 and up/b&w inside photo. Pays on acceptance. Credit line given. Buys all rights; negotiable. Simultaneous submissions and previously published work OK.

Tips: Looks for "grasp of subject/clarity/illustration of points-succinctly. Be available for assignment/flexible, keep work before prospects/work and submit possibilities list/keep in constant touch."

MEXICO EVENTS & DESTINATIONS, P.O. Box 188037, Carlsbad CA 92009. (619)433-0090. Fax: (619)433-0197. Art Director: Gabriela Flores. Circ. 100,000. Estab. 1992. Quarterly magazine. Emphasizes travel to Mexico for travel professionals and consumers. Readers are consumers, travel agents and travel industry people. Sample copy $4.50. Photo guidelines free with SASE.

Needs: Uses 30-40 photos/issue; 10 supplied by freelancers. Needs destination and travel industry shots—hotels, resorts, tourism officials, etc. in Mexico for US travel pros. Model/property release preferred. Captions required; include correct spelling of people's names, location, time of day/year. Send for Editorial Calendar before submitting.

Making Contact & Terms: Interested in receiving work from newer, lesser-known photographers. Does not keep samples on file. SASE. Reports in 1 month. Pays $200/color cover photo; $20-50/color inside photo. "We also pay in trade for travel." Pays 30 days from publication. Buys one-time rights. Previously published work OK.

Tips: Wants technically sound, inventive, creative shots.

MINORITY BUSINESS ENTREPRENEUR, 3528 Torrance Blvd., Suite 101, Torrance CA 90503. (310)540-9398. Fax: (310)792-8263. Executive Editor: Jeanie Barnett. Circ. 40,000. Estab. 1984. Bimonthly magazine. Emphasizes minority, small, disadvantaged businesses. Sample copy free with 9½×12½ SAE and 5 first-class stamps. "We have editorial guidelines and calendar of upcoming issues available."

Needs: Uses 5-10 feature photos/issue. Needs "good shots for cover profiles and minority features of our entrepreneurs." Model/property release required. Captions preferred; include name, title and company of subject, and proper photo credit.

Making Contact & Terms: Interested in receiving work from newer, lesser-known photographers. Query with résumé of credits. Provide résumé, business card, brochure, flier or tearsheets to be kept on file for possible assignments. "Never submit unsolicited photos." SASE. Reports in 5 weeks. NPI; payment negotiable. Pays on publication. Credit line given. Buys first North American serial rights; negotiable.

Tips: "We're starting to run color photos in our business owner profiles. We want pictures that capture them in the work environment. Especially interested in minority and women photographers working for us. Our cover is an oil painting composed from photos. It's important to have high quality b&ws which show the character lines of the face for translation into oils. Read our publication and have a good understanding of minority business issues. Never submit photos that have nothing to do with the magazine."

MODERN BAKING, Dept. PM, 2700 River Rd., Suite 418, Des Plaines IL 60018. (708)299-4430. Fax: (708)296-1968. Editor: Ed Lee. Circ. 27,000. Estab. 1987. Monthly. Emphasizes on-premise baking, in supermarkets, foodservice establishments and retail bakeries. Readers are owners, managers and operators. Sample copy for 9×12 SAE with 10 first-class stamps.

Needs: Uses 30 photos/issue; 1-2 supplied by freelancers. Needs photos of on-location photography in above-described facilities. Model/property release preferred. Captions required; include company name, location, contact name and telephone number.
Making Contact & Terms: Interested in receiving work from newer, lesser-known photographers. Provide résumé, business card, brochure, flier or tearsheets to be kept on file for possible future assignments. SASE. Reports in 2 weeks. Pays $50 minimum; negotiable. **Pays on acceptance.** Credit line given. Buys all rights; negotiable.
Tips: Prefers to see "photos that would indicate person's ability to handle on-location, industrial photography."

MODERN CASTING, 505 State St., Des Plaines IL 60016. (708)824-0181. Fax: (708)824-7848. Editor: Mike Lessiter. Circ. 25,000. Estab. 1938. Publication of American Foundrymen's Association. Monthly magazine. Emphasizes metal casting and the North American foundry industry. Readers are management and technical officials of foundries.
Needs: Uses 30 photos/issue; few supplied by freelancers. Needs photos of metal poured into sand/permanent molds; mold making; coremaking; foundry workers (at work); casting handling; shipments; some general industry. Captions necessary.
Making Contact & Terms: Interested in receiving work from newer, lesser-known photographers. Send unsolicited photos by mail for consideration. Query with stock photo list. Send any color prints. Keeps samples on file. Reports in 3 weeks. NPI. Credit line given.

MODERN PLASTICS, 1221 Sixth Ave., New York NY 10020. (212)512-3491. Art Director: Anthony A. Landi. Circ. 65,000. Monthly magazine. Readers are male buyers in the plastics trade.
Needs: Needs photos of how-to, etc. Purchases photos with accompanying ms only. Model release required. Property release preferred. Captions required; include manufacturer's name and model number.
Making Contact & Terms: Interested in receiving work from newer, lesser-known photographers. Arrange a personal interview to show portfolio. Cannot return material. Reports in 1 week. Pays $500/color cover photo and $100/color inside photo. **Pays on acceptance.** Credit line given. Buys first North American serial rights.
Tips: In portfolio or samples looks for concept covers.

***MORTGAGE ORIGINATOR MAGAZINE**, 1360 Sunset Cliffs Blvd., San Diego CA 92107. (619)223-9989. Fax: (619)223-9936. E-mail: mtgemom@aol.com Publisher: Chris Salazar. Circ. 8,000. Estab. 1991. Monthly magazine. Emphasizes mortgage banking. Readers are sales staff. Sample copy $6.95.
Needs: Uses 8 photos/issue. Needs photos of business.
Making Contact & Terms: Interested in receiving work from newer, lesser-known photographers. Query with stock photo list. Send unsolicited photos by mail for consideration. Send color prints; 35mm transparencies. Keeps samples on file. NPI; negotiable. Pays on publication. Credit line given. Buys exclusive industry rights. Simultaneous submissions and previously published work OK.

MOUNTAIN PILOT, (formerly *Wings West*), 7009 S. Potomac St., Englewood CO 80112-4029. (303)397-7600. Fax: (303)397-7619. Editor: Ed Huber. Bimonthly national magazine on aviation. Circ. 20,000. Estab. 1985. Published by Wisner Publishing Inc. Emphasizes aviation, travel. Readers are mid-life male, affluent, mobile. Sample copy free with SASE.
Needs: Uses both assignment and stock photos. Model release and photo captions required.
Making Contact & Terms: Provide résumé, business card, brochure, flier or tearsheets to be kept on file for possible assignments: contact by phone. SASE. Reports in 1 month. Pays $10-35/b&w; $35-75/color; $25-100/photo/text package. Pays on publication. Credit line given. Buys all rights; negotiable. Simultaneous submissions and previously published work OK.
Tips: Looks for "unusual destination pictures, general aviation oriented." Trend is "imaginative." Make shot pertinent to an active pilot readership. Query first. Don't send originals—color copies acceptable. Copy machine reprints OK for evaluation.

MUSHING MAGAZINE, P.O. Box 149, Ester AK 99725. (907)479-0454. Fax: (907)479-3137. Publisher: Todd Hoener. Circ. 7,000. Estab. 1987. Bimonthly magazine. Readers are dog drivers, mushing enthusiasts, dog lovers, outdoor specialists, innovators and sled dog history lovers. Sample copy $5 in US. Photo guidelines free with SASE.
Needs: Uses 20 photos/issue; most supplied by freelancers. Needs action photos: all-season and wilderness; also still and close-up photos: specific focus (sledding, carting, dog care, equipment, etc). Special photo needs include skijoring, feeding, caring for dogs, summer carting or packing, 1-3 dog-sledding and kids mushing. Model release preferred. Captions preferred.
Making Contact & Terms: Interested in receiving work from newer, lesser-known photographers. Send unsolicited photos by mail for consideration. Reports in 6 months. Pays $130 maximum/color

cover photo; $35 maximum/color inside photo; $15-30/b&w inside photo. Pays on publication. Credit line given. Buys first serial rights and second reprint rights.
Tips: Wants to see work that shows "the total mushing adventure/lifestyle from environment to dog house." To break in, one's work must show "simplicity, balance and harmony. Strive for unique, provocative shots that lure readers and publishers."

NAILPRO, 7628 Densmore Ave., Van Nuys CA 91406-2088. (818)782-7328. Fax: (818)782-7450. Executive Editor: Linda Lewis. Circ. 45,000. Estab. 1989. Published by Creative Age Publications. Monthly magazine. Emphasizes topics for professional manicurists and nail salon owners. Readers are females of all ages. Sample copy $2 with 9×12 SASE.
Needs: Uses 10-12 photos/issue; all supplied by freelancers. Needs photos of beautiful nails illustrating all kinds of nail extensions and enhancements; photographs showing process of creating and decorating nails, both natural and artificial. Model release required. Captions required; identify people and process if applicable.
Making Contact & Terms: Interested in receiving work from newer, lesser-known photographers. Send color prints; 35mm, 2¼×2¼, 4×5. Keeps samples on file. SASE. Reports in 1 month. Pays $500/color cover photo; $50-200/color inside photo; $50/b&w inside photo. **Pays on acceptance**. Credit line given. Buys one-time rights. Previously published work OK.
Tips: "Talk to the person in charge of choosing art about photo needs for the next issue and try to satisfy that immediate need; that often leads to assignments."

NATIONAL BUS TRADER, 9698 W. Judson Rd., Polo IL 61064-9049. (815)946-2341. Fax: (815)946-2347. Editor: Larry Plachno. Circ. 5,600. Estab. 1977. "The Magazine of Bus Equipment for the United States and Canada—covers mainly integral design buses in the United States and Canada." Readers are bus owners, commercial bus operators, bus manufacturers, bus designers. Sample copy free (no charge—just write or call).
Needs: Uses about 30 photos/issue; 22 supplied by freelance photographers. Needs photos of "buses; interior, exterior, under construction, in service." Special needs include "photos for future feature articles and conventions our own staff does not attend."
Making Contact & Terms: "Query with specific lists of subject matter that can be provided and mention whether accompanying mss are available." SASE. Reports in 1 week. Pays $3-5/b&w photo; $100-3,000/photo/text package. **Pays on acceptance.** Credit line given. Buys rights "depending on our need and photographer." Simultaneous submissions and previously published work OK.
Tips: "We don't need samples, merely a list of what freelancers can provide in the way of photos or ms. Write and let us know what you can offer and do. We often use freelance work. We also publish *Bus Tours Magazine*—a bimonthly which uses many photos but not many from freelancers; *The Bus Equipment Guide*—infrequent, which uses many photos; and *The Official Bus Industry Calendar*—annual full-color calendar of bus photos. We also publish historical railroad books and are looking for historical photos on midwest interurban lines and railroads. Due to publication of historical railroad books, we are purchasing many historical photos. In photos looks for subject matter appropriate to current or pending article or book. Send a list of what is available with specific photos, locations, bus/interurban company and fleet number."

***NATIONAL FISHERMAN**, 121 Free St., P.O. Box 7438, Portland ME 04112-7438. (207)842-5608. Fax: (207)824-5609. Production Director: Marydale Abernathy. Circ. 50,000. Estab. 1960. Monthly magazine. Emphasizes commercial fishing, boat building, marketing of fish, fishing techniques and fishing equipment. For amateur and professional boatbuilders, commercial fishermen, armchair sailors, bureaucrats and politicians. Free sample copy with 11×15 SAE and $2 postage.
Needs: Buys 5-8 photo stories monthly; buys 4-color action cover photo monthly. Action shots of commercial fishing, work boats, traditional sailing fishboats, boat building, deck gear. No recreational, caught-a-trout photos.
Making Contact & Terms: Query. Reports in 2 months. Pays $10-25/inside b&w print; $250/color cover transparency. Pays on publication.
Tips: "We seldom use photos unless accompanied by feature stories or short articles—i.e., we don't run a picture for its own sake. Even those accepted for use in photo essays must tell a story—both in themselves and through accompanying cutline information. However, we do use single, stand-alone photos for cover shots. We need sharp b&w glossy photos—5×7s are fine. For cover, please send 35mm transparencies; dupes are acceptable. We want high-quality b&w images for inside that will hold detail on newsprint. Send slide samples."

***NATIONAL HOME CENTER NEWS**, Division of Lebhar-Friedman Inc., 425 Park Ave., New York NY 10022. Art Director: Bob Brokman. Associate Managing Editor: Susan Carlucci. Circ. 45,000. Estab. 1974. Bimonthly tabloid. Emphasizes manufacturers and retailers in the home center industry (national and international). Readers are male and female (mostly male) executives in the home center industry. Sample copy $5.

Needs: Uses 24-30 photos/issue; 10% supplied by freelancers. Needs photos of technology, how-to, personalities, lumber yards, industry retailers, etc. Captions preferred.
Making Contact & Terms: Interested in receiving work from newer, lesser-known photographers. Submit portfolio for review. Query with stock photo list. Send unsolicited photos by mail for consideration. Provide résumé, business card, brochure, flier or tearsheets to be kept on file for possible future assignments. Send color and b&w prints; transparencies. Keeps samples on file. SASE. Pays $500-1,000/day; $350/color cover photo; $350/b&w cover photo; $150/color inside photo; $150/b&w inside photo. Credit line given. Buys negotiated rights. Simultaneous submissions and previously published work OK.

***NATION'S BUSINESS**, U.S. Chamber of Commerce, 1615 H St. NW, Washington DC 20062. (202)463-5447. Photo Editor: Laurence L. Levin. Assistant Photo Editor: Frances Borchardt. Circ. 865,000. Monthly. Emphasizes business, how to run your business better, especially small business. Readers are managers, upper management and business owners. Sample copy free with 9×12 SASE.
Needs: Uses about 40-50 photos/issue; 60% supplied by freelancers. Needs portrait-personality photos, business-related pictures relating to the story. Model release preferred. Captions required.
Making Contact & Terms: Arrange a personal interview to show portfolio. Submit portfolio for review. SASE. Reports in 3 weeks. Pays $200/b&w or color inside photo; $175-300/day. Pays on publication. Credit line given. Buys one-time rights.
Tips: In reviewing a portfolio, "we look for the photographer's ability to light, taking a static situation and turning it into a spontaneous, eye-catching and informative picture."

NEW JERSEY CASINO JOURNAL, 8025 Black Horse Pike, #470, Pleasantville NJ 08232-2900. (609)484-8866. Fax: (609)645-1661. E-mail: cpmag@aol.com. Photo/Graphic Editor: Rick Greco. Circ. 25,000. Estab. 1985. Monthly. Emphasizes casino operations. Readers are casino executives, employers and vendors. Sample copy free with 11×14 SAE and 9 first-class stamps.
Needs: Uses 40-60 photos/issue; 5-10 supplied by freelancers. Needs photos of gaming tables and slot machines, casinos and portraits of executives. Model release required for gamblers, employees. Captions required.
Making Contact & Terms; Interested in receiving work from newer, lesser-known photographers. Query with résumé of credits. Query with stock photo list. Also accepts digital images. Reports in 3 months. Pays $100 minimum/color cover photo; $10-35/color inside photo; $10-25/b&w inside photo. Pays on publication. Credit line given. Buys all rights; negotiable.
Tips: "Read and study photos in current issues."

NEW METHODS, P.O. Box 22605, San Francisco CA 94122-0605. (415)664-3469. Art Director: Ronald S. Lippert, AHT. Circ. 5,600. Estab. 1981. Monthly. Emphasizes veterinary personnel, animals. Readers are veterinary professionals and interested consumers. Sample copy $3.20 (20% discount on 12 or more). Photo guidelines free with SASE.
Needs: Uses 12 photos/issue; 2 supplied by freelance photographers. Assigns 95% of photos. Needs animal, wildlife and technical photos. Most work is b&w. Model/property releases preferred. Captions preferred.
Making Contact & Terms: Interested in receiving work from newer, lesser-known photographers. Arrange a personal interview to show portfolio. Query with résumé of credits, samples or list of stock photo subjects. Provide résumé, business card, brochure, flier or tearsheets. SASE. Reports in 2 months. Payment is rare, negotiable; will barter. Credit line given. Simultaneous submissions and previously published work OK.
Tips: Ask for photo needs before submitting work. Prefers to see "technical photos (human working with animal(s) or animal photos (*not cute*)" in a portfolio or samples. On occasion, needs photographer for shooting new products and local area conventions.

911 MAGAZINE, P.O. Box 11788, Santa Ana CA 92711. (714)544-7776. E-mail: Magaz911@aol.com. Editor: Randall Larson. Circ. 22,000. Estab. 1988. Bimonthly magazine. Emphasizes public safety communications and response—police, fire, paramedic, dispatch, etc. Readers are ages 20-65. Sample copy free with 9×12 SAE and 7 first-class stamps. Photo guidelines free with SASE.
Needs: Uses up to 25 photos/issue; 75% supplied by freelance photographers; 20% comes from assignment, 80% from stock. "From the Field" department photos are needed of incidents involving public safety communications and emergency agencies in action from law enforcement, fire suppres-

THE SUBJECT INDEX, located at the back of this book, can help you find publications interested in the topics you shoot.

sion, paramedics, dispatch, etc., showing proper techniques and attire. Model release preferred. Captions preferred; if possible include incident location by city and state, agencies involved, duration, dollar cost, fatalities and injuries.

Making Contact & Terms: Interested in receiving work from newer, lesser-known photographers. Query with list of stock photo subjects. Send unsolicited photos by mail for consideration. Provide résumé, business card, brochure, flier or tearsheets to be kept on file for possible assignments. Uses 35mm, 2¼×2¼, 4×5, 8×10 glossy contacts, b&w or color prints; 35mm, 2¼×2¼, 4×5, 8×10 transparencies. SASE. Reports in 3 weeks. Pays $100-300/color cover photo; $50-150/b&w cover photo; $50-150/color inside photo; $20-50/b&w inside photo. Pays on publication. Credit line given. Buys one-time rights. Simultaneous submissions and previously published work OK.

Tips: "We need photos for unillustrated cover stories and features appearing in each issue. Topics include rescue, traffic, communications, training, stress, media relations, crime prevention, etc. Calendar available. Assignments possible."

***O&A MARKETING NEWS**, 532 El Dorado St., Suite 200, Pasedena CA 91101. (818)683-9993. Fax: (818)683-0969. Editor: Kathy Laderman. Circ. 9,000. Estab. 1966. Bimonthly tabloid. Emphasizes petroleum marketing in the 13 western states. Readers are active in the petroleum industry and encompass all ages, interests and genders. Sample copy free with 10×13 SAE and $2.50 postage.

Needs: Uses 150-200 photos/issue; 10 supplied by freelancers. Needs photos of interesting—and innovative—activities at gasoline stations, car washes, quick lubes and convenience stores in the 13 western states. Model/property release preferred. Captions required (what is pictured, where it is, why it's unusual).

Making Contact & Terms: Interested in receiving work from newer, lesser-known photographers. Send unsolicited photos by mail for consideration. Send 5×7 (preferred, but others OK) matte or glossy b&w prints. SASE. Reports in 3 weeks. Pays $5/b&w inside photo; other forms of payment vary, depending on length of text submitted. Buys one-time rights. Simultaneous submissions and/or previously published work OK.

Tips: "We're looking for sharp, newspaper-style b&w photos that show our western readers something new, something different, something they wouldn't necessarily see at a gas station or convenience store near their home."

***OCULAR SURGERY NEWS**, Dept. PM, 6900 Grove Rd., Thorofare NJ 08086. (609)848-1000. Associate Editor: Conni Waddington. Circ. 18,000. Biweekly newspaper. Emphasizes ophthalmology, medical and eye care. Readers are ophthalmologists in the US. Sample copy free with 9×12 SAE and 10 first-class stamps.

Needs: Uses 30 photos/issue; less than 10% supplied by freelancers. Needs photos for business section on a monthly basis. Topics like managed care, money management, computers and technology, patient satisfaction, etc.

Making Contact & Terms: Query with list of stock photo subjects. Provide résumé, business card, brochure, flier or tearsheets to be kept on file for possible assignments. SASE. Reports in 2 weeks. Pays $300/color cover photo; $150/color inside photo; $150-250/day. Pays on publication. Credit line given. Buys one-time rights.

♥OH&S CANADA, Dept. PM, 1450 Don Mills Rd., Don Mills ON M3B 2X7 Canada. (416)445-6641. Fax: (416)442-2200. Art Director: Catherine Goard. Bimonthly magazine. Emphasizes occupational health and safety. Readers are health and safety professionals, median age of 40. Circ. 10,000. Estab. 1985.

Needs: Uses 3 photos/issue; 70% supplied by freelancers. Primarily uses photos of business, industry on-site, etc. Model release and photo captions preferred.

Making Contact & Terms: Provide résumé, business card, brochure, flier or tearsheets to be kept on file for possible assignments. Pays $800-1,000/color cover photo; $400-600/color inside photo. "Rates of payment vary quite substantially according to photographer's experience." **Pays on acceptance.** Credit line given. Buys one-time rights.

Tips: In portfolio or samples, looking for "industry shots."

OHIO TAVERN NEWS, 329 S. Front St., Columbus OH 43215. (614)224-4835. Fax: (614)224-8649. Editor: Chris Bailey. Circ. 8,200. Estab. 1939. Bimonthly. Emphasizes beverage alcohol/hospitality industries in Ohio. Readers are liquor permit holders: restaurants, bars, distillers, vintners, wholesalers. Sample copy free for 9×12 SASE.

Needs: Uses 1-4 photos/issue. Needs photos of people, places, products covering the beverage alcohol/hospitality industries in Ohio. Captions required; include who, what, where, when and why.

Making Contact & Terms: Interested in receiving work from newer, lesser-known photographers. Send unsolicited photos by mail for consideration. Send up to 8×10 glossy b&w prints. Deadlines: first and third Friday of each month. Keeps samples on file. SASE. Reports in 1 month. Pays $15/

photo. Pays on publication. Credit line given. Buys one-time rights; negotiable. Simultaneous submissions OK.

PACIFIC BUILDER & ENGINEER, Vernon Publications Inc., 3000 Northup Way, Suite 200, Bellevue WA 98004. (206)827-9900. Fax: (206)822-9372. Editor: Carl Molesworth. Circ. 14,500. Estab. 1902. Biweekly magazine. Emphasizes non-residential construction in the Northwest and Alaska. Readers are construction contractors. Sample copy $7.
Needs: Uses 8 photos/issue; 4 supplied by freelancers. Needs photos of ongoing construction projects to accompany assigned feature articles. Reviews photos purchased with accompanying ms only. Photo captions preferred; include name of project, general contractor, important subcontractors, model/make of construction equipment, what is unusual/innovative about project.
Making Contact & Terms: Interested in receiving work from newer, lesser-known photographers. Query with résumé of credits. Does not keep samples on file. SASE. Reports in 1 month. Pays $25-125/color cover photo; $15-50/b&w inside photo. Pays on publication. Buys first North American serial rights.
Tips: "All freelance photos must be coordinated with assigned feature stories."

PACIFIC FISHING, 1515 NW 51st, Seattle WA 98107. (206)789-5333. Fax: (206)784-5545. Editor: Steve Shapiro. Circ. 11,000. Estab. 1979. Monthly magazine. Emphasizes commercial fishing on West Coast—California to Alaska. Readers are 80% owners of fishing operations, primarily male, ages 25-55; 20% processors, marketers and suppliers. Sample copy free with 11 × 14 SAE and 8 first-class stamps. Photo guidelines free with SASE.
Needs: Uses 15 photos/issue; 10 supplied by freelancers. Needs photos of *all* aspects of commercial fisheries on West Coast of US and Canada. Special needs include "high-quality, active photos and slides of fishing boats and fishermen working their gear, dockside shots and the processing of seafood." Model/property release preferred. Captions required; include names and locations.
Making Contact & Terms: Query with résumé of credits. Query with list of stock photo subjects. Keeps samples on file. SASE. Reports in 2-4 weeks. Pays $175/color cover photo; $50-100/color inside photo; $25-50/b&w inside photo. Pays on publication. Credit line given. Buys one-time rights, first North American serial rights. Previously published work OK "if not previously published in a competing trade journal."
Tips: Wants to see "clear, close-up and active photos."

***PAPER AGE**, 51 Mill St., Suite 5, Hanover MA 02339-1650. (617)829-4581. Fax: (617)829-4503. Editor: John F. O'Brien Jr.. Circ. 35,000. Estab. 1884. Monthly tabloid. Emphasizes paper industry—news, pulp and paper mills, technical reports on paper making and equipment. Readers are employees in the paper industry. Sample copy free.
Needs: Uses 25-30 photos/issue; very few supplied by freelancers. Needs photos of paper mills—inside/outside; aerial; forests (environmentally appealing shots); paper recycling facilities. Property release preferred (inside shots of paper mill equipment). Photo captions required; include date, location, description of shot.
Making Contact & Terms: Interested in receiving work from newer, lesser-known photographers. Send unsolicited photos by mail for consideration. Send any size glossy prints. Keeps samples on file. SASE. Reports in 1-2 weeks. NPI. Pays on publication. Credit line given. Buys all rights; negotiable.

THE PARKING PROFESSIONAL, 701 Kenmore, Suite 200, Fredericksburg VA 22401. (540)371-7535. Fax: (540)371-8022. Editor: Marie E. Witmer. Circ. 2,300. Estab. 1984. Publication of the International Parking Institute. Monthly magazine. Emphasizes parking: public, private, institutional, etc. Readers are male and female public parking managers, ages 30-60. Free sample copy.
Needs: Uses 12 photos/issue; 4-5 supplied by freelancers. Model release required. Captions preferred, include location, purpose, type of operation.
Making Contact & Terms: Interested in receiving work from newer, lesser-known photographers. Contact through rep. Arrange personal interview to show portfolio for review. Query with résumé of credits. Provide résumé, business card, brochure, flier or tearsheets to be kept on file for possible assignments. Send 5×7, 8×10 color or b&w prints; 35mm, 2¼×2¼, 4×5, 8×10 transparencies. Keeps samples on file. SASE. Reports in 1-2 weeks. Pays $100-300/color cover photo; $25-100/color inside photo; $25-100/b&w inside photo; $100-500/photo/text package. Pays on publication. Credit line given. Buys one-time, all rights; negotiable. Previously published work OK.

PEDIATRIC ANNALS, 6900 Grove Rd., Thorofare NJ 08086. (609)848-1000. E-mail: ped@slackin c.com. Website: http://www.slackinc.com/ped.htm. Editor: Mary L. Jerrell. Circ. 36,000. Monthly journal. Readers are practicing pediatricians. Sample copy free with SASE.
Needs: Uses 1 cover photo/issue. Needs photos of "children in medical settings, some with adults." Written release required. Captions preferred.

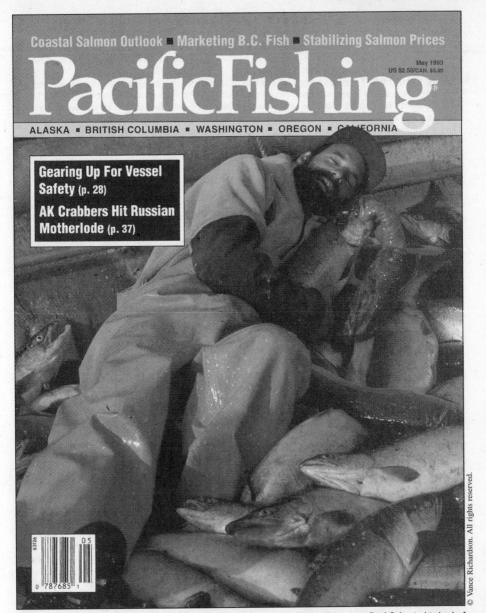

Coastal Salmon Outlook ■ Marketing B.C. Fish ■ Stabilizing Salmon Prices

PacificFishing

May 1993
US $2.50/CAN. $3.00

ALASKA ■ BRITISH COLUMBIA ■ WASHINGTON ■ OREGON ■ CALIFORNIA

Gearing Up For Vessel Safety (p. 28)

AK Crabbers Hit Russian Motherlode (p. 37)

During a fishing trip to Alaska, Vance Richardson captured on film fellow fisherman Paul Splan in his bed of salmon. "It's hard to find time to wipe off the fish slime and shoot that killer shot!" says Richardson. This image has been a successful one for the Houston-based photographer. *Pacific Fisherman* purchased one-time rights for $300 and used the work on its cover. The shot won a $599 third-place prize in Grumman's Photo Contest. Then *National Fisherman* bought one-time rights for $150.

Making Contact & Terms: Query with samples. Provide résumé, business card, brochure, flier or tearsheets to be kept on file for possible future assignments. Pays $200-400/color cover photo. Pays on publication. Credit line given. Buys one-time North American rights including any and all subsidiary forms of publication, such as electronic media and promotional pieces. Simultaneous submissions and previously published work OK.

PERSONAL SELLING POWER, INC., Box 5467, Fredericksburg VA 22405. (540)752-7000. Editor-in-Chief: Laura B. Gschwandtner. Magazine for sales and marketing professionals. Uses photos

for magazine covers and text illustration. Recent covers have featured leading personalities such as George Foreman, Gregg Lemond and Andy Grove.

Needs: Buys about 35 freelance photos/year; offers about 6 freelance assignments/year. Business, sales, motivation, etc. Subject matter and style of photos depend on the article. Most photos are business oriented, but some can also use landscape.

Making Contact & Terms: Query with résumé of credits, samples and list of stock photo subjects. Uses transparencies, or in some cases b&w; formats can vary. Report time varies according to deadlines. NPI. Payment and terms negotiable. **Pays on acceptance.** Credit line given. Buys one-time rights. Previously published work OK.

Tips: Photographers should "send only their best work. Be reasonable with price. Be professional to work with. Also, look at our magazine to see what types of work we use and think about ways to improve what we are currently doing to give better results for our readers." As for trends, "we are using more and better photography all the time, especially for cover stories."

PERSONNEL JOURNAL, 245 Fischer Ave., #B-2, Costa Mesa CA 92626. (714)751-1883. Fax: (714)751-4106. Art Director: Steve Stewart. Circ. 30,000. Estab. 1921. Monthly magazine. Emphasizes human resources. Readers are male and female business leaders in the hiring profession, ages 30-65. Sample copies can be viewed in libraries.

Needs: Uses 2-5 photos/issue; all supplied by freelancers. "We purchase business, news stock and assign monthly cover shoots." Model release required. Property release preferred. Captions preferred.

Making Contact & Terms: Interested in receiving work from newer, lesser-known photographers. Provide résumé, business card, brochure, flier or tearsheets to be kept on file for possible assignments. Query with stock photo list. Keeps samples on file. SASE. Reports in 1 month. NPI. Pays on publication. Credit line given. Buys one-time rights. Simultaneous submissions and previously published work OK.

PET BUSINESS, 7-L Dundas Circle, Greensboro NC 27407. (910)292-4047. Fax: (910)292-4272. Executive Editor: Rita Davis. Circ. 19,000. Estab. 1974. Monthly news magazine for pet industry professionals. Sample copy $3. Guidelines free with SASE.

Needs: Photos of well-groomed pet animals (preferably purebred) of any age in a variety of situations. Identify subjects. Animals: dogs, cats, fish, birds, reptiles, amphibians, small animals (hamsters, rabbits, gerbils, mice, etc.) Also, can sometimes use shots of petshop interiors—but must be careful not to be product-specific. Good scenes would include personnel interacting with customers or caring for shop animals. Model/property release preferred. Captions preferred; include essential details regarding animal species.

Making Contact & Terms: Interested in receiving work from newer, lesser-known photographers. Submit photos for consideration. Reports within 3 months with SASE. Pays $20/color print or transparency for inside use; $100 for cover use. Pays on publication. Credit line given. Buys all rights; negotiable.

Tips: Uncluttered background. Portrait-style always welcome. Close-ups best. News/action shots if timely. "Make sure your prints have good composition, and are technically correct, in focus and with proper contrast. Avoid dark pets on dark backgrounds! Send only 'pet' animal, not zoo or wildlife, photos."

PET PRODUCT NEWS MAGAZINE, P.O. Box 6050, Mission Viejo CA 92690. (714)855-8822. Fax: (714)855-3045. Editor: Stacy N. Hackett. Monthly tabloid. Emphasizes pets and business subjects. Readers are pet store owners and managers. Sample copy $5.50. Photo guidelines free with SASE.

Needs: Uses 25-50 photos/issue; 75-100% supplied by freelancers. Needs photos of people interacting with pets, pets doing "pet" things, pet stores and vets examining pets. Reviews photos with or without ms. Model/property release preferred. Captions preferred; include type of animal, name of pet store, name of well-known subjects, any procedures being performed on an animal that are not self-explanatory.

Making Contact & Terms: Interested in receiving work from newer, lesser-known photographers. Send unsolicited photos by mail for consideration. Send any size glossy color and b&w prints; 35mm transparencies or slides. SASE. Reports in 2 months. "Photo prices vary, typically ranging from $35-70/photo." Pays on publication. Credit line given; must appear on each slide or photo. Buys one-time rights. Previously published work OK.

Tips: Looks for "appropriate subjects, clarity and framing, sensitivity to the subject. No avant garde or special effects. We need clear, straight-forward photography. Definitely no 'staged' photos, keep it natural. Read the magazine before submission. We are a trade publication and need business-like, but not boring, photos that will add to our subjects."

***PETROGRAM**, 209 Office Plaza, Tallahassee FL 32301. (904)877-5178. Fax: (904)877-5864. Editor: Barbara Holloway. Circ. 700. Estab. mid-1970s. Association publication. Monthly magazine. Em-

phasizes the petroleum industry. Readers are predominantly male, increasingly female, ages 30-60. Sample copy free with 9×12 SAE and 4 first-class stamps.

Needs: Uses 3-15 photos/issue; 1 supplied by freelancer. Needs photos of petroleum equipment, convenience store settings, traffic situations and environmental protection (Florida specific). Needs portrait-oriented cover photos, not landscape-oriented photos. Reviews photos with or without a ms. Model/property release preferred. Captions preferred; include location and date.

Making Contact & Terms: Interested in receiving work from newer, lesser-known photographers. Submit portfolio for review. Query with stock photo list. Send unsolicited photos by mail for consideration. Provide résumé, business card, brochure, flier or tearsheets to be kept on file for possible assignments. Send 5×7, 8×10 glossy b&w or color prints. Keeps samples on file. SASE. Reports in 3 weeks. Pays $100/color cover photo; $75/b&w cover photo; $50/color inside photo; $25/b&w inside photo. Pays on publication. Credit line given. Rights negotiable.

Tips: "We are new at considering freelance. We've done our own up to now except very occasionally when we've hired a local photographer. We are a good place for 'non-established' photographers to get a start."

PETROLEUM INDEPENDENT, 1101 16th St. NW, Washington DC 20036. (202)857-4774. Fax: (202)857-4799. Editor: Pamela Lessard. Circ. 6,200. Estab. 1930. Monthly magazine. Emphasizes independent petroleum industry. "Don't confuse us with the major oil companies, pipelines, refineries, gas stations. Our readers explore for and produce crude oil and natural gas in the lower 48 states. Our magazine covers energy politics, regulatory problems, the national outlook for independent producers."

Needs: Photo essay/photo feature; scenic; and special effects/experimental, all of oil field subjects. Please send your best work.

Making Contact & Terms: Interested in receiving work from newer, lesser-known photographers. Uses 35mm or larger transparencies. Pays $35-100/photo; payment negotiable for cover. Buys one-time and all rights.

Tips: "We want to see creative use of camera—scenic, colorful or high contrast-studio shots. Creative photography to illustrate particular editorial subjects (natural gas decontrol, the oil glut, etc.) is always wanted. We've already got plenty of rig shots—we want carefully set-up shots to bring some art to the oil field."

PHOTO TECHNIQUES, (formerly *Darkroom & Creative Camera Techniques*), Dept. PM, Preston Publications, 7800 Merrimac Ave., P.O. Box 48312, Niles IL 60714. (847)965-0566. Fax: (847)965-7639. Publisher: Tinsley S. Preston, III. Editor: Mike Johnston. Circ. 40,000. Estab. 1979. Bimonthly magazine. Covers darkroom techniques, creative camera use, photochemistry and photographic experimentation/innovation, plus general user-oriented photography articles aimed at advanced amateurs and professionals. Sample copy $4.50. Photography and writer's guidelines free with SASE.

Needs: "The best way to publish photographs in *Photo* is to write an article on photo or darkroom techniques and illustrate the article. The exceptions are: cover photographs—we are looking for striking poster-like images that will make good newsstand covers; and the Portfolio feature—photographs of an artistic nature; most of freelance photography comes from what is currently in a photographer's stock." Model/property release preferred. Captions required if photo is used.

Making Contact & Terms: Interested in receiving work from newer, lesser-known photographers. "We do not want to receive more than 10 or 20 in any one submission. We ask for submissions on speculative basis only. Except for portfolios, we publish few single photos that are not accompanied by some type of text." Send dupe slides first. All print submissions should be 8×10. Pays $300/covers; $100/page and up for text/photo package; negotiable. Pays on publication only. Credit line given. Buys one-time rights.

Tips: "We are looking for exceptional photographs with strong, graphically startling images. No run-of-the-mill postcard shots please. We are the most technical general-interest photographic publication on the market today. Authors are encouraged to substantiate their conclusions with experimental data. Submit samples, article ideas, etc. It's easier to get photos published with an article."

PICKWORLD, 1691 Browning, Irvine CA 92714. (714)261-7425. Fax: (714)250-8187. Editor: Denis Hill. Circ. 25,000. Estab. 1984. Bimonthly magazine. Emphasizes the multidimensional database market: vendors and users. Readers are managers, technical staff of vendors or user entities in the multidimensional database market. Sample copy $8.

Needs: Uses 30 photos/issue; 10 supplied by freelancers. Needs photos of people and businesses, computers and related objects. Model release preferred.

Making Contact & Terms: Query with résumé of credits. Does not keep samples on file. SASE. Reports in 3 weeks. Pays $200/job; $300-500/color cover photo; $50/color inside photo. **Pays on acceptance**. Credit line given. Buys first North American serial rights. Simultaneous submissions and previously published work OK.

PIPELINE AND UTILITIES CONSTRUCTION, P.O. Box 219368, Houston TX 77218-9368. (713)558-6930. Fax: (713)558-7029. Editor: Robert Carpenter. Circ. 31,000. Estab. 1945. Monthly. Emphasizes construction and rehabilitation of oil and gas, water and sewer underground pipelines and cable. Readers are contractor key personnel and company construction managers. Sample copy $3.
Needs: "Uses photos of underground construction and rehabilitation, but must have editorial material on project with the photos."
Making Contact & Terms: Send unsolicited photos by mail for consideration. Accepts color prints and transparencies. SASE. Reports in 1 month. NPI. Pay rates negotiable. Buys one-time rights.
Tips: "Freelancers are competing with staff as well as complimentary photos supplied by equipment manufacturers. Subject matter must be unique, striking and 'off the beaten track' (i.e., somewhere we wouldn't travel ourselves to get photos)."

PIZZA TODAY, Dept. PM, P.O. Box 1347, New Albany IN 47151. (812)949-0909. Fax: (812)941-5329. Assignment Editor: Bruce Allar. Circ. 46,000. Estab. 1983. Monthly. Emphasizes pizza trade. Readers are pizza shop owners/operators. Sample copy free with 9½×12½ SAE.
Needs: Uses 40 photos/issue; 10 supplied by freelancers; 100% from assignment. Needs how-tos of pizza-making, product shots, profile shots. Special needs include celebrities eating pizza, politicians eating pizza. Captions required.
Making Contact & Terms: Provide résumé, business card, brochure, flier or tearsheets to be kept on file for possible assignments. SASE. Reports in 1 month. Pays $5-15/b&w photo; $20-30/color photo (prefers 35mm slides); all fees are negotiated in advance. Pays on publication. Credit line given. Buys all rights; negotiable. Previously published work OK.
Tips: Accepts samples by mail only. "Team up with writer/contributor and supply photos to accompany article. We are not looking for specific food shots—looking for freelancers who can go to pizza shops and take photos which capture the atmosphere, the warmth and humor; 'the human touch.' "

PLASTICS NEWS, 1725 Merriman Rd., Akron OH 44313. (216)836-9180. Fax: (216)836-2322. Managing Editor: Ron Shinn. Circ. 60,000. Estab. 1989. Weekly tabloid. Emphasizes plastics industry business news. Readers are male and female executives of companies that manufacture a broad range of plastics products; suppliers and customers of the plastics processing industry. Sample copy $1.95.
Needs: Uses 10-20 photos/issue; 1-3 supplied by freelancers. Needs photos of technology related to use and manufacturing of plastic products. Model/property release preferred. Captions required.
Making Contact & Terms: Send unsolicited photos by mail for consideration. Provide résumé, business card, brochure, flier or tearsheets to be kept on file for possible assignments. Query with stock photo list. Keeps samples on file. SASE. Reports in 2 weeks. Pays $125-175/color cover photo; $125-175/color inside photo; $100-150/b&w inside photo. Pays on publication. Credit line given. Buys one-time and all rights. Simultaneous submissions and previously published work OK.

PLUMBING & MECHANICAL, 3150 River Rd., Suite 101, Des Plaines IL 60018. (847)297-3757. Fax: (847)297-8371. E-mail: wcalc@aol.com. Art Director: Wendy Calcaterra. Circ. 40,324. Estab. 1984. Monthly magazine. Emphasizes mechanical contracting, plumbing, hydronic-heating, remodeling. Readers are company owners, presidents, CEOs, vice presidents, general managers, secretaries and treasurers.
Needs: Uses 10-12 photos/issue; 2-5 supplied by freelancers. Interested in showroom shots, job sites, personalities. Model/property release preferred. Captions preferred.
Making Contact & Terms: Interested in receiving work from newer, lesser-known photographers. Provide résumé, business card, brochure, flier or tearsheets to be kept on file for possible assignments. Deadlines: Photos are due during the first week of the month. Keeps samples on file. Cannot return material. Also accepts ditigal images in Photoshop TIFF images, CMYK, 300 DPI. Reports in 1 month. Pays $950/job. Pays on publication. Credit line given. Buys all rights.

POLICE MAGAZINE, 6300 Yarrow Dr., Carlsbad CA 92009. (800)365-7827. Fax: (619)931-9809. Managing Editor: Randy Resch. Estab. 1976. Monthly. Emphasizes law enforcement. Readers are various members of the law enforcement community, especially police officers. Sample copy $2 with 9×12 SAE and 6 first-class stamps. Photo guidelines free with SASE.
Needs: Uses about 15 photos/issue; 99% supplied by freelance photographers. Needs law enforcement related photos. Special needs include photos relating to daily police work, crime prevention, international law enforcement, police technology and humor. Model release required. Property release preferred. Captions preferred.
Making Contact & Terms: Interested in receiving work from newer, lesser-known photographers. Arrange a personal interview to show portfolio. Send b&w prints, 35mm transparencies, b&w contact sheet or color negatives by mail for consideration. Also accepts digital images. SASE. Pays $100/ color cover photo; $30/b&w photo; $30 (negotiable)/color inside photo; $150-300/job; $150-300/text/ photo package. **Pays on acceptance.** Buys all rights; rights returned to photographer 45 days after publication. Simultaneous submissions OK.

Tips: "Send for our editorial calendar and submit photos based on our projected needs. If we like your work, we'll consider you for future assignments. A photographer we use can grasp the conceptual and the action shots."

POLICE TIMES/CHIEF OF POLICE, 3801 Biscayne Blvd., Miami FL 33137. (305)573-0070. Fax: (305)573-9819. Executive Editor: Jim Gordon. Circ. 50,000. Bimonthly magazines. Readers are law enforcement officers at all levels. Sample copy $2.50. Photo guidelines free with SASE.
Needs: Buys 60-90 photos/year. Photos of police officers in action, civilian volunteers working with the police and group shots of police department personnel. Wants no photos that promote other associations. Police-oriented cartoons also accepted on spec. Model release preferred. Captions preferred.
Making Contact & Terms: Send photos for consideration. Send glossy b&w and color prints. SASE. Reports in 3 weeks. Pays $5-10 upwards/inside photo; $25-50 upwards/cover photo. **Pays on acceptance.** Credit line given if requested; editor's option. Buys all rights, but may reassign to photographer after publication. Simultaneous submissions and previously published work OK.
Tips: "We are open to new and unknowns in small communities where police are not given publicity."

POWERLINE MAGAZINE, 10251 W. Sample Rd., Suite B, Coral Springs FL 33065-3939. (954)755-2677. Fax: (954)755-2679. Editor: James McMullen. Photos used in trade magazine of Electrical Generating Systems Association and PR releases, brochures, newsletters, newspapers and annual reports.
Needs: Buys 40-60 photos/year; gives 2 or 3 assignments/year. "Cover photos, events, award presentations, groups at social and educational functions." Model release required. Property release preferred. Captions preferred; include identification of individuals only.
Making Contact & Terms: Interested in receiving work from newer, lesser-known photographers. Provide résumé, business card, brochure, flier or tearsheets to be kept on file for possible future assignments. Solicits photos by assignment only. Uses 5×7 glossy b&w and color prints; b&w and color contact sheets; b&w and color negatives. SASE. Reports as soon as selection of photographs is made. NPI. Buys all rights; negotiable.
Tips: "Basically a freelance photographer working with us should use a photojournalistic approach, and have the ability to capture personality and a sense of action in fairly static situations. With those photographers who are equipped, we often arrange for them to shoot couples, etc., at certain functions on spec, in lieu of a per-day or per-job fee."

THE PREACHER'S MAGAZINE, E. 10814 Broadway, Spokane WA 99206. (509)226-3464. Fax: (509)926-8740. Editor: Randal E. Denny. Circ. 18,000. Estab. 1925. Quarterly professional journal for ministers. Emphasizes the pastoral ministry. Readers are pastors of large to small churches in five denominations; most pastors are male. No sample copy available. No photo guidelines.
Needs: Uses one photo/issue; all supplied by freelancers. Large variety needed for cover, depends on theme of issue. Model release preferred. Captions preferred.
Making Contact & Terms: Send 35mm b&w/color prints by mail for consideration. Reports ASAP. Pays $25/b&w photo; $75/color cover photo. **Pays on acceptance.** Credit line given. Buys one-time rights. Simultaneous submissions and previously published work OK.
Tips: In photographer's samples wants to see "a variety of subjects for the front cover of our magazine. We rarely use photos within the magazine itself."

PRO SOUND NEWS, 2 Park Ave., New York NY 10016. (212)213-3444. Editor: Tim Wetmore. Managing Editor: Rena Adler. Circ. 21,000. Monthly tabloid. Emphasizes professional recording and sound and production industries. Readers are recording engineers, studio owners and equipment manufacturers worldwide. Sample copy free with SASE.
Needs: Uses about 24 photos/issue; all supplied by freelance photographers. Needs photos of recording sessions, sound reinforcement for concert tours, permanent installations. Model release required. Captions required.
Making Contact & Terms: Query with samples. Send 8×10 glossy color prints by mail for consideration. SASE. Reports in 2 weeks. NPI; pays by the job or for text/photo package. Pays on publication. Credit line given. Buys one-time rights. Simultaneous submissions and previously published work OK.

***PRODUCE MERCHANDISING, a Vance Publishing Corp. magazine**, Three Pine Ridge Plaza, 10901 W. 84th Terrace, Lenexa KS 66214. (913)438-8700. Fax: (913)438-0691. E-mail: 76207,2051@compuserv.com. Managing Editor: Stephanie Wiemann. Circ. 12,000. Estab. 1988. Monthly magazine. Emphasizes the fresh produce industry. Readers are male and female executives who oversee produce operations in US and Canadian supermarkets. Sample copy available. Photo guidelines free with SASE.

Needs: Uses 30 photos/issue; 2-5 supplied by freelancers. Needs in-store shots, either environmental portraits for cover photos or display pictures. Captions preferred; include subject's name, job title and company title—all verified and correctly spelled.

Making Contact & Terms: Provide résumé, business card, brochure, flier or tearsheets to be kept on file for possible future assignments. Keeps samples on file. Reporting time "depends on when we will be in a specific photographer's area and have a need." Pays $500-900/color cover transparencies; $25-50/color photo inside; $50-100/color roll inside photo. **Pays on acceptance.** Credit line given. Buys all rights.

Tips: "We seek photographers who serve as our on-site 'art director,' to ensure art sketches come to life. Supermarket lighting (fluorescent) offers a technical challenge we can't avoid. The 'greening' effect must be diffused/eliminated."

THE PROFESSIONAL COMMUNICATOR, 10605 Judicial Dr., Suite A-4, Fairfax VA 22030. (703)359-9000. Fax: (703)359-0603. E-mail: comunik@aol.com. Director of Communications: Colleen Phelan. Publication of Women in Communications. Quarterly. Emphasizes communications industry news and issues, professional development. Readers are women (and men) in communications industry, average age is 39. Sample copy $7.

Needs: Uses 5-10 photos/issue; all supplied by freelancers. Needs conference coverage, and photos to accompany stories. Captions preferred; include who, where, when, why.

Making Contact & Terms: Interested in receiving work from newer, lesser-known photographers. Query with stock photo list. Provide résumé, business card, brochure, flier or tearsheets. Does not keep samples on file. Cannot return material. Reports in 4-6 weeks. NPI. Pays on publication. Rights negotiable. Simultaneous submissions and previously published work OK.

PROGRESSIVE ARCHITECTURE, Dept. PM, 600 Summer St., P.O. Box 1361, Stamford CT 06904. (203)348-7531. Fax: (203)348-4023. E-mail: paeditor@aol.com (editorial); paart@aol.com (art department). Editor: John Morris Dixon. Art Director: Julie Yee. Circ. 75,000. Monthly magazine. Emphasizes current information on building design and technology for professional architects.
 ● This publication is doing computer manipulation/retouching as well as accessing images
 through computer networks.

Needs: Photos purchased with or without accompanying ms and on assignment; 90% assigned. Architectural and interior design. Captions preferred. Accompanying mss: interesting architectural or engineering developments/projects.

Making Contact & Terms: Interested in receiving work from newer, lesser-known photographers. Send material by mail for consideration. Uses 8×10 b&w glossy prints; 4×5 transparencies. Vertical format preferred for cover. Also accepts digital files in TIFF, EPS, Targa, JPEG or GIF formats. "We do not use photo CDs." SASE. Reports in 1 month. Pays $500/1-day assignment, $1,000/2-day assignment; $250/half-day assignment or on a per-photo basis. Pays $25 minimum/b&w photo; $50/color photo; $50/color cover photo. Pays extra for electronic use of images. Pays on publication. Credit line given. Buys one-time rights.

Tips: In samples, wants to see "straightforward architectural presentation. Send us regular updates (cards/samples) of new work, brief listing of future travel to coordinate with possible commissions on projects in those locations."

***PUBLIC WORKS MAGAZINE**, 200 S. Broad St., Ridgewood NJ 07451. (201)445-5800. Contact: Edward B. Rodie. Circ. 60,000. Monthly magazine. Emphasizes the planning, design, construction, inspection, operation and maintenance of public works facilities (bridges, roads, water systems, landfills, etc.) Readers are predominantly male civil engineers, ages 20 and up. Some overlap with other planners, including consultants, department heads, etc. Sample copy free upon request. Photo guidelines available, but for cover only.

Needs: Uses dozens of photos/issue. "Most photos are supplied by authors or with company press releases." Purchases photos with accompanying ms only. Captions required.

Making Contact & Terms: Provide résumé, business card, brochure, flier or tearsheets to be kept on file for possible assignments. SASE. Reports in 2 weeks. NPI; payment negotiated with editor. Credit line given "if requested." Buys one-time rights.

Tips: "Nearly all of the photos used are submitted by the authors of articles (who are generally very knowledgeable in their field). They may occasionally use freelancers. Cover personality photos are done by staff and freelance photographers." To break in, "learn how to take good clear photos of public works projects that show good detail without clutter. Prepare a brochure and pass around to

small and mid-size cities, towns and civil type consulting firms; larger (organizations) will probably have staff photographers."

PURCHASING MAGAZINE, (formerly *Electronic Business Buyer*), 275 Washington St., Newton MA 02158. (617)964-3030. Fax: (617)558-4705. Art Director: Michael Roach. Circ. 90,000. Estab. 1993. Bimonthly. Readers are management and purchasing professionals.
Needs: Uses 0-10 photos/issue, most on assignment. Needs corporate photos and people shots. Model/property release preferred. Captions required.
Making Contact & Terms: Interested in receiving work from newer, lesser-known photographers. Arrange a personal interview to show portfolio. Provide résumé, business card, brochure, flier or tearsheets to be kept on file for possible future assignments. Cannot return material. Pays $300-500/b&w photo; $300-500/color photo; $50-100/hour; $400-800/day; $200-500/photo/text package. **Pays on acceptance.** Credit line given. Buys one-time rights. Simultaneous submissions and previously published work OK.
Tips: In photographer's portfolio looks for informal business portrait, corporate atmosphere.

QUICK FROZEN FOODS INTERNATIONAL, 2125 Center Ave., Suite 305, Fort Lee NJ 07024-5898. (201)592-7007. Fax: (201)592-7171. Editor: John M. Saulnier. Circ. 13,000. Quarterly magazine. Emphasizes retailing, marketing, processing, packaging and distribution of frozen foods around the world. Readers are international executives involved in the frozen food industry: manufacturers, distributors, retailers, brokers, importers/exporters, warehousemen, etc. Review copy $8.
Needs: Buys 20-30 photos/year. Plant exterior shots, step-by-step in-plant processing shots, photos of retail store frozen food cases, head shots of industry executives, product shots, etc. Captions required.
Making Contact & Terms: Query first with résumé of credits. Uses 5×7 glossy b&w and color prints. SASE. Reports in 1 month. NPI. Pays on publication. Buys all rights, but may reassign to photographer after publication.
Tips: A file of photographers' names is maintained; if an assignment comes up in an area close to a particular photographer, he may be contacted. "When submitting names, inform us if you are capable of writing a story, if needed."

THE RANGEFINDER, 1312 Lincoln Blvd., Santa Monica CA 90401. (310)451-8506. Fax: (310)395-9058. Editor: Karre Marino. Circ. 50,000. Estab. 1952. Monthly magazine. Emphasizes topics, developments and products of interest to the professional photographer. Readers are professionals in all phases of photography. Sample copy free with 11×14 SAE and 2 first-class stamps. Photo guidelines free with SASE.
Needs: Uses 20-30 photos/issue; 70% supplied by freelancers. Needs all kinds of photos; almost always run in conjunction with articles. "We prefer photos accompanying 'how-to' or special interest stories from the photographer." No pictorials. Special needs include seasonal cover shots (vertical format only). Model release required. Property release preferred. Captions preferred.
Making Contact & Terms: Interested in receiving work from newer, lesser-known photographers. Query with résumé of credits. Keeps samples on file. SASE. Reports in 1 month. Pays $100 minimum/printed editorial page with illustrations. Covers submitted gratis. Pays on publication. Credit line given. Buys first North American serial rights; negotiable. Previously published work occasionally OK; give details.

RECOMMEND WORLDWIDE, Dept. PM, 5979 NW 151st St., Suite 120, Miami Lake FL 33014. (305)828-0123. Art Director: Janet Rosemellia. Managing Editor: Rick Shively. Circ. 55,000. Estab. 1985. Monthly. Emphasizes travel. Readers are travel agents, meeting planners, hoteliers, ad agencies. Sample copy free with $8\frac{1}{2} \times 11$ SAE and 10 first-class stamps.
Needs: Uses about 40 photos/issue; 70% supplied by freelance photographers. "Our publication divides the world up into seven regions. Every month we use travel destination-oriented photos of animals, cities, resorts and cruise lines. Features all types of travel photography from all over the world." Model/property release required. Captions preferred; identification required.
Making Contact & Terms: Interested in receiving work from newer, lesser-known photographers. "We prefer a résumé, stock list and sample card or tearsheets with photo review later." SASE. Pays $150/color cover photo; up to 20 square inches: $25; 21-35 square inches $35; 36-80 square inches $50; over 80 square inches $75; supplement cover: $75; front cover less than 80 square inches $50.

THE CODE NPI (no payment information given) appears in listings that have not given specific payment amounts.

Pays 30 days upon publication. Credit line given. Buys one-time rights. Simultaneous submissions and previously published work OK.
Tips: Prefers to see "transparencies—either 2¼ × 2¼ or 35mm first quality originals, travel-oriented."

REFEREE, P.O. Box 161, Franksville WI 53126. (414)632-8855. Fax: (414)632-5460. Senior Editor: Tom Hammill. Circ. 35,000. Estab. 1976. Monthly magazine. Readers are mostly male, ages 30-50. Sample copy free with 9 × 12 SAE and 5 first-class stamps. Photo guidelines free with SASE.
Needs: Uses up to 50 photos/issue; 75% supplied by freelancers. Needs action officiating shots—all sports. Photo needs are ongoing. Captions required.
Making Contact & Terms: Send unsolicited photos by mail for consideration. Any format is accepted. Reports in 2 weeks. Pays $100/color cover photo; $75/b&w cover photo; $35/color inside photo; $20/b&w inside photo. Pays on publication. Credit line given. Rights purchased negotiable. Simultaneous submissions and previously published work OK.
Tips: Prefers photos which bring out the uniqueness of being a sports official. Need photos primarily of officials at high-school level in baseball, football, basketball, soccer and softball in action. Other sports acceptable, but used less frequently. "When at sporting events, take a few shots with the officials in mind, even though you may be on assignment for another reason. Don't be afraid to give it a try. We're receptive, always looking for new freelance contributors. We are constantly looking for offbeat pictures of officials/umpires. Our needs in this area have increased."

REGISTERED REPRESENTATIVE, 18818 Teller Ave., Suite 280, Irvine CA 92715. (714)851-2220. Art Director: Chuck LaBresh. Circ. 90,000. Estab. 1976. Monthly magazine. Emphasizes stock brokerage industry. Magazine is "requested and read by 90% of the nation's stock brokers."
Needs: Uses about 8 photos/issue; 5 supplied by freelancers. Needs environmental portraits of financial and brokerage personalities, and conceptual shots of financial ideas, all by assignment only. Model/property release preferred. Captions required.
Making Contact & Terms: Interested in receiving work from newer, lesser-known photographers. Provide brochure, flier or tearsheets to be kept on file for possible future assignments. Cannot return material. Pays $250-600/b&w or color cover photo; $100-250/b&w or color inside photo. Pays 30 days after publication. Credit line given. Buys one-time rights. Simultaneous submissions and previously published work OK.
Tips: "I usually give photographers free reign in styling, lighting, camera lenses, whatever. I want something that is unusual enough to provide interest but not so strange that the subject can't be identified."

REMODELING, 1 Thomas Circle NW, Suite 600, Washington DC 20005. Managing Editor: Cheryl Weber. Circ. 100,000. Published 12 times/year. "Business magazine for remodeling contractors." Readers are "small contractors involved in residential and commercial remodeling." Sample copy free with 8 × 11 SASE.
Needs: Uses 10-15 photos/issue; number supplied by freelancers varies. Needs photos of remodeled residences, both before and after. Reviews photos with "short description of project, including architect's or contractor's name and phone number. We have three regular photo features: *Double Take* is a photo caption piece about an architectural photo that fools the eye. *Snapshots* is a photo caption showing architectural details. *Before and After* describes a whole-house remodel. Request editorial calendar to see upcoming design features."
Making Contact & Terms: Interested in receiving work from newer, lesser-known photographers. Provide résumé, business card, brochure, flier or tearsheets to be kept on file for possible future assignments. Reports in 1 month. Pays $100/color cover photo; $25/b&w inside photo; $50/color inside photo; $300 maximum/job. **Pays on acceptance.** Credit line given. Buys one-time rights.
Tips: Wants "interior and exterior photos of residences that emphasize the architecture over the furnishings."

RESCUE MAGAZINE, Dept. PM, Jems Communications, P.O. Box 2789, Carlsbad CA 92018. Fax: (619)431-8176. Editor: Jeff Berend. Circ. 25,000. Estab. 1988. Bimonthly. Emphasizes techniques, equipment, action stories with unique rescues; paramedics, EMTs, rescue divers, firefighters, etc. Rescue personnel are most of our readers. Sample copy free with 9 × 12 SAE and 7 first-class stamps. Photo guidelines free with SASE.
● *Rescue* is being distributed on the newsstand.
Needs: Uses 30-50 photos/issue; 5-10 supplied by freelance photographers. Needs rescue scenes, transport, injured victims, equipment and personnel, training, earthquake rescue operations. Special photo needs include strong color shots showing newsworthy rescue operations, including a unique or difficult rescue/extrication, treatment, transport, personnel, etc. b&w showing same. Captions required.
Making Contact & Terms: Interested in receiving work from newer, lesser-known photographers. Query with samples. Send 5 × 7 or larger glossy color prints or color contacts sheets by mail for consideration. Slide/transparencies preferred format. Don't send originals. SASE. Pays $125/color

inside photo; $10-95/hour; $80-795/day. Pays on publication. Credit line given. Buys one-time rights. Previously published work OK (must be labeled as such).

Tips: "Ride along with a rescue crew or team. This can be firefighters, paramedics, mountain rescue teams, dive rescue teams, and so on. Get in close." Looks for "photographs that show rescuers in action, using proper techniques and wearing the proper equipment. Submit timely photographs that show the technical aspects of rescue."

RESOURCE RECYCLING, P.O. Box 10540, Portland OR 97210. (503)227-1319. Editor: Meg Lynch. Circ. 16,000. Estab. 1982. Monthly. Emphasizes "the recycling of post-consumer waste materials (paper, metals, glass, plastics etc.) and composting." Readers are "recycling company managers, local government officials, waste haulers and environmental group executives." Sample copy free with 11 first-class stamps plus 9×12 SAE.

Needs: Uses about 5-15 photos/issue; 1 supplied by freelancers. Needs "photos of recycling facilities, curbside recycling collection, secondary materials (bundles of newspapers, soft drink containers), etc." Model release preferred. Captions required.

Making Contact & Terms: Send glossy color prints and contact sheet. SASE. Reports in 1 month. NPI; payment "varies by experience and photo quality." Pays on publication. Credit line given. Buys first North American serial rights. Simultaneous submissions OK.

Tips: "Because *Resource Recycling* is a trade journal for the recycling and composting industry, we are looking only for photos that relate to recycling and composting issues."

RISTORANTE MAGAZINE, P.O. Box 73, Liberty Corner NJ 07938. (908)766-6006. Fax: (908)766-6607. Art Director: Erica Lynn DeWitte. Circ. 50,000. Estab. 1994. Quarterly magazine. *Ristorante*, the magazine for the Italian connoisseur and Italian restaurants with liquor licenses; appears on newsstands.

Needs: Number of photos/issue varies. Number supplied by freelancers varies. "Think Italian!" Reviews photos with or without ms. Model/property release required. Captions preferred.

Making Contact & Terms: Interested in receiving work from newer, lesser-known photographers. Provide résumé, business card, brochure, flier or tearsheets to be kept on file for possible assignments. SASE. NPI. Pays on publication. Credit line given. Buys all rights; negotiable. Previously published work OK.

ROOFER MAGAZINE, 12734 Kenwood Lane, Bldg. 73, Ft. Myers FL 33907. (813)489-2929. Fax: (813)489-1747. Associate Publisher: Angela M. Williamson. Art Director: Alex Whitehair. Circ. 19,000. Estab. 1981. Monthly. Emphasizes the roofing industry and all facets of the roofing business. Readers are roofing contractors, manufacturers, architects, specifiers, consultants and distributors. Sample copy free with 9×12 SAE and 7 first-class stamps.

Needs: Uses about 25 photos/issue; few are supplied by freelancers. 20% of photos from assignment; 40-50% from stock. Needs photos of unusual roofs or those with a humorous slant (once published a photo with a cow stranded on a roof during a flood). Needs several photos of a particular city or country to use in photo essay section. Also, photographs of buildings after major disasters, showing the destruction to the roof, are especially needed. "Please indicate to us the location, time and date taken, and cause of destruction (i.e., fire, flood, hurricane)." Model release required. Captions required; include details about date, location and description of scene.

Making Contact & Terms: Interested in receiving work from newer, lesser-known photographers. Query with samples. Provide résumé, brochure and tearsheets to be kept on file for possible future assignments. Cannot return material. Reports in 1 month. Pays $25 maximum/b&w photo; $50 maximum/color photo; $125 maximum/page for photo essays. Pays on publication. Usually buys one-time rights, "exclusive to our industry."

Tips: "Good lighting is a must. Clear skies, beautiful landscaping around the home or building featured add to the picture. Looking for anything unique, in either the angle of the shot or the type of roof. Humorous photos are given special consideration and should be accompanied by clever captions or a brief, humorous description. No photos of reroofing jobs on your home will be accepted. Most of the photos we publish in each issue are contributed by our authors. Freelance photographers should submit material that would be useful for our photographic essays, depicting particular cities or countries. We've given assignments to freelance photographers before, but most submissions are the ideas of the freelancer."

SATELLITE COMMUNICATIONS, 6300 S. Syracuse Way, Suite 650, Englewood CO 80111. (303)220-0600. Group Publisher: Larry Lannon. Circ. 18,000. Monthly. Covers the international satellite communications industries. Readers are all professionals involved with business satellite communications. Sample copy free with SASE. Focus calendar available.

• Published by Intertec Publishing, this magazine thrives on cutting edge material and editors are interested in computer manipulated work.

Needs: Uses 15-20 photos/issue; 1-5 supplied by freelance photographers. Wants to see dramatic shots of high-tech satellite images, from terrestrial equipment, such as dishes, to orbiting space segment images.

Making Contact & Terms: Query with list of stock photo subjects; provide résumé, business card, brochure, flier or tearsheets to be kept on file for possible future assignments. Does not return unsolicited material. Reports in 3 weeks. Pays $300-500/color cover photo. Pays on publication. Credit line given. Buys one-time rights. Previously published work OK.

THE SCHOOL ADMINISTRATOR, 1801 N. Moore St., Arlington VA 22209. (703)875-0753. Fax: (703)528-2146. Managing Editor: Liz Griffin. Circ. 16,500. Publication of American Association of School Administrators. Monthly magazine. Emphasizes K-12 education. Readers are school administrators including superintendents and principals, ages 50-60, largely male though this is changing. Sample copy $7.

Needs: Uses 23 photos/issue. Needs classroom photos, photos of school principals and superintendents and school board members interacting with parents and students. Model/property release preferred for physically handicapped students. Captions required; include name of school, city, state, grade level of students and general description of classroom activity.

Making Contact & Terms: Interested in receiving work from newer, lesser-known photographers. Send unsolicited photos by mail for consideration (photocopy of b&w prints). Provide résumé, business card, brochure, flier or tearsheets to be kept on file for possible assignments. Photocopy of prints should include contact information including fax number. "Send a SASE for our editorial calendar. In cover letter include mention of other clients. Familiarize yourself with topical nature and format of magazine before submitting prints." Send 5×7, 8×10 matte or glossy color b&w prints; 35mm, $2\frac{1}{4} \times 2\frac{1}{4}$, 4×5, 8×10 transparencies. Work assigned is 3-4 months prior to publication date. Keeps samples on file. SASE. Reports in 3 weeks. Pays $200-300/color cover photo. $10-75/color and b&w inside photo. Credit line given. Buys one-time rights. Simultaneous submissions and previously published work OK.

Tips: "Prefer photos with interesting, animated faces and hand gestures. Always looking for unusual human connection where the photographer's presence has not made subjects stilted."

SEAFOOD LEADER, 5305 Shilshole Ave. NW, #200, Seattle WA 98107. (206)789-6506. Fax: (206)789-9193. Photo Editor: Scott Wellsandt. Circ. 16,000. Estab. 1981. Published bimonthly. Emphasizes seafood industry, commercial fishing. Readers are processors, buyers and sellers of seafood. Sample copy $5 with 9×12 SASE.

Needs: Uses about 40 photos/issue; 50% supplied by freelance photographers, most from stock. Needs photos of international seafood harvesting and farming, supermarkets, restaurants, shrimp, Alaska, many more. Captions preferred; include name, place, time.

Making Contact & Terms: Interested in receiving work from newer, lesser-known photographers. Query with list of stock photo subjects. Send photos on subjects we request. SASE. "We only want it on our topics." Reports in 1 month. Pays $100/color cover photo; $50/color inside photo; $25/b&w photo. Pays on publication. Credit line given. Buys one-time rights. Previously published work OK.

Tips: "Send in slides relating to our needs—request editorial calendar." Looks for "aesthetic shots of seafood and commercial fishing, shots of people interacting with seafood in which expressions are captured (i.e. not posed shots); artistic shots of seafood emphasizing color and shape. We want clear, creative, original photography of commercial fishing, fish species, not sports fishing."

SECURITY DEALER, Dept. PM, 445 Broad Hollow Rd., Suite 21, Melville NY 11747. (516)845-2700. Fax: (516)845-7109. Editor: Susan Brady. Circ. 28,000. Estab. 1967. Monthly magazine. Emphasizes security subjects. Readers are blue collar businessmen installing alarm, security, CCTV and access control systems. Sample copy free with SASE.

Needs: Uses 2-5 photos/issue; none at present supplied by freelance photographers. Needs photos of security-application-equipment. Model release preferred. Captions required.

Making Contact & Terms: Interested in receiving work from newer, lesser-known photographers. Send b&w and color prints by mail for consideration. SASE. Reports "immediately." Pays $25-50/b&w photo; $200/color cover photo; $50-100/inside color photos. Pays 30 days after publication. Credit line given. Buys one-time rights in security trade industry. Simultaneous submissions and/or previously published work OK.

Tips: "Do not send originals, dupes only, and only after discussion with editor."

***SHOOTER'S RAG—A PRACTICAL PHOTOGRAPHIC GAZETTE**, P.O. Box 76595, Atlanta GA 30358. (770)392-1013. Website: http://www.havelin.com. Editor: Michael Havelin. Circ. 2,000. Estab. 1992. Bimonthly. Emphasizes photographic techniques, practical how-tos and electronic imaging. Readers are male and female professionals, semi-professionals and serious amateurs. Sample copy $3 with 10×13 SAE and 75¢ postage. Photo guidelines free with SASE.

Needs: Uses 3-10 photos/issue; 50-75% supplied by freelancers. "Single photos are not needed. Photos with text and text with photographs should query." Special photo needs include humorous b&w cover shots with photographic theme and Band-Aid and detailed description of how the shot was done with accompanying set-up shots. Model/property release preferred. Captions required.

Making Contact & Terms: Interested in reviewing work from newer, lesser-known photographers. Query with résumé of credits, ideas for text/photo packages. Do not send portfolios. Also accepts digital images. Electronic submissions preferred via CIS (72517,2176). Does not keep samples on file. Cannot return material. Reports in 1-3 months. Pays $50/b&w cover photo; $25/b&w inside photo; $50-200/photo text package. Pays on publication. Credit line given. Buys one-time rights; negotiable. Simultaneous submissions and/or previously published work OK.

Tips: "Writers who shoot and photographers who write well should query. Develop your writing skills as well as your photography. Don't wait for the world to discover you. Announce your presence."

SIGNCRAFT MAGAZINE, P.O. Box 60031, Fort Myers FL 33906. (813)939-4644. Editor: Tom McIltrot. Circ. 20,000. Estab. 1980. Bimonthly magazine. Readers are sign artists and sign shop personnel. Sample copy $5. Photo guidelines free with SASE.

Needs: Uses over 100 photos/issue; few at present supplied by freelancers. Needs photos of well-designed, effective signs. Captions preferred.

Making Contact & Terms: Query with samples. Send b&w or color prints; 35mm, 2¼×2¼ transparencies; b&w, color contact sheet by mail for consideration. SASE. Reports in 1 month. NPI. Pays on publication. Credit line given. Buys first North American serial rights. Previously published work possibly OK.

Tips: "If you have some background or past experience with sign making, you may be able to provide photos for us."

***SMALL BUSINESS NEWS**, 14725 Detroit Ave., Cleveland OH 44107. (216)228-6397. Fax: (216)529-8924. Creative Director: Dean Buttner. Circ. 30,000. Estab. 1989. Monthly tabloid. Emphasizes small business. Readers are male and female business owners or managers, ages 25-75. Sample copy free with 11×14 SASE.

Needs: Uses 20 photos/issue; 10 supplied by freelancers. Needs photos of business and professionals. Reviews photos purchased with accompanying ms only. Special photo needs include cover photography for Washington, DC and Philadelphia markets. Model/property release preferred. Captions preferred.

Making Contact & Terms: Interested in receiving work from newer, lesser-known photographers. Provide résumé, business card, brochure, flier or tearsheets to be kept on file for possible assignments. Send 2¼×2¼ transparencies. Keeps samples on file. Reports in 1-2 weeks. Pays $100/hour. **Pays on acceptance.** Credit line given. Buys negotiated rights.

SOCIAL POLICY, 25 W. 43rd St., Room 620, New York NY 10036. (212)642-2929. Fax: (212)642-1956. Managing Editor: Audrey Gartner. Circ. 3,500. Estab. 1970. Quarterly. Emphasizes "social policy issues—how government and societal actions affect people's lives." Readers are academics, policymakers, lay readers. Sample copy $2.50.

Needs: Uses about 9 photos/issue; all supplied by freelance photographers. Needs photos of social consciousness and sensitivity. Model release preferred.

Making Contact & Terms: Arrange a personal interview to show portfolio. Query with samples. Provide résumé, business card, brochure, flier or tearsheets to be kept on file for possible future assignments. Reports in 2 weeks. Pays $100/b&w cover photo; $30/b&w inside photo. Pays on publication. Credit line given. Buys one-time rights. Simultaneous submissions and previously published work OK.

Tips: "Be familiar with social issues. We're always looking for relevant photos."

SOUTHERN LUMBERMAN, 128 Holiday Ct., Suite 116, P.O. Box 681629, Franklin TN 37068-1629. (615)791-1961. Fax: (615)790-6188. Managing Editor: Nanci Gregg. Circ. 12,000. Estab. 1881. Monthly. Emphasizes forest products industry—sawmills, pallet operations, logging trades. Readers are predominantly owners/operators of midsized sawmill operations nationwide. Sample copy $2 with 9×12 SAE and 5 first-class stamps. Photo guidelines free with SASE.

● This publication has begun to digitally store and manipulate images for advertising purposes.

Needs: Uses about 3-4 photos/issue; 25% supplied by freelancers. "We need b&ws of 'general interest' in the lumber industry. We need photographers from across the country to do an inexpensive b&w shoot in conjunction with a phone interview. We need 'human interest' shots from a sawmill scene—just basic 'folks' shots—a worker sharing lunch with the company dog, sawdust flying as a new piece of equipment is started; face masks as a mill tries to meet OSHA standards, etc." Looking for photo/text packages. Model release required. Captions required.

Making Contact & Terms: Interested in receiving work from newer, lesser-known photographers. Query with samples. Send 5×7 or 8×10 glossy b&w prints; 35mm, 4×5 transparencies, b&w contact sheets or negatives by mail for consideration. SASE. Reports in 6 weeks. Pays minimum $20-35/b&w

photos; $25-50/color photo; $100-150/photo/text package. Pays on publication. Credit line given. Buys first North American serial rights.

Tips: Prefers b&w capture of close-ups in sawmill, pallet, logging scenes. "Try to provide what the editor wants—call and make sure you know what that is, if you're not sure. Don't send things that the editor hasn't asked for. We're all looking for someone who has the imagination/creativity to provide what we need. I'm not interested in 'works of art'—I want and need b&w feature photos capturing essence of employees working at sawmills nationwide. I've never had someone submit anything close to what I state we need—try that. *Read* the description, shoot the pictures, send a contact sheet or a couple 5×7s."

SOUTHERN PLUMBING, HEATING AND COOLING MAGAZINE, Box 18343, Greensboro NC 27419. (910)454-3516. Fax: (910)454-3649. Managing Editor: Day Atkins. Circ. 9,000. Estab. 1946. Bimonthly magazine. Emphasizes plumbing, heating and cooling news, events and industry trends. Readers are male and female heads of companies (in plumbing, heating and cooling industry) ages 35-65. Sample copies free with 9×12 SAE and 5 first-class stamps.
Needs: Uses 20 photos/issue. Interested in photos of technology, business, industrial, how-to. Model/property release preferred. Captions preferred.
Making Contact & Terms: Interested in receiving work from newer, lesser-known photographers. Send 5×7, 8×10 glossy color or b&w prints. Deadlines: 15th of the month prior to publication. Keeps samples on file. SASE. Reports in 1-2 weeks. **Pays on acceptance**. Credit line given. Buys one-time rights. Simultaneous submissions and/or previously published work OK.
Tips: "We don't need mug shots, people shaking hands or group photos of people standing in front of something. We want vitality and strong visual interest. We are open to new directions and we will work with you on what you want to accomplish."

SPEEDWAY SCENE, P.O. Box 300, North Easton MA 02356. (508)238-7016. Editor: Val LeSieur. Circ. 70,000. Estab. 1970. Weekly tabloid. Emphasizes auto racing. Sample copy free with 8½×11 SAE and 4 first-class stamps.
Needs: Uses 200 photos/issue; all supplied by freelancers. Needs photos of oval track auto racing. Reviews photos with or without ms. Captions required.
Making Contact & Terms: Send unsolicited photos by mail for consideration. Send b&w, color prints. Reports in 1-2 weeks. NPI. Credit line given. Buys all rights. Simultaneous submissions and/or previously published work OK.

STEP-BY-STEP GRAPHICS, 6000 N. Forest Park Dr., Peoria IL 61614-3592. (309)688-2300. Fax: (309)688-8515. Managing Editor: Holly Angus. Circ. 45,000. Estab. 1985. Bimonthly. How-to magazine for traditional and electronic graphics. Readers are graphic designers, illustrators, art directors, studio owners, photographers. Sample copy $7.50.
Needs: Uses 130 photos/issue; all supplied by freelancers. Needs how-to ("usually tight") shots taken in artists' workplaces. Assignment only. Model release required. Captions required.
Making Contact & Terms: Query with samples. Provide résumé, business card, brochure, flier or tearsheets to be kept on file for possible future assignments. SASE. Reports in 1 month. NPI; pays by the job on a case-by-case basis. **Pays on acceptance.** Credit line given. Buys one-time rights or first North American serial rights.
Tips: In photographer's samples looks for "color and lighting accuracy particularly for interiors." Most shots are tight and most show the subject's hands. Recommend letter of inquiry plus samples.

SUCCESSFUL MEETINGS, 355 Park Ave. S., New York NY 10010. (212)592-6401. Fax: (212)592-6409. Art Director: Don Salkaln. Monthly. Circ. 75,000. Estab. 1955. Monthly. Emphasizes business group travel for all sorts of meetings. Readers are business and association executives who plan meetings, exhibits, conventions and incentive travel. Sample copy $10.
Needs: Special needs include *good*, high-quality corporate portraits, conceptual, out-of-state shoots (occasionally).
Making Contact & Terms: Arrange a personal interview to show portfolio. Query with résumé of credits and list of stock photo subjects. SASE. Reports in 2 weeks. Pays $500-750/color cover photo; $50-150/inside b&w photo; $75-200/inside color photo; $150-250/b&w page; $200-300/color page; $200-600/text/photo package; $50-100/hour; $175-350/½ day. **Pays on acceptance.** Credit line given. Buys one-time rights. Simultaneous submissions and previously published work OK "only if you let us know."

TEACHING TOLERANCE MAGAZINE, 400 Washington Ave., Montgomery AL 36104. Creative Director: Paul Forrest Newman. Circ. 300,000. Estab. 1992. National education magazine published by Southern Poverty Law Center. Quarterly. Emphasizes teaching racial/cultural tolerance. Readers are male/female teachers and educators, adult.

Needs: Uses approximately 36 photos/issue; all supplied by freelancers on assignment.
Making Contact & Terms: Story photographers only. Send tearsheets of previously published story photography. "No stock photos. No items returned. Absolutely no phone calls." Keeps samples on file. Pays $600-1,000/day; $600-1,000/job; $100-300/color inside photo. Rates depend on usage/negotiation. **Pays on acceptance.** Credit line given. Buys one-time rights, all rights; negotiable. Simultaneous submissions and/or previously published work OK.

***TECHNOLOGY & LEARNING**, 330 Progress Rd., Dayton OH 45449. (513)847-5900. Editor: Judy Salpeter . Art Director: David Levitan. Circ. 82,000. Monthly. Emphasizes computers in education. Readers are teachers and administrators, grades K-12. Sample copy $3.
Needs: Uses about 7-10 photos/issue; 2 or more supplied by freelance photographers. Photo needs "depend on articles concerned. No general categories. Usually photos used to accompany articles in a conceptual manner. Computer screen shots needed often." Model release required.
Making Contact & Terms: Contact Ellen Wright to arrange a personal interview to show portfolio. Query with nonreturnable samples. Provide résumé, business card, brochure, flier or tearsheets to be kept on file for possible future assignments. SASE. Reports in 3 weeks. Pays $300-700/color cover photo; $50-100/b&w inside photo; $100-300/color inside photo. **Pays on acceptance.** Credit line given. Buys one-time rights. Previously published work OK.

THOROUGHBRED TIMES, P.O. Box 8237, Lexington KY 40533. (606)260-9800. Editor: Mark Simon. Circ. 22,000. Estab. 1985. Weekly tabloid magazine. Emphasizes thoroughbred breeding and racing. Readers are wide demographic range of industry professionals. No photo guidelines.
Needs: Uses 18-20 photos/issue; 40-60% supplied by freelancers. "Looks for photos only from desired trade (thoroughbred breeding and racing)." Needs photos of specific subject features (personality, farm or business). Model release preferred. Captions preferred.
Making Contact & Terms: Provide résumé, business card, brochure, flier or tearsheets to be kept on file for possible assignments. SASE. Reports in 1 month. Pays $25/b&w cover or inside photo; $50/color; $150/day. Pays on publication. Credit line given. Buys one-time rights. Previously published work OK.

TOBACCO INTERNATIONAL, 130 W. 42 St., Suite 2200, New York NY 10036. (212)391-2060. Fax: (212)827-0945. Editor: Frank Bocchino. Circ. 5,000. Estab. 1886. Monthly international business magazine. Emphasizes cigarettes, tobacco products, tobacco machinery, supplies and services. Readers are executives, ages 35-60. Sample copy free with SASE.
Needs: Uses 20 photos/issue. "Prefer photos of people smoking, processing or growing tobacco products from all around the world, but any interesting news-worthy photos relevant to subject matter is considered." Model and/or property release preferred.
Making Contact & Terms: Query with photocopy of photos. Send unsolicited color positives, slides or prints by mail for consideration. Does not keep samples on file. Reports in 3 weeks. Pays $50/color photo. Pays on publication. Credit line may be given. Simultaneous submissions OK (not if competing journal).

TOP PRODUCER, Farm Journal Publishing, Inc., Centre Square West, 1500 Market St., Philadelphia PA 19102-2181. (215)557-8959. Fax: (215)568-3989. Website: http://www.farmjournal.com. Photo Editor: Tom Dodge. Circ. 250,000. Monthly. Emphasizes American agriculture. Readers are active farmers, ranchers or agribusiness people. Sample copy and photo guidelines free with SASE.
Needs: Uses 20-30 photos/issue; 50% supplied by freelance photographers. "We use studio-type portraiture (environmental portraits), technical, details and scenics." Model release preferred. Captions required.
Making Contact & Terms: Arrange a personal interview to show portfolio. Query with résumé of credits along with business card, brochure, flier or tearsheets to be kept on file for possible assignments. Also accepts digital images. "Portfolios may be submitted via CD-ROM or floppy disk." SASE. Reports in 2 weeks. Pays $75-400/color photo; $200-400/day. Pays extra for electronic usage of images. "We pay a cover bonus." **Pays on acceptance.** Credit line given. Buys one-time rights. Simultaneous submissions and previously published work OK.
Tips: In portfolio or samples, likes to "see about 40 slides showing photographer's use of lighting and photographer's ability to work with people. Know your intended market. Familiarize yourself with the magazine and keep abreast of how photos are used in the general magazine field."

THE SUBJECT INDEX, located at the back of this book, can help you find publications interested in the topics you shoot.

***TRUCK ACCESSORY NEWS**, 6255 Barfield Rd., Suite 200, Atlanta GA 30328. (404)252-8831. Fax: (404) 252-4436. Editor: Alfreda Vaughn. Circ. 8,500. Estab. 1994. Monthly magazine. Emphasizes retail truck accessories. Readers are male and female executives. Sample copy available.

Needs: Uses 75 photos/issue; 5-10 supplied by freelancers. Needs photos of trucks and truck accessory retailers. Model/property release required. Captions required.

Making Contact & Terms: Interested in receiving work from newer, lesser-known photographers. Provide résumé, business card, brochure, flier or tearsheets to be kept on file for possible assignments. Send 5×7, 8×10 color prints; 2¼×2¼, 4×5, 8×10 transparencies. Keeps samples on file. SASE. Reports in 3 weeks. Pays $350-450/half day. Pays on publication. Credit line given. Buys all rights; negotiable.

TURF MAGAZINE, 50 Bay St., P.O. Box 391, St. Johnsbury VT 05819. (800)422-7147. Fax: (802)748-1866. Managing Editor: Bob Labbance. Circ. 61,000. Estab. 1988. Monthly magazine. Emphasizes Turf and the green industry. Readers are all turf grass professionals—landscapers, golf course superintendents, groundskeepers, lawn care service and others, as well as university researchers, etc.

Needs: 75% of photos come from assigned work. Needs good cover photos that are turf-related: sports, professionals working on turf, landscapes, must have some green grass, large format preferred. Model release preferred.

Making Contact & Terms: Interested in receiving work from newer, lesser-known photographers. Send unsolicited photos by mail for consideration. Provide résumé, business card, brochure, flier, or tearsheets to be kept on file for possible assignments. Send 35mm, 2¼×2¼ transparencies; "must be vertical format." SASE. Reports in 3 weeks. Pays $100-200/color cover photo; $225-275/photo/text package. Pays on publication. Credit line given. Buys one-time rights. Previously published work OK.

Tips: "We are always looking for shots of professionals at work—mowing grass, laying sod, using leaf blowers, etc. Subjects must have proper safety equipment."

***U.S. NAVAL INSTITUTE PROCEEDINGS**, U.S. Naval Institute, Annapolis MD 21402. (301)268-6110. Picture Editor: Charles Mussi. Circ. 119,790. Monthly magazine. Emphasizes matters of current interest in naval, maritime and military affairs—including strategy, tactics, personnel, shipbuilding and equipment. Readers are officers in the Navy, Marine Corps and Coast Guard; also for enlisted personnel of the sea services, members of other military services in this country and abroad and civilians with an interest in naval and maritime affairs. Free sample copy.

Needs: Buys 15 photos/issue. Needs photos of Navy, Coast Guard and merchant ships of all nations; military aircraft; personnel of the Navy, Marine Corps and Coast Guard; and maritime environment and situations. No poor quality photos. Captions required.

Making Contact & Terms: Query first with résumé of credits. Uses 8×10 glossy, color and b&w prints or slides. SASE. Reports in 2 weeks on pictorial feature queries; 6-8 weeks on other materials. Uses 8×10 glossy prints or slides, color and b&w. Pays $10 for official military photos submitted with articles; $250-500 for naval/maritime pictorial features; $200/color cover photo; $50 for article openers; $25/inside editorial. Pays on publication. Buys one-time rights.

Tips: "These features consist of copy, photos and photo captions. The package should be complete, and there should be a query first. In the case of the $25 shots, we like to maintain files on hand so they can be used with articles as the occasion requires. Annual photo contest—write for details."

UTILITY AND TELEPHONE FLEETS, P.O. Box 183, Cary IL 60013. (847)639-2200. Fax: (847)639-9542. Editor & Associate Publisher: Alan Richter. Circ. 18,000. Estab. 1987. Magazine published 8 times a year. Emphasizes equipment and vehicle management and maintenance. Readers are fleet managers, maintenance supervisors, generally 35 and older in age and primarily male. Sample copy free with SASE. No photo guidelines.

Needs: Uses 30 photos/issue; 3-4% usually supplied by a freelance writer with an article. Needs photos of vehicles and construction equipment. Special photo needs include alternate fuel vehicles and eye-grabbing colorful shots of utility vehicles in action as well as utility construction equipment. Model release preferred. Captions required; include person's name, company and action taking place.

Making Contact & Terms: Interested in receiving work from newer, lesser-known photographers. Provide résumé, business card, brochure, flier or tearsheets to be kept on file for possible assignments. SASE. Reports in 2 weeks. Pays $50/color cover photo; $10/b&w inside photo; $50-200/photo/text package ($50/published page). Pays on publication. Credit line given. Buys one-time rights; negotiable.

Tips: "Be willing to work cheap and be able to write; the only photos we have paid for so far were part of an article/photo package." Looking for shots focused on our market with workers interacting with vehicles, equipment and machinery at the job site.

UTILITY CONSTRUCTION AND MAINTENANCE, P.O. Box 183, Cary IL 60013. (708)639-2200. Fax: (708)639-9542. Editor: Alan Richter. Circ. 25,000. Estab. 1990. Quarterly magazine. Emphasizes equipment and vehicle management and maintenance. Readers are fleet managers, mainte-

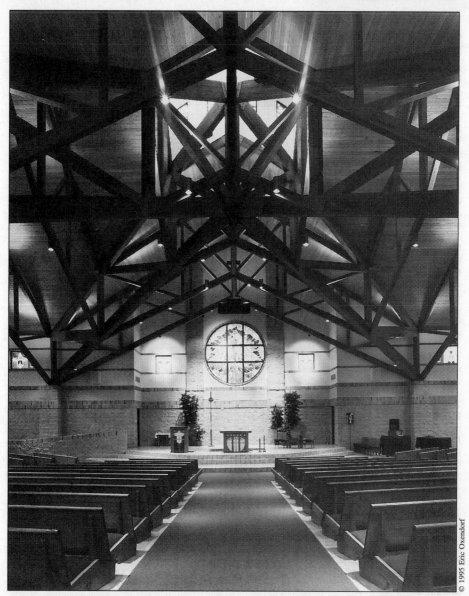

This striking interior shot by Milwaukee photographer Eric Oxendorf caught the eye of *Wisconsin Architect* magazine due to its "high impact, detail and good color balance." Oxendorf, who is exclusively an architectural photographer, was paid $350 for use of the photo, and "kept my name in front of 1,200 existing and potential clients."

nance supervisors, generally 35 and older in age and primarily male. Sample copy free with SASE. No photo guidelines.

Needs: Uses 80 photos/issue; 1-2% usually supplied by a freelance writer with an article. Needs photos of vehicles and construction equipment. Special photo needs include eye-grabbing colorful shots of utility construction equipment. Model release preferred. Captions required.

Making Contact & Terms: Provide résumé, business card, brochure, flier or tearsheets to be kept on file for possible assignments. SASE. Reports in 2 weeks. Pays $50/color cover photo; $10/b&w inside photo; $50-200/photo/text package ($50/published page). Pays on publication. Credit line given. Buys one-time rights.

Tips: "Be willing to work cheap and be able to write as the only photos we have paid for so far were part of an article/photo package."

VEHICLE LEASING TODAY, 800 Airport Blvd., Suite 506, San Francisco CA 94010. Fax: (415)548-9155. Art Director: Deborah Dembek. Circ. 4,000. Estab. 1979. Publication of National Vehicle Leasing Association. Bimonthly magazine. Emphasizes leasing industry. Readers are leasing companies and their affiliates, financial institutions, dealers. Sample copy free with SASE.
Needs: Uses 3-5 photos/issue; 1-3 supplied by freelancers. Interested mostly in automotive photos, some conceptual, legislative, city views and local conferences. Captions preferred.
Making Contact & Terms: Interested in receiving work from newer, lesser-known photographers. Query with stock photo list. Keeps samples on file. SASE. Reports in 2 weeks. Pays $400/color cover photo; $75/color inside photo. Pays on publication. Credit line given. Rights negotiable. Previously published work OK.

***WALLS & CEILINGS MAGAZINE**, 8602 N. 40th St., Tampa FL 33604. (813)989-9300. Fax: (813)980-3982. E-mail: greg@wco.org. Website: http://www.wco.org. Editor: Greg Campbell. Circ. 24,000. Monthly magazine. Emphasizes wall and ceiling construction, drywall, lath, plaster, stucco and exterior specialty finishes. Readership consists of 98% male, wall and ceiling contractors. Sample copy $4.
Needs: Uses 15-20 photos/issue; 30% supplied by freelancers. Needs photos of interior/exterior architectural shots, contractors and workers on job (installing drywall and stucco). Model release required.
Making Contact & Terms: Query with résumé of credits. Send unsolicited photos by mail for consideration. Send glossy b&w or color prints, any size, or 35mm, 2¼×2¼ or 4×5 transparencies. Also accepts digital files. SASE. Reports in 1 month. Pays $150/color cover photo; $50/color inside photo; $25/b&w inside photo; $50-150/photo/text package. Pays on publication. Credit line given. Buys exclusive, one-time and "our industry" rights. Simultaneous submissions and previously published work OK, provided not submitted to or published by competitors.

WATER WELL JOURNAL, 2600 Ground Water Way, Columbus OH 43219. (614)337-8229. Fax: (614)337-8445. Senior Editor: Gloria J. Swanson. Circ. 27,985. Estab. 1946. Monthly. Emphasizes construction of water wells, development of ground water resources and ground water cleanup. Readers are water well drilling contractors, manufacturers, suppliers and ground water scientists. Sample copy $3 (US); $6 (foreign).
Needs: Uses 1-3 freelance photos/issue plus cover photos. Needs photos of installations and how-to illustrations. Model release preferred. Captions required.
Making Contact & Terms: Interested in receiving work from newer, lesser-known photographers. Contact with résumé of credits; inquire about rates. "We'll contact." Pays $10-50/hour; $200/color cover photo; $50/b&w inside photo; "flat rate for assignment." Pays on publication. Credit line given "if requested." Buys all rights.

THE WHOLESALER, 1838 Techny Court, Northbrook IL 60062. (847)564-1127. Fax: (847)564-1264. Editor: John Schweizer. Circ. 29,600. Estab. 1946. Monthly news tabloid. Emphasizes wholesaling, distribution in the plumbing, heating, air conditioning, piping (inc. valves), fire protection industry. Readers are owners and managers of wholesale distribution businesses, also manufacturers and manufacturer representatives. Sample copy free with 11×15½ SAE and 5 first-class stamps.
Needs: Uses 1-5 photos/issue; 3 supplied by freelancers. Interested in field and action shots in the warehouse on the loading dock, at the job site. Property release preferred. Captions preferred. "Just give us the facts."
Making Contact & Terms: Interested in receiving work from newer, lesser-known photographers. Query with stock photo list. Send unsolicited photos by mail for consideration. Send any size glossy print, color and b&w. SASE. Reports in 2 weeks. Pays on publication. Buys one-time rights. Simultaneous and/or previously published work OK.

WINES & VINES, 1800 Lincoln Ave., San Rafael CA 94901. (415)453-9700. Contact: Philip E. Hiaring. Circ. 5,000. Estab. 1919. Monthly magazine. Emphasizes winemaking in the US for everyone concerned with the wine industry, including winemakers, wine merchants, suppliers, consumers, etc.
Needs: Wants color cover subjects on a regular basis.
Making Contact & Terms: Interested in receiving work from newer, lesser-known photographers. Query or send material by mail for consideration. Provide business card to be kept on file for possible future assignments. SASE. Reports in 3 months. Pays $10/b&w print; $50-100/color cover photo. Pays on publication. Credit line given. Buys one-time rights. Previously published work OK.

WISCONSIN ARCHITECT, 321 S. Hamilton St., Madison WI 53703. (608)257-8477. Managing Editor: Brenda Taylor. Circ. 3,700. Estab. 1931. Publication of American Institute of Architects Wisconsin. Bimonthly magazine. Emphasizes architecture. Readers are design/construction professionals.

Needs: Uses approximately 35 photos/issue. "Photos are almost exclusively supplied by architects who are submitting projects for publication. Of these, approximately 65% are professional photographers hired by the architect."
Making Contact & Terms: "Contact us through architects." Keeps samples on file. SASE. Reports in 1-2 weeks when interested. Pays $50-100/color cover photo when photo is specifically requested. Pays on publication. Credit line given. Rights negotiable. Simultaneous submissions and/or previously published work OK.

WOODSHOP NEWS, 35 Pratt St., Essex CT 06426. (860)767-8227. Senior Editor: Thomas Clark. Circ. 100,000. Estab. 1986. Monthly tabloid. Emphasizes woodworking. Readers are male, ages 20-60, furniture makers, cabinetmakers, millworkers and hobbyist woodworkers. Sample copy and photo guidelines free with 11 × 13 SAE.
Needs: Uses 40 photos/issue; less than 5% supplied by freelancers. Needs photos of people working with wood. Model release required. Captions required.
Making Contact & Terms: Provide résumé, business card, brochure, flier or tearsheets to be kept on file for possible assignments. SASE. Reports in 1 month. Pays $300/color cover photo; $35/b&w inside photo. Pays on publication. Credit line given. Buys one-time rights.

WORLD FENCE NEWS, Dept. PM, 6101 W. Courtyard Dr., Bldg. 3, Suite 115, Austin TX 78730. (800)231-0275. Fax: (512)349-2567. Managing Editor: Rick Henderson. Circ. 13,000. Estab. 1983. Monthly tabloid. Emphasizes fencing contractors and installers. Readers are mostly male fence company owners and employees, ages 30-60. Sample copy free with 10 × 12 SASE.
Needs: Uses 35 photos/issue; 20 supplied by freelancers. Needs photos of scenics, silhouettes, sunsets which include all types of fencing. Also, installation shots of fences of all types. "Cover images are a major area of need." Model/property release preferred mostly for people shots. Captions required; include location, date.
Making Contact & Terms: "If you have suitable subjects, call and describe." SASE. Reports in 3 weeks. Pays $100/color cover photo; $25/b&w inside photo. **Pays on acceptance.** Credit line given. Buys one-time rights. Previously published work OK.

Homestead-Floridian Cheryl Koenig Morgan drove past this pink cinderblock fence everyday. "I waited for the best light and angle, then I shot it with *World Fence News* in mind." Morgan earned $100 for the cover photo from the magazine she found in *Photographer's Market*. "You can't make a living photographing fences," says Morgan, "but this is an example of a specialty or niche market that can bring in extra income."

© Cheryl Koenig Morgan

***WRITER'S DIGEST/WRITER'S YEARBOOK**, 1507 Dana Ave., Cincinnati OH 45207. (513)531-2222. Fax: (513)531-1843. Managing Editor: Peter Blocksom. Circ. 250,000. Estab. 1921. Monthly magazine. Emphasizes writing and publishing. Readers are "writers and photojournalists of

all description: professionals, beginners, students, moonlighters, bestselling authors, editors, etc." Sample copy $3.50 ($3.70 in Ohio). Guidelines free with SASE.

Needs: Buys 15 photos/year. Uses about 10% freelance material each issue. Purchases about 75% of photos from stock or on assignment; 25% of those with accompanying ms. Primarily celebrity/personality ("to accompany profiles"); some how-to, human interest and product shots. All must be writer-related. Submit model release with photo. Captions required.

Making Contact & Terms: Query with résumé of credits, list of photographed writers, or contact sheet. Provide brochure and samples (print samples, not glossy photos) to be kept on file for possible future assignments. "We never run photos without text." Also accepts digital files—JPEG and TIFF acceptable; EPS preferred. Uses 8×10 glossy prints; send contact sheet. "Do *not* send negatives." Pays $75-200. "Freelance work is rarely used on the cover." Pays on acceptance. Credit line given. Buys first North American serial rights, one-time use only. Simultaneous submissions OK if editors are advised. Previously published work OK.

Tips: "We most often use photos with profiles of writers; in fact, we won't buy the profile unless we can get usable photos. The story, however, is always our primary consideration, and we won't buy the pictures unless they can be specifically related to an article we have in the works. We sometimes use humorous shots in our Writing Life column. Shots should not *look* posed, even though they may be. Photos with a sense of place, as well as persona, preferred. Have a mixture of tight and middle-distance shots of the subject. Study a few back issues. Avoid the stereotyped writer-at-typewriter shots; go for an array of settings. Move the subject around, and give us a choice. We're also interested in articles on how a writer earned extra money with photos, or how a photographer works with writers on projects, etc."

***YALE ROBBINS, INC.**, 31 E. 28th St., 12th Floor, New York NY 10016. (212)683-5700. Fax: (212)545-0764. Managing Editor: Peg Rivard. Circ. 10,500. Estab. 1983. Annual magazine and photo directory. Emphasizes commercial real estate (office buildings). Readers are real estate professionals—brokers, developers, potential tenants, etc. Sample copy $69.

Needs: Uses 150-1,000 photos/issue. Needs photos of buildings. Property release required.

Making Contact & Terms: Interested in receiving work from newer, lesser-known or established photographers. Provide résumé, business card, brochure, flier or tearsheets to be kept on file for possible future assignments. Send 35mm transparencies. Keeps samples on file. SASE. Reports in 1 month. Pays $35-45/color slide; payment for color covers varies. Pays on publication. Credit line given. Buys all rights; negotiable. Simultaneous submissions and previously published work OK.

Record Companies

The move away from traditional albums and toward CDs has not only changed the way music is packaged, but also affected the way it appears. Designers, for example, are using more photo and art collages to pump up the visual appeal of CDs and cassettes. Record producers want photos with odd angles and high-tech computer enhancements.

In many instances this signals a move meant to appeal to the Generation X crowd. As a photographer you have to adapt to this trend if you plan to market your work to the music industry. When working with record companies you will be asked to supply images for all kinds of uses. Assignments are made for album, cassette or CD covers, but frequently images are used in promotional pieces to sell the work of recording artists. As always, you should try to retain rights to images for future sales and the usage should help you establish a fair price during negotiations.

BUILDING YOUR PORTFOLIO

A good portfolio for record companies shows off your skills and style in an imaginative way, but especially illustrates your ability to solve creative problems facing art directors. Such problems may include coming up with fresh concepts for record art, working within the relatively limited visual format of the 5-inch compact disc liner sheet or assembling a complex shot on a limited budget. If you have not worked for a record company client, you still can study the needs of various companies in this section and shoot a series of self-assignments which clearly show your problem-solving abilities.

Shooters who go on to long-term, high-profile success often start working with smaller, independent music companies, or "indies." Larger companies typically rely on stables of photographers who are either on staff or work through art studios that deal with music companies. Because of this tendency, it can be difficult for newcomers to break in when these companies already have their pick of talented, reliable photographers. Start out slowly and develop a portfolio of outstanding images. Eventually the larger companies will become familiar with your work and they will seek you out when looking for images or handing out assignments.

Freelancers also must be alert when dealing with the independent market. Some newer companies have not learned the various aspects of professionalism and ethics in doing business, and, in a few cases, companies deliberately deceive freelancers in terms of payment and copyright. When trying to attract new clients in this field, query prospective companies and request copies of their various forms and contracts for photographers. Seeing the content of such material can tell you a great deal about how well organized and professional a company is. Also talk to people within the music industry to get a better understanding of the company with which you want to do business.

A&M RECORDS, 1416 N. Labrea Ave., Hollywood CA 90028. Did not respond to our request for information.

■**AFTERSCHOOL PUBLISHING COMPANY**, P.O. Box 14157, Detroit MI 48214. (313)894-8855. President: Herman Kelly. Estab. 1977. Handles all forms of music. Freelancers used for portraits, in-concert shots, studio shots and special effects for publicity, brochures, posters and print advertising. **Needs:** Buys 5-10 images annually. Offers 5-10 assignments annually. Examples of recent uses: "Garden of Garments," "Funk-A-Ma-Taz," and "Festival of Culture" (all CD covers). Interested in

animation, love. Reviews stock photos. Model/property release preferred. Captions preferred.
Audiovisual Needs: Uses videotape, prints, papers for reproductions. Subjects include: love, fun, comedy, life, food, sports, cars, cultures.
Specs: Uses prints, all sizes and finishes, and videotape, all sizes. Digital formats OK.
Making Contact & Terms: Interested in receiving work from newer, lesser-known photographers. Submit portfolio for review. Keeps samples on file. SASE. Reports in 1 month. Pays $5-500/b&w photo; $5-500/color photo; $5-500/hour; $5-500/day; payment negotiable. Credit line given. Buys one-time, exclusive product and all rights, negotiable.

***♣ALERT MUSIC, INC.**, 41 Britain St., Suite 305, Toronto, Ontario M5A 1R7 Canada. (416)364-4200. Fax: (416)364-8632. E-mail: alert@inforamp.net. Promotion Coordinator: Rose Slanic. Handles rock, pop and alternative. Freelancers used for cover/liner shots, inside shots and publicity.
Needs: Reviews stock photos. Model/property release preferred. Captions required.
Audiovisual Needs: Uses slides and videotape.
Specs: Uses color and b&w prints.
Making Contact & Terms: Query with résumé of credits. Works with local freelancers on assignment only. Keeps samples on file. SASE. Credit line given. Rights negotiable.

***♣AQUARIUS RECORDS/TACCA MUSIQUE**, 1445 Lambert Closse, Suite 200, Montreal, Quebec H3H 1Z5 Canada. (514)939-3775. Fax: (514)939-2778. Production Manager: Rene LeBlanc. Estab. 1971. Handles rock, contemporary, alternative—English and French. Freelancers used for portraits, in-concert shots, studio shots, cover/liner shots, inside shots, publicity, brochures, posters and print advertising.
Needs: Buys 30 images annually; all supplied by freelancers. Offers 10 assignments annually. Model/property release required for photos of artists.
Audiovisual Needs: Uses slides and videotape glossies for promotion.
Specs: Uses 8×10 color and b&w prints; 2¼×2¼ transparencies.
Making Contact & Terms: Provide résumé, business card, self-promotion pieces or tearsheets to be kept on file for possible future assignments. Works with local freelancers only. Keeps samples on file. SASE. Reports in 1 month. Pays $400-750/job; $1.50-2/b&w photo. **Pays on acceptance.** Credit line given. Buys all rights.

***ARIANA RECORDS**, 1324 S. Avenida Polar, #C208, Tucson AZ 85710. (520)790-7324. President: James M. Gasper. Estab. 1980. Handles all types of records. Freelancers used for portraits, studio shots, special effects, cover/liner shots, inside shots, publicity, posters and print advertising.
Needs: Buys 10-15 images annually; most supplied by freelancers. Offers 20-30 assignments annually. Reviews stock photos. Model/property release required for models, actors and musicians.
Audiovisual Needs: Uses film and videotape for music videos, animation films (shorts), documentary projects and commercials. Subjects include faces, forms, light and dark.
Specs: "Please transfer film to ½″ VHS videotape."
Making Contact & Terms: Interested in receiving work from newer, lesser-known photographers. Query with samples. Provide résumé, business card, self-promotion pieces or tearsheets to be kept on file for possible future assignments.. Works on assignment only. Keeps samples on file. SASE. Reports in 1 month. NPI; negotiable. Pays upon completion of project. Buys one-time rights.

ARISTA, 6 W. 57th St., New York NY 10019. Did not respond to our request for information.

ART ATTACK RECORDINGS/CARTE BLANCHE/MIGHTY FINE RECORDS, Dept. PM, Fort Lowell Station, P.O. Box 31475, Tucson AZ 85751. (602)881-1212. President: William Cashman. Handles rock, pop, country and jazz. Photographers used for portraits, in-concert shots, studio shots and special effects for album covers, inside album shots, publicity and brochures.
Needs: Offers 10-15 assignments/year.
Specs: "Depends on particular project."
Making Contact & Terms: Arrange a personal interview to show portfolio. Provide résumé, business card, self-promotion pieces or tearsheets to be kept on file for possible future assignments. Works on assignment only. "We will contact only if interested." NPI; payment negotiable. Credit line given.
Tips: Prefers to see "a definite and original style—unusual photographic techniques, special effects" in a portfolio. "Send us samples to refer to that we may keep on file."

 THE MAPLE LEAF before a listing indicates that the market is Canadian.

***ASYLUM RECORDS/EEG**, 1906 Acklen Ave., Nashville TN 37212. (615)292-7990. Fax: (615)298-4385. Director/Creative Services: Teresa M. Blair. Estab. 1992. Handles country. Freelancers used for portraits, in-concert shots, studio shots, special effects, cover/liner shots, inside shots, publicity, brochures, posters, event/convention coverage and print advertising.
Needs: Reviews stock photos.
Audiovisual Needs: Uses slides, film and videotape.
Making Contact & Terms: Interested in receiving work from newer, lesser-known photographers. Query with samples. Query with stock photo list. Provide résumé, business card, self-promotion pieces or tearsheets to be kept on file for possible future assignments. Keeps samples on file. Cannot return material. Will respond if interested in material for a current project. NPI; payment depends on project.
Tips: "Send promotional samples that reflect/represent your portfolio. This helps me remember the contents of a portfolio when reviewing 'my sample box' for upcoming projects."

ATLANTIC RECORDING CORP., 9229 Sunset Blvd., 9th Floor, Los Angeles CA 90069. Did not respond to our request for information.

B-ATLAS & JODY RECORDS INC., 1353 E. 59th St., Brooklyn NY 11234. (718)968-8362. Vice President A&R Department: Vincent Vallis. Public Relations: Cynthia Leavy. Handles rock, rap, pop, country. Freelancers used for portraits, in-concert shots and studio shots for cover/liner shots.
Needs: Buys 10 images annually; 10 supplied by freelancers.
Making Contact & Terms: Interested in receiving work from newer, lesser-known photographers. Query with samples. SASE. Reports in 1-2 weeks. NPI; payment on assignment. Credit line given. Buys first rights; negotiable.
Tips: "Keep trying."

ROBERT BATOR & ASSOCIATES, 31 State St., Apt. 44D, Monson MA 01057. (413)267-5319. Art Director: Joan Bator. Estab. 1969. Handles rock and country. Photographers used for in-concert shots and studio shots for album covers, inside album shots, publicity and posters.
Needs: Buys 5,000 photos/year. Offers 400 assignments/year. Model release preferred. Captions preferred.
Specs: Uses 4×5 and 8×10 glossy ("mostly color") prints.
Making Contact & Terms: Send unsolicited photos by mail for consideration. Provide résumé, business card, brochure, flier or tearsheets to be kept on file for possible future assignments. "You can submit female suggestive photos for sex appeal, or male, but in good taste." Works with freelancers on assignment only. SASE. Reports in 1 week. Pays $100-150/b&w photo; $150-250/color photo; $150-189/hour; $400-500/day; $375-495/job. Credit line given. Buys one-time rights; other rights negotiable.
Tips: Looks "for good clear photos of models. Show some imagination. Would like some sexually-oriented prints—because advertising is geared for it. Also fashion shots—men's and women's apparel, especially swimsuits and casual clothing."

■BLACK DIAMOND RECORDS, INC., P.O. Box 8073, Pittsburg CA 94565. (510)980-0893. Fax: (510)636-0614. Associate Director of Marketing: Sherece Burnley. Estab. 1987. Handles rhythm & blues, rap, hip-hop, jazz hip-hop, rock dance, blues rock, jazz. Freelancers used for portraits and studio shots for cover/liner shots, publicity, brochures, posters, print advertising.
Needs: Buys 50 images annually; 10% supplied by freelancers. Offers 2-3 assignments annually. Interested in clean, creative shots. Reviews stock photos. Model release required. Property release preferred. Captions preferred.
Audiovisual Needs: Uses videotape for reviewing artist's work. Wants to see style, creativity, uniqueness, avant garde work.
Specs: Uses 8×11 b&w prints; 35mm transparencies.
Making Contact & Terms: Interested in receiving work from newer, lesser-known photographers. Submit portfolio for review. Provide résumé, business card, self-promotion pieces or tearsheets to be kept on file for possible assignments. Works on assignment only. Keeps samples on file. SASE. Reports in 1-2 weeks, possibly 2 months to one year. NPI. Payment negotiable. Pays upon usage. Credit line given. Buys all rights; negotiable.
Tips: "Be flexible. Look for the right project. Create a memory."

BLASTER-BOXX HITS/MARICAO RECORDS/HARD HAT RECORDS, 519 N. Halifax Ave., Daytona Beach FL 32118. Phone/fax: (904)252-0381. CEO: Bobby Lee Cude. Estab. 1978. Handles country, MOR, pop, disco and gospel. Photographers used for portraits, in-concert shots, studio shots and special effects for album covers, inside album shots, publicity, brochures, posters, event/convention coverage and product advertising.

Needs: Offers 12 assignments/year. Examples of recent uses: "Broadway, USA!," CD album, Volume 1 (cover art); "Times-Square Fantasy Theatre," CD audio shows (cover art). Model/property release required. Captions preferred.
Specs: Uses b&w and color photos.
Making Contact & Terms: Interested in receiving work from newer, lesser-known photographers. Submit portfolio for review. Provide résumé, business card, self-promotion pieces, tearsheets or samples to be kept on file for possible future assignments. Works on assignment only. SASE. Reports in 2 weeks. NPI; pays "standard fees." Credit line sometimes given. Buys all rights.
Tips: "Submit sample photo with SASE along with introductory letter stating fees, etc. Read *Mix Music* magazine."

BMG MUSIC/RCA NASHVILLE, 1 Music Square West, Nashville TN 37203. Did not respond to our request for information.

BOUQUET-ORCHID ENTERPRISES, P.O. Box 1335, Norcross GA 30091. (770)798-7999. President: Bill Bohannon. Photographers used for live action and studio shots for publicity fliers and brochures.
Making Contact & Terms: Provide brochure and résumé to be kept on file for possible future assignments. Works on assignment only. SASE. Reports in 1 month. Pays $200 minimum/job.
Tips: "We are using more freelance photography in our organization. We are looking for material for future reference and future needs."

***CANYON RECORDS PRODUCTIONS**, 4143 N. 16th St., Suite 6, Phoenix AZ 85016. (602)266-7835. Fax: (602)279-9233. Executive Producer: Robert Doyle. Estab. 1951. Handles Native American. Freelancers used for portraits, studio shots, shots of pow-wows and traditional Native American dances, cover/liner shots, inside shots, publicity, brochures, posters and print advertising.
Needs: Buys 10-15 images annually; all supplied by freelancers. Offers 4 assignments annually. Reviews stock photos. Model/property release required.
Specs: Uses any size glossy color and b&w prints; 4×5 transparencies.
Making Contact & Terms: Interested in receiving work from newer, lesser-known photographers. Submit portfolio for review. Query with samples. Query with stock photo list. Keeps samples on file. SASE. Reports depending on current scheduling. NPI. Pays on usage. Credit line given. Buys one-time rights to reproduce on covers only; negotiable.

CAPITOL RECORDS, 1750 N. Vine St., Hollywood CA 90028. Did not respond to our request for information.

■CAREFREE RECORDS GROUP, Box 2463, Carefree AZ 85377. (602)230-4177. Vice President: Doya Fairbains. Estab. 1991. Handles rock, jazz, classical, country, New Age, Spanish/Mexican and heavy metal. Freelancers used for portraits, in-concert shots, studio shots and special effects for cover/liner shots, publicity, brochures, posters, event/convention coverage, print advertising, CD covers, cassette covers.
Needs: Buys 45-105 images annually. Offers 2-8 assignments/month. Interested in all types of material. Reviews stock photos. Model/property release required. Captions required.
Audiovisual Needs: Uses slides, film, videotape. Subjects include: outdoor scenes—horses, lakes, trees, female models.
Specs: Uses all sizes of glossy color or b&w prints; 8×10 transparencies; all sizes of film; all types of videotape.
Making Contact & Terms: Interested in receiving work from newer, lesser-known photographers. Submit portfolio for review. Works on assignment only. Keeps samples on file. SASE. Reports in 1 month. NPI. Pays upon usage. Credit line given. Buys all rights; negotiable.
Tips: "Keep your eyes and mind open to all types of photographs."

***♥■DEF BEAT RECORDS**, 38 Cassis Dr., Etobicoke, Ontario M9V 4Z6 Canada. (416)746-6205. Fax: (416)586-0853. Product Manager: Junior Smith. Estab. 1986. Handles R&B, hip hop, dance, Euro and soul. Freelancers used for portraits, in-concert shots, studio shots, cover/liner shots, inside shots, publicity, brochures, posters, event/convention coverage and print advertising.

 THE SOLID, BLACK SQUARE before a listing indicates that the market uses various types of audiovisual materials, such as slides, film or videotape.

Needs: Buys 25 images annually; 10 supplied by freelancers. Offers 30 assignments annually. Interested in concert and portrait shots. Reviews stock photos. Model/property release preferred.
Audiovisual Needs: Uses film and videotape for viewing and file. Subjects include: romantic settings, beaches, sunsets, ghetto streets.
Specs: Uses 5×7, 8×10 color and b&w prints; 8×10 transparencies; Beta SP/VHS videotape.
Making Contact & Terms: Interested in receiving work from newer, lesser-known photographers. Call first to arrange interview. Query with samples. Provide resume, business card, self-promotion pieces or tearsheets to be kept on file for possible future assignments. Works with local freelancers only. Keeps samples on file. SASE. Reports in 1 month. Pays $150-400/job. **Pays on acceptance.** Buys all rights.
Tips: "Make sure you are presenting your best work at the interview because you only get one try."

DMP RECORDS, 94 Southfield Ave., #1301, Stamford CT 06902. (203)327-3800. Fax: (203)323-9474. Marketing Director: Paul Jung. Estab. 1982. Handles jazz. Freelancers used for portraits and studio shots for cover/liner shots, inside shots and publicity.
Needs: Offers 10 assignments annually. Model/property release preferred. Captions preferred.
Audiovisual Needs: Uses slides.
Specs: Uses 2¼×2¼ transparencies.
Making Contact & Terms: Interested in receiving work from newer, lesser-known photographers. Query with samples. Keeps samples on file. SASE. Reports in 1-2 weeks. Pays $500/day. **Pays on acceptance.** Credit line given. Buys all rights; negotiable.
Tips: "The jazz industry is typically not a profitable one, especially for independent labels. While I realize that photographers aim to earn big money, there simply is not a big budget for photography."

EMA MUSIC, INC., P.O. Box 91683, Washington DC 20090-1683. (202)575-1774. President: J. Murphy. Estab. 1993. Handles gospel. Freelancers used for portraits, in-concert shots, studio shots and special effects for cover/liner shots, publicity, brochures, posters, event/convention coverage and print advertising.
Needs: All photos supplied by freelancers. Offers 2 assignments annually. Model/property release preferred. Captions preferred.
Making Contact & Terms: Interested in receiving work from newer, lesser-known photographers. Provide résumé, business card, self-promotion pieces or tearsheets to be kept on file for possible future assignment. Does not keep samples on file. Cannot return material. NPI. Pays on usage. Buys first, one-time and all rights; negotiable.

EMI RECORDS GROUP, 1290 Avenue of the Americas, New York NY 10104. Did not respond to our request for information.

FINER ARTISTS RECORDS, 2170 S. Parker Rd., Suite 115, Denver CO 80231. (303)755-2546. President: R.J. Bernstein. Estab. 1960. Handles rock, classical and country. Uses portraits, in-concert shots, studio shots and special effects for album covers, inside album shots, publicity, brochures and posters.
Needs: Uses 6 freelancers/year.
Making Contact & Terms: Query with résumé of credits. Send unsolicited photos by mail for consideration. Submit portfolio for review. Provide résumé, business card, self-promotion pieces or tearsheets to be kept on file for possible future assignments. Works on assignment only. Reports in 1 month. NPI; payment negotiable. Credit line given. Buys one-time or all rights; negotiable.

***■GEFFEN RECORDS, INC.**, 9130 Sunset Blvd., Los Angeles CA 90069. (310)285-2780. Fax: (310)275-8286. Art Department Manager: Sofie Howard. Estab. 1980. Handles rock, rap, alternative. Freelancers used for studio shots, location shots, cover/liner shots, inside shots, publicity, posters, event/convention coverage, print advertising and P-O-P displays.
Needs: Buys 100 images annually; all supplied by freelancers. Offers 40-45 assignments annually. Interested in "creative, new and different, yet classic, images." Reviews stock photos, "but arty, not run-of-the-mill stock images." Model/property release required for locations and people. Captions preferred; include where and when shot.
Audiovisual Needs: Uses video for promotional purposes.
Specs: Uses 8×10 color and b&w prints; 35mm, 2¼×2¼, 4×5 transparencies.
Making Contact & Terms: Interested in receiving work from newer, lesser-known photographers. Submit portfolio for review. Query with samples. Provide resume, business card, self-promotion pieces or tearsheets to be kept on file for possible future assignments. Keeps samples on file. SASE. Reports "only if we intend to hire." Pays $1,500-3,000/job; $100-500/color or b&w photo. Pays upon usage. Credit line given on package and poster. Buys all rights; negotiable.
Tips: "Be innovative with your pictures. Having perfect technique is not as important as being creative. Don't copy others; be true to your heart. Concepts are important—in your spare time, think of ideas."

GLOBAL PACIFIC RECORDS, 1275 E. MacArthur St., Sonoma CA 95476. (707)996-2748. Fax: (707)996-2658. Senior Vice President: Howard L. Morris. Handles jazz, World and New Age music. Photographers used for portraits, in-concert shots, studio shots and special effects for album covers, inside album shots, publicity, brochures, posters and product advertising.
Needs: Buys 12-18 images annually.
Specs: Uses 8×10 glossy b&w and color prints or transparencies.
Making Contact & Terms: Submit portfolio for review. Provide résumé, business card, self-promotion pieces or tearsheets to be kept on file for possible future assignments. SASE. Reports in 2 weeks. NPI. Buys all rights; negotiable.
Tips: Prefers "technically excellent (can be blown up, etc.), excellent compositions, emotional photographs. Be familiar with what we have done in the past. Study our music, album packages, etc., and present material that is appropriate."

■**HIT CITY RECORDS**, P.O. Box 64895, Baton Rouge LA 70896. (504)925-0288. Owner: Henry Turner. Estab. 1984. Handles reggae, funk, country and rap. Freelancers used for portraits, in-concert shots, studio shots for cover/liner shots, publicity and posters.
Needs: Buys 25 images annually; all supplied by freelancers. Offers 30 assignments annually. Interested in clean b&w glossy prints. Property release required.
Audiovisual Needs: Uses film and videotape for promotion of artists. Subjects include music video.
Specs: Uses 8×10 prints; broadcast quality film for TV; Super 8 ¾″ videotape.
Making Contact & Terms: Interested in receiving work from newer, lesser-known photographers. Submit portfolio for review. "You must send a $5 fee. Attn: Reviewing Department for a review." Works on assignment only. Does not keep samples on file. Reports in 3 weeks. NPI; determined by the project. Pays on usage. Credit line given. Buys first rights, one-time rights, all rights; negotiable.
Tips: "Send a portfolio at least once every 2 months and be patient because we can only use photos as they are needed for projects." Noticing that "Amiga work is increasing."

IRS RECORDS, Dept. PM, 3939 Lankershim Blvd., Universal City CA 91604. Did not respond to our request for information.

ISLAND INDEPENDENT LABELS, 8920 Sunset Blvd., 2nd Floor, Los Angeles CA 90069. Did not respond to our request for information.

■**JAZZAND**, 12 Micieli Place, Brooklyn NY 11218. (718)972-1220. President: Rick Stone. Handles jazz, acoustic and bebop. Freelancers used for portraits, in-concert shots and studio shots for cover/liner, publicity, brochures, posters, event/convention coverage and print advertising.
Needs: Buys 3-4 images annually; all supplied by freelancers. Offers 1-2 assignments annually. Interested in shots that have been used for covers. Good live and studio shots, portraits.
Audiovisual Needs: Uses videotape.
Specs: Uses 8×10 glossy color and b&w prints; VHS videotape.
Making Contact & Terms: Interested in receiving work from newer, lesser-known photographers. Arrange personal interview to show portfolio. Provide résumé, business card, self-promotion pieces or tearsheets to be kept on file for possible future assignments. Works with local freelancers only. Keeps samples on file. Cannot return material. Reports in 1 month. Pays $50-100/hour; $100-200/job; negotiable—depends on use. **Pays on acceptance.** Credit line given. Buys all rights; negotiable.
Tips: "We are a very small label with a miniscule budget. If you are good at location shots and want to establish a portfolio of cover shots, etc., we will be more than happy to supply you with copies of CD jackets, etc., which may help you to approach other labels."

KIMBO EDUCATIONAL, 10 N. Third Ave., P.O. Box 477, Long Branch NJ 07740. (908)229-4949. Production Manager: Amy Laufer. Handles educational—early childhood movement-oriented records, tapes and videocassettes. General entertainment songs for young children. Physical fitness programs for all ages. Photographers used for album and catalog covers, brochures and product advertising.
Needs: Offers 5 assignments/year.
Specs: Uses transparencies.
Making Contact & Terms: Provide résumé, business card, self-promotion pieces or tearsheets to be kept on file for possible future assignments. Cannot return material. "We keep samples on file and contact photographer if in need of their services." Payment for each job is different—small advertising job, $75 minimum; album covers, $200-400." Buys all rights; negotiable.
Tips: "We are looking for top quality work but our budgets do not allow us to pay New York City prices (need reasonable quotes). We prefer local photographers—communication is easier. We are leaning a little more toward photography, especially in our catalog. In the educational marketplace, it's becoming more prevalent to actually show our products being used by children."

PATTY LEE RECORDS, 6034 Graciosa Dr., Hollywood CA 90068. Phone/fax: (213)469-5431. Assistant to the President: Susan Neidhart. Estab. 1985. Handles New Orleans rock & roll, cowboy poetry, bebop and jazz. Freelancers used for cover/liner shots, posters.
Needs: "We look for unique artwork that works best for the genre of music we are promoting."
Making Contact & Terms: Interested in receiving work from newer, lesser-known photographers. Query with résumé of credits. "Send postcard query only; don't send actual art." Works with freelancers on assignment only. Keeps samples on file. Reports in 1 month. Payment based on project. Credit line given. Buys one-time rights.

***LIN'S LINES**, Suite 434, 156 Fifth Ave., New York NY 10010. (212)691-5630. Fax: (212)645-5038. President: Linda K. Jacobson. Estab. 1983. Handles all types of records. Uses photos for portraits, in-concert shots, studio shots for album covers, inside album shots, publicity, brochures, posters and product advertising.
Needs: Offers 6 assignments/year.
Specs: Uses 8×10 prints; 35mm transparencies.
Making Contact & Terms: Query with résumé of credits. Provide résumé, business card, self-promotion pieces or tearsheets to be kept on file for possible future assignments. "Do not send unsolicited photos." Works on assignment only. SASE. Reports in 1 month. Pays $50-500/b&w photo; $75-750/color photo; $10-50/hour; $100-1,500/day; $75-3,000/job. Credit line given. Buys one-time rights; all rights, but may reassign to photographer.
Tips: Prefers unusual and exciting photographs such as holograms and 3-D images. "Send *interesting* material, initially in postcard form."

LUCIFER RECORDS, INC., P.O. Box 263, Brigantine NJ 08203. (609)266-2623. President: Ron Luciano. Photographers used for portraits, live action shots and studio shots for album covers, record sleeves, publicity fliers, brochures and posters.
Needs: Freelancers supply 50% of photos.
Making Contact & Terms: Provide self-promotion pieces, résumé and samples. Submit portfolio for review. SASE. Reports in 2-6 weeks. NPI; payment negotiable. Buys all rights.

■**LEE MAGID**, P.O. Box 532, Malibu CA 90265. (213)463-5998. President: Lee Magid. Operates under Grass Roots Records label. Handles R&B, jazz, C&W, gospel, rock, blues, pop. Photographers used for portraits, in-concert shots, studio shots and candid photos for album covers, publicity, brochures, posters and event/convention coverage.
Needs: Offers about 10 assignments/year.
Specs: Uses 8×10 buff or glossy b&w or color prints and 2¼×2¼ transparencies.
Making Contact & Terms: Send print copies by mail for consideration. Works on assignment only. SASE. Reports in 2 weeks. NPI. Credit line given. Buys all rights.

MCA RECORDS, 1755 Broadway, 8th Floor, New York NY 10019. Did not respond to our request for information.

■**MIA MIND MUSIC**, 500½ E. 84th St., New York NY 10028. (212)861-8745. Fax: (212)861-4825. Promotions Director: Ashley Wilkes. Estab. 1982. Freelancers used for cover/liner shots, posters, direct mail, newspapers and videos.
Needs: Offers 3 assignments annually. Interested in photos of recording artists. Reviews stock photos appropriate for album/CD covers. Model/property release preferred. Captions preferred.
Audiovisual Needs: Uses slides and video to present an artist to record labels to obtain a record deal.
Specs: Uses 8×10 matte color and b&w prints.
Making Contact & Terms: Interested in receiving work from newer, lesser-known photographers. Arrange personal interview to show portfolio. Submit portfolio for review. Provide résumé, business card, self-promotion pieces or tearsheets to be kept on file for possible future assignments. Contact through rep. Works with freelancers on assignment only. Keeps samples on file. SASE. Reports in 1-2 weeks. Pays $200-1,500/job; $200-500/color photo; $200-500/b&w photo. **Pays on acceptance**. Credit line given.
Tips: Looking for conceptual, interesting, edgy borderline-controversial photography. Seeing a trend toward conceptual, art photography.

 THE ASTERISK before a listing indicates that the market is new in this edition. New markets are often the most receptive to freelance submissions.

■**MIRAMAR PRODUCTIONS**, 200 Second Ave. W., Seattle WA 98119. (206)284-4700. Fax: (206)286-4433. Contact: Mike Boydstun. Estab. 1985. Handles rock and New Age. Freelancers used for portraits, in-concert shots and studio shots for cover/liner, inside shots, publicity, brochure, posters and print advertising.
Needs: Buys 10-20 images annually; 10-20 supplied by freelancers. Offers 10-20 assignments annually. Reviews stock photos. Model/property release required. Captions preferred.
Audiovisual Needs: Uses slides, film and videotape.
Specs: Uses 35mm, 2¼×2¼, 4×5 transparencies; 35mm, 16mm film; no less than Betacam videotape.
Making Contact & Terms: Interested in receiving work from newer, lesser-known photographers. Query with samples. Works on assignment only. Keeps samples on file. SASE. Pays $100-2,500/job. **Pays on acceptance.** Credit line given. Buys all rights; negotiable.

NUCLEUS RECORDS, 885 Broadway, #282, Bayonne NJ 07002-3032. President: Robert Bowden. Estab. 1979. Handles rock, country. Photographers used for portraits, studio shots for publicity, posters and product advertising.
Needs: Send still photos of people for consideration. Model release preferred. Property release required. Captions preferred.
Making Contact & Terms: Interested in receiving work from newer, lesser-known photographers. Works on assignment only. SASE. Reports in 3 weeks. Pays $50-75/b&w photo; $100-125/color photo; $50-75/hour; $100-200/day; $500-550/job. Credit line given. Buys one-time and all rights.

POLYGRAM RECORDS, 825 8th Ave., 27th Floor, New York NY 10019. Did not respond to our request for information.

PRO/CREATIVES, 25 W. Burda Place, New City NY 10956-7116. President: David Rapp. Handles pop and classical. Photographers used for record album photos, men's magazines, sports, advertising illustrations, posters and brochures.
Making Contact & Terms: Query with examples, résumé of credits and business card. SASE. Reports in 1 month. NPI. Buys all rights.

‡**R.T.L. MUSIC/SWOOP RECORDS**, Stewart House, Hill Bottom Rd., Sands-IND-EST, Highwycombe, Bucks, HP124HJ England. (01630)647374. Fax: (01630)647612. Owner: Ron Lee. Estab. 1970. Uses portraits, in-concert shots, studio shots and special effects for album covers, inside album shots, publicity, brochures, posters, event/convention coverage and product advertising.
Needs: Wants to see all types of photos. Examples of recent uses: "Children of the Night," by Nightmare; "White Man Come," by Emmitt Till; and "Gotta Do It All Again," by Alvili Stardust (all CD covers). Model/property release required. Photo captions required.
Specs: Uses 8×10 glossy or matte, b&w or color prints.
Making Contact & Terms: Interested in receiving work from newer, lesser-known photographers. Reports in 3 weeks. NPI. Payment always negotiated. Credit line given. Buys exclusive product and all rights; negotiable.
Tips: Depending on the photographer's originality, "prospects can be very good."

RCA RECORDS, 1540 Broadway, New York NY 10036. Did not respond to our request for information.

RELATIVITY RECORDINGS, INC., 79 Fifth Ave., New York NY 10003. (212)337-5300. Fax: (212)337-5374. Art Director: David Bett. Estab. 1979. Handles primarily rap and rock. Freelancers used for portraits, in-concert shots, studio shots and cover concepts for cover/liner, publicity, posters, print advertising.
Needs: Offers 30-50 assignments annually.
Specs: Uses "any and all."
Making Contact & Terms: Interested in receiving work from newer, lesser-known photographers as well as established professionals. Submit portfolio for review. Provide promo card or tearsheets to be kept on file for possible future assignments. Contact by phone to arrange submission of portfolio or send card to be kept on file. Works on assignment only. SASE. Reports "when we want to hire a photographer." Pays $500-2,500/publicity photo; $1,500-4,000/album cover photo; $1,500-2,500/back cover photo. "Depends on level of the recording artist, sales potential." Credit line given. Buys one-time rights; all rights; negotiable.
Tips: "We're always looking for photographers with imagination and good rapport with artists. We probably use photography on about 75% of our covers, and somewhere on all our albums."

ROCKWELL RECORDS, 227 Concord St., Haverhill MA 01830. (508)373-5677. President: Bill Macek. Produces top 40 and rock 'n' roll records. Photographers used for live action shots, studio

shots and special effects for album covers, inside album shots, publicity, brochures and posters. Photos used for jacket design and artist shots.
Needs: Buys 1-2 images annually. Offers 1-2 assignments/annually. Freelancers supply 100% of photos. Interested in seeing all types of photos. "No restrictions. I may see something in a portfolio I really like and hadn't thought about using."
Making Contact & Terms: Arrange a personal interview. Submit b&w and color sample photos by mail for consideration. Submit portfolio for review. Provide résumé, business card or self-promotion pieces to be kept on file for possible future assignments. Local photographers preferred, but will review work of photographers from anywhere. SASE. NPI; payment varies.

***■SHAOLIN FILM & RECORDS**, P.O. Box 58547, Salt Lake City UT 84158. President: Sifu Richard O'Connor. A&R: Don Dela Vega. Estab. 1984. Handles rock, New Age. Uses portraits, in-concert shots, studio shots, special effects for cover/liner, inside shots, publicity, brochures, posters, event/convention coverage, print advertising.
Needs: Buys 500 images annually; 8-10 supplied by freelancers. Offers 12 assignments annually. Subjects vary with project.
Specs: Uses mostly color and fiber b&w prints; 35mm, 2¼ × 2¼, 4 × 5, 8 × 10 transparencies; videotape.
Making Contact & Terms: Interested in receiving work from newer, lesser-known photographers. Query with samples. Provide résumé, business card, self-promotion pieces or tearsheets to be kept on file for possible future assignments. Works on assignment only. Keeps samples on file. SASE. Reports in 2 months. Each project is bid or negotiated with expenses and spec. rates. **Pays on acceptance** and usage. "Occasionally the credit is not with the photo but elsewhere on product." Buys all rights; negotiable.
Tips: "Shoot for local magazines or just for the experience. Live is different than studio, which is different than locations . . . Shoot in all possible situations. Do what is right for the project or artist; not necessarily convenient for you. Groups seem to all be imitations of other successful artists. Meet the artist and develop an image that REALLY portrays them—not their aspirations."

SIRR RODD RECORD & PUBLISHING CO., 2453 77th Ave., Philadelphia PA 19150-1820. President/A&R: Rodney Jerome Keitt. Handles R&B, jazz, top 40, rap, pop, gospel and soul. Uses photographers for portraits, in-concert shots, studio shots and special effects for album covers, inside album shots, publicity, posters, event/convention and product advertising.
Needs: Buys 10 (minimum) photos/year.
Specs: Uses 8 × 10 glossy b&w or color prints.
Making Contact & Terms: Submit portfolio for review. Provide résumé, business card, self-promotion pieces or tearsheets to be kept on file for possible future assignments. SASE. Reports in 1 month. Pays $40-200/b&w photo; $60-250/color photo; $75-450/job. Credit line given. Buys all rights, negotiable.
Tips: "We look for the total versatility of the photographer. Of course, you can show us the more common group photos, but we like to see new concepts in group photography. Remember that you are freelancing. You do not have the name, studio, or reputation of 'Big Time' photographers, so we both are working for the same thing—exposure! If your pieces are good and the quality is equally good, your chances of working with record companies are excellent. Show your originality, ability to present the unusual, and what 'effects' you have to offer."

SONY MUSIC, 51 W. 52nd St., New York NY 10019. Did not respond to our request for information.

***‡SOUND CEREMONY RECORDS**, 23 Selby Rd E11, London, England. (081)5031687. Managing Director: Ron Warren Ganderton. Handles rock. Uses photographers for portraits, in-concert shots, studio shots and glamour shots promotion for album covers, inside album shots, publicity, posters and product advertising.
Needs: Buys up to 75 photos/year. "Any interest welcomed. All types of material will be considered as we are involved in diverse, versatile events."
Specs: Uses various sizes; b&w and color prints.
Making Contact & Terms: Query with résumé of credits. Send unsolicited photos by mail for consideration. Provide résumé, business card, brochure, flier or tearsheets to be kept on file for possible future assignments. Does not return unsolicited material. Reports in 2 weeks; international, 3 weeks.

 THE DOUBLE DAGGER before a listing indicates that the market is located outside the United States and Canada.

NPI. "All pay depends on negotiation." Credit line given. Buys one-time rights, all rights; negotiable.
Tips: Prefers to see diverse samples.

TRANSWORLD RECORDS, 2170 S. Parker Rd., Suite 115, Denver CO 80231. (303)755-2546.
President: R.J. Bernstein. Estab. 1960. Handles rock, classical and country. Uses portraits, in-concert
shots, studio shots and special effects for album covers, inside album shots, publicity, brochures and
posters.
Needs: Gives 6 assignments/year.
Making Contact & Terms: Query with résumé of credits. Send unsolicited photos by mail for
consideration. Submit portfolio for review. Provide résumé, business card, self-promotion pieces or
tearsheets to be kept on file for possible future assignments. Works on assignment only. Does not
return unsolicited material. Reports in 1 month. NPI; payment negotiable. Credit line given. Buys all
rights; negotiable.

UAR RECORD PRODUCTIONS, LTD., P.O. Box 1264, Peoria IL 61654. Phone/fax: (309)673-
5755. Owner: Jerry Hanlon. Estab. 1968. Handles country, country rock, Christian. Freelancers used
for portraits for cover/liner shots and publicity.
Needs: Reviews stock photos. Scenery (country scenes, water scenes), churches.
Specs: Uses color and/or b&w prints; 4×5 transparencies.
Making Contact & Terms: Interested in receiving work from newer, lesser-known photographers.
Submit portfolio for review. Provide résumé, business card, self-promotion pieces or tearsheets to be
kept on file for possible future assignments. Works on assignment only. Keeps samples on file. Cannot
return material. Reports in 1 month. NPI. Pays upon usage.

VIRGIN RECORDS, 338 N. Foothill Rd., Beverly Hills CA 90210. Did not respond to our request
for information.

WARNER BROS. RECORDS, 3300 Warner Blvd., Burbank CA 91505. Did not respond to our
request for information.

WINDHAM HILL RECORDS, 75 Willow Rd., Menlo Park CA 94025. (415)329-0647. Art Direc-
tor: Candace Upman. Handles mostly jazz-oriented, acoustic and vocal music. Uses freelance photogra-
phers for portraits and art shots (including natural subjects) for album packaging.
Needs: Buys 20-30 freelance photos/year.
Specs: Uses 35mm, 2¼×2¼, 4×5 and 8×10 transparencies as well as b&w prints.
Making Contact & Terms: For portrait work, submit portfolio for review, including FedEx account
number (or similar) if necessary for return. For album packaging imagery, send duplicate images only
with SASE for eventual return of unwanted images; originals not accepted. NPI; payment varies. Credit
given. Buys one-time rights or all rights.
Tips: "For both portrait photography and cover imagery, we are looking for something with a creative
twist or unusual point of view. Become acquainted with our covers before submitting materials. Send
materials that have personal significance—work with heart."

Stock Photo Agencies

Unless you're interested in taking stock photography seriously, you probably shouldn't read beyond this sentence. Stock agencies want photographers who produce quality images, and lots of them. They expect periodic submissions that have been edited and often consist of hundreds of photos. Most agencies demand model and property releases that take time to acquire. They, in short, want professionals.

Now, if you're still reading, this section has a lot to offer you. There are nearly 200 agencies listed here and 47 are new to this edition. They range from agencies with small staffs and archives of a couple thousand images, to worldwide image providers with millions of images, like FPG International, Tony Stone Images and Westlight. To learn more about the international stock business, see our interview with Alberto Sciama on page 510. Sciama is managing director of Pictor International Ltd. in London and his agency represents over 100 photographers worldwide.

If you've read the photo trade magazines over the past five years, you've seen the birth of CD storage and online presentation of images. Many agencies are just now starting to adopt these and other technologies to their businesses. As you read through these markets you will find information on new technology and its effects on stock agencies. Much of this material is new this year. We asked agencies how the new technology is changing the way they conduct business because photographers face some new challenges in the near future. Information that explains how an agency is adapting to the new technology is set off by a bullet (●).

Because of all these changes you should closely study agency contracts and find out how agency owners plan to market your work. For example, some agencies are willing to place images on clip art discs while others have campaigned against such practices. Most agencies are reputable, but some are either unethical in their practices or have not yet adopted professional attitudes. By knowing how various agencies operate you will know which ones should market your work.

Finally, there are a number of helpful references and organizations that will assist you in learning more about the stock industry and its standard practices. The following sources also can help you stay in touch with industry trends: *Taking-Stock*, a newsletter published by stock photo expert Jim Pickerell (301)251-0720; the *ASMP Stock Photography Handbook,* published by the American Society of Media Photographers (609)799-8300; and the Picture Agency Council of America, contact PACA Executive Administrator Lonnie Schroeder at (800)457-7222.

■�excAAA IMAGE MAKERS**, 337 W. Pender St., Suite 301, Vancouver, British Columbia V6B 1T3 Canada. (604)688-3001. Owner: Reimut Lieder. Estab. 1981. Stock photo agency. Has 200,000 photos. Clients include: advertising agencies, public relations firms, audiovisual firms, businesses, book/ency-clopedia publishers, magazine and textbook publishers, postcard publishers, calendar companies and greeting card companies.
Needs: People, families, business, travel and "much more. We provide our photographers with a current needs list on a regular basis."
Specs: Uses 8×10 glossy or pearl b&w prints; 35mm, 2¼×2¼, 4×5 and 8×10 transparencies.
Payment & Terms: Pays 50% commission on color and b&w. Average price per image (to clients): $300-500/b&w; $400/color. Enforces minimum prices. Offers volume discount to customers; terms specified in photographer's contract. Discount sales terms not negotiable. Works on contract basis only. Offers limited regional exclusivity, guaranteed subject exclusivity. Charges 50% duping fee, 50% catalog insertion. Statements issued quarterly. Payment made quarterly. Photographers allowed to

review account records. Rights negotiated by client needs. Does not inform photographer or allow him to negotiate when client requests all rights. Model release preferred. "All work must be marked 'MR' or 'NMR' for model release or no model release. Photo captions required.

Making Contact: Interested in receiving work from established, especially commercial, photographers. Arrange personal interview to show portfolio. Submit portfolio for review. Query with résumé of credits. Query with samples. Send SASE (IRCs) with letter of inquiry, résumé, business card, flier, tearsheets or samples. Samples kept on file. Expects minimum initial submission of 200 images. Reports in 2-3 weeks. Photo guideline sheet free with SASE (IRC). Market tips sheet distributed quarterly to all photographers on contract; free with SASE (IRCs).

Tips: "As we do not have submission minimums, be sure to edit your work ruthlessly. We expect quality work to be submitted on a regular basis. Research your subject completely and shoot shoot shoot!!"

■‡**ACE PHOTO AGENCY**, Satellite House, 2 Salisbury Rd., Wimbledon, London SW19 4EZ United Kingdom. (181)944-9944. Fax: (181)944-9940. Chief Editor: John Panton. Stock photo agency. Has approximately 300,000 photos. Clients include: ad agencies, audiovisual firms, businesses, book/encyclopedia publishers, magazine publishers, postcard companies, calendar companies, greeting card companies, design companies and direct mail companies.

Needs: People, sport, corporate, industrial, travel (world), seas and skies, still life and humor.

Specs: Uses 35mm, 2¼×2¼, 4×5 and 8×10 transparencies.

Payment & Terms: Pays 50% commission on color photos, 30% overseas sales. General price range: $135-1,800. Works on contract basis only; offers limited regional exclusivity and contracts. Contracts renew automatically for 2 years with each submission. Charges catalog insertion fee, $100 deducted from first sale. Statements issued quarterly. Payment made quarterly. Photographers permitted to review sales records with 1 month written notice. Offers one-time rights, first rights or mostly non-exclusive rights. Informs photographers when client requests to buy all rights, but agency negotiates for photographer. Model/property release required for people and buildings. Photo captions required; include place, date and function.

Making Contact: Arrange a personal interview to show portfolio. Query with samples. SASE (IRCs). Reports in 2 weeks. Photo guidelines free with SASE. Distributes tips sheet twice yearly to "ace photographers under contract."

Tips: Prefers to see "total range of subjects in collection. Must be commercial work, not personal favorites. Must show command of color, composition and general rules of stock photography. All people must be mid-Atlantic to sell in UK. Must be sharp and also original. No dupes. Be professional and patient. We are now fully digital. Scanning and image manipulation is all done inhouse. We market CD-ROM stock to existing clients. Photographers are welcome to send CD, SyQuest, cartridge or diskette for speculative submissions. Please provide data for Mac only."

ADVENTURE PHOTO, 24 E. Main St., Ventura CA 93001. (805)643-7751. Fax: (805)643-4423. Estab. 1987. Stock agency. Member of Picture Agency Council of America (PACA). Has 250,000 photos. Clients include: advertising agencies, public relations firms, businesses, magazine publishers, calendar and greeting card companies.

Needs: Adventure Photo offers its clients 5 principal types of images: adventure sports (sailing, windsurfing, rock climbing, skiing, mountaineering, mountain biking, etc.), adventure travel (all 50 states as well as Third World and exotic locations.), landscapes, environmental and wildlife.

Specs: Uses 35mm, 2¼×2¼ and 4×5 transparencies.

Payment & Terms: Pays 50% commission on color photos. Works on contract basis only. Offers nonexclusive contract. Contracts renew automatically with each submission; time period not specified. Statements issued monthly. Payment made monthly. Photographers allowed to review sales figures. Offers one-time rights; occasionally negotiates exclusive and unlimited use rights. "We notify photographers and work to settle on acceptable fee when client requests all rights." Model and property release required. Captions required, include description of subjects, locations and persons.

Making Contact: Write to photo editor for copy of submission guidelines. SASE. Reports in 1 month. Photo guidelines free with SASE.

Tips: In freelancer's portfolio or samples, wants to see "well-exposed, well-lit transparencies (reproduction quality). Unique outdoor sports, travel and wilderness images. We love to see shots of subject matter that portray metaphors commonly used in ad business (risk taking, teamwork, etc.)." To break in, "we request new photographers send us 40-80 images they feel are representative of their work. Then when we sign a photographer, we pass ideas to him regularly about the kinds of shots our clients are requesting, and we pass any ideas we get too. Then we counsel our photographers always to look at magazines and advertisements to stay current on the kinds of images art directors and agencies are using."

***ALASKA STOCK IMAGES**, 800 W. 21st Ave., Anchorage AK 99503. (907)276-1343. Fax: (907)258-7848. Owner: Jeff Schultz. Stock photo agency. Member of the Picture Agency Council

of America (PACA). Has 200,000 transparencies. Clients include: advertising agencies, businesses, newspapers, postcard publishers, book/encyclopedia publishers and calendar companies.

• Alaska Stock Images is currently represented by Picture Network International (PNI) and has a home page on the World Wide Web.

Needs: Outdoor adventure, wildlife, recreation—images which were or could have been shot in Alaska.

Specs: Uses 35mm, 2¼×2¼, 4×5, 6×17 panoramic transparencies. All images are low-res scanned for use by clients.

Payment & Terms: Pays 50% commission on b&w and color photos; minimum use fee $125. Offers volume discounts to customers; inquire about specific terms. Photographers can choose not to sell images on discount terms. Works on contract basis only. Offers nonexclusive contract; exclusive contract for images in catalogs. Contracts renew automatically with additional submissions; nonexclusive for 3 years. Charges variable catalog insertion fee. Statements issued monthly. Payment made monthly. Photographers allowed to review account records. Offers negotiable rights. Informs photographer and negotiates rights for photographer when client requests all rights. Model/property release preferred for any people and recognizable personal objects (boats, homes, etc.). Captions required; include who, what, when, where.

Making Contact: Interested in receiving work from newer, lesser-known photographers. Query with samples. Samples not kept on file. SASE. Expects minimum initial submission of 20 images with periodic submission of 100-200 images 1-4 times/year. Reports in 3 weeks. Photo guidelines free on request. Market tips sheet distributed 2 times/year to those with contracts.

***ALLURING STOCK PHOTOS**, 3015 Pickford Court, Indianapolis IN 46227. (317)889-6758. **All inquiries must be in written form ** Owner: Mary Lewis. Estab. 1994. Stock photo agency. Has 2,000 photos. Clients include: advertising agencies, public relations firms, audiovisual firms, businesses, book/encyclopedia publishers, magazine publishers, calendar companies, greeting card companies and postcard publishers.

Needs: Food still life; other stills also accepted.

Specs: Uses 35mm Kodachrome transparencies.

Payment & Terms: Pays 50% commission. Works on contract basis only. Offers nonexclusive contract. Contracts renew automatically with additional submissions for 3 years. Charges 100% filing fee, 100% duping fee and 100% catalog insertion fee. Statements issued quarterly. Payment made quarterly. Offers one-time rights. Informs photographer and allows him to negotiate when client requests all rights. Property release required when applicable. Captions required.

Making Contact: Interested in receiving work from newer, lesser-known photographers. Query with résumé and list of stock photos. Send 20 of what you consider to be your best work in a protective sleeve with SASE. Samples kept on file. Expects minimum of 20 images with periodic submissions of at least 50/month. Reports in 1 month. Photo guidelines available. Market tip sheet distributed bimonthly to contracted photographers.

Tips: "If you're good, we'll look at anything from A to Z. Everything you shoot should be done three times: horizontal, vertical and cropped for covers. Don't limit the potential of your transparencies. If it was good enough to shoot, isn't it good enough to cover your bases? Everything must be critically focused. Color saturation and composition are very important. Ask yourself what the picture says. If it is food, does it make me hungry? A photographer must be willing to submit at least 50 excellent slides per month."

■AMERICAN STOCK PHOTOGRAPHY, Dept. PM, 6255 Sunset Blvd., Suite 716, Hollywood CA 90028. (213)469-3900. Fax: (213)469-3909. President: Christopher C. Johnson. Manager: Sandra Capelli. Stock photo agency. Has 2 million photos. Clients include: advertising agencies, public relations firms, audiovisual firms, businesses, book/encyclopedia publishers, magazine publishers, newspapers, postcard companies, calendar companies, greeting card companies and TV and movie production companies.

• American Stock Photography is a subsidiary of Camerique, which is also listed in this section.

Needs: General stock, all categories. Special emphasis on California scenics and lifestyles.

Specs: Uses 35mm, 2¼×2¼, 4×5 transparencies; b&w contact sheets; b&w negatives.

Payment & Terms: Buys photos outright; pays $5-20. Pays 50% commission. General price range (to clients): $100-750. Works on contract basis only. Offers nonexclusive contracts. Contracts renew automatically with additional submissions. Charges 50% for catalog insertion, advertising, CD disks.

LISTINGS THAT USE IMAGES electronically can be found in the Digital Markets Index located at the back of this book.

Statements issued monthly. Payment made monthly. Photographers allowed to review account records. Offers one-time, electronic and multi-use rights. Informs photographer and allows him to negotiate when client requests all rights. Model/property release required for people, houses and animals. Captions required: include date, location, specific information on image.
Making Contact: Contact Camerique Inc., 1701 Skippack Pike., P.O. Box 175, Blue Bell, PA 19422. (610)272-4000. SASE. Reports in 1 week. Photo guidelines free with SASE. Tips sheet distributed quarterly to all active photographers with agency; free with SASE.

‡THE ANCIENT ART & ARCHITECTURE COLLECTION, 6 Kenton Rd., Harrow-on-the-Hill, Middlesex HA1 2BL London, England. (181)422-1214. Fax: (181)426-9479. Contact: The Librarian. Picture library. Has 200,000 photos. Clients include: public relations firms, audiovisual firms, book/encyclopedia publishers, magazine publishers and newspapers.
Specs: Uses 35mm, 2¼×2¼, 4×5 or 8×10 transparencies.
Payment & Terms: Pays 50% commission. Works with photographers on contract basis only. Offers nonexclusive rights. Contracts renew automatically with additional submissions. Statements issued quarterly. Payment made quarterly. Offers one-time rights. Fully detailed captions required.
Making Contact: Query with samples and list of stock photo subjects. SASE. Reporting time not specified.
Tips: "Material must be suitable for our specialist requirements. We cover historical and archeological periods from 25,000 BC to the 19th century AD, worldwide. All civilizations, cultures, religions, objects and artifacts as well as art are includable. Pictures with tourists, cars, TV aerials, and other modern intrusions not accepted."

■‡ANDES PRESS AGENCY, 26 Padbury Ct., London E2 7EH England. (0171)613-5417 Fax: (0171)739-3159. Director: Carlos Reyes. Picture library and news/feature syndicate. Has 500,000 photos. Clients include: audiovisual firms, book/encyclopedia publishers, magazine publishers and newspapers.
Needs: "We have a large collection of photographs on social, political and economic aspects of Latin America, Africa, Asia, Europe and Britain, specializing in contemporary world religions."
Specs: Uses 8×10 glossy b&w prints; 35mm and 2¼×2¼ transparencies; b&w contact sheets and negatives.
Payment & Terms: Pays 50% commission for b&w and color photos. General price range (to clients): £50-200/b&w photo; £50-300/color photo; (British currency). Enforces minimum prices. Works on contract basis only. Offers nonexclusive contract. Statements issued quarterly. Payment made quarterly. Photographers allowed to review account records to verify sales figures. Offers one-time rights and, if requested, electronic rights. Informs photographer and allows him to negotiate when client requests all rights. "We never sell all rights, photographer has to negotiate if interested." Model/property release preferred. Captions required.
Making Contact: Interested in receiving work from newer, lesser-known photographers. Query with samples. Send stock photo list. SASE. Reports in 1 week. Photo guidelines free with SASE.
Tips: "We want to see that the photographer has mastered one subject in depth. Also, we have a market for photo features as well as stock photos."

■ANIMALS ANIMALS/EARTH SCENES, 17 Railroad Ave., Chatham NY 12037. (518)392-5500. Branch office: 580 Broadway, Suite 1102, New York NY 10012. (212)925-2110. President: Eve Kloepper. Member of Picture Agency Council of America (PACA). Has 850,000 photos. Clients include: ad agencies, public relations firms, businesses, audiovisual firms, book publishers, magazine publishers, encyclopedia publishers, newspapers, postcard companies, calendar companies and greeting card companies.
 • This agency has joined the Kodak Picture Exchange, an online photo network.
Needs: "We specialize in nature photography with an emphasis on all animal life."
Specs: Uses 8×10 glossy or matte b&w prints; 35mm and some larger format color transparencies.
Payment & Terms: Pays 50% commission. Works on contract basis only. Offers exclusive contracts. Contracts renew automatically for 5 years. Charges catalog insertion fee of 50%. Photographers allowed to review account records to verify sales figures "if requested and with proper notice and cause." Statements issued quarterly. Payment made quarterly. Offers one-time and electronic media rights; other uses negotiable. Informs photographer and allows him to negotiate when client requests all rights. Model release required if used for advertising. Captions required, include Latin names, and "they must be correct!"
Making Contact: Interested in receiving work from newer, lesser-known photographers. Send material by mail for consideration. SASE. Reports in 1-2 months. Free photo guidelines with SASE. Tips sheet distributed regularly to established contributors.
Tips: "First, pre-edit your material. Second, know your subject."

APPALIGHT, Griffith Run Rd., Clay Rt. Box 89-C, Spencer WV 25276. Phone/fax: (304)927-2978. Director: Chuck Wyrostok. Estab. 1988. Stock photo agency. Has 20,000 photos. Clients include advertising agencies, public relations firms, businesses, book/encyclopedia publishers, magazine publishers, calendar companies, greeting card companies and graphic designers.
Needs: General subject matter with emphasis on child development and natural history, inspirational, cityscapes, travel. Special need for African-American and Hispanic people/lifestyles, active seniors, teens, handicapped people coping, US vacation spots. "Presently we're building comprehensive sections on animals, birds, flora and on positive solutions to environmental problems of all kinds."
Specs: Uses 8×10, glossy b&w prints; 35mm, 2¼×2¼, 4×5 transparencies.
Payment & Terms: Pays 50% commission. General price range: $150 and up. Works on contract basis only. Offers exclusive contracts only. Contracts renew automatically for 2-year period with additional submissions. Charges 100% duping rate. Statements issued annually. Payment made monthly. Photographers allowed to review account records during regular business hours or by appointment. Offers one-time rights, electronic media rights. "When client requests all rights photographer is contacted for his consent, but we handle all negotiations." Model release preferred. Captions required.
Making Contact: Interested in receiving work from newer, lesser-known photographers. Expects minimum initial submission of 300-500 images with periodic submissions of 200-300 several times/ year. Reports in 1 month. Photo guidelines free with SASE. Market tips sheet distributed "periodically" to contracted photographers.
Tips: "We look for a solid blend of topnotch technical quality, style, content and impact contained in images that portray metaphors applying to ideas, moods, business, endeavors, risk-taking, teamwork and winning."

■**AQUINO INTERNATIONAL**, P.O. Box 15760, Stamford CT 06901-0760. (203)967-9952. E-mail: aaquinoint@ad.com. Director: Andres Aquino. Stock photo agency, picture library. Has 300,000 photos. Clients include: ad agencies, public relations firms, audiovisual firms, businesses, book/encyclopedia publishers, magazine publishers, newspapers, postcard publishers, calendar companies, greeting card companies.
 • This agency markets images via CD-ROM.
Needs: Photos of all subjects; heavy on people, travel, glamour, beauty and fashion.
Specs: Uses b&w prints; 35mm, 2¼×2¼, 4×5, 8×10 transparencies; VHS and ¾" videotape.
Payment & Terms: Pays 50% commission on b&w and color photos. Also buys photographs in bulk. Average price per image (to clients): b&w $150-2,000; color $150-3,000. Enforces minimum prices. Offers volume discounts to customers; terms specified in photographer's contract. Photographers can choose not to sell images on discount terms. Works with or without signed contract. Offers exclusive and nonexclusive contracts. Contracts renew automatically with additional submissions for 2 years. Charges filing fee of $4/shipment; catalog insertion fee of 15%, 30% or 50%, "based on royalty desired by photographer." Statements issued bimonthly. Payment made monthly. Photographer is allowed to review account records pertaining to his/her sales from catalogs only. Offers one-time rights. Informs photographer and permits him to negotiate when client requests all rights. Model/ property release required. Captions required; include description and location.
Making Contact: Interested in receiving work from newer, lesser-known photographers. Query with samples. Query with stock photo list. Samples kept on file. SASE. Expects minimum initial submission of 20-100 images, with additional submission of 20/month or more. Reports in 3 weeks. Photo guidelines free with SASE. Market tips sheet distributed from time to time in the form of newsletter. Send $4 for sample requests and guidelines.
Tips: "We prefer sharp, carefully edited images in your area of specialization. Trends: images with specific commercial applications and images that evoke emotions and intellectual responses."

■**ARCHIVE PHOTOS**, 530 W. 25th St., New York NY 10001. (212)675-0115. Fax: (212)675-0379. Contact: Photo Editor. Estab. 1989. Picture library, news/feature syndicate. Member of the Picture Agency Council of America (PACA). Has 20 million photos; 14,000 hours of film. Has 8 branch offices. Clients include: advertising agencies, public relations firms, audiovisual firms, businesses, book/encyclopedia publishers, magazine publishers, newspapers, postcard publishers, calendar companies, greeting card companies, multimedia publishers.
 • This agency markets images in Photo CD format and on-line via Kodak Picture Exchange, Seymour, Press-Link, CompuServe and their own dial-up BBS.
Needs: All types of historical and new photos.
Specs: Uses 8×10 color and b&w prints; 35mm transparencies.
Payment & Terms: Pays 60% commission on b&w and color photos; 50% commission on film and videotape. Average price per image (to clients): $125-5,000/b&w; $125-5,000/color; $20-100/sec of film. Enforces minimum prices. Offers volume discounts to customers; inquire about specific terms. Discount sales terms not negotiable. Works with or without contract. Offers nonexclusive contract. Contracts renew automatically with additional submissions. Statements issued monthly. Payment made monthly within 15 days. Photographers allowed to review account records. Offers one-time rights,

electronic media rights, agency promotion rights. Does not inform photographer or allow him to negotiate when client requests all rights. Caption required.
Making Contact: Query with résumé of credits. Does not keep samples on file. SASE. Expects minimum initial submission of 100 images. Reports in 3 weeks.

ARMS COMMUNICATIONS, 1517 Maurice Dr., Woodbridge VA 22191. (703)690-3338. Fax: (703)490-3298. President: Jonathan Arms. Estab. 1989. Stock photo agency. Has 80,000 photos. Clients include: advertising agencies, public relations firms, businesses and magazine publishers.
Needs: Interested in photos of military/aerospace—US/foreign ships, foreign weapon systems (land, air and sea), weaponry being fired.
Specs: Uses 35mm transparencies.
Payment & Terms: Pays 50% commission on b&w and color photos. Average price per image (to clients): $200. Enforces minimum price of $100. Offers volume discounts to customers; terms specified in photographer's contract. Discount terms not negotiable. Works on contract basis only. Offers nonexclusive contracts. Contracts renew automatically with additional submissions for 3 years. Payment made within 60 days of invoice payment. Photographers allowed to review account records. Offers one-time rights. Does not negotiate when client requests all rights. Model release preferred. Captions required.
Making Contact: Interested in receiving work from newer, lesser-known photographers. Reports in 1-2 weeks.

***PETER ARNOLD, INC.**, 1181 Broadway, New York NY 10001. (212)481-1190 or (800)289-7468. Fax: (212)481-3409. General Manager: Daniel J. Russelman. Estab. 1975. Stock photo agency. Member of the Picture Agency Council of America (PACA). Has 500,000 photos. Clients include: ad agencies, public relations firms, audiovisual firms, businesses, book/encyclopedia publishers, magazine publishers, newspapers, calendar companies, greeting card companies, postcard publishers, CD-ROM publishers and anyone else who would buy stock photography.
Needs: Nature, wildlife, science, medical, travel, astronomy, geology, adventure sports, archaeology and weather.
Specs: Uses 35mm, 2¼ × 2¼ transparencies.
Payment & Terms: Pays 50% commission on b&w and color photos. Average price per image (to clients): $150-400/b&w; $180-450/color. "We attempt to hold minimum at $100 for editorial and $300 for commercial. However, increased competition and new technologies have driven fees down." Offers volume discounts to customers; terms specified in photographer's contract. Photographers can choose not to sell images on discount terms. Works with or without contract. Offers exclusive only, limited regional exclusivity or nonexclusive contracts; varies according to photographer. Charges 50% duping fee; 50% catalog insertion fee; 50% for CD-ROMs and industry sourcebooks. Statements issued quarterly. Payment made quarterly. Photographers allowed to review account records. Offers one-time and electronic media rights. "Exclusivity/nonexclusivity is also an option for clients, whether regionally, nationally or industry-wide." Informs photographer and allows him to negotiate when client requests all rights. Model/property release preferred for images depicting identifiable people, private property and pets. Captions required; include exact location, model release information, species name, approximate date of photo and specific information which will help researchers understand significance of photo.
Making Contact: Arrange personal interview to show portfolio. Query with résumé of credits. Query with samples. "Call first and talk with Danny Russelman or Peter Arnold." Works with local freelancers only. Samples kept on file. SASE. Expects initial submission of 200 images with later submissions of 200 images quarterly. Reports in 1-2 months. Market tips sheet distributed biannually.
Tips: "We have a UNIX-based database where we archive all of our images. This system allows us to search for images by caption information. We are currently reviewing options for possible future on-line and CD-ROM projects. Speak with the owner of each agency you are soliciting. Try and get a feel about the agency through the personality of the owner. If the owner is aggressive and smart, chances are so will the salespersons and editors. This will help increase your sales. Know something about the agency before you contact them—subjects, needs, clientele and other photographers represented."

■‡ARQUIVO INTERNACIONAL DE COR, COMUNICAÇÃO PELA IMAGEM, LDA., R.D. Cristovão da Gama, 138, 4150 Porto Portugal. (2)610 39 67. Fax: (2)610 89 50. Contact Manager: Maria Guimaraes. Estab. 1986. Stock photo agency. Has 100,000 photos. Clients include: advertising agencies, public relations firms, audiovisual firms, businesses, magazine publishers, newspapers, postcard publishers, calendar companies, greeting card companies and packaging companies.
Subject Needs: "As a stock photo agency, we deal with general subjects. We are, however, deeply interested in starting to work on representing video and films."
Specs: Uses b&w, color prints; 35mm, 2¼ × 2¼, 4 × 5, 8 × 10 transparencies; European PAL System videotape.

Payment & Terms: Pays agencies 40-60% commission on b&w and color photos; pays photographers 40-50% commission. Average price per image (to clients): $330/b&w or color photo depending on usage. Works with or without a signed contract, negotiable; offers exclusive contracts. Contracts renew automatically with additional submissions for 2 years. Statements issued monthly. Payment made monthly. Photographers permitted to review account records to verify sales figures or account for various deductions "whenever they want to check." Offers nonexclusive rights. Informs photographer and allows him to negotiate when client requests all rights. Model/property release required. Captions required; include reference number, site, situation.

Making Contact: Submit portfolio for review. Query with samples. Query with stock photo list. Samples kept on file. SASE. Expects minimum initial submission of 50-100 images. Reports in 1-2 months. Photo guidelines available. Market tips sheet distributed infrequently.

Tips: "As a stock photo agency, we should be prepared to provide any kind of image. Therefore we do have interest on general themes such as: men, architecture and art, economy, industry, traffic, science, technology and nature (animal and geography)."

■**ART RESOURCE**, 65 Bleecker St., 9th Floor, New York NY 10012. (212)505-8700. Fax: (212)420-9286. Permissions Director: Joanne Greenbaum. Estab. 1970. Stock photo agency specializing in fine arts. Member of the Picture Agency Council of America (PACA). Has access to 3 million photos. Clients include: advertising agencies, public relations firms, audiovisual firms, businesses, book/encyclopedia publishers, magazine publishers, newspapers, postcard publishers, calendar companies, greeting card companies and all other publishing and scholarly businesses.

Needs: Painting, sculpture, architecture *only*.

Specs: Uses 8×10 b&w prints; 35mm, 4×5, 8×10 transparencies.

Payment & Terms: NPI. Average price per image (to client): $75-500/b&w photo; $185-10,000/color photo. Negotiates fees below standard minimum prices. Offers volume discounts to customers; terms specified in photographer's contract. Discount sales terms not negotiable. Offers exclusive only or nonexclusive rights. Contracts renew automatically with additional submissions. Statements issued quarterly. Payment made quarterly. Photographers allowed to review account records. Offers one-time rights, electronic media rights, agency promotion and other negotiated rights. Photo captions required.

Making Contact: Query with stock photo list. "Only fine art!"

Tips: "We only represent European fine art archives and museums in U.S and Europe, but occasionally represent a photographer with a specialty in certain art."

*‡**AUSTRALIAN PICTURE LIBRARY**, 2 Northcote St., St. Leonards NSW 2065 Australia, (02)438-3011. Fax: (02)439-6527. Managing Director: Jane Symons. Estab. 1979. Stock photo agency and news/feature syndicate. Has over 1 million photos. Clients include: advertising agencies, public relations firms, audiovisual firms, businesses, book/encyclopedia publishers, magazine publishers, newspapers, postcard publishers, calendar companies and greeting card companies.

Needs: Photos of Australia, sports, people, industry, personalities.

Specs: Uses 8×10 b&w prints; 35mm, 2¼×2¼ and 6×7cm transparencies.

Payment & Terms: Pays 50% commission. Offers volume discounts to customers. Works on contract basis only; offers exclusive contracts. Statements issued quarterly. Payment made quarterly. Offers one-time rights. Informs photographer and allows him to negotiate when client requests all rights. Model/property release required. Captions required.

Making Contact: Submit portfolio for review. Expects minimum initial submission of 400 images with minimum yearly submissions of at least 1,000 images. Images can be digitally transmitted using modem and ISDN. Reports in 1 month. Photo guidelines free with SASE. Catalog available. Market tips sheet distributed quarterly to agency photographers.

Tips: Looks for formats larger than 35mm in travel, landscapes and scenics with excellent quality. "There must be a need within the library that doesn't conflict with existing photographers too greatly."

*‡**A-Z BOTANICAL COLLECTION LTD.**, Bedwell Lodge, Cucumber Lane, Essendon, Hatfield, Herts AL9 6JB Great Britain. Phone/fax: (01707)649091. Director: Jeremy Finlay. Estab. 1969. Stock photo agency and picture library. Has 160,000 photos. Clients include: ad agencies, public relations firms, businesses, book/encyclopedia publishers, magazine publishers, newspapers, calendar companies and greeting card companies.

 THE DOUBLE DAGGER before a listing indicates that the market is located outside the United States and Canada.

Needs: Any plant in all situations; all "wild" plants; all garden cultivars.

Specs: Uses 35mm, 2¼×2¼ transparencies.

Payment & Terms: Pays 50% commission on color photos. Average price per image (to clients): $75-150/color photo. Enforces minimum prices. Offers volume discounts to customers; inquire about specific terms. Discount sales terms not negotiable. Works with or without contract. Offers guaranteed subject exclusivity contract. Statements issued quarterly. Payment made quarterly. Photographers allowed to review account records. Offers one-time rights; negotiable. Informs photographer and allows him to negotiate when client requests all rights. Captions required; must have either Latin botanic name or the cultivar name.

Making Contact: Interested in receiving work from newer, lesser-known photographers. Query with samples. SASE. Expects minimum initial submission of 20 images and 100 more as ready. Reports in 1 month. Photo guidelines free with SASE. Market tips sheet distributed bimonthly; free with SASE.

■‡**BARNABY'S PICTURE LIBRARY**, Barnaby House, 19 Rathbone St., London W1P 1AF England. (0171)636-6128. Fax: (0171)637-4317. Contact: Mrs. Mary Buckland. Stock photo agency and picture library. Has 4 million photos. Clients include: ad agencies, public relations firms, audiovisual firms, businesses, book/encyclopedia publishers, magazine publishers, newspapers, film production companies, BBC, all TV companies, record companies, etc.

Specs: Uses 8×10 b&w prints; 35mm, 2¼×2¼, 4×5 and 8×10 transparencies.

Payment & Terms: Pays 50% commission on b&w and color photos. Works on contract basis only. Offers nonexclusive rights. "Barnaby's does not mind photographers having other agents as long as there are not conflicting rights." Statements issued semi-annually. Payment made semi-annually. "Very detailed statements of sales for photographers are given to them biannually and tearsheets kept." Offers one-time rights. "The photographer must trust and rely on his agent to negotiate best price!" Model release required. Captions required.

Making Contact: Interested in receiving work from newer, lesser-known photographers. Arrange a personal interview to show portfolio. Send unsolicited photos by mail for consideration. Submit portfolio for review. SASE. "Your initial submission of material must be large enough for us to select a minimum of 200 pictures in color or b&w and they must be your copyright." Reports in 3 weeks. Photo guidelines free with SASE. Tips sheet distributed quarterly to anyone for SASE.

Tips: "Please ask for 'photographer's information pack' which (we hope) tells it all!"

*‡**BAVARIA BILDAGENTUR GMBH**, Postfach 1160, 8035 Gauting, West Germany. (089)893390. Fax: (089)8509707. Director: Anton Dentler. Stock photo agency and picture library. Has 800,000 photos. Clients include: ad agencies, public relations firms, audiovisual firms, businesses, book/encyclopedia publishers, magazine publishers, newspapers, postcard companies, calendar companies and greeting card companies.

• This agency's last catalog, The European Creative Stockbook, appears on CD-ROM. The company was purchased in 1996 by London-based Visual Communications Group.

Needs: All subjects.

Specs: Uses 35mm, 2¼×2¼, 4×5 and 8×10 transparencies.

Payment & Terms: Pays 50% commission on color photos. Works on contract basis only. Charges filing fee; catalog insertion fee of 200 DM/image. Statements issued monthly. Payment made monthly. Photographers allowed to review account records. Offers one-time rights and first rights. Informs photographer and allows him to negotiate when client requests all rights. Model/property release required. Captions required.

Making Contact: Interested in receiving work from newer, lesser-known photographers. Query with samples. Send unsolicited photos by mail for consideration. Submit portfolio for review. SASE. Reports in 2 weeks. Photo guidelines sheet for SASE.

■**ROBERT J. BENNETT, INC.**, 310 Edgewood St., Bridgeville DE 19933. (302)337-3347, (302)270-0326. Fax: (302)337-3444. President: Robert Bennett. Estab. 1947. Stock photo agency.

Needs: General subject matter.

Specs: Uses 8×10 glossy b&w prints; 35mm, 2¼×2¼ and 4×5 transparencies.

Payment & Terms: Pays 50% commission US; 40-60% foreign. Pays $5-50/hour; $40-400/day. Pays on publication. Works on contract basis only. Offers limited regional exclusivity. Charges filing fees and duping fees. Statements issued monthly. Payment made monthly. Photographers allowed to review account records to verify sales figures. Buys one-time, electronic media and agency promotion rights. Informs photographer and allows him to negotiate when client requests all rights. Model/property release required. Captions required.

Making Contact: Interested in receiving work from newer, lesser-known photographers. Query with résumé of credits. Query with stock photo list. Provide résumé, business card, brochure or tearsheets to be kept on file for possible future assignments. Works on assignment only. Keeps samples on file. Reports in 1 month.

London-based Barnaby's Picture Library has sold this delightful shot a number of times for birthday cards, children's magazines, and an ad for cake frosting. "The little elephant was being looked after by the keeper at the zoo (who lived there) and it was difficult to keep the elephant out of the house—until he got too big!" explains Barnaby's Mary Buckland. "He was well-behaved and very gentle. The kids loved him." The playful pachyderm was captured on film by Barnaby's-represented David Hodgson, a freelance photographer who's supplied photos to newspapers and magazines for three decades.

***BRUCE BENNETT STUDIOS**, 329 W. John St., Hicksville NY 11801. (516)681-2850. Fax: (516)681-2866. E-mail: 74163.1605@compuserve.com. Studio Director: Brian Winkler. Estab. 1973. Stock photo agency. Has 3 million photos. Clients include: ad agencies, book/encyclopedia publishers, magazine publishers and newspapers.

Needs: Ice hockey and hockey-related, especially images shot before 1975.

Specs: Uses 35mm transparencies.

Payment & Terms: Buys photos outright; pays $5-30/color photo. Pays 50% commission on b&w and color photos. Average price per image (to clients): $25-50/b&w photo; $50-150/color photo. Negotiates fees below stated minimum prices. Offers volume discounts to customers; terms specified in photographer's contract. Discount sales terms not negotiable. Works with or without contract. Offers nonexclusive contracts. Statements issued quarterly. Payment made quarterly. Offers one-time, electronic media or agency promotion rights. Does not inform photographer or allow him to negotiate when client requests all rights.

Making Contact: Interested in receiving work from newer, lesser-known photographers. Query with samples. Works on assignment only. Samples not kept on file. SASE. Expects minimum initial submission of 10 images. Reports in 3 weeks.

Tips: "We have set up a subscribers-only bulletin board service where clients can call in and download photos they need."

BIOLOGICAL PHOTO SERVICE, P.O. Box 490, Moss Beach CA 94038. Phone/fax: (415)726-6244. E-mail: bpsterra@aol.com. Photo Agent: Carl W. May. Stock photo agency. Has 90,000 photos. Clients include: ad agencies, businesses, book/encyclopedia publishers and magazine publishers.

• This agency may begin CD storage of images, but May says he is uncertain whether his agency will get involved with networking of images. The network situation is still too unproven for them, he says.

Needs: All subjects in the life sciences, including agriculture, natural history and medicine. Stock photographers must be scientists. Subject needs include: electron micrographs of all sorts; biotechnology; contemporary medical problems; MRI, CAT scan, PET scan, ultrasound, and X-ray images; animal behavior; tropical biology; and biological conservation. All aspects of general and pathogenic microbiology. All aspects of normal human biology and the basic medical sciences, including anatomy, human embryology and human genetics. Computer-generated images of molecules (structural biology).
Specs: Uses 4×5 through 11×14 glossy, high-contrast b&w prints; 35mm, $2\frac{1}{4} \times 2\frac{1}{4}$, 4×5, 8×10 transparencies. "Dupes acceptable for rare and unusual subjects, but we prefer originals."
Payment & Terms: Pays 50% commission on b&w and color photos. General price range (for clients): $90-500, sometimes higher for advertising uses. Works with or without contract. Offers exclusive contracts. Statements issued quarterly. Payment made quarterly; "one month after end of quarter." Photographers allowed to review account records to verify sales figures "by appointment at any time." Offers one-time, electronic media, promotion rights; negotiable. Informs photographer and allows him veto authority when client requests all rights. "Photographer is consulted during negotiations for 'buyouts,' etc." Model or property release required for photos used in advertising and other commercial areas. Thorough photo captions required; include complete identification of subject and location.
Making Contact: Interested in receiving work from newer, lesser-known photographers if they have the proper background. Query with list of stock subjects and résumé of scientific and photographic background. SASE. Reports in 2 weeks. Photo guidelines free with query, résumé and SASE. Tips sheet distributed intermittently to stock photographers only.
Tips: "When samples are requested, we look for proper exposure, maximum depth of field, adequate visual information and composition, and adequate technical and general information in captions. Requests fresh light and electron micrographs of traditional textbook subjects; applied biology such as biotechnology, agriculture, industrial microbiology, and medical research; biological careers; field research. We avoid excessive overlap among our photographer/scientists. We are experiencing an ever-growing demand for photos covering environmental problems of all sorts—local to global, domestic and foreign. Tropical biology, marine biology, and forestry are hot subjects. Our three greatest problems with potential photographers are: 1) inadequate captions; 2) inadequate quantities of *fresh* and *diverse* photos; 3) poor sharpness/depth of field/grain/composition in photos."

BLACK STAR PUBLISHING CO., INC., 116 E. 27th St., New York NY 10016. Prefers not to share information.

■D. DONNE BRYANT STOCK PHOTOGRAPHY, P.O. Box 80155, Baton Rouge LA 70898. (504)763-6235. Fax: (504)763-6894. E-mail: dougbryant@aol.com. President: Douglas D. Bryant. Stock photo agency. Currently represents 110 professional photographers. Has 500,000 photos. Clients include: ad agencies, audiovisual firms, book/encyclopedia publishers, magazine publishers, CD-ROM publishers and a large number of foreign publishers.
 • This agency uses imagers to make up Kodak CD sample disks, and is setting up a web server/ISDN speed with home page and hyperlinks to allow customers to sample photos by subject category.
Needs: Specializes in picture coverage of Latin America with emphasis on Mexico, Central America, South America, the Caribbean Basin and the Southern USA. Eighty percent of picture rentals are for editorial usage. Important subjects include agriculture, anthropology/archeology, art, commerce and industry, crafts, education, festivals and ritual, geography, history, indigenous people and culture, museums, parks, political figures, religion, scenics, sports and recreation, subsistence, tourism, transportation, travel and urban centers.
Specs: Accepts 35mm, $2\frac{1}{4} \times 2\frac{1}{4}$ and 4×5 color transparencies.
Payment & Terms: Pays 50% commission; 30% on foreign sales through foreign agents. General price range: $85-5,000. Works with or without a signed contract, negotiable. Offers nonexclusive contracts. Statements issued monthly. Payment made immediately after lease. Does not allow photographers to review account records to verify sales figures. "We are a small agency and do not have staff to oversee audits." Offers one-time, electronic media, world and all language rights. Informs photographer and allows him to negotiate when client requests all rights. Offers $1,500 per image for all rights. Model/property release preferred, especially for ad set-up shots. Captions required; include location and brief description. "Must have good captions."
Making Contact: Interested in receiving work from professional photographers who regularly visit Latin America. Query with résumé of credits and list of stock photo subjects. SASE. Reports in 1 month. Photo guidelines free with SASE. Tips sheet distributed every 3 months to agency photographers.
Tips: "Speak Spanish and spend one to six months shooting in Latin America every year. Follow our needs list closely. Shoot Fuji transparency film and cover the broadest range of subjects and countries. We have an active duping service where we provide European and Asian agencies with images they market in film and on CD."

■**CALIFORNIA VIEWS/Pat Hathaway Historical Collection**, 469 Pacific St., Monterey CA 93940-2702. (408)373-3811. Photo Archivist: Pat Hathaway. Picture library; historical collection. Has 70,000 b&w images, 8,000 35mm color. Clients include: ad agencies, public relations firms, audiovisual firms, book/encyclopedia publishers, magazine publishers, museums, postcard companies, calendar companies, television companies, interior decorators, film companies.
Needs: Historical photos of California from 1860-1995.
Payment & Terms: NPI.
Making Contact: "We accept donations of photographic material in order to maintain our position as one of California's largest archives." Does not return unsolicited material. Reports in 3 months.

*■‡**CAMERA PRESS LTD.**, 21 Queen Elizabeth Street, London SE1 2PD England. (0171)378-1300. Fax: (0171)278-5126. Modem: (0171)378 9064. ISDN: (Planet) (0171)378 6078 or: (0171)378 9141. Operations Director: Roger Eldridge. Picture library, news/feature syndicate. Clients include: ad agencies, public relations firms, audiovisual firms, book/encyclopedia publishers, magazine publishers, newspapers, postcard companies, calendar companies, greeting card companies and TV stations. Clients principally press, but also advertising, publishers, etc.
 • Camera Press has a fully operational electronic picture desk to receive/send digital images via modem/ISDN lines.
Needs: Documentary, features, world personalities, i.e. politicians, athletes, statesmen, artists.
Specs: Uses prints; 35mm, 2¼×2¼ and 4×5 transparencies; b&w contact sheets and negatives.
Payment & Terms: Pays 50% commission for color or b&w photos. "Top rates in every country." Contracts renewable every year. Statements issued every 2 months. Payment made every 2 months. Photographers allowed to review account records. Offers one-time rights. Informs photographers and permits them to negotiate when a client requests to buy all rights. Model release preferred. Captions required.
Making Contact: SASE.
Tips: Prefers to see "lively, colorful (features) series which tell a story and individual portraits of up-and-coming world personalities. Exhibit photographic excellence and originality in every field. We specialize in worldwide syndication of news stories, human interest features, show business personalities 'at home' and general portraits of celebrities. Good accompanying text and/or interviews are an advantage. Remember that subjects which seem old-hat and clichéd in America may have considerable appeal overseas. Try to look at the U.S. with an outsider's eye."

■**CAMERIQUE INC. INTERNATIONAL**, Main office: Dept. PM, 1701 Skippack Pike, P.O. Box 175, Blue Bell PA 19422. (610)272-4000. Fax: (610)272-7651. Representatives in Boston, Los Angeles, Chicago, New York City, Montreal, Sarasota, Florida and Tokyo. Photo Director: Christopher C. Johnson. Estab. 1973. Has 1 million photos. Clients include: advertising agencies, public relations firms, audiovisual firms, businesses, book/encyclopedia publishers, magazine publishers, newspapers, postcard companies, calendar companies, greeting card companies.
 • Don't miss the listing in this section for American Stock Photography, which is a subsidiary of Camerique.
Needs: General stock photos, all categories. Emphasizes people activities all seasons. Always need large format color scenics from all over the world. No fashion shots. All people shots, including celebrities, must have releases.
Specs: Uses 35mm, 2¼, 4×5 transparencies; b&w contact sheets; b&w negatives; "35mm accepted if of unusual interest or outstanding quality."
Payment & Terms: Sometimes buys photos outright; pays $10-25/photo. Also pays 50-60% commission on b&w/color after sub-agent commissions. General price range (for clients): $300-500. Works on contract basis only. Offers nonexclusive contracts. Contracts are valid "indefinitely until canceled in writing." Charges 50% of cost of catalog insertion fee; for advertising, CD and online services. Statements issued monthly. Payment made monthly; within 10 days of end of month. Photographers allowed to review account records. Offers one-time rights, electronic media and multi-rights. Informs photographer and allows him to negotiate when client requests all rights. Model/property release required for people, houses, pets. Captions required; include "date, place, technical detail and any descriptive information that would help to market photos."
Making Contact: Query with list of stock photo subjects. Send unsolicited photos by mail for consideration. "Send letter first, we'll send our questionnaire and spec sheet." SASE. Reports in 2 weeks. "You must include correct return postage for your material to be returned." Tips sheet distributed periodically to established contributors.
Tips: Prefers to see "well-selected, edited color on a variety of subjects. Well-composed, well-lighted shots, featuring contemporary styles and clothes. Be creative, selective, professional and loyal. Communicate openly and often."

*❊**CANADA IN STOCK INC.**, 109 Vanderhoof Ave., Suite 214, Toronto, Ontario M4G 2H7 **Canada**. (416)425-8215. Fax: (416)425-6966. E-mail: 102223.2016. Director: Ottmar Bierwagen.

Estab. 1994. Stock photo agency. Member of the Picture Agency Council of America (PACA). Has 125,000 photos. Clients include: ad agencies, public relations firms, businesses, book/encyclopedia publishers, magazine publishers, calendar companies, government and graphic designers.

Needs: Photos of people, industry, Canada, Europe, Asia, sports and wildlife. "Our needs are model-released people, lifestyles and medical."

Specs: Uses 35mm, 2¼×2¼, 4×5, 8×10 transparencies.

Payment & Terms: Pays 50% commission on color photos. Average price per image (to clients): $400/color photo. Enforces minimum prices. Offers volume discounts to customers; inquire about specific terms. Photographers can choose not to sell images on discount terms. Works on contract basis only. Offers exclusive or limited regional exclusivity contracts. Contracts renew automatically with additional submissions. Charges 50% duping and catalog insertion fees. Statements issued quarterly. Payment made quarterly. Photographers allowed to review account records. Offers one-time rights; exclusivity and/or buyouts negotiated. "We negotiate with client, but photographer is made aware of the process." Model release required; property release preferred. Captions required; include location, detail, model release, copyright symbol and name (no date).

Making Contact: Interested in receiving work from newer, lesser-known photographers. Query with samples. Query with stock photo list. Works with local freelancers on assignment only. Samples kept on file. SASE. Expects minimum initial submission of 3-500 images with 300 more annually. Reports in 3 weeks. Photo guidelines free with SASE. Catalog free with SASE. Market tips sheet distributed monthly via fax to contracted photographers.

Tips: "Ask hard questions and expect hard answers. Examine a contract in detail. Accepting work is becoming more difficult with generalists; specialty niche photographers have a better chance."

CATHOLIC NEWS SERVICE, 3211 Fourth St. NE, Washington DC 20017-1100. (202)541-3251. E-mail: catholicnews@plink.geis.com. Photos/Graphics Manager: Nancy Wiechec. Photos/Graphics Researcher: Bob Roller. Wire service transmitting news, features and photos to Catholic newspapers and stock to Catholic publications.

Needs: News or feature material related to the Catholic Church or Catholics; head shots of Catholic newsmakers; close-up shots of news events, religious activities. Also interested in photos aimed toward a general family audience and photos depicting modern lifestyles, e.g., family life, human interest, teens, poverty, active senior citizens, families in conflict, unusual ministries, seasonal and humor.

Specs: Uses 8×10 glossy prints.

Payment & Terms: Pays $35/photo; $75-200/job. Charges 50% on stock sales. Statements never issued. Payment made monthly. Offers one-time rights. Informs photographer and allows him to negotiate when client requests all rights. Model/property release preferred. Captions preferred; include who, what, when, where, why.

Making Contact: Send material by mail for consideration. SASE.

Tips: Submit 10-20 good quality prints covering a variety of subjects. Some prints should have relevance to a religious audience. "Knowledge of Catholic religion and issues is helpful. Read a Diocesan newspaper for ideas of the kind of photos used. Photos should be up-to-date and appeal to a general family audience. No flowers, no scenics, no animals. As we use more than 1,000 photos a year, chances for frequent sales are good. Send only your best photos."

‡CEPHAS PICTURE LIBRARY, 20 Bedster Gardens, West Molesey, Surrey KT8 1SZ United Kingdom. (0181)979-8647. Fax: (0181)224-8095. Director: Mick Rock. Picture library. Has 80,000 photos. Clients include: ad agencies, public relations firms, businesses, book/encyclopedia publishers, magazine publishers, postcard companies and calendar companies.

Needs: "We are a general picture library covering all aspects of all countries. Wine industry, food and drink are major specialties."

Specs: Prefers 2¼×2¼ transparencies, 35mm accepted.

Payment & Terms: Pays 50% commission for color photos. General price range: £50-500 (English currency). Works on contract basis only. Offers global representation. Contracts renew automatically after 3 years. Photographers allowed to review account records. Statements issued quarterly with payments. Offers one-time rights. Informs photographers and permits them to negotiate when a client requests to buy all rights. Model release preferred. Captions required.

Making Contact: Send best 40 photos by mail for consideration. SASE. Reports in 1 week. Photo guidelines for SASE.

Tips: Looks for "transparencies in white card mounts with informative captions and names on front of mounts. Only top-quality, eye-catching transparencies required."

 THE MAPLE LEAF before a listing indicates that the market is Canadian.

***■CHARLTON PHOTOS, INC.**, 11518 N. Port Washington Rd., Mequon WI 53092. (414)241-8634. Fax: (414)241-4612. E-mail: charlton@mail.execpc.com. Director of Research: Karen Kirsch. Estab. 1981. Stock photo agency. Has 475,000 photos; 200 hours film. Clients include: ad agencies, public relations firms, audiovisual firms, businesses, book/encyclopedia publishers, magazine publishers, newspapers and calendar companies.
Needs: "We handle photos of agriculture, senior citizens, environment, scenics, people and pets."
Specs: Uses b&w prints and color photos; 35mm, 2¼×2¼, 4×5 transparencies.
Payment & Terms: Pays 50% on b&w and color photos and videotape. Average price per image (to clients): $500-650/color photo; $500-750/videotape. Offers volume discounts to customers; terms specified in photographer's contract. Works on contract basis only. Prefers exclusive contract, but negotiable based on subject matter submitted. Contracts renew automatically with additional submissons for 2 years minimum. Charges duping fee, 50% catalog insertion fee and materials fee. Statements issued monthly. Payment made monthly. Photographers allowed to review account records which relate to their work. Offers one-time rights. Informs photographer and allows him to negotiate when client requests all rights. Model/property release required for identifiable people and places. Captions required; include who, what, when, where.
Making Contact: Interested in receiving work from newer, lesser-known photographers. Query by phone before sending any material. SASE. No minimum number of images expected in initial submission. Reports in 1-2 weeks. Photo guidelines free with SASE. Market tips sheet distributed quarterly to contract freelance photographers; free wtih SASE.
Tips: "Provide our agency with images we request by shooting a self-directed assignment each month."

CHINASTOCK PHOTO LIBRARY, 22111 Cleveland, #211, Dearborn MI 48124-3461. Phone/fax: (313)561-1842 or (800)315-4462. Director: Dennis Cox. Estab. 1993. Stock photo agency. Has 20,000 photos. Has branch office in Beijing and Shanghai, China. Clients include: advertising agencies, public relations firms, book/encyclopedia publishers, magazine publishers, newspapers, calendar companies.
Needs: Only handles photos of China (including Hong Kong and Taiwan) including tourism, business, historical, cultural relics, etc. Needs hard-to-locate photos of all but tourism and exceptional images of tourism subjects.
Specs: Uses 5×7 to 8×10 glossy b&w prints; 35mm, 2¼×2¼ transparencies. Pays 50% commission on b&w and color photos. Occasionally negotiates fees below standard minimum prices. "Prices are based on usage and take into consideration budget of client." Offers volume discounts to customers. Photographers can choose not to sell images on discount terms. Works with or without a signed contract. "Will negotiate contract to fit photographer's and agency's mutual needs." Photographers are paid quarterly. Photographers allowed to review account records. Offers one-time rights and electronic media rights. Informs photographer and allows him to negotiate when client requests all rights. Model/property release preferred. Captions required; include where image was shot and what is taking place.
Making Contact: Query with stock photo list. "Let me know if you have unusual material." Keeps samples on file. SASE. Agency is willing to accept 1 great photo and has no minimum submission requirements. Reports in 1-2 weeks. Market tips sheet available upon request.
Tips: Agency "represents mostly veteran Chinese photographers and some special coverage by Americans. We're not interested in usual photos of major tourist sites. We have most of those covered. We need more photos of festivals, modern family life, joint ventures, and all aspects of Taiwan."

■BRUCE COLEMAN PHOTO LIBRARY, 117 E. 24th St., New York NY 10010. (212)979-6252. Fax: (212)979-5468. Photo Director: Linda Waldman. Estab. 1970. Stock photo agency. Member of Picture Agency Council of America (PACA). Has 1 million photos. Clients include: advertising agencies, public relations firms, audiovisual firms, businesses, book/encyclopedia publishers, magazine publishers, newspapers, postcard publishers, calendar companies, greeting card companies, zoos (installations), TV.
Needs: Nature, travel, science, people, industry.
Specs: Uses 35mm, 2¼×2¼, 4×5 color transparencies.
Payment & Terms: Pays 50% commission on color film. Average price per image (to clients): color $175-975. Works on exclusive contract basis only. Contracts renew automatically for 5 years. Statements issued quarterly. Payment made quarterly. Does not allow photographer to review account records; any deductions are itemized. Offers one-time rights. Model/property release preferred for people, private property. Captions required; location, species, genus name, Latin name, points of interest.
Making Contact: Query with résumé of credits. SASE. Expects minimum initial submission of 300 images with annual submission of 2,000. Reports in 3 months on completed submission; 1 week acknowledgement. Photo guidelines free with SASE. Catalog available. Want lists distributed to all active photographers monthly.

Tips: "We look for strong dramatic angles, beautiful light, sharpness. No gimmicks (prism, color, starburst filters, etc.). We like photos that express moods/feelings and show us a unique eye/style. We like work to be properly captioned. Caption labels should be typed or computer generated and they should contain all vital information regarding the photograph." Sees a trend "toward a journalistic style of stock photos. We are asked for natural settings, dramatic use of light and/or angles. Photographs should not be contrived and should express strong feelings toward the subject. We advise photographers to shoot a lot of film, photograph what they really love and follow our want lists."

‡COLORIFIC PHOTO LIBRARY, The Innovation Centre, 225 Marsh Wall, London E14 9FX England. (071)515-3000. Fax: (071)538-3555. Editorial Director: Christopher Angeloglou. Estab. 1970. Picture library, news/feature syndicate. Has 300,000 photos. Clients include: ad agencies, public relations firms, audiovisual firms, book/encyclopedia publishers, magazine publishers, newspapers, calendar companies.
Specs: Uses 35mm, 2¼×2¼ transparencies.
Payment & Terms: Pays 50% commission on color photos. Average price per image (to clients): $150-350/color photo. Enforces minimum prices. "Prices vary according to type of market." Photographers have option of not allowing their work to be discounted. Works with or without contract. Offers limited regional exclusivity and nonexclusive contracts. Contracts renew automatically with additional submissions every 3-5 years. Statements issued quarterly. Payment made quarterly. Offers one-time rights. Informs photographer and allows him to negotiate when client requests all rights. Model/property release preferred. Captions required.
Making Contact: Query with résumé of credits. SASE. Expects minimum initial submission of 250 images. Review held after first submission received. Reports as needed. Photo guidelines free with SASE (IRCs).

COMPIX PHOTO AGENCY, 3621 NE Miami Court, Miami FL 33137. (305)576-0102. Fax: (305)576-0064. President: Alan J. Oxley. Estab. 1986. News/feature syndicate. Has 1 million photos. Clients include: advertising agencies, public relations firms, book/encyclopedia publishers, magazine publishers and newspapers.
Needs: Wants news photos and news/feature picture stories, human interest, celebrities and stunts.
Specs: Uses 35mm, 2¼×2¼, 4×5, 8×10 transparencies.
Payment & Terms: Pays 50% commission. Price per image (to clients) $175 and up. Will sometimes negotiate fees below standard minimum, "if client is buying a large layout." Works with or without contract. Statements issued monthly. Payment made monthly. Photographers allowed to review account records "if showing those records does not violate privacy of other photographers." Offers one-time or negotiated rights based on story, quality and exclusivity. Photographer will be consulted when client wants all rights, but agency does negotiating. Photo captions required; include basic journalistic info.
Making Contact: "Show us some tearsheets."
Tips: "This is an agency for the true picture journalist, not the ordinary photographer. We are an international news service which supplies material to major magazines and newspapers in 30 countries and we shoot hard news, feature stories, celebrity, royalty, stunts, animals and things bizarre. We offer guidance, ideas and assignments but work *only* with experienced, aggressive photojournalists who have good technical skills and can generate at least some of their own material."

*‡DAS PHOTO, Domaine de Bellevue, 181, Septon 6940 Belgium. Phone/fax: +32-86-322426. Director: David Simson. Stock photo agency. Has 50,000 photos. Clients include: ad agencies, public relations firms, audiovisual firms, book/encyclopedia publishers, magazine publishers, calendar companies and greeting card companies. Previous/current clients include: Stern and Oggi, Oxford University Press; *Vogue*; Geographical Magazine; Spectator; Guardian; BBC; *Penthouse* and Times.
Needs: Handles "mainly reportage—suitable for publishers and magazines although we do deal with most subjects. We are specialists in selling photo material in all European countries."
Specs: Uses 8×10 glossy b&w prints; 35mm, 2¼×2¼, 4×5 and 8×10 transparencies.
Payment & Terms: Pays 50% commission. Pays $40-500/b&w photo; $60-1,000/color photo; $350/day plus expenses. Works on contract basis only. Offers limited regional exclusivity contract (normally European countries) and nonexclusive contract (worldwide). Guarantees subject exclusivity within files. Contracts renew automatically for 5 years with additional submissions. Charges duping fee of $5/image. Statements issued quarterly. Payment made quarterly, when sales are made. Photographers allowed to review account records to verify sales figures. Offers one-time, electronic media and agency promotion rights; exclusive rights only after consulting photographer. Informs photographers and allows them to negotiate when a client requests all rights. Model release required. Photo captions required; include description of location, country and subject matter.
Making Contact: Interested in receiving work from newer, lesser-known photographers. Query with samples. Send unsolicited photos by mail for consideration. SASE. Reports in 1 week. Photo guideline sheet and tips sheet free with SASE.

Tips: "We take a large variety of material but it has to be saleable, sharp and good color saturation. Send 100-500 good saleable images for selection."

***‡JAMES DAVIS TRAVEL PHOTOGRAPHY**, 65 Brighton Rd., Shoreham, Sussex BN43 6RE England. (+44)1273-452252. Fax: (+44)1273-440116. Contact: Paul Seheult. Estab. 1975. Travel picture library. Has 200,000 photos. Clients include: ad agencies, public relations firms, businesses, book/encyclopedia publishers, magazine publishers, newspapers, calendar companies, greeting card companies and postcard publishers.
Needs: Photos of worldwide travel.
Specs: Uses 2¼×2¼, 4×5 transparencies; Fuji and Kodak film.
Payment & Terms: Pays 50% commission. Offers volume discounts to customers; inquire about specific terms. Discount sales terms not negotiable. Works on contract basis only. Offers exclusive, limited regional exclusivity and nonexclusive contracts. Contracts renew automatically with additional submissions. Charges to photographer negotiable. Statements issued "if there have been sales." Photographers allowed to review account records. Offers one-time, electronic media and agency promotion rights; negotiable. Does not inform photographer or allow him to negotiate when client requests all rights. Model/property release preferred for people. Captions required; include where, what, who, why.
Making Contact: Interested in receiving work from newer, lesser-known photographers. Submit portfolio for review. Works with local freelancers only. Samples kept on file. No minimum number of images expected in initial submission. Reports "when we have time." Photo guidelines free with SASE. Market tips sheet distributed to all contributors "when we can."

■LEO DE WYS INC., 1170 Broadway, New York NY 10001. (212)689-5580. Fax: (212)545-1185. President: Leo De Wys. Office Manager: Laura Diez. Member of Picture Agency Council of America (PACA). Has 1 million photos. Clients include: ad agencies, public relations and AV firms; business; book, magazine and encyclopedia publishers; newspapers, calendar and greeting card companies; textile firms; travel agencies and poster companies.
Needs: Travel and destination (over 2,000 categories); and released people pictures in foreign countries (i.e., Japanese business people, German stockbrokers, English nurses, Mexican dancers, exotic markets in Asia, etc.).
Specs: Uses 35mm, medium format and 4×5 transparencies.
Payment & Terms: Price depends on quality and quantity. Usually pays 50% commission; 33⅓% for foreign sales. General price range (to clients): $125-6,500. Works with photographers on contract basis only. Offers exclusive and limited regional exclusive contracts; prefers to offer exclusive contract. Contracts renew automatically for 3 years. Offers to clients "any rights they want to have; payment is calculated accordingly." Charges 50% catalog insertion fee. "Company advances duping cost and deducts after sale has been made." Statements issued bimonthly and quarterly. Payment made bimonthly and quarterly. Photographers allowed to review account records to verify their sales figures. Offers one-time and electronic media rights. Informs photographers and permits them to negotiate when client requests all rights; some conditions. Model release required; "depends on subject matter." Captions preferred.
Making Contact: Query with samples—"(about 40 pix) is the best way." Query with list of stock photo subjects or submit portfolio for review. SASE. Reporting time depends; often the same day. Photo guidelines free with SASE.
Tips: "Photos should show what the photographer is all about. They should show technical competence—photos that are sharp, well-composed, have impact; if color they should show color. Company now uses bar coded computerized filing system." Seeing trend toward more use of food shots tied in with travel such as "key lime pie for Key West and Bavarian beer for Germany. Also more shots of people—photo-released and in local costumes. Currently, the destinations most in demand are the USA, Canada, Mexico and the Caribbean."

DESIGN CONCEPTIONS, 112 Fourth Ave., New York NY 10003. (212)254-1688. Owner: Elaine Abrams. Picture Agent: Joel Gordon. Estab. 1970. Stock photo agency. Has 500,000 photos. Clients include: book/encyclopedia publishers, magazine publishers, advertising agencies.
Needs: "Real people."
Specs: Uses 8×10 RC b&w prints; 35mm transparencies.
Payment & Terms: Pays 50% commission on b&w and color photos. Average price per image (to clients): $175/b&w; $200/color. Enforces minimum prices. Offers volume discounts to customers; terms specified in photographer's contract. Works with or without contract. Offers limited regional exclusivity, nonexclusive. Statements issued monthly. Payment made monthly. Photographers allowed to review account records. Offers one-time rights. Offers electronic media and agency promotion rights. Informs photographer when client requests all rights. Model/property release preferred. Captions preferred.
Making Contact: Interested in receiving work from newer, lesser-known photographers. Arrange personal interview to show portfolio. Query with samples.

Tips: Looks for "real people doing real, not set up, things."

DEVANEY STOCK PHOTOS, 755 New York Ave., Suite 306, Huntington NY 11743. (516)673-4477. Fax: (516)673-4440. President: William Hagerty. Photo Editors: Carole Boccia and Kathleen Bob. Has over 500,000 photos. Clients include: ad agencies, book publishers, magazines, corporations and newspapers. Previous/current clients: Young & Rubicam, BBD&O, Hallmark Cards, *Parade* Magazine, Harcourt Brace & Co.
Needs: Accidents, animals, education, medical, artists, elderly, scenics, assembly lines—auto and other, entertainers, schools, astronomy, factory, science, automobiles, family groups, aviation, finance, babies, fires, shipping, movies, shopping, flowers, food, beaches, oceans, skylines, foreign, office, birds, sports, gardens, operations, still life, pets, business, graduation, health, police, teenagers, pollution, television, children, history, hobbies, travel, churches, holidays, cities, weddings, communications, houses, women, writing, zoos, computers, housework, recreation, religion, couples, crime, crowds, dams, industry, laboratories, law, lawns, lumbering, restaurants, retirement, romance, etc.—virtually all subjects.
Specs: Uses all sizes of transparencies.
Payment & Terms: Does not buy photos outright. Pays 50% commission on color. Works with photographers with a signed contract. Contracts automatically renew for a 3-year period. Offers nonexclusive contract. Statements issued upon sale. Payment made monthly. Offers one-time rights. Model release preferred. Captions required.
Making Contact: Interested in receiving work from newer, lesser-known photographers. Query with list of stock photo subjects or send material by mail for consideration. SASE. Reports in 1 month. Free photo guidelines with SASE. Distributes monthly tips sheet free to any photographer. Model/property release preferred. Captions required. "Releases from individuals and homeowners are most always required if photos are used in advertisements."
Tips: "An original submission of 200 original transparencies in vinyl sheets is required. We will coach."

‡DIANA PHOTO PRESS, Box 6266, S-102 34 Stockholm Sweden. (46)8 314428. Fax: (46)8 314401. Manager: Diana Schwarcz. Estab. 1973. Clients include: magazine publishers and newspapers.
Needs: Personalities and portraits of well-known people.
Specs: Uses 18×24 b&w prints; 35mm transparencies.
Payment & Terms: Pays 30% commission on b&w and color photos. Average price per image (to clients): $150/b&w and color image. Enforces minimum prices. Works on contract basis only. Statements issued monthly. Payment made in 2 months. Offers one-time rights. Informs photographer and allows him to negotiate when client requests all rights. Captions required.
Making Contact: Query with samples. Samples kept on file. SASE. Does not report; "Wait for sales report."

***DIGITAL STOCK CORP.,** 400 S. Sierra Ave., Suite 100, Solana Beach CA 92075. (619)794-4040, (800)545-4514. Fax: (619)794-4041. President: Charles Smith. Specializes in royalty-free stock on CD-ROM. Has 5,000 photos. Clients include ad agencies, businesses, magazine publishers and newspapers.
Needs: Lifestyle, business and industry, technology and sports shots.
Specs: Uses transparencies.
Payment & Terms: Pays 20% commission on gross price of discs. Offers volume discounts to customers; inquire about specific terms. Discount sales terms not negotiable. Works on contract basis only. Offers nonexclusive contract. Statements issued quarterly. Payment made quarterly. Photographers allowed to review account records. Offers print and multimedia rights; no product for resale. Does not inform photographer or allow him to negotiate when client requests all rights. Model release required. Captions required.
Making Contact: Interested in receiving work from newer, lesser-known photographers. Submit portfolio for review. Samples kept on file. SASE. Expects minimum of at least 400-10,000 images. Reports in 1-2 weeks. Photo guidelines free with SASE. Markets tips sheet distributed; free upon request.
Tips: "All our images are marketed via CD-ROM and royalty-free. We have the highest quality work in this arena."

 THE ASTERISK before a listing indicates that the market is new in this edition. New markets are often the most receptive to freelance submissions.

■‡**DINODIA PICTURE AGENCY**, 13 Vithoba Lane, Vithalwadi, Kalbadevi, Bombay India 400 002. (91)22-2018572. Fax: (91)22-2067675. Owner: Jagdish Agarwal. Estab. 1987. Stock photo agency. Has 300,000 photos. Clients include: advertising agencies, public relations firms, audiovisual firms, businesses, book/encyclopedia publishers, magazine publishers, newspapers, postcard companies, calendar companies and greeting card companies.
Needs: "We specialize in photos on India—people and places, fairs and festivals, scenic and sports, animals and agriculture."
Specs: Uses 35mm, 2¼×2¼ and 4×5 transparencies.
Payment & Terms: Pays 50% commission on b&w and color photos. General price range (to clients): US $100-600. Negotiate fees below stated minimum prices. Offers volume discounts to customers; inquire about specific terms. Discount sales terms not negotiable. Works on contract basis only. Offers limited regional exclusivity. "Prefers exclusive for India." Contracts renew automatically with additional submissions for 5 years. Statement issued monthly. Payment made monthly. Photographers permitted to review sales figures. Informs photographer and allows him to negotiate when client requests all rights. Offers one-time rights. Model release preferred. Captions required.
Making Contact: Interested in receiving work from newer, lesser-known photographers. Query with résumé of credits, samples and list of stock photo subjects. SASE. Reports in 1 month. Photo guidelines free with SASE. Market tips sheet distributed monthly to contracted photographers.
Tips: "We look for style, maybe in color, composition, mood, subject-matter; whatever, but the photos should have above-average appeal." Sees trend that "market is saturated with standard documentary-type photos. Buyers are looking more often for stock that appears to have been shot on assignment."

■**DRK PHOTO**, 265 Verde Valley School Rd., Sedona AZ 86351. (520)284-9808. Fax: (520)284-9096. President: Daniel R. Krasemann. "We handle only the personal best of a select few photographers—not hundreds. This allows us to do a better job aggressively marketing the work of these photographers." Member of Picture Agency Council of America (PACA) and A.S.P.P. Clients include: ad agencies; PR and AV firms; businesses; book, magazine, textbook and encyclopedia publishers; newspapers; postcard, calendar and greeting card companies; branches of the government, and nearly every facet of the publishing industry, both domestic and foreign.
Needs: "Especially need marine and underwater coverage." Also interested in S.E.M.'s, African, European and Far East wildlife, and good rainforest coverage.
Specs: Uses 35mm, 2¼×2¼ and 4×5 transparencies.
Payment & Terms: Pays 50% commission on color photos. General price range (to clients): $100 "into thousands." Works on contract basis only. Offers nonexclusive contracts. Contracts renew automatically. Statements issued quarterly. Payment made quarterly. Offers one-time rights; "other rights negotiable between agency/photographer and client." Model release preferred. Captions required.
Making Contact: "With the exception of established professional photographers shooting enough volume to support an agency relationship, we are not soliciting open submissions at this time. Those professionals wishing to contact us in regards to representation should query with a brief letter of introduction and tearsheets."

***EARTH IMAGES**, P.O. Box 10352, Bainbridge Island WA 98110. (206)842-7793. Managing Director: Terry Domico. Estab. 1977. Picture library specializing in worldwide outdoor and nature photography. Member of the Picture Agency Council of America (PACA). Has 150,000 photos; 2,000 feet of film. Has 2 branch offices; contact above address for locations. Clients include: ad agencies, public relations firms, audiovisual firms, businesses, book/encyclopedia publishers, magazine publishers, newspapers, calendar companies, greeting card companies, postcard publishers and overseas news agencies.
Needs: Natural history and outdoor photography (from micro to macro and worldwide to space); plant and animal life histories, natural phenomena, conservation projects and natural science.
Specs: Uses 35mm, 4×5 transparencies.
Payment & Terms: Pays 50% commission. Enforces minimum prices. Offers volume discounts to customers. Works on contract basis only. Offers nonexclusive contract. Contracts renew automatically with additional submissions. Buys one-time and electronic media rights. Model release preferred. Captions required; include species, place, pertinent data.
Making Contact: Interested in receiving work from newer, lesser-known photographers. Query with resume of credits. "Do not call for first contact." Samples kept on file. SASE. Expects minimum initial submission of 100 images. "Captions must be on mount." Reports in 3-6 weeks. Photo guidelines free with SASE.
Tips: "Sending us 500 photos and sitting back for the money to roll in is poor strategy. Submissions must be continuing over years for agencies to be most effective. Specialties sell better than general photo work. Animal behavior sells better than portraits. Environmental (such as illustrating the effects of acid rain) sells better than pretty scenics. 'Nature' per se is not a specialty; macro and underwater photography are."

■**EARTHVIEWS, A Subsidiary of the Marine Mammal Fund**, Fort Mason Center, E205, San Francisco CA 94123. (415)775-0124. Fax: (415)921-1302. Librarian: Marilyn Delgado. Estab. 1971. Nonprofit stock photo agency. Has 8,000 photos. Clients include: advertising agencies, book/encyclopedia publishers, magazine publishers, newspapers, postcard publishers, calendar companies, exhibits and advocacy groups.
Needs: Wildlife (no captive animals) with emphasis on marine mammals.
Specs: Uses 35mm, 2¼×2¼, 4×5 transparencies; 16mm, 35mm film, Betacam SP, Hi-8, S-VHS videotape.
Payment & Terms: Pays 50% commission. Offers nonexclusive contract. Statements issued upon request. Payment made semiannually. Offers one-time rights. Informs photographer and allows him to negotiate when client requests all rights. Captions required; include species, location.
Making Contact & Terms: Interested in receiving work from newer, lesser-known photographers. Query with samples. Does not keep samples on file. SASE. Expects minimum initial submission of 20 images. Reports in 1-2 weeks.
Tips: "We do not hold originals. EarthViews will produce repro-quality duplicates and return all originals to the photographer. Contact us for more information."

*■**ECLIPSE AND SUNS**, 316 Main St., Box 669, Haines AK 99827-0669. (907)766-2670. Call for fax number. President and CEO: Erich von Stauffenberg. Estab. 1973. Photography, video and film archive. Has 1.3 million photos, 8,000 hours film. Clients include: advertising agencies, public relations firms, audiovisual firms, businesses, book/encyclopedia publishers, magazine publishers, calendar companies, greeting card companies, postcard publishers, film/television production companies and studios.
Needs: Uses 35mm, transparencies; 8mm Super 8, 16 mm, 35mm film; Hi8, ¾ SP, Beta SP videotape.
Payment & Terms: Buys photos/film outright. Pays $25-500/color photo; $25-500/b&w photo; $50-1,000/minute film; $50-1,000/minute videotape. Negotiates individual contracts. Works on contract basis only. Offers exclusive contract. Charges 25% filing fee and 5% duping fee. Statements issued when work is requested, sent, returned, paid for. Payment made immediately after client check clears. Photographers allowed to review account records. Offers negotiable rights, "determined by photographer in contract with us." Informs photographers and allows him to negotiate when client requests all rights. "We encourage our photographers to never sell all rights to images." Model/property release required for all recognizable persons, real and personal property, pets. Captions required; include who, what, where, why, when; camera model, lens F/stop, shutter speed, film ASA/ISO rating.
Making Contact: Interested in hearing from newer, lesser-known photographers. Query with résumé of credits. Query with stock photo list. Samples kept on file. SASE. Expects minimum initial submission of 25-50 images; 30-minute reel. Reports in 3 weeks; foreign submissions at rate of mail transit. Photo guidelines available for $5 US funds. Catalog available (on CD-ROM) for $29.95. Market tips sheet distributed quarterly; $5 US.
Tips: Uses Adobe Photo Shop, Kodak CD-ROMs, Nikon Scanner; multimedia authoring, Sanyo CD-ROM Recording Drives and Digital Workstation. "We only provide low res watermarked (with photographer's copyright) materials to clients for comps and pasteups. Images are sufficiently degraded, that no duplication is possible; any enlargement is totally pexil expanded to render it useless. Video footage is similarily degraded to avert copying or unauthorized use. Film footage is mastered on SP Beta returned to photo and degraded to an uncopyable condition for demo reels. We are currently seeking photographers from China, Japan, Korea, Southeast Asia, Europe, Middle East, Central and South America and Australia. Photos must be bracketed by ½ stops over and under each image, must be razor sharp, proper saturation, density with highlight detail and shadow detail clearly visible. We will accept duplicates for portfolio review only. Selected images for deposit must be originals with brackets, ½ stop plus and minus. All images submitted for final acceptance and deposit must be copyrighted by photographer prior to our marketing works for sale or submissions."

*‡**ECOSCENE**, The Oasts, Headley Lane, Passfield, Liphook, Hants AV30 7RX United Kingdom. (144)1428 751056. Fax: (144)1428 751057. E-mail: 100260.2443@compuserve.com. Owner: Sally Morgan. Estab. 1988. Stock photo agency and picture library. Has 80,000 photos. Clients include: audiovisual firms, book/encyclopedia publishers, magazine publishers, newspapers and multimedia.
Needs: Ecology, environment, pollution, habitats, conservation, energy, transport, polar habitats, agricultural, industrial, clean-up operations and any environmental topics in the news, especially ecological disasters.
Specs: Uses 35mm, 2¼×2¼, 4×5 transparencies.
Payment & Terms: Pays 55% commission on color photos. Average price per image (to clients): $100-300/color photo. Negotiates fees below stated minimum prices, depending on quantity reproduced by a single client. Offers volume discounts to customers; terms specified in photographer's contract. Discount sales terms not negotiable. Works on contract basis only. Offers nonexclusive contract. Statements issued quarterly. Payment made quarterly. Offers one-time and electronic media rights. Informs photographer and allows him to negotiate when client requests all rights. Model/property release

preferred. Captions required; include common and Latin names of wildlife and as much detail as possible.
Making Contact: Interested in receiving work from newer, lesser-known photographers. Query with résumé of credits. Samples kept on file. SASE. Expects initial submission of at least 100 images with submission of at least 50 images 2 times a year. Reports in 1-2 weeks. Photo guidelines free with SASE. Catalog available. Market tips sheet distributed quarterly to anybody who requests and to all contributors.

***ELLIS NATURE PHOTOGRAPHY**, 4045-A N. Massachusetts Ave., Portland OR 97227. (503)287-4179. Fax: (503)287-5087. E-mail: ellisnp@aol.com. Contact: Karen Kane. Estab. 1991. Stock photo agency. Has 250,000 photos. Clients include: ad agencies, design firms, businesses, book/encyclopedia publishers, magazine publishers, calendar companies, greeting card companies and postcard publishers.
Needs: Anything nature-related, especially wildlife, the environment and landscapes.
Specs: Uses 35mm, 2¼ × 2¼, 4 × 5, 8 × 10 transparencies.
Payment & Terms: Pays 50% commission on b&w and color photos. Enforces minimum prices. Offers volume discounts to customer; inquire about specific terms. Photographers can choose not to sell images on discount terms. Works on contract basis only. Offers guaranteed subject exclusivity contracts. Contracts renew automatically with additional submissions after 1 year. Statements issued monthly. Payments made monthly. Photographers allowed to review account records. Offers negotiable rights. Informs photographer and allows him to negotiate when client requests all rights. Model release required. Captions required.
Making Contact: Interested in receiving work from newer, lesser-known photographers. Arrange personal interview to show portfolio. Samples kept on file. SASE. Expects minimum initial submission of 200 images. Reports in 3 weeks. Market tips sheet distributed quarterly to contracted photographers upon request.

***‡■ENVIRONMENTAL INVESTIGATION AGENCY**, 15 Bowling Green Lane, London EC1 ROB1 England. (71)490-7040. Fax: (71)490-0436. E-mail: daniel@gr.apc.org. Communications Manager: Ben Rogers. Estab. 1986. Conservation organization with picture and film library. Has 5,000 photos, 13,000 hours film. Clients include: book/encyclopedia publishers, magazine publishers and newspapers.
Needs: Photos about conservation of animals and the environment; trade in endangered species and endangered wildlife; and habitat destruction.
Specs: Uses 7 × 5 color prints; 35mm transparencies; HI-8 or 16mm film; BetaSP HI-8 videotape.
Payment & Terms: Average price per image (to clients): $100/b&w photo; $200/color photo; $800/videotape. Negotiates fees below standard minimum prices. Offers volume discounts to customers; terms specified in photographer's contract. Photographers can choose not to sell images on discount terms. Offers one-time rights; will "negotiate on occasions in perpetuity or 5-year contract." Does not inform photographer or allow him to negotiate when client requests all rights. Captions required; include "full credit and detail of investigation/campaign where possible."
Making Contact: Interested in receiving work from newer, lesser-known photographers. Query with samples. Query with stock photo list. Works with local freelancers only. Samples kept on file. SASE. Expects minimum initial submission of 10 images with periodic submission of additional images. Reports in 1-2 weeks.

***‡THE ENVIRONMENTAL PICTURE LIBRARY LTD.**, 5 Baker's Row, London EC1R 3DB England. (171)833-1355. Fax: (171)833-1383. Manager: Liz Somerville. Estab. 1989. Picture library. Has 50-60,000 photos. Clients include: ad agencies, public relations firms, audiovisual firms, businesses, book/encyclopedia publishers, magazine publishers and newspapers.
Needs: Photos focusing on general environmental issues worldwide.
Specs: Uses 10 × 8 b&w prints; 35mm, 2¼ × 2¼, 4 × 5 transparencies.
Payment & Terms: NPI. Enforces minimum prices. Offers volume discounts to customers; terms specified in photographer's contract. Discount sales terms not negotiable. Works on contract basis only. Statements issued quarterly. Payment made quarterly. Buys one-time rights. Does not inform photographer or allow him to negotiate when client requests all rights. Captions required; include date and location.
Making Contact: Interested in receiving work from newer, lesser-known photographers. Submit portfolio for review. Samples kept on file. SASE. Expects minimum initial submission of 100 images. Reports in 1-2 weeks. Catalog free with SASE. Market tips sheet distributed quarterly upon request to photographers under contract.

■ENVISION, 220 W. 19th St., New York NY 10011. (212)243-0415. Director: Sue Pashko. Estab. 1987. Stock photo agency. Member of the Picture Agency Council of America (PACA). Has 150,000 photos. Clients include: advertising agencies, public relations firms, businesses, book/encyclopedia

publishers, magazine publishers, newspapers, calendar and greeting card companies and graphic design firms.

Needs: Professional quality photos of food, commercial food processing, fine dining, American cities (especially the Midwest), crops, Third World lifestyles, marine mammals, European landmarks, tourists in Europe and Europe in winter looking lovely with snow, and anything on Africa and African-Americans.

Specs: Uses 35mm, 2¼×2¼, 4×5 or 8×10 transparencies. "We prefer large and medium formats."

Payment & Terms: Pays 50% commission on b&w and color photos. General price range (to clients): $200 and up. Works on contract basis only. Statements issued monthly. Payment made monthly. Offers one-time rights; "each sale individually negotiated—usually one-time rights." Model/property release required. Captions required.

Making Contact: Arrange personal interview to show portfolio. Query with résumé of credits "on company/professional stationery." Regular submissions are mandatory. SASE. Reports in 1 month.

Tips: "Clients expect the very best in professional quality material. Photos that are unique, taken with a very individual style. Demands for traditional subjects *but* with a different point of view; African- and Hispanic-American lifestyle photos are in great demand. We have a need for model-released, professional quality photos of people with food—eating, cooking, growing, processing, etc."

■**EWING GALLOWAY**, 100 Merrick Rd., Rockville Centre NY 11570. (516)764-8620. Fax: (516)764-1196. Photo Editor: Tom McGeough. Estab. 1920. Stock photo agency. Member of Picture Agency Council of America (PACA), American Society of Media Photographers (ASMP). Has 3 million photos. Clients include: advertising agencies, public relations firms, audiovisual firms, businesses, book/encyclopedia publishers, magazine publishers, newspapers, postcard companies, calendar companies, greeting card companies and religious organizations.

• This agency is a charter member of the Kodak Picture Exchange, with more than 10,000 digital images online.

Needs: General subject library. Does not carry personalities or news items. Lifestyle shots (model released) are most in demand.

Specs: Uses 8×10 glossy b&w prints; 35mm, 2¼×2¼ and 4×5 transparencies.

Payment & Terms: Pays 30% commission on b&w photos; 50% on color photos. General price range: $400-450. Charges catalog insertion fee of $400/photo. Statements issued monthly. Payment made monthly. Offers one-time rights; also unlimited rights for specific media. Model/property release required. Photo captions required; include location, specific industry, etc.

Making Contact: Interested in receiving work from newer, lesser-known photographers. Query with samples. Send unsolicited photos by mail for consideration; **must include return postage**. SASE. Reports in 3 weeks. Photo guidelines with SASE (55¢). Market tips sheet distributed monthly; SASE (55¢).

Tips: Wants to see "high quality—sharpness, subjects released, shot only on best days—bright sky and clouds. Medical and educational material is currently in demand. We see a trend toward photography related to health and fitness, high-tech industry, and mixed race in business and leisure."

*‡**EYE UBIQUITOUS**, 65 Brighton Rd., Shoreham, Sussex BN43 6RE England. (+44)1273-440113. Fax: (+44)1273-440116. Owner: Paul Seheult. Estab. 1988. Picture library. Has 300,000 photos. Clients include: ad agencies, public relations firms, businesses, book/encyclopedia publishers, magazine publishers, newspapers and television companies.

Needs: Worldwide social documentary and general stock.

Specs: Uses 35mm, 2¼×2¼, 4×5 transparencies; Fuji and Kodak film.

Payment & Terms: Charges 50% commission. Offers volume discounts to customers; inquire about specific terms. Discount sales terms not negotiable. Works on contract basis only. Offers exclusive, limited regional exclusivity and nonexclusive contracts. Contracts renew automatically with additional submissions. Charges to photographers "discussed on an individual basis." Payment made quarterly. Photographers allowed to review account records. Buys one-time, electronic media and agency promotion rights; negotiable. Does not inform photographer or allow him to negotiate when client requests all rights. Model/property release preferred for people, "particularly Americans." Captions required: include where, what, why, who.

Making Contact: Interested in receiving work from newer, lesser-known photographers. Submit portfolio for review. Works with local freelancers only. Samples kept on file. SASE. No minimum

THE SOLID, BLACK SQUARE before a listing indicates that the market uses various types of audiovisual materials, such as slides, film or videotape.

number of images expected in initial submission but "the more the better." Reports as time allows. Photo guidelines free with SASE. Catalog free with SASE. Market tips sheet distributed to contributors "when we can"; free with SASE.

Tips: "Find out how picture libraries operate. This is the same for all libraries worldwide. Amateurs can be very good photographers but very bad at understanding the industry after reading some irresponsible and misleading articles. Research the library requirements."

■**FINE PRESS SYNDICATE**, Box 22323, Ft. Lauderdale FL 33335. Vice President: R. Allen. Has 49,000 photos and more than 100 films. Clients include: ad agencies, public relations firms, businesses, audiovisual firms, book publishers, magazine publishers, postcard companies and calendar companies worldwide.

Needs: Nudes, figure work and erotic subjects (female only).

Specs: Uses glossy color prints; 35mm, 2¼×2¼ transparencies; 16mm film; videocasettes: VHS and Beta.

Payment & Terms: Pays 50% commission on color photos and film. Price range "varies according to use and quality." Enforces minimum prices. Works on contract basis only. Offers exclusivity only. Statements issued monthly. Payment made monthly. Offers one-time rights. Does not inform photographer or permit him to negotiate when client requests all rights. Model/property release preferred.

Making Contact: Interested in receiving work from newer, lesser-known photographers. Send unsolicited material by mail for consideration or submit portfolio for review. SASE. Reports in 2 weeks.

Tips: Prefers to see a "good selection of explicit work. Currently have European and Japanese magazine publishers paying high prices for very explicit nudes. Clients prefer 'American-looking' female subjects. Send as many samples as possible. Foreign magazine publishers are buying more American work as the value of the dollar makes American photography a bargain. More explicit poses are requested."

FIRST IMAGE WEST, INC., 104 N. Halsted St., #200, Chicago IL 60661. (312)733-9875. Contact: Tom Neiman. Estab. 1985. Stock photo agency. Member of Picture Agency Council of America (PACA). Clients include: advertising agencies, public relations firms, businesses, book/encyclopedia publishers, magazine publishers and newspapers. Clients include: Bank of America, Wrangler Jeans, Jeep, America West Airlines.

Needs: Needs photos of lifestyles and scenics of the West and Midwest, model-released lifestyles.

Specs: Uses 35mm to panoramic.

Payment & Terms: Pays 50% commission on domestic photos. General price range (to clients): editorial, $185 and up; advertising, $230 base rate. Works on contract basis only. Offers limited regional exclusive and catalog exclusive contracts. Statements issued when payment is due. Payment made monthly. Photographers allowed to review account records to verify sales figures. Offers one-time rights and specific print and/or time usages. When client requests all rights, "we inform photographer and get approval of 'buyout' but agency is sole negotiator with client." Model/property release required for people, homes, vehicles, animals. Photo captions required.

Making Contact: Contact by mail for photographer's package. SASE. Reports in 1 month. Photo guidelines free with SASE.

FOLIO, INC., 3417½ M St., Washington DC 20007. President: Susan Soroko. Estab. 1983. Stock photo agency. Types of clients: newspapers, textbooks, education, industrial, retail, fashion, finance.

Needs: Photos used for billboards, consumer magazines, trade magazines, direct mail, P-O-P displays, catalogs, posters, signage and newspapers.

Specs: Uses 35mm, 2¼×2¼ and 4×5 transparencies.

Payment & Terms: Pays "50% of sales." Pays on publication or on receipt of invoice. Works on contract basis only. Offers one-time rights. Model release required. Photo captions required.

Making Contact: Arrange a personal interview to show portfolio. Provide résumé, business card, brochure, flier or tearsheets to be kept on file for possible future assignments. SASE. Reports in 3 weeks. Credit line given.

Tips: "Call first, send in requested information."

■❋**FOTO EXPRESSION INTERNATIONAL (Toronto)**, Box 1268, Station "Q," Toronto, Ontario M4T 2P4 Canada. (416)445-3594. Fax: (416)445-4953. Director: John Milan Kubik. Selective archive of photo, film and audiovisual materials. Clients include: ad agencies; public relations and audiovisual firms; TV stations and networks; film distributors; businesses; book, encyclopedia, trade and news magazine publishers; newspapers; postcard, calendar and greeting card companies.

Needs: City views, aerial, travel, wildlife, nature/natural phenomena and disasters, underwater, aerospace, weapons, warfare, industry, research, computers, educational, religions, art, antique, abstract, models, sports. Worldwide news and features, personalities and celebrities.

Specs: Uses 8×10 b&w; 35mm and larger transparencies; 16mm, 35mm film; VHS, Beta and commercial videotapes (AV). Motion picture, news film, film strip and homemade video.

Payment & Terms: Sometimes buys transparencies outright. Pays 40% for b&w; 50% for color and 16mm, 35mm films and AV (if not otherwise negotiated). Offers one-time rights. Model release required for photos. Captions required.

Making Contact: Submit portfolio for review. The ideal portfolio for 8 × 10 b&w prints includes 10 prints; for transparencies include 60 selections in plastic slide pages. With portfolio you must send $4 US money order or $4.50 Canadian money order for postage—no personal checks, no postage stamps. Reports in 3 weeks. Photo guidelines free with SASE. Tips sheet distributed twice a year only "on approved portfolio."

Tips: "We require photos, slides, motion picture films, news film, homemade video and AV that can fulfill the demand of our clientele." Quality and content is essential. Photographers, cameramen, reporters, writers, correspondents and representatives are required worldwide by FOTOPRESS, Independent News Service International, (416)445-3594, Fax: (416)445-4953.

***FOTOCONCEPT INC.**, 18020 SW 66th St., Ft. Lauderdale FL 33331. (305)680-1771. Fax: (305)680-8996. Vice President: Aida Bertsch. Estab. 1985. Stock photo agency. Member of Picture Agency Council of America (PACA). Has 250,000 photos. Clients include: magazines, advertising agencies, newspapers and publishers.

Needs: General worldwide travel, medical and industrial.

Specs: Uses 35mm, 2¼ × 2¼, 4 × 5 transparencies.

Payment & Terms: Pays 50% commission for color photos. Works on contract basis only. Offers nonexclusive contract. Contracts renew automatically with each submission for 1 year. Statements issued quarterly. Payment made quarterly. Photographers allowed to review account records to verify sales figures. Offers one-time rights. Informs photographer and allows him to negotiate when client requests all rights. Model release required. Captions required.

Making Contact: Query with list of stock photo subjects. SASE. Reports in 1 month. Tips sheet distributed annually to all photographers.

Tips: Wants to see "clear, bright colors and graphic style." Points out that they are "looking for photographs with people of all ages with good composition, lighting and color in any material for stock use."

■‡FOTO-PRESS TIMMERMANN, Speckweg 34A, D-91096 Moehrendorf, Germany. 499131/42801. Fax: 499131/450528. Contact: Wolfgang Timmermann. Stock photo agency. Has 100,000 slides. Clients include: ad agencies, audiovisual firms, businesses, book/encyclopedia publishers, magazine publishers, newspapers and calendar companies.

Needs: All themes: landscapes, countries, travel, tourism, towns, people, business, nature.

Specs: Uses 2¼ × 2¼, 4 × 5 and 8 × 10 transparencies.

Payment & Terms: Pays 50% commission on color prints. Average price per image (to clients): $130-300. Enforces strict minimum prices. Works on nonexclusive contract basis (limited regional exclusivity). First period: 3 years, contract automatically renewed for 1 year. Photographers allowed to review account records. Statements issued quarterly. Payment made quarterly. Offers one-time rights. Informs photographers and permits them to negotiate when a client requests to buy all rights. Model/property release preferred. Captions required, include state, country, city, subject, etc.

Making Contact: Interested in receiving work from newer, lesser-known photographers. Query with list of stock photo subjects. Send unsolicited photos by mail for consideration. SASE. Reports in 1 month.

■FOTOS INTERNATIONAL, 4230 Ben Ave., Studio City CA 91604. (818)508-6400. Fax: (818)762-2181. E-mail: entertainment@earthlink.net. Manager: Max B. Miller. Has 4 million photos. Clients include: ad agencies, public relations firms, businesses, book publishers, magazine publishers, encyclopedia publishers, newspapers, calendar companies, TV and posters.

Needs: "We are the world's largest entertainment photo agency. We specialize exclusively in motion picture, TV and popular music subjects. We want color only! The subjects can include scenes from productions, candid photos, rock, popular or classical concerts, etc., and must be accompanied by full caption information."

Specs: Uses 35mm color transparencies only.

Payment & Terms: Buys photos outright; no commission offered. Pays $5-200/photo. Works with or without contract. Offers nonexclusive contract and guaranteed subject exclusivity (within files). Offers one-time rights and first rights. Offers electronic media and agency promotion rights. Model release optional. Captions required.

Making Contact: Query with list of stock photo subjects. SASE. Reports in 1 month.

FPG INTERNATIONAL CORP., 32 Union Square E., New York NY 10003. (212)777-4210. Fax: (212)475-8542. Director of Photography: Rebecca Taylor. Affiliations Manager: Claudia Micare. A full service agency with emphasis on images for the advertising, corporate, design and travel markets. Member of Picture Agency Council of America (PACA).

Needs: High-tech industry, model-released human interest, foreign and domestic scenics in medium formats, still life, animals, architectural interiors/exteriors with property releases.
Specs: Minimum submission requirement per year—1,000 original color transparencies, exceptions for large format, 250 b&w full-frame 8×10 glossy prints.
Payment & Terms: Pays 50% commission upon licensing of reproduction rights. Works on contract basis only. Offers exclusive contract only. Contracts renew automatically upon contract date; 5-year contract. Charges catalog insertion fee; rate not specified. Statements issued monthly. Payment made monthly. Photographers allowed to review account records to verify sales figures. Licenses one-time rights. "We sell various rights as required by the client." When client requests all rights, "we will contact a photographer and obtain permission."
Making Contact: "Initial approach should be by mail. Tell us what kind of material you have, what your plans are for producing stock and what kind of commercial work you do. Enclose reprints of published work." Photo guidelines and tip sheets provided for affiliated photographers. Model/property releases required and must be indicated on photograph. Captions required.
Tips: "Submit regularly; we're interested in committed, high-caliber photographers only. Be selective and send only first-rate work. Our files are highly competitive."

FRANKLIN PHOTO AGENCY, 85 James Otis Ave., Centerville MA 02632. President: Nelson Groffman. Has 35,000 transparencies. Clients include: publishers, advertising and industrial.
Needs: Scenics, animals, horticultural subjects, dogs, cats, fish, horses, antique and classic cars, and insects.
Specs: Uses 35mm, $2\frac{1}{4} \times 2\frac{1}{4}$ and 4×5 color transparencies. "More interest now in medium size format—$2\frac{1}{4} \times 2\frac{1}{4}$."
Payment & Terms: Pays 50% commission. General price range (to clients): $100-300; $60/b&w photo; $100/color photo. Works with or without contract, negotiable. Offers nonexclusive contract. Statements issued when pictures are sold. Payment made within a month after sales when we receive payment. Offers one-time, electronic media and 1-year exclusive rights. Informs photographer and allows him to negotiate when client requests all rights. Model/property release required for people, houses; present release on acceptance of photo. Captions preferred.
Making Contact: Interested in receiving work from newer, lesser-known photographers. Query first with résumé of credits. SASE. Reports in 1 month.
Tips: Wants to see "clear, creative pictures—dramatically recorded."

‡FRONTLINE PHOTO PRESS AGENCY, P.O. Box 162, Kent Town, South Australia 5071. 61-8-333-2691. Fax: 61-8-364-0604. E-mail: fppa@tne.net.au. Director: Carlo Irlitti. Estab. 1988. Stock photo agency, picture library and photographic press agency. Has 300,000 photos. Clients include: advertising agencies, marketing/public relations firms, book/encyclopedia publishers, magazine publishers, newspapers, postcard publishers, calendar companies, poster companies, graphic designers, corporations and government institutions.
● This agency markets images via low resolution watermarked CD-ROM catalogs. Plans are to go on-line in late 1996 or early 1997. Digital picture transmission service available.
Needs: Wants photos of people (all walks of life, at work and at leisure), lifestyles, sports, cities and landscapes, travel, industrial and agricultural, natural history, enviromental, celebrities and important people, social documentary, concepts, science and medicine.
Specs: Uses $8\frac{1}{2} \times 12$ glossy color and b&w prints; 35mm color and b&w negatives; 35mm, $2\frac{1}{4} \times 2\frac{1}{4}$, 4×5, 8×10 transparencies; CD-ROMs in ISO 9660 Format, Kodak Photo/Pro Photo CD Masters (Base $\times 16$ and Base $\times 64$).
Payment & Terms: Pays 60% commission on all stock images. Average price per image: b&w $AUD175, color $AUD225 paid to the photographer, overall $AUD51-$AUD6,000. Prices vary considerably depending on use, market and rights requested. Enforces minimum prices. "Our lowest price is now fixed at $AUD85 ($AUD51 to the photographer) for all uses where reproductions are no bigger than 40mm or $1\frac{1}{2}$" across." Stock for AVs is charged at a lower rate (depending on the amount to be used) and includes duping costs paid by client. Prefers to work on contract basis but can work without if necessary. Offers exclusive, nonexclusive and tailored contracts to suit the individual photographer. Contracts are for a minimum of 3 years and are automatically renewed 6 months before the expiration date (if not advised in writing). Contracts concerning sports pictures are for a minimum of 1 year and are renewable at expiration date. No charges for filing or duping. No charge on low resolution CD-ROM catalog insertions (an in-house production) but charges 50% Photo CD insertion rate (approximately $AUD90¢ each image) on high resolution scans. Statements issued monthly. Payment made monthly and within 15 days (quarterly and within 15 days outside Australia). Photographers allowed to review account records as stipulated in contract. Offers one-time and first-time rights, but also promotional, serial, exclusive and electronic media rights. Photographers informed and allowed to negotiate when client requests all rights. Agency will counsel, but if photographer is unable to negotiate agency will revert to broker on his behalf. Model/property release required.

Making Contact: Interested in receiving work from competent amateur and professional photographers only. Query with samples or list of stock subjects. Send unsolicited photos (negatives with proofs, transparencies and CD-ROMs ISO 9660) for consideration. Works mostly with local freelancers but is willing to work with overseas freelancers on assignment. Samples kept on file with permission. SASE (include insurance and IRC). Expects minimum initial submission of 100-200 images with periodic submissions of 250-1,000 images/year. Reports in 1-2 weeks. Photo guidelines free with SAE and IRCs. Market tips sheet distributed 2 times/year to photographers on contract; free upon request.

Tips: "We look for the creative photographers who are dedicated to their work, who can provide unique and technically sound images and who are considering a long-term relationship with an Australian photo agency. We prefer our photographers to specialize in their subject coverage in fields they know best. All work submitted must be original, well-composed, well-lit (depending on the mood), sharp and meticulously edited with quality in mind. In the initial submission we prefer to see 100-200 of the photographer's best work. Send slides in 20-slide clear plastic files and not in glass mounts or loose in boxes. All material should be captioned or attached to an information sheet and indicate if model/property released. Model and property releases are mostly requested for advertising and are essential for quick, hassle-free sales. Please package work appropriately, we do not accept responsibility for losses or damage during transit. We would like all subjects covered equally but the ones mostly sought after are: environmental issues, science and medicine, people (occupations, life-style and leisure), dramatic landscapes/scenics (captioned), general travel. We also need more pictures of sports (up-and-coming and established athletes who make the news worldwide), celebrities and entertainers, important people and social documentary (contemporary issues) including captioned photo-essays for our editorial clients. Write, call or fax for complete subject list. We also provide regular advice for our contributors and will direct freelancers to photograph specific, market-oriented subjects as well as help in coordinating their own private assignments to assure saleable subjects."

■**FROZEN IMAGES, INC.**, 400 First Ave. N., Suite 512, Minneapolis MN 55401. (612)339-3191. Director of Photo Services: David Niebergall. Stock photo agency. Has approximately 175,000 photos. Clients include: ad agencies, public relations firms, audiovisual firms, graphic designers, businesses, book/encyclopedia publishers, magazine publishers, newspapers and calendar companies.

Needs: All subjects including abstracts, scenics, industry, agriculture, US and foreign cities, high tech, businesses, sports, people and families.

Specs: Uses transparencies.

Payment & Terms: Pays 50% commission on color photos. Works on contract basis only. Offers limited regional exclusivity. Contracts renew automatically with each submission; time period not specified. Charges catalog insertion fee; rate not specified. Statements issued monthly. Payment made monthly; within 10 days of end of month. Photographers allowed to review account records to verify sales figures "with notice and by appointment." Offers one-time rights. Informs photographers when client requests all rights, but agency negotiates terms. Model/property release required for people and private property. Photo captions required.

Making Contact: Query with résumé of credits. Query with list of stock photo subjects. SASE. Reports in 1 month or ASAP (sometimes 6 weeks). Photo guidelines free with SASE. Tips sheet distributed quarterly to photographers in the collection.

Tips: Wants to see "technical perfection, graphically strong, released (when necessary) images in all subject areas."

F-STOCK INC., P.O. Box 3956, Ketchum ID 83340. (208)726-1378. Fax: (208)726-8456. President: Kate Ryan. Vice President: Caroline Woodham. Estab. 1989. Stock photo agency. Member of the Picture Agency Council of America (PACA). Has 100,000 photos. Works with 3 agencies in France, Italy and Japan. Clients include: advertising agencies, public relations firms, audiovisual firms, businesses, book/encyclopedia publishers, magazine publishers, newspapers, postcard publishers, calendar companies, greeting card companies.

Needs: General stock agency—mostly specializing in outdoor sports, lifestyle, large format scenics, wildlife, adventure and travel.

Specs: Uses 35mm, 2¼×2¼, 4×5 transparencies (medium and large format); b&w images (chromes or however you can present).

Payment & Terms: Pays 50% on b&w; 50% on color. Enforces minimum prices . "We try to get the current market price." Works on contract basis only. Offers nonexclusive contract. Charges 25%

MARKET CONDITIONS are constantly changing! If you're still using this book and it's 1998 or later, buy the newest edition of *Photographer's Market* at your favorite bookstore or order directly from Writer's Digest Books.

duping fees, 50% separation fee for *Stock Workbook*. Statements issued monthly. Payment made monthly. Photographers allowed to review account records. Offers one-time rights. Does not inform photographer or allow him to negotiate when client requests all rights. Model/property release required. Captions required.

Making Contact: Interested in receiving work from newer, lesser-known photographers. "Write letter and we will send you guidelines." SASE. Expects minimum initial submission of 100 images for review with additional 2,000/year. Reports in 1-2 weeks. Photo guidelines free with SASE. Workbook ad available with SASE. "Market tips sheet distributed once/week on our answering machine."

Tips: "We do not like too much inter-agency competition. We also need all material released so they can be used for commercial market."

F/STOP PICTURES INC., P.O. Box 359, Springfield VT 05156. (802)885-5261. Fax: (802)885-2625. E-mail: fstoppic@vermontel.com. President: John Wood. Estab. 1984. Stock photo agency. Has 140,000 photos. Clients include: advertising agencies, public relations firms, audiovisual firms, businesses, book/encyclopedia publishers, magazine publishers, newspapers, postcard companies, calendar companies and greeting card companies.

Needs: "We specialize in New England and rural America, but we also need worldwide travel photos and model-released people and families."

Specs: Uses 35mm, 2¼×2¼, 4×5, 8×10 transparencies.

Payment & Terms: Pays 50% commission on color photos. Average price per image (to clients): $225. Enforces minimum prices, minimum of $100, exceptions for reuses. Works on contract basis only. Offers non-exclusive contract, exclusive contract for some images only. Contracts renew automatically for 4 years. Statements issued monthly. Payment made monthly by 31st of statement month. Photographers allowed to review account records to verify sales figures. Offers one-time rights. Informs photographer and allows him to negotiate when client requests all rights. Model/property release required for recognizable people and private property. Captions required; include complete location data and complete identification (including scientific names) for natural history subjects.

Making Contact: Arrange a personal interview to show portfolio. Query with list of stock photo subjects. Submit portfolio for review. SASE. Reports in 2 weeks. Photo guidelines free with SASE. Market tips sheet distributed quarterly to contracted photographers only.

Tips: Especially wants to work with "professional fulltime photographers willing to shoot what we need." Send minimum of 500 usable photos in initial shipment, and 500 usable per quarter thereafter." Sees trend toward "more realistic people situations, fewer staged-looking shots; more use of electronic manipulation of images."

FUNDAMENTAL PHOTOGRAPHS, Dept. PM, 210 Forsyth St., New York NY 10002. (212)473-5770. Fax: (212)228-5059. E-mail: 70214.3663@compuserve.com. Partner: Kip Peticolas. Estab. 1979. Stock photo agency. Applied for membership into the Picture Agency Council of America (PACA). Has 100,000 photos. Clients include: advertising agencies, book/encyclopedia publishers.

Needs: Science-related topics.

Specs: Uses 35mm, 2¼×2¼, 4×5 and 8×10 transparencies.

Payment & Terms: Pays on commission basis; b&w 40%, color 50%. General price range (to clients): $100-500/b&w photo; $150-1,200/color photo, depends on rights needed. Enforces minimum prices. Offers volume discount to customers. Informs photographer but does not allow him to negotiate when client requests all rights. Works on contract basis only. Offers guaranteed subject exclusivity. Contracts renew automatically with additional submissions. Charges 50% duping fees ($25/4×5 dupe). Payment made quarterly. Photographers allowed to review account records. Offers one-time and electronic media rights. Informs photographer when client requests all rights; negotiation conducted by Fundamental (the agency). Model release preferred. Captions required; include date and location.

Making Contact: Interested in receiving work from newer, lesser-known photographers. Arrange a personal interview to show portfolio. Submit portfolio for review. Query with résumé of credits, samples or list of stock photo subjects. Keeps samples on file. SASE. Expects minimum initial submission of 100 images. Reports in 1-2 weeks. Photo guidelines free with SASE. Tips sheet distributed.

Tips: "Our primary market is science textbooks. Photographers should research the type of illustration used and tailor submissions to show awareness of saleable material. We are looking for science subjects ranging from nature and rocks to industrials, medicine, chemistry and physics; macrophotography, stroboscopic; well-lit still life shots are desirable. The biggest trend that affects us is the increased need for images that relate to the sciences and ecology."

■GAMMA LIAISON, 11 E. 26th St., New York NY 10010. (212)779-6303. Fax: (212)779-6334. E-mail: 76366.217@compuserve.com. Website: http://www.liasoninte.com. Executive Vice President/ Director: Jennifer Coley. Photographer Relations: Umberto Venturini. Has 5 million plus photographs. Extensive stock files include news (reportage), human interest stories, movie stills, personalities/celebrities. Clients include: newspapers and magazines, book publishers, audiovisual producers and encyclopedia publishers.

● This agency has a second division, Liaison International, which specializes in corporate assignment work and stock files for advertising agencies and graphic designers.

Specs: Uses 35mm transparencies.

Payment & Terms: Pays 50% commission. Works with or without contract. Offers exclusive contract and guaranteed subject exclusivity (within files). Contracts renew automatically for 5 years. Charges processing and shipping fee. Statements issued monthly. Payment made monthly. Photographers allowed to review account records. Offers one-time rights. Informs photographers and permits them to negotiate when a client requests to buy all rights. Leases one-time rights. Captions required.

Making Contact: Submit portfolio with description of past experience and publication credits.

Tips: Involves a "rigorous trial period for first six months of association with photographer." Prefers previous involvement in publishing industry.

■‡**GEOSLIDES & GEO AERIAL (Photography)**, 4 Christian Fields, London SW16 3JZ England. Phone/fax: (0181)764-6292. Library Directors: John Douglas (Geoslides); Kelly White (Geo Aerial). Picture library. Has approximately 120,000 photos. Clients include: ad agencies, public relations firms, audiovisual firms, businesses, book/encyclopedia publishers, magazine publishers, newspapers, calendar companies and television.

Needs: Only from: Africa (South of Sahara); Asia; Arctic and Sub-Arctic; Antarctic. Anything to illustrate these areas. Accent on travel/geography and aerial (oblique) shots.

Specs: Uses 8×10 glossy b&w prints; 35mm and 2¼×2¼ transparencies.

Payment & Terms: Pays 50% commission. General price range (to clients) $70-1,000. Works with or without contract; negotiable. Offers nonexclusive contract. Statements issued monthly. Payment made upon receipt of client's fees. Offers one-time rights and first rights. Does not inform photographer or allow him to negotiate when client requests all rights. Model release required. Photo captions required; include description of location, subject matter and sometimes the date.

Making Contact: Query with résumé of credits and list of stock photo subjects. SASE. Reports in 1 month. Photo guidelines for SASE (International Reply Coupon). No samples until called for. Leaflets available.

Tips: Looks for "technical perfection, detailed captions, must suit lists (especially in areas). Increasingly competitive on an international scale. Quality is important. Need for large stocks with frequent renewals." To break in, "build up a comprehensive (i.e., in subject or geographical area) collection of photographs which are well documented."

GLACIER BAY PHOTOGRAPHY, P.O. Box 97, Gustavus AK 99826-0097. (907)697-2416. Contact: Pamela Jean Miedtke.

Needs: Alaska scenics, people in nature and wildlife. "We deal only with natural subjects in their natural habitats. No filters or manipulation of any sort is used."

Specs: Uses 35mm, 2¼×2¼, 4×5, 8×10 transparencies.

Payment & Terms: Usually charges 50% commission. Terms negotiated with photographer.

Making Contact: Query by mail only with list of stock photo subjects, samples and dupe slides to be kept on hand for future reference. Slides returned only if requested and SASE is enclosed.

Tips: When applying, dupes must be individually labeled. Originals must be readily available, razor sharp and free from distortions. "Be realistic. Expect rejection. Everyone is a photographer. If you are as good or better than what you are seeing published, and are consistent, plus enjoy what you are doing, stick with it. Someday it will happen."

JOEL GORDON PHOTOGRAPHY, 112 Fourth Ave., New York NY 10003. (212)254-1688. Picture Agent: Joel Gordon. Stock photo agency. Clients include: ad agencies, designers and textbook/encyclopedia publishers.

Specs: Uses 8×10 b&w prints, 35mm transparencies, b&w contact sheets and b&w negatives.

Payment & Terms: Usually pays 50% commission on b&w and color photos. Offers volume discounts to customers; terms specified in contract. Photographers can choose not to sell images on discount terms. Works with or without a contract. Offers nonexclusive contract. Payment made after customer's check clears. Photographers allowed to review account records to verify sales figures. Informs photographer and allows him to negotiate when client requests all rights. Offers one-time, electronic media and agency promotion rights. Model/property release preferred. Captions preferred.

Making Contact: Interested in receiving work from newer, lesser-known photographers.

GEORGE HALL/CODE RED, 426 Greenwood Beach, Tiburon CA 94920. (415)381-6363. Fax: (415)383-4935. Owner: George Hall. Stock photo agency. Member of the Picture Agency Council of America (PACA). Has 5,000 photos (just starting). Clients include: advertising agencies, public relations firms, businesses, book/encyclopedia publishers, magazine publishers, calendar companies.

Needs: Interested in firefighting, emergencies, disasters, hostile weather: hurricanes, quakes, floods, etc.

Specs: Uses color prints; 35mm, 2¼×2¼, 4×5 transparencies.

Payment & Terms: Pays 50% commission. Average price (to clients) $1,000. Enforces minimum prices of $300. Offers volume discounts to customers; terms specified in photographer's contract. Photographers can choose not to sell images on discount terms. Works on contract basis only. Offers nonexclusive contract. Payment made within 5 days of each sale. Photographers allowed to review account records. Offers one-time rights. Does not inform photographer or allow him to negotiate when client requests all rights. Model release preferred. Captions required.

Making Contact: Interested in receiving work from newer, lesser-known photographers. Call or write with details. SASE. Reports in 3 days. Photo guidelines available.

***HAVELIN COMMUNICATIONS, INC.**, P.O. Box 76595, Atlanta GA 30358. (770)392-1013. Website: http://www.havelin.com. Contact: Michael F. Havelin. Has 20,000 b&w and color photos. Clients include: advertising agencies, public relation firms, audiovisual firms, businesses, book/encyclopedia publishers, magazine publishers, newspapers, postcard companies, calendar companies and greeting card companies.

Subject Needs: "We stock photos of pollution and its effects; animals, insects, spiders, reptiles and amphibians; solar power and alternative energy sources; and guns and hunting."

Specs: Uses b&w prints; 35mm, 2¼×2¼, 8×10 and 4×5 transparencies.

Payment & Terms: Pays 50% commission. General price range: highly variable. Offers nonexclusive contract. Statements issued after sales. Payment made quarterly upon sales and receipt of client payment. Photographers allowed to review account records to verify sales figures upon request. Offers one-time rights. Informs photographer and allows him to negotiate when client requests all rights. Model release preferred for recognizable people. Photo captions required; include who, what, where, when, why and how.

Making Contact: Photo guidelines free with SASE. Tips sheet distributed intermittently; free with SASE.

Tips: "We stock well-exposed, informative images that have impact, as well as photo essays or images which tell a story on their own, and photo illustrated articles. Slicker work is selling better than isolated 'record' shots." To break in, "act professionally. People who work in visual media still need to write coherent business letters and intelligent, informative captions. Don't take rejection personally. It may not be the right time for the editor to use your material. Don't give up. Be flexible."

‡HOLT STUDIOS INTERNATIONAL, LTD., The Courtyard, 24 High St., Hungerford, Berkshire, RG17 0NF United Kingdom. (01488)683523. Fax: (01488)6835111. E-mail: holtlib@servelam.co.uk. Director: Nigel D. Cattlin. Picture library. Has 70,000 photos. Clients include: ad agencies, public relations firms, audiovisual firms, businesses, book/encyclopedia publishers, magazines, newspapers and commercial companies.

Needs: Photographs of world agriculture associated with crop production and crop protection including healthy crops and relevant weeds, pests, diseases and deficiencies. Farming, people and machines throughout the year including good landscapes. Livestock and livestock management, horticulture, gardens, ornamental plants and garden operations. Worldwide assignments undertaken.

Specs: Uses 35mm, 2¼×2¼ and 4×5 transparencies.

Payment & Terms: Occasionally buys photos outright. Pays 50% commission. General price range: $100-1,500. Offers photographers nonexclusive contract. Contracts renew automatically with additional submissions for 3 years. Photographers allowed to review account records. Statements issued quarterly. Payment made quarterly. Offers one-time rights. Model release preferred. Captions required; identity of biological organisms is critically important.

Making Contact: Interested in receiving work from newer, lesser-known photographers. Send unsolicited photos by mail for consideration. SAE (with sufficient return postage). Reports in 2 weeks. Photo guidelines free with SASE. Distributes tips sheets every 3 months to all associates.

Tips: "Holt Studios looks for high quality, technically well-informed and fully labeled color transparencies of subjects of agricultural and horticultural interest." Currently sees "expanding interest particularly conservation and the environment, gardening and garden plants."

***‡HOUSES & INTERIORS PHOTOGRAPHIC FEATURES AGENCY**, 18 Church St., Ticehurst, Wadhurst East Sussex TN5 7AH England. Phone/fax:(01)580-200905. Director: Richard Wiles. Estab. 1985. Stock photo agency and feature syndicate. Has 60,000 photos. Clients include: ad agencies, public relations firms, book/encyclopedia publishers, magazine publishers and newspapers.

LISTINGS THAT USE IMAGES electronically can be found in the Digital Markets Index located at the back of this book.

Needs: Interiors, exteriors, do-it-yourself, architectural details, crafts, gardens and gardening techniques and houseplants.

Specs: Uses 35mm, 2¼×2¼, 4×5, 6×7 transparencies.

Payment & Terms: Pays 50% commission. Average price per image (to clients): £80-200/color photo. Enforces minimum prices. Offers volume discounts to customers; terms specified in photographer's contract. Discount sales terms not negotiable. Works on contract basis only. Offers exclusive contract. Contracts renew automatically with additional submissions. Statements issued quarterly. Payment made quarterly. Photographers allowed to review account records. Offers one-time, electronic media, agency promotion and other types of negotiated rights. Model/property release preferred. Captions required; include "what's happening, where and when."

Making Contact: Interested in receiving work from newer, lesser-known photographers. Arrange personal interview to show portfolio. Submit portfolio for review. Query with resume of credits. Query with samples. Works with local freelancers only. Samples kept on file. SASE. No minimum number of images expected in initial submission. Reports in 3 weeks. Photo quidelines free with SASE. Market tips sheet distributed upon request with SASE.

***‡HULTON DEUTSCH COLLECTION**, 21-31 Woodfield Rd., London W9 2BA United Kingdom. (44)171 266 2660. Fax: (44)171 266 2414. E-mail: 100530,101@compuserve.com. Website: http://www.u-net.com/hulton. Marketing Manager: John Spring. Estab. 1938. Picture library. Has 15 million photos. Has branch offices in 19 other cities. Clients include: ad agencies, public relations firms, audiovisual firms, businesses, book/encyclopedia publishers, magazine publishers, newspapers, calendar companies, greeting card companies, postcard publishers, television and CD-ROM publishers.

Needs: Archive photographs/engravings and photojournalism.

Specs: Uses 35mm, 2¼×2¼, 4×5, 8×10 transparencies; all digital formats—CD-ROM, Photo CD, disk, ISDN.

Payment & Terms: Buys photos outright. NPI. Pays negotiable commission for photos. Offers volume discounts to customers; inquire about specific terms. Discount sales terms not negotiable. Works with or without contract. Offers exclusive, limited regional exclusivity, nonexclusive and guaranteed subject exclusivity contracts. Statements issued monthly. Payment made monthly. Photographers allowed to review account records. Offers one-time rights. Does not inform photographer or allow him to negotiate when a client requests all rights. Model/property release preferred. Captions preferred.

Making Contact: Interested in receiving work from newer, lesser-known photographers. Contact Matthew Butson. Submit portfolio for review. Samples kept on file. Expects minimum of 30 images for review with periodic submissions of at least 500 images. Reports in 1 month. Catalog free with SASE (IRCs).

‡THE IMAGE FACTORY, 7 Green Walks, Prestwich, Manchester M25 1DS England. (061)798-0435. Fax: (0161)247-6394. Principal: Jeff Anthony. Estab. 1988. Picture library. Has 350,000 photos. Has 2 branch offices. Clients include: advertising agencies, public relations firms, audiovisual firms, businesses, book/encyclopedia publishers, magazine publishers, newspapers, postcard publishers, calendar companies and greeting card companies.

● The Image Factory recently merged with an agency in Warsaw, Poland (Flash Media).

Needs: Needs photos from all over the world. Currently looking for good glamour, nude and humor as well as shots of the Bahamas—but will look at anything of good quality.

Specs: Uses 35mm, 2¼×2¼, 4×5, 8×10 transparencies.

Payment & Terms: Pays 40-60% commission. Works on contract basis only. Offers exclusive contracts. Contracts renew automatically with additional submissions; originally for 3 years and then annually. Statements issued annually. Payment made quarterly. Photographers allowed to review account records. Offers one-time rights. Informs photographer and allows him to negotiate when client requests all rights. Model/property release preferred. Captions required, include as many details as possible.

Making Contact: Interested in receiving work from newer, lesser-known photographers. Submit portfolio for review. SASE. Expects minimum initial submission of 100 images. Reports in 1 month. Photo guidelines free with SASE. Market tips sheet distributed annually; free with SASE.

Tips: "We will look at anything if the quality is good, good color saturation, clarity and good description. All mounts should be clearly captioned."

THE IMAGE FINDERS, 812 Huron, Suite 314, Cleveland OH 44115. (216)781-7729. Fax: (216)443-1080. E-mail: 75217.compuserve. Owner: Jim Baron. Estab. 1988. Stock photo agency. Has 100,000 photos. Clients include: advertising agencies, public relations firms, audiovisual firms, businesses, book/encyclopedia publishers, magazine publishers, calendar companies, greeting card companies.

● This agency posts images on the Kodak Picture Exchange.

Needs: General stock agency. Needs more people images. Always interested in good Ohio images.
Specs: Uses 35mm, 2¼×2¼. 4×5 transparencies. Pays 50% commission on b&w and color photos. Average price per image (to clients): $250-350/color. "This is a small agency and we will, on occasion, go below stated minimum prices." Offers volume discounts to customers; terms specified in photographer's contract. Works on contract basis only. Contracts renew automatically with additional submissions for 2 years. Statements issued quarterly; monthly, if requested. Payment made monthly. Photographers allowed to review account records. Offers one-time rights; negotiable depending on what the client needs and will pay for. Informs photographer and allows him to negotiate when client requests all rights. "This is rare for us. I would inform photographer of what client wants and work with photographer to strike best deal." Model release required. Property release preferred. Captions required; include location, city, state, country, type of plant or animal, etc.
Making Contact: Interested in receiving work from newer, lesser-known photographers. Query with stock photo list. Call before you send anything. SASE. Expects minimum initial submission of 100 images with periodic submission of at least 100-500 images. Reports in 3 weeks. Photo guidelines free with SASE. Market tips sheet distributed 2-4 times/year to photographers under contract.
Tips: Photographers must be willing to build their file of images. "We need more people images, industry, lifestyles, medical, etc. Scenics and landscapes must be outstanding to be considered."

■**THE IMAGE WORKS**, P.O. Box 443, Woodstock NY 12498. (914)246-8800. Fax: (914)246-0383. E-mail: mantman@theimageworks.com. Directors: Mark Antman, Vice President of ASPP, and Alan Carey, President of PACA. Stock photo agency. Member of Picture Agency Council of America (PACA). Has 500,000 photos. Clients include: ad agencies, audiovisual firms, book/encyclopedia publishers, magazine publishers and newspapers.
 ● The Image Works is marketing the Kodak Picture Exchange and is also in the process of producing a CD-ROM.
Needs: "We specialize in documentary style photography of worldwide subject matter. People in real life situations that reflect their social, economic, political, leisure time and cultural lives." Topic areas include health care, education, business, family life and travel locations.
Specs: Uses 8×10 glossy/semi-glossy b&w prints; 35mm and 2¼×2¼ transparencies.
Payment & Terms: Pays 50% commission on b&w and color photos. General price range: $160-900. Works on contract basis only. Offers nonexclusive contract. Offers guaranteed subject exclusivity (within files). Contracts renew automatically with additional submissions; 3-year renewal. Charges 100% duping fee. Charges catalog insertion fee of 50%. Statements issued monthly. Payment made monthly. Photographers allowed to review account records to verify sales figures by appointment. Photographer must also pay for accounting time. Offers one-time rights. Informs photographer and allows him to negotiate when client requests all rights. Model release preferred. Captions required.
Making Contact: Query with list of stock photo subjects or samples. SASE. Reports in 1 month. Tips sheet distributed monthly to contributing photographers.
Tips: "We want to see photographs that have been carefully edited, that show technical control and a good understanding of the subject matter. All photographs must be thoroughly captioned and indicate if they are model released. The Image Works is known for its strong multicultural coverage in the United States and around the world. Photographs should illustrate real-life situations, but not look contrived. They should have an editorial/photojournalistic feel, but be clean and uncluttered with strong graphic impact for both commercial and editorial markets. We are actively expanding our collection of humor photographs and are interested in seeing new work in this area. Photographers who work with us must be hard workers. They have to want to make money at their photography and have a high degree of self-motivation to succeed. As new digital-based photographic and design technology forces changes in the industry there will be a greater need for experienced photo agencies who know how to service a broad range of clients with very different needs. The agency personnel must be versed, not only in the quality and subject matter of its imagery, but also in the various new options for getting photos to picture buyers. As new uses of photography in new media continue to evolve, the need for agencies from the perspective of both photographers and picture buyers will continue to grow."

IMAGES PICTURES CORP., Dept. PM, 89 Fifth Ave., New York NY 10003. (212)675-3707. Fax: (212)243-2308. Managers: Peter Gould and Barbara Rosen. Has 100,000 photos. Clients include: public relations firms, book publishers, magazine publishers and newspapers.
Needs: Current events, celebrities, feature stories, pop music, pin-ups and travel.
Specs: Uses b&w prints, 35mm transparencies, b&w contact sheets and b&w negatives.
Payment & Terms: Pays 50% commission on b&w and color photos. General price range: $50-1,000. Offers one-time rights or first rights. Captions required.
Making Contact: Query with résumé of credits or with list of stock photo subjects. Also send tearsheets or photocopies of "already published material, original story ideas, gallery shows, etc." SASE. Reports in 2 weeks.
Tips: Prefers to see "material of wide appeal with commercial value to publication market; original material similar to what is being published by magazines sold on newsstands. We are interested in

ideas from freelancers that can be marketed and assignments arranged with our clients and sub-agents." Wants to see "features that might be of interest to the European or Japanese press, and that have already been published in local media. Send copy of publication and advise rights available." To break in, be persistent and offer fresh perspective.

INTERNATIONAL COLOR STOCK, INC., Dept. PM, 3841 NE Second Ave., Suite 304, Miami FL 33137. (305)573-5200. Contact: Dagmar Fabricius or Randy Taylor. Estab. 1989. Stock photo syndicate. Clients include: foreign agencies distributing to all markets.
Needs: "We serve as a conduit, passing top-grade, model-released production stock to foreign agencies. We have no U.S. sales and no U.S. archives." Currently promotes the Internet and CD-ROM.
Specs: Uses 35mm, $2\frac{1}{4} \times 2\frac{1}{4}$ transparencies.
Payment & Terms: Pays 70% commission. Works on contract basis only. Offers exclusive foreign contract only. Contracts renew automatically on annual basis. Charges duping fee of 100%/image. Also charges catalog insertion fee of 100%/image. Statements issued monthly. Payment made monthly. Photographers allowed to review account records to verify sales figures "upon reasonable notice, during normal business hours." Offers one-time rights. Requests agency promotion rights. Informs photographer and allows him to negotiate when client requests all rights, "if notified by subagents." Model/property release required. Captions preferred; include "who, what, where, when, why and how."
Making Contact: Query with résumé of credits. Reports "only when photographer is of interest." Photo guidelines sheet not available. Tips sheet not distributed.
Tips: Has strong preference for experienced photographers. "Our percentages are extremely low. Because of this, we deal only with top shooters seeking long-term success. If you are not published 20 times a month or have not worked on contract for two or more photo agencies or have less than 15 years experience, please do not call us."

INTERNATIONAL PHOTO NEWS, Dept. PM, 193 Sandpiper Ave., Royal Palm Beach FL 33411. (407)793-3424. Fax: (407)585-5434. Photo Editors: Jay Kravetz and Elliott Kravetz. News/feature syndicate. Has 50,000 photos. Clients include: newspapers, magazines and book publishers. Previous/current clients include: *Lake Worth Herald, S. Florida Entertainment Guide* and *Prime-Time*; all 3 celebrity photos with story.
Needs: Celebrities of politics, movies, music and television at work or play.
Specs: Uses 5×7, 8×10 glossy b&w prints.
Payment & Terms: General price range: $5. Works on nonexclusive contract basis only. Contracts renew automatically with additional submissions; 1 year renewal. Photographers allowed to review account records. Statements issued monthly. Payments made monthly. Pays $5/b&w photo; $10/color photo; 5-10% commission. Offers one-time rights. Model/property release preferred. Captions required.
Making Contact: Query with résumé of credits. Solicits photos by assignment only. SASE. Reports in 1 week.
Tips: "We use celebrity photographs to coincide with our syndicated columns. Must be approved by the celebrity."

INTERPRESS OF LONDON AND NEW YORK, 400 Madison Ave., New York NY 10017. Editor: Jeffrey Blyth. Has 5,000 photos. Clients include: magazine publishers and newspapers.
Needs: Offbeat news and feature stories of interest to European editors. Captions required.
Specs: Uses 8×10 b&w prints and 35mm color transparencies.
Payment & Terms: NPI. Offers one-time rights.
Making Contact: Send material by mail for consideration. SASE. Reports in 1 week.

BRUCE IVERSON PHOTOMICROGRAPHY, 31 Boss Ave., Portsmouth NH 03801. Phone/fax: (603)433-8484. Owner: Bruce Iverson. Estab. 1981. Stock photo agency. Has 10,000 photos. Clients include: advertising agencies, book/encyclopedia publishers.
 • This agency uses Kodak Photo CD for demos/portfolios.
Needs: Currently only interested in submission of scanning electron micrographs and transmission electron micrographs—all subjects.
Specs: Uses 8×10 glossy or matte color and b&w prints; 35mm, $2\frac{1}{4} \times 2\frac{1}{4}$, 4×5 transparencies; 6×17 panoramic.
Payment & Terms: Pays 50% commission on b&w and color photos. There is a minimum use fee of $175; maximum 10% discount. Terms specified in photographer's contract. Works on contract basis only. Offers nonexclusive contracts. Photographer paid within 1 month of agency's receipt of payment. Offers one-time rights. Captions required; include magnification and subject matter.
Making Contact: "Give us a call first. Our subject matter is very specialized." SASE. Reports in 1-2 weeks.
Tips: "We are a specialist agency for science photos and technical images taken through the microscope."

***✸■JAYDEE MEDIA**, 4009 Vance Place NW, Calgary, Alberta T3A 0M7 Canada. Phone/fax: (403)288-4040. Owner: J. David Corry. Stock photo agency. Has 60,000 photos; very little film (new area of business). Clients include: advertising agencies, public relations firms and businesses.
Needs: Agricultural—crop, livestock and food production.
Specs: Uses 35mm, 2¼×2¼, 4×5 transparencies; Betacam SP videotape.
Payment & Terms: Pays 50% commission. Average price per image (to clients): $50-200/b&w; $200-2,000/color; $50-100/second, videotape. Negotiates fees below stated minimum for educational purposes or noncommercial uses. Offers volume discounts to customers; terms specified in photographer's contract. Discount sales terms not negotiable. Works on contract basis only. Statements issued quarterly. Payment made quarterly. Offers one-time rights. Informs photographer and allows him to negotiate when client requests all rights. Model/property release preferred for people, recognizable vehicles, equipment and buildings. Captions preferred.
Making Contact: Interested in receiving work from newer, lesser-known photographers. Query with stock photo list. SASE. Expects minimum initial submission of 100-200 images with periodic submissions of 100-200 images. Reports in 1 month. Photo guidelines free with SASE (IRCs). Market tips sheet distributed annually; free with SASE.
Tips: Looks for talent with solid agricultural background and photographic expertise. Photos must be agriculturally and technically correct. Documentaries should "tell a true story with artistic composition and lighting."

***‡JAYAWARDENE TRAVEL PHOTO LIBRARY**, 7A Napier Rd., Wembley, Middlesex HA0 4UA United Kingdom. (0181)902-3588. Fax: (0181)902-7114. Contact: Rohith or Marion Jayawardene. Estab. 1992. Stock photo agency and picture library. Has 100,000 photos. Clients include: ad agencies, businesses, book/encyclopedia publishers, magazine publishers, newspapers, greeting card companies, postcard publishers and tour operators/travel companies.
Needs: Travel and tourism-related images worldwide, particularly of the US, the Caribbean and South America; couples/families on vacation and local lifestyle. "Pictures, especially of city views, must not be out of date."
Specs: Uses 35mm, 2¼×2¼, 6×4½ cm, 6×7cm transparencies.
Payment & Terms : Pays 50% commission. Average price per image (to clients): $125-1,000. Enforces minimum prices of $80-100, "but negotiable on quantity purchases." Offers volume discounts to customers; inquire about specific terms. Discount sales terms not negotiable. Works on contract basis only. Offers limited regional exclusivity contract. Statements issued semiannually. Payment made semiannually, within 30 days of payment received from client. Offers one-time and exclusive rights for fixed periods. Does not inform photographer or allow him to negotiate when client requests all rights. Model/property release preferred. Captions required; include country, city/location, subject description.
Making Contact: Interested in receiving work from newer, lesser-known photographers. Arrange personal interview to show portfolio. Query with samples. Query with stock photo list. SASE. Expects minimum initial submission of 300 images with periodic submission of at least 100 images on quarterly basis. Reports in 3 weeks. Photo guidelines free with SASE. Market tips sheet free with SASE.

JEROBOAM, 120-D 27th St., San Francisco CA 94110. (415)824-8085. Call for fax number. Contact: Ellen Bunning. Estab. 1972. Has 150,000 b&w photos, 150,000 color slides. Clients include: text and trade books, magazine and encyclopedia publishers and editorial.
Needs: "We want people interacting, relating photos, artistic/documentary/photojournalistic images, especially ethnic and handicapped. Images must have excellent print quality—contextually interesting and exciting, and artistically stimulating." Needs shots of school, family, career and other living situations. Child development, growth and therapy, medical situations. No nature or studio shots.
Specs: Uses 8×10 double weight glossy b&w prints with a ¾" border. Also uses 35mm transparencies.
Payment & Terms: Works on consignment only; pays 50% commission. Works without a signed contract. Statements issued monthly. Payment made monthly. Photographers allowed to review account records to verify sales figures. Offers one-time and electronic media rights. Informs photographer and allows him to negotiate when client requests all rights. Model/property release preferred for people in contexts of special education, sexuality, etc. Captions preferred; include "age of subject, location, etc."

 THE SOLID, BLACK SQUARE before a listing indicates that the market uses various types of audiovisual materials, such as slides, film or videotape.

Making Contact: Interested in receiving work from newer, lesser-known photographers. Call if in the Bay area; if not, query with samples; query with list of stock photo subjects; send material by mail for consideration or submit portfolio for review. SASE. Reports in 2 weeks.

Tips: "The Jeroboam photographers have shot professionally a minimum of five years, have experienced some success in marketing their talent and care about their craft excellence and their own creative vision. Jeroboam images are clear statements of single moments with graphic or emotional tension. We look for people interacting, well exposed and printed with a moment of interaction. New trends are toward more intimate, action shots even more ethnic images needed. Be honest in regards to subject matter (what he/she *likes* to shoot)."

■**KEYSTONE PRESS AGENCY, INC.**, 202 East 42nd St., New York NY 10017. (212)924-8123. Managing Editor: Brian F. Alpert. Types of clients: book publishers, magazines and major newspapers.
Needs: Uses photos for slide sets. Subjects include: photojournalism. Reviews stock photos/footage. Captions required.
Specs: Uses 8×10 glossy b&w and color prints; 35mm and 2¼×2¼ transparencies.
Making Contact & Terms: Cannot return material. Reports upon sale. NPI; payment is 50% of sale per photo. Credit line given.

*****KIDSTOCK**, P.O. Box 21505, Lehigh Valley PA 18002. Phone/fax: (610)559-0968. Editor: Anne Raisner. Estab. 1995. Stock photo agency. Clients include: ad agencies, public relations firms, businesses, book/encyclopedia publishers, magazine publishers, newspapers, calendar companies, greeting card companies and postcard publishers.
Needs: Photos of children and teenagers of all races and in all situations.
Specs: Uses 8×10 semigloss b&w prints; 35mm, 2¼×2¼ transparencies.
Payment & Terms: Pays 50% commission. Offers volume discounts to customers; terms specified in photographer's contract. Photographers can choose not to sell images on discount terms. Works on contract basis only. Offers nonexclusive contract. Contracts renew automatically with additionally submissions for 4 years. Statements issued quarterly. Payment made quarterly. Photographers allowed to review account records. Offers one-time rights. Model/property release preferred. Captions required; include who, what, when, where.
Making Contact: Interested in receiving work from newer, lesser-known photographers. Query with samples. Samples kept on file. SASE. Expects minimum initial submission of 60 images. Reports in 1-2 weeks. Photo guidelines free with SASE. Market tips sheet distributed twice a year to affiliated photographers; free with SASE.

■**JOAN KRAMER AND ASSOCIATES, INC.**, 10490 Wilshire Blvd., Suite 1701, Los Angeles CA 90024. (310)446-1866. Fax: (310)446-1856. President: Joan Kramer. Member of Picture Agency Council of America (PACA). Has 1 million b&w and color photos dealing with travel, cities, personalities, animals, flowers, lifestyles, underwater, scenics, sports and couples. Clients include: ad agencies, magazines, recording companies, photo researchers, book publishers, greeting card companies, promotional companies and AV producers.
Needs: "We use any and all subjects! Stock slides must be of professional quality."
Specs: Uses 8×10 glossy b&w prints; any size transparencies.
Payment & Terms: Pays 50% commission. Offers all rights. Model release required.
Making Contact: Query or call to arrange an appointment. Do not send photos before calling. SASE.

KYODO PHOTO SERVICE, 250 E. First St., Suite 1107, Los Angeles CA 90012. (213)680-9448. Fax: (213)680-3547. E-mail: kyodola@ichange.com. Business Manager: Shige Higashi. Estab. 1946. Photo department of a national news agency in Japan. Has 4 million photos in Tokyo. Clients include: newspapers.
Needs: News photos.
Specs: Uses any size prints and transparencies.
Payment & Terms: Buys photos/film outright. Pays $50-500/color photo; $50-500/b&w photo. Works with or without a signed contract. Offers nonexclusive contract. Offers one-time and electronic media rights. Captions required.
Making Contact: Query with samples. Works with local freelancers only. Cannot return material. Reports in 1 month. Catalog free, but not always available.

LANDMARK STOCK EXCHANGE, Dept. PM, 51 Digital Dr., Novato CA 94949. (415)883-1600. Fax: (415)382-6613. Photo Research Manager: Mark Sherengo. Estab. 1979. Stock photo agency and licensing agents. Clients include: advertising agencies, design firms, book publishers, magazine, postcard, greeting card and poster publishers, T-shirts, design firms and "many" gift manufacturers.
Needs: Scenics, model-released people (women/men in swimsuits, children, Afro-American), cars, still-life, illustration, unique artists and photographs, i.e., abstracts, hand-colored, b&w images.

Specs: Uses 35mm, 2¼×2¼, 4×5 transparencies.
Payment & Terms: Pays 50% commission for licensed photos. Enforces minimum prices. "Prices are based on usage." Payment made monthly. Offers one-time rights. Model/property release required. Captions preferred for scenics and animals.
Making Contact: Arrange personal interview to show portfolio. Submit portfolio for review. Query with nonreturnable samples. Query with stock photo list. Samples kept on file. SASE. Photo guidelines free on request.
Tips: "We are always looking for innovative, creative images in all subject areas, and strive to set trends in the photo industry. Many of our clients are gift manufacturers. We look for images that are suitable for publication on posters, greeting cards, etc. We consistently get photo requests for outstanding scenics, swimsuit shots (men and women), cats and dogs and wildlife."

***■LGI PHOTO AGENCY**, 241 W. 36th St., New York NY 10018. (212)736-4602. Fax: (212)643-2916. E-mail: 102115.1066@compuserve.com or lgi@interport.net. Estab. 1978. Stock photo agency and news/feature syndicate. Has 2 million photos. Clients include: advertising agencies, public relations firms, audiovisual firms, book/encyclopedia publishers, magazine publishers, newspapers and calendar companies, etc.
Needs: Images of newsworthy entertainment celebrities, politicians, sports personalities, etc. and events.
Specs: Preferably 35mm color transparencies, but also carries larger formats and b&w.
Payment & Terms: Pays 50% commission on sale of image reproduction rights. Payment made monthly.
Making Contact: Submit sample of work; include SASE or other means of return. "Not responsible for unsolicited material."

LIGHT SOURCES STOCK, 23 Drydock Ave., Boston MA 02210. (617)261-0346. Fax: (617)261-0358. E-mail: isources@tiac.net or isources@aol.com. Editor: Sonja L. Rodrigue. Estab. 1989. Stock photo agency. Has 150,000 photos. Clients include: advertising agencies, textbook/editorial publishers, magazine publishers, calendar companies, greeting card companies.
Needs: Children, families, lifestyles, educational, medical and scenics (travel).
Specs: Uses 35mm, 2¼×2¼, 4×5 transparencies/digital files.
Payment & Terms: Pays 50% commission. Average price per image (to clients): $100-2,000/ color photo. Enforces minimum prices. Offers volume discounts to customers; inquire about specific terms. Photographers can choose not to sell images on discount terms. Works on contract basis only. Offers nonexclusive contracts. Contracts renew automatically with additional submissions. Statements issued annually. "Payment is made when agency is paid by the client." Rights negotiated at time of purchase. Informs photographer and allows him to negotiate when client requests all rights. Model/property release preferred. Captions required.
Making Contact: Interested in receiving work from newer, lesser-known photographers. SASE. Send SASE to receive guidelines. Expects minimum initial submission of 200 images with periodic submission of at least 100 images every six months. Reports in 1-2 weeks.

LIGHTWAVE, 170 Lowell St., Arlington MA 02174. Phone/fax: (617)628-1052. (800)628-6809 (outside 617 area code). E-mail: lightwav1@usa1.com. Website: http//www1.usa1.com/~lightwav/. Contact: Paul Light. Has 250,000 photos. Clients include: ad agencies and textbook publishers.
 • Paul Light offers photo workshops over the Internet. Check out his website for details.
Needs: Candid photos of people in school, work and leisure activities.
Specs: Uses 35mm color transparencies.
Payment & Terms: Pays $210/photo. 50% commission. Works on contract basis only. Offers nonexclusive contract. Contracts renew automatically each year. Statements issued annually. Payment made "after each usage." Offers one-time rights. Informs photographer and allows him to negotiate when client requests all rights. Model/property release preferred. Captions preferred.
Making Contact: Send SASE or e-mail for guidelines.
Tips: "Photographers should enjoy photographing people in everyday activities. Work should be carefully edited before submission. Shoot constantly and watch what is being published. We are looking for photographers who can photograph daily life with compassion and originality."

‡LINEAIR DERDE WERELD FOTOARCHIEF, van der Helllaan 6, Arnhem 6824 HT Netherlands. (00.31)26.4456713. Fax: (00.31)26.3511123. Manager: Ron Giling. Estab. 1990. Stock photo agency. Has 100,000 photos. Clients include advertising agencies, public relations firms, book/encyclopedia publishers, magazine publishers.
 • This agency has been examining the possibilities of marketing its images via computer networks.
Needs: Interested in everything that has to do with the development of countries in Asia, Africa and Latin America.

Specs: Uses 8×10 b&w prints; 35mm, 2¼×2¼ transparencies. Pays 50% commission on color and b&w prints. Average price per image (to clients): $50-100/b&w; $100-400/color. Enforces minimum prices. Offers volume discounts to customers; inquire about specific terms. Photographers can choose not to sell images on discount terms. Works with or without a signed contract, negotiable. Offers limited regional exclusivity. Charges 50% duping fees. Statements issued quarterly. Payment made quarterly. Photographers allowed to review account records. "They can review bills to clients involved." Offers one-time rights. Informs photographer and allows him to negotiate when client requests all rights. Captions required; include country, city or region, description of the image.
Making Contact: Interested in receiving work from newer, lesser-known photographers. Submit portfolio for review. SASE. There is no minimum for initial submissions. Reports in 3 weeks. Brochure free with SASE (IRC). Market tips sheet available upon request.
Tips: "We like to see high-quality pictures in all aspects of photography. So we'd rather see 50 good ones, than 500 for us to select the 50 out of."

***♥MACH 2 STOCK EXCHANGE LTD.**, #204-1409 Edmonton Tr NE, Calgary, Alberta T2E 3K8 Canada. (403)230-9363. Fax: (403)230-5855. Manager: Pamela Varga. Estab. 1986. Stock photo agency. Member of Picture Agency Council of America (PACA). Clients include: advertising agencies, public relations firms, audiovisual firms and corporations.
Needs: Corporate, high-tech, lifestyle, industry. In all cases, prefer people-oriented images.
Specs: Uses 35mm, 2¼×2¼, 4×5, 8×10 transparencies.
Payment & Terms: Pays 50% commission on color photos. Average sale: $300. Works on contract basis only. Offers limited regional exclusivity. Contracts renew automatically with additional submissions. Charges 50% duping and catalog insertion fees. Statements issued monthly. Payment made monthly. "All photographers' statements are itemized in detail. They may ask us anything concerning their account." Offers 1-time and 1-year exclusive rights; no electronic media rights for clip art type CD's. Informs photographer and allows him to negotiate when client requests all rights. "We generally do not sell buy-out." Model/property release required. Captions required.
Making Contact: Query with samples and list of stock photo subjects. SASE. Reports in 1 month. Market tips sheet distributed 4 times/year to contracted photographers.
Tips: "Please call first. We will then send a basic information package. If terms are agreeable between the two parties then original images can be submitted pre-paid." Sees trend toward more photo requests for families, women in business, the environment and waste management. Active vibrant seniors. High-tech and computer-generated or manipulated images, minorities (Asians mostly).

***MAJOR LEAGUE BASEBALL PHOTOS**, 350 Park Ave., New York NY 10022. (212)339-8290. Fax: (212)750-3345. E-mail: rpilling@mlbp.com. Manager: Rich Pilling. Estab. 1994. Stock photo agency. Has 200,000 photos. Clients include: ad agencies, public relations firms, businesses, book/encyclopedia publishers, magazine publishers, newspapers, calendar companies, greeting card companies, postcard publishers and MLB licensees.
Needs: Photos of any subject for major league baseball—action, feature, fans, stadiums, umpires, still life.
Specs: Uses 8×10 glossy color prints; 35mm, 2¼×2¼ transparencies; CD-ROM digital format.
Payment & Terms: Buys photos outright; payment varies according to assignment. Pays 60% commission on color photos. Enforces minimum prices. Offers volume discounts to customers; inquire about specific terms. Discount sales terms not negotiable. Works on contract basis only. Offers exclusive contract only. Statements issued monthly. Payment made monthly. Photographers allowed to review account records. Offers one-time rights. Informs photographer and allows him to negotiate when client requests all rights. Captions preferred.
Making Contact: Interested in receiving work from newer, lesser-known photographers. Arrange personal interview to show portfolio. Works with local freelancers on assignment only. Samples kept on file. SASE. No minimum number of images expected with initial submission. Reports in 1-2 weeks. Photo guidlines available.

♥MASTERFILE, 175 Bloor St. E., South Tower, 2nd Floor, Toronto, Ontario M4W 3R8 Canada. (416)929-3000. Fax: (416)929-2104. E-mail: inquiries@masterfile.com. Website: http://www.masterfil e.com. Artist Liaison: Linda Crawford. Stock photo agency. Has 250,000 photos. Clients include: advertising agencies, public relations firms, audiovisual firms, book/encyclopedia publishers, magazine publishers, newspapers, postcard publishers, calendar companies, greeting card companies, all media.
 • This agency has "complete electronic imaging capabilities," including scanning, manipulation and color separations. Masterfile is also researching CD-ROM technology as a storage and cataloging medium.
Specs: Uses 35mm, 2¼×2¼, 4×5, 8×10 transparencies.
Payment & Terms: Pays 40-50% commission. Enforces minimum prices. Offers volume discounts to customers; terms specified in photographer's contract. Discount sales terms not negotiable. Works on contract basis only. Offers exclusive contract only. Contracts renew automatically with additional

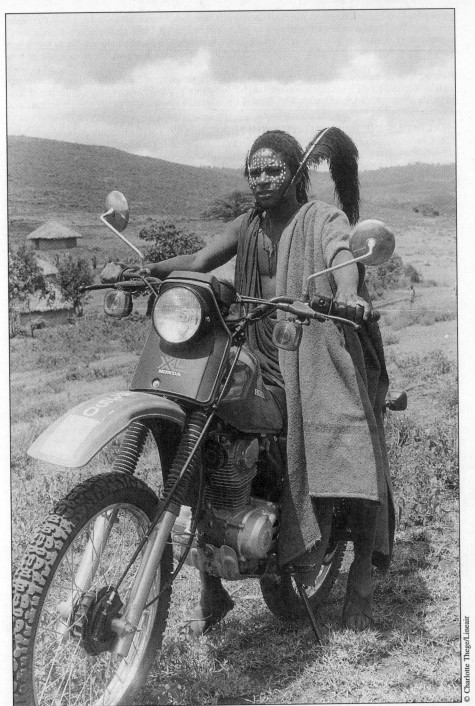

While living and working in Eastern Africa, Swedish photographer Charlotte Thege shot this photo of a Massaai youth which was used by a textbook publisher to illustrate an educational publication on indigenous people in today's world. The reprint rights were purchased through Netherlands stock agency Lineair. Thege is also represented by a Swedish stock agency.

submissions for 1 year. Charges duping and catalog insertion fees. Statements issued monthly. Payments made monthly. Photographers allowed to review account records. Informs photographer of price being negotiated; photographer given right to refuse sale. Offers one-time and electronic media rights and allows him to negotiate when client requests all rights. Model release required. Property release preferred. Captions required.

Making Contact: Ask for submission guidelines. Keeps samples on file. SASE. Expects maximum initial submission of 200 images. Reports in 1-2 weeks on portfolios; same day on queries. Photo guidelines free with SASE. Catalog $20. Market tips sheet distributed to contract photographers only.

‡**MAURITIUS DIE BILDAGENTUR GMBH**, Postfach 209, 82477 Mittenwald. Mühlenweg 18, 82481 Mittenwald Germany. Phone: 08823/42-0. Fax: 08823/8881. President: Hans-Jörg Zwez. Stock photo agency. Has 1.8 million photos. Has 5 branch offices in Germany, CFSR and Austria. Clients include: advertising agencies, businesses, book/encyclopedia publishers, magazine publishers, postcard companies, calendar companies and greeting card companies.

Needs: All kinds of contemporary themes: geography, people, animals, plants, science, economy.
Specs: Uses 2¼×2¼, 4×5 and 8×10 transparencies and 35mm for people shots.
Payment & Terms: Pays 50% commission for color photos. Offers one-time rights. Model release required. Captions required.
Making Contact: Query with samples. Submit portfolio for review. SASE. Reports in 2 weeks. Tips sheet distributed once a year.
Tips: Prefers to see "people in all situations, from baby to grandparents, new technologies, transportation."

*****MEDICAL IMAGES INC.**, 44B Sharon Rd., P.O. Box 141, Lakeville CT 06039. (860)435-8878. Fax: (860)435-8890. President: Anne Richardson. Estab. 1990. Stock photo agency. Has 50,000 photos. Clients include: advertising agencies, public relations firms, corporate accounts, book/encyclopedia publishers, magazine publishers and newspapers.

Needs: Medical and health-related material, including commercial-looking photography of generic doctor's office scenes, hospital scenarios and still life shots. Also, technical close-ups of surgical procedures, diseases, high-tech colorized diagnostic imaging, microphotography, nutrition, exercise and preventive medicine.
Specs: Uses 8×10 glossy b&w prints; 35mm, 2¼×2¼, 4×5 and 8×10 transparencies.
Payment & Terms: Pays 50% commission on b&w and color photos. Average price per image (to clients): $175-3,500. Enforces minimum prices. Works with or without contract. Offers nonexclusive contract. Contracts renew automatically. Statements and checks issued bimonthly. "If client pays within same period, photographer gets check right away; otherwise, in next payment period." Photographer's accountant may review records with prior appointment. Offers one-time and electronic media rights. Model/property release preferred. Captions required; include medical procedures, diagnosis when applicable, whether model released or not, etc.
Making Contact: Interested in receiving work from newer, lesser-known photographers. Query with list of stock photo subjects or telephone with list of subject matter. SASE. Reports in 2 weeks. Photo guidelines available. Market tips sheet distributed quarterly to contracted photographers.
Tips: Looks for "quality of photograph—focus, exposure, composition, interesting angles; scientific value; and subject matter being right for our markets." Sees trend toward "more emphasis on editorial or realistic looking medical situations. Anything too 'canned' is much less marketable."

■**MEDICHROME**, 232 Madison Ave., New York NY 10016. Manager: Ivan Kaminoff. Has 1 million photos. Clients include: advertising agencies, design houses, publishing houses, magazines, newspapers, in-house design departments, and pharmaceutical companies.

Needs: Everything that is considered medical or health-care related, from the very specific to the very general. "Our needs include doctor/patient relationships, surgery and diagnostics processes such as CAT scans and MRIs, physical therapy, home health care, micrography, diseases and disorders, organ transplants, counseling services, use of computers by medical personnel and everything in between."
Specs: "We accept b&w prints but prefer color, 35mm, 2¼×2¼, 4×5 and 8×10 transparencies."
Payment & Terms: Pays 50% commission on b&w and color photos. All brochures are based on size and print run. Ads are based on exposure and length of campaign. Offers one-time or first rights; all rights are rarely needed—very costly. Model release preferred. Captions required.
Making Contact: Query by "letter or phone call explaining how many photos you have and their subject matter." SASE. Reports in 2 weeks. Distributes tips sheet every 6 months to Medichrome photographers only.
Tips: Prefers to see "loose prints and slides in 20-up sheets. All printed samples welcome; no carousel, please. Lots of need for medical stock. Very specialized and unusual area of emphasis, very costly/difficult to shoot, therefore buyers are using more stock."

***■MEGA PRODUCTIONS, INC.**, 1714 N. Wilton Place, Los Angeles CA 90028. (213)462-6342. Fax: (213)462-7572. Director: Michele Mattei. Estab. 1974. Stock photo agency and news/feature syndicate. Has "several thousand" photos. Clients include: book/encyclopedia publishers, magazine publishers, television, film.

Needs: Needs television, film, studio, celebrity, paparazzi, feature stories (sports, national and international interest events, current news stories). Written information to accompany stories needed. "We do not wish to see fashion and greeting card-type scenics."

Specs: Uses 35mm, 2¼×2¼ transparencies.

Payment & Terms: Pays 50% commission on color photos. General price range (to clients): $100-20,000; 50% commission of sale. Offers one-time rights. Model release preferred. Captions required.

Making Contact: Query with résumé of credits. Query with samples. Query with list of stock photo subjects. Works with local freelancers. Occasionally assigns work.

Tips: "Studio shots of celebrities, and home/family stories are frequently requested." In samples, looking for "marketability, high quality, recognizable personalities and current newsmaking material. Also, looks for paparazzi celebrity at local and national events. We deal mostly in Hollywood entertainment stories. We are interested mostly in celebrity photography and current events. Written material on personality or event helps us to distribute material faster and more efficiently."

***♣MEGAPRESS IMAGES**, 5352 St. Laurent Blvd., Montreal, Quebec H2T 1S5 Canada. Phone/fax: (514)279-9859. Photo Editor: Tatiana Philiptchenko. Estab. 1992. Stock photo agency. Half million photos. Has 2 branch offices. Clients include: book/encyclopedia publishers, magazine publishers, postcard publishers, calendar companies, greeting card companies.

Needs: Photos of people (couples, children, beauty, teenagers, people at work, medical) also puppies in studio, animals, flowers, industries, celebrities and general stock.

Specs: Uses 35mm, 2¼×2¼, 4×5 transparencies.

Payment & Terms: Pays 50-60% commission on color photos. General price range (to client): $40-500/image. Enforces minimum prices. Will not negotiate below $40. Works with or without a signed contract. Offers limited regional exclusivity. Statements issued semiannually. Payments made quarterly and semiannually (depending on the sales of the photographer). Offers one-time rights. Model release preferred for people and controversial news. Captions required. Each slide must have the name of the photographer and the subject.

Making Contact: Submit portfolio for review. Query with stock photo list. Samples not kept on file. SASE. Expects minimum initial submission of 250 images with periodic submission of at least 500 pictures per year. Photo guidelines free with SASE. Market tips sheet distributed quarterly to all photographers; free with SASE.

Tips: "Pictures must be very sharp. Work must be consistent. We also like photographers who are specialized in particular subjects."

MIDWESTOCK, 1925 Central, Suite 200, Kansas City MO 64108. (816)474-0229. Fax: (816)474-2229. E-mail: midwestock@aol.com. Director: Susan L. Anderson. Estab. 1991. Stock photo agency. Has 100,000 photos. Clients include: advertising agencies, public relations firms, businesses, book/encyclopedia publishers, magazine publishers, newspapers, postcard publishers, calendar companies, greeting card companies.

• Midwestock currently uses CD-ROM discs to showcase categories of work and to provide economical scans for certain projects at standard stock prices. They do not distribute photo clip discs but are developing an online portfolio of selective photographers.

Needs: "We need more quality people shots depicting ethnic diversity." Also general interest with distinct emphasis in "Heartland" themes.

Specs: "Clean, stylized business and lifestyle themes are biggest sellers in 35mm and medium formats. In scenics, our clientele prefers medium and large formats." Uses 35mm, 4×5, 6×6, 6×7, 8×10 transparencies.

Payment & Terms: Pays 50% commission. Average price per image (to clients): $300/color. Enforces minimum prices of $195, except in cases of reuse or volume purchase. Offers volume discounts to customers; inquire about specific terms. Works on contract basis only. "We negotiate with photographers on an individual basis." Prefers exclusivity. Contracts renew automatically after 2 years and annually thereafter, unless notified in writing. Charges 50% duping and catalog insertion fees and mounting fee. Statements issued monthly. Payment made monthly. Model release required. Offers one-time and various rights; negotiable. Property release preferred. Captions required.

Making Contact: Interested in receiving work from newer, lesser-known photographers. Query with stock photo list. Request submittal information first. Expects minimum initial submission of 1,000 in 35mm format (less if larger formats). Reports in 3 weeks. Photo guidelines free with SASE. Market tips sheet distributed quarterly to photographers on contract.

Tips: "We prefer photographers who can offer a large selection of medium and large formats and who are full-time professional photographers who already understand the value of upholding stock prices and trends in marketing and shooting stock."

***MODEL IMAGE RESOURCES**, P.O. Box 21506, Lehigh Valley PA 18002. Phone/fax: (610)559-0968. Director: Richard Raisner. Estab. 1995. Specialized subject agency. Has 8,000 photos. Clients include: ad agencies, book/encyclopedia publishers, magazine publishers, calendar companies, greeting card companies, postcard publishers and international magazine publishers.

Needs: "All aspects of erotica, glamour and nudes, including abstract, couples, creative, explicit, mood and sets; photos covering desirable women of all ethnic groups for the men's publishing industry."

Specs: Uses 8×10 semigloss b&w prints; 35mm, $2\frac{1}{4} \times 2\frac{1}{4}$, 8×10 transparencies.

Payment & Terms Pays 50% commission. Enforces minimum prices. Works on contract basis only. Offers guaranteed subject exclusivity (within files). Contracts renew automatically with additional submissions for 4 years. Statement issued quarterly. Payment made quarterly. Photographers allowed to review account records. Offers one-time rights; negotiates all other types of rights except exclusive rights. Will "negotiate as intermediary for photographer when client requests all rights, but this is not a preferred option." Model release required; property release preferred. "Due to the nature of the photos we need, additional forms of identification with the release is highly desirable." Captions preferred.

Making Contact: Interested in receiving work from newer, lesser-known photographers. Query with samples. Samples kept on file. SASE. Expects minimum initial submission of 100-160 images with periodic submission of at least 1,000 images annually (bimonthly). Reports in 1-2 weeks. Photo guidelines free with SASE. Market tips sheet distributed quarterly to contracted photographers; "normally sent with statements or returned photographs."

Tips: "Seek out an agency that parallels your picture interests and strengths. We need more and more ethnic photo layouts and shots which are 'cover usable' and studio made. Exhibit professionalism: follow the tips sheets provided by the agent, use attractive models, master your lighting, provide interesting and varied backgrounds, pay attention to details and shoot, again and again and again. . . ."

MONKMEYER, 118 E. 28th St., New York NY 10016. (212)689-2242. Fax: (212)779-2549. Owner: Sheila Sheridan. Estab. 1930s. Has 500,000-800,000 photos. Clients include: book/encyclopedia publishers.

Needs: General human interest and educational images with a realistic appearance.

Specs: Uses 8×10 matte b&w prints; 35mm transparencies.

Payment & Terms: Pays 50% commission on b&w and color photos. Average price per image (to clients): $140/b&w, $185/color. "We hold to standard rates." Offers volume discounts to customers; terms specified in photographer's contract. Discount sales terms not negotiable. Offers nonexclusive contract. "We have very few contracts—negotiable." Statements issued monthly. Payment made monthly. Photographers allowed to review account records. Buys one-time rights. Informs photographer and allows him to negotiate when client requests all rights. Model/property release preferred. Captions preferred.

Making Contact: Interested in receiving work from newer, lesser-known photographers. Arrange personal interview to show portfolio. Submit portfolio for review. Keeps samples on file. SASE. Expects minimum initial submission of 200 images. Reports in 1-2 weeks. Publishes tip sheet.

Tips: "Dealing with publishers, we need specific images that will make an impact on students."

MOTION PICTURE AND TV PHOTO ARCHIVE, 16735 Saticoy St., Van Nuys CA 91406. (818)997-8292. Fax: (818)997-3998. President: Ron Avery. Estab. 1988. Stock photo agency. Member of Picture Agency Council of America (PACA). Has 100,000 photos. Clients include: advertising agencies, book/encyclopedia publishers, magazine publishers, newspapers, postcard publishers, calendar companies, greeting card companies.

Needs: Color shots of current stars and old TV and movie stills.

Specs: Uses 8×10 b&w/color prints; 35mm, $2\frac{1}{4} \times 2\frac{1}{4}$, 4×5 and 8×10 transparencies.

Payment & Terms: Buys photos/film outright. Pays 50% commission on b&w and color photos. Average price per image (to clients): $180-1,000/b&w image; $180-1,500/color image. Enforces minimum prices. Offers volume discounts to customers; terms specified in photographer's contract. Works on contract basis only. Offers exclusive contract. Contracts renew automatically with additional submissions. Statements issued monthly. Payment made monthly. Photographers allowed to review account records. Rights negotiable; "whatever fits the job."

Making Contact: Reports in 1-2 weeks.

■MOUNTAIN STOCK PHOTO & FILM, P.O. Box 1910, Tahoe City CA 96145. (916)583-6646. Fax: (916)583-5935. Manager: Meg deVré. Estab. 1986. Stock photo agency. Member of Picture Agency Council of America (PACA). Has 60,000 photos; minimal films/videos. Clients include: ad agencies, public relations firms, audiovisual firms, businesses, book/encyclopedia publishers, magazine publishers, newspapers, calendar companies, greeting card companies.

Needs: "We specialize in and always need action sports, scenic and lifestyle images."

Specs: Uses 35mm, 2¼×2¼, 4×5, transparencies.

Payment & Terms: Pays 50% commission on color photos. Enforces minimum prices. "We have a $100 minimum fee." Offers volume discounts to customers; inquire about specific terms. Discount sales terms not negotiable. Works on contract basis only. Some contracts renew automatically. Charges 50% catalog insertion fee. Statements issued quarterly. Payment made quarterly. Photographers are allowed to review account records with due notice. Offers unlimited and limited exclusive rights. Informs photographer and allows him to negotiate when client requests all rights. Model/property release required. Captions required.

Making Contact: Query with résumé of credits. Query with samples. Query with stock photo list. Samples kept on file. SASE. Expects minimum initial submission of 500 images. Reports in 1 month. Photo guidelines free with SAE and 58¢ postage. Market tips sheet distributed quarterly to contracted photographers; upon request.

Tips: "I see the need for images, whether action or just scenic, that evoke a feeling or emotion."

■‡**NATURAL SCIENCE PHOTOS**, 33 Woodland Dr., Watford, Hertfordshire WD1 3BY England. 01923-245265. Fax: 01923-246067. Partners: Peter and Sondra Ward. Estab. 1969. Stock photo agency and picture library. Members of British Association of Picture Libraries and Agencies. Has 175,000 photos. Clients include: ad agencies, public relations firms, audiovisual firms, businesses, book/encyclopedia publishers, magazine publishers, newspapers, postcard companies, calendar companies, greeting card companies and television.

Needs: Natural science of all types, including wildlife (terrestrial and aquatic), habitats (including destruction and reclamation), botany (including horticulture, agriculture, pests, diseases, treatments and effects), ecology, pollution, geology, primitive peoples, astronomy, scenics (mostly without artifacts), climate and effects (e.g., hurricane damage), creatures of economic importance (e.g., disease carriers and domestic animals and fowl). "We need all areas of natural history, habitat and environment from South and Central America, also high quality marine organisms."

Specs: Uses 35mm, 2¼×2¼ original color transparencies.

Payment & Terms: Pays 33-50% commission. General price range: $55-1,400. "We have minimum fees for small numbers, but negotiate bulk deals sometimes involving up to 200 photos at a time." Works on contract basis only. Offers nonexclusive contract. Statements issued semiannually. Payment made semiannually. "We are a private company, as such our books are for tax authorities only." Offers one-time and electronic media rights; exclusive rights on calendars. Informs photographers and permits them to negotiate when a client requests all rights. Copyright not sold without written permission. Captions required include English and scientific names, location and photographer's name.

Making Contact: Interested in receiving work from newer, lesser-known photographers. Arrange a personal interview to show a portfolio. Submit portfolio for review. Query with samples. Send unsolicited photos by mail for consideration. "We require a sample of at least 20 transparencies together with an indication of how many are on offer, also likely size and frequency of subsequent submissions." Samples kept on file. SASE. Reports in 1-4 weeks, according to pressure on time.

Tips: "We look for all kinds of living organisms, accurately identified and documented, also habitats, environment, weather and effects, primitive peoples, horticulture, agriculture, pests, diseases, etc. Animals, birds, etc., showing action or behavior particularly welcome. We are not looking for 'arty' presentation, just straightforward graphic images, only exceptions being 'moody' scenics. There has been a marked increase in demand for really good images with good color and fine grain with good lighting. Pictures that would have sold a few years ago that were a little 'soft' or grainy are now rejected, particularly where advertising clients are concerned."

NATURAL SELECTION STOCK PHOTOGRAPHY INC., 183 St. Paul St., Rochester NY 14604. (716)232-1502. Fax: (716)232-6325. E-mail: nssp@mail.netacc.net. Manager: Deborah A. Free. Estab. 1987. Stock photo agency. Member of the Picture Agency Council of America (PACA). Has 300,000 photos. Clients include: advertising agencies, public relations firms, businesses, book/encyclopedia publishers, magazine publishers, newspapers, postcard publishers, calendar companies, greeting card companies.

Needs: Interested in photos of nature in all its diversity.

Specs: All formats.

Payment & Terms: Pays 50% commission on b&w and color photos. Works on contract basis only. Offers nonexclusive contracts. Contracts renew automatically with additional submissions for 3 years.

● **A BULLET** has been placed within some listings to introduce special comments by the editor of *Photographer's Market*.

Charges 50% duping fees; 50% advertising fee. Statements issued quarterly. Payment made monthly on fees collected. Offers one-time rights. "Informs photographer when client requests all rights." Model/property release required. Captions required; include photographer's name, where image was taken and specific information as to what is in the picture.

Making Contact: Query with résumé of credits; include types of images on file, number of images, etc. SASE. Expects minimum initial submission of 200 images, with periodic submission of at least 200 images. Reports in 1 month. Photo guidelines free with SASE. Market tips sheet distributed quarterly to all photographers under contract.

Tips: "All images must be completely captioned, properly sleeved, and of the utmost quality."

NAWROCKI STOCK PHOTO, P.O. Box 16565, Chicago IL 60616. (312)427-8625. Fax: (312)427-0178. Director: William S. Nawrocki. Stock photo agency, picture library. Member of Picture Agency Council of America (PACA). Has over 300,000 photos and 500,000 historical photos. Clients include: ad agencies, public relations firms, editorial, businesses, book/encyclopedia publishers, magazine publishers, newspapers, postcard companies, calendar companies and greeting card companies.

Needs: Model-released people, all age groups, all types of activities; families; couples; relationships; updated travel, domestic and international; food.

Specs: Uses 35mm, 2¼ × 2¼, 2¼ × 2¾, 4 × 5 and 8 × 10 transparencies. "We look for good composition, exposure and subject matter; good color." Also, finds large format work "in great demand." Medium format and professional photographers preferred.

Payment & Terms: Buys only historical photos outright. Pays variable percentage on commission according to use/press run. Commission depends on agent—foreign or domestic 50%/40%/35%. Works on contract basis only. Contracts renew automatically with additional submissions for 5 years. Offers limited regional exclusivity and nonexclusivity. Charges duping and catalog insertion fees. Statements issued quarterly. Payment made quarterly. Offers one-time media and some electronic rights; other rights negotiable. Requests agency promotion rights. Informs photographer when client requests all rights. Model release required. Captions required. Mounted images required.

Making Contact: Interested in receiving work from newer, lesser-known photographers. Arrange a personal interview to show portfolio. Query with résumé of credits, samples and list of stock photo subjects. Submit portfolio for review. Provide return Federal Express. SASE. Reports ASAP. Allow 2 weeks for review. Photo guidelines free with SASE. Tips sheet distributed "to our photographers." Suggest that you call first—discuss your photography with the agency, your goals, etc. "NSP prefers to help photographers develop their skills. We tend to give direction and offer advice to our photographers. We don't take photographers on just for their images. NSP prefers to treat photographers as individuals and likes to work with them." Label and caption images. Has network with domestic and international agencies.

Tips: "A stock agency uses just about everything. We are using more people images, all types— family, couples, relationships, leisure, the over-40 group. Looking for large format—variety and quality. More images are being custom shot for stock with model releases. Model releases are very, very important—a key to a photographer's success and income. Model releases are the most requested for ads/brochures."

NETWORK ASPEN, 319 Studio N, Aspen Business Center, Aspen CO 81611. (970)925-5574. Fax: (303)925-5680. E-mail: jeffreya@infosphere.com. Founder/Owner: Jeffrey Aaronson. Studio Manager: Becky Green. Photojournalism and stock photography agency. Has 250,000 photos. Clients include: advertising agencies, public relations, businesses, book/encyclopedia publishers, magazine publishers, newspapers, calendar companies.

● This agency is a member of the Kodak Picture Exchange and has the ability to transmit photo CD images digitally via modem.

Needs: Reportage, world events, travel, cultures, business, the environment, sports, people, industry.

Specs: Uses 35mm transparencies.

Payment & Terms: Pays 50% commission on color photos. Works on contract basis only. Offers nonexclusive and guaranteed subject exclusivity contracts. Statements issued quarterly. Payments made quarterly. Photographers allowed to review account records. Offers one-time and electronic media rights. Model/property release preferred. Captions required.

Making Contact: "We prefer established photographers." Query with résumé of credits. Query with samples. Query with stock photo list. Keeps samples on file. SASE. Expects minimum initial submission of 250 duplicates. Reports in 3 weeks.

Tips: "Our agency focuses on world events, travel and international cultures, but we would also be interested in reviewing other subjects as long as the quality is excellent."

NEW ENGLAND STOCK PHOTO, 2389 Main St., Glastenburt CT 06033. (860)659-4949. Fax: (860)659-3235. President: Rich James. Stock photo agency. Has nearly 200,000 photos in files. Clients include: ad agencies; public relations firms; businesses; book/encyclopedia publishers; magazine publishers, postcard, calendar and greeting card companies.

• New England Stock Photo changed ownership in the fall of 1995.

Needs: "We are a general interest agency with a wide variety of clients and subjects. Always looking for good people shots—workplace, school, families, couples, children, senior citizens—engaged in everyday life situations, including recreational sports, home life, vacation and outdoor activities. We also get many requests for animal shots—horses, dogs, cats and wildlife (natural habitat). Special emphasis on New England—specific places, lifestyle and scenics, but also have considerable North American and international subject matter. Also use setup shots of flowers, food, nostalgia."

Specs: Uses 8×10 glossy b&w prints; 35mm, 2¼×2¼, 4×5 transparencies. "We are especially interested in more commercial/studio photography, such as food and interiors, which can be used for stock purposes. Also, we get many requests for particular historical sites, annual events, and need more coverage of towns/cities, mainstreets and museums."

Payment & Terms: Pays 50% commission for b&w and color photos; 75% to photographer on assignments obtained by agency. Average price per image (to client): $100-1,000/b&w photo; $100-3,000/color photo. Works with photographers on contract basis only. Offers nonexclusive contract. Charges catalog insertion fee. Statements issued monthly. Payments made monthly. Photographers allowed to review account records to verify sales figures. Offers one-time rights; postcard, calendar and greeting card rights. Informs photographer and allows him to negotiate when client requests all rights. Model/property release preferred (people and private property). Captions required; include who, what, where.

Making Contact: Interested in receiving work from newer, lesser-known photographers. Query with list of stock photo subjects or send unsolicited photos by mail for consideration. SASE. Reports in 3 weeks. Guidelines free with large SAE and 4 first-class stamps. Distributes monthly tips sheet to contributing photographers.

Tips: "Do a tight edit. Do not send overexposed or unmounted transparencies. We provide one of the most comprehensive photo guideline packages in the business, so write for it before submitting. Send a cross section of your best work. There has been an increased use of stock, but a demand for only top quality work. Images must have balanced lighting, great color saturation and strong focal point mood. Social issues and family situations, with an ethnic mix, are still at the top of our list of needs. Also travel (with people) and outdoor leisure activities. We work very hard to serve photographers and picture buyers as demand increases for new uses of photography through evolving technology and new media."

■**NEWS FLASH INTERNATIONAL, INC.,** Division of Observer Newspapers, 2262 Centre Ave., Bellmore NY 11710. (516)679-9888. Fax: (516)731-0338. Editor: Jackson B. Pokress. Has 25,000 photos. Clients include: ad agencies, public relations firms, businesses and newspapers.

Needs: "We handle news photos of all major league sports: football, baseball, basketball, boxing, wrestling, hockey. We are now handling women's sports in all phases, including women in boxing, basketball, softball, etc." Some college and junior college sports. Wants emphasis on individual players with dramatic impact. "We are now covering the Washington DC scene. There is currently an interest in political news photos."

Specs: Super 8 and 16mm documentary and educational film on sports, business and news; 8×10 glossy b&w prints or contact sheet; transparencies.

Payment & Terms: Pays 40-50% commission/photo and film. Pays $5 minimum/photo. Works with or without contract. Offers nonexclusive contracts. Informs photographer and allows him to negotiate when client requests all rights. Statements issued quarterly. Payment made monthly or quarterly. Photographers allowed to review account records. Offers one-time or first rights. Model release required. Captions required.

Making Contact: Interested in receiving work from newer, lesser-known photographers. Query with samples. Send material by mail for consideration or make a personal visit if in the area. SASE. Reports in 1 month. Free photo guidelines and tips sheet on request.

Tips: "Exert constant efforts to make good photos—what newspapers call grabbers—make them different than other photos, look for new ideas. There is more use of color and large format chromes." Special emphasis on major league sports. "We cover Mets, Yankees, Jets, Giants, Islanders on daily basis. Rangers and Knicks on weekly basis. We handle bios and profiles on athletes in all sports. There is an interest in women athletes in all sports."

NONSTOCK, 91 Fifth Ave., Suite 201, New York NY 10003. (212)633-2388. Fax: (212)989-9079. E-mail: nonstock1@aol.com. Vice President: Jerry Tavin. Stock photo agency. Clients include: advertising agencies, public relations firms, audiovisual firms, businesses, book/encyclopedia publishers, magazine publishers, newspapers, postcard publishers, calendar companies, greeting card companies.

Needs: Interested in images that are commercially applicable.

Specs: Uses 35mm transparencies.

Payment & Terms: Pays 50% commission. All fees are negotiated, balancing the value of the image with the budget of the client. Offers volume discounts to customers; inquire about specific terms. Photographers can choose not to sell images on discount terms. Works on contract basis only. Offers

nonexclusive contracts. Statements issued quarterly. Payment made quarterly. Photographers allowed to review account records. Offers all rights, "but we negotiate." Model/property release required. Captions preferred; include industry standards.

Making Contact: Interested in receiving work from newer, lesser-known photographers. Submit portfolio for review. Keeps samples on file. SASE. Expects minimum initial submission of 50 images. Reports in 1-2 weeks. Photo guidelines free with SASE. Catalog free with SASE.

‡OKAPIA K.G., Michael Grzimek & Co., D-60 385 Frankfurt/Main, Roderbergweg 168 Germany 01149/69/449041. Fax: 001149/69/498449; or Constanze Presse-haus, Kurfürstenstr. 72 -74 D-10787 Berlin Germany. 01149/30/26400180. Fax: 01149/30/26400182; or Bilder Pur Kaiserplatz 8 D-80803 München Germany. 01149/89/339070. Fax: 01149/89/366435. President: Grzimek. Stock photo agency and picture library. Has 700,000 photos. Clients include: ad agencies, book/encyclopedia publishers, magazine publishers, newspapers, postcard companies, calendar companies, greeting card companies and school book publishers.

Needs: Natural history, science and technology, and general interest.

Specs: Uses 35mm, $2\frac{1}{4} \times 2\frac{1}{4}$, 4×5 and 8×10 transparencies.

Payment & Terms: Pays 50% commission on b&w and color photos. Works on contract basis only. Offers nonexclusive and guaranteed subject exclusivity (within files). Contracts renew automatically for 5 years with additional submissions. Charges catalog insertion fee. Statements issued quarterly, semi-annually or annually, depending on money photographers earn. Payment made quarterly, semi-annually or annually with statement. Photographers allowed to review account records in the case of disagreements. Offers one-time, electronic media rights (if requested). Does not permit photographer to negotiate when client requests all rights. Model release required. Captions required.

Making Contact: Interested in receiving work from newer, lesser-known photographers. Send unsolicited material by mail for consideration. SASE. Expects minimum initial submission of 300 slides. Distributes tips sheets on request.

Tips: "We need every theme which can be photographed." For best results, "send pictures continuously." Work must be of "high standard quality."

*‡ORION PRESS, 1-13 Kanda-Jimbocho, Chiyoda-ku, Tokyo Japan 101. (03)3295-1400. Fax: (03)3295-0227. E-mail: orionprs@ppp.bekkoame.or.jp. Sales Manager: Shinichi Matsuoka. Estab. 1952. Stock photo agency. Has 700,000 photos. Has 3 branch offices. Clients include: advertising agencies, public relations firms, businesses, book/encyclopedia publishers, magazine publishers, newspapers, postcard publishers, calendar companies, greeting card companies.

Needs: All subjects, especially wish to have images of people.

Specs: Uses 35mm, $2\frac{1}{4} \times 2\frac{1}{4}$, 6×6 cm., 4×5, 8×10 transparencies.

Payment & Terms: Pays 40-50% commission on b&w and color photos. Average price per image (to clients): $175-290/b&w photo; $290-500/color photo. Negotiates fees below standard minimum prices. Offers volume discounts to customers; inquire about specific terms. Photographers can choose not to sell images on discount terms. Works on contract basis only. Offers limited regional exclusivity; negotiable. Contracts renew automatically with additional submissions for 2 years. Statements issued monthy. Payment made monthly. Photographers allowed to review account records. Offers one-time rights. Informs photographer and allows him to negotiate when client requests all rights. Model/property release required. Captions required.

Making Contact: Query with samples. SASE. Expects minimum initial submission of 100 images with periodic submission of at least 100-200 images. Photo guidelines free on request.

*■OUTLINE, Dept. PM, 596 Broadway, 11th Floor, New York NY 10012. (212)226-8790. President: Jim Roehrig. Personality/Portrait. Has 250,000 photos. Clients include: advertising agencies, public relations firms, magazine publishers, newspapers and production/film companies.

Needs: Heavy emphasis on personalities, film, TV, political feature stories.

Payment & Terms: General price range: negotiable. Rights negotiable. Model release preferred. Captions required.

Making Contact: Query with résumé of credits. Works with local freelancers by assignment only. Cannot return material. Reports in 3 weeks.

Tips: Prefers a photographer who can create situations out of nothing. "The market seems to have a non-ending need for celebrities and the highest-quality material will always be in demand."

■‡OXFORD SCIENTIFIC FILMS, Lower Road, Long Hanborough, Oxfordshire OX8 8LL England. +44 (993)881881. Fax: +44 (993)882808. Photo Library Assistant Manager: Suzanne Aitzetmuller. Photo Library Manager: Sandra Berry. Stock Footage Library Manager: Jane Mulleneux. Film unit and stills and film libraries. Has 350,000 photos; over one million feet of stock footage on 16mm, and 40,000 feet on 35mm. Clients include: ad agencies, design companies, audiovisual firms, book/encyclopedia publishers, magazine and newspaper publishers, merchandising companies, multimedia publishers.

Needs: Natural history: animals, plants, behavior, close-ups, life-histories, histology, embryology, electron microscopy. Scenics, geology, weather, conservation, country practices, ecological techniques, pollution, special-effects, high speed, time-lapse.

Specs: Uses 35mm and larger transparencies; 16 and 35mm film and videotapes.

Payment & Terms: Pays 40-50% commission on b&w and color photos. Enforces minimum prices. Offers volume discounts to regular customers; inquire about specific terms. Discount sale terms not negotiable. Works on contract basis only; prefers exclusivity, but negotiable by territory. Contracts renew automatically with additional submissions. "All contracts reviewed after two years initially, either party may then terminate contract, giving three months notice in writing." Statements issued quarterly. Payment made quarterly. Photographers permitted to review sales figures. Offers one-time rights and electronic media rights. Informs photographer and allows him to negotiate when client requests all rights. Photo captions required, Captions required; include common name, Latin name, behavior, location and country, magnification where appropriate.

Making Contact: Interested in receiving high quality work from both amateur and professional photographers. Enquire for stock photo list plus photographers pack. SASE. Reports in 1 month. Distributes want lists every 6 months to all photographers.

Tips: Prefers to see "good focus, composition, exposure, rare or unusual natural history subjects and behavioral shots."

■**PACIFIC STOCK**, 758 Kapahulu Ave., Suite 250, Honolulu HI 96816. (808)735-5665. Fax: (808)735-7801. E-mail: pacstock@pacstock.com. Owner/President: Barbara Brundage. Estab. 1987. Stock photo agency. Member of Picture Agency Council of America (PACA). Has 150,000 photos. Clients include advertising agencies, public relations firms, audiovisual firms, businesses, book/encyclopedia publishers, magazine publishers, postcard companies, calendar companies and greeting card companies. Previous/current clients: American Airlines, *Life* magazine (cover), Eveready Battery (TV commercial).

Needs: "Pacific Stock is the *only* stock photo agency worldwide specializing exclusively in Pacific- and Asia-related photography. Locations include North American West Coast, Hawaii, Pacific Islands, Australia, New Zealand, Far East, etc. Subjects include: people, travel, culture, sports, marine science and industrial."

Specs: Uses 35mm, 2¼×2¼, 4×5 and 8×10 (all formats) transparencies.

Payment & Terms: Pays 50% commission on color photos. Works on contract basis only. Offers limited regional exclusivity. Charges catalog insertion rate of 50%/image. Statements issued monthly. Payment made monthly. Photographers allowed to review account records to verify sales figures. Offers one-time or first rights; additional rights with photographer's permission. Informs photographer and allows him to negotiate when client requests all rights. Model and property release required for all people and certain properties, i.e., homes and boats. Photo captions are required; include: "who, what, where."

Making Contact: Query with résumé of credits and list of stock photo subjects. SASE. Reports in 2 weeks. Photo guidelines free with SASE. Tips sheet distributed quarterly to represented photographers; free with SASE to interested photographers.

Tips: Looks for "highly edited shots preferably captioned in archival slide pages. Photographer must be able to supply minimum of 1,000 slides (must be model released) for initial entry and must make quarterly submissions of fresh material from Pacific and Asia area destinations and from areas outside Hawaii." Major trends to be aware of include: "increased requests for 'assignment style' photography so it will be resellable as stock. The two general areas (subject) requested are: tourism usage and economic development. Looks for focus, composition and color. As the Asia/Pacific region expands, more people are choosing to travel to various Asia/Pacific destinations, while greater development occurs, i.e., tourism, construction, banking, trade, etc. Be interested in working with our agency to supply what is on our want lists."

PAINET, 466 Loring Place, El Paso TX 79927. (915)852-4840. Fax: (915)852-3343. Owner: Mark Goebel. Estab. 1985. Picture library. Has 60,000 photos. Clients include: advertising agencies and magazine publishers.

Needs: "We publish catalogs to market our photos. Our primary emphasis is on 'people' pictures. However, we would review animals and graphic scenics."

Specs: Uses 35mm transparencies, 8×10 b&w prints.

Payment & Terms: Pays 40-60% commission; at 40%, photographer keeps transparency—image is scanned and marketed electronically; at 60%, transparency remains in-house. Statements issued monthly. Payment made monthly. Photographers allowed to review account records. Offers one-time rights. Informs photographer and allows him to negotiate when client requests all rights.

Making Contact: Interested in receiving work from newer, lesser-known photographers. Query with samples. Samples not kept on file. SASE. Submit 20 of your best dupes in a 35mm slide preserver sheet. Include return postage. Reports in 1-2 weeks.

Tips: "Selected photographers will be asked to put 50 of their best images on Kodak Photo CD. Images will be immediately included in 5,000 image 4-color catalog which is distributed to over 2,000 markets. Kodak Photo CD will be returned to photographer. No original transparencies are kept by Painet, enabling photographers to market their images elsewhere. Painet only markets color images electronically or by contact with the photographer."

DOUGLAS PEEBLES PHOTOGRAPHY, 445 Iliwahi Loop, Kailua, Oahu HI 96734. (808)254-1082. Fax: (808)254-1267. E-mail: peeples@aloha.com. Owner: Douglas Peebles. Estab. 1975. Stock photo agency. Has 50,000 photos. Clients include: advertising agencies, public relations firms, businesses, magazine publishers, newspapers, postcard companies and calendar companies.
Needs: South Pacific and Hawaii.
Specs: Uses 35mm, 2¼×2¼, 4×5 color transparencies.
Payment & Terms: Pays 50% commission on color photos. General price range: $100-5,000/color photo. Works on contract basis only. Offers nonexclusive contract. Charges 50% duping fee. Statements issued quarterly. Payment made quarterly. Photographers allowed to review account records to verify sales figures. Offers one-time rights. Model/property release required. Captions preferred.
Making Contact: Contact by telephone. SASE. Reports in 1 month. Photo guideline sheet not available.
Tips: Looks for "strong color, people in activities and model released. Call first."

***PHOTO AGORA**, Hidden Meadow Farm, Keezletown VA 22832. Phone/fax: (540)269-8283. E-mail: photoagora@aol.com. Contact: Robert Maust. Estab. 1972. Stock photo agency. Has 25,000 photos. Clients include: businesses, book/encyclopedia and textbook publishers, magazine publishers and calendar companies.
Needs: Families, children, students, Virginia, Africa, work situations, etc.
Specs: Uses 8×10 matte and glossy b&w prints; 35mm, 2¼×2¼, 4×5 transparencies.
Payment & Terms: Pays 50% commission on b&w and color photos. Average price per image (to clients): $40-100/b&w photo; $125-250/color photo. Negotiates fees below standard minimum prices. Offers volume discounts to customers; inquire about specific terms. Photographers can choose not to sell images on discount terms. Works with or without a signed contract. Offers nonexclusive contract. Statements issued quarterly. Payment made quarterly. Photographer allowed to review account records. Offers one-time rights. Informs photographer and allows him to negotiate when client requests all rights. Model/property release preferred. Captions required; include location, important dates, names etc.
Making Contact: Interested in receiving work from newer, lesser-known photographers. Call. Samples not kept on file. SASE. No minimum number of images required in initial submission. Reports in 3 weeks. Photo guidelines free with SASE.

‡PHOTO DIRECT STOCK PHOTOGRAPHY, P.O. Box 312, Sans Souci 2219 NSW Australia. Phone/fax: (02)583-1778. Image Researcher: Goran Zdraveski. Estab. 1992. Has 12,500 photos. Has 2 branch offices. Clients include: advertising agencies, businesses, book/encyclopedia publishers, magazine publishers, postcard publishers, calendar companies.
 • This agency is using Kodak Photo CD for self-promotion and cataloging, and eventually wants to produce low resolution CD-ROM catalogs.
Needs: Corporate, travel, lifestyles and industry.
Specs: 35mm, 2¼×2¼, 4×5 transparencies.
Payment & Terms: Pays 30-50% commission. Offers volume discounts to customers; inquire about specific terms. Discount sales terms not negotiable. Works on contract basis only. Offers nonexclusive contract. Contracts renew automatically with additional submissions for 5 years. Charges 50% duping fee, 50% catalog insertion rate, scanning services at 50%. Statements issued quarterly. Payment made quarterly. Offers one-time and electronic media rights. Model/property release required. Captions required; include accurate descriptions, scientific names where appropriate (i.e., flowers and animals).
Making Contact: Interested in receiving work from newer, lesser-known photographers. Query with stock photo list. SASE. Expects minimum initial submission of 100 images with periodic submissions of at least 100 images every 3 months. Reports in 3 weeks. Photo guidelines free with SASE. Market tips sheet distributed every 6 months to contributing photographers with SASE upon request.

■‡PHOTO INDEX, 2 Prowse St., West Perth 6005 Western Australia. (09)481-0375. Fax: (09)481-6547. Manager: Lyn Woldendorp. Estab. 1979. Stock photo agency. Has 100,000 photos. Clients

‡ **THE DOUBLE DAGGER** before a listing indicates that the market is located outside the United States and Canada.

include: advertising agencies, public relations firms, audiovisual firms, businesses, book/encyclopedia publishers, magazine publishers, postcard publishers, calendar companies.
Needs: Needs generic stock photos, especially lifestyle, sport and business with people.
Specs: Uses 35mm, 2¼×2¼, 4×5 transparencies.
Payment & Terms: Pays 50% commission on color photos. Offers volume discounts to customers. Works on exclusive contract basis only. Five-year contract renewed automatically. Statements issued quarterly. Payment made quarterly. Photographers permitted to review account records to verify sales figures or account for various deductions "within reason." Offers one-time rights. Informs photographer and allows him to negotiate when client requests all rights. Model/property release required. Captions required.
Making Contact: Interested in receiving work from professional stock photographers. Query with samples. Expects minimum initial submission of 1,000 images with periodic submission of at least several hundred, quarterly. Reports in 1-2 weeks. Photo guidelines free with SASE. Catalog available. Market tips sheet distributed quarterly to contributing photographers.
Tips: "A photographer working in the stock industry should treat it professionally. Observe what sells of his work in each agency, as one agency's market can be very different to another's. Take agencies' photo needs lists seriously. Treat it as a business."

‡THE PHOTO LIBRARY (Photographic Library of Australia, Ltd.), Level 1, No. 7 West St., North Sydney 2060 N.S.W. Australia. (02)9929-8511. Fax: (02)9923-2319. Editor: Lucette Moore. General photo library. Has over 500,000 photos. Clients include: advertising agencies, book/magazine publishers, government departments and corporate clients.
Needs: Good-quality, strong images.
Specs: Uses 35mm, 120 roll film and 4×5 transparencies.
Payment & Terms: Pays 50% commission for photos. Offers exclusive images in Australia and New Zealand contract following expiration of agreement: continues until photographer wants to withdraw images. Statements issued quarterly. Photographers allowed to verify sales figures once a year. Payment made quarterly; 10 days after end of quarter. Photographer allowed to review his own account, once per year to verify sales figures. Requires model release (held by photographer) and accurate photo captions.
Making Contact: Send submission of photos (including return postage) by mail for consideration to Lucette Moore. Guidelines free with SASE.
Tips: Notes "35mm does not sell as well as the medium and large formats but will accept 35mm if other formats are included."

■‡PHOTO LIBRARY INTERNATIONAL, Box 75, Leeds LS7 3NZ United Kingdom. 0113 2623005. Managing Director: Kevin Horgan. Picture library. Clients include ad agencies, public relations firms, audiovisual firms, businesses, book/encyclopedia publishers, magazine publishers, newspapers, postcard companies, calendar companies and greeting card companies.
Needs: Most contemporary subjects, excluding personalities or special news events, i.e., industry, sport, travel, transport, scenics, animals, commerce, agriculture, people, etc.
Specs: Uses 35mm, 2¼×2¼ and 4×5 transparencies.
Payment & Terms: 50% commission.

■PHOTO NETWORK, Dept. PM, 1541 Parkway Loop, Suite J, Tustin CA 92680. (714)259-1244. Fax: (714)259-0645. Owner: Cathy Aron. Stock photo agency. Member of Picture Agency Council of America (PACA). Has 500,000 photos. Clients include: ad agencies, AV producers, textbook companies, graphic artists, public relations firms, newspapers, corporations, magazines, calendar companies and greeting card companies.
Needs: Needs shots of personal sports and recreation, industrial/commercial, high-tech, families, couples, ethnics (all ages), animals, travel and lifestyles. Special subject needs include people over 55 enjoying life, medical shots (patients and professionals), children and animals.
Specs: Uses 35mm, 2¼×2¼, 4×5 transparencies.
Payment & Terms: Pays 50% commission. Works on contract basis only. Offers limited regional exclusivity. Contracts automatically renew with each submission for 3 years. Charges catalog insertion fee, rate not specified. Statements issued monthly. Payment made monthly. Photographers allowed to review account records to verify sales figures. Offers one-time rights. Informs photographer and allows him to negotiate when client requests all rights. Model/property release preferred. Captions preferred; include places—parks, cities, buildings, etc. "No need to describe the obvious, i.e., mother with child."
Making Contact: Query with list of stock photo subjects. Send a sample of 200 images for review. SASE. Reports in 1 month.
Tips: Wants to see a portfolio "neat and well-organized and including a sampling of photographer's favorite photos." Looks for "clear, sharp focus, strong colors and good composition. We'd rather have many very good photos rather than one great piece of art. Would like to see photographers with a specialty or specialties and have it covered thoroughly. You need to supply new photos on a regular

basis and be responsive to current trends in photo needs. Contract photographers are supplied with quarterly 'want' lists and information about current trends."

PHOTO RESEARCHERS, INC., 60 E. 56th St., New York NY 10022. (212)758-3420. Fax: (212)355-0731. Stock photography agency representing over 1 million images specializing in science, wildlife, medicine, people and travel. Member of Picture Agency Council of American (PACA). Clients include: ad agencies, graphic designers, publishers of textbooks, encyclopedias, trade books, magazines, newspapers, calendars, greeting cards and annual reports in US and foreign markets.
 • Photo Researchers has 10,000 images on CD-ROM categorized by subject with The Picture Exchange online service.
Needs: All aspects of natural history, science, astronomy, medicine, people (especially contemporary shots of teens, couples and seniors). Particularly needs model-released people, European wildlife, up-to-date travel and scientific subjects.
Specs: Any size transparencies.
Payment & Terms: Rarely buys outright; works on 50% stock sales and 30% assignments. General price range (to clients): $150-7,500. Works on contract basis only. Offers limited regional exclusivity. Contracts renew automatically with additional submissions for 5 years initial term/1 year thereafter. Charges 50% foreign duping for subagents; 50% catalog insertion fee; placement cost when image sells (if no sales or sales less than 50% placement amount, 0-49%). Photographers allowed to review account records upon reasonable notice during normal business hours. Statements issued monthly, bimonthly or quarterly, depending on volume. Offers one-time, electronic media and one-year exclusive rights. Informs photographers and allows him to negotiate when a client requests to buy all rights, but does not allow direct negotiation with customer. Model/property release required for advertising; preferred for editorial. Captions required; include who, what, where, when. Indicate model release on photo.
Making Contact: Interested in receiving work from newer, lesser-known photograhers. Query with description of work, type of equipment used and subject matter available. Send to Bug Sutton, Creative Director. Submit portfolio for review when requested. SASE. Reports in 1 month maximum.
Tips: "When a photographer is accepted, we analyze his portfolio and have consultations to give the photographer direction and leads for making sales of reproduction rights. We seek the photographer who is highly imaginative or into a specialty and who is dedicated to technical accuracy. We are looking for serious photographers who have many hundreds of photographs to offer for a first submission and who are able to contribute often."

***PHOTO RESOURCE HAWAII**, 116 Hekili St., #204, Kaiwa HI 96734. (808)599-7773. Fax: (808)599-7754. Owner: Tami Dawson. Estab. 1983. Stock photo agency. Has 75,000 photos. Clients include: ad agencies, audiovisual firms, businesses, book/encyclopedia publishers, magazine publishers, calendar companies, greeting card companies and postcard publishers.
Needs: Photos mainly of Hawaii and some of the South Pacific.
Specs: Uses 35mm, 2¼×2¼, 4×5 transparencies.
Payment & Terms: Pays 50% commission. Enforces minimum prices. Offers volume discounts to customers. Discount sales terms not negotiable. Works on contract basis only. Offers nonexclusive contract. Contracts renew automatically with additional submissions. Statements issued bimonthly. Payment made bimonthly. Photographers allowed to review account records. Offers one-time and other negotiated rights. Does not inform photographer or allow him to negotiate when client requests all rights. Model/property release preferred. Captions required.
Making Contact: Interested in receiving work from newer, lesser-known photographers. Query with samples. Works with local freelancers only. Samples kept on file. SASE. Expects minimum initial submission of 100 images with periodic submissions at least 5 times a year. Reports in 3 weeks.

■✦PHOTO SEARCH LTD., 10130 103rd St., #107, Edmonton, Alberta T5J 3N9 Canada. (403)425-3766. Fax: (403)425-3766. Photo Editor: Gerry Boudrias. Estab. 1991. Stock photo agency. Has 75,000 photos. Clients include: advertising agencies, public relations firms, audiovisual firms, businesses, book/encyclopedia publishers, magazine publishers, newspapers, postcard publishers, calendar companies, graphic designers, government agencies.
Needs: "We are looking for, almost exclusively, top-notch lifestyle images. Couples, families, business people, industrial, and any other images that show people at work and at play. Good-looking models are a must, as are ethnic diversity, a variety of ages of models, and positive images of the disabled."
Specs: Uses 35mm, 2¼×2¼, 4×5 color transparencies. Prefers medium and large format.
Payment & Terms: Pays 50% commission on color photos. Average price per image (to clients): $100-400/color photo; editorial work ranges from $100-200; advertising work ranges from $200-500. Works on limited regional exclusivity contract basis only. "All contracts are automatically renewed for a one-year period, unless either party provides written notice." Statements issued "as required." Payment made "upon payment by client." Photographers allowed to review account records. Offers

one-time and electronic media rights; "will negotiate rights to meet clients' needs." Informs photographer and allows him to negotiate when client requests all rights. "While we reserve the right to final judgment, we confer with photographers about all-right sales. We insist on doing what we feel is right for the agency and the photographer." Model/property release required. "Model releases are imperative for photographers who wish to make sales in the advertising field." Captions required. "Point out information that could be important that may not be evident in the image."

Making Contact: Interested in receiving work from newer, lesser-known photographers who have adequate size collections. Submit portfolio for review. Query with samples. Query with stock photo list. SASE. Expects minimum initial submission of 200 images. Reports in 1 month. Photo guidelines free with SASE. Send international postage for all mailings outside Canada. "General list for anybody on request."

Tips: "Show as broad a range of subjects as possible, not just your best shots. Versatility is an important quality in stock photographers. Photographers should contact several agencies in the hope of finding one that can meet their needs and financial expectations. Who you sign with is a *very* important decision that could affect your career for many years to come. Marketing methods are constantly changing, due in part to the advent of electronic imaging. The way we serve our clientele, their needs, and the way we supply our images and services will continue to change in the near future. Only photographers with collections of lifestyle images should contact us. It is practically the only section of the collection in which the demand for material outweighs the supply."

PHOTO 20-20, 435 Brannan St., San Francisco CA 94107. (415)543-8983. Fax: (415)543-2199. Principal Editor: Ted Streshinsky. Estab. 1990. Stock photo agency. Has 350,000 photos. Clients include: advertising agencies, public relations firms, book/encyclopedia publishers, magazine publishers, newspapers, calendar companies, greeting card companies, design firms.

● This agency also markets images via the Picture Network International.

Needs: Interested in all subjects.

Specs: Uses 35mm, 2¼ × 2¼, 4 × 5, 8 × 10 transparencies.

Payment & Terms: Pays 50% commission on b&w and color photos; "25% to agency on assignment." Average price per image (to clients): $300/b&w; $300/color. Enforces minimum prices. Photographers can choose not to sell images on discount terms. Works on contract basis only. Offers nonexclusive contract. Contract renews automatically. "As payment for their work arrives checks are sent with statements." Photographers allowed to review account records. Offers one-time rights; negotiable. Requests photographer's permission to negotiate when client requests all rights. Model/property release preferred. Captions required; include location and all pertinent information.

Making Contact: Interested in receiving queries from photographers. Query with stock photo list. Expects minimum initial submission of 300 images with periodic submission of at least 300 images every 2 months. Reports in 1-2 weeks. Market tips sheet distributed every 2 months to contracted photographers.

Tips: "Our agency's philosophy is to try to avoid competition between photographers within the agency. Because of this we look for photographers who are specialists in certain subjects and have unique styles and approaches to their work. Photographers must be technically proficient, productive, and show interest and involvement in their work."

■PHOTOBANK, 17952 Skypark Circle, Suite B, Irvine CA 92714. (714)250-4480. Fax: (714)752-5495. Photo Editor: Ted Wilcox. Stock photo agency. Has 750,000 transparencies. Clients include: ad agencies, public relations firms, audiovisual firms, book/encyclopedia publishers, magazine publishers, postcard companies, calendar publishers, greeting card companies, corporations and multimedia users.

Needs: Emphasis on active couples, lifestyle, medical, family and business. High-tech shots are always needed. These subjects are highly marketable, but model releases are a must.

Specs: Uses all formats: 35mm, 2¼ × 2¼, 4 × 5, 6 × 7 and 8 × 10 transparencies; color only.

Payment & Terms: Pays 50% commission. Average price per image (to clients): $275-500/color photo. Negotiates fees below minimum prices. Offers volume discounts to customers; terms specified in photographer's contract. Photographers can choose not to sell images on discount terms. Works on contract basis only. Offers exclusive, limited regional exclusive, nonexclusive and guaranteed subject exclusivity contracts. Contracts renew automatically with additional submissions. Statements issued quarterly. Payment made quarterly. Photographers permitted to review account records to verify sales figures or account for various deductions. Offers one-time rights, electronic media rights and agency promotion rights. Informs photographer and allows him to negotiate when client requests all rights. Model/property release required. Captions preferred.

Making Contact: Query with samples and list of stock photos. SASE. Reports in 2 weeks. Photo guidelines free with SASE.

Tips: "Clients are looking for assignment quality and are very discerning with their selections. Only your best should be considered for submission. Please tightly edit your work before submitting. Model-released people shots in lifestyle situations (picnic, golf, tennis, etc.) sell."

PHOTOEDIT, 110 W. Ocean Blvd., Suite 430, Long Beach CA 90802-4623. President: Leslye Borden. Estab. 1987. Stock photo agency. Member of Picture Agency Council of America (PACA). Has 500,000 photos. Clients include: ad agencies, public relations firms, businesses, book/encyclopedia publishers, magazine publishers.
Needs: People—seniors, teens, children, families, minorities.
Specs: Uses 35mm transparencies.
Payment & Terms: Pays 50% commission on color photos. Average price per image (to clients): $200/quarter page textbook only, other sales higher. Works on contract basis only. Offers nonexclusive contract. Charges catalog insertion fee of $400/image. Statements issued quarterly; monthly if earnings over $1,000/month. Payment made monthly or quarterly at time of statement. Photographers are allowed to review account records. Offers one-time rights; limited time use. Consults photographer when client requests all rights. Model release preferred for people.
Making Contact: Arrange a personal interview to show portfolio. Submit portfolio for review. Query with samples. Samples not kept on file. SASE. Expects minimum initial submission of 1,000 images with additional submission of 1,000 per year. Reports in 1 month. Photo guidelines free with SASE.
Tips: In samples looks for "drama, color, social relevance, inter-relationships, current (*not* dated material), tight editing. We want photographers who have easy access to models (not professional) and will shoot actively and on spec."

***PHOTOGRAPHIC RESOURCES INC.**, 6633 Delmar, St. Louis MO 63130. (314)721-5838. Fax: (314)721-0301. President: Ellen Curlee. Estab. 1986. Stock photo agency. Member of the Picture Agency Council of America (PACA). Has 250,000 photos. Clients include: ad agencies, public relations firms, businesses, greeting card companies and postcard publishers.
Needs: Lifestyles, sports and medical.
Specs: Uses 8×10 glossy b&w prints; 35mm, 2¼×2¼, 4×5, 8×10 transparencies.
Payment & Terms: Pays 50% commission. Works on contract basis only. Offers exclusive and guaranteed subject exclusivity contracts. Contracts renew automatically with additional submissions. Charges catalog insertion fee. Statements issued monthly. Payment made monthly. Offers negotiable rights. Informs photographer when a client requests all rights. Model/property release required. Captions required.
Making Contact: Interested in receiving work from newer, lesser-known photographers. Query with samples. Reports in 3 weeks. Catalog free with SASE. Market tips sheet distributed quarterly to photographers on contract.

PHOTONICA, 141 Fifth Ave., 8 S, New York NY 10010. (212)505-9000. Fax: (212)505-2200. Director of Photography: Jane Yeomans. Estab. 1987. Stock photo agency. Member of the Picture Agency Council of America (PACA). Clients include: ad agencies, public relations firms, audiovisual firms, businesses, book/encyclopedia publishers, magazine publishers, newspapers, postcard publishers, calendar companies, greeting card companies, graphic designers.
Needs: Travel, scenics, still life, people, sports, industry, environment, conceptual, food.
Specs: Uses 8×10 color and b&w prints; 35mm, 2¼×2¼, 4×5, 8×10 transparencies.
Payment & Terms: Pays 50% commission on b&w and color photos. Works on contract basis only. Payment made quarterly. Photographers allowed to review account records. Offers one-time rights. Model/property release preferred. Captions required.
Making Contact: Interested in receiving work from newer, lesser-known photographers, as well as established photographers. Submit portfolio for review. Keeps samples on file. SASE. Expects minimum initial submisson of 20 images with periodic submissions of at least 1-100 images quarterly. Reports within the week (2-3 days). Photo guidelines free with SASE.
Tips: "We look for high-quality work that is marketable, yet still evocative and visually interesting."

■PHOTOPHILE, 2400 Kettner Blvd., Studio 250, San Diego CA 92101. (619)595-7989. Fax: (619)595-0016. Owner: Nancy Likins-Masten. Clients include: ad agencies, public relations firms, audiovisual firms, businesses, publishers, postcard and calendar producers, and greeting card companies.
Needs: Lifestyle, vocations, sports, industry, entertainment, business and computer graphics.
Specs: Uses 35mm, 2¼×2¼, 4×5 and 6×7 original transparencies.
Payment & Terms: Pays 50% commission. NPI. Works on contract basis only. Offers limited regional exclusivity. Contracts renew automatically for 5 years. Statements issued quarterly. Payment made quarterly; photographers paid 30 days after payment is received from client. Photographers are allowed to review account records. Rights negotiable; usually offers one-time rights. Informs photographer and allows him to negotiate when client requests all rights. Model/property release required. Captions required, include location or description of obscure subjects; travel photos should be captioned with complete destination information.

Making Contact: Write with SASE for photographer's information. "Professionals only, please." Expects a minimum submission of 500 saleable images and a photographer must be continuously shooting to add new images to files.

Tips: "Specialize, and shoot for the broadest possible sales potential. Get releases!" Points out that the "greatest need is for model-released people subjects; sharp-focus and good composition are important." If photographer's work is saleable, "it will sell itself."

PHOTOREPORTERS, INC., Dept. PM, 875 Avenue of the Americas, New York NY 10001. (212)736-7602. Fax: (212)465-0651. Owners: Bruce Pomerantz and Kerry McCarthy. Estab. 1950. Stock photo agency. Has 2 million photos. Member of the Picture Agency Council of America (PACA). Clients include: advertising agencies, public relations firms, book/encyclopedia publishers, magazine publishers, newspapers and calendar companies.

• Photoreporters accepts submissions on floppy disks or SyQuest.

Needs: Celebrities, politics, news and photo stories such as human interest.

Specs: Uses up to 8×10 glossy color and b&w prints; $2\frac{1}{4} \times 2\frac{1}{4}$ and 35mm transparencies.

Payment & Terms: Pays 50% commission on b&w and color photos. General price range (to clients): minimum \$175/b&w; minimum \$200/color; rate based on usage. Enforces minimum prices. Offers volume discounts. Photographers can choose not to sell images on discount terms. Works with or without contract; exclusive, negotiable. Contracts renew automatically with additional submissions. Statements issued monthly. Payment made monthly. Photographers are allowed to review account records to verify sales figures. Offers one-time and negotiated rights. "We consult with photographer on buying of all rights and price." Model release preferred. Captions required.

Making Contact: Interested in working with newer lesser-known photographers. Arrange personal interview to show portfolio. Keeps samples on file. SASE. Expects minimum initial submssion of 40. Reports in 3 weeks. Market tips sheet available on request.

PHOTOSEARCH, P.O. Box 92656, Milwaukee WI 53202. (414)271-5777. President: Nicholas Patrinos. Estab. 1970. Stock photo agency. Has 910,000 photos. Has 2 branch offices. Clients include: ad agencies, public relations firms, audiovisual firms, businesses, book/encyclopedia publishers, magazine publishers, newspapers, postcard publishers, calendar companies, greeting card companies, network TV/nonprofit market (social services types).

Needs: Interested in all types of photos.

Specs: Uses 8×10 any finish b&w prints; 35mm, $2\frac{1}{4} \times 2\frac{1}{4}$, 4×5, 8×10 transparencies.

Payment & Terms: Buys photos; pays \$300-5,000/image. Pays 50% commission on b&w and color photos. Offers volume discounts to customers; terms specified in photographer's contract. Photographers can choose not to sell images on discount terms. Works with or without contract. Offers limited regional exclusivity, nonexclusive, guaranteed subject exclusivity contracts. Contracts renew automatically with additional submissions. Statements issued upon sale. Payment made immediately upon sale receipt from clients. Offers one-time, electronic media and agency promotion rights. Does not inform photographer or allow him to negotiate when client requests all rights. "This is pre-arranged and understood with the photographers." Model/property release required. Captions preferred; include basic specifics (i.e., place, date, etc.).

Making Contact: Interested in receiving work from newer, lesser-known photographers. Query with stock photo list. Keeps samples on file. SASE. Expects minimum initial submission of 250 images. Reports in 6 weeks or less. Photo guidelines free with SASE. Market tips sheet faxed directly to photographer, free with SASE.

■PHOTRI INC., 3701 S. George Maxon Dr., Suite C2 North, Falls Church VA 22041. (703)931-8600. Fax: (703)998-8407. Subagency: MGA/Photri Inc., 40 E. Ninth St., Suite 1109, Chicago IL 60605. (312)987-0078. Fax: (312)987-0134. President: Jack Novak. Member of Picture Agency Council of America (PACA). Has 1 million b&w photos and color transparencies of all subjects. Clients include: book and encyclopedia publishers, ad agencies, record companies, calendar companies, and "various media for AV presentations."

Needs: Military, space, science, technology, romantic couples, people doing things, humor, picture stories. Special needs include calendar and poster subjects. Needs ethnic mix in photos. Has sub-agents in 10 foreign countries interested in photos of USA in general.

Specs: Uses 8×10 glossy b&w prints; 35mm and larger transparencies.

Payment & Terms: Seldom buys outright; pays 35-50% commission. Pays: \$45-65/b&w photo; \$100-1,500/color photo; \$50-100/film/ft. Negotiates fees below standard minimums. Offers volume discounts to customers; terms specified in photographer's contract. Discount sale terms not negotiable. Works with or without contract. Offers nonexclusive contract. Charges \$150 catalog insertion fee. Statements issued quarterly. Payment made quarterly. Photographers allowed to review records. Offers one-time, electronic media and agency promotion rights. Informs photographer and allows him to negotiate when client requests all rights. Model release required if available and if photo is to be used for advertising purposes. Property release required. Captions required.

Making Contact: Interested in receiving work from newer, lesser-known photographers. Call to arrange an appointment or query with résumé of credits. SASE. Reports in 2-4 weeks.

Tips: "Respond to current needs with good quality photos. Take, other than sciences, people and situations useful to illustrate processes and professions. Send photos on energy and environmental subjects. Also need any good creative 'computer graphics.' Subject needs include major sports events."

To portray "speed, multi-dimensional space and time, imagination, freedom, perspective, flight, infinity," this postcard image was created by Bill Howe of Photri, Inc. in Adobe Photoshop, combining three different photos wholly owned by Photri, a Virginia-based stock photo library. "The final image is being used as a mailer/postcard for the company sent to present and prospective clients."

■‡**PICTOR INTERNATIONAL, LTD.**, Lymehouse Studios, 30-31 Lyme St., London NW1 0EE England. (171)482-0478. Fax: (171)267-5759. Creative Director: Alberto Sciama. Stock photo agency and picture library with 17 offices including London, Paris, Munich, Milan, New York and Washington DC. Clients include: advertising agencies, public relations firms, audiovisual firms, businesses, book/encyclopedia publishers, magazine publishers, postcard companies, calendar companies, greeting card companies and travel plus decorative posters; jigsaw companies.

Needs: "Pictor is a general stock agency. We accept *all* subjects. Needs primarily people shots (released): business, families, couples, children, etc. Criteria for acceptance: photos which are technically and aesthetically excellent."

Specs: Uses 35mm, 6×6cm, 6×7cm and 4×5 transparencies.

Payment & Terms: Pays 50% commission for color photos. General price range: $100-$15,000. Statements issued monthly. Offers one-time rights, first rights and all rights. Requires model release and photo captions. Buys photos outright depending on subject.

Making Contact: Arrange a personal interview to show portfolio. Query with list of stock photo subjects. Send unsolicited photos by mail for consideration. Photo guidelines sheet available for SASE. Publishes annual catalog. Tips sheet for "photographers we represent only."

Tips: Looks for "photographs covering all subjects. Clients are getting more demanding and expect to receive only excellent material. Through our marketing techniques and PR, we advertise widely the economic advantages of using more stock photos. Through this technique we're attracting 'new' clients who require a whole different set of subjects."

■**THE PICTURE CUBE INC.**, Dept. PM, 67 Broad St., Boston MA 02109. (617)443-1113. Fax: (617)443-1114. E-mail: piccube@shore.net. President: Sheri Blaney. Member of Picture Agency Council of America (PACA). Has 300,000 photos. Clients include: ad agencies, public relations firms, businesses, audiovisual firms, textbook publishers, magazine publishers, encyclopedia publishers,

newspapers, postcard companies, calendar companies, greeting card companies and TV. Guidelines available with SASE.

Needs: US and foreign coverage, contemporary images, agriculture, industry, energy, high technology, religion, family life, multicultural, animals, transportation, work, leisure, travel, ethnicity, communications, people of all ages, psychology and sociology subjects. "We need lifestyle, model-released images of families, couples, technology and work situations. We emphasize New England/Boston subjects for our ad/design and corporate clients."

Specs: Uses 8×10 prints; 35mm, $2\frac{1}{4} \times 2\frac{1}{4}$, 4×5 and larger slides. "Our clients use both color and b&w photography."

Payment & Terms: Pays 50% commission. General price range (to clients): $150-400/b&w; $175-500/color photo. "We negotiate special rates for nonprofit organizations." Offers volume discounts to customers; inquire about specific terms. Discount sales terms not negotiable. Works on contract basis only. Offers limited regional exclusivity contract. Contracts renew automatically for 3 years. Charges 50% catalog insertion fee. Payment made bimonthly with statement. Photographers allowed to review account records to verify sales figures. Offers one-time rights. Model/property release preferred. Captions required; include event, location, description, if model-released.

Making Contact: Request guidelines before sending any materials. Arrange a personal interview to show portfolio. SASE. Reports in 1 month.

Tips: "Black & white photography is being used more and we will continue to stock it." Serious freelance photographers "must supply a good amount (at least 1,000 images per year, sales-oriented subject matter) of material, in order to produce steady sales. All photography submitted must be high quality, with needle-sharp focus, strong composition, correctly exposed. All of our advertising clients require model releases on all photos of people, and often on property (real estate)."

■PICTURE LIBRARY ASSOCIATES, 4800 Hernandez Dr., Guadalupe CA 93434. (805)343-1844. Fax: (805)343-6766. Director of Marketing: Robert A. Nelson. Estab. 1991. Stock photo agency. Has 32,000 photos. Clients include: ad agencies, public relations firms, audiovisual firms, businesses, book/encyclopedia publishers, magazine publishers, newspapers, postcard publishers, calendar companies, greeting card companies, electronic publishing companies.

Needs: All subjects. Specifically senior activities, health-related subjects; black, Hispanic, Asian and other ethnic people in everyday activities, animals, birds (other than North American). Write with SASE for want lists.

Specs: Uses 8×10 glossy b&w prints; 35mm, $2\frac{1}{4} \times 2\frac{1}{4}$, 4×5 transparencies; videotape (contact agency for specifics).

Payment & Terms: Photographer specifies minimum amount to charge. Pays 50% commission on b&w, color photos and videotape. Negotiates fees based on both media's published price schedule, minimum stated in photographer's contract, if any, and type of usage. This agency uses ASMP contract. Offers volume discounts to customers; terms specified in photographer's contract. Photographers can choose not to sell images on discount terms. Works on contract basis only. All renewal clauses are tailored to meet needs of a specific client, usually 1 time renewal option at a stated price. Charges 100% duping fees. Catalog insertion rate being determined. Charges shipping costs of images to and from Picture Library Associates and photographer. Statements issued bimonthly under terms listed in photographer/agency contract. Payment made within a few days of agency's receipt of payment. Photographers may review their sales records at any time during business hours. Offers electronic media rights, one-time North American rights, one-time world-wide rights, renewal rights based on original license fee. Photographer and agency negotiate with client on requests to buy all rights. Model/property release required for recognizable persons and recognizable property. Captions required; include who, what, common name, Latin name of principal subject in each image.

Making Contact: Interested in receiving work from newer, lesser-known photographers as well as established ones. Submit portfolio for review. Contact agency for guidelines before submission. Samples not kept on file. SASE. Expects minimum initial submission of 40-60 images. No required minimum. Prefer frequency of 60 days or less. Reports in 3 weeks. Photo guidelines with SAE and 78¢ postage. Computer printout of subject categories to clients on request. Publishes newsletter. No regular schedule. Distributed to photographers under contract and anyone requesting it; free with SASE. Established photographers asked to consider PLA as an additional agency.

Tips: "Primarily look at technical quality for reproduction, subject matter, similars with varied composition, color choices. Increased need for ethnic people. Need people doing things. Need senior citizen activity. Need health-related subject matter with people involved. Shoot for a theme when possible. Submit new stock regularly. Every image must be numbered. Arrange images on a slide page. Group images by category. Pre-edit images to include only technically excellent ones."

***■PICTURE PERFECT USA, INC.**, 254 W. 31st St., New York NY 10001. (212)279-1234. Fax: (212)279-1241. Contact: Robert Tod. Estab. 1991. Stock photo agency. Has 500,000 photos. Clients include: ad agencies, graphic design firms, public relations firms, audiovisual firms, businesses, book/

INSIDER REPORT

Agencies Hunt Worldwide for Creative Skills

Read magazines and newsletters that cover the stock photography industry and you will often encounter the name Pictor International Ltd. Established in 1957, Pictor has become one of the premier agencies in the world with offices in London, Paris, Munich, Hamburg, Vienna, New York, Washington DC, Atlanta and Santa Monica, California. In North America you might know them as Uniphoto, a branch based in Washington DC. (See Uniphoto's listing in this section.)

Managing Director Alberto Sciama says Pictor has agents in 15 countries and plans to expand. Since Sciama's agency represents over 100 photographers worldwide, we wanted him to offer advice to photographers who are new to the stock industry. In this article, Sciama offers opinions about the stock industry and, in particular, the best way to gain representation.

Q. How do you find new photographers for your agency? What attracts you, or your staff, to the work of a new photographer?

A. The photographers we represent recommend friends/colleagues to us and so do clients. We publish catalogs yearly and advertise heavily throughout the territories where we have offices. Photographers like what they see and contact us. We are naturally always attracted by the work of photographers who have a new creative approach to a standard subject, work where the photographer creates and communicates a message, or work that has a fresh look.

Q. Do you prefer larger formats over 35mm?

A. The photographer has to use the best camera he feels comfortable with to give him the shot he visualizes. For example, it is generally easier to take an industrial shot on 35mm. Once the shot is produced, the best way of selling it becomes a marketing exercise. The larger the picture is presented to the client, the better from a sales point of view.

Q. Are stock agencies saturated with photographers?

A. Not at Pictor. We are very choosy about the photographers we take on and are careful not to sign up too many who work in any one subject. We do not retain photographers who do not produce images regularly.

Q. Do photographers have a better chance to gain representation if they shoot very specific topics, or should they shoot a variety of subjects?

A. It is expensive to produce pictures. Not many photographers have the funds to shoot regularly on spec. Few photographers have the experience to produce, well, a multitude of subjects.

Q. Do you have any advice for someone interested in working with stock agencies, particularly when seeking foreign representation?

A. We prefer new photographers visit us, either in London or Washington DC, with their work. If a visit is not possible, we require them to send a representative

INSIDER REPORT, *Sciama*

Alberto Sciama of Pictor International Ltd. in London says stock agencies worldwide are interested in building lasting relationships with quality photographers. The key is for photographers to provide images that communicate messages to viewers in innovative ways. Take, for instance, this image which was digitally created to represent surfing the Internet.

INSIDER REPORT, *continued*

portfolio. Work/advice is discussed at this point. We stress to all our photographers that their work must have an excellent aesthetic/creative and technical quality. Financial returns are commensurate with the number of good images accepted. A photographer who sends one submission a year cannot usually expect to receive comparable returns to those of a photographer who sends a submission every month.

Also, photographers should search for one agent with whom they can build a rapport and trust, and expect to stay with for a long time. An open, loyal, solid relationship is vital. The agent should have a network of offices and sub-agents around the world. Also, it is vital that the photographer produces top-quality material, some of which the agent can use in annual catalogs.

Q. Discuss the importance of model releases.

A. Model releases are essential. A photographer can lose a lot of sales if releases aren't available. Clients are now starting to ask for property releases, not only in the U.S., but in Europe as well.

Q. What's your impression of the international market for stock photographs? What topics are the most popular among buyers?

A. The international market for stock images is very good if the right pictures are produced and sent to the right countries. Travel is a very good subject sales wise. However, only expertly produced images sell well as the market is flooded with such material and there are excellent people producing such pictures. Other subjects that sell well include business, people, industry, medical and social issues, educational, ethnic groups and conceptual work.

Q. What common mistakes do you see photographers making on a regular basis?

A. Some photographers think they can shoot everything. Some tend to produce a picture "on-the-cheap" and the final product reflects it. Also, they often don't thoroughly study the subjects they want to shoot.

Q. Discuss the financial end of stock. Can a photographer expect to make a lot of money shooting stock?

A. It could take up to two years before returns start coming in. Unless a photographer can invest in regular production, the returns will be erratic and sometimes depressing. Yes, photographers can expect to make a good living shooting stock, but it takes a lot of discipline, finances, creativity and determination to regularly produce products of the highest standards. ✉

encyclopedia publishers, magazine publishers, newspapers, postcard publishers, calendar companies, greeting card companies, corporations.

Needs: General—people, lifestyles, business, industry, travel, recreation, sports.

Specs: Uses 35mm, 4×5, 6×4.5, 6×6, 6×7, 6×9 transparencies.

Payment & Terms: Pays 50% commission. Average price per image (to clients): varies by usage. Enforces minimum prices. Offers volume discounts to customers. Works on contract basis only. Offers nonexclusive contract. Contracts renew automatically with additional submissions; usually same as original contract. Catalog insertion rate varies according to project. Statements issued quarterly on paid up accounts. Payment made quarterly. Photographers allowed to review account records. Offers one-time rights. "We negotiate on photographer's behalf." Model/property release required. Captions required.

Making Contact: Interested in receiving work from established commercial photographers only. Submit portfolio for review. "Phone/write—first." SASE. Expects minimum initial submission of 1-2,000 images with submissions of 500-2,000 images 2 times/year. Photo guidelines free with SASE.
Tips: "All subjects, commercial applications, sharp, well composed, colorful—any format—color only. Business situations, lifestyles, model-released people shots in particular. We market photos nationally and are heavily involved in catalog distribution worldwide."

***PICTURE THAT, INC.**, Dept. PM, 880 Briarwood Rd., Newtown Square PA 19073. (215)353-8833. Stock Librarian: Lili Etezady. Estab. 1978. Stock photo agency. Clients include: ad agencies, public relations firms, businesses, book/encyclopedia publishers, magazine publishers, postcard companies, calendar companies and greeting card companies.
Needs: Handles all subjects: nature, scenics, sports, people of all types and activities, animals, some abstracts and art, and travel (especially East Coast and Pennsylvania).
Specs: Uses 35mm and 2¼ × 2¼ transparencies and others.
Payment & Terms: Pays 50% commission on photos. General price range (to clients): varies with usage and circulation. Works with or without contract. Offers limited regional exclusivity and guaranteed subject exclusivity in contracts. Charges 100% duping fees. Statements issued monthly. Payment made "within ten days from when we get paid." Offers one-time rights. Informs photographer and allows him to negotiate when client requests all rights. "We negotiate for them if they agree." Model release preferred. Captions required.
Making Contact: Query with list of stock photo subjects. SASE. Call for info.
Tips: Likes to see good color and good exposure. Send images in plastic sheets with captions and photographer's name on slides. "We encourage new photographers as we build our stock. We are receiving more and more requests for lifestyle photos, people in all situations, especially active and sports shots; also senior citizens. They must be model-released."

■PICTURESQUE STOCK PHOTOS, 1520 Brookside Drive #3, Raleigh NC 27604. (919)828-0023. Fax: (919)828-8635. Manager: Syd Jeffrey. Estab. 1987. Stock photo agency. Member of Picture Agency Council of America (PACA). Has 200,000 photos. Clients include: ad agencies, design firms, corporations, book/encyclopedia publishers and magazine publishers.
Needs: Travel/destination, model-released people, lifestyle, business, industry and general topics.
Specs: Uses 35mm, 2¼ × 2¼, 4 × 5 transparencies.
Payment & Terms: Pays 50% commission. Works on contract basis only. Offers nonexclusive contract. Contracts renew automatically. Statements issued monthly. Payment made monthly. Photographers allowed to review account records. Offers one-time, electronic media and various rights depending on client needs. Contacts photographer for authorization of sale when client requests all rights. Model/property release required. Captions required.
Making Contact: Interested in receiving work from newer, lesser-known photographers. Contact by telephone for submissions guidelines. SASE. Reports in 1 month. Tips sheet distributed quarterly to member photographers.
Tips: Submission requirements include maximum 200 original transparencies; wide range of subjects.

***■‡PLANET EARTH PICTURES**, 4 Harcourt St., London E14 9FX England. 0171 293 2999. Fax: 0171 293 2998. Managing Director: Gillian Lythgoe. Has 200,000 photos. Clients include: ad agencies, public relations and audiovisual firms, businesses, book/encyclopedia and magazine publishers, and postcard and calendar companies.
Needs: "Marine—surface and underwater photos covering all marine subjects, marine natural history, seascapes, natural history. All animals and plants: interrelationships and behavior, landscapes, natural environments, pollution and conservation." Special subject needs: polar and rainforest animals and scenery, animal behavior.
Specs: Uses any size transparencies.
Payment & Terms: Pays 50% commission on color photos. General price range: £50 (1 picture/1 AV showing), to over £1,000 for advertising use. Prices negotiable according to use. Charges £100 per page catalog insertion fee. Works on contract basis only. Offers exclusive and nonexclusive contracts and limited regional exclusivity. Statements issued quarterly. Payment made quarterly. Photographers allowed to review account records. Offers one-time rights. Informs photographer and allows him to negotiate when client requests all rights. Model release preferred. Captions required.
Making Contact: Arrange a personal interview to show portfolio. Send photos by mail for consideration. SASE. Reports ASAP. Distributes tips sheet every 6 months to photographers.
Tips: "We like photographers to receive our photographer's booklet and current color brochure that gives details about photos and captions. In reviewing a portfolio, we look for a range of photographs on any subject—important for the magazine market—and the quality. Trends change rapidly. There is a strong emphasis that photos taken in the wild are preferable to studio pictures. Advertising clients still

like larger format photographs. Exciting and artistic photographs used even for wildlife photography, protection of environment."

***POSITIVE IMAGES**, 89 Main St., Andover MA 01810. (508)749-9901. Fax: (508)749-2747. Manager: Pat Brown. Stock photo agency. Member ASPP. Clients include ad agencies, public relations firms, book/encyclopedia publishers, magazine publishers, greeting card companies, sales/promotion firms, design firms.
 ● This agency has images on *The Stock Workbook* CD-ROM.
Needs: Garden/horticulture, nature, human nature—all suitable for advertising and editorial publication.
Payment & Terms: Pays 50% commission. "3% of all our stock sales are donated to charity. Our photographers decide to whom the money should go." Works on contract basis only. Offers limited regional exclusivity. Charges 50% fee for CD insertion, 100% of which is refunded when photo sells. Statements issued quarterly. Payment issued monthly. Photographers allowed to review account records. Offers one-time and electronic media rights. "We never sell all rights."
Making Contact: Query letter. Call to schedule an appointment. Reports in 2 weeks.
Tips: "We take on only one or two new photographers per year. We respond to everyone who contacts us and have a yearly portfolio review. Positive Images accepts only fulltime working professionals who can contribute regular submissions for review."

■‡PRO-FILE, 2B Winner Commercial Building, 401-403 Lockhart Rd., Wanchai, Hong Kong. (852)2574-7788. Fax: (852)2574-8884. E-mail: nfarrin@nk.linkage.net. Director: Neil Farrin. Stock photo agency. Has 100,000 photos. Clients include: ad agencies, public relations firms, audiovisual firms, businesses, book/encyclopedia publishers, magazine publishers and calendar companies.
 ● Pro-File will be using computer networks and CD-ROMs to market and store images.
Needs: General stock, emphasis on Asian destinations and Asian model-released pictures.
Specs: Uses 35mm, 2¼×2¼ and 4×5 transparencies.
Payment & Terms: Pays 50% commission; 70% on films. Works on contract basis only. Offers guaranteed subject exclusivity (within files) and limited regional exclusivity. Charges duping and catalog insertion fees. Statements issued quarterly. Payment made quarterly. Photographers allowed to review account records to verify sales figures. Offers one-time, electronic media and agency promotion rights. Requests agency promotion rights. Informs photographer and allows him to negotiate when client requests all rights. Model/property release required. Captions required.
Making Contact: Interested in receiving work from newer, lesser-known photographers. Query with résumé of credits and list of stock photo subjects. SASE. Reports in 3 months. Distributes tips sheet "as necessary" to current photographers on file.
Tips: Has second office in Singapore; contact main office for information.

***■RAINBOW**, Dept. PM, P.O. Box 573, Housatonic MA 01236. (413)274-6211. Fax: (413)274-6689. E-mail: rainbow@bcn.net.com. Director: Coco McCoy. Library Manager: Maggie Leonard. Estab. 1976. Stock photo agency. Member of Picture Agency Council of America (PACA). Has 195,000 photos. Clients include: public relations firms, design agencies, audiovisual firms, book/encyclopedia publishers, magazine publishers and calendar companies. 20% of sales come from overseas.
 ● In the near future this agency plans to offer its own CD-ROM discs with around 2,000 images.
Needs: Although Rainbow is a general coverage agency, it specializes in high technology images and is continually looking for talented coverage in fields such as computer graphics, pharmaceutical and DNA research, photomicrography, communications, lasers and space. "We are also looking for graphically strong and colorful images in physics, biology and earth science concepts; also active children, teenagers and elderly people. Worldwide travel locations are always in demand, showing people, culture and architecture. Our rain forest file is growing but is never big enough!"
Specs: Uses 35mm and larger transparencies.
Payment & Terms: Pays 50% commission. General price range: $165-1,000. Works with or without contract, negotiable. Offers limited regional exclusivity contract. Contracts renew automatically with each submission; no time limit. Charges duping fee of 50%/image. Statements issued quarterly. Payment made quarterly. Photographers allowed to review account records to verify sales figures. Offers one-time rights. Informs photographer and allows him to negotiate when client requests all rights. Model release is required for advertising, book covers or calendar sales. Photo captions required for scientific photos or geographic locations, etc.; include simple description if not evident from photo

✱ THE ASTERISK before a listing indicates that the market is new in this edition. New markets are often the most receptive to freelance submissions.

© Neil Farrin/Pro-file

Photos like this shot by Pro-file Photo Library founder Neil Farrin showing "Asian families who are affluent and modern" are increasingly in demand in Asian countries, says Pro-file's Mark Graham. This photo has been used in a variety of editorial and corporate publications. "As a stock agency we are aware of this need. We brought out an Asian catalog in 1996."

both Latin and common names for plants and insects help to make photos more valuable.

Making Contact: Interested in receiving work from newer, lesser-known photographers. "Photographers may write or call us for more information. We may ask for an initial submission of 150-300 chromes." Arrange a personal interview to show portfolio or query with samples. SASE. Published professionals only. Reports in 2 weeks. Guidelines sheet for SASE. Distributes a tips sheets twice a year.

Tips: "The best advice we can give is to encourage photographers to better edit their photos before sending. No agency wants to look at grey rocks backlit on a cloudy day! With no caption!" Looks for well-composed, well-lit, sharp focused images with either a concept well illustrated or a mood conveyed by beauty or light. "Clear captions help our researchers choose wisely and ultimately improve sales. As far as trends in subject matter go, strong, simple images conveying the American Spirit . . . - families together, farming, scientific research, winning marathons, hikers reaching the top, are the winners. And include females doing 'male' jobs, black scientists, Hispanic professionals, Oriental children with a blend of others at play, etc. The importance of model releases for editorial covers, selected magazine usage and always for advertising/corporate clients cannot be stressed enough!"

■✳**REFLEXION PHOTOTHEQUE**, 1255 Square Phillips, Suite 307, Montreal, Quebec H3B 3G1 Canada. (514)876-1620. Fax: (514)876-3957. President: Michel Gagne. Estab. 1981. Stock photo agency. Has 100,000 photos. Clients include: ad agencies, public relations firms, audiovisual firms,

businesses, book/encyclopedia publishers, magazine publishers, newspapers, postcard companies, calendar companies and greeting card companies.
- Reflexion Phototheque sells mostly by catalog.

Needs: Model-released people of all ages in various activities. Also, beautiful homes, recreational sports, North American wildlife, industries, US cities, antique cars, hunting and fishing scenes, food, and dogs and cats in studio setting.

Specs: Uses 35mm, $2\frac{1}{4} \times 2\frac{1}{4}$, 4×5, 8×10 transparencies.

Payment & Terms: Pays 50% commission on color photos. Average price per image: $150-500. Enforces minimum prices. Offers volume discounts to customers; inquire about specific terms. Discount sales terms not negotiable. Works on contract basis only. Offers limited regional exclusivity. Contracts renew automatically for 5 years. Charges 50% duping fee and 100% catalog insertion fee. Statements issued quarterly. Payment made monthly. Offers one-time rights. Model/property release preferred. Photo captions required; include country, place, city, or activity.

Making Contact: Interested in receiving work from newer, lesser-known photographers. Arrange a personal interview to show portfolio. Query with list of stock photo subjects. Submit portfolio for review. SASE. Reports in 1 month. Photo guidelines available.

Tips: "Limit your selection to 200 images. Images must be sharp and well exposed. Send only if you have high quality material on the listed subjects."

RETNA LTD., 18 E. 17th St., 3rd Floor, New York NY 10003. (212)255-0622. Contact: Julie Grahame. Estab. 1979. Member of the Picture Agency of America (PACA). Stock photo agency, assignment agency. Has 1 million photos. Clients include advertising agencies, public relations firms, book/encyclopedia publishers, magazine publishers, newspapers and record companies.
- Retna wires images worldwide to sub agents.

Needs: Handles photos of musicians (pop, country, rock, jazz, contemporary, rap, R&B) and celebrities (movie, film, television and politicians). Covers New York, Milan and Paris fashion shows; has file on royals.

Specs: Uses 8×10 b&w prints; 35mm and $2\frac{1}{4} \times 2\frac{1}{4}$ transparencies; b&w contact sheets; b&w negatives.

Payment & Terms: Pays 50% commission on b&w and color photos. General price range (to clients): $125-1,500. Works on contract basis only. Contracts renew automatically with additional submissions for 5 years. Statements issued monthly. Payment made monthly. Offers one-time rights; negotiate. When client requests all rights photographer will be consulted, but Retna will negotiate. Model/property release required. Captions required.

Making Contact: Works on contract basis only. Arrange a personal interview to show portfolio. Primarily concentrating on selling stock, but do assign on occasion. Does not publish "tips" sheets, but makes regular phone calls to photographers.

Tips: Wants to see a variety of musicians/actors shot in studio, as well as concert. Photography must be creative, innovative and of the highest aesthetic quality possible.

■**REX USA LTD**, 351 W. 54th St., New York NY 10019. (212)586-4432. Fax: (212)541-5724. Manager: Charles Musse. Estab. 1935. Stock photo agency, news/feature syndicate. Affiliated with Rex Features in London. Member of Picture Agency Council of America (PACA). Has 1.5 million photos. Clients include: ad agencies, public relations firms, audiovisual firms, businesses, book/encyclopedia publishers, magazine publishers, newspapers, postcard companies, calendar companies, greeting card companies and TV, film and record companies.

Needs: Primarily editorial material: celebrities, personalities (studio portraits, candid, paparazzi), human interest, news features, movie stills, glamour, historical, geographic, general stock, sports and scientific.

Specs: Uses all sizes and finishes of b&w and color prints; 35mm, $2\frac{1}{4} \times 2\frac{1}{4}$, 4×5, and 8×10 transparencies; b&w and color contact sheets; b&w and color negatives; VHS videotape.

Payment & Terms: Pays 50-65% commission; payment varies depending on quality of subject matter and exclusivity. "We obtain highest possible prices, starting at $100-100,000 for one-time sale." Pays 50% commission on b&w and color photos. Works with or without contract. Offers nonexclusive contracts. Statements issued monthly. Payment made monthly. Photographers allowed to review account records. Offers one-time rights, first rights and all rights. Informs photographer and allows him to negotiate when client requests all rights. Model release required. Captions required.

Making Contact: Interested in receiving work from newer, lesser-known photographers. Arrange a personal interview to show portfolio. Query with samples. Query with list of stock photo subjects. SASE if mailing photos, send no more than 40. Reports in 1-2 weeks.

■**H. ARMSTRONG ROBERTS**, Dept. PM, 4203 Locust St., Philadelphia PA 19104. (800)786-6300. Fax: (800)786-1920. President: Bob Roberts. Estab. 1920. Stock photo agency. Member of the Picture Agency Council of America (PACA). Has 2 million photos. Has 2 branch offices. Clients include: advertising agencies, public relations firms, audiovisual firms, businesses, book/encyclopedia

publishers, magazine publishers, newspapers, postcard publishers, calendar companies and greeting card companies.

Needs: Uses images on all subjects in depth except personalities and news.

Specs: Uses b&w negatives only; 35mm, $2\frac{1}{4} \times 2\frac{1}{4}$, 4×5 and 8×10 transparencies.

Payment & Terms: Buys only b&w negatives outright. NPI; rate varies. Pays 35% commission on b&w photos; 45-50% on color photos. Works with or without a signed contract, negotiable. Offers various contracts including exclusive, limited regional exclusivity, and nonexclusive. Guarantees subject exclusivity within files. Charges duping fee 5%/image. Charges .5%/image for catalog insertion. Statements issued monthly. Payment made monthly. Payment sent with statement. Photographers allowed to review account records to verify sales figures "upon advance notice." Offers one-time rights. Informs photographer and allows him to negotiate when client requests all rights. Model release and captions required.

Making Contact: Interested in receiving work from newer, lesser-known photographers. Query with résumé of credits. Does not keep samples on file. SASE. Expects minimum initial submission of 250 images with quarterly submissions of 250 images. Reports in 1 month. Photo guidelines free with SASE.

■**RO-MA STOCK**, 1003 S. Los Robles Ave., Pasadena CA 91106-4332. (818)799-7733. Fax: (818)799-6622. Owner: Robert Marien. Estab. 1989. Stock photo agency. Member of Picture Agency Council of America (PACA). Has more than 150,000 photos. Clients include: ad agencies, multimedia firms, corporations, graphic design and film/video production companies.

• RO-MA STOCK markets its best images on-line through the new Kodak Picture Exchange and throughout its affiliated domestic agency, Index Stock Photography, Inc. located in New York City. CD-ROM catalog under production to be distributed nationwide and internationally.

Needs: Looking for fictional images of Earth and outerspace, microscopic and electromicrographic images of insects, micro-organisms, cells, etc. General situations in sciences (botany, ecology, geology, astronomy, weather, natural history, medicine). Also extreme close-up shots of animal faces including baby animals. Very interested in people (young adults, elderly, children and babies) involved with nature and/or with animals and outdoor action sports involving every age range. People depicting their occupations as technicians, workers, scientists, doctors, executives, etc. Most well-known landmarks and skylines around the world are needed.

Specs: Primarily uses 35mm. "When submitting medium and large formats, these images should have a matching 35mm slide for scanning purposes. This will speed up the process of including selected images in their marketing systems. All selected images are digitized and stored on Photo-CD."

Payment & Terms: Pays 50% commission on b&w and color; international sales, 40% of gross. General price range: $200. Offers volume discounts to customers; terms specified in photographer's contract. Contract renews automatically with each submission (of 1,000 images) for 1 year. Charges 100% duping fees; 50% catalog insertion fee from commissions and $3.50/each image in the Kodak Picture Exchange and CD-ROM catalog to cover half of digitizing cost. Statements issued with payment. Offers one-time rights and first rights. Informs photographer when client requests all rights for approval. Model/property release required for recognizable people and private places "and such photos should be marked with 'M.R.' or 'N.M.R.' respectively." Captions required for animals/plants; include common name, scientific name, habitat, photographer's name; for others include subject, location, photographer's name.

Making Contact: Interested in receiving work from newer, lesser-known photographers. Query with résumé of credits, tearsheets or samples and list of specialties. No unsolicited original work. Responds with tips sheet, agency profile and questionnaire for photographer with SASE. Photo guidelines and tips distributed periodically to contracted photographers.

Tips: Wants photographers with "ability" to produce excellent competitive photographs for the stock photography market on specialized subjects and be willing to learn, listen and improve agency's file contents. Looking for well-composed subjects, high sharpness and color saturation. Emphasis in medical and laboratory situations; people involved with the environment, manufacturing and industrial. Also, photographers with collections of patterns in nature, art, architecture and macro/micro imagery are welcome.

■**S.K. STOCK**, P.O. Box 460880, Garland TX 75046-0880. (214)494-5915. Photo Manager: Sam Copeland. Estab. 1985. Stock photo agency. Has 1,500 photos. Clients include: public relations firms, book/encyclopedia publishers, magazine publishers, calendar companies and greeting card companies.

Needs: Wants to see nudes, flowers.

Specs: Uses 4×6, 4×4, color and/or b&w prints; 35mm $2\frac{1}{4} \times 2\frac{1}{4}$, 4×5 and 8×10 transparencies; film; VHS videotape.

Payment & Terms: Buys photos when needed; pays $50/color photo; $50/b&w photo; $80/minute of videotape footage. Pays 50% commission on b&w, color, film and videotape. Average price per image (to clients): $100-300/b&w; $75-150/color; $100-400/film. Negotiates fees below standard minimum prices. Works on contract basis only. Offers nonexclusive contract. Charges $5 catalog insertion

fee. Statements issued bimonthly. Payment made at time of sale. Photographers allowed to review account records "so that they can see they are not being cheated." Offers one-time rights. Informs photographer and allows him to negotiate when client requests all rights "as long as I get 10 percent." Model/property release required. Captions required; include title, what, when, where and send a list of all work.

Making Contact: Interested in receiving work from newer, lesser-known photographers. Query with samples. Query with stock photo list. Keeps samples on file. SASE. Expects minimum initial submission of 30 images with periodic submission of at least 30 images every other month. Reports in 3 weeks. Photo guidelines free with SASE. Market tips sheet distributed every 3 months; free with SASE upon request.

Tips: "Your work must be sharp. We need people who will submit work all the time, clear and sharp."

■‡**SCIENCE PHOTO LIBRARY, LTD.**, 112 Westbourne Grove, London W2 5RU England. (0171)727-4712. Fax: (0171)727-6041. Research Director: Rosemary Taylor. Stock photo agency. Has 100,000 photos. Clients include: ad agencies, public relations firms, audiovisual firms, businesses, book/encyclopedia publishers, magazine publishers, newspapers, postcard companies, calendar companies and greeting card companies.

Needs: SPL specializes in all aspects of science, medicine and technology. "Our interpretation of these areas is broad. We include earth sciences, landscape, and sky pictures; and animals. We have a major and continuing need of high-quality photographs showing science, technology and medicine *at work*: laboratories, high-technology equipment, computers, lasers, robots, surgery, hospitals, etc. We are especially keen to sign up American freelance photographers who take a wide range of photographs in the fields of medicine and technology. We like to work closely with photographers, suggesting subject matter to them and developing photo features with them. We can only work with photographers who agree to our distributing their pictures throughout Europe, and preferably elsewhere. We duplicate selected pictures and syndicate them to our agents around the world."

Specs: Uses color prints and 35mm, 2¼×2¼, 4×5, 6×7, 6×5 and 6×9 transparencies.

Payment & Terms: Pays 50% commission for b&w and color photos. General price range (to clients): $80-1,000; varies according to use. Only discount below minimum for volume or education. Offers volume discounts to customers; inquire about specific terms. Discount sales terms not negotiable. Works on contract basis only. Offers exclusivity; exceptions are made; subject to negotiation. Agreement made for 4 years; general continuation is assured unless otherwise advised. Statements issued quarterly. Payment made quarterly. Photographers allowed to review account records to verify sales figures; fully computerized accounts/commission handling system. Offers one-time and electronic media rights. Model release required. Captions required.

Making Contact: Query with samples or query with list of stock photo subjects. Send unsolicited photos by mail for consideration. Returns material submitted for review. Reports in 1 month.

Tips: Prefers to see "a small (20-50) selection showing the range of subjects covered and the *quality*, style and approach of the photographer's work. Our bestselling areas in the last two years have been medicine and satellite imagery. We see a continuing trend in the European market towards very high-quality, carefully-lit photographs. This is combined with a trend towards increasing use of medium and large-format photographs and decreasing use of 35mm (we make medium-format duplicates of some of our best 35mm); impact of digital storage/manipulation; problems of copyright and unpaid usage. The emphasis is on an increasingly professional approach to photography."

SHARPSHOOTERS, INC., 4950 SW 72nd Ave., Suite 114, Miami FL 33155. (305)666-1266. Fax: (305)666-5485. Manager, Photographer Relations: Edie Tobias. Estab. 1984. Stock photo agency. Member of Picture Agency Council of America (PACA). Has 500,000 photos. Clients include: ad agencies.

Needs: Model-released people for advertising use. Well-designed, styled photographs that capture the essence of life: children; families; couples at home, at work and at play; also beautiful landscapes and wildlife geared toward advertising. Large format preferred for landscapes.

Specs: Uses transparencies only, all formats.

Payment & Terms: Pays 50% commission on color photos. General price range (to clients): $275-15,000. Works on contract basis only. Offers exclusive contract only. Statements issued monthly. Payments made monthly. Photographers allowed to review account records; "monthly statements are derived from computer records of all transactions and are highly detailed." Offers one-time and electronic media rights usually, "but if clients pay more they get more usage rights. We never offer all rights on photos." Model/property release required. Photo captions preferred.

Making Contact: Interested in receiving work from newer, lesser-known photographers. Query along with nonreturnable printed promotion pieces. Cannot return unsolicited material. Reports in 1 week.

Tips: Wants to see "technical excellence, originality, creativity and design sense, excellent ability to cast and direct talent and commitment to shooting stock." Observes that "photographer should be in control of all elements of his/her production: casting, styling, props, location, etc., but be able to make a photograph that looks natural and spontaneous."

SILVER IMAGE PHOTO AGENCY, INC., 4104 NW 70th Terrace, Gainesville FL 32606. (352)373-5771. Fax: (352)374-4074. E-mail: silverima@aol.com. President/Owner: Carla Hotvedt. Estab. 1988. Stock photo agency. Assignments in Florida/S. Georgia. Has 20,000 color/b&w photos. Clients include: public relations firms, book/encyclopedia publishers, magazine publishers and newspapers.

Needs: Florida-based travel/tourism, Florida cityscapes and people, nationally oriented topics such as drugs, environment, recycling, pollution, etc. Humorous people, animal photos and movie/TV celebrities.

Specs: Uses 35mm transparencies and prints.

Payment & Terms: Pays 50% commission on b&w/color photos. General price range (to clients): $150-600. Works on contract basis only. Offers nonexclusive contract. Statements issued monthly. Payment made monthly. Photographers allowed to review account records. Offers one-time rights. Informs photographer and allows him to negotiate when client requests all rights. Model release preferred. Captions required: include name, year shot, city, state, etc.

Making Contact: Query with list of stock photo subjects. SASE; will return if query first. Reports on queries in 1 month; material up to 2 months. Photo guidelines free with SASE. Tips sheets distributed as needed. SASE. Do not submit material unless first requested.

Tips: Looks for ability to tell a story in 1 photo. "I will look at a photographer's work if they seem to have images outlined on my stock needs list which I will send out after receiving a query letter with SASE. Because of my photojournalistic approach my clients want to see people-oriented photos, not just pretty scenics. I also get many calls for drug-related photos and unique shots from Florida."

■**SIPA PRESS/SIPA IMAGE**, 30 W. 21st St., New York NY 10010. Prefers not to share information.

‡**THE SLIDE FILE**, 79 Merrion Square, Dublin 2 Ireland. (0001)6766850. Fax: (0001)66224476. Picture Editor: Ms. Carrie Fonseca. Stock photo agency and picture library. Has 100,000 photos. Clients include: ad agencies, public relations firms, businesses, book/encyclopedia publishers, magazine publishers, newspapers and designers.

Needs: Overriding consideration is given to Irish or Irish-connected subjects. Has limited need for overseas locations, but is happy to accept material depicting other subjects, particularly people.

Specs: Uses 35mm, $2\frac{1}{4} \times 2\frac{1}{4}$ and 4×5 transparencies.

Payment & Terms: Pays 50% commission on color photos. General price range: £60-1,000 English currency ($90-1,500). Works on contract basis only. Offers exclusive contracts and limited regional exclusivity. Contracts renew automatically with additional submissions. Statements issued quarterly. Payment made quarterly. Photographers allowed to review account records. Offers one-time rights. Informs photographer when client requests all rights, but "we take care of negotiations." Model release preferred. Captions required.

Making Contact: Interested in receiving work from newer, lesser-known photographers. Query with list of stock photo subjects. Works with local freelancers only. Does not return unsolicited material. Expects minimum initial submission of 250 transparencies; 1,000 images annually. "A return shipping fee is required: important that all similars are submitted together. We keep our contributor numbers down and the quantity and quality of submissions high. Send for information first." Reports in 1 month.

Tips: "Our affiliation with international picture agencies provides us with a lot of general material of people, overseas travel, etc. However, our continued sales of Irish-oriented pictures need to be kept supplied. Pictures of Irish-Americans in Irish bars, folk singing, Irish dancing, would prove to be useful. They would be required to be beautifully lit, carefully composed and good-looking, model-released people."

■**SOUTHERN STOCK PHOTO AGENCY**, 3601 W. Commercial Blvd., Suite 33, Ft. Lauderdale FL 33309. (800)486-7118. Fax: (305)486-7118. Contact: Victoria Ross. Estab. 1976. Stock photo agency. Member of Picture Agency Council of America (PACA). Has 750,000 photos. Clients include: ad agencies, design firms, businesses, book/encyclopedia publishers, magazine publishers, newspapers, calendar and greeting card companies.

Needs: Needs photos of "southern U.S. cities, Bahamas, Caribbean, South America, and model-released lifestyle photos with young families and active seniors, as well as all general categories."

Specs: Uses color, 35mm, $2\frac{1}{4} \times 2\frac{1}{4}$, 4×5 transparencies.

Payment & Terms: Pays 50% commission on color photos. General price range (to clients): $225-5,000. Works on contract basis only. Offers nonexclusive contract. Contracts renew automatically. Statements issued bimonthly. Payment made bimonthly. Photographers allowed to review account records. Offers one-time rights, first time rights and all rights. Informs photographer and allows him to negotiate when client requests all rights. Model release and photo captions required.

Making Contact: Query with samples/phone call. SASE. Reports in 1 month. Photo guidelines free with SASE.

Tips: In portfolio or samples, wants to see approximately 200 transparencies of a cross section of work. Photographers "must be willing to submit new work on a consistent basis."

■**SOVFOTO/EASTFOTO, INC.**, 48 W. 21 St., 11th Floor, New York NY 10010. (212)727-8170. Fax: (212)727-8228. Director: Victoria Edwards. Estab. 1935. Stock photo agency. Has 1 million photos. Clients include: audiovisual firms, book/encyclopedia publishers, magazine publishers, newspapers.
 • This agency markets images via the Picture Network International.
Needs: Interested in photos of Eastern Europe, Russia, China, CIS republics.
Specs: Uses 8×10 glossy b&w and color prints; 35mm transparencies.
Payment & Terms: Pays 50% commission. Average price per image to clients $150-250/b&w photo; $150-250/color photo. Negotiates fees below standard minimum prices. Offers exclusive contracts, limited regional exclusivity and nonexclusivity. Statements issued quarterly. Payment made quarterly. Photographers permitted to review account records to verify sales figures or account for various deductions. Offers one-time, electronic media and nonexclusive rights. Model/property release preferred. Captions required.
Making Contact: Arrange personal interview to show portfolio. Query with samples. Query with stock photo list. Samples kept on file. SASE. Expects minimum initial submission of 50-100 images. Reports in 1-2 weeks.
Tips: Looks for "news and general interest photos (color) with human element."

SPECTRUM PHOTO, 3127 W. 12 Mile Rd., Berkley MI 48072. Phone: (313)398-3630. Fax: (313)398-3997. Owner: Laszlo Regos. Estab. 1990. Stock photo agency. Has 300,000 images. Clients include: ad agencies, public relations firms, businesses, magazine publishers, postcard publishers, calendar companies and display companies.
Needs: All subjects, but especially "high-tech, business, industry, lifestyles, food and backgrounds."
Specs: Uses 8×10 glossy b&w prints; 35mm, 2¼×2¼, 4×5 transparencies, 70mm and panoramic.
Payment & Terms: Pays 50% commission on b&w and color film. General price range (to clients): $50-300/b&w photo; $150-1,500/color photo. Works on contract basis only. Offers limited regional exclusivity. Contracts renew automatically with each submission; time period not specified. Charges duping fee of 50%/image. Statements issued monthly. Payment made bimonthly. Photographers allowed to review account records to verify sales figures. Offers one-time and electronic media rights. Requires agency promotion rights. Informs photographer and permits negotiation when client requests all rights, with some conditions. Model/property release required. Captions required.
Making Contact: Query with samples. Does not keep samples on file. SASE. Submit maximum of 50-75 images in initial query. Expects periodic submissions of 300-600 images each year. Reports in 3 weeks. Photo guidelines sheet free with SASE. Tips sheet available periodically to contracted photographers.
Tips: Wants to see "creativity, technical excellence and marketability" in submitted images. "We have many requests for business-related images, high-tech, and lifestyle photos. Shoot as much as possible and send it to us."

SPORTSLIGHT PHOTO, 127 W. 26 St., Suite 800, New York NY 10001. Website: http://www.foto show.com/fotoshow/sportslight/. Director: Roderick Beebe. Stock photo agency. Has 500,000 photos. Clients include: ad agencies, public relations firms, corporations, book publishers, magazine publishers, newspapers, postcard companies, calendar companies, greeting card companies and design firms.
Needs: "We specialize in every sport in the world. We deal primarily in the recreational sports such as skiing, golf, tennis, running, canoeing, etc., but are expanding into pro sports, and have needs for all pro sports, action and candid close-ups of top athletes. We also handle adventure-travel photos, e.g., rafting in Chile, trekking in Nepal, dogsledding in the Arctic, etc."
Specs: Uses 35mm transparencies.
Payment & Terms: Pays 50% commission. General price range (to clients): $100-6,000. Contract negotiable. Offers limited regional exclusivity. Contract is of indefinite length until either party (agency or photographer) seeks termination. Charges fees for catalog and CD-ROM promotions. Statements issued quarterly. Payment made quarterly. Photographers allowed to review account records to verify sales figures "when discrepancy occurs." Offers one-time rights, rights depend on client, sometimes exclusive rights for a period of time. Informs photographer and consults with him/her when client

requests all rights. Model release required for corporate and advertising usage. (Obtain releases whenever possible.) Strong need for model-released "pro-type" sports. Captions required; include who, what, when, where, why.

Making Contact: Interested in receiving work from newer and known photographers. Query with list of stock photo subjects, "send samples *after* our response." SASE must be included. Cannot return unsolicited material. Reports in 2-4 weeks. Photo guideline sheet free with SASE.

Tips: In reviewing work looks for "range of sports subjects that show photographer's grasp of the action, drama, color and intensity of sports, as well as capability of capturing great shots under all conditions in all sports. Well edited, perfect exposure and sharpness, good composition and lighting in all photos. Seeking photographers with strong interests in particular sports. Shoot variety of action, singles and groups, youths, male/female—all combinations. Plus leisure, relaxing after tennis, lunch on the ski slope, golf's 19th hole, etc. Clients are looking for all sports these days. All ages, also. Sports fashions change rapidly, so that is a factor. Art direction of photo shoots is important. Avoid brand names and minor flaws in the look of clothing. Attention to detail is very important. Shoot with concepts/ideas such as teamwork, determination, success, lifestyle, leisure, cooperation and more in mind. Clients look not only for individual sports, but for photos to illustrate a mood or idea. There is a trend toward use of real-life action photos in advertising as opposed to the set-up slick ad look. More unusual shots are being used to express feelings, attitude, etc."

***■TOM STACK & ASSOCIATES**, 977 Elkton Dr., Colorado Springs CO 80907. (719)593-1100. Contact: Jamie Stack. Member of the Picture Agency Council of America (PACA). Has 1.5 million photos. Clients include: ad agencies, public relations firms, businesses, audiovisual firms, book publishers, magazine publishers, encyclopedia publishers, postcard companies, calendar companies and greeting card companies.

Needs: Wildlife, endangered species, marine-life, landscapes, foreign geography, people and customs, children, sports, abstract/art and mood shots, plants and flowers, photomicrography, scientific research, current events and political figures, Native Americans, etc. Especially needs women in "men's" occupations; whales; solar heating; up-to-date transparencies of foreign countries and people; smaller mammals such as weasels, moles, shrews, fisher, marten, etc.; extremely rare endangered wildlife; wildlife behavior photos; current storms; lightning and tornadoes; hurricane damage. Sharp images, dramatic and unusual angles and approach to composition, creative and original photography with impact. Especially needs photos on life science, flora and fauna and photomicrography. No run-of-the-mill travel or vacation shots. Special needs include photos of energy-related topics—solar and wind generators, recycling, nuclear power and coal burning plants, waste disposal and landfills, oil and gas drilling, supertankers, electric cars, geo-thermal energy.

Specs: Uses 35mm transparencies.

Payment & Terms: Pays 60% commission. General price range (to clients): $150-200/color; as high as $7,000. Offers one-time rights, all rights or first rights. Model release preferred. Captions preferred.

Making Contact: Query with list of stock photo subjects or send at least 800 transparencies for consideration. SASE or mailer for photos. Reports in 2 weeks. Photo guidelines with SASE.

Tips: "Strive to be original, creative and take an unusual approach to the commonplace; do it in a different and fresh way." Have "more action and behavioral requests for wildlife. We are large enough to market worldwide and yet small enough to be personable. Don't get lost in the 'New York' crunch—try us. Shoot quantity. We try harder to keep our photographers happy. We attempt to turn new submissions around within two weeks. We take on only the best so we can continue to give more effective service."

STOCK IMAGERY, INC., 1822 Blake St.. Suite A, Denver CO 80303. (303)293-0202. Fax: (303)293-3140. E-mail: stocimage@aol.com. Contact: Yunhee Pettibone. Estab. 1981. Stock photo agency. Member of Picture Agency Council of America (PACA). Has over 150,000 photos. "With representation in over 40 countries worldwide, our highly competitive catalogs receive maximum exposure." Clients include: ad agencies, public relations firms, audiovisual firms, book/encyclopedia publishers, magazine publishers, newspapers, postcard publishers, calendar companies, greeting card companies, TV and a variety of businesses. Quarterly newsletter gives market tips, agency updates, etc.

Needs: All subjects, color and b&w.

Specs: Uses 35mm, 2¼×2¼, 4×5, 8×10 transparencies.

Payment & Terms: Pays 50% commission on image sales. NPI. "We have set prices, but under special circumstances we contact photographer prior to negotiations." Works on contract basis only. Offers nonexclusive contracts. Statements and payments issued monthly. Photographers allowed to review account records. Offers one-time and electronic media rights. Informs photographer and allows him to negotiate when client requests all rights. Model/property release required. Captions required.

Making Contact: "We are always willing to review new photographers' work; please call for a photographer information packet that includes submission guidelines and other pertinent information. Photographer must have 200 images on file to be put under contract. Submit a well edited sample of

your work. Selection must be a good representation of the type and caliber of work that you can supply on a regular basis."

■**THE STOCK MARKET**, 360 Park Ave. S., New York NY 10010. (212)684-7878. Fax: (212)532-6750. Contact: Gerry Thies or Catherine DeMaria. Estab. 1981. Stock photo agency. Member of Picture Agency Council of America (PACA). Has 2 million images. Clients include: ad agencies, public relations firms, corporate design firms, book/encyclopedia publishers, magazine publishers, newspapers, postcard companies, calendar companies and greeting card companies.
● This agency has released its second CD-ROM disc of 6,000 low resolution images and is now producing specialty discs to complement its annual printed catalogs.
Needs: Topics include lifestyle, corporate, industry, nature, travel and digital concepts.
Specs: Uses color, all formats.
Payment & Terms: Pays 50% gross sale on color photos. Works on exclusive contract basis only. Charges catalog insertion fee of 50%/image for US edition only. Statements issued monthly. Payment made monthly. Photographers allowed to review account records to verify sales figures. Offers one-time rights. When client requests to buy all rights, "we ask permission of photographer, then we negotiate." Model/property release required for all people, private homes, boats, cars, property. Captions are required; include "what and where."
Making Contact: Call or write with printed samples. Arrange a personal interview or send portfolio of 250 transparencies. SASE. Reports in 2-3 weeks. Tips sheet distributed as needed to contract photographers only.
Tips: "The Stock Market represents work by some of the world's best photographers. Producing work of the highest caliber, we are always interested in reviewing work by dedicated professional photographers who feel they can make a contribution to the world of stock."

STOCK OPTIONS, Dept. PM, 4602 East Side Ave., Dallas TX 75226. (214)823-6262. Fax: (214)826-6263. Owner: Karen Hughes. Estab. 1985. Stock photo agency. Member of Picture Agency Council of America (PACA). Has 100,000 photos. Clients include: ad agencies, public relations firms, audiovisual firms, corporations, book/encyclopedia and magazine publishers, newspapers, postcard companies, calendar and greeting card companies.
● This agency hopes to market work on CD-ROM in the near future.
Needs: Emphasizes the southern US. Files include Gulf Coast scenics, wildlife, fishing, festivals, food, industry, business, people, etc. Also western folklore and the Southwest.
Specs: Uses 35mm, 2¼×2¼ and 4×5 transparencies.
Payment & Terms: Pays 50% commission on color photos. General price range (to clients): $300-3,000. Works on contract basis only. Offers nonexclusive contract. Contract automatically renews with each submission to 5 years from expiration date. When contract ends photographer must renew within 60 days. Charges catalog insertion fee of $300/image and marketing fee of $5/hour. Statements issued upon receipt of payment from client. Payment made immediately. Photographers allowed to review account records to verify sales figures. Offers one-time and electronic media rights. "We will inform photographers for their consent only when a client requests all rights, but we will handle all negotiations." Model/property release preferred for people, some properties, all models. Captions required; include subject and location.
Making Contact: Interested in receiving work from newer, lesser-known photographers. Arrange a personal interview to show portfolio. Query with list of stock photo subjects. Contact by "phone and submit 200 sample photos." Tips sheet distributed annually to all photographers.
Tips: Wants to see "clean, in focus, relevant and current materials." Current stock requests include: industry, environmental subjects, people in up-beat situations, minorities, food, cityscapes and rural scenics.

■**STOCK PILE, INC.**, Main office: Dept. PM, 2404 N. Charles St., Baltimore MD 21218. (410)889-4243. Branch: P.O. Box 30168, Grand Junction CO 81503. (303)243-4255. Vice President: D.B. Cooper. Picture library. Has 28,000 photos. Clients include: ad agencies, art studios, slide show producers, etc.
Needs: General agency looking for well-lit, properly composed images that will attract attention. Also, people, places and things that lend themselves to an advertising-oriented marketplace.
Specs: Transparencies, all formats. Some b&w 8×10 glossies.
Payment & Terms: Pays 50% commission on b&w and color photos. Works on contract basis only. Contracts renew automatically with additional submissions. Payment made monthly. Offers one-time rights. Informs photographer and permits him to negotiate when client requests all rights. Model release preferred. Captions required.
Making Contact: Interested in receiving work from newer, lesser-known photographers. Inquire for guidelines, submit directly (minimum 200) or call for personal interview. All inquiries and submissions must be accompanied by SASE. *Send all submissions to Colorado address.* Periodic newsletter sent to all regular contributing photographers.

■**THE STOCKHOUSE, INC.**, Box 540367, Houston TX 77254-0367. (713)942-8400. Fax: (713)526-4634. Sales and Marketing Director: Celia Jumonville. Stock photo agency. Member of Picture Agency Council of America (PACA). Has 500,000 photos. Clients include: ad agencies, public relations firms, audiovisual firms, businesses, book/encyclopedia publishers, magazine publishers, newspapers, postcard companies, calendar companies and greeting card companies.

Needs: Needs photos of general topics from travel to industry, lifestyles, nature, US and foreign countries. Especially interested in Texas and petroleum and medical.

Specs: Uses 35mm, 2¼×2¼, 4×5, 8×10 transparencies; "originals only."

Payment & Terms: Pays 50% commission on color photos. General price range (to clients): $200-1,000. Works on contract basis only. Offers limited regional exclusivity. Statements issued monthly. Payment made following month after payment by client. Photographers allowed to review account records to verify sales figures by appointment. Offers one-time rights; other rights negotiable. Informs photographer and allows him to negotiate when client requests all rights; must be handled through the agency only. Model/property release preferred for people and personal property for advertising use; photographer retains written release. Photo captions required; include location, date and description of activity or process.

Making Contact: Interested in receiving work from newer, lesser-known photographers. Query with samples; request guidelines and tipsheet. Send submissions to 3301 W. Alabama, Houston TX 77098. SASE. Photo guidelines free with SASE. Tips sheet distributed quarterly to contract photographers.

Tips: In freelancers' samples, wants to see "quality of photos—color saturation, focus and composition. Also variety of subjects and 200-300 transparencies on the first submission. Trends in stock vary depending on the economy and who is needing photos. Quality is the first consideration and subject second. We do not limit the subjects submitted since we never know what will be requested next. Industry and lifestyles and current skylines are always good choices."

■**TONY STONE IMAGES, INC.**, 6100 Wilshire Blvd., #1250, Los Angeles CA 90048. (213)938-1700. (Offices in 25 locations worldwide). Director of Photography: Sarah Stone. Estab. in US 1988, worldwide 1968. Stock photo agency. Member of Picture Agency Council of America (PACA). Clients include: advertising agencies; public relations firms; audiovisual firms; businesses; book/encyclopedia publishers; magazine publishers; newspapers; calendar, greeting card and travel companies.

● This agency has worked hard to accommodate digital submissions. Tony Stone Images accepts work in any form, including digital. As technology improves so does the agency's capabilities. Keep in touch with them to know what digital formats are accepted.

Needs: Very high quality, technically and creatively excellent stock imagery on all general subjects for worldwide and US distribution.

Specs: Wants to see great images in any format—print, transparencies or digital. "Large and medium format transparencies are always put into our custom mounts, so you do not have to mount them. We do, however, want them submitted (with acetate sleeves) in appropriately-sized viewing sheets." As for digital submissions "at the moment, only high resolution drum scans will yield image files of the quality and resolution to meet our standards. We are not accepting digital imagery which originates from Kodak's Photo CD's or the new desktop scanners."

Payment & Terms: Pays 50% commission on b&w and color photos. Price ranges vary according to usage. "Minimum price in the United States is $100 unless very exceptional circumstances, e.g., very specialized, low-level usage or limited exposure of imagery." Offers volume discounts to customers, "but *maximum* 10% and then rarely"; inquire about specific terms. Works on contract basis only. "We ask for exclusivity on a photographer's best work only." Charges catalog insertion fee. "No upfront charges are required; deductions are made if image sells." Statements and payment issued monthly. Offers various rights. "When client requests all rights, we ask photographer's permission and negotiate accordingly." Model/property release required. "Call us if you need samples of release forms designed for stock photography. Too often we have to reject perfectly good images for lack of releases." Photo captions required with as much detail as possible. Print captions on the front of each mount, or number each mount and print the captions on a separate sheet of paper.

Making Contact: "Please do not send unsolicited images. Call our Creative Department for free submission guidelines." Expects minimum initial submission of 50 images.

Tips: Wants to see "technical ability, creativity, commitment to high standards." Sees increased demand for high quality. "If you can't shoot better imagery than that already available, don't bother at all."

*‡**SUPERBILD BILDARCHIV**, Schlo␣Bstr. 19, Grünwald Germany 82031. (089)641-7777. Fax: (089)641-4032. Vice Director: Günter Gräfenhain. Estab. 1987. Stock photo agency. Member of BVPA/German Association of Picture Libraries. Has 1.3 million photos. Has branch offices in 5 cities: SUPERBILD GMBH Charlottenstr. 3 D, 10969 Berlin, Germany; SUPERBILD PHOTOPRODUCTION Bussardstr. 2 D, 82024 Taufkirchen, Germany; INCOLOR AG Vogelsangstr. 48, CH 8006 Zürich, Switzerland; INCOLOR FOTOSTOCK INTERNATIONAL S.L. Calle General Diaz Porlier 17 E, 28001 Madrid, Spain; BRITSTOCK-IFA 41/42 Berners St., GB, London W1P-3AA United

Kingdom. Clients include ad agencies, public relations firms, audiovisual firms, businesses, book/encyclopedia publishers, magazine publishers, newspapers, calendar companies, greeting card companies, postcard publishers and company advertising departments.

Needs: Photos of all subjects—people, technical, lifestyle, food, animals, computer graphics, cities, nature.

Specs: Uses 2¼×2¼ transparencies; SyQuest, DAT-TIFF digital formats.

Payment & Terms: Pays 50% commission. Average price per image (to clients): $150-3,000. Enforces minimum prices. Works on contract basis only. Offers exclusive contracts. Contracts renew automatically with additional submissions for 1 year. Statements issued quarterly. Payment made quarterly. Photographers allowed to review acount records. Offers one-time rights. Informs photographer and allows him to negotiate when client requests all rights. Model/property release required for people, art, architecture, interior shots. Captions required; include subject, place, country.

■SUPERSTOCK INC., 7660 Centurion Pkwy, Jacksonville FL 32256. (904)565-0066. Photographer Liaison: Kai Chiang. International stock photo agency represented in 38 countries. Extensive vintage and fine art collection available for use by clients. Clients include: ad agencies, public relations firms, audiovisual firms, businesses, book/encyclopedia publishers, magazine publishers, newspapers, postcard companies, calendar companies, greeting card companies and major corporations.

Needs: "We are a general stock agency involved in all markets. Our files are comprised of all subject matter."

Specs: Uses 35mm, 2¼×2¼, 4×5 and 8×10 transparencies.

Payment & Terms: "We work on a contract basis." Statements issued monthly. Payment made monthly. Photographers allowed to review account records to verify sales figures. Rights offered "varies, depending on client's request." Informs photographer and allows him to negotiate when client requests all rights. Model release required. Captions required.

Making Contact: Query with résumé of credits. Query with tearsheets only. Query with list of stock photo subjects. Submit portfolio for review "when requested." SASE. Reports in 3 weeks. Photo guidelines sheet free with SASE or sent if requested via phone. Newsletter distributed bimonthly to contracted photographers.

Tips: "The use of catalogs as a buying source is a very effective means of promoting photographs, and a continuing trend in the industry is the importance of bigger, comprehensive catalogs. We produce the SuperStock Photo Catalog in the U.S. Space is available to professional photographers regardless of any of their other photographic affiliations. Participation in this catalog provides an excellent opportunity for photographers to take advantage of the growing international market for stock, and receive the highest royalty percentage for internationally distributed photographs."

SWANSTOCK AGENCY INC., P.O. Box 2350, Tucson AZ 85702. (520)622-7133. Fax: (520)622-7180. Contact: Submissions. Estab. 1991. Stock photo agency. Has 100,000 photos. Clients include: ad agencies, public relations firms, book/encyclopedia publishers, magazine publishers, newspapers, postcard publishers, calendar companies, greeting card companies, design firms, record companies and inhouse agencies.

Needs: Swanstock's image files are artist-priority, not subject-driven. Needs range from photo-illustration to realistic family life in the '90s. (Must be able to provide releases upon request.)

Specs: Uses 8×10 or smaller color and b&w prints; 35mm, 2¼×2¼, 4×5, 8×10 transparencies. *Send dupes only.*

Payment & Terms: Pays 50% commission on stock sale; 75% commission otherwise. Average price per image (to clients): $200-1,000. Negotiates fees below standard minimum prices if agreeable to photographer in exchange for volume overrun of piece for promotional needs. Offers volume discounts to customers; terms specified in photographer's contract. Photographers can choose not to sell images on discount terms. Works on contract basis only. Offers nonexclusive contracts. Photographers provide all dupes for agency files. Charges editing fee. Statements issued upon sales only, within 1 month of payment by client. Photographers allowed to review account records by appointment only. "We sell primarily one-time rights, but clients frequently want one of the following arrangements: one year, domestic only; one year, international; one year with an option for an immediate second year at a predetermined price; one year, unlimited usage for a specific market only; one year, unlimited usages within ALL markets; all rights for the life of that specific edition only (books) and so forth." Informs photographer when client requests all rights and allows photographer to negotiate if they have experi-

 THE SOLID, BLACK SQUARE before a listing indicates that the market uses various types of audiovisual materials, such as slides, film or videotape.

ence with negotiation and have a prior relationship with the client. Model release often required. Captions preferred; include where and when.

Making Contact: Interested in receiving work from lesser-known photographers with accomplished work. Query with samples. Include SASE to receive submission details. Keeps samples on file. SASE. Reporting time may be longer than 1 month.

Tips: "We look for bodies of work that reflect the photographer's consistent vision and sense of craft—whether their subject be the landscape, still lifes, family, or more interpretive illustration. Alternative processes are encouraged (i.e., Polaroid transfer, hand-coloring, infrared films, photo montage, pinhole and Diana camera work, etc.). Long-term personal photojournalistic projects are of interest as well. We want to see the work that you feel strongest about, regardless of the quantity. Artists are not required to submit new work on any specific calendar, but rather are asked to send new bodies of work upon completion. We do not house traditional commercial stock photography, but rather work that was created by fine art photographers for personal reasons or for the gallery/museum arena. The majority of requests we receive require images to illustrate an emotion, a gesture, a season rather than a specific place geographically or a particular product. Our goal with each submission to clients is to send as many different photographers' interpretations of their need, in as many photographic processes as possible. We communicate with our clients in order to keep the usages within the original intent of the photographer (i.e., submitting proofs of desired placement of copy, wrapping an image around a book jacket, etc.) and frequently place the artist in communication with the client with regard to creative issues. Swanstock offers a nonexclusive contract and encourages photographers to place specific bodies of their work with the appropriate agency(s) for maximum return. We do NOT publish a catalog and ask that photographers supply us with appropriate promotional materials to send to clients. Under no circumstances should artists presume they will make a living on fine art stock in the way that commercial stock shooters do. However, we are confident that this 'niche' market will continue to improve, and encourage artists who previously felt there was no market for their personal work to contact us."

✦TAKE STOCK INC., 307, 319 Tenth Ave. SW, Calgary, Alberta T2R 0A5 Canada. (403)261-5815. Fax: (403)261-5723. Estab. 1987. Stock photo agency. Clients include: ad agencies, public relations firms, audiovisual firms, corporate, book/encyclopedia publishers, magazine publishers, newspapers, postcard companies, calendar companies and greeting card companies.

Needs: Model-released people, lifestyle images (all ages), Canadian images, arts/recreation, industry/occupation, business, high-tech.

Specs: Uses 35mm, medium to large format transparencies.

Payment & Terms: Pays 50% commission on transparencies. General price range (to clients): $200-700. Works on contract basis only. Offers limited regional exclusivity. Contracts renew automatically with additional submissions with "one-year review, then every three years." Charges 100% duping fees. Statements issued monthly. Payment made monthly. Photographers allowed to review account records to verify sales figures, "anytime by appointment." Offers one-time rights, exclusive rights. Model/property release required. Captions required.

Making Contact: Query with list of stock photo subjects. SASE. Reports in 3 weeks. Photo guidelines free with SASE. Tips sheet distributed every 2 months to photographers on file.

TERRAPHOTOGRAPHICS, Box 490, Moss Beach CA 94038. Phone/fax: (415)726-6244. Fax: (415)726-6244. E-mail: bpsterra@aol.com. Photo Agent: Carl May. Stock photo agency. Has 30,000 photos on hand; 45,000 on short notice. Clients include: ad agencies, businesses, book/encyclopedia publishers and magazine publishers.

Needs: All subjects in the earth sciences: geological features seen from space, paleontology, volcanology, seismology, petrology, oceanography, climatology, mining, petroleum industry, meteorology, physical geography. Stock photographers must be scientists. "Currently, we need more on energy conservation, gems, economic minerals, volcanic eruptions, earthquakes, floods and severe weather." Much more needed from southern hemisphere, China, formerly Communist countries and the Middle East.

Specs: Uses 8×10 glossy b&w prints; 35mm, 2¼×2¼, 4×5 and 8×10 transparencies.

Payment & Terms: Pays 50% commission on all photos. General price range (to clients): $90-500. Works with or without a signed contract, negotiable. Offers exclusive contract only. Statements issued quarterly. Payment quarterly within 1 month of end of quarter. Photographers allowed to review account records to verify sales figures. Offers one-time rights and electronic media rights for specific projects only; other rights negotiable. Informs photographer and allows participation when client requests all rights. Model release required for any commercial use, but not purely editorial. Thorough photo captions required; include "all information necessary to identify subject matter and give geographical location."

Making Contact: Will consider work from newer, lesser-known scientist-photographers as well as established professionals. Query with list and résumé of scientific and photographic background. SASE. Reports in 2 weeks. Photo guidelines free with query, résumé and SASE. Tips sheet distributed intermittently only to stock photographers.

Tips: Prefers to see proper exposure, maximum depth of field, interesting composition, good technical and general information in caption. Scientists at work using modern equipment. "We are a suitable agency only for those with both photographic skills and sufficient technical expertise to identify subject matter. We only respond to those who provide a rundown of their scientific and photographic background and at least a brief description of coverage. Captions must be neat and contain precise information on geographical locations. Don't waste your time submitting images on grainy film. Our photographers should be able to distinguish between dramatic, compelling examples of phenomena and run-of-the-mill images in the earth and environmental sciences. We need more on all sorts of weather phenomena; the petroleum and mining industries from exploration through refinement; problems and management of toxic wastes; environmental problems associated with resource development; natural areas threatened by development; and oceanography."

TEXSTOCKPHOTO INC., 5320 Gulfton, #8, Houston TX 77081. (713)661-1411. Fax: (713)661-2597. President: Hal Lott. Estab. 1993. Stock photo agency. Member of Picture Agency Council of America (PACA). Has 200,000 photos. Has 1 branch office. Clients include: ad agencies, public relations firms, audiovisual firms, businesses, book/encyclopedia publishers, magazine publishers, postcard publishers, calendar companies and greeting card companies.
- They are either using currently, or will be using in the future, all digital and/or electronic means of marketing at their disposal.

Needs: Interested in photos of people, Texas, Southwest, lifestyle, general interest.
Specs: Uses 8×10 b&w prints; 35mm, 2¼×2¼, 4×5 transparencies.
Payment & Terms: Pays 50% commission on b&w photos. Enforces minimum price of $150. Offers volume discounts to customers; inquire about specific terms. Photographers can choose not to sell images on discount terms. Works on contract basis only. Offers nonexclusive contract and limited regional exclusivity. Charges 50% catalog insertion fee; one-time initial submission fee $125. Statements issued quarterly. Payment made monthly. Photographers allowed to review account records. Informs a photographer and permits him to negotiate when a client requests to buy all rights. Model release required. Property release preferred. Captions required; include specifics that add value to the image.
Making Contact: Interested in receiving work from newer, lesser-known photographers. Query with samples. Query with stock photo list. Keeps samples on file. SASE. Expects minimum initial submission of 200-300 images. Reports in 1-2 weeks. Market tips sheet distributed bimonthly to contracted photographers only.

THIRD COAST STOCK SOURCE, 740 N. Plankinton Ave, Suite 824, Milwaukee WI 53203-2403. (414)765-9442. Fax: (414)765-9342. Director: Paul Henning. Managing Editor: Mary Ann Platts. Sales and Research Manager: Paul Butterbrodt. Member of Picture Agency Council of America (PACA). Has over 150,000 photos. Clients include: ad agencies, public relations firms, audiovisual firms, corporations, book/encyclopedia publishers, magazine publishers, graphic designers, calendar companies and greeting card companies.
- Third Coast is affiliated with the Picture Cube in Boston and also has affiliates in Japan, Argentina, Canada and Europe. They have images on *The Stock Workbook* CD-ROM.

Needs: People in lifestyle situations, business, industry, sports and recreation, medium format scenics (domestic and foreign), traditional stock photo themes with a new spin.
Specs: Uses 35mm, 2¼×2¼, 4×5 and 8×10 transparencies (slow and medium speed color transparency film preferred).
Payment & Terms: Pays 50% commission on all photos. General price range (to clients): $200 and up. Enforces minimum prices. Works on contract basis only. Offers various levels regional and image exclusivity. Contracts with photographers renew automatically for 2 or 3 years. Charges duping and catalog insertion fees; print and electronic promotions costs are shared with contributors. Statements issued bimonthly. Payment made bimonthly. Photographers allowed to review account records to verify sales figures. Offers one-time and electronic media rights. Informs photographer when client requests all rights; "we will consult with the photographer, but all negotiations are handled by the agency." Model release required. Captions required.
Making Contact: Interested in receiving work from any photographer with professional-quality material. Submit 200-300 images for review. SASE. Reports in 1 month. Photo guidelines free with SASE. Tips sheet distributed 2 times/year to "photographers currently working with us."
Tips: "We are looking for technical expertise; outstanding, dramatic and emotional appeal. We are anxious to look at new work. Learn what stock photography is all about. Our biggest need is for photos of model-released people: couples, seniors, business situations, recreational situations, etc. Also, we find it very difficult to get great winter activity scenes (again, with people) and photos which illustrate holidays: Christmas, Thanksgiving, Easter, etc."

‡**TROPIX PHOTOGRAPHIC LIBRARY**, 156 Meols Parade, Meols, Merseyside L47 6AN England. Phone/fax: 151-632-1698. Website: http://www.connect.org.uk/merseymall/tropix. Proprietor:

Veronica Birley. Picture library specialist. Has 60,000 transparencies. Clients include: book/encyclopedia publishers, magazine publishers, newspapers, ad agencies, public relations firms, audiovisual firms, businesses, television/film companies and travel agents.

Needs: "All aspects of the developing world and the natural environment. Detailed and accurate captioning according to Tropix guidelines is essential. Tropix documents the developing world from its economy and environment to its society and culture. Education, medicine, agriculture, industry, technology and other developing world topics. Plus the full range of environmental topics worldwide."

Specs: Uses 35mm and medium format transparencies; some large format.

Payment & Terms: Pays 50% commission. General price range (to clients): £60-250 (English currency). Works on contract basis only. Offers guaranteed subject exclusivity. Charges cost of returning photographs by insured/registered post, if required. Statements made quarterly with payment. Photographers allowed to have qualified auditor review account records to verify sales figures in the event of a dispute but not as routine procedure. Offers one-time rights and agency promotion rights. Other rights only by special written agreement. Informs photographer when a client requests all rights but agency handles negotiation. Model release preferred, especially for medical images. Full photo captions required; accurate, detailed data, to be supplied on disk. Guidelines are available from agency.

Making Contact: Interested in receiving work from both established and newer, lesser-known photographers. Query with list of stock photo subjects and destinations, plus SASE (International Reply Paid Coupon to value of £3). *No* unsolicited photographs, please. Reports in 1 month, sooner if material is topical. "On receipt of our leaflets, a very detailed reply should be made by letter. Transparencies are requested only after receipt of this letter, if the collection appears suitable. When submitting transparencies, always screen out those which are technically imperfect."

Tips: Looks for "special interest topics, accurate and informative captioning, sharp focus always, correct exposure, strong images and an understanding of and involvement with specific subject matters. Travel scenes, views and impressions, however artistic, are not required except as part of a much more informed, detailed collection. Not less than 150 saleable transparencies per country photographed should be available." Sees a trend toward electronic image grabbing and development of a pictorial data base.

UNICORN STOCK PHOTO LIBRARY, 7809 NW 86th Terrace, Kansas City MO 64153-1769. (816)587-4131. Fax: (816)741-0632. President/Owner: Betts Anderson. Has 300,000 color slides. Clients include: ad agencies, corporate accounts, textbooks, magazines, calendars and religious publishers.

Needs: Ordinary people of all ages and races doing everyday things: at home, school, work and play. Current skylines of all major cities, tourist attractions, historical, wildlife, seasonal/holiday, and religious subjects. "We particularly need images showing two or more races represented in one photo and family scenes with BOTH parents. There is a critical need for more minority shots including Hispanics, Orientals and blacks. We also need ecology illustrations such as recycling, pollution and people cleaning up the earth."

Specs: Uses 35mm color slides.

Payment & Terms: Pays 50% commission. General price range (to clients): $50-400. Works on contract basis only. Offers nonexclusive contract. Contracts renew automatically with additional submissions for 3 years. Charges duping fee; rate not specified. Statement issued quarterly. Payment made quarterly. Offers one-time rights. Informs photographer and allows him to negotiate when client requests all rights. Model release preferred; increases sales potential considerably. Photo captions required; include: location, ages of people, dates on skylines.

Making Contact: Write first for guidelines. "We are looking for professionals who understand this business and will provide a steady supply of top-quality images. At least 500 images are required to open a file. Contact us by letter including $10 for our 'Information for Photographers' package."

Tips: "We keep in close, personal contact with all our photographers. Our monthly newsletter is a very popular medium for doing this. Our biggest need is for minorities and interracial shots. If you can supply us with this subject, we can supply you with checks. Because UNICORN is in the Midwest, we have many requests for farming/gardening/agriculture/winter and general scenics of the Midwest."

U.S. NAVAL INSTITUTE, 118 Maryland Ave., Annapolis MD 21402. (410)268-6110. Fax: (410)269-7940. E-mail: straight@pensacola.nadn.navy.mil. Photo Archivist: Mary Beth Straight. Picture library. Has 450,000 photos. Clients include: ad agencies, public relations firms, audiovisual firms, businesses, book/encyclopedia publishers, magazine publishers, newspapers, calendar companies,

LISTINGS THAT USE IMAGES electronically can be found in the Digital Markets Index located at the back of this book.

greeting card companies. "Anyone who may need military photography. We are a publishing press, as well."

Needs: US and foreign ships, aircraft, equipment, weapons, personalities, combat, operations, etc. Anything dealing with military.

Specs: Uses 5×7, 8×10 color and/or b&w prints; 35mm transparencies.

Payment & Terms: Buys photos outright. Works with or without contract. Offers contracts on a case-by-case basis. Payment made 1 month after usage. Offers rights on a case-by-case basis. Informs photographer and allows him to negotiate when client requests all rights, "if requested in advance by photographer." Model/property release preferred. Captions required; include date taken, place, description of subject.

Making Contact: Interested in receiving work from newer, lesser-known photographers. Query with samples. Samples kept on file. SASE and Social Security number. Expects minimum initial submission of 5 images. Reports in 1 month. Photo guidelines free with SASE.

Tips: "We do not look for posed photography. Want dramatic images or those that tell story. The U.S. Naval Institute is a nonprofit agency and purchases images outright on a very limited basis. However, we do pay for their use within our own books and magazines. Prices are somewhat negotiable, but lower than what the profit-making agencies pay."

■**VIESTI ASSOCIATES, INC.**, P.O. Box 20424, New York NY 10021. (212)787-6500 or (500)FOR-STOK. Fax: (212)595-6303. President: Joe Viesti. Estab. 1987. Stock photo agency. Has 20 affiliated foreign sub-agents. Clients include: ad agencies, businesses, book/encyclopedia publishers, magazine publishers, calendar companies, greeting card companies, design firms.

• Viesti is involved with CD-ROM and modem transmission of images. The images contain a watermark to protect copyright. Viesti is "dead set against clip art sales."

Needs: "We are a full service agency."

Specs: Uses 35mm, 2¼×2¼, 4×5, 6×7, 8×10 transparencies; both color and b&w transparencies; all film formats.

Payment & Terms: Charges 40-50% commission. "We negotiate fees above our competitors on a regular basis." Works on contract basis only. "Catalog photos are exclusive." Contract renews automatically upon expiration for 5 years unless photographer or agency opts for termination. Charges duping fees "at cost. Many clients now require submission of dupes only." Statements issued monthly. "Payment is made the month after payment is received. Photographers' accountants may review records upon proper notice, and without disrupting office operations." Rights vary. Informs photographer and allows him to negotiate when client requests all rights. Model/property release preferred. Captions required.

Making Contact: Interested in receiving work from newer, lesser-known (but serious) photographers as well as from established photographers. Query with samples. Send no originals. Send dupes or tearsheets only with bio info and size of available stock; include return postage if return desired. Samples kept on file. Expects minimum submissions of 500 edited images; 100 edited images per month is average. Submissions edited and returned usually within one week. Catalog available for fee, depending upon availability and size.

Tips: There is an "increasing need for large quantities of images from interactive, multimedia clients and traditional clients. No need to sell work for lower prices to compete with low ball competitors. Our clients regularly pay higher prices if they value the work."

*****VINTAGE IMAGES**, P.O. Box 228, Lorton VA 22199. (703)550-1881. Fax: (703)550-7992. President: Brian Smolens. Estab. 1987. Photo marketing company. Clients include: consumers only.

Needs: "We are seeking images (mostly vintage) consumers would buy as low-medium-priced prints, both color and b&w. All topics considered; male nudes especially needed."

Specs: Uses 2¼×3¼ negatives.

Payment & Terms: Buys vintage (pre-1920) photos outright. Pays commission. Average price per image (to consumers): $30/b&w and color photos. Terms specified in photographer's contract. Offers nonexclusive contracts. Statements issued annually. Payment made annually. Photographers allowed to review account records. Offers no reproduction rights.

Making Contact: Interested in receiving work from newer, lesser-known photographers. "Submit photocopies or proof sheets that we can keep on file." SASE. Expects minimum initial submission of 25 images. Reports in 1 month. Photo guidelines free with SASE.

♣**VISUAL CONTACT**, 67 Mowat Ave., Suite 241, Toronto, Ontario M6K 3E3 Canada. (416)532-8131. Fax: (416)532-3792. E-mail: viscon@interlog.com. Website: http://www.interlog.com/~viscon. President: Thomas Freda. Library Administrator: Laura Chen. Estab. 1990. Stock photo agency. Has applied to become PACA member. Has 30,000 photos. Clients include: ad agencies, public relations firms, businesses, book/encyclopedia publishers, magazine publishers, calendar companies, greeting card companies.

Needs: Interested in photos of people/lifestyle, people/corporate, industry, nature, travel, science and technology, medical, food.

Specs: Uses transparencies.

Payment & Terms: Pays 50% commission on color photos. Offers volume discounts to customers; inquire about specific terms. Works with or without signed contract, negotiable. Offers exclusive only, limited regional, nonexclusive, or guaranteed subject exclusivity contracts. Contracts renew automatically with additional submissions for 1 year (after first 5 years). Charges 100% duping fee, 100% mounting, 100% CD/online service. Statements issued quarterly. Payment made quarterly. Photographers allowed to review account records in cases of discrepancies only. Offers one-time rights. Informs photographer and allows him to negotiate when client requests all rights. Model/property release required. Captions required; include location, specific names, i.e., plants, animals.

Making Contact: Interested in receiving work from newer, lesser-known photographers. Arrange personal interview to show portfolio. Submit portfolio for review. Query with résumé of credits. Query with samples. Query with stock photo list. Keeps samples on file. SASE. Expects minimum initial submission of 100-200 images. Reports in 4-6 weeks. Photo guidelines free with SASE. Market tips sheet distributed free with SASE; also available, along with periodic newsletter, at website.

VISUALS UNLIMITED, Dept. PM, P.O. Box 146, East Swanzey NH 03446-0146. (603)352-6436. Fax: (603)357-7931. President: Dr. John D. Cunningham. Stock photo agency and photo research service. Has 500,000 photos. Clients include: ad agencies, public relations firms, audiovisual firms, businesses, book/encyclopedia publishers, magazine publishers, CD-ROM producers, television and motion picture companies, postcard companies, calendar companies and greeting card companies.

Needs: All fields: biology, environmental, medical, natural history, geography, history, scenics, chemistry, geology, physics, industrial, astronomy and "general."

Specs: Uses 5×7 or larger b&w prints; 35mm, $2\frac{1}{4} \times 2\frac{1}{4}$, 4×5 and 8×10 transparencies.

Payment & Terms: Pays 50% commission for b&w and color photos. Negotiates fees based on use, type of publication, user (e.g., nonprofit group vs. publisher). Average price per image (to clients): $30-90/b&w photo; $50-190/color photo. Offers volume discounts to customers; terms specified in contract. Photographers can choose not to sell images on discount terms. Works on contract basis only. Offers nonexclusive contract. Contracts renew automatically for an indefinite time unless return of photos is requested. Statements issued monthly. Payment made monthly. Photographers not allowed to review account records to verify sales figures; "All payments are exactly 50% of fees generated." Offers one-time rights. Informs photographer and allows him to negotiate when client requests all rights. Model release preferred. Captions required.

Making Contact: Interested in receiving work from newer, lesser-known photographers. Query with samples or send unsolicited photos for consideration. Submit portfolio for review. SASE. Reports in 2 weeks. Photo guidelines free with SASE. Distributes a tips sheet several times/year as deadlines allow, to all people with files.

Tips: Looks for "focus, composition and contrast, of course. Instructional potential (e.g., behavior, anatomical detail, habitat, example of problem, living conditions, human interest). Increasing need for exact identification, behavior, and methodology in scientific photos; some return to b&w as color costs rise. Edit carefully for focus and distracting details; submit anything and everything from everywhere that is geographical, biological, geological, environmental, and people oriented."

‡**DEREK G. WIDDICOMBE**, Worldwide Photographic Library, Oldfield, High Street, Clayton West, Huddersfield, Great Britain HD8 9NS. Phone/fax: (011)44 1484 862638. Proprietor: Derek G. Widdicombe. Picture library. Has over 150,000 photos. Clients include: ad agencies, public relations firms, audiovisual firms, businesses, book/encyclopedia publishers, magazine publishers, newspapers, postcard companies, calendar companies, greeting card companies, television, packaging, exhibition and display material, posters, etc.

Needs: "The library covers many thousands of different subjects from landscape, architecture, social situations, industrial, people, moods and seasons, religious services, animals, natural history, travel subjects and many others. We have some archival material. These subjects are from worldwide sources."

Specs: Uses 20.3×24.4 cm. glossy b&w prints. Also, all formats of transparencies; 35mm preferred.

Payment & Terms: Pays 50% commission for b&w and color photos. General price range (to clients): reproduction fees in the range of £25-200 (English currency); pays $52-333 or higher/b&w photo; $73-500 or higher/color photo. Works with or without contract; negotiable. Offers limited regional exclusivity and nonexclusive contract. Statements issued quarterly. Payment made quarterly. Photographers not allowed to review account records to verify sales figures. Offers one-time and electronic media rights. Requests agency promotion rights. Does not inform photographer or allow him to negotiate when client requests all rights. Model/property release required for portraits of people and house interiors. Photo captions required.

Making Contact: Interested in receiving work from newer, lesser-known photographers. "Send letter first with details on what you have to offer. If invited, send small selection at own risk with return postage/packing." SASE.

Tips: Looks for "technical suitability (correct exposure, sharpness, good tonal range, freedom from defects, color rendering [saturation] etc.). Subject matter well portrayed without any superfluous objects in picture. Commercial suitability (people in pictures in suitable dress, up-to-date cars—or none, clear-top portions for magazine/book cover titles). Our subject range is so wide that we are offering the whole spectrum from very traditional (almost archival) pictures to abstract, moody, out-of-focus shots. Always send details of what you have to offer first. When invited we normally require small batches of around 100 pictures."

THE WILDLIFE COLLECTION, Division of Cranberry Press Inc., 69 Cranberry St., Brooklyn NY 11201. (718)935-9600. Fax: (718)935-9031. Director: Sharon A. Cohen. Estab. 1987. Stock photo agency. Has 250,000 photos. Clients include: ad agencies, public relations firms, businesses, book/encyclopedia publishers, magazine publishers, newspapers, postcard companies, calendar companies, greeting card companies, zoos and aquariums.
 • The Wildlife Collection has scanned thousands of images onto CD-ROM which they use for promotion.
Needs: "We handle anything to do with nature—animals, scenics, vegetation, underwater. We are in particular need of coverage from India, the Caribbean, Europe, and the Middle East, as well as endangered animals, in particular chimpanzees, bonobos and California Condors. We are also in need of excellent underwater photographers."
Specs: Uses 35mm, 2¼×2¼, 4×5, 6×4½ transparencies.
Payment & Terms: Pays 50% commission on color photos. General price range (to clients): $100-6,000. Works on contract basis only. Minimum US exclusivity but prefers world exclusivity. Contracts renew automatically for 1 year. There are no charges to be included in catalogs or other promotional materials. Statements issued monthly. Payment made monthly. Photographers allowed to review sales figures. Offers one-time rights. Informs photographers when client requests all rights, "but they can only negotiate through us—not directly." Model release "not necessary with nature subjects." Photo captions required; include common, scientific name and region found.
Making Contact: Interested in receiving work from newer, lesser-known photographers, as well as more established photographers. Query with samples. Printed samples kept on file. SASE. Expects minimum initial submission of 200 images. "We would like 2,000 images/year; this will vary." Reports in 2 weeks. Photo guidelines and free catalog with 6½×9½ SAE with 78¢ postage. Market tips sheet distributed quarterly to signed photographers only.
Tips: In samples wants to see "great lighting, extreme sharpness, *non-stressed* animals, large range of subjects, excellent captioning, general presentation. Care of work makes a large impression. The effect of humans on the environment is being requested more often as are unusual and endangered animals."

‡**WILDLIGHT PHOTO AGENCY**, 87 Gloucester St., The Rocks, NSW 2000 Australia. (02)251-5852. Fax: (02)251-5334. Contact: Manager. Estab. 1985. Stock photo agency, picture library. Has 300,000 photos. Clients include: ad agencies, public relations firms, audiovisual firms, businesses, book/encyclopedia publishers, magazine publishers, newspapers, postcard publishers, calendar companies, greeting card companies.
Specs: Uses 35mm, 2¼×2¼, 4×5, 8×10, 6×12, 6×17 transparencies.
Payment & Terms: Pays 50% commission on color photos. Works on exclusive contract basis only. Statements issued quarterly. Payment made quarterly. Offers one-time rights. Model/property release required. Captions required.
Making Contact: Arrange personal interview to show portfolio. Expects minimum initial submission of 1,000 images with periodic submission of at least 250/month. Reports in 1-2 weeks. Photo guidelines available.

‡**WORLD VIEW-HOLLAND BV**, A.J. Ernststraat 181, Amsterdam, 1083 GV Holland. 31-20-6420224. Fax: 31-20-6611355. Managing Director: Bert Blokhuis. Estab. 1985. Stock photo agency. Has 150,000 transparencies. Clients include: ad agencies, audiovisual firms, businesses, calendar companies and corporations.
Needs: Wants to see "sizes bigger than 35mm, only model-released commercial subjects."
Specs: Uses 2¼×2¼, 4×5, 8×10 transparencies only.
Payment & Terms: Pays 50% commission on transparencies. General price range (to clients): US $300/color photos, minimum $100. Offers volume discounts to customers; inquire about specific terms. Discount sales terms not negotiable. Works on contract basis only. Offers limited regional exclusivity. Contracts renew automatically for 4 years. Statements issued monthly. Payment made quarterly. Photographers permitted to review sales figures. Offers one-time rights. Informs photographer and allows him to negotiate when client requests all rights. Model release required. Captions required.

Making Contact: Interested in receiving work from newer, lesser-known photographers. Query with samples. SASE. Reports in 3 weeks.

Tips: In freelancer's samples, wants to see "small amount of pictures (20 or 30) plus a list of subjects available and list of agents." Work must show quality.

■**WORLDWIDE IMAGES**, P.O. Box 150547, San Rafael CA 94915. (415)459-0627. Owner: Norman Buller. Estab. 1988. Stock photo agency. Has 4,000 photos. Clients include: publishers, magazine publishers, postcard companies, calendar companies, greeting card companies and men's magazines, foreign and domestic.

Needs: Nude layouts for men's magazines, foreign and domestic; celebrities, rock stars, all professional sports teams, amateur X-rated videos and photos, glamour, swimsuit—"anything in this field!"

Specs: Uses all size prints, slides and transparencies, VHS videos.

Payment & Terms: Pays 50% commission on all sales. Works without a signed contract, negotiable. Offers nonexclusive contract. Statements issued upon request. Payment made immediately upon payment from client. Photographers allowed to review account records to verify sales figures. Offers one-time or first rights and all rights. Informs photographer and allows him to negotiate when client requests all rights but handles all negotiation. Model release required. Captions required.

Making Contact: Interested in receiving work from newer, lesser-known photographers. Query with samples and list of stock photo subjects. Send unsolicited photos by mail for consideration. Reports immediately.

Tips: "Work must be good. We have worldwide clientele, don't edit too tightly, let me see 90% of your material on hand and critique it from there! We're getting new clients around the world every week! We have more clients than photos! We need new and varied photographers ASAP!"

*‡**WORLDWIDE PRESS AGENCY**, Box 579, 1000 Buenos Aires, Argentina. (54)1 962 3182. Fax: (54)1 951 2420. Director: Victor Polanco. Stock photo agency and picture library. Clients include: ad agencies, book/encyclopedia publishers, magazine publishers, newspapers, postcard companies, calendar companies and greeting card companies.

Needs: Handles picture stories, fashion, human interest, pets, wildlife, film and TV stars, pop and rock singers, classic musicians and conductors, sports, interior design, architectural and opera singers.

Specs: Uses 8×12 glossy b&w prints; 35mm and $2\frac{1}{4} \times 2\frac{1}{4}$ transparencies.

Payment & Terms: Pays 40% commission for b&w and color photos. General price range (to clients): "The Argentine market is very peculiar. We try to obtain the best price for each pic. Sometimes we consult the photographer's needs." Works on limited regional exclusivity. Statements issued semi-annually. Payment made "as soon as collected from clients." Photographer allowed to review account records. Offers one-time rights. Informs photographer and allows him to negotiate when client requests all rights. Model release preferred. Captions preferred.

Making Contact: Query with list of stock photo subjects. Does not return unsolicited material. Reports "as soon as possible."

Resources
Art/Photo Representatives

Several interviewees in this book refer to their relationships with photo representatives. Toronto photographer Derek Shapton, for instance, recognizes the importance of his rep Kristina Jansz. In Shapton's interview on page 101 he discusses how invaluable it is to have Jansz attracting high-end clients to his style. Even veteran Eddie Adams (see page 27) mentions the fact that his editorial style is something that rep Elyse Weissberg is pushing on advertising clients, a field about which he admits to knowing very little.

The beauty of the photographer-representative relationship is that it allows photographers to concentrate on taking photos. They can develop concepts, experiment with new techniques and tackle projects without having to worry about rounding up new clients. And while the photographer is shooting, the rep's role is simple—sell, sell, sell.

Representatives charge fees (usually 20-30 percent commission) for marketing a photographer's skills and freelancers often pay 75 percent of any advertising fees (such as sourcebook ads or direct mail pieces). However, the marketing expertise gained from a rep is well worth the money. Good photo representatives can boost a photographer's income many times over, usually by adding clients who specialize in advertising or design. Reps can increase a photographer's marketability by improving portfolios, helping create direct mail pieces and selecting appropriate advertising space.

As you examine the 68 listings in this section you will see that some reps are members of SPAR, the Society of Photographer and Artist Representatives. This organization sponsors educational programs and maintains a code of ethics to which all members must adhere. For more information on the group, contact SPAR, 60 E. 42nd St., Suite 1166, New York NY 10165. (212)779-7464.

ANNE ALBRECHT AND ASSOCIATES, 68 E. Wacker Place, Suite 800, Chicago IL 60601. (312)853-4830. Fax: (312)629-5656. Contact: Anne Albrecht. Commercial photography and illustration representative. Estab. 1991. Member of C.A.R. (Chicago Artists Representatives) and Graphic Artists Guild. Represents 3 photographers and 7 illustrators. Markets include advertising agencies, corporations/clients direct, design firms, editorial/magazines, publishing/books and sales/promotion firms.
Handles: Illustration, photography.
Terms: Agent receives 25% commission. Advertises in *American Showcase*, *Creative Black Book* and *The Workbook*.
How to Contact: For first contact, send tearsheets. Reports only if interested. After initial contact drop off or mail materials for review. Portfolios should include photographs, tearsheets and/or photocopies.

***ARF PRODUCTIONS**, 59 Wareham St., Suite #8, Boston MA 02118. (617)423-2212. Fax: (617)423-2213. Contact: Amy R. Frith. Commercial photography and illustration representative. Estab. 1991. Member of SPAR. Represents 8 photographers, 2 illustrators. Specializes in photography, illustration, film directors, music production. Markets include: advertising agencies; corporations/clients direct; design firms; editorial/magazines.
Handles: Illustration, photography. Looking for humorous photos and illustrations.
Terms: Rep receives 25% commission. Exclusive area representation required. Talent pays 100% of advertising costs. For promotional purposes, talent must provide a minimum of 4 portfolios, 1 for

show, 3 for shipping. New portfolio pieces must be provided at least 3 times a year. Advertises in *American Showcase, Creative Black Book, The Workbook.*
How to Contact: For first contact, send query letter, direct mail flier/brochure, tearsheets and SASE. Reports in 2 weeks. Portfolios should include a focused body of work that reflects who you are as an artist.
Tips: Obtains new talent through referrals and magazines.

ARTIST DEVELOPMENT GROUP, 21 Emmett St., Suite 2, Providence RI 02903-4503. (401)521-5774. Fax: (401)521-5776. Contact: Rita Campbell. Represents photography, fine art, graphic design, as well as performing talent. Staff includes Rita Campbell. Estab. 1982. Member of Rhode Island Women's Advertising Club. Markets include: advertising agencies; corporations/clients direct.
Handles: Illustration, photography.
Terms: Rep receives 20-25% commission. Advertising costs are split: 50% paid by talent; 50% paid by representative. For promotional purposes, talent must provide direct mail promotional piece; samples in book for sales meetings.
How to Contact: For first contact, send résumé, bio, direct mail flier/brochure. Reports in 3 weeks. After initial contact, drop off or mail in appropriate materials for review. Portfolios should include tearsheets, photographs.
Tips: Obtains new talent through "referrals as well as inquiries from talent exposed to agency promo."

***ARTLINE**, 439 S. Tryon St., Charlotte NC 28202. (704)376-7609. Fax: (704)376-0207. Contact: Chris Omirly. E-mail: artline1@aol.com. Commercial photography and illustration representative. Estab. 1992. Represents 3 photographers, 5 illustrators. Staff includes Lon Murdick, Steve Murray and Rick Smith (photographers); Rob Cheney, K.C. Clark, Tom Ogburn, Harry Roolaart and Richard Smith (illustrators). Specializes in providing service as a resource center for commercial arts in the Southeast. Markets include: advertising agencies; corporations/clients direct; design firms; editorial/magazines; publishing/books.
Handles: Illustration, photography, fine art. Looking for digital photography.
Terms: Rep receives 25% commission. Charges photographers $300/month; once commissions exceed the total annual fee of $3,600, it is reduced to $100/month. Charges illustrators a flat fee of $50/month. Exclusive area representation required. Advertising costs are split: 75% paid by talent; 25% paid by representative. For promotional purposes, talent must provide 2 portfolios and 2 new promo pieces per year. Portfolios are to be updated every 4 months. Advertises in *American Showcase.*
How to Contact: For first contact, send query letter, bio, direct mail flier/brochure, tearsheets. Reports in 2 weeks only if interested. After initial contact, call to schedule an appointment. Portfolios should include slides, transparencies of tearsheet copies.
Tips: Obtains new talent through recommendations, solicitations and inquiries. "Come forth with an open mind and a will to work. Just having a rep is not enough—both parties have to work together."

***ROBERT BACALL REPRESENTATIVE**, 380 Lafayette St., New York NY 10003. (212)254-5725. Fax: (212)979-9524. Contact: Robert Bacall. Commercial photography representative. Estab. 1988. Represents 6 photographers. Specializes in food, still life, fashion, beauty, kids, corporate, environmental, portrait, life style, location, landscape. Markets include: advertising agencies; corporations/clients direct; design firms; editorial/magazines; publishing/books; sales/promotion firms.
Terms: Rep receives 25% commission. Charges 50% of messenger costs. Exclusive area representation required. Advertising costs are split: 75% paid by talent; 25% paid by representative. For promotional purposes, talent must provide portfolios, cases, tearsheets, prints, etc. Advertises in *Creative Black Book, NY Gold, The Photographers DayBook.*
How to Contact: For first contact, send query letter, direct mail flier/brochure. Reports only if interested. After initial contact, drop off or mail materials for review.
Tips: "I usually get solicited and keep seeing new work until something interests me and I feel I can sell it to someone else. Seek representation when you feel your portfolio is unique and can bring in new business."

***CECI BARTELS ASSOCIATES**, 3286 Ivanhoe, St. Louis MO 63139. (314)781-7377. Fax: (314)781-8017. Contact: Ceci Bartels. Commercial illustration and photography representative. Estab. 1980. Member of SPAR, Graphic Artists Guild, ASMP. Represents 20 illustrators and 3 photographers. "My staff functions in sales, marketing and bookkeeping. There are 7 of us. We concentrate on

THE ASTERISK before a listing indicates that the market is new in this edition. New markets are often the most receptive to freelance submissions.

advertising agencies and sales promotion.'' Markets include advertising agencies; corporations/client direct; design firms; publishing/books; sales/promotion firms.

Handles: Illustration, photography. "Photographers who can project human positive emotions with strength interest us."

Terms: Rep receives 30% commission. Advertising costs are split: 70% paid by talent; 30% paid by representative "after sufficient billings have been achieved. Artists pay 100% initially. We need direct mail support and advertising to work on the national level. We welcome 6 portfolios/artist. Artist is advised not to produce multiple portfolios or promotional materials until brought on." Advertises in *American Showcase, Creative Black Book, RSVP, The Workbook, CIB.*

How to Contact: For first contact, send query letter, direct mail flier/brochure, tearsheets, slides, SASE, portfolio with SASE or promotional materials. Reports if SASE enclosed. After initial contact, drop off or mail in appropriate materials for review. Portfolio should include tearsheets, slides, photographs, 4×5 transparencies. Obtains new talent through recommendations from others; "I watch the annuals and publications."

BEATE WORKS, 7916 Melrose Ave., #2, Los Angeles CA 90046. (213)653-5088. Fax: (213)653-5089. E-mail: beateworks@aol.com. Contact: Beate Chelette. Commercial photography, illustration and graphic design representative. Estab. 1992. Represents 5 photographers, 2 illustrators and 2 designers. Staff includes Larry Bartholomew (fashion); Rick Steil (fashion); and Maura McCarthy (graphic design). A full service agency that covers preproduction to final product. Markets include advertising agencies, corporations/clients direct, design firms and editorial/magazines.

Handles: Photography. Only interested in established photographers. "Must have a client base."

Terms: Rep receives 25-30% commission. Exclusive area representation required. Advertising costs are split: 75% paid by talent; 25% paid by representative. For promotional purposes, talent must provide at least 3 portfolios.

How to Contact: For first contact, sent query letter and direct mail flier/brochure. Reports in several days if interested. After initial contact, call to schedule an appointment. Portfolios should include tearsheets, photographs and photocopies.

Tips: Typically obtains new talent through recommendations and referrals. "Do your research on a rep before you approach him."

BERENDSEN & ASSOCIATES, INC., 2233 Kemper Lane, Cincinnati OH 45206. (513)861-1400. Fax: (513)861-6420. Contact: Bob Berendsen. Commercial illustration, photography, graphic design representative. Estab. 1986. Represents 24 illustrators, 4 photographers, 4 Mac designers/illustrators. Specializes in "high-visibility consumer accounts." Markets include: advertising agencies; corporations/clients direct; design firms; editorial/magazines; paper products/greeting cards; publishing/books; sales/promotion firms.

Handles: Illustration, photography. "We are always looking for illustrators that can draw people, product and action well. Also, we look for styles that are unique."

Terms: Rep receives 25% commission. Charges "mostly for postage but figures not available." No geographic restrictions. Advertising costs are split: 75% paid by talent; 25% paid by representative. For promotional purposes, "artist must co-op in our direct mail promotions, and sourcebooks are recommended. Portfolios are updated regularly." Advertises in *RSVP, Creative Illustration Book, The Ohio Source Book* and *American Showcase.*

How to Contact: For first contact, send query letter, résumé, tearsheets, slides, photographs, photocopies and SASE. Reports in weeks. After initial contact, drop off or mail in appropriate materials for review. Portfolios should include tearsheets, slides, photographs, photostats, photocopies.

Tips: Obtains new talent "through recommendations from other professionals. Contact Bob Berendsen, president of Berendsen and Associates, Inc. for first meeting."

BERNSTEIN & ANDRIULLI INC., 60 E. 42nd St., New York NY 10165. (212)682-1490. Fax: (212)286-1890. Contact: Howard Bernstein. Commercial illustration and photography representative. Estab. 1975. Member of SPAR. Represents 54 illustrators, 15 photographers. Staff includes Sam Bernstein; Martha Dunning; Michele Schiavone; Tony Andriulli; Howard Bernstein; Fran Rosenfeld; Molly Birenbaum; Craig Hoberman; Randi Fiat; Ivy Glick; Liz McCann; Susan Wells; Helen Goon. Markets include: advertising agencies; corporations/clients direct; design firms; editorial/magazines; paper products/greeting cards; publishing/books; sales/promotion firms.

Handles: Illustration and photography.

Terms: Rep receives a commission. Exclusive career representation is required. No geographic restrictions. Advertises in *Creative Black Book, The Workbook, Bernstein & Andriulli International Illustration, CA Magazine, Archive Magazine, Creative Illustration Book.*

How to Contact: For first contact, send query letter, direct mail flier/brochure, tearsheets, slides, photographs, photocopies. Reports in 1 week. After initial contact, drop off or mail in appropriate materials for review. Portfolio should include tearsheets, slides, photographs.

***BROOKE & COMPANY**, 4323 Bluffview, Dallas TX 75209. (214)352-9192. Fax: (214)350-2101. Contact: Brooke Davis. Commercial illustration and photography representative. Estab. 1988. Represents 10 illustrators, 3 photographers. "Owner has 18 years experience in sales and marketing in the advertising and design fields."
Terms: Rep receives 25% commission. Advertising costs are split: 75% paid by talent; 25% paid by representative.
How to Contact: For first contact, send bio, direct mail flier/brochure, "sample we can keep on file if possible" and SASE. Reports in 2 weeks. After initial contact, write for appointment to show portfolio or drop off or mail in portfolio of tearsheets, slides or photographs.
Tips: Obtains new talent through referral or by an interest in a specific style. "Only show your best work. Develop an individual style. Show the type of work that you enjoy doing and want to do more often. We must have a sample to leave with potential clients."

MARIANNE CAMPBELL, Pier 9 Embarcadero, San Francisco CA 94111. (415)433-0353. Fax: (415)433-0351. Contact: Marianne Campbell or Quinci Payne. Commercial photography representative. Estab. 1989. Member of APA, SPAR, Western Art Directors Club. Represents 4 photographers. Markets include: advertising agencies; corporations/clients direct; design firms; editorial/magazines.
Handles: Photography.
Terms: Rep receives 25% commission. Charges a percentage for FedEx charges. Advertising costs are split: 75% paid by talent; 25% paid by representative. For promotional purposes, talent must provide direct mail pieces "in which we share cost. Portfolio must consistently be updated with new, fresh work."
How to Contact: For first contact, send direct mail flier/brochure, printed samples of work. Reports in 2 weeks, only if interested. After initial contact, call for appointment to show portfolio of tearsheets, slides, photographs.
Tips: Obtains new talent through recommendations from art directors and designers, outstanding promotional materials. "Be considerate of rep's time."

STAN CARP, INC., 2166 Broadway, New York NY 10024. (212)362-4000. Contact: Stan Carp. Commercial photography representative and producer. Estab. 1959. Represents 3 photographers. Markets include: advertising agencies; corporations/clients direct; design firms; editorial/magazines; paper products/greeting cards; publishing/books; sales/promotion firms.
Handles: Photography and "commercial directors."
Terms: Rep receives 25% commission. Exclusive area representation is required. No geographic restrictions. Advertising costs are split: 75% paid by talent; 25% paid by representative. Advertises in *Creative Black Book*, *The Workbook*, and other publications.
How to Contact: For first contact, send photographs. Reporting time varies. After initial contact, call for appointment to show a portfolio of tearsheets, slides, photographs.
Tips: Obtains new talent through recommendations from others.

***CORCORAN FINE ARTS LIMITED, INC.**, 2915 Fairfax Rd., Cleveland Heights OH 44118. (216)397-0777. Fax: (216)397-0222. Contact: James Corcoran. Fine art representative. Estab. 1986. Member of NOADA (Northeast Ohio Art Dealers Association); ISA (International Society of Appraisers). Represents 5 photographers, 11 fine artists (includes 3 sculptors). Staff includes Meghan Wilson (gallery associate); Joe Haefner (office administrator); James Corcoran (owner/manager). Specializes in representing high-quality contemporary work. Markets include: architects; corporate collections; developers; galleries; interior decorators; museums; private collections.
Handles: Fine art.
Terms: Agent receives 50% commission. Exclusive area representation is required. Advertising costs are "decided case by case."
How to Contact: For first contact send a query letter, résumé, bio, slides, photographs, SASE. Reports back within 1 month. After initial contact, drop off or mail in appropriate materials for review. Portfolio should include slides, photographs.
Tips: Usually obtains new talent by solicitation.

CORPORATE ART PLANNING, 16 W. 16th St., 6th Floor, New York NY10011. (212)645-3490. Fax: (212)741-8608. E-mail: mmcap@pipeline.com. Contact: Maureen McGovern. Fine art representative. Estab. 1986. Specializes in art management expertise, curatorial services. Markets include advertising agencies, corporations/clients direct. Fine art markets include architects, corporate collections.
Handles: Photography, fine art.
Terms: Agent receives 50% commission. Advertising costs are split: 50% paid by talent; 50% paid by the representataive. Advertises in *Creative Black Book* and *The Workbook*.
How to Contact: For first contact, send query letter, résumé, bio, direct mail flier/brochure, SASE and color photocopies. Reports in 10 days. After initial contact, call to schedule an appointment.

Portfolios should include tearsheets, slides, photographs and photocopies.

***CVB CREATIVE RESOURCE**, 1856 Elba Circle, Costa Mesa CA 92626. (714)641-9700. Fax: (714)641-9700. Contact: Cindy Brenneman. Commercial illustration, photography and graphic design representative. Estab. 1984. Member of SPAR, ADDOC. Specializes in "high-quality innovative images." Markets include: advertising agencies; corporations/client direct; design firms.
Handles: Illustration. Looking for "a particular style or specialized medium."
Terms: Rep receives 30% commission. Exclusive area representation is required. Advertising costs are split: 70% paid by talent; 30% paid by representative, "if rep's name and number appear on piece." For promotional purposes, talent must provide promotional pieces on a fairly consistent basis. Portfolio should be laminated. Include transparencies or Cibachromes. Images to be shown are mutually agreed upon by talent and rep.
How to Contact: For first contact, send slides or photographs. Reports in 2 weeks, only if interested. After initial contact, call for appointment to show portfolio of tearsheets, slides, photographs, photostats.
Tips: Obtains new talent through referrals. "You usually know if you have a need as soon as you see the work. Be professional. Treat looking for a rep as you would looking for a freelance job. Get as much exposure as you can. Join peer clubs and network. Always ask for referrals. Interview several before settling on one. Personality and how you interact will have a big impact on the final decision."

KATIE DALEY REPRESENTS, 245 W. 29th St., New York NY 10001. (212)465-2420. Fax: (212)268-2650. Contact: Katie Daley. Commercial photography and illustration representative. Estab. 1985. Represents 4 photographers and 1 illustrator. Specializes in fashion and interiors. Markets include advertising agencies, corporations/clients direct, design firms, editorial/magazines, publishing/books and sales/promotion firms.
Handles: Illustration and photography.
Terms: Agent receives 25% commission. Charges messenger and promotional card fees. Exclusive area representation required. Advertising costs are split: 75% paid by the talent; 25% paid by the representative. For promotional purposes, talent must provide promotional cards (4 times/year); 2-6 portfolios.
How to Contact: For first contact, send promotional card. Reports in 2-3 days only if interested. After initial contact drop off or mail materials for review. Portfolios should include tearsheets, photographs and photostats.
Tips: Advises photographers to know "what your goals are and be ready to discuss how you and your rep can achieve them."

LINDA DE MORETA REPRESENTS, 1839 Ninth St., Alameda CA 94501. (510)769-1421. Fax: (510)521-1674. Contact: Linda de Moreta. Commercial photography and illustration representative; also portfolio and career consultant. Estab. 1988. Member of San Francisco Creative Alliance, Western Art Directors Club. Represents 4 photographers, 13 illustrators. Markets include: advertising agencies; design firms; corporations/clients direct; editorial/magazines; paper products/greeting cards; publishing/books; sales/promotion firms.
Handles: Photography, illustration, calligraphy.
Terms: Rep receives 25% commission. Exclusive representation requirements vary. Advertising costs are split: 75% paid by talent; 25% paid by representative. Materials for promotional purposes vary with each artist. Advertises in *The Workbook*, *American Showcase*, *The Creative Black Book*.
How to Contact: For first contact, send direct mail flier/brochure, tearsheets, slides, photocopies, photostats and SASE. "Please do *not* send original art. SASE for any items you wish returned." Responds to any inquiry in which there is an interest. Portfolios are individually developed for each artist and may include prints, transparencies, tearsheets.
Tips: Obtains new talent primarily through client and artist referrals, some solicitation. "I look for a personal vision and style of photography or illustration and exceptional creativity, combined with professionalism, maturity and a willingness to work hard."

RHONI EPSTEIN/Photographer's Representative, 11977 Kiowa Ave., Los Angeles CA 90049-6119. (310)207-5937. Contact: Rhoni Epstein. Photography representative. Estab. 1983. Member of APA. Represents 5-8 photographers. Specializes in advertising/entertainment photography.
Handles: Photography.
Terms: Agent receives 25-30% commission. Exclusive representation required in specific geographic area. Advertising costs are paid by talent. For promotional purposes, talent must have a strong direct mail campaign and/or double-page spread in national advertising book, portfolio to meet requirements of agent. Advertises in *The Workbook*.
How to Contact: For first contact, send direct mail samples. Reports in 1 week, only if interested. After initial contact, call for appointment or drop off or mail in appropriate materials for review. Portfolio should demonstrate own personal style.

Tips: Obtains new talent through recommendations. "Research the rep and her agency the way you would research an agency before soliciting work! Remain enthusiastic. There is always a market for creative and talented people."

FORTUNI, 2508 E. Belleview Place, Milwaukee WI 53211. (414)964-8088. Fax: (414)332-9629. Contact: Marian Deegan. Commercial photography and illustration representative. Estab. 1990. Member of Graphic Artists Guild and ASMP. Represents 2 photographers and 5 illustrators. Fortuni handles artists with unique, distinctive styles appropriate for commercial markets. Markets include advertising agencies, corporations/clients direct, design firms, editorial/magazines, publishing/books.
Handles: Illustration and photography. "I am interested in artists with a thorough professional approach to their work."
Terms: Agent receives 30% commission. Exclusive area representation required. Advertising costs are split: 70% paid by the talent; 30% paid by the representative. For promotional purposes, talent must provide 4 duplicate transparency portfolios, leave behinds and 4-6 promo pieces per year. "All artist materials must be formatted to my promotional specifications." Advertises in *American Showcase*, *Workbook*, *Directory of Illustration* and *Chicago Source Book*.
How To Contact: For first contact, send query letter, résumé, bio, direct mail flier/brochure, tearsheets, photocopies and SASE. Reports in 2 weeks only if interested. After initial contact, call to schedule an appointment. Portfolios should include roughs, tearsheets, slides, photographs, photocopies and transparencies.
Tips: "I obtain new artists through referrals. Organize your work in a way that clearly reflects your style, and the type of projects you most want to handle; and then be professional and thorough in your initial contact and follow-through."

JEAN GARDNER & ASSOCIATES, 444 N. Larchmont Blvd., Suite 108, Los Angeles CA 90004. (213)464-2492. Fax: (213)465-7013. Contact: Jean Gardner. Commercial photography representative. Estab. 1985. Member of APA. Represents 6 photographers. Specializes in photography. Markets include: advertising agencies; design firms.
Handles: Photography.
Terms: Rep receives 25% commission. Exclusive representation is required. No geographic restrictions. Advertising costs are paid by the talent. For promotional purposes, talent must provide promos, *Workbook* advertising, a quality portfolio. Advertises in *The Workbook*.
How to Contact: For first contact, send direct mail flier/brochure.
Tips: Obtains new talent through recommendations from others.

MICHAEL GINSBURG & ASSOCIATES, INC., 240 E. 27th St., Suite 24E, New York NY 10016. (212)679-8881. Fax: (212)679-2053. Contact: Michael Ginsburg. Commercial photography representative. Estab. 1978. Represents 7 photographers. Specializes in advertising and editorial photographers. Markets include advertising agencies, corporations/clients direct, design firms, editorial/magazines, sales/promotion firms.
Handles: Photography.
Terms: Rep receives 25% commission. Charges for messenger costs, Federal Express charges. Exclusive area representation is required. Advertising costs are split: 75% paid by talent; 25% paid by representative. For promotional purposes, talent must provide a minimum of 5 portfolios—direct mail pieces 2 times per year—and at least 1 sourcebook per year. Advertises in *Creative Black Book* and other publications.
How to Contact: For first contact, send query letter, direct mail flier/brochure. Reports in 2 weeks, only if interested. After initial contact, call for appointment to show portfolio of tearsheets, slides, photographs.
Tips: Obtains new talent through personal referrals and solicitation.

BARBARA GORDON ASSOCIATES LTD., 165 E. 32nd St., New York NY 10016. (212)686-3514. Fax: (212)532-4302. Contact: Barbara Gordon. Commercial illustration and photography representative. Estab. 1969. Member of SPAR, Society of Illustrators, Graphic Artists Guild. Represents 9 illustrators, 1 photographer. "I represent only a small select group of people and therefore give a great deal of personal time and attention to the people I represent."
Terms: Agent receives 25% commission. No geographic restrictions in continental US.
How to Contact: For first contact, send direct mail flier/brochure. Reports in 2 weeks. After initial contact, drop off or mail in appropriate materials for review. Portfolio should include tearsheets, slides, photographs; "if the talent wants materials or promotion piece returned, include SASE."
Tips: Obtains new talent through recommendations from others, solicitation, at conferences, etc. "I have obtained talent from all of the above. I do not care if an artist or photographer has been published or is experienced. I am essentially interested in people with a good, commercial style. Don't send résumés and don't call to give me a verbal description of your work. Send promotion pieces. *Never* send original art. If you want something back, include a SASE. Always label your slides in case they

get separated from your cover letter. And always include a phone number where you can be reached."

CAROL GUENZI AGENTS, INC., 865 Delaware, Denver CO 80204-4533. (303)820-2599. Fax: (303)820-2598. Contact: Carol Guenzi. Commercial illustration, film and animation representative. Estab. 1984. Member of Denver Advertising Federation and Art Directors Club of Denver. Represents 25 illustrators, 5 photographers, 3 computer designers. Specializes in a "wide selection of talent in all areas of visual communications." Markets include: advertising agencies; corporations/clients direct; design firms; editorial/magazine, paper products/greeting cards, sales/promotions firms.
Handles: Illustration, photography. Looking for "unique style application" and digital imaging.
Terms: Rep receives 25-30% commission. Exclusive area representative is required. Advertising costs are split: 70-75% paid by talent; 25-30% paid by the representation. For promotional purposes, talent must provide "promotional material after six months, some restrictions on portfolios." Advertises in *American Showcase, Creative Black Book, The Workbook, Creative Options, Rocky Mountain Sourcebook.*
How to Contact: For first contact, send direct mail flier/brochure, tearsheets, slides, photocopies. Reports in 2-3 weeks, only if interested. After initial contact, call or write for appointment to drop off or mail in appropriate materials for review, depending on artist's location. Portfolio should include tearsheets, slides, photographs.
Tips: Obtains new talent through solicitation, art directors' referrals, an active pursuit by individual. "Show your strongest style and have at least 12 samples of that style, before introducing all your capabilities. Be prepared to add additional work to your portfolio to help round out your style. We do a large percentage of computer manipulation and accessing on network. All our portfolios are on disk or CD-ROM."

***PAT HACKETT/ARTIST REPRESENTATIVE**, Suite 502, 101 Yesler Way, Seattle WA 98104-2552. (206)447-1600. Fax: (206)447-0739. E-mail: pathackett@aol.com. Contact: Pat Hackett. Commercial illustration and photography representative. Estab. 1979. Member of Graphic Artists Guild. Represents 27 illustrators, 2 photographers. Markets include: advertising agencies; corporations/client direct; design firms; editorial/magazines.
Handles: Illustration.
Terms: Rep receives 25-33% commission. Exclusive area representation is required. No geographic restrictions, but sells mostly in Washington, Oregon, Idaho, Montana, Alaska and Hawaii. Advertising costs are split: 75% paid by talent; 25% paid by representative. For promotional purposes, talent must provide "standardized portfolio, i.e., all pieces within the book are the same format. Reprints are nice, but not absolutely required." Advertises in *American Showcase, Creative Black Book, The Workbook, Creative Illustration, Medical Illustration Source Book.*
How to Contact: For first contact, send direct mail flier/brochure. Reports in 1 week, only if interested. After initial contact, drop off or mail in appropriate materials: tearsheets, slides, photographs, photostats, photocopies.
Tips: Obtains new talent through "recommendations and calls/letters from artists moving to the area. We prefer to handle artists who live in the area unless they do something that is not available locally."

***HOLLY HAHN AND CO.**, 770 N. Holsted, P102, Chicago IL 60626. (312)338-7110. Fax: (312)338-7004. Commercial photography and illustration representative. Estab. 1988. Member of Chicago Artists Representatives. Represents 2 photographers, 5 illustrators. Markets include: advertising agencies; corporations/clients direct; design firms; editorial/magazines; paper products/greeting cards; publishing/books; sales/promotion firms.
Handles: Illustration, photography.
Terms: Rep receives 30% commission. For promotional purposes, talent must provide 4 new pieces a year in addition to advertising in the books." Advertises in *The Workbook*, other sourcebooks.
How to Contact: For first contact, send query letter, direct mail flier/brochure, tearsheets and SASE. Reports in 2-3 weeks only if interested. After initial contact, drop off or mail materials for review. Portfolio should include tearsheets, slides, photographs.
Tips: Obtains new talent through recommendations from others and reviewing samples.

HALL & ASSOCIATES, 1010 S. Robertson Blvd, #10, Los Angeles CA 90035. (310)652-7322. Fax: (310)652-3835. Contact: Marni Hall. Commercial illustration and photography representative. Estab. 1983. Member of SPAR, APA. Represents 7 illustrators and 8 photographers. Markets include: advertising agencies; design firms. Member agent: Joy Asbury (artist representative).
Handles: Illustration, photography.
Terms: Rep receives 30% commission. Exclusive area representation is required. No geographic restrictions. Advertising costs are paid by talent. For promotional purposes, talent must advertise in "one or two source books a year (double page), provide two direct mail pieces and one specific, specialized mailing. No specific portfolio requirement except that it be easy and light to carry and send out." Advertises in *Creative Black Book, The Workbook.*

How to Contact: For first contact, send direct mail flier/brochure. Follow with a call before 7 days. After initial contact, drop off (always call first) or mail in appropriate materials for review. Portfolios should include tearsheets, transparencies, prints (4×5 or larger).

Tips: Obtains new talent through recommendations from clients or artists' solicitations. "Don't show work you think should sell but what you enjoy shooting. Only put in tearsheets of great ads, not bad ads even if they are a highly visible client."

HAMILTON GRAY, 3519 W. Sixth St., Los Angeles CA 90020. (213)380-3933. Fax: (213)380-2906. Contact: Maggie Hamilton. Commercial photography. Estab. 1990. Member of AIGA, APA. Represents 12 photographers. Specializes in entertainment, editorial, advertising. Markets include: advertising agencies; corporations/clients direct; editorial/magazines.

Handles: Photography.

Terms: Rep receives 30% commission. Charges for messengers or FedEx if photographer has requested sending. Exclusive area representation required. Advertising costs are paid by talent. For promotional materials, talent must provide current portfolios (2-4 books), mailing pieces and be open to sourcebooks. Advertises in *American Showcase, Creative Black Book, The Workbook* and *California Sourcebooks* (Black Book Publishing).

How to Contact: For first contact, send query letter with direct mail flier/brochure. Reports in 1 week. After initial contact, call for appointment to show portfolio of tearsheets, slides, photographs.

Tips: "Obtain new talent through my own awareness and recommendations from others. Think about if you were a rep, what you would want in photographer? Portfolio—2-4 books; material—mailers, etc.; and a good sense of how hard it is to accomplish success without vision and commitment."

BARB HAUSER, ANOTHER GIRL REP, P.O.Box 421443, San Francisco CA 94142-1443. (415)647-5660. Fax: (415)285-1102. Estab. 1980. Represents 10 illustrators and 1 photographer. Markets include: primarily advertising agencies and design firms; corporations/clients direct.

Handles: Illustration and photography.

Terms: Rep receives 25-30% commission. Exclusive representation in the San Francisco area is required. No geographic restrictions.

How to Contact: For first contact, send direct mail flier/brochure, tearsheets, slides, photographs, photocopies and SASE. Reports in 3-4 weeks. After initial contact call for appointment to show portfolio of tearsheets, slides, photographs, photostats, photocopies.

***INTERPRESS WORLDWIDE**, P.O. Box 8374, Universal City CA 91608-0374. (213)876-7675. Contact: Ellen Bow. Commercial photography, illustration, fine art, graphic design, actors/musicians representative; also illustration or photography broker. Estab. 1989. Represents 10 photographers, 2 illustrators, 2 designers and 5 fine artists. Specializes in subsidiaries worldwide: Vienna, Austria; Milano, Italy; London, England; and Madrid, Spain. Markets include: advertising agencies; corporations/clients direct; editorial/magazines; publishing/books; movie industry; art publishers; galleries; and private collections.

Handles: Illustration, photography, fine art, design, graphic art.

Terms: Rep receives 30% commission. Charges initial rep fee and for postage. Exclusive representation negotiable. Advertising costs are split: 80% paid by the talent; 20% paid by representative. For promotional purposes, talent must provide 2 show portfolios, 6 traveling portfolios. Advertises in *Creative Black Book, The Workbook, Production-Creation, The Red Book*.

How to Contact: For first contact, send query letter, résumé, bio, direct mail flier/brochure, tearsheets, photos, photostats, e-folio. Reports in 45-60 days. After initial contact, call or write for appointment or drop off or mail materials for review. Portfolios should include thumbnails, roughs, original art, tearsheets, slides, photographs, photostats, e-folio (Mac disk), CD-ROM (Mac).

Tips: Obtains new talent through recommendations from others and the extraordinary work, personality and talent of the photographer. "Try as hard as you can and don't take our 'no' as a 'no' to your talent."

***JILL ANN REPRESENTS**, 1770 Broadway, Suite 301, San Francisco CA 94109. (415)921-7735. Studio Manager: Michelle. Commercial photography representative. Estab. 1991. Member of SPAR, ASMP, APA. Represents 4 photographers, 4 illustrators. Markets include: advertising agencies, corporations/clients direct, design firms, editorial/magazines, paper products/greeting cards, stock houses.

Handles: Photography. Only interested in "extremely technically, as well as creatively, qualified photographers with unique vision."

Terms: Rep receives 25% commission. Charges monthly operational expense. Advertising costs are split: 75% paid by talent; 25% paid by representative. For promotional purposes, talent must provide 2 show portfolios, 1 additional travel portfolio, leave-behinds and additional promotional pieces. Advertises in *Single Image, Workbook CD-ROM*.

How to Contact: For first contact, send query letter, direct mail flier/brochure and SASE. Reports in 1 month only if interested.

Tips: Obtains new talent through personal referrals and photo magazine articles. Interested in graphic designers, hand-letters and calligraphers. "Be very business-like, professional and follow submission instructions."

THE TRICIA JOYCE CO., 80 Warren St., New York NY 10007. (212)962-0728. Send to: Tricia Joyce. Commercial photography representative. Estab. 1988. Represents 8 photographers and 4 stylists. Specializes in fashion, still life, architecture, interiors, portraiture. Markets include advertising agencies, corporations/clients direct, design firms, editorial/magazines and sales/promotion firms.
Handles: Photography and fine art.
Terms: Agent receives 25% commission. Advertising costs are split 75% paid by talent; 25% paid by the representative.
How to Contact: For first contact, send query letter, résumé, direct mail flier/brochure and photocopies. Reports only if interested. After initial contact "wait to hear—please don't call."
Tips: "Write/send work to reps whose clients' work you respect."

ELLEN KNABLE & ASSOCIATES, INC., 1233 S. LaCienega Blvd., Los Angeles CA 90035. (310)855-8855. Fax: (310)657-0265. Contact: Ellen Knable, Kathee Toyama. Commercial illustration, photography and production representative. Estab. 1978. Member of SPAR, Graphic Artists Guild. Represents 6 illustrators, 5 photographers. Markets include: advertising agencies; corporations/clients direct; design firms.
Terms: Rep receives 25-30% commission. Exclusive West Coast/Southern California representation is required. Advertising costs split varies. Advertises in *The Workbook*.
How to Contact: For first contact, send query letter, direct mail flier/brochure and tearsheets. Reports within 2 weeks. Call for appointment to show portfolio.
Tips: Obtains new talent from creatives/artists. "Have patience and persistence!"

KORMAN & COMPANY, PHA, 135 W. 24th St., New York NY 10011. (212)727-1442. Fax: (212)727-1443. Contact: Alison Korman. Commercial photography representative. Estab. 1984. Member of SPAR. Represents 3 photographers. Markets include: advertising agencies; corporations/clients direct; editorial/magazines; publishing/books; sales/promotion firms.
Handles: Photography.
Terms: Rep receives 25-30% commission. "Talent pays for messengers, mailings, promotion." Exclusive area representation is required. Advertising costs are paid by talent "for first two years, unless very established and sharing house." For promotional purposes, talent must provide portfolio, directory ads, mailing pieces. Advertises in *Creative Black Book*, *The Workbook*, *Gold Book*.
How to Contact: For first contact, send direct mail flier/brochure. Reports in 1 month if interested. After initial contact, write for appointment or drop off or mail in portfolio of tearsheets, photographs.
Tips: Obtains new talent through "recommendations, seeing somebody's work out in the market and liking it. Be prepared to discuss how you can help a rep to help you."

***ELAINE KORN ASSOCIATES, LTD.**, 2E, 372 Fifth Ave., New York NY 10018. (212)760-0057. Fax: (212)465-8093. Commercial photography representative. Estab. 1981. Member of SPAR. Represents 6 photographers. Specializes in fashion, fashion-related still life, children and family (lifestyle). Markets include: advertising agencies; editorial/magazines.
Handles: Photography.
How to Contact: For first contact, send promotional pieces. After initial contact, write for appointment to show portfolio.

***JOAN KRAMER AND ASSOCIATES, INC.**, 10490 Wilshire Blvd., #1701, Los Angeles CA 90024. (310)446-1866. Fax: (310)446-1856. Contact: Joan Kramer. Commercial photography representative and stock photo agency. Estab. 1971. Member of SPAR, ASMP, PACA. Represents 45 photographers. Specializes in model released lifestyle. Markets include: advertising agencies; design firms; publishing/books; sales/promotion firms; producers of TV commercials.
Handles: Photography.
Terms: Rep receives 30% commission. Advertising costs split: 50% paid by talent; 50% paid by representative. Advertises in *Creative Black Book*, *The Workbook*.
How to Contact: Call to schedule an appointment. Portfolio should include slides. Reports only if interested.
Tips: Obtains new talent through recommendations from others.

LEE + LOU PRODUCTIONS INC., 8522 National Blvd., #108, Culver City CA 90232. (310)287-1542. Fax: (310)287-1814. Commercial illustration and photography representative, digital and traditional photo retouching. Estab. 1981. Represents 10 illustrators, 5 photographers. Specializes in automotive. Markets include: advertising agencies.

Handles: Photography.
Terms: Rep receives 25% commission. Charges shipping, entertainment. Exclusive area representation required. Advertising costs are paid by talent. For promotional purposes, talent must provide direct mail advertising material. Advertises in *Creative Black Book*, *The Workbook* and *Single Image*.
How to Contact: For first contact, send direct mail flier/brochure, tearsheets. Reports in 1 week. After initial contact, call for appointment to show portfolio of photographs.
Tips: Obtains new talent through recommendations from others, some solicitation.

LEVIN•DORR, 1123 Broadway, Suite 1005, New York NY 10010. (212)627-9871. Fax: (212)243-4036. Contact: Bruce Levin or Chuck Dorr. Commercial photography representative. Estab. 1982. Member of SPAR. Represents 11 photographers. Markets include: advertising agencies; design firms; editorial/magazines; sales/promotion firms.
Handles: Photography.
Terms: Rep receives 25% commission. Exclusive area representation is required. Advertising costs are split: 75% paid by talent; 25% paid by representative. For promotional purposes, "talent must have a minimum of five portfolios which are lightweight and fit into Federal Express boxes." Advertises in *Creative Black Book*, *The Workbook*, *Gold Book*.
How to Contact: For first contact, send "portfolio as if it were going to advertising agency." After initial contact, call for appointment to show portfolio of tearsheets, slides, photographs.
Tips: Obtains new talent through recommendations, word-of-mouth, solicitation. "Don't get discouraged."

***LORRAINE & ASSOCIATES**, 2311 Farrington, Dallas TX 75207. (214)688-1540. Fax: (214)688-1608. Contact: Lorraine Haugen. Commercial photography, illustration and digital imaging representative. Estab. 1992. Member of DSVC. Represents 2 photographers, 2 illustrators, 1 fine artist. "We have over 8 years experience marketing and selling digital retouching and point-of-purchase advertising in a photographic lab." Markets include: advertising agencies; corporations/clients direct; design firms; interior decorators; high-end interior showrooms and retail.
Handles: Illustration, photography, digital illustrators and co-animators. Looking for unique established photographers and illustrators, CD digital animators and interactive CD-ROM animators.
Terms: Rep receives 25-30% commission. Charges monthly retainer fee of $300 per talent. Advertising costs are split: 80% paid by talent; 20% paid by representative. For promotional purposes, talent must provide 2 show portfolios, 1 traveling portfolio, leave-behinds and at least 5 new promo pieces per year. Must advertise in *American Showcase* and regional sourcebook, and participate in pro bono projects. Advertises in *American Showcase*, *The Workbook*, regional sourcebooks.
How to Contact: For first contact, send bio, direct mail flier/brochure, tearsheets. Reports in 2-3 weeks if interested. After initial contact, call to schedule an appointment. Portfolios should include photographs.
Tips: Obtains new talent through referrals and personal working relationships. "Talents' portfolios are also reviewed by talent represented for approval and compliment of styles to the group represented. Photographer should be willing to participate in group projects and be very professional in following instructions, organization and presentation."

***MCCONNELL MCNAMARA & CO.**, 182 Broad St., Wethersfield CT 06109. (860)563-6154. Fax: (860)563-6159. E-mail: jack_mcconnell@msn.com. Contact: Paula B. McNamara. Commercial illustration, photography and fine art representative. Estab. 1975. Member of SPAR, Graphic Artists Guild, ASMP, ASPP. Represents 1 illustrator, 1 photographer and 1 fine artist. Staff includes Paula B. McNamara (photography, illustration and fine art). Specializes in advertising and annual report photography. Markets include: advertising agencies; corporations/client direct; design firms; editorial/magazines; paper products/greeting cards; publishing/books; sales/promotion firms; stock photography/travel; corporate collections; galleries.
Handles: Photography. "Looking for photographers specializing in stock photography of New England."
Terms: Rep receives 25-30% commission. Exclusive area representation is required. Advertising costs are split: 75% paid by talent; 25% paid by representative. For promotional purposes, talent must provide "professional portfolio and tearsheets already available and ready for improving; direct mail piece needed within 3 months after collaborating."

How to Contact: For first contact, send query letter, bio, résumé, direct mail flier/brochure, tearsheets, SASE. Reports in 1 month if interested. "Unfortunately we don't have staff to evaluate and investigate new talent or offer counsel." After initial contact, write for appointment to show portfolio of tearsheets, slides, photographs.

Tips: Obtains new talent through "recommendations by other professionals, sourcebooks and industry magazines. We prefer to follow our own leads rather than receive unsolicited promotions and inquiries. It's best to have repped yourself for several years to know your strengths and be realistic about your marketplace. The same is true of having experience with direct mail pieces, developing client lists, and having a system of follow up. We want our talent to have experience with all this so they can properly value our contribution to their growth and success—otherwise that 25% becomes a burden and point of resentment."

***COLLEEN MCKAY PHOTOGRAPHY**, 229 E. Fifth St., #2, New York NY 10003. (212)598-0469. Fax: (212)598-4059. Contact: Colleen McKay. Commercial editorial and fine art photography representative. Estab. 1985. Member of SPAR. Represents 6 photographers. "Our photographers cover a wide range of work from location, still life, fine art, fashion and beauty." Markets include: advertising agencies; design firms; editorial/magazines; stores.

Handles: Commercial and fine art photography.

Terms: Rep receives 25% commission. Exclusive area representation is required. Advertising costs are split: 75% paid by talent; 25% paid by representative. "Promotional pieces are very necessary. They must be current. The portfolio should be established." Advertises in *Creative Black Book*, *Select*, *New York Gold*.

How to Contact: For first contact, send query letter, résumé, bio, direct mail flier/brochure, tearsheets, slides, photographs. Reports in 2-3 weeks. "I like to respond to everyone but if we're really swamped I may only get a chance to respond to those we're most interested in." Portfolio should include tearsheets, slides, photographs, transparencies (usually for still life).

Tips: Obtains talent through recommendations of other people and solicitations. "I recommend that you look in current resource books and call the representatives that are handling the kind of work that you admire or is similar to your own. Ask these reps for an initial consultation and additional references. Do not be intimidated to approach anyone. Even if they do not take you on, a meeting with a good rep can prove to be very fruitful! Never give up! A clear, positive attitude is very important."

***GARY MANDEL ARTISTS REPRESENTATIVE**, 126 Fifth Ave., Suite 804, New York NY 10011. (212)727-1135. Fax: (212)206-8323. Contact: Hector Marcel. Commercial photography and makeup artists representatives. Member of ASMP. Represents 4 photographers. Staff includes Gary Mandel and Hector Marcel. Specializes in fashion, beauty, music and advertising. Markets include advertising agencies, corporations/clients direct, design firms and editorial/magazines.

Handles: Photography.

Terms: Rep receives 25-30% commission. Charges for messengers, Fed Ex, mail-outs, etc. Exclusive area representation required. Advertising costs are split: 75% paid by talent; 25% paid by representative. For promotional purposes, talent must provide portfolios, cards and mail-outs (once a year). Advertises in *American Showcase*, *Creative Black Book* and *Le Book*.

How to Contact: For first contact, send query letter. Reports in 2 weeks. After initial contact, call to schedule a folio drop off. Portfolios should include tearsheets.

Tips: Obtains new talent through recommendations and solicitations based on material sent or seen.

***MASLOV AGENT INTERNATIONAL**, 608 York St., San Francisco CA 94110. (415)641-4376. Contact: Norman Maslov. Commercial photography, fine art and illustration representative. Estab. 1986. Member of APA. Represents 5 photographers, 1 illustrator. Markets include: advertising agencies, corporations/clients direct, design firms, editorial/magazines, paper products/greeting cards, publishing/books, private collections.

Handles: Photography. Looking for "original work not derivative of other artists. Artist must have developed style."

Terms: Rep receives 25% commission. Exclusive area representation required in prearranged region. Advertising costs split varies. For promotional purposes, talent must provide 3-4 direct mail pieces a year. Advertises in *Single-Image*, *Archive*, *Workbook*.

How to Contact: For first contact, send query letter, direct mail flier/brochure, tearsheets. DO NOT send original work. Reports in 2-3 weeks only if interested. After initial contact, call to schedule an appointment or drop off or mail materials for review. Portfolio should include photographs.

Tips: Obtains new talent through suggestions from art buyers and recommendations from designers, art directors and other agents. "Enter your best work into competitions such as *Communication Arts* and *Graphis* photo annuals. Create a distinctive promotion mailer if your concepts and executions are strong."

SUSAN MILLER REPRESENTS, 1641 Third Ave., Suite 29A, New York NY 10128. (212)427-9604. Fax: (212)427-7777. E-mail: futurelady@aol.com. Contact: Susan Miller. Commercial photography representative. Estab. 1983. Member of SPAR. Represents 8 photographers. "Firm deals mainly in advertising photography." Markets include: advertising agencies; sales/promotion firms, design firms, some editorial.
Handles: Photography.
Terms: Rep receives 25-30% commission in US; 33% in Europe. Advertising costs are paid by talent. "Talent must be able to self-promote in a directory page and other mailers if possible." Advertises in *Creative Black Book*, *The Workbook* and by direct mail.
How to Contact: For first contact, send query letter, direct mail flier/brochure, photocopies and SASE. May e-mail, but "no faxes, please." Reports in 3 weeks. After initial contact, call for appointment to show portfolio of slides, photographs.
Tips: "New talent comes to us through a variety of means; recommendation from art buyers and art directors, award shows, editorial portfolios, articles and direct solicitation. Photographers and illustrators sending portfolio must pay courier both ways. Talent should please check directory ads to see if we have conflicting talent before contacting us. Most people calling us do not take the time to do any research, which is not wise."

MONTAGANO & ASSOCIATES, 401 W. Superior, 2nd Floor, Chicago IL 60610. (312)527-3283. Fax: (312)642-7543. E-mail: dmontag@aol.com. Contact: David Montagano. Commercial illustration, photography and television production representative and broker. Estab. 1983. Member of Chicago Artist Representatives. Represents 8 illustrators, 1 photographer, 8 directors. Markets include: advertising agencies; corporations/clients direct; design firms; editorial/magazines; paper products/greeting cards.
Handles: Illustration, photography, design. Looking for tabletop food photography.
Terms: Rep receives 30% commission. No geographic restrictions. Advertising costs are split: 70% paid by talent; 30% paid by representative. Advertises in *American Showcase*, *The Workbook*, *Creative Illustration Book*.
How to Contact: For first contact, send direct mail flier/brochure, tearsheets, photographs, disk samples. Reports in 5 days. After initial contact, call to schedule an appointment. Portfolio should include original art, tearsheets, photographs.
Tips: Obtains new talent through recommendations from others.

***MUNRO GOODMAN ARTISTS REPRESENTATIVES**, 405 N. Wabash Ave., Chicago IL 60611. (312)321-1336. Fax: (312)321-1350. Contact: Steve Munro. Commercial photography and illustration representative. Estab. 1987. Member of SPAR, CAR (Chicago Artist Representatives). Represents 2 photographers, 22 illustrators. Markets include: advertising agencies; corporations/clients direct; design firms; publishing/books.
Handles: Illustration, photography.
Terms: Rep receives 25-30% commission. Exclusive area representation required. Advertising costs are split: 75% paid by talent; 25% paid by representative. For promotional purposes, talent must provide 2 portfolios, leave-behinds, several promos. Advertises in *American Showcase*, *Creative Black Book*, *The Workbook*, other sourcebooks.
How to Contact: For first contact, send query letter, bio, tearsheets and SASE. Reports in 2 weeks only if interested. After initial contact, write to schedule an appointment.
Tips: Obtains new talent through recommendations, periodicals. "Do a little homework and target appropriate rep."

***100 ARTISTS**, 4170 S. Arbor Circle, Marietta GA 30066. (404)924-4793. Fax: (404)924-7174. Contact: Brenda Bender. Commercial photography, illustration and graphic design representative; also illustration or photography broker. Estab. 1990. Member of Society of Illustrators, Graphic Artists Guild. Represents 8 photographers, 40 illustrators, 8 designers. Specializes in first-rate, top-quality work. Markets include: advertising agencies; corporations/clients direct; design firms; editorial/magazines; publishing/books; sales/promotion firms.
Handles: Illustration, photography. "We will consider new talent but you must be ready to invest in portfolio, tearsheets, national advertisement and promos."
Terms: Rep receives 25-30% commission. $30-50 added to all out-of-town projects to lower expenses, i.e. fax, long-distance, etc. Exclusive area representation negotiable. Advertising costs are split: 75% paid by talent; 25% paid by representative. For promotional purposes, talent must provide portfolio, 2 traveling portfolios, leave-behinds, and at least 4 new promo pieces per year. Advertises in *American Showcase*, *The Workbook*.
How to Contact: For first contact, send query letter, direct mail flier/brochure, tearsheets and SASE. Reports in 2 weeks. After initial contact, call to schedule an appointment or drop off or mail materials for review. Portfolio should include tearsheets, slides, photographs.

Tips: Obtains new talent through recommendations from others and solicitations. "Be very business like and organized, check out work rep already has, and follow up."

JACKIE PAGE, 219 E. 69th St., New York NY 10021. (212)772-0346. Commercial photography representative. Estab. 1987. Member of SPAR and Ad Club. Represents 10 photographers. Markets include: advertising agencies.
Handles: Photography.
Terms: "Details given at a personal interview." Advertises in *The Workbook*.
How to Contact: For first contact, send direct mail flier/brochure. After initial contact, call for appointment to show portfolio of tearsheets, slides, photographs.
Tips: Obtains new talent through recommendations from others and mailings.

MARIA PISCOPO, 3603 S. Aspen Village Way #E, Santa Ana CA 92704-7570. (714)556-8133. Fax: (714)556-0899. E-mail: mpiscopo@aol.com. Website: http://commarts.com. Contact: Maria Piscopo. Commercial photography representative. Estab. 1978. Member of SPAR, Women in Photography, Society of Illustrative Photographers. Markets include: advertising agencies; design firms; corporations.
Handles: Photography. Looking for "unique, unusual styles; handles only established photographers."
Terms: Rep receives 25-30% commission. Exclusive area representation is required. No geographic restrictions. Advertising costs are split: 50% paid by talent; 50% paid by representative. For promotional purposes, talent must provide 1 show portfolio, 3 traveling portfolios, leave-behinds and at least 6 new promo pieces per year. Advertises in *American Showcase, The Workbook, New Media*.
How to Contact: For first contact, send query letter, bio, direct mail flier/brochure and SASE. Reports in 2 weeks, if interested.
Tips: Obtains new talent through personal referral and photo magazine articles. "Be very business-like, organized, professional and follow the above instructions!"

***ALYSSA PIZER**, 13121 Garden Land Rd., Los Angeles CA 90049. (310)440-3930. Fax: (310)440-3830. Contact: Alyssa Pizer. Commercial photography representative. Estab. 1990. Member of APCA. Represents 5 photographers. Specializes in entertainment (movie posters, TV Gallery, record/album); fashion (image campaign, department store); automobiles. Markets include: advertising agencies, corporations/clients direct, design firms, editorial/magazines, record companies; movie studios, TV networks, publicists.
Handles: Photography. Established photographers only.
Terms: Rep receives 25% commission. Photographer pays for Federal Express and messenger charges. Talent pays 100% of advertising costs. For promotional purposes, talent must provide1 show portfolio, 2-3 traveling portfolios, leave-behinds and quarterly promotional pieces.
How to Contact: For first contact, send query letter or direct mail flier/brochure or call. Reports in a couple of days. After initial contact, call to schedule an appointment or drop off or mail materials for review.
Tips: Obtains new talent through recommendations from clients.

***REDMOND REPRESENTS**, 4 Cormer Court, Apt. #304, Timonium MD 21093. (410)560-0833. Fax: (410)560-0804. E-mail: sonyisd@aol.com. Contact: Sharon Redmond. Commercial illustration and photography representative. Estab. 1987. Markets include: advertising agencies; corporations/client direct; design firms.
Handles: Illustration, photography.
Terms: Rep receives 30% commission. Exclusive area representation is required. No geographic restrictions. Advertising costs and expenses are split: 50% paid by talent; 50% paid by representative. For promotional purposes, talent must provide a small portfolio (easy to Federal Express) and at least 6 direct mail pieces (with fax number included). Advertises in *American Showcase, Creative Black Book*.
How to Contact: For first contact, send photocopies. Reports in 2 weeks. After initial contact, representative will call talent to set an appointment.
Tips: Obtains new talent through recommendations from others, advertising in *Black Book* etc. "Even if I'm not taking in new talent, I do want *photocopies* sent of new work. I never know when an ad agency will require a different style of illustration/photography, and it's always nice to refer to my files."

 THE ASTERISK before a listing indicates that the market is new in this edition. New markets are often the most receptive to freelance submissions.

REPRESENTED BY KEN MANN INC., 20 W. 46th St., New York NY 10036. (212)944-2853. Fax: (212)921-8673. Contact: Ken Mann. Commercial photography representative. Estab. 1974. Member of SPAR. Represents 5 photographers. Specializes in "highest quality work!" Markets include: advertising agencies.
Handles: Photography.
Terms: Rep receives 25% commission in US; 30% international. Exclusive area representation is required. Advertising costs are split in US. 75% paid by talent; 25% paid by representative. International: photographer pays all advertising costs. Advertises in *Creative Black Book*, *The Work Book*, *N.Y. Gold*.
How to Contact: For first contact, send query letter, résumé, bio, direct mail flier/brochure, photocopies, photostats, "nothing that needs to be returned." Reports in 1 week if interested. After initial contact, call for appointment to show portfolio of tearsheets and photographs; drop off or mail materials for review.
Tips: Obtains new talent through editorial work, recommendations. "Put together the best portfolio possible because knowledgable reps only want the best!"

***JULIAN RICHARDS**, 457 Washington St., New York NY 10013. (212)219-1269. Fax: (212)941-6203. Contact: Julian Richards. Commercial photography representative. Estab. 1992. Represents 5 photographers. Specializes in portraits, still life, travel. Markets include: advertising agencies; design firms; editorial/magazines; publishing/books.
Terms: Exclusive area representation required. Advertising costs are split: 80% paid by talent; 20% paid by representative.
How to Contact: For first contact, send direct mail flier/brochure.
Tips: Obtains new talent by working closely with potential representees over a period of months. "Be reasonable in your approach—let your work do the selling."

THE ROLAND GROUP INC., 4948 St. Elmo Ave., #201, Bethesda MD 20814. (301)718-7955. Fax: (301)718-7958. E-mail: rolandgrp@aol.com. Contact: Rochel Roland or Jason Bach. Commercial photography and illustration representatives as well as illustration and photography brokers. Estab. 1988. Member of SPAR, ASMP, Art Directors Club and Ad Club. Markets include advertising agencies, corporations/clients direct, design firms and sales/promotion firms.
Handles: Illustration, photography and design. Searching for photographers and illustrators who are "computer oriented."
Terms: Agent receives 25-35% commission. Charges $150 marketing fee. Requires exclusive area representation for core talent. For promotional purposes, talent must provide transparencies, slides, tearsheets and a digital portfolio. Advertises in *Print Magazine*, *American Showcase*, *The Workbook* and *Creative Sourcebook*.
How to Contact: For first contact, send résumé, tearsheets or photocopies and any other nonreturnable samples. Reports only if interested. After initial contact, drop off portfolio materials for review. Portfolios should include tearsheets, slides, photographs, photocopies.
Tips: "Roland provides the National Photography Network Service in which 150 photographers are assigned to specific geographic territories across the country to handle projects for all types of clients."

***LINDA RUDERMAN**, 1245 Park Ave., New York NY 10128. Phone/fax: (212)369-7531. Contact: Linda Ruderman. Commercial photography representative. Estab. 1988. Represents 2 photographers. Specializes in children and still life photography. Markets include: advertising agencies; corporations/clients direct; design firms; sales/promotion firms.
Handles: Photography.
Terms: To be discussed. Charges for messengers. Advertises in *Creative Black Book* and *The Workbook*.
How to Contact: For first contact send bio, direct mail flier. Reports back only if interested.
Tips: Obtains new talent through recommendations, *Creative Black Book* portfolio review and by calling photographers who advertise in *The Creative Black Book* and *The Workbook*.

FREDA SCOTT, INC., 1015-B Battery St., San Francisco CA 94111. (415)398-9121. Fax: (415)398-6136. Contact: Freda Scott. Commercial illustration and photography representative. Estab. 1980. Member of SPAR. Represents 10 illustrators, 10 photographers. Markets include: advertising agencies; corporations/clients direct; design firms; editorial/magazines; paper products/greeting cards; publishing/books; sales/promotion firms.
Handles: Illustration, photography.
Terms: Rep receives 25% commission. No geographic restrictions. Advertising costs are split: 75% paid by talent; 25% paid by representative. For promotional purposes, talent must provide "promotion piece and ad in a directory. I also need at least three portfolios." Advertises in *American Showcase*, *Creative Black Book*, *The Workbook*.

How to Contact: For first contact, send direct mail flier/brochure, tearsheets and SASE. If you send transparencies, reports in 1 week, if interested. "You need to make follow up calls." After initial contact, call for appointment to show portfolio of tearsheets, photographs (4×5 or 8×10).
Tips: Obtains new talent sometimes through recommendations, sometimes solicitation. "If you are seriously interested in getting repped, keep sending promos—once every six months or so. Do it yourself a year or two until you know what you need a rep to do."

DANE SONNEVILLE ASSOC. INC., 67 Upper Mountain Ave., Montclair NJ 07042. (201)744-4465. Fax: (201)744-4467. Contact: Dane. Commercial illustration, photography and graphic design representative, illustration or photography broker, paste up, printing, hair and make up, all type stylists, computer image artists, writers. Estab. 1971. Represents 20 illustrators, 10 photographers, 10 designers, 40 writers in all disciplines. Specializes in "resourcefulness and expeditious service." Markets include: advertising agencies; corporations/clients direct; design firms; editorial/magazines; publishing/books; sales/promotion firms.
Handles: Illustration, photography, design, writing, all creative support personnel.
Terms: Rep receives 25% commission. Advertising costs are paid by talent. For promotional purposes, talent must provide unlimited promo pieces (leave-behinds). Advertises in *American Showcase*, *Creative Black Book*, *RSVP*, *The Workbook*.
How to Contact: For first contact, send résumé, direct mail flier/brochure, tearsheets. Reports in 1 week if interested. After initial contact, call for appointment to show portfolio of original art, tearsheets, slides, photographs.
Tips: Obtains new talent through recommendations from others. "Knock on every door."

***■SOODAK REPRESENTS**, 11135 Korman Dr., Potomac MD 20854. (301)983-2343. Fax: (301)983-3040. Contact: Arlene Soodak. Commercial photography representative. Estab. 1985. Member of ASMP, AIGA. Represents 4 photographers. Specializes in international capabilities—photography, food, location, still life. Markets include: advertising agencies; design firms, corporations.
Handles: Photography. Looking for "established or award winners such as Kodak's European Photographer of the Year, former *National Geographic* photographer, etc."
Terms: Rep receives 25% commission. Exclusive area representation is required. Payment of advertising costs "depends on length of time artist is with me." For promotional purposes, talent must provide "intact portfolio of excellent quality work and promo package and direct mail campaign which I will market." Advertises in *The Workbook* and featured on cover of *CA Magazine*, January 1996.
How to Contact: For first contact, send direct mail flier/brochure, tearsheets, photocopies. Reports in 10 days. After initial contact, drop off or mail in portfolio for review.
Tips: Obtains new talent through recommendations from others and direct contact with photographers.

SULLIVAN & ASSOCIATES, 3805 Maple Ct., Marietta GA 30066. (770)971-6782. Fax: (770)973-3331. E-mail: sullivan@atlcom.net. Contact: Tom Sullivan. Commercial illustration, commercial photography and graphic design representative. Estab. 1988. Member of Creative Club of Atlanta, Atlanta Ad Club. Represents 14 illustrators, 7 photographers and 7 designers, including computer graphic skills in illustration/design/production and photography. Staff includes Tom Sullivan (sales, talent evaluation, management), Debbie Sullivan (accounting, administration). Specializes in "providing whatever creative or production resource the client needs." Markets include: advertising agencies, corporations/client direct; design firms; editorial/magazines; publishing/books; sales/promotion firms.
Handles: Illustration, photography. "Open to what is marketable; computer graphics skills."
Terms: Rep receives 25% commission. Exclusive area representation in Southeastern US is required. Advertising costs paid by talent. For promotional purposes, talent must provide "direct mail piece, portfolio in form of 8½×11 (8×10 prints) pages in 22-ring presentation book." Advertises in *American Showcase*, *The Workbook*.
How to Contact: For first contact, send bio, direct mail flier/brochure; "follow up with phone call." Reports in 2 weeks if interested. After initial contact, call for appointment to show portfolio of tearsheets, photographs, photostats, photocopies, "anything appropriate in nothing larger than 8½×11 print format."
Tips: Obtains new talent through referrals and direct contact from creative person. "Have direct mail piece or be ready to produce it immediately upon reaching an agreement with a rep. Be prepared to immediately put together a portfolio based on what the rep needs for that specific market area."

T & M ENTERPRISES, 270 N. Canon Dr., Suite 2020, Beverly Hills CA 90210. (310)281-7504. Fax: (310)274-7957. Contact: Tony Marques. Commercial photography representative and photography broker. Estab. 1985. Represents 50 photographers. Specializes in women photography only: high fashion, swimsuit, lingerie, glamour and fine (good taste) *Playboy*-style pictures. Markets include: advertising agencies; corporations/clients direct; editorial/magazines; paper products/greeting cards; publishing/books; sales/promotion firms; medical magazines.
 ● T&M Enterprises is opening a second office in Coral Gables, Florida.

Handles: Photography.

Terms: Rep receives 50% commission. Exclusive area representation is not required. Advertising costs are paid by representative. "We promote the standard material the photographer has available, unless our clients request something else." Advertises in Europe, South and Central America and magazines not known in the US.

How to Contact: For first contact, send everything available. Reports in 2 days. After initial contact, drop off or mail in appropriate materials for review. Portfolio should include slides, photographs, transparencies, printed work.

Tips: Obtains new talent through worldwide famous fashion shows in Paris, Rome, London and Tokyo; participating in well-known international beauty contests; recommendations from others. "Send your material clean. Send your material organized (neat). Do not borrow other photographers' work in order to get representation. Protect—always—yourself by copyrighting your material. Get releases from everybody who is in the picture (or everything owned by somebody)."

WARNER & ASSOCIATES, 1425 Belleview Ave., Plainfield NJ 07060. (908)755-7236. Contact: Bob Warner. Commercial illustration and photography representative. Estab. 1986. Represents 4 illustrators, 4 photographers. "My specialized markets are companies that are developing/emerging new technologies and science."

Handles: Illustration, photography. Looking for medical illustrators: microscope photographers (photomicrography), science illustrators, special effects photographers.

Terms: Rep receives 25% commission. "Promo pieces and portfolios obviously are needed; who makes up what and at what costs and to whom, varies widely in this business."

How to Contact: For first contact, send query letter "or phone me." Reports back in days. Portfolio should include "anything that talent considers good sample material."

Tips: Obtains new talent "by hearsay and recommendations. Also, specialists in my line of work often hear about my work from art directors and they call me."

DAVID WILEY REPRESENTS, 282 Second St., 2nd Floor, San Francisco CA 94105. (415)442-1822. Fax: (415)442-1823. E-mail: dwr@slip.net. Website: http://www.dwrepresents.com/dwr. Contact: David Wiley. Commercial illustration and photography representative. Estab. 1984. Member of AIP (Artists in Print), Society of Illustrators. Represents 9 illustrators, 1 photographer. Specializes in "Going beyond expectations!"

Terms: Rep receives 25% commission. No geographical restriction. Artist is responsible for 100% of portfolio costs. Promotional materials and expenses including portfolio courier costs are split: 75% paid by artist, 25% paid by agent. Each year the artists are promoted in *American Showcase* and through direct mail (bimonthly mailings).

How to Contact: For first contact, send query letter, direct mail flier/brochure, tearsheets, slides, photographs, and SASE ("very important"). Will call back if requested within 48 hours. After initial contact, call for appointment or drop off appropriate materials. "To find out what's appropriate, just ask! Portfolio should include roughs, original art, tearsheets—color and b&w if possible."

Tips: "Generate new clients through creative directories, direct mail and a rep relationship. To create new images that will hopefully sell, consult an artist rep or someone qualified to suggest ideas keeping in alignment with your goals. I suggest working with a style that will allow quick turnaround, 1-2 weeks, preferably within 10 days (this includes pencils and making changes). Present portfolios with examples of roughs and finished commissioned work. Show color and b&w imagery, concepts to finish process, i.e., paper napkin sketches through finish. Ask questions and then sit back and listen! and take notes. Three key words I work with: 'vision, action and manifestation.' Learn how to work with these and new discoveries will unfold! Remember to give yourself permission to make mistakes—it's just another way of doing something."

■**WINSTON WEST, LTD.**, 204 S. Beverly Dr., Suite 108, Beverly Hills CA 90212. (310)275-2858. Fax: (310)275-0917. Contact: Bonnie Winston. Commercial photography representative (fashion/entertainment). Estab. 1986. Represents 8 photographers. Specializes in "editorial fashion and commercial advertising (with an edge)." Markets include: advertising agencies; client direct; editorial/magazines.

 THE SOLID, BLACK SQUARE before a listing indicates that the market uses various types of audiovisual materials, such as slides, film or videotape.

Handles: Photography.

Terms: Rep receives 25% commission. Charges for courier services. Exclusive area representation is required. No geographic restrictions. Advertising costs are split: 75% paid by talent; 25% paid by representative. Advertises by direct mail and industry publications.

How to Contact: For first contact, send direct mail flier/brochure, photographs, photocopies, photostats. Reports in days, only if interested. After initial contact, call for appointment to show portfolio of tearsheets.

Tips: Obtains new talent through "recommendations from the modeling agencies. If you are a new fashion photographer or a photographer who has relocated recently, develop relationships with the modeling agencies in town. They are invaluable sources for client leads and know all the reps."

WORLDWIDE IMAGES, P.O. Box 150547, San Rafael CA 94915. (415)459-0627. Contact: Norman Buller. Commercial photography representative. Estab. 1988. Represents 20 photographers. Specializes in nudes, all pro sports, celebrities, rock stars, men's magazine layouts, calendars, posters. Markets include: advertising agencies; clients direct; magazines; paper products/greeting cards; publishing/books; amateur x-rated videos.

Handles: Photography (all formats); videos of all kinds.

Terms: Rep receives 50% commission. Advertising costs are paid by the representative.

How to Contact: For first contact send résumé, slides, photographs, videos and SASE. Reports immediately.

Tips: Obtains new clients through recommendations from others and solicitation. "I am advertised all over the world and have tripled my clients in the last six months."

ZACCARO PRODUCTIONS INC., 315 E. 68th St., New York NY 10021. (212)744-4000. Fax: (212)744-4442. Contact: Jim Zaccaro. Commercial photography and fine art representative. Estab. 1961. Member of SPAR, DGA. Represents 4 photographers.

Terms: Agent receives 25% commission.

How to Contact: For first contact, send query letter, direct mail flier/brochure. Reports in 10 days. After initial contact, call for appointment to show portfolio.

DAVID ZAITZ ARTIST REPRESENTATIVE, 11830 Darlington Ave., #10, Los Angeles CA 90049. (310)207-4806. Fax: (310)207-6368. E-mail: dzaitz@aol.com. Contact: D. Zaitz. Commercial photo rep. Estab. 1985. Represents 5 photographers. Specializes in advertising. Markets include: advertising agencies; design firms.

Handles: Photography.

Terms: Rep receives 25% commission. Exclusive area representation is required. Advertising cost split varies. For promotional purposes, talent must provide promo cards and/or sourcebook ad reprints to use as leave-behinds or mailers. Advertises in *The Workbook*.

How to Contact: For first contact, send direct mail flier/brochure and tearsheets. Reports in 1 week. Call for appointment to show portfolio of photographs.

Tips: Obtains new talent through referrals from art directors, contact from photographers. "Learn to represent yourself *first*, then delegate that responsibility to a rep that best reflects your personal/business style. A rep should augment, embellish and help direct your business—not be a quick fix to the problem of 'no work.' "

Contests

The proliferation of photo contests around the world tells us a lot about the photography industry. First, there are thousands of amateurs and professionals shooting huge quantities of film every year. And second, associations, magazines and businesses are eager to sponsor contests because of photography's popularity. For photographers this shows the good (a popular industry filled with money-making possibilities) and the bad (a glut of professionals). Eventually competition will weed out the less-skilled photographers who consider themselves "professionals," but in the meantime there is a fierce battle for recognition.

This section contains 54 competitions and 17 are new this year. They range in scope from the tiny juried county fairs to the massive international competitions. Whether you're a seasoned veteran or a newcomer still cutting your teeth, you may want to enter a few to see how you match up against other shooters. When possible we've included entry fees and other pertinent information, but our space is limited and, therefore, you should ask sponsors for an entry form for more details.

Once you receive rules and an entry form, pay particular attention to the section describing rights. Regrettably, some sponsors retain all rights to winning entries or even *submitted* images. Don't get lured into such traps. While you can benefit from the publicity and awards connected with winning prestigious competitions, you do not want to unknowingly forfeit copyright. Granting limited rights for publicity is reasonable, but never assign rights of any kind without adequate financial compensation or a written agreement. If such terms are not stated in contest rules, ask sponsors for clarification.

If you are satisfied with the contest's copyright rules, check with contest officials to see what types of images won in previous years. By scrutinizing former winners you might notice a trend in judging that could help when choosing your entries. If you can't view the images, ask what styles and subject matters have been popular.

■**AMERICAN INTERNATIONAL FILM/VIDEO FESTIVAL**, P.O. Box 4034, Long Beach CA 90804. Festival Chairman: George Cushman. Sponsored by the American Motion Picture Society. Sponsors worldwide annual competition and festival. In its 67th consecutive year for film and videotape.

ANACORTES ARTS & CRAFTS FESTIVAL, 819 Commercial, Suite E, Anacortes WA 98221. (360)293-6211. Director: Joan Tezak. Two-day festival, first weekend in August. An invitational, juried fine art show with over 250 booths. Over $1,500 in prizes awarded for fine arts.

ANNUAL INTERNATIONAL UNDERWATER PHOTOGRAPHIC COMPETITION, P.O. Box 2401, Culver City CA 90231. (310)437-6468. Cost: $7.50 per image, maximum 4 images per category. Offers annual competition in 9 categories (8 underwater, 1 water related). Thousands of dollars worth of prizes. Deadline mid-October.

AQUINO INTERNATIONAL, (formerly Picture Perfect), P.O. Box 15760, Stamford CT 06901. (203)967-9952. Publisher: Andres Aquino. Ongoing photo contest in many subjects. Offers Publishing opportunities, cash prizes and outlet for potential stock sales. Send SAE with 2 first-class stamps for details.

ART OF CARING PHOTOGRAPHY CONTEST, Caring Institute, 320 "A" St. NE, Washington DC 20002-5940. (202)547-4273. Director: Marian Brown. Image must relate to the subject of caring. Photos must be 8×10, color or b&w and must be submitted with a completed entry blank which may be obtained from Caring Institute.

ART ON THE GREEN, P.O. Box 901, Coeur d'Alene ID 83816. (208)667-9346. Outdoor art and crafts festival including juried show first August weekend each year.

***ARTIST FELLOWSHIP GRANTS**, c/o Oregon Arts Commission, 775 Summer St., NE, Salem OR 97310. (503)986-0086. Fax: (503)986-0260. (800)233-3306 (in Oregon). E-mail: vincent.k.dunn@ state.or.us. Website: http://www.das.state.or.us/oac/. Assistant Director: Vincent Dunn. Offers cash grants to Oregon photographers in odd-numbered years.

***BOTAMANIA**, P.O. Box 19002, Lenexa KS 66285. Editor: Amy Bersh. Cost: $10 for 5 slides. Annual photo contest offered by the *Sunflower* botanical photo magazine.

■THE CAMERA BUG INTERNATIONAL CONTEST, World Headquarters, 2106 Hoffnagle St., Philadelphia PA 19152. (215)742-5515. Director: Leonard Freidman. Annual contest open to all "amateur" photographers and videographers. Provide SASE or 32¢ postage for details.

***CASEY MEDALS FOR MERITORIOUS JOURNALISM**, Casey Journalism Center for Children & Families, 8701-B Adelphi Rd., Adelphi MD 20783-1716. (301)445-4971. Administrative Director: Lori Robertson. Honors distinguished coverage of disadvantaged and at-risk children and their families. Photojournalism category: Single photo or series of photos from daily newspaper or general interest magazine. Deadline: early August. Contact for official entry form.

■THE CREATIVITY AWARDS SHOW, 456 Glenbrook Rd., Glenbrook CT 06906. (203)353-1441. Fax: (203)353-1371. Show Director: Dan Barron. Sponsor: *Art Direction* magazine. Annual show for photos and films appearing in advertising and mass communication media, annual reports, brochures, etc.

***■DANCE ON CAMERA FESTIVAL**, Sponsored by Dance Films Association, Inc., 3rd Floor, 31 West 21st St., New York NY 10010. (212)727-0764. Executive Director: Victor Lipari. Annual festival competition for 16mm films with optical soundtrack and ¾-inch videotapes in NTSC format, on all aspects of dance. Entrants must be members in good standing of Dance Films Association.

***FIRELANDS ASSOCIATION FOR THE VISUAL ARTS**, 80 S. Main St., Oberlin OH 44074-1683. (216)774-7158. Gallery Director: Susan Jones. Cost: $15/photographer; $12 for FAVA members. Annual photography contest for residents of Ohio, Kentucky, Indiana, Michigan, Pennsylvania and West Virginia. Both traditional and experimental techniques welcome. Photographers may submit up to three works completed in the last three years. Call for entry form. 1997 entry deadline: mid February.

48th INTERNATIONAL EXHIBITION OF PHOTOGRAPHY, Del Mar Fair Entry Office, 2260 Jimmy Durante Blvd., Del Mar CA 92014-2216. (619)792-4207. Sponsor: Del Mar Fair (22nd District Agricultural Association). Annual event for still photos/prints. Pre-registration deadline: May 2, 1997. Send #10 SASE for brochure, available March 1.

GALLERY MAGAZINE, 401 Park Ave. S., New York NY 10016-8802. Contest Editor: Judy Linden. Sponsors monthly event for still photos of nudes. Offers monthly and annual grand prizes. Write for details or buy magazine.

GOLDEN ISLES ARTS FESTIVAL, P.O. Box 20673, Saint Simons Island GA 31522. (912)638-8770. Contact: Registration Chairman. Sponsor: Glynn Art Association. Annual 2-day festival for still photos/prints; all fine art and craft. Deadline: August 30.

GREATER MIDWEST INTERNATIONAL XIII, CMSU Art Center Gallery, Clark St., Warrensburg MO 64093-5246. (816)543-4498. Gallery Director: Morgan Dean Gallatin. Sponsor: CMSU Art Center Gallery/Missouri Arts Council. Sponsors annual competition for 2-D and 3-D all media. Send SASE for current prospectus after June 1, 1997. Entry deadline October 15, 1997.

IDAHO WILDLIFE, P.O. Box 25, Boise ID 83707-0025. (208)334-3746. Fax: (208)334-2148. Editor: Diane Ronayne. Annual contest; pays cash prizes of $20-150. Rules in summer and fall issues of *Idaho Wildlife* magazine. Deadline October 1. Winners published. Freelance accepted in response to

 THE ASTERISK before a listing indicates that the market is new in this edition.

want list. Pays b&w or color inside $40; cover $80. Fax request for submission guidelines.

***INDIVIDUAL ARTIST FELLOWSHIP PROGRAM**, % Montana Arts Council, P.O. Box 202201, 316 N. Montana, Helena MT 59620. (406)444-6430. Director of Artists Services: Fran Morrow. Offers several annual awards of $2,000 in all visual arts, including photography. *Open to Montana residents only.* Deadline: August.

‡INTERNATIONAL DIAPORAMA FESTIVAL, Auwegemvaart 79, B-2800 Mechelen, Belgium. President: J. Denis. Sponsor: Koninklijke Mechelse Fotokring. Competition held every other year (even years) for slide/sound sequences.

INTERNATIONAL WILDLIFE PHOTO COMPETITION, 280 E. Front St., Missoula MT 59802. (406)728-9380. Chairman: Jennifer Mandel. Professional and amateur catagories, color and b&w prints, color slides accepted; $1,700 in cash and prizes. Entry deadline-March 4. Co-sponsored by the 17th Annual International Wildlife Film Festival and the Rocky Mountain School of Photography.

LARSON GALLERY JURIED PHOTOGRAPHY EXHIBITION, Yakima Valley Community College, P.O. Box 1647, Yakima WA 98907. (509)575-2402. Director: Carol Hassen. Cost: $5/entry (limit 4 entries). National juried competition with approximately $2,000 in prize money. Held annually in April. Write for prospectus in January.

MATRIX INTERNATIONAL, Matrix Gallery and Workshop of Women Artists, 1725 I St., Sacramento CA 95814. (916)441-4818. Director: Sheri Tatsch. Cost: $5/work with limit of 5 entries. Send SASE for details. Open to all media except installation, video, film and performance. Pays $25 honorarium to each accepted artist, plus substantial cash awards.

MAYFAIR JURIED PHOTOGRAPHY EXHIBITION, 2020 Hamilton St., Allentown PA 18104. (610)437-6900. Maximum 3 entries, $10 non-refundable fee to enter. May juried exhibition open to all types of original photographs by artists within 75-mile radius of Allentown. Send for prospectus; entry deadline March 1.

MOTHER JONES INTERNATIONAL FUND FOR DOCUMENTARY PHOTOGRAPHY AWARDS, 731 Market St., Suite 600, San Francisco CA 94103. Fax: (415)665-6696. E-mail: photofund@motherjones.com. Contact: Hannah Frost. Sponsors awards programs for in-progress, in-depth (lasting more than 1 year) social documentary projects. Awards four grants of $7,000 each and the Leica Medal of Excellence worth $10,000. Write, fax or e-mail for guidelines.

***■NATIONAL EDUCATIONAL MEDIA NETWORK**, 655 13th St., Oakland CA 94612. (510)465-6885. Fax: (510)465-2835. Director: Susan Davis Cushing. Largest annual competition for educational media (films, videos and multimedia programs). Entry fees begin at $30 (discounted student rate), depending on length and format. Also sponsors annual market for educational media and conference.

NATURAL WORLD PHOTOGRAPHIC COMPETITION & EXHIBITION, The Carnegie Museum of Natural History, 4400 Forbes Ave., Pittsburgh PA 15213. (412)622-3283. Contact: Division of Education. Held each September, contest accepts color and b&w prints depicting the "natural world." Prizes totaling $1,650 are awarded and a juried show is selected for exhibition in the museum.

■NEW YORK STATE YOUTH MEDIA ARTS SHOWS, Media Arts Teachers Association, 1401 Taylor Rd., Jamesville NY 13078. (315)469-8574. Co-sponsored by the New York State Media Arts Teachers Association and the State Education Department. Annual regional shows and exhibitions for still photos, film, videotape and computer arts. *Open to all New York state, public and non-public elementary and secondary students.*

1997 PHOTOGRAPHY ANNUAL, 410 Sherman, P.O. Box 10300, Palo Alto CA 94303. (415)326-6040. Executive Editor: Jean A. Coyne. Sponsor: *Communication Arts* magazine. Annual competition for still photos/prints. Write or call for entries. Deadline: March 16, 1997.

***■NORTH AMERICAN OUTDOOR FILM/VIDEO AWARDS**, 2017 Cato Ave., Suite 101, State College PA 16801-2768. (814)234-1011. Sponsor: Outdoor Writers Association of America. $125 fee/entry. Annual competition for films/videos on conservation and outdoor recreation subjects. Two categories: Recreation/Promotion and Conservation/Natural History. Receiving deadlines: January 10, 1997, for 1996 production date; January 10, 1998, for 1997 production date.

Johnny Quirin's photo entitled "Pictures and Words" won a $200 prize in the 45th International Exhibition of Photography—which Quirin found through *Photographer's Market*—and has since sold more than 10 times. Quirin snapped the shot in a bookstore he visited while vacationing in Toledo, Spain. It's been purchased by various art collectors and others interested in his work. "The piece is responsible for making me take a focused effort at pursuing a career in photography," says the San Diego-based Quirin. "Also, I paid for the cost of my ticket to Spain with the sales from this one print."

***‡NORTHERN COUNTIES INTERNATIONAL COLOUR SLIDE EXHIBITION**, 9 Cardigan Grove, Tynemouth, Tyne & Wear NE30 3HN England. (0191)252-2870. Honorary Exhibition Chairman: Mrs. J.H. Black, ARPS, APAGB. Judges 35mm slides—4 entries per person. Three sections: general, nature and photo travel. PSA and FIAP recognition and medals.

GORDON PARKS PHOTOGRAPHY COMPETITION, Fort Scott Community College, 2108 S. Horton, Fort Scott KS 66701. (316)223-2700. Chair, Lucile James Fine Arts Committee: Johnny Bennett. Cost: $15 for 2 photos; maximum of 2 additional photos for $5 each. Prizes of $1,000, $500, $250; winners and honorable mentions will be featured in annual nationwide traveling exhibition. Entry deadline September 30; write for entry form.

***PHOTO MANIA/THE ONE GALLERY**, 15821 Ventura Blvd., #120, Encino CA 91436. Director: Rod Davis. Cost: $25 flat entry fee. Photo exhibition and competition open to all photo media. The first 100 entries accepted. Registration and fee must be received by December 8th. Send SASE for registration form.

PHOTO REVIEW ANNUAL COMPETITION, 301 Hill Ave., Langhorne PA 19047. (215)757-8921. Editor: Stephen Perloff. Cost: $18 for up to 3 prints or slides, $5 each for up to 2 more. National annual photo competition; all winners reproduced in summer issue of *Photo Review* magazine. One entrant selected for 1-person show at the Print Club Center for Prints and Photographs, Philadelphia, PA. Awards $1,000 cash prizes. Deadline: May 15-31.

PHOTOGRAPHIC ALLIANCE U.S.A., 1864 61st St., Brooklyn NY 11204-2352. President: Henry Mass. FPSA, HonESFIAP. Sole US representative of the International Federation of Photographic Art. Furnishes members with entry forms and information regarding worldwide international salons (over 100 each year) as well as other information regarding upcoming photographic events. Recommends members for distinctions and honors in FIAP (Federation de la Art Photographique) as well as approves US international salons for patronage in FIAP.

PHOTOGRAPHIC COMPETITION ASSOCIATION QUARTERLY CONTEST, P.O. Box 53550-B, Philadelphia PA 19105. (610)828-2773. Contact: Competition Committee. Sponsor: Photographic Competition Association (PCAA). Quarterly competition for still photos/prints.

PHOTOGRAPHY NOW, % the Center for Photography at Woodstock, 59 Tinker St., Woodstock NY 12498. (914)679-9957. Sponsors annual competition. Call for entries. Juried annually by renowned photographers, critics, museums. Deadline: March.

PHOTOSPIVA 97, Spiva Center for the Arts, 222 W. Third St., Joplin MO 64801. (417)623-0183. Director: Darlene Brown. National photography competition. Send SASE for prospectus.

***PHOTOWORK 97**, Barrett House Galleries, 55 Noxon St., Poughkeepsie NY 12601. (914)471-2550. National photography exhibition judged by New York City curator. Deadline for submissions: December 1996. Send SASE in September for prospectus.

PICTURES OF THE YEAR, 105 Lee Hills Hall, Columbia MO 65211. (573)882-4442. Coordinator: Lisa Barnes. Photography competition for professional magazine, newspaper and freelance photographers and editors.

***POSITIVE NEGATIVE #12**, P.O. Box 70708, East Tennessee State University, Johnson City TN 37614. (615)461-7078. Gallery Director: Ann Ropp. Juried national show open to all media. Call or write for prospectus. Deadline for application: November 2.

PULITZER PRIZES, 702 Journalism, Columbia University, New York NY 10027. (212)854-3841 or 3842. Costs: $20/entry. Annual competition for still photos/prints published in American newspapers. February 1 deadline for work published in the previous year.

***SAN FRANCISCO SPCA PHOTO CONTEST**, SF/SPCA, 2500 16th St., San Francisco CA 94103. (415)554-3000. Coordinator: Frank Burtnett. Entry fee $5 per image, no limit. Photos of pet(s) with or without people. Color slides, color or b&w prints, no larger than 8×12 (matte limit 11×14). Make check payable to SF/SPCA. Three best images win prizes. Deadline for entry: December 15 each year; include return postage and phone number.

■SINKING CREEK FILM/VIDEO FESTIVAL, 402 Sarratt, Vanderbilt University, Nashville TN 37240. (615)322-2471. Director: Meryl Truett. Sponsors annual competition for 35mm, 16mm film and ¾″ videotape. All genres judging on ½″ video. Holds screening of selected films from its national

film/video competition. Festival held in November at Vanderbilt University, Nashville, TN. May deadline. Also accepts Canadian and international entries.

SISTER KENNY INSTITUTE INTERNATIONAL ART SHOW BY DISABLED ARTISTS, 800 E. 28th St., Minneapolis MN 55407-3799. (612)863-4630. Art Show Coordinator: Linda Frederickson. Show is held once a year in April and May for disabled artists. Deadline for entries: March 20. Award monies of over $5,000 offered.

***TEXAS FINE ARTS ASSOCIATION'S NEW AMERICAN TALENT**, 3809-B W. 35th St., Austin TX 78703. (512)453-5312. Contact: Leslie Cox. A national all-media competition selected by a nationally prominent museum curator. Provides catalog and tour. Entry deadline: January 1997. Send SASE for prospectus.

■THREE RIVERS ARTS FESTIVAL, 207 Sweetbriar St., Pittsburgh PA 15211. (412)481-7040. Assistant Director, Visual Arts: Jamie Gruzska. Annual competition for still photos/prints and videotape. Early February deadline.

UNLIMITED EDITIONS INTERNATIONAL JURIED PHOTOGRAPHY COMPETITIONS, % Competition Chairman, P.O. Box 1509, Candler NC 28715-1509. (704)665-7005. President/Owner: Gregory Hugh Leng. Sponsors juried photography contests offering cash and prizes. Also offers opportunity to sell work to Unlimited Editions.

VAL-TECH PUBLISHING INC., (formerly Minnesota Ink), P.O. Box 25376, St. Paul MN 55125. (612)730-4280. Contact: Valerie Hockert. Cost: $3/entry. Deadlines: June 15 and November 30. Photos can be scenic, with or without people. Send SASE for guidelines.

WELCOME TO MY WORLD, P.O. Box 20673, Saint Simons Island GA 31522. (912)638-8770. Contact: Registration Chairman. Sponsored by the Glynn Art Association. Call or write for application. Cash awards. Deadline June.

***WESTCHESTER INTERNATIONAL SALON**, Warren Rosenberg. P.O. Box 307, Scarborough Manor, Scarborough NY 10510. Color slide competition worldwide; pictorial, nature, photo-travel, photo-journalism divisions. Held annually in March. Cost: $5 entry fee per division, 4 slides, domestic; $6 entry fee per division, 4 slides, foreign.

***WESTMORELAND ART NATIONALS**, P.O. Box 355A, Rd. #2, Latrobe PA 15650. (412)834-7474. Executive Director: Olga Gera. Produces two exhibitions with separate juries and awards. Write for details. SASE. Deadline: March 27, 1997.

***YOSEMITE RENAISSANCE**, P.O. Box 100, Yosemite CA 95389. (209)372-4946. Director: Robert Woolard. Annual all media exhibit. Cash awards of $4,000. Deadline for slide entry: Early October. Theme: Yosemite and the Sierra. Send SASE for entry form.

YOUR BEST SHOT, % *Popular Photography*, P.O. Box 1247, Teaneck NJ 07666. Monthly photo contest, 2-page spread featuring 5 pictures: first ($300), second ($200), third ($100) and two honorable mention ($50 each).

 THE SOLID, BLACK SQUARE before a listing indicates that the market uses various types of audiovisual materials, such as slides, film or videotape.

Workshops

Unless your head has been buried in the sand you certainly have noticed that photography is headed in a new direction, one filled with computer manipulation and compact discs. Technological advances are no longer the wave of the future—they're here.

Even if you haven't invested a lot of time and money into electronic cameras, computers or software, you should understand what you're up against if you plan to succeed as a professional photographer. Although outdoor and nature photography still are popular with instructors, technological advances are examined closely in some of the nearly 127 workshops listed in this section.

As you peruse these pages take a good look at the quality of workshops and the level of photographers the sponsors want to attract. It is important to know if a workshop is for beginners, advanced amateurs or professionals and information from a workshop organizer can help you make that determination.

These workshop listings contain only the basic information needed to make contact with sponsors and a brief description of the styles or media covered in the programs. We also include information on workshop costs.

The workshop experience can be whatever the photographer wishes it to be—a holiday from his working routine, or an exciting introduction to new skills and perspectives on the craft. Some photographers who start out by attending someone else's workshops come away so inspired that eventually they establish their own. One of these is photographer John Sexton, who began his career as an assistant to Ansel Adams. Sexton discusses the importance of workshops on page 556.

AERIAL AND CREATIVE PHOTOGRAPHY WORKSHOPS, P.O. Box 470455, San Francisco CA 94147. (415)563-3599. Fax: (415)771-5077. Director: Herb Lingl. Offers Polaroid sponsored seminars covering creative uses of Polaroid films and aerial photography workshops in unique locations from helicopters, light planes and balloons.

ALASKA ADVENTURES, P.O. Box 111309, Anchorage AK 99511. (907)345-4597. Contact: Chuck Miknich. Offers photo opportunities of Alaska wildlife and scenery on remote fishing/float trips and remote fish camp.

***ALASKA UP CLOSE**, P.O. Box 32666, Juneau AK 99803. (907)789-9544. Contact: Judy Shuler. Costs: $1,299 and up in 1996. Offers photography tours and workshops in nature and wildlife subjects, custom travel plans for independent photographers.

AMBIENT LIGHT WORKSHOPS, 5 Tartan Ridge Rd., Burr Ridge IL 60521. (708)325-5464. Contact: John J. Mariana. $45-125/day. In-the-field and darkroom. One-day and one-week travel workshops of canyons, Yosemite and the Southwest.

AMERICAN SOUTHWEST PHOTOGRAPHY WORKSHOPS, P.O. Box 220450, El Paso TX 79913. (915)757-2800. Director: George B. Drennan. Offers intense field and darkroom workshops for the serious b&w photographer.

♣AMPRO PHOTO WORKSHOPS, 636 E. Broadway, Vancouver BC V5T 1X6 Canada. (604)876-5501. Fax: (604)876-5502. Course tuition ranges from under $100 for part-time to $6,300 for full-time. Approved trade school. Offers part-time and full-time career courses in commercial photography and photofinishing. "Fifty-three different courses in camera, darkroom and studio lighting—from basic to advanced levels. Special seminars with top professional photographers. Career courses in photofinishing, camera repair, photojournalism, electronic imaging and commercial photography." New winter, spring, summer and fall week-long field photography shoots.

Workshops Light a Pathway to Better Photographs

Photographer John Sexton's subjects glow with il-
lumination—whether they are trees that sweep sky-
ward like giant letter "Js" against the backdrops of
wooded groves, or boulders gleaming in creek
beds. As a connoisseur of black & white photogra-
phy, Sexton understands the importance of brilliant
lighting. "I have seen many potentially good photo-
graphs that have been spoiled by an inappropriate
use of light," he says.

Sexton, of Carmel Valley, California, perceives
light as the ultimate subject matter of photography.
In his view, whether or not a photo should be taken
actually depends upon lighting and its applicability
to the subject. It's a topic he investigates through **John Sexton**
his work and discusses in various workshops.

A former assistant to Ansel Adams, Sexton serves as director for his own
workshops and teaches classes worldwide at top sites, including Anderson Ranch
Arts Center, Maine Photographic Workshops, and The Palm Beach Photographic
Workshops. His workshops are legendary for their intensity and Sexton's "work-
shop-till-you-drop" attitude. "It is a wonderful experience to be in a group of
people who are in love with photography," he says. "If a person comes to my
workshop they want to be immersed in photography and that's what we try to
do."

To get the most out of workshops, attendees must fully participate and not be
afraid to ask questions, he says. Every photographer needs different types of
instruction and inspiration, and workshops can be an effective way to get both.
"You can get first-hand insights into the way a photographer works." Quoting a
Chinese proverb, Sexton adds that a workshop is an opportunity to "learn from
the mistakes of others, since you don't have time to make them all yourself."

The first workshop Sexton ever attended was the 1973 Ansel Adams Workshop
in Yosemite National Park. The experience of seeing how Adams and other pho-
tographers approach photography made Sexton realize that photography was not
just "a way to make a living." The craft was part of their lives. "It was an
experience that truly changed my approach to photography, and most certainly
changed my life," he says.

Sexton's association with Adams did not stop after the workshop. Sexton
worked as a technical and photographic assistant to Adams from 1979 to 1982,
and as a technical consultant until 1984 when Adams died. Sexton continues to
serve as Special Photographic Consultant to the Ansel Adams Publishing Rights
Trust.

INSIDER REPORT, *Sexton*

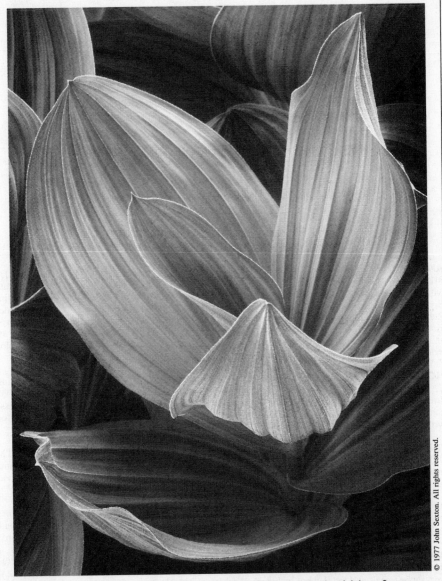

John Sexton honed his skills in black & white photography while assisting Ansel Adams. Sexton sees the student-teacher relationship as an essential part of any photographer's development. He teaches workshops worldwide and says such educational experiences help photographers learn from the mistakes of others.

INSIDER REPORT, *continued*

Away from workshops and consulting, Sexton concentrates on his own work, in the darkroom and behind the camera. His photos have appeared in *American Photo*, *Backpacker* and *Outdoor Photographer*, and have been featured on CBS's "Sunday Morning" and PBS's "MacNeil/Lehrer News Hour." In 1990 his book *Quiet Light* was published by Bulfinch Press/Little Brown and Company and in 1994 Bulfinch produced his second book, *Listen to the Trees*.

Sexton says *Quiet Light* originated as a retrospective that was requested by Bulfinch. In 1990 the book earned awards during the Book Builders West show and the New England Book Show. It is now in its fourth printing. *Listen to the Trees* came about after an editor attended one of Sexton's lectures that contained numerous images of trees. "I have been fortunate to have considerable control over all aspects of my books."

—Michael Willins

ANDERSON RANCH ARTS CENTER, P.O. Box 5598, Snowmass Village CO 81615. (970)923-3181. Fax: (970)923-3871. Cost: $395 and up. Weekend to 2-week workshops run June to August with such recognized photographers/teachers as Sam Abell, Annie Griffiths Belt, Richard Benson, Jim Bones, Linda Connor, Judy Dater, Eikoh Hosoe, Mark Klett, Jay Maisel, Holly Roberts, Meridel Rubenstein, John Sexton, Clarissa Sligh, Maggie Steber, John Szarkowski and Jerry Uelsmann. Program highlights include portrait and landscape photography; technical themes include photojournalism and advanced techniques. Offers field expeditions to the Grand Canyon, Utah Canyonlands and Colorado Rockies.

NOELLA BALLENGER & ASSOCIATES PHOTO WORKSHOPS, P.O. Box 457, La Canada CA 91012. (818)954-0933. Fax: (818)954-0910. Contact: Noella Ballenger. Three-day travel and nature photo workshops in California. Individual instruction in small groups emphasizes visual awareness, composition and problem solving in the field. All formats and levels of expertise welcome. Call or write for information.

***BIG BEND STATE PARK PHOTO WORKSHOPS**, 1019 Valley Acres Rd., Houston TX 77062. (713)486-8070. Director: Jim Carr. Cost: $450, includes meals, lodging, film processing and models. Offers workshops featuring photography of spring desert wildflowers and models on a movie set. Dates: April 10-12, 1997 and April 17-20, 1997.

BIXEMINARS, 919 Clinton Ave. SW, Canton OH 44706-5196. (330)455-0135. Founder/Instructor: R.C. Bixler. Offers 3-day, weekend seminars for beginners through advanced amateurs. Usually held third weekend of February, June and October. Covers composition, lighting, location work and macro.

BODIE, CALIFORNIA STATE HISTORIC PARK PHOTOGRAPHY WORKSHOPS, P.O. Box 1761, Mendocino CA 95460. (707)937-2261. Instructor: Clinton Smith. Cost: $225 for 3-day workshops (meals and lodging not included). Workshop participants are allowed to explore inside and out, before, during and after normal park hours, the best preserved gold mining ghost town in the American West. The general public is not allowed inside the buildings.

HOWARD BOND WORKSHOPS, 1095 Harold Circle, Ann Arbor MI 48103. (313)665-6597. Owner: Howard Bond. Offers 1-day workshop: View Camera Techniques; and 2-day workshops: Zone System for All Formats, Refinements in B&W Printing and Unsharp Masking for Better Prints. Also offers b&w field workshop: 3 days at Colorado's Great Sand Dunes.

 THE MAPLE LEAF before a listing indicates that the market is Canadian.

***BURREN COLLEGE OF ART WORKSHOPS**, Burren College of Art, Newton Castle, Bally-vaughan, County Clare Ireland. (353)65-77200. Fax: (353)65-77201. "These workshops present unique opportunities to capture the qualities of the west of Ireland landscape. The flora, prehistoric tombs, ancient abbeys and castles that abound in the Burren provide an unending wealth of subjects in an ever-changing light." For full brochure and further information contact Ciara Cronin at the above address.

CAMERA-IMAGE WORKSHOPS, P.O. Box 1501, Downey CA 90240. Instructors (since 1984): Craig Fucile and Jan Pietrzak. Offers 3- and 4-day workshops during winter, spring and fall in California desert, Sierra Nevada Mountains and the California central coast. Workshop fees are approximately $65/day and cover tuition only. Instruction in color, b&w techniques, exposure, Ilfochrome and hand-coated printmaking. All camera formats welcome. Moderately priced motels and campgrounds are nearby. College credit is available.

JOHN C. CAMPBELL FOLK SCHOOL, Rt. 1, Box 14-A, Brasstown NC 28902. (704)837-2775 or (800)365-5724. Cost: $130-232 tuition; room and board available for additional fee. The Folk School offers weekend and week-long courses in photography year-round (b&w, color, wildlife and plants, image transfer, darkroom set-up, abstract landscapes). Please call for free catalog.

❧A CANVAS WITHOUT AN EASEL IS LIKE A CAMERA WITHOUT A TRIPOD, 10430 Hollybank Dr., Richmond, British Columbia V7E 4S5 Canada. (604)277-6570. Teacher: Dan Propp. Cost: $200/day (group of 5 maximum). "An old-fashioned scenic and postcard photographer will provide a fun day in scenic Vancouver showing you how to 'see' as opposed to simply 'look,' via the good old-fashioned, steady tripod!"

CANYONLANDS FIELD INSTITUTE PHOTO WORKSHOPS, P.O. Box 68, Moab UT 84532. (801)259-7750. Contact: Director of Programs. Program fees: $375-475. Offers programs in landscape photography in Monument Valley (Bluff, UT residential workshops for Elderhostel, age 55 and older).

***VERONICA CASS ACADEMY OF PHOTOGRAPHIC ARTS**, 7506 New Jersey Ave., Hudson FL 34667. (813)863-2738. President: Veronica Cass Weiss. Price per week: $410. Price per class: $410. Offers 8 one-week workshops in photo retouching techniques.

CLOSE-UP EXPEDITIONS, 858 56th St., Oakland CA 94608. (510)653-1834 or (800)995-8482. Guide and Outfitter: Donald Lyon. Sponsored by the Photographic Society of America. Worldwide, year-round travel and nature photography expeditions, 7-25 days. Professional photography guides put you in the right place at the right time to create unique marketable images.

***COASTAL CENTER FOR THE ARTS**, 2012 Demere Rd., St. Simons Island GA 31522. Executive Director: Mittie B. Hendrix.

CORY NATURE PHOTOGRAPHY WORKSHOPS, P.O. Box 42, Signal Mountain TN 37377. (423)886-1004 or (800)495-6190. Contact: Tom or Pat Cory. Small workshops with some formal instruction, but mostly one-on-one instruction tailored to each individual's needs. "We spend the majority of our time in the field. Cost and length vary by workshop. Many of our workshop fees include single occupancy lodging and some also include home-cooked meals and snacks. We offer special prices for two people sharing the same room and, in some cases, special non-participant prices. Workshops include spring and fall workshops in Smoky Mountain National Park and Chattanooga, Tennessee. Other workshops vary from year to year but include locations such as the High Sierra of California, Olympic National Park, Arches National Park, Acadia National Park, the Upper Peninsula of Michigan and Glacier National Park." Write or call for a brochure or more information.

CREATIVE ADVENTURES, 67 Maple St., Newburgh NY 12550-4034. E-mail: richie.suraci@bbs. mhv.net. Website: http://www.geopages.com/hollywood/1077. (914)561-5866. Contact: Richie Suraci. Photographic adventures to "exotic, sensual, beautiful international locations to photograph beautiful nude women and men."

CREATIVE ARTS WORKSHOP, 80 Audubon St., New Haven CT 06511. (203)562-4927. Photography Department Head: Harold Shapiro. Offers advanced workshops and exciting courses for beginning and serious photographers.

❧■DAWSON COLLEGE CENTRE FOR IMAGING ARTS AND TECHNOLOGIES, 4001 de Maisonneuve Blvd. W., Suite 2G.2, Montreal, Quebec H3Z 3G4 Canada. (514)933-0047. Fax: (514)937-3832. Director: Donald Walker. Cost: Ranges from $160-400. Workshop subjects include

imaging arts and technologies, animation, photography, computer imaging, desktop publishing, multi-media and video.

F/8 AND BEING THERE, (formerly Outback Photo Tours and Workshops), Bob Grytten and Associates, P.O. Box 3195, Holiday FL 34690. (813)934-1222; (800)990-1988. E-mail: f8news@aol.com. Director: Bob Grytten. Offers weekend tours and workshops in 35mm nature photography, emphasizing Florida flora and fauna. Also offers programs on marketing one's work.

ROBERT FIELDS PHOTOGRAPHIC WORKSHOPS, P.O. Box 3516, Ventura CA 93006. (805)641-2150. E-mail: fieldsr@aol.com. Instructor: Robert Fields. Cost: $79-212 per person. California photo workshops to Yosemite, Death Valley, Mono Lake, San Francisco, Morro Bay, Sequoia and Anza Borrego Desert. Both practical application and theory.

FINDING & KEEPING CLIENTS, 2038 Calvert Ave., Costa Mesa CA 92626-3520. (714)556-8133. Fax: (714)556-0899. Instructor: Maria Piscopo. "How to find commercial photo assignment clients and get paid what you're worth! Call for schedule and leave address or fax number."

FOCUS ADVENTURES, P.O. Box 771640, Steamboat Springs CO 80477. Phone/fax: (970)879-2244. Owner: Karen Schulman. Workshops in the art of seeing, self-discovery through photography and hand coloring photographs. Field trips to working ranches and wilderness areas. Customized private and small group lessons available year round. Workshops are summer and fall.

FORT SCOTT COMMUNITY COLLEGE PHOTO WORKSHOP & TOURS, 2108 S. Horton, Fort Scott KS 66701. (800)874-3722. Photography Instructor: John W. Beal. Cost: $85-150 workshops; $250-900 tours. Weekend nature photo workshops spring and fall. Other workshops cover Zone System, color printing, b&w fine printing, etc. Photo tours (2-7 days) of Ozarks, Kansas prairie, Rocky Mountains.

FRIENDS OF ARIZONA HIGHWAYS PHOTO WORKSHOPS, P.O. Box 6106, Phoenix AZ 85005-6106. (602)271-5904. Offers photo adventures to Arizona's spectacular locations with top professional photographers whose work routinely appears in *Arizona Highways*.

FRIENDS OF PHOTOGRAPHY, 250 Fourth St., San Francisco CA 94103. (415)495-7000. Curator of Education: Julia Brashares. "One- and two-day seminars are conducted by a faculty of well-known photographers and provide artistic stimulation and technical skills in a relaxed, focused environment."

GETTING & HAVING A SUCCESSFUL EXHIBITION, 163 Amsterdam Ave., # 201, New York NY 10023. (212)838-8640. Speaker: Bob Persky. Cost: 1996 tuition, $75 for 1-day seminar; course manual $24.95.

THE GLACIER INSTITUTE PHOTOGRAPHY WORKSHOPS, P.O. Box 7457. Kalispell MT 59904. (406)755-1211. General Manager: Kris Bruninga. Cost: $130-175. Workshops sponsored in the following areas: nature photography, advanced photography, wildlife photography and photographic ethics. "All courses take place in beautiful Glacier National Park."

GLOBAL PRESERVATION PROJECTS, P.O. Box 30866, Santa Barbara CA 93130. (805)682-3398. Fax: (805)563-1234. Director: Thomas I. Morse. Offers workshops promoting the preservation of environmental and historic treasures. Produces international photographic exhibitions and publications.

***GREAT PLAINS PHOTOGRAPHY WORKSHOPS**, P.O. Box 19002, Lenexa KS 66285. (316)343-7162. President: William Johnson. Cost: $35-100/workshop. Photographic workshops covering all types of subjects with over 200 locations in Kansas, Montana, Nebraska, Colorado, Oklahoma, Texas, New Mexico, Wyoming, North Dakota and South Dakota.

***HALLMARK INSTITUTE OF PHOTOGRAPHY**, P.O. Box 308, Turner's Falls MA 01376. (413)863-2478. Director: George J. Rosa III. Tuition: $11,950. Offers workshops in commercial and professional portrait photography and 10-month resident professional photography studio management program.

HEART OF NATURE PHOTOGRAPHY WORKSHOPS, 14618 Tyler Fte Rd., Nevada City CA 95959. (916)292-3839. Contact: Robert Frutos. Cost: $150/weekend workshop. "Nature Photography: The Creative Edge," is designed to assist all levels of photographers, in developing their personal strengths and styles and to inspire and sharpen their creative edge."

HORIZONS: THE NEW ENGLAND CRAFT PROGRAM, 108 North Main St., Sunderland MA 01375. (413)665-0300. Fax: (413)665-4141. Director: Jane Sinauer. International programs: Tuscany, Italy (October 5-12); The American Southwest: Horizons in New Mexico (April 19-26). long-weekend intensives in Massachusetts (spring, summer and fall); and two 3-week residential programs in b&w for high school students (July and August).

IN FOCUS WITH MICHELE BURGESS, 20741 Catamaran Lane, Huntington Beach CA 92646. (714)536-6104. President: Michele Burgess. Tour prices range from $4,000 to $5,000 from US. Offers overseas tours to photogenic areas with expert photography consultation, at a leisurely pace and in small groups (maximum group size 20).

INTERNATIONAL PHOTO TOURS (VOYAGERS INTERNATIONAL), P.O. Box 915, Ithaca NY 14851. (607)257-3091. Managing Director: David Blanton. Emphasizes techniques of nature photography.

IOWA SEMINARS, 10 E. 13th St., Atlantic IA 50022. Director: Jane Murray. Offers workshops in developing personal vision for beginning and intermediate photographers.

IRISH PHOTOGRAPHIC & CULTURAL EXCURSIONS, Voyagers, P.O. Box 915, Ithaca NY 14851. (607)257-3091. Cost: $1,995 (land). Offers 12-day trips in County Mayo in the west of Ireland from May-October.

THE LIGHT FACTORY PHOTOGRAPHIC ARTS CENTER, P.O. Box 32815, Charlotte NC 28232. (704)333-9755. Executive Director: Bruce Lineker. Since 1972. Gallery and non-profit organization dedicated to fine art photography. Offers exhibitions, classes, workshops and outreach programs.

***C.C. LOCKWOOD WILDLIFE PHOTOGRAPHY WORKSHOP**, 8939 Jefferson Hwy., #2C, Baton Rouge LA 70807. (504)926-2100. Photographer: C.C. Lockwood. Cost: Atchafalaya Swamp, $95; Yellowstone, $1,250. Each October and April C.C. conducts a 2-day Atchafalaya Basin Swamp Wildlife Workshop. It includes lecture, canoe trip into swamp, critique session. Every other year C.C. does a 7-day winter wildlife workshop in Yellowstone National Park. Each May and August C.C. leads a 7-day Grand Canyon raft trip photo workshop.

JOE McDONALD'S WILDLIFE PHOTOGRAPHY WORKSHOPS AND TOURS, 73 Loht Rd., McClure PA 17841-9340. (717)543-6423. Owner: Joe McDonald. Offers small groups, quality instruction with emphasis on wildlife. Workshops and tours range from $400-2,000.

***■THE MacDOWELL COLONY**, 100 High St., Peterborough NH 03458. (603)924-3886. Offers studio space to writers, composers, painters, sculptors, printmakers, photographers and filmmakers competitively, based on talent. Residency up to 2 months. Artists are asked to contribute toward cost of their residency according to financial resources. Application deadline: January 15 for summer; April 15 for fall/winter; September 15 for winter/spring. Call or write for application, guidelines and brochure.

McNUTT FARM II/OUTDOOR WORKSHOP, 6120 Cutler Lake Rd., Blue Rock OH 43720. (614)674-4555. Director: Patty L. McNutt. 1994 Fees: $140/day/person, included lodging. Minimum of 2 days. Outdoor shooting of livestock, pets, wildlife and scenes in all types of weather.

MACRO TOURS PHOTO WORKSHOPS, P.O. Box 460041, San Francisco CA 94146. (800)369-7430. Director: Bert Banks. Fees range from $55-2,995 for 1- to 10-day workshops. Offers travel workshops on wildflowers, scenics, wildlife in California, Alaska, Southwest, western National Parks and New England fall color. Brochure available; call or write.

■THE MAINE PHOTOGRAPHIC WORKSHOPS, Rockport ME 04856. (207)236-8581. Fax: (207)236-2558. Website: http://www.meworkshops.com. Director: David H. Lyman. Offers more than 200 one-week workshops for professionals and serious amateurs in photography, film and television, screenwriting, digital imaging from May through October. Also professional year-round resident programs in photography and film and video production. Associate of Arts and Master of Fine Arts degrees also available. Request catalog by mail, phone, fax or internet. Specify primary area of interest.

MENDOCINO COAST PHOTOGRAPHY SEMINARS, P.O. Box 1629, Mendocino CA 95460. (707)937-2805. Program Director: Hannes Krebs. Offers a variety of workshops, including a foreign expedition to Chile.

MEXICO PHOTOGRAPHY WORKSHOPS, Otter Creek Photography, Hendricks WV 26271. (304)478-3586. Instructor: John Warner. Cost: $1,300. Intensive week-long, hands-on workshops held throughout the year in the most visually rich regions of Mexico. Photograph snow-capped volcanos, thundering waterfalls, pre-Columbian ruins, fascinating people, markets and colonial churches in jungle, mountain, desert and alpine environments.

MIDWEST MEDIA ARTISTS ACCESS CENTER, 2388 University Ave., St. Paul MN 55114. (612)644-1912. Directors: Steve Westerlund and Althea Faricy. Offers basic through intermediate level courses in photography, film/video production and sound design.

MIDWEST PHOTOGRAPHIC WORKSHOPS, 28830 W. Eight Mile Rd., Farmington Hills MI 48336. (810)471-7299. Fax: (810)542-3441. Directors/Instructors: Alan Lowy, C.J. Elfont and Bryce Denison. Workshops, seminars and lectures taught on landscape photography and including the Classical Nude Figure in the Environment (Ludington, Michigan sand dunes); also a week-long workshop in Grand Junction, Colorado and Moab, Utah. "We also teach the nude figure with studio lighting techniques, as well as workshops on boudoir and fashion photography." Other workshops include nature, still life and product photography, wedding and portraiture, as well as week-long workshops in the Smoky Mountains and weekend workshops in Tobermory, Canada on nature and macro photography.

MISSISSIPPI VALLEY WRITERS CONFERENCE, 3403 45th St., Moline IL 61265. Director: David R. Collins. Registration $25, plus individual workshop expenses. Open to the basic beginner or polished professional, the MVWC provides a week-long series of workshops in June, including 5 daily sessions in photography.

MISSOURI PHOTOJOURNALISM WORKSHOP, 105 Lee Hills Hall, Columbia MO 65211. (314)882-4442. Coordinator: Lisa Barnes. Workshop for photojournalists. Participants learn the fundamentals of documentary photo research, shooting, editing and layout.

***MONO LAKE PHOTOGRAPHY WORKSHOPS**, P.O. Box 29, Lee Vining CA 93541. (619)647-6595. Contact: Workshop Coordinator. Cost: $100-225. "The Mono Lake Committee offers a variety of photography workshops in the surreal and majestic Mono Basin." 2- to 3-day workshops take place from May to October. Call or write for free brochure.

NATURE IMAGES, INC., P.O. Box 2037, West Palm Beach FL 33402. (407)586-7332. Director: Helen Longest-Slaughter. Photo workshops offered in Yellowstone National Park, North Carolina Outer Banks, Costa Rica and Everglades National Park.

NATURE PHOTOGRAPHY EXPEDITIONS, 418 Knottingham Dr., Twin Falls ID 83301. (800)574-2839. Contact: Douglas C. Bobb. Cost: $1,200/person, includes room, meals and transportation during the tour; requires a $300 deposit. Offers week-long trips in Yellowstone and the Tetons from June to October.

NEVER SINK PHOTO WORKSHOP, P.O. Box 641, Woodbourne NY 12788. (212)929-0008; (914)434-0575. Fax: (212)929-2689. Owner: Louis Jawitz. Offers weekend workshops in scenic, travel, location and stock photography from late July through early September in Catskill Mountains.

NEW ENGLAND SCHOOL OF PHOTOGRAPHY, 537 Commonwealth Ave., Boston MA 02215. (617)437-1868. Academic Director: Martha Hassell. Instruction in professional and creative photography.

***NEW YORK CITY COLOR PRINTING WORKSHOPS**, 230 W. 107th St., New York NY 10025. (212)316-1825. Joyce Culver, professional photographer and color printer, offers 1-day, 6-hour

MARKET CONDITIONS are constantly changing! If you're still using this book and it's 1998 or later, buy the newest edition of *Photographer's Market* at your favorite bookstore or order directly from Writer's Digest Books.

Saturday workshops in color printing. Attendees make 8 × 10 and larger prints from color negatives or internegatives in a professional New York City lab. Cost: $250. Classes of 4-5. Call or write for registration form and description.

NORTHEAST PHOTO ADVENTURE SERIES WORKSHOPS, 55 Bobwhite Dr., Glemont NY 12077. (518)432-9913. President: Peter Finger. Price ranges from $99 for a weekend to $600 for a week-long workshop. Offers over 20 weekend and week-long photo workshops, held in various locations. Recent locations have included: Cape Cod, Maine, Acadia National Park, Vermont, The Adirondacks, The Catskills, Block Island, Martha's Vineyard, Nantucket, Prince Edward Island, Nova Scotia and New Hampshire. "Small group instruction from dawn till dusk." Write for additional information.

***BOYD NORTON'S WILDERNESS PHOTOGRAPHY WORKSHOPS**, P.O. Box 2605, Evergreen CO 80437-2605. (303)674-3009. Contact: Boyd Norton. Past workshops have taken participants to Peru, Siberia, Borneo and Africa, to name a few locations.

***■OHIO INSTITUTE OF PHOTOGRAPHY AND TECHNOLOGY**, 2029 Edgefield Rd., Dayton OH 45439. (513)294-6155. Director of Education: Helen Morris. Convenient, affordable, intense workshops. Summer weekend workshops in still photography offer a variety of topics including nature, fashion/glamour, pet photography, photographing people, color printing, darkroom effects and more. Cost $150.

OREGON COLLEGE OF ART AND CRAFT, (formerly Oregon School of Arts and Crafts), 8245 SW Barnes Rd., Portland OR 97225. (503)297-5544. Offers workshops and classes in photography throughout the year: b&w, alternative processes and digital imaging. Call or write for a schedule.

OUTBACK RANCH OUTFITTERS, P.O Box 384, Joseph OR 97846. (503)426-4037. Owner: Ken Wick. Offers photography trips by horseback or river raft into Oregon wilderness areas.

OZARK PHOTOGRAPHY WORKSHOP FIELDTRIP, 40 Kyle St., Batesville AR 72501. (501)793-4552. Conductor: Barney Sellers. Retired photojournalist after 36 years with *The Commercial Appeal*, Memphis. Cost for 2-day trip: $100. Participants furnish own food, lodging, transportation and carpool. Limited to 12 people. No slides shown. Fast moving to improve alertness to light and outdoor subjects. Sellers also shoots.

***PALM BEACH PHOTOGRAPHIC WORKSHOPS**, Suite 104, 600 Fairway Dr., Deerfield Beach FL 33432 (407)391-7557. Executive Director: A.B. Nejame. Palm Beach Photographic Workshops is an innovative learning facility offering 3 and 5 day plus 1 day seminars in photography and digital imaging all year round. For free brochure call (305)481-9698.

***THE PALO ALTO PHOTOGRAPHIC WORKSHOPS**, 991 Commercial St., #1, Palo Alto CA 94303. (415)424-0105. Co-Directors: Douglas Peck and Stacy Geiken. Cost: $95. Offers one-day classes in beginning photography, nature photography, 4 × 5 view camera and lighting techniques.

❋FREEMAN PATTERSON/DORIS MOWRY PHOTO WORKSHOP, Rural Route 2, Clifton Royal, New Brunswick E0G 1N0 Canada. (506)763-2271. Partner: Doris J. Mowry. Cost: $600 (Canadian) for 6-day course. All workshops are for anybody interested in photography, from the complete novice to the experienced amateur or professional. "Our experience has consistently been that a mixed group functions best and learns the most."

PETERS VALLEY CRAFT CENTER, 19 Kuhn Rd., Layton NJ 07851. (201)948-5200. Fax: (201)948-0011. Offers workshops June, July and August, 3-5 days long. Offers instruction by talented photographers as well as gifted teachers in a wide range of photographic disciplines as well as classes in blacksmithing/metals, ceramics, fibers, fine metals and woodworking. Located in northwest New Jersey in the Delaware Water Gap National Recreation Area, 1½ hours west of New York City. Write, call or fax for catalog.

PHOTO ADVENTURE TOURS, 2035 Park St., Atlantic Beach NY 11509-1236. (516)371-0067. Fax: (516)371-1352. Manager: Pamela Makaea. Offers photographic tours to Iceland, India, Nepal, Russia, China, Scandinavia and domestic locations such as New Mexico, Navajo Indian regions, Hawaiian Islands, Albuquerque Balloon Festival and New York.

PHOTO ADVENTURES, P.O. Box 591291, San Francisco CA 94159. (415)221-3171. Instructor: Jo-Ann Ordano. Offers practical workshops covering creative and documentary photo technique in California nature subjects and San Francisco by moonlight.

PHOTO EXPLORER TOURS, (formerly China Photo Workshop Tours), 22111 Cleveland, #211, Dearborn MI 48124. (800)315-4462. Director: Dennis Cox. Specialist since 1981 in annual photo tours to China's most scenic areas and major cities with guidance to special photo opportunities by top Chinese photographers. Program now includes tours to various other countries, for example Turkey, India and Antarctica, with emphasis on travel photography and photojournalism.

PHOTO FOCUS/COUPEVILLE ARTS CENTER, P.O. Box 171 MP, Coupeville WA 98239. (360)678-3396. Director: Judy Lynn. Cost: $235-330. Locations: Whidbey Island, Olympic Peninsula, Mt. Rainier, North Cascades in Washington and the Oregon coast. Held April-July and October. Workshops in b&w, photojournalism, stock photography, portraiture, human figure, nature photography and more with outstanding faculty.

PHOTO METRO MAGAZINE AND DIGITAL WORKSHOPS, 17 Tehama St., San Francisco CA 94105. (415)243-9917. E-mail: jo_leggett@photometro.com. Website: http//www.photometro.c om. Publisher: Jo Leggett. Photo magazine published 10 times yearly; subscription $20. Computer workshops for Adobe Photoshop, QuarkXPress, Illustrator, Director, etc. Call for dates, prices. Yearly contest in fall; SASE after July for information.

PHOTOCENTRAL/INFRARED WORKSHOP, 1099 E St., Hayward CA 94541. (510)881-6721. Fax: (510)881-6763. E-mail: photcentrl@aol.com. Website: http://www.Hard.DST.CA.US. Coordinators: Geir and Kate Jordahl. One-day workshops, $56-76; 2- and 3-day, $110-150. Intimate workshops for travel and technical topics—dedicated to seeing more. Led by Geir and Kate Jordahl, specialists in infrared and panoramic photography. Workshops are open in all formats to photographers wanting to grow visually.

PHOTOGRAPHY AT THE SUMMIT: JACKSON HOLE, 3200 Cherry Creek Dr. S., Suite 650, Denver CO 80209. (303)744-2538 or (800)745-3211. Administrator: Rich Clarkson. A week-long workshop and weekend conferences with top journalistic, fine art and illustrative photographers and editors.

***‡PHOTOGRAPHY COURSES**, Dillington House, Ilminster Somerset TA19 9DT England. (0460)52427. Booking Secretary: Helen Howe. Cost: £290 for a week. Weekend and week-long practical photography courses in the sixteenth century setting of Dillington House.

***PHOTOGRAPHY INSTITUTES**, % Pocono Environmental Education Center, RR2, Box 1010, Dingmans Ferry PA 18328. (717)828-2319. Attention: Tom Shimalla. Offers weekend and week-long institutes throughout the year focusing on subjects in the natural world.

PHOTOGRAPHY WORKSHOPS INTERNATIONAL, 319 Pheasant Dr., Rocky Hill CT 06067. (800)563-9156. Directors: Stephen Sherman and Jack Holowitz. Workshops take place on Block Island, Rhode Island and also in the deserts of California, the canyons of the Southwest, the Pacific Northwest and Scotland. Offers workshop programs in b&w zone system, portraiture and landscapes. "We also conduct one portrait/figure and darkroom workshop each summer in Springfield, Massachusetts."

PT. REYES FIELD SEMINARS, Pt. Reyes National Seashore, Pt. Reyes CA 94956. (415)663-1200. Director: Julie Milas. Fees range from $50-225. Offers weekend photography seminars taught by recognized professionals.

PORT TOWNSEND PHOTOGRAPHY IMMERSION WORKSHOP, 1005 Lawrence, Port Townsend WA 98368. (604)469-1651. Instructor: Ron Long. Cost: $450. Six-day workshops include lectures, critiques, overnight processing, individual instruction, field trips and lots of shooting. All levels welcome.

PROFESSIONAL PHOTOGRAPHER'S SOCIETY OF NEW YORK PHOTO WORKSHOPS, 121 Genesee St., Avon NY 14414. (716)226-8351. Director: Lois Miller. Cost is $475. Offers week-long, specialized, hands-on workshops for professional photographers.

***PUBLISHING YOUR PHOTOS AS CARDS, POSTERS, & CALENDARS**, #201, 163 Amsterdam Ave., New York NY 10023. (212)362-6637. Lecturer: Harold Davis. 1996 cost: $150 including course manual. Course manual alone $22.95. A one-day workshop.

ROCKY MOUNTAIN SCHOOL OF PHOTOGRAPHY, P.O. Box 7697, Missoula MT 59807. (406)543-0171 or (800)394-7677. "RMSP offers professional career training in an 11-week 'Summer Intensive' program held each year in Missoula, Montana. Program courses include: basic and advanced

color and b&w, studio and natural lighting, portraiture, marketing, stock, intro to digital, portfolio and others. We also offer over 20 workshops year-round with Galen Rowell, Bruce Barnbaum, Alison Shaw, David Middleton and others. Locations all across U.S. and abroad—including New Zealand and the Galapagos."

ROCKY MOUNTAIN SEMINARS, Rocky Mountain National Park, Estes Park CO 80517. (970)586-1258. Seminar Coordinator: Kris Marske. Cost: $45-175, day-long to 5½-day seminars. Workshops covering photographic techniques of wildlife and scenics in Rocky Mountain National Park. Professional instructors include David Halpern, Perry Conway, Wendy Shattil and Bob Rozinski.

RON SANFORD, P.O. Box 248, Gridley CA 95948. (916)846-4687. Contact: Ron or Nancy Sanford. Travel and wildlife workshops and tours.

PETER SCHREYER PHOTOGRAPHIC TOURS, P.O. Box 533, Winter Park FL 32790. (407)671-1886. Tour Director: Peter Schreyer. Specialty photographic tours to the American West, Europe and the backroads of Florida. Travel in small groups of 10-15 participants.

***THE SEATTLE WORKSHOP**, P.O. Box 272, Earlysville VA 22936. (206)322-6886. Contact: Glenn Showalter. Cost: $200-500, depending on curriculum and length of program. Course projects include downtown Seattle markets and piers, cruises to the San Juan Islands, aerial photography, field visits to winerys, the Washington seacoast and various areas in the Cascade Mountains. All camera formats, primarily 35mm. "Emphasis is on the art of seeing, composition, visual communication and camera work for the productive scientist and businessman as well as the artist. Glenn Showalter has degrees in photography and education and has worked at Gannett Rochester Newspapers, UPI, AP and DuPont Corporation." Send for information. "Would like to see a 3 × 5 postcard with a photograph you have produced."

"SELL & RESELL YOUR PHOTOS" SEMINAR, by Rohn Engh, Pine Lake Farm, Osceola WI 54020. (715)248-3800. Fax: (715)248-7394. Seminar Coordinator: Sue Bailey. Offers half-day workshops in major cities. 1996 cities included: Philadelphia, Washington DC, Detroit, Minneapolis, San Francisco, Atlanta, Charlotte, Orlando, St. Louis, Las Vegas, Denver and Houston. Workshops cover principles based on methods outlined in author's best-selling book of the same name. Marketing critique of attendee's slides follows seminar. Phone for free 1997 schedule.

JOHN SEXTON PHOTOGRAPHY WORKSHOPS, 291 Los Agrinemsors, Carmel Valley CA 93924. (408)659-3130. Director: John Sexton. Offers a selection of intensive workshops with master photographers in scenic locations throughout the US and abroad.

SHENANDOAH PHOTOGRAPHIC WORKSHOPS, P.O. Box 54, Sperryville VA 22740. (703)937-5555. Directors: Frederick Figall and John Neubauer. Three days to one week photo workshops in the Virginia Blue Ridge foothills, held in summer and fall. Weekend workshop held year round in Washington DC area.

SIERRA PHOTOGRAPHIC WORKSHOPS, 3251 Lassen Way, Sacramento CA 95821. (800)925-2596. In Canada, phone: (916)974-7200. Contact: Sierra Photographic Workshops. Offers week-long workshops in various scenic locations for "personalized instruction in outdoor photography, technical knowledge useful in learning to develop a personal style, learning to convey ideas through photographs."

BOB SISSON'S MACRO/NATURE PHOTOGRAPHY, P.O. Box 1649, Englewood FL 34295. (941)475-0757. Contact: Bob Sisson (Former Chief Natural Sciences Division, *National Geographic Magazine*.) Cost: $200/day. Special one-on-one course; "you will be encouraged to take a closer look at nature through the lens, to learn the techniques of using nature's light correctly and to think before exposing film."

***THE 63 RANCH PHOTO WORKSHOPS**, P.O. Box 979, Livingston MT 59047. (406)222-0570. Director: Sandra Cahill. Workshops in June and September for intermediate to advanced amateur (or beginning professional) photographers.

CLINTON SMITH PHOTOGRAPHY WORKSHOPS, P.O. Box 1761, Mendocino CA 95460. (707)937-2261. Instructor: Clinton Smith. Cost: $250-500. Landscape workshops conducted at Bodie State Historic Park, Mono Lake/Eastern Sierra, Mendocino Coast, Redwood National Park, Glacier National Park and Zion National Park. Color printing workshops are conducted in Sacramento, California.

***SNAKE RIVER INSTITUTE PHOTO WORKSHOPS**, P.O. Box 128, Wilson WY 83014. (307)733-2214. Program Coordinator: Samantha Strawbridge. Offers landscape photography workshops.

SOUTHAMPTON MASTER PHOTOGRAPHY WORKSHOP, % Long Island University-Southampton College, Southampton NY 11968-9822. (516)287-8349. Contact: Carla Caglioti, Summer Director. Offers a diverse series of 1-week photo workshops during July and August.

SPECIAL EFFECTS BACKGROUNDS, P.O. Box 1745, San Marcos TX 78667. (512)353-3111. Director of Photography: Jim Wilson. Offers 3-day programs in background projection techniques. Open to all levels of photographic education; participants are limited to 12/workshop.

SPRING AND FALL COLOR PRINTING WORKSHOP, 707 Myrtle Ave., St. Joseph MI 49085. (616)983-5893. Contact: Bob Mitchell. Offers biannual workshops with intensive exercises in shooting, processing and printing.

STONE CELLAR DARKROOM WORKSHOPS, 51 Hickory Flat Rd., Buckhannon WV 26201. (304)472-1111. Photographer/Printmaker: Jim Stansbury. Master color printing and color field work. Small classes with Jim Stansbury. Work at entry level or experienced level.

SUPERIOR/GUNFLINT PHOTOGRAPHY WORKSHOPS, P.O. Box 19286, Minneapolis MN 55419. Director: Layne Kennedy. Prices range from $585-785. Write for details on session dates. Fee includes all meals/lodging and workshop. Offers wilderness adventure photo workshops twice yearly. Winter session includes driving your own dogsled team in northeastern Minnesota. Summer session includes kayak trips into border waters of Canada-Minnesota and Apostle Islands in Lake Superior. All trips professionally guided. Workshop stresses how to shoot effective and marketable magazine photos.

SYNERGISTIC VISIONS WORKSHOPS, Gallery 412, 412 Main St., Grand Junction CO 81501. (970)245-6700. Fax: (970)245-6767. E-mail: synvis@aol.com. Director: Steve Traudt, ASMP. Costs vary. Offers a variety of classes, workshops and photo trips including Galapagos, Costa Rica, Patagonia and more. All skill levels welcome. Author of *Heliotrope-The Book* and designer of *Hyperfocal Card*, "Traudt's trademark is enthusiasm and his workshops promise a true synergy of art, craft and self." Call or write for brochures.

***TAOS INSTITUTE OF ARTS**, 5280NDCBU, Taos NM 87571-6155. (505)758-2793. Director: Judith Krull. Cost: $350. Workshops in photographing New Mexico—the churches, the landscape, the architecture, the ruins, wildlife.

TEN MANAGEMENT NUDE FIGURE PHOTOGRAPHY WORKSHOPS, (formerly As We Are Nude Figure Photography Workshops), 5666 La Jolla Blvd., Suite 111, La Jolla CA 92037. (619)459-7502. Director: Bob Stickel. Cost: $100-185/day. Ten Management offers a range of studio and location (mountain, beach, desert, etc.) workshops on the subject of photographing the male nude figure.

TOUCH OF SUCCESS PHOTO SEMINARS, P.O. Box 194, Lowell FL 32663. (904)867-0463. Director: Bill Thomas. Costs vary from $250-895 (US) to $5,000 for safaris. Offers workshops on nature scenics, plants, wildlife, stalking, building rapport and communication, composition, subject selection, lighting, marketing and business management. Workshops held at various locations in US. Photo safaris led into upper Amazon, Andes, Arctic, Alaska, Africa and Australia. Writer's workshops for photographers who wish to learn to write.

UC-BERKELEY EXTENSION PHOTOGRAPHY PROGRAM,% University of California Berkeley Extension, 55 Laguna St., San Francisco CA 94102. (415)252-5249. Director, Photography Program: Michael Lesser. Offers courses and workshops for beginning, advanced and professional photographers.

UNIVERSITY OF CALIFORNIA SANTA CRUZ EXTENSION PHOTOGRAPHY WORKSHOPS, 740 Front St., Suite 155, Santa Cruz CA 95060. (408)427-6620. Contact: Photography Program. Ongoing program of workshops in photography throughout California and international study tours in photography. Call or write for details.

UNIVERSITY OF WISCONSIN SCHOOL OF THE ARTS AT RHINELANDER, 726 Lowell Hall, 610 Langdon St., Madison WI 53703. (608)263-3494. Coordinator: Kathy Berigan. One-week interdisciplinary arts program held during July in northern Wisconsin.

JOSEPH VAN OS PHOTO SAFARIS, INC., P.O. Box 655, Vashon Island WA 98070. (206)463-5383. Fax: (206)463-5484. Director: Joseph Van Os. Offers over 50 different photo tours and workshops worldwide.

VENTURE WEST, P.O. Box 7543, Missoula MT 59807. (406)825-6200. Owner: Cathy Ream. Offers various photographic opportunities, including wilderness pack and raft trips, ranches, housekeeping cabins, fishing and hunting.

VISITING ARTISTS WORKSHOPS, % Southwest Craft Center, 300 Augusta, San Antonio TX 78205. (210)224-1848. Workshops range from $150-200. Approximately four photography workshops are offered during the spring and fall sessions.

MARK WARNER NATURE PHOTO WORKSHOPS, P.O. Box 142, Ledyard CT 06339. (860)376-6115. Offers 1-4-day workshops on nature and wildlife photography by nationally published photographer and writer at various East Coast locations.

WFC ENTERPRISES, P.O. Box 5054, Largo FL 34649. (813)581-5906. Owner: Wayne F. Collins. Cost: $325. Photo workshops (glamour), January through December, all on weekends (2 days long). Free brochure on request.

WILD HORIZONS, INC., P.O. Box 5118-PM, Tucson AZ 85703. (520)743-4550. Fax: (520)743-4551. President: Thomas A. Wiewandt. Average all-inclusive costs: domestic travel $1,400/week; foreign travel $2,000/week. Offers workshops in field techniques in nature/travel photography at vacation destinations in the American West selected for their outstanding natural beauty and wealth of photographic opportunities. Customized learning vacations for small groups are also offered abroad.

WILDERNESS ALASKA, Box 113063, Anchorage AK 99511. (907)345-3567. Contact: MacGill Adams. Offers custom photography trips featuring natural history and wildlife to small groups.

WILDERNESS PHOTOGRAPHIC WORKSHOPS, (formerly On Location Seminars), P.O. Box 1653, Dept. PM, Ross CA 94957. (415)927-4579. President: Brenda Tharp. Offers multiday photography workshops and tours throughout the US, including Alaska. Specializes in outdoor and travel photography with an emphasis on creativity and low-impact experiences. Personalized, one-on-one instruction with small group sizes. Brenda Tharp leads all workshops/tours, occasionally using coleaders. Destinations planned for 1997 include Alaska, Arizona, Baja, California, Hawaii, Maine, Montana, Utah, Washington, Wyoming.

WILDERNESS PHOTOGRAPHY EXPEDITIONS, 402 S. Fifth, Livingston MT 59047. (406)222-2302. President: Tom Murphy. Offers programs in wildlife and landscape photography in Yellowstone Park and special destinations.

WILDLIFE PHOTOGRAPHY SEMINAR, LEONARD RUE ENTERPRISES, 138 Millbrook Rd., Blairstown NJ 07825. (908)362-6616. Program Support: Barbara. This is an indepth day-long seminar covering all major aspects of wildlife photography. Based on a slide presentation format with question and answer periods. Topics covered include animal, bird, closeup, reptile and landscape photography as well as exposure and equipment.

WINSLOW PHOTO TOURS, INC., P.O. Box 334, Durango CO 81302-0334. (970)259-4143. Fax: (970)259-7748. President: Robert Winslow. Cost: varies from workshop to workshop and photo tour to photo tour. "We conduct wildlife model workshops in totally natural settings. We also run various domestic and international photo tours concentrating mostly on intense wildlife photography."

WOMEN'S PHOTOGRAPHY WORKSHOP, P.O. Box 3998, Hayward CA 94540. (510)278-7705. E-mail: kpjordahl@aol.com. Coordinator: Kate Jordahl. Cost: $150/intensive 2-day workshop. Workshops dedicated to seeing more through photography and inspiring women toward growth in their image making and lives through community and interchange. Specializing in women's concerns in photography.

WORKSHOPS IN THE WEST, P.O. Box 1261, Manchaca TX 78652. (512)295-3348. Contact: Joe Englander. Costs: $275-3,650. Photographic instruction in beautiful locations throughout the world, all formats, color and b&w, darkroom instruction.

YELLOWSTONE INSTITUTE, P.O. Box 117, Yellowstone National Park WY 82190. (307)344-2294. Registrar: Pam Gontz. Offers workshops in nature and wildlife photography during the summer, fall and winter. Custom courses can be arranged.

YOSEMITE FIELD SEMINARS, P.O. Box 230, El Portal CA 95318. (209)379-2646. Seminar Coordinator: Penny Otwell. Costs: $60-250. Offers small (8-15 people) workshops in outdoor field photography throughout the year. Write or call for free brochure. "We're a nonprofit organization."

YOUR WORLD IN COLOR, % Stone Cellar Darkroom, P.O. Box 253, Buckhannon WV 26201. (304)472-1111. Director: Jim Stansbury. Offers workshops in color processing, printing and related techniques. Also arranges scenic field trips. Work at entry or advanced level, one-on-one with a skilled printmaker. "Reasonable fees, write for info on variety of workshops."

Schools

Whether you are a long-time professional or a newcomer to photography, continuing education is very important to your success. Earlier in this book we listed dozens of workshops. This section lists schools that specialize in photography. Because of space constraints we chose not to include the numerous colleges and universities throughout the world that offer academic degrees in photography. For information about university degrees in photography, check your local library for the most recent edition of *Peterson's Guide to Four-Year Colleges*.

THE AEGEAN CENTER FOR THE FINE ARTS, Paros, Cyclades 84400, Greece. Director: John A. Pack. American art school in Greece.

ANTONELLI COLLEGE OF ART AND PHOTOGRAPHY, 124 E. Seventh St., Cincinnati OH 45202. (513)241-4338.

ANTONELLI INSTITUTE, P.O. Box 570, 2910 Jolly Rd., Plymouth Meeting PA 19462. (610)275-3040.

BROOKS INSTITUTE OF PHOTOGRAPHY, 801 Alston Rd., Santa Barbara CA 93108. (805)966-3888.

CENTER FOR IMAGING ARTS & TECHNOLOGY, 4001 de Maisonneuve Blvd. W., Suite 2G2, Montreal, Quebec H3Z 3G4 Canada. (514)933-0047.

CREATIVE CIRCUS, 1935 Cliff Valley Way, Suite 210, Atlanta GA 30329. (800)704-4150 or (404)633-1990.

HALLMARK INSTITUTE OF PHOTOGRAPHY, P.O. Box 308, Turners Falls MA 01376. (413)863-2478.

INTERNATIONAL CENTER OF PHOTOGRAPHY, Education Dept., 1130 Fifth Ave. at 94th Street, New York NY 10128. (212)860-1776.

THE MAINE PHOTOGRAPHIC WORKSHOPS, 2 Central St., Rockport ME 04856. (207)236-8581.

NEW ENGLAND SCHOOL OF PHOTOGRAPHY (NESOP), 537 Commonwealth Ave., Kenmore Square, Boston MA 02215. (617)437-1868.

OHIO INSTITUTE OF PHOTOGRAPHY AND TECHNOLOGY (OIPT), 2029 Edgfield Rd., Dayton OH 45439. (513)294-6155.

PORTFOLIO CENTER, Admissions Department, 125 Bennett St., Atlanta GA 30309. (800)255-3169 or (404)351-5055.

ROCHESTER INSTITUTE OF TECHNOLOGY, Bausch & Lomb Center, 60 Lomb Memorial Dr., Rochester NY 14623-5604. Admissions Office: (716)475-6631.

WEST DEAN COLLEGE, West Dean, Chichester, West Sussex P.O. 18 0QZ, England. Public Relations Manager: Heather Way.

THE WESTERN ACADEMY OF PHOTOGRAPHY, 755A Queens Ave., Victoria, British Columbia V8T 1M2 Canada. (604)383-1522. Fax: (604)383-1534.

WINONA INTERNATIONAL SCHOOL OF PROFESSIONAL PHOTOGRAPHY, 57 Forsyth St. NW, Suite 1500, Atlanta GA 30303. (404)522-3030.

Professional Organizations

The organizations in the following list can be valuable to photographers who are seeking to broaden their knowledge and contacts within the photo industry. Typically, such organizations have regional or local chapters and offer regular activities and/or publications for their members. To learn more about a particular organization and what it can offer you, call or write for more information.

ADVERTISING PHOTOGRAPHERS OF NEW YORK (APNY), 27 W. 20th St., Room 601, New York NY 10011. (212)807-0399.

AMERICAN SOCIETY OF MEDIA PHOTOGRAPHERS (ASMP), 14 Washington Rd., Suite 502, Princeton Junction NJ 08550-1033. (609)799-8300.

AMERICAN SOCIETY OF PICTURE PROFESSIONALS (ASPP), ASPP Membership, Woodfin Camp, 2025 Pennsylvania Ave. NW, Suite 226, Washington DC 20006. (202)223-8442. Executive Director: Cathy Sachs.

BRITISH ASSOCIATION OF PICTURE LIBRARIES AND AGENCIES, 13 Woodberry Crescent, London N1O 1PJ England. (081)883-2531. Fax: (081)883-9215.

CANADIAN ASSOCIATION OF JOURNALISTS, PHOTOJOURNALISM CAUCUS, 2 Mullock St., St. Johns, Newfoundland A1C 2R5 Canada. (709)576-2297. Contact: Greg Locke.

THE CENTER FOR PHOTOGRAPHY AT WOODSTOCK (CPW), 59 Tinker St., Woodstock NY 12498. (914)679-9957. Executive Director: Colleen Kenyon.

EVIDENCE PHOTOGRAPHERS INTERNATIONAL COUNCIL (EPIC), 600 Main St., Honesdale PA 18431. (717)253-5450.

THE FRIENDS OF PHOTOGRAPHY, 250 Fourth St., San Francisco CA 94103. (415)495-7000.

INTERNATIONAL CENTER OF PHOTOGRAPHY (ICP), 1130 Fifth Ave., New York NY 10128. (212)860-1781.

THE LIGHT FACTORY (TLF) PHOTOGRAPHIC ARTS CENTER, 311 Arlington at South Blvd., Charlotte NC 28203. Mailing Address: P.O. Box 32815, Charlotte NC 28232. (704)333-9755.

NATIONAL PRESS PHOTOGRAPHERS ASSOCIATION (NPPA), 3200 Croasdaile Dr., Suite 306, Durham NC 27705. (800)289-6772. NPPA Executive Director: Charles Cooper.

NORTH AMERICAN NATURE PHOTOGRAPHY ASSOCIATION (NANPA), 10200 W. 44th Ave., Suite 304, Wheat Ridge CO 80033-2840. (303)422-8527. President: Mark Lukes.

PHOTOGRAPHIC SOCIETY OF AMERICA (PSA), 3000 United Founders Blvd., Suite 103, Oklahoma City OK 73112. (405)843-1437.

PICTURE AGENCY COUNCIL OF AMERICA (PACA), P.O. Box 308, Northfield MN 55057-0308. (800)457-7222.

PROFESSIONAL PHOTOGRAPHERS OF AMERICA (PPA), 57 Forsyth St. NW, Suite 1600, Atlanta GA 30303. (404)522-8600.

PROFESSIONAL WOMEN PHOTOGRAPHERS, % Photographics Unlimited, 17 W. 17 St., 4th Floor, New York NY 10011-5510. (212)289-6072. President: Katherine Criss.

SOCIETY OF PHOTOGRAPHER AND ARTIST REPRESENTATIVES, INC. (SPAR), 60 E. 42nd St., Suite 1166, New York NY 10165. (212)779-7464.

VOLUNTEER LAWYERS FOR THE ARTS, 1 E. 53rd St., 6th Floor, New York NY 10022. (212)319-2787.

WEDDING & PORTRAIT PHOTOGRAPHERS INTERNATIONAL (WPPI), P.O. Box 2003, 1312 Lincoln Blvd., Santa Monica CA 90401. (310)451-0090.

WHITE HOUSE NEWS PHOTOGRAPHERS' ASSOCIATION, INC. (WHNPA), P.O. Box 7119, Ben Franklin Station, Washington DC 20044-7119. (202)785-5230.

WORLD COUNCIL OF PROFESSIONAL PHOTOGRAPHERS, 654 Street Rd., Bensalem PA 19020.

Websites of Interest

If you have access to an online computer service, such as Prodigy, America Online or Compuserve, you may want to visit the numerous websites on the Internet that are useful for photographers. The list below is new this year and contains some of the better webpages we've found. It includes sites for online portfolios, retailers and general information for photographers. This list does not include web addresses for the numerous magazines, book publishers, stock agencies or other markets that exist. Those website addresses can be found within the market listings in this book. One final note, the sites listed were available at press time. If you have trouble accessing them, or if you find other quality sites, drop us a line via e-mail: MikeW99722@aol.com.

ONLINE PORTFOLIOS

These websites contain online portolios that art buyers can access when seeking new talent. They also include general information that can be helpful to freelancers. Some of these sites showcase work from other visual artists, such as designers, fine artists and illustrators. Perhaps these sites will give you some ideas for publicizing your own work.

Art World Online: http://www.artworld.ddwi.com

Creative Contacts: http://www.creativecontacts.com

DesignSphere Online: http://www.dsphere.net

Global Photographers Search: http://www.photographers.com

Kaleidoscope: http://www.kspace.com

Photographer's Folio: http://www.digigold.net/folio

Portfolios Online: http://www.portfolios.com

Studio Net: http://studionet.com

RETAILERS

The following is a list of major companies that produce products for photography. You will find new product information and technical advice at many of these sites. This, of course, is only a partial list.

Agfa Film: http://www.agfahome.com

Canon: http://www.usa.canon.com

Fuji: http://www.fujifilm.co.jp/index.html

Kodak: http://www.Kodak.com

Nikon: http://www.kit.co.jp/Nikon

Pacific Coast Software: http://www.pacific-coast.com

ADDITIONAL INFORMATION

American Society of Media Photographers: http://swissnet.ai.mit.edu/photo/asmp-copyright.text
 This site gives you an overview of the copyright laws as they relate to photographers.

TakingStock: http://www.pickphoto.com
 Created by stock photo industry guru Jim Pickerell, this site provides information relating to the stock field.

U.S. Copyright Office: http://lcweb.loc.gov/copyright
 This site is excellent for anyone wanting to know the laws regarding registration of your photos.

Index Stock: http://www.indexstock.com/pages/pricing.htm
 Index Stock is a stock agency, but this site provides helpful tips for pricing your images.

Recommended Books & Publications

Photographer's Market recommends the following additional reading material to stay informed of market trends as well as to find additional names and addresses of photo buyers. Most are available either in a library or bookstore or from the publisher. To insure accuracy of information, use copies of these resources that are no older than a year.

AMERICAN PHOTO, 1633 Broadway, 43rd Floor, New York NY 10019. (212)767-6086. Monthly magazine, emphasizing the craft and philosophy of photography.

ART CALENDAR, P.O. Box 199, Upper Fairmont MD 21867-0199. (410)651-9150. Monthly magazine listing galleries reviewing portfolios, juried shows, percent-for-art programs, scholarships and art colonies, among other art-related topics.

ASMP BULLETIN, 14 Washington Rd., Suite 502, Princeton Junction NJ 08550-1033. (609)799-8300. Monthly newsletter of the American Society of Media Photographers. Subscription comes with membership in ASMP.

THE COMMERCIAL IMAGE, PTN Publishing, 445 Broad Hollow Rd., Melville NY 11747. (516)845-2700. Monthly magazine for photographers in various types of staff positions in industry, education and other institutions.

COMMUNICATION ARTS, 410 Sherman Ave., Box 10300, Palo Alto CA 94303. http://www.com marts.com. Magazine covering design, illustration and photography. Published 8 times a year.

CREATIVE BLACK BOOK, 10 Astor Place, 6th Floor, New York NY 10003. (800)841-1246. Sourcebook used by photo buyers to find photographers.

DIRECT STOCK, 10 E. 21st St., 14th Floor, New York NY 10010. (212)979-6560. Sourcebook used by photo buyers to find photographers.

EDITOR & PUBLISHER, The Editor & Publisher Co., Inc., 11 W. 19th St., New York NY 10011. (212)675-4380. http://www.mediainfo.com. Weekly magazine covering latest developments in journalism and newspaper production. Publishes an annual directory issue listing syndicates and another directory listing newspapers.

ENCYCLOPEDIA OF ASSOCIATIONS, Gale Research Inc., 645 Griswold St., 835 Penobscot Building, Detroit MI 48226-4094.(313)961-2242. Annual directory listing active organizations.

F8 and BEING THERE, P.O. Box 8792, St. Petersburg FL 33738. (813)397-3013. A bimonthly newsletter for nature photographers who enjoy travel.

FOLIO, 911 Hope St., P.O. Box 4949, Bldg. 6, Stamford CT 06907-0949. (203)358-9900. Monthly magazine featuring trends in magazine circulation, production and editorial.

GRAPHIS, 141 Lexington Ave., New York NY 10016-8193. (212)532-9387. Fax: (212)213-3229. http://www.pathfinder.com. Magazine for the visual arts.

GREEN BOOK, % AG Editions, 41 Union Square West, #523, New York NY 10003. (212)929-0959. Annual directory of nature and stock photographers for use by photo editors and researchers.

GUIDE TO TRAVEL WRITING & PHOTOGRAPHY, by Ann and Carl Purcell, published by Writer's Digest Books, 1507 Dana Ave., Cincinnati OH 45207. (513)531-2222.

GUILFOYLE REPORT, % AG Editions, 41 Union Square West, #523, New York NY 10003. (212)929-0959. Quarterly market tips newsletter for nature and stock photographers.

HOW, F&W Publications, 1507 Dana Ave., Cincinnati OH 45207. (513)531-2222. Bimonthly magazine for the design industry.

HOW TO SHOOT STOCK PHOTOS THAT SELL, by Michal Heron, published by Allworth Press, distributed by Writer's Digest Books, 1507 Dana Ave., Cincinnati OH 45207. (513)531-2222.

HOW YOU CAN MAKE $25,000 A YEAR WITH YOUR CAMERA, by Larry Cribb, published by Writer's Digest Books, 1507 Dana Ave., Cincinnati OH 45207. (513)531-2222. Newly revised edition of the popular book on finding photo opportunities in your own hometown.

KLIK, published by American Showcase, 915 Broadway, 14th Floor, New York NY 10010. (212)673-6600. Sourcebook used by photo buyers to find photographers.

LIGHTING SECRETS FOR THE PROFESSIONAL PHOTOGRAPHER, by Alan Brown, Tim Grondin and Joe Braun, published by Writer's Digest Books, 1507 Dana Ave., Cincinnati OH 45207. (513)531-2222.

LITERARY MARKET PLACE, R.R. Bowker Company, 121 Chanlon Rd. New Providence NJ 07974. (908)464-6800. Directory that lists book publishers and other book industry contacts.

NEGOTIATING STOCK PHOTO PRICES, by Jim Pickerell. Available through American Society of Media Photographers, 14 Washington Rd., Suite 502, Princeton Junction NJ 08550-1033. (609)799-8300. Hardbound book which offers pricing guidelines for selling photos through stock photo agencies.

NEWS PHOTOGRAPHER, 1446 Conneaut Ave., Bowling Green OH 43402. (419)352-8175. Monthly news tabloid published by the National Press Photographers Association.

NEWSLETTERS IN PRINT, Gale Research Inc., 645 Griswold St., 835 Penobscot Building, Detroit MI 48226-4094. (313)961-6083. Annual directory listing newsletters.

O'DWYER DIRECTORY OF PUBLIC RELATIONS FIRMS, J.R. O'Dwyer Company, Inc., 271 Madison Ave., New York NY 10016. (212)679-2471. Annual directory listing public relations firms, indexed by specialties.

OUTDOOR PHOTOGRAPHER, 12121 Wilshire Blvd., Suite 1220, Los Angeles CA 90025. (310)820-1500. Monthly magazine emphasizing equipment and techniques for shooting in outdoor conditions.

PETERSEN'S PHOTOGRAPHIC MAGAZINE, 6420 Wilshire Blvd., Los Angeles CA 90048-5515. (213)782-2200. Monthly magazine for beginning and semi-professional photographers in all phases of still photography.

PHOTO DISTRICT NEWS, 1515 Broadway, New York NY 10036. Monthly trade magazine for the photography industry.

THE PHOTOGRAPHER'S BUSINESS & LEGAL HANDBOOK, by Leonard Duboff, published by Images Press, distributed by Writer's Digest Books, 1507 Dana Ave., Cincinnati OH 45207. (513)531-2222. A guide to copyright, trademarks, libel law and other legal concerns for photographers.

PHOTOGRAPHER'S SOURCE, by Henry Horenstein, published by Fireside Books, % Simon & Schuster Publishing, Rockefeller Center, 1230 Avenue of the Americas, New York NY 10020. (212)698-7000.

PHOTOSOURCE INTERNATIONAL, Pine Lake Farm, 1910 35th Rd., Osceola WI 54020. (715)248-3800. This company publishes several helpful newsletters, including PhotoLetter, PhotoMarket, Photo-Bulletin *and* PhotoStockNotes.

POPULAR PHOTOGRAPHY, 1633 Broadway, New York NY 10019. (212)767-6000. Monthly magazine specializing in technical information for photography.

PRICING PHOTOGRAPHY: THE COMPLETE GUIDE TO ASSIGNMENT & STOCK PRICES, by Michal Heron and David MacTavish, published by Allworth Press, 10 E. 23rd St., New York NY 10010. (212)777-8395.

PRINT, RC Publications Inc., 104 Fifth Ave., 19th Floor, New York NY 10011. (212)463-0600. Fax: (212)989-9891. Bimonthly magazine focusing on creative trends and technological advances in illustration, design, photography and printing.

PROFESSIONAL PHOTOGRAPHER, published by Professional Photographers of America (PPA), 57 Forsyth St. NW, Suite 1600, Atlanta GA 30303. (404)522-8600. Monthly magazine, emphasizing technique and equipment for working photographers.

PROFESSIONAL PHOTOGRAPHER'S GUIDE TO SHOOTING & SELLING NATURE & WILDLIFE PHOTOS, by Jim Zuckerman, published by Writer's Digest Books, 1507 Dana Ave., Cincinnati OH 45207. (513)531-2222.

PROFESSIONAL PHOTOGRAPHER'S SURVIVAL GUIDE, by Charles E. Rotkin, published by Writer's Digest Books, 1507 Dana Ave., Cincinnati OH 45207. (513)531-2222. A guide to becoming a professional photographer, making the first sale, completing assignments and earning the most from photographs.

PUBLISHERS WEEKLY, Bowker Magazine Group, Cahners Publishing Co., 249 W. 17th St., New York NY 10011. (212)645-0067. Weekly magazine covering industry trends and news in book publishing, book reviews and interviews.

THE RANGEFINDER, 1312 Lincoln Blvd., Santa Monica CA 90401. (310)451-8506. Monthly magazine on photography technique, products and business practices.

SELL & RESELL YOUR PHOTOS, by Rohn Engh, published by Writer's Digest Books, 1507 Dana Ave., Cincinnati OH 45207. (513)531-2222. Newly revised edition of the classic volume on marketing your own stock images.

SHUTTERBUG, Patch Communications, 5211 S. Washington Ave., Titusville FL 32780. (407)268-5010. Monthly magazine of photography news and equipment reviews.

STANDARD DIRECTORY OF ADVERTISING AGENCIES, A Reed Reference Publishing Co., 121 Chanlon Rd., New Providence NJ 07974. (908)464-6800. Annual directory listing advertising agencies.

STANDARD RATE AND DATA SERVICE, 1700 Higgins Rd., Des Plains IL 60018. (847)375-5000. http://www.srds.com. Monthly directory listing magazines, plus their advertising rates.

STOCK PHOTOGRAPHY HANDBOOK, by Michal Heron, published by American Society of Media Photographers, 14 Washington Rd., Suite 502, Princeton Junction NJ 08550-1033. (609)799-8300.

STOCK PHOTOGRAPHY: The Complete Guide, by Ann and Carl Purcell, published by Writer's Digest Books, 1507 Dana Ave., Cincinnati OH 45207. (513)531-2222.

THE STOCK WORKBOOK, published by Scott & Daughters Publishing, Inc., 940 N. Highland Ave., Suite A, Los Angeles CA 90038. (213)856-0008. Annual directory of stock photo agencies.

SUCCESSFUL FINE ART PHOTOGRAPHY, by Harold Davis, published by Images Press, distributed by Writer's Digest Books, 1507 Dana Ave., Cincinnati OH 45207. (513)531-2222.

TAKING STOCK, published by Jim Pickerell, 110 Frederick Ave., Suite A, Rockville MD 20850. (301)251-0720. http://www.pickphoto.com. Newsletter for stock photographers; includes coverage of trends in business practices such as pricing and contract terms.

WRITER'S MARKET, Writer's Digest Books, 1507 Dana Ave., Cincinnati OH 45207. (513)531-2222. Annual directory listing markets for freelance writers. Lists names, addresses, contact people and marketing information for book publishers, magazines, greeting card companies and syndicates. Many listings also list photo needs and payment rates.

Glossary

Absolute-released images. Any images for which signed model or property releases are on file and immediately available. For working with stock photo agencies that deal with advertising agencies, corporations and other commercial clients, such images are absolutely necessary to sell usage of images. Also see Model release, Property release.

Acceptance (payment on). The buyer pays for certain rights to publish a picture at the time he accepts it, prior to its publication.

Agency promotion rights. In stock photography, these are the rights that the agency requests in order to reproduce a photographer's images in any promotional materials such as catalogs, brochures and advertising.

Agent. A person who calls upon potential buyers to present and sell existing work or obtain assignments for his client. A commission is usually charged. Such a person may also be called a *photographer's rep*.

All rights. A form of rights often confused with work for hire. Identical to a buyout, this typically applies when the client buys all rights or claim to ownership of copyright, usually for a lump sum payment. This entitles the client to unlimited, exclusive usage and usually with no further compensation to the creator. Unlike work for hire, the transfer of copyright is not permanent. A time limit can be negotiated, or the copyright ownership can run to the maximum of 35 years.

All reproduction rights. See All rights.

All subsidiary rights. See All rights.

ASMP member pricing survey. These statistics are the result of a national survey of the American Society of Media Photographers (ASMP) compiled to give an overview of various specialties comprising the photography market. Though erroneously referred to as "ASMP rates," this survey is not intended to suggest rates or to establish minimum or maximum fees.

Assignment. A definite OK to take photos for a specific client with mutual understanding as to the provisions and terms involved.

Assignment of copyright, rights. The photographer transfers claim to ownership of copyright over to another party in a written contract signed by both parties. Terms are almost always exclusive, but can be negotiated for a limited time period or as a permanent transfer.

Assign (designated recipient). A third-party person or business to which a client assigns or designates ownership of copyrights that the client purchased originally from a creator, such as a photographer.

Audiovisual. Materials such as filmstrips, motion pictures and overhead transparencies which use audio backup for visual material.

Automatic renewal clause. In contracts with stock photo agencies, this clause works on the concept that every time the photographer delivers an image, the contract is automatically renewed for a specified number of years. The drawback is that a photographer can be bound by the contract terms beyond the contract's termination and be blocked from marketing the same images to other clients for an extended period of time.

AV. See Audiovisual.

Betacam. A videotape mastering format typically used for documentary/location work. Because of its compact equipment design allowing mobility and its extremely high quality for its size, it has become an accepted standard among TV stations for news coverage.

Bimonthly. Every two months.

Biweekly. Every two weeks.

Bleed. In a mounted photograph it refers to an image that extends to the boundaries of the board.

Blurb. Written material appearing on a magazine's cover describing its contents.

Body copy. Text used in a printed ad.

Bounce light. Light that is directed away from the subject toward a reflective surface.

Bracket. To make a number of different exposures of the same subject in the same lighting conditions.

Buyout. A form of work for hire where the client buys all rights or claim to ownership of copyright, usually for a lump sum payment. Also see All rights, Work for hire.

Capabilities brochure. In advertising and design firms, this type of brochure—similar to an annual report—is a frequent request from many corporate clients. This brochure outlines for prospective clients the nature of a company's business and the range of products or services it provides.

Caption. The words printed with a photo (usually directly beneath it) describing the scene or action. Synonymous with *cutline*.

Catalog work. The design of sales catalogs is a type of print work that many art/design studios and advertising agencies do for retail clients on a regular basis. Because the emphasis in catalogs is upon selling merchandise, photography is used heavily in catalog design. Also there is a great demand for such work, so many designers, art directors and photographers consider this to be "bread and butter" work, or reliable source or income.

CD-ROM. Compact disc read-only memory; non-erasable electronic medium used for digitized image and document storage and retrieval on computers.

Cibachrome. A photo printing process that produces fade-resistant color prints directly from color slides.

Clip art. Collections of copyright-free, ready-made illustrations available in b&w and color, both line and tone, in book form or in digital form.

Clips. See Tearsheets.

CMYK. Cyan, magenta, yellow and black—refers to four-color process printing.

Collateral materials. In advertising and design work, these are any materials or methods used to communicate a client's marketing identity or promote its product or service. For instance, in corporate identity designing, everything from the company's trademark to labels and packaging to print ads and marketing brochures is often designed at the same time. In this sense, collateral design—which uses photography at least as much as straight advertising does—is not separate from advertising but supportive to an overall marketing concept.

Commission. The fee (usually a percentage of the total price received for a picture) charged by a photo agency or agent for finding a buyer and attending to the details of billing, collecting, etc.

Composition. The visual arrangement of all elements in a photograph.

Copyright. The exclusive legal right to reproduce, publish and sell the matter and form of a literary or artistic work.

C-print. Any enlargement printed from a negative. Any enlargement from a transparency is called an R-print.

Credit line. The byline of a photographer or organization that appears below or beside published photos.

Crop. To omit unnecessary parts of an image when making a print or copy negative in order to focus attention on the important part of the image.

Cutline. See Caption.

Day rate. A minimum fee which many photographers charge for a day's work, whether a full day is spent on a shoot or not. Some photographers offer a half-day rate for projects involving up to a half-day of work. This rate typically includes mark-up but not additional expenses, which are usually billed to the customer.

Demo(s). A sample reel of film or sample videocassette which includes excerpts of a filmmaker's or videographer's production work for clients.

Disclaimer. A denial of legal claim used in ads and on products.

Dry mounting. A method of mounting prints on cardboard or similar materials by means of heat, pressure, and tissue impregnated with shellac.

EFP. Abbreviation for Electronic Field Processing equipment. Trade jargon in the news/video production industry for a video recording system that is several steps above ENG in quality. Typically, this is employed when film-like sharpness and color saturation are desirable in a video format. It requires a high degree of lighting, set-up and post-production. Also see ENG.

ENG. Abbreviation for Electronic News Gathering equipment. Trade jargon in the news/video production industry for professional-quality video news cameras which can record images on videotape or transmit them by microwave to a TV station's receiver.

Exclusive property rights. A type of exclusive rights in which the client owns the physical image, such as a print, slide, film reel or videotape. A good example is when a portrait which is shot for a person to keep, while the photographer retains the copyright.

Exclusive rights. A type of rights in which the client purchases exclusive usage of the image for a negotiated time period, such as one, three or five years. Can also be permanent. Also see All rights, Work for hire.

Fee-plus basis. An arrangement whereby a photographer is given a certain fee for an assignment—plus reimbursement for travel costs, model fees, props and other related expenses incurred in filling the assignment.

First rights. The photographer gives the purchaser the right to reproduce the work for the first time. The photographer agrees not to permit any prior publication of the work for a specified amount of time.

Format. The size, shape and other traits giving identity to a periodical.

Four-color printing, four-color process. A printing process in which four primary printing inks are run in four separate passes on the press to create the visual effect of a full-color photo, as in magazines, posters and various other print media. Four separate negatives of the color photo—shot through filters—are placed identically (stripped) and exposed onto printing plates, and the images are printed from the plates in four ink colors.

Gaffer. In motion pictures, the person who is responsible for positioning and operating lighting equipment, including generators and electrical cables.

Grip. A member of a motion picture camera crew who is responsible for transporting, setting up, operating, and removing support equipment for the camera and related activities.

Holography. Recording on a photographic material the interference pattern between a direct coherent light beam and one reflected or transmitted by the subject. The resulting hologram gives the appearance of three dimensions, and, within limits, changing the viewpoint from which a hologram is observed shows the subject as seen from different angles.

In perpetuity. A term used in business contracts which means that once a photographer has sold his copyrights to a client, the client has claim to ownership of the image or images forever. Also see All rights, Work for hire.

Internegative. An intermediate image used to convert a color transparency to a b&w print.

IRC. Abbreviation for International Reply Coupon. IRCs are used instead of stamps when submitting material to foreign buyers.

Leasing. A term used in reference to the repeated selling of one-time rights to a photo; also known as *renting*.

Logo. The distinctive nameplate of a publication which appears on its cover.

Model release. Written permission to use a person's photo in publications or for commercial use.

Ms, mss. Manuscript and manuscripts, respectively. These abbreviations are used in *Photographer's Market* listings.

Multi-image. A type of slide show which uses more than one projector to create greater visual impact with the subject. In more sophisticated multi-image shows, the projectors can be programmed to run by computer for split-second timing and animated effects.

Multimedia. A generic term used by advertising, public relations and audiovisual firms to describe productions using more than one medium together—such as slides and full-motion, color video—to create a variety of visual effects. Usually such productions are used in sales meetings and similar kinds of public events.

News release. See Press release.

No right of reversion. A term in business contracts which specifies once a photographer sells his copyrights to an image or images, he has surrendered his claim to ownership. This may be unenforceable, though, in light of the 1989 Supreme Court decision on copyright law. Also see All rights, Work for hire.

NPI. An abbreviation used within listings in *Photographer's Market* that means "no payment information given." Even though we request specific dollar amounts for payment information in each listing, the information is not always provided.

Offset. A printing process using flat plates. The plate is treated to accept ink in image areas and to reject it in nonimage areas. The inking is transferred to a rubber roller and then to the paper.

One-time rights. The photographer sells the right to use a photo one time only in any medium. The rights transfer back to the photographer on his request after the photo's use.

On spec. Abbreviation for "on speculation." Also see Speculation, Assignment.

PACA. See Picture Agency Council of America.

Page rate. An arrangement in which a photographer is paid at a standard rate per page. A page consists of both illustrations and text.

Panoramic format. A camera format which creates the impression of peripheral vision for the viewer. It was first developed for use in motion pictures and later adapted to still formats. In still work, this format requires a very specialized camera and lens system.

Pans. See Panoramic format.

PICT. The saving format for bit-mapped and object-oriented images.

Picture Agency Council of America. A trade organization consisting of stock photo agency professionals established to promote fair business practices in the stock photo industry. The organization monitors its member agencies and serves as a resource for stock agencies and stock photographers.

Picture Library. See Stock photo agency.

Point-of-purchase, point-of-sale. A generic term used in the advertising industry to describe in-store marketing displays which promote a product. Typically, these colorful and highly-illustrated displays are placed near check out lanes or counters, and offer tear-off discount coupons or trial samples of the product.

P-O-P, P-O-S. See Point-of-purchase.

Portfolio. A group of photographs assembled to demonstrate a photographer's talent and abilities, often presented to buyers.

Press release. A form of publicity announcement which public relations agencies and corporate communications staff people send out to newspapers and TV stations to generate news coverage. Usually this is sent in typewritten form with accompanying photos or videotape materials. Also see Video news release.

Property release. Written permission to use a photo of private property and public or government facilities in publications or commercial use.

Publication (payment on). The buyer does not pay for rights to publish a photo until it is actually published, as opposed to payment on acceptance.

Release. See Model release, Property release.

Rep. Trade jargon for sales representative. Also see Agent.

Query. A letter of inquiry to an editor or potential buyer soliciting his interest in a possible photo assignment or photos that the photographer may already have.

Résumé. A short written account of one's career, qualifications and accomplishments.

Royalty. A percentage payment made to a photographer/filmmaker for each copy of his work sold.

R-print. Any enlargement made from a transparency. Any enlargement from a negative is called a C-print.

SAE. Self-addressed envelope. Rather than requesting a self-addressed, stamped envelope, market listings may advise sending a SAE with the proper amount of postage to guarantee safe return of sample copies.

SASE. Abbreviation for self-addressed stamped envelope. Most buyers require SASE if a photographer wishes unused photos returned to him, especially unsolicited materials.

Self-assignment. Any photography project which a photographer shoots to show his abilities to prospective clients. This can be used by beginning photographers who want to build a portfolio or by photographers wanting to make a transition into a new market.

Self-promotion piece. A printed piece which photographers use for advertising and promoting their busi-

nesses. These pieces usually use one or more examples of the photographer's best work, and are professionally designed and printed to make the best impression.

Semigloss. A paper surface with a texture between glossy and matte, but closer to glossy.

Semimonthly. Twice a month.

Serial rights. The photographer sells the right to use a photo in a periodical. Rights usually transfer back to the photographer on his request after the photo's use.

Simultaneous submissions. Submission of the same photo or group of photos to more than one potential buyer at the same time.

Speculation. The photographer takes photos on his own with no assurance that the buyer will either purchase them or reimburse his expenses in any way, as opposed to taking photos on assignment.

Stock photo agency. A business that maintains a large collection of photos which it makes available to a variety of clients such as advertising agencies, calendar firms, and periodicals. Agencies usually retain 40-60 percent of the sales price they collect, and remit the balance to the photographers whose photo rights they've sold.

Stock photography. Primarily the selling of reprint rights to existing photographs rather than shooting on assignment for a client. Some stock photos are sold outright, but most are rented for a limited time period. Individuals can market and sell stock images to individual clients from their personal inventory, or stock photo agencies can market a photographer's work for them. Many stock agencies hire photographers to shoot new work on assignment, which then becomes the inventory of the stock agency.

Stringer. A freelancer who works part-time for a newspaper, handling spot news and assignments in his area.

Stripping. A process in printing production where negatives are put together to make a composite image or prepared for making the final printing plates, especially in four-color printing work. Also see Four-color printing.

Subagent. See Subsidiary agent.

Subsidiary agent. In stock photography, this is a stock photo agent which handles marketing of stock images for a primary stock agency in certain US or foreign markets. These are usually affiliated with the primary agency by a contractual agreement rather than by direct ownership, as in the case of an agency which has its own branch offices.

SVHS. Abbreviation for Super VHS. Videotape that is a step above regular VHS tape. The number of lines of resolution in a SVHS picture is greater, thereby producing a sharper picture.

Table-top. Still-life photography; also the use of miniature props or models constructed to simulate reality.

Tabloid. A newspaper that is about half the page size of an ordinary newspaper, and which contains many photos and news in condensed form.

Tearsheet. An actual sample of a published work from a publication.

TIFF. Tagged Image File Format—a computer format used for saving or creating certain kinds of graphics.

Trade journal. A publication devoted strictly to the interests of readers involved in a specific trade or profession, such as doctors, writers, or druggists, and generally available only by subscription.

Transparency. A color film with positive image, also referred to as a slide.

Tungsten light. Artificial illumination as opposed to daylight.

U-Matic. A trade name for a particular videotape format produced by the Sony Corporation.

Unlimited use. A type of rights in which the client has total control over both how and how many times an image will be used. Also see All rights, Exclusive rights, Work for hire.

VHS. Abbreviation for Video Home System. A standard videotape format for recording consumer-quality videotape; the format most commonly used in home videocassette recording and portable camcorders.

Video news release. A videocassette recording containing a brief news segment specially prepared for broadcast on TV new programs. Usually, public relations firms hire AV firms or filmmaker/videographers to shoot and produce these recordings for publicity purposes of their clients.

Videotape. Magnetic recording tape similar to that used for recording sound, but which also records moving images, especially for broadcast on television.

Videowall. An elaborate installation of computer-controlled television screens in which several screens create a much larger moving image. For example, with eight screens, each of the screens may hold a portion of a larger scene, or two images can be shown side by side, or one image can be set in the middle of a surrounding image.

VNR. See Video news release.

White Paper. An article on a specific subject that, once written, is considered an industry standard.

Work for hire, Work made for hire. Any work that is assigned by an employer and the employer becomes the owner of the copyright. Copyright law clearly defines the types of photography which come under the work-for-hire definition. An employer can claim ownership to the copyright only in cases where the photographer is a fulltime staff person for the employer or in special cases where the photographer negotiates and assigns ownership of the copyright in writing to the employer for a limited time period. Stock images cannot be purchased under work-for-hire terms.

World rights. A type of rights in which the client buys usage of an image in the international marketplace. Also see All rights.

Worldwide exclusive rights. A form of world rights in which the client buys exclusive usage of an image in the international marketplace. Also see All rights.

Zone System. A system of exposure which allows the photographer to previsualize the print, based on a gray scale containing nine zones. Many workshops offer classes in Zone System.

Zoom lens. A type of lens with a range of various focal lengths.

Digital Markets Index

The growth in computer technology has created a need among buyers for digitally stored images. The trend is easy to spot by the number of markets in this book that list website addresses. This index contains those companies that have shown an interest in working with freelancers who can supply photos on CD-ROM, computer disk or via online services. An asterisk (*) before a listing in this index signifies that the market is new.

Subject Index

This index can help you find editors who are searching for the kinds of images you are producing. Consisting of markets from the Publications section, this index is broken down into 24 different subjects. If, for example, you shoot sports photos and want to find out which publishers purchase sports material, turn to that category in this index. An asterisk (*) before a listing in this index signifies that the market is new.

Animals

Celebrities

Documentary/ Journalistic

Entertainment

Erotica/Nudity

Fashion

Food

GET YOUR WORK INTO THE RIGHT BUYERS' HANDS!

You work hard... and your hard work deserves to be seen by the right buyers. But with the constant changes in the industry, it's not always easy to know who those buyers are. That's why you'll want to keep up-to-date and on top with the most current edition of this indispensable market guide.

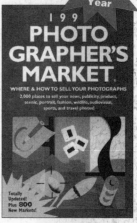

Totally Updated Each Year

Keep ahead of the changes by ordering *1998 Photographer's Market* today. You'll save the frustration of getting photographs returned in the mail, stamped MOVED: ADDRESS UNKNOWN. And of NOT submitting your work to new listings because you don't know they exist. All you have to do to order the upcoming 1998 edition is complete the attached order card and return it with your payment or credit card information. Order now and you'll get the 1998 edition at the 1997 price—just $23.99—no matter how much the regular price may increase! *1998 Photographer's Market* will be published and ready for shipment in September 1997.

Keep on top of the fast-changing industry and get a jump on selling your work with help from the *1998 Photographer's Market*. Order today! You deserve it!

Turn over for more books to help you sell your photos →

More Great Books To Help You Sell What You Shoot!

NEW!

Techniques of Natural Light Photography
Explore the photographic possibilities in all kinds of natural lighting situations—complete with stunning 4-color photos, captions explaining conditions, camera settings, film specifications and more.
#10471/$27.99/144 pages/paperback

Revised Edition!

How to Shoot Stock Photos That Sell
This new, expanded edition shows you how to capture the terrific shots of subjects other shutterbugs ignore—but stock photo houses clamor for. You'll also find up-to-date information on marketing, pricing, copyrights and more.
#10477/$19.95/208 pages/paperback

The Professional Photographer's Guide to Shooting & Selling Nature and Wildlife Photos
Discover outstanding secrets to capturing the wonder of nature in photos. Plus, get priceless advice on marketing your shots.
#10227/$24.99/134 pages/paperback

Location Photography Secrets: How To Get the Right Shot Every Time
With this problems/solutions manual you'll turn adversity to your advantage and get the shots you want! You'll learn to conquer technical challenges using lenses, creative composition, filters, lighting techniques and more!
#10416/$26.99/144 pages/paperback

Essential!

Professional Photographer's Survival Guide
Discover everything you need to know about making it in the photography business. You'll learn how to make the crucial first sale, how to earn the most from your photographs, and more!
#10327/$17.99/368 pages/paperback

Stock Photography: The Complete Guide
Let highly successful photographers, Ann and Carl Purcell, show you what to shoot, how to organize your photos, how to present your work and make the sale, and more.
#10359/$19.95/144 pages/paperback

A Guide to Travel Writing & Photography
Travel the world and get paid for it! Learn where to go, what to write and shoot, and how to sell it with this expert advice.
#10228/$22.95/144 pages/paperback

Lighting Secrets for the Professional Photographer
Explore new approaches to lighting. You'll learn special lighting tricks and techniques for shooting common and difficult subjects.
#10193/$26.99/144 pages/paperback

Order these helpful guides from your local bookstore, or use the handy order form on the reverse.

Health

History

Humor

Memorabilia/ Hobbies

Outdoors/ Environmental

People

Political

Portraits

Product Shots/ Still Lifes

Religious

Science

Sports

General Index

You'll notice as you flip through this index that more than 400 asterisks (*) appear. This symbol appears for the first time in the index and it denotes markets that are new to this edition. Also for the first time, we list companies that appeared in the 1996 edition of *Photographer's Market*, but do not appear this year. Instead of page numbers beside these markets you will find two-letter codes in parentheses that explain why these markets no longer appear. The codes are: **(ED)**—Editorial Decision, **(NS)**—Not Accepting Submissions, **(NR)**—No (or late) Response to Listing Request, **(OB)**—Out of Business, **(RR)**—Removed by Market's Request, **(UC)**—Unable to Contact, **(UF)**—Uncertain Future.

T

More Great Books to Help You Sell What You Shoot!

Techniques of Natural Light Photography—Capture magnificent images as you learn to read the light in all situations! With the guidance of renowned photographer, Jim Zuckerman, you'll learn how to shoot in virtually any kind of natural light—from clear sky to clouds, from snow to industrial haze. *#10471/$27.99/144 pages/150 color illus./paperback*

How to Shoot Stock Photos That Sell, Revised Edition—Get terrific shots of the subjects that stock photo houses clamor for! You'll discover 35 step-by-step assignments on how to shoot for these markets, including stock ideas that photographers haven't thought of, those that were tried but in the wrong style, and those for which there is never enough coverage. *#10477/$19.95/208 pages/20 b&w illus./paperback*

Professional Photographer's Survival Guide—Earn the most from your photographs! This one-of-a-kind book guides you through making your first sale to establishing yourself in a well-paying career. *#10327/$17.99/368 pages/paperback*

The Professional Photographer's Guide to Shooting & Selling Nature & Wildlife Photos—This all-in-one guide shows you the ins and outs of capturing the wonder of nature in photos. Plus, you'll get great advice on how to market your work. *#10227/$24.99/134 pages/250 color photos/paperback*

How You Can Make $25,000 a Year With Your Camera—This one-of-a-kind guide shows you how to uncover photo opportunities in your own community! You'll get special sections on pricing and negotiating rights, as well as boudoir photography. *#10211/$14.99/224 pages/46 b&w illus./paperback*

Outstanding Special Effects Photography on a Limited Budget—Create eye-popping effects—without busting the bank! Dozens of tips and techniques will show you how to make the most of your equipment—and how to market your dazzling shots. *#10375/$24.95/144 pages/175+ color photos/paperback*

Lighting Secrets for the Professional Photographer—Don't be left in the dark! This problems-solutions approach gives you everything you need to know about special lighting tricks and techniques. *#10193/$26.99/134 pages/300 color illus./paperback*

Handtinting Photographs—Learn how to use handtinting to reveal detail and change emphasis. You'll discover information on materials, techniques and special effects. *#30148/$32.99/160 pages/color throughout*

Creative Techniques for Photographing Children—Capture the innocence and charm of children in beautiful portraits and candid shots. Professionals and parents alike will create delightful photos with dozens of handy hints and loads of advice. *#10358/$26.99/144 pages/paperback*

Stock Photography: The Complete Guide—Discover how to break into this very lucrative market! Two highly successful photographers show you what to shoot, how to organize your pictures, how to make the sale and more! *#10359/$19.95/144 pages/paperback*

Location Photography Secrets: How to Get the Right Shot Every Time—This problem-solution manual helps you overcome the many problems you may encounter while shooting on location. You'll find solutions using lenses, creative composition, filters, lighting techniques and much more. *#10416/$26.99/144 pages/150 color illus./paperback*

A Guide to Travel Writing & Photography—This book introduces you to the colorful and appealing opportunities that allow you to explore your interest in travel while making a living. *#10228/$22.95/144 pages/80 color photos/paperback*